The Dictionary of

SCULPTORS IN BRONZE

James Mackay

ANTIQUE COLLECTORS' CLUB

ISBN 1 85149 110 4

Published for the Antique Collectors' Club
by the Antique Collectors' Club Ltd.

Printed in England by Antique Collectors' Club Ltd.
Church Street, Woodbridge, Suffolk.

For Reni and Derek

The Antique Collectors' Club

The Antique Collectors' Club was formed in 1966 and now has a five figure membership spread throughout the world. It publishes the only independently run monthly antiques magazine *Antique Collecting* which caters for those collectors who are interested in widening their knowledge of antiques, both by greater awareness of quality and by discussion of the factors which influence the price that is likely to be asked. The Antique Collectors' Club pioneered the provision of information on prices for collectors and the magazine still leads in the provision of detailed articles on a variety of subjects.

It was in response to the enormous demand for information on "what to pay" that the price guide series was introduced in 1968 with the first edition of *The Price Guide to Antique Furniture* (completely revised, 1978 and 1989), a book which broke new ground by illustrating the more common types of antique furniture, the sort that collectors could buy in shops and at auctions rather than the rare museum pieces which had previously been used (and still to a large extent are used) to make up the limited amount of illustrations in books published by commercial publishers. Many other price guides have followed, all copiously illustrated, and greatly appreciated by collectors for the valuable information they contain, quite apart from prices. The Antique Collectors' Club also publishes other books on antiques, including horology and art reference works, and a full book list is available.

Club membership, which is open to all collectors, costs £17.50 per annum. Members receive free of charge *Antique Collecting,* the Club's magazine (published ten times a year), which contains well-illustrated articles dealing with the practical aspects of collecting not normally dealt with by magazines. Prices, features of value, investment potential, fakes and forgeries are all given prominence in the magazine.

Among other facilities available to members are private buying and selling facilities, the longest list of "For Sales" of any antiques magazine, an annual ceramics conference and the opportunity to meet other collectors at their local antique collectors' clubs. There are over eighty in Britain and more than a dozen overseas. Members may also buy the Club's publications at special pre-publication prices.

As its motto implies, the Club is an amateur organisation designed to help collectors get the most out of their hobby: it is informal and friendly and gives enormous enjoyment to all concerned.

For Collectors — By Collectors — About Collecting

The Antique Collectors' Club, 5 Church Street, Woodbridge, Suffolk

CONTENTS

AUTHOR'S PREFACE

The primary purpose of this dictionary is to enable the collector, dealer and student to identify bronzes that bear a signature. For this reason I have cast the net rather wider than was strictly necessary, since there is a large and ill-defined area of activity, in which sculptors better known for their direct-carving *may* also have modelled in clay or wax and such preliminary models and studies may have subsequently been cast in bronze. For various, often hypothetical, reasons it is impossible to be dogmatic about a sculptor and to say categorically that he or she never produced a bronze; and thus it has been deemed wiser to give them the benefit of the doubt and include their biographical details. This problem is particularly acute in the case of the vast army of decorative sculptors of the eighteenth and nineteenth centuries whose profession consisted largely of carving stone façades, bas-reliefs and friezes for civic adornment, but who often eked out a precarious existence by modelling portrait busts of their contemporaries, or sculpted small ornamental figures and groups for commercial casting in bronze, brass, pewter or spelter.

The period covered by this dictionary is purely arbitrary, from the beginning of the eighteenth century to about 1960. A number of sculptors, mostly of the French and Italian schools, who were active in this medium in the second half of the seventeenth century, are included if their careers continued into the eighteenth. At the other end of the time-scale, however, it was felt advisable to have a cut-off date at 1960. Twentieth century sculptors who are still active are listed. Broadly speaking, the criterion here is that artists who completed their training in the 1950s and had embarked on their careers before 1960 have merited an entry. Regrettably, this excludes many promising young sculptors of the present day, such as Jonathan Kenworthy and Lorne McKeen whose bronzes are very fashionable at this moment, but it is hoped that, as and when later editions of this book are produced, the date criterion may be adjusted accordingly.

The designation 'Western' I have interpreted loosely to include sculptors working in Europe and the more Europeanised parts of the world, such as America and Australasia. Oriental sculptors are included in such cases where their training, environment and sculptural styles have been in the western idiom.

Where possible, each entry gives the sculptor's dates of birth and death, or at least the period in which he or she flourished. Details of training are often useful as giving some indication of a sculptor's style and the masters who influenced its development. Information on exhibitions and galleries in which the artist has participated, like the medals and prizes awarded, may be less useful in gauging the sculptor's true worth, but at least they give some inkling as to his standing in the contemporary artistic world and for this reason they are given in some detail. Tendencies and specialities are noted, together with the titles of individual works, and museums and other institutional collections preserving these works are listed on the grounds that they are an invaluable source for study and comparison of individual pieces.

A select bibliography is given at the end of the dictionary; biographies of individual artists, or catalogues of their works, are listed at the end of the appropriate entry.

This dictionary is the fruit of a twelve-year study of the subject. All the major secondary works, such as Bénézit, Gunnis and Thieme-Becker, were combed thoroughly as a preliminary exercise. Sale catalogues of the major London and continental auction houses have been consulted over a thirty-year period, and the art and antique journals of the past eighty years have been perused. Catalogues and guides to important exhibitions, from the Great Exhibition of 1851 onwards, have proved a fertile source of information on many of the more obscure sculptors. An undertaking of this nature has inevitably involved a considerable amount of leg-work; most of the museums and art galleries in the British Isles and many of the major institutions of Europe have been visited by the author personally in the past decade. This labour of love, however, has had many rewards, such as the rescue from oblivion of competent artists hitherto unrecorded in Bénézit. Bronze-hunting has not been confined to Europe by any means and the writer recalls the pleasure of finding old favourites, like Rosa Bonheur's Reclining Ewe and Grazing Ewe, in Wanganui, New Zealand, of all places!

The compilation of a work such as this, however, is open-ended and hitherto unknown sculptors of bronzes were being discovered even as the book was going through the press. The author would be grateful for any information which complements that given in the dictionary, in particular the names of sculptors of bronzes not already listed. It is hoped to publish such data as a supplement to this volume.

INTRODUCTION AND PRICE GUIDE TO BRONZES

The unusual — one might almost say anomalous — position of bronzes in regard to the fine arts presents enormous problems for any accurate assessment of value. In this respect a bronze is more akin to a print than an oil-painting, in that much may depend on the interpretation and amount of after-work applied to the artist's original. Very few bronzes may be said to be entirely 'autograph' — the work of the original artist who not only modelled it in clay or wax but produced the moulds, cast the bronze, chiselled off the flashing, runners and risers and attended to the minor details of the surface before applying the patination. In most cases the artist's involvement in the work ceases with the completion of the clay or wax original and the success (or otherwise) of the eventual bronze depends on the care and skill of the bronze-founder and his staff of mould-makers, chisellers, finishers and patinators. The various factors which have to be taken into consideration are enumerated below.

Methods of Casting

The oldest method is that known as the *cire perdue* (lost wax) process, in which the mould was formed over a wax model which was then melted out to leave the hollow space for the molten bronze to be run in. Variations of this process are known to have been practised in Mesopotamia, Egypt and China many centuries before the Christian era. In its simplest form the process involved a solid model of wax which, when melted out of the surrounding mould (baked in fire-clay) left a space which could be filled entirely by molten bronze, resulting in a solid cast. This method was wasteful in that it required a comparatively large amount of bronze. A refinement of this process was the use of a fire-clay core roughly modelled in the shape desired for the finished object. Over this was placed a skin of wax of sufficient thickness to permit the sculptor to model the required detail. The mould was then formed over the model in the usual way. Molten bronze could then be poured into the mould, occupying the space between the core and the mould in order to produce a cast which would be hollow inside. The disadvantage of this method was that the mould and the inner core then had to be broken away from the cast. The first two methods in the *cire perdue* category thus involved the loss of the original model and could be used only in the production of single casts.

The Greeks devised a third method by which the mould was formed over the original model and then carefully removed. A coating of wax then lined the inside of the mould and on to this was poured an inner core of refractory material. Subsequently the wax was melted out and bronze poured into the intervening space. The mould and core had to be chipped away, as in the previous method, but the original model was preserved and could be used again and again in the production of further moulds. This was the basic process adopted for the casting of bronzes from the classical period right down to the early part of the nineteenth century. *Cire perdue* continues to be employed to this day for the casting of bronzes in limited editions, usually in such cases where a maximum of ten or eleven casts is desired.

Sand-casting, a technique which involved boxes containing fine sand as the moulding agent, has been used for the production of flat objects. This process was favoured in the manufacture of mirrors, knives and sword blades during the Bronze

Age and was suited to the production of basically two-dimensional objects. This ancient technique was applied to sculpture in the round by the ingenious use of piece-moulds and half-moulds. Instead of producing a single mould, as in the *cire perdue* process, a series of part-moulds was made from the original and these were used in sand-boxes to produce casts which could then be assembled. Such sand-casts have tell-tale seam-lines, though skilful after-work often reduced their presence to a bare minimum. As more accurate mechanical processes were evolved in the late eighteenth century, the production of small bronzes by sand-casting was greatly improved and speeded up and this method rapidly undercut the more traditional *cire perdue* process. Generally speaking, bronzes cast in this way lack the very fine, crisp detail of *cire perdue* casts, but it is dangerous to generalise, since much may depend on the skill and degree of after-work.

Variations on the piece-mould technique are still used, though many mechanical refinements have further removed the human element from production. In recent years cold-casting, using compounds of epoxy-resin and metal powders, has greatly reduced the cost of production. Superficially cold-cast bronzes may be similar to the traditional hot-metal casts but they are technically inferior and it must be a matter of conjecture to what extent they will supplant the age-old methods and alloys.

The application of electrolysis to bronze production in the mid-nineteenth century gave rise to mass-produced articles, using techniques variously known as galvano-plasty and electro-typing. 'Bronzes' produced by this means are light, have a very 'tinny' ring when knocked, have a generally smooth surface and lack the convincing details of genuine cast bronzes. They were produced by the hundred thousand to satisfy the mass-market of the nineteenth and early twentieth centuries for something which looked like a bronze. By means of this technique, Coustou's spirited Marly horses were reduced to a banal form of kitsch. No collector of bronzes would, of course, be taken in by these electrotypes for a single moment.

After-work

The newly cast bronze, fresh from the bronze-founder's furnace, is a sad-looking thing, festooned with rods and runners, crusted with flashing, its surface flawed and blemished by impurities and pieces of refractory material. All of these excrescences and blemishes have to be sawn, filed and chiselled off and roughness and imperfections removed by chasing. It is not surprising that the *ciseleur*, or chiseller, was as important a craftsman in his own right as the *fondeur* — an artist who could transform an indifferently cast bronze into a true work of art by the deft use of his chisels, files and graving tools. The dividing line between the sculptor and the goldsmith is extremely fine and it is sometimes difficult to say at what point a bronze ceases to be true sculpture and becomes an example of the goldsmith's art. In extreme cases the bronze may be little more than the vehicle for the gilder, the enameller, the lacquerer and the jeweller to practise their arts. Throughout the eighteenth century, and fitfully thereafter, there have been periodic fashions for exotically decorated bronzes. Enamelling, engraving and inlaying of bronzes with precious metals, jewels, ivory and other substances, have been fashionable from the Baroque to the Art Deco and provide many instances where the finished article bears little resemblance to the work as originally conceived by the sculptor.

The commonest form of decoration applied to a bronze after casting and chasing is gilding. This practice was popular in the first half of the period covered by this book. Powdered gold mixed with mercury formed a pasty amalgam which was painted over the finished bronze. Since mercury becomes gasified at a temperature of 357$^\mathrm{o}$ Centigrade, the application of great heat to the bronze drove off the

mercury leaving an even deposit of gold on the surface of the bronze. Apart from the high cost of the materials used this process was dangerous to the craftsmen, who invariably suffered mercuric poisoning if subjected to it for any length of time. Under the name of ormolu (*doré d'or moulu*) this form of bronze gilding was fashionable in France particularly during the eighteenth century. Various cheap (and less harmful) substitutes have been used for ormolu but unlike those with a true gold foundation they tarnish readily and flake off, exposing the bronze beneath. Where gilding is present on a bronze the condition of this decoration may greatly affect the value of the piece. True ormolu may not enhance the value of a bronze, in comparison with a bronze which is similar but not gilded. Imitation ormolu, on the other hand, will detract from the value of a bronze, particularly if it is not in pristine condition. Where the original gilding has been damaged it may be quite legitimate to restore it to its original condition, but attempts to patch it with some more *ersatz* material are little short of vandalistic. In purchasing gilt bronzes expert advice should be sought first.

Patination

All bronze tarnishes to some degree in the atmosphere but in the majority of cases surface corrosion is not harmful and, in fact, serves to protect the bronze from further rusting. Copper being the predominant element in bronze, it is in the form of one of the copper oxides that this tarnish manifests itself. Everyone is familiar with the brilliant golden red lustre of a bright new penny. This is the appearance of newly cast bronze, sometimes described as 'fire-gilt'. On exposure to the atmosphere this lustre dims and turns to darker shades, ranging from the reddish brown to dark sepia — the shades of the copper alloy known as cuprite. Other oxides are malachite (green) and asurite (blue) while copper sulphate is commonly found and is recognisable by its brilliant shades of green. Bronzes which have lain in the ground tend to tarnish more readily but exhibit a wider range of coloration from the salts and elements found in the soil of different localities. Prolonged immersion in water results in an olive-green patination of a remarkable smoothness. Patina, as this protective tarnish is called, has long been recognised not only for its protective powers but also for its aesthetic qualities and consequently is often deliberately contrived by subjecting the bronze to various chemical and physical agents. Pickling or curing best describe the commonest methods — dipping the bronze in various chemical solutions or exposing it to smoke created by burning certain types of wood or old leather.

Alternatively the surface may be protected by varnish and, again, different effects can be achieved by using different colours and substances, ranging from a light neutral varnish to the deep rich black lacquer which was favoured by Riccio and the sixteenth century Paduan School. Such varnishes may be evenly distributed but more often than not they will be found to have flaked in parts. This need not necessarily detract from the value of a bronze and, indeed, the combination of the varnish or lacquer with the patination of the exposed bronze may be quite attractive. Several sculptors in modern times have experimented with variegated patination, with contrasting browns, reds, greens and blues, adding, in a sense, a new dimension to their work.

Signatures and Stamps

Herein lie many of the greatest pitfalls that beset the collector since it is undeniable that the presence of a signature can enormously enhance the interest and value of a bronze. Unfortunately the practice of signing their work varies considerably, not only from one sculptor to another, but even within the working

life of the same artist. Antoine-Louis Barye, for example, executed his name simply as BARYE in neat capitals, rarely with the initials A-L preceding. In addition, however, he sometimes added a stamped name, with or without a serial number, and conversely there are many works whose provenance establishes them as by his hand, which have no signature or stamp at all. When such perplexities exist for a sculptor whose work invariably commands a high price, it can be imagined how much more complex the situation becomes in the case of the myriads of lesser artists about whose work we know relatively little even now. Erasures, changes of initials (where two sculptors shared the same surname) and outright substitutions of names of fashionable artists are not unknown, but the commonest problem is the addition of a name to a genuinely unsigned bronze. As this is invariably done by engraving or incising the lettering into a finished cast a careful examination of the signature with a powerful magnifier will often reveal tell-tale ridges and too-sharp edges. This is absent from casts taken from a signed model.

Almost as important as the sculptor's signature is the mark of the bronze-founder. In the case of the more reputable companies this is almost a mark of guarantee. On their own, bronze-founders' stamps may not seem very significant, but taken in conjunction with the artists' signatures they can assume major importance and help to prove or disprove the authenticity of a bronze. Unfortunately the history of the various bronze-founders has never been fully explored and much remains to be unravelled concerning their activities. The same applies to the numbering of casts, since the vast majority of bronzes were issued unnumbered. As a rule the presence of a number on its own or expressed as a fraction of some other figure, indicates a limited edition, probably *cire perdue*, and thus likely to be of some considerable value. But there is no hard and fast rule and numbers, like signatures, can all too easily be faked. To keep matters in perspective, moreover, it should be remembered that a great many indifferent bronzes of the late nineteenth and early twentieth centuries are either unique casts or exist in editions of no more than two or three, since their sculptors could not afford to have them cast in more commercial quantities. The number of bronzes in an edition is therefore not necessarily the most important criterion of likely value.

Casts

Dealing as we are with objects which are usually only indirectly connected with their creator, much will depend on the type of cast and the circumstances surrounding it. The most desirable cast might be one taken from the wax or clay original by the sculptor himself, chased, chiselled and patinated by the sculptor without outside assistance; in other words, a truly 'autograph' bronze. It is not inconceivable that casts might exist of the same sculpture by both *cire perdue* and sand-cast methods. Each *cire perdue* cast might differ from its fellows, depending on the amount of after-work lavished on them, and there would be fundamental differences between the *cire perdue* and sand-cast bronzes. A popular sculpture might be the subject of casts made over a lengthy period of years, during which time progressive deterioration of the original moulds might be evident and would be reflected in the quality of the casts. This, in turn, might entail a greater amount of after-work on each successive cast and this, too, would materially affect the end-product. Then there are posthumous casts from original models and moulds which have been preserved by bronze-founders long after the sculptor's death. Casts from worn-out models may be heavily reworked and eventually bear little resemblance to the original; and then there are casts from moulds taken from an actual bronze. Because of shrinkage during the making of the moulds, the resultant

bronzes will be appreciably smaller than the original, and usually the finer detail of the original will have been lost. Yet all these variants, including out-and-out replicas, may be found with the signature of the sculptor 'in all good faith'. It is well, therefore, to appreciate that a signature is not everything, but attention to the quality of casting and after-work is more important.

Other Metals

Although bronze was the traditional metal for casting sculpture, other metals may frequently be met with. The most popular nineteenth century substitute was spelter, an alloy of zinc and lead, used extensively in Germany at the turn of the century. Though having a brilliant silvery appearance when new, it patinated badly and had a dull, leaden appearance. Collectors should be on their guard against small figures in this alloy which have been given a bronzed surface, a technique devised by a German scientist named Geiss. Various brass alloys have also been used from time to time but they were generally confined to vulgar imitations of famous subjects, and are unlikely to confuse the collector. Various versions of well-known figures, both Romantic and Animalier subjects of the mid-nineteenth century, were also cast in iron and these are not without considerable interest in their own right. Lead was favoured for garden statuary, and continued to be used in the lean years of the eighteenth century when the vogue for small decorative bronzes was at a low ebb. Aluminium, prized at first for its curiosity value, was employed in sculpture rather fleetingly in the second half of the nineteenth century, the statue of Eros in Piccadilly, London, being a notable example, and only became fashionable as a medium for small decorative pieces in the Art Deco period, It should be noted that the same subject may be found in various materials. Thus a clay model for a large work, later carved direct in marble or stone, may be cast in bronze or some other metal, or may be produced commercially in terra cotta or porcelain. Or the order may be reversed, and a large piece of statuary carved direct may be the subject of a reduction using the ingenious machine patented by A. Collas in the 1830s, and edited as a small decorative bronze. Many of the small *bronzes d'ameublement* so fashionable in the nineteenth century were merely commercially edited and reduced versions of much larger works, whose original sculptor had conceived them on a grand scale and never intended them for the confines of study or drawing room. Thus the grandiose works of Coustou and Bouchardon might re-emerge, as *bronzes d'éditions*, more than a century after they originally saw the light of day. These small bronzes, therefore, must be judged on their own merits, and not lean too heavily on the reputations of the Great Masters from whom they ultimately sprang.

Market Values

The price of bronzes depends so much on the whims and caprices of fashion, but general awareness of the interest and potential value of bronzes as a whole means that there are no longer the sadly neglected areas and unconsidered fields of a few years ago. Such is the scarcity of any half-decent bronzes these days that even quite nondescript pieces frequently fetch hefty sums — especially in country auctions, where this writer has witnessed unsigned commercial bronzes of the mid-nineteenth century, which a few years ago would have fetched no more than their scrap value in shillings, now go for as many pounds. We have reached a point where the most self-effacing nymphs and cupids and anonymous classical deities are in the price range £25-£60 and £50-£120 for matched pairs, with larger pieces (8-12 inches) in the range £120-£300.

Neo-classical bronzes in the form of applied art, such as inkstands and candelabra, start about £300 and may rise to £1,250, or more if there are special features. Full-sized bronzes, standing several feet high, are in the range £3,500-£12,000. Those bearing the

authentic signature of a minor artist of the eighteenth and early nineteenth centuries, may range from £150-£750, depending on the quality of the cast and the attractiveness of the subject. Medium-sized works 'after' famous artists of the period range from £600 for an average Canova to over £8,000; and bronzes by major nineteenth century artists could be in the range £1,000-£15,000.

The Romantic bronzes of the nineteenth and early twentieth centuries have been the subject of renewed interest in recent years and prices have hardened appreciably as a result. At the lower end of the scale are the statuettes of females at work and play, in native costume and illustrating the peasant life of Europe. Reasonable examples start around £80 and go up to about £350; but where the subject is of unusual interest (native costume or customs) the price may go as high as £1,200. Genre groups and narrative subjects range from £100 to £1,800, depending on the quality of the composition and the artistry of the group. Signed bronzes range from £450 to £1,500 for minor artists and £1,000-£15,000 for the more fashionable sculptors.

The Animalier School has been well documented for a number of years now, and a systematic analysis of prices for individual artists and subjects is given in *Bronze Sculpture of Les Animaliers Reference and Price Guide* by Jane Horswell. Supplementing the guidance given therein, it should be noted that unsigned and unattributed animal figures also have a certain value. Single horses are generally worth from £150 to £600, matched pairs from £300-£1,200 and hunting subjects from £350-£1,500. Domestic and farmyard animals are less sought after and range from as little as £25 for a single item to £200 for groups. Bronzes by the American Animaliers are highly prized nowadays, top prices being for Western groups by Frederic Remington (£2,000-£7,500), Charles Russell (£1,000-£3,500) and Cyrus Dallin (£750-£2,000). Animal figures by less fashionable artists are generally in the range from £450-£1,750 but there are many early twentieth century examples by little known artists of the Middle and Far West which can still be picked up for under £200. Among European Animaliers the top names include Lanceray, Gaul, Sintenis, Gornik, Kauba, Liberich, Tuaillon and Vierthaler; bronzes by these artists have now been known to pass the £4,000-mark and even average casts of small items would be in the range from £600-£1,200.

Because of the immense popularity of Art Nouveau in general it is hardly surprising that bronzes in this distinctive style now command a very high premium. At the top of the scale come the figures and busts of dreamy-eyed females by Alfons Mucha, now in the range from £5,000-£28,000. Other artists in this genre whose idealised female beauties are in the range from £3,000-£7,500 include Gurschner and Larche. Art Nouveau bronzes by lesser artists range from £200-£2,000, enamelling, gilding, lacquering and jewelled decoration being major plus factors. Unsigned bronzes with the inimitable characteristics of Art Nouveau range from £75-£600 for busts, £250-£750 for figurines, and £100-£400 for animal groups. Fine examples of table lamps, inkstands and other useful articles incorporating bronze figures range from £100-£1,000, depending on size and complexity.

The bronzes of the Art Deco period present many problems, since quality and composition vary enormously. The best bronzes redolent of the Jazz Age are now approaching the £5,000-mark, and this also applies to chryselephantine bronzes by the more 'established' names, such as Preiss, Chiparus, Zack and Rivoire, whose larger and more impressive works are now in the range from £2,000-£7,000. Lesser artists, such as Colinet, Etling, Jaeger and Fayral, have not caught the attention of collectors to the same extent and their bronze and ivory confections are generally in the range from £250-£1,000. The absence of an identifiable signature, however, need not detract from the desirability of a particularly fine bronze of this type, since anonymous examples have been known to fetch £1,000-£2,500, and this applies especially to those groups of haughty females accompanied by dogs and horses.

Works by the great *maestros* of modern sculpture, from Maillol, Rodin, Degas and Bourdelle onwards, have long been the subject of astronomic bidding in the salerooms. Even the smallest and least significant of their bronzes would now be far in excess of £3,000 and five- and six-figure sums are not uncommon. The same also applies to bronzes by the leading figures of Cubism and the other modern movements which developed in the generation after Rodin. The works of Picasso, Braque, Matisse, Rosso, Marini, Richier, Moore, Hepworth, Arp, Archipenko, Zadkine and Zwobada would now be in the range from £8,000-£80,000, with outstanding examples commanding even higher sums. There are many sculptors in the second rank whose bronzes, both figurative and abstract, are probably still a good buy in the range from £2,500 to £12,000; but it should be borne in mind that because of the cost of labour and materials alone it would be impossible to secure any work by a modern artist, cast in the traditional *cire perdue* process, for less than £800. A curious exception to this is portrait busts and heads. Many such works are of prime importance only to the sitters. Portraiture is the bread and butter work of modern sculpture and no matter how worthy the subject or competent the artist, the interest in these bronzes does tend to be transient. Even so, one should expect to pay £120 to £300 for such busts. Commercially cast busts of contemporary celebrities were very fashionable in the second half of the nineteenth century. The sitter may be instantly recognisable but many of these portraits are unsigned and were virtually mass-produced. They range from a mere £35 for small nondescript busts of Napoleon (a perennial favourite) to £300 for detailed and flamboyant busts of the German Kaisers. Queen Victoria and King Edward VII occupy a midway position, but there is seemingly little market at present for busts of political figures such as Disraeli and Gladstone.

If there could be said to be any area of the market which is relatively unconsidered and undervalued at present it would be the two-dimensional bronze. This includes bas-reliefs, plaques, roundels and medallions, both portraits and allegorical subjects, which have never captured the imagination of the collector in the same manner or extent as sculpture in the round. The medallions of David d'Angers are now over the £250-mark, but many other medallists of the nineteenth and earlier twentieth centuries are relatively neglected. Plaques and medals in bronze by Dubois, Legros, Spicer-Simpson, De Saulles, Gray, Laura Fraser, Paul Manship and Bessie Potter Vonnoh can still be picked up for £50 or less, and there are countless examples of small medallions and plaquettes by obscure or unknown artists in the £10-£40 range which might repay further study.

AALTONEN, Waino fl. 20th century
Born in Finland, he worked in Helsinki during the early part of the 20th century. He is best known for his statue of the Finnish athlete, Paavo Nurmi, erected in Helsinki following his Olympic victories which earned Nurmi the nickname of the Flying Finn. Bronzes by Aaltonen consist mainly of human figures combining classical Greek and modern Scandinavian influences, as exemplified by his group Goddess of Victory bestowing a wreath on Youth.

AARONS, George fl. 20th century
Sculptor of nude figures and reliefs, working in the United States in the first half of this century.

AARTS, A. fl. 19th-20th century
Belgian sculptor working at the turn of the century and a pioneer of bronze and ivory figures. He exhibited a head of a smiling infant at the Brussels Exposition of 1897.

ABART, Franz 1769-1863
Born at Schlining in Switzerland on December 22, 1769, he died at Kerns, Unterwalden, on September 10, 1863. He studied under Mathias Punt in his native town and subsequently worked in Strasbourg. On his return to Switzerland he settled in Lucerne where he won a high reputation for his religious sculpture. He specialised in crucifixes, many of which still adorn Swiss churches. He married the daughter of a high official in Kerns. He took part in the Berne exhibitions of 1804 and 1810 and this established him in the front rank of Swiss artists. Many of his smaller figures and groups were purchased by collectors in France, Germany and Britain. His best-known works include Mater Dolorosa, The Three Graces (1812) and the Berne Bear (1828). His secular works consist mainly of athletic and pastoral subjects, such as wrestlers and shepherds.

ABARY, Marie Mathilde fl. late 19th century
Born in Paris in the second half of the 19th century, she studied painting under Chaplin, Jacquet and Buttin and sculpture under Madame Berteaux. She exhibited at the Salon from 1880 to 1892 and specialised in medallions and portrait reliefs.

ABBAL, André 1876-
Born at Montech (Tarn et Garonne) on November 16, 1876, the son and grandson of sculptors who were his teachers. He went to Paris and enrolled at the École des Beaux Arts where he studied under Falguière and Mercié. At the age of twenty he exhibited at the Salon des Artistes Français and participated in these exhibitions from then until 1914, winning a third class medal in 1900 for a bas-relief of Labour. Subsequent awards included a second class medal in 1907. After service in the first world war he took part in the exhibition of combatant artists and also participated in the Salon d'Automne until 1922 when he became a member of the Jury. He was awarded the Légion d'Honneur in 1933 and a Grand Prix at the Exposition Internationale in 1937. Most of his work was executed in sandstone and granite and he specialised in public busts and statues for public buildings, large reliefs and architectural sculpture, but some of his smaller works, such as the portrait busts and reliefs of contemporary political figures, were subsequently cast in bronze.

ABBATE, Paolo Salvatore 1884-
Born in Villarosa, Italy in 1884, he began his artistic studies there before emigrating to the United States. Works include monuments in stone and figures and busts in terra cotta.

ABBOTT, Miss D. fl. late 19th century
English sculptress of the late 19th century, known to have been working in London in 1886-88 when she exhibited two figures at the Royal Academy.

ABBOTT, George 1803-1868 (?)
Born in London on July 18, 1803. He took part in the Royal Academy exhibitions from 1829 till 1867. A bust of his wife, exhibited in 1834, attracted favourable attention, but it was not until 1839 that he enrolled at the Royal Academy schools, on the recommendation of Benjamin Wyon. Abbott specialised in small cabinet busts of contemporary personalities, many of which were exhibited at the Royal Academy and included those of Dr. Solomon Herschell (1838), Thomas Blizard (1840), Lord Raglan (1857) and Maria Dickson (1858). He was best known for his busts of Robert Peel and the Duke of Wellington, reproduced in large numbers by Messrs. Hetley of Soho Square, London. His most ambitious work was Alexander the Great Crossing the Granicus, shown at the Great Exhibition of 1851. In 1862 he modelled small seated figures of the Prince Consort and the Duke of Wellington for Copeland who later produced them in parian ware. Figures by this sculptor are also thought to have been reproduced in iron, lead and bronze.

ABBRUZZESE, J.
Sculptor of Italian origin working in Paris at the turn of the century. He exhibited figures at the Salon des Artistes Français in 1911.

ABELLOOS, Michel 1828-1881
Born in Louvain, Belgium, on January 28, 1828, he spent his entire working life in that town and died there on April 19, 1881. A leading exponent of the 19th century Flemish School, he maintained in his work the tradition of the primitives. He is best known for his decoration on the high altars of the Church at St. Basil in Bruges and the Church of St. Cruces near Bruges. Many of his smaller religious and genre figures are in collections in Belgium, northern France and England.

ABELOOS, Jean François fl. 19th century
Born in Louvain in the early 19th century. He was a pupil of Geerts and succeeded him as professor at the Academy of Arts in 1855. He produced a large number of sculptures, mainly for Belgian churches, but also specialised in portrait busts, mainly of Belgian personalities. At the Brussels Exhibition of 1854 he showed a group of the Virgin, Child and St. Cecilia.

ABISETTI, Natale
Born in Switzerland in the second half of the 19th century, he worked in Paris at the turn of the century and participated in the Salons of 1890-93 and 1897-99. At the Exposition Universelle of 1900 he exhibited a group Metchtal and his Son. The École Polytechnique in Zürich has four statues by this sculptor.

ABLEITNER, Franz
Born in Munich in the second half of the 17th century, he died there in 1728. He was the son and pupil of the sculptor Balthasar Ableitner and, like his father, specialised in religious sculpture, mainly in stone. His works include the Seated Virgin in the entrance to the Burghers Hall, Munich and the decorative sculpture in the chapel of St. Theresa in Trinity Church.

ABLEITNER, Johann Blasius fl. early 18th century
Younger son of Balthasar Ableitner and brother of Franz. Following the death of his father in 1705 he was appointed Bavarian Court Sculptor and produced many decorative sculptures, reliefs and figures. He is best known for the ornate candelabra in Munich Town Hall.

ABLONET, Henri Jean 1877-1914
Born at Bordeaux on January 11, 1877, he took part in the Salons des Artistes Français in 1911-12 and 1914, exhibiting portrait busts.

ABRAHAM, Richard fl. 19th-20th centuries
German sculptor working at the turn of the century. At the Berliner Kunstaustellung of 1910 he exhibited a bronze study of a young girl.

ABRAHAMS fl. 19th century
English sculptor working in the 19th century. The Sydney Museum has a bust of John Rae signed by him.

ABRANSKI-GIMMI, Cecile fl. 20th century
Born in Estonia, she moved to Switzerland after the first world war and was subsequently naturalised. She made her début as a portrait sculptor at the Salon des Tuileries in 1933 with a plaster study and subsequently exhibited portrait reliefs and busts at the Salon d'Automne in 1934-35 and 1937-38. Her earlier work consisted of figures and groups of cats, which she exhibited at the Salon des Indépendants between 1928 and 1931.

ABRIEL fl. 20th century
Born at Dinard in the early years of this century. He exhibited paintings and sculpture at the Salon des Indépendants in 1932 and 1937-38, comprising flowers and social and philosophical subjects.

ABRY, Paul 1865-
Born in Huningue (Haut-Rhin) on December 28, 1865. He studied sculpture under E. Dogg at Strasbourg before settling in Zürich where his best-known work is the monumental fountain on the quai d'Uto. He also produced small figures and groups, mainly classical in concept.

ACEZAT, Kety Marguerite Henriette fl. 20th century
Born in Paris at the beginning of this century, she studied under Adler and Berges. Although better known for her Breton landscapes she exhibited a portrait bust at the Salon des Artistes Français in 1927.

ACHALME, Simone fl. 20th century
Born at Armentières early in the 20th century, she was a pupil of Jean Camus and took part in the Parisian exhibitions from 1926 to 1932, winning an honourable mention in 1930. She was a prolific sculptor of heads and busts, the best known being 'Laughing Child', exhibited in 1929.

ACHARD, François
Worked at Grenoble in the latter half of the 18th century, mainly as a decorative sculptor.

ACHARD, Jean Georges Pierre 1871-
Born at Abzac (Gironde) on March 13, 1871. He went to Paris and studied under Falguière. He began exhibiting at the Paris Salons in 1894, winning a third class medal in 1903 and a silver medal in 1922. He continued to exhibit at the Salon till 1935 and was made Chevalier of the Legion of Honour in 1930. He concentrated on portrait reliefs and busts the best known of which include his head of President Kruger (1901) and the mask of Tolstoy (1935). The most ambitious of his completed works was the group of Czar Nicholas II receiving the homage of French Industry and Commerce (now in the Chambre Syndicale du Commerce at de L'Industrie in Paris). At the pre-war Salons he exhibited busts and heads but most of the work exhibited in the 1920s consisted of studies for a war memorial.

ACHESON, Anne C. 1882-1962
Born at Portadown, Northern Ireland, in 1882 and educated at Victoria College, Belfast, she studied sculpture under Professor Lanteri at the Royal College of Art and received her diploma in 1910. She exhibited at the Royal Academy throughout her working career and also participated in international exhibitions, including the Paris Salons of 1914 and 1922. F.R.B.S., A.R.C.A., awarded the C.B.E. (1919) and the Gleichen Memorial Award (1938), Miss Acheson lived and worked in London and Glenavy, Co. Antrim. Much of her earlier work was in wood but later she turned to stone, concrete and various forms of metal. Her best-known work in bronze is the Architectural Screen, executed in 1956.

ACHIAM 1916-
Born at Bet Gan, Palestine (now Israel), in 1916 and educated at the National School of Agriculture. He took part in the Zionist struggle against the Arabs and the British mandatory forces in Palestine leading up to the war of Liberation in 1948. He made his début as a sculptor in 1940, learning the art of direct carving in stone. He worked mainly in the black basalt found in the vicinity of Jerusalem and carved biblical subjects. He emigrated to France in October 1947 and had his first one-man exhibition at the Galerie Drouin in 1948. Since then he has taken part regularly in the Salon de Mai, the Salon d'Automne and the Salon de la Jeune Sculpture. He won the first prize of the State of Israel in 1955. Though he has extended his repertoire to include many forms of stone, exploring the textural qualities of the different materials, none of his works has so far been reproduced in bronze.

ACHTERMANN, Theodor-Wilhelm 1799-1884
Born at Münster on August 15, 1799, he died in Rome on May 26, 1884. His father was a cabinetmaker but he came from farming stock and was sent to work on an uncle's farm as a boy. In 1827 he went to Berlin and enrolled at the Academy. His early works attracted the attention of Finke who recommended him to Rauch. He concentrated exclusively on religious figures, the best-known from this period being his Adoration of the Kings in St. Hedwig's Church, Berlin. In 1840 he moved to Italy where, as a fervent Catholic, he found a more congenial atmosphere than the Prussia of the mid-19th century. His Christ on the Cross, executed in 1842 and later purchased by the Duke of Aremberg, set the seal on his reputation. Münster Cathedral has a Pieta, a Descent from the Cross and a marble altar bearing reliefs illustrating the life of Christ. Most of his work consisted of figures and reliefs carved in marble.

ACIER, Michel Victor 1736-1799
Born at Versailles on January 20, 1736, he died in Paris, 1799. Acier studied in Paris and entered the competition for the Grand Prix of the old Academy in 1759. He produced numerous statues for Parisian churches, though his works may also be found in Burgundy. In 1764 he went to Saxony and became a sculptor-modeller at the Meissen porcelain works. He was a prolific modeller of figurines and groups, mainly reproduced in terra cotta and porcelain but also known in bronze. His best-known work in this field was the group representing the death of Marshal Schwerin. Acier was regarded as one of the finest artists in this medium. Following his retirement from the porcelain works in 1781 he was admitted to membership of the Dresden Academy.

ACKER, Georges fl. 20th century
Born at Laon at the beginning of this century. He exhibited a bust at the Salon of the Société Nationale des Beaux Arts in 1927.

ACKERMANN, R.
Little is known of this sculptor other than the fact that he resided in Brighton in 1854, in which year he exhibited at the Society of British Artists in Suffolk Street, London.

ACQUAVIVA, Pietro Paolo fl. early 19th century
Employed as a modeller at the Royal Porcelain Factory in Naples at the end of the 18th century and the early 19th century, Acquaviva was appointed Professor of Sculpture in 1802. He is best-known for a series of biscuit medallions of Napoleon. Many of his small figures and reliefs were subsequently cast in bronze.

ACQUISTI, Luigi 1745-1823
Born at Forli in 1745 and dying in Bologna in 1823, Acquisti worked at Rome, Milan and Bologna. In Rome he worked on the decoration of the altar of the chapel of San Giuseppe Colasonzio in the Church of San Pantaleo. A series of reliefs decorating the staircase of the Palazzo Braschi, illustrating the works of Homer, was executed by him. Acquisti sculpted the decoration in the Oratory of San Giobbe and four statues in the Cupola of Santa Maria della Vita in Bologna. In 1805 he produced a group of Peace, commissioned by the Count of Sommariva for his villa on Lake Como, the subject being Venus calming Mars. Acquisti specialised in statues, busts and plaques portraying the popes, especially Nicholas XII and Pius VI at Orvieto. He also produced many copies of the celebrated Venus de Medicis, with various modifications to the bust and arms.

ACUNA, Luis Alberto fl. 20th century
Born at Suiata in the province of Santander, Colombia, at the beginning of this century. After studying painting and sculpture in South America he came to Paris in the 1920s and studied under Bouchard and Landowsky. Though primarily known as a painter of portraits (exhibited at the Salon des Indépendants, 1926-29) Acuna sculpted the head of a little Inca princess, shown at the Salon des Artistes Français in 1926.

ADAM, François fl. 20th century
Born in Paris at the turn of the century. Adam exhibited a genre group of an old man and a child in bronze at the Salon d'Automne in 1923 and this was subsequently purchased by the State.

ADAM, François Gaspard Balthasar 1710-1761
Born near Nancy on May 23, 1710, he died in Paris in 1761. He belonged to the prolific family which was responsible for much of the decorative sculpture produced in France in the 18th century. The distinguished sculptor Clodion was related to them. With his brothers Lambert and Nicolas, François studied under his father at Nancy, but came to Paris while still in his teens. He took part in the Academy competitions and was awarded a second prize in 1740 and the first prize the following year with his Healing of Tobias. He went to Rome, where his brothers were already settled, and worked with them for the Cardinal Prince de Polignac. He returned to France in 1746 and from there went on to Berlin where he became the leading sculptor at the Court of Frederick the Great. He stayed in Berlin for thirteen years before returning in ill health to Paris where he died. His best work is preserved in Germany to this day and his classical statuary, manifesting a greater originality than his brothers, is to be seen at Potsdam and the castle and gardens of Sans-Souci. Many of his classical figures and groups were reproduced as bronze reductions.

ADAM, Gaspard Louis Charles 1760-c.1830
Born in Paris on September 2, 1760, he was the son of the sculptor Nicolas Sebastian Adam. Through is aunt, Anne Adam, who married Thomas Michel, he was a cousin of Claude-Michel (Clodion). He enrolled at the school of the Académie Royale in November 1779. His father died in March 1778 and he subsequently found employment in the studio of Antoine Bridan. Nothing is known for certain regarding his work. Small classical figures in the manner associated with the Adam family have been attributed to him.

ADAM, Gregoire Joseph 1737-1820
Born in Valenciennes in 1737, he died there in 1820. He worked for the architect Gombert on the interior decoration of the Hotel Merghelynck at Ypres, particularly the relief panels and roundels bearing the portraits of contemporary celebrities such as Voltaire, Louis XV and Marie Leczynska.

ADAM, Henri Georges 1904-
Born in Paris of jeweller-goldsmith parents. He studied art at the Collège Lavoisier and worked as a jeweller in his father's studio, subsequently taking up painting and engraving. He continued his studies at the École Germain Pilon, the Cours Montparnasse and the École Nationale des Beaux Arts. He taught art and practised draughtsmanship, designing costumes and theatre sets. He took up sculpture in 1940 and exhibited at the Salon de la Liberation (1944) a highly controversial Recumbent Figure which, though strongly condemned by many critics at the time, won for him the friendship of Picasso. He became a founder member of the Salon de Mai and took part regularly in its exhibitions. He had his first one-man exhibitions at the Galerie Maeght in 1949 and at the Stedelijk Museum in Amsterdam in 1955. He is best known for his monumental abstract erected at Le Havre, on the open space in front of the Museum. He participated unsuccessfully in the competition for the Monument to the Unknown Political Prisoner (1952). Though many of his earlier works were executed in concrete on the grand scale, Adam has also produced many smaller works in bronze, often decorating the surfaces with intricate patterns of engraving, a technique derived from pre-war work as an engraver. The best known of his bronzes is the Marine Mutations. Since 1959 he has been director of the department of sculpture at the École Nationale des Beaux Arts.

ADAM, Jacob Sigisbert 1670-1747
Born at St. Sebastien de Nancy in October 1670, he died in Nancy or Paris on May 27, 1747. He was the founder of the Adams family of sculptors and was himself the son of Lambert Adam a bronze founder. He studied sculpture under Cesar Bagard and spent most of his life in Nancy, apart from a twelve-year period in Metz and the last six years of his life, which were largely spent in Paris. He married Sebastienne Leal in 1699 and she bore him three sons and two daughters, one of whom was the mother of Clodion. He produced a large number of statues and decorative sculptures, strongly influenced by the prevailing classical taste for cupids and furies, but he also executed many animal figures and religious groups. A retrospective exhibition of his works was held at Nancy in 1875. Numerous terra cotta were attributed to him and many of his works were cast in bronze as mantel and table ornaments.

ADAM, Jacques fl. 18th century
Enrolled at the school of the Académie de Saint-Luc in 1746 and subsequently practised as a master sculptor in Paris, specialising in decorative sculpture.

ADAM, Jacques Felix died c.1787
He was the son of Nicolas Felix Adam and was born in Paris about 1740. He became a member of the Académie de Saint-Luc in 1759 and collaborated with his father in decorative sculpture.

ADAM, Jean fl. mid-18th century
Probably the same as Jean-Baptiste Adam, the brother of Nicolas Felix Adam. He became a member of the Académie de Saint-Luc in 1716, and was appointed rector in 1731 and subsequently director. He died in Paris in 1766.

ADAM, Johan Gottfried Benjamin c.1776-1813
He worked in Dresden on monuments and decorative sculpture.

ADAM, Lambert Sigisbert 1700-1759
Born at Nancy on October 10, 1700, he died in Paris on May 13, 1759. He was the eldest son of Jacob Sigisbert Adam who taught him the rudiments of sculpture. In 1719 he went to Paris where he worked in the studio of François Dumont. In 1723 he was awarded a Grand Prix and spent the next ten years in Rome, as a protégé of the Cardinal de Polignac and working on the restoration of his collection of antiquities. To this period belong his busts of Neptune and Amphitrite. He won the prize in an open competition for the Trevi fountain, commissioned by Pope Clement XII and subsequently executed many busts and statues for the Church of St. John Lateran. The period after his return to Paris in 1733 was a most prolific one and the works completed range from the group for the waterfall at St. Cloud, commissioned by the Duke of Orléans, to the decorative sculpture in the Hôtel Soubise (now the Hôtel des Archives Nationales). Adam specialised in small statuary, figures, groups and reliefs intended for interior decoration, but his work was regarded, even in his lifetime, as fussy and finicky. Bachaumont dismissed him as 'a shabby man of mean manners' and this reproach seems to have stuck to him ever since. Among his minor works are numerous genre figures, classical groups, busts of contemporary figures and allegorical compositions.

ADAM, Maxime – See ADAM-TESSIER, Maxime

ADAM, Nicolas Félix 1707-1759
Born in Paris in 1707, he died in the same city on July 19, 1759. Little is known of this sculptor other than the fact that he was director of the Académie de Saint-Luc. His son Félix Adam and his two brothers, Jean and Jean-Baptiste, were also sculptors, but it is thought that they were not closely connected with the famous Adam family of Nancy.

ADAM, Nicolas Sebastien (known as 'Adam the Younger') 1705-1778
Born in Nancy on March 22, 1705, the second son of Jacob Sigisbert Adam. He left Nancy in 1721 and went to Paris where he died on March 27, 1778. He secured employment as a decorative sculptor and spent four years working on the decoration of the Château de la Mosson near Montpellier. In 1726 he went to Rome and collaborated with his brother Lambert on the restoration of de Polignac's antique sculptures. He left Rome in 1734 and rejoined his elder brother in Paris. In the ensuing years he executed numerous works for the Château de Versailles, the abbey of St. Denis and the cathedral of Beauvais. He collaborated in the decoration of the Hôtel Soubise, the façade of the Old Chambre des Comptes and the Oratory of the rue St. Honoré. With his brother he worked on the basin of the Neptune fountain at Versailles. Their partnership broke up in 1740 since he was dissatisfied with a subordinate role. Thereafter he worked on his own, producing many of the decorative sculptures for Beauvais Cathedral, the mansion of Catherine Opalinska, Queen of Poland and Lorraine, the villa of Prince Ossolinski, the Jesuit chapels in the rue

St. Antoine and in the Collège du Grammont, and the old Hôtel de Choiseul. From 1760 to 1775 he worked in Chantilly. His last work, a statue of Iris, was completed posthumously by Clodion. Adam became an Academician in 1762 and elevated to the status of Professor in 1778, but this was purely honorific as he was totally blind and died soon afterwards. His numerous works consisted of figures, groups and bas-reliefs in the classical manner, executed in marble and stone, but many of them were reproduced as *bronzes d'ameublement*.

ADAM, Mlle S.L. fl. 19th century
Mlle Adam exhibited at the Paris Salon between 1883 and 1892, both plaster studies and finished works cast in bronze, including figures of the child Diana (1888), a bust of General Bourbaki and a figure of John the Baptist (1890) and a bust of the Queen of Sheba (1892). Her stone statue of St. Geneviève is in Bayonne Museum.

ADAM-FERRON, Louis Henri Eugène fl. early 20th century
Born at St. Denis on the island of Réunion, he came to Paris in the early years of this century and studied sculpture under Coutan and Pourquet. He exhibited at the Salon des Artistes Français in 1923-4, showing a figure of a Bacchante and portrait busts.

ADAM LE NERU, Mlle E. fl. late 19th century
She exhibited animal studies at the Paris Salon – a head of a cat (1883) and a greyhound (1892).

ADAM-SALOMON, Antony Samuel (known as 'Adama') 1818-1881
Born at Ferlé-sous-Jouarre in 1818, he died on April 28, 1881. He was a pupil of Vercelle and was originally interested in photography which he subsequently exploited in his work as a sculptor and medallist. He is considered, in fact, to have been the first sculptor to make use of photography in this manner, and exhibited medallions and busts derived from photographs in Paris, 1844. Many of his busts, reliefs and medals were executed in plaster but some of them were later cast in bronze and include the busts of Lantara (Fontainebleau), Hubert Robert (the Louvre) and the medallion of Lamartine (Orléans). His wife was Georgina Cornelie Adam-Salomon (married 1850, died February 8, 1878) who exhibited at the Salon of 1853 medallions of Comte de Bubrow, Baron de Shonen and Blanche de Paiva.

ADAMS, George Gammon 1821-1898
Born at Staines, Middlesex on April 21, 1821, he died at Acton Green Lodge, Chiswick on March 4, 1898. He was a pupil of William Wyon at the Royal Mint and entered the Royal Academy schools in 1840 on his master's recommendation. He was awarded the silver medal in 1840 and the following year sculpted a medallion of Melpomene which received favourable comment. In 1844 he exhibited a statue of an ancient Briton at Westminster Hall and two years later went to Rome where he studied under J. Gibson. He returned to England in 1847 and at the Great Exhibition of 1851 he was awarded the R.A. Gold Medal for his group Murder of the Innocents. In the same exhibition he also showed a Combat of Centaurs and Lapithae and a Figure with a Torch. In 1852 he made the death mask of the Duke of Wellington, later used in a marble statue. His statue of Lord Napier of Magdala – one of eight statues by him in Trafalgar Square – was regarded as 'perhaps the worst piece of sculpture in England' (*Art Journal*, 1862). He executed a series of bas-reliefs on red marble pedestals for Baroness Burdett–Coutts and also designed and engraved numerous medals. Several portrait busts, including the Duke of Wellington, were cast in bronze.

ADAMS, Herbert 1858-c.1930
Born in Concord, Vermont on January 28, 1858. Adams studied at the Massachusetts Normal Art School and subsequently spent five years studying in Paris under Mercié. During that period he sculpted his first marble bust, a portrait of his fiancée Adeline V. Pond, which won for him a reputation as a sculptor of elegance and beauty. He exhibited at the Salon in 1888-9, getting an honourable mention. He was awarded the gold medal of the Philadelphia Art Club in 1892 and exhibited his work at the world's fairs in Chicago (1893) and St. Louis (1904). His last major award was the Elizabeth N. Watrous gold medal of the National Academy of Design in 1916. Apart from the bust of his wife he is best known for the statue of William Ellery Channing and a number of coloured marble busts. He turned to bronze in the latter part of his career, producing bronze doors for the

Library of Congress in Washington, D.C. and for St. Bartholomew's Church in New York, as well as a bronze group entitled The Dance and a gilded bronze head of A Nordic Type.

ADAMS, Robert 1917-
Born in Northampton on October 5, 1917, he was educated at Hardingstone School and the Northampton School of Art. In the early part of his career he was strongly influenced by Henry Moore but later turned to non-figurative sculpture. Since 1949 he has been an instructor at the Central School of Arts and Crafts in London, but also has a studio in Hampstead. He has had one-man shows at Gimpel Fils (London), Galerie Jeanne Boucher (Paris) and the Passedoit Gallery (New York), and taken part in the Biennials of Sao Paulo (1950 and 1957), Antwerp (1951 and 1953) and Venice (1952). He is one of the most versatile artists working in Britain today, equally accomplished in prints and drawings as in wood-carving, stone-carving, small sculpture and monumental works. His metal abstracts include work in rods and sheet metal as well as geometric reliefs cast in bronze.

ADAMS-ACTON, John 1831-1910
Born at Acton, London in 1831, he studied under Timothy Butler before enrolling at the Royal Academy schools where he was awarded a gold medal for an original group. Part of the prize was a travelling scholarship which enabled him to study in Rome under John Gibson for ten years. He began exhibiting at the Royal Academy in 1851, under his original name of John Adams, but adopted the hyphenated name in 1868 to distinguish himself from the painter called John Adams. He continued to exhibit at the Academy until 1892. He was also a member of the Society of British Artists and participated regularly in their exhibitions. He specialised in statues and busts of his celebrated contemporaries in marble and bronze. His works include busts of Queen Victoria, the Prince Consort, King Edward VII and Sir Titus Salt, and statues of Gladstone at Liverpool and Blackburn. He died on October 28, 1910.

ADAMS-TESSIER, Maxime 1920-
Born at Rouen in 1920 and educated locally, he came to Paris in 1939 and enrolled at the Académie Julian where he studied sculpture under Niclausse, Despiau and later Laurens. Originally influenced by Cubism, he later abandoned figurative art for purely abstract sculpture inspired by machinery and industrial inventions. He has exhibited in the Salon d'Automne, Salon des Tuileries, Salon de Mai and the Salon de la Jeune Sculpture in Paris, as well as various international exhibitions in Austria, Brazil, Belgium and Austria. His first one-man show took place at the Galerie Arc-en-Ciel in Paris (1947) and subsequently he exhibited at Gimpel Fils, London (1948), Galerie Evrard, Lille (1953). He now lives and works in Paris.

ADELSPERGER, Mary fl. early 20th century
She worked in Chicago in 1909-10.

ADET, Édouard fl. early 20th century
He took part in the Salon of the Société Nationale des Beaux Arts in 1913-14, exhibiting portrait busts and genre figures.

ADJEMIAN, Nerces fl. 20th century
Born in Constantinople of Armenian parents, he settled in Paris after the first world war and exhibited at the Salon des Indépendants from 1929 till 1935. He specialised in figurines and genre groups, including Après le Péché and En Moto.

ADLERSBERG, Bror Beinhold 1791-1834
Born in Sweden in 1791, he studied under G. Gosse and specialised in portrait busts, relief portraits and medallions. Portraits of Odman Samuel and G.F. Wirsein by this artist are in the Stockholm Museum.

ADRON, Henry fl. 19th century
Specialised in portrait busts. He exhibited at the Salon 1852-7.

AESCHBACHER, Hans 1906-
Born at Zürich in 1906, he began his working life as a printer's apprentice, but later earned a living as a plasterer, devoting his leisure hours to drawing and painting. He took up sculpture in the 1930s and his earliest works were executed in plaster and terra cotta. It is possible that some of these early pieces may have been cast in bronze. Since 1945, however, he has worked almost exclusively in stone.

AFFANI, Garibaldo 1862-1891
Born in Parma in 1862, the son of the painter Iganzio Affani, he first exhibited his sculpture in 1876, two figurines receiving favourable notice at the time. Most of the surviving smaller works, figures and groups, belong to his teens, but from 1880 onwards he concentrated on monumental sculpture. He died of a sudden illness at the age of 29.

AFINGER, Bernhard 1813-1882
Born in Nuremberg on May 6, 1813, he died in Berlin on December 25, 1882. Afinger was the son of a poor labourer but he was regarded as something of an infant prodigy in art. He served a four-year apprenticeship with a Nuremberg silversmith and studied renaissance and medieval sculpture at evening classes in the local art school. In 1840 he went to Berlin where he continued his studies under Rausch. His first major work was a colossal stone statue of Christ for the Church of Dinkelsbühl (1842). but his most memorable work is the statuette of the actress Rachael commissioned by Kaiser Wilhelm for the peacock island at Potsdam

AGA KHAN, Ginette fl. 20th century
Born in Turin at the beginning of this century, she practised sculpture under the professional name of Ila Shah. She specialised in character studies, both figurines and heads, cast in bronze. She exhibited at the Salon d'Automne in 1922.

AGARD, J. fl. early 20th century
He exhibited figures and groups at the Salon des Artistes Français in 1911-14.

AGARONIAN, Gregor fl. 20th century
Born in Tiflis of Armenian stock, he moved to France after the October Revolution. At the Salon d'Automne (1928) and Salon des Artistes Français (1929) he exhibited various bronze figures and busts.

AGNUS, Germaine fl. 20th century
She exhibited a bronze bust at the Salon des Tuileries in 1933.

AGREDA, Esteban 1759-1842
Born in Lograno, Spain on December 26, 1759, he worked under Robert Michel as a cameo-cutter and also modelled figures for reproduction in porcelain. In 1797 he was admitted to membership of the Academy of San Fernando where he deposited as his masterpiece an equestrian statuette of Philip V. Subsequently he became Director of the Academy and Court Painter to Charles II of Spain. He produced numerous statuettes and small groups and many examples of his work are to be found in the museums of Burgos and Madrid. He is best known for his fountain groups, of Ceres and Narcissus in Aranjuez and the two groups of children on the fountain of Apollo.

AGREDA, Manuel de 1773-
Brother of the above, born at Haro in 1773. He entered the Academy of San Fernando in 1823. From 1805 to 1808 he was employed as a modeller at the Buen Retiro porcelain factory, but later produced a great deal of decorative sculpture, reliefs and panels, as well as figures of saints.

AGUIAR, Joao-José fl. 18th century
Born at Bellas in Portugal in the second half of the 18th century, he began studying architecture and sculpture at Lisbon. In 1785 he went to Rome on a scholarship awarded by the Intendant and studied under Labruzzi and Joseph Angeli and eventually became a pupil of Canova. On his return to Portugal he succeeded François Antoine as sculptor to the royal foundry. In this workshop he executed numerous bronzes for Mafra. His most notable works include the statue of the King of Portugal in the Lisbon Arsenal and the statues in the Ajuda Palace.

AGUIRRE, Marcial 1841-1906
Born at Vergara, Spain on November 22, 1841, he died at San Sebastian on May 10, 1906. He studied in Rome under Giuseppe Obici and made his début in Madrid in 1864 with a statuette of a huntsman. Two years later he exhibited a bust of St. Ignatius Loyola for which he was awarded a medal.

AGULLO Y JUST, Pascual fl. 19th century
Born in the late 18th century, he was a pupil of Cloostermans and was admitted a member of the Academy of Valencia in 1828, later being appointed professor of sculpture. He was a prolific sculptor, specialising in religious figures and his works are to be found in many of the churches of Potries, Orihnela and Almoradi.

AGURTO, L. fl. 20th century
Spanish sculptor working in France before the first world war. He took part in the Salon des Artistes Français in 1913.

AHLBORN, Lea (née Lundgren) fl. late 19th century
Awarded a bronze medal for sculpture at the Exposition Universelle, Paris, 1889.

AHRENFELDT, Eva Hélène fl. 20th century
Born in London but settled in France. She studied sculpture under Bouchard and later exhibited at the Salon des Artistes Français, figures in stone, plaster and bronze.

AICHELE, Paul fl. late 19th-20th centuries
He first exhibited sculpture at the Berlin Art Exhibition of 1891, showing a statuette of a Bacchante. The following year he became a member of the German Academy of Arts and exhibited a statuette of an enchained slave. Subsequently he participated in the Berlin exhibitions, the Crystal Palace Exhibition in Munich and the Düsseldorf Arts Exhibition, mainly genre and allegorical figures and groups, such as Sacrifice, Girl with Snail and Paradise Lost.

AIGON, Antonin 1837-1885
Born at Montpellier in 1837, he died in Paris in 1885. Aigon specialised in animal groups. His group, Wild-cat and Pheasant, is in the Montpellier Museum.

AIGON, E.A. fl. late 19th century
Probably a son of the above, he specialised in bronze medallions, plaques and reliefs. He exhibited at the Salon of 1888.

AIMONE, Victor fl. 19th century
Born at Novara, near Turin in the latter half of the 19th century, he worked in France at the turn of the century. He exhibited at the Paris Salon from 1897 till the first world war, mainly genre figures and groups such as Le Plaidoyer de Buffon (honourable mention, 1897), and, Impudent Frolics (1912), allegorical and neo-classical studies such as Glory to the Nation and the Repose of Diana (both 1911), as well as numerous heads and busts.

AINSCOUGH, Hilda fl. 20th century
Born in Buenos Aires of English parents, she studied sculpture in Paris under Bourdelle and exhibited at the Salon des Artistes Français and later the Société Nationale des Beaux Arts in the 1920s. Her work consisted mainly of busts, figures and groups of classical subjects (Pan and fauns), worked in terra cotta and subsequently cast in bronze.

AITKEN, Pauline 1893-
Born in Accrington, Lancs. on June 30, 1893, she studied at the Manchester School of Art, Chelsea Polytechnic and the Royal Academy schools. In the 1920s she exhibited at the Royal Academy and the Salon des Artistes Français as well as various provincial exhibitions. Her chief works included The Frog Prince, Danse Fantasque, Incantation, Bacchante and Ariadne. Miss Aitken had a studio in London.

AITKEN, Robert Ingersolt 1878-
Born in San Francisco on May 8, 1878, he studied at the Mark Hopkins Institute of Art, under Arthur Matthews and Douglas Tilden, succeeding the latter as professor of sculpture in 1901. In 1904 he went to Paris where he continued his studies till 1907. On his return to the United States he became an instructor in sculpture at the Art Students' League and National Academy of Design. Regarded as one of the most promising sculptors of his generation, his many awards included the Gold Medal of Honor for sculpture, awarded by the New York Architectural League (1915) and the Elizabeth N. Watrous Gold Medal of the National Academy of Design (1921). His most important commission was the figure of Victory, erected on a colossal pedestal as a memorial to the United States Navy after the first world war. Other war memorials of the same period included Comrades in Arms and Doughboy, both of which exist as quarter size models or other reductions, and the Alpha Delta Phi bronze statuette.

AJOLFI, Elia 1879-1906
Born at Bergamo, Italy in 1879, he died in the same town in September 1906. Ajolfi spent much of his working life in Milan, where he studied sculpture under Prince Trubetzkoy. In the last year of his life he showed a figure of a seated girl at the Milan Exhibition. Most of his sculpture consists of small genre and animal figures.

AKELEY, Carl Ethan 1864-1926
Born at Clarendon, New York in 1864, he combined a passion for sculpture with a life-long interest in wildlife. He was on the staff of the Field Museum of Chicago from 1895 till 1909 and thereafter worked for the American Museum of Natural History. He died at Mount Mikeno in the Belgian Congo in 1926 while on a wildlife expedition. As a sculptor he specialised in bronze figures and groups of exotic creatures. Two of his animal studies are in the Brooklyn Institute and numerous groups are in the American Museum of Natural History. He is best remembered for his two bronzes of African elephants – The Charging Herds, and The Wounded Comrade.

AKERBERG, Knut fl. 20th century
Born in Bavaria in the late 19th century, he studied art in Munich and made his début at the Crystal Palace Exhibition of 1901, with a small stone relief of Pan playing his pipes. He joined the Sezession and took part in the 1906 exhibition, showing a stone relief of Grape-gathering and bronze figures of Hercules and a Shepherd.

AKERMAN, Bror Morgan Werner 1854-1903
Born in Göteborg on January 1, 1854, he died on February 6, 1903. He studied at the Stockholm Academy of Arts in 1883-6, spending the winters in Rome. He produced numerous medallions, portrait reliefs and busts but his major works – Spring Frost, Abandoned (1890) and Madonna (1891) – were later cast as bronze reductions.

ALALOU-JONQUIERES, Tatiana 1901-
Born in Bialystok, Russia, she studied art at the Moscow Academy and was a pupil of Archipenko in 1918-20. In the latter year she went to Paris and studied under Bourdelle, later becoming his assistant. She took part in the various Paris Salons from the 1920s onwards, culminating in her monumental work, commissioned by the State, for the Exposition Internationale in 1937. She had an exhibition at the Galerie de Beaune in 1946 and also participated in the Salon de la Jeune Sculpture, but an accident which affected her eyesight prevented her from working for several years. In her earlier period she worked in stone, but later turned to clay and bronze. Her early work included busts and heads of her artistic contemporaries but since the second world war she has concentrated on abstracts and less figurative works.

ALBACINI, Achille fl. 19th century
Born in Rome on April 19, 1841, the son of Carlo Albacini from whom he had his earliest instruction in sculpture. Later he studied at the Academy of St. Luke in Rome and specialised in statuettes and busts of historic figures. His best known works are his busts of Rebecca and Andromache.

ALBACINI, Carlo 'The Elder' fl. 18th century
Born in Italy in the mid-18th century and died in Rome about 1807. His father was Carlo Albacini or Albaghini, sometime employed as a sculptor of allegorical groups at the Imperial Russian Court. He himself became professor of sculpture at the Academy of St. Luke and was mainly occupied in the restoration of classical statuary. His best-known work is a statue of St. Peter, commissioned by Catherine the Great for the tomb of Raphael Mengs.

ALBACINI, Carlo 'The Younger' 1777-1858
Born in Rome in 1777, the son of Carlo the Elder. He was influenced by Canova but strove to give a more realistic expression to his works, though this tended towards caricature in some cases. Eventually his realism descended into gross exaggeration, notably in the statuettes which decorate the Oratory of Pesci Vendoli in Rome. He also made copies of classical figures, particularly Silene and the child Dionysus, Xenon, Venus Callipyge and the Belvedere Apollo.

ALBERMANN, Wilhelm 1835-1890
Born at Werden in the Ruhr on May 28, 1835, he was apprenticed to a sculptor at Elberfeld (now Wuppertal). Later he enrolled at the Academy of Arts in Berlin where he studied till 1865 under Fischer and Hagen. In 1865 he established a studio at Cologne where he was also professor of modelling till 1890. His work consists mainly of small figures and groups, both genre and neo-classical.

ALBERTI, Achille 1860-
Born in Milan in March 1860, he studied sculpture at the Brera Academy of Arts. At the height of his career around the turn of the century he took part in many international exhibitions, in Munich, Vienna and Paris. He worked exclusively in bronze and his works were distinguished by their realism and vitality. Typical of his style is his allegorical group Vileness, shown at the Exposition Universelle (1900), First Love (Munich, 1909) and Rejected (Brussels, 1910).

ALBERT-LEFEUVRE, Louis Étienne Marie fl. 19th century
Born in Paris in the mid-19th century, he was a pupil of Dumont and Falguière. He first exhibited at the Salon in 1875, with a marble figure of the young Joan of Arc. He exhibited regularly at the Salon from 1881 till 1905, showing various statues, busts and groups in plaster, subsequently cast in bronze, finished bronzes and wax reliefs. Several of his bronze busts and figures are in the museums of Montpellier and Perpignan.

ALBERTOLLI, Family, flourishing in Bedano, northern Italy, 18th century
Giocondo the Elder (1742-1839) was an architect and ornamental sculptor, specialising in figures and reliefs for the decoration of buildings. He studied in Parma and Rome and in 1776 was appointed professor of ornamental sculpture at the Milan Academy, but was compelled to resign following an accident which robbed him of his sight. He is best known for his ornamentation of public buildings and the monuments which he imbued with freshness and vitality. His nephew, Giocondo the Younger, worked in Switzerland and participated in the Zürich Exhibition of 1883 with genre figures of The Scamp and Melancholy. Raffaello (1770-1812) was a son of Giocondo the Elder and is known mainly as a designer and etcher. Grato (died 1812) was the elder brother of Giocondo the Elder and father of Giocondo the Younger. He worked as an ornamental sculptor and collaborated with his brother on the sculpture for the ducal villa at Poggio Reale near Florence in 1772-5. Grato on his own also did the ornamental sculpture for the Royal Palace in Florence.

ALBIKER, Karl 1878-
Born at Uhlingen in the Black Forest on June 16, 1878. He studied initially under Volz at the Karlsruhe Academy (1898-99) and then became a pupil of Rodin (1899-1900). He continued his studies in Munich (1900-2) and completed them in Rome (1902-5). From 1906 to 1915 he worked in Ettlingen and after the first world war obtained a teaching post at the Dresden Academy. After the second world war he retired to Ettlingen. Albiker belongs to that generation of German sculptors, originally influenced by Rodin, who developed a more austere form of sculpture in the 1920s. There is thus a marked difference between his early works, such as the bronze nude shown at the Crystal Palace Exhibition in Munich (1901) or the bust of a little girl and The Bather, shown at the Berlin Exhibition in 1909. The combination of Greek classical influence and the technique of Rodin gave way to something less ethereal during and after the first world war, but the heroic sculpture of 1919-24 gave way to a much simpler style evocative of classical Greece. His figure of Hygieia for the Dresden Museum of Hygiene is characteristic of this phase. During the last years of his career he produced massive monuments for the Third Reich. Today he is best remembered for his smaller works executed in the decade from 1901 to 1911.

ALBRECHT, Karl Ludwig fl. 19th century
Born in Leipzig on October 1, 1834, he learned the rudiments of sculpture from Knaur. Later he studied at Leipzig Academy of Arts and subsequently studied the works of Rietschel and Hanel. His first major works, the figures of Bacchus and Gambrinus, were so successful that they were often reproduced in terra cotta or bronze. He specialised in small figures intended for reproduction in silver, though some were also cast in bronze.

ALBRECHTSHOFER, Georg fl. 19th-20th centuries
Born at Neuberg-an-Donau on October 19, 1864. He studied at the Munich Academy under Professor von Rümann and for many years was employed in the workshop of the pewterer Miller. He was responsible for many small figures and groups cast in bronze, spelter and pewter, but also executed several larger works. The Monument to Kneipp at Worrishofen (1902) is regarded as his finest work.

ALBRIGHT, Malvin Marr 1897-
Born in Chicago.

ALCAIDE, Zamorano
Worked in Spain during the 19th century.

ALCOVERRO Y AMOROS, José fl. 19th century
Born in Tarrangona, he studied at the Academy of Fine Arts in Madrid, under José Piquer. His Ismael quenching his Thirst was widely acclaimed at the Madrid Exhibition of 1867. His later work consisted mostly of religious figures, such as Lazarus and John the Baptist. Figures of St. Isidore and Combat were shown at the Exposition Universelle in 1900. Many of his statuettes were executed in plaster and subsequently cast in bronze. The National Museum in Madrid has several examples of his bronzes.

ALCOVERRO Y LAPEZ, José fl. 19th-20th centuries
The son of the above, he was born in Madrid and studied at the Academy of Fine Arts. He worked as an assistant to his father and participated in international exhibitions at the turn of the century. His best known work is The Wave, a recumbent female figure.

ALEGRE, José fl. 19th century
Born in Calatayud, Spain, he died in 1865. He spent most of his working life in Saragossa and was a member of the Academy of San Luis. He specialised in ecclesiastical ornament and religious statuary, many examples of his work being in the churches of Aragon and Catalonia. Of his son, Ramon, little is known other than the fact that he won a silver medal for a terra cotta Mercury, at the Madrid Exhibition of 1850.

ALEGRE-RODRIGO, D. fl. early 20th century
At the Salon des Artistes Français, 1913, he exhibited a figure of a woman of Pompeii.

ALEXANDER, E.M. fl. 20th century
Born at Edinburgh in 1881, he exhibited at the Royal Academy and the Royal Scottish Academy. After an education in Scotland he settled in London as a bronze sculptor.

ALEXY, Karl 1823-c.1880
Born at Poprad, Hungary in 1823, the exact date of his death is unknown but it was some time before 1880. He studied at the Vienna Academy but was largely self-taught. Among his earliest works was an equestrian statuette of Queen Victoria, executed in 1840. He continued his studies in Germany, Italy and France. He settled in Pressburg (Przemysl) but spent nine years (1852-61) in London where he worked for William Behnes and achieved a measure of success at the Crystal Palace exhibitions with his busts of Raphael and La Fornarina. Following his return to Hungary he was employed on the ornamental sculpture of public buildings in Budapest and sculpted the colossal marble bust of Count Batthyany, together with the bronze statuettes of celebrated 15th century generals. In his later years he also produced many other small bronzes.

ALLAN, Eva Dorothy 1892-
Born at Millbrook, Southampton on June 22, 1892, she trained as a teacher of domestic science before taking up the study of art at Westminster School of Art and the Royal Academy schools. In 1926 she went to Florence and worked in Italy and Yugoslavia in the early 1930s. In 1929 she changed her name to Julian Phelps Allan. She exhibited at the Royal Academy from 1928 and was elected A.R.B.S. (1937) and E.R.B.S. (1947). She specialised in busts, heads and figures but also produced some ecclesiastical work.

ALLAR, André Joseph 1845-1926
Born in Toulon on August 22, 1845 and died in 1926. He was a pupil of Dantan, Guillaume and Cavelier. In 1869 he won the Grand Prix de Rome and continued his studies in Italy. Subsequently he won a first class medal (1873), a first class medal at the Exposition Universelle (1878), a medal of honour (1882) and gold medals at the Expositions of 1889 and 1900. He was created a Chevalier of the Legion of Honour in 1878 and raised to the rank of Officier in 1896. He was elected a member of the Institute in 1905. A prolific sculptor in many media, his chief works in bronze included Child of the Abruzzi (Musée de Compiègne, 1873), various studies and models for monumental groups, such as the Dispute between Achilles and Agamemnon, four caryatids and various maquettes for allegorical reliefs on the façades of public buildings.

ALLEN, Arthur Baylis 1889-
Born in Burnley, Lancs. on February 6, 1889. He studied architecture and sculpture at the Royal College of Art (diploma, 1912) and subsequently exhibited at the Royal Academy. He settled at Beckenham in Kent and practised as an architect and decorative sculptor.

ALLEN, Charles John 1862-1955
Born at Greenford, Middlesex on September 2, 1862. He served his apprenticeship as a wood carver with the Liverpool firm of Farmer and Brindley and was responsible for some of the wood panelling at Eaton Hall, Cheshire and the decoration of the ocean liners, *Britannic* and *Majestic*. Subsequently he studied sculpture at the Lambeth School of Art and the Royal Academy schools. He began exhibiting at the Royal Academy in 1890 and won four silver medals. In 1894 he returned to Liverpool to become teacher of sculpture at the School of Art. He was regarded as a highly fashionable sculptor in the northwest of England and many of his works are preserved in the Walker Gallery in Liverpool and also in Dublin. Eventually he held the position of Vice-Principal at Liverpool City School of Art but retired to live in Albury in Surrey. He was awarded a gold medal at the Exposition Universelle in 1900. His most ambitious project was a colossal monument to Queen Victoria, 56 feet high, but he also produced numerous busts of contemporary celebrities in the north of England and Ireland, and allegorical and classical statuettes and groups cast in bronze.

ALLEN, George 1900-
Australian sculptor born in 1900. He served as an official war artist in 1939-45 and is now senior lecturer at the Royal Melbourne Technical College. His chief works are the memorial in Kew, Victoria and figures and reliefs in the Canberra National War Memorial. He also sculpts portrait busts and reliefs.

ALLENBY, John Ivor 1899-
Born in Breslau, Germany (now Wroclaw, Poland) on May 24, 1899, the son of Max Allerbach the concert pianist and conductor. He was educated at Jena grammar school and Strasbourg University, later studying art at the Bauhaus in Weimar under Gropius and Engelmann (1918-21). Later he moved to Paris where he worked till 1933 before settling in Oxford. He exhibited at the Paris Salons and the Royal Academy from the late 1920s sculpting figures in stone, wood, terra cotta and bronze.

ALLINSON, Adrian Paul 1890-1959
Born in London on January 9, 1890, he died there on February 20, 1957. He studied painting at the Slade School of Art under Tonks, Steer, Brown and Russell and won the Slade Scholarship in 1912. He worked in Munich and Paris for some time and later taught painting and drawing at Westminster School of Art. He designed posters for British Rail and theatrical sets for the Beecham Opera Company. He sculpted portrait busts and reliefs.

ALLIOT, Lucien Charles Édouard fl. early 20th century
Born in Paris on November 16, 1877, he was a pupil of Barrias and Coutan. He exhibited at the Salon from 1905 till 1939 and was a member of the Jury from 1934 onwards. His father Napoleon Alliot was also a sculptor (died 1907) but little is known of him other than that he exhibited a plaster study of a child at the Salon in 1881. The bust of a cellist won him a third class medal in 1905 and a travelling scholarship. His later works included Maternity (1911), Echo of the Sea (1912), Poilu (a French soldier), Virgin and Baby Jesus (1925), Archer (1926), St. Francis of Assisi (1933) and an allegorical study of Peace (1939).

ALLOATI, Adriano 1909-
He executed a series of bronze Naiads and also a number of preliminary studies for them which were cast in bronze.

ALLOUARD, Henri 1844-1929
Born in Paris on July 11, 1844, and died there on August 12, 1929. He studied under Lequesne and Schanewerck and exhibited at the Salon des Artistes Français from 1865 till 1928, winning a gold medal in 1900. He was a member of the Jury for sculpture and the decorative arts at the universal exhibitions of 1889 and 1900. He is best known as a monumental sculptor, but his minor works included a number of busts and small bas-reliefs and genre groups in terra cotta and bronze, such as Lutinerie (goblins and sprites) and The Awakening of Love.

ALLOY, Léonce fl. 20th century
Born at Fauquenbergues in the Pas de Calais in the late 19th century, he studied sculpture in Paris under Barrias, Chaplain, Vernon and Coutan. He exhibition regularly at the Salon des Artistes Français from 1902 till 1942, winning a third class medal in 1902 and a silver medal in 1925.

ALLWARD, Walter S. fl. 20th century
Canadian sculptor working in the first half of this century. He specialised in monuments and is best known for the Canadian War Memorial at Vimy. He was involved in a grandiose project to commemorate King Edward VII, but this scheme was abandoned because of the outbreak of the first world war and as a result only two of the lengthy series of allegorical figures were cast in bronze. These figures, known as Justice-Justitia and Truth-Veritas, were subsequently erected in front of the Supreme Court of Canada building in Toronto. Allward's minor works included portrait busts and figures of Canadian celebrities of the early 20th century.

ALMECH, Jane fl. 19th-20th centuries
She lived in Paris at the turn of the century and produced a number of statuettes of dancers and skaters, exhibited at the Salon des Indépendents and the Salon des Humoristes in 1910.

ALMGREN, Gösta 1888-
Born in Sweden, she studied sculpture in France, Germany and Italy before returning to her native country. She exhibited portrait reliefs at the Salon des Artistes Français in 1914 and took part in various Swedish exhibitions in the 1920s. At the Exhibition of Swedish Art, held at the Jau de Paume in 1929, she showed a bronze death-mask of Archbishop Söderblom.

ALONSO, Ignazio fl. 18th century
Worked in Spain in the early part of the 18th century, collaborating with Diego Rodriguez de Luna on the decoration of the bronze doors made by Raymundo Capuz for the front of Toledo Cathedral. Subsequently he produced small reliefs and roundels for furniture and other forms of decorative sculpture.

ALONZO, Dominique fl. 20th century
Born in Paris in the late 19th century he was a pupil of Falguière and exhibited at the Salon des Artistes Français from 1912 till 1926.

ALTHABE, Julian 1911-
Born in Buenos Aires in 1911 of mixed English and German parentage. He studied at the School of Decorative Arts and the Advanced School of Fine Arts in Buenos Aires where he has a studio. His first one-man show took place in Argentina in 1952. He produces non-figurative abstracts.

ALVÄR, Gunnar fl. 19th century
Born in Norway he studied art under Skeibrok in Christiania (Oslo) and exhibited there between 1892 and 1897, mainly small figures.

ALVARADO, Daniel fl. 19th-20th centuries
Born in Cuenca in Ecuador. He showed a carved wooden bust at the Exposition Universelle in 1900. Little is known of this sculptor and no bronzes are known by his hand.

ALVAREZ, Don Manuel 1727-1797
Born at Salamanca in 1727, he was educated in that city before going to Madrid and continuing his studies under Alessandro de Castro. During this early period he assisted his master in the decorative sculpture for the Royal Palace. In 1757 he was elected a member of the Academy and five years later became deputy-director. He unsuccessfully competed for the equestrian statue of Philip V and also produced a model for an equestrian statue of Charles III. In 1784 he became director of the Academy and ten years later was appointed Court Sculptor. He died in Madrid in 1797 after a lengthy illness. His chief works were executed in stucco, but among his bronzes is the group of angels, now in the Convent of the Incarnation. Other bronzes are in Salamanca, Toledo, Saragossa, Burgos and Madrid museums.

ALVAREZ Y BOUGEL, José 1805-30
Born in Paris on February 2, 1805, the son of the Spanish sculptor José Alvarez y Cubiro under whom he studied. Later he became a pupil of the painter Ingres. Alvarez went to Spain and worked as a painter primarily, though he also modelled a statuette of King Ferdinand VII and worked on figures of King Ferdinand and Queen Amalia for the city of Saragossa. Similar statues, commissioned by the city of Cadiz, were uncompleted at the time of his sudden death.

ALVAREZ Y CUBIRO, José 1768-1827
Born in Priego, Spain on April 23, 1768 and died at Madrid on December 26, 1827. He studied art in Granada and Cordoba and enrolled at the Academy of San Fernando in 1788. In 1799 he recieved a travelling scholarship from the king and this enabled him to study in Paris and Rome. Latterly he studied under Canova and went from Rome to Engelsburg in 1809, rather than return to Spain and acknowledge Joseph Bonaparte as his sovereign. For some time he worked on the decorative sculpture at the Quirinal in Rome. On the restoration of Ferdinand VII he returned to Spain, and was appointed Court Sculptor in 1816. He was made director of the Academy in 1827 but died soon afterwards. His works include Ganymede (1804), the figures of Charles IV and Queen Marie-Louise, Isabella of Braganza, many busts of Spanish royalty and nobility, including Charles IV, Ferdinand VII, Marie-Louise, D. Carlos Isidro, D. Francisco de Paula, the composer Rossini and his son, José Alvarez y Bougel, as well as a large number of mythological and classical groups featuring Apollo, Diana, Hercules, Prometheus and Venus.

AMANDRY, Robert 1905-
Born at Romilly-sur-Seine on January 29, 1905, he studied sculpture under Patey, Dropsy and J. Boucher. He won a gold medal of honour in 1930 and subsequently took part in the exhibitions of the Société des Artistes Français between 1934 and 1942.

AMARI, Michele fl. 19th century
Worked in Rome on decorative sculpture, busts and portrait reliefs. He was awarded a medal for his maquette of a bust of Mazzini, subsequently erected in the Monte Pincio in 1892.

AMAT, Anna fl. 20th century
Born in Barcelona, she later moved to Paris and studied under Claude Devenet and Leo Hermann. She exhibited at the Salon des Artistes Français between 1930 and 1933.

AMATEIS, Louis 1855-1913
Born in Turin in 1855 and educated at the Royal Academy in that city before emigrating to the United States and settling in Washington, D.C. where he died in 1913. He is best known for the statues of the Defenders of the Alamo erected at Austin and Galveston in Texas. He was a member of the Society of Washington Artists and the National Sculpture Society of New York, and exhibited figures and busts at the Pan-American Exposition in Buffalo, 1901. His son, Edmond Romulus Amateis (born in Rome, 1897) was also a sculptor.

AMATUCCI, Carlo fl. 18th century
Born in Naples and died at Mafra in 1809. He studied sculpture under Vasallo and went to Lisbon in 1804 where he sculpted the statue of Generosity for the Ajuda Palace. He modelled the medallion profile of the hereditary Prince of Mafra, now preserved in that town, shortly before his death. He is best known for his numerous statuettes of horses.

AMBERG, Adolphe 1874-
Born in Hanau, Germany, he became a student at the Berlin Academy and later the Académie Julian in Paris. He took part in the international exhibitions in Paris (1900), Berlin (1904) and Munich (1906), showing figures and busts.

AMBROIS, Maurice fl. 20th century
Born at Bois-Commun (Loiret), he studied art in Paris and exhibited at the Salon d'Automne from 1935 till 1943. Best known for his realistic study entitled Comrade of Captivity.

AMBROSI, Gyslings fl. 20th century
Born at Eisenstadt in Austria he studied sculpture in Paris in the 1930s. He specialised in portrait busts. Those of Painlevé and Clémenceau were exhibited at the Salon des Artistes Français in 1932 and 1933 respectively.

AMBROSIO, Gabriele fl. 19th century
Born in Turin in 1844, he studied under Vincenzo Vela. He had a high reputation as a monumental sculptor working on the grand scale and is best remembered for the memorials to Giambattista Bodoni (Saluzzo), Diodata da Saluzzo (Ivrea) and General Perrone di San Martino. Apart from his numerous monuments, tombs and colossal busts he also produced bronze statuettes. A cast of his figure of the sculptor Carlo Marochetti is in the National Gallery, London.

AMBROSIO, Louis d' 1879-1946
Born at Picinisco, Italy on June 21, 1879, he emigrated to France as a young man and died in Paris in 1946. He studied under P. Gasq and H. Greber and became a *Sociétaire* of the Artistes Français, winning an honourable mention (1908), a bronze medal (1923) and a silver medal (1925). He was decorated with the Legion of Honour in 1932. Ambrosio produced many busts and relief portraits as well as figures of athletes, a number of which were purchased by the French government. He exhibited at the Salon des Artistes Français from 1911 till 1937 and at the Indépendants from 1928 to 1942, the latter staging a retrospective exhibition of his work in 1947. He was Vice-President of Samothrace, an association for wounded artists, during both world wars.

AMBUCCI, Torello fl. mid-19th century
Born in Italy, he emigrated to England and lived in London. He exhibited at the Royal Academy from 1851 to 1860 as well as the British Institution and specialised in allegorical busts, figures and groups.

AMEEN, Märta 1871-
Born at Vienna on February 28, 1871, the daughter of the Swedish diplomat, Count Sparre. She studied art in Paris under Curtois and Dagnan-Bouveret. At first she concentrated on animal painting but later turned to sculpture in the same field. She took part in the international and national exhibitions in Paris, Stockholm and Munich at the turn of the century. Her animal studies tended to have humanoid characteristics, in the manner of Landseer. Her best known works include Percherons in Harness, Old Comrades and For Sale and Works.

AMES, Sarah Fisher 1817-1901
Born in Lewes, Delaware in 1817, she died in Washington in 1901. She specialised in busts and portrait reliefs and sculpted a wide range of American celebrities in the mid-19th century. Her works are in the Senate Gallery, Washington.

AMIEL, L.R. fl. 19th century
A sculptor of small figures and busts who exhibited at the Paris Salon from 1883 to 1892.

AMIGUET, Marcel fl. 20th century
Born in Ollon in the Swiss canton of Vaud, he worked in Switzerland in the first half of this century. He exhibited figures and groups at the Salon des Artistes Français in 1920 and 1922, the Salon des Tuileries in 1923 and at the Salon d'Automne in 1922-24.

AMLEHN, Franz Sales fl. 19th century
Born at Sursee, Switzerland on January 29, 1838, he studied sculpture in Munich, but returned to Switzerland where he specialised in religious sculpture, producing statuettes for churches, altar pieces and the relief decoration on tombs. He also did a number of secular works, especially busts of contemporaries such as Pestalozzi, Paul Deschwanden and Bishop Lachat. His son and daughter were also sculptors.

AMLEHN, Paul 1867-
Born at Sursee, the son of Franz Sales Amlehn (q.v.). He studied at the Villa Medicis in Rome and later in the workshop of Édouard Boutry in Paris where he produced a series of sculptures in 1894. His best known work is the statue of a horseman in Dunkirk Town Hall. He worked mainly in marble, though busts and medallions were executed in plaster and then cast in bronze. The bulk of his work belongs to the period 1894-1905.

AMLEHN, Salesia fl. 19th-20th centuries
Daughter of F.S. Amlehn, known only for her marble sculptures signed under the alias of L. Thibault.

AMORE, Antonio d' fl. 19th century
Worked in Sicily during the second half of the 19th century. He took part in various Italian national exhibitions and exhibited a statue of Ciullo d'Alcamo (Parma, 1870), Woman Drawing (Milan, 1872) and an allegorical group entitled Song (Rome, 1883).

AMUTIO Y AMIL, Federico fl. 19th-20th centuries
Born in Madrid on July 18, 1869, he studied at the Academy of San Fernando before going to Rome. He was awarded the first prize for sculpture at the Madrid Exhibition at 1890-2. His works include For the Motherland (Rome, 1890), the Sons of Cain (1893) and various medallions, plaques and busts. He also worked as a painter.

AMY, Jean Barnabe 1839-1907
Born in Tarascon on June 11, 1839 he spent most of his life in that town and died there in March 1907. He studied in Paris under Dumont and Bonnassieux and enrolled at the École des Beaux Arts in October 1864. He was awarded a medal at the Salon of 1868 and an honourable mention at the Exposition Universelle of 1900 but his work was otherwise uninspired and undistinguished. His better works include the bronze figure of Figaro for the façade of the Hotel Figaro, 1874, the bust of Paul Soleillet (1888), The Drum of Arcole (1897), the bronze relief of La Tarasque (1883). At the Exposition Universelle of 1900 he showed a series of eight bronze, terra cotta and tinted plaster masks. Other sculptures by Amy are known in marble, stone and plaster.

ANASTESESCO, Démetre (Dimitri) fl. 20th century
Born at Rucar in Romania he emigrated to France and studied under Boucher in Paris. He specialised in busts and heads, some of which were exhibited at the Salon des Artistes Français in 1929-30.

ANCIAUX VON ELSBERG (Anciaux d'Elberg), Albert
fl. 19th-20th centuries
Born in Alsace some time after 1870 he moved to Paris, hence the change in the form of his surname. He studied under Cavelier and Barrias. He exhibited regularly at the Salon des Artistes Français, getting an honourable mention in 1898 and becoming a *Sociétaire* in 1901. A minor member of the Animalier School, best known for his statuette of an African Elephant (1936).

ANDERS, Richard fl. 19th century
Born at Quedlinburg in Germany on February 10, 1853, he studied at the Berlin Academy and worked for eight years under E. Hundrieser. He produced many impressive statues and monuments, including those to Gustav Nachtigal (1889) and the Kaiser Wilhelm memorial at Cologne (begun in 1891 and completed in 1897). His best work is probably the Charging Cuirassier at the battle of Mars-la-Tour on the monument to the Franco-Prussian War at Quedlinburg. His minor works include figures of Bismarck and General Count von Haaseler, shown at the Berlin Exhibition of 1909, and the series of German savants for the Prussian Ministry of Culture.

ANDERSON, Christopher 1914-
Born at Yorkley in the Forest of Dean on February 25, 1914, he studied art at the Royal College of Art under Garbe (diploma 1939) and subsequently at Goldsmiths' College School of Art. A versatile artist, both as a painter in oils and as a sculptor in terra cotta, stone, wood and metal, he has exhibited at the Royal Academy and at provincial exhibitions. Elected A.R.B.S., he lives and works in London.

ANDERSON, Jeremy 1921-
Born at Palo Alto, California in 1921, he studied at the California School of Fine Arts from 1946 to 1950, subsequently becoming a teacher at that school and then a lecturer at the University of California (1955). He lives in California and has had exhibitions of his sculptures at the Metart Gallery, San Francisco (1949) and the Stable Gallery, New York (1955).

ANDERSON, William Wallace d. 1975
Australian sculptor and painter who died in October 1975. He was an official war artist during the first world war and served with the Australian Imperial Force at Gallipoli in 1915. His best known works are the figures and reliefs on the Shrine of Remembrance to the A.I.F. in Melbourne and the statue of Simpson and His Donkey. He also sculpted genre figures and portraits.

ANDRAU, Joseph fl. 20th century
Born in Toulouse, he exhibited at the Salon des Artistes Français in 1935-36. Best known for his group The Wrestlers, he also specialised in portrait busts.

ANDRÉ, Alexis fl. 19th-20th centuries
Born in Paris in the mid-19th century, he studied under Mercié and Cavelier and exhibited at the Salon from 1878 to 1933, winning honourable mentions in 1885 and 1886 and a third class medal in 1904. He specialised in busts and among these the better known were Joan of Arc, Aphrodite, Henry Milne-Edwards and Maréchal Lefebvre.

ANDRÉ, Jean fl. 20th century
Born at Auxerre at the turn of the century, he specialised in animal figures and groups which he exhibited at the Salon Nationale in 1921-22, the Salon des Tuileries in 1923-25 and at the Salon d'Automne in 1937-38.

ANDREEV, Nikolai fl. 20th century
He worked in Moscow in the early years of this century. At the Munich Exhibition of 1909 he showed a bronze figure of Mother. After the Bolshevik Revolution he continued to work in Russia and sculpted busts of Lenin and other political figures.

ANDREI, René Jean Louis fl. 20th century
Born in Paris in the late 19th century, he studied art under Louis Lejeune, Injalbert and Bouchard. A prolific and versatile artist, he worked as a painter, engraver and sculptor and exhibited his works at the Salon des Artistes Français between 1918 and 1934.

ANDREONI, Orazio fl. 19th century
Worked in Italy in the later half of the 19th century and produced many small works, examples of which often turn up in the United States and Britain. His best known works include The Pharisee (Turin Exhibition, 1884 — a cast is in the Sydney Museum), Messalina (Munich, 1893) and the Blind Nidia. His figures of Negro and Moorish women are also known reproduced in porcelain.

ANDREOTTI, Libero 1877-1933
Born at Pescia, Tuscany, in 1877 and died in Florence on April 4, 1933. He worked in Milan and latterly Paris until the outbreak of the first world war when he returned to Florence and was appointed professor at the Royal Institute of Fine Arts. He strove to emulate the great Italian sculptors of the Quattrocento and was particularly inspired by Donatello and Ghiberti. He exhibited his bronzes at the Salon d'Automne in 1910-11 and at the Nationale in 1910-13. A retrospective exhibition of his work was held in connection with the 19th Venice Biennale. His smaller works consist mainly of busts and allegorical studies.

ANDREOU, Constantin 1917-
Born in Sao Paulo, Brazil, of Greek parents who returned to Athens in 1924 where he began his artistic studies. He became a pupil of Jenny Maroussi in 1935 and studied sculpture with her until the end of the second world war when he came to France with the aid of a grant from the French government. To his early period belong a wide range of sculptures, both wood and stone carving and modelling in clay and metal. Since 1948, however, he has concentrated on cut, hammered and soldered sheets of brass used in the construction of abstract works. A frequent exhibitor at the Salon de la Jeune Sculpture, he has also participated in many international exhibitions and had several one-man shows at the Galerie Gerard Mourgue in Paris.

ANDRESEN, Emerich 1843-1902
Born at Utersen in Holstein on February 20, 1843, he died in Dresden on October 7, 1902. He studied sculpture under Vivie in Hamburg and Hahnel in Dresden and became professor of modelling and director of sculpture at the Meissen porcelain works. Many of his figurines produced initially in porcelain were subsequently reproduced in bronze or spelter and include Psyche Enchained, the Spirit of Glory, Small Boy with a Frog and the Four Seasons personified as little children. He also sculpted the monuments to Holderlinden at Tubingen and Gutzkow at Dresden.

ANDRIESSEN, Mari Silvester 1897-
Born at Haarlem in 1897, he studied at the Academy of Fine Arts, Amsterdam and later at the Munich Academy. Originally concentrating on religious sculpture he turned to secular memorials and monuments after the second world war and is best known for his monuments to the Dutch Resistance in Enschede, Amsterdam, Rotterdam and Haarlem. Since 1950 he has produced a number of secular works and statues for public buildings, the most notable being his bronze figure The Docker, 1953. He lives in Haarlem, but travels widely in Europe and Latin America.

ANDRIEU, M.A. Ferdinand fl. 20th century
Born at Rodez in the late 19th century he studied sculpture under Mercié in Paris and exhibited at the Salon des Artistes Français from 1911 till 1933. He won a third class medal in 1911 with his figure of Mercury. Later works included Invocation, Marshal Fayolle (1931) and Saint Peter (1933).

ANDRIEU-GEZE, Monique fl. 20th century
Born in Toulouse, she specialises in busts and heads of children. Her work was shown at the Salon Nationale in 1936-38.

ANFRIE, C. fl. 19th century
He exhibited at the Salon between 1883 and 1890, various busts, portrait reliefs and medals.

ANGELA, Emilio 1889-
Born in Italy in 1889 he emigrated with his family to the United States and studied sculpture at the Cooper Union, Art Students' League, and National Academy of Design. He worked as pupil and assistant to A.A. Weinman. He was awarded first prize for composition and second prize for sculpture by the National Academy of Design. He is best known for his bronze garden groups Goose Girl and Goose Boy.

ANGHEL, Georges fl. 20th century
Born at Turnu Severin in Romania he came to France and studied under Injalbert. He specialised in portraiture and some of his heads and busts were exhibited at the Salon des Artistes Français between 1929 and 1933. His works include portraits of Romanian celebrities such as Enescu.

ANGHELATON, Lamprothea fl. 20th century
Born in Corfu, he exhibited busts at the Salon, 1934-39.

ANGELI, Horace fl. 20th century
Born at Bagni di Lucca, Italy, he exhibited busts at the Salon des Artistes Français, 1911-26.

ANGELINI, Tito 1806-1878
Spent his entire life in Naples apart from brief periods of study in other Italian cities and Paris. He became professor of sculpture in Naples and later director of the School of Design. He specialised in portrait busts of contemporary celebrities, both Italian and French.

ANGLADE, Alexandre fl. 19th century
Born in Toulouse in the mid-19th century, he died there in 1903. He studied under Falguière in Paris and exhibited at the Salon from 1881 till 1900, winning a third class medal in 1891. Most of his work consisted of bronze busts, reliefs and protrait medallions though he also sculpted a marble profile shown at the Exposition Universelle in 1900.

ANGLE, Beatrice fl. 19th-20th centuries
She worked in London in the late 19th century and participated in various exhibitions in Liverpool and London between 1885 and 1899. At the Paris Salon of 1892 she showed a figure of a young Venetian. She specialised in small busts and imaginative groups worked in porcelain or cast in bronze.

ANGLES, Joaquin fl. 19th-20th centuries
Born at Toulouse in the second half of the 19th century, he exhibited at the Salons from 1890 to 1899, winning an honourable mention in the latter year. His works include Idyll (1890), and Gavroche (street urchin) in 1892.

ANNENKOFF, Maria Nikolaievna fl. 19th century
Little is known of this sculptress beyond the fact that she died in St. Petersburg in 1889. At the exhibition of the St. Petersburg Academy in 1868 she entered a number of portrait busts, plaques and medallions.

ANREITH, Anton 1755-1822
Born in Freiburg, Baden in 1755, he died in Cape Town on March 4, 1822. Of Hungarian origin, he enlisted in the army of the Dutch East India Company and was sent to the Cape of Good Hope. Here he was encouraged by Louis Michel Thibault to develop his skill as a sculptor and he secured many commissions from the Cape authorities under both Dutch and British rule. His best known works are the lions at the top of Government Avenue and those at the entrance to Cape Castle. He also worked as a decorative sculptor in wood and stone, on many of the Cape churches and public buildings, notably the Groote Kerk in Adderley Street, and the pediment of the wine cellars at Groot Constantia. Many of his maquettes and wax models have been preserved by the museums of Cape Province.

ANSELL, Norah 1906-
Born in Birmingham on July 6, 1906, she was educated at the Birmingham College of Arts and Crafts and now lives in Edgbaston, Birmingham. She has sculpted in ivory and wood as well as bronze and has exhibited at the Royal Academy and in New York.

ANTOINE, Victor Charles fl. 20th century
Born at St. Die in the late 19th century he exhibited at the Salon des Artistes Français from 1911 to 1920, winning an honourable mention in 1913. He specialised in busts and heads.

ANTOKOLSKI, Markus 1843-1902
Born in Vilna on October 21, 1843, he died in Hamburg on July 14, 1902. He was trained as an engraver but enrolled at the Academy of St. Petersburg and studied sculpture. Following a period in Berlin he settled in St. Petersburg and sculpted the statue of Ivan the Terrible, for which he was elected Academician. Bronze reductions of the statue of Ivan the Terrible were popular in Russia in the late 19th century and a cast is in the Victoria and Albert Museum. Other works include the genre groups The Jewish Tailor and The Judas Kiss, figurines of Peter the Great, Jaroslav, Dimitri Danskoi and Ivan III, Nestor, Ermak the Conqueror of Siberia and the group of Christ before the People. Apart from his bronzes he also sculpted a number of busts and statues in marble.

ANTONIO, Assino fl. 19th-20th centuries
Sculptor in Barcelona who exhibited a figure entitled Dance at the Brussels International Exhibition in 1910.

ANTONIO, Julio 1889-1919
Considered as something of a child prodigy in Madrid at the turn of the century, he was one of the most expressive artists in Spain at that time. He specialised in busts depicting the racial types of Spain. Examples of his work are in the Museum of Modern Art, Madrid.

ANTRIM, Angela Christina, Countess of 1911-
Born at Malton, Yorkshire on September 6, 1911, the daughter of Sir Mark Sykes, Bt. She studied art in Brussels and worked in the studio of M. d'Haveloose from 1927 to 1932. Later she studied at the British School in Rome before marrying the Earl of Antrim. She now lives in Northern Ireland. She has exhibited at the Royal Academy, the Royal Hibernian Academy and the Royal Ulster Academy and had her own show at the Beaux Arts Gallery, London in 1937. Her figures and groups, busts and heads have been worked in stone, terra cotta and bronze.

APARTIS, Athanasios fl. 20th century
Born in Smyrna of Greek parentage he moved to Greece after the first world war. His work consists mainly of statuettes and busts of contemporary personalities such as Eleftherios Venizelos and Professor John Psichari. Outside Greece he has taken part in the Salon des Indépendants in 1926 and 1937, the Salon des Tuileries from 1923 to 1931 and the Salon d'Automne from 1921 to 1938.

APEL, Marie fl. early 20th century
Born at Upton Park in London in 1888 she studied sculpture in London and Munich and exhibited at the Salon Nationale in 1912 and at the Salon des Artistes Français in 1913. Her best known works are the statue of Chin Gee Hee in Hong Kong and the marble and bronze fountain in Pasadena, California. She also executed a number of bronze heads and busts, of which the Young Satyr is the most notable.

ARBUS, André 1903-
Born at Toulouse in 1903, Arbus made his reputation as a decorator and furniture designer before turning to architecture and only latterly to sculpture. He made his début in 1934 at the Salon d'Automne with interior designs. He teaches sculpture at the École des Arts Décoratifs in Paris and has produced a number of heads, busts, torsos and figures characterised by an intense and disturbing realism.

ARBUTHNOT, Malcolm 1874-1967
A painter of landscapes and seascapes working in oils and watercolours, he studied art under C.A. Brindley, J.W. Fergusson, W.P. Robins and Charles Simpson. Late in life he turned to sculpture and produced several noteworthy bronzes in the 1950s.

ARCHIPENKO, Alexander 1887-
Born in Kiev on May 30, 1887, he studied painting and sculpture at Kiev Art School from 1902 to 1905, then in Moscow from 1906 to 1908 where he took part in several exhibitions. In 1908 he went to Paris and attended the École des Beaux Arts for some time, rounding off his formal education by studying classical sculpture in the Paris museums. He had his first one-man shows in Hagen and Berlin in 1910, opened his own art school in Paris that year, and exhibited at the Salon d'Automne in 1911. During the first world war he played a major part in the Russian art movement in Paris but in 1919 he went to Berlin and subsequently established an art school there. During his Parisian period he introduced new aesthetic elements into sculpture, particularly the idea of concave as well as transparent materials. He participated in the various Cubist exhibitions from 1912 onwards and made his American début in 1913 at the New York Armory Show. In 1919 he exhibited again at the Salon d'Automne, but also accompanied his sculptures on a tour of Europe. After his two years in Berlin he moved, in 1923, to New York where he founded yet another art school. The following year he devised the technique of painted sculpture which he name 'archipainting'. He became an American citizen in 1928 and has lived there ever since, holding numerous one-man exhibitions as well as participating in major national and international art exhibitions. He taught at Washington University (1935-36) then taught sculpture at the new Bauhaus in Chicago founded by Moholy-Nagy (1937-39). In 1939 he re-opened his school in New York and in the ensuing decade produced some of his finest and most inventive work. In 1950 he taught for a time at Kansas University and now lives in New York.

Most of his work in bronze belongs to the decade from 1909 to 1919 and consists of heads and torsos in the Cubist idiom. To the later period belong his more grandiose and experimental works, in stone and iron, while the transparent sculptures with inside lighting date from 1948 when he sought to explore the concept of the 'modelling of light'.

ARDOUIN, Georges Edmond fl. 20th century
Born in Paris in the late 19th century, he studied sculpture under Falguière and Hiolin. He exhibited figures and groups at the Salon des Artistes Français from 1907 to 1929.

ARMBRUSTER, Leopold fl. 19th century
Born at Rippoldsau in Baden on June 6, 1862, he studied in Dresden where the best examples of his work are preserved. He specialised in reliefs done in marble or bronze. His bronze Young Man Dying was shown at the Munich Exhibition of 1893.

ARMITAGE, Kenneth 1916-
Born in Leeds on July 18, 1916, he studied at Leeds College of Art (1934-7) and the Slade School in London (1937-9). After military service during the second world war he taught at the Bath Academy of Art, Corsham (1946-56) and was Gregory Fellow in Sculpture at Leeds University (1953-5). He made his international début in 1952 at the Venice Biennale and has since participated in most of the major international art exhibitions throughout the world. His first one-man show was held at the Gimpel Fils Gallery, London in 1952 and he has since taken part in the open air sculpture salons from Paris to Sydney. He has received several important international awards, including the David E. Bright Foundation Award for the best sculptor under 45, at the Venice Biennale in 1958. Armitage has worked almost exclusively in bronze, producing groups in which the individual figures form an integral part of a large, flattened mass. His works include People in a Wind and Family going for a Walk (both 1951), Seated Group Listening to Music (1952), Diarchy and Two Seated Figures (1957) together with a number of reliefs.

ARMSTEAD, Henry Hugh, R.A. 1828-1905
Born in London on June 18, 1828, he died in the same city on December 4, 1905. He studied at the Royal Academy schools under Bailey, Leigh and Carey and exhibited at the Royal Academy from 1851 till his death, being elected ARA in 1875 and RA four years later. Armstead was one of the most versatile artists of his period, having worked successively as a designer, wood engraver, wood carver, silversmith and sculptor in marble and bronze. He produced numerous busts and reliefs and many of his larger works in marble were also reproduced as bronze reductions by the Art Union of London. His best known works included his allegorical groups in the Albert Hall, St. Michael and the Serpent, the statue of the Earl of Pembroke, the bronze studies of Religion and Philosophy, the statue of King Henry VI for the fountain in Cambridge and the figures of David, Moses and St. Paul in Westminster Abbey. Much of his work was architectural and he had many commissions for bronze reliefs and panels for the decoration of churches and public buildings.

ARMSTEAD, Hugh Wells fl. late 19th century
Born in London on November 8, 1865, the son of H.H. Armstead under whom he studied sculpture. A surgeon by profession, he also studied at St. John's Wood School of Art and practised as a sculptor in his leisure time. Several small allegorical studies and bronze figurines are attributed to him.

ARNAU Y MASCORT, Eusebio fl. 19th century
Born in Catalonia, he studied at the School of Fine Arts, Barcelona before going to Rome, Florence and Paris to further his studies. His first exhibited work was a plaster bas-relief Placing the Relics of Saint Eulalia on a Bier, shown at the Palace of Fine Arts in Barcelona in 1891. His later works, cast in bronze, included Ave Maria, Hope and the door for the Church of Comillas, distinguished by its interesting reliefs.

ARNHEIM, Hans 1881-
Born in Berlin on January 8, 1881, he studied under Peter Breuer and Ernst Herter at the Royal School in Charlottenburg. He was a prolific sculptor of groups, the most noteworthy being The Night and Norwegian Skater. At the Berlin Exhibition of 1909 he showed the bronze statuette of an athlete.

ARNOLD, Anne 1925-
Born at Melrose, Massachusetts in 1925, she studied at the Art Students' League from 1949 to 1954 and subsequently took part regularly in exhibitions in New York where she lives. She is noted for her very liberal interpretation of animal studies, in bronze and wood.

ARNOLD, Henry fl. 19th-20th centuries
Born in Paris in the second half of the 19th century, he worked primarily as a painter but also exhibited a number of busts and figures at the various Paris Salons up to 1931. He made his début as a sculptor in 1906 at the Société Nationale with a plaster study The Slave. His bronzes include two figures shown at the Salon d'Automne in 1928; one of these, The First Offering, was purchased by the French government. The Musée de Luxembourg has his bronze bust of Madame K.

ARNOLD, Reginald Edward 1853-1938
Educated at Lancing College, Sussex, he studied painting and sculpture under Alphonse Legros at the Slade and under Carolus-Duran in Paris. His bronzes consisted largely of classical groups, such as Perseus freeing Andromeda (1909). He exhibited at the Royal Academy and the British Institution from 1876 onwards. He lived in Dorking but died in London on February 10, 1938.

ARNOLD, Walter 1909-
Born in Leipzig in 1909 he has been professor of sculpture at the Dresdner Hochschule für bildende Kunst since 1949 and one of the most formative influences on the East German sculptors since the second world war. He is equally versatile as a wood-carver and as a modeller for casting in bronze, in both small works and in large monuments, such as the memorial to Ernst Thälmann at Weimar (1958) and his colossal allegory of Youth – Builder of the G.D.R. (1952). His smaller works have included many busts and portraits of contemporary German personalities and the bronze figure of a dancer at rest, Tanzpause.

ARONSON, Naum fl. 19th-20th centuries
Born at Kieslavka in Russia in the second half of the 19th century, he worked in western Europe at the beginning of this century. His allegorical work Dream of Love was exhibited in Berlin in 1901 and five years later he showed at the Salon in Paris a bust of Beethoven, a study for a monument which was erected much later in Bonn. He was awarded a large gold medal at the Liège Exhibition and elected Sociétaire of the Nationale des Beaux Arts in 1909, taking part in the Salons of that group from 1909 to 1938. Most of his work consisted of busts, figures and torsos carved in marble or porphyry, the most notable being his Salome and Lenin (1937) but his bronzes include figures of an old man and Beethoven.

AROSENIUS, Karin Magdalena fl. 19th century
Born at Norrköping in Sweden on July 29, 1851, she studied at the local technical school and the Academy of Stockholm. From 1870 to 1874 she travelled extensively and completed her studies in Copenhagen, Rome and Paris. Her speciality was statuettes, of which she produced a vast number, the Young Girl of Syracuse being the best known. At the Exposition Universelle of 1889 she was awarded an honourable mention.

ARP, Jean (Hans) 1887-
Born in Strasbourg in 1887 he became one of the great creative and artistic influences of the 20th century as a poet, painter, writer, sculptor and artist in tapestry, collage, and reliefs in polychrome woods. With his wife, Sophie Täuber, and Theo van Doesburg he executed the series of remarkable decorations for the Aubette in Strasbourg, unfortunately destroyed during the second world war. His earliest experiments in sculpture consisted of abstract reliefs painted white. His first sculptures in the round appeared in 1931. Arp studied at the Weimar Academy and the Académie Julian in Paris and later, while working as a painter in Weggis, Switzerland, he turned to modelling. His early sculpture was influenced by Rouault and Seurat. In 1912 he took part in the Blaue Reiter exhibition and the following year exhibited at the Herbstsalon of the Sturm Gallery in Berlin. He spent the first world war in Switzerland where he became one of the founders of Dadaism which influenced his early works such as Forest (1916) and Hammer-flower (1917). From 1922 to 1928 he was a member of the French group of Surrealists and Dadaists in Paris, but in the 1930s he turned towards more conventional sculpture in the round. To this period belong the fantasy sculptures such as Bust of a Goblin, Little Sphinx, Head on Claws and Sculpture of a Being Lost in a Forest. During the second world war he lived in Grasse in the south of France and later settled in Greece. To this period belong his so-called 'Mediterranean' works, exemplified by Orphic Song (1941), Idol (1950) and Cypriana (1951). In the 1950s he developed the concept of more open sculpture in which mass and space define and balance each other, as in Ptolemy (1953). In more recent years he has also sculpted a number of reliefs for universities in the United States and South America and the UNESCO Building in Paris. Other notable bronzes include Growth (1938), Star (1939), Mediterranean Group (1941-2), Shell Crystal (1946), Head on Claw (1949) and Figure without Name (1951).

See *Unsertäglichen Traum* (Our Daily Dreams), Arp's autobiography (1955). Carola, G.W. *Jean Arp* (1957). Read, Herbert *Arp* (1967). Soby, James Thrall *Arp* (1958). Trier, Edward *Jean Arp – Sculpture 1957-66* (1968).

ARSAL, Eugène René fl. 19th-20th centuries
Born in Paris in the late 19th century, he studied under Hiolle and A. Lemaire. He exhibited at the Salon des Artistes Français from 1905 to 1939, specialising in busts heads and portrait medallions.

ARSENIUS, G. fl. 19th century
He exhibited a bronze statuette at the Société Nationale in 1901.

ARSON, Alphonse Alexandre 1822-1880
Born in Paris on January 11, 1822, he studied under Joseph Combette and specialised in animal and bird studies, though he also exhibited a genre group of a Washerwoman and her Children at the Salon of 1859. His animalier groups include Hen and Chicks, Fighting Cocks (1859), Pheasants (1863), Pheasant and Young (1864), Partridge surprised by a Weasel (1865), Pheasants (1866), Partridge and Young surprised by an Ermine (1867). Later works included Cock Pheasant and Golden Pheasant and the humorous but realistic group of a Frog riding on the back of a Hare.

ARTHEZ, Philippe d' fl. 19th century
Born in Paris in the latter half of the 19th century, he studied sculpture under Frémiet, but is better known for portrait busts than animal studies. He exhibited busts of Eugène Grandsire and General Alex at the Salons of 1905 and 1911.

ARTHOZOUL, Julien Pierre fl. 20th century
Born at Carcassonne he studied painting and sculpture and exhibited at the Salon des Artistes Français in 1933-9, winning an honourable mention in 1934.

ARTUS, Charles 1897-
Born at Etretat in France on July 16, 1897, he studied under Navelier. He exhibited at the Salon des Artistes Français (1920-7), the Salon des Indépendants (1931-2) and the Nationale des Beaux Arts (1941). He worked exclusively as an animalier and his bronzes include Guinea Fowl, Cow (1921), Wild Boar (1922), Sow (1923), Red Ibis (1935). The Musée d'Art Moderne in Paris has his Hare and Senegalese Blackbird.

ASCHERSON, Pamela 1923-
Born on March 3, 1923 she studied at Farnham School of Art under Charles Vyse and won a scholarship to the Royal College of Art in 1941. Since then she has exhibited at the Royal Academy and in provincial exhibitions. She lived in London but latterly in France where she has worked as an illustrator and modeller primarily in terra cotta.

ASKEW, Felicity Katherine Sarah 1899-
Born in London on December 19, 1899, she studied art under Max Kruse, Frank Calderon and Ernesto Bazzaro. She lived at Newmarket and latterly in Berwick-on-Tweed and worked as a painter and sculptor of equestrian subjects. She exhibited in London, Liverpool, Paris and various European exhibitions. Her best known work is the bronze group of horses entitled Companions of Labour (1926).

ASSA, René fl. 20th century
Born in Paris in the late 19th century and died in the same city in 1949. He was a pupil of Guilloux, Blondat and la Monaca and exhibited at the Salon des Artistes Français in 1912-14, 1921 and 1926-8, mainly figurines and small groups. He also modelled figures for reproduction in ceramics.

ASSIS, Nicolina de 19th-20th centuries
A pupil of Rodolpho Bernardelli, she lived and worked in South America at the turn of the century. At the Rio de Janeiro exhibition of 1902 she showed two studies, Head of a Woman and Young Girl Asleep.

ASSY, Hubert d' fl. 19th-20th centuries
Born at Fontaine en Sologne, he exhibited at the Salon des Artistes Français from 1885 to 1933, specialising in statuettes of horses.

AST, Otto fl. 19th century
Born at Schöneberg, near Berlin, on October 26, 1849, he studied at the Berlin Academy from 1868 to 1871 and made numerous statues and busts. His bust of Goethe is his best known work.

ASTANIÈRE, Eugène Nicolas Clément, Comte d' fl. 19th century
Born in Paris in 1841, he studied under Falguière and worked in marble, plaster and bronze. His works include Child in the Wave (Douai Museum), Virgin and various bas-reliefs in the Church of St. Clotilde. He was awarded a bronze medal at the Exposition Universelle of 1889 and was an Officier of the Legion of Honour. He exhibited at the Salon des Artistes Français for many years.

ASTE, Joseph d' fl. 20th century
Born in Naples in the late 19th century he moved to Paris at the turn of the century and exhibited at the Salon des Artistes Français from 1905 to 1934, specialising in genre groups, portrait busts and animal studies.

ASTIE, Hector fl. 20th century
Born at Nérac, France, in the late 19th century, he exhibited at the Salon d'Automne from 1913 and the Nationale from 1914 onwards, concentrating on studies of babies, mothers and children and draped nudes. His best known work is Thus Spake Zarathustra shown at the Salon des Indépendants in 1927. He was also a prolific painter, devoting the later years of his career to this medium.

ASTOUD-TROLLEY, Louise 1828-1884
Born and lived in Paris, where she studied under Monanteuil. She exhibited at the Salon from 1865 to 1878, specialising in portrait medallions, reliefs and busts.

ASTRUC, Zacharie 1835-1907
Born in Angers on February 8, 1835, he died in Paris on May 24, 1907. He began exhibiting at the Salon in 1871 and was a prolific sculptor of busts, bas-reliefs, statues and figurines, his best known works including The Dawn, Édouard Manet, Mars and Venus, Hamlet, King Midas, Prometheus, My Daughter Isabella, Sar Peladan, Child and Toys, Rabelais, Carmen, The First Pangs of Love, St. Francis of Assisi and Blanche of Castille. His most remarkable work, however, is the Bronze Merchant of Masks in the Luxembourg gardens — the figure of a young man carrying the masks of Balzac, Carpeaux, Barbey, d'Aurevilly, Berlioz, Théodore de Banville, Delacroix, Corot, Gambetta, Dumas, Fauré, Gounod and Hugo. In addition to the diverse range of his work as a sculptor he was also a noted painter and watercolourist.

ATKINS, Albert Henry fl. early 20th century
Born in Milwaukee, Wisconsin in the late 19th century he studied at the Cowles Art School in Boston, 1896-8 and spent some time between 1893 and 1900 at the Julian and Colarossi academies in Paris. In 1909 he was appointed to the teaching staff of the Rhode Island School of Design. Several of his important works consisted of bronze on wood and included a series illustrating the Stations of the Cross. Among his other bronzes may be mentioned Spirit of the Sea, Peace and Portrait Relief.

ATKINSON, Arthur G. fl. 19th century
He exhibited at the Royal Academy and the British Institution between 1879 and 1891. His works included the Wounded Gladiator and the Martyrdom of St. Stephen.

ATKINSON, George 1880-1941
Born in Cork, Ireland on September 18, 1880 he lived in Dublin till his death on March 24, 1941. He studied art at the Royal College of Art in London and subsequently studied in Paris and Munich. He became head of the Metropolitan School of Art in Dublin and Director of the National College of Art in the same city. He exhibited regularly at the Royal Academy and the Royal Hibernian Academy (R.H.A. 1912), both etchings and oil paintings as well as sculpture.

AUBAN, Paul C.A. fl. 19th-20th centuries
Born at Mirebeau-sur-Beze on March 7, 1869, he studied in Paris under Falguière and Mercié and exhibited at the Salon des Artistes Français. He was awarded a first class medal in 1913 and later became a Chevalier of the Legion of Honour. His work consisted mostly of portrait reliefs, médallions and busts, genre studies and allegorical compositions, such as Souvenir, Malediction and He is Dead.

AUBARÈDE fl. 20th century
The *nom de travail* of a sculptor who exhibited a sculpture entitled Sadness, at the Salon d'Automne in 1945.

AUBERT, Antoine Pierre fl. 19th century
Born in Lyons on January 26, 1853, the son of Jean Antoine Aubert who taught him the rudiments of modelling. He studied at the École Nationale des Beaux Arts in Lyons and Paris and was a pupil of Dumont and Bonnassieux. He became professor of sculpture at Lyons in 1901 in succession to Dufraine. He made his début in Lyons in 1876 with portrait busts, which were later to become his speciality, Later works included a marble Guardian Angel and a plaster study of Judith. He sculpted a number of bas-reliefs and medallions in terra cotta, many of which were subsequently cast in bronze. He carried out many ecclesiastical commissions for statues, reliefs and altar decorations. Of his bronze busts the best known is that of the architect René Bardel (1884).

AUBERT, Arthur fl. late 19th century
Born in Moscow of French parents, he specialised in animalier sculpture. He became a member of the Imperial Academy of St. Petersburg and most of his works are preserved in Leningrad museums. These include Lion and Gazelle, Chimpanzee and Tortoise and Gazelle hunted by Dogs, the last-named being awarded a silver medal at the Exposition Universelle of 1900.

AUBERT, Jean Antoine 1822-1883
Born at Digne on April 14, 1822, the son of a baker, he worked for fifteen years in the studio of Nyons in Marseilles and also studied art in Lyons where he eventually settled. He specialised in decorative sculpture, much of which is preserved in the churches of Lyons and the surrounding district, and was also employed by the architect Tony Desjardins on the ornamental sculpture for the new town hall of Lyons. He carried out the restoration of the décor in the chapel of the Hôtel-Dieu under the direction of Perret de la Menue. Apart from his decorative sculpture he executed a number of statues and figurines. He died in Lyons on December 11, 1883.

AUBERT, J.J. fl. 19th century
A sculptor of this name exhibited several medallions and bas-reliefs at the Salons from 1888 to 1890.

AUBERT, Pierre d. 1912
Born at Lyons, a son of Jean Antoine Aubert, he studied sculpture there and in Paris where he was a pupil of Bonnassieux and Dumont. He exhibited at the Salon from 1879 to 1911 and became professor of sculpture at the School of Fine Arts in Lyons. He produced a large number of medallions, portrait reliefs and busts as well as such allegorical works as The Source and The Spirit of the Waves.

AUBRY, Alexandre Paul Victor 1808-1864
Born in Paris on April 22, 1808 he died in the same city on July 4, 1864. He exhibited at the Salon from 1842 to 1849. His figure entitled The Last Hope was awarded a medal in 1845.

AUBRY, Antoinette Marie fl. 20th century
Born in Paris at the beginning of this century, she studied under Millet, Marcilly and Peyraune and exhibited at the Salon des Artistes Français in 1931-36. She concentrated on portrait busts of her contemporaries, including Mlle. Gautier de Bonneval (1934), Yves Dusanter (1935) and Jacqueline de Billy (1936).

AUERBACH, Arnold 1898-
Born in Liverpool on April 11, 1898, he studied at the Liverpool School of Art and furthered his studies in Paris and Switzerland. He has lived in London for many years and exhibited at the Royal Academy and various provincial shows. His works include etchings and paintings as well as sculpture.

AUGUSTINCIC, Anton fl. 20th century
Born at Klavjeo in Yugoslavia, he specialises in portrait busts and female figures. He exhibited his works at the Paris Salon in 1925-26, and has had many State commissions since the second world war, notably the Victory monument at Nova Gradiska. Other works include statues and busts of Marshal Tito and figures of workers.

AURICH, Oskar fl. 19th-20th centuries
Born at Neukirchen, Germany in 1877, he studied at the School of Arts and Crafts in Dresden, where he subsequently established his studio. He specialised in statuettes, of which The Stupid Boy of Meissen won wide acclaim. Later he produced a number of busts of German historical personalities, the best known being his portrait of Martin Luther.

AURICOSTE, Emmanuel 1908-
Born in Paris, he studied sculpture under Bourdelle and Despiau and has exhibited at the Salon des Tuileries since 1928 and at the Salon des Indépendants since 1945. His early work consisted of figures and busts, executed in plaster, clay and bronze. Later he turned to monumental works, of which the bronze door for the League of Nations building in Geneva is the best known. A figurative sculptor, regarded as 'a baroque realist', he has experimented in more recent years with lead and iron as materials for his figures and groups. He taught at the École des Arts Décoratifs, the Académie de la Grand Chaumière and the École des Beaux Arts in Orléans. Retrospective exhibitions of his works were held at the Galerie Dina Vierny (1949) and the Galerie Galanis (1954).

AURIOL, André Lucien fl. 20th century
Born at Stenay in France at the end of the 19th century, he exhibited at the Salon des Artistes Français from 1923 to 1932 and won an honourable mention in 1928. He specialised in busts and statuettes.

AUTENZIO, S. fl. 19th century
He worked in Italy in the latter half of the 19th century as a sculptor of busts in bronze and terra cotta. Some of his works were exhibited at the Paris Salon from 1888 to 1893.

AUTER, Ludovico Marazhani fl. 20th century
Born in Florence at the end of the 19th century, he studied under Auteri-Pomar and produced a large number of statuettes and small groups. His work was exhibited at the Salon des Artistes Français in 1921-22 and 1926.

AVANZO, Lea d' fl. 20th century
Born in Padua at the beginning of this century, she studied under E. Roscitano. Her work consists mainly of genre and neo-classical figures and groups, such as The Slave (1931).

AVRAMIDIS, Joannis 1922-
Born in Batum, Russia in 1922 of Greek parents. He studied at the Batum Art School in 1937-39 before moving to Athens. In 1943 he left Greece and went to Vienna where he subsequently settled. He studied painting from 1945 to 1953 before turning to sculpture under Wotruba for three years. Since 1956 he has participated in major Austrian and international exhibitions and had one-man exhibitions in Arnhem and Vienna in 1958. He specialises in heads and figures, many of them abstract.

AYETTES, J. des fl. 19th-20th centuries
He worked in France as a sculptor of portrait reliefs, heads and medallions. His work was exhibited at the Salon between 1889 and 1893.

AYRES, Arthur James John 1902-
Born in London, he studied at the Royal Academy schools and later in Paris and at the British School in Rome, after winning the Prix de Rome in 1931. He has since exhibited at the Royal Academy and in national and international exhibitions. Elected F.R.B.S. in 1948, he works as a sculptor in stone, marble, wood and ivory as well as bronze. He is married to the painter Elsa Grunvold and lives in London.

AYRTON, Michael 1921-1975
Born in London on February 20, 1921, he studied at Heatherley's Art School and the St. John's Wood School of Art and completed his studies in Paris, Vienna and Rome. He shared a studio with the painter John Minton in Paris and exhibited at the Salons and also in international exhibitions since the second world war. He worked in Toppesfield, Essex as a painter, writer and sculptor of figures and heads. He began sculpting in bronze in 1954 and from then on produced numerous figures in this medium, including Shepherd (1954), various heads of Talos (1954-57), head of a Sceptic (1956), Figures in Balance (1956-57), Bather and Child (1956-57), Mother

and Child Bathing (1957), Watching Figure (1957), Acrobats (1958), Stylite (1958), Figure and Image (1957), Orpheus (1957), Minoan Landscape (1958), Minotaur and various versions of Daedalus and Icarus (1960-61).

Ayrton, Michael *Drawing and Sculpture* (1962).

AZIBERT, J. fl. 19th century
He specialised in portrait reliefs and medallions in terra cotta and bronze and exhibited at the Salon from 1887 to 1897.

BABB, Stanley Nicholson 1874-1957
Born in Plymouth, Devon in 1874, he died in London on September 16, 1957. He studied art in Plymouth and at the Royal Academy schools. His group of Boadicea swearing Vengeance for the Death of her Daughters won him a gold medal and travelling scholarship in 1901-2, which enabled him to continue his studies in Italy. He exhibited regularly at the Royal Academy from 1898 onwards, showing medallions, reliefs, busts, statuettes and groups. He produced a number of war memorials in the 1920s and lived in London for many years.

BABIN, Marguerite L. fl. 20th century
Born in Paris in the late 19th century, she was a pupil of Landowski and Bouchard. She exhibited at the Salon des Artistes Français from 1913 to 1935 and at the Salon d'Automne in 1919. She specialised in busts and heads, but is best known for her allegorical work The Armistice (1919).

BABLOT, Micheline fl. 20th century
Born in Montmorency at the beginning of this century, she studied under Jean Camus and Dropsy. Her figure entitled Repose was exhibited at the Salon des Artistes Français in 1939.

BACARDI-CAPE, Mimi fl. 20th century
Born in Cuba in the late 19th century, she studied under Landowski and Bouchard in Paris and exhibited a statuette at the Salon des Artistes Français in 1914.

BACCHI, Césare fl. 20th century
Born in Bologna in the late 19th century, he studied painting under Gervais and Savini in Verona and exhibited portraits and landscapes in various French and Italian exhibitions between 1911 and 1939. After the first world war, however, he studied sculpture under Barberi and produced a number of busts in the 1920s.

BACHELET, Émile Just 1892-
Born in Nancy on January 2, 1892, he studied sculpture in Nancy and Paris. He began exhibiting at the Salon des Artistes Français in 1920 and was awarded a gold medal at the Exposition des Art Décoratifs in 1925 for a bas-relief in the Nancy Pavilion. A *Sociétaire* of the Salon d'Automne, he exhibited at that Salon from 1926 to 1938, specialising in busts, small groups, figures and animal studies. He also exhibited at the Nationale, becoming an associate in 1929 and a member in 1933. His best known works are Pietá, Danseuse and Foal. Many of his figurines were also reproduced in terra cotta and porcelain. The main collections of his sculpture are in the museums of Nancy and Épinal.

BACON, Charles 1821-1885
Worked in London as a gem-cutter as well as a sculptor. He exhibited at the Royal Academy from 1842 till 1884, showing intaglios in cornelian and other gemstones as well as portrait reliefs, busts, bronze reliefs and neo-classical figures. His works include the bust of his friend Watts (1847), the bust of Shakespeare in Islington (1864) and the group of Helen Veiled before Paris (1853). His best known works are the Franklin Memorial (1861) and the equestrian statue of the Prince Consort at Holborn Circus, together with the reliefs on the plinth.

BACON, John 1740-1799
Born in Southwark, London, on November 24, 1740, he died in London on August 4, 1799. The son of a clothworker, he was apprenticed at the age of fourteen to the Lambeth porcelain works as a modeller. Apart from his prolific work as a ceramicist he did a number of bronzes, including the figures of Hercules and Atlas at Oxford Observatory, the group of George III and the River Thames at Somerset House (1789) and the ornamental clockcase at Buckingham Palace decorated with figures of Vigilance and Patience (1789). Between 1767 and 1799 he executed numerous monuments, statues and busts listed in *Gunnis*.

BACQUÉ, Daniel Joseph fl. 19th-20th centuries
Born at Viane, France, on September 20, 1874, he studied art in Paris under Bernstamm and Fumadelles. He exhibited regularly at the Salon des Artistes Français from 1900 onwards, obtaining a third class medal in 1910, a second class medal the following year and a gold medal in 1922. He was appointed a Chevalier of the Legion of Honour in 1920 and awarded a medal of honour at the Exposition Internationale in 1937. He also exhibited at the Salon d'Automne, (1920-25) and the Salon des Tuileries (1928). He specialised in allegorical studies and busts including those of General Duport (1927), Jehan Fouquet (1931), the sculptor Dropsy (1934), F. Sabatté (1936) and Bourdelle (1939).

BADEAU, Georges Laurent fl. 20th century
Born in Paris, he belonged to the Animalier school of sculpture and exhibited at both the Salon d'Automne and the Société Nationale from 1921 onwards and at the Salon des Tuileries in 1932-33. His animal figures and groups include Bison, Elephant and other exotic creatures. He also sculpted portrait busts.

BADEN-POWELL, Frank Smyth 1850-1933
Born in Oxford in 1850 and died in London on December 25, 1933, he was the elder brother of Lord Baden-Powell, founder of the Boy Scout movement. He trained as a barrister at the Inner Temple and was called to the bar in 1883. Subsequently he studied painting and sculpture in Paris under Carolus-Duran and Rodin respectively. He exhibited at the Royal Academy and the Paris Salon at the turn of the century and made two round-world trips (in 1902-3 and 1908-9) gathering material for his work.

BADII, Libero 1916-
Born in Italy but emigrated to Argentina in 1927. He studied at the Buenos Aires Art School and won a travelling scholarship in 1944 which enabled him to continue his studies in Bolivia, Peru and Ecuador. He visited Europe in 1948-49 and began exhibiting his work following his return to Buenos Aires. He again spent several months working in Paris and was awarded the Palanza prize in 1959. His early figurative work gave way to more abstract sculpture about 1955 and many of his bronzes are constructed as mobiles. His early works include Night and Day, Dance, Desire and Mother.

BADIN, Jean Victor fl. 19th-20th centuries
He was born in France and studied under Falguière and Mercié. He exhibited regularly at the Salon des Artistes Français and was given an honourable mention in 1897, and also at the Exposition Universelle in 1900. Much of his work consisted of plaster groups and studies of classical projects; among his finished bronzes may be mentioned Leda and the Swan (1927). He exhibited heads in terra cotta and bronze at the Salon d'Automne between 1927 and 1938.

BADOCHE, Edmond fl. 20th century
Born at Nevers in the late 19th century, he studied under Carlus and exhibited at the Salon des Artistes Français from 1904 onwards. He specialised in genre figures and groups including The Kiss (1906), the Crab (1934) and Ceasefire (1938).

BADRE, Elie fl. 20th century
Born at Hautes Rivières in France at the beginning of this century, he studied under Coutan, Bouchard and Landowski. He exhibited at the Salon des Artistes Français, such works as Funerary Urn (1931) and the portrait bust of his wife (1935).

BAENNINGER, Otto Charles 1897-
Born in Zürich where he also learned the techniques of sculpture during the first world war. In 1920 he went to Paris and enrolled at the Académie de la Grande Chaumière where he studied for a year before working in Bourdelle's studio. After his master's death in 1929 it was he who completed various unfinished works. From 1931 to 1939 he commuted between Paris and Zürich, finally settling in his birthplace on the outbreak of the second world war. He won the sculpture prize at the Venice Biennale of 1941. His large groups have been widely acclaimed but the best and most sensitive of his work is to be found among the smaller heads and busts.

BAER, Lillian 1887-
Born in New York, she received her artistic training at the Art Students' League, and worked under James Earle Fraser (1908-11) and Kenneth Hayes Miller (1918-20). She specialises in statuettes, decorative book-ends, mantel ornaments and busts, of which her Portrait of a Negro is the best known.

BAER, Nelly fl. 20th century
At the Salon des Tuileries she exhibited plaster busts (1933) and Young Girl in a Bonnet (1934).

BAFFIER, Jean Eugène 1851-1921
Born at Neuwy-le-Barrois on November 18, 1851, and educated at the Ecole des Beaux Arts in Nevers and the École des Arts Décoratifs in Paris under Aimé Millet. He exhibited at the Salon from 1883 (third class medal) and won a silver medal six years later. He also

participated in the Salon des Indépendants and the Salon d'Automne in 1911-13. He produced numerous medallions, reliefs, busts and statuettes in terra cotta, bronze and pewter, the best known being Fireside Corner, Jeanette, The Gardener, King Louis XI and Jacques Bonhomme. His works are preserved in the museums of Bourges, and Uzès.

BAGLIETO, Leoncio fl. 19th century
Born in Murcia, Spain, he studied at the special school of painting and sculpture in Madrid and later taught the modelling class at the School of Fine Arts in Seville. Most of his work was monumental and public sculpture, his best known works being the statue of Fray Domingo de Silos Moreno, Cadiz (1854) and the colossal bust of Murillo (1860), but he also sculpted a number of small figures and groups.

BAILLY fl. 19th-20th centuries
Said to have been a pupil of Falguière, he exhibited at the Salon of 1900 a figure Child playing with Marbles.

BAILLY, Charles Eloy 1830-1895
Born on January 7, 1830, he died in Paris in September 1895. He studied under Robinet at the École des Beaux Arts and exhibited at the Salon from 1863 onwards. He made his début with a plaster figure of St. Sebastian and was awarded a medal in 1867 for his group The Beggar's Wallet derived from the fable of La Fontaine. He also produced numerous medallions, busts, figures and groups in marble and plaster. His bronzes include the figure of Abbé Grigoire at Lunéville (1885), the figure of Diogenes (1895) and portrait busts of Julie Kieffer-Grandidier, Soliman Pasha, and the engineer Simon Maupin.

BAILLY, Charles François 1844-1910
Born at Tarare, France on February 12, 1844, he came to Lyons about 1860 and studied under Fabisch at the École des Beaux Arts. He exhibited regularly at the Lyons Salon from 1873 onwards and also at the Salon des Artistes Français at the turn of the century. While best known as a monumental sculptor, working in stone and marble, he also produced a number of smaller works in terra cotta, and several of his large works were also reproduced as bronze reductions. It is possible that some of the portrait busts attributed to Charles Eloy Bailly were, in fact, executed by Charles François.

BAILLY, Paul Ernest fl. 19th century
Born in France in the mid-19th century, he was a pupil of Vital-Dubray and Aimé Millet. He exhibited at the Salon des Artistes Français between 1885 and 1898, mainly figures and groups in plaster but including a bronze bust of Simon Saint-Jean.

BAILY, Edward Hodges 1788-1867
Born in Bristol on March 10, 1788, he died at Holloway in London in 1867. He was the son of a woodcarver whose speciality was the decoration of ships and the modelling of figureheads. At the age of fourteen he became a clerk in a merchant's accounts office but during the ensuing two years he took lessons in wax modelling and became a professional wax portraitist in 1804. Gradually he became more involved in serious sculpture and eventually became a pupil of Flaxman with whom he worked for seven years. In 1808 he was awarded the silver medal of the Society of Arts for a plaster figure of Laocoon and in the same year he enrolled at the Royal Academy schools, winning their silver medal in 1809 and the gold medal in 1811 with a prize of 50 guineas for his group of Hercules Restoring Alcestis to Admetus. From 1816 to 1846 he was Chief Modeller at the goldsmiths' Rundell and Bridges and was responsible for the Doncaster Cup (1843) and the Ascot Gold Cup (1844). His best known work, Eve at the Fountain, was originally conceived in 1821 as the ornamental handles for a soup tureen, but was later carved in marble on the grand scale for the Bristol Literary Institute. He received many important public commissions, including the frieze for the Masonic Hall, Bristol (1825), the Marble Arch (1826), the National Gallery (1828) for which he did friezes and bas-reliefs on the façade. Despite his many monuments and busts his work is not now regarded very highly and he has been dismissed as a mechanical portraitist*. He exhibited at the Royal Academy from 1810 to 1862 and was elected R.A. in 1821. His work was exhibited at the British Institution from 1812 to 1840. Many of his groups and models for monuments, or portions of them, were later cast in bronze, the best

known being the equestrian statuette of George IV.

* Jeremy Cooper in *Nineteenth-Century Romantic Bronzes* (1975). A full list of his works appears in *Gunnis*.

BAIZERMAN, Saul 1889-1957
Born in Vitebsk, Russia in the late 19th century, the son of a poor saddler, he first studied in the home of an artist who employed him as a handyman. Later he found employment as a model at the Odessa Art Academy. In 1910 he emigrated to the United States and settled in Greenwich Village, New York where he died in 1957. He earned his living as a sewing-machinist and part-time teacher, while attending evening classes at the National Academy of Design and the Institute of Fine Arts. He acquired the rudiments of sculpture from Solon Borglum and Lloyd Warren. He married a painter and spent two years in France and Italy in the early 1920s. His first exhibition of sculptures in hammered copper and bronze was held at the Artist Gallery, New York in 1938. During the last decade of his life he worked on a series of small bronzes of working people, echoing a theme which he had developed in the 1920s, as exemplified by Man with Shovel (1926).

BAKIC, Vojin 1915-
Born at Bjelovar in Croatia (Yugoslavia) he studied at the Academy of Fine Arts in Zagreb with Ivan Mestrovic and Frank Krsinik (1934-8). His first exhibition was in his home town in 1940 and later he was commissioned to do a series of monuments for Bjelovar and other Yugoslav towns. Later he travelled to Italy, France and Britain. After the second world war his work was exhibited internationally, at the Venice Biennale, the Brussels World Fair (1958), the Galerie Denise René in Paris and the Documenta Exhibition in Cassel (both 1959). Following his early realist and neo-Cubist periods he attained an essential simplification in his choice and shaping of pure organic forms. He created compact masses in marble in the manner of Brancusi, but in more recent years has produced a number of open bronzes folded at the edges as if to enclose space. His aim is 'the simultaneous composition of the concave and the convex' as he himself has formulated it. He lives in Zagreb and has won many international awards in recent years.

BALDIN, Hermann fl. 19th-20th centuries
He worked in Zürich at the turn of the century and took part in the art exhibitions of that city between 1897 and 1904. He studied at the School of Arts and Crafts in Zürich and later at the Berlin Academy and worked for a time in Florence before settling in his native town. He is best known for the bronze reliefs on the doors of the Swiss parliament building in Berne. Most of his smaller work consisted of busts and heads, but he showed at the Berlin Exhibition of 1909 a genre figure Studying a Passage in a Book.

BALDY, Guillaume (Guglielmo Baldi) fl. 19th-20th centuries
Born in Rome, he studied at the Academy of Florence before emigrating to France. His bronze figurine of Electricity was exhibited at the Salon des Artistes Français in 1903.

BALESTRIERI, Bernardo fl. early 20th century
He worked in Palermo in the early years of this century. His best known work is Commission, shown at the Crystal Palace Exhibition in Munich.

BALICK, Robert fl. 20th century
Born in Paris at the end of the last century, he studied under Navelier and exhibited at the Salon des Artistes Français from 1920 to 1934. He specialised in animal groups and the heads and busts of women and children.

BALL, Louis fl. 20th century
He was born in Paris and exhibited at the Salon des Artistes Français, of which he was a *Sociétaire,* before the second world war. His best known work is The Holy Virgin sustained by the female saints (1938).

BALL, Percival fl. 19th century
He studied at the Royal Academy schools and exhibited at the Royal Academy from 1865 to 1882. He was awarded a medal in 1866 for his bas-relief entitled The Serpent in Bronze. Subsequently he worked in Rome for several years, and to this period belongs the marble bust of the author A. Blandford Edwards in the National Gallery, London. Sydney Museum has his group of Phryne before Praxiteles.

BALL, Ruth Norton fl. 19th-20th centuries
Born in Madison, Wisconsin in the late 19th century she worked in Cincinnati, Ohio at the turn of the century, specialising in busts, heads, reliefs and small figures.

BALL, Thomas 1819-1911
Born at Charlestown, near Boston on June 3, 1819, he died in Montclair, New Jersey in 1911. He began his artistic career as a painter but at the age of 25 he turned to sculpture and went to Europe to continue his studies. He spent some time in Florence and worked in other parts of Europe for two years before returning to the United States. His earliest major work, completed before he left for Europe, was a statue of the lexicographer Daniel Webster at Concord and this was published as a bronze reduction by C.W. Nicholls, bringing Ball both fame and fortune. From 1860 till the end of the century Ball ranked among the most fashionable American sculptors, receiving many public commissions and producing a large number of groups and ornamental sculpture whose simple and direct naturalism had enormous appeal to the Americans of the late 19th century. These works include the equestrian statue of Washington (Boston), Josiah Quincy (Boston Town Hall), Lincoln and the kneeling Negro Slave (Park Square), the Emancipation memorial in Washington, D.C., published as bronze reductions, as well as minor genre groups such as The Little Thought, Christmas and St. Valentine's Morning.

BALL-DÉMONT, Adrienne Elodie Clémence 1886-
Born in Montgeron, France on March 16, 1886, she studied under H. Royer and M. Baschet and also received instruction from her father, the painter Adrien Démont. She exhibited at the Salon des Artistes Français from 1911 to 1936, winning an honourable mention (1911), a silver medal (1926) and a gold medal (1936). Her work consisted mainly of allegorical figures and groups, the best known being the bronze of La France, shown at the Petit Palais during the first world war.

BALME, Jean Marie Jules 1831-1898
Born at Puy-en-Velay on December 4, 1831, he died in the same town on April 5, 1898. He was professor of sculpture at the Industrial School of Puy. The Puy Museum has his equestrian statuette of Joan of Arc and a group entitled The Four Seasons.

BALZICO, Alfonso 1820-1901
Born at Cava near Naples in 1820, he died in Rome on February 2, 1901. He began his studies at the Naples Academy and won the Rome Prize, subsequently studying in that city and in other parts of Italy. In 1860 he was commissioned by the Court of Savoy at Turin to execute two busts and an equestrian statue of Duke Ferdinand for Genoa, the latter being completed in 1867 and regarded as his finest work. He returned to Rome in 1872 and did the statues of Bellini and King Victor Emmanuel. His minor works include the Virgin of Purity, Noli Me Tangere and busts of Flavio Gioja, the Crown Prince of Portugal and the Portuguese ambassador Count Nigra, a group of Romulus and Remus and statuettes entitled The Ingénue, La Povera, The Vendetta and La Civetta.

BALZUKIEWICZ, Boleslas fl. 19th-20th centuries
Born in Poland in the late 19th century, he came to Paris and studied under Mercié. He specialised in busts and portrait reliefs, and exhibited at the Salon des Artistes Français in 1914.

BANBURY, William 1871-
Born in Leicester on October 19, 1871, he studied at the Leicester College of Art and the Royal College of Art, London before going to Paris. Later he became head of the sculpture department at Aberdeen College of Art before retiring to Leicester. He exhibited at the Royal Academy, the Royal Scottish Academy and various principal exhibitions and sculpted figures and groups in stone, marble, wood and bronze.

BANK, Jacques fl. 20th century
Born in Paris in the late 19th century, he exhibited at the Salon des Artistes Français in 1921-24, specialising in statuettes, busts and portrait reliefs.

BANKS, Thomas 1735-1805
Born in Lambeth on December 22, 1735, the son of William Banks,

steward to the Duke of Beaufort, he died in Paddington on February 2, 1805. He was educated at Ross-on-Wye and apprenticed in 1750 to William Barlow with whom he worked for seven years. He also studied sculpture under Peter Scheemakers and worked for William Kent as an ornamental sculptor. He was awarded a prize by the Society of Arts in 1763 for his Portland stone relief of the Death of Epaminondas, and obtained a further award two years later for a marble relief of the Redemption of the Body of Hector. He later worked for R. Hayward and studied at the Royal Academy which awarded him a gold medal in 1770 for his bas-relief of the Rape of Proserpine. In 1772 he was awarded a travelling scholarship and following his marriage in 1766 he went to Rome for seven years and worked on neo-classical groups. He returned to London in 1779 and went to St. Petersburg in 1781 where he sculpted a relief symbolising Armed Neutrality. He returned to London in 1782 and was elected ARA in 1784 and RA in 1786. Many busts and monuments by Banks are to be found in Westminster Abbey, St. Paul's Cathedral and other London churches. Apart from his larger works, he produced numerous small plaster and terra cotta models, many of which were sold at Christie's after his death and were subsequently cast as bronzes. The best known of his bronzes is the bust of Warren Hastings (1794), now in the National Portrait Gallery.

C.F. Bell *Annals of Thomas Banks* (1938).

BANNINGER, Otto Charles 1897-
Born in Zürich on January 24, 1897, he studied in Paris under Bourdelle and worked in France from 1920 onwards. He exhibited at the Salon des Tuileries (1923-32), the Salon d'Automne (1928-32) and the Swiss national salons in Geneva, Basle and Zürich. His work consists mainly of busts and portrait medallions.

BAR, Marie Louise fl. 20th century
Born in Thiais, France at the end of the 19th century, she exhibited at the Salon d'Automne (1919-26), the National (1921-22) and the Salon des Tuileries (1923-29), specialising in portraits, busts and animal studies.

BAR, Nelly fl. 20th century
Born in Cologne at the beginning of this century, she has concentrated on statuettes, busts and groups portraying young girls. She exhibited widely in Germany and at the various Paris salons in the 1930s.

BARALIS, Louis A. fl. 19th-20th centuries
Born in Toulon on July 7, 1862, he studied in Paris under Cavalier and Barrias. He exhibited at the Salon from 1888 onwards and also at the Salon des Artistes Français from 1913 to 1920. He won a third class medal in 1888 and a travelling scholarship six years later. In 1902 he was awarded a second class medal and was made a *Sociétaire* of the Artistes Français. He is best known for his genre groups, with a nautical flavour, such as Bathing, Saved and Shipwreck.

BARASCHI, Constantin fl. 20th century
Born at Campu-Lung in Romania, at the beginning of the century, he studied in Bucharest and Paris and exhibited a bronze Angel of Grief at the Salon d'Automne in 1928. He has also produced many busts and heads including those of Eminescu and Lenin.

BARBEAU, Michele fl. 20th century
Born at La Roche-sur-Yon at the end of the 19th century, she studied under Georges Barreau and Joseph Gauthier. She was a regular exhibitor at the Salon des Artistes Français in the 1920s, specialising in bas-reliefs and busts portraying provincial types and occupations.

BARBEDIENNE, Bernard 1909-1929
Probably a relative of Ferdinand Barbedienne the well-known bronze founder, he showed great promise as an animal sculptor and landscape painter. His works were exhibited at the Salon des Indépendants from 1927 to 1930.

BARBEE, William Randolph fl. 19th century
Died in Virginia in June 1868. During the first half of the 19th century he built up a reputation for his genre figures and groups of which Young Fisher-girl and Flirt are the best known. Similar works, including copies of the Fisher Girl, were made after his death by his son Herbert with whom he collaborated.

BARBIER, Nicolas François 1768-1826
Born in Namur, Belgium on September 8, 1768, he died on June 10, 1826. He studied in Antwerp and Paris and later practised as an architect and engraver as well as a sculptor. He specialised in plaques, reliefs and medallions, of which the best known are Christ, Vestal Virgin, Lion and Old Man absorbed in his Thoughts. He exhibited at the Haarlem National Exhibition in 1825.

BARBOROCKI, Zoltan fl. 20th century
South African sculptor of Hungarian origin. He emigrated to South Africa after the second world war and works on abstracts and architectural sculpture in Cape Town.

BARDELLE, Léon R. fl. 19th-20th centuries
Born in Limoges in the late 19th century, he studied under Bonnaissieux, Dumont and Thomas. He exhibited at the Salon from 1891 and also at the Salon des Artistes Français up to 1922. He specialised in portraits and busts but his genre group Despair was awarded a third class medal in 1895.

BARGAS, Henri fl. 20th century
Born in Paris, he studied under Vermare. He exhibited a group entitled Broken Wings at the Salon des Artistes Français in 1932.

BARGAS, Paul fl. 19th-20th centuries
He studied under Vimonti and specialised in portrait reliefs and medallions. At the Salon of 1901 he exhibited two medallions and, in 1903 a bust of Madame Tellier.

BARIGIONI, Filippo 1690-1753
Born in Rome where he worked during the first half of the 18th century, mainly on commissions from the popes Clement XI, Innocent XIII and Clement XII. He was a prolific sculptor of monuments, catafalques, statues and ornaments, mainly in marble, though a number of his works were later issued as bronze reductions. He also modelled the bronze figures decorating the tomb of Augustus II, King of Poland.

BARLACH, Ernst 1870-1938
Born at Wedel in Holstein on January 2, 1870, he died in Rostock in 1938. The son of a country doctor, he studied at the School of Arts and Crafts in Hamburg (1888-91), the Dresden Academy (1891-95) and the Académie Julian in Paris (1895-96). He was strongly influenced by Robert Dietz at Dresden. He worked as an illustrator on the magazines *Jugend* (1898-1902) and *Simplicissimus* (1907-8), joined the Berlin Sezession (1907) and spent some time in Russia. In 1910 he settled in Gustrow. He served in the German army during the first world war and became a member of the Berlin Academy in 1919. He exhibited at the various German art shows from 1906, in Berlin, Munich, Düsseldorf and Dresden and was one of the leading exponents of Expressionism in Germany before the first world war. His experiences during the war coloured his work in the 1920s when he executed a number of war memorials and allegorical groups such as Avenger, Death and Fugitive. Gradually the influence of Gothic art spread over his work. He fell foul of the Nazis as a 'degenerate artist' and several of his important public works, notably the monuments at Kiel and Gustrow were smashed and melted down, and no fewer than 381 of his minor works were withdrawn from public exhibition or confiscated by the Third Reich. The effect of this persecution hastened his death in 1938. In addition to his bronzes, Barlach worked extensively in wood and as well as his work as a graphic artist he was one of the leading dramatists of the Expressionist theatre.

Carls, Carl D. *Ernst Barlach* (1968). Werner, Alfred *Ernst Barlach* (1968).

BARLOW, Sibyl Margaret fl. early 20th century
Born in Essex in the late 19th century, she died in Chelsea in 1933. She studied art in London and at the Dresden Academy and exhibited at the Royal Academy and the Salon des Artistes Français in the 1920s.

BARNARD, George Gray 1863-1938
Born at Bellefonte, Pennsylvania in 1863, he studied at the Art Institute of Chicago and was a pupil of Carlier at the École des Beaux Arts in Paris. He exhibited at the Salon in 1894 and returned to the United States two years later. He was awarded a gold medal at the

Exposition Universelle of 1900. Though best known for the series of colossal statues, 35 feet high, for the Harrisburg Capitol, and other monumental groups, he also executed many small bronze statues, busts and heads, including the statue of Abraham Lincoln (Lytle Park, Cincinnati and also in Manchester, England), the heroic head of Lincoln, and the bronze bas-relief of Conception.

BARON, René fl. 20th century
Born at Neuilly-sur-Seine in the late 19th century. He exhibited at the Salon from 1913 to 1939 (*Sociétaire*, 1923) and specialised in busts of women, groups of children and bas-reliefs and ornamental sculpture for fountains and monuments.

BARON, Robert fl. 19th-20th centuries
Born at Thiel in France in the late 19th century, he studied sculpture under Verlet and Gardet, concentrating on the modelling of animal figures and groups. He exhibited at the Salon des Indépendants in 1909-10 and at the Salon des Artistes Français in 1912-14.

BARRAU, Théophile Eugène Victor 1848-1913
Born in Carcassonne on October 3, 1848, he died in April 1913. He studied under Jouffroy and Falguière and first exhibited at the Salon in 1874, subsequently winning third class (1879), second class (1880) and first class medals (1892), a silver medal at the Exposition Universelle (1889) and was appointed Chevalier of the Legion of Honour in 1892. At the Exposition Universelle of 1900 he was awarded a gold medal. Most of his work consists of large monuments and groups in stone and marble but among his minor works has been noted the bronze group The Sleep of Innocence (1897).

BARRE, Aristide 1840-1922
Born at Trappes on October 23, 1840, he studied in Paris and exhibited at the Paris salons in the early 1900s. Though best known as a portrait painter he also executed medallions and reliefs in silver and bronze.

BARRETT, Oliver O'Connor 1908-
Born in Eltham, London, he spent most of his working life in East Anglia, working in Ipswich and Colchester, apart from a short period in the United States. He has exhibited both in Britain and America and has had several one-man shows, especially in the United States. He has experimented with many different styles and worked in every medium of sculpture, and also done figurative paintings.

BARRIAS, Louis Ernest 1841-1905
Born in Paris on April 13, 1841, he died there on February 4, 1905. He was the son of the miniaturist and ceramic decorator known as Barrias the Elder, and brother of the painter Félix Barrias. He studied under Cavelier, Jouffroy and Coigniet at the École des Beaux Arts. He was runner-up in the Prix de Rome in 1861 and won the prize in 1865 with his allegorical group The Foundation of Marseilles. He began exhibiting at the Salon in 1861, with marble busts of Jazet and Barrias the Elder. Barrias was regarded as the leading exponent of the classical school and his numerous monuments, bas-reliefs and groups are to be found all over France. His many awards included a first class medal (1878), the Grand Prix (1889), Officer of the Legion of Honour and Member of the Academy (1884). Bronzes exist of many of his models, or reductions of finished works, in addition to numerous busts, statuettes, bas-reliefs and groups of contemporary and historical subjects and allegorical compositions.

BARRON, Eduardo fl. 19th-20th centuries
Born at Moraleja in Spain in the mid-19th century, he died in 1911. He studied painting and sculpture at the Special School in Madrid under R. Alvarez and was awarded a second class medal at the Madrid Exhibition of 1884. Subsequently he worked at the Spanish Academy in Rome, which preserves a plaster study by him for a statue of St. Joseph. He became Conservator and chief restorer of sculpture in the National Museum of Antique Art, Madrid. The Museum of Modern Art in Madrid has his bronze figure of the Portuguese Viriathus.

BARRY, Iraida fl. 20th century
Born in Sevastopol, Russia of mixed Irish and Persian descent. She came to France after the Revolution and took part in the Paris salons in the 1930s. Her work consists mainly of heads, busts and nude figures.

BARTELLETI, Adonis fl. 20th century
Born at Seravezzo in Italy at the end of the 19th century, he studied under his brother Aldo Bartelleti and Fontaine. He specialised in animalier sculpture, and is best known for his studies of polar bears.

BARTELLETI, Aldo fl. 20th century
Born at Seravezzo, Italy, he studied sculpture under M. Marx and H. Daillon. He settled in France and exhibited regularly at the Salon des Artistes Français from 1922 onwards and also at the Salon des Indépendants in 1941. He is best known for a remarkable incident in 1941 when he gave a demonstration before the press of the sculpting of a bust in stone, from start to finish, in one hour thirty-five minutes. Like his brothers, however, he specialised in animal figures and groups in terra cotta, marble and bronze.

BARTELLETTI, Daniel fl. 20th century
Younger brother of the above, and born in Paris in the early years of this century. He practised as an animal sculptor in the 1930s, specialising in studies of greyhounds. His group of the Death of Actaeon was exhibited at the Salon des Artistes Français in 1936.

BARTFAY, Tomas fl. 20th century
Sculptor of allegorical and genre figures, such as Friendship, working in Prague.

BARTH, Carl Georg fl. 19th-20th centuries
He worked in Munich at the turn of the century, producing monuments and statuary in marble, as well as small figures, groups, busts and heads in bronze. Among the latter may be mentioned Young Nymph and Children (1909), Fauns Making Music, Youth, Harmony and Head of a Child.

BARTHÉLEMY, Antonin fl. 20th century
Born in Paris in the late 19th century he studied at the École Nationale des Beaux Arts in 1912-14 and exhibited animal figure and groups at the Salon d'Automne in 1919 and 1924.

BARTHÉLEMY, Raymond 1833-1902
Born in Toulouse on June 18, 1833, he died in Paris on October 1, 1902. He enrolled at the École des Beaux Arts in 1857 and began exhibiting at the Salon two years later. His work was highly regarded by his contemporaries and he received many awards at the Salon and also at the Expositions of 1867 and 1889. Although best known for his large public sculptures, he also did various ecclesiastical bas-reliefs in bronze and genre groups such as Young Faun with a Goat (1866).

BARTHOLDI, Frédéric-Auguste 1834-1904
Born at Colmar in Alsace on April 2, 1834, he died in Paris on October 4, 1904. He studied architecture in Colmar before going to Paris where he joined the studio of the painter Ary Scheffer and later worked for the sculptor Soitoux. He exhibited at the Salon from 1853 onwards, making his début with a figure of the Good Samaritan. He later travelled extensively in Greece, Egypt and the Levant. The first of his sculptures on the grand scale was the colossal statue of General Rapp. His reduction of Liberty Lighting the World was shown at the Paris Exposition of 1878 and later offered to the United States by France full-size. His other famous work was the Lion of Belfort, cut from the living rock as a memorial to French resistance to invasion in the Franco-Prussian War of 1870-71. Although best known for his colossal statuary he also produced numerous small works, such as the bronze La Gravure (Mulhouse) and various groups based on episodes from the Siege of Paris and the Franco-Prussian War. Both the Lion of Belfort and the Statue of Liberty are known in terra cotta and bronze reductions. Among his numerous awards may be cited the Legion of Honour in which he was successively Chevalier (1864), Officier (1882) and Commandeur (1887).

Art et Décoration by Bartholdi (1899)

BARTHOLOMÉ, Albert 1848-1928
Born at Thiverval on August 29, 1848, he died in Paris in 1928. He studied painting under Barth, Menn of Geneva and Gerome in Paris. During the Franco-Prussian War he served as a volunteer. He continued painting till the 1880s when he turned to sculpture and was largely self-taught, though influenced by Rodin, Bourdelle and Despiau. His style was imbued with stark realism and often a deep sense of melancholy, best exemplified in his colossal Monument aux Morts in Père-Lachaise cemetery. He was a regular exhibitor at the

Salon of the Société Nationale des Beaux Arts and became successively Associate (1892), Vice President (1914) and President (1921-24) and Honorary President till his death. He was awarded a Grand Prix at the Exposition Universelle of 1900 and was successively Chevalier (1895), Officier (1900) and Commandeur (1911) of the Legion of Honour. He was a close friend of Degas. He is best known for his studies of women in tears symbolising despair, melancholy and the overthrow of the great moral crises. His works include Young Girl Lamenting, Weeping Child and Sadness. He also produced several portrait busts of his contemporaries.

BARTLETT, Paul Wayland 1865-1925
Born in New Haven, Connecticut on January 23, 1865, he died in Paris in 1925. He was the son of the sculptor and art critic Truman Bartlett and studied under his father from an early age before enrolling at the Boston School of Art. A bust of his grandmother, executed when he was only twelve years old, was exhibited at the Paris Salon in 1880. He came to France and studied at the Jardin des Plantes under Frémiet, and was also a pupil of Cavelier at the École des Beaux Arts. Later he worked with Rodin and studied ceramic sculpture under Carrier as well as taking a keen interest in the techniques of bronze-casting. In his later years he had his own foundry where he cast small bronzes and experimented with fine alloys and unusual patination. The chief collection of these bronzes is in the Luxembourg Museum. He won an honourable mention at the Salon of 1887 for his Bear Tamer, a figure of a Bohemian with a dancing bear. He was a member of the Jury at the Exposition Universelle of 1889 at the age of 24. In 1895 he became a Chevalier of the Legion of Honour and later became Officier (1908) and Commandeur (1924). He was a member of many European academies and was at the height of his career between the two great Expositions of 1889 and 1900. He also executed many large commissions for public statuary, the best known being his statue of Lafayette, from which the well-known bronze bust was taken. This statue took ten years to complete and was a gift of the schoolchildren of America to France in exchange for Bartholdi's Statue of Liberty. Among his minor works are the bronzes of Adam, Decorative Horses, Brazilian Frog, Sculpin (fish) and the bronzed plaster head of Michelangelo. His work is preserved in museums and art galleries in New York, Philadelphia, Chicago and St. Louis.

BARTLETT, Truman Howe fl. 19th century
Born in Dorset, Vermont in 1835, the father of Paul Bartlett. He worked in Boston on bronze statues and figurines. His best known works are the statue of Horace Wells at Hartford, Connecticut and the Angel of Life in Hartford cemetery.

BARY, Renée de fl. 20th century
Born at Reims in the late 19th century she studied under Guéniot and Rousaud. Her work consisted mainly of busts and statuettes of women. She exhibited at the Salon des Artistes Français from 1921 to 1927.

BARYE, Alfred fl. 19th century
The son and pupil of Antoine Louis Barye, he carried on his work after the latter's death. He exhibited at the Salon from 1864 onwards. His early bronzes consisted mainly of racehorses but he also sculpted bird groups and genre figures, such as the 16th century Italian clown (1882).

BARYE, Antoine Louis 1796-1875
Born in Paris on September 24, 1796, the son of a jeweller from Lyons. At the age of thirteen he was apprenticed to Fourrier, an engraver of military equipment. Later he switched to the jewellery trade and learned the technique of moulding reliefs from his master Biennais. He was conscripted into the army in 1812 but was employed in the cartographic section making reliefs of mountains. After the collapse of the Napoleonic regime Barye returned to his work as an engraver, but turned to sculpture in 1817 and worked in the studios of F.J. Bosio and A.J. Gros and was strongly influenced by the paintings of Géricault. In 1819 he took part in the competition of the École des Beaux Arts and was runner-up with a medallion of Milo of Croton. He won second prize in 1820 with his figure of Cain cursed by God. He worked with the goldsmith Fauconnier (1823-31) and continued to practise modelling in his spare time, studying

ancient sculpture at the Louvre, and the animals at the Jardin des Plantes. To this early period belong the small animal figures cast as jewellery or as ornaments on silver and gold table ware. He exhibited at the Salon from 1827 onwards, making his début with portrait busts. In 1831 he won a second prize at the Salon with his bronze of a Tiger devouring a Gavial and this marked the turning point in his career. He established his own studio and was awarded the Legion of Honour in 1832, being raised to the grade of Officier in 1855. His career was often turbulent and he fell foul of the artistic establishment in 1834 and did not exhibit again at the Salon till 1851. Under the Second Empire his reputation grew steadily. He obtained several important State commissions, became professor of drawing at the Museum (1854), won a large gold medal at the Exposition of 1855, and was elected to the Academy in 1867. Unfortunately the downfall of the empire of Napoleon III in 1870 adversely affected his work, including a series of Napoleonic statues which were hastily removed from public view. Though his work as a fashionable sculptor had its ups and downs he continued to model figures and groups of animals and it is these which established him as the father of the Animalier School. In a career spanning half a century he had a prodigious output of bronzes covering every aspect of animal life, from the domestic to the exotic, imbued with a realism and naturalism and a meticulous attention to anatomical detail. For a detailed account of his work see *The Barye Bronzes: a Catalogue Raisonné* by Stuart Pivar (1974). Other works on Barye and his bronzes include:

Alexandre, Arsène *A.L. Barye* (1889); Ballu, Roger *L'Oeuvre de Barye* (1890); De Kay, Charles *Barye* (1889); Grolier Club of New York *Exhibition of Bronzes and Paintings by A.L. Barye* (1909); Guillaume, Eugène *Catalogue des Oeuvres de Barye* (1889); Louvre, Musée du *Barye, Sculptures, Peintures et Aquarelles* (1957); Saunier, Alfred *Barye* (1925).

BASALDELLA, Mirko (known simply as MIRKO) 1910-
Born in Udine, Italy on September 28, 1910, he studied in Venice, Florence and Monza before settling in Rome in 1934. He has had a number of one-man shows in various Italian cities since 1935 and has also exhibited internationally, in Paris, Brussels, Vienna, Budapest, London, San Francisco and New York. He had one-man shows of his painting and sculpture at the Knoedler Gallery, New York in 1947 and 1948, the Viviano Gallery, New York (1950) and the Galleria San Marco, Rome (1951). His work includes the bronze balustrades in the Mausoleo delle Fosse Ardeatine (dedicated to the victims of Nazi atrocities during the second world war), and many of the reliefs, murals, mosaics and balustrades for the Food and Agricultural Organisation building in Rome (1951). In 1953 he won second prize in the international competition for the Monument to the Unknown Political Prisoner. More recently his work has been represented at the Brussels World Fair (1958), the Documents Exhibition, Cassel (1959, and the Venice Biennale (1960). In 1958 he became professor at the Graduate School of Design at Harvard University. His minor bronzes include The Bull (1948), the Great Initiated (1956), Warrior Dance (1958), Warrior (1958), Figure (1960) and various models for the mausoleum of the Ardeatine caves.

BASKERVILLE, Margaret fl. 20th century
Australian sculptress of figures, groups and animal subjects since the Second World War.

BASS, Thomas Dwyer 1916-
Born in Lithgow, Australia in 1916, he was a founder member of the Australian Society of Sculptors. He has produced many bas-reliefs and architectural sculptures, cast in bronze or by copper deposited electrolytically on a non-metallic base. His major works include the figure of Ethos (Canberra), the sculpture on the I.C.I. Building, Sydney and many bas-reliefs and decorative sculptures executed in 1952-8 for Wilson Hall at Melbourne University.

BASTIN fl. 19th century
Born at Daussais in Belgium he studied at the Schaerbeek Academy and also in Brussels. He gave up his career as a lecturer to concentrate on animal sculpture, particularly the beasts of the field. His best known work is the Angry Bull. He also did genre figures and groups with an agricultural background, such as The Reapers, and many portrait reliefs and busts.

BATE, Howard Edward Davis 1894-
He studied art in Plymouth and Torquay (1914-15), the Regent Street Polytechnic School of Art (1917) and the Royal Academy schools (1920). He exhibited at the Royal Academy and in provincial exhibitions from 1920 onwards and was elected A.R.B.S. in 1949. He had a studio in Edgeware, Middlesex and produced a wide range of figures, busts and reliefs.

BATE, Louis Robert fl. 20th century
Born in Bordeaux at the turn of the century, he studied under Coutan and Landowski and began exhibiting at the Paris salons in 1925, obtaining an honourable mention (1925) and a bronze medal (1933) at the Salon des Artistes Français. His work consists mainly of genre figures and groups, such as Spanish Dancer, Diana and Young Girl with Dog, and animal studies, such as Spaniels (1933), busts and high reliefs.

BATES, Harry 1850-1899
Born at Stevenage, Herts. on June 2, 1850, he died in London on January 31, 1899. He worked for Farmer and Brindley as a sculptor of ornaments for interior decoration and studied at the Lambeth School of Art. In 1879 he worked for Dalou during his stay in London and subsequently worked under both Dalou and Rodin in Paris in 1883-85. He was something of a late developer, becoming a student at the Royal Academy schools in 1880, but his work soon commanded attention and in 1883 he won a gold medal and a travelling scholarship for his relief of Socrates instructing the People in the Public Place. The French training of the 1880s influenced his figures, such as Peace (1888), but he is best remembered for his series of Homeric bas-reliefs of 1885-88 with their marvellous sense of perspective. Other bronzes include a statue of Queen Victoria (1890), a bust of Lord Roberts, Pandora and the lively group Hounds on a Leash. He was elected A.R.A. in 1892.

BATESON, Edith fl. 19th-20th centuries
Born in Cambridge in the latter half of the 19th century, she studied painting and sculpture at the Royal Academy schools. She exhibited at the Royal Academy, the British Institution and the Paris salons from 1891 to 1935 and lived at Bushey in Hertfordshire. Her bronzes consist mainly of statuettes and small groups.

BATTEN, Mark Wilfred 1905-
Born in Kirkcaldy, Fife on July 21, 1905, he studied at the Beckenham School of Art and the Chelsea Art School under Jowett. He turned from painting to sculpture in 1934 and has since worked in every medium, but prefers direct carving in stone, marble and granite. He has exhibited at the Royal Academy and the Royal Scottish Academy since 1936 and at the Paris salons since the second world war. He is the author of *Stone Sculpture by Direct Carving* (1957) and *Direct Carving in Stone* (1966).

BAUCKE, Heinrich 1875-
Born in Düsseldorf on April 15, 1875, he studied at the Düsseldorf Academy from 1891 to 1900 under Carl Janssens. He swiftly made a reputation for himself in modelling and won many prizes for his figures. The best known is his figure of a boxer entitled The Victor. He later concentrated on statues of the Prussian kings, William I, William II and Frederick I. He also made busts of Moltke and Bismarck and a statue of Prince Maurits of Nassau.

BAUCOUR, René Albert 1878-
Born in Paris on August 10, 1878, he studied under Falguière and Mercié and exhibited at the Salon des Artistes Français from 1909 to 1932, winning a silver medal in 1920. He specialised in busts and heads and genre and neo-classical groups such as Chansons de Bilitis (1926), Rapture of Silene (1927) and Caresses.

BAUDISCH, Wilhelm fl. early 19th century
Born in Saxony at the beginning of the 19th century, he studied in Breslau and made his début at the Breslau Exhibition of 1824 with a bust of Stawinsky and a bas-relief of Niobe. In 1825 he went to Berlin and then studied in Rome from 1828 to 1831, working on a frieze of Valhalla for Wagner. He returned to Breslau in 1840 and continued to exhibit his work in Saxony and Prussia till 1853. He worked in plaster or wax, for subsequent casting in bronze. His works include Perseus with the Head of Medusa, Love and busts of Thorwaldsen and the King of Saxony.

BAUDITZ, Peter Jakob Frederik von 1817-1864
Born in Holstein on July 29, 1817, he died in Flensburg on April 30, 1864. He studied at the Academy of Fine Arts in Copenhagen and worked under H.V. Bissen. During the Danish-Prussian War of 1864 he served as an officer, was wounded at the battle of Dybböl and died in captivity. Bauditz pioneered the garden gnome industry. His best works were carved in wood or ivory, but his larger works were cast in lead or bronze as garden ornaments and consisted mainly of trolls and gnomes and other creatures from Scandinavian folklore.

BAUM, Otto 1900-
Born at Leonberg, Württemberg, in 1900, the son of a farmer. He studied mechanics and served in the German navy during the first world war. He attended the Stuttgart Academy in 1924-27 and 1930-33 where he was a pupil of Spiegel and Waldschmidt. He worked on his own during the Nazi period, but got an appointment at the Stuttgart Academy in 1946. His bronzes consist of abstracts and figures of women and animals.

BAUSCH, Theodor fl. 19th century
Born in Stuttgart on December 19, 1849, he was the pupil and assistant of Johann Schilling with whom he collaborated at Dresden on the Niederwald monument. He established his own studio in Stuttgart in 1883. The Stuttgart Museum has his bronze Elegy.

BAXTER, F. Fleming fl. 19th-20th centuries
Born in London on January 8, 1873, he studied in London and Paris and was latterly a pupil of Van der Stappen. He exhibited at the Paris salons from 1904 till 1930. His work consisted mainly of busts and heads, but he also produced groups such as the Three Witches (1928).

BAXTER, Frank 1865-
Born at Sutton in Lancashire on December 5, 1865, he studied art in Paris under Puech and Dampt. He had a studio in Chelsea and exhibited at the Royal Academy, the Paris salons and in Liverpool and Glasgow up to about 1930. He specialised in animal figures and groups, of which North American Bison is the best known.

BAYES, Gilbert 1872-1953
Born in London on April 4, 1872, the son of the painter and etcher Alfred Walter Bayes and brother of the painter Walter John Bayes. He studied at the City and Guilds Technical College, Finsbury and the Royal Academy schools, winning a medal in 1899 and a travelling scholarship which enabled him to continue his studies in France and Italy. He participated in national and international exhibitions and was awarded the R.B.S. medal in 1931, becoming President in 1939-44. He specialised in reliefs and statuettes modelled on the antique or derived from folklore and biblical subjects. His works include the bronze relief of Assurnazipal, King of Assyria (Sydney), Santa Barbara and the Knight Erant, cast in silver (1900). Many of his works combine a variety of materials, such as the Valkyrie Fountain in Auckland, New Zealand (bronze, marble and mosaic), Sigurd (bronze, enamel and marble) and the Frog Princess (bronze on a salt-glazed stoneware base). He also designed and executed copper- and bronze-mounted furniture.

BAYSER-GRATRY, Marguerite de fl. 20th century
Born at Lille in the early years of this century, she studied under Vital-Cornu. She won the Grand Prix of the Salon des Artistes Décorateurs in 1925 and became a member of the Society of Colonial Artists, specialising in the sculpture of animals and native types. Her works include Woman of Martinique (1929), the Jungle (bas-relief, 1930), Gazelle (1931), Dog (1935) and a bas-relief of Stags and Hinds (1939).

BAZIN, Charles Louis 1802-1859
Born in Paris on April 3, 1802, he died in Lyons in 1859. He was a pupil of Gérard and Girodet-Trioson, and worked as an engraver and lithographer, but also painted in oils. He first exhibited at the Salon in 1822, with the portrait of a girl and later made his name as the painter of The Bride of Lammermoor. As a sculptor he produced a notable bronze bust of Olivier de Beauregard.

BAZIN, François Victor 1897-
Born in Paris on October 31, 1897, he studied under Navellier, Denis Puech and Injalbert. He exhibited regularly at the Salon des Artistes Français from 1913, becoming an Associate and winning an

honourable mention (1923), a bronze medal (1924) and a gold medal (1929). He specialised in heads and busts of his contemporaries and his work includes the portraits of the Bishop of Quimper (1932), Henri Levesque (1933), Madame A. le F. (1934), Charles David (1935). He also produced a group entitled Mermaids.

BEACH, Chester 1881-
Born in San Francisco, he studied in Paris under Verlet and Roland, and subsequently studied in Rome. He was a member of the National Academy of Design and also A.R.A. He exhibited in the United States, at the Royal Academy and the Paris salons. Although best known for his medallions and plaques, he also sculpted busts and garden figures in marble and bronze and executed a number of architectural sculptures in bronze, marble and concrete.

BEADLE, Paul fl. 20th century
Professor of sculpture at Elam School, Auckland, N.Z., he has designed a number of monuments and memorials in Christchurch, and sculpts portrait busts, groups, medallions and bas-reliefs of historical and contemporary subjects.

BEATTIE, William fl. 19th century
Nothing is known of his early life, but he exhibited at the Royal Academy from 1829 to 1864 and at the British Institution from 1834 to 1848. He was a prolific and versatile sculptor, producing numerous medals, busts, statuary and ornamental sculpture. At the Great Exhibition of 1851 he showed a vase surmounted by a four foot statuette of the Prince Consort in solid silver. He was employed by Wedgwood for whom he modelled The Finding of Moses, The Flute Player and allegorical figures representing England, Scotland, Ireland and America. He is best known for his bronze figure of Lord Byron. His bronze Group of Boys was exhibited at the Birmingham Society of Artists (1855). He sculpted a statue of Robert Bruce, King of Scots, later published as a bronze reduction. His statuette of Sir Isaac Newton is in Windsor Castle.

BEAUDIN, André Gustave 1895-
Born at Mennecy, Seine et Oise, on February 3, 1895, he studied at the École des Arts Décoratifs in Paris (1911-15). He is best known for his work as a painter, following and continuing the Cubist tradition, which he simplified and treated in light colours and dominant lines. His work as a sculptor shows the same predeliction for severity and simplicity. His sculpture has been exhibited at the Galerie Louise Leiris in Paris. He began modelling in plaster or clay for bronze-casting in 1930 and has concentrated on busts and abstract profiles. His works include the bust of Paul Eluard (1947) and Three Profiles (1931).

BEAUMONT-CASTRIES, Jeanne de fl. 19th century
Born in France in the mid-19th century she exhibited at the Salon from 1873 to the end of the century. She is best known for her bronze bust of Admiral Coligny at Châtillon-sur-Seine.

BEAUNE, Louis Eugène de fl. 19th century
Born at Larçay in the mid-19th century, he studied sculpture under Frémiet and Peter. Though better known for his paintings and engravings, he also sculpted reliefs and medallions at the turn of the century.

BEAUPRÉ fl. 18th century
A sculptor whose works bear this signature worked in Covent Gardens, London from 1764 to 1787 and exhibited at the Society of Artists from 1764 to 1767. He also took part in the exhibition of the Free Society in 1766 and in the same year executed an equestrian statue in lead of King George III, erected by Princess Amelia in Berkeley Square. The statue collapsed in 1827 and was subsequently melted down. He is though to have been a native of Besançon and a pupil of Pigalle who recommended him to would-be patrons in London as a wood carver, specialising in floral ornament. He worked in Dublin from 1777 to 1783, but no record has survived of his activities in Ireland.

BECHER, Hugo Emmanuel 1871-
Born in Leipzig, he studied in Rome before settling in Munich. He participated in the Crystal Palace Exhibitions in Munich and also the Paris salons. His works include The Prodigal Son, The Water Carrier and a bust of Professor Kellermann.

BECHLER, Theobald fl. 19th century
Born at Ehingen, Germany on February 16, 1834, he studied at the Academy of Munich (1853-58) and then at the Stuttgart Academy. He spent some time in Paris and settled in Munich in 1870. He specialised in groups and figures of domestic animals. His works include Hunter and his Dog, Love playing with a Dog and The Young Milkmaid.

BECQUEREL, André Vincent fl. early 20th century
Born at St. André-Farivilliers in the late 19th century, he studied under Hector Lemaire and Prosper Lecourtier. He specialised in animal sculpture, which he exhibited at the Salon des Artistes Français from 1914 to 1922. His best known work is The Finish, showing two racehorses in a photo-finish.

BECQUET, Justin 1829-1907
Born at Bescançon on June 17, 1829, he died in Paris on February 28, 1907. Becquet was a pupil of Rude and began exhibiting at the Salon in 1853. His numerous works include busts of V. Cousin, R.P. Ducoudray, Himly and P. Klein. Among his many biblical groups may be mentioned Ishmael, St. Sebastian, Christ and, Joseph in Egypt. He also sculpted animal figures, notably Panther and Fawn.

BEDFORD, Richard Perry 1883-1967
Born in Torquay on November 15, 1883, he died in West Mersea, Essex. He was educated at Cheltenham and studied sculpture at the Central Schools of Arts and Crafts. He had his first one-man show at the Lefevre Gallery in 1936 and exhibited at the Royal Academy and in provincial exhibitions. He was Keeper of the Department of Sculpture at the Victoria and Albert Museum, 1924-38, head of the Department of Circulation, 1938-46 and Curator of Pictures for the Ministry of Works, 1947-48. He lived in London before retiring to West Mersea. Most of his works was executed in marble or stone.

BEER, Friedrich 1846-1912
Born at Brunn (Brno in Czechoslovakia) on September 1, 1846, he died in 1912. He studied at the Vienna Academy from 1865 to 1870 under Radnitzky and Bauer, before going to Rome where he executed a bust of the Austrian naval hero, Admiral Tegethoff. He moved to Paris in 1875 and spent the rest of his life there. He exhibited at the Salon des Artistes Français, winning an honourable mention in 1880. His work includes the figure of a Bacchante in the Vienna Kunstlerhaus (1873) and the bronze of the artist Munkacsy in the Budapest Museum.

BEETZ-CHARPENTIER, Elisa fl. 20th century
She exhibited at the Salon of the Société Nationale des Beaux Arts from 1905 to 1924. She was a prolific and versatile artist, producing statuettes, genre groups, portraits of children, busts, dancing girls, plaques and medallions.

BEGAS, Karl 1845-
Born at Berlin on November 25, 1845, the son of the painter Karl Begas and younger brother of the sculptor Reinhold Begas. He studied at the Berlin Academy and worked in his brother's studio. For some time also he worked with Sussmann and studied in Rome. Following his return to Germany in 1889 he was appointed professor at the Academy of Arts in Cassel. Later he settled in Berlin and executed many important commissions for the cities of Berlin, Cassel and Barmen (Wuppertal). A prolific sculptor in the prevailing classical tradition, he produced numerous busts of his illustrious contemporaries, such as von Moltke, Bismarck and Prince Friedrich-Karl, statues of historic figures such as Solon and Aristotle (Kiel University), Frederick the Wise (Berlin Cathedral), various statues and groups in the public parks of Berlin, Potsdam and Urville (Alsace) and the Bismarck monument at Minden. His smaller works include genre groups of mothers and childen, brothers and sisters, allegorical studies of Charity and Victory, classical groups such as Young Faun and the Child Bacchus, and decorative sculpture on the bridges and public buildings of Berlin.

BEGAS, Reinhold 1831-1911
Born in Berlin on July 15, 1831, he died there in August 1911. With his brothers Karl the sculptor and Oskar the painter he began his studies under his father Karl Joseph Begas before going to the Berlin Academy in 1851 and studying under Wichmann, Schadow and

Rauch in whose studios he also worked for several years. He made his début at the Berlin Academy exhibition in 1852 with a group of Hagar and Ishmael. Four years later he won the Academy Prize and a travelling scholarship which enabled him to continue his studies in Italy (1856-58) where he was strongly influenced by the work of Michelangelo. He returned to Berlin in 1858 and became professor at the Weimar School of Art (1861-63) but then went to Paris and Rome. From 1870 till the end of the century Begas dominated the development of sculpture in Prussia. Much of his work consists of large monumental groups such as the façade of the Berlin Exchange, the allegories of Strasbourg and Metz in the Potsdamer Platz, the mausoleum to Frederick III and the national monument to William I (with his brother Karl), the Neptune fountain on the Schlossplatz and the colossal statue of Borussia for the Hall of Glory. The statue of Schiller in the Gendarmenmarkt and several of the statues of German historical personalities in the Siegesallee were by him. His minor works in bronze include the allegory of Empire, the figure of Germania (the original full-size version of which decorated the old Reichstag) and a large series of portrait busts of the Hohenzollern dynasty. He had a penchant for mythological and decorative subjects, of which his Mercury and Psyche (1874) were typical. He also sculpted the silver statuette of Italia, the gift of Kaiser Wilhelm II to the King of Italy. Many of his works in marble were published as reductions in bronze or spelter.

BEGUE, Hortense 1892-
Born at Caubous in the Pyrenees in 1892, she was self-taught. In 1909 she came to Paris and began sketching animals at Jardin des Plantes. She first exhibited her work in Barcelona in 1915 and since 1922 took part in the Salon d'Automne, the Salon des Indépendants, the Salon des Tuileries and the Salon des Surindépendants. She specialised in animal figures and groups, some of which were executed life-size. She married the Spanish painter Celso Lagar.

BEGUIN, Gaston fl. 20th century
Born at La Lale in Switzerland at the end of the 19th century, he sculpted busts, heads, busts and statuettes. He exhibited his work at the Salon d'Automne in 1919-20.

BEGUINE, Michel Léonard 1855-1929
Born at Uxeau on August 9, 1855, he died in April 1929. He studied in Paris under Dumont and Aimé Millet. He was a prolific artist whose works include Sadness (honourable mention, 1878), David the Victor (third class medal, 1887), Spring, and a bronze bust of Delescluze. Many of his busts, statues and groups were executed in stone or marble. He exhibited regularly at the Paris salons and also participated in the Chicago Columbian Exposition (1893), the St. Louis World's Fair (1904) and the Brussels and Munich exhibitions of 1909-10. He was made a Chevalier of the Legion of Honour in 1904.

BEHN, Fritz 1878-
Born at Grabow in Germany on June 16, 1878, he spent most of his life in Munich. In 1898 he entered the Munich Academy and later worked in the studio of W. Ruemann. He first exhibited his work in 1901 and was widely acclaimed for his bronze statuette of The Victor. The best known of his later works is the figure of St. John on the fountain in Lübeck. At the Munich exhibition of 1909 he showed a number of animalier groups including Bacchus with a Leopard, African Elephant, Suallah, African Antelope (bronze and ivory), Lion and female Buffalo, African Antelope (bronze and stone), African Leopard (bronze and stone), African Buffalo (bronze and stone) and Lioness and Antelope. At the Sezession exhibition of 1909 he showed a Dwarf Gazelle, Leopard and Antelope. Later he sculpted figures and busts of contemporary personalities in the artistic world, such as Caruso and Nijinsky. He also exhibited at the Salon d'Automne in 1911-13.

BEHNES, Henry 1802-1837
Born in Dublin in 1802, he died of cholera in Rome in 1837. He was the younger brother of William Behnes and attended the Royal Academy schools in 1821-3, winning the silver medal in the latter year. He exhibited at the Royal Academy in 1831-3 and went to Rome in 1834. He changed his surname to Burlowe, allegedly at the suggestion of the art critic S.C. Hall, in order to avoid confusion with his elder brother, but it has also been suggested that he did this in order to dissociate himself from his brother's dissolute way of life. He sculpted numerous busts of English society, both in London and in Rome. The majority of his portraits were sculpted in marble.

BEHNES, William 1794-1864
Born in London in 1794, he died there on January 3, 1864. When still an infant, he was taken to Dublin by his father, a piano-maker from Hanover, but the family returned to London in 1802. He enrolled at the Royal Academy schools in 1813 and was also a pupil of P.F. Chenu, who lodged with the Behnes household. He had a brilliant career in the early years, winning silver medals at the Royal Academy in 1816-17 and 1819 and the silver medal (1814) and gold medal (1819) of the Society of Arts. He became Sculptor in Ordinary to Queen Victoria in 1837 and sculpted a very large number of busts and statues. The smaller works were usually carved in marble and the larger monuments in bronze. He was at his best in sculpting busts and heads of women and children, but his statues and monuments were less successful. He became bankrupt in 1861, through dissolute living, and died a pauper. He exhibited at the Royal Academy in 1815-63 and participated in the Great Exhibitions of 1851 and 1862. Several of his busts were also cast in plaster or bronze. Among his minor works were a remarkable statuette of Lady Godiva and a bas-relief of the Seven Ages of Man, after Shakespeare, modelled in clay but never sculpted in marble as originally intended.

BEHRENS, Christian 1852-1905
Born in Gotha on June 12, 1852, he died in Breslau on October 14, 1905. Initially he worked with Ernst Hähnel at Dresden but later went to Vienna and worked in the studios of Kundmann and Hellmer till 1881. On his return to Dresden he concentrated on statuary. The city of Dresden formerly had many of his public works, the best known being the figures of Cellini and the Elector Christian I. Later he specialised in fantasy and genre groups, including children and allegorical compositions. His figures of Eros and Psyche were in the Court Theatre, Dresden. He also executed statues of William I and Frederick III for Berlin and Kaiser Wilhelm II for Breslau.

BELARD, Gustave fl. 19th-20th centuries
Born at Toulouse in the mid-19th century, he died there in 1912. He studied in Paris under Falguière and Mercié and exhibited at the Salon till 1899, gaining honourable mention.

BELL, Edith A. fl. 20th century
Born in the late 19th century, she specialised in relief portraits and medallions, one of which (of Francis Bute) was exhibited at the Royal Academy in 1907.

BELL, John 1812-1895
Born at Hopton in Suffolk in 1812, he died in Kensington, London on March 14, 1895. He enrolled at the Royal Academy schools in 1829 and four years later won a large silver medal for a model of a bust. In 1839 he competed for the Nelson memorial, but though the model was rejected he later presented it to Greenwich Hospital. He exhibited at the Royal Academy from 1832 to 1871. He did some of the ornamental sculpture on the Wellington monument in Guildhall and numerous busts and groups. His group of Una and the Lion was also reproduced in Parian ware by Copeland. His figure of the Eagle Slayer was one of the first bronze reductions to be offered by the Art Union (1845). His deerhound hall-table, cast in iron by Coalbrookdale, was a monstrosity that enjoyed enormous success at a time when public taste had reached its nadir. At the Great Exhibition he showed a full-size figure of the Eagle Slayer, and statuettes of the Queen and the Prince Consort in gilded bronze. His heads of animals, sculpted in 1858, were later cast in iron for the railings of the Metropolitan Cattle Market in Pentonville. His later allegorical and genre groups typify the maudlin sentimentality and bathos of the mid-Victorian period and include Cherub with Primroses (1865), Mother and Child (1867), the Last Kiss (1868) and Dove's Refuge (1871).

BELL, Ophelia Gordon — see COOPER, Joan Ophelia Gordon

BELL, Quentin 1910-
Born in London on August 19, 1910, the son of the writer Clive Bell. He has worked as a painter, ceramicist and author as well as a sculptor and has had a number of one-man shows since 1935. He was professor

of Fine Art at Leeds University, 1962-7, Slade professor at Oxford, 1964-5 and professor of the History and Theory of Art at Sussex University since 1967. He is well known as an art critic and author of a number of books on art subjects. He now lives at Beddingham in Sussex. His sculpture is in several public collections, notably the Glasgow Art Gallery.

BELLING, Rudolf 1886-
Born at Berlin in 1886, he studied under Peter Breuer and became a member of the Sturm group in 1913 and later a founder member of the November group (1918). He had a one-man show at the Berlin National Gallery in 1924. After the advent of the Nazis in 1933 he fled to Turkey where he taught at Istanbul Academy. Since 1951 he has also taught in the department of architecture at the Istanbul Technical College. Belling was one of the pioneers of abstract sculpture in Germany and his theories of hollow and solid forms anticipated the later work of Henry Moore. His works in wood, stone and bronze include Combat (1916), Threefold Harmony, Erotic Sculpture (1920), Head in Brass (1921) and many architectural and decorative sculptures.

BELLOC, Jean Baptiste fl. 19th-20th centuries
Born at Panniers in France in the mid-19th century, he died about 1920. He studied under Mercié and Thomas and exhibited at the Salon des Artistes Français between 1889 and 1913. He won an honourable mention in 1889 and second class medal in 1905. His works include Future Time (1895), Tobias and the Angel (1896), Brunhilda (1897), Bacchus and Spring (1905) and a bust of the Bey of Tunis (1899). His son Georges (born in Bordeaux) was also a sculptor and exhibited at the Salon des Artistes Français in 1923.

BELLONI, José fl. 20th century
Born in Montevideo, he is the leading sculptor in Uruguay at the present day. His works include the Combat and Carreta monuments, numerous statues, bas-reliefs, portraits and genre works.

BELLORA, Giovanni fl. 19th century
Born in Italy in the early 19th century, he was employed on the decorative sculpture of Milan Cathedral in 1856 and sculpted the Padulli monument in that city. He is best known for the bronze figure of a Savoyard ensign on the Montebello battle memorial, 1866.

BELMONDO, Paul 1898-
Born in Algiers on August 8, 1898, he studied architecture at the School of Fine Arts in Algiers. After service in the first world war he won a travelling scholarship and went to Paris, where he studied under Jean Boucher at the École des Beaux Arts. He was brought to the attention of Rodin by Despiau and subsequently became a leading sculptor of monuments and memorials. He exhibited at the Salon des Artistes Français and the Salon des Tuileries and won the Prix Blumenthal in 1928. His minor works include numerous busts and bronze figures. Many of his public statues are to be found in France and Algeria.

BELSKY, Franta 1921-
Born in Brno, Czechoslovakia on April 6, 1921, he studied at the Prague Academy of Fine Arts but came to England following the Nazi seizure of Czechoslovakia and continued his studies at the Central School of Arts and Crafts in London. Later he studied under Garbe and Dobson at the Royal College of Art, where he received his diploma in 1950. He has exhibited at the Royal Academy and was President of the Society of Portrait Sculptors from 1963 to 1968. He specialises in busts, heads and profiles and lives in London.

BELT, Richard Claude 1851-1920
The son of a blacksmith, he worked as a boy messenger in the House of Commons but became interested in wood carving and was apprenticed for a short time to William Plows. Later he was employed by John Foley and collaborated on the group of Asia for the Albert Memorial. While engaged on this work he made the acquaintance of Charles Lawes, with whom he worked for a time before establishing his own studio. He won the competition for the statue of Lord Byron in Hyde Park and had many public commissions. Jealousy impelled Lawes to accuse him of exploiting the talents of others more skilled than himself and this led to the famous law-suit of Belt v. Lawes, 1882, in which Belt was eventually awarded £5,000 damages for libel.

The case was second only to the Tichborne trial in length and was the last to be heard at Westminster Hall. Belt exhibited at the Royal Academy from 1873 to 1885 and also at the Grafton Gallery. Apart from his public monuments he also excelled as a portraitist and produced a number of bronze busts and heads of late-Victorian celebrities.

BENEDETTI, Michele de fl. 20th century
He worked in Rome in the early years of this century. His bronze figure of a Violinist was shown at the Munich Exhibition of 1909.

BENEDUCE, G. fl. early 20th century
Italian sculptor working in the early years of this century. He specialised in bronze statuettes of dancers and nudes in the Art Deco manner.

BENET, Eugène Paul fl. 19th-20th centuries
Born in Dieppe on July 13, 1863, he studied under Jouhan, Falguière and Marqueste. He had a brilliant début at the Salon of 1884 and subsequently won many major awards between 1897 and 1925 for his statues and allegorical groups. Many of these were subsequently published as bronze reductions, notably the Dieppe war memorial of 1870-71. After 1900 he concentrated more on busts, reliefs and portrait medallions.

BENNES, J. fl. 19th century
The otherwise unknown sculptor of a relief showing a stalking lion, strongly influenced by Barye.

BENNETEAU-DESGROIS, Felix 1879-
Born in Paris on May 9, 1875, he studied under Mercié, Falguière and Puech at the École des Beaux Arts and won the Prix de Rome in 1909. He exhibited at the Salon des Artistes Français from 1895 and was awarded a bronze medal in 1923. He also participated in the Salon d'Automne (1921-45) and the Indépendants (1927-37). He specialised in busts and heads, mainly of actors and political figures. The main collections of his works are in the Théâtre Français and the Sorbonne.

BENNETT, Belle 1900-
Born in New York City in 1900, she studied for two years under Solon Borglum and was a pupil of the School of American Sculpture. She specialised in decorative sculpture, such as the bronze andirons featuring Sea-horses.

BENOIT, Georges fl. 20th century
Born in Paris, he exhibited at the Salon des Indépendants in 1928-30, specialising in chimney pieces and electric lamps in marble, glass and bronze.

BENON, Alfred 1887-
Born in Saumur on July 11, 1887, he studied in Paris and exhibited at the Nationale from 1912 to 1936, becoming Vice-President in 1927. He also exhibited at the Salon d'Automne (1920-38), the Tuileries (1925-43) and the Indépendants (1926-7). He later became a member of the Academy of Fine Arts. His stone group Contemplation won the Piot Prize in 1920. His later works include Girl Playing, Rugby (game), Ballet-dancer, Fillette au Coquillage, nude Child, Parisienne and a bust of the poet André Turquet.

BENSON, Eva fl. 20th century
Australian sculptress of portraits and figures, active since the second world war.

BENTHAM, Percy George 1883-1936
He lived and worked in London. A.R.B.S.

BENVENUTI, Augusto 1839-1899
Born in Venice on January 8, 1839, he died there on February 2, 1899. He established his reputation with a marble figure of Giorgione at Castelfranco in 1878, and his later monument statuary, such as the memorials to Victor Emmanuel at Vicenza and Garibaldi in Venice (1887). He also produced genre figures and groups and his bronze entitled Bertha the Spinner was shown at the Vienna Jubilee Exhibition of 1888.

BEOTHY, Etiènne 1897-
Born at Heves in Hungary, he went to Budapest to study at the School of Architecture in 1918 but abandoned architecture two years later and took up sculpture instead. He studied for four years at the Budapest Art School and won a travelling scholarship which permitted him to continue his studies in Germany, Austria, Britain, Italy and France. He settled in Paris in 1925 and had his first one-man show there the following year. His experiments with the various materials of sculpture belong to his early period and since 1926 he has preferred to work in wood, though he has also turned to stone and metal on occasion. He became a founder of the Abstraction-Creation group and in 1938 organised the first exhibition of abstract sculpture in Budapest. Since the second world war he has had several one-man shows at the Galerie Denise Rene and a retrospective at the Galerie Maeght in 1948. In 1952 he began teaching at the department of architecture in the École des Beaux Arts.
Beothy, Etiènne *The Golden Series* (1939).

BERG, Frans Oskar Theodor fl. 19th century
Born in Stockholm on January 10, 1839, he studied at the Stockholm Academy and later in Rome and London. In Rome he sculpted the group of Pan and Psyche. He specialised in busts of Swedish celebrities and genre figures such as the Mandoline Player and The First Step.

BERGE, Edward 1876-
Born in Baltimore, Maryland in 1876, he studied at the Maryland Institute and the Rhinehart School of Sculpture, Baltimore before going to Paris and studying at the Académie Julian. He also worked with Verlet and Rodin for some time. He specialised in medallions and plaques and bronze statuettes, such as Sea Urchin and Woodwind.

BERGFELD, George fl. early 20th century
Born in Bremen in the late 19th century, he specialised in animal figures and groups. His works include Sacred Bird and Horse at the Abattoir.

BERGSLIEN, Brynjulf Larsen 1830-1898
Born in Voss, Norway on November 12, 1830, he died in Oslo on September 18, 1898. He was the younger brother of the painter Knud Larsen Bergslien. In his youth he worked for a jeweller in Christiania (Oslo) and then won a travelling scholarship in 1852 which took him to Copenhagen. He was strongly influenced by the work of Thorwaldsen and worked with Jerichau and Bissen. Under the latter's direction he completed four marbles begun by Thorwaldsen. In 1861 he settled in Christiania and spent the rest of his life there, apart from a sojourn in Rome in 1864. He is best known for the equestrian statue of King Karl Johan. His bronzes include statuettes of the writer Asbjörnsen and King Christian IV.

BERNARD, Antoine Louis fl. 19th century
Born in Paris on March 5, 1821, he studied at the École des Beaux Arts under Duret and Klagmann. In 1848 he exhibited his bronze statuette of a Neapolitan playing with a Crayfish. In subsequent years down to 1861 he exhibited at the Salon a series of bronze busts and portrait medallions.

BERNARD, Joseph Antoine 1866-1928
Born in Vienne (Isère) on January 17, 1866, he died in Paris in 1928. He studied under Cavelier at the École des Beaux Arts and later became an assistant at the Lyons École des Beaux Arts, but this period is thought to have stifled his originality and inspiration. Only after he broke free did his art develop along distinctive lines — 'joyful crowds of young girls in simple forms and vibrating with life, smiling or banterers, permeating all his work with poetry as a crown of grace and beauty' (Armand Dayot). He first exhibited at the Salon in 1893 with a plaster group entitled Hope Conquered. His group Separation won acclaim at the Exposition Universelle of 1900. At the Exposition des Arts Décoratifs (1925) he showed a frieze of the Dance, subsequently purchased by the Paris Chamber of Commerce. He exhibited at the Salon d'Automne (1910-27) and the Tuileries (1923-27). His bronzes include Fragment of a Monument to Michel Servet, Study of a Man, Dancing Faun, Young Girl with a Pitcher and The Thinker. He also sculpted numerous marble groups, some of which were offered as bronze reductions. He as made Chevalier of the Legion of Honour in 1910.

BERNARD, Joseph Victor fl. 20th century
Born at Ribeauville he specialised in animal sculpture, some of which was exhibited at the Salon d'Automne in 1937.

BERNARDELLI, José Maria Oscar Rodolfo 1852-1931
He enrolled at the Imperial Academy of Fine Arts, Rio de Janeiro in 1870 and won first prize for sculpture in 1876 and a travelling scholarship which took him to Italy. Here he sculpted allegorical and religious groups, of which the marble Christ and the Adulteress is the best known. On his return to Brazil he was appointed teacher of statuary at the Imperial Academy, a position which he held for twenty years. During this period he received many public commissions and sculpted memorials, monuments and architectural bas-reliefs for many parts of Brazil. His minor works include statuettes, bas-reliefs and medallions, maquettes and projects for his monuments. His allegory of The Dance, decorating the façade of the Municipal Theatre in Rio de Janeiro, is known as a bronze reduction. Bronzes by Bernardelli are preserved in the National Museum of Fine Arts, Rio de Janeiro.

BERNET-ROLLANDE-FERRIÈRE, Germaine Louis fl. 20th century
Born at Riom in the late 19th century, she studied in Paris under Marqueste and Laporte-Blairsy. She exhibited figures and groups at the Salon des Artistes Français (1912-23).

BERNHARDT, Sarah (Rosine Bernard) 1844-1923
Born in Paris on October 22, 1845, of mixed French and Dutch Jewish parentage. She was baptized at the age of twelve and educated in Grandchamp Covent near Versailles. At the age of thirteen she entered the Paris Conservatoire and gained second prize in tragedy (1861) and comedy (1862). She made her début the same year at the Comédie Française in the role of Iphigenie. She was the most versatile and outstanding actress of her generation and played all the great female (and not a few of the male) heroic roles from classical to early 20th century drama. She gave performances all over the world and even made several films. Though she lost a leg in an accident in 1915 she continued to perform to the troops at the battlefront, visited America in 1917 and was on the London stage only months before her death in Paris on March 26, 1923. She wrote a number of plays and novels and the monumental *Art of the Theatre*. She studied painting under Alfred Stevens and sculpture under Gustave Doré and won an honourable mention at the Salon of 1876. She produced a notable series of busts, including Clairin, Emile de Girardin, Damala, Sardou, Ophelia and a self-portrait, a genre group After the Tempest and a number of small animal figures and groups.
Bernhardt, Sarah *Ma Double Vie* (1907). Arthur, Sir George *Sarah Bernhardt* (1923). Huret, Jules *Sarah Bernhardt* (1889).

BERNSTAMM, Leopold Bernard 1859-1910
Born in Riga on April 20, 1859 he left Latvia as a young man and worked in Paris, where he eventually became director of the Musée Grévin. He studied under Jensen in St. Petersburg and also at the St. Petersburg Academy. In 1884 he visited Florence and studied under Rivalti and went to Paris the following year where he worked with Mercié. He is best known for his bust of Édouard Pailleron in the Parc Monceau (1906). He exhibited at the Salon des Artistes Français in 1900-5. His bronzes include Christ and the Sinner, busts of Dostoievsky, Sardou, Dupuy, The Comte de Brazza, Waldeck-Rousseau, Bonnat, Lemaitre, Flaubert, Chevreul, Berthelot and Casimir-Perier. He received many awards including the Legion of Honour, of which he was made a Commandeur in 1908.

BERTAGNIN, Roberto 1914-
He sculpted a bronze figure, Cloaked Woman.

BERTHET, Paul fl. 19th century
Born in Dijon, he studied under Jouffroy in Paris and exhibited at the Salon from 1870 onwards, making his début with Woman Playing a Flute. He won a bronze medal at the Salon des Artistes Français in 1889. His work consisted mainly of busts, of which those of Rude, Dolet and Jean Jacques Rousseau are the best known.

BERTHIER, Adolphe fl. 19th century
Born in Lille in the mid-19th century, he studied under Cleyre and Laurent Daragon. He exhibited a bronze figure, The Dreamer at the Salon of 1875.

BERTIN, Jules 1826-1892
Born at St. Denis near Paris on March 1, 1826, he died in Paris on March 19, 1892. He studied at the Antwerp Academy from 1842 to 1848 and settled in Liège where he helped to restore the Church of Our Lady of Tongeren and erected the memorial to Ambiorix. He returned to Paris after the Franco-Prussian War. He specialised in heroic and historic figures and groups. At the Brussels Salon of 1880 he exhibited an allegorical bronze, Alsace in Mourning. His best known work is the statue of Vercingetorix at St. Denis.

BERTOIA, Harry 1915-
Born in San Lorenzo, Italy in 1915, he emigrated to the United States in 1930 and acquired American citizenship. He studied at the Detroit Art School and became an instructor in metalwork at the Cranbrook Academy. For many years he lived in California but moved to Pennsylvania in 1950 where Hans Knoll put a workshop at his disposal in the village of Barto. In 1951 he completed a lengthy series of free metal sculptures and also created a new process for manufacturing metal and wire chairs which have since revolutionised furniture and interior design. Though best known for his chairs, Bertoia has also sculpted several remarkable bronze friezes and the massive bronze screen in the Manufacturers' Trust Company office in New York. His smaller bronzes are conceived as free-form and moving wall decorations. He has taken part in many technical and art exhibitions in America and Europe since the second world war.

BERTON, Marie fl. 20th century
Born at Roubaix at the end of the 19th century, she studied under Humbert, Mlle. Minier and Pharaon de Winter. She exhibited at the Salon des Artistes Français from 1920 onwards, winning an honourable mention in 1928. She has also exhibited at the Salon des Humoristes and is a member of the Union of Female Painters and Sculptors. Her genre statuettes and groups are usually cast *cire perdue*.

BERTONI, Wander 1925-
Born in Codisotto, Italy, he was deported to Austria in 1943 by the Nazis as a forced labour conscript and settled in Vienna at the end of the war. He began studying at the Vienna Academy in 1945 and also worked in Wotruba's studio. His early work was in sandstone and limestone, but gradually he moved from the figurative to the purely abstract and experimented with polychrome wood, marble and bronze. His more recent works have all been in polished metal. His work includes Imaginary Alphabet (1954) Totems (1956) and seventeen variations on the theme Ecclesia. He has participated in many international exhibitions, including the Brussels World Fair (1958).

BERTRAND, Charlotte Stephanie Emilie fl. early 20th century
Born in Paris in the late 19th century, she studied under Valton and Frémiet and exhibited at the Salon des Artistes Français from 1900 to 1921. She specialised in animal figures and groups and her works include Lion attacking a young Elephant, Lioness and Snake, Lioness at the Waterhole, Relay-horses, Seated Bear, Mouse nibbling at a Feather.

BERTRAND, Philippe 1661-1724
The exact year of his birth is unknown, some authorities giving it as 1661 and others as 1664. He died in Paris on January 30, 1724. He studied in Paris under Louis le Comte and went to Montpellier in 1694, where he executed four reliefs representing the Triumph of Religion, the Construction of the Languedoc Canal, the Passage of the Rhine and the Assault on Mons. These reliefs were intended for a triumphal arch in honour of Louis XIV, erected at the Porte du Peyrou by the architect d'Aviler. As a result he won numerous important State commissions and was made Sculptor to the King. His works include statuary and reliefs in the château of Marly, the Trianon, the churches of Notre Dame, the Invalides and the chapel at Versailles. He was elected Académicien in 1701, his *morceau de réception* being a bronze of the Rape of Helen. The Wallace Collection in London possesses a bronze allegorical group commemorating the achievements of Louis XIV, showing three female figures, each holding medals portraying Louis XIII and Louis XIV. This remarkable group was given as a prize in a poetry competition of 1713, in which Voltaire was runner-up to the otherwise unknown Abbé du Jarry.

BESNARD, Philippe fl. 19th-20th centuries
The son of the painter Albert Besnard, he was taught the rudiments of sculpture by his mother, daughter of the sculptor Vital Dubray, and later he was helpted by Rodin. His earliest work was a bust of his father and subsequently he specialised in portraiture. He produced a large number of busts and heads of contemporary celebrities, but also did many allegorical compositions and public monuments, especially after the first world war when there was a large demand for war memorials. He exhibited regularly at the Salon of the Société Nationale, the Salon d'Automne and the Salon des Tuileries and was made a Chevalier of the Legion of Honour.

BESSERDICH fl. late 19th century
Nothing is known of this sculptor except that he worked in the vicinity of Prague at the turn of the century, specialising in small bronzes of animals and figures and groups illustrating Bohemian peasant life.

BEVIS, L. Cubitt 1891-
Lived in London and later in Sutton, Surrey, where he specialised in busts, heads and portrait reliefs. He exhibited at the Royal Academy and other British exhibitions before the second world war.

BEYER, Josef fl. 19th century
Born in Vienna on February 28, 1843, he was apprenticed to a bronze founder at the age of ten and worked under the direction of the sculptor Fernkorn till 1873. During this period he also studied at the Vienna Academy. His best known works are the three bronzes of the Printer, the Merchant, and Justice, intended as decoration for the new Town Hall (1878-79). He also sculpted the figures of Democritus and Empedocles for Vienna University (1883).

BEYLARD, Louis Charles fl. 19th-20th centuries
Born in Bordeaux in the mid-19th century, he died there in 1925. He studied under Dumont and Perraud and exhibited at the Salon des Artistes Français from 1878 to 1914, winning a bronze medal in 1900. Most of his work was sculpted in marble or plaster and consists of figures of saints and funerary busts. He also produced bronzes of classical figures; his statuette of Meleager is in Troyes Museum.

BEYRER, Eduard Maximilian fl. 19th-20th centuries
Born in Munich on October 24, 1866, he studied under his father, Josef Beyrer, and then attended the Munich Academy for three years under von Rümann. Later he visited Rome before settling in Munich. where he produced numerous statues, monuments and busts. His best known works include the statue of Duke John of Bavaria (Munich Town Hall) and the war memorial at Grunstadt. His bronzes include busts of Leon Putz, Miss L., Madame K. and a bronze figure for a fountain, shown at the Munich Exhibition of 1909. His father and uncle, Heinrich, sculpted in wood and stone, but no bronzes are recorded for them.

BIAFORA, Enea 1892-
Born in San Giovanni in Fiore, Italy in 1892, he studied under his father, who was an architect and sculptor of friezes. In 1907 he went to Naples and studied at the Instituto di Belle Arti. Subsequently he taught drawing and modelling in various technical and normal schools in southern Italy. In 1914 he came to New York and later worked in the studio of Paul Manship. Among his bronzes may be mentioned genre figures and groups such as Antique Dance and portrait reliefs.

BIAGINI, Alfredo 1886-
Born in Rome on January 20, 1886, he studied at the School of Fine Arts in Rome. His best known work was the bronze doors of Orvieto Cathedral. His bronze figure of a Young Girl Outstretched was shown at the Exhibition of Italian Art in Paris, 1935. He specialised in animal figures and groups and took part in various international exhibitions such as the Rome Quadrennial, the Barcelona Exhibition and the French salons.

BIANCHI, Aimée fl. 20th century
Born at Limoges at the end of the 19th century, she specialised in busts and heads of contemporary personalities, but also produced a number of classical and genre bronzes such as Head of a Bacchante and Incantation. She exhibited at the Salon d'Automne, the Indépendants and the Tuileries between 1922 and 1938.

BIANCHI, Dominique fl. 19th-20th centuries
Born at Alfedena, Italy in the mid-19th century, he settled in France
and died there in 1913. He studied under Falguière, Albert-Maignan
and Carlès and exhibited at the Salon des Artistes Français from 1898
till his death. He was awarded a bronze medal at the Exposition
Universelle (1900) and a third class medal in 1910. His work consisted
of small figures, busts and reliefs.

BIANCHI, Mathilde fl. 19th-20th centuries
Born at Châteaudun in the mid-19th century, she died in 1927. She
exhibited at the Salon from 1879 onwards, obtaining an honourable
mention in 1886 and a second class medal at the Exposition
Universelle of 1889. She specialised in busts and heads of her
contemporaries, but also produced several genre groups, such as Child
with Cat (1880) and Child holding a Bird (1881).

BIBERSTEIN, Alfred fl. 20th century
Born at Soleure, Switzerland in the late 19th century, he studied
under Mercié and exhibited at the Salon des Artistes Français (1913),
the Nationale (from 1919) and the Salon d'Automne from 1920 to
1938. He specialised in busts and heads of women and children.

BICHOFF, Odette fl. 20th century
She worked in Paris before the second world war, and sculpted
statuettes and small genre groups.

BIDAULD, Joseph Pierre Henri 1760-1812
Born at Carpentras on July 5, 1760, he died about 1812. He worked
as a jeweller and silversmith in Toulouse, but also sculpted figures and
groups in wood and bronze.

BIERLING, Ludwig 1840-1886
Born at Oberammergau in 1840, he died on May 27, 1886. He studied
under Sickinger in Munich and produced numerous portrait reliefs
and busts. He is best known for his colossal bust of the Kaiser
Wilhelm I in 1871.

BIESBROECK, Jules Pierre van 1873-
Born at Portici in Italy on October 25, 1873. His father was a Belgian
painter from Ghent and he was educated in that town when his family
returned to Belgium. He studied painting under his father, but later
opted for sculpture and studied at the Ghent Academy. He began
exhibiting his paintings in 1888 and his sculpture from 1895 onwards.
At the Exposition Universelle of 1900 he was awarded a Grand Prix,
and won a gold medal at the Munich exhibition the following year.
Though best known for his monuments to the socialist leader Jean
Volder and François Laurent in Ghent, he also sculpted biblical
classical and allegorical groups, such as Adam and Eve beside the
Corpse of Abel and Our Dead (Venice Museum). He also modelled the
ornamental bronze base for the Flagstaff in Ghent.

BIESBROECK, Louis Pierre van fl. 19th century
Born in Ghent on February 17, 1839, the uncle of the foregoing. He
studied at Ghent Academy and travelled in France and Italy before
taking up an appointment as professor of sculpture in his native city
(1867). His works include Prometheus Bound, Grief and Hope,
various busts preserved in Brussels Museum and decorative sculpture
in Ghent Museum.

BILANCINI, Reginaldo fl. 19th-20th centuries
Born at Pesaro, Italy, he died at Calenzano near Florence on March 8,
1907. He studied under L. Bartolini and specialised in busts and heads
of contemporary Italian celebrities.

BILEK, Frantisek 1872-
Born at Tabor, Czechoslovakia on November 6, 1872, he studied in
Prague and became one of the leading Czech painters of the modern
movement after the first world war, specialising in peasant women
and nudes. His sculpture of the same subjects combined symbolism
and expressionism.

BILL, Max 1908-
Born at Winterthur, Switzerland in 1908, he studied at the School of
Arts and Crafts in Zürich and then at the Dessau Bauhaus in 1927-29.
He began practising as an architect in Zürich in 1930, but extended
his artistic activities into painting, sculpture, typography and other
forms of graphic art. He was absorbed in the problems of perpetual
motion in sculpture and produced large constructions in bronze and
marble, intended for display in open spaces. However, the distinctive

nature of his sculpture, and the intricacy of its components, can be
seen in the smaller models cast in bronze and other metals. He was
awarded first prize for sculpture at the Sao Paulo Biennale of 1951
and had an entire room devoted to his work at the Venice Biennale of
1958. He organised the Exhibition of Concrete Art in Basle, 1944 and
has since participated in many Swiss and international exhibitions.

BILLING, Miss C. fl. 19th-20th centuries
She worked as a painter and sculptor in London at the turn of the
century and exhibited at the Royal Academy. Her sculpture consisted
mainly of small genre figures and groups.

BILOTTI, Salvatore fl. early 20th century
Born at Cosenza in Italy in 1880, he studied in Philadelphia, Paris and
Rome, being successively a pupil of Charles Grafly, Injalbert and
Verlet. He settled in the United States and specialised in bronze genre
figurines.

BINQUET, Albert fl. 20th century
Born in Bordeaux at the end of the 19th century, he exhibited at the
Salon d'Automne from 1923 to 1931 and specialised in bronze reliefs
and ornaments for gates, doors and façades.

BINZ, Hermann 1876-
Born in Karlsruhe on June 22, 1876, he studied at the School of Arts
and Crafts in Karlsruhe and later at the Academies of Karlsruhe and
Berlin. He travelled in Italy and France and was strongly influenced
by Rodin. He produced numerous sculptures, mainly for Karlsruhe
and is best known for the fountain of St. Stephen. He also sculpted
small figures and groups.

BION, Paul Laurent 1845-1897
He lived in Paris and studied at the École des Beaux Arts under
Jouffroy. His works include Mercury (Paris Chamber of Commerce)
and figures of Hylas and The Young Beggar. His father, Louis Eugène
Bion (1807-60) was also a sculptor, specialising in plaster religious
figures and allegorical groups, such as The Genius of Medicine and
The Genius of Charity, some of which were also cast in bronze.

BIRCH, Charles Bell 1832-1893
Born in London in September 1832, he died there on October 16,
1893. He studied at the Royal Academy schools and also for a time in
Berlin under Rauch. He was a pupil and assistant of Foley. His
bronzes include the figure of John Henry Foley and genre groups such
as Revenge and The Last Call.

BIRD, Francis 1667-1731
Born in London in 1667, he died on February 20, 1731. He studied in
Brussels and then went to Rome, where he was a pupil of Le Gros. On
his return to England in 1716 he assisted Christopher Wren in the
decoration of St. Paul's Cathedral, particularly the relief of The
Conversion of St. Paul. Among his works are the bronze statues of
Henry IV at Eton, The Duke of Newcastle in Westminster Abbey and
Cardinal Wolsey at Christchurch, Oxford.

BIRNIE-RHIND fl. 19th century
He studied in Paris under Denis Puech and exhibited at the Salon des
Artistes Français at the turn of the century.

BIRON, Stanislaus Francis fl. 19th-20th centuries
Born in Nantes in the late 19th century, he studied under J.J. Potel
and exhibited at the Salon des Artistes Français at the turn of the
century. He specialised in portrait medallions and reliefs.

BIROT, Pierre Albert fl. early 20th century
Born in Angoulême in the late 19th century, he was a pupil of
Falguière and Alfred Boucher. He exhibited small bronzes at the
Salon des Artistes Français in 1900-4.

BISORDI, Domenico fl. 20th century
Born in Pescia, Italy in the late 19th century, he studied in Paris
under Vital-Cornu and exhibited at the Salon des Artistes Français in
1921-23. He worked on war memorials but also sculpted statuettes of
children.

BISSEN, Herman Vilhelm 1798-1868
Born in Slesvig on October 13, 1798, he died in Copenhagen on
March 10, 1868. He showed great talent as a youth and friends of the
family clubbed together to send him to Copenhagen to be educated.

He studied at the Academy from 1816 to 1823, switching from painting to sculpture in 1820, after winning the silver medal for painting. In 1823 he won a gold medal and a travelling scholarship and went to Rome the following year. Five years later his work A Blind Man seated with a Child begging Alms created a sensation. He returned to Copenhagen in 1834 and was elected to the Academy, his inaugural work being a figure of a Valkyrie. In 1840 he became professor at the Academy of Fine Arts and worked on the friezes and decoration of Christiansborg Castle. Thereafter he produced numerous monuments and memorials, particularly in the aftermath of the war of 1864, his best known being the figure of a soldier at Fredericia. His minor works include Young Girl with Flowers, Psyche, Paris, Amor, Nymph, Hunter, Girl Fishing, Shepherdess and Reaper, and a bust of Frederick VII.

Rostrup, H. *H.V. Bissen* (undated).

BISSEN, Christian Gottlieb Vilhelm 1836-1900
Son of Herman Vilhelm Bissen, under whom he studied at the Academy. In 1857 he went to Rome, where his father continued to maintain a studio, and remained there on his own till 1863. Notable works of this period include Aegea searching for the Ship of Theseus. He was again in Italy in 1866-68 on a travelling scholarship from the Copenhagen Academy and became a member of that body in 1871. His best known work is the statue of Absalon, in front of Copenhagen Town Hall. He assisted his father in his old age with many of his works, especially the statue of Frederick VII. He became professor of modelling at the Academy in 1890. He took part in the Expositions in Paris, being awarded a bronze medal in 1889 and a gold medal in 1900. His minor works include Atalanta, Woman in Repose, A Lady, Christian IX and The Huntress.

BISSETT, Douglas Robertson 1908-
Born in Strichen, Aberdeenshire on May 25, 1908, he studied sculpture at the Glasgow School of Art (1930-33), the Royal Danish Academy in Copenhagen (1933) and the British School in Rome (1934-35). He settled in London and has exhibited at the Royal Academy. His work consists mainly of busts, heads and figures.

BITTER, Karl Theodore Francis 1867-1915
Born in Vienna on December 6, 1867, he died in New York in 1915. He studied at the Vienna Academy under Edmund Hellmer and emigrated to the United States in 1889. He sculpted numerous monuments, statues and bas-reliefs of historical subjects for which he was awarded medals at the Exposition Universelle (1900), the Pan-American Exposition (1901) and the St. Louis World's Fair (1904).

BITTERLICH, Eduard 1834-1872
Born at Stupnicka, Galicia in 1834, he died at Presbaum in 1872. He studied under Waldmüller in Vienna and became assistant to Carl Rahl, working on theatrical sets and a series of frescoes. After Rahl's death he completed his master's unfinished works with the help of Christian Griepenkerl. He was a prolific sculptor of small bronze figures and groups, many of them cast at the Klinkosch foundry. His larger works include the monuments to Schiller in Vienna and Goethe in Berlin.

BITTERLICH, Hans 1860-
Born in Vienna, the son of Eduard Bitterlich, he studied under his father and also at the Vienna Academy under Karl von Zumbusch. He produced many busts, statues and bas-reliefs. The best known of his monumental works was the memorial to the Austrian Empress in Vienna.

BIZARD, Susanne fl. 20th century
Born at St. Amand on August 1, 1873, she exhibited at the Salon des Artistes Français from 1900 till 1936. She produced many portrait reliefs, busts, statuettes of children and genre groups of which Vers l'Idéal (1900) and Honour and Money (1903) are the best known.

BIZETTE-LINDET, André fl. 20th century
Born at Savernay at the beginning of this century, he studied under Injalbert at the École des Beaux Arts and won the Grand Prix de Rome in 1930. He exhibited at the Salon des Artistes Français from 1929 and was awarded a gold medal in 1935 and a diploma of honour at the Exposition Internationale in 1937. He is best known for the

figures decorating the bronze doors of the Musée d'Art Moderne in Paris, but he has also produced numerous busts, heads and small figures.

BIZZARI, Luciano 1830-1905
Born at Macerata in Italy on May 30, 1830, he died in 1905. He studied design under the painter Venturi in Rome. As a student he took part in the defence of Rome in 1849 and wrote a poem in praise of Garibaldi which led to his banishment from Rome in 1851. He returned to Macerata, where he practised as a jeweller. He was also a musician of considerable talent and invented a curious instrument called a Bizzarifero. He married in 1858 and returned to Rome to take part in the conspiracy for Italian unity. During this period he exhibited a gold bust of Jupiter, after Phidias. In 1870 he won first prize for a small crucifix modelled in the manner of Cellini. His best known work was Inspiration of the Morning, a bronze figure which was exhibited in Rome and Paris. For his sensitive modelling of the bust of the Queen of Italy (cast in gold) he won first prize and was decorated with the order of the Crown of Italy.

BLACHETTE, Lucienne fl. 20th century
Born in Constantine, Algeria, in the early years of this century, she studied art in Algeria and Paris and specialised in nude figures and portrait busts. She exhibited at the Nationale (1932-37) and the Salon des Tuileries (1933-34).

BLACKMAN, Audrey (née Seligman) 1907-
Born in London on July 28, 1907, she studied at Goldsmiths' College School of Art in 1926-30 and at Reading University in 1931-35. She has exhibited at the Royal Academy and also participated in many national and international exhibitions. She lives in Oxford. Her work is represented in several public collections.

BLADEN, Alfred fl. 20th century
Born in Oldham c.1900, he studied at Wolverhampton School of Art and the Royal College of Art. He worked in London and Wolverhampton from 1925 to 1960 as a painter and portrait sculptor.

BLANC, Pierre fl. 20th century
Born in Lausanne, he works in Switzerland, specialising in busts and heads and animal figures and groups, such as Ostrich, Bison and Boar. He exhibited at the Nationale, the Salon d'Automne, the Tuileries and other salons in France and Switzerland in the inter-war period.

BLARD, Pierre Jacques Theodore fl. 19th century
Born in Dieppe on August 27, 1822, he studied in Paris under David d'Angers and exhibited at the Salon from 1842 onwards. His bronze bust of Jean Bougard (1882) is in Dieppe Museum.

BLASCO, Ferrer 1907-
Born at Foz-Calanda, Aragon, on February 20, 1907, he studied at the School of Fine Arts in Barcelona. His sculpture, in terra cotta, bronze and iron, is noted for its realism.

BLASER, Gustav 1813-1874
Born in Düsseldorf on May 9, 1813, he died in Cannstadt on April 30, 1874. He studied under Schöll in Mainz and Rauch in Berlin. His works include bronze statuettes of the painter K.T. Lessing and the sculptor Schadow.

BLASHFIELD, J.H. fl. 19th century
He was an Australian sculptor, working in Sydney in the latter half of the 19th century. His bust of the explorer John Blaxland is in the Sydney Museum.

BLAY Y FABREGA, Miguel fl. 19th-20th centuries
Born at Olot, Catalonia in 1866, he studied the painter Berga in Barcelona and then studied sculpture under Chapu in Paris. He exhibited at the French and Spanish salons at the turn of the century, winning a Grand Prix at the Exposition Universelle (1900) and being made Chevalier of the Legion of Honour the following year. His works include Prodigal Son (1892), Marguerite (1893), Woman and Flower (1900), The Illusion (1903), Hatching (1905) and various heads and busts.

BLECKER, Bernhard fl. 19th-20th centuries
He exhibited a number of bronze portrait busts at the Munich Exhibition of 1909.

BLOC, André Lucien Albert 1896
Born in Algiers in 1896 he studied at the Central School and graduated in 1924 as an engineer in the applied arts. During the inter-war period he worked in decorative architecture and founded the magazine *Architecture d'Aujourd'hui* which he continues to edit to this day. During the second world war, however, he moved from Paris to the unoccupied zone in the south of France and then turned to modelling busts and figures in terra cotta. In 1951 he founded the art journal *Art d'Aujourd'hui* and became leader of the Espace group. His architectural and engineering background has strongly influenced his sculpture. After the war he turned to abstract sculpture in concrete, but for a time in the late 1940s he also worked in brass, bronze and iron. Later he utilised plastics such as plexiglass, sheet metal and marble in his constructions. His best known work is the monumental sculpture Brasilia, commissioned for the new capital of Brazil. He has also tried his hand, with considerable success, at painting, stained glass, tapestry and mosaics.

BLOCH, Armand Lucien 1866-1933
Born at Montbeliard, France on July 1, 1866, he died in Paris in 1933. He studied under Falguière and Mercié and exhibited at the Salon des Artistes Français from 1888 till his death. He was awarded silver medals at the Exposition Universelle (1900) and the Exposition des Arts Décoratifs (1924), and made a Chevalier of the Legion of Honour in 1931. Much of his work was carved in wood or stone, and included a series of masks as well as busts, groups and animal studies. Among his bronzes, however, were busts and portrait reliefs. His best known work is the bronze bust of the Chevalier de la Barre in Montmartre.

BLOCH, Elisa (née Marcus) 1848-1904
Born in Breslau (Wroclaw) in 1848, she died in Paris in 1904. She studied under Chapu and made her début at the Salon in 1878 with a bronze medallion portrait of her husband. Subsequently she exhibited a large number of busts, including those of the kings of Spain and Portugal, Jules Barbier, M. de Bornier, Quesnay de Beaurepaire, Flammarion, Buffalo Bill Cody, Weckerlin, General Crespo, Leonide Leblanc and Zadoc Kahn, as well as various religious groups, such as David and Moses receiving the Ten Commandments.

BLONAY, Marguerite Anne 1897-
Born at Zinsviller, Switzerland on July 9, 1897, she specialised in busts and animal figures and groups. She exhibited at the Salon des Indépendants (1926-28), and the Salon des Artistes Français (1927-33). Her works include Head of a Child (1924) and Pelican (1934).

BLONDAT, Max 1879-1926
Born at Crain, France on July 3, 1879, he died in Paris in 1926. He studied under Thomas, Mathurin-Moreau and Valton and exhibited at the Salon des Artistes Français from 1911 to 1914 and from 1920 to 1925. He was a prolific producer of fountains, tombs and memorials, patriotic groups, allegorical statuettes and portrait busts. One of his more notorious works is a burlesque statuette of Victor Hugo, parodying the famous statue of the poet by Rodin. Blondat received many awards, culminating in the cross of Officier of the Legion of Honour in 1925.

BLUMENTHAL, Barbara 1910-
Born in Shanghai in 1910 of French parentage, she exhibited at the Salon des Artistes Français from 1926 to 1930. She specialised in statuettes, small groups and busts.

BLUMENTHAL, Hermann 1905-1942
Born in Essen in 1905, he was killed in action on the Russian Front in 1942. He trained as a stone-mason before entering the Berlin Academy and also worked in the studio of Edwin Scharff. He won the Prix de Rome in 1930 and spent the next three years studying in Italy. Following his return to Berlin in 1934 he worked in the Arts City built by the Third Reich. His work consists mainly of studies of adolescence, from every angle and aspect, together with a number of busts and heads and several bas-reliefs which have his characteristic feeling for youth and purity.

BLUNDSTONE, Ferdinand Victor 1882-1951
Born in Switzerland on July 17, 1882, the son of the English artist C. Blundstone, and died in West Drayton, Middlesex on January 5, 1951. He studied at the South London Technical Art School and the Royal Academy schools, winning a gold medal and a travelling scholarship. Thereafter he studied sculpture in Paris, Rome, Egypt and Greece and exhibited at the Royal Academy and various provincial galleries. He specialised in memorials and statuary and was awarded a silver medal at the Exposition des Arts Décoratifs in 1925 for his garden sculptures. He sculpted the bronze war memorial in the Prudential Assurance building in London.

BOCCIONI, Umberto 1882-1916
Born in Reggio di Calabria on October 19, 1882, he died in an accident at Sorte, near Verona, on August 16, 1916. He studied architecture in Catania and painting and sculpture in Rome from 1898 to 1902, thereafter travelling in Paris and St. Petersburg (1902-3) and Padua and Venice (1906). In 1908 he established a studio in Milan and the following year met Marinetti, who converted him to Futurism. In 1910 he signed, with Balla, Carra, Russolo and Severini, the famous Manifesto of Futurist Paintings, and in 1912 drafted his Technical Manifesto of Futurist Sculpture. The first exhibition of his spatial sculpture was held in Italy that year and in 1913 it was repeated at the Galerie La Boëtie in Paris. The public reaction to the exhibition was violent and in the uproar on the opening day one of the plaster exhibits was smashed. Boccioni's works found a permanent home in 1914 when a gallery of Futurist art was established in the Galleria Sprovieri, Rome. He enlisted as soon as Italy entered the war, but was killed in a riding accident the following year. He was the only sculptor of the Futurist movement. His works include La Madre Antigrazioso (bronze, 1911), Development of a Bottle in Space (silvered bronze, 1912) and Unique Forms of Continuity in Space (bronze, 1913) (all now in the Harry Winston Collection), Muscles in Motion (1913) and Empty and Full Abstracts of a Head (1913).

BODENMÜLLER, Beat 1795-1836
Born at Einsiedeln in 1795, he died in Baden in 1836. He worked mainly at Mellingen in Switzerland, though in his later years he was professor of drawing at Baden. He specialised in medallion portraits and reliefs of celebrated contemporaries, such as Pestalozzi, Orelli, Nägeli, Johann Jakob Hess and Ludwig Vogel.

BODMER, Walter 1903-
Born in Basle, where he studied at the School of Arts and Crafts, he began his career as a painter but in 1936 began modelling his drawings in iron wire and thus created his first pictures in relief. From this he progressed to three-dimensional sculptures and also experimented with mobiles. Later he developed a more solid and geometric style. In 1956 he abandoned spatial sculpture and concentrated on small sculptures in which great play was made in their patination, and the pitting and coruscation of their surfaces. More recently, however, he has returned to spatial constructions on the grand scale.

BOEHM, Sir Joseph Edgar 1834-1890
Born in Vienna on July 6, 1834, he died in London on December 12, 1890. He was the son and pupil of the medallist and engraver Joseph Daniel Boehm of Hungarian origin. He studied in Vienna, Rome and Paris and settled in London in 1862 where he became the Court Sculptor and for many years the keystone of the Establishment in British sculpture. He was immensely popular with Queen Victoria, whose own daughter, Princess Louise, was his star pupil, and he could afford to employ the most promising of the younger sculptors in his studio. The result was a prolific series of works, technically perfect but stylistically pedestrian — very much in tune with the taste of the late 19th century. He exhibited at the Royal Academy from 1862 till 1891, (R.A. 1882) and was created a baronet in 1889. Many of his works in plaster and marble were subsequently published as bronze reductions. His best known works include the group of St. George and the Dragon, a popular subject as an ornamental bronze, and the figures of soldiers decorating the Wellington memorial at Hyde Park Corner (1883). Among his monumental pieces were the colossal equestrian statues of the Prince of Wales and Lord Napier, for Bombay and Calcutta respectively; and these works show his skill in the depiction of horses, a subject to which he returned in the form of small bronzes, such as The End of the Day, a study of a tired hunter. He also sculpted cattle and domestic animals.

BOFILL, Antoine fl. 20th century
Born in Barcelona in the late 19th century, he studied at the Academy of Fine Arts in that city. He exhibited in Spain and also at the Paris salons from 1902 to the 1920s. He specialised in small figures and groups.

BOILEAU, Martine 1923-
Born at Neuilly-sur-Seine, she emigrated to the United States at the beginning of the second world war. She studied architecture for two years, then joined the Art Students' League, where she studied sculpture under William Zorach. She returned to France in 1946 and attended the Académie de la Grande Chaumière. She was strongly influenced by Germaine Richier, who taught her to break up the surface of her sculptures and introduce new elements. She exhibited at the Paris salons from the early 1950s and has also exhibited in the Netherlands. Since 1952 she has abandoned the traditional materials, such as clay and plaster, and has modelled her abstracts in wax, for bronze-casting.

BOISECQ, Simone 1922-
Born in Algiers, where she studied philosophy at the University. Thereafter she took up sculpture without going through any formal course of education in this medium, though her husband, the sculptor Karl Jean Longuet, gave her help with mastering the techniques of modelling. Her abstract figures in cement, plaster and bronze, have been exhibited at the Salon de la Jeune Sculpture and she has had one-man shows at several Paris galleries.

BOISSEAU, Émile André 1842-1923
Born at Vanzy in France on March 29, 1842, he died in Paris in 1923. He studied under Dumont and Bonnassieux at the École des Beaux Arts. His best known works are The Daughter of Celuta weeping over her Child (1869), Figaro (1874), The Evil Genius (1880), Twilight (1883), Fruits of War, Diogenes (1899), The Sons of Clodomir (1899) and The Love which takes the place of Friendship (1909). A bronze bust of Amédée Jullien is in the Clamecy Museum. He also did various studies in plaster and terra cotta.

BÖLTZIG, Reinhold fl. 19th-20th centuries
Born in Berlin on March 9, 1863, he studied at the Berlin Academy and specialised in genre figures and groups. His group for a fountain is in the Hamburg Museum, and The Quoit Thrower is in the Leipzig Museum. He won a bronze medal at the St. Louis World's Fair (1904) and a silver medal at Salzburg (1907). He also exhibited in Munich and Berlin in 1909 and 1910 respectively.

BONAZZA, Giovanni fl. 1695-1730
He worked in Venice with his sons Antonio, Francesco and Tomasso on the decoration of churches in Padua and the churches of St. John and St. Peter in Venice. There are two statues by Giovanni in the Church of Sant' Antonio Abate at Rovigo. Various bronze religious vessels and bas-reliefs are preserved in the Correr Museum.

BONCQUET, Henri 1868-1908
Born at Ardoye in Belgium on April 7, 1868, he died at Ixelles near Brussels on April 10, 1908. He studied under Dupon at Roulers and C. Van der Stappen at the Brussels Academy. His group of Thor wrestling with the Serpent won the Prix de Rome in 1897 and he began exhibiting at the Brussels and Antwerp salons from that year. His works include the figure of an Eagle (Brussels Botanic Gardens), Illusion, Destiny and The Mischievous Child.

BONE, Phyllis Mary 1896-1972
Born at Hornby in Lancashire on February 15, 1896, she died in Kirkcudbright on July 12, 1972. She took her diploma at the Edinburgh Art College and later studied in Paris under Navellier. She exhibited at the Royal Academy, the Royal Scottish Academy (A.R.S.A. 1939, R.S.A. 1944), the Salon des Artistes Français and many other exhibitions in Britain and Europe. She had a studio in Edinburgh but spent her last years in Kirkcudbright. She specialised in animal figures and groups.

BONETTI, Giuseppe fl. 19th century
Born in Milan in 1840, he studied at the Academia de la Brera, but abandoned his studies in 1859 to serve as a volunteer under Garibaldi in the war for the unification of Italy. After the war he settled in Florence when it was the capital of Italy and executed many works for the noble families of Italy. His best known work is the monument to Pietro Micca in Turin. He also produced a number of trophies and elaborate presentation pieces which were cast in silver. An ornate silver drinks table with lavish decoration won a prize at the Florence Exhibition of 1887.

BONHEUR, Isidore Jules 1827-1901
Born at Bordeaux on May 15, 1827, the third child of Raymond Bonheur and brother of Rosa Bonheur. Like the other members of his family he showed great aptitude for drawing and modelling from an early age and was taught by his father. In 1849 he enrolled at the École des Beaux Arts, though he made his début at the Salon the previous year with a painting entitled African Horseman Attacked by a Lion and a plaster model of the same subject. He exhibited regularly at the Salon from then on but only his picture Pepin le Bref (1874) was regarded as in any way remarkable. He exhibited at the Royal Academy in 1875-76 and won a gold medal at the Exposition Universelle of 1889. Though a prolific but undistinguished painter of animal subjects and landscapes, his sculpture is better known. His best known works include the memorial to Rosa Bonheur, Fontainebleau and the two stone lions on the steps of the Palais de Justice, Paris. He produced numerous small bronzes of animals, chiefly sheep and cattle, often modelled to complement figures by Rosa, and cast by his brother-in-law, Hippolyte Peyrol. He also sculpted several figures and groups of horses, the most notable being the silvered bronze equestrian statuette of King Edward VII when Prince of Wales. He sculpted a number of hunting groups, featuring deer, game-birds and hounds.

BONHEUR, Rosa 1822-1899
Born in Bordeaux on March 22, 1822, the eldest child of the drawing master Raymond Bonheur. She was something of an infant prodigy, showing great talent in drawing from pre-school age. Her family moved to Paris in 1828 and Rosa was apprenticed to a dressmaker but soon gave up this profession and concentrated on art. She worked for the Bisson family, who specialised in heraldic crests and subsequently she was a pupil of Cogniet and studied the statuary in the Louvre. From 1841 onwards she concentrated on animal studies, haunting the circuses and abattoirs as well as the Jardin des Plantes. She exhibited at the Salon from 1841, her earliest work consisting of drawings of rabbits and sheep. The following year she submitted paintings and a terra cotta figure of a Shorn Sheep which attracted considerable attention. Thereafter she exhibited both paintings and sculpture of animals, mainly domestic and agricultural studies. The figures and groups were often exhibited in plaster or terra cotta and later edited as bronzes. Among her many awards were a third class medal (1845), a gold medal (1848) and the Legion of Honour – Chevalier (1865) and Officier (1893). She visited Scotland in 1856 and this resulted in the series of bronzes depicting Scottish shepherds, sheep, Skye ponies and Highland cattle. In general, however, her animal sculpture ceased in 1853 and thereafter she devoted the bulk of her time to painting. She left Paris in 1860 and settled at the Château de By in the forest of Fontainebleau, where she died in 1899.

Bonnefon, P. *Rosa Bonheur* (1905). Hird, Frank *Rosa Bonheur* (1904). Klumke, A. *Rosa Bonheur, sa vie, son oeuvre* (1908). Lapelle de Bois-Gallais, F. *Mlle. Rosa Bonheur* (1956). Peyrol, R. *Rosa Bonheur: her Life and Work* (1889). Roger-Miles, L. *Rosa Bonheur* (1900). Stanton, Theodore *Reminiscences of Rosa Bonheur* (1903).

BONNARUEL, Pierre Antoine Hippolyte 1824-1856
Born at Bonnay, France on January 14, 1824, he died in Rome on July 2, 1856. He studied at the School of Fine Arts, Lyons and later at the École Nationale des Beaux Arts in Paris under Ramey and Dumont. He won the Prix de Rome in 1851, but died five years later after a long mental illness. His works, though few, were outstanding and included Telemachus bringing to Phalanta the urn containing the ashes of Hippias (second Prix de Rome, 1847), the Greeks and Trojans disputing the corpse of Patrocles (Prix de Rome, 1851), a statue of Ruth (1852) and a maquette for the first medal of the Great Exhibition (1851).

BONNEMÈRE, Lionel 1843-1905
Born at Angers about the year 1843, he died in Paris on November 28, 1905. He studied under Barye and specialised in animal bronzes, which he exhibited at the Salon between 1869 and 1878.

BONNESEN, Carl Johan 1868-1920
Born in Aalborg, Denmark on May 26, 1868, he died about 1920. He was originally apprenticed to a carpenter but studied sculpture from 1887 onwards and was a pupil at the Academy of Fine Arts, Copenhagen, where he exhibited his first work in 1889. This statuette of a Chief of the Huns attracted a great deal of favourable comment at the time. He won prizes at the Academy in 1889 and 1890 and various bursaries and bequests enabled him to establish himself as a fashionable sculptor. He participated in Danish exhibitions and also the Salon des Artistes Français. At the Exposition Universelle of 1900 he was awarded a bronze medal. He specialised in animal figures and groups and also subjects with an Oriental or biblical theme. His works include Hun Soldier lifting up a young Chinese, Cain, Jutland Bull, Group of Lions, En Barbar, Life and Death, The Captive. His works are preserved in various Danish public collections, particularly the Royal Museum of Fine Arts in Copenhagen.

BONNET, Guillaume 1820-1873
Born at St. Germain-Laval on June 27, 1820, he died in Lyons on April 26, 1873. The son of a poor smallholder, he was orphaned and subsequently brought up by a charitable lady. He studied at the School of Fine Arts, Lyons under Ruolz in 1840-42 and went to Paris to continue his studies under Dumont and Ramey. In 1848 he competed for the Prix de Rome and won a second prize for a group of medals. In 1853 he went to Rome and spent a year there. He returned to Lyons in May 1854 and worked there for the rest of his life, his most prolific period being the decade 1860-70. His best known work is the semi-circular bas-relief in the Lyons Palais de Justice and the figures of Thalia and Melpomene in the Grand Theatre. His smaller works consist mainly of busts, reliefs and portrait medallions of his contemporaries. His figures of Erato and Thalia are known as bronze reductions.

BONOMI, Joseph 1796-1878
Born in Rome on October 9, 1796, he died in London on March 3, 1878. He was the son of the architect Joseph Bonomi the Elder who brought him to England as a child. He was awarded the silver medal of the Society of Arts in 1815 for a plaster bas-relief and the following year he entered the Royal Academy schools. He was the favourite pupil of Nollekens and won silver medals in 1817 and 1818. In 1823 he returned to Rome and from then until 1844 he lived in Egypt and the Near East. After his return to England he exhibited sculpture in the Egyptian Court at the Crystal Palace (1852-53) and became Curator of the Soane Museum in 1861, a position which he held till his death in 1878. He exhibited at the Royal Academy from 1820 to 1838, his work comprising groups of classical and biblical subjects such as Jacob wresting with the Angel (1820), and busts of contemporary personalities. Casts of these busts were formerly in the Crystal Palace. Aylesbury Museum has his bust of Dr. John Lee.

BOOL, George M. fl. 19th century
Born in 1812, he studied at the Royal Academy schools in 1831-34, winning a silver medal in the latter year. He exhibited at the Royal Academy from 1832 to 1836, specialising in busts, bas-reliefs and portrait medallions. His best known work is the bust of King William IV (1834), regarded as one of the finest likenesses of the king.

BOR, Paul fl. 20th century
Born in Budapest at the end of the 19th century. He exhibited at the Salon d'Automne in 1923-24, genre figures entitled The Kiss, The Dancer, Young Mother and Woman Praying.

BORCH, Elna Inger Cathrine fl. 19th-20th centuries
Born at Roskilde in Denmark on December 6, 1869, she studied in Copenhagen under A.V. Saabye. She specialised in portrait reliefs, busts, and genre statuettes and groups which she exhibited at the Copenhagen Academy between 1891 and 1908.

BORDEAUX-MONTRIEUX, Jacques fl. 20th century
Born at Angers, he studied in Paris under Navellier. He exhibited animal groups and statuettes at the Salon des Artistes Français from 1913 to 1924.

BORDINI, Pietro fl. 19th century
Born in Verona on February 20, 1856, he studied at the Academy of Fine Arts in Verona, and later worked in Naples, Rome and Florence.

His first major work was the bronze eagle and the trophies of arms on the memorial to the war of 1848 at Santa Lucia. Other works include the monument to the Heroes of Two Worlds (Iseo) and the equestrian statue of Garibaldi at Verona (1887).

BORGA, Eugène Antoine fl. early 20th century
Born in Paris in the late 19th century, he exhibited at the Salon des Artistes Français from 1912 to 1939, winning an honourable mention in 1921 and a gold medal at the Exposition Internationale in 1937. He also exhibited at the Salon d'Automne from 1919 to 1938. He specialised in animal figures, and groups illustrating the different types of men he had observed in prison camps during the first world war.

BORGLUM, John Gutzon Mothe 1871-1941
Born of Danish parents near Bear Lake, Idaho on March 15, 1871, he died in 1941. He was educated at St. Mary's College, Kansas and studied sculpture in San Francisco and later went to Paris where he continued his studies at the Académie Julian and the École des Beaux Arts. He exhibited both painting and sculpture at the Paris Salon and at the Royal Academy before returning to the United States in 1901. His spirited bronze group of the Mares of Diomedes was the first piece of sculpture purchased for the Metropolitan Museum of Art in New York. He is best known for his colossal group of heads of Washington, Jefferson, Lincoln and Theodore Roosevelt at Mount Rushmore, South Dakota, on which he was working at the time of his death (the work being completed by his son Lincoln Borglum). Earlier essays in sculpture on the colossal scale were his procession of Robert E. Lee, his staff and soldiers hewn from the living rock of Stone Mountain, Georgia and the six ton stone head of Lincoln in the capitol in Washington. He was a prolific sculptor whose bronzes included a series of 42 heroic figures in Newark, N.J., two equestrian statues of General Sheridan and numerous monuments to military and political figures of the Civil War era, beside a number of war memorials. His smaller bronzes include the statuette of Earth, the figure of the Dying Nero and his Portrait of Ruskin.

BORGLUM, Solon Hannibal 1868-1922
Born at Ogden, Utah on December 22, 1868, the son of an immigrant Danish wood-carver, and elder brother of Gutzon Borglum. He studied at the Cincinnati Art Academy under Louis Rebisso and worked with Frémiet in Paris. He made a speciality of Western life, and spent considerable periods with the Indians and cowboys. He lived for some time in France and exhibited at the Salon getting an honourable mention (1899), and was awarded a medal at the Exposition Universelle (1900). He served with the American YMCA in France during the first world war and was awarded the Croix de Guerre. His bronzes include the equestrian group One in a Thousand, the Rough Rider, the equestrian statue of Captain Bucky O'Neil in Prescot, Arizona, The Last Round-up and Burial on the Plains. His last bronze was God's Command to Retreat, representing the Emperor Napoleon in the Russian campaign of 1812.

BORGORD, Martin fl. 19th-20th centuries
Born in Norway in 1869, he studied in Paris under J.P. Laurens and Raoul Verlet. Though best known for his paintings exhibited at the Salon des Artistes Français in 1900-26, he also produced statuettes (1923-26) and showed a bronze study of a head at the Salon d'Automne in 1921. He died in the United States.

BÖRJESON, Johan Laurentius Helenus 1835-1910
Born at Tölö in Sweden in 1835, he died in Stockholm in 1910. He studied in Stockholm, Paris and Rome and specialised in busts of contemporary celebrities, such as von Holberg (Bergen), von Geijer (Uppsala), Scheele and Nils Ericsson (Stockholm). Other works include genre subjects, such as The Skittles-player, The Horse-trainer and Young Fisher of Capri and classical studies such as Psyche.

BORNE, Daisy Theresa 1906-
Born in London on July 18, 1906, she studied sculpture in London and the United States. She works in London and has exhibited figures and groups at the Royal Academy.

BORSOS, Miklos fl. early 20th century
He worked in Budapest as a sculptor of figures and busts of contemporary and historical personalities.

BOSCHETTI fl.19th century
A sculptor of this name worked in Rome during the first half of the 19th century and specialised in bronze plaques, bas-reliefs and medallions of classical subjects. His ornamental bronzes are to be found in the villa Albani and the villa Adriana in Rome, and he also sculpted marble friezes and reliefs. His bronze plaue of Antinous was featured in Sotheby's sale of medals, plaques and sculpture in Florence, April 1974.

BOSE, Fanindra fl. 19th-20th centuries
Sculptor of Indian origin, working in Scotland at the turn of the century. He studied in Edinburgh and worked in that area till his death in 1926. He exhibited at the Royal Scottish Academy and was elected ARSA. He sculpted several monuments, notably the Ormiston war memorial, portrait figures and busts.

BOSIO, François Joseph 1768-1845
Born in the principality of Monaco on March 19, 1768, he died in Paris on July 18, 1845. He studied in Paris under Pajou and went to Rome where he was a pupil of Canova. He worked in Italy on neo-classical sculpture for seventeen years, returning to Paris in 1808, where he spent the rest of his career. In the course of four decades he enjoyed the patronage of the Bonapartes, the Bourbons and Louis Philippe and ranks as the most highly decorated sculptor of his generation, receiving the rank of Officier of the Legion of Honour from Napoleon, the Ordre Royale de St. Michel from Louis XVIII and raised to the nobility by Charles X. He became a member of the Institut in 1816 and was subsequently professor of sculpture at the École des Beaux Arts. His best work is the series of busts of the Imperial family, but he produced numerous statues, figurines and groups illustrating the Bourbons past and present and many other groups and statues commissioned by the State. His best known works today are the classical series including Venus in her Chariot, Love seducing Innocence, the Nymph Io and the Nymph Salmacis. Although much of his work has been criticised for its stereotyped, lack-lustre qualities, here and there the mannered character gives way to sensitivity and naturalism, as revealed in one of his last works, The Young Indian Girl (1845). Many of his larger works were edited as bronze reductions.

BOTTIAU, Alfred Alphonse 1889-
Born in Valenciennes on February 6, 1889, he studied in Paris under Injalbert and exhibited at the Salon des Artistes Français from 1920 to 1938. He won a travelling scholarship in 1921 and a gold medal (1935) and a similar award at the Exposition Internationale in 1937. He was made a Chevalier of the Legion of Honour in 1938.

BOTZARIS, Sava fl. 20th century
Sculptor of Greek origin, working in the United States in the first half of the 20th century, specialising in genre figures and groups. His works include a bronze statuette entitled Nigger.

BOUCHARD, Louis Henri 1875-
Born in Dijon December 13, 1875, he studied under Barrias and won the Prix de Rome in 1901. He worked in the tradition of the medieval 'Ymagiers' of Burgundy and concentrated on popular expressions of national sentiment, the majesty of labour and the transitory glories of the world. He exhibited at the Salon from 1905 onwards and received many awards, including a medal of honour in 1925. He became a member of the Institut, in 1933 and was a Commandeur of the Legion of Honour. His works include Burgundian Ditch-digger, Labourer at Rest, Clearing the Land (a group incorporating three pairs of oxen dragging a plough led by a peasant), the monument to the victims of the airship *République,* the monument to the unknown heroes of war in the Pantheon, an allegorical group celebrating the return of Alsace to France, The Airman and a bas-relief commemorating the first crossing of the Sahara.

BOUCHARDON, Edmé 1698-1762
Born at Chaumont on May 29, 1698, he died in Paris on July 27, 1762. He was the son of an architect who taught him the elements of design. In 1722 he won the Prix de Rome and spent the next ten years working for Pope Clement XII and Cardinal de Polignac. Having established an international reputation, he returned to France and became Sculptor to the King. Many of his works may be found at Versailles, Grosbois and other former royal residences. A member of the old Royal Academy, he was strongly influenced by classical Greek sculpture. Many of his larger works, executed in marble were edited as bronze reductions.

BOUCHARDON, Jacques Philippe 1711-45
Born at Chaumont on May 1, 1711, he died in Stockholm in 1745. He was the younger brother of Edmé Bouchardon and after training in Paris he went to Sweden in 1735 to become the Court Sculptor and Director of the Stockholm Academy. He executed many important commissions for the royal palaces, and, in particular, the decorative sculpture of the chapel. He modelled the lead medallions portraying the Swedish kings from Gustavus Vasa to Charles XI. His other works include Minerva receiving from the Guardian Angel of Sweden the young Prince Gustav (later Gustav III), Charles III, The Labours of Hercules, Boreas and Orytha, Pluto and Proserpine, Romulus and Hersileia, Paris and Helen and numerous allegorical figures. Many of his works in wax or terra cotta were subsequently cast in bronze, others were produced in bronzed plaster.

BOUCHER, Alfred 1850-1934
Born at Nogent-sur-Seine in 1850, he died in Paris in 1934. He studied under P. Dubois, Ramus and Dumont and exhibited at the Salon from 1874 onwards, winning a third class medal for his Child on the Fountain and a Grand Prix at the Exposition Universelle of 1900. He was made a Chevalier of the Legion of Honour in 1887 and an Officier Grand Croix in 1925. His works include a bust of Lucien Fugère, Eve after the Fall, The Young Fulvius, The Runner and a bust of Trumet de Fontarce. Many of his works in plaster and terra cotta were subsequently cast in bronze.

BOUCHER, Jean 1870-1939
Born at Cesson (Ille et Vilaine) on November 20, 1870, he died in Paris on June 17, 1939. He studied under Chapu, Falguière and Mercié and showed immense promise while a student at the École des Beaux Arts, but his romanticism is thought to have cost him the Prix de Rome. He exhibited at the Salon des Artistes Français and won numerous awards including the Prix National and medal of honour (1901) and the Grand Prix at the Exposition Internationale of 1937. A Chevalier of the Legion of Honour in 1904, he was raised to the grade of Officier in 1914 and became a member of the Institut in 1936. His best known works include a number of monuments, such as the Renan memorial at Treguier, Victor Hugo in Guernsey (1908) and the monument commemorating the union of Britanny and France (1912). His minor works include many busts, portrait reliefs and genre or allegorical groups.

BOUCHERON, Alexandre fl. 19th century
Born at Sens in the mid-19th century, he died there in 1887. He specialised in animal figures in wax or bronze, exhibited at the Salon in 1880-85.

BOUCHON-BRANDELY, Germain fl. 19th century
Born at Bort early in the 19th century, he studied under Jouffroy and specialised in busts, reliefs and portrait medallions. He exhibited at the Salon from 1869 to 1883.

BOUDAREL, Albert Vidal Alexandre 1888-
Born on September 19, 1888, he studied under P. Loiseau-Rousseau. He exhibited at the Salon des Artistes Français (Associate) and was awarded a silver medal and the Prix du Palais de Longchamps in 1920. He produced a large number of statuettes, allegorical groups and animal studies.

BOUFFE, Pauline fl. 19th century
Born in Paris on December 12, 1837, the daughter of the actor Bouffe. She studied under Aimé Millet and Mlle. Dubois-Davesnes and specialised in busts and figures of theatrical personalities. Her best known works are the busts of her father in the role of Poor Jacques or as a dramatic actor.

BOUFFEZ, François Camille Paul fl. 20th century
Born at Montbeliard in the late 19th century, he specialised in busts and heads which he exhibited from 1914 onwards at the Salon d'Automne, the Salon des Tuileries and the Salon of the Société Nationale des Beaux Arts.

BOULTON, Joseph Lorkowski (Joseph M. Lore) 1896-
Born at Fort Worth, Texas in 1896, he studied at the National Academy of Design and the Beaux Arts Institute of Design, followed by six years as assistant to Hermon A. MacNeil. His best known work is the bronze animal group entitled The Prairie Fire.

BOUMPHREY, Pauline (née Firth) 1886-
Born in Boston, Mass., on October 11, 1886, she was educated in England at Roedean. She settled in London and later at Sandiway in Cheshire where she specialised in statuettes and small groups. She exhibited at the Royal Academy, the Salon des Artistes Français (honourable mention, 1925), Liverpool and at the Manchester Academy of Fine Arts (Associate, 1925).

BOUQUILLON, Albert fl. 20th century
Born at Douai at the beginning of this century, he studied under Injalbert and Bouchard. He exhibited at the Salon des Artistes Français in the 1930s, winning a silver medal and a travelling scholarship in 1933 and the Prix de Rome the following year.

BOURDELLE, Émile Antoine 1861-1929
Born at Montauban on October 30, 1861, he died at Le Vesinet near Paris in 1929. He studied under Maurette at the School of Fine Arts in Toulouse and came to Paris in 1885 where he studied under Falguière at the École Nationale des Beaux Arts. He later came under the influence of Dalou, Rodin, Rude and Carpeaux. The influence of classical Greek sculpture, however, gradually supplanted that of Rodin. He was a versatile sculptor in many media and drew on many styles from the classical to the romantic in his work, trying always to express movement and integrating his sculpture into architecture. He exerted a tremendous influence on the young French sculptors of the 1920s. He exhibited many large works, of which his colossal Virgin and Child of Alsace, on the summit of the Vosges (1922) has been hailed by Maurice Denis as the greatest masterpiece of modern religious art. He was Vice President of the Salon des Tuileries and a Commandeur of the Legion of Honour (1924). He was equally versatile as a painter and ceramicist. His bronzes include Head of an Aged Woman, Woman with Raisins, Head of a Young Woman Bending, Head of a Woman, Head of Apollo the Archer, Coquelin, Spirit mastering Material, Hercules the Archer, The Stubborn Ram, Dreamer, Hercules wrestling with a Hind, The Fruit, Self-Portrait, Eloquence, Large Tragic Mask of Beethoven, Selene, Dying Centaur, Sappho, Beethoven. Many of these works are preserved in the Bourdelle Museum. He also sculpted the Alvear monument (Buenos Aires), the Mickiewicz monument (Paris) and the Miners' monument at Montceaux-les-Mines.

BOURÉ, fl. 1850-1870
The Brussels Museum has a bronze of a Child with a Lizard, signed by this artist.

BOUREILLE, Pascal fl. 20th century
Born in Paris at the turn of the century, he exhibited at the Salon des Artistes Français, the Salon des Indépendants, the Salon d'Automne and the Nationale. He was an animalier sculptor who specialised in bird studies.

BOURGEOIS, Louis Maxmilien 1839-1901
Born in Paris on February 11, 1839, he died there in October 1901. He studied under Jouffroy and Thomas and exhibited at the Salon from 1863 to 1901. Though best known for his medallic portraits of political figures, he also sculpted figures and groups including War and Geography (Trocadero), Eustace Lesueur (Paris Town Hall), Commandant Beaurepaire (Coulommiers) and a bust of M. Delasalle (Chalons-sur-Marne). The Bordeaux Museum has his figure of Mercury.

BOURGEOIS, Louise 1911-
Born in Paris, where she attended the Lycée Fenelon and the Sorbonne before studying sculpture at the École des Beaux Arts and the Académie Ranson under Bissière. She emigrated to the United States in 1938 and lives in New York, though she has spent her summers in Paris since 1950. Apart from early works in terra cotta, plaster and bronze she prefers to work in wood.

BOURGEOISET, Marguerite fl. 20th century
Born at Nuits St. Georges at the beginning of the century, she exhibited at the Paris salons in the inter-war years and specialised in bird figures and groups.

BOURGEOT, Joseph Marie fl. 19th century
Born in Lyons on July 5, 1851 he studied at the School of Fine Arts in that city under Paguy and Vasselot. He began exhibiting in Lyons at the age of fifteen. Many of his works were executed in bronzed plaster, but his actual bronzes include Dauphin (1891).

BOURGOUIN, Eugène 1880-c.1924
Born in Reims in 1880, he died in Paris in 1924 or 1925. He exhibited at the Salon d'Automne and the Nationale from 1907 to 1924 and produced a number of war memorials as well as bas-reliefs, busts and statues.

BOURROUX, André fl. 20th century
Born at Levallois-Peret at the end of the 19th century, he exhibited at the Paris salons in the 1920s, gaining a bronze medal at the Salon des Artistes Français in 1926. His speciality was busts of young girls.

BOURSE, Marguerite fl. 20th century
She exhibited at the Salon des Artistes Français in 1936-39, showing busts and a figure of a bird.

BOUSCAU, Claude Lucien Jean fl. 20th century
Born at Arcachon at the beginning of this century, he won the Prix de Rome and a silver medal in 1935. He has exhibited at the Salon des Artistes Français and specialises in statues, busts and bas-reliefs.

BOUSSUGE, Antoine Marius fl. 20th century
Born in Paris at the beginning of the century, he studied under Landowski and Bouchard. He exhibited at the Salon des Artistes Français and the Salon d'Automne in the late 1920s.

BOUTAREL, Simone fl. 20th century
Born in Paris at the beginning of the century, she took part in the Paris salons from 1925 onwards and won a silver medal in 1937. She has produced a number of busts and heads, but her speciality is statuettes and groups of animals in the manner of Pompon.

BOUTRY, Edgar Henri 1857-1939
Born at Lille in 1857, he studied under Cavelier and won the Prix de Rome in 1887. Subsequent awards included a bronze medal at the Exposition Universelle (1900), a second class medal (1891) and Chevalier of the Legion of Honour (1903). He worked mainly in plaster or marble on statues, busts and groups, but his bronzes include a bust of Cordonnier and a group of Hunters, shown at the Salon of 1892.

BOUVIER, Paul fl. 20th century
Born in Paris at the beginning of the century, he exhibited at the Salon des Artistes Français before the second world war. He specialised in statuettes, busts and medallions.

BOUVRY, Léon fl. 19th century
Born at Roubaix in the mid-19th century, he exhibited at the Salon des Artistes Français and worked as an animalier sculptor at the turn of the century.

BOVY, Jean François Antoine 1795-1877
Born in Geneva on December 14, 1795, he died in Switzerland in 1877, though he had become a naturalised Frenchman. He studied in Paris under Pradier and specialised in medallions and busts portraying historic personalities. His works include the portraits of Mesdemoiselles J. Baron and N. d'Hervas, the Abbé Liszt and members of the La Rochefoucauld and Bovy families. He did a series of eight large bronze maquettes for medallions representing Telegraphy, the Peace of Paris and other allegorical subjects.

BOWCHER, Frank 1864-1938
Born in London in 1864, he was the son of the etcher and cartoonist Henry Boucher. He studied at the National Art Training College, South Kensington (1885) and later exhibited at the Royal Academy and overseas exhibitions. He was a founder member of the Royal Society of British Sculptors. He was awarded a silver medal at the Exposition Universelle of 1900 and a similar award at the Brussels Exhibition of 1910. He lived and worked in London and specialised in busts, heads, and portrait reliefs.

BOWE, Francis Dominic 1892-
Born in Dublin on January 20, 1892, he studied at the Metropolitan School of Art in that city. He was a regular exhibitor at the Royal Hibernian Academy before the second world war, his works including The Green Shirt, The Dreamer, and Despair.

BOWKER, Alfred fl. 20th century
Born at Winchester, he studied in Paris under Guillemet and exhibited statuettes at the Salon des Artistes Français in 1928-39.

BOYD, David 1924-
Born in Melbourne, Australia in 1924, he studied art there and in London and works in Australia as a sculptor of memorials, statues, portrait reliefs and busts.

BOYD, Mary Syme fl. 20th century
Born in Edinburgh at the beginning of this century, she studied in Paris under Navellier and exhibited animal figures and groups at the Salon des Artistes Français in 1934.

BOYEDOU-BROMBERG, Oscar Hugh fl. early 20th century
Born in Hamburg in the late 19th century, he specialised in animal sculpture. His figure of a Dog was exhibited at the Salon of the Société Nationale des Beaux Arts in 1911.

BOYES, S. fl. c.1920
He specialised in busts and heads of celebrities of the 1920s.

BOZZONI, Bruno Albert fl. 19th century
Born in Carrara, Italy in the mid-19th century, he specialised in busts, groups and animal studies in marble and bronze. He exhibited at the Salon des Artistes Français in 1911-12.

BRACKETT, Edward Augustus 1818-1908
Born at Vassalboro, Maine in 1818, he died in Winchester, Mass., in 1908. He was a prolific sculptor of statues, genre groups and portrait busts. His works are in the Metropolitan Museum of Art, New York, and the Worcester Museum.

BRADBURY, George Eric 1881-1954
Born in London on February 25, 1881, he died there on December 24, 1954. He was the son of the architect Frederick Bradbury and studied at the Lambeth School of Art. He served his apprenticeship as a designer of stained glass and worked in this medium, though he also produced statuettes and busts. He exhibited at the Royal Academy before the second world war.

BRADSHAW, Laurence Henderson 1899-
Born in Cheshire on April 1, 1899, he studied at the Liverpool School of Art and then spent a year (1916-17) in the studio of William Penn and later worked with Sir Frank Brangwyn (1920-25). He exhibited at the Royal Academy and the leading London galleries and lives in London. He has worked as a painter in oils and tempera and his sculptures have been executed in stone and wood as well as bronze.

BRAHMSTÄDT, Franz fl. 19th-20th centuries
Born in Krefeld in the late 19th century. He took part in the Berlin Exhibition of 1909 where he showed genre bronze figures entitled Withered and Old Man Shivering.

BRAILSFORD, Alfred 1888-
Born near Carmarthen on February 5, 1888, he studied art at the Bournemouth Municipal College and settled in Southbourne. He exhibited his sculptures at the Royal Academy and in provincial exhibitions.

BRAMWELL, Edward George 1865-1944
Born in London on July 29, 1865, he died at Wroxall, Isle of Wight on November 7, 1944. He studied art at the City and Guilds School in London and won a bursary and a travelling scholarship, with the silver medal for sculpture. Subsequently he worked under Sir George Frampton, W.S. Frith and T. Stirling Lee. He became a teacher of modelling at Westminster School of Art. He is best known for his statuettes and small groups which he exhibited at the Royal Academy from 1898 onwards.

BRANCUSI, Constantin 1876-1957
Born at Pestisani near Targa-Liu in Romania on February 21, 1876, he died in Paris in April 1957. The son of a poor farmer, he ran away from home at the age of eleven and had numerous odd jobs before settling down as an apprentice carpenter and studied part-time at the School of Arts and Crafts in Craiova (1894-98). He won a scholarship which took him to the School of Fine Arts in Bucharest (1898-1902). He went to Munich and thence to Paris where he studied at the École des Beaux Arts and worked in the studio of Mercié (1904-7). He exhibited his work at the Luxembourg Museum in 1906 and this brought his work to the attention of Rodin who offered him a post as his assistant. Brancusi declined the offer saying 'Nothing grows in the shade of giant trees'. However he took Rodin's advice and gave up his formal studies, and in 1908 abandoned naturalism when he sculpted The Kiss. Thereafter he followed his own path and matured into the greatest and most original sculptor of the 20th century. During the lean years from 1908 to 1928, while his reputation was being established, he worked first as a waiter and then as cantor to the Romanian Church in the rue Jean de Beauvais. In 1913 he took part in the New York Armory Show with five sculptures and had his first one-man show at the Stieglitz Gallery in New York the following year. His figure of Princess X caused enormous controversy when exhibited at the Salon des Indépendants in 1920 and had to be withdrawn. His work was better appreciated in the United States in the early 1920s and he made a trip to New York in 1926 for a one-man show at Brummer's Gallery. This was the celebrated occasion on which the U.S. Customs refused to accept his Bird in Flight as a work of art and imposed a 40% duty on the value of $600. Brancusi sued the U.S. Customs and won his legal battle after a two-year struggle. His reputation was established in 1928 by the ornamental gates for the public park in Targa-Liu, as well as the Round Table and the Column without End in gilt metal. He produced an enormously wide range of sculpture, from the neo-classical to the ultra-modern. His Antinous ecorché (1902) was used as an anatomical model at Bucharest School of Fine Arts. In his early years he did standard works, such as portrait busts and memorials, including the bronze of General Davila, but later he veered more and more towards the abstract. He worked in every medium, from wood to marble, but bronze was always a speciality – often with a highly polished, streamlined effect. In 1945 he took part in the exhibition Seven Pioneers of Modern Sculpture in Yverdon, Switzerland. A retrospective exhibition was held at the Solomon R. Guggenheim Museum in New York in 1955-56. He became a naturalised Frenchman a few weeks before his death in order that his studio in the Impasse Ronsin and its contents should pass to the French State, and this has since become the Brancusi Museum. His works include The Fish (1925), Leda (Chicago, 1925), Bird in Space (1926), Blonde Negress (1926), The Cock (1924), Maiastra (1912), Torment (1906). In his later years he returned time and time again to the theme of Bird in Space, of which there are many versions.
Joray, Marcel *Constantin Brancusi.* Selz, Jean *Modern Sculpture: Origins and Evolution* (1963).

BRANDSTRUP, Ludvig fl. 19th-20th centuries
Born at Tranekoer in Denmark on August 16, 1861, he was apprenticed to a woodworker, but thanks to his patron, F.L. Liebenberg, he was able to further his studies in sculpture. He became an apprentice to Vilhelm Bissen and attended the Academy of Fine Arts from 1885 to 1888. His first exhibit, a plaster statuette of his benefactor, won the Neuhausen Prize and was later cast in bronze. He won several scholarships between 1890 and 1894 and a number of awards, including a first class medal (1892) and a first class medal at the Antwerp Exhibition of 1894. He is best remembered for his equestrian statue of King Christian IX at Esbjerg, but he also sculpted numerous busts and heads of Danish contemporaries. His bronze bust of a child was shown at the Munich Exhibition in 1909.

BRAQUE, Georges 1882-1963
Born at Argenteuil on May 13, 1882, he died in Paris on August 31, 1963. The son of a house painter, he studied at the School of Fine Arts in Le Havre and latterly in Paris. He became a Fauve painter and one of the leading representatives of the Cubist movement, being a lifelong friend of Picasso. During the first world war he was seriously wounded. Though continuing to work as painter, he first turned to sculpture in 1920 and the most prolific phase in this medium came between 1939 and 1957, living alternately in Paris and Varengeville in

Normandy. His bronzes included Ibis (1940-45), Horse's Head (1943-46), Head of a Horse (1957), The Chase (1943) and Standing Woman (1920).

Braque, Georges *Cahier de Georges Braque* (1947).

BRAYOVITCH, Yanko 1889-
Born at Cetinje in Montenegro, he studied at the High Academy of Sculpture in Vienna and emigrated to Britain after the first world war, settling in Hampstead. He exhibited his figures and busts at the Royal Academy.

BRECHERET, Victor 1894-1955
Born in Sao Paulo, Brazil where he also died. He studied in Sao Paulo and held his first exhibition there before the first world war. Later he travelled extensively in Europe, studied under Mestrovic, and settled in Paris in 1924. He was a founder member of the Salon des Tuileries and exhibited there from 1925 to 1932. He also exhibited at the Salon d'Automne (1921-28) and the Salon des Indépendants (1928-30), and got an honourable mention at the Salon des Artistes Français in 1925. He also took part in the Rome International Exhibition of 1925. After his return to Sao Paulo he obtained numerous important commissions. He won the major prizes at the Sao Paulo Biennale (1951) and the Santiago Salon (1952). Though his larger works were invariably sculpted in stone, he also produced many smaller sculptures in terra cotta and bronze and these include Head, Ascension, Madeleine aux Parfums, Dancer and various statuettes of nudes and figures and groups of animals.

BREESE, Alan 1922-
Born on March 15, 1922, he studied at the Camberwell Art School and the Kennington City and Guilds. In 1948 he visited Turkey as artist to an archaeological expedition. He has since lived in London and exhibits at the Royal Academy and various London and provincial galleries.

BREFEL, Jean fl. 20th century
Born at Toulouse in the late 19th century. He exhibited at the Salon des Artistes Français in the 1920s and specialised in busts and statuettes.

BRENNER, Victor David fl. 19th-20th centuries
Born in Russia in 1871, he was employed as a die-cutter in St. Petersburg and went to Paris in 1898 where he studied under Oscar Roty till 1901. He also studied at the Académie Julian under Puech, Verlet and Dubois and was awarded a bronze medal at the Exposition Universelle of 1900 and an honourable mention at the Salon the same year. He was the author of a bronze bust entitled Elizabeth.

BREUIL, Michel Léon 1826-1901
Born at Flavigny about 1826, he died in Dijon on February 22, 1901. He studied under Ramey and Dumont and exhibited at the Salon between 1859 and 1873. He sculpted the bronze bust of Jouffroy which appears on the façade of Jouffroy's birthplace in Dijon.

BRIAND, Bernard fl. 19th century
Born at Chalons-sur-Saone on December 24, 1829, he exhibited at the Salon up to 1865 and also participated in the Paris Exposition of 1855. He was an animalier, specialising in bird groups and figures.

BRIDAN, Désiré 1850-1937
Born at Chapelle St. Luce in 1850, he was a pupil of Dumont and Thomas and exhibited at the Salon from 1881 onwards. He specialised in genre figures and groups, exhibited in plaster but often later cast in bronze. He also produced a series of portrait medallions, plaques and busts of contemporary celebrities, such as Carnot. Émile Vaudé, Charles Fichot, Jules Hervey, André and Jeanne Michelot, Dr. Viardin and M. Jeannet.

BRIDGEMAN, John 1916-
Born in Felixstowe, Suffolk, on February 2, 1916, he studied at the Colchester School of Art and the Royal College of Art, after service in the second world war. He settled in Ufton, Warwickshire where he sculpts figures and groups in concrete, and stone as well as bronze. He was elected A.R.B.S. in 1960.

BRIDGWATER, Alan 1903-
Born on June 17, 1903, he studied at the Birmingham College of Art from 1923 to 1933 and was elected Associate of the R.B.S.A. in 1936, R.B.S.A. in 1948 and A.R.B.S. the same year. He taught at Birmingham School of Art and lives in Edgbaston. He has exhibited his etchings, oil paintings and sculptures in stone and wood as well as bronze at the Royal Academy, the Royal Scottish Academy and other exhibitions in London and the provinces.

BRIGAUD, Florentin fl. 20th century
Born in France at the beginning of this century, he exhibited a *cire perdue* bronze of a Gnu at the Salon des Tuileries in 1938.

BRIGNONI, Serge 1903-
Born in Chiasso, Switzerland in 1903, he studied at the School of Arts and Crafts in Berne before going to the Berlin Academy. The most formative period of his artistic development, however, was spent in Paris where he lived, apart from brief intervals, from 1924 to 1940. He began experimental sculpture about 1932 and worked in wide variety of materials including wood, copper, brass and aluminium. At the fall of France he moved back to Switzerland and has lived ever since in Berne. His work has been widely exhibited all over Europe.

BRISTOL, René 1888-1934
Born at Thiviers, France on July 7, 1888, he died in Paris in 1934. He studied under Mercié and Lorieux and exhibited at the Salon des Artistes Français (silver medal, 1922), the Salon d'Automne (1926-28) and the Salon des Tuileries (1930-32). He specialised in bronze statuettes, busts and masks.

BRIZARD, Suzanne fl. 20th century
Born in Paris at the beginning of this century, she exhibited at the Nationale and the Salon d'Automne from 1921 onwards. She specialised in busts, statuettes, small groups and figures of birds and has also sculpted reliefs and medallions.

BROCK, Else fl. 20th century
Born in Denmark at the end of the 19th century, she studied in Paris under Valton and exhibited at the Salon des Artistes Français in 1912-13. She specialised in figures of animals and birds.

BROCK, Sir Thomas 1847-1922
Born in Worcester in 1847, he died at Mayfield, Sussex on August 22, 1922. He studied under Foley and exhibited numerous works at the Royal Academy from 1868 onwards, being elected A.R.A. (1883), R.A. (1891), H.R.S.A. (1910) and receiving a knighthood in 1911. Though best known for his public monuments and statuary in London, particularly the Victoria Memorial outside Buckingham Palace, he sculpted a large number of smaller works cast in bronze. His group A Moment of Peril is in the Tate Gallery. Although schooled in the classical tradition he successfully made the transition to the New Sculpture at the turn of the century and this is manifest in his naturalistic figure of Eve (1898). His bronze busts of Lord Leighton and Queen Victoria are reductions derived from the larger memorials.

BRODIE, William 1815-1881
Born in Banff in 1815, he died in Edinburgh on October 30, 1881. He was the son of a ship-master who moved to Aberdeen in 1821 where William was apprenticed to a plumber but studied modelling at the Mechanics Institute and cast lead figures of local celebrities. He progressed to medallion portraits and this brought him to the notice of John Hill Burton who persuaded him to go to Edinburgh in 1847. There he studied for four years at the Trustees' School of Design and learned to model on a large scale. His bust of his patron Lord Jeffrey belongs to this period. In 1853 he went to Rome and studied under Laurence Macdonald for whom he modelled Corinna the Lyric Muse, subsequently published by Copeland in Parian ware. He exhibited at the Royal Academy from 1850 to 1881 and at the Royal Scottish Academy from 1847 to 1881, being elected A.R.S.A. (1857) and R.S.A. (1859). At the Great Exhibition of 1851 he showed a group of Little Nell and her Grandfather. He produced numerous portrait medals, busts and statues, mainly of his Scottish contemporaries.

BRODZKI, Lodzia Ladislav fl. 19th century
Born at Ociatowka, Poland in 1829, he trained as a lawyer but gradually took up sculpture as a vocation. He studied modelling in St. Petersburg and later moved to Rome where he enjoyed a moderate success with his allegorical figures and bas-reliefs. Much of his work belongs to the realm of the applied arts, since he produced inkstands and table wares decorated with small figures and bas-reliefs.

BROGGINI, Luigi 1908-
He is the author of a bronze entitled Victory with Clipped Wings.

BROMET, Mary (née Pownall) fl. 19th-20th centuries
Born in Leigh, Lancashire in the late 19th century, she died near Watford on February 26, 1937. She studied art in London and Paris under Puech and Champeil. She exhibited at the Royal Academy, the Salon (honourable mention, 1899) and various London and provincial galleries, and was elected A.R.B.S. in 1932. She specialised in genre figures and groups, such as When Granny was a Bride, Happy, An Intruder and Bolshevik Commissar.

BRONKHORST, Marcel Louis fl. 19th-20th centuries
He exhibited at the Salon de la Société Nationale des Beaux Arts from 1910 to 1934, and was a prolific sculptor of busts of adults and children, figures of dancers, groups of animals and high reliefs.

BROQUET, Gaston 1880-1947
Born at Void in France on September 9, 1880, he died in Paris on April 25, 1947. He studied under Injalbert and exhibited at the Salon des Artistes Français and the Salon d'Automne at the turn of the century. His work includes numerous masks, busts and statuettes, such as L'Engueulade and The Washerwoman.

BROUGH, Alan 1890-
Born at Wilmslow in Cheshire on January 17, 1890, he studied at the Manchester School of Art and was elected a member of the Manchester Academy of Fine Arts in 1927. He lived at Wilmslow and later in Prestbury and sculpted heads, busts and small groups.

BROUGHTON, Owen 1922-
Born in Townsville, Queensland in 1922, he has sculpted a number of decorative and architectural works in that state since the second world war, as well as plaques, medallions and small figures.

BROWN, Alfred fl. 1845-1856
He first came to prominence in 1845 when he won the gold medal of the Royal Academy for a relief The Hours leading out the Horses of the Sun. He exhibited at the Royal Academy from 1845 to 1855 and his statue of David before Saul was shown at the Great Exhibition of 1851. He was employed as a designer and modeller in silver by Roskell and Hunt and produced the Czar of Russia's trophy for the Ascot Races of 1845, an elaborately decorated candelabrum presented to the Marquis of Tweeddale by his friends in India (1850) and the magnificent Stags in Bradgate Park for the Earl of Stamford in 1856.

BROWN, Atri 1906-
Born in London on May 22, 1906, he studied under Emerson at the Wolverhampton School of Art and the Royal College of Art where he graduated in 1927. He won the Prix de Rome in 1928 and after his return from studies abroad he became a lecturer at the Chelsea Art School. He exhibited at the Royal Academy and also in Europe and America from the 1930s onwards. He has sculpted in bronze and marble and also practised wood-carving. He is best known for his statue of Shakespeare in the Ambrosiana Library, Milan.

BROWN, Henry Kirke 1814-86
Born at Leyden, Massachusetts in 1814, he died in Brooklyn, New York in 1886. Although trained as a stonecutter, and working principally in the medium of marble and stone, he also pioneered bronze statuary in the United States, his statue of De Witt Clinton being cast by the Ames Manufacturing Company in 1852. His best known work was the equestrian statue of Washington (1856). Many of his large Romantic groups were later published as bronze reductions.

BROWN, James 1918-
Born in Paris, he graduated in law at the École des Sciences Politiques and worked in the Ministry of Finance till 1945 when he took up sculpture. In this respect he was entirely self-taught and developed his own highly idiosyncratic style. He came to sculpture by the novel avenue of a concern with problems of industrial design, particularly motor cars and his use of sculptural techniques in designing car bodies led him to the modelling of animals, birds and human figures. He also draws and paints and has experimented with collage and tapestry. Since 1955 he has worked mainly in the new plastic materials.

BROWN, Jean Louis fl. 19th-20th centuries
Born in France in the second half of the 19th century, he died in Paris in 1930. He exhibited at the Salon des Artistes Français at the turn of the century, specialising in figures and groups of animals, particularly horses.

BROWN, John Ernest 1915-
Born in Shawforth, Lancashire on March 15, 1915, he studied at the Manchester School of Art and settled in Monmouthshire. His work as a sculptor (mainly wood-carving) and as a painter in oils and watercolours, has been exhibited in Lancashire and Wales.

BROWN, Kellock 1856-1934
Born in Glasgow on December 15, 1856 and died in the same city on February 20, 1934. His brother was Alexander Kellock Brown the painter. He studied at the Glasgow School of Art and later as a pupil of Lanteri at the Royal College of Art in London. He also studied at the Royal Academy schools and exhibited at the Academy from 1887 onwards. He returned to Glasgow and taught at the School of Art at the turn of the century. He produced a number of large monuments and memorials, but his best known work is the bronze statuette of Robert Burns in the Glasgow Museum and Art Gallery, Kelvingrove (1919).

BROWN, Mortimer J. 1874-
Born at Stoke-on-Trent on April 27, 1874, he studied at Hanley School of Art, the Royal College of Art and the Royal Academy schools and completed his studies in Greece and Italy at the beginning of this century. For several years he was assistant to Sir Hamo Thornycroft and exhibited at the Royal Academy from 1898 to 1903 and the R.B.S. from 1906 to 1927. He settled in Twickenham, Middlesex where he specialised in busts and statuettes.

BROWN, Percy 1911-
Born in London, he studied at the Royal College of Art and has exhibited at the Royal Academy and the principal London galleries. He was formerly head of the School of Sculpture and Pottery at Leeds and later became head of the department of Art at Hammersmith College of Art. He lives at St. Margarets on Thames, Middlesex and practises as a sculptor and potter.

BROWN, Ralph 1928-
Born in Leeds in April 24, 1928, he studied at Leeds College of Art, Hammersmith School of Art and the Royal College of Art (where he was a pupil of Dobson and John Skeaping), and rounded off his studies in Paris. He joined the staff of the Royal College of Art in 1958 and now lives in Gloucestershire. His first one-man show was at the Leicester Galleries in 1968 and he also exhibits regularly at the Royal Academy (A.R.A.).

BROWNE, Irene M. fl. 1920-1950
She studied at the Chelsea Polytechnic School of Art and had studios in Richmond, Surrey and later East Sussex. After the first world war she exhibited at the Royal Academy and provincial galleries, notably in Manchester, and specialised in statuettes in stoneware or bronze.

BROWNE, Matilda fl. 19th-20th centuries
Born at Newark, N.J. on May 8, 1869, she studied under the painter Dewey in the United States and H.C. Bisbing and Julien Dupré in Paris. Though best known as a painter, she also modelled animal figures and groups, such as The Calf (1921).

BROWNING, Robert Barrett 1846-1912
Son of Robert and Elizabeth Browning, the famour poets, he studied in Antwerp and Paris and exhibited at the Royal Academy from 1878 and also at the Grafton Gallery in London. He spent most of his life painting and sculpting in Belgium and was awarded a bronze medal at the Exposition Universelle of 1889. As a sculptor he concentrated on genre figures and groups.

BROWNSWORD, Harold 1885-
Born in Hanley, Staffordshire on February 2, 1885, he studied at Hanley School of Art and the Royal College of Art in London from 1908 to 1913 and exhibited in London and provincial galleries in the interwar period. He taught sculpture from 1914 to 1938 and was head of the Regent Street Polytechnic in London from then until 1950. He sculpted figures and portraits in wood and marble as well as bronze.

BRUCE-JOY, Albert 1843-1924
Born in Dublin, he died there on July 22, 1924. He studied in South Kensington, the Royal Academy schools and then in Paris and Rome. He exhibited at the Royal Academy from 1866 onwards and also took part in several international exhibitions, including the Exposition Internationale (1878), the Philadelphia Centennial Exposition (1876) and the Vienna Weltaustellung (1873). He visited the United States twice and exhibited in galleries in Boston, New York, and Philadelphia. He spent much of his working life in Haslemere, Surrey and is known chiefly for his portrait busts in Westminster Abbey, St. Paul's Cathedral and the House of Commons, as well as in various public collections.

BRUHN, Ernst Adam 1827-1864
Born in Copenhagen on August 12, 1827, he was killed in action at the battle of Dybböl on March 16, 1864. He trained as an army officer, but gave up a military career to study art. He was a pupil of the Copenhagen Academy in 1844 and later worked in the studio of Bissen. During the war of 1848 he served as a volunteer but soon returned to sculpture, specialising in animal figures and groups, particularly horses. He re-enlisted during the Dano-Prussian War of 1864 but was killed during the only major engagement of that conflict.

BRULOIS, Jean fl. 19th-20th centuries
Born at Croix-Wasquehal in the mid-19th century, he exhibited at the Salon des Artistes Français till 1914, specialising in animal studies.

BRUTT, Adolf Karl Johannes fl. 19th-20th centuries
Born at Husum in Schleswig on May 10, 1855, he was apprenticed to a stone-mason in Kiel, but later studied under Schaper and Karl Begas at the Berlin Academy and worked for some time in Munich. He became director of a sculpture studio in Weimar in 1905 and took part in the major exhibitions at the turn of the century, including the Exposition Universelle (1900) and the Berlin Exhibition (1909), showing a bronze figure for a fountain at the latter. He specialised in biblical, allegorical and genre figures and groups, mainly sculpted in marble, such as Diana and Eve and her Children. The Berlin Museum has his bronze group Saved.

BRUYER, Léon fl. 19th century
Born in Paris, where he died in 1885. He studied under Rude and exhibited at the Salon from 1860 till his death, specialising in portrait medallions and busts. He also sculpted allegorical groups such as Autumn and Hope and is best known for his group of the Virgin presenting the World for the Benediction of her Son.

BRYDEN, Robert 1865-1939
Born at Coylton, near Ayr on June 11, 1865, he died in Ayr on August 22, 1939. He was educated at Ayr Academy and worked for some time in an architect's office before coming to London where he studied at the Royal College of Art and the Royal Academy schools. He visited Belgium, France and Italy in 1894 and later travelled in Spain (1896) and Egypt (1897). He is best known as an etcher and woodcut engraver (A.R.E. 1891, R.E. 1899), noted for his volumes of etchings and engravings of portraits and scenery. He also sculpted small figures, groups, bas-reliefs and busts.

BRZEGA, Adalbert fl. 20th century
Born at Zakopane in Poland, he studied in Paris under Thomas and exhibited busts, statuettes and bas-reliefs at the Salon des Artistes Français.

BUCHER, Edwin fl. 19th-20th centuries
Born in Lucerne in the late 19th century, he studied in Paris under Rodin and Bourdelle. He exhibited at the Nationale from 1910 to 1921 and at the Salon des Artistes Français in 1923, specialising in busts, statuettes and animal groups. He also sculpted bas-reliefs and ornamental bronze doors.

BUFF, Alison fl. 20th century
New Zealand sculptress, working in Auckland on public statuary, memorials, portrait busts and reliefs.

BUGATTI, Rembrandt 1885-1916
He was born in Milan in 1885 and committed suicide in Paris on January 10, 1916. He was the son of Carlo Bugatti, the painter, silversmith and furniture designer, nephew of the painter Giovanni Segantini and younger brother of Ettore Bugatti the car designer. He studied at the Milan Academy and came to Paris in 1892 where he became a pupil of Prince Trubetzkoy. He drew and modelled animals at the Jardin des Plantes and in 1906 went to Antwerp where he continued to study animal life at the Zoo. Apart from advice from Trubetzkoy, Bugatti never had any formal training as a sculptor and thus developed his own distinctive style of Impressionism in this field. He exhibited at the Salon de la Nationale and the Salon d'Automne from 1910 onwards and was awarded the Legion of Honour in 1911. At the beginning of the first world war he worked for the Belgian Red Cross but returned to Paris suffering from a nervous break-down and committed suicide during a fit of depression. Several retrospective exhibitions were held of his work in Paris and Antwerp shortly after the war, and a major one-man exhibition was staged in London in 1929. His sculpture has also been the subject of extensive exhibitions at the Sladmore Gallery, London in recent years. The Institute of Fine Arts in Antwerp founded the Bugatti Prize in his memory. His works are preserved in the Bugatti Museum at Molsheim in Alsace and also in public collections in France, Belgium and England. Bugatti forms an important link between the faithful and sensitive representation of animal life which the 19th century animaliers aimed at, and the sculptors of the present day who have used animal subjects to create an increasingly formalised and intensified reality. Bugatti's work belongs to neither, or perhaps to both, of these categories for he achieved, at his best, something far subtler and more difficult — a purely abstract beauty of plastic harmony and rhythm without ever sacrificing the literal structure and vitality of the animals he portrayed. For a complete list of the animal bronzes by Bugatti see the Appendix in *The Animaliers* by James Mackay (1973).

Horswell, Jane K. *Les Animaliers. The Horse in Bronze* (1970).
Schiltz, Marcel *Rembrandt Bugatti* (1955).

BUHOT, Louis Charles Hippolyte 1815-1865
Born in Paris on September 8, 1815 he died in the same city on October 20, 1865. He was a pupil of David d'Angers and studied at the École des Beaux Arts in 1832. He exhibited at the Salon from 1837 to 1865 and produced numerous portrait medallions, busts and statuettes, including Sara the Bather (1851), Grape-gathering (1853), Hope feeding the Chimera (1855), Immaculate Virgin (1861) and Jupiter and Hebe (1865). His Irrequietus Amor was produced in the then novel technique of galvanised metal in imitation of oxydised silver.

BULLOCK, George fl. 18th-19th centuries
He worked in Liverpool where he died in 1819. He exhibited at the Royal Academy and the Liverpool Academy from 1804 to 1816 and became president of the latter in 1810-11. He worked in marble and terra cotta as well as bronze and produced figurines, lamps, candelabra, sphinxes, griffins and portrait busts (mainly of Liverpool celebrities). His bust of Shakespeare was very popular and was reproduced in many bronze editions, being based on the bust in Stratford Church. He was a director of the Mona Marble Works in London in 1813.

BURCKHARDT, Carl 1878-1923
Born at Lindau near Zürich on January 13, 1878, he died at Ligornetto, Tessin on December 12, 1923. The son of a Swiss pastor, he began modelling during a visit to Rome in 1901. The simplification of natural forms was strongly influenced by the severe classicism of the statuary he witnessed in Rome. He executed many commissions for public monuments in Switzerland. A retrospective of his work was held in the Berne Kunsthalle in 1952. He also worked as a painter and engraver, influenced by Max Klinger. His bronzes include In Memory of H. Dieterle (1919), St. George (1923) and Amazon (1923) and the figures for the fountains at the Baden station in Basle.

BUREAU, Léon fl. 19th-20th centuries
Born at Limoges on September 17, 1866, he studied at the École des Beaux Arts and was a pupil of Falguière. He exhibited at the Salon from 1884 and his works include Child with Crab (1896) and Abyssinian Lion and Lioness (1897).

BURGER-HARTMANN, Sophie fl. 19th-20th centuries
Born in Munich in the mid-19th century, she studied painting there and in Paris, but taught herself sculpture and worked at Charlottenburg, Berlin at the turn of the century. She was awarded a silver medal at the Exposition Universelle in 1900 and a gold medal at the Women's Exhibition in London the same year. She specialised in decorative bronze stands and candelabra as well as genre statuettes. Her husband was the painter Fritz Burger.

BURLISON, Frances Bessie fl. 20th century
Born in London in the late 19th century, she studied under Sir George Frampton and exhibited at the Royal Academy and the Salon des Artistes Français in the early 1900s. She specialised in statuettes of children.

BURNETT, Thomas Stuart 1853-1888
Born in Edinburgh in 1853, he died there on March 3, 1888. He was a pupil of William Brodie and the Trustees' School in Edinburgh and won the gold medal in 1875. He later studied at the Royal Scottish Academy and was elected A.R.S.A., and travelled widely in western Europe. He exhibited at the Royal Academy in 1885-87. His chief works are statues of General Gordon and Rob Roy, but his minor bronzes include such genre figures as Florentine Priest.

BURN-MURDOCH, W.G. 1862-1939
Educated in Edinburgh and at the Antwerp Academy where he studied art under Verlet and in Paris under Carolus-Duran. He also travelled in Florence, Naples and Madrid and exhibited at the Royal Academy and the Paris salons from 1891 onwards. He wrote several books on his travels in the Far East and the Antarctic, was a painter and lithographer of polar scenery and sculptor of animal figures and groups.

BURROUGHS, Edith Woodman (Mrs Bryson) 1871-1916
Born at Riverdale-on-Hudson, New York in 1871, she died at Flushing, New York in 1916. She was awarded the Julia Shaw prize of the National Academy of Design in 1907 for her bronze statuette of Circe.

BURTON, Ralph Molyneux 1922-
Born in Cheshire in 1922, he studied at the Royal College of Art from 1947 to 1950 under Frank Dobson and John Skeaping and teaches modelling at the Adult Education Centre, Tunbridge Wells. He works in stone and cold-cast resin as well as bronze, and sculpts portraits and figures. His works are represented in various public collections in London, the Midlands and Home Counties. He lives in Ticehurst, Sussex.

BUSCHER, Clemens fl. 19th-20th centuries
Born in Düsseldorf in 1855 he worked as a sculptor in that city at the turn of the century. He sculpted the statues of Kaiser Wilhelm I (Frankfurt) and Karl Immermann and Felix Mendelsohn (Düsseldorf). His minor works include a number of bronze portrait busts, the best known being that of Andreas Achenbach.

BUSH-BROWN, Henry Kirke fl. 19th-20th centuries
Born at Ogdensburg, New York in 1857, he studied under his uncle, Henry Kirke Brown, at the National Academy of Design and later studied under Mercié at the Académie Julian. He specialised in bronze busts, that of Viscount Bryce being his best known.

BUTLER, Margaret 1890-
Born in Wellington, New Zealand on April 30, 1890, she studied in England and Paris and exhibited at the Paris salons in the 1920s. Her sculpture includes several busts and a project for a fountain.

BUTLER, Reginald 1913-
Born at Buntingford, Herts. on April 13, 1913, he trained as an architect and practised under the name of Cottrell Butler from 1936 to 1950. He was a lecturer at the Architectural Association School in 1937-39. He worked as a blacksmith during the second world war and this led him to sculpture in metal. In 1947 he became assistant to Henry Moore and had his first one-man show in 1949. He taught at the Slade from 1950 and was Gregory Fellow at Leeds University in 1950-53. He took part in the Venice Biennale of 1952 and 1954. He now lives in Berkhampstead, Herts. He was commissioned to do sculpture for the Festival of Britain (1951) and has taken part in all the major national and international exhibitions since that date. In 1953 he won the Grand Prix for the Unknown Political Prisoner competition of the Institute of Contemporary Arts. His earlier work was wrought in iron, but after the second world war he experimented with a bronze shell, and his more recent work has tended towards a more naturalistic interpretation of the human form. His bronzes include The Oracle (1952), Young Girl (1952-53), Manipulators (1955) and Girl 5253 and other nude studies.

BUTLER, Vincent 1933-
Born in Manchester in 1933, he teaches at the Edinburgh College of Art and exhibits at the Royal Scottish Academy. He specialises in bronze statuettes and groups and has had one-man shows at the Crestine Gallery, Edinburgh, the New Grafton, London and the Birley Gallery, Manchester. His bronzes are signed V.B. or the name in full.

BUTLIN, William 1794-1836
He worked in London and was sent to Rome by his patron, Lord Spencer, to perfect his art. He exhibited at the Royal Academy from 1828 to 1835 but had little success as a sculptor and was given a grant of 8 guineas by the Academy in 1836. The following year his widow and seven children were granted a small pension by the Academy. He sculpted portrait busts and medals as well as a bronze statuette of Lord Althorp.

BUXTON, Alfred 1883-
Born in London on August 25, 1883, he studied at the Royal Academy schools and received the gold medal and a travelling scholarship in 1909. Subsequently he worked in London and exhibited at the Royal Academy and the Salon des Artistes Français (honourable mention, 1914).

BYING, Leonard, H.R. 1920-
Born in London, he studied at the Ruskin School of Art (1939) and the Slade School of Art (1944). He has since worked in London, Sandwich (Kent) and Paris and exhibited at the Royal Academy and provincial galleries. He was elected A.R.B.S. in 1948. His work is sculpted in terra cotta and bronze.

BYSE, Fanny (née Lee) fl. 19th century
Born in London in 1849, she did not take up sculpture until 1893 when she went to Geneva and studied in the workshop of Jules Salmson, director of the School of Industrial Arts in that city. Subsequently she studied in Rome, Florence and Paris and exhibited at the Salon des Artistes Français at the turn of the century. She specialised in busts and heads.

BYSTROM, Johan Niklas 1783-1848
Born at Filipstad in Sweden in 1783, he died in Rome in 1848. He sculpted figures and groups in the classical tradition, such as his group of Cupid and Hymen sleeping on a lion-skin beneath the spirits, or heroic statuary of young men and maidens. He also modelled portraits of the Swedish kings and members of the Bernadotte family, and a number of plaques and medallions. His works are preserved in the Stockholm Museum.

CABRERA, German 1903-
Born at Las Piedras, Uruguay in 1903, he studied at the Fine Arts Circle of Montevideo from 1918 to 1926, and later spent two years travelling in Germany, Belgium and France. He settled in Paris where he became the pupil of Despiau and Bourdelle. He returned to Las Piedras, but with the aid of a government grant he again went to Europe and stayed in Paris. He took part in the Exposition Internationale of 1937 and exhibited at the Paris salons of 1937-38. He began teaching sculpture in Caracas in 1938. In 1958 he won first prize for sculpture at the National Salon and the following year won a scholarship at the Montevideo Biennial. An accomplished craftsman in many media and materials (including cement, clay, plaster, sandstone, tempered glass and enamelled iron) he has also sculpted figures, busts and groups in bronze.

CABUCHET, Émilien 1819-1902
Born at Bourg on August 16, 1819, he died in Paris on February 24, 1902. He began exhibiting at the Salon in 1846, making his début with a bronze portrait bust, but subsequently he worked entirely on religious sculpture. His best known work is the statue of St. Claude reviving a little drowned person, in the Basilica du Sacré Coeur.

CACCIAPUOTI, Ettore fl. 19th-20th centuries
Born in Naples, a member of a prolific family of sculptors, painters and modellers, he studied under J.B. Amendola and exhibited in the Italian and French salons at the turn of the century. He specialised in genre figurines such as The Reader, At Longchamps, The Moment Approaches, etc. Other members of the family were his brother Guglielmo who specialised in statuettes of Neapolitan street urchins, his father Giuseppe, who modelled figures for the Capodimonte porcelain factory and whose groups are also known in terra cotta, and Gennaro Cacciapuoti (another brother?) who sculpted genre groups, such as A New Surprise and The First Conquest.

CADÉ, Nicolas Constant 1846-1887
Born at Corciaux in April 1846, he died in Besançon on February 25, 1887. He studied in Paris under Dumont and Jules Franceschi and exhibited at the Salon from 1868 to 1880. He became professor at the School of Fine Arts in Besançon and specialised in busts and statuettes. His best known work is The Dying Gladiator, in Besançon Museum.

CADENAT, Gaston Jules Louis fl. 20th century
Born in Marseilles, he studied under Coutan, Landowski and Carli and exhibited at the Salon des Artistes Français in the 1930s (bronze medal, 1930).

CADORIN, Ettore 1876-
Born in Venice on March 1, 1876, the son of the wood-carver Vincenzo Cadorin under whom he studied. Later he enrolled at the Academy of Fine Arts in Venice where he won two first class medals and a travelling scholarship, enabling him to continue his studies in Rome and Paris. He studied under Dal Zotto from whom he got an excellent grounding in anatomy. Later he settled in Paris and exhibited at the Nationale (1910-11) and also at the Galerie Georges Petit. His works consist mainly of bronze statuettes such as Tambourine Dancer and Resignation.

CAFFIERI, Jacques 1687-1755
Born in Paris on August 25, 1678, the son of Philippe Caffieri the Elder, and died in the same city in 1755. He produced numerous bronze busts, the best known being that of Baron de Bezenval of the Swiss Guard. He was also a noted bronze founder and was the father of Jean Jacques and Philippe the Younger.

CAFFIERI, Jean Jacques 1725-1792
Born in Paris on April 29, 1725, he died on June 21, 1792. He won the Prix de Rome in 1748 and became an Academician (1759), Associate Professor (1765) and Professor (1773). He exhibited at the Salon from 1757 to 1789. His many portrait busts include those of Rameau, the Prince of Condé, Quinault, Lulli, Piron, Thomas and Pierre Corneille, Jean Rotrou, Molière and Rousseau. His allegorical groups include Echo, Innocence, Hope nourishing Love, and Friendship surprised by Love.

CAFFIERI, Philippe the Younger 1714-1774
Born in Paris in 1714, he died there in 1774. He studied at the Academy of St. Luc and was noted as a bronze founder as well as a sculptor.

CAILLE, Pierre 1912-
Born at Tournai in Belgium in 1912, he studied at the Abbaye de la Cambre in Brussels and worked initially as a painter. Henry Van de Velde, the architect and designer, persuaded him to try his hand at pottery which he modelled and painted. Since 1949 he has taught at the École Nationale Superieure d'Architecture et des Arts Décoratifs and was responsible for the post-war revival of ceramics in Belgium. After the second world war he also turned his attention to sculpture in metal, mainly in beaten copper.

CAIN, Auguste Nicolas 1822-1894
Born in Paris on November 4, 1822, he died there on August 7, 1894. He began working as a joiner but came under the influence of his father-in-law, P.J. Mêne and turned to sculpture which he studied under Rude and Guionnet as well as Mêne. He began exhibiting animal figures and groups at the Salon in 1846, his first work being a wax group of a Linnet defending her nest against a Rat. This was later edited in bronze and shown at the Salon of 1855. Several of his wax groups were given a bronze metallic coating, but his later works were cast in bronze. He was awarded third class medals in 1851 and 1863 and a similar prize at the Exposition Universelle of 1867. From 1868 onwards he devoted much of his time to monumental statuary, his best known work being the colossal equestrian statue of Duke Charles of Brunswick for the city of Geneva (1879). He was a prolific modeller of small bronzes of animals and birds, both domestic and exotic, between 1846 and 1868. His large figure of a French Cock (1883) was also published as a bronze reduction.

CALANDRA, Davide fl. 19th-20th centuries
Born in Turin in 1856, he studied under G.B. Gamba and Tabacchi at the Turin Academy, and later worked with A. Balzico. His chief works were the Vigil of Penelope (1880), Judas, Royal Tiger, Flower of the Cloister (1884) and a bronze study of a horse shown at the Brussels Exhibition of 1910. He is best known for his large equestrian monuments to Garibaldi (Parma), the Duke of Aosta, King Humbert I (Ivrea) and Amadeus of Savoy in bronze and stone (Turin).

CALDER, Alexander 1898-1976
Born in Philadelphia in 1898, he trained as an engineer and studied art at evening classes in New York. He went to Paris in 1926 and has lived in France ever since, with brief spells in the United States. In the 1920s he produced a Circus of small animated creatures, utilising his skill as an engineer, and this laid the foundation for his later and better known work as a sculptor of colossal mobiles. His work was first shown at the Salon des Humoristes in 1927 and he had a one-man show in New York the following year. His large moving constructions date from 1931. A prolific and exceptionally versatile artist, he has designed theatrical sets, jewellery, gouaches, and even painted Braniff air liners to create large works of art literally moving through space. His mobiles and large constructions are modelled in metals, wood, plaster and plastic substances. He has done relatively little work in bronze, the best known being his figure of a Rope Dancer.

CALDER, Alexander Stirling 1870-
Born in Philadelphia on January 11, 1870, the son of the Scottish stone-mason and sculptor, Alexander Milne Calder under whom he trained. He studied at the Pennsylvania Academy of Fine Arts, and

later in Paris under Chapu and Falguière. He became a teacher at the National Academy of Design and the Art Students' League of New York. He was deputy chief of the department of sculpture at the Panama-Pacific International Exposition in 1915. He was awarded a medal at the St. Louis World's Fair of 1904. His bronzes consist of medallions, plaques and genre statuettes, such as Scratching her Heel. He sculpted the Leifr Erikson monument in Reykjavik, Iceland.

CALDERINI, Luigi 1880-
Born in Turin in 1880 he is best known as a landscapist and animal painter, but he has also dabbled in sculpture. His bronze group of Elephants was shown at the Florence Exhibition of 1908.

CALDWELL, Gladys fl. 20th century
Born in Colorado at the beginning of this century, she studied in the United States and France. She exhibited at the Salon des Indépendants in 1929, two bronzes of a Whippet and Mouflon Sheep.

CALLCOTT, Florence (née Newman) fl. 1890-1930
Born in London, she studied at the Slade School of Art and exhibited at the Royal Academy and the leading London and provincial galleries from 1830 to 1930. She worked with her husband, Frederick Callcott, in London and specialised in portrait reliefs and medallions.

CALLCOTT, Frederick Thomas c.1850-1923
He worked in London and exhibited at the Royal Academy and the British Institution from 1877 onwards and also took part in the Salon des Artistes Français in 1898.

CALLENDER, Bessie Stough fl. 20th century
Born at Wichita, Kansas, at the beginning of this century, she specialised in figures and groups of animals. She exhibited at the Salon des Indépendants in 1928-31, her works including Guinea-fowl, Eagle and a Monkey.

CALLERY, Mary 1903-
Born in New York but brought up in Pittsburgh, she studied at the Art Students' League under Edward McCartan for four years and then spent two years in Paris studying under Loutchansky. She exhibited at the Salon des Tuileries and had a series of one-man shows at the Buchholz Gallery, New York, from 1944 to 1955. She has also exhibited in Paris and various parts of the United States since the Second World War. Many of her larger works have been commissioned for public buildings and she also exhibited a mobile fountain at the Brussels Exposition of 1958. Her bronzes include Amity (1946), Fish in Reeds (1948), The Seven (1956) and a Study for La Fontaine's Fables.

CALO, Aldo 1910-
Born in San Cesario di Lecce, Italy, in 1910, he studied at the art schools of Lecce and Florence before becoming director of the Voltera Art School. He has taken part in all the major Italian exhibitions since the second world war and now lives in Voltera near Pisa. He worked for some time with Henry Moore. His sculptures often combine several materials, such as wood and iron or bronze and crystal (such as Biform, 1960).

CALVANIA, Bruno 1904-
Born at Mola near Bari in 1904, he studied sculpture under Adolfo Wildt and has taken part in Italian and French exhibitions since 1930. He specialises in busts and statuettes, such as Pulcinella (1955).

CALVET, Gregoire fl. 19th-20th centuries
Born at Cadarcel, in France, he studied under Falguière and exhibited at the Salon des Artistes Français, winning an honourable mention (1896) and a third class medal (1897). He specialised in portrait busts of contemporary personalities, but also sculpted genre figures, such as Courtesan.

CALVET, Henri fl. 19th-20th centuries
Born at Mèze on June 12, 1877, he studied under Falguière, Mercié and Barrad. He began exhibiting at the Salon des Artistes Français in 1898 and specialised in genre figures, such as Glass-blower (1904) and Guitarist (1905), as well as numerous plaques and medallions. His works are in the Gobelins and Nimes museums.

CAMPBELL, Nora Molly fl. 1915-1950
Born in London in the late 19th century, she studied at Goldsmiths' College of Art and the Crystal Palace School of Art, winning a scholarship in 1913. She exhibited at the Royal Academy and other leading exhibitions in London and the provinces from 1915 onwards and worked in Upper Norwood and latterly Worthing, Sussex, as a painter, etcher and sculptor of humanoid animal subjects. Her best known works are The Next Door Neighbour, The Millionaire, The Pauper and The Murder Trial.

CAMPBELL, Thomas 1790-1858
Born in Edinburgh on May 1, 1790, he died in London on February 4, 1858. He was apprenticed to a marble-cutter, John Marshall, and later worked for James Dalzell. He enjoyed the patronage of Gilbert Innes, who subsidised his studies at the Royal Academy schools in London. In 1817-18 he worked for E.H. Baily and then went to Rome where he studied the carving of stone busts and made a reputation for his skill in sculpting 'speaking' portraits. During this period he undertook several commissions for the Duke of Devonshire, notably the statue of Princess Pauline Borghese, of which he later made casts in bronze and silver. He exhibited at the Royal Academy from 1827 to 1857 and at the Great Exhibition he showed a portrait of a Lady as a Muse. His bronzes include the busts of the Duke of Devonshire (1823), the Duke of Wellington (1828) and the Earl of Newburgh.

CANA, Louis Émile fl. 19th century
Born in Paris in 1845, he studied under Arson and exhibited animal figures and groups at the Salon from 1863. At the Exposition Universelle of 1878 he exhibited a group entitled Cockfight.

CANARD, Suzanne fl. 19th-20th centuries
Born in Tournus in the late 19th century, she studied under Landowski and J. Boucher. She exhibited at the Salon des Artistes Français (honourable mention, 1914) and specialised in busts and relief portraits.

CANLERS, Charles Stanislas fl. 18th-19th centuries
Born at Tournai in the late 18th century, he was murdered in Paris in 1812. He studied under Dejoux and was awarded a third grand prix in 1808. Though better known as a bronze founder and ciseleur, he exhibited a bronze seated figure of Napoleon at the Louvre in 1810.

CANNILLA, Franco 1911-
Born at Caltagirone, Sicily, in 1911, he studied art under his father and later enrolled at the local art school, where he was taught by Luigi Bartolini. Later he switched from painting to sculpture and studied at the Palermo School of Art. In 1940 he settled in Rome and held his first one-man show there in 1943. He competed in 1952 for the competition for the Monument to the Unknown Political Prisoner and was one of the runners-up. He has worked in every medium of metalcraft, from brass and bronze to silver and gold, producing abstract sculptures.

CANOVA, Antonio 1757-1822
Born at Possagno near Treviso on November 1, 1757, he died in Venice on October 13, 1822. He came from a long line of stone-masons and worked in his grandfather's studio in his early childhood. Tradition has it that his genius was recognised when, at the age of twelve, he modelled the figure of a lion in butter. Be that as it may, he came to the attention of the influential Falieri family who undertook to have him trained by Bernardo Torretti and his nephew Giuseppe. He modelled in clay but his great forte was direct carving in marble and it is for this medium that he is chiefly remembered. In 1780 he moved to Rome, having secured the equivalent of a travelling scholarship from the Venetian Senate, and spent most of the remaining years of his life working for the Papacy. He sculpted innumerable portraits of the Popes, past and present, numerous monuments, bas-reliefs and statues of historical and contemporary figures as well as classical and allegorical subjects. His chief work was the cenotaph of Pope Clement XIII in St. Peter's (1787-92). He visited Vienna and Berlin in 1798 and worked for Napoleon in Paris in 1802 and also spent some time in London in 1815. Canova was the most fashionable of sculptors in the whole of Europe at the beginning of the 19th century. He received many honours, including a marquisate from the Pope, and the ambition of every aspiring young sculptor was to spend time in Rome working under the great master. Canova epitomised the very essence of classicism, reviving a taste for the antique without really understanding its meaning and technique.

With the rise of romanticism in the 1830s the influence and the reputation of Canova and his disciples waned. The great bulk of Canova's work was executed in stone and marble, but a number of his works were later published in bronze, such as the bronze reduction of his colossal nude of Napoleon, which was placed in the courtyard of the Brera Academy in Milan. Many of his allegorical and classical works, such as the various versions of The Three Graces, Amor and Psyche, Venus and Perseus with the Head of Medusa, were immensely popular bric-à-brac figures of the early 19th century.

Anzelmi *Opere scelte di Antonio Canova* (1842). Borzelli, Angelo *La Relazione del Canova con Napoli* (1901). Malamani, V. *Canova* (1911). Meyer, A. *Canova* (1898). Quincy, Quatremere de *Canova et ses Ouvrages* (1834). Treviso Gallery *Catalogue of the Canova Exhibition* (1957).

CANTRÉ, Joseph 1890-1957
Born in Ghent, Belgium, in 1890, he trained at the Ghent Academy and began sculpture in 1909, under the influence of Meunier and Minne. He practised as an illustrator and wood-engraver, and it was the latter technique which induced him to turn from modelling to direct carving in wood or stone. His bronzes thus belong to the earliest period of his career. During the first world war he fled to Holland and lived there till 1930. He returned to Ghent and taught typography at the Institute of Decorative Arts at the Abbaye de la Cambre in Brussels. He became a member of the Fine Arts section of the Royal Belgian Academy in 1941. His work is preserved in the main Belgian museums.

CAPPELLO, Carmelo 1912-
Born in Ragusa, Sicily, in 1912, he served his apprenticeship in his home town, before studying sculpture in Rome and Milan, where he now lives. He has taken part in all the major Italian exhibitions since 1947 and had several one-man shows since 1957. His abstract bronzes include Water Skis (1957) and Eclipse (1959).

CAPTIER, François Étienne 1840-1902
Born at Baugy on March 27, 1840, he committed suicide in Paris in 1902. He studied under Dumont and Bonnassieux and exhibited at the Paris salons. He was awarded a silver medal at the Exposition Universelle of 1889 and made a Chevalier of the Legion of Honour. His chief works include Faun (1869), Mucius Scaevola (1872), Adam and Eve (1874), Hebe (1875), Timon and Venus (1876), Dew (1877), Last Refuge (1878), The Egalitarian (1887) and Slave and Avenging Fury (1893).

CAPY, Eugène 1829-1894
Born in Paris on June 17, 1829, he died there in 1894. He studied at the École des Beaux Arts in 1849, under Drolling and Pradier and exhibited busts and medallions at the Salon from 1849 to 1853.

CARABIN, François Rupert 1862-1921
Born in Saverne on March 27, 1862, he died in 1921. A founder member of the Société des Indépendants in 1884, he exhibited at that salon till 1891 when he entered the Société Nationale des Beaux Arts and exhibited at that salon from then onwards. He was awarded a bronze medal at the Exposition Universelle of 1900 and made a Chevalier of the Legion of Honour in 1903. He is chiefly remembered for his attempts to revitalise industrial sculpture and its applications to furniture and interior design.

CARAGEA, Boris fl. 20th century
Sculptor working in Romania since the second world war. His bronzes include figures of Lenin and other Communist personalities and genre groups, such as Reunion.

CARAVANNIEZ, Alfred 1855-
Born in St. Nazaire on October 7, 1855, he died in Paris some time before the first world war. He studied under Cavelier, Millet and Barrias and exhibited at the Salon des Artistes Français from 1885 onwards, obtaining a third class medal in 1903. He specialised in figures of historical Breton characters, such as Bayard, Surcouf and Anne of Brittany.

CARBONELL Y HUGUET, Pedro fl. 19th-20th centuries
Born in Sarria near Barcelona in the second half of the 19th century, he studied at the School of Fine Arts in Barcelona and exhibited his work in Madrid (1890, 1895), Berlin (1891) and Paris (1900). His works included the Angelus and an equestrian statue of General Ulysse Heureux.

CARCANO, José fl. 19th-20th centuries
He worked in Barcelona at the turn of the century and exhibited in Madrid (1881-84) and Barcelona (1885-87). His work consisted of portrait busts, religious figures and genre groups, such as The Telephone and Flamenco Dancer.

CARDENAS, Augustin 1927-
Born at Matanzas in Cuba in 1927, he studied at the Havana Academy from 1943 to 1949 and worked in the studio of the sculptor Sicré who had once been a disciple of Bourdelle. In 1954 he won the National Prize for sculpture and the following year went to Paris, where has since exhibited regularly. His earliest work was modelled in plaster and cast in bronze, but from 1955 onwards he has preferred direct wood-carving. His work consists of abstracts, such as Homage to Brancusi and Totems.

CAREW, John Edward c.1785-1868
Born at Tramore, Co. Wexford, about 1785, he died in London on November 30, 1868. The son of a Dublin monumental sculptor, he learned the techniques of stone carving from his father and also studied in Dublin before coming to London in 1809 as assistant to Sir Richard Westmacott. In 1822 he got a contract to work exclusively for the Earl of Égremont and this continued till the earl's death in 1837. He then brought an action against the earl's executors, claiming a legacy of £50,000 but lost the case and was made bankrupt in 1841. At the very nadir of his fortunes, however, his Descent from the Cross established his reputation and in 1844 he carved the royal arms for the Royal Exchange. His best known work is the bronze relief of the Death of Nelson for the column in Trafalgar Square. He exhibited at the Royal Academy from 1821 to 1846 and at the British Institution from 1824 to 1843.

CARILLON, René Phileas fl. early 20th century
Born at Cravant in France in the late 19th century, he studied under Cavelier, Millet Barrias and Allar and exhibited at the Salon des Artistes Français from 1904 onwards. His work consists mainly of busts, heads and portrait reliefs.

CARION, Louis Adolphe fl. 19th century
Born at Valenciennes in the mid-19th century, he was a pupil of Cavelier and Fache. He exhibited portrait busts at the Salon from 1878 to the turn of the century.

CARL, Jules Antoine fl. 19th-20th centuries
Born at Ste. Croix-aux-Mines in 1863, he studied under Falguière and Desbois and exhibited at the Salon des Artistes Français (honourable mention, 1903). He specialised in busts, including those of Madeleine D., Pierre de Blarru and Ligier Richier, and also genre figures such as Willing.

CARL-ANGST, Albert fl. 19th-20th centuries
Born in Geneva in the late 19th century, he worked in that city as a portrait sculptor. He exhibited at the Paris salons around the turn of the century.

CARL-NIELSEN, Anne Marie fl. early 20th century
Born at Kolding, Denmark, in the late 19th century, she worked in Copenhagen before the first world war and exhibited in Copenhagen and Paris about 1911-14. Her work consists of busts and heads.

CARLÈS, Jean Antoine 1851-1919
Born at Gimont on July 24, 1851, he died in Paris on February 18, 1919. He studied in Marseilles and Toulouse and then became a pupil of Jouffroy and Hiolle at the École des Beaux Arts in Paris. He worked mainly in marble and plaster, sculpting the statues of Abel and Youth in Luxembourg Museum, and the allegorical group On the Field of Honour for Château de la Boisière, 1894. His bronzes include Return from the Hunt (Tuileries gardens 1888) and numerous portrait busts including Gérard de Ganay, A. Berton, M. Chartran and various ladies of the French aristocracy. He exhibited at the Salon from 1878 onwards, winning many prizes and the Grand Prix at the Exposition Universelle of 1889. He was a Commandeur of the Legion of Honour.

CARLET, Gabriel Jules fl. 19th-20th centuries
Born at Moulins near Paris in 1860, he studied under Gaulthier. His allegorical work La Céramique is preserved in the museums of Limoges and Moulins, the latter also possessing his bust of M. de Tracy.

CARLI, Auguste Henri 1868-1930
Born in Marseilles on July 2, 1868, he died in Paris in January 1930. He studied under Cavelier and Barrias and exhibited at the Salon des Artistes Français from 1898, winning a travelling scholarship the same year and a third class medal. He won second class and first class medals in 1900 and 1902 respectively and was made a Chevalier of the Legion of Honour. He specialised in busts, small figures and groups. His younger brother Louis François (born 1872) studied under Adalbert and exhibited figures at the Salon from 1907 to 1920.

CARLIER, Émile Joseph Nestor 1849-1927
Born in Cambrai on January 3, 1849, he died in Paris on April 11, 1927. He studied at the art schools in Cambrai and Valenciennes and subsequently came to Paris where he was a pupil of Jouffroy, Cavelier and Chapu at the École des Beaux Arts. He made his début at the Salon of 1875 with a statuette of the historian Enguerrand de Monstrelet. Later he concentrated on allegorical and genre groups, such as The Fraternity of the Blind and the Paralysed, Natural History, The Family and The Resurrection. He also produced many busts and portrait reliefs, including those of Berlioz, Victor Massé, Firmin Didot and Eugène Bouty. In his declining years he turned to animal sculpture and produced a number of noteworthy groups and figures. He was awarded a gold medal at the Exposition Universelle (1889), and medals at the Antwerp and Amsterdam exhibitions at the turn of the century. He held the rank of Officier in the Legion of Honour.

CARLIER, Marc Georges fl. 20th century
He exhibited at the Tuileries in 1934 a group entitled Seagull in Flight.

CARLISKY 1914-
Born in Buenos Aires, he came to sculpture relatively late in life, having earlier been a journalist and a cinema actor, among other things. He took up sculpture at the age of 35 and was largely self-taught until 1952, when he came to Paris and studied at the Académie de la Grande Chaumière and worked in Zadkine's studio. In 1954 he had two one-man shows and participated in the Venice Biennale (1956) and the Sao Paulo Biennial (1957). He has lived in France since 1959 and exhibits at the Salon de la Jeune Sculpture. His abstract bronzes consist of small groups of faces, crucifixes and thread-like figures. He has also modelled in papier mâché and various plastic substances.

CARLSSON, Alexander 1846-1878
Born in Stockholm in 1846, he died in Rome in 1878. He studied at the Stockholm Academy from 1865 to 1871 and then worked under J.P. Molin in Rome. The Stockholm Museum has a decorative bronze cup which was modelled by him. He produced busts and portrait reliefs and groups inspired by Scandinavian mythology, such as The Norse God, Lake in Chains.

CARLUS, Jean fl. 19th-20th centuries
Born at Lavaur on March 21, 1852, he studied under Falguière and Mercié and exhibited at the Salon des Artistes Français from 1886, winning medals in 1889, 1899 and 1900. His works include Molière and his Servant, the statue of Buffon in the Paris Museum, The Waters (Toulouse) and Jewellery (Paris).

CARMINATI, Antonio 1859-1908
Born at Brembate di Sotto near Bergamo in 1859, he died in Milan in 1908. He studied under E. Butti in Milan, Tabacchi in Turin and Giulio Monteverde in Rome. His most important commission was the statuary on the dome of Milan Cathedral. His other works, mainly allegorical in composition, include Resurrexit, Nunc est Bibendum, Signorina and Nostalgia.

CARMINE, Carlo fl. 19th century
Born at Bellingona in Switzerland, he worked in that neighbourhood as a portrait sculptor and medallist.

CARNEVALE, Giuseppe fl. 19th century
Born at Castelnuovo Scrivia in the mid-19th century. He began exhibiting in Naples in 1877, when he showed busts of a shepherd and shepherdess. His later works include Diana the Huntress, exhibited at Turin in 1879, and Modesty (Turin, 1884).

CARNIELO, Rinaldo 1853-1910
Born at Boscomontello-Biadone on February 11, 1853, he died in Florence on August 17, 1910. He studied at the Florence Academy under Costoli and specialised in allegorical and genre groups. His works include The Death of Mozart, Non Posso Pregare, The Castellan, The Angel of Death, Tenax Vitae and Labor Imperat.

CARNO, Helene fl. 20th century
Born in Poland at the beginning of this century, she studied in Warsaw and later in Paris. She exhibited at the Paris salons between 1934 and 1938 and specialised in portraiture. Her best known work is the bust of Marshal Pilsudski's daughter, shown at the Nationale in 1938.

CARO, Anthony 1924-
Born in London, he took a degree in engineering at Cambridge and served in the Fleet Air Arm during the Second World War. On demobilisation he went to Regent Street Polytechnic and the Royal Academy schools (1947-52) and also spent some time as assistant to Henry Moore (1951-53). Since then he has taught sculpture at St. Martin's School of Art in London. He has taken part in national and international exhibitions since 1956. He is a leading exponent of anti-rationalism and savage art, spurning the formalism of earlier sculptors and aiming for free expressiveness in his figures.

CARO, François fl. 19th century
Born in Milan of French parents, he studied in Paris under Marqueste and Injalbert and later settled in Neuilly-sur-Seine. He exhibited at the Salon des Artistes Français in the late 19th century, winning a bronze medal at the Exposition Universelle of 1900.

CARON, Alexandre Auguste fl. 19th-20th centuries
Born in Paris on April 16, 1857, he studied under Barrau, Roufosse and Scaillet. He exhibited at the Salon des Artistes Français from 1893 and won an honourable mention five years later. His works were characterised by a combination of ivory, silver, gold and gemstones with bronze and his sculptures possessed a peculiarly *fin de siècle* air of decadence. They include the statuettes Slave for Sale, After the Bath, Mlle. Suzanne, Eva, Eros, Atalanta and Venus.

CARPEAUX, Jean Baptiste 1827-1875
Born in Valenciennes on May 11, 1827, the son of a stone-mason, he died at Courbevoie on October 12, 1875. In 1842 he came to Paris and spent two years working in a drawing school before being admitted to the École des Beaux Arts, studying under Rude from 1844 to 1850. Though greatly influenced by Rude's approach to naturalism in sculpture he deliberately cut adrift from his master and cynically pursued the strictly classical course which would enable him to win the Prix de Rome (1856) with his statue of Hector bearing in his arms his son Astyanax. In Rome, however, he soon realised the sterility of the classical teaching and cut the formal classes to study the works of Donatello and Michelangelo, the latter in particular having a strong influence on his subsequent career. Something of Michelangelo's vehement and passionate action is conveyed in his group of Ugolino and his Sons which he sent to the Salon of 1863 and which immediately established his reputation as the leading Romantic sculptor in France. Thereafter he secured many important State commissions for public statuary, and also had a prolific private practice as a portrait sculptor. His most controversial work was The Dance (1869), one of the four groups for the façade of the new Opera House, the nudity of the hermaphroditic figure being only too realistic. Realism dominated his work, in attention to anatomical detail in his genre figures, and in the photographic likenesses of his busts of the aristocracy and celebrities in the dying years of the Second Empire. He died of cancer, at the very pinnacle of his career, at the Château de Bécon. Apart from his numerous figurines and busts, many of his larger statues and groups were also cast as bronze reductions.

Bournand, Francois *J.B. Carpeaux* (1893). Chesneau, Ernest *Carpeaux, sa vie et son oeuvre* (1880). Claretie, Jules *J. Carpeaux* (1882). Clément-Carpeaux *La Vérité sur l'oeuvre et la vie de J.B.*

Carpeaux (1934). Foucart, Paul *Catalogue du Musée Carpeaux, Valenciennes* (1882). Petit Palais *Works of J.B. Carpeaux* (1955-56). Riotor, L. *Carpeaux* (1906).

CARPENTIÈRE, Andries (Andrew Carpenter) c.1670-1737
Sculptor of Flemish origin who became principal assistant to John Nost in London, but soon set up in business on his own account. He produced numerous statues in stone and marble and for some time enjoyed the patronage of the Duke of Chandos. He established a foundry at Hyde Park Corner for casting figures in lead and bronze as garden statuary. He also produced bronze busts, decorative urns and portrait medallions.

CARRETERO, Aurelio fl. 19th century
Born near Valladolid, Spain, in 1863, he studied at the School of Fine Arts in Madrid. He specialised in tombs and memorials, notably those to Isabella the Catholic, General Pinto and the poet Zorille. He also sculpted a number of medals. His bronze group Las Lamentos is in the Museo de Arte Moderno in Madrid.

CARRICK, Alexander 1882-1966
Born in Musselburgh near Edinburgh, he died at Melrose, Roxburghshire on January 26, 1966. He studied at the Edinburgh School of Art and the Royal College of Art, London and exhibited at the Royal Academy and the Royal Scottish Academy (A.R.S.A. 1918; R.S.A. 1929). He specialised in bronze figures, groups and busts. He is best remembered for his bronze figures and bas-reliefs on the Scottish National War Memorial, Edinburgh (1926) and the series of portrait busts of his female relatives.

CARRIER-BELLEUSE, Albert Ernest (Carrier de Belleuse) 1824-1887
Born at Anizy le Château on June 12, 1827, he died at Sèvres on June 3, 1887. He studied under David d'Angers at the École des Beaux Arts in Paris from 1840, and first exhibited at the Salon in 1851. From 1850 to 1854 he worked in England, under Léon Arnoux at Minton's porcelain works, and thereafter continued to model many small figures and groups for production in terra cotta and porcelain as well as bronze. One of the most prolific and versatile sculptors of the 19th century, he made his reputation with the group Salve Regina, shown at the Salon of 1861. His later works Bacchante (1863) and The Messiah (1867) brought him medals and the Legion of Honour. In the last years of the Second Empire he executed many public commissions and was highly regarded by Napoleon III, who referred to him as 'our Clodion', though his slickness and facile sculpture repelled many of the intelligentsia. During the Paris Commune of 1871 he took refuge in Brussels but returned the following year and continued to work in Paris till his death. He worked in every medium, both traditional and modern, and even experimented with galvanoplasty and electroplating. His combination of materials, such as porcelain, for the features of his bronze statuettes anticipated the chryselephantine figures of the turn of the century. In his later years he was director of works of art at the Sèvres porcelain factory. He employed a galaxy of rising young sculptors as assistants in his vast output of decorative bronzes and architectural sculpture, and his assistants at one time or another included Rodin and Mathurin Moreau, though his own work showed little sympathy with the modern movement which Rodin was instrumental in developing. His bronzes include many busts of historic and contemporary celebrities, classical and allegorical figures, genre groups, figures in period costume, nude statuettes, bas-reliefs and even sculptural staircases and interior decoration.

Segard, A. *Carrier-Belleuse* (1928).

CARRIER-BELLEUSE, Louis Robert 1848-1913
Born in Paris on July 4, 1848, the son of Albert Ernest, he died in the same city on June 14, 1913. He studied sculpture under his father and painting at the École des Beaux Arts under Cabanel and Boulanger. He worked initially as a painter, exhibiting at the Salon from 1870 onwards, but turned to sculpture in 1889 and continued to work in this medium till his death. Like his father he worked as a modeller for porcelain, and was artistic director of the Choisy le Roi factory. He produced a number of bronze busts and genre figures, and the national monuments of Guatemala and Costa Rica.

CARRIÈRE, Jean René fl. 19th-20th centuries
Born in France in the late 19th century, the son of the painter and engraver Eugène Carrière. He exhibited at the Nationale (Associate, 1909), the Salon d'Automne (1912-) and the Tuileries in the late 1920s and produced various monuments, nude statuettes and busts.

CARRIÈS, Jean Joseph Marie 1855-1894
Born in Lyons on February 15, 1855, he died in Paris on July 1, 1894. Best known for his remarkable series of busts and portrait masks, including Charles I, Franz Hals, Louise Labe, Auguste Vacquerie and Jules Breton. He also sculpted heads and busts combining realism with the Symbolism of the 1880s, and works of this nature are preserved in the Lyons Museum. He was also a prolific ceramicist, concentrating on gargoyles and groups whose weird imagery was allegedly inspired by his own dreams.

CARTELLIER, Pierre 1757-1831
Born in Paris on December 2, 1757, he died there on June 12, 1831. He studied under C.A. Bridan and exhibited at the Salon from 1796 till 1822. He became a pillar of the artistic establishment under the restored Bourbon kings, member of the Institut (1816), Chevalier de St. Michel (1824) and for many years professor of sculpture at the École des Beaux Arts. He exerted a tremendous influence on the French neo-classical and romantic sculptors of the 19th century, his pupils including Rude, Petitot, Lemaire, Dumont and Jalley. His works consist mainly of genre and allegorical groups in plaster, marble or bronze, and he won numerous commissions for statues and busts of contemporary celebrities, from Napoleon and his marshals to the political figures of the Second Kingdom.

CARTER, Albert Clarence 1894-
Born in London on June 19, 1894, he studied at the Lambeth School and the Central School of Art, and exhibited at the Royal Academy and provincial galleries, as well as the Paris salons before the second world war. He specialised in figurines and small groups, plaques, medallions and small ornamental bronzes as well as jewellery.

CARTON, Jean Maurice 1912-
Born in Paris in May 1912, he studied at the School of Applied Arts and the École des Beaux Arts and began exhibiting in 1936, both in the Paris salons and internationally. He had his first one-man show at the Galerie Pascaud in 1938 and won the Blumenthal Prize in 1946. During the second world war he exhibited at the Salon des Tuileries and specialised in busts and heads at this period. Later, however, he turned to figures and groups. His work is modelled in clay and subsequently cast in bronze. He was a founder member of the Salon de la Jeune Sculpture.

CARVILLANI, Renato fl. 20th century
Born in Rome at the end of the 19th century, he came to France after the first world war and exhibited at the Nationale (1920-1940), the Salon des Indépendants (1927-30) and the Salon d'Automne (1923-31), and at the Salon des Artistes Français from 1945 onwards. His work covers a wide range, from projects for fountains and memorials to busts of historic figures and genre groups and statuettes, such as Sportive.

CARVIN, Louis Albert fl. 19th-20th centuries
Born in Paris in the latter half of the 19th century, he studied under Frémiet and Gardet and exhibited at the Salon des Artistes Français from 1894 to 1933. Not surprisingly, his early work was largely animalier in concept, his best known group being La Becquée (a study of a bird feeding its young). Later, however, he concentrated on genre compositions, such as Lassitude and Maternity.

CASA, Raymond fl. 20th century
He exhibited at the Salon des Indépendants in the 1920s and specialised in busts and small figures.

CASAGLIA, Giovanni 1819-1902
Born in Florence on May 6, 1819, he died there on April 11, 1902. He studied sculpture under Costoli at the School of the Nude in the Academy of Fine Arts, Florence. In 1854 he was appointed professor of design at Pietrasanta and nine years later became deputy director of the School of Ornament in the Florentine Academy. He produced numerous figures, genre groups and busts.

CASAGRANDE, Marco 1804-1880
Born at Campea in 1804, he died in Venice in 1880. For much of his life, however, he lived in Hungary, and did a number of monuments, statues and groups in Eger and Budapest.

CASALONGA, Raymond Antoine Mathieu fl. 20th century
Born in Paris at the beginning of this century, he exhibited at the Salon des Artistes Français in 1932 and the Indépendants in 1937.

CASANOVAS, Enrico (Enrique) fl. 20th century
Born in Spain, he worked in France during the first half of the 20th century, and was regarded as one of the most promising young Spanish sculptors of the period.

CASAS OCAMPO, Emilio fl. 20th century
Born in Cordoba at the beginning of this century, he works in Argentina. He exhibited at various European art shows before the second world war.

CASEBLANQUE, Georges fl. 20th century
Born at Baixas in France, he exhibited at the Salon des Indépendants from 1935 to 1943 and at the Tuileries in 1946. He specialises in figures and groups.

CASH, Harold 1895-
Born at Chattanooga on September 20, 1895, he worked in the United States and also in France from 1929 to 1932. He specialised in busts, portrait reliefs and masks.

CASHWAN, Samuel Adolph fl. 20th century
An American sculptor of this name exhibited statuettes at the Salon d'Automne in 1923.

CASINI, Ernest fl. 19th-20th centuries
Born at Dinan of Italian parentage in the late 19th century, he studied under Dujardin in Paris and became a naturalised Frenchman. He exhibited at the Salon des Artistes Français, becoming an Associate in 1906. He got honourable mentions in 1888 and at the Exposition Universelle of 1900, and specialised in busts, heads, reliefs and portrait medallions.

CASPICARA fl. late 18th century
Spanish sculptor working in South America in the late 18th century, specialising in religious figures and bas-reliefs.

CASSAGNE, Jean Henri 1842-1867
Born at Toulouse in 1842, he died there in 1867. He produced a number of statuettes, reliefs and busts.

CASSAIGNE, Joseph fl. early 20th century
Born in Toulouse in the late 19th century, he studied under Falguière, Mercié and Labatut and exhibited at the Salon des Artistes Français, winning an honourable mention in 1901 and a third class medal in 1907. His works include Narcissus, Cupid and Psyche, Wedding Night, Peace, Retreats of Workers and Peasants and a figure of Clémence Isaure. His brother Marius was also a sculptor of genre groups and figures.

CASSANI, Giovanni fl. late 19th century
Born in Milan, he took part in many of the Italian national exhibitions at the end of the last century. He specialised in allegorical and genre groups and figures, such as Adalgisa, Sadness without Name and A Good Inspiration.

CASSAR, Hanns fl. 19th-20th centuries
Born in Mannheim, the son of Karl Cassar, with whom he worked as a sculptor of monuments and busts.

CASSAR, Karl 1856-1904
Born at Frankfurt-am-Main in 1856, he died in Mannheim in 1904. He studied in Frankfurt, Vienna and Munich and specialised in decorative sculpture as well as busts and portrait reliefs.

CASSIDY, John 1860-1939
Born at Slane, Co. Meath, on January 1, 1860, he died at Ashton-on-Mersey, Cheshire, on July 19, 1939. As a boy he left Ireland and studied at the Manchester School of Art, where he won four national medals and several queen's prizes. He began sculpting professionally in 1887, producing numerous busts, portrait reliefs and statues. He was elected F.R.B.S. in 1914 and became successively Vice-president of the Manchester Academy of Fine Arts and President of the Manchester Sculpture Society.

CASSOU, Charles Georges 1887-
Born in Paris on November 24, 1887, he studied under Coutan and won the Prix de Rome in 1920 and a gold medal of the Salon des Artistes Français in 1926. His best known work is his Mirror of Venus, purchased by the city of Paris.

CASTAGNOLI, Giovanni fl. 19th century
Born at Borgotaro, Parma, in 1864, he studied in Rome and Florence and began exhibiting in the latter city in 1886. His works include genre figures and groups, such as Sleeping Child, and Episode from the Disaster of Casmicciola. He emigrated to the United States at the turn of the century.

CASTAN, Louis 1828-1909
Born at Berlin in 1828, he died there in 1909. He studied under Rauch at the Berlin Academy and exhibited in Berlin and at the Royal Academy from 1865 onwards, specialising in genre groups.

CASTANOS AGANEZ, Manuel 1875-
Born in Seville, he studied under Antonio Pena and later enrolled at the Seville Academy. He exhibited in Madrid from 1895 onwards. Examples of his work are preserved in the Museum of Modern Art, Madrid and the Cordoba Museum.

CASTBERG, Oscar Ambrosius fl. 19th century
Born at Bygland in Norway in 1846, he studied at the School of Fine Arts in Christiania (Oslo) and the Middelthun art school. He specialised in portrait busts of contemporary Scandinavian personalities, such as Bjornsterne Björnson and Johan Sverdrup, and exhibited nationally and in Copenhagen and Paris in the 1880s.

CASTELLI, Alfio 1917-
Born at Senigallia, Italy, in 1917, he studied at the Florence Academy and later the Academy in Rome, where he settled in 1941. He had his first one-man show in Rome in 1940. After the second world war he was director of the School of Medallic Art in Rome for two years and was made professor of sculpture at the Venice Institute of Arts (1959) and the Palermo Academy (1960). His work consists of wood carving, plaster with a metallic coating and bronzes of human figures, from nudes to bishops, acrobats to shepherds, often approximating to bas-reliefs through a distinctive flattening of forms.

CASTEX, Jean Jacques fl. 18th-19th centuries
Born in Toulouse in the late 18th century, he moved to Paris during the turmoil of the Revolution and began exhibiting at the Salon in 1796, his first works being a statuette of Leda and two groups of Centaurs. He was a member of the Egyptian expedition of 1798 and produced models based on ancient motifs. One of these, a Zodiac, was shown at the Salon of 1819, as well as a model for a tomb to General Kleber. He also sculpted a number of bas-reliefs and medallions.

CASTEX, Louis fl. 19th-20th centuries
Born at Saumur on December 2, 1868, he studied under Barrias, Cavelier and Maurette. He exhibited at the Salon des Artistes Français from 1898 to 1933, winning a second class medal in 1910. He specialised in religious figures and his works include Vision of the Virgin, Moment of Contemplation, and the Communion of St. Stanislas Kostka, as well as various figures of the Virgin Mary.

CASTIGLIONE-COLONNA, the Duchess Edale de 1836-1879
Born at Fribourg in Switzerland on July 6, 1836, she died at Castellamare, Italy, on July 16, 1879. She spent most of her life in Nice and the Italian Riviera. She studied drawing under Fricero and sculpture under Imhof before settling in Rome, where she married Duke Carlo Colonna in 1856. The duke, many years her senior, died soon afterwards. She retired to the Monastery of Trinita dei Monti for a time, but later moved to Paris, where she worked in the studio of Madame Lefevre-Deumier. She exhibited at the Salon from 1863 to 1870 and founded the Museo Marcello in Fribourg, which contains the major part of her work. The Fribourg Museum also has several of her sculptures. She produced many classical statuettes and busts of her contemporaries including Liszt, the Empress Eugénie, Thiers, and Elizabeth of Austria.

CASTNER, Friedrich Wilhelm August fl. early 19th century
He worked in Berlin as a bronze founder and sculptor of small figures and groups.

CATALDI, Amieto 1886-1930
Born in Naples in 1886, he died in Rome in 1930. He produced numerous classical and genre figures and groups and exhibited nationally and at the Paris salons from 1924 till his death. His bronzes are preserved in the galleries of Modern Art in Rome and Venice, the Petit Palais and the Musée Galliéra in Paris.

CATANEO, Charles Henri fl. 19th-20th centuries
Born in Paris of Italian parentage, he studied under Cavelier, and exhibited small bronzes at the Salon from 1877 till the first world war.

CATILLON, Jean Louis Marie Léon fl. 20th century
Born in Paris, he studied under J. Camus and exhibited bronzes at the Salon des Artistes Français.

CATTEAU, Alfred Pierre Henri Antoine Joseph fl.19th-20th centuries
Born in Tourcoing, he studied under Coutan and exhibited at the Paris salons at the turn of the century.

CATTIER, Armand Pierre 1830-1892
Born at Charleville on February 20, 1830, he died at Ixelles, near Brussels on June 5, 1892. He was a pupil of Eugène Simonis and exhibited at the Paris Salon from 1857 to 1867 before returning to Belgium. His classical, genre and heroic groups were produced in terra cotta and bronze and include The Point of Aim, After the Battle, Spring and Autumn and Daphnis.

CAUDRON, Jacques Eugène 1818-1865
Born in Paris on November 16, 1818, he died there on August 5, 1865. He studied under David d'Angers at the École des Beaux Arts from 1835 to 1840, and exhibited at the Salon from 1851 onwards. His work consists mainly of busts, figurines and allegorical studies and includes busts of Grétry and Molière, statuettes of Christ, Judas and Gozlin, The Indian Hunter, The Awakening and Innocence hiding Love.

CAUDRON, Théophile 1805-1848
Born at Combes on March 21, 1805, he died at Amiens in 1848. He studied under Cartellier at the École des Beaux Arts from 1827 to 1833 and exhibited at the Salon from 1831, winning a second class medal in 1833. He specialised from the outset in historical groups and bas-reliefs, from classical personalities, such as Archimedes, to near-contemporary figures such as Charles Dufresne at Amiens. His best known works are the bronze bas-reliefs at Arles, depicting Louis XIV, the Queen Mother and Cardinal Mazarin visiting Arles and the relief showing Childebert at Arles.

CAUER, Emil the Elder 1800-1867
Born at Dresden in 1800, he died at Kreuznach on August 6, 1867. He studied under Rauch and Johann Haller in Munich, and after continuing his studies in Bonn and Dresden he settled in Kreuznach. He modelled a number of statuettes, genre figures and allegorical groups (the best known being the Four Seasons), theatrical celebrities, Shakespearean characters and German historic personalities such as Hutten, Melanchthon and Mozart.

CAUER, Emil the Younger fl. 19th century
Born at Kreuznach in the mid-19th century, he studied under his father Karl Cauer and completed his studies in Rome before settling in Berlin in 1888. The Berlin Museum has his marble Young Girl drawing Water (1900), and he also sculpted a number of small bronze genre figures.
See Cauer Family Tree.

CAUER, Hanna fl. 20th century
She specialised in busts and portrait reliefs and worked in Germany and France in the 1930s.

CAUER, Karl 1828-1885
Born at Bonn in 1828, he died at Kreuznach on April 18, 1885. He studied under his father, Emil Cauer the Elder, and was later a pupil of Albert Wolff in Berlin. Subsequently he pursued his studies in Rome and London and exhibited at the Royal Academy in 1869-70. He specialised in portrait busts and heads of contemporary personalities including Frederick William IV of Prussia, the Emperor Franz Josef and Prince Metternich. He also produced a number of classical compositions, including the Olympic Victor, The Dying Achilles, Cassandra, Hector and Andromache and The Sorceress. His sons Hugo, Robert the Younger, Emil the Younger, Hans and Ludwig were all sculptors working at the turn of the century on statuettes and groups (see Family Tree). The more important members of the family are separately noticed.

CAUER, Ludwig fl. 19th-20th centuries
Born at Kreuznach on May 28, 1866, he studied under his father Karl Cauer, Reinhold Begas and Albert Wolff. Later he worked for a time in Rome, London and Paris before settling in Berlin. He exhibited at the Royal Academy in 1892-93 and in Paris from 1895 to 1900, winning an honourable mention in 1895 and a third class medal at the Exposition Universelle. His figure of a Young Greek is in the Berlin Museum.

CAUER, Robert the Elder 1831-1893
Born in Dresden in 1831, he died at Cassel in 1893. The son of Emil Cauer the Elder, he worked with his father and elder brother Karl at Kreuznach. The twin themes of classical poesy and romanticism permeate all his work. He specialised in groups of romantic or tragic figures, derived from mythology and literature, including Sleeping Beauty, Snow White, Puss in Boots, Hermann and Dorothea, Paul and Virginia, the Lorelei and Ondine. He also produced a number of portrait busts including those of Frau J. Schmidt (Hamburg Museum) and, the poet C. Simrock (Cologne). His sons Stanislaus and Friedrich were also sculptors, the latter (born 1874) working as a painter and sculptor at Obercassel near Düsseldorf.

CAUER, Robert the Younger 1863-
Born at Kreuznach in 1863, the son and pupil of Karl Cauer. He studied in Rome and spent three years (1889-92) working in the United States, where he produced numerous portrait reliefs and busts. From 1893 onwards he worked in Kreuznach and Berlin.

CAUER, Stanislaus 1867-
Born at Kreuznach, the son and pupil of Robert Cauer the Elder. He later studied in Rome and settled in Königsberg (now Kaliningrad) in 1907, being appointed professor of sculpture at the Königsberg Academy. His figure of a Young Man was at one time in the Königsberg Museum, while his Standing Woman was in the Albertinum in Dresden.

CAUJAN, François Marie fl. 20th century
Born at Landernau in Finistère, he was killed in a car crash on February 20, 1945. He exhibited at the Paris salons before the second world war, and specialised in Breton maritime subjects. His works include a bust of a Breton fisherman and a nude figure of the same subject.

CAUMONT, Martial Denis fl. 19th-20th centuries
Born at Tarbes in the late 19th century, he became an Associate of the Société des Artistes Français and won an honourable mention in 1908 with his genre statuettes.

CAUSSÉ, Julien fl. late 19th century
Born at Bourges, he studied in Paris under Falguière and exhibited at the Salon des Artistes Français in the 1890s, obtaining honourable mentions in 1892 and 1900 and a third class medal in 1893. He also took part in the Exposition Universelle of 1900 and specialised in small figures.

CAUSSÉ, Paul fl. 20th century
He exhibited at the Salon des Tuileries in 1938-39, showing busts and reliefs.

CAVACOS, Emmanuel Andrew 1885-
Born at Potamos in Greece on February 10, 1885. He emigrated to the United States and studied at the School of Fine Arts in Baltimore. Later he became a pupil of Coutan and Peter in Paris and won the Prix de Rome for North America in 1911. He worked in Rome till 1915 and later commuted between Baltimore and Paris, exhibiting regularly on both sides of the Atlantic until 1933. He was awarded a silver medal for sculpture at the Exposition des Arts Décoratifs in 1925.

CAVAILLON, Elisée 1873-
Born at Nimes on March 8, 1873, he exhibited at the Salon from 1903 to 1925, the Salon d'Automne from 1913 and the Salon des Tuileries from its inception in 1925. His bronze figures and groups are in the public park of Quimper and the museums of Nimes, Tarbes and Carpentras.

CAVANAGH, John fl. 20th century
New Zealand sculptor working in Christchurch on figures, groups, busts and memorials.

CAVELIER, Pierre Jules 1814-1896
Born in Paris on August 30, 1814, he died there in 1896. He was a son of the architect and interior designer Adrien Louis Cavelier and studied under David d'Angers and P. Delaroche at the École des Beaux Arts from 1831 to 1836. He was awarded prizes for his historical figures, Diomedes removing his palladium (1834) and the Death of Socrates (1836). He began exhibiting at the Salon in 1834, obtaining a third class medal. His many subsequent awards included medals of honour in 1849, 1853 and 1861. He was appointed professor in 1864, member of the Institut the following year and was a member of the Jury from 1864 to 1867. His best known works were the caryatids on the Turgot Pavilion and the Grand Pavilion at the Louvre. Most of his work was carved direct in marble or stone, but many of his statues were later issued as bronze reductions, including the series of statues for the Church of St. Augustin and the allegory of Justice for Trinité Church in Paris. He also produced many portrait busts of contemporary figures, such as Ary Scheffer and Isaac Pereira, and historical personalities like Dante.

CAVERLEY, Charles 1883-1914
Born in Albany, New York, in 1883, he died at Essex Falls, New Jersey, in 1914. He produced portrait busts, reliefs, plaques and medallions.

CAWOOD, Herbert Harry 1890-1957
Born in Sheffield on July 21, 1890, he died in London on October 27, 1957. He studied at Sheffield Technical School of Art and the Royal Academy schools, winning bronze and silver medals. He exhibited at the Royal Academy and the leading provincial galleries and was Treasurer of the R.B.S. in 1946-47. He worked in London as a sculptor of statuettes and portrait busts.

CAWTHRA, Hermon 1886-
Born in London in 1886, he studied at Salts Art School, Shipley (1904-7), Leeds Art School (1907-9), the Royal College of Art (1909-11) and the Royal Academy schools (1912-16). He exhibited at the Royal Academy and the principal galleries in the provinces and was elected Fellow of the Royal Society of British Sculptors in 1937. He worked in London and sculpted numerous monuments and memorials in stone and wood as well as bronze, and is best known for his restoration and correction of Turnerelli's bas-relief in the Burns Mausoleum, Dumfries.

CAYRON, L.M. fl. early 20th century
He specialised in busts of children, which he exhibited at the Salon des Artistes Français in 1911-13.

CAZAUD, Roger fl. 20th century
Born in Paris at the beginning of this century, he exhibited at the Salon des Artistes Français in the interwar period.

CAZAUX, Édouard fl. early 20th century
Born at Canneille in France towards the end of the last century, he exhibited at the major Paris salons from 1921 onwards and specialised in portrait busts, heads and reliefs. He also worked as a potter.

CAZIN, J.M. Michel 1869-1917
Born in Paris on April 12, 1869, he was killed in an accident on February 1, 1917. During the first world war he served as a coastguard at Dunkirk. He and his wife Berthe were invited aboard the torpedo-boat *Rafale,* when a torpedo exploded killing Cazin and the ship's captain, Lieutenant Erzbishoff. Madame Cazin was blinded and died of her injuries shortly afterwards. Cazin was the son of Jean Charles and Marie Cazin, under whom he studied painting and sculpture respectively. He later became an outstanding medallist, engraver and painter as well as a sculptor in the round. He began exhibiting in 1885, though his many awards were given mostly for his work as an engraver and medallist. He specialised in small figures, busts and bas-reliefs.

CAZIN, Marie (née Guillet) 1844-1924
Born at Painbeuf in 1844, she died at Equihen in 1924. She studied under the painter and ceramicist Jean Charles Cazin, whom she later married. For a time she also worked with Rosa Bonheur and was equally versatile as a painter and sculptor. She made her début at the Salon of 1876, exhibiting landscape paintings and statuettes. She also exhibited regularly at the Royal Academy and was awarded a gold medal at the Exposition Universelle of 1889, and a silver at the Exposition of 1900. She was elected Associate of the Société Nationale des Beaux Arts in 1890 and exhibited in its Salon till 1914. As a sculptor she specialised in statuettes and groups of genre subjects. Her works include Young Girls (in the Luxembourg Museum) and Donkeys Grazing.

CECCARELLI, Ezio fl. 19th century
Born at Montecatini, Italy, in 1865, he studied at the Academy of Florence under Rivolta and Bortone. He worked in Florence on statues and busts in the later part of the 19th century.

CECIONI, Adriano 1838-1886
Born at Fontebuona near Florence in 1838, he died in Florence in 1886. He studied at the Academy of Florence from 1850 to 1860 and then went to Naples, where he was influenced by Nittis. On his return to Florence he was appointed professor of drawing at the Scuola Superiore di Magistero. For some time he lived in London where he worked as an illustrator and contributed cartoons to *Vanity Fair.* He also wrote prolifically on art criticism and his complete works were published at Florence in 1905. As a sculptor he was mainly interested in allegorical and narrative groups, such as The Suicide, Mother, The First Step, Child with Cockerel and Child with Dog. He was also the author of a bust of Leopardi.

CEDERCREUTZ, Émile Herman Robert, Baron de fl. early 20th century
Born in Helsinki, Finland, in the late 19th century, he worked as a sculptor in the town of Seipohja. He exhibited his work at the Salon of the Société Nationale in Paris at the turn of the century, specialising in figures and groups of dogs and horses with such titles as After the Task, The Unspeakable and The Impure. He also sculpted a maquette for a table centrepiece.

CEDERSTRÖM, Minna fl. 20th century
Born in Stockholm at the beginning of this century, she studied under Madame Debillemont-Chardon in Paris and exhibited statuettes at the Salon des Artistes Français in 1928.

CELINSKI, Slawomir fl. 19th-20th centuries
Born in Warsaw in 1852, he studied at the School of Art in Cracow under Matejko. Later he studied under Zumbusch at the Vienna Academy. He returned to Warsaw in 1878 and had a studio there for some time, before moving to St. Petersburg in 1889. He travelled extensively in search of material for his sculpture groups and spent three years in Manchuria (1899-1902) before eventually settling in the United States. He sculpted statuettes and groups of native types, wild life, busts and reliefs.

CELLAI, Raffaello fl. 19th century
Born in Florence in 1840, he studied under Pio Fedi. Subsequently he travelled all over Europe and worked from 1864 to 1876 in Vienna, Dresden, Berlin and Munich before returning to Florence where he produced the figures for the Victory Monument erected in Dresden in 1880.

CELLIER, Charles Robert Camille fl. 19th-20th centuries
Born at Bègles in the late 19th century, he studied in Paris under Larche and Coutan. He exhibited at the Salon des Artistes Français and won a third class medal in 1914.

CELLINI, Gaetano fl. early 20th century
Born in Ravenna in the late 19th century, he worked in Turin before the first world war and exhibited at Turin, Venice and Munich. He specialised in allegorical and genre groups, such as Humanity against Evil (Gallery of Modern Art, Rome), Vinta and Il Giglio.

CELSO, Antonio fl. 20th century
Born at Maranha, Brazil, at the turn of the century, he specialised in heads, busts and portrait reliefs. He participated in the Salon d'Automne in 1924.

CENCETTI, Adalberto 1847-1907
Born in Rome, where he studied at the Academy of St. Luke and later practised as a sculptor of genre and allegorical groups, mainly in marble and stone but published as small bronzes to satisfy the Italian market for decorative sculpture. His best known work is Art triumphing over Study, and Peace, on the façade of the Palace of Exhibitions in Rome. Other works include Too Fast, Ignara mali (Gallery of Modern Art) and Temptation (Museo Rivolta, Trieste).

CENTANARO, Gaetano fl. early 19th century
Born in Genoa, where he worked in the early years of the 19th century. He was the son of Girolamo Centanaro who worked on plaster friezes and figures. Gaetano worked in the same medium but later turned to painting. His nephew Girolamo the Younger (died 1865) continued his work in interior decoration. Some of the plaster figurines of the Centanaro family were later cast in bronze.

CENTORE, Emmanuele fl. 20th century
Born in Italy at the beginning of this century, he specialised in genre figures, especially illustrating the gipsy way of life.

CEPTOWSKI, Karl 1801-1848
Born in Poznan in 1801, he died in Cracow in 1848. He studied under Malinski at the Warsaw Art School and later was a pupil of König in Breslau. He visited Munich and Rome, where he worked for four years with Thorwaldsen. In 1834 he settled in Potsdam and worked as an assistant to Schintel. Later he worked with Ottmer in Brunswick and with Pradier in Rome. In 1840 he became professor of sculpture at the Cracow Art School. He produced a number of busts and figures of classical and genre subjects.

CERACCHI, Giuseppe 1751-1801
Born in Rome in 1751, he studied under Tomasso Righi and later enrolled at the Academy of St. Luke. He went to London in 1773 and worked for Carlini on marble statuary. He exhibited a group of Castor and Pollux at the Royal Academy in 1777. He travelled widely and worked at various times in the Netherlands, Austria and the United States, sculpting portrait busts of the leading American political figures of the decade immediately following Independence. He returned to Rome and eventually moved to Paris, where he was implicated in a plot to assassinate Napoleon. He was tried in 1801 and guillotined. He is best known for his busts of American personalities which exist in various versions, in marble, plaster, terra cotta and bronze.

CERAGIOLI, Giorgio fl. 19th-20th centuries
Born in Turin, where he worked at the turn of the century on statuettes and groups.

CERÉMONIE, Jean Adolphe fl. late 19th century
Born in Paris about the middle of the last century, he exhibited at the Salon from 1869 onwards. He was a versatile and prolific sculptor, producing numerous heads and busts, as well as animal groups, such as Horse drawing an Omnibus, Draught-Ox, a Horse difficult to shoe and Percheron Stallion.

CERIBELLI, Cesar fl. 19th-20th centuries
Born in Rome on July 11, 1841, he studied under Rodolini and Chelli at the Académie de France in Rome. He later went to France, where he became naturalised in 1866. He was an Associate of the Salon des Artistes Français, where he exhibited regularly till 1907. He specialised in genre figures and groups including Naughtiness (1879), Bianca Capella (1881), Masked Woman (1886), The Pigeons of Venice, Nounou (1887), the Childhood of Paul and Virginia (1900) and The Rose (1907). He also sculpted portrait busts in marble and bronze.

CERIBELLI, Marguerite fl. 20th century
Born in Paris, the daughter of Cesar Ceribelli, she exhibited at the Salon des Artistes Français from 1912 to 1926. She specialised in portrait medallions, reliefs and busts, but also produced a number of animal groups, including A Good Hunter, The Cat and the Rat and other feline studies. She had a studio at Boulogne-sur-Seine.

CERLES, Celestin fl. 19th-20th centuries
Born at Firmin in France in the late 19th century, he studied under Mercié and Puech and exhibited at the Salon des Artistes Françai..

CERNIL, Moritz fl. 19th century
Born at Gross Wisternitz (now part of Czechoslovakia) in 1859, he worked at Horitz in Bohemia where he was appointed professor of sculpture in 1885.

CERRACCHIO, Eugenio Filiberto fl. early 20th century
Born at Castel Vetro Val Eurtore in 1880, he worked as a sculptor at the turn of the century and participated in the Italian exhibitions up to the second world war.

CERTOWICZ, Tola fl. 19th century
Born in the Ukraine in 1864, she studied in Cracow under Guyski and later worked in Paris under Saint-Marceaux, Mercié and Chapu. She exhibited at the Salon between 1885 and 1888, specialising in classical and religious statuettes such as The Good Shepherd, St. Cecilia and Morpheus.

CESAR, (Cesar Baldaccini) 1921-
Born in Marseilles of Italian parentage, he enrolled at the School of Fine Arts in Marseilles at the age of fourteen and studied drawing and modelling. For a time he worked as a pupil-assistant to Cornu, himself a pupil of Rodin, and studied direct carving in wood and stone. In 1943 he went to Paris where he studied at the École des Beaux Arts and worked in the *atelier* of Gaumont. After the second world war he turned to sculpture in metal and worked in iron and plaster, hammered lead, iron wire, iron plates and bronze, alternating between the figurative and the abstract. In the 1950s he experimented with an amalgam of old nuts and bolts, tin cans and pieces of scrap iron, flirting with surrealism and developing a highly personal style out of abstract and functional art.

CESAR-BRU, Jean fl. 19th-20th centuries
Born at Senlis on August 7, 1870, he studied under Falguière and Barrau. He exhibited at the Salon des Artistes Francais at the turn of the century, being elected an Associate in 1898 and winning a third class medal in 1902.

CESARI, Desiderio fl. 19th century
He worked in Milan in the mid-19th century as a sculptor and *ciseleur* of small figures.

CEVASCO, Giovanni Battista fl. 19th century
Born in Italy in the early 19th century, he studied under G.B. Caraventa and later attended the Academia Ligustica in Genoa. Later he established a studio in that city, where he was still working in 1866. He worked in various materials, including wood and stone, and produced a number of decorative friezes and figures for the Villa Pallavicini at Pegli near Genoa. He also sculpted statues of Charles Albert of Savoy (Turin), Christopher Columbus and Isabella the Catholic (Genoa) and the Revolution monument in the Lima Pantheon, Peru. His Columbus and Isabella were also published as bronze reductions.

CHABANNES LA PALICE, Jean Pierre Charles, Comte de
fl. 19th-20th centuries
Born at Clermont-Ferrand on April 8, 1862, he studied under Benjamin Constant and Jean Paul Laurens. He was equally versatile as a painter and sculptor and exhibited at the Paris Salons at the turn of the century, winning a third class medal at the Nationale in 1910.

CHABAUD, Felix Louis 1824-1902
Born at Venelles on March 14, 1824, he died there in April 1902. He studied under Pradier and specialised in medallions, plaques and bas-reliefs. He won the Prix de Rome in 1848. He exhibited regularly at the Salon and his numerous works include the allegory of Agriculture on the monumental fountain at Aix, the bas-relief of The Abolition of Slavery and a group entitled The Hunt. He also sculpted the decoration for the Palais of Justice, the Museum and the Prefecture of Marseilles.

CHABOT, Hendrik 1894-
Born in Rotterdam, where he has since worked mainly as a painter of landscapes dominated by animal and human figures. He has also produced sculpture, notably a series of statues in Rotterdam, and various smaller figures and groups.

CHABRE-BINY, Augustin Marie fl. 19th-20th centuries
Born at Grenoble in the late 19th century he specialised in busts and heads. He exhibited at the Salon des Artistes Français (honourable mention, 1898) and at the Nationale in 1911-14.

CHABRIE, Jean Charles 1842-1897
Born in Paris on March 22, 1842, he died there in 1897. He was a pupil of Jouffroy and Chevillard and exhibited at the Salon from 1868 onwards. His figure of a Dreaming Child (1874) is in the Amiens Museum.

CHADWICK, Lynn 1914-
Born at Barnes, London, on November 24, 1914, he was educated at Merchant Taylors School and served in the Fleet Air Arm during the second world war. He trained as a draughtsman and worked in architects' offices, but was largely self-taught as a sculptor. His first one-man show was at the Gimpel Fils Gallery in 1950. Since then he has exhibited internationally and was awarded the Sculpture Prize at the Venice Biennale of 1956, and the CBE in 1964. He now works in Stroud, Gloucestershire. He executed several commissions for the Festival of Britain (1951) and won a prize in the competition for the monument to the Unknown Political Prisoner (1952-53). His early work includes abstract ribbed skeletons, mobiles, stabiles and groups in bronze, iron, plaster and other materials, often in combination.

CHAGALL, Marc 1887-
Born in Vitebsk, Russia, he studied painting at the Academy in St. Petersburg before coming to Paris in 1910 and eventually settling at St. Roche. He gave up painting in 1914 when he returned to Russia but, following the revolution, he again made his way to Paris and took up engraving in the 1920s. During the second world war he lived in the United States and returned to France in 1947, settling in Vence. Since then he has worked in ceramics and stained glass and as a sculptor he has modelled figurines and small groups and carved bas-reliefs from stone. He received the Grand Cross of the Legion of Honour in 1977.

CHAILLOUX, Fernand 1878-1904
He spent his entire life in Paris, where he studied under Jules Thomas and exhibited figures at the Salon des Artistes Français.

CHAINAYE, Achille (known as Champal) fl. 19th-20th centuries
Born in Liège on August 26, 1862, he studied at Liège Academy and exhibited at the Liège Artistic Circle from 1882 onwards. His works include the bronze bust of San Giovanni and such genre figures as The Old Man and The Choir Boy.

CHAINE, Jules fl. 19th-20th centuries
Born in Paris, he studied under Layraud and Halon and exhibited terra cottas and bronzes at the Salon from 1877 onwards.

CHALAMBERT, Marie Alexandre Abel de 1838-1920
Born in Paris on February 27, 1838, he died there about 1920. He studied under Boischevalier, Gustave Boulanger and Jules Lefebvre and practised mainly as a painter. He exhibited at the Salon des Artistes Français from 1877 onwards and worked at Dammartin-en-Goële, near Paris. His bronzes include Saint Martin, Hallali and The War.

CHALIAPIN(E), Boris fl. 20th century
Born in Moscow at the beginning of this century, he studied under Archipov and Kardovsky and worked in Paris before the second world war, exhibiting bronze statuettes at the Salon d'Automne (1930-31) and the Salon des Artistes Français in 1934.

CHALON, Georges fl. 19th-20th centuries
Probably a younger brother of Louis Chalon, under whom he studied sculpture. He specialised in portrait busts, which he exhibited at the Salon des Artistes Français at the turn of the century.

CHALON, Louis fl. 19th-20th centuries
Born in Paris on January 15, 1866, he studied painting under Lefebvre and Boulanger and worked as a painter and book illustrator. He also produced a number of portrait busts and classical figures, such as Agamemnon (1887), Circe (1888), The Silence (1889), Death of Sardanapalus (1891), Orpheus (1898) and Phryne at the Festival of Venus (1885). He won honourable mentions at the Expositions of 1889 and 1900.

CHALONNAX, Jean Baptiste fl. 19th century
Born at Clermont-Ferrand in 1819, he studied under Rude and Barye and specialised in portrait reliefs and busts of contemporary French celebrities. He exhibited at the Salon intermittently from 1869 to 1885.

CHALOPIN, Albert fl. early 20th century
Born at Dijon in the late 19th century, he studied under Barrias and Coutan and exhibited busts at the Salon des Artistes Français from 1912 to 1925.

CHAMAILLARD, Ernest Ponthier de fl. early 20th century
Born at Quimper in the late 19th century, he died in Paris in 1930. He studied law and practised as a barrister at Chateaulin, but took up painting as a hobby and collaborated with Gauguin at Pont Aven in painting and sculpture, the latter being very rare. He occasionally exhibited small bronzes and ceramic pieces at the Salon d'Automne from 1907 to 1925.

CHAMARD, Albert Louis 1879-
Born in Paris on September 28, 1879, he exhibited at the Salon des Artistes Français from 1900 onwards, producing a number of statuettes, portraits and small groups.

CHAMBARD, Louis Leopold 1811-1895
Born at St. Amour on August 25, 1811, he died in Paris in 1895. He enrolled at the École des Beaux Arts in 1836 and studied painting and sculpture under Ingres and David d'Angers respectively. He won the Prix de Rome in 1837 and the prize medal of the École in 1842. He exhibited at the Salon from 1841 to 1868. His major works, such as Bacchus and Modesty, were carved in marble, but he also sculpted numerous portrait busts and statues which were often cast in bronze. His minor works include Love Enchained, The Flight into Egypt and Adam and Eve.

CHAMBELLAN, Marcel fl. 20th century
Born in the United States of French parents in the late 19th century, he studied and worked in Paris. He won an honourable mention at the Salon des Artistes Français in 1911.

CHAMBERS, Frank Portland 1900-
Born in the United States in November 1900, he has produced figures, groups and busts mainly of contemporary subjects.

CHAMBOMIR, Manuel fl. 19th century
Born in Valencia on January 5, 1848, he produced numerous statues, bas-reliefs and ornaments for the churches of Valencia. His bust of Dante is in the Valencia Athenaeum.

CHAMBOULERON, Madame A.A. fl. 19th-20th centuries
She worked in Paris at the turn of the century, and specialised in busts, heads and portrait reliefs, which she exhibited at the Salon des Artistes Français.

CHAMBRADE, Gaspard fl. early 20th century
Born at Arconsat in the late 19th century, he settled in Lyons where he took part in the annual art exhibitions from 1904 onwards.

CHAMONARD, C. fl. 19th-20th centuries
He worked in Mâcon at the turn of the century, and exhibited at the Salon des Artistes Français from 1887 to 1911. He specialised in portrait busts, the most noteworthy being those of Beethoven and Minister Dupuy.

CHAMOUARD, Marcelle fl. 20th century
She specialised in statuettes and small groups, which she exhibited at the Salon des Artistes Français in 1937.

CHAMPEIL, Jean Baptiste Antoine 1866-1913
Born in Paris on February 19, 1866, he died there on October 12, 1913. He studied under Charles Gauthier and Jules Thomas and won the Prix de Rome in 1896 with a figure of Mucius Scaevola, and later won a third class medal at the Salon of the same year. In 1900 he was awarded a silver medal at the Exposition Universelle and got a first class medal in 1902. He was made a Chevalier of the Legion of Honour. His best known work is the monument to the Children of Cantal, erected in 1903 in Aurillac. He also produced a number of busts and small genre groups.

CHAMPEIL, Odile (née Philippart) fl. 19th-20th centuries
Born at Le Havre on December 31, 1860, she was the wife and pupil of J.B. Champeil. She exhibited small bronzes at the Salon des Artistes Français at the turn of the century and was awarded a bronze medal in 1913.

CHAMPETIER DE RIBES, Antoinette fl. 20th century
Born in Paris at the beginning of the century, she studied under Landowski and exhibited at the principal Paris salons from 1930 till the outbreak of the second world war. Though best known for her portrait busts, she has also sculpted genre figures such as Imploration.

CHAMPIER, Louise fl. 20th century
Born in Paris at the beginning of the century, she studied under Olle. She exhibited busts and heads at the Salon des Artistes Français from 1921 to 1933.

CHAMPION, Benoit Claude fl. early 20th century
Born at Sevrey in the late 19th century, he studied under Falguière and exhibited figures and small groups at the Salon des Artistes Français.

CHAMPY, Clotaire 1887-
Born at Vanzy in France on April 7, 1887, he studied under Peter and Injalbert and exhibited at the Salon des Artistes Français, becoming an associate in 1913 and winning a second class medal in 1932. His works include the marble Faune and the bronze group Faunesse.

CHANA ORLOFF (born Orloff, Chana) 1888-
see ORLOFF, CHANA

CHANDLER, Clyde Giltner fl. 19th-20th centuries
Born in Evansville, Indiana, in the late 19th century, she studied under Lorado Taft and took part in the Chicago Art Exhibitions at the turn of the century. Her work includes busts, figures and reliefs.

CHANOT, Albert fl. 20th century
Born in the late 19th century, he studied under Pinta and exhibited at the Paris salons from 1909 to 1943. Though mainly known as a painter of nudes and landscapes, he also produced genre statuettes and heads.

CHANTREL, Marie Madeleine fl. early 20th century
Born in Paris at the end of the 19th century, she studied under Ferrand and exhibited at the Salon des Artistes Français from 1914 to 1926.

CHANTREY, Sir Francis Legatt 1781-1841
Born in Norton, Derbyshire, on April 7, 1781, he died in London on November 25, 1841. His father was a carpenter, who died when he was twelve, and he was therefore forced to go out to work for a grocer as an errand boy, but was later apprenticed to a carver and gilder in Sheffield. He received lessons in drawing from Raphael Smith and at the age of twenty began painting portraits in Sheffield. Then he went to London as an assistant to a wood carver and spent some time working in Ireland, but returned to London after a severe illness. Here he worked as a painter and wood-carver, turning to modelling in clay about 1805. From then until 1810 he produced a number of bronze busts, the best known being that of Horne Tooke. He married an heiress, whose dowry of £10,000 helped to establish him as a fashionable sculptor, and thereafter he had many public commissions for statues, monuments and busts, most of which were executed in marble. He became the most famous sculptor of his day, and was knighted in 1835. He studied in Rome in 1814 and exhibited at the Royal Academy from 1804 till his death, becoming A.R.A. (1815) and R.A. (1818). His personal fortune formed the basis of the Chantrey Bequest administered by the Royal Academy. He operated a bronze foundry in Eccleston Place, London, where he cast his statues, busts, groups and portrait medallions. The listing of his works occupies seven columns in *Gunnis*.

Fish, Arthur *Chantrey and his Bequest* (1904). Raymond, A.J. *Life and Work of Sir Francis Chantrey* (1904). Holland *Memorials of Sir Francis Chantrey*.

CHAPIN, Cornelia fl. 20th century
Born at Waterford, Connecticut, at the beginning of the century, she worked in France in the inter-war period and exhibited at the Salon d'Automne. She specialised in animal figures and her works include Elephant, Bear-cub and The Harvest.

CHAPLAIN, Jules Clément 1839-1909
Born in Mortagne on July 12, 1839, he died in Paris on July 13, 1909. His reputation rests mainly on his work as a medallist and engraver of security documents and banknotes. As a sculptor, however, he produced a number of portrait busts remarkable for their realism. He studied under Jouffroy and Oudiné and won the Prix de Rome in 1863. He became a Chevalier of the Legion of Honour in 1877, Officier in 1888 and Commandeur in 1900. He became a member of the Academy in 1881 and was on the jury of the Exposition Universelle in 1900.

CHAPLIN, Alice Mary fl. late 19th century
She worked in London as a sculptor of animal figures and groups. She exhibited at the Royal Academy from 1877 to the end of the century, and also exhibited at the New Water Colour Society.

CHAPONNIÈRE, Jean Étienne 1801-1835
Born in Geneva on July 11, 1801, he died at Mormex, near Geneva, on June 19, 1835. He came to Paris in 1825 and studied at the École des Beaux Arts under Pradier before going on to Naples (1826-29). On his return to Paris he failed to get a post as a teacher of modelling at the Design School of the Society of Arts and thereafter suffered a great deal of misfortune. He abandoned sculpture and took up painting but died of his privations. In his later years, however, he enjoyed the patronage of Thiers, who secured for him the commission to sculpt the bas-relief of the Capture of Alexandria by General Kleber for the Arc de Triomphe, his last and greatest work. His sculptures consist mainly of small romantic bronzes and bas-reliefs.

CHAPONNIÈRE, Marguerite fl. early 20th century
Born at Rheims in the late 19th century, she studied under Coutan and exhibited at the Salon des Artistes Français from 1912 to 1932.

CHAPPOY, Victor François 1832-1896
Born in Grenoble on August 4, 1832, he died in Paris in 1896. He studied at the École des Beaux Arts under A. Toussaint from 1852 to 1857, and began exhibiting at the Salon in the latter year. He worked in marble but several of his plaster models were later cast in bronze and include such genre works as The Squirrel Hunter, The Cup and Ball Player, The Sheep-shearer, Sara the Bather and a statue of Jacques Vaucanson.

CHAPU, Henri Michel Antoine 1833-1891
Born at Mée on September 29, 1833, he died in Paris on April 21, 1891. He enrolled at the École des Beaux Arts in 1849 and studied under Pradier and Duret. He was runner-up for the Prix de Rome in 1851 and won the prize in 1855, spending the next five years studying in Italy. He exhibited regularly at the Salon, winning bronze medals in 1863, 1865 and 1866 and the grand medal in 1867. He had a distinguished career as a cameo carver and portrait medallist, but he also produced many fine portrait busts, statues, groups and monuments, raising the standard of allegorical composition to a new level. Many of these works were sculpted in marble or stone. Apart from the bronze reductions of his more important public commissions, Chapu also produced numerous small decorative figures and groups, statuettes of dancers, the bronze roundel of Joan of Arc at Melun, Youth (high-relief) and a maquette for a monument to Félicien Rops.

Fidere, O. *Chapu, sa vie et son oeuvre* (1894).

CHAPUY, Jean Désiré Baptiste Agenor fl. 19th century
Born at Francheville in the mid-19th century, he died about 1899. He studied under Calmels and Jouffroy and exhibited at the Salon from 1868. He specialised in portrait busts. His figure of Alcibiades is in the Musée de Gray.

CHARBONNEAU, Pierre fl. 20th century
Born in Rheims at the end of the 19th century. He exhibited statuettes at the Salon des Artistes Français, winning an honourable mention in 1909.

CHARBONNIER, Étienne fl. 19th-20th centuries
Born in Paris in the mid-19th century, he exhibited at the Salon des Artistes Français from 1890 till the first world war and sculpted small figures and groups.

CHARD, Walter Goodman 1880-
Born in Buffalo, New York, he worked as an ornamental sculptor in the early 20th century and sculpted busts and reliefs.

CHARDAR, Charles fl. 20th century
Born in Buenos Aires at the turn of the century, he studied in Paris under Lemaire, Camille Lefebvre and Niclausse. He specialised in busts and exhibited at the Salon des Artistes Français from 1926 to 1929.

CHARDEL, Jean Marie fl. 20th century
Born at Lille in the early years of this century, he studied under A. Guilloux and R. Busnel. He specialised in busts, and genre figures and groups and exhibited in Belgium and France in the inter-war period.

CHARDIGNY, Barthélemy François 1757-1813
Born in Rouen in 1757, he died in Paris in 1813. He studied under Allegrain and won the Prix de Rome in 1782 with his group illustrating the Parable of the Good Samaritan. He worked in Aix and then in Marseilles and became a member of the Marseilles Academy. He produced a number of bas-reliefs, which are on monuments and public buildings in these towns. He was killed when he fell from the scaffolding while working on two bas-reliefs at the Louvre. His works include statues of Henri IV, King René, Daphnis and Chloe, Priam holding the corpse of Hector and busts of King René and Liberty wearing the Phrygian Cap. He also modelled heads of dogs.

CHARDIGNY, Jules 1842-1892
Born in London in 1842, the son of Pierre Joseph Chardigny, he died in December 1892. He is best known as a painter of romantic subjects, but he also modelled figures and groups, of which the most notable was his Paul and Virginia.

CHARDIGNY, Pierre Joseph 1794-1866
Born at Aix on February 20, 1794, he died in Paris in 1866. He was the son of B.F. Chardigny and father of Jules. He studied sculpture under his father and enrolled at the École des Beaux Arts in 1814, studying under Bosio and Cartellier. He began exhibiting at the Salon in 1819, with roundels portraying Homer and Belisarius. He exhibited at the Royal Academy in 1842-43 while living in London. He specialised in bas-reliefs and medallions portraying historical and contemporary celebrities.

CHARDIN, Camille François fl. 19th century
Born in Paris on September 19, 1841, the date of his death is unknown, and nothing is known of him after 1867. He studied under Schoenewerk and enrolled at the École des Beaux Arts in 1865. In the same year he exhibited at the Salon and specialised in busts.

CHARDON, Jean 1819-1898
Born at Andard in 1819, he died in 1898. He studied in Paris under Simonis and exhibited at the Salon from 1855 to 1868. He specialised in genre figures, of which his Quoit-player is the best known.

CHARDONNET, Mlle. A. de fl. 20th century
Born in Lyons at the turn of the century, she studied under P. and J. Franceschi and Mathurin Moreau. She exhibited at the Salon des Artistes Français from 1911 to 1926, a wide range of sculpture including groups, statuettes and busts. Her best known works are Serenade, Louis XVII and The Sleeping Valkyrie.

CHARLEMONT, Louis Charles fl. 19th century
Born in Paris on November 21, 1862, he exhibited at the Nationale and became a Chevalier of the Legion of Honour. His work consisted mainly of small figures and ornaments.

CHARLEMONT, Theodor fl. 19th century
Born at Znaim, Austria, in 1859, he studied under Kaspar von Zumbusch and Edmund Hellmer at the Vienna Academy. He produced numerous animal, historical and allegorical figures and groups, many of which are preserved in the Vienna Parliament buildings, the Museum of Natural History and the Reichenberg Museum.

CHARLES, Charles fl. early 20th century
Born in Paris in the late 19th century, he studied under Thomas and Injalbert and exhibited at the Salon des Artistes Français from 1913 to 1930.

CHARLES, Constantin fl. 19th century
Born in Boulogne in the early 19th century, he died there in 1887. He studied under Dumont and Bonnassieux and exhibited at the Salon till 1872. He specialised in busts, statuettes and small groups.

CHARLES, Laurent 1875-
Born in Paris on June 12, 1875, he studied under Louis Moreau and Thomas. He exhibited at the Salon des Artistes Français, getting an honourable mention in 1895 and a third class medal in 1909. He produced a number of portrait busts, reliefs and heads and genre figures and groups such as The Return and Alone.

CHARLES-VENARD, Salomé fl. 20th century
She specialised in busts and heads and exhibited at the Salon d'Automne in 1937-38.

CHARLET, José 1916-
Born at Bourg-en-Bresse in 1916, he enrolled at the École des Beaux Arts in 1937 and graduated as an architect in 1943. In the closing campaigns of the second world war he fought with the U.S. Third Army in France and Germany and in 1946 headed a French mission from the Department of Cultural Relations to the United States. Following his return to France he held several one-man shows of paintings and published a volume of lithographs. He turned to sculpture in 1951 and works mainly in mahogany, boxwood and ebony, producing abstracts. No bronzes have so far been recorded by him.

CHARLIER, Guillaume fl. 19th century
Born at Ixelles near Brussels in 1854, he studied under Cavelier and won the Prix de Rome in 1882. He exhibited regularly in Brussels, Paris, Cologne, Munich and Dresden in the latter years of the 19th century, winning a third class medal at the Salon of 1887 and a gold medal at the Exposition Universelle of 1889. He specialised in genre and allegorical works, such as Vanity, Leonides, The Sower of Evil, Before the Madonna, Maternal Anxiety, the Prayer, The Young Mother, and The Blind.

CHARMOT, Georges 1866-1899
Born in Geneva in 1866, he died there in 1899. He specialised in busts, several of which were erected in public places in Geneva.

CHARMOY, Georges fl. early 20th century
He worked as a sculptor in Vincennes at the turn of the century, and exhibited busts and figures at the Salon des Artistes Français from 1901.

CHARMOY, José de fl. 19th-20th centuries
Born in Mauritius in the mid-19th century, he died in Paris in 1919. He exhibited at the Nationale and the Salon d'Automne at the turn of the century. He specialised in portraiture, ranging from busts, heads and reliefs to full-sized monuments and memorials. His chief work was the monument to Charles Baudelaire in Montparnasse cemetery, and he also sculpted the bust of Saint-Beuve in the Luxembourg gardens. In addition, however, he also modelled animal groups, especially studies of birds.

CHARNAUX, Madeleine fl. early 20th century
Born at Vichy, she was killed in an air crash while piloting her own plane in 1936. She exhibited figurines at the Salon d'Automne and the Tuileries in the early 1930s.

CHARON, Honoré Henri fl. 19th century
Born at Angers, he died there in 1900. He studied under David d'Angers and spent his entire life working in his home town, exhibiting at the Salon in 1885 and 1888 only. His best known works were his monuments to the Chevalier Guerin des Fontaines and Jeanne d'Arc, but he also sculpted several statues (Jeanne de Laval) and specialised in busts and heads, including those of Père Leduc, Mgr. Freppel and Godard Faultrier.

CHARON, Pierre fl. early 20th century
Born at Chateau Goutier in the late 19th century, he studied under Gérôme, Henner and Barrias. Initially working as a painter, he later concentrated on the sculpture of portrait busts and exhibited them at the Salon des Artistes Français from 1902 to 1932.

CHAROUX, Siegfried 1896-1967
Born in Vienna of French parentage on November 15, 1896, he died in London in 1967. He studied at the School of Arts and Crafts in Vienna and later the Vienna Academy of Fine Arts. He came to England in 1935 and was naturalised ten years later. He spent the latter part of his life working in London and exhibited at the Royal Academy (A.R.A. 1949, R.A. 1956). He also exhibited in Vienna, Munich, Berlin, Dresden and Essen before the second world war, and also in New York and Chicago since the war. He was an accomplished watercolourist as well as sculpting in bronze, terra cotta and stone. His chief works are the monument to Lessing in Vienna and the Amy Johnson memorial in Hull. He also sculpted a large number of statuettes.

CHARPENTIER, Alexandre Louis Marie 1856-1909
Born in Paris on January 10, 1856, he died in Neuilly on March 3, 1909. He studied under Ponscarme and exhibited at the Salon from 1874 till his death, winning an honourable mention in 1883 and the Grand Prix and the Legion of Honour at the Exposition Universelle of 1900. His chief work is the monument to Charlet, erected in the square Lion de Belfort. He produced a large number of plaques, reliefs and medallions as well as genre figures and groups such as Mother Feeding her Infant, Head of a Child, The Dance No. 1 and No. 2, La Glyptique, Maternity and Mother and Child.

CHARPENTIER, Félix Maurice 1858-1924
Born at Bollene on January 10, 1858, he died in Paris on December 7, 1924. He studied under Cavelier at the École des Beaux Arts and exhibited at the Salon from 1884 onwards, winning several medals. He was regarded as one of the outstanding sculptors of his day, his work being characterised by powerful sentiments and expression. The execution of his sculpture was marked by freedom of expression and beauty of form and personified 'modern art' at its most harmonious (Boucheny de Grandval). His chief work was the monument celebrating the centenary of the French annexation of Venaissin, but his lesser works included genre and allegorical groups in plaster, marble and bronze, such as Young Faun, The Improvisor, The Wrestlers, Chanson, Illusion,The Sleeping World, Shooting Star and The Little Bather.

CHARPENTIER, Francine fl. early 20th century
Born in Paris in the late 19th century, she worked at the turn of the century on portraits and genre figures. She exhibited at the Salon des Artistes Français in 1907-8 figures of Poussin and The Lover of Chianti.

CHARPENTIER, Jacques fl. 20th century
Born in Caen in the early years of this century, he exhibited at the Salon d'Automne in 1937.

CHARPENTIER, Julie 1765-1843
Born at Blois about 1765, she died in Paris in 1843. She was the daughter of the engraver François Philippe Charpentier and studied under her father as well as Pajou. At the Salon de la Correspondance in 1787 she showed a bust of her sister and a bronze bas-relief of the Duke of Orleans. She exhibited at the Salon from 1793 to 1824, mainly busts, including those of François Montgolfier, Marcel (director of the Imperial Printing Works), Captain Morland, the King of Rome, the architect Pierre Lescot, General Ordener, the engraver Gerard Audran and Joseph Marie Vien. In addition to her bronzes, many of her works are known in plaster or terra cotta.

CHARPENTIER-MIO, Maurice fl. early 20th century
Born in Paris at the turn of the century, he specialised in statuettes and small groups in terra cotta, coloured plaster and bronze. He exhibited at the Salon of the Société Nationale des Beaux Arts.

CHARPENTREAU, Armand fl. 19th century
Born in Paris in the mid-19th century, he studied under A. Dumont and exhibited sculpture at the Salon in 1877.

CHARRIER, Pierre Édouard 1820-1895
Born at Niort on June 12, 1820, he died there in 1895. He was employed on the decorative sculpture of the Louvre in 1854-55, but specialised in portrait busts. His works include Portrait of a Woman and busts of General Cler and J.F. Carl. He exhibited at the Salon only in 1853.

CHARRON, Alfred Joseph fl. 19th century
Born at Poitiers on July 8, 1863, the son of Amedée Charron, he studied under his father and later was a pupil of Cavelier, Barrias and Coutan. He exhibited at the Salon des Artistes Français from 1883 onwards, becoming an Associate in 1889 and winning an honourable mention in 1892.

CHARRON, Amedée fl. 19th century
Born at Saint Denis in 1837, he studied at the Academy of Fine Arts in Poitiers where he later became director of a large workshop specialising in religious sculpture. His secular works include The Violin Player, Brennus and the group of Clovis after Tolbiac.

CHARTIER, Albert Louis Edmond 1898-
Born in Coutres on May 7, 1898, he studied in Paris under Coutan and exhibited at the Salon des Artistes Français from 1923 onwards, winning a third class medal in 1925.

CHARTRAIN, Saint-Yves fl. 19th century
Born in Paris in the mid-19th century, he studied at the École des Beaux Arts and was later pupil and assistant to A. Dumont. He exhibited at the Salon from 1873 to the end of the century, and produced small romantic figures and groups.

CHASE, Elizabeth fl. early 20th century
Of English origin, she worked in France in the inter-war period, specialising in bronze figurines, heads and portrait busts. She exhibited at the Salon d'Automne in 1927-30.

CHASSAIGNE, René fl. 19th century
Born in Orleans in the mid-19th century, he studied under G.J. Thomas and A. Péchiné. He exhibited at the Salon from 1882 to 1886 and specialised in busts and portrait medallions, but also modelled figures of hunting dogs.

CHASSAING, Edouard fl. 20th century
Born at Clermont-Ferrand at the end of the last century, he worked in Paris in the inter-war period, specialising in portraits and decorative figurines. He exhibited at the Nationale and the Salon d'Automne from 1920 onwards.

CHASTEL, Jean Pancrase 1726-1793
Born at Avignon in 1726, he died at Aix on March 30, 1793. From 1774 till his death he was professor of modelling at the Aix School of Art. Much of his work has been preserved in the Museum of Aix en Provence, mainly medallions, maquettes, roundels and bas-reliefs of contemporary personalities. He also sculpted animal figures, such as Crouching Greyhound.

CHASTENET, André de 1879-
Born in Bayonne on March 18, 1879, he was an Associate of the Société Nationale and exhibited at that Salon from 1906, and also at the Salon d'Automne from 1922. A versatile sculptor, he produced numerous busts, including those of Max Outrey, Marcel Jousse and Albert Sorel, a large number of statuettes of women, historical and religious figures, such as Jeanne d'Arc, St. Theresa, Virgin, Jesus preaching. His most important work was the War Memorial at Tence.

CHATEAUBRUN, René de fl. early 20th century
Born at Noirante in the late 19th century, he studied under M. Thomas and exhibited at the turn of the century, winning an honourable mention at the Exposition Universelle of 1901 and becoming an Associate of the Artistes Français the following year.

CHATEAUGOMBERT, Xavier fl. late 19th century
Born in Paris, where he worked as a decorative sculptor at the turn of the century. He became an Associate of the Artistes Français in 1893.

CHATEIGNON, Ernest fl. 19th-20th centuries
Born in Paris in the mid-19th century, he began exhibiting at the Salon des Artistes Français in 1887 and became an Associate in 1905. His work includes numerous bronze statuettes of genre subjects, such as Siesta, Peasants and Shepherd. He also produced a large number of landscape paintings with particular emphasis on agricultural subjects.

CHATEIGNON, Jean fl. early 20th century
Born in Paris in the late 19th century, the son and pupil of Ernest Chateignon, and later studying under Bouty and Perrotte. He exhibited genre figures and groups at the Salon des Artistes Français from 1911 to 1924.

CHATILLON, Alfred fl. early 20th century
He worked in Paris at the turn of the century and exhibited small bronzes at the Salon des Artistes Français from 1902 till the first world war.

CHATILLON, Auguste de 1813-1881
Born in Paris, he worked as a poet and painter as well as a sculptor. He occupied a major position in the development of the Romantic movement and in the beginning of the epoch of Realism. He exhibited at the Salon from 1831 onwards. As a sculptor he specialised in portraiture and produced many busts and figures of the Orleanist Royal Family and contemporary celebrities.

CHATROUSSE, Émile François 1829-1896
Born in Paris on March 6, 1829, he died there on November 12, 1896. A prolific writer on art criticism as well as a sculptor, he studied under Rude and Abel de Pujol. He exhibited at the Salon from 1848 onwards, and won medals in 1863-65. He worked mainly in marble and stone and carved a number of religious figures and groups for churches. Some of his other statuary is in Paris Town Hall and the Théâtre du Châtelet. His allegorical works, such as Pity, War Crimes and Repentant Magdalene, were later edited as small bronzes.

CHATZ, Boris – see SHATZ, Boris

CHAUDET, Antoine Denis 1763-1810
Born in Paris on March 3, 1763, he died there on April 19, 1810. He worked as a painter and sculptor and studied under J.B. Stouf and E. Gois. In 1781 he was runner-up in the Prix de Rome and won the top award three years later with a tableau of Joseph and his Brothers. In 1789 he was elected a member of the old Royal Academy of Painting and became a member of the Institut in 1805. He exhibited sculpture at the Salon from 1798 to 1810 and was awarded the commission to do the figure of Napoleon for the Vendôme column (erected in 1814). He modelled a figure of Peace, later cast in silver and preserved at the Tuileries. He was professor of sculpture at the École des Beaux Arts and collaborated in the editing of the Dictionary of Fine Arts. His minor sculpture consists of various busts and figures of Napoleon and his generals.

CHAUDIN-FROIDFOND, Germaine fl. 20th century
Born in Paris at the turn of the century, she studied under Guenardeau and specialised in reliefs, plaques and medallions of genre subjects.

CHAULEUR, Madeleine fl. early 20th century
Born in Lille at the beginning of this century, she exhibited at the Salon des Artistes Français in 1926.

CHAUMONT-QUITRY, Marquis de fl. early 20th century
He exhibited figures and groups, busts and reliefs at the Salon des Artistes Français at the turn of the century, and also at the Nationale from 1914 onwards.

CHAUMOT, Georges fl. 20th century
Born in Paris at the beginning of this century, he worked in Paris in the inter-war period, exhibiting at the Salon d'Automne and the Tuileries from 1935 to 1942. He specialised in portrait busts and nude statuettes.

CHAUVANCY, Jean fl. 20th century
Born in Paris at the beginning of the century, he specialised in busts, heads and portrait medallions. He exhibited at the Salon des Artistes Français from 1927 onwards.

CHAUVEAU, Robert fl. early 20th century
Born at Bordeaux in the late 19th century, he specialised in genre and allegorical figures and groups, such as Despair (1913).

CHAUVEL, Georges 1886-
Born at Elbeuf on September 7, 1886, he exhibited at the principal Paris salons during the first half of this century. His figures were true to life but combined realism with modern expressionism. His works include Ondine, Caryatid, Reclining Nude, Dancer, Woman Squatting, Woman Sleeping and Woman with Necklace.

CHAUVENET-DELCLOS, Marcel Marie Auguste fl. 20th century
Born at Perpignan in the early years of this century, he studied under J. Boucher and specialises in portrait busts and heads.

CHAUVET, Florentin-Louis 1878-
Born at Beziers on March 4, 1878, he studied under Thomas and exhibited at the Salon des Artistes Français from 1902 (third class medal, 1905) and later at the Nationale, of which he became an Associate in 1921. Originally a painter, he turned to sculpture relatively late in life and specialised in busts of nude or semi-clothed women.

CHAUVIN, Gabriel Georges 1895-
Born in Paris on September 28, 1895, he studied under Injalbert and Desvergnes. He exhibited at the Salon des Artistes Français and later at the Nationale, winning an honourable mention in 1924 and a silver medal six years later. He specialised in busts, but also sculpted a monumental fountain.

CHAUVIN, Jean Louis 1889-
Born at Rochefort sur Mer in 1889, he exhibited busts and statuettes at the Salon d'Automne from 1913 onwards. He worked in wood, polished to a hard gloss, and later turned to marble and bronze, which materials were also honed to the same perfection. He had a one-man show at the Galerie Maeght in Paris and took part in the exhibition Sept Pionniers de la Sculpture Moderne at Yverdon, Switzerland, in 1954. He worked latterly in Malakoff near Paris. Over the years his work has changed from realistic busts to abstract groups with increasingly severe geometric forms.

CHAUVIN, Odette fl. 20th century
Born in Marseilles, she studied under Landwoski and took part in the Paris salons from 1930 onwards, specialising in statuettes of females.

CHAVALLIAUD, Leon Joseph 1858-1921
Born in Rheims in 1858, where he also died in 1921, he studied in Paris under Jouffroy and the younger Roubeaud. He exhibited at the Salon des Artistes Français from 1885 and won a third class medal in 1891. He specialised in portrait busts; his bronze of the Rev. James Holy is in the Dublin Museum.

CHAVANNE, Jean Maurice 1797-1860
Born in Lyons on January 2, 1797, he died in the same town about 1860. He was a painter and medallic engraver as well as sculptor and studied under his father, the medallist Jean Marie Chavanne (1766-1826). He later studied at the School of Fine Arts in Lyons under Légendre-Héral and took part in the annual art exhibitions of Lyons from 1822 to 1852. He was exceedingly versatile both as a painter and as a sculptor, his work in the latter medium including busts, genre groups and statuettes of women.

CHAVEZ, Carolina de fl. 20th century
Born in Lima, Peru, at the beginning of this century, she studied in Paris and exhibited at the Salon d'Automne from 1927 to 1931. Her speciality was statuettes, particularly studied of the Peruvian Indians.

CHAVIGNIER, Louis 1922-
Born at Montbondif, France, in 1922, he settled in Paris after the Liberation and enrolled at the École des Beaux Arts. He first found employment as a restorer of antiquities in the Egyptian and Chaldean departments of the Louvre and in the Khmeres collection at the Musée Guimet. Subsequently he began exhibiting his sculptures at the Salon des Réalités Nouvelles, the Salon de la Jeune Sculpture and the Antwerp Biennale and won the Fenelon Prize in 1952. His work, though inspired by nature, is almost abstract in form. He models in clay for casting in bronze.

CHECA Y SANZ, Ulpiano 1860-1916
Born in Colmenar de Oreja on April 3, 1860, he died at Dax in France on January 16, 1916. He studied painting and sculpture in Madrid under Manuel Doniguez, Federico de Madrazo and P. Gonzalvo and won the Grand Prix de Rome in 1884. After spending the next three years in Rome he went to Paris where he exhibited at the Salon des Artistes Français from 1888 onwards. His numerous awards culminated in the grand gold medal at the Exposition Universelle of 1900. Much of his painting was inspired by classical subjects and his sculpture of similar themes was distinguished by a vigorous, highly personal approach.

CHEDEVILLE, Leon fl. 19th century
Born at Rosay in the early 19th century, he died in Paris on February 2, 1883. He studied under Millet and Villeminot and began exhibiting at the Salon in 1875. He was a prolific sculptor of heads and busts, but also produced several genre figures such as Jeanne and Negro.

CHEDEVILLE, R. fl. 19th-20th centuries
He worked in Paris at the turn of the century, specialising in animal figures and groups, including Vulture and Gazelle and The Prey.

CHEERE, Sir Henry, Bart. 1703-1781
Born in Clapham in 1703, he died there on January 15, 1781. He studied under John Nost and later was in partnership with Henry Scheemakers. He had a workshop near Hyde Park Corner in London, where he sculpted in marble and stone and modelled for casting in lead and bronze. He produced numerous portrait and allegorical statues, chimney pieces, garden statuary and several portrait medallions. He was a member of the committee responsible for the foundation of the Royal Academy, was knighted in 1760 and raised to a baronetcy six years later.

CHEERE, John d. 1787
Brother of Henry Cheere, with whom he was initially in partnership, but later he took over John Nost's yard and moulds for the casting of garden statuary and chimney ornaments. J.T. Smith's *Streets of London* has a vivid description of his studio and mentions the life-size lead figures painted to resemble nature. He produced a number of mythological and allegorical figures, such as the wyverns for the Bishop of Durham, Mars, Augusta and Flora (all 1759), Apollo, Venus, Mercury and Livia (1762-63) and various sphinxes, lions and lionesses. His best known work was the lead figure of Shakespeare, presented by Garrick to Stratford Corporation. He also sculpted a series of portrait busts of Roman personalities such as Brutus and Seneca.

CHEMIN, Joseph Victor 1825-1901
Born in Paris on August 25, 1825, he died there in 1901. He studied under Barye and specialised in the modelling of dogs, foxes and hares, which he exhibited at the Salon from 1857 onwards.

CHENILLION, Jean Louis 1810-1875
Born at Auteuil on November 15, 1810, he died in Paris on October 30, 1875. He enrolled at the École des Beaux Arts in 1829 and studied under David d'Angers and Daubigny. He exhibited at the Salon from 1835 to 1863 and made his début with a plaster figure Young Captive meditating on his Slavery. He received a number of public commissions for religious and historical statues, mainly in marble or plaster. He also produced numerous busts of contemporary political figures of the reign of Louis Philippe.

CHENOT-ARBENZ, Denise fl. 20th century
Born in Nantes in the early 20th century, she studied under Sicard and Carli and exhibited at the Salon des Artistes Français in the inter-war period.

CHENU, Denis Marie fl. 18th-19th centuries
Born in Paris in the second half of the 18th century, he attended the Académie de St. Luc in 1781 and following the outbreak of the Revolution spent some time in London, where he enrolled at the Royal Academy schools (1794) and also exhibited busts of children at the Royal Academy. His father was the portrait sculptor Nicolas François Chenu (d. 1792).

CHENU, Peter Francis 1760-c.1840
Born in London on October 8, 1760, he was still active in 1833 and died some years later, though the exact date is unknown. He studied at the Royal Academy schools, winning the silver medal in 1785 and the gold medal the following year. He exhibited at the Royal Academy from 1788 to 1822 and at the British Institution from 1811 to 1822. He was a prolific sculptor of monuments and statues to contemporary celebrities, especially between 1788 and 1817, though his monumental reliefs were frequently pathetic and mawkish. His bronzes include several portrait busts (notably Sir John Herschell), figures designed to hold lights and ornamental candelabra. His last work was a bronze of Aurora which he exhibited at Suffolk Street in 1833.

CHÉRER, François fl. 19th-20th centuries
Born at Verviers in Belgium on November 14, 1868, he moved to France and studied under Cordonnier in Paris. He began exhibiting at the Salon des Artistes Français at the turn of the century, specialising in such genre figures and groups as Dreamer, Grief, Echo, Playing Knucklebones and The Time and the Inclination (1911).

CHÉRET, Gustave Joseph 1838-1894
Born in Paris on September 12, 1838, he died there on June 13, 1894. He was the younger brother of the poster artist Jules Chéret and studied under Vallois and Carrier-Belleuse, whose daughter Marie he subsequently married. He exhibited at the Salon from 1863 and won honourable mentions in 1883 and 1886. He later exhibited at the Nationale and succeeded his father-in-law as director of works of art at Sèvres. He is best known for his terra cottas and porcelain vases, but he also sculpted figurines cast in bronze as well as ceramic materials. His works are in the Musée des Arts Décoratifs.

CHERVET, Léon 1839-1900
Born at Tramayes on June 19, 1839, he died in Paris in 1900. He studied under Dumont at the École des Beaux Arts in 1864-8, winning a medal in the latter year. He modelled genre figures and groups. The museum of Niort has his figure The Child Giotto.

CHESNAU, Aimé fl. 19th century
Born in Paris in the first half of the 19th century, he studied under Carrier-Belleuse and J. Salmson. He spent some time in England and exhibited at the Royal Academy and the British Institution from 1863 to 1875. He specialised in bronze busts, reliefs and roundels portraying his contemporaries.

CHESNAU, Georges 1883-
Born in Angers on May 5, 1883, he studied under Barrias and Coutan and exhibited at the Salon des Artistes Français in the early years of this century, winning a third class medal in 1913.

CHEURET, Albert fl. early 20th century
Born in Paris in the late 19th century, he studied under Perrin and Lemaire and exhibited at the Salon des Artistes Français at the turn of the century. He specialised in statuettes and small objets d'Art.

CHEVALIER, Jacques Marie Hyacinthe 1825-1895
Born at St. Bonnet le Château on April 7, 1825, he died in Paris in October 1895. He studied under Toussaint at the École des Beaux Arts from 1847 to 1851 and began exhibiting at the Salon the following year. He got an honourable mention at the Exposition Universelle of 1889 and his figures and groups are preserved in the museums of Clermont-Ferrand and Lisieux.

CHEVILLON, Jean Louis fl. early 19th century
A bronze of a seated Greyhound dated 1836 is in the Puy Museum.

CHÈVRE, Paul Romain fl. 19th-20th centuries
Born in Brussels of French parentage, he studied in Paris under Cavelier and Barrias and exhibited at the Paris salons from 1891 to 1913. He won a third class medal (1895), a travelling scholarship (1897) and a bronze medal at the Exposition Universelle of 1900 for decorative sculpture and figurines.

CHEWETT, Jocelyn 1906-
Born in Weston, Ontario, in 1906, she left Canada in 1914 and studied sociology and comparative religion before turning to modelling at the Slade (1927-31) under Henry Tonks and A.H. Gerrard. In 1931 she went to Paris and worked with Zadkine for two years, learning the techniques of direct carving. Following her return to England she married the painter and sculptor Stephen Gilbert. They spent the war years in Ireland and in 1946 they moved to France. Her postwar sculpture has been mainly in stone, but to the period 1932-34 belong her statuettes of biblical and mythological characters. Her later work ranges from the cubist to the constructivist and is now purely abstract.

CHIAFFARINO, Carlo Filippo 1856-1884
Born in Genoa in 1856, he studied in Rome and later specialised in religious sculpture. His works include a series of five bronze bas-reliefs for the Church of the Immaculate Conception in Genoa, the Angel of Peace in Bassegia cemetery and the figure of David, examples of which are in the Vatican Library and the Genoa Museum.

CHIALLI, Giuseppe fl. early 19th century
Born at Citta di Castello in the late 18th century, he studied under Minardi in Perugia and Canova and Thorwaldsen in Rome where he worked from 1800 to 1839. He had many commissions from the Duke of Torlonia and the kings of Sweden and Sardinia and worked on allegorical statuary, mainly in marble, though some of his groups were also edited as bronze reductions. The museum of Citta di Castello has examples of his work.

CHIARADIA, Enrico 1851-1901
Born at Caneva in Italy in 1851, he died at Sacite near Udine in 1901. He studied in Munich and Vienna and later was a pupil of Monteverde in Rome. His chief works include Cain (Rome, 1880) and Figure of a Woman (Venice, 1887). He was noted for his ability to capture facial expression.

CHIATTONE, Antonio 1856-1904
Born at Lugano in 1856, he died in the same town in 1904. He studied under Barzaghi-Cattaneo and Vincenzo Vela at Ligornetto and later worked for a time in Milan and Florence before returning to his home town. His best known work was the statue of the ill-starred Crown Prince Rudolf, which the Empress Elizabeth of Austria commissioned for her villa in Corfu. He also sculpted a statue of her which was erected after her death, in Montreux. He won a Grand Prix at the Exposition Universelle of 1900. His works included Repose, Summer, Winter and similar allegorical figures, and the monument to the Swiss politician G.B. Piodo at Lugano.

CHIATTONE, Giuseppe 1865-
Born at Lugano, the younger brother and pupil of Antonio Chiattone. He later studied at the Milan and Turin Académies. His figure entitled Ave Maria, shown at the Exposition Universelle in 1900, is now in Berne Museum.

CHICOT, Louis fl. 19th century
Born at Mâcon in the mid-19th century, he died in 1896. He was a prolific portrait sculptor and his busts and heads were exhibited at the Salon from 1876 to 1890.

CHIERICI, Giovanni fl. 19th century
Born at BigareÍlo near Mantua in 1830, he worked as a sculptor of figures and busts in Parma.

CHINARD, Joseph 1756-1813
Sometimes shown as Pierre Chinard, he was born in Lyons on February 12, 1756, and died there of an aneurism on May 9, 1813. He studied under Blaise and went to Rome where he won the papal prize for his group Perseus delivering Andromeda. He exhibited at the Salon from 1798 onwards and specialised in groups redolent of the heavy classical allegory of the time. This conventional and uninspired statuary, however, won him a high reputation. He became a professor at the Lyons Art School and a corresponding member of the Institut. He produced a vast number of busts, especially of the Bonaparte family and the Napoleonic generals.

CHILLIDA, Eduardo 1924-
Born at San Sebastian, Spain, in 1924. After studying architecture at the Madrid Art School from 1943 to 1947 he devoted himself to sculpture, working at first in clay and plaster for bronze-casting and then turning to direct carving in granite. About 1950 he switched to wrought iron and has used this medium ever since for his abstract works. Best known for his monument to Sir Alexander Fleming at San Sebastian and the decorative gates of the Franciscan basilica at Aranzazu.

CHIO, (Ernesto Galeffi) 1917-
The pseudonym of a sculptor producing bronzes of birds and fishes since the second world war.

CHIPARUS, Dimitri (Demetre) fl. 20th century
Born in Romania in the late 19th century, he studied under Mercié and J. Boucher in Paris and exhibited at the Salon des Artistes Français from 1914 to 1928. Chiparus developed the chryselephantine bronze, pioneered in Belgium at the turn of the century, and gave it its peculiarly Art Deco flavour. He produced numerous statuettes and small groups of girls, their features carved in ivory set into the bronze which was often chased, gilded and enamelled.

CHIQUET, Georges Maxime fl. 20th century
Born in Paris at the beginning of this century, he studied under Landowski. His brother Maxime Louis Chiquet was born in Montrouge and studied under Bouchard. Both of them exhibited small bronzes at the Salon des Artistes Français in 1933.

CHOAIN, Gerard fl. 20th century
Born in France at the turn of the century, he exhibited at the Salon des Artistes Français and the Salon des Tuileries before the second world war. He produced figures, such as Eve (1937) and portrait busts.

CHOATE, Nathaniel 1899-
Born in Southboro, Massachusetts, he has worked as a sculptor of figures, busts and reliefs.

CHODZINSKI, Casimir fl. 19th-20th centuries
Born in Cracow in 1861, he sculpted historical and genre figures in Poland at the turn of the century.

CHOISELAT, Ambroise 1815-1879
Born in Paris on October 30, 1815, he died about 1879. He studied at the École des Beaux Arts under Klagmann and Eugène Lami and exhibited at the Salon from 1843 to 1878. His best known work consisted of the two stone figures for the façade of the Luxembourg fountain in Paris, but he also sculpted small groups and statuettes, in the Romantic idiom.

CHOLMELAY, Isabel fl. 19th century
Of English origin, she worked in Rome in the mid-19th century and was a regular exhibitor at the Royal Academy and the Paris Salon. She specialised in portrait busts, the best known being those of Gibson and Liszt.

CHOMEAUX, Roger fl. 20th century
Born at Berlaimont at the turn of the century, he studied under Coutan and exhibited small sculptures at the Salon des Artistes Français in 1927.

CHONEZ, Claudine fl. 20th century
Born in Paris at the beginning of this century, she studied under Févola and Jubert. She specialised in busts and torsos, which she exhibited at the Salon des Artistes Français and the Tuileries from 1929 till the second world war.

CHOPPIN, Paul François fl. 19th-20th centuries
Born at Auteuil on February 26, 1856, he studied at the National School of Design under Falguière and Jouffroy and exhibited at the Salon from 1877 to 1923, winning a third class medal in 1888 and a bronze medal at the Exposition Universelle the following year. He concentrated mainly on figures and groups of a historical nature, such as Young Archer and The Death of Britannicus.

CHOPPIN DE JANVRY fl. 20th century
Better known as a landscape painter, he also modelled portrait busts and heads which were exhibited at the Salon des Tuileries from 1939 onwards.

CHOREL, Jean Louis 1875-
Born in Lyons, he studied at the School of Fine Arts there and later became a pupil of Barrias and Coutan in Paris. He exhibited at the Salon des Artistes Français, winning an honourable mention in 1903 and a third class medal four years later. His works include The Muse of Pierre Dupont, and busts of Gaspard André and Puvis de Chavannes.

CHOUKLIN, Ivan fl. 20th century
Born at Kursk in Russia, he came to France after the Revolution and worked in Paris. He specialised in genre busts and heads, depicting the peasantry of the Basque country.

CHRETIEN, Eugène Ernest 1840-1909
Born at Elbeuf on June 14, 1840, he died in Paris in 1909. He studied at the School of Fine Arts in Marseilles and later under Dumont in Paris. He exhibited at the Salon from 1874 and became an Associate in 1904. He won a second class medal in 1874 and a bronze medal at the Exposition Universelle of 1889. His works include A Follower of Bacchus, Force overcomes Right, A Gaul at the Siege of Alesia, Springtime, Maternal Joy, The Curse, Young Bacchant and various portrait busts of his contemporaries.

CHRIST, Adam 1856-1881
Born in Bamberg in 1856 and died in Munich in 1881, he sculpted memorials, monuments, groups and figures.

CHRIST, Fritz 1866-1906
Born at Bamberg, he was the younger brother of Adam with whom he worked in Munich. He studied under Widnmann at the Munich Academy and exhibited his figures and groups in Paris, Copenhagen, Chicago and Munich at the turn of the century.

CHRISTALLER, Paul 1860-
Born in Basle, he worked in Stuttgart as a modeller and stone-carver of monuments, statues and small groups.

CHRISTEN, Daniel fl. early 19th century
The eldest son of the sculptor Joseph Christen with whom he worked in Berne in the early years of the 19th century. He exhibited his bronzes in Berne but died at a very early age.

CHRISTEN, Joseph Anton Maria 1769-1838
Born at Buochs, Switzerland, on February 2, 1769, he died at Königsfelden on March 30, 1838. From the earliest age he assisted his father, who made a living as a wood-carver of religious figures and animals. About 1785 he went to Lucerne where he enrolled at the School of Art and studied under Johan Melchior Wyrsch. In 1788 he went to Rome where he spent three years before returning to Switzerland and working successively in Zurich, Stans, Lucerne, Berne, Basle and Aarau. During his second visit to Rome (1805) he did a bust of Napoleon and this was hailed as his masterpiece. He also spent some time in Vienna and sculpted numerous busts of leading figures about 1815. He also worked for a short time in Germany (1831). He is best remembered for the heads of lions on the Emmen bridge near Lucerne and the statue of his brother Klaus.

CHRISTEN, Raphael 1811-1880
Born in Berne in 1811, he died there on January 14, 1880. He was the son of Joseph Christen and worked with his father. Later he studied under Sonnenschein and Volmar at Berne and completed his studies in Geneva and Rome, latterly working with Thorwaldsen. For a time he worked at the Briens School of Sculpture. His work was mainly carved direct in marble or stone, but his bronzes include the figure on the fountain in front of the Berne Town Hall.

CHRISTEN, Wilhelm fl. 19th century
Born in 1818 he worked as a sculptor of genre and historical figures at Graz in Austria.

CHRISTENSEN, Jeremias 1859-1908
Born at Tingloff in Schleswig on March 26, 1859, he died in Charlottenburg, Berlin, in 1908. He studied at Copenhagen Academy in 1883-85 and won the Stoltenberg travelling scholarship which took him to Rome. He produced portrait busts and small historical figures.

CHRISTENSEN, Theodor Anton Emanuel (known as Thod Edelmann) fl. 19th-20th centuries
Born at Horsens in Denmark on December 23, 1856, he was the son of a master mason and learned the elements of stone carving from his father. He went to Copenhagen in 1876 and studied under A.V. Saabye at the Academy till 1882. He later travelled extensively all over Europe and took part in international exhibitions, winning a bronze medal at the Exposition Universelle of 1900. He produced figures and groups illustrating the Danish peasantry.

CHRISTIAN, Max fl. 19th century
Born in Vienna in 1864 he sculpted portraits and figures at the turn of the century.

CHRISTIANSEN, Sievert 1862-1897
Born at Westerland in 1862, he died in Munich in 1887. During his very brief career he produced several busts and statuettes.

CHRISTIE, Henry C. fl. 19th century
He worked in London as a portrait sculptor in the later 19th century and exhibited at the Royal Academy from 1881 onwards.

CHRISTOPHE, Ernest Louis Aquilas 1827-1892
Born at Loches in January 1827, he died in Paris on January 16, 1892. He studied under Rude and collaborated with him in a number of works, notably the Cavaignac monument. He exhibited sporadically at the Salon from 1850 till his death. He was awarded a third class medal for The Mask (1875), now in the Tuileries Gardens. In his later years he turned from Romanticism to Symbolism and was pre-occupied with the interpretation of the supreme moments of passion as death in the embrace of the Sphinx. This theme occurs in his strange groups, such as The Fatality and The Supreme Kiss, both in the Musée de Luxembourg.

CHRISTOPHE, Pierre Robert 1880-
Born at St. Denis on July 16, 1880, he studied under Thomas and Gardet and exhibited at the Salon des Artistes Français from 1900 and at the Salon d'Automne from 1929 till the second world war. He specialised in portrait busts of his contemporaries, but also (under the influence of Gardet) produced a number of animal studies, notably Hinds at Rest in the Nice Museum.

CHRYSTAL, Margaret fl. 20th century
Born in Scotland in the late 19th century, she studied in France before the first world war and exhibited at the Nationale (1910-12) and the Salon des Artistes Français in 1913. She specialised in busts, statuettes and masks.

CHURCHILL, Lallah fl. 20th century
Of English origin, she worked in Trieste in the period between the world wars and produced masks, portrait reliefs, busts and small figures.

CIAMPI, Almondo 1876-
Born in Italy, he worked in the Florence area at the turn of the century and sculpted heads and busts. Examples of his work are preserved in the Florence Gallery of Modern Art.

CIAN or CIANCIANAINI, Fernand fl. 20th century
Born at Carrara in the late 19th century, he came to Paris and studied under Laporte-Blairsy and exhibited at the Salon des Artistes Français from 1911 to 1928. He produced busts and statuettes of contemporary and historical subjects, his best known works being his figures of Joan of Arc. A Mlle. J. Cian who exhibited small sculptures at the Salon des Artistes Français in 1913-14 may have been a sister.

CIANI, Guglielmo 1817-1890
Born at Castrocaro in Italy on May 20, 1817, he died in Perugia in 1890. He took up art against his parents' wishes and ran away from home to study sculpture in Florence. After some fourteen months there, he produced his first work, a statuette The Pastor which brought him the patronage of the Grand Duke of Tuscany and a 10-year pension. In 1853 he was appointed professor of sculpture in Perugia and spent the rest of his life there. He produced a number of busts and genre statuettes and groups.

CIANI, Vittore 1858-1908
Born in Florence in 1858, he died in Perth Amboy, U.S.A., in 1908. He studied under Monteverde in Rome and emigrated to the United States in 1896, settling in New York. He produced portrait medallions and busts as well as small figures and groups and was created a Knight of the Crown of Italy.

CIFARIELLO, Filippo 1865-1936
Born at Malfata in 1865, he died in Naples in 1936. He studied at the Naples Academy and attained a high reputation for his statuettes and monumental sculpture. He exhibited in Naples, Rome, Venice and Paris. Later he turned to busts of contemporary celebrities which were modelled in his vigorous and inimitable style. Apart from these his major works include Ad majorem Dei Gloriam (Barcelona) and the group of Christ and Mary Magdalene in the Museum of Modern Art, Rome.

CILA D'AIRE, Adrien Victor fl. 20th century
Born in Geneva at the beginning of this century, he worked in Switzerland and Paris in the inter-war period as a portrait sculptor. His busts and figures were carved direct in marble, or modelled in clay or plaster for casting in bronze.

CIMIOTTI, Emil 1927-
Born at Göttingen in 1927, he studied under Otto Baum at Stuttgart, Karl Hartung in Berlin and Ossip Zadkine in Paris. He won several prizes including the Massimo Prize in Rome and has exhibited widely in Europe since 1958. His bronzes are abstracts derived in part from groups of people fused together to form ghostly bushes and shrubs or strange submarine growths or wraiths tossed by a storm.

CINISELLI, Giovanni 1832-1883
Born at Novale in Lombardy in 1832, he died in Rome in 1883. He studied at Milan Academy and was a pupil of Logni, Sabatelli, Hayez, Antonio Labus and Antonio Gallo. He was noted for his allegorical and fantasy works which included The Lecture, The Ruses of Love, Aurora and the Dawn, Suzanne and Ruth. He won a medal for sculpture at the Melbourne Exhibition of 1881.

CIPRIANI, Giovanni Pinotti fl. early 20th century
Born in Naples at the end of the 19th century, he studied at the School of Fine Arts in Rome and was a pupil of Allouard. Later he moved to France and was subsequently naturalised. He exhibited heads and busts at the Salon des Artistes Français from 1903 onwards.

CIRASSE, Louis Joseph Félix 1853-1926
Born at Chartres on April 4, 1853, he died there in 1926. He studied at the École des Beaux Arts under Cavelier and exhibited at the Salon from 1874 onwards, only rising as high as an honourable mention two years before his death. He specialised in figures and groups of a historical or heroic nature, including Man Lying Down, Achilles, Henri Garnier and Thiers, Liberator of Territory.

CITARELLA, Francesco fl. 19th century
He worked in Naples in the mid-19th century and specialised in religious sculpture, busts and heads. He modelled the heads of the Evangelists for the Church of Santa Maria di Piedigrotto.

CITARELLA, Francesco Saverio fl. 19th century
Possibly the same person as the above. A sculptor of this name produced the figure of Love Asleep which was purchased by the King of Naples for the Galeria de Capodimonte.

CITRIN or CITRINOVICH, Jacob fl. 20th century
Born in Russia at the turn of the century he came to Paris after the Bolshevik Revolution and exhibited at the Salon d'Automne and the Tuileries in the late 1920s, specialising in statuettes and small groups.

CIVILETTI, Benedetto (Benoît) 1846-1899
Born in Palermo, Sicily, on October 1, 1846, he died on September 23, 1899. The son of very poor peasants, he had a hard struggle to become established, but by sheer perseverence he won through, to become one of the greatest Italian sculptors of the late 19th century. His first work, a figure of Mercury, attracted the favourable attention of Professor d'Antoni who subsequently guided his career. Later he studied under Delisi in Rome. He exhibited a figure of a Faun in Palermo (1863) and was awarded a state pension which enabled him to go to Florence and study under Dupré. He returned to Palermo in 1865 and thereafter specialised in monuments and memorials, though also producing a number of works illustrating the life of Christ, classical celebrities, historical figures and genre groups. His works were exhibited at the major Italian exhibitions, the Paris Salon and the Royal Academy (silver medal, 1880). He was a corresponding member of the French Institut and a Chevalier of the Legion of Honour. His works include First Souvenir, Little Dante, Life of Jesus, The Garden of Gethsemane, Julius Caesar and Canaris.

CIVILETTI, Pasquale fl. 19th century
Born in Palermo on July 26, 1859, the younger brother and pupil of Benedetto. His chief works include After the Offence, Fisherman, Evening in Sicily and Chastising the Child.

CLADEL, Marius Léon 1883-1948
Born at Sèvres on April 15, 1883, he died in January 1949. He studied under Bourdelle and exhibited at the Nationale and the Salon d'Automne. He specialised in bas-reliefs and statuettes of historical and contemporary personalities.

CLAIR, Pierre 1821-c.1855
Born at La Guillotière on March 9, 1821, he died about 1855. He studied under Cruchet at the École des Beaux Arts in 1840 and exhibited figures and groups at the Salon from 1844 to 1849.

CLAITTE, Philibert fl. 19th century
Born at Belleville in 1859, he exhibited at the Salon from 1882 to 1889, specialising in busts and heads. His bust of General Seriziat is in the Lyons Museum.

CLAPP, Elizabeth Anna 1885-
Born in Reading, Berkshire, in 1885, she studied art in Brighton and at the Regent Street Polytechnic. She worked in the London area and exhibited at the Royal Academy, the Royal Scottish Academy and the leading London and provincial galleries. She produced busts and heads and small decorative sculptures.

CLAPPERTON, Thomas John 1879-
Born in Galashiels on October 14, 1879, he studied at the Edinburgh College of Art and exhibited at the Royal Scottish Academy. His best known works are the twin statues of Robert the Bruce and William Wallace at the entrance to Edinburgh Castle (1929). He produced a number of contemporary and historical portrait busts.

CLARA, Juan 1875-
Born at Olot near Gerona in 1875, he specialised in figures and heads of children and worked in Spain and France at the turn of the century.

CLARAMUNT Y MARTINEZ, Augustin 1846-1905
He spent his entire life in Barcelona where he worked on Catalan monuments and memorials. One of the few exceptions to his monumental sculpture was his figure of Ishmael in the Wilderness, shown at the Madrid Exhibition of 1884.

CLARASO Y DAUDI, Enrico fl. 19th-20th centuries
Born at San Felix de Castellar in 1857, he produced decorative sculpture at the turn of the century. He was awarded a gold medal in Paris, 1900.

CLARET, Joaquin fl. early 20th century
Born at Camprodon in Catalonia at the end of the 19th century, he sculpted figures and reliefs, both genre and allegorical. He exhibited at the Nationale in Paris from 1911 onwards and also at the Tuileries in 1927.

CLARK, Allan 1896-
Born at Missoula in Montana in 1896, he studied under Albin Polasek at the Art Institute of Chicago and under Robert Aitken at the National Academy of Design in New York. He later became a teacher at the Beaux-Arts Institute of Design. He produced a number of bronze figures and groups, notably Ted Shawn's Antelope Dance, Nymph and Satyr.

CLARK, James H. fl. 20th century
Scottish sculptor working in Edinburgh between about 1927 and 1947. He exhibited at the Royal Scottish Academy (ARSA) and various provincial galleries.

CLARK, Michael 1918-
Born in Cheltenham on December 19, 1918, the son and pupil of the sculptor P. Lindsey Clark. He studied at the Chelsea School of Art from 1935 to 1937 and resumed his studies at the Kensington City and Guilds School after war service. He has exhibited at the Royal Academy since 1950 and was President of the Royal Society of British Sculptors. He has a studio in London, and works in stone and wood as well as bronze.

CLARK, Philip Lindsey 1889-
Born in London on January 10, 1889, he was the son of Robert Lindsey Clark. He studied art in Cheltenham (1905-10), the City and Guilds School, Kensington (1910-14) and the Royal Academy schools after service in the first world war. He exhibited at the Royal Academy from 1920 onwards and at the Salon des Artistes Français from 1921. His early work consisted largely of war memorials but he later worked on decorative sculpture for churches and cathedrals and worked on figures, groups and bas-reliefs in London.

CLARK, Russell fl. 20th century
One of the more prominent sculptors in New Zealand, he was a founder and first Vice President of the N.Z. Society of Sculptors (1962). He sculpts portrait busts, figures and reliefs, monuments, memorials and architectural sculpture.

CLARK, Walter A. 1848-1917
Born in Brooklyn in 1848, he died in Bronxville in 1917. He worked in New York as a painter and sculptor, producing figures and reliefs.

CLARKE, Dora (Mrs. Middleton) fl. 20th century
Born in Harrow at the turn of the century, she studied at the Slade School of Art under Harvard Thomas and Tonks and began exhibiting at the Royal Academy in 1922, and the Salon des Artistes Français, later concentrating mainly on the R.B.A. Her earliest sculptures were portrait busts and heads by private commission. In 1927-28 she travelled in East Africa gathering material which resulted in a series of bronzes and wood carvings of Kenyan tribesmen. Since then she has abandoned bronze as a sculptural medium and worked mainly in wood, ivory, stone and whale teeth, carving human figures.

CLARKE, Geoffrey Petts 1924-
Born at Darley Dale, Derbyshire, on November 28, 1924, he studied at the Royal College of Art in London and has exhibited at the Royal Academy, the leading London galleries and major international exhibitions since the second world war. He is one of the most accomplished artists of the present time, working in such disparate media as etching, drawing, painting, stained glass and sculpture. His work as a sculptor has combined glass and metal to produce abstracts which have found favour in recent years as ecclesiastical decoration.

CLARKE, Thomas Shields 1860-1920
Born in Pittsburg, Pennsylvania, in 1860, he died in 1920. He studied in Philadelphia and later enrolled at the École des Beaux Arts in Paris and finished his studies in Florence and Rome. He worked on portrait sculpture and statuettes at the turn of the century, and was a member of the National Sculpture Society and the American National Academy from 1902.

CLARKSON, George Henry fl. 20th century
He worked as a figure sculptor in the period between the world wars.

CLARKSON, Jack 1906-
Born in Silsden on July 7, 1906, he studied at Keighley School of Art (1921-27) and the Royal College of Art (1927-30) and exhibited at the Royal Academy and in the provinces. He later became head of the sculpture department at Sheffield College of Art and in 1944 became Principal of the School of Art in Newcastle, Staffordshire. He has worked as an oil painter and sculpts figures and groups in wood, terra cotta and bronze.

CLASGENS, Frederick fl. early 20th century
Born at New Richmond, Ohio, in the late 19th century, he studied at the Cincinnati Academy and later the École des Beaux Arts in Paris under Benet (sculpture) and J.P. Laurens (painting). Subsequently he worked as a landscape painter, but also sculpted expressive busts and genre figures, such as Spanish Water-carrier. His best known work is the fountain in Madison, Wisconsin.

CLASTRIER, Stanislas fl. late 19th century
Born at Marseilles in the mid-19th century, he studied under Jouffroy and Allar and exhibited at the Salon from 1878 to the end of the century.

CLATWORTHY. Robert 1928-
Born in Bridgwater, Somerset, in 1928, he studied at the West of England College of Art and the Chelsea School of Art from 1944 to 1950. Since then he has taken part in many national and international exhibitions. He specialises in figures and groups in which animal subjects are used in Expressionistic modelling which often approaches the Abstract. His best known work is the great Bull exhibited at Holland Park in 1957. Other figures depict horses, dogs and cattle.

CLAU, Antonin fl. 19th century
Born at Toulouse, he died in Paris in April 1898. He studied under Falguière and exhibited at the Salon from 1889 to 1898, winning an honourable mention in 1893. He specialised in bas-reliefs of nymphs and other classical subjects.

CLAUDEL, Camille 1856-1920
The sister of the poet Paul Claudel, she was born at Fère-en-Tardenois in 1856 and died about 1920. She studied under Rodin, Boucher and Dubois and exhibited at the Salon from 1888. Best known for her various busts of her brother, she also sculpted genre groups, such as The Gossips.

CLAUDET, Max 1840-1893
Born at Fécamp on August 18, 1840, he died at Salins on May 28, 1893. He studied under Perraud and Jouffroy at the École des Beaux Arts and settled in Salins. He exhibited at the Salon from 1864 to 1893. He produced many public statues and groups, several of which were edited as small bronzes and the best known of these is his figure of Cain (1868). He was equally versatile as a painter and ceramicist and also wrote a critical biography of Gustave Courbet.

CLAUGHTON, Richard Bentley 1917-
Born in London on February 28, 1917, he studied at the Slade School of Art under Schwabe from 1946 to 1949 and has since exhibited at the Royal British Academy and the leading provincial galleries. He works in London and carves in wood and stone as well as working in metal.

CLAUSADE, Louis 1865-1899
Born in Toulouse in 1865, he died in Paris on December 19, 1899. He studied under Falguière and exhibited at the Salon from 1884 to 1898. His best known works are the statue of Beaumarchais in the Rue St. Antoine, Paris, the monument to Carnot in Lyons and the allegory of Roman Art on the façade of the Grand Palais. He died of a cerebral haemorrhage while working on the site of the Exposition 'Universelle of 1900. This promising young sculptor also left a number of statuettes and bas-reliefs, small groups and busts.

CLAVELIN, Paul fl. early 20th century
Born in Rio de Janeiro in the late 19th century of French parentage, he specialised in animal figures and groups, with a bias towards the more exotic creatures of South America.

CLAY, Mary F.R. fl. 19th-20th centuries
Born in Philadelphia in the late 19th century, she studied sculpture under Collin and MacMonnies in Paris and painting under William Chase. She won the Mary Smith Prize of the Pennsylvania Academy in 1900 and was an Associate of the Plastic Club of America. She produced figurines and portrait sculpture.

CLEMENCIN, François André 1878-
Born in Lyons on October 7, 1878, he studied under Coutan and exhibited at the Salon des Artistes Français from the beginning of this century till the late 1930s. He won a second class medal in 1921 and a gold medal in 1930, and was also made a Chevalier of the Legion of Honour.

CLEMENS, Benjamin c.1875-1957
Born in London about 1875, he died there on December 27, 1957. He studied at the Royal College of Art and later worked as assistant to Lanteri. He exhibited at the Royal Academy from 1903 onwards and took part in the Rome Exhibition of 1911, as well as exhibiting in the London and provincial galleries. He produced a number of memorials, statues, figures and small groups, busts and portrait reliefs.

CLEMENT, Auguste Roger fl. 20th century
Born at Cadenet in the late 19th century, he studied under Th. Cartier and exhibited at the Salon des Artistes Français in 1921.

CLEMENT, Jean fl. 20th century
Born at Belâbre in the late 19th century, he became an Associate of the Société des Artistes Français and won an honourable mention at their salon in 1922. He specialised in portrait sculpture.

CLEMENT, Jules 1800-1871
Born at Grandcamp on June 8, 1800, he died in Paris in 1871. He studied under Dantan the Younger and exhibited at the Salon from 1866 to 1872, specialising in busts, heads and portrait reliefs.

CLEMENT, Marie Therese fl. 20th century
Born in Paris at the beginning of the century, she exhibited at the Paris salons from 1935 to 1943 and specialised in busts and nude statuettes.

CLERC, Georges Albert Jehan fl. 20th century
Born in Paris at the beginning of the century, he studied under Fromental and exhibited at the Salon des Artistes Français in 1928-29. He specialised in heads of children.

CLERC, Sylvestre 1892-
Born at Toulouse on December 31, 1912, he studied under Coutan and exhibited at the Salon des Artistes Français, winning a third class medal in 1923 and a second class five years later.

CLERE, Georges Prosper 1819-1901
Born in Nancy on November 9, 1819, he died there in 1901. He studied under Rude and exhibited at the Salon from 1853 onwards. Much of his later work consisted of monuments, friezes and façades carved in stone, but he also produced several small classical or historical groups, such as Histrion and Hercules strangling the Nemean Lion, Maloine at the Grave of Oscar and the figure of Joan of Arc in the Châteaudun Museum.

CLERGET, Alexandre fl. 19th-20th centuries
Born at St. Palais on September 20, 1856, he exhibited at the Salon des Artistes Français from 1891 to 1924, winning a third class medal in 1897 and a second class in 1910. He produced busts and small historical groups and figures.

CLERGET, Marie Henriette fl. 20th century
Born in Paris at the beginning of this century, she studied under Sicard and Rivoire and exhibited statuettes at the Salon des Artistes Français.

CLERIAN, Josephine fl. 19th century
She was the daughter of the painter Louis Clerian and wife of the sculptor Bondoux with whom she worked in Marseilles on groups and statuary.

CLERIN, Celine Henriette fl. 20th century
Born in Paris, she studied under J. Boucher and exhibited busts and heads at the Salon des Artistes Français in 1924-5.

CLERK, Janet fl. 20th century
Born in Barton, Yorkshire, at the beginning of the century, she worked in England and France in the inter-war period as a painter and sculptor of figurines and small groups. She exhibited at the Tuileries, the Salon des Indépendants and the Salon des Artistes Français from 1929 to 1939.

CLERK, Oscar de 1892-
Born in Ostend on December 11, 1892, he became a member of the Royal Society of Fine Arts of Belgium and worked his way through the various artistic styles of the 20th century, producing figures and groups in the cubist, impressionist, expressionist and surrealist idioms in turn.

CLESINGER, Jean Baptiste (known as Auguste) 1814-1883
Born in Besançon on October 20, 1814, he died on January 6, 1883. He was the son and pupil of Georges Philippe Clesinger, a monumental sculptor and stone mason. He began exhibiting at the Salon in 1863, making his debut with a marble bust of the Vicomte Jules de Valdahon. He specialised in portrait sculpture and is best known for the colossal bust of Liberty on the Champ de Mars. He won numerous medals and was created an Officier of the Legion of Honour in 1864. He married the daughter of Georges Sand and moved in fashionable circles during the Second Empire, bringing him many commissions for portrait busts from the celebrities of that period. Most of his work was sculpted in marble but several of the busts were also cast in bronze. Among his other bronzes are the figures of Orestes and Iphigenia and the maquette for a statue to the Huguenot leader Admiral Coligny.

CLEVE, Franz 1889-
Born in the Lower Rhineland, he studied under Eberle and worked in Munich on monuments and heroic statuary as well as small groups in the same idiom, popular at the beginning of this century as table ornaments.

CLEVERGER, Shobald Vail 1812-1843
Born in Middletown, Ohio, in 1812, he was drowned at Gibraltar in 1843. He was a prolific sculptor of busts, heads and portrait reliefs of his American contemporaries.

CLIFF, Thomas James fl. 19th-20th centuries
Born in London on August 19, 1873, he exhibited at the Royal Academy at the turn of the century and specialised in portraits and statuettes.

CLIVILLES Y SERRANO, Francisco 1873-
Born in Madrid, he studied under J. Samso and exhibited groups and figures at Madrid from 1895 onwards.

CLODION (Claude Michel) 1738-1814
Born in Nancy, a descendant on his mother's side from the Adam family of Lorraine sculptors. He was a prolific producer of statuettes, terra cotta figurines and small groups, often very erotic and much appreciated by his contemporaries. His best known works include Young Girl playing with Birds, The Bather, Young Nymph putting on the Cothurnis and numerous versions of Bacchantes and Fauns. He also decorated porcelain vases with reliefs of cupids and bacchanalian revels. His satyrs, centaurs, naiads and nymphs are characteristic of the classical sculpture of France before the Revolution. He tried to adapt to the sterner ideals of the Revolutionary period, but was less successful with his figures of Julius Caesar, Alexander and the other heroes of antiquity, which came into fashion in the Napoleonic era.

CLOSTERMANS, José 1783-1836
Born at Alcora near Valencia in 1783, he died in Valencia in 1836. He specialised in religious statues and figurines and ecclesiastical ornament for the churches of Jaltiva and Aldiva and the monasteries of Valencia.

CLUYSENAAR, John Edmond 1899-
Born in Brussels on September 27, 1899, he won the Prix de Rome and later became a member of the Royal Society of Fine Arts of Belgium. He produced busts, reliefs and figures.

CLUZEL, Jean Jules Désiré fl. 19th century
Born at Chartres on March 31, 1852, he studied under Chenillion at the École des Beaux Arts. He specialised in portrait busts and heads and his work is represented in the museum at Chartres.

COATON, Helen Mary fl. 20th century
Born in England at the beginning of this century, she studied under Percy Brown and won the Hinton Prize of the Leicester Society of Artists in 1942. Her sculptures are preserved in the Leicester Museum.

COBB, Cyrus 1834-1903 **and Darius** 1834-1919
Twin brothers, born in Malden, Massachusetts, who worked together as painters and sculptors of monuments, statues, busts and reliefs. Cyrus died at Allston and Darius at Newton Upper Falls.

COCCIA, Francesco fl. 20th century
Sculptor of figures, bas-reliefs, busts and monuments working in Italy since the second world war. His best known work is the Martyrs monument in the Ardeatine Caves.

COCHEY, Claude fl. 19th century
Born in Nuits in France, he died in Constantine, Algeria, in 1881. He studied under Dameron at the School of Fine Arts in Dijon, and later exhibited at the Salon, from 1874 to his death. He specialised in portrait sculpture.

COCHI, Vincenzo fl. 19th-20th centuries
Born at Florence in 1855, he worked in Italy and France at the turn of the century. He won honourable mentions at both Expositions of 1889 and 1900 and exhibited at the Paris Salons from 1914 onwards, specialising in small groups.

COCKERELL, Samuel Pepys fl. 19th-20th centuries
Born at Hendon in 1844, the son of the architect Charles Robert Cockerell. He exhibited at the Royal Academy from 1874 to 1903 and also took part in the exhibitions at Suffolk Street and the Grosvenor Gallery. He was a painter and sculptor of portraits and genre subjects.

COCLEZ, Arthur fl. 19th century
Born at Bellicourt in France, he died in Paris at the end of 1882. He studied under Salmson and Jouffroy and exhibited at the Salon from 1880 onwards. He specialised in genre and heroic figures and groups, such as The Shipwreck (1881).

CODREANO, Irene fl. 20th century
Born in Bucharest at the end of the 19th century, she studied under Brancusi and A. Bourdelle in Paris. She settled in Paris in 1919 and was a founder member of the Salon des Tuileries, as well as exhibiting regularly at the Salon d'Automne in the 1920s. She sculpted figures and groups and her work is preserved in various public collections, including the Musée de Jeu de Paume (Paris), the Pinakothek and Toma Stelian (Bucharest) and the Liège Museum.

COEFFARD, Louis André 1818-1887
He worked mainly in the Bordeaux area and specialised in busts and heads of his contemporaries. His bust of Félix de Verneilh is in the Perigueux Museum.

COEFFIN, Josette fl. 20th century
Born in Rouen in the early years of this century she specialised in animal studies, particularly figures and groups of birds.

COETLOGON, Yves de fl. 20th century
Born in Paris, he exhibited at the Salon d'Automne in the 1930s. He specialised in animal and bird figures and groups as well as neo-classical statuettes such as Discus Thrower.

COFFEE, H. 1795-c.1870
Born in Lambeth, London, on May 14, 1795, he was probably a son of the monumental sculptor William Coffee. He exhibited at the Royal Academy from 1819 to 1845, various works in marble or wax, the latter subsequently being cast in silver or bronze as presentation pieces and table ornaments. He specialised in hunting scenes, such as Death of a Boar.

COFFIN, Fernand d. 1946
Born in Paris in the late 19th century, he died there in June 1946. He exhibited at the Salon des Artistes Français before the second world war and specialised in genre figures. such as The Intruder (1929).

COGIOLA, Jean Ange (Giovanni Angelo) 1768-1831
Born in Turin in 1768 he later moved to France and died in Paris in 1831. He exhibited at the Salon from 1808 to 1817 and specialised in portrait busts and medallions.

COGNASSE, Paul fl. 20th century
Born in Angoulême at the beginning of this century, he exhibited figures at the Salon d'Automne and the Tuileries in the inter-war period.

COGNÉ, François Victor fl. early 20th century
Born in Aubin at the turn of the century, he studied under Barrias and Puech and exhibited at the Salon des Artistes Français from 1909, winning a third class medal in 1921. Later he switched to the Nationale and exhibited there after the first world war. He specialised in busts and heads of contemporary figures, such as Clémenceau, Mussolini, Maréchal Foch, Lyautey, the Prince of Monaco, Cardinal Verdier, General Dubail, Louis Barthou and Albert Sarraut. His many public commissions brought him the rank of Officier in the Legion of Honour.

COHEN, Ellen Gertrude fl. 19th-20th centuries
Born in London in the mid-19th century, she studied in Paris under B. Constant, J.P. Laurens and R. Collin and exhibited oil paintings, watercolours and sculpture at the Royal Academy and the New Water Colours Society from 1881, and at the Salon des Artistes Français from 1897 to 1939.

COHEN, Katherine 1859-1914
She spent her entire life in Philadelphia, where she worked as a painter and sculptor of genre subjects.

COHEN, Nessa fl. early 20th century
Born in New York, she studied under James Earle Fraser and the Cooper Union and Art Students' League, later specialising in small genre bronzes, such as Moment Musicale.

COHN, Ola fl. 20th century
Born in Bendigo, Australia, at the turn of the century, she came to London after the first world war and studied there and in Paris where she exhibited at the Nationale in 1929-30. She produced busts and statuettes.

COIN, Robert Fleury 1901-
Born at St. Quentin on December 17, 1901, he studied under Injalbert and won the Grand Prix de Rome in 1929. He exhibited figures and groups at the Salon des Artistes Français in the inter-war period, winning a third class medal in 1926 and a second class medal in 1932.

COLAROSSI, Filippo fl. 19th century
Sculptor of historic and romantic figures and groups, working in Italy in the second half of the 19th century. He exhibited in Italy and also at the Salon des Artistes Français in 1885-9.

COLAS, Charles Tranquille 1839-c.1890
Born in Cambremer on February 1, 1839, he died about 1890. He studied under Gérome and Jouffroy and exhibited at the Salon from 1869 to 1890. He specialised in heads, portrait reliefs and busts.

COLE, A. Ernest 1890
Born at Greenwich on July 9, 1890, he studied at Goldsmiths' College school of Art and later finished his studies in Italy and Paris. He was professor of sculpture at the Royal College of Art from 1924 to 1926 and later established a studio near Canterbury. He has exhibited widely and his sculptures are represented in several public collections.

COLE, Laurie 1890-
Born in the United States on November 6, 1890, she studied at Columbia University and subsequently studied art in Paris and Düsseldorf. She works as a painter and engraver as well as collaborating with her husband in sculpture and has exhibited at the Royal Academy, the Royal Glasgow Institute, the Salon des Artistes Français and Columbia University.

COLEMAN, Alan 1920-
Born in Croydon, Surrey, he studied at Goldsmiths' College School of Art and the Royal College of Art and now works near Guildford. He was elected R.B.A. in 1952 and F.R.B.S. in 1961.

COLIN, Georges 1876-
Born at Vincennes on April 26, 1876, he studied under Valton and Thomas and exhibited at the Salon des Artistes Français at the turn of the century. He produced figures, animal studies and portraits.

COLIN, Paul Herbert fl.19th century
Born in Paris on August 3, 1801, he studied at the École des Beaux Arts from 1820 under Bosio and Romagnesi. He exhibited at the Salon from 1833 to 1840. He became professor of sculpture and ornamental design at Nimes in 1836 and produced a number of public monuments and ecclesiastical statues for that town. His minor works include small figures and busts and his work is preserved in the museums of Nimes and Douai.

COLINET, Claire Jeanne Roberte fl. early 20th century
Born in Brussels at the turn of the century, she studied under Lambeaux and settled in France where she exhibited at the Salon des Artistes Français from 1913 and at the Indépendants from 1937 to 1940. She specialised in female statuettes and small groups in the chryselephantine tradition, the bronze frequently being gilded or enamelled and the features carved in ivory.

COLLADO Y TEJEDA, Pedro fl. 19th century
Born in Madrid in 1829, he studied under Jose de Tomas and Mariano-Bellver before going to Italy in 1855 where he continued his studies in Rome, Naples, Florence, Milan and Venice. Following his return to Spain in 1858 he exhibited regularly in Madrid till the end of the 19th century and specialised in historical and genre figures and portrait sculpture.

COLLE, Charles Alphonse 1857-1933
Born in Charleville in 1837, he died about 1933. He studied under Croisy and exhibited at the Salon des Artistes Français from 1880 to 1922, working mainly in portraiture and statuettes.

COLLET, Edouard Louis 1876-
Born in Geneva on August 4, 1876, he studied at the School of Industrial Arts in Geneva and later was a pupil of Dampt in Paris. He became professor of woodcarving and furniture at Geneva and a member of the Société des Artistes Décorateurs in Paris. He exhibited at the Nationale in Paris and also the Swiss National Exhibition in Basle, 1908. Apart from his wood carvings he produced various statues and monuments including the war memorial at St. Germain-Beaupré.

COLLI, Alois fl. early 20th century
Born at Buchenstein in the Tyrol in the late 19th century, he worked in Merano at the beginning of this century and is best known for his group, Apotheosis of the Empress Elisabeth of Austria, preserved in Merano Museum.

COLLIN, Albéric fl. 20th century
Born in Antwerp at the turn of the century, he worked as an Animalier sculptor in the inter-war period. He exhibited at the Salon des Artistes Français from 1922 to 1927 and won a third class medal in 1922.

COLLIN, André fl. late 19th century
He worked in Liège in the second half of the 19th century, producing genre figures and groups. His wife, Madame J. Collin, exhibited sculpture at the Salon des Artistes Français in 1913-14.

COLLINA, Giovanni Battista 1792-1873
Born in Parma in 1792, he died in Paris in 1873. A pupil of Sbravati, he specialised in portrait busts of Italian personalities, such as P. Rubini and Angelo Mazza, and also did a series of paintings for the Cathedral of Parma. His sons, Giuseppe (born at Faenza in 1847) and Raffaele (born at Faenza in 1853) were both modellers in faience in the late 19th century and their figurines and small groups are preserved in the Ferniani Museum in Faenza.

COLLINGWOOD, Barbara Crystal 1887-1961
The younger daughter of the painter William G. Collingwood, she married Oscar Gnosspelins, a surveyor and engineer. She specialised in portrait sculpture and executed numerous busts and heads of her father's artistic coterie, including John Ruskin. She was President of the Lake Artists' Society from 1932 to 1946.

COLLINS, William fl. 18th century
He worked in Driffield, Yorkshire, and in London where he died on May 31, 1793. He was a portrait sculptor and a close friend of Gainsborough, and was a prominent member of the Saint Martin's Lane Academy. Oliver, in his *History of Beverley* mentions life-sized figures of St. John of Beverley and King Athelstan, sculpted in lead by William Collins about the year 1731, and also states that he modelled figures of animals, 'but for want of patronage he passed his days in obscurity and wretchedness and was frequently reduced to absolute indigence.'

COLLORIDI fl. 20th century
Born in Milan at the beginning of the century he worked in Italy and Paris in the inter-war period. His figures and groups bear his surname only.

COLO-LEPAGE, Ciad fl. early 20th century
Born in Warsaw in the late 19th century, she came to France and eventually settled in Tunis. She specialised in statuettes and portraits of Bedouin tribesmen, which she exhibited at the Paris salons from 1911 to 1914.

COLOMBIER, Amélie fl. early 20th century
She exhibited figurines at the Salon des Artistes Français from 1911 to 1920.

COLOMBO, Ambrogio 1821-c.1890
Born in Milan, he was a prolific and versatile sculptor in genre, classical, historical and contemporary portrait media and exhibited in Milan, Turin and Venice from 1870 to 1887.

COLOMBO, Pierre 1905-
Born in Tunis on June 19, 1905, he studied at the School of Fine Arts in Tunis and later studied in Antwerp. He made his début at the age of thirteen and continued to exhibit in the Paris salons till 1947. He worked mainly in wood and his best-known works are Demosthenes, Jesus and the Moneylenders, Dante and Farewell.

COLOM-DELUSC, Antoine fl. 20th century
Born at Moussages in Cantal in the early years of this century, he studied under Champeil and Pourquet and exhibited statuettes at the Salon des Artistes Français from 1928 to 1930.

COLONNA-CESARI, Joseph fl. 19th century
Born at Porto Vecchico in Corsica in the 19th century, he worked in Paris and exhibited at the Salon from 1880 to 1883. He sculpted portrait busts in terra cotta and bronze.

COLTON, William Robert 1867-1921
Born in Paris on December 25, 1867, he died in Kensington on November 13, 1921. He returned to England with his parents in 1870 and studied at the Lambeth School of Art, the Royal College of Art and the Royal Academy schools. He returned to Paris in 1899, exhibited at the Salon and won a silver medal at the Exposition Universelle of 1900. He became a teacher of sculpture at the Royal Academy schools (1907-12) and also at the Royal College of Art. His work was very fashionable at the turn of the century, and he ranged from public monuments to portrait busts and classical and genre statuettes. He exhibited regularly at the Royal Academy (A.R.A., 1903, R.A. 1919) and was President of the Royal Society of British Sculptors at the time of his death. His works include The Wavelet (Tate Gallery) and The Springtide of Life.

COLVIN, Marta 1917-
Born at Chillan in Chile in 1917, she studied at the Santiago Academy and settled in Paris in 1948 where she joined the Académie de la Grande Chaumière and studied under Zadkine. She has also been strongly influenced by Laurens and Brancusi and worked with Henry Moore in 1952. In the late 1950s she travelled widely in Europe and Latin America and was inspired by the primitive art of the Pacific Islands to turn to wood carving of non-figurative sculpture. Since then she has worked almost exclusively in wood. Her figures and groups in stone, terra cotta and bronze belong to the period up to 1957.

COMANDIN, Mario fl. 20th century
Born at Cesena in Italy early this century, he worked in France in the inter-war period and exhibited figures and busts at the Salon d'Automne.

COMBARIEU, Frédéric Charles 1834-1884
Born in Paris on October 9, 1834, he committed suicide in July 1884. He studied under Dumont and Bonnassieux and exhibited figures and groups at the Salon in 1868 and 1878.

COMBESCOT, Albert fl. early 20th century
Born in Paris in the late 19th century, he studied under Falguière and Marqueste and exhibited small sculptures at the Salon des Artistes Français from 1911 to 1921.

COMENDADOR, Enrico fl. 20th century
Born in Spain, where he worked in the first half of this century as a sculptor of portrait reliefs, busts and heads.

COMERRE—PATON, Jacqueline fl. 19th century
Born in Paris on May 1, 1859, she studied under Cabanel and worked aminly as a painter, though she also sculpted genre busts and heads, such as Young Soubrette.

COMES, Albert 1887-
Born at Neunkirchen, Germany on October 14, 1887, he worked in Strasbourg, Munich, Berlin and Paris (studying under Rodin in the last-named city). He sculpted portrait reliefs and busts of contemporary celebrities, his best known work being his portrait of Paul Kruger.

COMETTI, Giacomo fl. 19th century
Born in Turin on October 23, 1863, he studied at the Academy of Fine Arts in that city and later became professor at the School of Industrial Arts in Turin. He exhibited figures and groups in the Italian exhibitions and won a medal at the Antwerp Exhibition of 1894.

COMEYN, Polydor fl. 19th century
Born at Ypres, Belgium in 1848, he studied in Brussels and exhibited there and in Berlin at the turn of the century. He specialised in genre figures, such as Little Mother (Ghent Museum).

COMMUN DU LOCLE, Henri Joseph du (known as Daniel) 1804-1884
Born at Nantes on April 15, 1804, he died in Rethel in 1884. He studied in Paris under Bosio and Cortot at the École des Beaux Arts and exhibited at the Salon from 1839 to 1863, winning various medals (1839-49) and attaining the rank of Officier in the Legion of Honour (1865). He sculpted portraits, genre figures and historical groups.

COMOLERA, Paul 1818-1897
Born in Paris, he studied under Rude and exhibited at the Salon from 1847. He worked exclusively as an Animalier sculptor, making his début with a study of a Golden Pheasant. His later works ranged from

domestic animals to game birds, mainly modelled in the natural manner, but including a symbolic *Reveil de la Gaule*, the Gallic Cock crowing. His works were cast in bronze and some of them were also reproduced in faience by Boulanger of Choisy-le-Roi.

COMOLÈRA, Paul C. fl. late 19th century
Son and pupil of the above, he studied also under A.A. Dumont and exhibited animal studies at the Salon from 1870 to 1887.

COMOLI, Giovanni Battista 1775-1830
Born at Valenza, Italy, in 1775, he died in Milan on September 16, 1830. He studied in Rome but later spent many years abroad. For some time he worked in Grenoble and sculpted a number of busts of contemporary personalities for the library of that town. About 1800 he became professor of sculpture at Turin Academy. The Versailles Museum has his bust of Eugène de Beauharnais.

COMPAN, Henri Eugène fl. 19th century
He worked in Paris in the latter part of the 19th century and exhibited at the Salon from 1880 to 1900. Best known for his paintings of still-life, and the friezes and murals he executed for the Paris Town Hall, he also sculpted portrait busts and heads of contemporary figures.

COMPÈRE, Marcel Paul Charles fl. early 20th century
He worked in Paris in the early years of this century, exhibiting busts and figurines at the Salon des Artistes Français and the Salon of the Société Nationale des Beaux Arts.

COMSTOCK, Frances Bassett 1881-
Born at Elyria, Ohio, in 1881, he worked in America as a painter, magazine and book illustrator and sculptor of genre subjects at the turn of the century.

CONANT, Sylvia Ferguson fl. 20th century
Born in the United States at the beginning of this century, she came to Europe to study and settled in France in the inter-war period. She specialised in busts and portrait bas-reliefs, which she exhibited at the Nationale and the Tuileries from 1928 to 1935.

CONDAMIN or COND'AMAIN, Joseph Henri fl. early 20th century
Born at Lyons in the late 19th century, he studied under Bonirote in Lyons and Cabanel in Paris. He exhibited at the salons of Lyons and Paris, mainly as a painter of portraits, still-life, landscapes and genre subjects, but also sculpted heads, busts and portrait reliefs.

CONDÉ, André Affolter 1920-
Born at La Chaux de Fonds, Switzerland, in 1920, he studied at the local art school and won a Swiss federal scholarship in 1943. He taught drawing in La Chaux de Fonds and Neuchâtel before moving to Paris after the second world war. He worked with Germaine Richier from 1946 to 1948. In this period he worked in terra cotta and bronze, but from about 1950 he turned away from figurative to abstract sculpture and worked mostly in marble, stone and wood. More recently he has concentrated on welded copper, iron and brass in the construction of architectural abstracts. He has exhibited at the Salon de la Jeune Sculpture and the Salon des Réalités Nouvelles.

CONDOY, Honorio Garcia 1900-1953
Born in Saragossa, Spain, he died in Madrid after a long illness. He worked in the studio of a sculptor in Barcelona and spent a year (1929) in Paris where he came under the influence of Laurens, Arp, Brancusi and Zadkine. He won the Prix de Rome in 1933 and worked in Italy till 1936. Prevented by the Civil War from returning home, he worked in Belgium and then in France. His earlier Cubist works gave way to a more realistic approach to figures and busts. Later he turned to Expressionism and latterly to pure Abstract art. To the period from 1936 to 1945 belong his works in terra cotta and bronze, including Bacchante (1944) and Marseillaise of the Liberation (1945).

CONFALONIERI, Francesco fl. late 19th century
Born in Milan, he exhibited in Rome in 1883 and later took part in the Paris salons at the turn of the century. He sculpted figures and groups of neo-classical and allegorical subjects.

CONKLING, Mabel 1871-
Born at Bootbay, Maine, in 1871, she studied drawing at the Académie Julian under Bouguereau (1895) and sculpture at the Académie Vitti under Collin (1899). The following year she worked for a time with MacMonnies and later sculpted several bronze or bronzed plaster statuettes, such as Temptation and The Lotus Girl.

CONKLING, Paul 1871-
Born in New York City in 1871, he studied at the Kensington School of Art in London and at the École des Beaux Arts in Paris, later working in the ateliers of Falguière and MacMonnies. He specialised in portrait reliefs, medallions, busts and heads of American and French personalities of the turn of the century.

CONLON, George fl. early 20th century
Born in Maryland in the late 19th century, he studied under Bartlett and later, in Paris, under Landowski, Bouchard and Injalbert. He settled in Paris where he exhibited at the Salon des Artistes Français from 1913 to 1934, specialising in busts and heads.

CONNE, Louis fl. 20th century
Born at Oerliken near Zürich at the beginning of this century, he studied in Paris and exhibited groups and statuettes at the Salon d'Automne and the Indépendants in the late 1920s.

CONNOR, Jerome 1875-
Born in Ireland on October 12, 1875, he emigrated to the United States with his family while still in infancy. Later he worked as a sculptor of monuments, statues and busts in Philadelphia and New York.

CONNY, Julien Edouard, Baron de fl. 19th century
Born at Moulins near Paris on May 29, 1818, he studied under Dantan the elder and Etex and sculpted historic and neo-classical figures. He was awarded second class medals at the Salons of 1861 and 1866.

CONOLLY, Francis U. fl. mid-19th century
He worked in London and exhibited at the Royal Academy from 1849 to 1870. He specialised in genre and classical statuettes, such as Sappho and Girlhood.

CONRADSEN, Harald 1817-1905
Born in Copenhagen on November 17, 1817, he died there on March 11, 1905. He studied at the Copenhagen Academy and became one of the most fashionable sculptors in 19th century Denmark. He was made a Knight of the Dannebrog in 1860 and was an Honorary Member of the St. Petersburg Academy from 1873 onwards. He specialised in portrait medallions and reliefs, busts and heads of contemporary figures, but also sculpted classical, biblical and genre figures and groups.

CONRART, Ilse 1880-
Born in Vienna on January 20, 1880, she studied in Brussels under Van der Stappen. She specialised in busts, heads and portrait reliefs. Her best known work is the tomb of Johannes Brahms in Vienna.

CONSAGRA, Pietro 1920-
Born in Mazara, Sicily, in 1920, he studied at the Academy of Fine Arts in Palermo and settled in Rome in 1944. He spent some time in Paris in 1946 and had his first one-man show at the Galleria Mola in Rome the following year. Later the same year he helped to found the first postwar group of non-figurative artists in Italy. Since 1950 he has exhibited in many parts of Europe and America. He works in bronze and wrought iron and has also experimented with unusual techniques such as scorched wood. He took part in the international competition of 1953 for the monument to the Unknown Political Prisoner. His bronzes show great attention to surface textures, polished areas contrasting sharply with the patinated portions, and include Oracle of the Chelsea Hotel and Dialogue at San Angelo.

CONSANI, Vincenzo 1815-1887
Born at Lucca in 1815, he died in Florence on June 29, 1887. He studied in Florence and specialised in portrait busts. His works are in the Gallery of Modern Art in Florence.

CONSONOVE, Antoine François Boniface 1812-1882
Born at Aix in 1812, he died in Paris in 1882. He studied at the Schools of Fine Arts in Paris and Florence and exhibited at the Salon from 1872 till his death. His work included many important state commissions for monuments and decorative sculpture and his best known work is the monument to Laura and Petrarch at Avignon. He sculpted portrait busts and roundels of historic personalities.

CONSTANCIEL, Jean fl. 19th century
Born at Fleurs on October 6, 1827, he studied at the École des Beaux Arts and exhibited at the Salon from 1861 to 1877. He specialised in bas-reliefs and figurines of a religious nature.

CONSTANT, Amedée fl. 19th-20th centuries
Born at Libourne in the mid-19th century, he studied under Cogniet and Chiffart and exhibited at the Salon from 1874 onwards. He is best known as an enameller, but he also sculpted statuettes and small groups.

CONSTANT-BRULÉ fl. 20th century
Born at Dammartin-en-Goüle in the early years of this century, he exhibited bas-reliefs, statuettes and busts at the Salon des Artistes Français in 1935-38.

CONSTANTINESCO, Marc 1900-
Born at Charlottenburg in Berlin on June 29, 1900, of Romanian parentage, he worked in Romania and later in France. He founded the Museum of Popular Art in Bucharest and produced a wide range of sculpture from the portrait to the non-figurative. Since the second world war he has had many state commissions, such as the monument to the Peasant Uprising of 1907.

CONSTANTINIDES, Lea fl. 20th century
Born in Athens, she studied in Paris under Navellier and exhibited at the Salon des Artistes Français in 1928. Later she returned to Greece, where she worked as a sculptor of busts, reliefs, figures and groups.

CONTAUX, Georges fl. 20th century
He worked in France in the early years of this century, specialising in medallions and bas-reliefs.

CONTE, Carlo 1898-
He worked in Italy in the first half of this century as a sculptor of portraits and statuettes, such as Woman twisting her Hair (1941).

CONTESSE, Gaston Louis Joseph 1870-1946
Born in Toulouse on December 28, 1870, he died in 1946. He studied under Falguière and Mercié and won a travelling scholarship in 1901. He exhibited at the Paris salons from 1901 onwards and specialised in genre and classical statuettes (Bather, Faun, etc.) and numerous portrait busts.

CONTI, Alessandro fl. 19th-20th centuries
He worked in Milan at the turn of the century and had a high reputation for excellent portraiture. He specialised in heads and busts of contemporary personalities.

CONTI, Angelo fl. 19th century
Born at Ferrara in the mid-19th century, he worked in Rome and specialised in monuments and memorials. He also produced a number of busts, including those of Garibaldi and King Victor Emmanuel II. His works are preserved in Ferrara Museum.

CONTI, Vincenzo fl. 19th century
Born at Sulmona, where he later worked as an engraver and painter as well as sculptor of genre figures.

CONTINI, Massimiliano fl. late 19th century
Born at Foggia, Italy, about 1850, he exhibited statuettes and small groups in Italy and France from 1883 to 1895.

CONTOUR, Alphonse Jules 1811-1888
Born in Paris in 1811, he died there in 1888. He studied under Barye and exhibited animal figures and groups at the Salon from 1842 to 1846 and from 1868 to 1875.

CONTRATTI, Luigi fl. early 20th century
Born in Brescia at the turn of the century, he worked in Turin as a portrait sculptor.

CONTRERAS, Jesus fl. late 19th century
Born in Mexico, where he died in 1902. He sculpted figures, groups and busts and exhibited in Mexico, the United States and France from 1880 to 1900, winning a Grand Prix at the Exposition Universelle.

CONVENTI, Francesco fl. late 19th century
Born at Naples in 1855, he studied under Angelini and later studied at the Academy of Fine Arts in Naples. He specialised in genre figures and groups, such as Shepherd in Contemplation and Neapolitan Flower-seller.

CONVERS, Louis J. 1860-1919
Born in Paris, he studied under Aimé Millet, Cavelier and Barrias and won the Prix de Rome in 1888. He won medals at the Salons of 1892 and 1894, a gold medal at the Exposition Universelle of 1900, and was made a Chevalier of the Legion of Honour. His works consisted of genre, allegorical and biblical subjects and included The Enigma, Justice, The Legend and the Passing, and Salome.

CONWAY, John Severinus fl. 19th-20th centuries
Born at Dayton, Ohio, in 1852 he worked in the United States at the turn of the century as a painter and sculptor of genre subjects.

CONWAY, William John 1872-
Born at St. Paul, Minnesota, he worked in the early 20th century as a painter and sculptor of portrait busts, reliefs and medallions.

CONY, Jean Baptiste 1828-1873
Born at Panissières in 1828, he died at Lyons in 1873. He studied under Ruolz and worked as a sculptor of figures and groups in the Lyons area.

COOD, Mlle. E.M. fl. early 20th century
A sculptress of this name exhibited small bronzes at the Salon des Artistes Français in 1912.

COOK-SMITH, Jean Beman 1865-
Born in New York, she worked as a painter, illustrator and sculptor of genre subjects.

COOKE, Jean (Mrs. Bratby) 1927-
Born in London on February 18, 1927, she was educated at Blackheath High School and later studied painting and sculpture at the Central School of Arts and Crafts, the Goldsmiths' College School of Art, the Camberwell School of Art, the City and Guilds and the Royal College of Art. She married the painter John Bratby in 1953 and lectures at the Royal College of Art. She is a painter of portraits and still-life, and a ceramicist as well as modeller and sculptor of heads and figures.

COOL, Delphine de (nèe Fortin) 1830-c.1911
Born in Limoges, the daughter and pupil of the painter P. Fortin, she exhibited statuettes at the Salon de la Société Nationale from 1859 to 1911.

COOPER, Elizabeth 1901-
Born at Dayton, Ohio, in 1901, she studied under Sally James Farnham at the American School of Sculpture and specialised in genre and animal figures. Her best known work is the bronze Elephant Child.

COOPER, Joan Ophelia Gordon 1915-
Born in Scotland on July 1, 1915, the daughter and pupil of the artist Lawrence Bell. She studied under H. Brownsword, Charlotte Gibson and Geoffrey Daley and exhibited at the Royal Academy, the Royal Scottish Academy, the Royal Glasgow Institute and the Lake Artists Society. Her bronzes are signed Ophelia Gordon Bell.

COOPER, Mary Cuthbert fl. late 19th century
She exhibited genre figures at the Royal Academy in 1880-84.

COP, Aloys fl. 19th-20th centuries
Born at Maria Bistrica in 1863, he worked in Vienna at the turn of the century on allegorical and genre groups and reliefs.

COPNALL, Edward Bainbridge 1903-1973
Born in Cape Town, South Africa, on August 29, 1903, he died in Kent on October 18, 1973. He studied at the Goldsmiths' College School of Art and the Royal Academy schools, and exhibited at the Royal Academy, the Royal Scottish Academy, the Paris salons and the leading British provincial galleries. His work is represented in several British and foreign public collections. He worked at Slinfold, Sussex and latterly at Littlebourne in Kent as a painter of figures and animals and a sculptor of busts and heads.

COPPEDÉ, Adolfo 1871-
Born in Florence, the son and pupil of a wood-carver, Mariano Coppedé, he later worked in Genoa on reliefs and small groups.

COPPET, Yvonne de fl. 20th century
Born in France at the beginning of this century, she exhibited at the Salon des Artistes Français from 1926 and at the Indépendants from 1938 onwards. She painted landscapes and scenes from antiquity and also sculpted portrait busts and reliefs.

COPPINI, Pompeo 1870-
Born in Mantua, Italy, he studied under Augusto Rivolta in Florence before emigrating to the United States. He specialised in statues and busts of contemporary celebrities, including Theodor Mommsen, Queen Margaret and King Humbert of Italy.

COPPOLA, Giuseppe 1848-
Born in Naples, he studied at the Institute of Fine Arts and exhibited at Naples in the late 19th century. He specialised in classical and religious figures, many of which were destined for churches in the Naples area. His works include various figures of Bacchus, the Immaculata and St. Anne.

COQUELIN, Gabriel Eugène fl. 20th century
Born at Agen in France at the turn of the century, he studied under Coutan and exhibited at the Salon des Artistes Français from 1926 to 1932 and at the Salon d'Automne from 1929 to the second world war. He specialised in portrait busts, but also sculpted a maquette for a fountain entitled The Bathing Place and various torsos and statuettes of women.

COQUELIN, Gabriel Marius fl. 19th century
Born at Aix-en-Provence, he studied under A. Dumont and exhibited historical figures and groups at the Salon from 1875 onwards.

CORBEL, Jacques Ange fl. 19th century
Born in Paris, where he died in 1904, he studied under Cavelier and J.G. Thomas. He exhibited figures and reliefs at the Salon in the late 19th century and won a third class medal in 1877 and a travelling scholarship in 1884.

CORBEL, Victor 1814-1874
The father of Jacques Ange Corbel, he worked in Paris as a sculptor of small ornaments and *bronzes appliqués* for furniture and interior decoration.

CORBELLINI, Luigi fl. 20th century
Born at Piacenza at the turn of the century, he later settled in Paris where he exhibited both painting and sculpture at the major salons in the inter-war period. His sculptures consist mainly of statuettes of girls.

CORBELLINI, Quintilia fl. 19th century
Born in Milan, where she worked as a sculptor of portrait busts and reliefs and small genre groups.

CORBET, Charles Louis 1758-1808
Born in Douai on January 26, 1758, he died in Paris on December 10, 1808. He studied under Berruer and exhibited at the Salon from 1798, making his début with a plaster bust of Napoleon. Later he specialised in portraiture and produced busts that ranged chronologically from Homer and Democritus to La Tour d'Auvergne and General Beyrand. His best known work is the group showing the death of Socrates. He also wrote copiously on art history and criticism.

CORBET, Fidèle fl. 18th-19th centuries
Born at Douai, he exhibited at the Salon de la Correspondance, Paris in 1781. The Douai Museum has several terra cottas by this sculptor.

CORBETT, Gail Sherman fl. 19th-20th centuries
Born at Syracuse, New York, in the late 19th century, she studied modelling under Caroline Peddle and later attended the Art Students' League as a pupil of Saint-Gaudens, Siddons Mowbray and George de Forest Brush. She taught drawing and modelling at Syracuse University for two years before going to Paris in 1898 to continue her studies under Saint-Gaudens and at the École des Beaux Arts. She worked almost exclusively in bronze, her best known works being the bronze doors for the auditorium of the municipal buildings, and a large zodiac and compass in front of the tower, in Springfield, Massachusetts. Other works include statuettes and small groups.

CORBIER, Désiré J. 1860-
Born at St. Brieuc, he studied under Madrassi and specialised in biblical and genre sculpture. His best known work is The Prodigal Son (St. Brieuc Museum).

CORBIN, Raymond fl. 20th century
Born at Rochefort-sur-Mer at the beginning of this century, he studied under Dropsy and Matossy and exhibited at the Paris salons from 1932 onwards. His portrait medallions, reliefs and busts are distinguished by their great delicacy and sensitivity.

CORDIER, Charles Henri Joseph 1827-1905
Born in Cambrai on November 1, 1827, he died in Algiers in May 1905. He studied at the École des Beaux Arts in Paris and worked under Rude in 1847. He began exhibiting at the Salon the following year and spent a great deal of his time in North Africa, studying and modelling the various racial types. This work brought him into contact with the Musée du Luxembourg and the Museum of Natural History in Paris, where many of his sculptures are now preserved. His best known works are his statues of Marshal Gérard, Ibrahim Pasha and Christopher Columbus (the last-named erected in Mexico). His minor works include Wounded Greek Soldier, Negro of Timbuktoo, Head of a Greek Woman, Cardinal Giraut, The Young Army and various studies of Algerians and Nubians. Many of his busts and figurines were produced in the combined media of bronze and polished hardstones, which heightened their exotic nature.

CORDIER, Henri Louis 1853-1926
Born in Paris on October 26, 1853, he died there in 1926. He studied under his father, Charles H.J. Cordier, and also Frémiet and Mercié and exhibited at the Salon from 1877 onwards. He specialised in equestrian figures, such as Rally (1877) and Cuirassier (1884). Other works include ethnographical figures, such as Eskimo (1878), Nubians (1880), Algerian Jewess and Salome (1879), and more conventional busts of French contemporary celebrities. He was awarded a bronze medal at the Exposition of 1889 and a silver at the Exposition of 1900 and made a Chevalier of the Legion of Honour in 1903.

CORDIER, Maurice fl. 20th century
Sculptor of genre figures and groups since the end of the second world war. His works include Maternity (1945).

CORDONNIER, Alphonse Amédée 1848-1930
Born at La Madeleine-lez-Lille in 1848, he died in Paris in 1930. He studied under Dumont at the École des Beaux Arts in Paris and won the Grand Prix de Rome in 1877, a silver medal at the Exposition of 1889 and a gold medal in 1900. He received many public commissions and became an Officier of the Legion of Honour. His chief works included Medea killing her Children (1876), Joan of Arc at the Stake, the allegory of Electricity for the Palais des Machines. His minor works include allegorical figures of Night and Day, and genre figures, busts and heads, such as Condottiere, Bullfighter and Snake-charmer.

CORDONNIER, L.
A sculptor of this name exhibited small bronzes at the Salon des Artistes Français in 1913 and 1914.

CORIN, Jean fl. early 20th century
Born at Le Havre at the end of the last century, he studied under Landowski and Coutan and exhibited figures and groups at the Salon des Artistes Français from 1924 to 1933.

CORMIER, Joseph Descombes 1869-
Born at Clermont-Ferrand on January 18, 1869, he studied under Hiollin and exhibited at the Salon des Artistes Français, winning third class (1921), second class (1925) and first class (1928) medals. He worked at La Charité in Nièvre and also exhibited at the Salon d'Automne and the Tuileries. He specialised in neo-classical figures, such as Artemis, Danaid and Pandora, which were designed for commercial publication in low-grade bronze and spelter.

CORNACCHIA, Fidèle fl. early 20th century
Born at Vallerotunda, Italy, in the late 19th century, he studied in Paris under Hiollin and exhibited small bronzes at the Salon des Artistes Français from 1912 to 1926.

CORNET, Paul 1892-
Born in Paris on March 18, 1892, he studied at the School of Decorative Arts. He was noted for his interpretation of reality according to the qualities of the precise plastic art. He won many State commissions for bronzes, including Campagne (Trocadero), La Tour d'Auvergne (Pantheon). His minor works include Bather Walking, Bather Lounging, Bust of My Daughter, Venus and Cupid, Hygeiea and various heads and busts, in terra cotta as well as bronze.

CORNETTE, Hélène fl. 19th-20th centuries
Born at Ypres, Belgium, in the late 19th century, she studied in Brussels and began exhibiting there in 1890. She also took part in the Munich exhibitions from 1894. She specialised in rather gloomy genre figures, such as Misery, The Dead Child and Prostration.

CORNILS, Hermann 1869-
Born in Altona on October 29, 1869, he studied under John Schilling at Dresden before settling in Hamburg. He specialised in ecclesiastical statuary and monuments. He also sculpted the war memorial at Garding in Schleswig.

CORNISH, Norman 1906-
Born in England on April 26, 1906, and studied under Reeve-Fowlkes and Oliver Semin. He exhibited sculpture at the Royal Academy.

CORNNELL, Martha Jackson 1892-
Born at Louisville, Kentucky, she sculpted portrait reliefs and busts in the early years of this century.

CORNU, Auguste Paul Gustave 1876-
Born in Paris on October 10, 1876, he studied under Falguière and Rodin and exhibited at the Nationale from 1908 till 1925. He specialised in busts and statuettes of children. His best known works are the war memorial at Grosrouve and the figure of Christ in the Church of St. Léon, Paris. His works are preserved in the museums of Dijon and Brooklyn.

CORNU, Eugène fl. 19th century
He died in Paris on April 13, 1875. He was the owner of onyx and marble quarries in Algeria and various factories (including a bronze foundry) in Paris. He studied art under E. Lamyn-Deriere and exhibited genre and classical statuettes in combinations of bronze and marble or onyx.

CORNU, Vital 1851-
Born in Paris on April 17, 1851, he studied under Delaplanche and Jouffroy and exhibited at the Salon during the last quarter of the 19th century. He won third class medals in 1882 and 1883, a second class medal in 1886 and a bronze medal at the Exposition Universelle of 1889. He was made a Chevalier of the Legion of Honour in 1896. He produced numerous small figures and groups of historical and genre subjects. His bronze Spleen is in the Grenoble Museum.

CORPORANDI, Xavier 1812-1886
Born at Gillettes on October 30, 1812, he died about 1886. He studied at the École des Beaux Arts in 1839-45 under Bosio and won a third class medal at the Salon of 1846. He specialised in busts and bas-reliefs, mainly in marble, but often edited in bronze. His best known works are the portraits of Gisberti, Cavour and Landelle and the decorative bas-reliefs in the hospital at Carcassonne.

CORRADO, Porelli fl. 20th century
Born in Rome at the beginning of this century, he specialised in historic and heroic statuettes, which were fashionable in the 1930s.

CORSINI, Fulvio fl. early 20th century
Born at Siena in the late 19th century, he worked as a decorative and portrait sculptor in the period up to the first world war.

CORTÉS, Pascual fl. 18th-19th centuries
Born at Pancorbo, Spain, in the mid-18th century, he died at Palma de Majorca in 1814. He studied at the Academy of San Fernando and specialised in genre, allegorical and classical figures. His statuette of Love is in the Raxa Museum and his group of Perseus and Andromeda is in Madrid.

CORTI, Constantino 1824-1873
Born at Belluna in 1824, he died in Milan in 1873. He exhibited in the major Italian galleries of the mid-19th century, and also at the Paris Salon and the Royal Academy. He specialised in monuments and memorials but also sculpted busts, portrait reliefs and figures of classical and biblical subjects.

CORTOT, Jean Pierre 1787-1843
Born in Paris, he studied at the École des Beaux Arts and won the Prix de Rome in 1809. His cold, clinical approach was well-suited to the spirit of the period and he was given responsibility for the decoration of one of the rooms of the French Academy in Rome. This was highly successful and guaranteed a professorship at the École on his return to Paris. In 1825 he became a member of the Institut. He assisted Dupaty and completed a number of works left unfinished at his master's death, notably the figures of Louis XIII and the Duc de Berry. Later he executed a series of statues on the theme of the virtues of the ill-fated King Louis XVI, but this was not completed, due to the Revolution of 1830 which overthrew the Bourbons. His works included numerous public monuments and memorials, such as those dedicated to Maréchal Lannes, the Soldier of Marathon, the Apotheosis of Napoleon, and he sculpted the decorative façade for the Chamber of Deputies. His smaller works include Narcissus, a portrait bust of Dupaty, Pandora, Pierre Corneille, Louis XV and Louis XVI.

COSSACEANU-LAVRILLIER, Margaretta fl. early 20th century
Born in Bucharest at the turn of the century, she studied in Paris under Bourdelle and worked in Romania in the inter-war period. She contributed a number of figures and groups to the Exhibition of Romanian Art, at the Jeu de Paume in Paris.

COSSOS, Ioannis fl. 20th century
Sculptor working in Athens on genre and symbolic figures and groups, such as Night.

COSTA, Alois fl. 19th-20th centuries
Born in Austria in the late 19th century, he worked at Kastebruth in the Tyrol on religious and ecclesiastical sculpture.

COSTA, Antonio da fl. 20th century
Born in Lisbon at the turn of the century, he specialised in busts, torsos and statuettes of female figures.

COSTA, Joachim 1888-
Born at Lezignan, France, on January 8, 1888, he studied under Injalbert and exhibited at the Nationale and the Salon d'Automne. He won the Grand Prix for sculpture at the Exposition des Arts Décoratifs in 1925 and became a Chevalier of the Legion of Honour. He specialised in busts and heads of artists and writers. His best known work was the monument to the dead of Pezenas.

COSTA, Pietro 1849-1901
Born in Genoa on June 29, 1849, he died in Rome on April 18, 1901. He spent his youth in Florence and having obtained a pension, went to Rome where he studied seriously. He won acclaim with his monument to Victor Emmanuel II in Turin. He studied under Gazzarini who gave him the job of sculpting the colossal statue of Christopher Columbus. His statue of Francesco Redi is in the Uffizi Gallery.

COSTA, Thomas d'Aracyo 1861-
Born at Oliveira d'Azanaeis, Portugal, in 1861, he worked in Portugal and France at the turn of the century and won medals for his genre groups at the Expositions of 1889 and 1900.

COSTE, Georges fl. early 20th century
Born at Romans in the late 19th century, he studied in Paris under J. Boucher and exhibited figures and busts at the Salon des Artistes Français, winning a third class medal in 1925.

COSTE, L.K. fl. early 20th century
Busts, heads and portrait reliefs thus signed were exhibited at the Salon des Artistes Français in 1911-14.

COSTEL, Alphonse 1837-c.1895
Born at St. Die in 1837, he died in Paris about 1895. He studied under Geefs and exhibited busts and heads at the Salon from 1880 and the Salon des Artistes Français in 1895.

COSTENOBLE, Karl 1837-1907
Born in Vienna on November 26, 1837, he died there on June 20, 1907. He studied sculpture in Vienna, Munich, London and Rome and worked as a portrait sculptor in Vienna. His best known work is the statue of Prince Adolf of Schwarzenburg. His speciality was medieval and historical portrait busts and figures.

COSTIGAN, Ida 1894-
Born in Germany, she came to the United States at an early age and was largely self-taught. She exhibited genre figures and portraits at the National Academy of Design and the Pennsylvania Academy of Fine Arts. Her works include Old Annie and a bronze group entitled Marketing.

COSTOLI, Aristodemo 1803-1871
He spent his entire life in Florence, where he worked as a painter of portraits and religious subjects. He also sculpted statuettes and busts.

COSTOLI, Leopoldo 1850-1908
The son and pupil of Aristodemo, he worked in Florence, sculpting genre and religious figures. His best known work was the memorial to Tommaseo at Setignano (1878).

COTTARD-FOSSEY, Louise Jeanne fl. late 19th century
Born at St. Romain de Colbosc, she studied under M.H. Peyrol and exhibited small figures of animals at the Salon des Artistes Français at the turn of the century.

COTTARO, André Paul fl. early 20th century
Born at Le Havre in the late 19th century, he exhibited figures at the Salon des Artistes Français in 1923-27.

COTTE, Narcisse 1828-c.1885
Born at Bouvron on April 7, 1828, he studied under Ramey and Pascal. He exhibited at the Salon from 1857 to 1866 and his last-known work was a bronze bas-relief for the Church of St. Denis de la Chapelle in 1885. He specialised in ecclesiastical statues and bas-reliefs, executed in plaster or bronze and his work is to be found in various Parisian churches.

COTTERILL, Edmund fl. 19th century
Born in 1795, he enrolled at the Royal Academy schools in 1820 and exhibited at the Royal Academy from 1822 to 1858, the British Institution (1832-55) and the Suffolk Street Galleries from 1829 to 1836. He specialised in portrait busts of contemporary celebrities, such as Sir Edward Banks (1832) and R.S. Kinstry (1836) and produced bas-reliefs of classical subjects, such as Theseus and Hippodamia (1829). He also sculpted a series of equestrian statuettes of Queen Victoria, the Duke of Wellington and the Marquis of Anglesey and a bronze alto-relievo of the Duke of Buccleuch.

COTTI, Edoardo 1871-
Born at Frassinello-Monferrato in Italy on June 26, 1871, he studied in Turin and exhibited historical figures and groups in Turin and Modena at the turn of the century.

COUASNON, Jean Louis 1747-1812
Born at Culan in 1747, he died in Paris in 1812. He studied under J.B. d'Huez and worked in Paris on 'small trifles' (presumably ornamental bronzes) and portrait busts, which he exhibited regularly at the two Paris Salons then existing, between 1779 and 1802.

COUBILLIER, Frédéric 1869-
Born at Lougeville near Metz in 1869, he studied under Karl Janssen at the Düsseldorf Academy and completed his studies in Rome. He sculpted a number of public statues and monuments in Düsseldorf, the monument to Count Berg and the colossal statue of Kaiser Wilhelm II at Elberfeld (1902), various tombs in Düsseldorf and portrait reliefs and busts.

COUBIN(E) O. 1883-
Born at Boskowitz in Moravia (now Czechoslovakia), he studied at the academies of Prague and Antwerp and travelled in France and Italy at the turn of the century. After the first world war he settled in France. Best known for his landscape paintings and engravings of Provence, Auvergne and the Alps, he was also a versatile and prolific sculptor of medallions, bas-reliefs, plaques, busts and masks, often combining gilt-bronze with marble.

COUCHERY, Victor 1791-1855
Born in Paris in 1791 he died at Charenton on November 20, 1855. He studied at the Dijon Academy. He specialised in ornament and interior and external decorative sculpture. He worked on the Louvre, the Quai d'Orsay and other public buildings in Paris. His minor works include various busts and statuettes in terra cotta and bronze.

COUDRAY, François Gaston fl. late 19th century
Born at Billancourt, he exhibited at various Paris Salons from 1886 to 1893, showing statuettes and portraits.

COUDRAY, Georges Charles fl. 19th-20th centuries
Born in Paris, he studied under Thomas and Falguière and exhibited at the Salon from 1883 to 1903. He specialised in statues, busts and portrait medallions.

COUDRAY, Marie M.L. 1864-
Born in Paris on February 21, 1864, she won the Prix de Rome in 1893 and a second class medal at the Exposition Universelle of 1900. She specialised in portrait busts, reliefs and medals.

COUGNY, Antonin fl. late 19th century
Born at Nevers in the mid-19th century, he studied under Gleyre and his father L.E. Cougny, and exhibited genre and classical figures at the Salon from 1870 to the turn of the century.

COUGNY, Louis Edmond 1831-1900
Born in Nevers on October 3, 1831, he died in Paris on February 17, 1900. He studied under Jouffroy and exhibited at the Salon from 1855 onwards. He specialised in figures and busts of historical and contemporary personalities, and also produced a number of genre figures and groups, such as At the Workshop, Bacchante and The Wreck.

COULANGE, Hélène fl. early 20th century
Born at Dobrudja-Fulcha in Bulgaria, of French parents, she was educated in France and exhibited statuettes of dancers and nudes at the Salon d'Automne in the 1920s.

COULENTIANOS, Costas 1918-
Born in Athens, he studied at the School of Fine Arts in that city, 1936-40. After the second world war he came to France on a French state scholarship and worked with Henri Laurens, becoming a convert to Cubism. He exhibited at the Salon de la Jeune Sculpture from 1948 onwards and had his first one-man shows in Athens and London in 1955. His work consists mainly of abstracts worked in iron, lead and bronze, often in combination.

COULET, Léon Gabriel Louis 1873-
Born at Montpellier on November 7, 1873, he worked as a painter and sculptor in his home town. His works are preserved in the Montpellier Museum.

COULHON, Vital fl. early 20th century
Born in Montlucon, he worked there as a decorative and portrait sculptor at the turn of the century.

COULLAUT VALERA, Lorenzo 1876-
Born at Marchena in Seville in April 1876, he spent his childhood in France, but returned to Madrid to study sculpture. He produced busts and small figures and these are usually signed C. Valera.

COULON, Jean fl. late 19th century
Born at Ebreuil on April 17, 1853, he studied under Cavelier and exhibited at the Salon from 1880, winning a third class medal in 1880, a second class medal in 1886 and a bronze medal at the Exposition Universelle of 1889. His works include such classical groups as Flora and Zephyr (Toulon), the Death of Pyramis (Dinan) and Hebe (Nice), as well as busts and statues of contemporary figures.

COULON, Marthe Jacqueline fl. early 20th century
Born at Castelsarrazin in France in the late 19th century, she studied under Leroux and Sicard and exhibited statuettes at the Salon des Artistes Français.

COULON, Raymond fl. 20th century
Born at Sayal in France at the turn of the century, he studied under Niclausse and exhibited busts and heads at the Paris Salons in the 1930s.

COUPER, William fl. late 19th century
Born at Norfolk, Virginia, on September 20, 1853, he studied in New York, Munich and Florence and produced numerous busts of American personalities as well as a great many monuments and memorials.

COUPON, Jean Joseph 1822-c.1871
Born at Bois-les-Baronnies on May 31, 1822, he died in Paris about 1871. He studied at the École des Beaux Arts in 1845-49 and was a pupil of Ramey and A. Dumont. He exhibited at the Salon from 1849 to 1870. He specialised in religious sculpture and is best known for the stone statue of St. John the Evangelist in the Madeleine.

COURBE, Marie Paule fl. late 19th century
Born in Nancy, she studied under Delorme, Hiolle and Chapu and exhibited romantic and historical figures at the Salon from 1869 to 1877.

COURBE, Mathilde Isabelle fl. late 19th century
The third of the Courbe sisters, she studied under Delorme and exhibited figurines at the Salon in 1874-5.

COURBE, Nathalie Blandine fl. 19th century
Born at Nancy, she was a sister of Marie Paule Courbe and also studied under Delorme. She exhibited paintings and sculpture at the Salon from 1876 onwards.

COURBIER, Marcel Louis Maurice fl. 20th century
Born at Nimes, he studied under J. Coutan and F. Charpentier. He specialised in portrait busts and genre statuettes, which he exhibited at the Salon des Artistes Français in the inter-war period, winning a second class medal in 1926.

COURMONT, Auguste fl. late 19th century
Born in Paris, he studied under Weimer and exhibited portrait busts and bas-reliefs at the Salon in 1869-70.

COURNAND, Étienne Napoleon 1807-1863
He spent his entire career in Avignon, sculpting religious figures and groups.

COUROW, Wilford S. fl. early 20th century
Born in New York in the late 19th century, he specialised in medallions and portrait reliefs. For a long time he worked in France and had a studio at Moret-sur-Loing.

COURRAS, Suzanne fl. 20th century
Born in Paris, she studied under Mlle. Joubert and Févola and exhibited statuettes at the Salon des Artistes Français in 1931-33.

COURROIT, Jules fl. 19th-20th centuries
He studied at the Hasselt Academy and worked in Belgium at the turn of the century, specialising in portrait busts. His work is preserved in the Louvain Museum.

COURROY, Roger Henri fl. 20th century
Born at Bordeaux, he studied under Malric and exhibited figures and groups at the Salon des Artistes Français.

COURT, Louis fl. 19th-20th centuries
He studied in Munich and Cologne and worked as a portrait and figure sculptor at the turn of the century.

COURTENS, Alfred fl. early 20th century
Born at St. Josse in Belgium in the late 19th century, he had a studio in Brussels where he specialised in portrait busts, heads, medallions and reliefs of Belgium royalty and celebrities. He exhibited in Belgium and at the Nationale in Paris in the 1920s.

COURTET, Xavier Marie Auguste (known as Augustin) 1821-1891
Born in Lyons in 1821, he studied at the School of Fine Arts and was a pupil of Pradier, Ramey the younger and A. Dumont. He began exhibiting at the Salon in 1847 and won a second class medal in 1848. He produced numerous busts and classical groups, such as Female Centaur and Faun and Dancing Faun (the latter in the Louvre). His busts consisted of historical and contemporary personages, such as Carle van Loo, the Comte de Castellane, the scientist Ampére and Adrienne Lecouvreur.

COUSINET, Marguerite fl. 20th century
Born in Paris, where she worked in the first half of this century. She specialised in busts and heads and exhibited at the Nationale, the Salon d'Automne and the Tuileries.

COUSINS, Harold 1916-
Born in Washington, he read classics at New York University and began studying painting and modelling at the Art Students' League under Zorach. After the second world war he turned to sculpture full-time and in 1949 settled in Paris where he worked in Zadkine's studio. His earlier sculpture concentrated on wrought metal, mainly iron, and constructed linear structures used as self-standing mobiles or as wall decoration. In more recent years, however, he has experimented with more compact sculpture using iron, nickel and bronze, resulting in perforated masses with sprouting antennae.

COUSTAURY, Louis fl. 19th century
Born in Paris, he died in 1897, the year in which he won an honourable mention at the Salon for his genre figures.

COUSTOU, Guillaume the Elder 1677-1746
Born in Lyons on April 25, 1677, he died in Paris on February 20, 1746. He was the son of a wood-carver, François Coustou, and studied sculpture under his uncle Antoine Coysevox. He attended the Academy School and won a second prize in 1696 and a first prize the following year. He followed his elder brother Nicolas to Rome, having obtained a small pension from the King. In Rome he worked on ecclesiastical ornament and bas-reliefs and returned to Paris in 1703. His marble statuette of the Death of Hercules was submitted in 1704 when he was elected a member of the Academy and this is now in the Louvre. Three years later he was appointed Sculptor to Louis XIV and worked on the chapel at Versailles. He married Genevieve Morel and had seven children, of whom Guillaume the Younger was one. He was successively deputy professor (1706), professor (1715), associate rector (1726), rector (1733) and director of the Academy (1735-38). He worked extensively on palaces in and around Paris, and sculpted numerous statues for royal and public commissions. Coysevox and the Coustou brothers led the younger French sculptors in revolt against Lebrun, the director of the *bâtiments de roi* and then his successor Girardon. In particular Guillaume Coustou became involved in a protracted dispute concerning his most famous work, the pair of marble Marly horses (1740-45), claiming a payment of 128,000 livres but receiving only 85,000. The dispute was still unsettled at the time of his death. The pair of marble groups, each showing a nude figure restraining a rearing horse, stood originally at the entrance to the riding school in Marly Park, but now stand at the entrance to the Champs Elysées. The gilt-bronze reductions in the Wallace Collection may have been contemporary with the marbles, but the Marly horses later became probably the most popular of all French statuary and countless copies have been made throughout the 18th and 19th centuries, in bronze, spelter and lead and latterly even electrotypes. Many of Coustou's other marbles were subsequently edited as bronze reductions. He himself sculpted several important pieces which were cast in lead, pewter or bronze and these include the bronze bas-relief of the Visitation and the lead Angel of Adoration at the Invalides, the allegory of the Rhône at Lyons Town Hall, the decoration on the tomb of Louis XIV, figures of angels in silver, bronze or gilt-bronze, and the gilt-bronze trophies and cartouches on the pedestal of the equestrian statue of Louis XIV by Girardon.

Gougenot, Louis *Éloge de M. Coustou le jeune* (1903).

COUSTOU, Guillaume the Younger 1716-1777
Born in Paris on March 19, 1716, he died there on July 13, 1777. He was the fourth child of Guillaume the Elder and was elected associate professor of the Academy on the death of his father. He was a member of the Academy (1742) and Sculptor to the King. More of an establishment figure than his father and uncle, he became successively rector and treasurer of the Academy and curator of the Royal Antiques, and was made a Chevalier of the order of St. Michel. For much of his career he worked with his father and undoubtedly owed much of his advancement to the reputation of his more accomplished relatives. No bronzes have so far been discovered which can be attributed to him with any certainty.

COUSTOU, Nicolas 1658-1733
Born in Lyons on January 9, 1658, he died in Paris on May 1, 1733.
He was the elder son of François Coustou who taught him the
elements of sculpture. He went to Paris to study under his uncle
Coysevox in 1677. He won the Colbert Prize in 1682 at the old École
Académique and worked in Rome from 1683 to 1686, copying
classical sculpture in marble. He returned to Paris in 1687 after a
short stay in Lyons and worked on the royal castles and palaces till
his death in 1733. He executed numerous decorative sculptures for
Versailles, the Trianon, the Invalides and Marly, and many busts,
statues, reliefs and mausolea. He was appointed associate professor in
1695, professor (1702), deputy rector (1715), rector (1720) and
chancellor (1733). He worked mostly in marble, but also in terra
cotta, lead and bronze. His works in the metallic medium include the
bas-relief of a Battle (Les Invalides), the gilt-lead group of Three
Tritons (Marly), gilt-lead group of Sphinx and Children (Marly), the
lead group of Shepherds and Shepherdesses (Marly), the bronze
Crucifix (Marly), the bronze of Diana the Huntress and a number of
gilt-bronze medallions and plaques at Versailles.

COUTAN, Jules Félix 1848-1939
Born in Paris in 1848, he died there on February 23, 1939. He studied
under Cavelier and won the Prix de Rome in 1871. He made a
remarkable début at the Salon of 1876, winning a first class medal
and five years later was the winner of a competition for a monument
to commemorate the Constituent Assembly at Versailles. He played a
major part in the decoration of the Exposition Universelle of 1889
and was awarded a gold medal. In 1900 his services to the Exposition
brought him a Grand Prix d'Honneur. He succeeded Falguière as
member of the Academy in 1900 and was professor at the École des
Beaux Arts in 1905, in succession to Barrias. He rose to the grade of
Grand Officier in the Legion of Honour. He is best known for his
public statuary, including the allegory of the Republic at Dijon, the
figures of Eros (Luxembourg gardens) and Love (St. Lo), St.
Christopher (Tarbes) and The Bread Carrier (St. Louis). Many of these
works were published as bronze reductions and he also sculpted a
number of small genre figures and portraits.

COUTAN-MONTORGUEIL, Laure (née Martin) 1855-1915
Born at Dun-sur-Auron in 1855, she died about 1915. She studied
under J. Boucher and specialised in marble statuary, but also
produced a number of bronze busts and portrait reliefs. She exhibited
regularly at the Salon and became an Officier of the Academy. Her
works include The Source, The Soldier Guindey and Springtime.

COUTHEILLAS, Henri François 1862-1928
Born at Limoges in 1862, he died in 1928. He studied at the schools
of fine arts in Limoges and Paris and was a pupil of Gauthier, Aimé
Millet, Cavelier and Barrias. He exhibited at the Salon des Artistes
Français, winning a third class medal in 1892 and a second class two
years later. He was made a Chevalier of the Legion of Honour in
1919. His works include Nymph Huntress, Death of the Cigale and
The Woodcutter.

COUTIN, Auguste fl. 19th-20th centuries
He was a pupil of Millet and Moreau-Vauthier and worked in Rheims at
the turn of the century. He exhibited portrait bas-reliefs and busts at
the Salon d'Automne and the Tuileries.

COUTIN, Robert Elie fl. early 20th century
Son of Auguste Coutin, under whom he studied. Later he became a
student at the National School of Decorative Arts and exhibited at
the Salon des Artistes Français from 1912 onwards. He specialised in
portrait sculpture, and exhibited busts, heads and torsos at the Salon
d'Automne and the Tuileries in the inter-war period.

COUTOULY, Pierre de fl. early 20th century
He worked as a portrait sculptor in St. Pierre le Vieux at the
beginning of this century, but his career was cut short when he was
killed in action in the opening campaign of the first world war.

COUTRE, Robert fl. 20th century
Born at Gien, he exhibited figures and bas-reliefs at the Salon des
Indépendants in the early years of this century.

COUTURIER, C.P. fl. 19th-20th centuries
He exhibited statuettes at the Salon des Artistes Français in 1914 and
worked in Paris at the turn of the century.

COUTURIER, Robert 1905-
Born in Angoulême, he studied under Maillol and exhibited at the
Salon des Tuileries from 1935 to 1944 and at the Salon de Mail since
the end of the second world war. His first major commission was for
bas-reliefs to decorate the Exposition Internationale in 1937. Most of
his earlier work was carved direct in stone but from 1944 to 1954 he
worked in bronze before returning to his original medium. His
bronzes rank among the more controversial and least understood
works of modern sculpture and include Adam and Eve, Leda,
Monument to Étienne Dolet and Woman in an Armchair as well as a
number of attenuated or elongated female figures. He has taken part
in many major international exhibitions and latterly taught at the
École Nationale des Arts Décoratifs.

COUVEGNES, Raymond Émile 1893-
Born at Ermont on February 27, 1893, he studied under Injalbert and
won the Prix de Rome in 1927. He won several prizes for his figures,
busts and groups at the Salon des Artistes Français in the inter-war
period.

COUZIJN, Wessel 1912-
Born in Amsterdam, he studied under Bronner at the Amsterdam
Academy and travelled in Paris, Rome and New York, returning to his
native country after the war. Since 1946 he has been one of the
foremost Dutch sculptors and has exerted a significant influence on
the present generation of sculptors. Under his guidance and example
Dutch sculpture has broken free from the historicism of the pre-war
period and absorbed elements of non-figurative and abstract art. His
figures have been described as 'intense, demanding and violently
emotional' (Jos de Gruyter). He works in terra cotta and bronze and
his works are in various public collections in Amsterdam, The Hague,
Scheidam and Arnhem.

COWAN, Jean Hunter (née Hore) fl. 20th century
One of the most versatile artists working in Scotland in the first half
of this century, she excelled in many fields, being a violinist of note,
the first woman to fly in Britain (1911), an international golf
champion and tennis champion of the 1920s and an oil painter and
water-colourist as well as sculptor of heads, busts and portrait reliefs.
She had a studio in Edinburgh from 1940 till the early 1960s and
exhibited at the Royal Scottish Academy.

COWAN, Theodora fl. 20th century
Born in Australia at the end of the last century, she worked as a
portrait sculptor in Sydney before going to London and later
Florence.

COWELL, George H. Sydney fl. 19th-20th centuries
He worked in London at the turn of the century and specialised in
genre and allegorical works, such as The Water Witch and The Dream
Spirit.

COWELL, George J. fl. late 19th century
He worked in London on figures and busts in the late 19th century
and exhibited at the Royal Academy and the Salon des Artistes
Français.

COX-MACCORMACK, Nancy 1885-
Born in Nashville, Tennessee, in 1885, she studied in New York and
later settled in Rome where she had a studio in the 1920s. She
specialised in busts and heads of contemporary celebrities.

COYSEVOX or QUOIZEVAUX, Antoine 1640-1720
Born in Lyons on September 29, 1640, he died in Paris on October
10, 1720. He came to Paris in 1657 and studied under Louis
Lerambert, whose niece Marguerite he married in 1666. He was
appointed Sculptor to the King the same year and subsequently
worked on the decoration of the Louvre. On the death of his wife in
1667 he accepted a commission from Cardinal de Furstenberg, Bishop
of Strasbourg, to decorate his palace in Saverne and he spent the next
four years in Alsace. He returned to Paris in 1671 but went back to
Lyons four years later. He was elected a member of the Academy in
1676 and settled in Paris the following year. Later he worked for the
Gobelins tapestry factory and carried out numerous public
commissions. Many of his works may be seen at Marly, the Trianon,
Versailles and St. Cloud. His bronze statue of Louis XV, formerly in
front of Paris Town Hall is now in the Musée Carnavalet, but the

bronze equestrian statue of Louis XVI at Rennes was destroyed during the revolution. He worked mainly in marble and stone, but also in terra cotta and bronze. His bronzes include two vases and nine trophies at Versailles, the busts of Michel le Tellier and the Great Condé in the Louvre, the allegories of the Dordogne and Garonne at Versailles, several busts of Lulli and Louis XIV, the statue of Prudence in the Louvre, gilt-bronze medallions at Chantilly, Crouching Venus and a bust of Louis XIV in the Wallace Collection. He also sculpted allegorical groups in gilt-lead, such as France triumphing over Spain and the Holy Roman Empire, and lead and pewter bas-reliefs for Versailles. Many of his larger statues and groups in marble were subsequently published as small bronzes, popular in the 18th and early 19th century.

Jouin, Henri *A. Coysevox, sa vie, son oeuvre* (1883). Keller-Dorian, G. *Antoine Coysevox: catalogue raisonné de son oeuvre* (2 vols.) (1920).

COZLIN, Joseph fl. 19th century
Born in Lyons in the mid-19th century, he died there in 1896. He studied under Fabisch and exhibited busts, medallions and portrait reliefs at the Salon from 1876 till his death.

COZZA, Adolfo Conte 1848-1910
Born at Orvieto in 1848, he died in Rome in 1910. He studied under Giovanni Dupré in Florence and, at a very early age, sculpted the statues for the doorway of Orvieto Cathedral. Later he collaborated on the memorial to King Victor Emmanuel II. His most important work was the bronze reliefs for the Villa Borghese. He produced a number of statuettes and heads and also painted portraits.

CRACO, Arthur 1869-
Born in Brussels, he studied under Meunier and worked for many years in Paris and Orchies. His works include The Ivy (Brussels Botanic Gardens) and the statue of Pope Leo XIII at Louvain.

CRAFT, Marjorie Hinman fl. 20th century
Born in Philadelphia, she studied in Paris in the 1930s and exhibited busts and torsos at the Salon d'Automne from 1932 to 1940.

CRAMAUSSEL, Jo fl. 20th century
Born in Geneva at the beginning of the century, she studied under M. Baud-Bovy and exhibited statuettes at the Salon des Artistes Français in 1924.

CRAMPTON, Arthur Edward Sean 1918-
Born in Manchester on March 15, 1918, he studied at the Vittoria Junior School of Art in Birmingham in 1930-33 and later at the Birmingham Central School of Art and in Paris. He exhibited at the Royal Academy, the Royal Scottish Academy and the leading London and provincial galleries. He was elected A.R.B.S. (1953), F.R.B.S. (1965) and President of the Royal Society of British Sculptors in 1966. His busts, heads, reliefs and plaques are signed 'Sean Crampton'. He has a studio in Brentford, Middlesex.

CRANE, Doris Martha Alice 1911-
Born in Clapham, London, on February 20, 1911, she studied under W. Everatt Gray and exhibited at the Royal Academy, the Royal Scottish Academy and the Salon des Artistes Français. She lives in Felixstowe, Suffolk, and sculpts figures and reliefs, mainly in wood or ivory.

CRANNEY-FRANCESCHI, Marie Anne fl. late 19th century
Born in Paris, she studied under her father Jules Franceschi and specialised in genre and classical figures, such as The Snake-charmer (Amiens) and The Nymph Echo (Troyes). She got an honourable mention at the Salon of 1889.

CRASKE, Leonard 1882-
Born in London, he was educated at the City of London School and London University where he studied medicine for three years (St. Thomas's Hospital), before turning to art. He studied sculpture under the Dicksees and worked as assistant to Paul Montford. He emigrated to the United States in 1910 and has since lived in Boston and Gloucester, Massachusetts. He exhibited at the Royal Academy and various American galleries. He sculpted genre and allegorical figures, such as The Joy of Life, a figure intended for a fountain.

CRAUK, Gustave Adolphe Désiré 1827-1905
Born in Valenciennes on July 16, 1827, he died in Paris on November 17, 1905. He studied at the École des Beaux Arts and was a pupil of Pradier. He won the Prix de Rome in 1851 with his group of Greeks and Trojans fighting over the body of Patroclus. He exhibited at the Salon from 1857 and won numerous prizes. In the Legion of Honour he was successively Chevalier (1864), Officier (1878) and Commandeur (1903). Crauk was one of the great Establishment sculptors of France in the second half of the 19th century and a wide range of his minor works may be seen in the Gustave Crauk Museum at Valenciennes. His best known works include his statues of Marshal MacMahon, General Changarnier, Fenelon, Cardinal Girard and other contemporary figures, as well as classical figures and groups such as Satyrs, and Amphitrite.

CRAWFORD, Thomas 1814-1857
Born in New York on March 22, 1814, he died in London on October 10, 1857. Though his career was relatively brief, it was an important landmark in the development of American sculpture. He was the first American to work in Rome rather than Florence and he turned from the simple naturalism and neo-classicism of his predecessors to the ideal, the romantic and the sentimental which were to dominate the bronzes of the second half of the 19th century. He went to Rome in the summer of 1835 and studied under Thorwaldsen. On his return to the United States in 1844 he was elected the youngest member of the National Academy of Design and he married Louisa Ward the same year. Thereafter he spent most of his time working in Rome, returning to his native country only briefly in 1849 and 1856, though he executed many important commissions for the United States. He sculpted numerous statues in the Capitol in Washington and, in particular, the colossal figure of Armed Liberty. His other major works include the equestrian statue of George Washington in Richmond. He produced numerous portrait busts of contemporary American personalities, neo-classical and ideal figures, such as Orpheus entering Hades in search of Eurydice (sculpted in 1839 and exhibited at the Boston Athenaeum in 1844), Flora, Hebe and Ganymede, Sappho, Vesta, The Babes in the Wood (1851), various figures and groups of Dancers, Hunter and The Dying Indian (Metropolitan Museum of Art, New York). He worked in marble and stone, but many of his works were cast in bronze by Von Müller and helped to establish the fashion for romantic bronzes in America. At the time of his death he was working on a series of bronze bas-reliefs illustrating the progress of American civilisation for the doors in the Capitol, and these were completed by W.H. Rinehart. His other bas-reliefs were derived from biblical subjects.

Hicks, Thomas *Eulogy on Thomas Crawford* (1865).

CREEFT, José Mariano de 1884-
Born in Guadalajara on November 27, 1884, he was educated in Barcelona and apprenticed to a carver of religious figures in 1898. Later he worked in a bronze foundry and learned the *cire perdue* technique. In 1891 he moved to Madrid, where he worked under Agustin Querol, then official sculptor to the Spanish State. In 1905 he went to Paris and studied under Rodin and enrolled at the Académie Julian (1906-7), where he was a pupil of Landowski. He exhibited at the Salon des Artistes Français from 1911 onwards and exhibited at the Salon d'Automne, the Nationale and the Salon des Indépendants up to 1928, when he married Alice Carr and emigrated to the United States. He had his first one-man show in America at the Ferargil Gallery, New York in 1932 and exhibited regularly at the Passedoit Gallery from 1936 onwards. He taught at the Art Students' League in New York. In his later years he produced a number of large pieces commissioned for public buildings and parks, such as The Poet (Philadelphia, 1950) and Alice in Wonderland (New York Central Park, 1958). During his very long career, spanning more than half a century, he produced works in every medium of sculpture. His bronzes belong to the earlier part of his career, when he specialised in busts and small groups. He was also engaged on projects for war memorials in the early 1920s and these resulted in a number of maquettes and models later cast as individual works. His work combined the traditionalism and classicism of his early training with the Cubist influence of Gris and Picasso, and later his eclecticism made good use of Chinese styles and the Gothic of medieval Europe. At the height of his career Creeft epitomised the best in sculpture, in the manner of the Art Deco style.

CREMER, F. fl. 20th century
Sculptor working in East Germany since the second world war, producing Impressionist figures and reliefs. His best-known work consists of the human figures in the Buchenwald memorial, near Weimar.

CRENIER, Camille Henri 1880-1915
Born in Paris on April 30, 1880, he was killed in action in the first world war. He studied under Falguière at the École des Beaux Arts and exhibited at the Salon des Artistes Français, winning an honourable mention in 1897 and a third class medal in 1908. He specialised in genre groups and his works include a decorative bronze sundial, Boy and Turtle (Metropolitan Museum of Art, New York) and Girl and Butterflies.

CRESPI, Francisco 1861-1891
Born at Arsizio, near Milan, in 1861, he committed suicide in Milan in 1891. He produced numerous busts and heads, and statuettes and small groups of a military nature.

CRESPIN, Paule fl. 20th century
Born in Paris at the turn of the century, she exhibited at the Nationale in the 1920s and produced a number of busts, nude statuettes and masks.

CRESSIGNY, Ferdinand 1837-1890
Born at Vernon, France, on June 2, 1837, he died about 1890. He studied in Paris under Duret and Guillaume and exhibited at the Salon from 1870 to 1887, specialising in busts and relief portraits.

CRESSON, Margaret French 1889-
Born at Concord, Massachusetts, in 1889, she produced busts, reliefs and figurines during the early years of this century.

CRESWICK, Benjamin fl. late 19th century
Born in Birmingham, he exhibited genre groups and figures at the Royal Academy from 1888 to the end of the century.

CRÉTON, Pierre 1789-1870
Born in France in 1789, he died in St. Petersburg in 1870. He spent most of his life in Russia, where he worked on the decorative sculpture in the Winter Palace, and also taught sculpture and modelling in St. Petersburg. He was known in Russian as Peter Federovich Kreton and produced a number of busts, reliefs and genre figures.

CRETTÉ, Albert Louis Victor fl. 20th century
Born at Vannes at the beginning of the century, he studied under A. Larroux and H. Lemaire and exhibited at the Salon des Artistes Français (1923-31) and the Indépendants (1926-43), statuettes, groups and bas-reliefs.

CREUSOT, Frédéric fl. 19th century
Born at Semur on March 21, 1832, he studied under Darbois and Dumont and sculpted genre, neo-classical and biblical figures and animal studies. The Semur Museum has a number of his works including Moses, Child wrestling on the Beach, Bullfinch and A Bacchanal.

CRICK, Alfred Egide fl. 19th century
Born at Antwerp in 1858, he studied under Eugène Simoni and Léon Jacquet in Brussels. He specialised in portrait sculpture, his chief works being the statues of Jan de Beers and Jenneval.

CRINON, Hector fl. 19th century
Born at Vraignes, France, in 1808, he studied under Dehaussey and specialised in ecclesiastical sculpture. His best-known work is the figure of St. Jean at Peronne. He also produced decorative sculpture for the churches of Vraignes.

CRIPPA, Francesco fl. 19th century
He worked in Milan in the late 19th century and is best known for the monument to King Victor Emmanuel I at Monza. He also sculpted portrait busts and statuettes.

CRIPPA, Roberto 1921-
Born in Milan, he studied at the Academia Brera and began exhibiting at the Bergamini Gallery in Milan in 1947 and at the Zanarini Gallery, Bologna from 1949 onwards. He has had numerous one-man shows in the United States since 1951 and Paris since 1955 and participated in the Venice Biennale since 1948. He has been a prominent member of the spatial and *Art Brut* movements since 1948, though his Expressionism has mellowed in more recent years. He works in iron, brass and bronze, often combining these metals in his surrealist allegories, such as Thirst and Victory.

CRISSAY, Marguerite fl. 20th century
Born in Mirecourt, she died in Paris in July 1945. She exhibited at the major Paris salons in the inter-war period and specialised in busts and heads of contemporaries and small figures and groups, particularly of bathers. She was also an accomplished painter in oils.

CRISTIANI, Romeo fl. 19th-20th centuries
He worked in Verona at the turn of the century, producing busts and heads of contemporary personalities. His best-known works are the statue of Paul Veronese and the monument to King Umberto I at Verona.

CROFTS, Stella Rebecca 1898-
Born in Nottingham on January 9, 1898, she studied at the Central School of Arts and Crafts from 1916 to 1922 and at the Royal College of Art in 1922-23. She exhibited at the Royal Academy from 1925 and at the various provincial galleries, and took part in art exhibitions in Milan, Venice, Toronto and Paris. She was awarded a silver medal at the Paris Exposition des Arts Décoratifs in 1925. Her work is represented in several public collections, notably the Victoria and Albert Museum, the Manchester Art Gallery and the Museum of Decorative Art in Milan. She worked in Ilford and later Billericay, Essex as a painter and sculptor of animal subjects. Her works in the latter medium include Giraffes, Goose, Pelicans, Jaguar and Sable Antelopes.

CROISY, Aristide Onesime 1840-1899
Born at Fagnon on March 31, 1840, he died in Paris on November 6, 1899. He studied under Toussaint, Dumont and Gumery at the École des Beaux Arts and was runner-up in the Prix de Rome in 1863. He exhibited at the Salon from 1867, winning a second class medal in 1882 and a first class medal three years later. He was a Chevalier of the Legion of Honour. A prolific sculptor with wide-ranging interests, his works included allegorical and genre figures, historical groups and portraits of historical and contemporary personages. His best-known works are the statues of Generals Chanzy, Boulanger, Jaurequibeny and Niedermeyer. Other works include Malatesta and Francesca da Rimini, Bayard, The Nest, The Army of the Loire, Girl with Raisins and The Prayer of Abel.

CROIZET, Hippolyte Émile fl. late 19th century
Born at St. Mande (Seine) in the second half of the 19th century, he studied under Falguière, Mercié Gauthier and Levillain and produced romantic and historic figurines, which he exhibited at the Salon des Artistes Français in the 1890s.

CROLARD, François Joseph fl. early 20th century
Born at Crau-Gevrier at the turn of the century, he studied under Lemaire and Injalbert and exhibited figures and reliefs at the Salon des Artistes Français in 1922-23.

CROOK, Thomas Mewburn 1869-1949
Born at Tonge Moor, near Bolton, Lancashire on December 4, 1869, he died in London on January 18, 1949. He studied at the Royal College of Art and continued his studies in Paris, Brussels, Madrid, Barcelona, Rome, Düsseldorf, Berlin, Budapest and Vienna. He exhibited at the Royal Academy and the other leading British exhibitions and was elected R.B.A. (1910) and F.R.B.S. (1923). He worked in London as a sculptor of portraits and statuettes.

CROS, César Isidore Henri 1840-1907
Born at Narbonne on November 16, 1840, he died in Paris on February 4, 1907. He studied under Etex and J. Valadon and exhibited at the Salon from 1864. He took part in the great Expositions of 1889 and 1900 and was awarded silver and gold medals respectively. He was a Chevalier of the Legion of Honour. The bulk of his sculptural work was executed in ceramics and glass and he was a prominent craftsman in *pâte de verre*. His bronzes consist of statuettes and small bas-reliefs.

CROS, Désiré Victor Marie fl. early 20th century
Born in Paris, he exhibited at the Salon des Artistes Français in the 1920s.

CROS, Jean fl. 19th-20th centuries
He worked as a modeller of figures and groups for the Sèvres porcelain factory at the turn of the century. He sculpted works of a genre character, some of which were later cast in bronze.

CROSBY, Caresse (née Polly Peabody) 1892-
Born in New York on April 20, 1892, she came to Paris and studied under Landowski and Bourdelle. She settled in Paris where she organised exhibitions of the works of American artists residing in France, and also exhibited at the Salon d'Automne. She specialised in busts and heads, the best known being those of D.H. Lawrence and her husband Harry Crosby. Mrs. Crosby was a direct descendant of Robert Fulton, the American pioneer of the steamboat, and claimed heredity as the source of her own inventiveness. She designed and produced the world's first brassiere, later selling her patent and the brand name of Kestos to the Warner Brothers Corset Company for $15,000. With her husband she ran the Black Sun Press in Paris, publishing the works of Joyce, D.H. Lawrence and other controversial figures.

CROSBY, Katherine van Rensellaer 1897-
Born at Colorado Springs in 1897, she worked as a portrait sculptor in the early years of this century.

CROUZAT, Georges Leopold fl. 20th century
Born at Castres in the late 19th century, he worked in Paris in the inter-war period as a portrait sculptor. He exhibited at the Salon des Artistes Français, becoming an Associate and winning an honourable mention in 1928. His best known work is the bust of the politician Jean Jaurès.

CROUZET, Jean Baptiste Louis Symphorien 1825-1886
Born at Charnay on August 19, 1825, he died in Paris in 1886. He studied under Rude and exhibited historical and romantic figures and groups at the Salon from 1847 to 1852.

CROUZET, Jean Paul Camille fl. 19th century
Born at Puy-en-Velay in 1812, he worked in that town as a sculptor of portraits and allegorical figures. The Puy Museum has his group symbolising the Town of Puy and his portrait of the sculptor Julien.

CROZATIER, Charles 1795-1855
Born at Puy-en-Velay in 1795, he died in Paris on February 8, 1855. He studied under Pierre Cartellier and later worked mainly as a bronze founder. The Puy Museum has a number of his own bronzes, including King Henri IV as a child, a bronze decorative vase, and a group of the Virgin and Baby Jesus. His Prometheus Bound is in the Bayonne Museum.

CRUMBS, Charles P. fl. 19th-20th centuries
Born at Bloomfield, Massachusetts, in 1874, he worked at the turn of the century on busts and reliefs.

CRUNELLE, Leonard 1872-
Born at Lens on August 8, 1872, he later emigrated to the United States where he studied under Lorado Taft and worked in Chicago on statues, busts and reliefs. His best known work is the statue of an Indian Girl, in the grounds of the state capitol at Bismarck, North Dakota.

CSAKY, Joseph 1888-
Born at Szeged, Hungary, on March 18, 1888, he studied at the School of Decorative Arts in Budapest (1904-5) but left prematurely as he was unhappy at the rigid classicism of the teaching. He was greatly influenced by Rodin and came to Paris in 1908, becoming naturalised in 1914. He was later influenced by Maillol and by 1911 had turned to Cubism, exhibiting sculpture in this idiom at the Salon d'Automne that year. During the first world war he served in the French army, and following his demobilisation in 1919 he settled in Paris. Though remaining a steadfast adherent to Cubism he tempered this with his studies of nature and this inspired the allegorical and figurative works of the inter-war period. He produced a number of heads and busts in marble and stone, abstracts such as Stele (1929) in stone, and bronze figures and groups, such as Mother and Children, Priestess, Danseuse, Purity and small figurines of seated women designed as pendants. He

has also produced a number of watercolours and gouache paintings. In the late 1930s he went through a phase of direct carving, but after the second world war he returned to bronze as his favourite medium. His best known work of the post-war period consisted of two large bas-reliefs commissioned by the education authorities of Amiens.

CSORBA, Geza fl.20th century
He worked in France in the inter-war period and exhibited figurines at the Salon des Tuileries in 1932.

CUADRADO, Matias fl. 19th century
He worked in Barcelona and later Tortosa as a decorative sculptor.

CUADRAS, Pedro fl. 19th century
Of Catalan origin, he studied in Barcelona and Rome before settling as a portrait and ornamental sculptor in Vich, Spain.

CUAIRAN, F. fl. 20th century
South African sculptor of European origin, he has produced portrait busts, figures and reliefs.

CUBISOLE, Jean Antoine 1811-1877
Born in Montaure on April 9, 1811, he died at Puy-en-Velay on September 12, 1877. He studied in Rome and worked in Puy as as sculptor of friezes, bas-reliefs and statuary in marble. His minor works, many of which were cast in bronze, include statuettes of a Bacchante (1852), Christ on the Cross (1853), Eve picking an Apple (1867), Minerva, Sibyl, Madonna, Pius IX and the Empress Eugénie.

CUBITT, Charlotte fl. late 19th century
She exhibited figures and portraits at the Royal Academy from 1873 to 1880.

CUBITT-BEVIS, Leslie fl. 20th century
Born in the United States in the early years of this century, he produced genre statuettes. His figures of a Buddha was shown at the Salon des Tuileries in 1934.

CUCCINI, Antonio 1830-1874
Born at Melide, Switzerland, in 1830, he died there on November 18, 1874. He studied in Milan and Bissone and was a pupil of Somaini. He produced busts, reliefs and statuettes.

CUCCINI, Ulisse 1825-1887
Born at Melide in 1825, he died in Bissone on January 20, 1887. He studied at the Academy of Fine Arts in Milan and lived for many years in Casale. He exhibited regularly in the salons of Turin and Rome in the 1860s and 1870s. He specialised in portrait sculpture, particularly of contemporary personalities. His best known works include the monument to Colonel Morelli for the town of Casale and two statues for Voghera hospital.

CUETO, German fl. 20th century
Born in Mexico in the late 19th century, he served under Emiliano Zapata in the Mexican Revolution and sculpted a number of portraits of the personalities involved in the conflict. After the Revolution he concentrated on statuettes and groups of Indian women and also modelled masks. An exhibition of his sculpture was staged in Paris in 1929.

CUGLIERERO, Angelo 1850-
Born in Turin, where he worked in the late 19th century as a sculptor of romantic and historic figures and portraits.

CUGNOT, Louis Léon 1835-1894
Born in Paris on October 17, 1835, he died there in 1894. He studied at the École des Beaux Arts and was a pupil of Deiboldt and Duret. He painted large historical canvases, but also sculpted genre and calssical figures and groups, such as the Drunken Faun, Spinner and Messenger of Love. Several of his statues at St. Cloud and Trinité Church, Paris were also edited as small bronzes.

CUISIN, Alexandre 1820-1893
Born in Toulon about 1820, he died there in 1893. He worked mainly as a wood-carver of reliefs, and sculpted ornamental friezes in plaster, his work in metal consisted of small reliefs and *bronzes d'ameublement* for interior decoration.

CULLEN, Cyril Crofton fl. 20th century
Born in the United States, he later moved to France and worked at Fontenay-aux-Roses in the inter-war period. He specialised in busts, heads, portrait reliefs and statuettes of historic and contemporary personalities.

CULLET, A. fl. 19th-20th century
He worked in Paris at the turn of the century, producing genre figures and groups which were exhibited at the Salon des Artistes Français from 1889 to 1903.

CUMBERWORTH, Charles 1811-52
Born at Verdun on February 17, 1811, he died in Paris on May 19, 1852. He enrolled at the École des Beaux Arts in 1829 and exhibited at the Salon from 1833 to 1843. His chief works were statues of Queen Marie-Amelie, the Duke of Montpensier and other members of the Orleanist Royal Family. His minor works include a number of portrait busts and reliefs of contemporary celebrities and genre figures, such as Self Love and Young Girl with A Pigeon.

CUMMINGS, Melvin Earl 1876-
Born at Salt Lake City, Utah, in 1876, he worked as a portrait and figure sculptor in San Francisco at the turn of the century.

CUNLIFFE, Mitzi (née Solomon) 1918-
Born in New York on January 1, 1918, she studied at the Art Students' League, New York, from 1930 to 1933 and at Columbia University from 1935 to 1940. She was a runner up in the Prix de Rome competition of 1947. Since the second world war she has lived in England, mainly in the Brighton area and sculpts portraits and figures in stone, wood and plaster as well as clay and bronze. Her works are represented in several British and American public collections.

CUNNINGTON, E.B. (Mrs. Attrill) 1914-
Born in London on July 13, 1914, she studied at the Slade School of Art, 1936-39 and now works in Oxford as a portrait sculptor and watercolourist. She has exhibited at the Royal Academy, R.B.A. and provincial galleries.

CURABET, Georges Michel fl. 20th century
Born in Paris in the early years of this century, he worked there in the inter-war period as a sculptor of figures and busts.

CURATELLA-MANES, Pablo fl. early 20th century
Born in Buenos Aires in the late 19th century, he worked in France before the first world war and exhibited small bronzes at the Nationale.

CURFESS, Ernest 1849-1896
Born at Aalen in 1849, he died at Stuttgart in 1896. He worked in Württemberg as a sculptor of monuments and historical groups.

CURIE, Militza fl. 20th century
Born in Bessarabia, Romania, at the turn of the century, she studied in Bucharest and Paris and exhibited figures and busts at the Salon des Indépendants in the 1920s.

CURILLON, Jean fl. 20th century
Born in Paris at the end of the last century, he studied under his father Pierre Curillon and also Coutan. He specialised in busts, heads and portrait bas-reliefs and exhibited at the Salon des Artistes Français in the 1920s.

CURILLON, Pierre fl. 19th-20th centuries
Born at Tournus on March 6, 1866, he worked in Paris at the turn of the century as a sculptor of portraits and genre groups such as Thrill of Wave. He exhibited at the Salon des Artistes Français, winning medals between 1899 and 1908.

CURTIS, Domenico de fl. 20th century
Born at Roslin, New York, in the early 1900s. After studying art in New York he moved to Paris and exhibited regularly at the major Paris salons in the 1930s. He specialised in allegorical, symbolist and genre bronzes. His chief work was Phantom (1931).

CURTIS, George Carroll 1872-1926
He worked in the United States as a sculptor of memorials, figures, busts and portrait reliefs.

CURTIS-HUXLEY, Claire A. fl. 19th-20th centuries
Born at Palmyra, New York, in the second half of the 19th century. Later he moved to Paris where he studied under Denis Puech and established a studio there. He exhibited at the various Paris salons at the turn of the century, and got an honourable mention at the Exposition Universelle of 1900. He specialised in genre and allegorical statuettes. His figure La Lumière is in the Luxembourg Museum.

CURTOIS, Ella Rose 1860-1944
Born at Branstone, Lincs., in 1860, she died in Paris in 1944. She sculpted genre figures and portraits and exhibited at the Royal Academy from 1885 and the Paris salons in the early years of this century.

CUSTOR, Antoine fl. 19th century
Born at Neuchâtel on November 11, 1852, the son of the Swiss genre sculptor Antoine Custor the Elder (1825-92). He worked in Zürich and later studied in Rome where he enrolled at the Academy. During this period he won the Prix de Rome with his group Bird-nester and Eaglets. On returning to Switzerland he settled in Geneva and specialised in portrait busts, statues and ornamental sculpture for public buildings in Geneva.

CUTLER, Harriette fl. 20th century
Born in Cleveland, Ohio, she studied in New York and Paris and specialised in genre statuettes which she exhibited in the late 1920s.

CUVELIER, Joseph fl. 19th century
Born in Commines, where he worked as a sculptor of busts, figures and groups. He exhibited at the Salon from 1868 till his death in 1888.

CUVELLIER, Louis Eugène Joseph fl. 19th century
Born at Cherbourg in the first half of the 19th century, he studied in Paris under Carpeaux. He specialised in portraiture, mainly busts, bas-reliefs and medals, and exhibited at the Salon from 1872 to 1883.

CUYPER, Johannes Baptista de 1807-1852
Born in Antwerp on March 13, 1807, he died there on April 26, 1852. He studied under J. van der Neer and M. de Bree and worked in Antwerp as a portrait, genre and classical sculptor. His works include figures of St. Cecilia, St. Francis de Sales and his old master Mathieu de Bree, and alleggorical compositions such as Eternity, and Justice protecting Innocence.

CUYPER, Leonard de 1813-70
Born in Antwerp on January 1, 1813, he died there on February 18, 1870. He was the younger brother and pupil of J.B. de Cuyper and specialised in religious sculpture and portrait busts of contemporary personalities. His works include the monument to Antony Van Dyck in Antwerp and statues of Theo van Ryswyck and Lazare Carnot.

CUYPER, Pieter Joseph de 1808-1883
Born in Antwerp on November 16, 1808, he died at Duffel on November 10, 1883. A brother of J.B. de Cuyper, he studied at Antwerp Academy and later worked on decorative sculpture for churches in Antwerp, Liège and Amsterdam. He also sculpted portraits and produced the statue of P. Coudenberg in the Antwerp botanic gardens.

CUYPERS, Jean 1844-1897
Born in Louva in 1844, he died there in 1897. He studied in Louvain and Antwerp and won the Grand Prix de Rome in 1872. He specialised in genre and allegorical figures and groups such as Slavery and Hallali, both in the Louvain Museum.

CZAJKOWSKI, F. fl. 20th century
Sculptor of genre and allegorical figures and groups, working in Warsaw since the second world war.

CZAPEK, S. fl. 20th century
Born in Bohemia in the late 19th century, he studied in Prague and Vienna, settling in the latter city at the turn of the century. He sculpted busts, portrait reliefs and groups and exhibited in Austria, Germany and France before the first world war.

DABIS, Anna fl. 19th century
She worked in London in the late 19th century and exhibited figures
and portraits at the Royal Academy from 1888 to 1895.

DABROWSKA, Waleria fl. 19th-20th century
Born in Galicia, she worked in Cracow at the turn of the century,
sculpting statuettes and reliefs.

DADIE-ROBERG, Dagmar 1897-
Born in Stockholm on October 1, 1897, she studied under Akzap
Gudjan and has exhibited regularly in Stockholm since 1925. In the
inter-war period she also participated in the major Paris salons. Her
work consists largely of statuettes and small symbolic groups, such as
Slave to Life, Man Slave to Himself, Standing Woman, as well as heads
and busts of contemporary Swedish personalities.

DADSWELL, Lyndon Raymond 1908-
Born at Stanmore, Australia in 1908, he studied at the Royal
Academy schools, London and later in Germany, France and Italy. He
served as a war artist with the Australian Imperial Forces during the
second world war and sculpted the series of twelve panels representing
the fighting units of the A.I.F., for the Shrine of Remembrance in
Melbourne, Victoria. He was awarded a Fulbright scholarship and a
Carnegie grant to study in the United States in 1957-58. He is a
prolific sculptor of portraits and figures, reliefs, groups and allegorical
compositions. His best known works are the architectural decorations
in the Commonwealth Bank, Sydney and the Union Theatre of
Sydney University, and he sculpted the bronze figures in the War
Memorial Cultural Centre in Newcastle, New South Wales. His work is
represented in all the art galleries of the Australian state capitals.

DA FANO, Dorothea Natalie Sophia fl. early 20th century
(née Landau)
She worked in London as a painter and sculptor of figurines and small
groups, heads and busts, up to about 1930 and died in London on
November 16, 1941. Many of her pieces are signed with her maiden
surname Landau.

DAGAND, Michel fl. 19th century
Born at La Mothe-en-Bauges, France in the early 19th century, he
studied under Cortot and Jacquot and exhibited historical and
neo-classical figures at the Salon from 1843 to 1870.

DAGGET, Maud 1885-
Born in Kansas City on February 10, 1885, she studied under Lorado
Taft at the Chicago Art Institute and later continued her studies in
Rome and Paris. On her return to the United States she became a
member of the Art Club of California and won a silver medal at the
Panama-Pacific Exposition of 1915. She also exhibited at the Salon de
la Société Nationale in Paris in the late 1920s. She specialised in
portrait reliefs and heads.

DAGONET, Ernest 1856-1926
Born at Chalons-sur-Marne on May 4, 1856, he died in 1926. He was a
pupil of J.P. Laurens and Moreau-Vautier and exhibited at the Salon
from 1883 onwards, winning a third class medal (1890) and a second
class medal (1895), as well as bronze and silver medals at the
Expositions of 1889 and 1900 respectively. He was noted as an
animalier, with figures and groups of animals in ivory and marble as
well as bronze. He also worked on a number of public monuments
and memorials and sculpted portrait medallions and busts.

DAHL-JENSEN 1874-
Born in Copenhagen, he was employed as a modeller at the Royal
Copenhagen porcelain factory. A few of his figurines are known in
terra cotta or bronze as well as porcelain.

DAHLERUP, Hans Birch 1871-1892
Born in Copenhagen on April 1, 1871, he died in Paris on January 15,
1892. He was the son of the Danish Chancellor, Baron Dahlerup and
studied under Saabye at the Danish Academy in Copenhagen, but felt
stifled by the rigid classicism of Danish sculpture at that period. After
a year he went to Paris where he became a pupil of Chapu for a time,
but returned to Denmark in order to execute the monument to his
grandfather Admiral Dahlerup, much of the work for this being done
in Vienna. From there he went back to Paris in 1891 but committed
suicide while his mind was deranged. Apart from the Dahlerup
monument, he left a number of portrait reliefs, busts, heads and
maquettes.

DAILLION, Gustave fl. 19th century
Born at Cambrai on June 15, 1842, he exhibited at the Salon in 1868
only, showing a terra cotta bust of Silene. The Cambrai Museum has
his figure Child with a Fly.

DAILLION, Horace 1854-c.1938
Born in Paris on November 10, 1854, he died there shortly before the
second world war. He studied under Dumont and Aimé Millet and
began exhibiting at the Salon in 1876. Later he switched to the Salon
des Artistes Français, of which he became an Associate in 1888, and
won a second class medal in 1882 and a first class medal in 1885. He
won the Prix du Salon in 1885 and gold medals at the Expositions of
1889 and 1900 and the medal of honour in 1924 and also at the
Exposition Internationale of 1937. He was also an Officier of the
Legion of Honour. He is best remembered for his numerous
monuments and public statuary, the chief work being The Age of
Stone, in the Jardin des Plantes. He also produced numerous portrait
busts and the charming genre group Child's Bedtime.

DAILLION, Palma (née d'Annunzio) 1863-
Born at Atina, near Caserta, Italy on March 7, 1863, she studied
under Horace Daillion whom she subsequently married. She was also a
pupil of Bottee and Deschamps and exhibited at the Salon from 1889
onwards, winning a second class medal in 1914. She specialised in cire
perdue portrait busts and heads.

DAJON, Nicolai 1748-1823
Born in Copenhagen on January 21, 1748, he died there on December
12, 1823. Of mixed French and Russian descent, he studied at the
Danish Academy from 1759 to 1766 under Wiedewelt and was
awarded a large gold medal and a travelling scholarship in 1775 which
took him to Rome. Here he sculpted his figure of Paris which earned
him entry to the Academy on his return to Copenhagen. He became a
professor in 1803 and succeeded Wiedewelt as director, a post which
he held from 1815 to 1821. He sculpted public statuary and
monuments, but his minor words include statuettes of classical and
allegorical subjects, portrait reliefs and busts.

DAKIN, Rose Mabel (Mrs. Phipps) fl. early 20th century
Born at Grappenhall, Cheshire in the late 19th century, she studied at
the Manchester School of Art and later was a pupil of Stanhope
Forbes at Newlyn, Cornwall. She worked in the period from the
beginning of the century to about 1930, mainly as a painter of
portrait miniatures, but also sculpted heads and busts. She exhibited
at the Royal Academy, the Salon des Artists Français, the British
provincial galleries and in several overseas exhibitions. Though
working mainly in London, she also worked in Australia and India in
the 1920s.

DALBANG, Marthe fl. early 20th century
Born at Fourmies, France at the end of the 19th century, she
specialised in busts, heads and small figures.

DALBET, Louis fl. 20th century
Born at Mehun-sur-Yevre, France, he exhibited figures and portraits at
the Salon d'Automne in 1942-44.

DALBOY, Blanche fl. 20th century
She worked at Sainte Mande at the beginning of this century and exhibited at the Salon des Artistes Français from 1907 to the first world war, specialising in busts and statuettes.

DALDINI, Vittore 1867-
Born at Aranno, Switzerland in 1867, he was the son of the painter Andreas Daldini. He had a studio in Thun in the 1880s and moved to Vienna in 1898 where he studied under Dr. C. Brun for a time. He produced a number of busts and small groups.

DALHOFF, Jorgen Balthasar 1800-1890
Born at Orslev, Falster on November 11, 1800, he died in Copenhagen on March 2, 1890. He studied at the Danish Academy from 1815 to 1819 and won a travelling scholarship which took him to Vienna. Later he became professor of modelling at the Copenhagen Academy and specialised in portrait busts and genre statuettes.

DALLET, Liza fl. 20th century
Born in New York at the beginning of this century, she studied there and in Paris where she settled in the 1930s. She specialised in portrait sculpture.

DALLIER, Jules fl. 19th-20th centuries
Born in Paris, he studied under Dupérier and exhibited at the Salon from 1879 to the first world war with conspicuous lack of success. He produced busts, heads, statuettes and small bas-reliefs.

DALLIN, Cyrus Edwin 1861-1944
Born at Springville, Utah on November 22, 1861, he died in Boston on November 14, 1944. He studied under Truman H. Bartlett in Boston and later enrolled at the École des Beaux Arts, Paris and the Académie Julian where he studied under Chapu and Dampt. On his return to the United States he became a member of the National Sculpture Society and taught sculpture at the Massachusetts State Normal Art School. He later became a member of the American Academy of Arts and Letters and a Fellow of the Royal Society of Arts, London. He exhibited on both sides of the Atlantic at the turn of the century and won many awards, including a silver medal at the Exposition Universelle (1900), a gold medal at the Salon of 1909, gold medals at the St. Louis World's Fair (1904) and the Panama-Pacific Exposition (1915) and the first prize for the monument to American servicemen at Syracuse, New York (1906). A versatile sculptor in every medium of the plastic arts, he is best known for his representations of the American Indian. His bronzes in this field include The Last Arrow, Medicine Man (Philadelphia), Mystery Man, The Appeal to the Great Spirit (Boston), Massasoit (Plymouth, Mass.) and The Signal of Peace (Chicago). His later works included the Pioneer Monument at Salt Lake City and the figure of Sir Isaac Newton in the Library of Congress. He also sculpted a number of busts and portrait and allegorical medallions.

DALOU, Aimé Jules 1838-1902
Born in Paris on December 31, 1838, he died in the same city on April 15, 1902. He studied under Carpeaux and Duret, combining the richness and vivacity of the former with the academic purity and scholarship of the latter, and became one of the most versatile and outstanding French sculptors of the 19th century. He was vehemently opposed to the monumental classicism which dominated sculpture under the Second Empire and, along with other artists of a kindred feeling, boycotted the official Salon from 1861 onwards, exhibiting instead at the so-called Salon des Refusés. He took an active part in the Paris Commune and fled to England after the collapse of the revolution. He worked in London from 1871 till 1879 when he was amnestied by the French Republic. During his period in England he taught sculpture at South Kensington and influenced the trend in English sculpture of the late 19th century towards greater humanism and a penchant for naturalism in domestic subjects. To this period belongs his French Peasant Woman, later edited in bronze and erected, under the guise of Maternity outside the Royal Exchange in London. Following his return to Paris he secured many public commissions, the greatest of which was his Triumph of the Republic, on which he worked for twenty years. Ironically this highly elaborate group, in the Place de la Nation, is redolent of the florid symbolism which characterised sculpture in the reign of Louis XIV and was at variance with Dalou's earlier work. His last work was

the monument to Léon Gambetta for the town of Bordeaux (1901) and it likewise embodied all the symbolic grandeur of an earlier epoch. By the end of the century the rebel of earlier years had become the very keystone of the Establishment, an Officier of the Legion of Honour and winner of the medal of honour and the Grand Prix at the Exposition Universelle of 1889. He was a founder member of the Société Nationale des Beaux Arts in 1890. His work covered a very wide range of sculpture and includes bas-reliefs and friezes, monuments and statuary in marble, stone and plaster. Many of the maquettes and individual figures or groups from these monuments were also edited as bronzes. His projected Monument aux Ouvriers (incomplete at the time of his death) was utilised by the bronze founders Hebrard and Susse who between them cast limited editions from 107 different terra cotta figures illustrating the working classes of France. He also produced numerous bronze statues and busts of contemporary personalities, such as Blanqui, Victor Noir, Lavoisier, Charcot, Loze, Albert Wolff and Floquet, neo-classical groups, such as Nessus lifting up Deianeira, the Guardian Angel, and genre figures, such as The Embrace, The Rocking Chair, The Bather and Head of a Sleeping Child.
Cailloux, H. *Jules Dalou* (1935). Dreyfus, M. *Dalou* (1903). Mallet *Dalou* (1966).

DALTCHEV, Lubomir fl. 20th century
Born in Bulgaria where he worked in the first half of this century. He studied sculpture in Sofia and later went to Rome, Paris and London. He had produced a number of monuments and public statuary, as well as small genre figures and portraits.

DALTON, Peter C. 1894-
Born in Buffalo, New York on December 26, 1894, he studied under Robert Aitken and won the gold medal of the Allied Artists of America in 1935. He specialises in busts, portrait reliefs and religious figures, such as Moses.

D'ALTRI, Arnold 1904-
Born in Cesena, Italy, he was educated in Zürich and studied at the School of Arts and Crafts in that city. Later he worked in the studio of Otto Kappeler and finished his studies in Rome, Paris and London. He taught in Zürich for a time before moving to Cassel in 1959. His best known works are the public monuments in Zürich and Leverkusen, but he specialises in small abstracts and Surrealist groups, such as Trinity and Homo Faber. He has had several one-man shows in Paris, Milan and Rome from 1951 onwards and participated in the open-air exhibition of Swiss sculpture at Biel in 1958.

DALWOOD, Hubert Cyril 1924-
Born in Bristol on June 2, 1924, he studied at the Bath Academy of Art under Kenneth Armitage, 1946-49 and worked in a bronze foundry in Milan for two years after winning an Italian state scholarship. He had his first one-man show at Gimpel Fils Gallery in 1954 and won the David E. Bright Prize for Sculpture in 1962 at the Venice Biennale. He taught at Newport School of Art from 1951 to 1955 and was Gregory Fellow at Leeds University from 1955 to 1959. He has taken part in many exhibitions, both in England and western Europe since the mid-1950s. He has produced groups and abstract reliefs, non-figurative works and 'un-idealized' human figures in concrete, lead and bronze.

DAMBOISE, Marcel 1903-
Born in Marseilles in 1903, he worked at Villa Abd-el-Tif in Algiers up to the late 1950s and exhibited at the Salon des Indépendants, the Tuileries and the Salon d'Automne in the 1930s. He specialised in human figures in the pure classical tradition, and excelled in portraiture. Though preferring to carve in stone life-size, he has also produced statuettes cast in bronze and terra cotta sketches for his larger works. His works include Young Girl Dressing, Figure of a Woman and Bust of a Child.

DAME, Ernest 1843-1920
Born at St. Florentin on October 1, 1843, he died in Paris on November 22, 1920. He studied under Lequesne-Cavelier and Guillaume and exhibited at the Salon des Artistes Français, winning a second class medal in 1875 and bronze medals at the Expositions of 1889 and 1900. He was a prolific sculptor of statues, public

memorials and monuments in Paris. His works include the statues of Claude Chappe and Victor Jacquemont and classical groups, such as Cephalus and Procris. His minor works include a number of statuettes and many portrait busts of contemporary celebrities.

DAMERAT fl. early 19th century
Nothing is known of this sculptor or bronze founder other than a bronze statuette of a draped nude Napoleon I and a companion figurine of the Empress Marie Louise c.1810-14, both in the Wallace Collection, and inscribed 'Damerat Coelavit'.

DAMERON, François 1835-1900
Born at Dijon in 1835, he died on August 13, 1900. He studied under Jouffroy and exhibited at the Salon from 1873. He specialised in portrait busts and bas-reliefs.

DAMIENS, Pierre 1824-1902
Born at St. Germain d'Arcé in 1824, he died in Paris in 1902. He studied under Bonnassieux and exhibited at the Salon from 1849 to 1861, specialising in classical and historical figures.

DAMKO, Jozsef 1872-
Born at Nemet-Proua, Hungary on October 16, 1872, he studied under A. Strobl in Budapest where he later established a studio. He took part in many national and international exhibitions. He produced a wide range of sculpture, from large monuments to statuettes and portrait busts and reliefs.

DAMMAN, Paul Marcel 1885-
Born at Montgeron on June 13, 1865, he studied under J. Chaplain and won the Prix de Rome in 1908. He exhibited at the Salon, winning a second class medal (1914), a first class medal (1921) and the medal of honour (1928). He was made a Chevalier of the Legion of Honour. He specialised in statuettes, medallions and small plaques of female subjects.

DAMMANN, Hans 1867-
Born at Proskau in Silesia on June 16, 1867. He studied at the Technical High School in Hanover and later became a pupil of Gerhard Janensch and Peter Breuer in Berlin. His work ranged from memorials and monumental statuary to portrait reliefs and busts.

DAMMOUSE, Albert Louis fl. 19th-20th centuries
Son of Pierre Adolphe Dammouse from whom he learned the rudiments of modelling. Later he studied under Jouffroy and exhibited at the Salon from 1869. For a time he worked for Solon Milès and eventually built up a reputation for art pottery at the turn of the century. His bronzes belong to the early part of his career and consist mainly of busts and small genre groups.

DAMMOUSE, Pierre Adolphe fl. 19th century
Born in Paris on April 2, 1817, he studied under A.L. Barye and exhibited at the Salon from 1848 to 1880. He was employed on the decorative sculpture for the Louvre in the early 1850s and specialised in bas-reliefs of naval emblems and trophies of arms. Later he worked as a modeller at the Sèvres porcelain factory. He produced a number of busts, portrait reliefs and statuettes.

DAMON, Alfred Eugène fl. 19th century
Born in Paris, he studied under Levillain and exhibited figures and small groups at the Salon des Artistes Français, becoming an Associate in 1895 and winning an honourable mention the following year.

DAMPT, Jean Auguste 1853-1946
Born at Venarcy on March 6, 1857, he died at Dijon in September 1946. He studied at the School of Fine Arts in Dijon and was a pupil of Jouffroy and Dubois at the École des Beaux Arts in Paris. He exhibited at the Salon from 1879 to 1935, making his début with a plaster figure of Ishmael. He subsequently produced many marble statues and busts, but also worked extensively in ivory, wood and plaster. He was one of the most versatile and ingenious of French sculptors at the turn of the century and was outstanding in the variety of his skills, techniques and artistic expression. His bronzes include At the Forge, Before the Fantasy, Saint John, Child in Prayer and numerous busts and bas-reliefs. His figure Le Baiser de Chevalier, was executed in silver and ivory. Dampt won numerous awards, ranging from a second class medal (1879) to a gold medal at the Exposition Universelle of 1889. He became a Chevalier of the Legion of Honour

in the latter year and was successively Officier (1900) and Commandeur (1926). He became a member of the Institut in 1919.

DAN, Hans Pedersen fl. 19th century
Born at Itzehoe, Denmark on August 1, 1859, he studied in Copenhagen and later at the Academy of Fine Arts in Rome. He exhibited in Copenhagen from 1887 and specialised in historical and genre figures such as The Little Trumpeter. He executed the statues of King Christian IX at Nyborg and Drewsen at Silkeborg.

DAN, Johanne Pedersen (née Betzonick) fl. 19th century
Born in Copenhagen on May 13, 1860, she studied under Hans Dan whom she later married, and for a time she was also a pupil of Stephan Sinding. She exhibited in Copenhagen from 1890 and also in Paris, Munich and Berlin at the turn of the century, and the Columbian Exposition, Chicago (1893). She specialised in genre statuettes, such as Snake Charmer (1891).

DANDELOT, Pierre fl. 20th century
Born at Neuilly-sur-Seine, he studied under E. Guillaume, C. Lefevre and Niclausse. He exhibited at the Paris salons from 1929 to the second world war, winning a silver medal (1934) and a gold medal two years later. He specialised in animalier sculpture, with a penchant for the wild and more exotic animals. He also produced many figures and groups of a religious nature.

DANFORD, John Alexander 1913-
Born in Dublin on July 12, 1913, he studied at the Wimbledon School of Art from 1929 to 1934, under S. Nicholson Babb, and later at the Royal Academy schools where he won a gold medal in 1935, the Landseer scholarship (1934)' and the British Institution scholarship (1937). He worked in Nigeria and Trinidad for many years before settling at Kinsale in Co. Cork. He has sculpted animal and genre subjects, portraits and reliefs in wood, terra cotta and bronze, and also paints in watercolours. His work has been exhibited at the Royal Academy, the Royal Scottish Academy, the Royal Hibernian Academy and in provincial and overseas galleries.

D'ANGERS, David — see DAVID, Pierre Jean

DANIEL, Mlle. fl. 20th century
She worked at St. Étienne, France in the 1920s, specialising in busts, heads and portrait plaques. She exhibited at the Salon des Artistes Français, 1920-24.

DANIEL, Peter Stöhrmann fl. 19th century
Born at Oldensworth, Denmark on October 7, 1821, he studied at the Copenhagen Academy in 1845-48 and also worked in the studio of H.V. Bissen. He produced several important monuments, but his reputation rests mainly on his wax modelling for the various museums in Scandinavia and was the first wax modeller to adopt the Panoptic technique.

DANIELLI Bassano 1864-
Born at Cremona on May 27, 1864, he exhibited in Milan, Turin and Venice from 1881 onwards and won a gold medal at the Exposition Universelle of 1889. He specialised in genre and allegorical groups, such as Visions (Galeria dell'Arte Moderne, Rome).

DANIELS, Elmer Harland 1905-
Born at Owosso, Michigan on October 23, 1905, he studied at the Beaux-Arts Institute of New York and the Art Students' League. He took part in the exhibition of Indiana Art, in Indianapolis and specialised in memorials, monuments, busts and portrait reliefs.

DANIELS, John Karl 1875-
Born in Norway on May 14, 1875, he studied under Okerberg and A. O'Connor. He produced historical and genre figures and portrait sculpture and was awarded a gold medal at the St. Louis World's Fair in 1904.

DANKBERG, Friedrich Wilhelm 1819-66
Born in Halle on October 9, 1819, he died in Berlin on October 13, 1866. He studied under Holbein in Berlin and established a workshop specialising in ornamental sculpture for interior and exterior decoration. He worked on the decoration of the Orangerie at Sans Souci, Potsdam and produced various fountains and the series of statuettes of the Electors of Brandenburg.

DANNECKER, Johan Heinrich von 1758-1841
Born at Waldenbusch on October 15, 1758, he died there on December 8, 1841. He studied under Adam Bauer, A.F. Harper, Nicolas Guibal and P.F. Lejeune. He was appointed Sculptor to the Saxon Court in 1780 and three years later went to Paris where he worked under Pajou. In 1785 he was in Rome, studying under Canova and returned to Germany in 1790. He was appointed professor of sculpture at the Karlsacadémie and became a close friend of Schiller and Goethe, whose portrait busts by him are now in the Weimar Museum. He was a prolific sculptor of portraits, mainly in marble, plaster and terra cotta, but several of them were also edited in bronze. His other sculpture consisted of genre and classical subjects, such as Ariadne and the Panther, Drunken Faun, Water Nymph, Nymph at the Spring and Mars Seated.

Spemann, A. *Dannecker* (1909).

DANNHAUSER, Johan Eduard 1869-
Born in Berlin on August 8, 1869, he studied at the Berlin Academy and later specialised in groups featuring horses. These include Having Lost his Master, Death from Fatigue, Polo Player, Horse Quenching its Thirst, Sheep slaking their Thirst. He also sculpted portrait busts.

DANNINGER, Franz fl. early 19th century
Younger brother of Johann Georg the Younger, with whom he worked on ornamental bronzes.

DANNINGER, Ignaz fl. mid-19th century
Son of Johann Georg the Younger, he worked in Vienna about 1830-50 as a bronze founder and sculptor of ornament for panelling and furniture.

DANNINGER, Johann Georg the Elder fl. late 18th century
He worked in Vienna at the end of the 18th century, executing ecclesiastical ornament plate and statuettes in gilt-bronze.

DANNINGER, Johann Georg the Younger fl. 18th-19th centuries
Son of the above, he was employed as a decorative sculptor at the Austrian Imperial Court and produced bronze ornament for furniture and interior decoration.

DANO, Marthe fl. 20th century
Born at Rennes at the beginning of this century, she specialised in portrait busts and heads, in terra cotta and bronze. She exhibited at the Salon des Artistes Français in 1923.

DANS, Susan fl. 20th century
Born in Berlin at the turn of the century, she worked in France in the 1920s and specialised in portrait busts and reliefs and small landscape and genre groups.

DANSON, Elsa 1885-
Born in Stockholm on January 13, 1885, she studied in Paris under Bourdelle and Zadkine and exhibited figures and portraits at the Paris salons in the 1920s.

DANTAN, Antoine Laurent 1798-1878
Born at St. Cloud on December 8, 1798, he died in Paris on May 25, 1878. He studied under Bosio and Brou at the École des Beaux Arts from 1816 to 1819, and exhibited at the Salon from 1819 to 1868, being runner-up in the Prix de Rome in 1823. Subsequently he won numerous medals and the Prix de Rome (1828) with a group showing the Death of Hercules. He was made a Chevalier of the Legion of Honour in 1843. His sculpture in the classical idiom was distinguished by a purity and simplicity of line. He is best known for his monumental statue of Juvenal on the façade of Paris Town Hall and other colossal public statuary, but his smaller works include numerous busts of contemporary figures and various allegorical and genre groups, such as Young Bather playing with his Dog, Drunkenness of Silene and Young Girl playing the Tambourine.

DANTAN, Jean Pierre (Dantan the Younger) 1800-1869
Born in Paris on December 28, 1800, he died in Baden on September 6, 1869. The younger brother of the foregoing, he studied under him and Bosio. Despite his studies of sculpture in Italy his work was quite unlike the classical pattern and it was almost as if he sought to reproduce the art of caricature in the plastic medium. He specialised in grotesque statuettes parodying contemporary figures, yet there was nothing malicious in these caricatures which included such people as Victor Hugo, Balzac, Rossini, Dumas, Paganini and Lemaître. These statuettes were very successful both in France and England and were highly prized at the time. They included prominent British personalities as well. He is said to have assembled a secret museum of these figurines attached to his workshop, but nothing could be learned of this after his death. Many of these statuettes, however, have been preserved in various museums. These humorous portraits were cast for him by Susse Frères from 1832 onwards.

Seligman, J. *Figures of Fun: the Caricature-Statuettes of Jean Pierre Dantan* (1957).

DANTZELL, Joseph 1805-1877
Born in Lyons on December 17, 1805, he died in Paris on April 22, 1877. He learned the elements of sculpture from his father who was a gem engraver. Later he studied at the Lyons School of Fine Arts and exhibited busts, heads and portrait medallions at the Salon from 1841 till his death.

DANTZIG, Rachel Margaretha van 1878-
Born in Rotterdam on November 12, 1878, she studied at Rotterdam Academy and worked in the studio of Van der Stappen in Brussels. Later she studied under Colarossi in Paris. She travelled widely, studying museum collections in Italy, Spain and Germany before settling in Amsterdam. She exhibited in the Netherlands and abroad, but her works, both portraiture and figurative sculpture, are mainly preserved in private collections.

DARAGON, Charles Laurent fl. late 19th century
Born in Paris, where he died in September 1904. He worked in Paris as a sculptor of figures, reliefs and portraits and got an honourable mention at the Salon of 1892.

DARBEFEUILLE, Paul 1855-1930
Born in Toulouse, he studied in Paris under Jouffroy, Falguière and Mercié and exhibited at the Salon from 1880 onwards. He won a third class medal (1898), a bronze medal at the Exposition Universelle of 1900, a second class medal in 1902 and a medal of honour in 1928. He was a prolific sculptor of busts and heads, but also executed a series of four panels for the Church of St. Marthe in Paris and a number of genre works, such as Child with Sea-shell (1880); Laughing Child (1881), The Future (1882), Woman at her Toilet (1885), Apotheosis of Victor Hugo (1886) and Dragon Fly (1896).

DARBOIS, Pierre Paul 1785-1861
Born in Dijon on January 11, 1785, he died there on September 30, 1861. He studied under François Devosges, Augustin and Bornier. Later he became professor at the Dijon School of Design and curator of the town's museum in 1829. Though mainly known as a painter of miniatures he also produced several statues for his native town and figures of St. Bernard and Minerva.

DARCQ, Albert 1848-1895
Born at Lille in 1848, he died there in 1895. He studied under Cavelier and exhibited at the Salon from 1874 to 1892, winning a third class medal in 1881. Lille Museum has his bust of a Bacchante.

DARDÉ, Paul 1890-
Born at Olmet on July 5, 1890, he studied at the École des Beaux Arts in 1912 and later went to Italy to continue his studies. On his return to Paris he worked with Rodin and then established his own studio. He exhibited at the Salon des Artistes Français from 1920 onwards and made a great impression with his figure of an Old Faun of truculent mien. He specialised in busts and heads, noted for their very expressive features. His best known works were Neanderthal Man (1930), Christ with His Wounds, and Thaïs (1934).

DARDEL, Robert Guillaume 1749-1821
Born in Paris in 1749, he died there on July 29, 1821. He studied under Pajou and exhibited at the old Salon de la Correspondance and then at the Louvre exhibitions from 1791 to 1817. He executed the bronze group of the Great Conde at Rocroy for the Prince of Conde and did numerous busts and portrait reliefs of historical and contemporary personalities, in marble, terra cotta and bronze. These include the busts of Descartes, Buffon, Bossuet, Pascal, Turenne, Jacques Elliot and Sir Isaac Newton and a group illustrating The Recapture of Calais.

DAREL, Marcel V.E. fl. early 20th century
Born in Paris, where he worked as a portrait sculptor at the turn of the century. He exhibited at the Salon des Artistes Français from 1905 till the first world war.

DARLES, Laurent fl. 20th century
Born in Toulouse, he worked there in the inter-war period. He exhibited at the Salon des Artistes Français and won a third class medal and the Henriette-Ernestine Boisy Prize in 1937.

DARLEY, Maxime fl. early 20th century
Born at Neuvy-Santour in the second half of the 19th century, he studied under Dané and exhibited at the Salon des Artistes Français at the turn of the century. He specialised in equestrian statuettes after the first world war, particularly figures of Marshal Foch, General Gouraud and other heroes of the recent conflict.

DARLINGTON, Francis fl. 19th-20th centuries
He worked as a figure and portrait sculptor in London at the turn of the century and exhibited at the Royal Academy in 1901.

DARMONT, Jean Claude fl. 18th century
He worked in Besançon in the second half of the 18th century as a sculptor of decorative pieces and figurines, often rendered in gilt-bronze.

DARNAULT, Florence Malcolm 1905-
Born in New York, she studied at the National Arts Club of New York. She specialised in portrait reliefs and busts, both historical and contemporary. Her best known work is the bas-relief of Frank Sprague for the American Institute of Electrical Engineers.

DARSOW, Johannes 1877-
Born in Berlin on August 12, 1877, he studied at the Dresdner Kunstgewerbeschule and the Berlin Academy. He settled in Berlin and exhibited there and in Munich from 1906 to the first world war, specialising in genre figures and groups.

DARTOIS, Jacques 1754-1848
Born in Liège in 1754, he died there on August 12, 1848. He learned the jewellery trade under his father and later studied goldsmithing in Paris under Auguste Masson. At this time he began producing small decorative sculptures in bronze or copper, and this culminated in the decorative doors for the Tabernacle in the Church of St. John, Liège, featuring the Revolution of 1789 at Liège. Other works included a figure of Christ, a bas-relief of the serpent of Aaron, and a group of Hercules and Omphalos.

DARVANT, Alfred 1830-1909
Born in Paris about the year 1830, he died there in October 1909. He became an Associate of the Salon des Artistes Français in 1884 and exhibited bas-reliefs and busts. He also worked on the decorative sculpture in the new Paris Opera.

DASIO, Ludwig 1871-
Born in Munich, he studied under Syrius Eberle and later travelled extensively in Europe. He specialised in bronze statuettes of genre subjects.

D'ASTE, Joseph fl. 20th century
Born in Naples he worked as a portrait and figure sculptor in the early part of this century. He exhibited in Italy and France in the early 1920s.

D'AUBARÉOLE, Christian fl. 20th century
He worked in France as a sculptor of genre figures and groups, such as Maternity, exhibited at the Nationale in 1944.

DAUDELIN, Charles fl. 20th century
Canadian painter and sculptor of figures and portraits, working in the first half of this century.

DAUGER, Xavier, Vicomte fl. 19th century
Born at Meuneval in the mid-19th century, he exhibited at the Salon from 1880 to the end of the century. He specialised in portrait busts and reliefs, mainly in marble.

DAUMAS, Jean Barthélemy 1815-1879
Born in Toulon on August 6, 1815, he died in Paris on August 9, 1879. He was the younger brother and pupil of Louis Joseph Daumas and also studied under David d'Angers. He specialised in busts and heads and completed a statue of Molière (begun by J.E. Caudron) for the Comédie Française.

DAUMAS, Louis Joseph 1801-1887
Born in Toulon on January 24, 1801, he died in Paris on January 22, 1887. He studied at the École des Beaux Arts in 1826 and was a pupil of David d'Angers. He exhibited at the Salon from 1833 and won a third class medal in 1843 and second class medals in 1845 and 1848. He became a Chevalier of the Legion of Honour in 1868. He worked mainly in plaster and marble, sculpting statues of historic and contemporary celebrities. Several of these works were later published as bronzes. He also produced allegorical and classical groups, such as The Genius of Industry, Meditation, Comedy and Lyric Poetry.

DAUMIER, Honoré 1808-1879
Born at Marseilles on February 20, 1808, he died at Valmondois on February 11, 1879. He is best known as a painter and caricaturist, working as an illustrator for such humorous and satirical periodicals as *La Caricature* and *Charivari*. He produced no fewer than 3,958 lithographs and was a pioneer of naturalism in painting, though this latter work received little recognition in his own lifetime. Daumier was a tireless opponent of the monarchist principle and lampooned both the decline of the reign of Louis Philippe and the cult of Louis Napoleon which led to the coup of 1852 in which the short-lived republic was transformed into the Bonapartist Second Empire. His sculptures were inspired by the three-dimensional caricatures of Dantan and he began modelling figures such as Ratapoil about 1850. His caricatures of Louis Philippe in 1832 earned him a prison sentence; his reverence for the earlier Napoleonic ideal won him a precarious immunity during the Second Empire. Thus Ratapoil, which satirised the Bonapartist conspirators who overthrew the republic of 1848-51, was not cast in bronze till long after Daumier's death. Other works, such as Meprisant (1830) and bas-reliefs like The Emigrants (1871) and the Panathenaea of Poverty are now regarded as tentative forerunners of Expressionism. His chief sculptural works, which broke free from all the academic conventions of his time, include a series of 36 busts of French deputies.

Adhémar, J. *Honoré Daumier* (1954). Alexandre, Arsène *Honoré Daumier, l'homme et son oeuvre* (1890). Fogg Art Museum *Daumier* (1969). Frantz, Henri and Uzanne, Octave *Daumier and Gavarni* (1904). Geffroy, Gustave *Daumier* (n.d.). Gobin, M. *Daumier, sculpteur* (1953). Klossowski, E. *Honoré Daumier* (1923). Marcel, H. *Honoré Daumier* (1907). Ruemann, A. *Daumier als Illustrator* (1919). Sadler, M.T. *Daumier, the Man and the Artist* (1924)

DAUMILLER, Gustav Adolf 1876-
Born in Menningen, on November 10, 1876, he worked in Munich but won a certain following in London where he frequently exhibited at the turn of the century. He specialised in bronze statuettes of classical, allegorical and genre subjects, such as Aphrodite, Idyll, and Fairy Tale.

DAUN, Alfred fl. 19th century
Born at Baranow in Galicia in 1854, he studied under Gadomski in Cracow. After spending some time in Vienna he established a studio in Cracow where he specialised in memorials, busts and portrait bas-reliefs.

DAUPHINÉ, Delo Chesme c.1826-1856
Born in Florence about 1826, he died there on August 17, 1856. He studied under Bartolini and produced ecclesiastical decorative sculpture, busts and reliefs.

DAUSCH, Constantin 1841-1908
Born at Waldsee in 1841, he died in Rome in 1908. He studied at the School of Fine Arts in Munich and went to Rome in 1889 where he spent the rest of his life. He specialised in allegorical and classical groups, such as Samson and Delilah, The Four Seasons, Calliope and Erato, Youth and Old Age, and Hercules and the Centaur.

DAUSSIN, Emile fl. 19th-20th centuries
Born in Paris, he studied under Ponscarme and Bouguereau. He worked as a sculptor of busts, heads and portrait medallions at the beginning of the century, winning honourable mentions at the Exposition Universelle and the Salon of 1900.

DAUTEL, Pierre Victor 1873-
Born at Valenciennes on March 19, 1873, he studied under Maugendre, Villers, Barrias and Coutan and won the Prix de Rome in 1902. Later he exhibited at the Salon des Artistes Français and won medals in 1907-13 and the medal of honour in 1927. He was made a Chevalier of the Legion of Honour two years later. He produced a number of monuments and public statues, but is best known for his large range of plaques and medallions, many of which are preserved in the Valençiennes Museum.

DAUTERT, Karl fl. 19th-20th centuries
American sculptor working at the turn of the century on portrait busts and medallions of historical and contemporary celebrities.

DAVANZO, Lea fl. 20th century
Born in Padua, she studied under M. Roseituna. She had a studio at Como in the period before the second world war and produced genre and historical bronzes such as Joust (1933). She exhibited in the Italian and French salons of the 1930s.

DAVENPORT, Jane (Mrs. Reginald C. Harris) 1897-
Born at Cambridge, Massachusetts on September 11, 1897, she studied under Sandy Calder, Bourdelle and Jacques Lonchavsky in Paris and also at the Art Students' League in New York. She specialised in busts and figures. Her best known works are the statues at the American University Union in Paris and the Carnegie Foundation in Washington.

DAVID, Adolphe 1828-1895
Born at Baugé in 1828, he died in Paris in 1895. He studied under Jouffroy and became a founder member of the Société des Artistes Français. At the Salon of 1874 he was awarded a third class medal. He specialised in portraits and historical bas-reliefs, such as his Apotheosis of Napoleon (Angers Museum).

DAVID, Albert Eugène Marie 1896-
Born at Liernais on November 30, 1896, he studied under J. Boucher at the École des Beaux Arts. After the first world war he exhibited in the major Paris salons, mainly projects, studies and maquettes for the numerous war memorials on which he was engaged. He won a gold medal at the Exposition Internationale of 1937 and was made a Chevalier of the Legion of Honour the following year.

DAVID, Anna 1855-1930
Born in Paris on September 4, 1855, she died there about 1930. She studied under A. Séraphin and exhibited regularly at the Salon des Artistes Français, mostly statuettes and portraits.

DAVID, Edouard fl. late 19th century
He specialised in busts, and portrait reliefs which he exhibited at the Salon from 1875 to the end of the 19th century.

DAVID, Fernand 1872-1927
Born in Paris, he studied under Barrias and Fagel and exhibited at the Salon des Artistes Français and the Salon d'Automne from 1899 to 1923. He specialised in terra cotta and bronze genre statuettes.

DAVID, Pierre Jean (known as David d'Angers) 1788-1856
Born at Angers on March 12, 1788, he died in Paris on January 6, 1856. He was the fourth son of the sculptor Pierre Louis David, who tried to dissuade him from an artistic career on account of the unsettled times during the Revolution. The younger David persisted, and was encouraged by Marchand and Delusse, professors at the Central School in Angers. In 1808 he went to Paris where, through the good offices of the painter Jacques Louis David and the sculptor Roland, he got employment at 25 sous a day, working on the preliminary decorations destined for the Arc du Carrousel and the Louvre. In his garret he practised modelling the figures in the paintings of Poussin and this paid off in the Academy competitions of 1809-10. In 1811 he won the Prix de Rome and spent five years in Italy, part of the time being with Canova. He returned to France in 1816, but could not bear to see Paris under Allied occupation so he went to London. Here his would-be patrons tactlessly commissioned him to sculpt a Waterloo memorial so he returned to Paris in disgust after a mere three weeks. He then worked on the statue of Condé, left unfinished by Roland at his death, and this established David's reputation. He was decorated in 1826 and became a member of the Academy and a professor at the École des Beaux Arts. Two years later

he was almost killed in a brawl with a painter over a love affair, but after his recovery he concentrated on his artistic career. He prospered under the July Monarchy, and was commissioned to sculpt the façade of the Pantheon in 1830. In the Revolution of 1848 he turned to politics and was elected deputy for Maine et Loire, but with the coup of Louis Napoleon three years later he went into exile and worked in Belgium and Greece before returning to France in 1855, but died a few months later. He was one of the greatest French sculptors of the first half of the 19th century and had enormous influence on his country's artistic development. His vigorous and powerful technique combined the classicism and historicism of his predecessors, but fore-shadowed the full development of the romanticism which was to characterise French sculpture for much of the century. His copious writings were published in their entirety in 1958 and are of paramount importance for an understanding of French art of the mid-19th century. Angers Museum has no fewer than 676 statues, statuettes, busts and medallions as well as his famous Carnets (notebooks), while the Louvre has 478 medallions, 12 maquettes and several busts. He revolutionised portraiture and for the first time contemporary and near-contemporary figures were depicted exactly as they were, stripped of the idealised classicism and stereotyped poses which were used previously. Other important portrait sculptures include the Gutenberg monument at Strasbourg, the bust of Goethe in Weimar Library and the memorial to General Gobert in Père Lachaise cemetery.
Hôtel de la Monnaie David d'Angers (1966). Jouin, H. David d'Angers et ses relations litteraires (1890). Musée David, Angers Catalogue de la collection de portraits des contemporains.

DAVID, Pierre Louis 1760-1821
Born at Margancy in 1760, he died at Angers in December 1821. He was the son of a farmer who died when he was a child. His mother encouraged his artistic leanings and he became a wood-carver and modeller. He was caught up in the counter-revolution of the Vendée, captured and only saved from the guillotine by the intercession of Bouchamps. He subsequently enlisted in the Army of the Rhine but soon resigned to concentrate on sculpture. Most of his work was done in Angers, notably the decoration of the choir in the Church of St. Maurice.

DAVID, Robert 1833-1912
Born in Paris in 1833, he died at Neuilly-sur-Seine on June 2, 1912. He was the son of David d'Angers, but unfortunately did not inherit his father's genius. He produced rather insipid portrait medallions, examples of which are in the Musée David at Angers.

DAVID, Theodore Pierre Maurice 1869-1902
Born in Lausanne on June 26, 1869, he died in Paris on May 3, 1902. His father was the landscape painter, Emile François David and he himself worked as a painter and industrial designer as well as sculptor. He lived in Switzerland and Italy in his youth and studied under Guiseppe Berardi. Later he turned to modelling and stone-carving and studied under Salmson and Jacques at the School of Industrial Arts in Geneva. He was also a pupil of Denys Puech in Paris for some time. He produced decorative sculpture, friezes, statuettes and bas-reliefs.

DAVIDSON, Jo 1883-
Born in New York on March 30, 1883, he studied under George de Forest Brush and Hermon A. MacNeil at the Art Students' League and later studied at the École des Beaux Arts in Paris where he subsequently spent most of his life. He won the Maynard Prize of the National Academy of Design in 1934. He specialised in busts and figures of politicians and generals of the first world war period, including Foch, Joffre, Pershing, Wilson and Clemenceau. Later he did busts or heads of Bernard Baruch, Joseph Conrad, Ida Rubenstein and 'Uncle' Joe Cannon and bronze statuettes, such as Russian Dance, Japanese Girl and Supplication.

DAVIDSON, Robert 1904-
Born in Indianapolis on May 13, 1904, he studied under Myra Richards, A. Polasek and A. Ianelli. He was a member of the Portfolio Club of Indianapolis and won first prize at the Indiana State Fairs of 1923 and 1924, the Grand Prix (1928) and the second prize at the Chicago Salon of 1940. He specialises in busts, bas-reliefs, medallions and ceramics.

DAVIE, Alan 1920-
Born at Grangemouth, Stirlingshire on September 28, 1920. He studied at Edinburgh College of Art (1938-40) and won a travelling scholarship in 1941. He had his first one-man show in Edinburgh in 1946 and later exhibited at the Gimpel Fils Gallery in London. Originally a painter and then a jazz musician, he has concentrated on silversmithing, jewellery and sculpture since 1948. He travelled all over western Europe in 1948-9 and worked in the United States in 1956. He was awarded the prize for the best foreign painter at the Sao Paulo Biennale of 1963.

DAVIES, William 1826-1901
Born at Glebeland, South Wales on January 26, 1826, he died in London on September 22, 1901. He studied under Sir William Behnes and exhibited at the Royal Academy from 1851 onwards. He specialised in portrait busts of contemporary personalities as well as genre and neo-classical statuettes.

DAVIGE, John William fl. late 19th-20th centuries
Born at St. Étienne, he worked in France at the turn of the century, specialising in medallions and bas-reliefs.

DAVIN, Louis Auguste Ernest 1866-
Born at St. Michel-en-Beaumont on December 6, 1866, he studied under Falguière and Chaplain. Later he worked in Paris and Grenoble and exhibited at the Salon des Artistes Français from 1889 onwards. His works include The Pious Sergeant and portraits of Dr. B. Niepce and the painter E. Hébert.

DAVIS, Emma L. fl. 20th century
She worked at Santa Monica, California in the first half of this century, and exhibited at the Pennsylvania Academy of Fine Arts in 1938-39 and also at the New York World's Fair of 1939. She specialised in busts and reliefs.

DAVIS, Faith Howard 1915-
Born in Chicago on July 8, 1915, she works as a painter, illustrator and sculptor of busts, heads, statuettes and bas-reliefs.

DAVIS, Goodman fl. 20th century
Born in New York, he studied there and in Paris where he exhibited at the Salon d'Automne in 1930. His work consists mainly of wood and stone carving, but he has also modelled in clay, terra cotta and bronze.

DAVIS, Hallie fl. 20th century
Born in Piedmont, U.S.A., he studied under Charles Grafly and specialised in neo-classical and genre figures, such as the statuette of Baby Centaurs and Fountain with Child.

DAVIS, Helen S. fl. 20th century
Born in Philadelphia at the beginning of the century, she studied under G. Brewster and was a member of the National Academy of Lady Painters and Sculptors.

DAVIS, John Warren 1919-
Born in Christchurch, Hampshire on February 24, 1919, he studied at Westminster School of Art under Meninsky and Gertler (1937-39) and the Brighton College of Art under James Woodford (1948-52). He now works in Eastgate, Sussex as a sculptor in wood, stone, clay and bronze. His figures and reliefs are represented in several British and foreign public collections.

DAVIS, Richard 1904-
Born in New York on December 7, 1904, he studied under A. Ben-Shumuel and J. Flanagan and went to Paris where he continued his studies under Bourdelle and Creeft. He was a member of the American Artists' Congress and the Society of Independent Artists of New York. His figures and reliefs were shown at the New York World's Fair in 1939.

DAVIS, William Arthur fl. late 19th century
Born in Florence of English parents, he worked in London and Paris in the late 19th century, sculpting genre figures and portraits.

DAVOINE, Jean Irénée 1888-
Born at Charolles on October 14, 1888, he studied at the School of Fine Arts in Buenos Aires before returning to France in the 1920s. He won a third class medal at the Salon des Artistes Français in 1925 and a second class medal in 1937. He is known mainly as a wood-carver and no bronzes have so far been recorded.

DAVRIL, Eugène fl. 19th century
Born at Douai, he studied under Lequien the younger and exhibited busts and portrait reliefs at the Salon from 1878 onwards.

DAWINT, Simon fl. 20th century
Born at Genoa of French parents, he studied in Paris and exhibited at the Salon d'Automne in the 1920s. He specialised in allegorical and symbolic figures and groups.

DAWS, Frederick Thomas 1878-
Born at Beckenham, Kent on October 2, 1878, he studied at the Lambeth School of Art and exhibited at the Royal Academy from 1896 onwards, and also at the Royal Institute and the Royal Society of British Artists. He worked in London, specialising in animal sculpture. His works include Royal Tiger Shoot in Nepal, Combat of Tigers, Lion's head, The Keddah Gate and The Outpost. His sculptures often combine stone and bronze. He was also noted as a painter of wild animals and prize dogs.

DAWSON, Archibald 1894-1938
Scottish sculptor of bronze figures and bas-reliefs, most of which were cast by George Mancini. His best known work was his decorative sculpture for the Glasgow Empire Exhibition of 1938. He exhibited figures and reliefs at the Royal Scottish Academy.

DEARE, Joseph 1803-1835
Born in London in 1803, he was killed in a fall while working on a mural in Liverpool. He was the nephew and pupil of the stone-carver John Deare and attended the Royal Academy schools in 1822-25, winning a silver medal in 1823 and the gold medal two years later for a group of David and Goliath. He won the Isis silver medal of the Society of Arts in two consecutive years for a figure of Bacchus and a bas-relief respectively. In 1832 he moved to Liverpool and had a studio in the old Excise Office in Hanover Street, where he worked as a sculptor and portrait painter. He exhibited at the Royal Academy from 1826 to 1832 and his works include portrait busts of contemporary worthies and classical groups. Several of the portrait busts executed in his later years are preserved in Liverpool Academy. His bust of Lord Brougham was formerly in the Crystal Palace.

DEBAISIEUX, Yvonne fl. 20th century
Born in Buenos Aires of French parents, she studied in Paris and exhibited at the Salon des Artistes Français in the 1930s. She specialised in genre and allegorical statuettes.

DEBARRE, René Auguste fl. 20th century
Born in Paris at the turn of the century, he studied under Coutan and Verlet and exhibited figures and reliefs at the Salon des Artistes Français in the mid-1920s.

DEBAY, Auguste Hyacinthe 1804-1865
Born at Nantes on April 2, 1804, he died in Paris on March 24, 1865. He studied under his father, J.B. Debay and Gros. He made his début at the Salon at the age of thirteen, with a bust of Louis XVIII. He won a medal in 1819 and the Grand Prix de Rome four years later. He gave up painting to concentrate on sculpture and won a first class medal at the Exposition of 1855. He was made a Chevalier of the Legion of Honour in 1861. His works include The Primitive Cradle, Episode of 1793 at Nantes, Lucretia and a bust of Baron Gros.

DEBAY, Jean Baptiste Joseph 1779-1863
Born at Malines on October 16, 1779, he died in Paris on June 14, 1863. He studied at the Royal Academy of Paris and later became a pupil of Chaudet. He won a second class medal at the Salon of 1817 and was decorated in 1825. He was in charge of the workshop doing repairs and renovations to the Louvre in the mid-1840s and executed a large number of public commissions in Paris and Nantes. His smaller works include Faustulus, Girl with Shells, Mercury, The Sleeping Argus, a number of groups illustrating scenes from the career of Général Jean Bouzard and numerous portrait busts of his contemporaries, such as Talma, Baron Gros, Général Joubert, Vallongue, Mustapha Ben Ismail, Général Daumesnil, and Jean Thaureau.

DEBAY, Jean Baptiste Joseph, the Younger 1802-1862
Born at Nantes on August 31, 1802, he died in Paris on January 7, 1862. He was the elder won of the above. He won the Prix de Rome in 1829 and on his return to France he worked in Paris as a sculptor of allegory, such as The Spririt of the Chase, The Spirit of the Navy, Shame yielding to Love and other groups destined for public buildings. His minor works include a group of The Infant Hercules strangling the Serpents as well as numerous portrait busts of his contemporaries.

DE BAYSER, Marguerite (née Gratry) fl. 20th century
Born in Lille in the late 19th century, she studied in Paris and exhibited at the Salon d'Automne in the inter-war period. She won an honourable mention in 1909, a third class medal (1922) and a second class medal (1933) and was made a Chevalier of the Legion of Honour. She was a versatile sculptress in many media and her work includes genre and animal studies as well as portrait busts, carved in stone or cast *cire perdue*.

DEBERT, Camille Charles Jules fl. late 19th century
Born in Lille, he worked in Paris at the turn of the century and got an honourable mention at the Salon of 1898 for his statuettes.

DEBIAGGI, Casimiro fl. 19th century
Born at Duccio Valsesia, Piedmont in 1855, he studied under Frigolini at Vercelli before moving to Lyons. Later he worked in Turin and Rome on genre and historic figures. His works include The Good Shepherd and Musica Rusticana.

DEBIENNE, Noémie fl. 19th-20th centuries
Born at Moulins, she worked in Paris at the turn of the century. She studied under Marquet, Vasselot and Palley and exhibited at the Salon des Artistes Francais from 1894 to 1909, showing figures, groups and bas-reliefs.

DEBLAIZE, Gaston Victor André fl. 20th century
Born at La Houssière in the late 19th century, he exhibited at the Salon des Indépendants from 1927 to 1932. He worked mainly as a potter. but also modelled genre statuettes and portrait busts.

DEBON, Antony fl. 19th century
Born in Paris, where he died in 1901, he studied under Bra and Jacquant and specialised in wood-carving. He exhibited at the Salon from 1878 till his death. His works in bronze include reliefs, medallions and small genre figures.

DEBON, Frédéric J. fl. 19th-20th centuries
Born in Paris, where he worked at the turn of the century. He specialised in busts, heads and portrait medallions and exhibited at the Salon des Artistes Français from 1897 to 1920.

DEBOULET, Emile fl. 19th century
Born in Strasbourg, he died there in 1901. He exhibited sculpture at the Salon des Artistes Français from 1887 to 1899, and won an honourable mention in 1894.

DE BREMAECKER fl. late 19th century
Bronzes of genre and allegorical subjects, such as The Criminal and By Reason and By Force are known with this signature. A sculptor of this name worked in Brussels at the turn of the century.

DEBRIE, Gustave Joseph 1842-c.1935
Born in Paris on September 17, 1842, he died there in the mid-1930s. He studied under A. Dumont, L. Cogniet and 4. Poitevin and exhibited at the Salon from 1864. He became Associate of the Artistes Français in 1883 and got honourable mentions at the Salon of 1886 and the Exposition Universelle of 1889, a third class medal in 1897 and a bronze medal at the Exposition of 1900. He was made a Chevalier of the Legion of Honour in 1902. He specialised in busts of his contemporaries, but also produced several historic or neo-classical groups, such as The Dog of Montargis. He is best known for the Girondins memorial in Bordeaux.

DEBRY, Sophie Victoire fl. early 20th century
Born at Charleville in the late 19th century, she studied under Marqueste and became an Associate of the Artistes Français. She exhibited at the Salon in the early 1920s and specialised in portrait busts and ornamental weathercocks.

DE BUS, Maurice fl. 20th century
Born at Mitry, France, he studied under Bouchard and became a Life Associate of the Artistes Français. He won a second class medal in 1932 and the year prize three years later. He specialises in bas-reliefs of animal and genre subjects.

DÉBUT, Jean Didier 1824-1893
Born at Moulins near Paris on June 4, 1824, he died in Paris in April, 1893. He studied under David d'Angers and was runner-up in the Prix de Rome of 1851. He exhibited at the Salon from 1848 onwards and produced a wide range of sculpture. His works include various portrait busts of contemporary personalities and classical figures and groups such as Faun and Bacchantes, The Danaids and Alexander the Great after the Death of Clitus. He was employed on the decoration of various public buildings in Paris. His figure of the Empress Eugénie was destroyed by the Communards in 1871.

DÉBUT, Marcel 1865-
Born in Paris on March 27, 1865, he studied at the École des Beaux Arts and was a pupil of Thomas and Chapu. He exhibited paintings and sculpture at the Salon des Artistes Français in the 1890s.

DE CAMP, André fl. 20th century
He worked in Paris during and after the second world war, producing portrait busts, figures and bas-reliefs.

DECATOIRE, Alexandre fl. 19th-20th centuries
He worked in Douai at the turn of the century on historical and genre figures.

DECHIN, Géry 1882-1915
Born at Lille on March 17, 1882, he was killed in action in the first world war. He studied under Thomas and got an honourable mention at the Salon des Artistes Français in 1911.

DECHIN, Jules 1869-
Born at Lille on November 12, 1869, he studied under Chapu, Cavelier and L. Noel. He exhibited at the Salon des Artistes Français and won medals in 1900-7. He specialised in portrait busts in marble or bronze, but also sculpted a number of figures and groups in the 1920s alluding to the late war, such as Armistice (1922) and Military Driver.

DECKER, Alice (Mrs. Davidson Sommers) 1901-
Born at St. Louis, Missouri on September 1, 1901, she studied in Paris under Bourdelle, Despiau and R.Laurent and sculpted figures and portraits.

DECKERS, Edward 1873-
Born in Antwerp on December 26, 1873, he studied under his father, Jan Frans Deckers and later was a pupil of Vinçotte at the Antwerp Academy. Though best known for his medallions and plaques, he also modelled classical groups, such as Nymph discovering the head of Orpheus (Antwerp Museum).

DECKERS, Jan Frans fl. 19th century
Born in Antwerp on March 20, 1835, he became a professor at the Antwerp Academy and sculpted genre and classical figures, such as Bacchus and The Blind Consoled.

DECORCHEMONT, Louis Émile fl. 19th century
Born at St. Pierre d'Autils on July 11, 1851, he studied under Aimé Millet and A. Dumont. He was a prolific sculptor whose works include Young Martyr (1877), Offering to Pan (1882), Colonel Langlois (1885) and many busts of his contemporaries. He was the father of the ceramicist François-Emile Decorchemont.

DECOURCELLE, Louis Edouard 1819-1900
Born in Paris on March 12, 1819, he died there in 1900. He exhibited genre figures at the Salon of 1851.

DECROUX, Ernest Jean Lucien Paul fl. 20th century
He studied under J. Lamasson and exhibited at the Salon des Artistes Français in the 1930s. He specialised in busts and heads.

DE FAIS VAN DYCK, Corsy fl. 20th century
Born in Holland in the early years of this century, he worked as a painter, interior designer and sculptor. He exhibited at the Nationale in Paris in 1936, drawings, paintings, decorative panels and bronze statuettes.

DEFERNEX, Jean Baptiste c.1729-1783
Born in Paris about 1729, he died there in May, 1783. Little is known about this artist, whose name may also be found as Deferneix, de Fernex or Fernex. He was a member of the old Académie de St. Luc in 1760 and deputy professor three years later. He worked mainly in marble and plaster on portrait busts and statuary. His bronzes include the Duc de Valentinois, and two groups of children decorating the great staircase of the Palais Royal. *Benezit* gives a lengthy critique of his work as a sculptor of marble statuary.

DE FIORI, Ernesto 1884-1945
Born in Rome in 1884, the son of a German stone-carver and an Austrian mother, he died in Sao Paulo, Brazil in 1945. In his early years he was a painter and worked in Rome. He visited Munich (1903), London (1908-9) and Paris (1911-14), returning to Germany on the outbreak of the first world war and becoming a naturalised German. When the Nazis came to power in 1933 he fled to South America and settled in Sao Paulo. He produced a number of statuettes and busts of contemporary figures, especially in the sporting world, semi-stylised female nudes and abstracts, sculpted in terra cotta or bronze. His work shows the influence of Hermann Haller, Maillol and Degas.

DEFRAIGUE, Gilberte fl. 20th century
Born at Bethune, she worked in the early years of this century and was an Associate of the Salon d'Automne. She specialised in figures cast in bronze decorated with silver and gold incrustations.

DE FRANCISCI, Antony 1887-
Born in Italy on June 13, 1887, he emigrated to the United States at the turn of the century and studied under George Brewster at Cooper Union and James Earle Fraser at the Art Students' League. He worked as assistant to Brewster, Philip Martiny, MacNeil, Charles Niehaus and A.A. Weinman, acquiring under the last-named a very thorough technical training lasting six years. He became an instructor in modelling at the Columbia University school of architecture, the Beaux Arts Institute evening classes. He modelled the Maine commemorative half dollar and sculpted numerous medallions and reliefs. Among his bronze statuettes were The Bayadère (Cincinnati Art Museum), Dolphins, the actor Henry Hull in the leading role in 'The Man who came back', and other contemporary figures.

DEGAND, fl. 19th century
Bronze portrait busts bearing this signature are believed to be the work of a sculptor who worked in Douai in the late 19th century, probably a descendant of P.G.P. Degand.

DEGAND, Pierre Guislain Philibert 1747-1825
Born at Arras on March 3, 1747, he died in Douai on July 18, 1825. He was professor of sculpture at the Douai Academy and specialised in classical groups and portrait busts. The Douai Museum has his Three Graces as well as several portraits of Claude Michel, Edmé Liegards, Pierre Taffin and other personalities of the early 19th century.

DÉGAS, Hilaire Germain Edgar de Gas, known as Dégas 1834-1917
Born in Paris on July 19, 1834, he died in Paris on September 26, 1917. His importance as one of the most prominent of the French Impressionist painters entirely overshadowed his work as a sculptor during his lifetime. Indeed, with the exception of the wax figure of a Dancer Aged Fourteen Years, exhibited in 1880, he preferred to keep his activities as a modeller secret. Although he may have had some advice from his friends Cuvelier and Bartholome, he seems to have been largely self-taught in this medium, and used modelling in clay as an aid to a fuller understanding of line and form in his painting. He apparently modelled in clay for upwards of half a century and derived great comfort from this pastime in his declining years, when his failing eyesight prevented him from painting. After his death some 150 models were discovered in his studio and these were stored by the bronze-founder Hébrard until after the first world war. In 1919-22 Hébrard made casts from 73 of these models (the remainder being in too poor a state for reproduction). The important group of seventeen horses, racing, galloping, trotting, prancing and rearing, establish Dégas as a major force in the Impressionist Animalier school. The other figures consist mainly of dancers and nudes. The little Dancer of 1880 was also cast in bronze and there is an example in the Tate Gallery. A few of his sculptures were cast in plaster in his lifetime.

Bitry, Paul *Catalogue of the Exhibition of Bronzes by Dégas* (1921). Manson, J.B. *The Life and Work of Dégas* (1927). Rewald, John *Edgar Dégas: Works in Sculpture* (1944). Rewald, J. and Matt, L. von *Dégas Sculpture: The Complete Works* (1957). Rich, D.C. *Edgar Hilaire Germain Dégas* (1951). Vollard, Ambroise *Dégas* (1928).

DE GEORGE, Charles Jean Marie 1837-1888
Born in Lyons on March 31, 1837, he died in Paris on November 2, 1888. He studied under Duret, Flandrin and Jouffroy and won the Grand Prix de Rome for a group of medallions. He exhibited at the Salon from 1864 onwards and was awarded a third class medal at the Exposition Universelle of 1878. He became a Chevalier of the Legion of Honour two years later. He specialised in portrait busts, heads, medals and bas-reliefs of historic and contemporary personalities. His figure The Youth of Aristotle, is in the Louvre.

DE GHAYE, Marcelle fl. 20th century
She studied under Sicard and Carli and worked in Paris in the inter-war period, specialising in genre figures and groups, particularly of children and animals.

DEGOULET, Maurice Clovis Georges fl. 20th century
Born in Paris in the early years of this century, he exhibited at the Salon des Artistes Français in the 1940s, winning the Vital-Cornu Prize in 1944. His works include The Sower and The Age of Stone.

DE HELLEBRANTH, Bertha fl. 20th century
Born in Budapest, she emigrated to the United States and worked in Brooklyn in the first half of this century. She specialised in portraits and genre groups, such as Sisters (Brooklyn Museum).

DEI, Enzo fl. 20th century
Born at Bologna, he later became a naturalised Frenchman and a Life Associate of the Artistes Français. He exhibited at the Salon and won a third class (1942) and second class (1944) medals. He specialised in female statuettes.

DEICHMANN, Jens Charles fl. 19th century
Born in Copenhagen on July 31, 1832, he studied at the Copenhagen Academy from 1848 to 1857 and also worked in the studio of H.V. Bissen. He returned to the Academy in 1865 to study painting, and later concentrated on book and periodical illustration. As a sculptor he specialised in portrait busts and heads.

DEITENBECK, Ernst fl. 19th century
He worked in Germany as a sculptor of busts, bas-reliefs and medallions.

DEITERICH, George fl. 18th century
He studied under Sir Henry Cheere and worked on portraits and figures. In 1758 he was awarded a prize by the Society of Arts for a clay model.

DEJEAN, Louis 1872-
Born in Paris on June 9, 1872, he studied at the School of Decorative Arts and worked with Carlès and Rodin. He exhibited at the Nationale and the Salon d'Automne and became an Officier of the Legion of Honour in 1899. He produced a remarkable series of terra cotta statuettes of women, which had great influence on French sculpture at the turn of the century. Dejean, however, had ambitions to do larger work and executed a series of grandiose allegorical works, such as The Passions raised against the Muses, Maternity, Boxer at Rest, Seated Woman, Young Wrestler, various female torsos and numerous busts of his contemporaries.

DEKEIREL, Alfred Alphonse Charles fl. 20th century
He worked at Dunkirk on monuments. memorials, portrait reliefs and busts.

DE KORTE, Maurice fl. early 20th century
Born in Brussels in the late 19th century, he specialised in genre and allegorical sculpture. His bronze group Autumn was shown at the Salon d'Automne in 1913.

DELABASSÉE, Jean Theodore 1902-
Born in Lille on April 17, 1902, he studied under Injalbert and Bouchard and exhibited figures and groups at the Salon des Artistes Français in the late 1920s.

DELABRIERRE, Paul Édouard 1829-1912
Born in Paris on March 29, 1829, he died there in 1912. He studied painting under Delestre but at a very early stage in his career he concentrated on animal sculpture and made his début at the Salon of 1848 with Terrier holding a Hare and Wounded Deer. He exhibited regularly at the Salon till 1882 and covered a wide range of animal studies, from racehorses and hunting dogs to game birds and exotic zoological specimens. His lions, tigers, antelopes, camels and bears were imbued with a spirit of realism and characterisation which was outstanding in the Animalier school. The vast majority of his animal sculptures were sand-cast in bronze. Of his works on a larger scale the best known is the group entitled L'Equitation for the face of the Louvre (1875).

DELACOUR, Clovis fl. early 20th century
Born at Châtillon-sur-Seine in the late 19th century, he studied under Aimé Millet, Moreau-Vauthier (Paris) and Lanteri (London). He exhibited at the Salon des Artistes Français and the Royal Academy at the turn of the century and specialised in medallions, plaques and portrait bas-reliefs.

DELACROIX, François Joseph Ferdinand fl. 20th century
An Animalier sculptor specialising in horse subjects, he worked in St. Lothian, France in the first half of this century. He exhibited such works as Half-bred Horse and Breton Stallion, cast *cire perdue* at the Nationale in 1933-37.

DELAFONTAINE, Pierre Maximilien 1774-1860
Born in Paris in 1774, he died there in 1860. He studied under David and exhibited at the Salon from 1798 to 1802. He specialised in decorative bronzes and also worked as a bronze founder.

DELAFOUHOUSE, E. fl. early 20th century
Bronzes bearing this signature were produced in Paris at the turn of the century and exhibited at the Salon des Artistes Français from 1911 to 1914.

DELAGE, Marguerite c.1860-1936
Born at Tonnay-Charente about 1860, she died in Paris in 1936. She studied under Navellier and exhibited at the Salon des Artistes Français till 1920 and also at the Salon d'Automne before the first world war. She specialised in figures and groups of animals.

DELAGRANGE, Léon Noël 1872-1910
Born at Orleans on March 13, 1872, he was killed in an air crash near Bordeaux on January 4, 1910. He studied under Barrias and Vital-Cornu and exhibited figures at the Salon des Artistes Français in 1900-1.

DELAHAYE, Antoinette fl. 20th century
Born at Boisguillaume-les-Rouen at the beginning of the century, she studied under A. Guilloux and specialised in busts, heads and portrait plaques. She became an Associate of the Artistes Français in 1930.

DELAHAYE, Charles 1928-
Born in Paris, he studied at the School of Applied Arts and later the École des Beaux Arts. He began sculpting bronze birds about 1950 and gradually evolved a more abstract approach to these figures which he entitled 'Personnages'. These have since been followed by his series of Cavaliers, Aviatiques and Figures, exhibited since the mid-1950s at the Salon de la Jeune Sculpture and the Salon de Mai. He has had one-man shows regularly at the Galerie Stadler, Paris since 1956.

DELAIGUE, Victor Constantin fl. early 20th century
Born at Gaujac in the late 19th century, he became an Associate of the Artistes Français in 1909 and exhibited at that Salon from 1907 to the 1920s. He produced genre figures and nudes, in marble, stone, terra cotta and bronze.

DELAISTRE, François Nicolas 1746-1832
Born in Paris on March 9, 1746, he died there on April 24, 1832. He won the Prix de Rome in 1772 and later worked on the decoration of many of the churches in the south and west of France. His chief work consisted of bas-reliefs in the Pantheon. He specialised in portrait busts of historic and contemporary figures, from the Caesars to the Bonaparte family, and also sculpted a series of classical statuettes, such as Bacchus, Flora and Minerva.

DELAMARRE, Henri fl. 20th century
He studied at the National School of Decorative Arts and exhibited genre groups, such as Death of a Child, at the Salon des Artistes Français in the 1920s.

DELAMARRE, Raymond 1890-
Born in Paris on June 8, 1890, he studied under Coutan and won the Prix de Rome in 1919. He exhibited at the Salon des Artistes Français, winning medals between 1922 and 1939, and was awarded a gold medal at the Exposition of 1925. His work consisted mainly of large monuments, but he also sculpted a number of busts and the allegorical group dedicated To Nations Enslaved, to Peoples Untamed (1945). A bust by him of his wife, the painter Suzanne Delamarre, is in the Petit Palais.

DELANDRE, Robert Paul 1876-
Born at Elbeuf on October 6, 1876, he studied under Falguière, Puech and Mercié. He exhibited at the Salon des Artistes Français, winning an honourable mention (1904), third class medal (1923) and a second class medal (1928), and was made a Chevalier of the Legion of Honour in 1930. He specialised in monuments, memorials and allegorical groups. His works include the war memorials at St. Hippolyte Military Academy and the Foreign Legion headquarters at Sidi bel Abes. His minor works included portrait busts of contemporary French personalities and allegorical statuettes, such as Summer (Paris Town Hall).

DELANGLADE, Charles Henri fl. early 20th century
Born at Marseilles on May 26, 1870, he studied under Barrias and exhibited at the Salon des Artistes Français in 1909-10.

DELANNOY, Maurice 1885-
Born in Paris on March 11, 1885, he studied under Valton and Roiné. He became an Associate of the Artistes Français and won a first class medal in 1931. He is best known for his medals, plaques and bas-reliefs.

DELAPCHIER, Louis Marie Jules fl. 20th century
Born at St. Denis, he studied under Rolard and Gauquié and exhibited at the Nationale and the Salon des Artistes Français between 1904 and the late 1920s. He specialised in female statuettes cast *cire perdue* and ceramic groups.

DELAPLANCHE, Eugène 1836-1891
Born at Bellville on February 28, 1836, he died in Paris on January 10, 1891. He was a pupil of Deligand and exhibited at the Salon from 1861, winning the Prix de Rome three years later. He became a Chevalier of the Legion of Honour in 1876 and won a first class medal at the Exposition Universelle of 1878. He produced genre, allegorical and portrait sculpture and his works include Eve before the Fall, Aurora, The Virgin of Lys, St. Agnes and the portrait of Madame Delaplanche. His statuettes were very popular in England, following his participation in the inaugural exhibition of the Grosvenor Gallery in 1877.

DELAPORTE, Augustin fl. 19th-20th centuries
Born in Paris in the mid-19th century, he studied under Jouffroy and exhibited at the Salon from 1883. His work consisted mainly of genre statuettes, such as The Piper, or portrait busts of contemporary celebrities such as Pope Leo XIII and the composer Ambroise Thomas.

DELARCHE ? fl. late 18th century
Bronze reductions of larger works in marble may be found with the signature of this otherwise unknown sculptor who seems to have been working in Paris in the 1770s. His best known work is the bronze reduction of J.B. Lemoine's equestrian statue of Louis XV.

DELARUE, Sebastian 1822-c.1870
Born at Romorantin in 1822, he died about 1870. He was a pupil of Rude and C. Bazin and exhibited bronzes at the Salon from 1838 to 1853.

DELARUE-MARDRUS, Lucie 1884-1945
Born at Honfleur on November 3, 1884, she died in Paris in 1945. She was the wife of Dr. Mardrus, the French scholar and translator of the *Arabian Nights*. She herself was a poet, author of more than 50 romances, interior designer, painter and sculptor, though she only

turned to art in the latter part of her career. She exhibited at the Nationale in the 1930s statuettes of nudes and dancers and the curious group entitled Dame Patricia, her Negro and her Lover.

DELASPRE, Guillaume Claude Henri fl. 20th century
Born at Bordeaux in the late 19th century, he worked as an Animalier sculptor in the period up to the second world war, exhibiting at the Salon des Artistes Français from 1921 and subsequently also at the Nationale.

DELATTRE, Henri Amédée fl. 20th century
Born in Hanley, where his father was employed as a modeller, he returned to his ancestral country after the first world war and worked as a sculptor of busts, heads, plaques and medallions in terra cotta and bronze. He exhibited at the Salon des Artistes Français in 1933.

DELATTRE, Thérèse fl. 19th century
She studied under Hegel, Madame Bertaux and Vasselot and exhibited at the Salon from 1879, winning an honourable mention in 1883. She specialised in medallions, plaques and bas-reliefs.

DELAUNAY, Paul 1883-
Born in Paris on October 19, 1883, he studied under J.P. Laurens, B. Constant, Gérome, Bonnat, Frémiet and C. David. Later he emigrated to the United States and became a member of the American Artists' Professional League and director of the Academy of Fine Arts in Birmingham, Alabama. He sculpted monuments and memorials, genre figures and portraits.

DE LAUTOUR, Amelia Cate fl. early 20th century
Born in Scotland, she studied at the Bournemouth School of Art, and the Central School of Arts and Crafts. She settled in Bournemouth where she worked in the 1920s as a painter and sculptor of animal subjects. She exhibited at the Royal Academy, the Salon des Artistes Français and leading British galleries.

DELAVALLÉE, Jean Gabriel Henri 1887-
Born at Marlotte on April 22, 1887, he studied under Injalbert and became an Associate of the Artistes Français in 1912. He also exhibited at the Nationale from 1921 onwards. He was an Animalier, specialising in figurines and groups featuring monkeys.

DELAVILLE, Louis fl. early 19th century
Born at Jouy-sur-Thelles in the late 18th century, he died at Lens on July 1, 1841. He studied in Paris and won the Prix de Rome in 1798. His figure of Bonaparte as First Consul is in the Troyes Museum.

DELBAUVE, Louis Émile fl. late 19th century
Born at Contres on November 12, 1854, he exhibited at the Salon from 1881 and became an Associate of the Artistes Français in 1895. He had a studio in Limoges and specialised in portrait sculpture.

DELBET, Pierre fl. 19th-20th centuries
He worked in Paris at the turn of the century, sculpting genre and allegorical figures and groups. His bronze statuette of Grief is in the Luxembourg Museum.

DELBEY, Désiré Théophile fl. 19th-20th centuries
Born at Berthen in the mid-19th century, he studied art at Bailleul School and made his début at the Salon in 1881 with a wood-carving The Night. He produced a large number of genre works in wood, stone, terra cotta and bronze and was still active in 1930, when his Death of a Saint was exhibited.

DELBO, Romolo fl. 20th century
He worked in Milan in the early years of this century and showed figures and reliefs at the Brussels International Exhibition of 1910.

DELCAMBRE, Henri fl. 20th century
He has exhibited bronzes and terra cottas at the various Paris salons since 1944.

DELCOUR-GUIGNARD, Marcelle fl. 20th century
Born at Cointroin, Switzerland, she studied under Ségoffin and exhibited at the Salon des Artistes Français, winning an honourable mention in 1925 and a third class medal in 1932. She specialised in busts of her contemporaries.

DEL DEBBIO, André fl. 20th century
Born at Carrara, he studied under Theunissen and Bertrand and exhibited at the Salon des Artistes Français in 1931-36 and

subsequently at the Indépendants, the Tuileries and the Salon d'Automne. She specialised in busts and heads.

DELÉCOLE, Louis Auguste 1828-1868
Born at Troyes on March 24, 1838, he died at Grenoble on May 21, 1868. He produced numerous busts and several portrait statuettes, such as François Pithou and Pierre in the Troyes Museum.

DELÉPINE, Émile A.A. fl. late 19th century
He worked in Paris in the late 19th century, becoming an Associate of the Artistes Français in 1887 and runner-up in the Prix de Rome of 1892. He produced small figures and groups.

DELÉPINE, Émile Alexandre fl. 20th century
Born at Vendôme in the late 19th century, he studied under Cavelier, Barrias, Coutan and Morice, and exhibited at the Salon des Artistes Français. He produced a number of neo-classical statuettes and groups, such as Faun and Dryad.

DELESALLE, Edouard Henri 1823-1851
Born in Lille on January 21, 1823, he died in Paris on February 25, 1851. He studied under Ramay at the École des Beaux Arts in 1847, but died before his early promise was fulfilled. The Lille Museum has plaster statuettes of Lyderic and Sappho.

DELESTRE, Jean Baptiste 1800-1871
Born in Lyons on January 10, 1800, he died in Paris in January 1871. He originally studied architecture and enrolled at the École des Beaux Arts in 1816. Later he worked in the studio of Baron Gros and exhibited at the Salon from 1838 to 1847. He was an active politician and writer, painter and engraver. His sculpture seems to have consisted mainly of bas-reliefs and plaques.

DELÉTREZ, Louis Alexis Joseph 1841-c.1870
Born at Orchies on November 17, 1841, he died about 1870. He enrolled at the École des Beaux Arts in 1857 and was a pupil of Lemaire and Jouffroy. He exhibited at the Salon in 1866-68, a wide range of genre, allegorical and neo-classical works including Oedipus and Antigone, the Foundation of Marseilles, Farmer, two academic figures, a portrait of Monsieur C. and a bas-relief.

DELEY fl. early 19th century
Bronzes, plasters and terra cottas bearing this name were sculpted by an artist who worked in Paris at the beginning of the 19th century and exhibited at the Salon from 1808 to 1817.

DELFIM, Maya fl. 20th century
Born at Oporto, Portugal, she worked there and in Paris in the 1930s on statuettes, groups, bas-reliefs and portraits.

DELHIAS, Ambroise fl. 20th century
Born at Huisme, France in the early years of this century, he exhibited at the Salon des Indépendants from 1925 to the second world war, both paintings and genre sculpture.

DELHOMME, Léon Alexandre 1841-1895
Born at Tournon-sur-Rhône on July 20, 1841, he died in Paris on March 16, 1895. He studied under Dumont and Fabisch and exhibited at the Salon from 1867 to 1884. He specialised in historical and genre statuettes such as Wounded Gaul, the Martyrdom of Joan of Arc, Democritus and The Challenge. His bronze statue of the politician Louis Blanc stands in the Place Mougre, Paris.

DELHOMMEAU, Charles 1883-
Born in Paris on March 21, 1883, the early part of his career was devoted to portrait busts, heads and bas-reliefs, but later he turned exclusively to animal sculpture. His works as an Animalier include Panther, Gazelle, Serval and other figures of wild animals.

DELIGAND, Louis Auguste 1815-1874
Born at Sens on November 8, 1815, he died at Coutances on December 29, 1874. He was a pupil of A. Dumont and Ramey at the École des Beaux Arts and exhibited at the Salon from 1846 to 1857, winning a third class medal in the latter year. He specialised in monuments and statues dedicated to historic personalities. In his later years he entered holy orders and was titular canon of Coutances Cathedral. His works, many of which were also edited as small bronzes, include St. Martin of Tours, the mathematician Poisson, Napoleon Bonaparte and a project for a monument to Jean Cousin.

DELLAMBRE, Henri fl. 20th century
Genre sculptor working since the second world war. His Mother of the Family was exhibited at the Salon d'Automne in 1945.

DELORME, Jean André fl. 19th-20th centuries
Born at Ste. Agathe en Donzy, he died there on August 27, 1905. He studied under Bonnassieux and exhibited at the Salon from 1888 to 1897. He was runner-up in the Prix de Rome in 1857. He specialised in portrait busts, statues, monuments and memorials.

DELOUCHE-GUEORGUIEFF, Hélène fl. 20th century
Born at Fucha in Bulgaria she emigrated to France at the beginning of the century and was later naturalised. She exhibited at the Salon des Artistes Français and the Salon d'Automne in the 1920s and specialised in portrait busts and reliefs of contemporary celebrities.

DELOYE, Jean Baptiste Gustave 1848-1899
Born at Sedan on April 30, 1844, he died in Paris in February 1899. He studied under Jouffroy and Dantan the Younger and was runner-up in the Prix de Rome. He won a third class medal in 1887 and a bronze medal at the Exposition Universelle two years later. He was a Chevalier of the Legion of Honour. He produced over 200 medallions and busts of contemporary figures, including those of Frédéric Lemaire, Littré, Ribot, Count Andrassy, the Prince of Liechtenstein, Count Levachov and Cavalotti. He also produced a number of maquettes and bas-reliefs for the decoration of fountains and pedestals.

DELPECH, Pierre Charles Eugène fl. early 20th century
Born at Clairac in the late 19th century, he studied under A. Carlès and exhibited at the Salon des Artistes Français, winning an honourable mention in 1912. He specialised in rural subjects such as Oxen at Work (1924) and The Sower.

DELPÉRIER, Georges 1865-
Born in Paris on November 20, 1865, he studied under Thomas and Falguière and exhibited at the Salon des Artistes Français from 1885 onwards, winning the Medal of Honour in 1925. He is best remembered for the monument to Ronsard at Tours and a number of family memorials in the same district. The Tours Museum has a collection of his minor works, including statuettes and portrait busts.

DELPÉRIER, Paul fl. 20th century
He worked in Paris in the first half of this century and specialised in animal figures and groups which were exhibited at the Salon des Artistes Français.

DELPHANT, Edmund fl. 20th century
Sculptor of portraits and genre subjects, he got an honourable mention at the Salon des Artistes Français in 1933.

DELRUE, Ernest fl. late 19th century
He worked in Arras in the late 19th century and exhibited figures at the Salon des Artistes Français (Associate, 1891).

DEL SARTE, Marie Anne Elisabeth fl. 19th century
Born in Paris on March 9, 1848, she studied under T. Robert-Fleury and exhibited portrait medallions, plaques and heads at the Salon from 1868 to 1883.

DELSAUX, Willem fl. 19th century
Born at Ixelles, near Brussels on May 4, 1862, he studied in Brussels and Paris and travelled extensively in Europe before settling in Brussels. Mainly known for his landscape painting, he also dabbled in genre sculpture.

DELSON, Robert 1909-
Born in Chicago on December 30, 1909, he studied under W.P. Welsh, O. Gross and H. von Schroeter and is a member of the Artists Union of Chicago. He specialises in wood-carving and portrait painting, but has also modelled figurines.

DELSUME, Jules d. 1897
He worked in Paris in the second half of the 19th century as a genre and a portrait sculptor and was an Associate of the Artistes Français.

DE LUC, Donald fl. 20th century
American sculptor of neo-classical friezes, figures and groups, such as Pegasus.

DE LUNA, Francis P. 1891-
Born in the United States on October 6, 1891, he studied under MacNeil and J. Gregory. He was a member of the National Sculpture Society and the Architects' League, both of New York and was professor of sculpture at New York University. He sculpted memorials, statuettes and portrait reliefs.

DELUOL, André 1909-
Born at Valence, France in 1909, he studied painting at the École des Beaux Arts in Paris and did not turn to sculpture till 1930. He began exhibiting at the Tuileries in 1933 and later also at the Salon d'Automne and the Salon des Artistes Décorateurs. Deluol avoided the conflict then raging between the traditionalists and the Cubists and derived inspiration for his female figures and bas-reliefs from the ancient sculpture of Cambodia and Annam, resulting in a strange baroque style which he has made his own. He works mainly in stone, but has also modelled in clay, plaster and bronze.

DEMAGNEZ, Marie Antoinette fl. 19th-20th centuries
Born in Paris, she studied under Mercié and exhibited at the Salon des Artistes Français and the Nationale at the turn of the century. She was awarded a bronze medal at the Exposition Universelle of 1900 and specialised-in portraits and statuettes.

DEMAILLE, Louis Cosmé 1837-1906
Born at Gigondas on May 21, 1837, he died in Paris on December 10, 1906. He studied under Émile Leconte and exhibited at the Salon from 1863 to the end of the century, winning a third class medal (1866), a second class medal (1885) and an honourable mention at the Exposition of 1900. He produced a number of allegorical and neo-classical groups such as Love and Hercules strangling the Serpents.

DEMAINE, George Frederick 1892-
Born at Keighley, Yorkshire on February 2, 1892, he studied at Keighley School of Art and the Royal College of Art after the first world war. He exhibited at the Royal Academy and the main provincial galleries and worked in London. He is best known as a landscape painter, but has also sculpted statuary and reliefs for architectural decoration.

DEMANET, Victor Joseph Ghislain fl. 20th century
Born at Giret in Belgium, he studied under D. Hurbin and worked in Brussels. He exhibited at the Nationale and Salon des Artistes Français before the second world war. He is best known for his statues and busts of members of the Belgian royal family, including Leopold II (Namur, 1929) and the busts of Albert I and Queen Astrid. He also produced a number of bronze masks, including that of the painter James Ensor.

DEMANGE, Marguerite fl. 20th century
Born at Boulogne, she studied under J.G. Achard and has exhibited at the Salon des Artistes Français since 1930. She specialises in portrait busts and animal groups.

DE MARCO, Jean 1898-
Born in Paris on May 2, 1898, he was a pupil of Bourdelle and also studied at the National School of Decorative Arts. He emigrated to the United States after the first world war and became a member of the Sculptors' Guild. He exhibited figures and reliefs at the New York World's Fair, 1939.

DEMAREST, Eda Lord 1881-
Born at Blue Earth, Minnesota on March 20, 1881, she studied under G. Lober and Archipenko and won first prize at the New Jersey Arts Association Exhibition in 1932. She worked in New York and specialised in busts and genre groups.

DEMAY, Germain fl. early 19th century
Born in France at the beginning of the 19th century, he originally studied medicine but later turned to modelling and was a pupil and assistant of A.L. Barye. He exhibited animal figures and groups at the Salon in 1844 and 1848, but later turned to seal-engraving and became keeper of the seals at the National Archives.

DEMESMAY, Camille 1815-1890
Born at Besançon on August 23, 1815, he died there on April 4, 1890. He was employed as a decorative sculptor on the Louvre, the old Paris Town Hall and various churches in the Paris area. He

exhibited at the Salon from 1838 to 1882 and won a silver medal in 1848. His best known work is the statue of Mlle. de Montpensier in the Jardin du Luxembourg. His other works include Young Faun, Nais and other neo-classical figures. A cast of the figure of Mlle. de Montpensier is in the Besançon Museum.

DEMETRIADES, Georgios fl. 20th century
Born in Athens where he worked in the first half of this century. He sculpted a number of monuments, notably that of Demetrios Karatasios, as well as busts, reliefs, statuettes and female torsos. He exhibited a Head of Christ at the Nationale, Paris in 1932.

DE MEUNYNCK, Jeanne Marie Nelly fl. 20th century
Born in Paris at the turn of the century, she studied under R. Janson and became an Associate of the Artistes Français in 1930. She specialised in busts and heads.

DEMI, Paulo Emilio 1798-1863
Born at Leghorn in 1798, he died there on March 8, 1863. He worked in Pisa, Rome and Florence and was assistant to Canova for a time. On his return to his native town he specialised in monuments and memorials, of which the best known is the colossal statue of Leopold II of Tuscany. He also produced a number of busts, statuettes and maquettes.

DEMIZEL, Augustin Louis Joseph fl. 20th century
Born in Boulogne at the beginning of this century, he studied under L. Bonnat and exhibited painting and sculpture at the Paris salons of the inter-war period.

DEMMLER, Anton fl. 19th century
Born near Bautzen, he died in Dresden on October 4, 1863. He spent much of his life in Prague before settling in Dresden and worked as a sculptor of monuments and memorials. His minor works include genre and historical reliefs and statuettes.

DEMONNEROT, Marguerite fl. 20th century
Born at Thirzy, France in the early years of this century, she studied under Benneteau and exhibited at the Salon des Artistes Français in 1928-30, specialising in statuettes and reliefs.

DEMONTREUIL, Hortense fl. 20th century
Born in Ars-sur-Moselle at the turn of the century, she was a pupil of Louis Noël. She specialised in busts and statuettes and exhibited at the Salon des Artistes Français in the inter-war period.

DEMOULIER, Jules Joseph Henri 1812-1835
Born in Douai on April 30, 1812, he died in Paris on June 15, 1835. A pupil of David d'Angers, he worked in the Douai area and his figures and groups are preserved in the Douai Museum.

DEMOULIN, Emile A. fl. 19th century
He worked in Paris in the 1890s, and produced a number of busts and figures, exhibited at the Salon des Artistes Français.

DEMPSTER, Elizabeth 1909-
Born in Edinburgh in 1909, she studied at the Edinburgh College of Art and exhibited at the Royal Scottish Academy, being elected an Associate. Her figures and groups were sculpted in plaster, terra cotta and bronze.

DEMUTH-MALINOWSKY, Vassili Ivanovich 1779-1846
Born in St. Petersburg on March 2, 1779, he died there on July 16, 1846. He completed his studies in Rome under Canova and later became professor and rector of the St. Petersburg Academy. He sculpted many monuments and public statues in St. Petersburg, notably that of Prince Barclay de Tolly, as well as numerous portrait busts of the imperial family and the Russian nobility.

DENBY, Edwin H. fl. late 19th century
He was born in Philadelphia and completed his studies in Paris where he later settled. He sculpted portraits, figurines and reliefs and exhibited at the Salon des Artistes Français in 1898.

DENÉCHEAU, Elisabeth Felicité fl. 19th century
Born at Nimes, she was the pupil and later the wife of Seraphin Denécheau. She exhibited at the Salon in 1868-73 and sculpted genre and neo-classical groups, such as Faunesse, in marble, plaster and terra cotta. Several of these works were subsequently edited in bronze.

DENÉCHEAU, Seraphin 1831-1912
Born at Vihiers on October 21, 1831, he died in 1912. He studied under Rude and David d'Angers and exhibited at the Salon from 1859 to 1868 and also in 1877. He produced a great many public monuments and statuary and decorative sculpture carved direct in marble and stone. His minor works, however, include numerous portrait medallions, roundels, plaques and busts. His portrait of the father of the steam age, James Watt, may be seen at the Gare du Nord. The Angers Museum has his group of a Woman caressing a Chimera.

DENGLER, Frank 1853-1879
Born in Cincinnati in 1853, he died at Convington, Kentucky on January 17, 1879. He studied art in Munich and on his return to the United States he specialised in busts, heads and portrait reliefs.

DENIAU fl. 19th century
Lami records two busts and a figure of a Young Girl lying down, bearing this signature, exhibited at the Salon of 1833.

DENIC, Dujam fl. 20th century
Yugoslav sculptor working in Split (Spalato) in the first half of this century, on monuments, statues and portrait busts.

DENIERE fl. 19th century
Bronze statuettes of medieval and oriental warriors bearing this signature were the work of a sculptor working in Paris in the mid-19th century.

DENIKER, Georges Jean 1889-
Born in Paris on January 17, 1889, he studied under Canova and Manuel Ugni (Manolo). Though destined for a diplomatic career he turned instead to sculpture. He was also an enthusiastic balloonist at the turn of the century and was involved with the Cubist movement from its inception. He invented sculpture in wire or string and exhibited at the Salon d'Automne and the Tuileries. His bronzes, however, show the strong influence of ancient Chinese sculpture, an inspiration gained during his service as a consular official in the Far East.

DENIS, Clément fl. 19th century
Born in Paris in the mid-19th century, he enlisted in the Franco-German war and died of wounds and privation in December 1870. He studied under Jouffroy and exhibited at the Salon of 1868 a plaster figure of Giotto. His other works included several busts, models and statuettes of historic figures.

DENIZARD, Orens fl. 20th century
Born at St. Quentin in the late 19th century, he studied under Bonnat and Cormon and exhibited at the Paris salons in the 1920s. He was an accomplished painter, etcher and engraver as well as sculptor of plaques and medallions.

DENNERT, Max 1861-
Born in Friedeberg, Germany on March 13, 1861, he worked in Berlin and Hanover as a young man before settling in France. He is best known for the memorials to Frederick the Great and the Kaiser Wilhelm I in his native town. He also sculpted portrait busts and genre statuettes.

DENOTH, Alois 1851-1896
Born at Nauders in the Tyrol in 1851, he died in Hamburg on December 24, 1896. He specialised in medallions, plaques, busts and statuettes portraying contemporary personalities. His figure of Burgomaster Dr. Petersen is in the Hamburg Museum.

DENZLER, Ferdy fl. 20th century
Born in Austria at the beginning of this century, he later worked in Paris and exhibited at the Paris salons in the 1930s as well as in Austria and Germany. He produced busts, figures and groups.

DEPAULIS, Alexis Joseph 1792-1867
Born in Paris on August 30, 1792, he died there on September 15, 1867. He studied under Adrien and Cartiér and worked as a painter and portrait sculptor. He exhibited at the Salon from 1815 to 1855 and was made a Chevalier of the Legion of Honour in 1834 and specialised in portrait medallions, bas-reliefs and busts.

DEPLANTE, Berthe 1869-
Born in Paris on January 19, 1869, she studied under Carrière, B. Laurent, Moreau-Vauthier and Max Blondat. She exhibited figures and groups at the Salon des Artistes Français from 1908 onwards.

DEPLECHIN, Valentin Eugène fl. 19th century
Born at Roubaix on May 27, 1852, he studied under E. Delaplanche and also at the School of Fine Arts in Lille. He exhibited at the Salon des Artistes Français in the 1890s, winning a third class medal in 1893 and a bronze medal at the Exposition Universelle of 1900. His works include Faun and Bacchante, Young Nubian, Drunkenness, Snake Charmer, Fellah, Amphitrite, Fountain of Bacchus, Heartache and similar genre and classical subjects.

DEPLYN, Eugène fl. 19th century
He worked in Belgium in the second half of the 19th century and exhibited at Antwerp from 1864 onwards. He specialised in decorative sculpture, bas-reliefs and allegorical figures.

DEPREAUX, Albert Marie Louise fl. 20th century
Born in Columbus, Ohio at the turn of the century, she studied under Bartlett and later Injalbert in Paris. She specialised in nude female statuettes and exhibited in France and America in the period before the second world war.

DEPREZ, Paul Gaston fl. 19th-20th centuries
He worked in Paris at the turn of the century, specialising in classical and allegorical figures, such as Andromeda (1895).

DERAIN, André 1880-1954
Born at Chatou, France on June 10, 1880, he died at Garches in 1954. His career as a Cubist painter overshadowed his work as a sculptor which he first took up about 1905 during his Fauvist period. His earliest work consists of caryatids and statues carved direct in stone. During the first world war he fashioned masks from shell cases, but does not seem to have returned seriously to sculpture until the beginning of the second world war and modelled a number of works which were cast posthumously. His busts and small bas-reliefs of 1939-53 bear an uncanny resemblance to the famous Benin bronzes of West Africa and his statuettes were truly eclectic, deriving inspiration from the mythology of the Aegean and the Celtic world, though curiously enough the Italian Renaissance (which latterly influenced so much of his painting) had little or no bearing on his sculpture.

DERAISME, Georges Pierre 1865-
Born in Paris on May 24, 1865, he exhibited at the Salon des Artistes Français and the Salon des Artistes Décorateurs. His figures, reliefs and groups are preserved in the Musée d'Art Décoratif.

DERCHEAU, Jules Alfred Alexandre 1864-1912
Born in Paris in 1864, he died there in 1912. He studied under Aimé Millet and exhibited at the Salon des Artistes Français, winning a second class medal and a travelling scholarship in 1896. At the Exposition Universelle of 1900 he won a silver medal. He specialised in neo-classical figures and groups, such as Diana at Rest and Diana pursued by Apollo. His works are in the Limoges Museum.

DERRE, Émile 1867-
Born in Paris on October 22, 1867, he exhibited at the Salon from 1895 to 1926 and won a third class medal and a travelling scholarship in 1898. His group Capital of Kisses (Jardin du Luxembourg) was awarded a second class medal, and he won a gold medal at the Exposition of 1900. He was regarded as one of the most sensitive and refined of sculptors working in France at the turn of the century. His minor works included the little fountain of the Innocents, various busts of contemporaries, genre figures and statues.

DERRE, François fl. 19th century
Born in Bruges, Belgium, he died in Paris on August 7, 1888. He worked in Belgium and Paris, carrying out the decorative sculpture for the Church of St. Vincent de Paul and the fountain of St. Sulpice. His other works consist mainly of bas-reliefs and figurines, which he exhibited in Paris, London and Brussels.

DERWENT-WOOD, Francis 1871-1926
Born in London in 1871, he studied at the Slade School of Art and was an assistant to Alphonse Legros (1891-92) and completed his studies in Paris in 1895-97. He exhibited at the Royal Academy and the Salon des Artistes Français at the turn of the century and produced allegorical and genre figures and groups which were strongly influenced by Rodin. His best known bronze is the small group entitled Maternity (1905).

DESAYE, F. fl. 19th-20th centuries
Sculptor of bronzes and terra cottas working in Paris at the turn of the century. He exhibited at the Salon des Artistes Français up to the outbreak of the first world war.

DESBOEUFS, Antoine 1793-1862
Born in Paris on October 13, 1793, he died at Passy on July 12, 1862. Originally he worked as an engraver of medals and dies and did not turn to sculpture until about 1830 when he began modelling statuettes and busts of historical personages, such as Alain Lesage, St. Bernard of Clairvaux, Charles, Duke of Orleans and Jean de Cassion, Maréchal de France, and religious groups, such as Mary Magdalene weeping over the Body of Christ. He sculpted the group of Christ and St. Anne in the Madeleine.

DESBOIS, Jules fl. 19th century
Born at Parcay on December 20, 1851, he studied under Cavelier and exhibited at the Salon from 1875, winning a second class medal in 1877, a first class medal in 1887 and a gold medal at the Exposition Universelle of 1889. He became an Officer of the Legion of Honour and a member of the Jury for the 1900 Exposition. He was Vice-President of the Société Nationale des Beaux Arts. His works include such classical and allegorical groups as Otryades, Death of Bucheron (Lyons), Misery (Nancy), The Source, Leda, Sisyphus, Female Archer, Woman, Winter (Louvre), Nanny Goat and a project for a monument, the latter being both cast by the lost wax process by Hebrard.

DESBROSSES, Joseph Gabriel 1819-1846
Born at Bouchain on December 22, 1819, he died in 1846. He was the brother of the painters Jean Alfred and Leopold Desbrosses. He specialised in genre and allegorical works such as Winter (Compiegne Museum).

DESCA, Edmond 1855-1918
Born at Vic-en-Bigorre on November 26, 1855, he died in Paris on June 22, 1918. He was apprenticed to a stone-mason and monumental sculptor, but later studied at the École des Beaux Arts under Jouffroy. He won a gold medal at the Exposition of 1889 and was a Chevalier of the Legion of Honour. In the early part of his career he produced a number of monuments and statuary groups in marble but later he worked almost exclusively in bronze. His works include The Hunter of Eagles, The Hurricane, Revenge and the bronze animal figures decorating the monumental fountain at Tarbes.

DESCAT, Achille fl. 19th century
He worked in France in the second half of the 19th century and died in Paris in 1897. He exhibited figurines and reliefs at the Salon des Artistes Français.

DESCAT, Henriette fl. 19th century
Born at Carrières in the mid-19th century, she studied under Frère and exhibited portrait busts and animal studies, mainly of dogs, at the Salon from 1881. She got honourable mentions in 1883 and 1885 and also at the Exposition Universelle of 1889.

DESCATOIRE, Alexandre 1874-
Born at Douai on August 22, 1874, he studied under Thomas and exhibited at the Salon des Artistes Français at the turn of the century. He won a third class medal in 1904 and a travelling scholarship the following year, a second class medal in 1911 and a medal of honour in 1927. He became an Officier of the Legion of Honour and a member of the Institut in 1939. He specialised in busts, most of which were cast *cire perdue*.

DESCHAMPS, Augustin François fl. 19th century
He worked in Tours in the mid-19th century and the local museum preserves a bronze bust of his grandfather Avisseau.

DESCHAMPS, Frédéric fl. late 19th century
Born at St. Erblon, France in the mid-19th century. He is better known as a watercolourist, but also sculpted portraits which were exhibited at the Salons in the 1890s.

DESCHAMPS, Jean Baptiste 1841-1867
Born at Tournus on November 1, 1841, he died in Naples on July 20, 1867. He was a pupil of the Abbé Garnier at Tournus and later studied at the School of Fine Arts in Lyons and the École des Beaux Arts, Paris under Truphème. He won the Prix de Rome in 1864, but died three years later, of typhus contracted during a visit to Pompeii. His works were in the classical genre and included a bust of Tanaquil (1866), a bas-relief entitled Offering to Hermes (1865) and Discus Thrower, exhibited at the Salon in plaster and cast in bronze posthumously.

DESCHAMPS, Léon Julien 1860-
Born in Paris on May 26, 1860, he studied under Dumont, Delhomme, Hippolyte Moreau and J. Thomas. He exhibited figures, groups and reliefs at the Salon des Artistes Français and won various medals between 1891 and 1903.

DESCHAMPS, Marguerite fl. 20th century
She worked in Paris before the first world war and exhibited figures at the Salon des Artistes Français.

DESCHAMPS, Raphael fl. 20th century
Born in Sanvic, France at the beginning of this century, he exhibited at the Salon des Artistes Français and won a silver medal in 1938.

DESCHAMPS-AVISSEAU, Léon Edouard fl. late 19th century
Born in Tours in the mid-19th century, he studied under his relative, Avisseau and exhibited medallions, plaques and bas-reliefs in terra cotta and bronze at the Salon from 1875 to the end of the century.

DESCHAMPS-FAVERAIS, Jeanne fl. 20th century
Born at Etigny, she exhibited at the Salon des Artistes Français from 1929 and specialised in busts and heads.

DESCHKOWITZ (Deskovic) Branko fl. 20th century
Born at Puchische, Serbia at the turn of the century, he studied in Belgrade, Vienna and Paris after the first world war and specialised in animal figures and groups.

DESCLERS, Georges fl. early 20th century
Born in Paris in the late 19th century he worked as an ornamental sculptor at the turn of the century and exhibited figures and groups at the Salon des Artistes Français, obtaining an honourable mention in 1909.

DESCLOS, François Auguste fl. 19th century
Born at Bruyeres in the mid-19th century, he studied under Boyer and Poyatier and exhibited medals, roundels and plaques at the Salon from 1869 onwards.

DESCOMPS, Jean Bernard 1872-
Born at Agen on May 14, 1852, he studied under Falguière and later worked in Paris. He won a third class medal at the Salon of 1903 and became a Chevalier of the Legion of Honour. He produced a number of memorials, notably the monument to Charles Floquet, and sculpted genre and animal groups, figures of birds and the classical group The Childhood of Bacchus.

DESCOMPS, Joseph J.E. fl. late 19th century
Born at Clermont-Ferrand, he studied under Hiollin and exhibited figures and reliefs at the Salon des Artistes Français (Associate, 1883).

DESCROIX, Marc Maurice fl. 20th century
Born at Choisy le Roi, he exhibited statuettes and portraits at the Salon des Artistes Français.

DESEINE, Claude André 1740-1823
Born in Paris on April 12, 1740, he died at Petit Gentilly near Paris on December 30, 1823. He studied under Pajou and overcame the disability of being a deaf-mute from birth to become a fashionable portrait sculptor in the last years of the Ancien Regime. His busts of contemporary personalities include Rousseau, Mirabeau, the Abbé de l'Epée, Voltaire and the Comte de Ségur. His bust of Madame Dantan (Troyes Museum) was modelled immediately after her death.

DESEINE, Louis Pierre 1749-1822
Born in Paris on July 20, 1749, he died there on October 11, 1822. He won the Prix de Rome in 1780 and was admitted to associate membership of the Academy in 1785, becoming an Academician six years later. He was official sculptor to the Prince of Condé and remained loyal to the monarchy. This steadfastness during the turbulent upheavals of the Revolution and subsequent regimes was rewarded by the Bourbons at their restoration with many royal and public commissions, including busts of the royal family, statues, memorials, tombs and decorative sculpture mostly of a religious nature. He was deeply imbued with the spirit of classical art and was a vigorous and prolific pamphleteer on matters of art. He produced a number of busts of his contemporaries, such as Winckelmans, de Luynes, La Fontaine and Lagrange, figures of the Abbé Pouillard, Mucius Scaevola, M.A. Thouret and genre statuettes such as Young Girl garlanded with Flowers.

DESEINE, Madeleine Anne 1758-1839
Born in Paris in 1758, she was the younger sister of the Deseine brothers and worked with them on portrait busts and genre figures. (Her bust of Louis Pierre Deseine is in the Musée Carnavalet).

DESENFANS, Albrecht Constant 1845-
Born at Genappe in Belgium, he later worked in Brussels. His best known work is The Resurrection (Antwerp Museum) and he sculpted a number of genre and religious works.

DESGRANGES, Gerard Alain Guillaume fl. 20th century
Born at Coutances, the son and pupil of the painter and engraver Guillaume Desgranges, he worked mainly as a painter, but also exhibited figures and groups at the Salon des Artistes Français in the 1930s.

DESGREY, Georges Ernest fl. 20th century
Born in Paris at the turn of the century, he won a silver medal at the Salon des Artistes Français in 1937 for his portraits and groups.

DESIGNOLLE, P. fl. 19th century
Sculptor of genre figures and groups who worked in Paris in the 1880s.

DESMARCHIX, Alexandre fl. 20th century
Born in Nantes, he worked there in the early years of this century and exhibited busts and figures at the Salon des Artistes Français.

DESMARETS, François Adrien fl. mid-19th century
Born in Paris, he studied under Fauconnier and exhibited at the Salon from 1848 to 1852. He specialised in genre sculpture, such as Souvenirs of the People and figures of small children. His works are preserved in Lille Museum.

DESMOND, Creswell Hartley 1877-
Born in Streatham, London on July 6, 1877, he worked at Lymington, Hampshire as a painter and sculptor of portraits and figures. He exhibited at the Royal Academy and the Salon des Artistes Français at the turn of the century.

DESNOYER, François 1894-
Born at Montauban on September 30, 1894, he studied at the School of Decorative Arts under Bourdelle and later worked as assistant to Gromaire, Villon and Waleh. He sought to reconcile classical styles with contemporary ideas in form. He worked as a painter and lithographer as well as a sculptor and also did tapestries, book illustrations, murals and watercolours.

DESOUCHES, Charles d. 1905
He studied under the painter Geoffrey Dechaumes but later turned to portrait sculpture. He exhibited busts and heads at the Salon from 1868 to 1901.

DESPAGNE, Artus fl. early 19th century
He studied under Giraudet and exhibited figures and groups at the Salon between 1824 and 1835.

DESPIAU, Charles 1874-1946
Born at Mont de Marsan on November 4, 1874, he died in Paris on October 28, 1946. He was educated at the local *lycée*, where he showed no interest in the collection of traditional and classical models, even though he produced his first portrait bust while still at

school. He came to Paris at the end of 1891 and enrolled at the School of Decorative Arts, where he studied under Hector Lemaire, and subsequently went to the École des Beaux Arts. For a time he worked in the studio of Barrias, but also studied in the Louvre and Museum of French Monuments. He was influenced by Rodin and Schnegg and worked with the former as his assistant in 1907. He exhibited at the Salon des Artistes Français from 1904 onwards, and also at the Nationale, from 1899 to 1923 and the Salon d'Automne and the Tuileries in the 1920s. He was a prolific sculptor of busts and this earned him the nickname 'the Donatello of France'. He was one of the leading French sculptors of the first half of this century. His busts and figures constantly strove to capture a feeling of serenity and tranquillity, and he was at his best in depicting the human figure in repose. To this was allied sensitive and lively portraiture. He brought a new lease of life to portraiture, at a time when *avant-garde* sculptors favoured the abstract. His chief works were Little Girl from the Landes, of which he sculpted various versions between 1904 and 1909, Seated Man (1928), Standing Nude (1925), Eve (1925), Dionysus (1945) and Apollo (1946). His bronze portrait busts include those of Madame B., Line Aman Jean (1925), Mlle. Bianchin and Maria Lani (1929), Madame Fontaine (1933) and Princess Murat (1934). His bronzes were often cast *cire perdue* by Valsuani.

DESPOIS DE FOLLEVILLE, Jules Hector fl. 19th century
Born in Rouen on January 26, 1848, he worked in that district as an amateur sculptor of historical and allegorical figurines.

DESPRAT-PODROVZKOVA, Françoise fl. 20th century
She exhibited statuettes at the Salon des Artistes Français before the second world war.

DESPREY, Georges Ernest fl. early 20th century
A pupil of Mercié, he specialised in portrait medallions and plaques and exhibited at the Salon des Artistes Français before the first world war.

DESPREY, Louis Antoine Prudent 1832-1892
Born at Châtillon-sur-Seine on March 22, 1832, he died in Paris in 1892. He enrolled at the École des Beaux Arts in 1851 and studied under Petitot and Jouffroy. He exhibited figures and bas-reliefs at the Salon from 1853 till about 1880.

DESPREZ, Louis 1799-c.1871
Born in Paris on July 7, 1799, he died there shortly after the Franco-Prussian war. He entered the École des Beaux Arts in 1813 and was a pupil of J.F. Bosio. He was runner-up in the Prix de Rome of 1822 and won the prize four years later with a group showing the death of Orion. He exhibited at the Salon from 1824 to 1865, winning a second class medal in 1831 and a first class medal in 1843. He became a Chevalier of the Legion of Honour in 1851. His works included memorials, statues, busts and bas-reliefs, mainly in marble for the decoration of Parisian churches and public buildings. Minor works, including editions in bronze, were such classical and allegorical works as Milo of Croton, Mother Love, Innocence and also a number of statuettes of historical personages.

DESRUELLES, Félix Alfred 1865-
Born at Valenciennes on June 7, 1865, he studied under Fache and Falguière and was runner-up in the Prix de Rome and winner of the prize in 1897. He was awarded a gold medal at the Exposition Universelle of 1900 and a medal of honour at the Exposition des Arts Décoratifs in 1925. He became an Officier of the Legion of Honour. He specialised in busts of historic, biblical and contemporary personalities.

DESSART, Edmund Henri 1862-
Born at Combles on December 1, 1862, he exhibited at the Salon des Artistes Français in 1890 and worked as a sculptor of statuettes and portraits at the turn of the century.

DESSERPRIT, Roger 1923-
Born in Burgundy, he began studying painting in 1936 in Chalons-sur-Sâone and was at the École des Beaux Arts in Paris from 1941 to 1943. He turned to sculpture in 1948 and worked initially as a wood-carver. Three years later, however, he abandoned wood and concentrated on sculpting in concrete, iron, copper, bronze and other metals, often combining different substances and experimenting with

patination and polishes to heighten the contrast of his abstracts. He has exhibited at the Salon des Réalités Nouvelles since 1950 and the Salon de la Jeune Sculpture since 1959. His works also include the statues for the Church of St. Jacques in Amiens (1957). He has had several one-man shows since 1951 and won prizes in international exhibitions in Milan, Bordeaux and Venice.

DESTOUESSE, André Maurice 1894-
Born in Bordeaux on January 18, 1894, he studied at the School of Fine Arts in that town and exhibited figures and groups at the Salon des Indépendants in the 1920s.

DESTREEZ, Jules Constant fl. 19th century
Born at Glisors on April 5, 1831, he studied under Triqueti and exhibited at the Salon from 1855 to 1882. He obtained a number of important public commissions and specialised in marble busts and statuary. Several of his works, notably The Prisoners, were edited as bronze reductions.

DESVERGNES, Charles Jean Cléophas 1860-
Born at Bellegarde on August 19, 1860, he studied under Jouffroy and Chapu and exhibited at the Salon from 1880 onwards. He won the Prix de Rome in 1889 and was awarded a third class medal in 1895 and a silver medal at the Exposition of 1900. He became a Chevalier of the Legion of Honour in 1903. He specialised in busts and figures of contemporary personalities.

DESVIGNES, Louis fl. 20th century
Born at Creusot, he studied under Verlet, Auban and H. Dubois and exhibited figures and reliefs at the Salon des Artistes Français in the early years of this century.

DESY, Pauline 1905-
Born in Montreal, Canada on September 7, 1905, she studied under Delamare and exhibited bronzes in the Canadian galleries, notably Montreal.

DETREY, Narcisse Alexandre 1793-1881
Born at Breurey les Favernay on June 28, 1793, he died in Rheims on April 27, 1881.

DÉTRIER, Pierre Louis 1822-1897
Born at Vougécourt on July 25, 1822, he died in 1897. He studied under Gayrard and exhibited at the Salon from 1866 till his death. He specialised in bas-reliefs, plaques and medallions.

DETTMANN, Paul 1860-
Born in Hamburg on April 17, 1860, he studied under Hähnel at Dresden. He specialised in tombs, memorials, monuments and bas-reliefs of contemporary figures.

DEUCHARS, Louis Reid 1871-
Born in Lanarkshire in 1871, he studied at the Glasgow Athenaeum and then went to London, where he was a pupil of C.F. Watts. He exhibited at the Royal Academy and the Modern Gallery in London and worked in London as a painter and figure sculptor.

DEVAULX, Alexandre Henri fl. late 19th century
Born in Paris, he worked there as a sculptor of plaques, bas-reliefs and medallions. He exhibited at the Salon from 1876 onwards and got an honourable mention in 1888.

DEVAULX, Edmond Georges Augustin fl. 19th-20th centuries
Son and pupil of A.H. Devaulx, he also studied under Hébert and specialised in plaques and medallions which he exhibited at the Salon from 1880 onwards.

DEVAULX, Ernest Théophile fl. 19th-20th centuries
Elder son of A.H. Devaulx, under whom he studied portrait sculpture. He exhibited at the Salon from 1872 and specialised in portrait busts and reliefs.

DEVAULX, François Théodore fl. 19th century
Born in Paris on September 15, 1802, he studied under Ramey the younger at the École des Beaux Arts and was runner-up in the Prix de Rome of 1833. He exhibited at the Salon from 1845 to 1872 and specialised in portrait reliefs, plaques and busts.

DEVAUX, François Alexandre 1840-1904
Born at Fécamp on February 24, 1840, he died at Rouen in August 1904. He studied at Rouen Municipal School and later became professor of sculpture there. He exhibited at the Salon from 1870 onwards and was a prolific sculptor of busts.

DEVAUX, Pierre fl. 19th century
Born at Tassin, France in the mid-19th century, he worked in the Lyons area and exhibited busts, heads and portrait reliefs at the Salon des Artistes Français in the 1890s.

DEVENET, Claude Marie fl. 19th century
Born at Uchizy, near Tournus, on October 28, 1851, he studied under Dumont at the Lyons School of Fine Arts. He began exhibiting at the Salon in 1879 and won a third class medal in 1882. He was awarded a bronze medal at the Exposition Universelle of 1900. He specialised in plaques and portrait medallions.

DEVIATOV, Jacov Mihailovich fl. late 19th century
He worked in St. Petersburg, where he had studied under J.J. Podoserov. He specialised in portraiture and executed a series of busts of the Imperial family.

DEVIGNE, Paul 1843-c.1901
Born in Brussels on April 26, 1843, he died there some time after 1901. He was one of the outstanding Belgian sculptors of the second half of the 19th century. He broke away from the rigid academic traditions and sought new inspiration by going back to nature. His monument to Breydel and De Coninck in Bruges illustrates this vividly. He had a great influence on the development of Belgian sculpture at the turn of the century. He had numerous public commissions but among his smaller bronzes may be mentioned the busts of The Republic, Pompeian Girl, Volumnia, Emmanuel Hiel, Roman Woman, Psyche, Narcissus, The Triumph of Art (group) and the bust of Wilson in the Musée Communal, Brussels. Among his allegorical bronze reliefs the best known is that epitomising Sleep.

DEVILLEZ, Louis Henry fl. late 19th century
Born at Mons on July 19, 1855, he studied in Paris and exhibited at the Salon des Artistes Français (third class medal, 1897) and the Nationale and won a gold medal at the Exposition Universelle of 1889. He was employed on the decoration and small ornamental sculpture for the Botanic Gardens and the Palace of Fine Arts in Brussels. He was a prominent figure in the Belgian Aesthetic movement but produced relatively little himself. His bronzes include statuettes of St. George and Salome, a group, The Sylvans, and various portrait medallions.

DEVIN fl. 20th century
Sculptures bearing this signature were the work of a sculptor working in France in the early years of this century.

DEVREESE, Godefroid 1861-
Born at Courtrai on August 19, 1861, he studied under Simonis and Van der Stappen in Brussels. He exhibited at the Brussels Salon and also the Nationale in Paris at the turn of the century. He is best known for his medallions, but he also sculpted genre statuettes such as The Little Philosopher and The Fisherman, equestrian figures and small animal groups.

DEVRIEZ, Philippe fl. 20th century
Born in Torun, Poland, at the turn of the century, he came to Paris after the first world war and exhibited figures and groups at the Salon des Artistes Français in the 1920s.

DEWICK, William Graham 1827-1898
He worked in London and specialised in heads, busts and portrait roundels.

DEXTER, Henry 1806-1876
Born at Nelson, New York, on October 11, 1806, he died in Cambridge, Massachusetts on June 23, 1876. He was self-taught and struggled to become established as a sculptor. Eventually, however, he had a successful practice in Boston and specialised in busts and heads of contemporary American celebrities. He is chiefly remembered for his grandiose scheme to sculpt the heads of the governors of every state in the Union.

D'HAESE, Roel 1921-
Born in Grammont, Belgium on October 26, 1921, he studied at the Alost Academy of Fine Arts and the Brussels Institute of Decorative Arts, where he worked under Oscar Jespers from 1938 to 1942. He had his first one-man show in Brussels in 1948 and took part in the Sao Paulo Biennale of 1953 and 1955. Since 1958 he has participated regularly in all the major open-air sculpture exhibitions in Belgium and France. He has worked successively in stone, wrought iron, sheet metal and bronze (cire perdue), his last works in the last-named medium including The Great Ghost, Legendary Personage (1956) and Sculpture (1958). He works in Rhode St. Genèse, Brabant.

DHOTEL, Jules 1879-
Born in Neufchâtel on November 16, 1879, he was a prolific sculptor of medallions, plaquettes and busts, particularly of celebrities in the world of medicine.

DIALER, Joseph Alois 1797-1846
Born at Imst, Tyrol on March 3, 1797, he died in Vienna on December 5, 1846. He worked in Vienna as a sculptor of ornament on public buildings, particularly theatres, and produced numerous portrait reliefs and busts of historical and contemporary composers and actors.

DIAZ Y GARCIA, Andres fl. 19th century
He worked as a decorative sculptor in Spain in the second half of the 19th century and exhibited reliefs and figures at Cadiz in 1879.

DIAZ Y PACHON, Vicente fl. 19th century
He worked in Spain in the late 19th century, producing memorials, statues and portrait busts. His best-known work is the statue of Columbus, which he completed in 1880.

DIAZ Y SANCHEZ fl. late 19th century
Born in Madrid, where he worked in the late 19th century and participated in the Madrid exhibitions of 1878-81. He specialised in genre figures and groups, particularly of children. His group, The Daughters of the Cid, is in the Madrid Museum.

DICK, Sir William Reid 1879-1961
Born in Glasgow on January 13, 1879, he died in London on October 1, 1961. He studied at the Glasgow School of Art till 1907 and then attended the City and Guilds School, Kennington. He exhibited at the Royal Academy from 1912 and the Royal Society of British Sculptors (F.R.B.S. 1915, A.R.A. 1921, R.A. 1928, R.S.A. 1939) and was President of the latter society in 1933-38. He was a member of the Royal Fine Arts Committee and the Board of Trustees of the Tate Gallery. He was knighted in 1935 and was King's Sculptor in Ordinary for Scotland from 1938 to 1952 and Queen's Sculptor thereafter. He lived and worked in London for many years. He produced a large number of monuments and memorials, including the RAF Monument, the equestrian statue of Lady Godiva, Coventry, the statue of Franklin D. Roosevelt, Grosvenor Square and the statue of David Livingstone at the Victoria Falls. He also sculpted numerous busts of British royalty, political figures and celebrities of the first half of this century and genre bronzes, such as The Kiss.

DIDERICHSEN, Christian Julius 1823-1896
Born in Copenhagen on November 8, 1823, he died there on December 19, 1896. He studied at the Copenhagen Academy and was a pupil of Lodberg and Christian Christiansen. Up to 1864 he concentrated on jewellery but then turned to sculpture and exhibited plaster figures of Judas (1874) and Prometheus (1879) at the Copenhagen Academy salons. He settled in Aarhus in 1882 and sculpted reliefs for a villa and the marble group The Struggle of Man for Freedom. He later produced many other genre and allegorical groups in marble and figures in marble, terra cotta, plaster and bronze.

DIDERON, Louis Jules 1901-
Born in Marseilles on April 16, 1901, he studied under Coutan and exhibited at the Paris salons in the period up to the second world war, winning a bronze medal at the Salon des Artistes Français in 1937. He specialised in busts and figures of children and young ladies.

DIDIER, Albert fl. 19th century
Born in Orleans, he studied under Vital-Dubray and exhibited busts and relief portraits at the Salon from 1877 and the Salon des Artistes Français (Associate, 1887).

DIDIER, Lucienne fl. early 20th century
Daughter and pupil of Albert Didier, she likewise specialised in portrait busts and bas-reliefs and exhibited at the Salon des Artistes Français up to 1944.

DIDIER, Maxime 1876-1915
Son of Albert Didier, he was born in Orleans on May 26, 1876 and was killed in action on the Western Front. Like his father he specialised in portrait busts and exhibited them at the Salon des Artistes Français from 1911 to 1914.

DI DOMENICO, Mario fl. 20th century
Born at Alfedena, Italy in the early years of this century, he worked in Italy and France and sculpted numerous nude statuettes, animal figures and groups and portrait reliefs, busts and heads, which he exhibited in Rome, Milan and Paris in the inter-war period.

DIEBOLT, Georges 1816-1861
Born in Dijon on May 6, 1816, he died in Paris on November 7, 1861. He studied under Ramey, Darbois and Dumont and won the Prix de Rome in 1841 with his Death of Demosthenes. While in Rome he sent works to the Salon which established his reputation at a comparatively early age. He won a second class medal for The Raising of Dejaneira (1848) and a second class medal for The Meditation (1852) and was made a Chevalier of the Legion of Honour the following year. On his return to Paris he worked on the decoration of the new Paris Town Hall and was awarded the gold medal of the City of Paris for his statue La France Remuneratrice (Champs Elysée). He also sculpted the figures of a Zouave and a Grenadier on the Pont de l'Alma. His finest work, the group of Hero and Leander, was exhibited posthumously. He was one of the leading statuaries of the 19th century and is best known for the series of allegorical works Science, Industry, Architecture, Sappho, The Force, The Law and similar groups, may of which were also edited as small bronzes.

DIEDERICH, Fritz 1869-
Born in Hanover on May 20, 1869, he worked as an ornamental and portrait sculptor in Berlin at the turn of the century.

DIEDERICH, Hunt 1884-
Born in Hungary he emigrated to the United States at the beginning of this century and studied in Philadelphia, Rome and Paris. He exhibited in Philadelphia and New York and also at the Salon des Artistes Français and the Salon d'Automne. He produced numerous busts and portrait reliefs, but is best known for his sculpture of animals, particularly dogs and horses. His works include Spanish Horseman, Might and Right, Polo, Horse Group, Fountain Sketch, Cats and Bull Fighter (several versions).

DIELMAN, Ernest 1893-
Born in New York on April 24, 1893, he studied in New York and later worked in Paris where he exhibited at the Salon d'Automne and the Salon des Tuileries from 1928 to 1933. He specialised in exotic statuettes (houris and odalisques) and animal groups.

DIELMANN, Johannes Christian 1819-1886
Born at Sachsenhausen on October 26, 1819, he died at Frankfurt am Main on October 14, 1886. He studied under Krampz and Zwerger and specialised in decorative sculpture for churches and public buildings.

DIES, Cesare fl. 19th century
Born in Rome in 1830, he studied architecture and drawing under Stafano Poggi, but on his death he went to the Académie de France where he studied painting, and later attended the Academy of St. Luke where he was a pupil of Minardi. Subsequently he worked for a time as a sculptor of historical and allegorical figures and groups, but abandoned sculpture for painting on becoming Minardi's assistant.

DIETELBACH, Rudolph fl. 19th century
Born in Stuttgart on December 22, 1847, he studied under Th. von Wagner at Stuttgart and subsequently worked in France, Italy and England as a sculptor of historical figures and bas-reliefs. On his

return to Germany he worked on a number of monuments and also sculpted busts of the imperial family, both historical and contemporary.

DIETERLE, Marie Yvonne fl. late 19th century
Born in Paris in the mid-19th century, she worked in Paris and exhibited at the Salon des Artistes Français. Her bronzes won an honourable mention at the Exposition of 1900.

DIETERLE, Yvonne Emma 1882-
Born in Paris on March 7, 1882, she studied under F. Hannaux and her father, the painter P.G. Dieterle. She exhibited figures and groups at the Salon des Artistes Français and got an honourable mention at the Exposition of 1900.

DIETRICH, Anton 1799-1872
Born in Vienna in 1799, he died there on April 27, 1872. He studied under Kleber and specialised in ecclesiastical sculpture, though he also sculpted numerous busts of his contemporaries.

DIETRICH. Friedrich August Theodor fl.19th century
Born at Bojanovo in Bosnia on October 23, 1817, he studied under Drake in Berlin and specialised in portrait busts of European nobility and royalty, particularly in Prussia and Russia.

DIETRICH, Hans 1868-
Born at Zauchte, Austria on June 30, 1868, he produced numerous busts of contemporary and historic personalities.

DIETSCHE Fridolin 1861-1908
Born at Schönau, Baden on December 31, 1861, he died in Hamburg on June 25, 1908. He studied in Munich and Karlsruhe and later in Berlin and Rome. Eventually he became professor of sculpture at Karlsruhe. He is best known as a ceramicist, but he also sculpted figures and portraits.

DIEUDONNÉ, Guillaume Marius 1827-1897
Born at Arles on January 9, 1827, he died in 1897. He studied at the École des Beaux Arts under Bonnassieux and exhibited at the Salon from 1853 to 1882. He specialised in genre figures and groups, such as Clog Game (Clamecy Museum).

DIEUDONNÉ, Jacques Augustin 1795-1873
Born in Paris on May 17, 1795, he died in the same city on March 2, 1873. He enrolled at the École des Beaux Arts in 1816 and was taught by Gros and Bosio. He was runner-up in the Prix de Rome of 1819 and exhibited at the Salon from that year till 1868. He won third, second and first class medals in 1843-45 and was made a Chevalier of the Legion of Honour in 1867. He specialised in busts of historic figures, such as Gaston de Foix and the Comte de Blois, as well as contemporary personalities and members of the Bourbon royal family (Charles X and the Duc de Angoulême). He also sculpted genre figures, like The Young Mother, and religious works.

DIEUPART, Henri Germain Étienne 1888-
Born in Paris on July 30, 1888, he studied under Injalbert and exhibited busts, bas-reliefs and genre figures at the Salon des Artistes Français in the early years of this century.

DIEZ, Robert fl. 19th century
Born at Pössneck in Germany on April 20, 1844, he studied at the Dresden Academy in 1863-64 and was a pupil of Schilling. He won a first prize at the Academy with his group of Venus consoling Love. He established a studio in 1873 and did a number of decorative sculptures for public buildings in Dresden, notably the new Theatre. He was awarded a Grand Prix at the Exposition Universelle in 1900 for his bronze The Tempest.

DI FILIPPO, Antonio 1900-
Born at Bivona in Italy, he emigrated to the United States and studied at the Beaux Arts Institute of Design in New York. He specialises in busts and heads, and his works include bronze portraits of Dr. Goldberger, Abraham Lincoln and an Italian Boy.

DILIGENT, Raphael Louis Charles 1885-
Born at Flize in France, he was one of the more picturesque figures working in Montparnasse at the turn of the century. He specialised in delicate statuettes in the Art Nouveau style and busts of his contemporaries and exhibited at the Salon d'Automne and the Indépendants.

DILLENS, Julien 1849-1904
Born in Antwerp on June 8, 1848, he died at St. Gilles near Brussels on December 24, 1904. He was the son and pupil of the painter Hendrick Dillens and later studied sculpture under Simonis in Brussels. He made his début at the Brussels Salon in 1874 with paintings, but having won the Prix de Rome three years later he subsequently concentrated more and more on sculpture. His figure of Justice sculpted during his stay in Rome subsequently won him medals in Antwerp, Amsterdam and Paris. He became a very prolific sculptor of figures, groups and medallions. His allegorical and genre works included Urchin, Enigma and the Chariot of Peace. He sculpted numerous ornaments and bas-reliefs for the public buildings in Brussels, but these public commissions tended to stifle his originality and most of them have been described as academic' bric-à-brac or theological trash. He had his occasional flashes of genius, however, as in the two female figures at the foot of the Anspach monument in Brussels and the t'Serclaes monument. His bust of Minerva, in bronze with ivory features, was one of the forerunners of the chryselephantine sculptures of the late 19th century. His other minor works include bronze busts of De Pède and Rubens, Hermes (marble and bronze) and the bronze bust Etruria (1880).

DILLON, Maria Lwowna 1858-
Born at Ponevicz, Poland, she studied in St. Petersburg, Paris and Rome and specialised in portrait busts and small decorative groups. Many of her works were in the Imperial Palace of St. Petersburg.

DILLY, Anna fl.19th century
Born in Lille on January 21, 1849, she specialised in portrait busts and genre figures.

DILLY, J. fl. early 20th century
Bronzes thus signed were by a French artist working at the turn of the century. He exhibited at the Salon des Artistes Français in 1912.

DIMITRIADES, Constantin 1879-
Born at Stenimachos in Greece in 1879, he studied in Athens and Paris, being a pupil of Barrias and Coutan. He sculpted figures, female torsos, busts and genre groups and exhibited in Paris from 1906 to 1914.

DIMITRU-BERLAD, Jean fl. 20th century
He studied under Landowski and Bouchard in Paris and exhibited at the Salon des Artistes Français in the inter-war years. He specialised in busts, bas-reliefs and portrait medallions.

DIMO, Zita fl. 20th century
Born in St.Petersburg before the first world war, she came to Paris after the Revolution and studied under Ségoffin and Carli. She exhibited statuettes at the Salon des Artistes Français and the Tuileries in 1933-35.

DIMPRE, Oswald fl. 19th century
Born at Abbeville on March 25, 1819, he worked in that town on monuments and memorials. His bust of Admiral Courbet is in the Abbeville Museum.

DING, Henri Marius 1844-1898
Born at Grenoble, he studied under Irvoy and E. Hébert and exhibited at the Salon in 1876-78, winning a third class medal in 1877. His best known work is the Vizelle monument in Grenoble, commemorating the Revolution. His allegorical group, the Muse of Berlioz, is in Grenoble Museum.

DINI, Dario fl. late 19th century
He worked in Turin in the late 19th century and exhibited there and in Milan in the 1880s. His marble figure The Prisoner was highly acclaimed. He specialised in genre figures and groups such as The Unattended Meeting and The Young Pastor.

DINI, Giuseppe 1820-1890
Born in Novara in September 1820, he died in Turin on May 13, 1890. His works include the monuments to Cavour at Novara, Alfieri in Asti and Barbaroux at Cuneo, as well as numerous portrait reliefs and busts.

DINNSEN, Edlef Karsten 1853-
Born at Ellhöft on May 8, 1853, he studied in Hamburg and worked in Dresden, Hanover and Berlin on monuments and memorials.

DION, Auguste Louis fl. 19th century
Born in Paris in 1827, he studied under Heizler and exhibited at the Salon in 1865-70. He specialised in animal figures and groups, executed in plaster and bronze.

DIOSI, Ernest Charles 1881-
Born in Paris on April 4, 1881, he studied under Barrias and Coutan and exhibited at the Salon des Artistes Français from 1908, winning a gold medal in 1926 and a silver medal at the Exposition Internationale of 1937. He specialised in portrait busts.

DI PALMA, Ernesto fl. 20th century
Born in Alfedena, Italy at the turn of the century, he studied in Paris under Mercié and exhibited at the Salon des Artistes Français from 1920 to 1939. His work includes figures and groups of animals and portrait busts.

DI PALMA, Falco Henri Manfred fl.20th century
Born at Alfedena, he worked with his brothers and exhibited figures and busts at the Salon des Artistes Français in 1924.

DI PALMA, Octave fl. 20th century
Brother of Ernesto, he worked in Italy and France in the 1920s, specialising in heads and busts.

DIRINGER, Eugène Henri fl. 20th century
Born in Strasbourg, he specialised in animal figures, but also produced genre groups and portraiture, notably a Head of Christ.

DISSAD, Clémentine 1890-
Born in Alfortville, near Paris, on March 30, 1890, she studied under Marqueste and Ségoffin and became an Associate of the Artistes Français. She won a bronze medal in 1923 and specialised in portrait busts and figures of peasants.

DISTELBARTH, Friedrich 1768-1836
Born at Ludwigsburg in 1768, he died at Stuttgart in 1836. He studied under Dannecker and Scheffauer and completed his studies in Rome and Paris. On his return to Stuttgart he became Sculptor to the Royal Württemberg Court and specialised in decorative sculpture.

DIXON, Harry 1861-1942
Born in Watford, Herts on June 21, 1861, he died in London on New Year's Day, 1942. He studied art at Heatherley's school and was later a pupil of Bouguereau and Lefebvre at the Académie Julian in Paris. He exhibited at the Royal Academy from 1886 and the New Gallery from 1895. He worked as a watercolourist and painter of animal subjects and landscapes, and also sculpted competent figures and groups of wild animals. He was elected F.R.B.S. in 1904.

DMOCHOWSKI, Heinrich Sanders 1810-1863
Born in Vilna in 1810, he died in Philadelphia in 1863. He fled to France after the collapse of the Polish Uprising of 1830 and after studying there for a time he emigrated to the United States and settled in Philadelphia where he built up a considerable reputation as a portrait sculptor. His best known work is the statue of his compatriot, Casimir Pulaski, at Savannah, Georgia. He also sculpted numerous busts, heads and portrait reliefs.

DOAR, M. Wilson 1898-
Born in Sussex on June 24, 1898, she went to school in Eastbourne and later studied at Heatherley's under Bernard Adams and Frederic Whiting. She settled in London and worked as a painter and sculptor of animal subjects.

DOBBELS, Georges fl. 20th century
Born at Menin in Belgium, he studied under Chamagiand Leti and worked in Flanders and France in the period before the second world war.

DOBBERTIN, Otto fl. 19th century
Born in Hamburg on September 29, 1862, he studied in Dresden and worked as a sculptor of monuments, memorials, busts and portrait reliefs.

DOBSON, Annie fl. 19th century
She worked in London in the second half of the 19th century, specialising in portraits. The Sydney Museum has her busts of Amivitti and the explorer Leichhardt.

DOBSON, Frank 1888-1963
Born in London on November 18, 1888, he died there on July 22, 1963. He was the son and pupil of Frank Dobson the painter and illustrator. Later he worked in the studio of Sir William Reynolds-Stephen (1902-6) and studied in Arbroath, Angus (1906-10) and the City and Guilds school, Kennington. He first exhibited his drawings and paintings at the Chenil Gallery in 1914. He turned to sculpture shortly before the first world war, working initially as a wood-carver, but later turning to stone, terra cotta and bronze. He had his first one-man show as a sculptor at the Leicester Galleries in 1921. He exhibited regularly at the Royal Academy (A.R.A. 1942, R.A. 1953) and was awarded the C.B.E. in 1947 for his services as a war artist. He taught sculpture at the Royal College of Art from 1946 to 1953 and exhibited sculpture in major international exhibitions, including the Venice Biennale.

DOCK, Eugen 1827-1890
Born in Strasburg in 1827, he died there on April 19, 1890. He studied at the École des Beaux Arts, Paris and specialised in portrait medallions, plaques and busts. His works are in the Mulhouse Museum.

DODEIGNE, Eugène 1923-
Born at Rouvreux, near Liège, in 1923, he studied at the School of Fine Arts in Tourcoing and the Académie des Beaux Arts in Paris. In 1949 he settled in Bondues and has worked there ever since. He received his early training from his father who was a stone-mason and he has shown a marked preference for this medium ever since. He also produced a number of Surrealist groups carved in wood. No bronzes have been recorded by him so far.

DODIN, Marie Ginette fl. 20th century
She worked in Paris in the period immediately after the second world war and specialised in portrait busts.

DODS, Andrew 1898-1976
Scottish sculptor specialising in female statuettes and portraits who exhibited at the Royal Scottish Academy.

DOEBBEKE, Christoph 1883-
Born in Hanover on July 14, 1883, he studied under Fischer in Berlin and specialised in monuments and memorials.

DOELL, Leopold Friedrich fl. 19th century
He died in Gotha on November 3, 1856. He was the son and pupil of the painter Friedrich Doell and worked in Saxony as a sculptor of historical and allegorical figures.

DOHLMANN, Helen 1870-
Born in Copenhagen, she studied under Stephan Sinding and produced busts and statuettes at the turn of the century. She exhibited in Copenhagen and Paris, getting an honourable mention at the Salon des Artistes Français in 1907.

DOISY, C.J.V. fl. early 20th century
Born in Lisieux in the late 19th century, he specialised in portrait reliefs and busts and was awarded a third class medal at the Salon des Artistes Français in 1914.

DOLINAR, Louis fl. 20th century
Born in Serbia at the beginning of this century, he worked in Belgrade and Paris in the inter-war period. Best known for his bronze of Moses, he sculpted portraits, genre and biblical figures. He produced a number of allegorical statues in the post-war period, notably Reconstruction, in Belgrade.

DOLIVET, Emmanuel fl. 19th century
Born in Rennes in the mid-19th century, he died in Paris in 1911. He studied under Cavelier and exhibited at the Salon from 1877 to the end of the century, winning a third class medal in 1886, a second class medal in 1890 and a silver medal at the Exposition Universelle of 1900. He specialised in busts and genre figures. His statuettes of La Madeleine and Mignon are in Rennes Museum.

DOLLIAC, Henri fl. 20th century
Born in Paris, he worked in the 1930s as a painter, caricaturist and sculptor of rather whimsical statuettes and portraits. He exhibited at the Salon des Humoristes and the Indépendants.

DOLOT, Conrad Étienne Gabriel fl. early 20th century
Born at Premeny in the late 19th century, he produced a large number of statuettes and allegorical medallions which he exhibited at the Salon des Artistes Français from 1912.

DOMAN, Charles Leighfield J. 1884-
Born in Nottingham on August 31, 1884, he studied at Nottingham Municipal School of Art and the Royal College of Art and was a pupil of Elsie and O. Sheppard. He won a travelling scholarship in 1908 and continued his studies in Paris. He exhibited at the Royal Academy, the Royal Society of British Sculptors and the Salon des Artistes Français from 1910 to 1939 and worked in Wimbledon on decorative and architectural sculpture.

DOMANOECK, Anton Matthias Joseph 1713-1779
Born in Vienna on April 21, 1713, he died there on March 7, 1779. He was employed as a jeweller and sculptor by the Empress Maria Theresa and produced a number of small bronze ornaments and bas-reliefs.

DOMAS, Louis Théodore fl. late 19th century
Born in Paris, he worked there as an engraver and painter as well as a sculptor. He studied under Justin Lequien and Henri François and exhibited reliefs and plaques at the Salon des Artistes Français in the 1890s.

DOMBROWSKA, Lucia fl. late 19th century
Born in Vilna of Polish and French parents, she studied in Paris under Berthaux and Frémiet. She exhibited at the Salon from 1881, specialising in portrait busts.

DOMELA, César 1900-
Born in Amsterdam on January 15, 1900, he was self-taught and worked as a painter and engraver as well as a sculptor of non-figurative marbles and bronzes. He worked in Paris in the 1920s but later settled in the United States. His works are in the Museum of Living Art, New York, the Guggenheim Museum and various university collections.

DOMENECH Y VICENTE, Luis fl. early 20th century
Born in Barcelona in the second half of the 19th century, he studied under Fusca and exhibited in Madrid, Barcelona and Paris in the 1900s, winning a third class medal at the Salon des Artistes Français in 1905. He sculpted female statuettes and decorative bronze vases.

DOMINGUEZ, Oscar 1906-1958
Born in Tenerife on January 7, 1906, he died in Paris on January 1, 1958. A self-taught artist, he first exhibited his paintings in Tenerife about 1924 but moved three years later to Paris, where he studied sculpture in the 'free academies' of Montmartre and Montparnasse. In 1935 he joined a Surrealist group and was a close friend of the poets A. Breton and P. Eluard. He took part in a series of Surrealist exhibitions in Copenhagen (1935), London (1936), Tokio (1937), Oslo and Paris (1938) and Amsterdam and Mexico City (1940). He also exhibited at the Salon des Indépendants in 1939 and was represented in the Spanish Art Exhibition held in Paris in 1942. After the second world war he abandoned Surrealism and explored the different fields of figurative and abstract sculpture.

DONATH, Gyula 1850-1909
Born in Budapest on March 13, 1850, he died there on September 27, 1909. He studied in Vienna and was a pupil of G. Semper. He sculpted numerous busts and statuettes for the Royal Palace in Budapest and won several important commissions for public statuary, especially at the time of the Millenium of Hungary (1898) and the Imperial Jubilee (1908).

DONATO, Giuseppe 1881-
Born at Maida in Calabria, Italy, in 1881, he emigrated to the United States and studied at the Pennsylvania Academy of Fine Arts under Charles Grafly. He completed his studies at the École des Beaux Arts in Paris and the Académies Julian and Colarossi. He worked for a time in the studio of Rodin and his portraits and figures were strongly influenced by him. He sculpted a number of busts and heads of Americans in the period up to the second world war.

DONEGA, Jetta fl. 20th century
Born in Robbio Lomellina, Italy, she studied under Marini and Manzu at the Albertine Academy in Turin (1941-42) and at the Academy of St. Luke in Rome (1943), working for a time in the studio of Michele Guerrisi. She began exhibiting after the war and took part in the Rome Quadriennale, the exhibitions in Turin, Venice and Salzburg and the exhibition of Italian Twentieth Century Sculpture in 1957. She has had several one-man shows at the Bussola Gallery in Rome and the Blu Gallery in Milan since 1957. Her abstracts, in wood, marble or bronze, have the same degree of attention to patina and polished surface found in the work of Brancusi and Arp. Her works include Form 1 and 2, Surviving Goddess, River in Spate and Leviathan.

DONGEON, Albert fl. 20th century
Born in Paris at the beginning of the century, he worked as a sculptor of busts and portrait reliefs and exhibited at the Salon des Artistes Français from 1933.

DONINGTON, Mary 1909-
Born in London, she studied for a year under Frank Dobson (1945-46), but is largely self-taught. She has exhibited at the Royal Academy and leading London and provincial galleries and works at Headley Down, Hampshire.

DONNDORF, Adolf fl. 19th century
Born in Weimar, Saxony on February 16, 1835, he studied under Rietschel and F. Jade. He was appointed professor of sculpture at Stuttgart in 1877 and executed a number of major memorials and monuments, notably that of Schumann at Bonn and the equestrian statue of King Karl-August. He specialised in busts and statuettes of historical personalities and also neo-classical figures, such as Nymph of the Springs.

DONNDORF, Karl August 1870-
Born in Dresden on July 17, 1870, the son and pupil of Adolf Donndorf. He specialised in portraits and figures of genre subjects. His figure Thoughts is in the Weimar Museum.

DONOGHUE, John 1853-1903
Born in Chicago in 1853, he died in New York on July 2, 1903. He worked for some time in London and Paris at the turn of the century and sculpted figures and groups.

DOPMEYER, Carl 1824-1899
Born in 1824, he died in Hanover on November 9, 1899. He worked in that town as a sculptor of memorials and public statuary and is best remembered for his colossal statue of Johan Gutenberg.

DORCIÈRE, Louis Étienne André 1805-1879
Born in Geneva in 1805, he died there on August 30, 1879. He studied engraving under Detalle, drawing and painting under Reverdin and modelling under Jacquet. He also studied in Paris for a time under Auguste Boret and worked as a medallist. Later he became professor of sculptor in Geneva. His works include the figures and decorative reliefs on the fountain in the Place des Alpes, Geneva, genre and biblical groups such as Hagar and Ishmael and Confidence, and numerous portrait busts and medallions of his contemporaries.

DORÉ, Louis fl. early 20th century
Born at Rennes in the late 19th century, he worked in that town in the early years of this century, specialising in busts and groups portraying young children. He exhibited at the Salon des Artistes Français in 1913 and at the Nationale in 1919.

DORÉ Paul Gustave Louis Christophe 1832-1883
Born in Strasburg on January 6, 1832, he died in Paris on January 28, 1883. He was the son of a civil engineer and came to Paris in 1848 where he found employment as a cartoonist and illustrator in the *Journal pour rire*. He became a prolific illustrator of books and periodicals and also produced a number of large and ambitious oil paintings of religious subjects. He only turned to sculpture in the later years of his life, his best known work in this medium being the monument to Alexandre Dumas in the Place Malesherbes, Paris, distinguished by the refreshingly natural treatment of the group of readers at the base. This original approach to naturalistic sculpture is also evident in his remarkable little group of Acrobats. Doré became

an Officier of the Legion of Honour in 1879.
Jerrold, W.B. *Life of Gustave Doré* (1891). Rose, M. *Gustave Doré* (1946).

DORER, Robert Eugène 1830-1893
Born in Basle on February 13, 1830, he died there on April 13, 1893. He studied under Schwanthaler at the Munich Academy and later under Ernst Rietschel and Hähnel in Dresden before completing his studies in Rome. Following his return to Geneva he won many important commissions, including the National Monument in Geneva (1869). He also worked in Berne and sculpted a series of eight politicians for the Gesellschafts Museum. He was also responsible for a number of ornaments, friezes and small groups decorating public buildings in St. Gall.

DORET DE LA HARPE, David fl. 19th century
Born at Vevey, Switzerland on June 30, 1821, he studied under Louis Dorcière in Geneva and Imhof in Berne. He worked for much of his life in France and was made a Chevalier of the Legion of Honour at the Exposition Universelle of 1878. He produced a number of monuments (Max de Meuron, and the Leopold Robert memorial in Venice) and sculpted the decorative figures on the mausoleum of the Duke of Brunswick.

DORILLAC, Jean Georges fl. 20th century
Born at Bergerac, he studied under Niclausse and Harion and exhibited medallions and bas-reliefs at the Salon des Artistes Français.

DORIOT, Adrien Antoine fl. 19th century
Born in Vendôme on April 29, 1821, he attended the École des Beaux Arts from 1846 to 1850 and studied under Rude. He exhibited busts and statuary at the Salon from 1851 to 1872. His best known work was the marble bust of the Duc de St. Simon.

DORIOT, Théodore fl. 19th century
Born at Vendôme in the first half of the 19th century, he studied under Rude and his elder brother, Adrien Doriot, and exhibited statuettes at the Salon from 1868 to 1870.

DORLIAC, Norma Marcella fl. 20th century
American sculptress working in the first half of this century. She was a pupil of Voletchnikov and executed busts and statuettes of female figures in the 1920s, in cement, plaster and bronze.

DORN, Alois 1840-1890
Born in Vienna in 1840, he committed suicide there about 1890. He specialised in busts of his contemporaries, many of which are preserved in the Vienna Museum.

DORN, Carl fl. 19th century
Born in Berlin on January 31, 1831, he studied under G. Bläser and exhibited regularly at the Berlin Academy. He specialised in busts and portrait reliefs.

DORNIS, Gustav von fl. 19th century
Born in Coburg in the early 19th century, he worked there as a sculptor of plaques and medallions.

DORRENBACH, Franz 1870-
Born in Düsseldorf on February 11, 1870, he sculpted genre and historical figures at the turn of the century.

D'ORSAY, Count Alfred 1801-1852
Much doubt has been cast on the work of this sculptor, much of it being thought to have been 'ghosted' by other craftsmen, including Thomas Henry Nicholsom and William Behnes. Others, however, have maintained that he did his work unaided. He exhibited at the Royal Academy in 1843-48 and produced a number of marble portrait busts and reliefs. His bronzes include busts of Lord Lyndhurst, Lord Brougham, the Empress of Austria, Count d'Orsay the elder, equestrian statuettes of Wellington and Napoleon, and statuettes of Louis Napoleon Bonaparte (later the Emperor Napoleon III), the Tsar of Russia and Daniel O'Connell.

DORVAL-DÉGLISE, Jacques fl. late 19th century
Born in Algiers in the mid-19th century, he studied in Paris under Delaplanche and specialised in portrait busts of his contemporaries and genre statuettes, such as The Blind Beggar (Algiers Museum).

DOUAY, Marc Christophe fl. late 19th century
Born in Cambrai, he studied at the Cambrai School of Design and
exhibited at the Paris Salon in the 1880s. He produced portrait busts
and reliefs and genre statuettes, such as The Slave (Château Thierry
Museum).

DOUBLEMARD, Amédée Donatien 1826-1900
Born at Beaurain on July 8, 1826, he died in Paris in 1900. He studied
under Duret at the École des Beaux Arts in 1842-44 and began
exhibiting at the Salon in the latter year. He was runner-up in the Prix
de Rome of 1854 and won the prize the following year. On his return
from Rome he specialised in busts of his famous contemporaries. He
also sculpted a number of statues and statuettes of historic figures and
genre groups. He was made a Chevalier of the Legion of Honour in
1877 and won a silver medal at the Exposition Universelle of 1889.
His works include Young Fawn and Panther (1875), Marine Officer
(Amiens Museum) and Admiral Hamelin (Versailles Gallery).

DOUBLEMARD, Charles Joseph fl. 19th century
Born in Paris, he was the son and pupil of the above. He specialised in
portraits and exhibited at the Salon from 1875 to the end of the
century.

DOUCAS, Loucas fl. early 20th century
Born in Athens at the turn of the century, he came to Paris and
studied under J. Boucher. He specialised in busts and heads and
exhibited at the Salon des Artistes Français in the 1920s.

DOUCET-CLEMENTZ, Marguerite 1876-
Born in Strasburg on April 1, 1876, she studied at the School of Fine
Arts in Geneva and specialised in busts of historic and contemporary
personalities. She exhibited at the Nationale and the Salon
d'Automne from 1914 to 1927.

DOUDEAU, L. fl. 19th century
Decorative sculptor working in Paris in the early 19th century. He
specialised in memorials and bas-reliefs, small figures and portrait
roundels.

DOUDNEY, Henry Eric John 1905-
Born in Watford, Herts. on December 28, 1905, he studied at the
Richmond School of Art and Kennington School and the Royal
Academy schools. He has exhibited at the Royal Academy, the Royal
Society of British Sculptors and the leading London and provincial
galleries. He worked in Chingford for some years but later emigrated
to New Zealand. His figures and groups have been executed in stone,
wood and plastics as well as bronze. He is the head of the sculpture
department at the Christchurch School of Art, and has sculpted
portraits, figures, groups and bas-reliefs for public buildings and parks
in New Zealand.

DOUDOULOV, Anastas fl. 20th century
Sculptor of genre and allegorical figures, working in Bulgaria in the
first half of this century.

DOUGLAS, E. Bruce fl. 20th century
Born at Cedar Rapids, U.S.A. at the turn of the century, he studied in
New York and Paris and specialised in busts, torsos, masks and figures
of animals. He exhibited at the Paris salons from 1930 to 1938.

DOUILLET, Alfred Alexandre fl. 19th century
Born in Paris, he studied under Lequien the elder and exhibited
medallions and plaques at the Salon from 1866 to 1877.

DOUIN, Joseph Charles Louis fl. 19th century
Born at Caen on August 22, 1825. He worked with his son Raoul
Joseph Douin (born December 1855) in Caen and sculpted memorials,
statuary busts and small figures.

DOUIS, Gaetan Pierre fl. 20th century
Born at Orbec, France at the turn of the century, he specialised in
animal figures and groups which he exhibited at the Salon d'Automne
and the Indépendants from 1927 onwards.

DOUMENC, Eugénie Baptiste fl. early 20th century
Born in Geneva on March 12, 1873, she worked in Geneva and Paris
as a sculptor of plaques, bas-reliefs and medallions. Her work is
preserved in the Museum of Decorative Arts in Geneva. She exhibited
at the Salon des Artistes Français, winning a second class medal in

1924 and a gold medal in 1936 and was also a Chevalier of the Legion
of Honour.

DOUMER, Hélène fl. 20th century
Born in Lille, she studied under Landowski and Bottiau and exhibited
busts and heads at the Salon des Artistes Français in the 1930s.

DOUMICHAUD DE LA CHASSAGNE-GROSSE, Laetitia
fl. 19th-20th centuries
Born at Henrichemont in the second half of the 19th century, she
studied painting and sculpture under Lefebvre, Bouguereau, G.
Fevrier, Flameng and Baschet. Better known for her paintings of
portraits, nudes and flowers, she also sculpted statuettes, busts and
bas-reliefs.

DOURNOFF, G. fl. 19th century
He worked in St. Petersburg in the mid-19th century as a sculptor of
portrait busts of his artistic contemporaries, such as Outkin,
Chebouyeff and F.P. Tolstoi. His portraits are preserved in the
Leningrad Academy of Arts.

DOUSSAULT, Charles fl. 19th century
Born at Fougères, he worked as an architect, painter and sculptor. He
studied under Achille and Eugène Devéria and travelled extensively in
the East. This is reflected in his paintings and sculpture of native
types. He exhibited at the Salon from 1834 to 1870. His figure of an
Antique Dancer is in the Nantes Museum.

DOW, Harold James 1902-
Born in London on June 15, 1902, he studied at the Royal College of
Art and has exhibited at the Royal Academy since 1926.

DOWIE, John 1915-
Born in Adelaide, South Australia, in 1915, he produces decorative
sculpture, figures, monuments, memorials and portraits. His work is
represented in many public collections in Australia.

DOWNING, Edith 1857-
Born in Cardiff, she studied under Lanteri in Kensington and later
completed her studies in Paris. She exhibited at the Royal Academy
and the Salon des Artistes Français in the late 19th century and
specialised in portraits and genre figures.

DOYLE, Alexander fl. 19th century
Born at Steubenville, Ohio, on January 28, 1857, he spent many years
in Italy before settling in New York and later worked in Washington
on memorials and portrait busts.

DOYLE-JONES, Francis William 1873-1938
Born in West Hartlepool on November 11, 1873, he died in London
on May 10, 1938. He studied under Lanteri in Kensington and
established a studio in London, where he specialised in portrait busts,
bas-reliefs and heads. He exhibited at the Royal Academy and the
Royal Hibernian Academy, much of his work being commissioned in
Ireland. His chief work is the monument of John Mandeville in
Michelstown.

DRAGOMIR, Arambacic fl. early 20th century
Born in Belgrade in the late 19th century, he studied there, and also
in Vienna and Paris before and after the first world war. He sculpted
figures and groups exhibited in Paris and Belgrade in the 1920s.

DRAHN, A. fl. 19th century
Born in Berlin at the beginning of the 19th century, he sculpted
memorials, monuments and decorative reliefs in Berlin in the 1830s.
He also produced statuettes and busts of historical and contemporary
personalities, Prussian royalty and nobility.

DRAKE, Friedrich Johann Heinrich 1805-1882
Born at Pyrmont on June 23, 1805, he died in Berlin on April 6,
1882. He was apprenticed as a mechanic but gave this up to
concentrate on sculpture. He became a pupil of Rauch and swiftly
acquired a great reputation all over Germany. His chief works were
the colossal statue of Justus Moeser at Osnabruck (1836) and the
marble statues of King Frederick William III in Stettin and Berlin. He
exhibited at the Exposition Universelle of 1867 and was awarded a
silver medal and the Legion of Honour, ironically enough for his
equestrian statue of King William of Prussia, victor in the
Franco-Prussian war three years later and first German Kaiser. He

exhibited at the Paris Salon from 1855 and was an Associate Member of the French Academy of Fine Arts. He was also decorated by the Kaiser for sculpting the Victory monument (Siegessaüle) in Berlin in 1873. His minor works include a large number of portrait busts and statuettes. A decorative bronze vase by him is in the Antwerp Museum.

DRAKE, Henrich 1903-
Born at Ratsiek, Lippe in 1903, he learned the techniques of wood-carving before studying sculpture at the Dresden Academy in 1927 and later completing his studies in Berlin. In 1946 he was appointed lecturer in sculpture at the Berlin-Weissensee School of Art and became a member of the Academy of Arts of the German Democratic Republic. He has had a great influence on the development of sculpture in East Germany since the second world war. He has sculpted genre figures, such as Young Wife (1949) but is mainly known for his animal figures and groups, such as Panther (1953), sheep, horses and Shetland ponies. His works are in the Staatliche Museen, Berlin.

DRAKE, Ludwig 1826-1897
Born at Pyrmont on February 4, 1826, he died in Berlin on October 28, 1897. He was the younger brother and pupil of Friedrich Drake and worked in Berlin, mainly on busts of German royalty, the nobility and contemporary personalities.

DRAPER-SAVAGE fl. 20th century
Portrait busts bearing this signature were produced by a sculptor working at Wilmington, North Carolina, in the first half of this century. He worked in Paris in the inter-war period and exhibited at the Salon d'Automne and the Tuileries from 1926 to 1934.

DRECHSEL, Johanne (née Thomsen) 1867-
Born in Copenhagen on January 17, 1867, she studied under Bredal, C. Thomsen and A.V. Saabye. She specialised in busts and heads and worked in Copenhagen at the turn of the century.

DREESER, Johann Friedrich 1814-1886
Born in Cologne in 1814, he died there on March 16, 1886. He studied at the Munich Academy and exhibited figures and busts at the annual Cologne exhibitions.

DREIER fl. 18th-19th centuries
Bronzes bearing this name in Cyrillic were produced by a sculptor who worked at St. Petersburg about 1805.

DRENEAU, Marie Louise fl. 20th century
Born at Montreux, Switzerland, in the early years of this century, she studied under Hairon and exhibited in Paris in the 1920s. She specialised in portrait medallions and bas-reliefs.

DRESCHFELD, Violet J. fl. 20th century
Born in Manchester in the late 19th century, she worked in Manchester as a portrait sculptor, specialising in female busts.

DRESCO, Arturo 1875-
Born in Buenos Aires, he studied there and in Florence and worked in Argentina as a sculptor of figures, groups and busts. His works are in the Buenos Aires Museum.

DRESSLER, Adolph 1814-1868
Born in Berlin in 1814, he died in Rome in 1868. He specialised in portrait busts of European royalty and the aristocracy and exhibited in Berlin from 1834 onwards.

DRESSLER, Alberto 1879-
Born in Milan of German parents, he studied at the Brera Academy and was a pupil of Butti at the Milan Academy. Later he went to Germany and worked with Kühn in Berlin. He specialised in portrait reliefs and busts. His best known work is the monument to the poet Carlo Porta in Milan.

DRESSLER, Conrad 1856-1940
Born in London on May 22, 1856, he died at St. Brévin l'Océan, France, on August 3, 1940. He studied at the Royal College of Art under Lanteri and completed his studies in Paris. He was greatly encouraged by John Ruskin (whose bust by Dressler is in the National Gallery) and worked as a potter with Harold Rathbone in Birkenhead from 1893 to 1895. Later he worked with William De Morgan in

Chelsea and invented the tunnel kiln. He exhibited at the Royal Academy from 1883 and was elected F.R.B.S. in 1905. After the first world war he lived for a time in the United States before settling in France. He sculpted numerous busts of his contemporaries and also statuettes of genre subjects.

DRESSLER, Franz 1848-1885
Born in Brno in 1848, he died there on January 12, 1885. He worked in Brno and sculpted the ornament for the Town Hall, as well as a number of busts, reliefs and memorials.

DREUX, Paul Édouard fl. late 19th century
Born in Paris on October 5, 1885, he worked as a modeller for the Sèvres porcelain factory, but also exhibited plaster, terra cotta and bronze figures of animals at the Salon des Artistes Français and the Salon d'Hiver. Examples of his sculpture are in the Musée des Arts Décoratifs.

DREXLER, Franz fl. 19th century
Born at Osterhöfen, Germany on October 6, 1857. He worked in Osterhöfen and Munich as a sculptor of statues, memorials and portrait busts.

DREYFUS, Leopold fl. 20th century
Born at Fontenay-le-Comte at the turn of the century, he exhibited figures and groups at the Salon des Indépendants in 1920-27.

DRIPPE, Eugen 1873-1906
Born in Berlin on January 21, 1873, he died in the same city on May 18, 1906. He specialised in genre and neo-classical sculpture such as The Lovers and Bacchantes.

DRISCHLER, Josef fl. 19th century
Born at Rinteln, Germany on October 11, 1838. He worked in Berlin as a sculptor of portrait busts and genre groups.

DRIVIER, Léon Ernest 1878-1951
Born at Grenoble on October 22, 1878, he died in Paris in 1951. He studied under Rodin, who thought very highly of him. He produced a great many statuettes of women, noted for purity of expression but tending towards sentimentality. He exhibited at the Salons of Paris and became a Chevalier of the Legion of Honour. His works are preserved in museums in Paris, Lyons, Grenoble, Algiers and Washington. His larger works include Joy of Living (Palais de Chaillot) and Colonial France (Porte Dorée). Among his minor works are numerous portrait busts and genre bronzes, such as The Kiss, and Faun and Child.

DROBOIS, André fl. early 20th century
Born at St. Quentin in the late 19th century, he studied under J. Boucher and exhibited at the Salon des Artistes Français in 1921-22. He specialised in genre statuettes and portrait medallions.

DROPSY, Henri 1885-
Born in Paris on January 21, 1885, he studied under Thomas, Vernon, Injalbert and Patey and exhibited regularly at the Salon des Artistes Français. He was a Chevalier of the Legion of Honour. He specialised in portrait busts of celebrated contemporaries and allegorical groups, such as Electricity and Winter.

DROPSY, J.B. Émile fl. 19th-20th centuries
Born in Paris, he studied at the École des Beaux Arts and exhibited at the Salon des Artistes Français from 1887 to the first world war, winning third class medals in 1898 and 1903 and an honourable mention at the Exposition Universelle of 1900 for his bronze statuettes and allegorical compositions.

DROPSY, Lucien Émile fl. early 20th century
Born in Paris in the late 19th century, he was killed in action during the first world war. He specialised in portrait busts, which he exhibited at the Salon des Artistes Français from 1911 to 1914.

DROSSIS, Leonidas 1836-82
Born in Athens on December 4, 1836, he died in Naples on December 6, 1882. He studied under Siegel in Athens, then went to Munich and Rome to complete his studies. On his return to Greece, he became professor of sculpture at the Athens Academy. He produced a number of figures and groups portraying classical Greek celebrities, such as the poetess Sappho and Alexander the Great.

DROUCKER, Léon 1867-
Born in Vilna in 1867, he settled in France in 1886 and exhibited at the Salon d'Automne, the Tuileries and the Nationale at the turn of the century. He specialised in busts and monumental statuary. He is best remembered for the series of bas-reliefs for the capitol building in Havana, Cuba.

DROUET, Charles 1836-1908
Born in Paris on May 6, 1836, he died there in 1908. He studied under Toussaint and exhibited genre and historical figures at the Salon from 1861 onwards.

DROUOT, Édouard fl. 19th-20th centuries
Born at Sommevoire, France on April 3, 1859, he studied in Paris under Thomas and Mathurin-Moreau. He is better known as a genre painter and won a third class medal at the Salon of 1892 and an honourable mention at the Exposition Universelle of 1900 for such work. He also modelled equestrian bronzes, such as Farmer Harrowing and Huntsman, as well as genre statuettes of semi-nude women, dancing or playing musical instruments.

DROZ, Jules Antoine 1804-1872
Born in Paris on March 12, 1804, he died there on January 26, 1872. He was the son and pupil of the painter Jean Pierre Droz and also studied sculpture under Cartellier at the École des Beaux Arts. He exhibited at the Salon from 1831 to 1855 and won a third class medal in 1833. He became Chevalier of the Legion of Honour in 1854. Most of his work consists of statuary and monuments in stone and marble, but among his minor sculptures are the bronzes of Conte and Baron Thénard.

DRUIELLE, Jean fl. 20th century
Born in Toulouse, he worked there before the second world war as a sculptor of busts, heads and portrait reliefs. He exhibited at the Salon des Artistes Français in 1936-38.

DRUMH, August 1862-1904
Born in Ulmet on May 26, 1862, he died in Munich on October 21, 1904. He studied under Eberle in Munich before going to Italy and established a studio in Munich on his return from Rome. His works include Peace (Edenkoben) and the figure of Emperor Louis of Bavaria.

DRUOTON-FROMENTIN, Paul Émile Robert fl. 20th century
He worked in Besançon in the inter-war period, sculpting busts and portrait reliefs. He was an Associate of the Artistes Français and exhibited at that Salon in 1934-35.

DRURY, Edward Alfred 1856-1944
Born in London on November 11, 1856, he died at Wimbledon on December 24, 1944. He studied at the Oxford School of Art, the Royal College of Art and South Kensington where he was a pupil of Dalou. He followed his master back to Paris when he was amnestied in 1879, and worked with him on the Triumph of the Republic. He returned to England in 1885 and exhibited at the Royal Academy from that year onward, becoming A.R.A. (1900) and R.A. (1913). The strong influence of Dalou, evident in Triumph of Silenus (1885), gradually diminished, and Drury's reputation rests largely on his portrait sculpture. His bust of Sir Joshua Reynolds (Burlington House) is regarded as his finest work in the field of portraiture. He also produced a number of decorative statues, in plaster and bronze, such as Circe (honourable mention at the Salon of 1893). His minor works in bronze also include Young Bacchanal, The Kiss and genre groups such as He Loves Me, He Loves Me Not.

DRY DE SENNECY, Fanny fl. early 20th century
Born in London of French parents in the late 19th century, she returned with her family to Paris and studied under Roufosse. She exhibited romantic and genre figures at the Salon des Artistes Français from 1902 onwards.

DUBAUT, Maxime fl. 20th century
Born in Paris, he specialises in busts, heads and portrait reliefs which he has exhibited at the Salon d'Automne since 1942.

DUBERRY, Émile fl. 20th century
Born at St. Armand, he exhibited statuettes at the Salon des Artistes Français in 1927.

DUBERTEAU, Pierre fl. 19th century
Born at Caudéran about the middle of the century, he died in 1871. He studied under Carpeaux and exhibited at the Salon of 1870, but died suddenly the following year. He sculpted genre figures and small groups.

DUBIEF, Joanny fl. early 20th century
Born at Villefranche in the late 19th century, he worked as a sculptor of portraits and statuettes in that town and exhibited at the Salon des Artistes Français from 1901.

DUBIEF, Louis Jean Claude fl. 20th century
Born at Mâcon, he studied under Thomas and Bertrand and specialised in groups and allegorical medallions. He exhibited at the Salon des Artistes Français from 1923-29.

DUBOIS, Anatole fl. 20th century
Born in St. Petersburg of French parents, he returned with his family to France after the Revolution and exhibited at the Salon des Independants, the Salon d'Automne and the Tuileries from 1928 onwards. He specialised in portrait busts and heads, particularly of personalities of the Bolshevik faction during the Revolution.

DUBOIS, Constance 1840-
Born at Fère-en-Tardenois on January 8, 1840, she studied under Matabon and exhibited statuettes at the Salon from 1870 to the end of the 19th century.

DUBOIS, Ernest Henri 1863-1931
Born in Dieppe on March 16, 1863, he died there in 1931. He studied under Falguière, Chapu and Mercié and exhibited at the Salon des Artistes Français in the 1890s. In 1894 he won a first class medal and a travelling scholarship and crowned his success with the Medal of Honour (1899) and the gold medal of the Exposition Universelle and Officier of the Legion of Honour in 1900. His works include numerous portrait busts and genre groups, such as The Pardon, casts of which are in the Louvre and the museums of Arras and Rouen.

DUBOIS, Eugène 1825-1893
Born in Paris on April 3, 1825, he died there in 1893. He studied under Duret and exhibited figures and groups at the Salon from 1869 to 1882.

DUBOIS, Georges fl. 19th century
Born in Paris, he studied under P. Lehoux and exhibited figures at the Salon from 1887.

DUBOIS, Henri Alfred Auguste fl. 19th-20th centuries
Born in Rome on August 21, 1859, he was the son of the engraver and medallist Alphée Dubois. Later he studied sculpture under Chapu and Falguière. He was runner-up in the Prix de Rome of 1878 and exhibited at the Salon des Artistes Français from then until the first world war period. His many awards included a first class medal (1898), a silver medal at the Exposition of 1900 and the Legion of Honour (1903). He specialised in medallions, plaques, bas-reliefs and busts.

DUBOIS, Jules Charles 1806-c.1870
He worked under the pseudonym of Julien. Born in Rennes on October 24, 1806, he died in Paris about 1870. He studied at the École in 1829-33 and was a pupil of Logerat and Chaumont. He exhibited at the Salon from 1837 to 1869 and won a third class medal in 1842. He produced genre figures and groups, such as The Player (Rennes Museum).

DUBOIS, Madeleine fl. 20th century
She specialises in busts and portrait reliefs and has exhibited at the Salon des Femmes Peintures et Sculpteurs since the second world war.

DUBOIS, Paul 1829-1905
Born at Nogent-sur-Seine on July 8, 1829, he died in Paris on May 22, 1905. He trained as a lawyer but soon turned to art instead. He entered the studio of Toussaint in 1856 and studied at the École two years later. He went to Italy for several years but returned to Paris in 1863 and shared a studio with Falguière for a number of years. He began exhibiting at the Salon in 1863, showing a group of medallions and plaques, but later he turned to painting in the late romantic style and his reputation rests largely on his work in this medium. He became a member of the Institut in 1876 and rose through the grades

of the Legion of Honour to become a holder of the Grand Cross (1896) – one of the few artists to achieve this distinction. He was Curator of the Luxembourg Museum and Director of the École Nationale des Beaux Arts. His sculptures, however, include a considerable number of portrait busts of contemporary personalities, in plaster and marble as well as bronze, such as those of Bonnat, General Foy, Paul Baudry, Alexandre Cabanel, Louis Pasteur and Duhamel du Monceau. He also sculpted romantic bronzes, such as his allegories of Alsace and Lorraine and his Florentine Singer (silvered bronze), which earned him the Legion of Honoui at the Exposition Universelle of 1867.

DUBOIS, Paul fl. late 19th century
Born at Aywaille, Belgium on September 23, 1859, he studied in Brussels under Simonis and Van der Stappen. He made his début in 1884 with a figure of Hippocrates which won him the Godecharles Prize. He was a very prolific artist whose works may be found in many Belgian, French and German museums. They include decorative busts and genre figures, such as The Violinist, The Renamed, Young Woman Seated, Woman in a Helmet and Congolese Woman.

DUBOIS, Vincent Joseph fl. 19th century
Born at Soignies, Belgium on March 6, 1823, he worked in Douai and is best known for the figure of a Chimaera on the façade of Douai Town Hall. A cast from the model of this sculpture is preserved in Douai Museum.

DUBOIS-DAVESNE, Marguerite Fanny 1832-1900
Born in Paris in 1832, she died there in 1900. She studied under Desboeufs and L. Cogniet and exhibited at the Salon from 1853 onwards. She specialised in portrait busts of contemporary celebrities, mainly sculpted in marble.

DUBOIS-PONSOT, Eva fl. 19th-20th centuries
Born in Paris, she worked there at the turn of the century on statuettes and portraits and exhibited at the Salon des Artistes Français (Associate, 1894).

DUBOS, Armand Gilbert fl. 20th century
Sculptor of statuettes and small groups, working in Paris in the 1920s.

DUBOURG, Pierre fl. early 20th century
Born at Levallois-Perret in the late 19th century, he exhibited figures and groups at the Salon des Artistes Français from 1906 onwards.

DUBOY, Paul 1830-c.1887
Born in Tours on July 8, 1830, he died there about 1887. He enrolled at the École des Beaux Arts in 1849 and studied under Gechter and C. Elshoecht. He exhibited at the Salon from 1853 to 1882 and specialised in bas-reliefs, plaques and medallions in plaster or bronze.

DUBRAY, Eugénie Giovanna fl. 19th century
Born in Florence of French parents, she studied under her father V.G. Dubray and later worked under L. Dieu in Paris. She exhibited portrait busts, in plaster or bronze, at the Salon from 1875 to 1885.

DUBRAY, Vital Gabriel 1813-1892
Born in Paris on February 28, 1813, he died there in 1892. He studied under Ramey and exhibited at the Salon from 1840 to 1882, winning a third class medal in 1844. He became a Chevalier of the Legion of Honour in 1857 and an Officier in 1865. He was a prolific sculptor of busts and statues and his bronzes include Spontini inspired by the Genius of Music, Colonel Abbatucci, a bas-relief illustrating the Coronation of the Empress Eugénie, the bas-relief of Cardinale Fesch (Ajaccio), Slaughter of the Innocents and Christ Healing the Sick. His most ambitious work in this field was the series of ten bas-reliefs illustrating the career of Joan of Arc which decorate the pedestal of her monument in Orleans.

DUBRET, Henri fl. early 20th century
Born in Paris he worked as a sculptor of figures and portraits in that city from 1900 onwards.

DUBREUIL, Alexis Théophile the Elder 1825-1898
Born at Dancevoir in 1825, he died at Lyons on November 14, 1898. With his brother Eucher he worked on monuments and memorials for the Loyasse cemetery in Lyons.

DUBREUIL, Ambroise 1795-1878
Born at Dancevoir in 1795, he died in Lyons on November 25, 1878. He studied under Pierre Robert and specialised in decorative sculpture and statuettes, mainly of religious subjects.

DUBREUIL, Eucher 1829-1887
Born at Dancevoir in 1829, he died in Lyons on April 29, 1887. He was the younger son of Ambroise and worked with him and his brother Alexis on ecclesiastical sculpture in Dancevoir and later in Lyons.

DUBRUCQ, Pierre Isidore 1844-1886
Born in Ghent on May 6, 1844, he died there on April 30, 1886. He studied under Pierre Devigne and A. van Eenaeme and became a very prolific sculptor of busts and genre figures. His statuette The Young Sculptor is in the Ghent Museum.

DUBUCAND, Alfred fl. 19th century
Born in Paris on November 25, 1828, he studied under Lequien and exhibited at the Salon from 1867 to 1883, winning a third class medal in 1879. He worked entirely as an Animalier and his wax models (subsequently cast in bronze) covered a wide field. His figures and small groups include Valet restraining the Dogs (1868), Griffon attacking a Duck (1868), Spaniel and Hare (1869), Stag and Hind, Return from the Hunt at Courre (1870), Egyptian Gazelle Hunt (1873), Hunting in the Sahara (1874), Persian Hunter (1878), Ostrich Hunt (1875), Ass-driver of Cairo (1876). Other groups include staghounds, famous racehorses, Labrador dogs and domestic fowls.

DUBUCAND, E.A. fl. late 19th century
Son and pupil of Alfred Dubucand, he exhibited animal sculpture at the Salon from 1883 to 1890.

DUBUCQUOY, Marguerite Pallu fl. late 19th century
She worked in Paris in the 1880s and 1890s as a sculptor of portraits and statuettes.

DUBUFE, Juliette (née Zimmermann) fl. 19th century
She was the wife of the painter Édouard Dubufe and specialised in portrait busts which she exhibited at the Salon from 1848 to 1853 (third class medal, 1842).

DUBUT, Berthe fl. 20th century
Born at St. Ouen in the late 19th century, she studied under Marqueste, Patey, Ségoffin and Carli. She exhibited statuettes and reliefs at the Salon des Artistes Français in the inter-war years.

DUBUT, Frédéric Guillaume 1711-1779
Born in Berlin in 1711, he died in Danzig on May 4, 1779. He was the son of Charles Claude Dubut, a French-born interior decorator and *stuccateur* employed by the Prussian Court. He worked with his father and later studied in Munich before becoming Sculptor to the Court of Augustus III of Poland. In 1756 he went to St. Petersburg and worked for the Empress Elizabeth, but settled in Danzig ten years later. He produced statuary and friezes in marble, but his reputation rests mainly on his busts and profiles modelled in wax, some of them being subsequently cast in bronze.

DUCHAMP-VILLON, Raymond 1876-1918
Born in Damville on November 5, 1876, he died at Cannes on October 7, 1918 of war wounds. He was the brother of the painters Marcel Duchamp and Jacques Villon. He originally studied medicine, but gave it up in 1898 and turned to architecture and sculpture. He was influenced at first by Rodin but broke away about 1904 to concentrate on the study of simplified forms and became a founder member of the Cubist movement. At the Salon d'Automne of 1913 he exhibited a model of a house decorated in Cubist motifs. His sculpture from 1910 onwards represented an important landmark in the development of Cubism and includes Athlete's Torso (1910), Head of Baudelaire (1911), Lovers (1913), Seated Woman (1914), Horse's Head (1914), Head of Maggy (1912), Head of Professor Gosset (1917). His Torso of a Woman was cast posthumously and shown in a retrospective exhibition of his works in 1928. His other bronzes include models for a decorative vase.

DUCHE, Michel fl. 19th-20th centuries
Born at Herson in the mid-19th century, he studied under Lequien and exhibited human and animal figures at the Salon from 1876 onwards.

DUCHENE, Yvette fl. 20th century
Born in Paris at the turn of the century, she studied under Benneteau and exhibited busts, mainly of children, at the Salon des Artistes Français from 1929.

DUCHERT, J.M. fl. 19th century
Bronzes bearing this signature were the work of a sculptor working in the Heidelberg area in the mid-19th century. The Heidelberg Museum has his bas-relief celebrating the jubilee of Heidelberg University.

DUCKWORTH, Ruth (née Windmüller) 1919-
Born in Hamburg on April 10, 1919, she studied in Liverpool (1936-40), Kennington (1942-3), Hammersmith School of Art and the Central School of Arts and Crafts and has a studio at Kew where she produces pottery and sculpture in stone, lead, terra cotta, wood and bronze. She has exhibited at the Royal Academy and various provincial galleries since the end of the second world war.

DUCLUZEAUD, Marcel fl. early 20th century
Born in Paris in the late 19th century, he studied under Mercié, Peter and Larroux and exhibited at the Salon des Artistes Français from 1910. He specialises in bas-reliefs and figures, mainly of religious subjects.

DUCOMMUN DU LOCLE, David Henri Joseph (known as Daniel) 1804-1884
Born at Nantes in 1804, he died in Rethel on September 19, 1884. He studied under Bosio and Cortot and exhibited at the Salon from 1839 to 1846, winning numerous medals and becoming a Chevalier of the Legion of Honour. He abandoned his artistic career about 1865. His sculpture consists mostly of allegorical and neo-classical figures, such as Music (Louvre) and Cleopatra (Tuileries).

DUCOUDRAY, Marie fl. late 19th century
Born at Romorantin in the second half of the 19th century, she studied under Franceschi and Astruc and exhibited at the Salon des Artistes Français in the 1890s. She produced portrait busts and genre figures and won honourable mentions in 1898 and at the Exposition Universelle of 1900.

DUCRETET, André fl. 20th century
He worked as a portrait sculptor in the inter-war years, and exhibited heads and busts at the Salon des Artistes Français in 1932-34.

DUCROS, Jacques fl. 19th century
Born at St. Germain-Laval on January 12, 1845, he studied under A. Dumont and specialised in busts, heads and portrait reliefs. He exhibited at the Salon of 1870.

DUCROT-ICARD, Francine fl. 19th century
Born at Pont de Vaux, she studied under Levasseur, Valton and Bouches and worked as a sculptor of figures and portraits in the 1890s. She got a third class medal at the Salon des Artistes Français in 1894 and an honourable mention at the Exposition of 1900.

DUCUING, Charles fl. 20th century
Born at Bordeaux he exhibited statuettes at the Salon des Artistes Français in the 1930s.

DUCUING, Paul fl. 19th-20th centuries
Born at Lannemezan on March 1, 1868, he studied under Falguière and Mercié and exhibited figures and groups at the Salon des Artistes Français from 1888 to the 1920s, winning medals from 1898 to 1906. In the latter year he became a Chevalier of the Legion of Honour and was raised to the grade of Officier in 1923. He also sculpted a number of public statuary, monuments and war memorials.

DUCZYNSKA, Irma von fl. early 20th century
Born in Lemberg (now Lwow) in Galicia, she was the niece of the designer Eduard von Duczynski and studied in Vienna under H. Lefler and F. Andri. She exhibited paintings, watercolours and genre bronzes at Vienna from 1901 onwards and later exhibited in Munich, Dresden, Cracow and Paris. She had a one-man show in Vienna in 1909. Her bronze figure Little Brother was widely acclaimed in Venice (1907) and Paris (1908).

DUDENEY, Wilfred 1911-
Born in Leicester on September 30, 1911, he studied at the Central School of Arts and Crafts under Alfred Turner (1928-33) and has since exhibited at the Royal Academy, the Royal Hibernian Academy and leading provincial galleries. He became F.R.B.S. in 1952 and was Vice-President of the Royal Society of British Sculptors in 1971. He works in London as a sculptor of portraits, bas-reliefs, figures and groups.

DUDLEY, Colin Joseph 1923-
Born at Greenwich on April 13, 1923, he studied at Sidcup School of Art and the Goldsmiths' College School of Art. He has exhibited paintings and sculpture at the Royal Academy and leading London and provincial galleries.

DUFAUR, Marguerite fl. 19th century
She worked in the Bourges district in the late 19th century as a sculptor of busts and genre figures.

DUFAUX, Frédéric the Elder 1820-1871
Born in Geneva in 1820, he died there in 1871. He specialised in portrait busts of contemporary Swiss personalities.

DUFAUX, Frédéric the Younger fl. late 19th century
Born in Geneva on July 12, 1852, the son and pupil of Frédéric Dufaux the elder. He studied at the Geneva School of Art and later in Florence and Paris. He is better known as a landscape painter, but he also sculpted bronze portrait busts.

DUFOIX, Henri Celestin Alexandre fl. 20th century
Born at Ville aux Clercs in the early years of this century, he specialised in portrait busts which he has exhibited at the Salon des Artistes Français since 1929.

DUFOSSEZ, Eugène Clément fl. early 20th century
Born in Thuin, Belgium in the late 19th century, he worked as a portrait sculptor. He exhibited busts of children at the Brussels Exhibition of 1910 and the Salon des Artistes Français, winning a gold medal in 1923.

DUFOUR, Richard Gaston fl. 20th century
Born at Ardentes in the late 19th century, he worked in France in the 1920s as a sculptor of portrait busts, genre statuettes and masks. He exhibited at the Salon des Artistes Français and the Salon d'Automne.

DUFRAINE, Charles 1827-1900
Born at St. Germain du Plain in 1827, he died in Lyons in 1900. He studied under Bonnet and collaborated with him in the sculpture of the fountain in the Place Louis XIV in Lyons. He specialised in ecclesiastical decorative sculpture and his statues and bas-reliefs may be seen in the churches of Lyons, Bourg, Ars and Courson. He also produced a number of portrait busts of his contemporaries.

DUFRASNE, Gabriel fl. 19th-20th centuries
He worked in Paris at the turn of the century, producing genre and allegorical statuettes and small groups.

DUFRÈNE, Léon fl. 19th-20th centuries
Born in Paris, he was killed in the first world war. He studied under Barrias and Desca and exhibited figures and portraits at the Salon des Artistes Français, winning a third class medal in 1909.

DUFRESNE, Alexandre Henry fl. 19th century
Born in Paris on April 2, 1820, he studied under Paul Delaroche and Drolling. He exhibited at the Salon from 1855 to 1861, winning a third class medal in the latter year. He became a member of the Higher Council for Special Secondary Education in 1876. His sculptural work consisted of bas-reliefs and *repoussé* silver plaques and medallions.

DUFRESNE, Jacques Pierre 1922-
Born in Paris on October 25, 1922, the son and pupil of the painter Charles Dufresne. He studied at the École des Beaux Arts and worked in the studios of Wlerick and Laurens. He concentrated at first on modelling, but after 1946 turned to abstract sculpture in wire but later returned to the sculpture of the human figure, sometimes carved direct in stone but more usually cast in bronze and other metals. He has exhibited regularly at the Tuileries since 1943 and since the war has participated in the Salon de Mai and the Salon de la Jeune Sculpture.

DUGUET, Simon fl. 18th century
Born in Paris in the early 18th century, he died in Turin in 1795. He worked at Turin with F. Ladatte and succeeded him as Sculptor to the King of Piedmont. He produced decorative bronzes and portraits.

DUJARDIN, Auguste fl. 19th century
Born in Paris on June 4, 1847, he studied under Dumont and went to Rome in 1867. He produced a large number of plaques, bas-reliefs and roundels in marble and bronze.

DULAC, Adolphe Édouard fl. late 19th century
Born in Paris, he studied under Levasseur and exhibited portrait medallions, bas-reliefs and busts at the Salon from 1877 to the end of the century.

DULAC, Jean fl. 20th century
Born at Bourgoin, he studied under Landowski and exhibited portrait busts and reliefs at the Salon des Artistes Français and the Salon d'Automne from 1930 onwards.

DULAU, Jacques Victor fl. 20th century
Born at Dax in the early years of this century, he specialised in portrait busts and bas-reliefs of animal subjects, such as his Renards, showing a family of foxes. He exhibited at the Salon d'Automne in 1941-4.

DULER, Eugène Henry fl. 20th century
Born at Boucau where he worked in the inter-war period as a sculptor of busts and statuettes of genre and neo-classical subjects.

DULL, Alois 1843-1900
Born in Vienna on June 28, 1843, he died there on March 12, 1900. He studied at the Vienna Academy of Arts and was a pupil of Franz Bauer and Karl Kundmann in Vienna and then Hähnel in Dresden. He spent two years working in Italy and on his return to Vienna became professor in various departments of the Academy. He specialised in monuments and statues for public buildings and parks in the Vienna area and these were mainly classical in inspiration. He also sculpted numerous busts of his contemporaries. His classical and allegorical groups and statuettes include Drunken Faun, Pieta, Pan and a Bacchante, The Lost Son, Rebecca and other biblical figures. His bronze statuette of Mozart was shown at the Jubilee Exhibition of the Vienna Kunstlerhaus, 1888.

DULL, Heinrich 1867-
Born in Munich on September 19, 1867, he studied under A.H. Hess and B. Romeis at the Professional School of Arts in Munich, and under Eberle and Friedrich Thiersch at the Academy of Munich. Later he worked with Georg Pezold and collaborated with him in the sculpture of many monuments and statues in the Munich area. He also worked with Max Heilmaier on a colossal monument to Peace (Prinz Luitpold Terrasse). On his own account he produced numerous ornamental figures and groups for fountains and parks, both allegorical and genre subjects.

DUMAIGE, Étienne Henry 1830-1888
Born in Paris on March 30, 1830, he died at St. Gilles-Croix de Vie in 1888. He studied under Feuchère and exhibited at the Salon from 1862 to 1877. He produced a large number of busts, groups and statues in marble, plaster and bronze. His minor works include the statuettes of Camille Desmoulins and Rabelais.

DUMANDRÉ, Joaquin fl. 19th century
He was the son and pupil of the stone mason and monumental sculptor Antonio Dumandré. He worked in Madrid and Aranjuez as a sculptor of ornaments and bas-reliefs. He is best known for his decorative sculpture in Segovia Cathedral.

DUMAS, Félix fl. 20th century
Born in Lyons in the late 19th century he exhibited figures and portraits at the Salon des Artistes Français in the early 1900s.

DUMAS-MARY fl. 20th century
Female statuettes bearing this signature were produced by a sculptor of Polish or Lithuanian origin who worked in Czechoslovakia in the 1920s.

DUMILATRE, Jean Alphonse Edmé Achille fl. 19th century
Born in Bordeaux on April 22, 1844, he studied under Dumont and

Cavelier and was a runner-up in the Prix de Rome of 1867. He exhibited at the Salon from 1866 to 1878 and won a first class medal in 1878. He sculpted allegorical statues and groups, genre figures and portrait busts, in marble and bronze.

DUMONT, Aimé Gaston fl. 20th century
Born at Beaumont-en-Argonne, he studied under Coutan, Peter and Carli and won a travelling scholarship (the Chenavard and Roux prizes) in 1930. He exhibited genre figures and groups at the Salon des Artistes Français and won a third class medal in 1926. He also won a silver medal at the Exposition Internationale of 1937. A number of his genre works are in the Pantin Museum.

DUMONT, Augustin Alexandre 1801-1884
Born in Paris on August 4, 1801, he died there in February 1884. He belonged to a very distinguished artistic family and studied under his father Jacques Edmé Dumont and Cartellier. He was runner-up in the Prix de Rome in 1821 and won the prize two years later. He exhibited at the Salon, winning a first class medal in 1831 and the Legion of Honour five years later. He was made a member of the Institut in 1838 and a professor at the École in 1852. He was awarded the Grande Medaille d'Honneur at the Exposition Universelle of 1855 and rose to the rank of Commandeur (1870). He was a very prolific sculptor and had a profound influence on French sculpture in the second half of the 19th century. He sculpted numerous monuments and statues in marble and stone and many of these were also edited as bronze reductions. His larger bronzes included the colossal statue of Napoleon as Caesar, on the column of the Grand Armée in the Place Vendôme (1863) and the monument to Marshal Davout in Auxerre (1867). His minor works include a number of portrait busts and allegorical and genre figures such as Love tormenting the Spirit, Young Roman Woman at her Toilet, Eros and a Butterfly, France, Peace and War (Semur), the Infant Bacchus taught by the Nymph Leucothe, Prudence, Truth, the Muse of Harmony, Architecture and Sculpture.
Vattier, G. *Une Famille d'Artistes* (1890).

DUMONT, Charles fl. early 20th century
Born at Daville-lès-Rouen in the late 19th century, he exhibited figures and reliefs at the Salon des Artistes Français from 1912 to 1926.

DUMONT, Daniel fl. 20th century
Born at L'Isle Adam, he worked in Paris in the 1930s as a sculptor of statuettes.

DUMONT, Edmé 1722-1775
Born in Paris in 1720 or 1722, he died there on November 10, 1775. He was a pupil and assistant to Bouchardon and was admitted to the Academy in 1752, becoming an Academician in 1768. He exhibited at the Salon from 1753 to 1771. He worked mainly in marble and sculpted the decorative façades of the Sèvres porcelain factory and the Hôtel de la Monnaie (Mint) in Paris. Many of his classical figures and groups, such as Milo of Croton, and the Sleeping Endymion were later cast as bronze reductions.

DUMONT, Gaston Aimé - see **DUMONT, Aimé Gaston**

DUMONT, Jacques Edmé 1761-1844
Born in Paris on April 10, 1761, he died there on February 21, 1844. The son of Edmé Dumont, he studied under Pajou and was runner-up in the Prix de Rome in 1783, winning the prize five years later with his Death of Tarquin. He exhibited at the Salon from 1791 to 1824 and won a third class medal in 1795. He produced numerous busts of his contemporaries, including many of the Revolutionary personalities such as Mirabeau, allegorical figures, groups and bas-reliefs, such as Liberty presenting the Rights of Man, and genre figures of women.

DUMONT, Jacques Philippe 1745-1821
Born at Valenciennes on August 14, 1745, he died in Paris in 1821. He studied under Duret and Clodion and was Sculpteur Ordinaire to the Duke of Orléans. He produced numerous busts and statues in marble and bronze and did the decorative sculpture on the stables of the Carrousel. Among his minor works are the bronze statuettes of Voltaire and Rousseau and classical groups such as Pericles and Aspasia, Julia the daughter of Augustus Caesar and the Pilot of King Melas.

DUMONTET, Madame Gabriel fl. late 19th century
Born at Bourg-sur-Gironde, she studied under Jules Franceschi and Alfred Boucher and exhibited statuettes at the Salon des Artistes Français in the 1890s.

DUMOUCHEL, Louis fl. 20th century
He worked as a sculptor of animal figures and groups and exhibited at the Salon des Tuileries in 1932-33.

DUMOULIN, Léonce fl. early 20th century
Born in Limoges in the late 19th century, he studied under Verlet and exhibited figures at the Salon des Artistes Français in the early 1900s.

DUMOUTET, Jules fl. 19th century
Born at Bourges in the early 19th century, he studied under Dantan the Elder and exhibited at the Salon from 1841 to 1857. His best known work is the Christ on the Cross in Bourges Cathedral. He produced numerous portrait medallions, busts (including that of the famous preacher, Bourdaloue), statuettes of prominent contemporaries and figures and groups of religious subjects, such as Seated Virgin and The Daughter of Jephtha.

DUNAISZKY, Laszlo 1822-1904
Born in Budapest in 1822, he died there in 1904. He was the son and pupil of Lorincz Dunaiszky and later studied in Munich under Schwanthaler and also in Vienna. He sculpted numerous portrait busts of his contemporaries in the world of the art and politics, such as Vörösmarty, Liszt, Erkel and Holly, Petöfi, Jokai, Deak and Szechenyi. He also produced a number of classical and biblical groups, such as Nessus and Dejaneira or Samson and Delilah.

DUNAISZKY, Lorincz 1784-1833
Born at Litbetbanya, Hungary in 1784, he died in Budapest on February 5, 1833. He studied at the Vienna Academy form 1804.to 1809 and was a pupil of F. Zanner and J.M. Fischer. He settled in Budapest and worked as a sculptor and wood-carver. Many of his works were in the rigid classical convention of the period and were intended as ornament to the churches of Budapest. He also did a number of bas-reliefs for monuments and memorials, and several busts in the Gallery of Historic Portraits in Budapest.

DUNAND. Jean 1877-
Born at Lancy near Geneva on May 20, 1877. He studied at the Professional School of Arts, Geneva and was a pupil of Jean Dampt in Paris. He was equally proficient as a jeweller and silversmith and specialised in small decorative works, such as statuettes and vases with relief ornament. His works are preserved in the Museum of Modern Art and the Museum of Decorative Arts (Paris) and the museums of Geneva, Lausanne and Zürich.

DUNBAR, David the Younger fl. 19th century
Son of the stone-mason and monumental sculptor known as David Dunbar the Elder, he was born in Scotland at the beginning of the 19th century and died in Dumfries in 1866. He studied in Rome and subsequently worked for Chantrey. Later he went to Newcastle, but returned to London about 1840. He exhibited a statue of Robert Burns in Westminster Hall (1844) of which the *Literary Gazette* commented that 'it would have been very pleasing had the execution been equal to the intention'. He was chiefly known for his carving in wood and stone, but he also made numerous bas-reliefs, medallions and busts, notably those of the lifeboat heroine Grace Darling and her father William, a number of replicas of them being cast in bronze. He exhibited at the Royal Academy from 1841 to 1848 and also in 1859 and at the British Institution in 1844

DUNBAR, Ulric S.J. 1862-
Born in London, Ontario on January 31, 1862, he worked in Toronto and Washington, D.C. He is best known for his bronze statue of Governor Alexander R. Shepherd in Washington Town Hall and his busts of Hendricks and Martin Van Buren in the Senate. His portrait busts, heads and statuettes are preserved in the Corcoran Gallery, Washington, the Union Club, New York and the St. Louis Museum.

DUNIKOWSKI, Xawery 1875-1964
Born in Cracow in 1875, he died there in 1964. He studied in Cracow and Warsaw under A. Daun and K. Laszczka and won a scholarship which took him to Rome. On his return to Poland he became professor of sculpture at the Warsaw School of Art. On his retirement he returned to his native city and spent the last years of his life there, sculpting monuments and obtaining many important State commissions. He was President of the Polish Artists Group 'Sztuka' and the Society of Sculptors 'Rzezba'. His works include the huge symbolic group Jesus who blesses and Humanity which suffers and prays (1911) for the doorway of the Jesuit Church in Cracow. Among his more recent works the best known is the colossal stone monument to the Silesian Insurrectionists, erected on the St. Anne Mountain. His minor works include numerous portrait busts of his artistic contemporaries, such as the painter Szczyglinski, the writer Korczak and the actor Kaminski, genre busts and statuettes such as Worker and Foundryman, modernistic allegories such as Breath, and the remarkable series of self-portraits known as the Wawel Heads.

DUPARC, Antoine fl. 19th century
Born in Marseilles, where he worked in the first half of the 19th century as a decorative sculptor, specialising in tombs and memorials. His best known work was the mausoleum of the Marquis de Villeneuve in the Church of the Madeleine at Aix. His other works include bas-reliefs, busts and allegorical figures.

DUPARCQ, René André 1897-
Born at Valenciennes on October 28, 1897, he studied under J. Boucher and exhibited genre and historical statuettes at the Salon des Artistes Français, winning several medals between 1928 and 1935. He received a first class medal at the Exposition Internationale of 1937.

DUPATY, Louis Marie Charles Henri Mercier 1771-1825
Born in Bordeaux on September 29, 1771, he died in Paris on November 12, 1825. He trained as a lawyer but turned to art and practised as a painter and sculptor. Initially he concentrated on landscapes and historical subjects under the direction of Valenciennes, but gradually he changed direction and devoted his career to sculpture, with much success. He won the Prix de Rome in 1799, but the political upheavals of the period prevented him from visiting Italy till 1803. He worked in Rome till 1811. He exhibited at the Salon from 1793 to 1822, became a member of the Institut in 1816 and a professor at the École des Beaux Arts in 1823. He was made a Chevalier of the Legion of Honour in 1814 and an Officier five years later. He eventually became Deputy Curator of the Musée du Luxembourg. His works include numerous statues of classical and allegorical subjects carved direct in marble, but often copied or edited as bronze reductions. He also produced a great many portrait busts of contemporary figures modelled in the classical manner so fashionable during the Napoleonic era. Dupaty is regarded as the last great exponent of the French classical school of sculpture. His last works were completed posthumously by Cortot.

DUPON, Jozuë 1864-
Born at Ichteghem in Belgium, he studied under Vinçotte and also at the Antwerp Academy. He worked as a sculptor in bronze and ivory in Antwerp at the turn of the century and his works in this genre include Vulture swooping on its Prey and a statuette of Antony Van Dyck (Antwerp Museum) and The First Hunter (Simu Museum, Bucharest).

DUPONCHEL, fl. 19th century
This name appears on a bronze bust of General Lahure in the Douai Museum.

DUPONT, Raymond Pierre fl. 20th century
Born at Brebières in the early years of this century, he studied under H. Blaise and specialised in busts and heads which he exhibited at the Salon des Artistes Français in 1934-35.

DUPONT-GAGNEUR, J.L.J. fl. early 20th century
He sculpted figures and busts and worked in Paris up to the first world war.

DUPORT et fils fl. 19th century
Two sculptors working at the Château de Meudon in the early years of the 19th century who sculpted classical figures and groups, such as Telemachus and Mentor.

DUPRÉ Amalia fl. 19th century
Born in Florence in 1845, she was the daughter and pupil of Giovanni Dupré with whom she collaborated in producing religious figures and groups.

DUPRÉ, Georges fl. early 20th century
Born at St. Étienne in the late 19th century, he studied under Roty and Thomas and exhibited at the Salon des Artistes Français at the turn of the century. He won the Prix de Rome in 1896 and various medals between 1893 and 1904 for his bas-reliefs, medallions and plaques.

DUPRÉ, Giovanni 1817-1882
Born of French parents at Siena on March 1, 1817, he died in Italy in 1882. He was one of the most interesting and original of the Tuscan sculptors of the 19th century and was noted for his ecclesiastical figures and groups, of which the best known are Pietà and Triumph of the Cross. Among his secular works was the Cavour memorial in Turin (1873) and a number of portraits and bas-reliefs. He was an Associate Member of the French Institut and took part in the Expositions Universelles of 1855 and 1867, winning a first class medal and the Legion of Honour respectively.

DUPREY, Jean Pierre 1930-1959
Born in Rouen in 1930, he commited suicide in Paris on October 2, 1959. Although he had literary aspirations, and contributed to the Surrealist writings of André Breton, he soon turned to sculpture. It was during this first period (1948-53) that his work in bronze was chiefly done and consisted of figures executed in a frankly extravagant style. Later he switched to painting but returned to sculpture in 1957, working mainly in wrought iron and painted concrete. The Surrealism of his early works gave way to a more restrained style inspired by Celtic, Roman and Gothic art and mythology. He took part in various Paris exhibitions in the early 1950s and had a one-man show at the Galerie Furstemberg in 1956.

DUPUIS, Daniel Jean Baptiste 1849-1899
Born at Blois on February 15, 1849, he died in Paris in 1899. He studied at the École des Beaux Arts and became a painter, but later turned to sculpture. He won the Prix de Rome for a series of medals, and this continued to be his speciality. The Museum of Blois preserves a large collection of his medallions, plaques and bas-reliefs. He also sculpted a number of genre and religious groups, such as Lullaby and Samson breaking his Bonds. His neurasthenic wife is thought to have killed him in her sleep and then committed suicide in a fit of remorse.

DUPUIS, Félix fl. 19th century
Born at Châlons-sur-Marne at the beginning of the 19th century, he worked in that town from 1838 to 1858 and did the renovation and restoration of the friezes, bas-reliefs and statuary in the Church of Notre Dame.

DUPUIS, Louis François Joseph fl. 19th century
Born at Lixhe near Liège in 1842, he studied at the Antwerp Academy and specialised in portraits. The Antwerp Museum has his bust of J.J. de Caju.

DUPUIS, Toon 1877-
Born in Antwerp, the son and pupil of L.F.J. Dupuis. He also studied at the Antwerp Academy and later worked in The Hague. He exhibited in Brussels in 1910. Like his father he specialised in portrait reliefs and busts.

DUPUY, Alexandre Édouard fl. 19th century
Born in Tours in the mid-19th century, he studied under Toussaint and exhibited at the Salon from 1874. He specialised in genre and historical statuettes, notably a series depicting the Kings of France.

DUPUY, Laurence fl. early 20th century
Born at Nimes in the late 19th century, she worked in that town at the turn of the century and became a *Sociétaire* of the Artistes Français. She sculpted portraits and genre figures.

DUQUE Y DUQUE, Eugenio fl. 19th century
Regarded as one of the most accomplished Spanish sculptors of the 19th century, he studied under Piquer and exhibited in Madrid from 1860 to the end of the century. He produced a wide range of sculpture, from heads, busts and portrait reliefs to genre and religious figures and groups.

DURAN, Jeanne M. fl. early 20th century
Born in Toulouse in the late 19th century, she exhibited figures and groups at the Salon des Artistes Français in the period up to the first world war.

DURAND, Amédée Pierre 1789-1873
Born in Paris in 1789, he died there in September 1873. He studied at the École des Beaux Arts and won the Prix de Rome in 1810 for his medallions and sculpture. In Italy he sculpted portrait busts of the Murat family and was influenced by Ingres. In 1816 he came to England and worked in London for a time on medallions and plaques. He exhibited at the Salon from 1817 and is best known for his series of medals showing scenes from the life of Napoleon.

DURAND, Georges Alexandre 1881-
Born in Montpellier on February 11, 1881, he studied under Bausson and Mercié and exhibited heads, busts and genre figures at the Salon des Artistes Français. The Montpellier Museum has his head of a young girl and the figure Shepherd of Arcadia.

DURAND, Jean Aimé Roger 1914-
Born in Bordeaux on June 23, 1914, he studied at Bordeaux School of Fine Arts and worked in that town for ten years before going to Paris. Later he worked for a time in Morocco and settled in Algeria in 1938, turning thereafter to painting. His busts, figures and groups illustrating North African life are in the Museums of Oran and Algiers.

DURAND, Joanny 1886-
Born at Boën-sur-Lignon on July 23, 1886, she studied under Injalbert, Dampt and Mariston and exhibited genre figurines at the Salon des Artistes Français and the Salon des Humoristes.

DURAND, Ludovic Eugène 1832-1905
Born at St. Brieuc on February 11, 1832, he died at Courbevoie in October, 1905. He enrolled at the École in 1848 and studied under Toussaint. He exhibited at the Salon from 1855 to 1879, winning a second class medal in 1872 and a first class medal two years later. He produced numerous busts and allegorical groups, such as Weeping, The Spring Mercury and Exile, in marble and bronze.

DURAND, Victor Henri fl. 20th century
Born in Paris, he studied at Boulle School of Art and specialised in medallions and plaques which he exhibited at the Salon des Artistes Français in 1921-24.

DURANT, Susan 1820-1873
Born about 1820, she died in Paris on January 1, 1873. She studied sculpture in Paris and was a pupil of Baron de Triqueti. She later worked in London and Paris and exhibited at the Royal Academy and the Salon from 1847 to 1873. She was one of Queen Victoria's favourite sculptors and executed many busts and medallions of the royal family, and even had Princess Louise as a pupil. In 1856-57 she worked with Baron de Triqueti on a monument to Leopold, King of the Belgians. At the Great Exhibition of 1851 she showed two figures The Chief Mourner and Belisarius. Her statuette of Robin Hood was shown at the Art Treasures Exhibition in Manchester (1857) and The Faithful Shepherdess at the Mansion House (1863). Among her other genre works were Negligent Watch-boy of the Vineyard catching Locusts (1858) and a figure of Ruth (1869). Her numerous portrait busts included self-portraits and those of Miss Allwood (1847) Daniel Harvey (1851), Harriet Beecher Stowe (1857), Lady Killeen (1858) and Triqueti (1864).

DURANTE, Giuseppe fl. 18th-19th centuries
He worked in Sicily on decorative sculpture and executed the friezes and bas-reliefs for Messina Cathedral in 1801.

DURAS, Marie fl. 20th century
Born in Vienna, she moved to Czechoslovakia after the first world war and specialised in portrait busts and female statuettes.

DURASSIER, Eugène fl. early 20th century
Born in France in the late 19th century, he studied under Vion and exhibited at the Salon des Artistes Français in the early years of this century. He specialised in figures of birds and allegorical bas-reliefs.

DUREL, Auguste Armand fl. 20th century
Born at Toulouse at the turn of the century, he studied under Vergeaud and exhibited statuettes at the Salon des Artistes Français in the 1920s.

DURET, Francisque Joseph 1804-1865
Born in Paris on October 19, 1804, he died there on May 26, 1865. He was the son and pupil of François Joseph Duret and enrolled at

the École des Beaux Arts in 1818 where he studied under Bosio. His group entitled The Grief of Evander over the Corpse of his Son won him the Grand Prix. He exhibited at the Salon from 1831 to 1863 and won a first class medal in 1831 and the Grand Medaille in 1855. He became a Chevalier of the Legion of Honour in 1833 and an Officier in 1853. He was elected to the Institut in 1845 and had numerous important state commissions. Most of his monuments and statuary were executed in stone and marble, but his bronzes include Paillet, ancient mace bearer of the Order of Advocates (Soissons), Venus bathing (Champs Elysées), two caryatids at the entrance to Napoleon's tomb, St. Michael for the fountain in the Place St. Michel, and numerous genre statuettes illustrating Neapolitan life, such as Young Fisherman, Old Man playing the Guitar, Neapolitan improvising at the Vine-gathering, Neapolitan Boy dancing the Tarantella, The Lute Player, Fisher-folk Dancing and Mercury inventing the Lyre.

DURET, François Joseph 1732-1816
Born in Valenciennes in 1732, he died in Paris on August 7, 1816. He studied under Antoine Gilis and was a member of the Académie de St. Luc. He exhibited at the Salon from 1791 to 1812 and was Sculptor Ordinaire to the Comte de Provence. He was responsible for the sculptural decoration at national festivals in the reign of Louis XVI and held on to this position during the Republic and the Napoleonic era. His sculpture included wood carving for church interiors, stone carving on the façades of churches and public buildings and numerous busts and statues in the classical mould.

DÜRFFELOT, Johann Nicolaus fl. 19th century
He worked at Seebergen in the duchy of Saxe-Coburg-Gotha as a decorative sculptor in the early 19th century.

DURHAM, Joseph 1814-1877
Born in London, he was apprenticed to J. Francis and worked for a time in the studio of E.H. Baily. He exhibited at the Royal Academy from 1835 onwards and was a prolific sculptor, no fewer than 128 works being listed in the R.A. catalogues. He won a first prize in 1858 for a model of Britannia presiding over the Four Quarters of the Globe and this was later executed as a memorial to the Great Exhibition. He sculpted the statue of the Prince Consort (1863), eventually erected in front of the Albert Hall. The following year he sculpted the group entitled Santa Filomena which includes a portrait of Florence Nightingale. He sculpted a number of fountains and many statues, groups, busts and allegorical studies, mostly in stone and marble but frequently cast in bronze.

DURLET, Lodewijk Franciscus 1829-1871
Born in Antwerp on July 8, 1829, he died there on February 5, 1871. He studied at the Antwerp Academy and worked mainly as a wood carver. He was employed on the restoration of Antwerp Cathedral and sculpted numerous figures and ornaments of a religious nature.

DUROUSSEAU, Paul Léonard fl. early 20th century
He worked as a sculptor of figures and groups in Paris at the beginning of this century and was an Associate of the Nationale from 1907 onwards.

DÜRRICH, Hermann 1864-
Born in Stuttgart on January 13, 1864, he sculpted a large number of bas-reliefs, plaques and medallions of genre and historical subjects. He is best known for the many commemorative medals struck in Germany at the turn of the century marking such events as the marriage of Kaiser Wilhelm II (1898), the birth centenary of Wilhelm I (1897), Bismarck and the Millenary of Cassel (1913).

DURRIO, Francisco (known as Durrieu de Madron) 1875-1940
Born in Spain in 1875, he died in Paris in 1940. He spent his entire working life in Paris, though without losing contact with Spain, for which he executed numerous commissions. He was a close friend of Gauguin and Picasso and lived near the latter in the Rue Ravignan in Montparnasse. He specialised in vases and jardinières decorated in high relief. He also modelled hollow wares and figures for the Sèvres porcelain factory.

DURST, Alan Lydiat 1883-1970
Born at Alverstoke, Hampshire on June 27, 1883, he died in London on December 22, 1970. He was educated at Marlborough College and

in Switzerland and served as an officer in the Royal Marines. He resigned his commission in 1913 and enrolled at the Central School of Arts and Crafts, but returned to active service on the outbreak of war the following year and it was not until 1920 that he was able to resume his studies. Later he worked for a time at Chartres in France. He had his first one-man show at the Leicester Galleries in 1930 and exhibited regularly at the Royal Academy (A.R.A. 1953, F.R.B.S. 1949). He specialised in ecclesiastical decorative sculpture and worked mainly in stone, marble, ivory and wood.

DURST, Marius fl. 19th century
Born at Ternes near Paris on April 8, 1832, he studied under Rude and specialised in portrait busts carved direct in marble or modelled in plaster and terra cotta as well as bronze. He exhibited at the Salon from 1857 to 1880.

DURVIS, Marie fl. late 19th century
Born in Paris, she sculpted portraits and figures. She got an honourable mention at the Salon des Artistes Français in 1882.

DUSCHEK, Leopold 1876-
Born at Alt-Weitra in Austria, he studied under Karl Waschmann of Vienna in whose studio he was subsequently employed as a carver and modeller.

DUSEIGNEUR, Jean Bernard (known as Jehan) 1808-1866
Born in Paris on June 23, 1808, he died there on March 6, 1866. He exhibited at the Salon from 1831 to 1866 and got a second class medal in 1834. He worked mainly in plaster, either plain or with a metallic finish, but a number of his works were subsequently cast in bronze. He also sculpted several stone statues for public buildings in Paris. Typical of his works are Orlando Furioso (bronzed plaster) and A Tear for a Drop of Water (gilt plaster). He also produced more than 80 portrait medallions and numerous busts. The Versailles Museum has many of his sculptures.

DUSEK, Jean V. fl. 20th century
Born at Tabor in Czechoslovakia at the turn of the century, he studied in Prague and Paris and worked in Czechoslovakia. He specialised in busts, plaques and medallions mainly of contemporary Czech personalities. He exhibited at the Salon de la Société Nationale des Beaux Arts from 1929 to the outbreak of the second world war.

DUSOLD, Joseph fl. late 18th century
Born at Rattelsdorf near Bamberg in 1750, he studied at the academies of Vienna and Paris and worked in the studio of Karl Wurzer in Bamberg. He worked as a decorative sculptor on friezes, bas-reliefs and small ornaments, such as his tour de force 'a pretty group of flowers from nature' for the Prince-Bishop F.L. von Erthal.

DUSOUCHET, Pierre Léon 1876-
Born at Versailles on April 25, 1876, he studied at the School of Decorative Arts and worked as a painter and sculptor. Though best known for his frescoes he also produced decorative sculpture and often combined painting and sculpture in such works as Top of a Door (1912). He exhibited at the Salon d'Automne and the Indépendants and became an Officier of the Academy.

DUSS, Roland fl. 20th century
Born at Entlebuch near Lucerne in the early years of this century, he exhibited figures and reliefs at the Salon d'Automne in the 1930s.

DUTHEIL, Georges Denys 1888-
Born in Paris on May 24, 1888, he studied at the École des Beaux Arts and exhibited at the Nationale, later becoming a member of the jury, and also at the Salon d'Automne and the Indépendants. He travelled in French Equatorial Africa and produced paintings and sculpture of native types. He also sculpted the figure The Spirit as a monument to his mother in St. Ouen cemetry.
See Duthoit Family Tree.

DUTHOIT, Aimé 1805-1869
Son of Louis Joseph Duthoit, he worked in Amiens and died there in March 1869. He specialised in bronze portrait busts and reliefs. His bust of Auguste Leprince was exhibited at the Salon of 1857.

DUTHOIT, Alcide fl. 19th century
Second son of Louis Joseph Duthoit, he worked in Amiens in the mid-19th century and sculpted busts and bas-reliefs in plaster and bronze. He exhibited at the Salon from 1833 to 1835.

DUTHOIT, Florence fl. 19th century
She exhibited portrait sculpture at the Salon in 1848. Her relationship, if any, with the Duthoit family of sculptures has not been ascertained but she may have been the wife of one of the third generation sculptors.

DUTHOIT, Jean Baptiste 1811-1883
Born at Toulon on August 10, 1811, he died there on December 11, 1883. He was the third son of Marcelin Duthoit with whom he worked and whose sculptures he completed after his death. He was employed on the decoration of warships at the naval base from 1853 to 1862 and sculpted the ornaments for no fewer than 68 ships of the line. He also sculpted the great altar in the parish church of St. Louis in Toulon.

DUTHOIT, Louis 1807-1874
Born at Amiens in 1807, he died there in 1874. He was the youngest son of Louis Joseph Duthoit and worked with his elder brother Aimé on ecclesiastical decoration. He sculpted friezes, bas-reliefs and figures of saints for Amiens Cathedral and St. Vulfram's Church in Abbeville.

DUTHOIT, Louis Joseph 1766-1824
Born in Lille on December 7, 1766, he died at Amiens on November 12, 1824. He was the son of Jacques François Duthoit, an ecclesiastical wood and stone-carver of Tournai. He worked at Amiens, mainly on church restoration and ecclesiastical sculpture.

DUTHOIT, Marcelin François 1765-1845
Born in Marseilles in 1765, he died in Toulon on April 1, 1845. He was the eldest son of Jacques François Duthoit and spent his career in the naval dockyard at Toulon where he was put in charge of all sculpture intended for the French Navy in 1805.

DUTHOIT, Seraphin Joseph fl. 18th-19th centuries
Born in Lille about 1760, he worked with his elder brother Louis Joseph Duthoit.

DUTILLE, Yvonne fl. 20th century
Born at Vincennes in the late 19th century, she studied under Hannaux and exhibited statuettes and portraits at the Salon des Artistes Français in the 1920s.

DUTILLEUL, Marcelle fl. 20th century
Born in Paris at the turn of the century, she worked as a sculptor of animal figures and exhibited at the Salon des Artistes Français from 1926 onwards.

DUTRIEUX, Amable 1816-1886
Born at Tournai in 1816, he died there on April 13, 1886. He studied at Tournai Academy and was later a pupil of Geefs in Brussels, where he lived for many years before returning to Tournai. His works include the statues of Leopold I at Ixelles (1851), the Princess of Épinay (Tournai, 1863) and a figure of Justice for the Brussels Palais de Justice. Minor bronzes and terra cottas are in the museums of Brussels, Tournai and Namur.

DUTTO, Clementino 1874-1963
Born in Bordighera, Italy in 1874, he died in London in 1963. He studied in Turin and Genoa and went to Paris at the turn of the century, where he worked as a modeller for the silversmith Cartier. He moved to England in 1933 and set up a studio in London where he produced small decorative articles, objects of *vertu*, figurines, bas-reliefs and jewellery, in precious and base metals. He was one of the modern pioneers of sculptured jewellery. He was also a stage and cinema actor in the late 1930s, his best known role being that of King Henry VIII (1937). He continued to work as a character actor right up until his death in 1963. He joined Ernest Pobjoy in 1939 and worked as a designer and modeller till shortly before his death.

DUTY, Marcelle fl. 20th century
Born in Paris in the late 19th century, she exhibited statuettes at the Salon des Artistes Français in the 1920s.

DUVAL, Jean Louis fl. 18th-19th centuries
He studied under Boizot at the École des Beaux Arts and was runner-up in the Prix de Rome of 1797 with his group of Ulysses and Neoptelemus bringing to Philoctetus the Bow and Arrows of Hercules. He produced a number of classical and allegorical figures and groups in the early 19th century, mainly in marble or plaster but some cast in bronze.

DUVENECK, Frank fl. 19th century
Born at Covington, Kentucky on October 9, 1848, he studied in New York, Paris and Florence and worked in the last-named for several years before returning to the United States and settling in Cincinnati. He worked as a painter and engraver as well as a sculptor and sculpted statues, memorials and portraits.

DÜYFFCKE, Paul fl. 19th century
Born in Hamburg on December 17, 1846, he studied under Verlat in Weimar and made his début in Berlin in 1872. He worked as a painter of genre and historical subjects and sculpted a number of bronze portrait busts, including those of Brahms (Hamburg Gallery of Arts) and Amalbergis (Weimar).

DVORALZ fl. 20th century
With Sturza, Gutfreund, Landa and Kostki he belongs to the school of Czechoslovakian sculptors who developed immediately after the first world war and were profoundly influenced by Rodin in the later years of his career.

DYFVERMAN, Karl Johan 1844-1892
Born at Morlanda, Sweden on February 18, 1844, he died in Stockholm on January 10, 1892. He studied at Stockholm Academy and worked as a decorative sculptor. His best known work is the bronze doors for Lund Cathedral.

DYKAS, Thomas fl. late 19th century
Born at Gumniska in Galicia in 1850, he studied at the School of Fine Arts in Cracow and was also a pupil of von Zumbusch in Vienna. He travelled in Germany, Italy and France before settling in his native town. He won prizes in 1881 and 1885 for projects regarding a national monument to Mickiewicz. Later he moved to Lwow where he specialised in tombs, memorials and monumental statuary and did a series of marble sculptures for the Roman Catholic Cathedral and the Armenian Church. He sculpted the statues of Mickiewicz in Przemysl, Tarnopol and Zloczow in Galicia as well as a number of portrait reliefs and busts of his contemporaries.

DYLEFF, Peter Alexandrovich 1842-1886
He studied at the Academy of St. Petersburg and specialised in figures and groups of classical and historical personalities. He was awarded a gold medal at the St. Petersburg exhibition of 1868 for his Prometheus Enchained. Other works include the bas-relief of Alexander the Great and his physician Philip (1870) and a figure of Peter the Great (1871).

DZAMONJA, Dusan 1928-
Born in Strumica, Croatia in 1928 he studied at the Academy of Zagreb and worked for two years in the studio of Frano Krsinic and has exhibited in Zagreb, Belgrade, Milan, Venice, Zürich, Paris, Brussels, London and New York since 1954. His bronzes belong to the early part of his career and consist of torsos and figures. He abandoned more conventional sculpture in 1957 and has since produced abstracts using nails and charred wood. His earlier works are represented in many public collections including the Museum of Modern Art, New York, and the Guggenheim Collection in Venice.

DZANG, Tze-su fl. 20th century
Born at Chekiang, China, at the beginning of this century, she studied in Paris under Sicard and exhibited portrait busts at the Salon des Artistes Français in the 1930s.

DZENIS, Burkards 1879-
Born near Riga, Latvia in 1879, he studied at the School of Fine Arts in Stieglitz and later the Academy of St. Petersburg. He won a travelling scholarship in 1905 and after completing his studies in western Europe he returned to Riga. He eventually became director of the Latvian State Museum in Riga. He produced numerous monuments, statues, busts and portrait reliefs and his minor works were included in the exhibition of Baltic Art in Paris, 1939.

DZIELINSKA, Sophie fl. 20th century
Born at Toryczow, Poland in the early years of this century, she specialised in portrait reliefs and busts.

EAKINS, Thomas 1844-1916
Born in Philadelphia on July 25, 1844, he died there on June 25, 1916. He studied at the École des Beaux Arts under Gérome and Bonnat (painting) and Dumont (sculpture). On his return to the United States he settled in Philadelphia in 1870. He later became professor of anatomy at the Pennsylvania Academy of Fine Arts. Though much better known for his genre and sporting paintings, he also modelled figures and portrait busts. His best-known work in this medium was the group of heroic Prophets for the Witherspoon Building in Philadelphia.

EARLE, Thomas 1810-1876
Born at Hull in 1810, he died in London in 1876. He studied at the Royal Academy schools and exhibited at the Academy from 1834 to 1873. He won a gold medal for his Hercules delivering Hesione from the Sea Monster. He specialised in figures of classical and historic personalities, contemporary celebrities and Shakespearean heroines, such as Ophelia (1863) and Miranda (1865).

EARLE, Winthrop 1870-1902
Born at Yonkers, New York in 1870, he died in New York on March 2, 1902. He studied under Saint-Gaudens in New York and worked in Paris with Rodin and also at the Académie Colarossi. On his return to America he became a member of the Art Students' League. He produced portrait busts and figures.

EBBINGHAUS, Karl 1872-
Born in Hamburg in 1872, he worked for a time in Munich and then in Dresden (1904-6) and Weimar. He was largely self-taught, though influenced by the work of Hildebrand and Volkmann. He exhibited at the Munich Crystal Palace in 1901, 1905 and 1908 and specialised in portrait busts and figurines in bronze and silver. He also produced garden statuary of an allegorical nature, such as the Four Seasons and Imagination. At the Brussels Exhibition of 1910 he showed an equestrian statuette of a woman with a cornucopia. He exhibited portrait busts in Berlin (1912).

EBERBACH, Walther fl. late 19th century
Born at Besigheim, Württemberg on January 1, 1866, he trained as a sculptor in Gmund and Stuttgart and finished his studies in Cologne, London, Berlin and Frankfurt. He settled in Strasbourg where he taught modelling. Later he became professor of sculpture at Heilbronn and specialised in monuments, memorials and portrait busts.

EBERHARD, Konrad 1768-1859
Born at Hindelang on November 25, 1768, he died in Munich on March 12, 1859. He was the son and pupil of Johann Richard Eberhard, a cabinet-maker, and later studied sculpture under Boos at Munich. He completed his studies in Rome and returned to Bavaria in 1806, becoming professor of sculpture at the Munich Academy in 1816. He was a prolific painter and his sculpture includes numerous public statues and monuments, with a strong classical bias. His minor works include The Muse and Love, Faun and Bacchus, Endymion, Leda and the Swan, Diana and Apollo as well as various portrait busts of his contemporaries. such as Wohlgemuth, Vischer and Höwart.

EBERHARD, Robert George 1884-
Born in Geneva on June 18, 1884, he studied under Mercié, Tony Noel, Carlier, Peter and Rodin in Paris and MacNeil at the Art Students' League in New York. He exhibited at the Salon des Artistes Français, the New Havana Paint and Clay Club and various galleries in the United States and became head of the sculpture department at Yale University. He specialised in genre statuettes, such as Over and plaquettes commemorating the first world war.

EBERHART, Serafin fl. 19th century
Born at Vendels, near Innsbruck, on December 6, 1844, he studied at the Vienna Academy and later was a pupil of J. Ritter von Gasser. He worked as a painter and sculptor and exhibited at Innsbruck from 1875 onwards, specialising in religious figures and groups. Later he went to Rome and Florence for a time before settling in Innsbruck. Apart from his biblical sculptures he also did numerous statuettes, busts, bas-reliefs and medallions.

EBERL, Sebastian 1711-1770
Born at Neumarkt, near Salzburg, in 1711, he died at Grosskestendorf in 1770. He specialised in ecclesiastical statuary and decoration.

EBERLE, Abastenia St. Leger 1878-
Born in Webster City, Iowa on April 6, 1878, she studied under George Gray Barnard and Gutzon Borglum at the Art Students' League. She worked in New York and was a member of the Women's Art Club. In her youth she lived in Puerto Rico and was influenced by the colourful native life of that island. Many of her later sculptures portrayed women and children of Puerto Rico at work and play in New York's East Side. At one time she also produced a number of statuettes of dancers and sculpted numerous portrait busts. Her genre sculptures include The Termagant, Playing Dolls, Rag Time, The Little Mother, The Stray Cat, Roller Skates and Staircase in the Wind. Her work is represented in many public collections, including the Chicago Art Institute and the New York Metropolitan Museum of Art.

EBERLE, Joseph 1839-1903
Born in Munich on February 13, 1839, he died in Uberlingen on June 7, 1903. He studied under von der Launitz in Frankfurt and Knabl at the Munich Academy and settled in Uberlingen on the shore of Lake Constance, where he specialised in ecclesiastical work. His figures and bas-reliefs are in many churches in Baden, Bavaria and Winterthur.

EBERLE, Syrius 1844-1903
Born Pfronten, Allgau in 1844, he died in Bozen (Bolzano) in 1903. He studied in Munich and became professor of sculpture there. He wielded considerable influence on the development of romantic sculpture in Germany in the late 19th century and executed many important works for Ludwig II of Bavaria. His minor works include statuettes, small groups, portraits and bas-reliefs.

EBERLEIN, Gustav Heinrich 1847-1926
Born at Spiekershausen on July 14, 1847, he died in Berlin on February 5, 1926. He studied at the Nuremberg School of Art and was a pupil of Blaser. He spent several years in Italy before settling in Berlin. In 1887 he became a member of the Berlin Academy of Fine Arts. He specialised in allegorical, genre and neo-classical figures. His genre and allegorical works include The Men of Peace in 1870-71, The Tragedy, Drawing a Thorn and Girl playing a Greek Flute. Among his classical groups may be mentioned Mercury and Psyche, Cupid bending his Bow, The Wounded Nymph. His biblical figures and groups include Cain, Abel, Eve beside the Corpse of Abel, Adam and Eve at the End of their Lives, Angels rolling away the Stone from the Tomb of Christ and The Ascension. In addition he sculpted numerous portrait busts and statuettes of German royalty and contemporary celebrities. His works are in various German museums and, in particular, the Eberlein Museum at Münden.

EBSTEIN, Joseph 1881-
Born at Batna in Algeria on May 12, 1881, he studied in Paris under Barrias and Coutan and exhibited figures and groups at the Salon des Artistes Français in the early years of this century. He became a Chevalier of the Legion of Honour in 1930.

ECHEANDIA Y GAL, Julio fl. 19th century
Born in Spain in the mid-19th century he sculpted historical and genre figures. He won a bronze medal at the Exposition Universelle in 1900.

ÉCHÉRAC, Auguste Arthur d' fl. 19th century

Born at Gueret in 1832, he exhibited at the Salon from 1870 to 1881 and specialised in portrait medallions and busts, the best known being his bronze bust of Michel Möring. He was also a prolific writer and art critic under the *nom de plume* of G. Dargenty.

ECHTELER, Josef 1853-1908

Born at Legau on January 5, 1853, he died in Mainz on December 23, 1908. He began as a cowherd but was later apprenticed to a sculptor of religious images. He became a pupil at the Stuttgart School of Fine Arts and studied under Widnmann and Knabl in Munich. He specialised in portrait busts, animal figures and groups inspired by classical mythology and the life and teachings of Christ. His best known work is the General Grant monument in the United States.

ECHTERMEIER, Carl Friedrich 1845-1910

Born in Cassel on October 27, 1845, he died at Brunswick on June 30, 1910. He was something of an infant prodigy who won a bursary from his home town to study sculpture in Dresden under Hähnel. Later became professor of modelling at Brunswick Technical High School. He is best known for his colossal statuary in marble, in Cassel and Brunswick, but he also produced a number of portrait busts and small allegorical groups and neo-classical figures such as Faun and Bacchante.

ECHTLER, Johann Peter 1741-1810

Born at Steingaden, Bavaria on August 21, 1741, he died in Berlin in 1810. He studied under Zimmermann at Lamberg an der Lech and won a high reputation for his ecclesiastical decoration. He worked mainly in stucco, marble and stone and specialised in the imitation of porphyry, marble and other hardstones. No bronzes have so far been noted.

ECKERT, Jacob 1847-1882

Born at Mainz on November 25, 1847, he died in Munich on February 23, 1882. He originally worked on furniture in Vienna and Furth, but then enrolled at the Munich Academy and later became assistant to Anton Hess at the School of Arts and Crafts in that city. He created models for fountains and all manner of useful domestic wares. At the other extreme, however, were his grandiose monuments in Kissingen and the elaborate bronze doors for Cologne Cathedral. Though highly individualistic in his style he had many elements of the Italian Renaissance in his work.

ECKHARDT, Johann Kaspar 1712-1778

Born in Darmstadt in 1712, he died in Vienna on April 17, 1778. He settled in Vienna in 1740 and studied at the Academy. His brother Johann Paul Eckhardt remained in Hesse and specialised in religious sculpture in the churches of Darmstadt and also bas-reliefs and statuary for the Dianaburg Castle. Five descendants of Johann Kaspar worked as decorative sculptors in Vienna:

Anton I – son of Johann Kaspar, born in Vienna in 1761.

Anton II – son of Lorenz, born in Vienna on December 20, 1783. He studied at the Vienna Academy from 1797 to 1806.

Friedrich – son of Anton II, born in Vienna about 1818 and studying at the Academy in 1834.

Johann – son of Anton I, born in Vienna in 1795. He also studied at the Academy and sculpted religious and genre works.

Lorenz – son of Johann Kaspar, born in Vienna in 1757 and died about 1822. He studied at the Academy and sculpted figures, groups and busts.

See Eckhardt Family Tree.

ECKHARDT, Rudolf Johann Christian 1842-1897

Born in Frankfurt am Main or February 2, 1842, he died there on December 9, 1897. He studied under Zwerger and Blaser and worked for many years in Berlin, where he sculpted the monuments to Frederick William III and Frederick William IV at Cologne and the Frederick William IV statue at Sans Souci, Potsdam. He produced numerous statues and monuments in Frankfurt and decorative sculpture for public buildings such as the Stock Exchange and the Opera, as well as many fountains and small ornamental works.

ECKSTEIN, Friedrich 1787-1832

Born in Berlin in 1787, he died in the United States in 1832. He was the son of the painter and lithographer Johannes Eckstein the elder and emigrated to the United States in the early years of the 19th century. He specialised in monuments, statues and portrait busts and sculpted the portrait of General Andrew Jackson at Cincinnati in 1820.

ECKSTEIN, Johannes the Younger fl. 18th-19th centuries

Born at Potsdam in the mid-18th century, he was the son of Johannes Eckstein the Elder. He studied at the Berlin Academy in 1786 and executed an equestrian figure of Frederick the Great dressed as a Roman emperor. He specialised in neo-classical figures and groups in terra cotta and bronze. With his younger brother Friedrich he emigrated to America and was thereafter known as John Eckstein. He worked mainly as an engraver and illustrator but was involved in a project for a statue of George Washington in 1806.

EDEIKIN, Ephraim fl. 20th century

Born in Riga, Latvia at the turn of the century, he specialised in portrait busts of European celebrities and exhibited his work in Riga, Berlin and Paris in the inter-war period.

EDELE, Benedikt fl. 19th century

Born in Germany, he died at Brunn (Brno) in 1867. He studied under J.E. Ruhl at Cassel, and moved to Moravia in 1821 where he worked as a wood-carver and sculptor of ecclesiastical ornament.

EDOUARDS, Boris Vasilievich 1861-

Born at Odessa in 1861, of English origin, he studied at St. Petersburg Academy. He exhibited at the Academy from 1888 onwards and specialised in allegorical groups such as The Glory of God in the Heavens (Leningrad Museum) and portrait busts of contemporary celebrities, such as Louis Pasteur and Madame Rubinstein, mother of the composer.

EDSTROM, David 1873-

Born at Smaland in Sweden, on March 27, 1873, he wandered round America for some years before returning to Sweden and studying art at the Stockholm Academy. Later he completed his studies in Paris, London and Florence. He specialised in rather grotesque subjects, such as his figure of Caliban (Göteborg), Head of a Man (Stockholm) and The Hunchback (Thiel Gallery).

EDWARDES, Clara fl. 20th century

Born in London at the turn of the century, she studied in London and Paris and exhibited at the Royal Academy and the Salon des Artistes Français in the 1920s. She specialised in portrait busts and reliefs and also did portrait painting.

EDWARDS, Arthur Sherwood 1887-

Born in Leicester on February 7, 1887, he exhibited painting and sculpture at the Royal Academy and leading London and provincial galleries and worked at Ashton-on-Mersey, Cheshire.

EGGENSCHWYLER, Urs fl. 19th century

Born at Subingen, Switzerland on January 24, 1849, he studied at the Soleure cantonal art school where he was a pupil of Taverna (drawing) and Pflüger (sculpture). Later he studied under Spiess at Aussersihl and Max von Widnmann at the Munich Academy. He spent some time in Bavaria working for King Ludwig II before settling in Zürich. He did a number of statues in 1884-86 for the municipal authorities. He specialised in animal figures and groups and maintained a private zoo for this purpose as well as frequenting the circus in search of material. His chief forte was lions – in all sizes and poses – and many of his leonine studies are to be found all over Switzerland. The best known examples are the lions on the Stauffach bridge and the Berne federal parliament building.

EGGENSCHWYLER, Urs Pankraz 1756-1821

Born at Matzendorf on February 23, 1756, he died at Soleure on October 11, 1821. Apprenticed to a coachmaker, he sculpted ornament for carriages and coaches. Later he went to Paris and developed his artistic bent. He won the Prix de Rome in 1802 and subsequently spent seven years in Rome. During this period he sculpted the statue of Love at Fontainebleau and a colossal statue of Napoleon. He returned to Switzerland in 1815 and did various classical groups in Soleure, as well as portrait busts of prominent European personalities, such as Byst, von Flüe and Kosciuszko.

EGIDY, Emmy von 1872-
Born in Pirna, Germany in 1872, she studied at the Dresden Academy and took part in its exhibitions at the turn of the century. She produced coloured plaster statuettes, relief portraits and busts.

EHBISCH, Johan Frederik 1668-1748
Born in Copenhagen in 1668, he died there on May 6, 1748. He was the son of Hans Ehbisch, gardener to Queen Sofia Amalia and eventually became Royal Sculptor in 1705. The figure of Hercules, cast in lead, in the garden of Rosenborg Castle, was executed by him.

EHEHALT, Henri 1879-
Born in Strasbourg on September 13, 1879, he studied at Karlsruhe Academy and was a pupil of Schmid-Reutte and H. Volz. He specialised in fountains, statues, roundels, plaques and memorials and also did a large number of medals. His works are preserved in the museums of Bruchsal, Philippsburg, Karlsdorf and Ottenheim.

EHRL, Alexius 1871-1913
Born in Nuremberg in 1871, he died there on February 17, 1913. He studied in Munich and worked there for some time. He returned to Nuremberg and did a large number of relief portraits. He assisted Professor Hautmann of Bavaria in taking the death mask of Ludwig II. He also sculpted several portrait busts of his contemporaries.

EHRLICH, Bianca (née Alexander-Katz) fl. late 19th century
Born at Ols in Silesia in 1852, she studied in Paris, Rome and Berlin. She specialised in portrait busts, notably those of Max Reger and the bacteriologist Paul Ehrlich. Her work ranged far and wide, from fountain statues in the manner of Bernini to genre portraits of Alpine peasants.

EHRLICH, Georg 1897-1966
Born in Vienna on February 22, 1897, he died in London in 1966. He studied at the School of Applied Arts in Vienna (1912-15) and settled in England after the first world war. He exhibited in Austria, Switzerland, France and Germany, as well as at the Royal Academy, and the Royal Scottish Academy and was awarded a gold medal at the Exposition Internationale of 1937. He worked as an etcher and draughtsman as well as a sculptor of animal figures and groups.
Tietze-Conrat, Erica *Georg Ehrlich* (1956).

EICHLER, Theodor Karl fl. 19th-20th centuries
Born at Oberspaar near Meissen on May 15, 1868, he was employed as a modeller at the Meissen porcelain works before taking up the serious study of sculpture at the School of Arts and Crafts and later the Academy in Dresden. He took part in the exhibitions of these schools and also exhibited in Berlin, Düsseldorf and Hanover. He specialised in genre statuettes and small groups, many of which were produced in porcelain at Meissen, but also edited as bronzes. They include Little Girl with a Spinning Top, Small Boy with Basket and various statuettes of dancers.

EILERS, Emma fl. 20th century
Born in New York at the turn of the century, she studied at the Art Students' League under W.M. Chase and later sculpted figures and portrait reliefs.

EINBERGER, Josef 1847-1905
Born at Brislegg in 1847, he died in Innsbruck on December 1, 1905. He was employed in the studio of Dominikus Trenkwalder in Innsbruck and completed a number of wood-carvings after his master's death. He himself sculpted numerous memorials and monuments in the Innsbruck and South Tyrol areas, the best known being the Way of the Cross in the Mariahilf cemetery, Innsbruck.

EINSPINNER, Josef fl. late 19th century
Born at Murzzuschlag, Austria on September 4, 1861, he studied under Hellmer and von Zumbusch at the Vienna Academy. He worked in Vienna on statues of Kaiser Franz Josef I and Freiherr A. von Dietrichstein. Among his other works were figures of Cain, a Faun and a Nymph as well as many portrait busts.

EISENMAYER, Ernst 1920-
Born in Vienna on September 18, 1920, he came with his family to England at the time of the *Anschluss* and studied at the Camberwell School of Art after the war. He lives in London and sculpts figures and groups in stone and steel as well as bronze and has had a number of important public commissions.

ELAND, John Shenton 1872-1933
Born in London in 1872, he died in New York on January 7, 1933. He studied at the Royal Academy schools (1893) and also at the École des Beaux Arts, Paris and exhibited at the Royal Academy from 1894 onwards. He was better known as a painter of portraits in oils, watercolours and pastels and a lithographer (member of the Senefelder Club), but he also produced busts and reliefs mainly of children.

ELDH, Carl Johan 1873-
Born at Film in Sweden, he studied in Paris where he was a pupil of Injalbert and Roland. He was a member of the Stockholm Academy and exhibited regularly in Stockholm and also in Copenhagen and Paris. He specialised in portrait busts of distinguished Scandinavian personalities.

ELIA, Edoardo d' fl. late 19th century
He worked in Piedmont-Savoy in the late 19th century. Benezit describes him as 'a genial artist who knew how to give his works a character of bonhomie that was always sympathetic'. He sculpted numerous portrait busts, mainly in marble, notably his head of Garibaldi (1880) and also produced several genre figures, such as Euterpe (1881), First-Fit of Temper and Alms.

ELIA, Michel fl. 20th century
He exhibited portraits at the Salon des Artistes Français from 1929 to the second world war.

ELIAS, Edouard Pierre Joseph fl. late 19th century
Born in Brussels, where he worked as a sculptor of figures and busts at the turn of the century.

ELIAS BURGOS, Francisco fl. 19th century
Born in Madrid, he studied under his father Elias Vallejo and became a member of the Academy of San Fernando in 1840. He specialised in classical and biblical groups and bas-reliefs, such as the Death of Epaminondas, Priam at the feet of Achilles and the Death of Abel and also did portrait busts of his contemporaries.

ELIAS VALLEJO, Francisco 1783-1858
Born at Soto de Canuras in 1783, he died in Madrid on September 22, 1858. He studied at the Academy of San Fernando and became director of its sculpture department in 1818. He specialised in portrait busts of personages associated with the Spanish Court and also sculpted a number of monuments in the classical style. The best known of these is the infant Hercules on the Hercules Fountain in Aranjuez.

ELIASZ, Wladyslaw fl. 19th century
He worked in Cracow where he exhibited busts and religious statues from 1871 to 1885. His works include the bust of Prince Lubomirski in Cracow and the series of eight busts portraying the kings of Poland at Rapperswill.

ELKAN, Benno 1877-1960
Born in Dortmund on December 2, 1877, he died in London on January 10, 1960. He originally studied painting at Munich under W. Thor and J. Herterich and later worked with N. Gysis. In 1901-2 he attended the Karlsruhe Academy and studied sculpture under F. Fehr. Subsequently he studied under J. Bartholome in Paris for three years and then went to Rome. On his return he settled in Alsbach where he produced paintings, drawings, medals, busts, groups, statuettes and memorials. His smaller sculptures included a bronze figure of Persephone, allegorical studies of Nostalgia, and Farewell, and busts of his contemporaries such as Trübner, Carl Einstein, Lotte Herbst, G.L. Meyer and Ludwig von Bar. His sculptures were in many public collections, not only in Germany but also in Rome, The Hague and Copenhagen. The advent of the Nazis in 1933 forced him to leave Germany and he settled in London where he exhibited at the Royal Academy. He continued to specialise in portrait sculpture.

ELLERHUSEN, Ulric Henry 1879-
Born at Waren in Mecklenburg on April 7, 1879, he left Germany for the United States in 1894 and studied at the Arts Institute of Chicago under Lorado Taft, and later at the Art Students' League of New York under Gutzon Borglum. He was also a pupil of Karl Bitter for some time (1906-12). His many awards include first prize of the St. Louis Art League and the medal of honour of the Architectural League of New York (1929). His best known works include the Peace

Monument, New York and the communion table in the Church of St. Gregory the Great, New York, and the March of Religion façade for the chapel at Chicago University. He worked mainly in plaster which was often bronzed, but bronze casts are known of several of his works, notably the group The Navy Put 'Em Across.

ELLICOTT, Henry Jackson A. 1848-1901
Born at Ellicott in 1848, he died in Washington on February 11, 1901. He studied art in Washington and later was a pupil of the National Academy of Design in New York. His best known works were the equestrian statues of General Hancock (Washington) and General McClellan (Philadelphia), but he also sculpted a number of portrait busts and statuettes.

ELLIS, Harvey 1852-1904
Born at Rochester, New York in 1852, he died in Syracuse on January 2, 1904. He studied under Edwin White at the National Academy of Design and became a member of the New York Water Color Club and President of the Rochester Society of Arts and Crafts. He worked at the turn of the century as a painter and sculptor of genre subjects.

ELLIS, Joseph Bailey 1890-
Born at North Scituate, Massachusetts on May 24, 1890, he studied under A.H. Munsell, Bela Pratt, Peter and Injalbert. He was a member of the Copley Architectural Club of Boston, the Pittsburgh Art Association and the Salmagundi Club and sculpted memorials, bas-reliefs, figures and groups.

ELLIS, William 1824-1882
Born in Sheffield in 1824, he died there in 1882 'of exhaustion, disappointed and in poverty' (*Hallamshire Worthies*). He studied in Sheffield under Edward Law and went to London in 1850 where he was associated with Alfred Stevens. On his return to Sheffield he established his own studio but the venture was singularly unsuccessful. The Sheffield Art Gallery preserves a number of bronze plaques, medallions and portrait busts by him.

ELMQVIST, Hugo 1862-
Born at Carlshamn, Sweden in 1862, he studied at the Stockholm Academy and won the Prix de Rome, subsequently studying in Italy and France. His works, mostly in bronze, include Arrival of Springtime, Old Age, Cain, Urchin, Eve, Naturalist and other genre and neo-classical figures.

ELOFF, Paul fl. early 20th century
Born in Pretoria, South Africa in the late 19th century, he studied in Paris before the first world war and exhibited figures and portraits at the Salon des Artistes Français in 1912.

ELSAESSER, Christian 1861-
Born at Bauschlott near Pforzheim on October 29, 1861, he studied at Karlsruhe under H. Volz and later at the Académie Julian in Paris. He specialised in decorative reliefs, memorials and portrait busts. His small bronzes include a figure Audifax.

ELSE, Joseph 1874-1955
Born in Nottingham on February 8, 1874, he died there on May 8, 1955. He studied at the Royal College of Art and later became principal of Nottingham School of Art. He also had a studio at Newnham-on-Severn for some years. He sculpted portraits and figures and exhibited at the Royal Academy.

ELSTER, Gottlieb 1867-
Born in Bavaria on October 8, 1867, he studied at the Munich Academy in 1888-89. He sculpted the statues of Von Kleist, King Frederick II and Queen Louise as well as numerous memorials and monuments, especially in the aftermath of the first world war. His minor bronzes include genre and allegorical busts and statuettes such as Ave Maria (Berlin) and Eros, Joy and The Hero (Brunswick Museum).

ELWELL, Frank Edwin fl. late 19th century
Born in Concord, Massachusetts on June 15, 1856, he studied under Daniel Chester French in New York and completed his studies at the École des Beaux Arts, Paris, where he was a pupil of Falguière. He received many awards for his sculpture and had the distinction of being the first American to have a statue erected in Europe. He tried to revive the Egyptian style and adapt it to modern sculpture. He became Curator of Ancient and Modern Sculpture at the Metropolitan Museum of Art, New York. His works include Diana and a Lion (Chicago) and Aqua Viva (Metropolitan Museum of Art).

ELWELL, Robert Farrington 1874-1962
Born in Boston, Massachusetts in 1874, he died in Wickenburg, Arizona in 1962. He was largely self-taught, though both his parents were amateur painters of some talent. He was inspired by the Buffalo Bill Wild West show to take up the art of the prairies and spent some time with Cody at his ranch in Wyoming, sketching the Indians and cowboys and their horses. He became an illustrator of books and periodicals for the Lothrop publishing company in Boston which specialised in Wild West literature and from 1902 onwards he also painted western landscapes in oils. This was a sideline to his main career as an engineer, but he gave this up to become manager of one of Cody's spreads in Wyoming. During the second world war he returned to engineering, but afterwards took up modelling and devoted the last fifteen years of his life to the sculpture of the Wild West. Most of his figures of Indians and cowboys were cast by the *cire perdue* process in London after his death.

EMANUELI, Giovanni 1816-1894
Born at Brescia in 1816, he died in Milan on December 18, 1894. He studied at the Brera and Milan academies and specialised in portrait busts and religious figures. At the age of fourteen he sculpted a bust of Kaiser Franz I of Austria and later did busts of Napoleon and Radetzky. Other works include the memorial to Bishop Ferrari in Brescia Cathedral and various statues in Milan Cathedral. He exhibited in Vienna, Munich and Paris as well as the principal Italian galleries.

EMBRY, Georges fl. late 19th-20th centuries
Born in Paris, where he worked as a sculptor of figures and bas-reliefs at the turn of the century. He exhibited at the Salon des Artistes Français, getting an honourable mention in 1897.

EMERSON, Robert Jackson 1878-1944
Born at Rothley in Leicestershire on June 21, 1878, he died in Wolverhampton on December 7, 1944. He studied at the Leicester College of Art under B.J. Fletcher and J.C. McClure, and finished his studies in London and Paris. He became a lecturer at the Wolverhampton School of Art and was elected F.R.B.S. in 1913. His bronze figures and bas-reliefs include Portrait of a Boy (Leicester Museum), Flight, Spirit of Heroism and Mother and Child.

EMILIAN, Celine fl. 20th century
She studied under E. Bourdelle and exhibited portrait busts at the Salon des Artistes Français from 1930 onwards. Her work includes busts of E. Bourdelle, Cortot and the composer d'Indy.

EMMANOUILOVA, Vasca fl. 20th century
Born in Bulgaria, she studied in Sofia under I. Lazarov and was influenced by Marco Marcov. She spent a year in Paris finishing her studies. Her work includes portraits, figures and genre groups.

ENCKE, Erdmann 1843-1896
Born in Berlin in 1843, he died at Neu Babelsberg in 1896. He studied under A. Wolff at the Berlin Academy and later became a follower of the Rauch School of Sculpture. His works included statues of Frederick the Great (Berlin Arsenal), the Great Elector (Berlin Town Hall), the sarcophagus of Kaiser Wilhelm I and the Kaiserin Augusta, and numerous monuments and statues of Goethe, Luther, Lessing and other German historical celebrities.

ENDER, Axel Hjalmar fl. 19th century
Born at Asker near Oslo on September 14, 1853, he studied at the School of Fine Arts and the School of Arts and Crafts in Christiania (Oslo). He also studied painting under J.F. Eckenberg and later went to the Stockholm Academy and the Munich Academy. He took part in the exhibitions of the Christiania Artists' Association from 1872 to 1889 and specialised in religious painting and sculpture. His bronzes and marble sculpture also include the statue of P.W. Tordenskjold in Oslo and various statuettes in the Oslo Museum.

ENDERLIN, Joseph Louis fl. 19th-20th centuries
Born at Aesch near Basle in 1851 of French parents, he studied in Paris under Jouffroy, and Robert the Younger. He exhibited at the Salon in 1878-80 and at the Salon des Artistes Français. He was

awarded a gold medal at the Exposition Universelle of 1889 and made a Chevalier of the Legion of Honour in 1902. He specialised in portrait busts and genre figures and bas-reliefs in marble, terra cotta, plaster and bronze.

ENGEL, Friedrich 'Fritz' c.1879-
Born at Eisenach about 1879, he worked in Zurich and specialised in the modelling of portrait busts from photographs. His busts include those of Gottfried Keller and C.F. Meyer.

ENGEL, Jozsef 1815-1891
Born at Satoralja-Ujhely in 1815, he died in Budapest in 1891. He worked in Budapest and specialised in busts and statuettes of Hungarian historical and contemporary celebrities. He exhibited in Budapest, Vienna, Paris and London in the late 1880s and was awarded a bronze medal at the Exposition Universelle of 1889.

ENGELHARD, Josef fl. late 19th century
Born at Aschaffenburg on June 23, 1859, he studied in Nuremberg, Dresden and Berlin and settled in Munich where he exhibited between 1890 and 1896.

ENGELHARD, Roland 1868-
Born in Hanover on April 18, 1868, he was the son and pupil of the painter Wilhelm Engelhard. Later he studied at the Berlin Academy under Otto Lessing and also at the School of Arts and Crafts in Vienna. He returned to Hanover where he specialised in portrait busts, bas-reliefs and memorials. He exhibited portrait reliefs in Berlin in 1896 and 1901.

ENGELHARDT, Hermann 1874-
Born in Berlin on June 28, 1874, he studied at the Academy and established a studio in his native city after completing his studies in Rome and Florence. He produced a large number of ornaments, statues and monuments for public buildings, churches and private houses in Berlin, Breslau, Stolp and Tangermünde and was an extremely versatile sculptor in every medium from wood to bronze. He also sculpted numerous portrait busts and allegorical statuettes, such as Flora (Darmstadt Exhibition, 1910). He also exhibited regularly in Munich and Berlin from 1906 onwards.

ENGELHARDT, Ludwig 1924-
Born in Saalfeld in 1924, he has worked in Berlin since 1958 and is one of the foremost of the younger sculptors at work in the German Democratic Republic at the present day. He is a member of the Academy of Arts of the G.D.R. He studied at the Kunsthochschule in Berlin-Weissensee under Heinrich Drake. He has produced numerous bronze statuettes of genre subjects, such as Am Strand (a young woman seated on the beach) and Worker Reading and heads and busts of contemporary personalitites of eastern Europe.

ENGELKE, Karl Martin fl. 19th century
Born in Tilsit, East Prussia on June 22, 1852, he studied under Schilling in Dresden and later worked in Vienna before settling in Dresden where he produced numerous bas-reliefs and allegorical figures, such as Poesy, Religion, History, Faith, Hope and Charity, and The Three Graces. He also sculpted a number of busts of his contemporaries.

ENGELMANN, Richard 1868-
Born in Bayreuth on December 5, 1868, he studied in Munich, Florence and Paris before settling in Berlin. He produced a number of busts and genre statuettes, such as Lounging Woman (Weimar Museum).

ENGL, Josef B. 1867-1907
Born in 1867, he died in Munich on August 25, 1907. He is mainly known as an illustrator for the satirical magazine Simplicissimus at Munich and his genre sketches of Bavarian society at the turn of the century. He sculpted figures in the same manner.

ENGLISH, Stanley Sydney Smith 1908-
Born at Romford, Essex on April 19, 1908, he studied at the Lambeth School of Arts and the Royal Academy schools under William McMillan. He has exhibited at the Royal Academy and the main London and provincial galleries. He has taught ceramics at Liverpool College of Art since 1946 and also has a studio in that city. He sculpts figures, busts, heads and reliefs in wood, stone and bronze.

ENGRAND, Georges fl. 19th century
Born at Aire on October 5, 1852, he exhibited at the Salon from 1878 and won a third class medal in 1898 and a bronze medal at the Exposition Universelle of 1889. He specialised in bronze busts and allegorical statuettes, such as Idyll, Grief, The Wave and Arion. He also sculpted the marble bust of Molière for the Orange Theatre.

ENHORMING, Karl 1745-1821
Born at Södermanland in 1745, he died in Stockholm in 1821. He specialised in heads, busts, portrait reliefs and medallions. His works include the head of Dr. K.F. von Schulzenheim and the bust of Baron S.G. Hermelin.

ENNEVIÈRES, Cecile d' fl. 20th century
Born at Comines, she studied under E.J. de Bremaeker and exhibited busts at the Salon des Artistes Français in the 1920s.

ENRIQUE, Barros Fernandez fl. 20th century
Born at Bilbao, Spain in the early years of this century, he studed in Bilbao and later in Paris under J. Boucher. He exhibited in Spain and France in the 1930s and specialised in genre figures and groups, such as First Love (1929).

ENTRES, Guido 1846-1909
Born in Munich on October 4, 1846, he died there on June 2, 1909. He studied under his father, Joseph Otto Entres and later at the Munich Academy. He executed a great many small bronzes and later sculpted the statue of the astronomer J. von Lamart. He directed the restoration of the decorative sculpture in St. Jacobskirche, Munich.

ENTRES, Joseph Otto 1804-1870
Born at Fürth on March 13, 1804, he died in Munich on May 14, 1870. He was an accomplished stone- and wood-carver by the age of fifteen and subsequently entered the Munich Academy where he studied under K. Eberhard. His best known work is the colossal figure of Christ. He also sculpted the equestrian figure of Godefroy of Bouillon. Most of his ecclesiastical work was carved in wood in the medieval manner and he formed an extensive collection of medieval religious sculpture.

ÉPINAY, Prosper d' fl. 19th-20th centuries
Born at Pamplemousses, Mauritius, in 1836, he was the son of a prominent political figure on the island, Adrien d'Épinay. He was educated in Paris and studied sculpture under Dantan the younger. Later he was a pupil of Amici in Rome. He settled in Paris and specialised in portrait busts of his contemporaries, such as Sarah Bernhardt, Henri Regnault and Fortuny. He sculpted a bronze statuette of St. John in the Wilderness and a number of statues in marble, terra cotta or bronze. He also worked as a caricaturist and exhibited at the Salon des Humoristes in 1909.

EPLATTENIER, Charles l' 1874-
Born in Nuremberg of Swiss parents, he worked as a painter and sculptor at La Chaux de Fonds, Switzerland. He took part in the Munich Exhibition of 1909. He sculpted allegorical figures of Helvetia and statuettes in the Art Nouveau style and also designed postage stamps for Switzerland at the turn of the century.

EPLER, Heinrich Karl 1846-1905
Born in Königsberg (now Kaliningrad) on August 5, 1846, he died in Dresden on April 30, 1905. He studied under Schilling in Dresden, where he subsequently settled. He won a silver medal for a bust of a man and a figure of Ulysses. Most of his work may be found in the Dresden area, mainly monuments and public statuary, but he also sculpted genre statuettes in marble or bronze, such as Child Playing and the Bowls Players.

EPPLE, Emil 1877-
Born in Stuttgart on March 6, 1877, he studied under A. Donndorf at the Stuttgart Academy and later was a pupil of Ruemann at Munich. He spent some time in Berlin, London and Munich before settling in Stuttgart. He worked mostly in bronze, producing heads, busts and statuettes, such as Orpheus, Roman, Prometheus and Diana with a Stag. He also did the curious group, in green and white marble, of Anadyomenes on his knees under torture.

EPSTEIN, Sir Jacob 1880-1959
Born in New York of Russian-Polish parents on November 10, 1880, he died in London on August 19, 1959. He studied at the Art Students' League in New York and the École des Beaux Arts and the Académie Julian in Paris and settled in London in 1905. His first major commission was the highly controversial series of eighteen figures for the British Medical Association's headquarters in London (1907). For many years he had an uphill struggle to drag British sculpture out of its 18th century classicism into the 20th century era of Rodin and few sculptors have suffered so much vilification and misunderstanding from the artistic establishment of their time. Nevertheless Epstein rose above the hatred and misunderstanding to become the pillar of artistic establishment himself. He received numerous awards and honorary degrees late in life and was knighted in 1955. Despite the frequent criticism of his work he secured numerous important commissions and sculpted large monuments and public statuary, ranging from the tomb of Oscar Wilde in Père Lachaise cemetry (1909) to the memorial to working class victims of the second world war, outside the headquarters of the Trades Union Congress in Great Russell Street, London. In the 1920s and 1930s he sculpted large monuments by the direct carving method in stone and marble, but also modelled numerous small figures and busts which were cast in bronze. He produced a whole galaxy of the international celebrities of this century over a period of four decades – politicians and royalty, artists, writers, actors, composers and leading men and women in many walks of life. His other bronzes include Madonna and Child (1927), The Visitation (1926), Christ (1920), Lucifer (1945) and Conrad (Muirhead Bone collection). Among his last works were the Madonna and Child for the Convent of the Holy Child Jesus (1952) and Christ in Majesty for Llandaff Cathedral (1957). The Madonna of 1952 is regarded as one of the finest sculptures erected in Britain this century.
Buckle, Richard *Jacob Epstein, Sculptor* (1963). Contemporary British Artists *Epstein* (1925). Epstein, Jacob *The Sculptor Speaks* (1931). *Let There be Sculpture* (1940). Van Dieren, Bernard *Epstein* (1920).

ERICSON-MOLARD, Ida fl. 19th century
Born in Stockholm on February 13, 1853, she studied at the Stockholm Academy and later settled in Paris, where she sculpted romantic bronzes and portraits.

ERICSSON, Johan Edward 1836-1871
Born in Göteborg in 1836, he died in Stockholm in 1871. He worked in Stockholm as a sculptor of bas-reliefs, plaques and medallions in plaster and bronze.

ERIKSEN, Edvard 1876-
Born in Copenhagen on March 10, 1876, he studied at the School of Fine Arts in Copenhagen and won a gold medal for his group Meditation. He later won a travelling scholarship which took him to Italy where he spent several years. He is best remembered for his Little Mermaid at the entrance to Copenhagen Harbour, subject of countless bronze reductions and copies. His other works include Mother and Child and Adam and Eve after their expulsion from Paradise.

ERIKSSON, Christian fl. 19th century
Born at Arvika, Sweden in 1858, he studied in Paris under Falguière and exhibited at the Paris Salons, winning a third class medal in 1888 and gold medals at the Expositions of 1889 and 1900. He produced many decorative works in Sweden, ranging from the large stone sculptures for the Stockholm Theatre to busts, statuettes and reliefs in plaster, terra cotta, marble, porcelain, wood and stone as well as bronze. His work in the latter medium includes bronze vases of A Miracle and Colin-Mailland, and statuettes of Thuuri (casts in Helsinki and Stockholm), The Youth that Dances (Saltsjobaden), Skaters and Young Breton.

ERLANGER, Philipp Jakob 1870-
Born in Frankfurt on May 3, 1870, he studied at the Städel Institute, Frankfurt under Hasselhorst, and completed his studies in Karlsruhe and Munich under Weisshaupt and Ziegel respectively. He settled in Breslau in 1899 and periodically studied in Paris and Italy. He exhibited neo-classical figures and reliefs in Berlin, Düsseldorf and Munich.

ERLER, Franz Christian 1829-1911
Born at Kitzbühel on October 5, 1829, he died in Vienna on January 6, 1911. He worked mainly as a decorative sculptor and produced friezes, bas-reliefs and ornamental statuary for churches and public buildings in Vienna, Mayerling and Klosterneuburg.

ERNST, Joseph Anton 1816-1893
Born at Schöllang on March 7, 1816, he died there on July 20, 1893. He worked with his brother Michael (died 1850) in the Passau area and sculpted bas-reliefs, memorials and busts.

ERNST, Max 1891-1976
Born at Bruehl near Cologne, on April 2, 1891, he died in Paris in 1976. He is best known as a painter, a founder of Dadaism and an associate of Arp and Giacometti, and co-founder of the Surrealist movement in Paris, 1924. In 1935, however, he sculpted granite stone figures of Moloja in Switzerland and three years later sculpted figures and bas-reliefs for his country house at St. Martin d'Ardèche. On the fall of France he moved to Switzerland and thence to the United States in 1941. He lived in New York till 1946 when he settled in Arizona. He was visiting professor of sculpture at the University of Honolulu in 1951 and returned to Paris the following year. He exhibited sculpture at the Galerie Creuzevault, 1958. He worked in polychrome wood, plaster and stone as well as bronze. His works in the latter medium include King playing Chess with his Queen, A Worried Friend, Parisienne and other statuettes which were mainly produced in the 1940s.

ERSKINE, Harold Perry 1879-
Born at Racine, Wisconsin, on June 5, 1879, he studied at the École des Beaux Arts in Paris and was also a pupil of Sherry Fry in America. He specialised in busts and also sculpted the war memorial for the St. Anthony Club, New York (1920).

ESCUDERO, François Xavier fl. early 20th century
Born in Huesca, Spain, at the turn of the century, he studied in Madrid and Paris and exhibited at the salons in these cities in the inter-war period. He specialised in medallions, roundels, plaques and bas-reliefs in bronze and plaster.

ESCUOLA, Jean 1851-1911
Born at Bagnères de Bigorre on October 26, 1851, he died in Paris in August 1911. He studied under Gautherin and exhibited at the Salon from 1876, becoming an Associate of the Artistes Français in 1885. He won third and second class medals in 1881-82 and gold medals at the Expositions of 1889 and 1900. He was made an Officier of the Legion of Honour. He specialised in genre figures, such as The Young Bathers and allegorical groups such as Angelique and Grief.

ESCUOLA-MAROT, Jean Marie fl. 19th-20th centuries
Born at Bagnères de Bigorre in the late 19th century, the son of the above. He made his début at the Salon of 1889 and exhibited until the first world war period. His figure of The Stone Mason is in Nice Museum.

ESDERS, Madeleine 1891-
Born in Paris on May 29, 1891, she exhibited statuettes at the Salon des Artistes Français in the 1920s.

ESHERICK, Whardon 1887-
Born in Philadelphia on July 15, 1887, he worked in that city at the beginning of this century as a painter, wood-engraver, designer and sculptor.

ESPARZA ABAD, Lino 1842-1889
Born in Valencia on August 2, 1842, he died there in April, 1889. He studied at the Academy of Fine Arts, Valencia and specialised in portrait reliefs and busts of Spanish celebrities of the mid-19th century.

ESPERCIEUX, Jean Joseph 1757-1840
Born in Marseilles on July 22, 1757, he died in Paris on May 6, 1840. He was self-taught, his brilliance and originality untramelled by academic teaching. He exhibited at the Salon from 1793 to 1836. His earlier works conformed to the classicism that was demanded by the jury (composed of members of the Institut) but after the fall of the Bourbon monarchy in 1830 and the relaxation of the ban on anything relating to the Napoleonic era, he began sculpting statues and busts of

Napoleonic generals, mainly in marble but also cast in bronze. He also produced a number of small allegorical works including Victory and Peace, and genre subjects such as Young Bather, Greek Lady entering her Bath, and Nymph getting out of the Bath.

ESPINOSA-PACEDA, Romano fl. 20th century
Born at San Mateo in Peru, he studied in Paris under A. Boucher. His figures and groups were strongly influenced by the pre-Columbian art of his country.

ESSEX, Thomas R. fl. late 19th century
He worked in London in the late 19th century, and exhibited at the Royal Academy from 1888 onwards. He specialised in portraits, and the Bristol Museum has his bust of Christopher James Thomas.

ESTE, Alessandro d' 1787-1826
Born in Rome in 1787, he died there on December 8, 1826. He was the son and pupil of Antonio d'Este and later worked as assistant to Canova. His statues and groups were invariably sculpted in marble, though some are known to have been published as bronzes.

ESTE, Antonio d' 1754-1837
Born in Venice in 1754, he died in Rome on September 13, 1837. He worked with Canova for many years and was also Director of the Vatican Museum.

ESTEBAN Y LOZANO, José fl. 19th century
He studied under José Piquer and worked in Madrid as a sculptor of medallions and portrait reliefs. He exhibited in Madrid from 1862 onwards.

ESTÈVE Y ROMERO, Antonio 1859-
He was the son of José Estève y Villela and grandson of José Estève y Bonet, stone masons and monumental sculptors in Valencia. He studied at the Academy of San Carlos in Valencia and worked in busts and statues, mainly in marble or plaster. His works are in Bilbao, Burgos, Madrid, Pampluna and Valencia.

ESTOPIÑAN, Roberto 1920-
Born in Havana, Cuba, in 1920 of Armenian descent, he studied under Juan José Sicre at the Academy of San Alejandro. Later he completed his studies in Mexico, Portugal, France, Italy and the United States and has become one of the foremost non-figurative sculptors in Latin America today. His abstracts are sculpted in iron, copper and bronze and include The Prisoner and Project for a Fountain. He won first prize for sculpture in Havana in 1954.

ETCHETO, Jean François Marie 1853-1889
Born in Madrid on March 9, 1853, he died in Paris on November 10, 1889. He exhibited at the Salon from 1881 and sculpted figures and groups of historical personalities.

ETEX, Antoine 1808-1888
Born in Paris on March 20, 1808, he died at Chaville on June 14, 1888. He studied under Pradier at the École des Beaux Arts and worked as a painter and architect as well as a sculptor. He made his début at the Salon in 1833 with a marble Death of Hyacinthus and a plaster cast of his Cain and his Race Cursed by God. On the strength of these works in the true classical idiom he was commissioned by Thiers to sculpt the allegories of Peace and War which now decorate the Arc de Triomphe. He is best remembered for designing the tomb of Napoleon at Les Invalides and the monument to the Revolution of 1848. He received numerous State commissions and became one of the wealthiest sculptors of his time. He also sculpted a number of portraits, bas-reliefs, memorials and statuettes. One of the most remarkable is his bronze bas-relief, on the tomb of Géricault, reproducing that master's most famous painting, The Raft of the Medusa. This extraordinary concession to Romanticism was not matched by any of his other works, which remained firmly in the classical convention.
Mangeant, P.E. *Antoine Etex, peintre, sculpteur et architecte 1808-1888* (1894).

ETLING, fl. 20th century
Art Deco bronzes and gilt-bronze statuettes of nudes, dancers and athletes bearing this signature were produced by a sculptor working in Paris in the 1920s.

ETTL, Alexander J. 1898-
Born at Fort Lee, New Jersey on December 12, 1898, he studied under his father, John Ettl, and specialised in monuments, memorials, bas-reliefs and plaques.

ETTL, John 1872-
Born in Budapest on August 1, 1872, he studied in Budapest, Vienna, Paris and Munich, before emigrating to the United States. He worked mainly as a monumental sculptor, and is best known for his Lincoln memorial in New York Arsenal and the war memorial at East Rutherford, New Jersey. He also sculpted the bas-reliefs on the Place de la Justice in Berne and produced a number of allegorical busts and figures in plaster and bronze, such as Chief Oratam.

ETTLE, Franz 1847-c.1881
Born at Biberach, Germany on January 24, 1847, he died, probably in Berne, in or after 1881. He succeeded Franz Bosinger as professor of sculpture and drawing at Interlaken, where he worked till 1876, and then spent the remaining years of his life in Berne. He sculpted portraits, figures and reliefs.

ETTLIN, Joseph Maria 1791-1874
Born at Kerns, Switzerland in 1791, he died there on November 1, 1874. He studied under Abart and worked on ecclesiastical sculpture for churches in Samen, Kerns and other Swiss towns.

ETTLIN, Nikolaus the Elder fl. 19th century
Born at Kerns on March 3, 1830, he was the son and pupil of Joseph Maria Ettlin and also studied at the School of Design in Basle. For a time, however, he served with the Swiss Guard in Rome and this gave him an opportunity to study sculpture in the Eternal City. On his return to Switzerland he became drawing master at Sachseln and Kerns and produced numerous figures and bas-reliefs of religious subjects.

ETTLIN, Nikolaus the Younger 1869-
Born at Kerns on April 4, 1869, he was the son and pupil of Nikolaus the Elder. He worked exclusively in stone or wood on ecclesiastical sculpture and no bronzes have so far been attributed to him.

EUDE, Jean Louis Adolphe 1818-1889
Born at Arès in 1818, he died in Paris on April 8, 1889. He was a pupil of David d'Angers and exhibited at the Salon from 1847, winning a third class medal in 1859 and a first class medal in 1877. His works were invariably highly praised for their graceful elegance. His figures and groups, in marble or bronze, were usually of classical or allegorical subjects.

EUSTACHE, Georgette 1874-
Born at Fontenay-aux-Roses, she studied under Sicard and exhibited statuettes and busts at the Salon des Artistes Français in the 1920s.

EUSTACHE, Sylla fl. 19th century
Born in Paris on December 1, 1856, he studied under Émile Laporte and Gabriel Guay in the *atelier* of Lequien. He specialised in medals and medallions, plaques and bas-reliefs at the turn of the century.

EVANGELISTA, Francesco Paolo fl. 19th century
Born at Penne, Italy in 1837, he studied in Naples and Florence and specialised in allegorical groups and genre figures which he exhibited in Naples and Rome.

EVANS, David 1895-
Born in Manchester in 1895, he studied at the Manchester School of Art, the Royal College of Art and the Royal Academy schools. He won the Prix de Rome and the Landseer scholarship in 1922. He worked in Welwyn Garden City before the second world war sculpting portraits and figures and carving bas-reliefs. He exhibited at the Royal Academy and the Manchester and Glasgow galleries.

EVANS, Merlyn Oliver 1910-1973
Born in Cardiff on March 31, 1910, he died in London on October 31, 1973. He studied at the Glasgow School of Art under J.D. Revel (1927-30) and having won a travelling scholarship spent some time in France, Germany and Scandinavia. Later he studied at the Royal College of Art under Rothenstein (1931-33) and in Paris under S.W. Hayter (1934-36). Though better known as a Surrealist and abstract painter, he also practised engraving and taught etching at the Central School of Arts and Crafts from 1952 onwards. As a sculptor, he produced a number of abstracts, which were shown in a retrospective exhibition at the Whitechapel Gallery in 1956.

EVANS, Rudolph 1878-
Born in Washington, D.C. on February 11, 1878, he studied at the Corcoran Art Gallery in Washington, the Art Students' League, New York and the Académie Julien and the École des Beaux Arts in Paris, under Falguière and Rodin. He won a third class medal at the Salon des Artistes Français in 1914 and the Watrous gold medal of the National Academy of Design in 1919. His best known work is the marble statue of Simon Bolivar at the Bureau of American Republics in Washington. He also sculpted the figure of James Pierce in New York and The Golden Hour (Metropolitan Museum of Art). Among his minor works were numerous bronze busts and heads of his contemporaries, such as Maude Adams, Dean Joseph French Johnson of New York University, Frank Vanderlip and others. He also sculpted the bronze group Boy and Panther.

EVENS, Otto Frederik Theobald 1826-1895
Born in Copenhagen on February 16, 1826, he died there on November 21, 1895. The son of a coppersmith and bronze-founder, he learned the trade from his father and simultaneously studied at the Copenhagen Academy (1839). Later he worked with H.V. Bissen for many years. He won the Neuhausen Prize in 1857 for his group Maternal Love. A travelling scholarship took him to Rome (1858-65) and on his return he sculpted the Eckersberg statue and later the two statues of Saxo and Grundtvig. He became a member of the Academy in 1871. His minor works include a number of genre figures and groups such as Groom watering his Horse, Little Boy on the point of having a Bath and Fisherman asking a Boy to play his Flute. His bronze figure of Tycho Brahe the astronomer is in the Copenhagen Museum.

EVERDING, Hans fl. 19th-20th centuries
He worked in Cassel at the turn of the century and won a bronze medal at the Exposition Universelle (1900) and the Grand Prix of the Berlin Academy (1899) for his figures.

EVERDING, Wilhelm 1863-
Born in Bremen on July 18, 1863, he was the pupil and assistant of Robert Dorer. Later he became professor of sculpture in Bremen where he produced numerous monuments, memorials and portrait reliefs.

EVERETT, Elizabeth fl. 20th century
Born at Toledo, Ohio in the early years of this century, she worked as an etcher and illustrator as well as sculptor. She studied under Walter Isaacs and also at the Pratt Institute. She won a number of prizes and medals in the 1920s for her portraits and groups.

EVERETT, Herbert Edward fl. 19th-20th centuries
Born in Worcester, Massachusetts, he worked in Philadelphia at the turn of the century. He studied at the Boston Museum of Fine Arts and the Académie Julian in Paris and later taught modelling in Philadelphia. He produced a number of busts, heads, reliefs and statuettes.

EVERETT, Louise 1899-
Born in Des Moines, Iowa on April 9, 1899, she studied at various American academies and also at the Académie Julian and the École des Beaux Arts in Paris (1925). She exhibited figures and groups in American galleries in the late 1920s.

EVERETT, Raymond 1885-
Born in Englishtown, New Jersey on August 10, 1885, he became professor of drawing and painting at the University of Texas and also sculpted busts and reliefs.

EVERETT, Roberta (née Hatcher) 1906-
Born in Surrey on May 29, 1906, she studied at the Goldsmiths' College School of Art and the City and Guilds and settled in Hornchurch, Essex, where she sculpts mainly in clay and stone. She has exhibited at the Royal Academy, the Paris Salons and the provincial galleries.

EVRARD, Gustave Gregoire fl. 19th century
Born at Magimont in the Ardennes in the first half of the 19th century, he studied in Paris under Bosio and worked with him from 1851 to 1868. He specialised in busts of his contemporaries, mainly theatrical personalities.

EVRARD, René Hippolyte fl. 20th century
Born at Le Havre, he exhibited figures and portraits at the Salon des Artistes Français from 1924 onwards.

EVRARD, Victor fl. 19th century
Born at Aire on October 4, 1807, he studied under Dantan the Elder and exhibited at the Salon from 1838 to 1877. He worked exclusively in bronze and his sculptures include Young Faun getting a Bacchante Drunk, St. Anthony the Hermit, Homer and Christ (silvered bronze).

EWING, George Edwin 1828-84
Born in Birmingham in 1828, he died in New York on April 26, 1884. He spent much of his life in Scotland and many of his busts are of prominent Scots of the late 19th century. He exhibited at the Royal Academy from 1862 to 1877 and later emigrated to the United States. His busts of Dr. Norman MacLeod and James Newlands are in the Liverpool Museum.

EWING, James A. 1843-1900
Born in Carlisle in 1843, he died in Glasgow in 1900. He was the younger brother and collaborator of George Edwin Ewing and spent his entire career in Glasgow working on portrait busts of his contemporaries. His bust of Sir Michael Connal is in the Glasgow Museum and Art Gallery, Kelvingrove.

EXTER, Julius 1863-
Born in Ludwigshafen on September 20, 1863, he studied at the Nuremberg School of Art (1881-87) and later at the Munich Academy. He worked for two years in the studio of Alexander Wagner and exhibited in Munich in 1888-89. He won a bronze medal at the Exposition Universelle of 1900. His works include The Young Judith, Two Men (both at Bremen), Little Girl Asleep (Bucharest) and Good Friday (Munich).

EYCKMANS, Johannes 1749-1815
Born at Breda, Holland in 1749, he died in Antwerp in 1815. He studied under Walter Pompe and specialised in religious and genre figures.

EYRE, Louisa fl. 19th-20th centuries
Born in Newport, Rhode Island in 1872, she studied at the Pennsylvania Academy of Fine Arts (1888-91), the Art Students' League (1891-94) and was also a pupil of Augustus Saint-Gaudens (1894-95). Her speciality was portraits and idealised groups of children. She also sculpted bronze tablets of General George Sykes (Memorial Hall, West Point), and John A. Kasson, a bas-relief of Mary Ballard, a bronze statuette of Dudley Perkins and a bronze head of an Italian boy.

EZEKIEL, Moses Jacob fl. 19th century
Born in Richmond, Virginia on October 28, 1844, he came to Europe in 1869 and studied at the Berlin Academy under Albert Wolff. He exhibited in Berlin, Rome, New York and Cincinnati and specialised in genre, allegorical and neo-classical sculpture such as The Martyrs, Consolation and Pan and Cupid.

FABBRUCCI, Aristide fl. 19th century
Born in Florence, he worked in London in the late 19th century and exhibited figures and groups at the Royal Academy from 1880 to 1885.

FABBRUCCI, Luigi 1829-1893
Born in Florence in 1829, he died in London in 1893. He exhibited at the Salon des Artistes Français and the Royal Academy and specialised in busts of his contemporaries.

FABI-ALTINI, Francesco 1830-1906
Born at Fabriano, Italy on September 15, 1830, he died at San Manano in March 1906. He studied in Rome under Tadolini and specialised in ecclesiastical figures, monuments and memorials.

FABISCH, Joseph Hugues 1812-1856
Born at Aix on March 19, 1812, he died in Lyons on September 7, 1886. He studied at the School of Fine Arts in Aix and exhibited at the Salon from 1846 to 1878, winning a second class medal in 1861. He became professor of sculpture at the Lyons School of Fine Arts in 1860. He is best known for his marble statuary of classical, biblical and medieval figures, but he also sculpted a number of bronze busts of contemporary and historic personalities.

FABISCH, Philippe 1845-1881
Born in Lyons on August 12, 1845, he died there on June 14, 1881. He was the son and pupil of Joseph Fabisch and later worked as assistant to Dumont. He exhibited at the Salon from 1868 to 1881, specialising in genre and biblical figures. His Rebecca is in the Museum at Le Havre.

FABRE, Abel fl. late 19th century
Born at Blagnac, France where he worked at the end of the 19th century as a sculptor of memorials and portraits.

FABRES Y COSTA, Antonio Mario fl. 19th-20th centuries
Born at Gracia near Barcelona in 1850, he studied at the School of Fine Arts in Barcelona and lived in Rome for many years. He took part in the major international exhibitions at the turn of the century and won gold medals in Vienna and Munich and a silver medal at the Exposition Universelle of 1900. He produced genre figures and groups.

FABRI, Agenore 1911-
Born at Barba, Italy in 1911, he studied at the Pistoia Art School and later worked as a designer in a porcelain factory at Albisola. He exhibited his sculptures for the first time in Naples in 1937, but his work was interrupted by war service. He took part in the 1952 Venice Biennale and has since participated in many major international exhibitions in Europe and America. He turned from figurative sculpture in the style of Marini to abstracts and Surrealist groups in terra cotta or bronze. His bronzes include Big Bird (1956), Night Bird and Spatial Figure (1959).

FABRIS, Antonio 1792-1865
Born at Udine on November 24, 1792 he died in Venice on February 8, 1865. He worked with Canova for several years in Rome and his statue of the great master is in the Udine Museum. Though the bulk of his work was sculpted in marble, he also modelled statuettes in terra cotta and bronze and several of these are preserved by the Academy of Venice.

FABRIS, Giuseppe 1790-1860
Born at Nove di Bassano near Venice on August 19, 1790, he died in Rome on August 22, 1860. He worked in Rome and was a member of the Academy of St. Luke, his *morceau de réception* being a figure of Milo of Croton. He is best remembered for his numerous monuments and statues and was a corresponding member of the French Institut from 1846.

FACHARD, Robert 1921-
Born in Paris, he studied at the School of Fine Arts in Toulouse but returned to Paris and worked in the studio of Henri Laurens where he received an excellent grounding in every sculptural medium. At the beginning of his career he worked mainly as a sculptor of large monuments in the Toulouse area and he founded a group of abstract sculptors in 1950. Since 1953, his work has been much more varied and, in particular, he has developed what he terms 'bivalent sculpture', in which two or more different substances are combined to heighten the contrast of colour and texture. His favourite combination for such bas-reliefs is slate and bronze. He has exhibited at the Salon de la Jeune Sculpture (since 1953) and the Salon des Réalités Nouvelles (since 1958) and had his first one-man show at the Galerie Simone Badinier in 1955.

FACHE, René 1816-1891
Born at Douai on November 23, 1816, he died in Valenciennes in March 1891. He studied under David d'Angers and T. Bra and later became professor of sculpture at Valenciennes. He specialised in bronze busts and portrait reliefs of contemporary personalities. He also sculpted a number of marble statues and groups of a religious nature for churches and cathedrals in northern France. His best known work was the series of stone caryatids in front of Valenciennes Town Hall. Several of his minor bronzes are preserved in Douai Museum.

FACONNET, Marie Anne Eugénie fl. late 19th century
Born in Paris, where she worked as a sculptor of medallions, plaques and bas-reliefs. She exhibited at the Salon from 1870 onwards.

FADRUSZ, Janos 1858-1903
Born at Pozsony on September 2, 1858, he died in Budapest on October 26, 1903. His chief work was the monument to the Empress Maria Theresa at Pressburg (Przemysl). He was relatively unknown outside Galicia and created quite a sensation at the Exposition Universelle of 1900 with his figures of Christ on the Cross and Matthias Corvinus, which won him the Grand Prix.

FADY-CAJANI, Louis E. 1869-
Born in Paris on April 6, 1869, he worked there at the turn of the century as a sculptor of figures and reliefs and was elected an Associate of the Artistes Français in 1903.

FAGAN, William Bateman 1860-1948
Born in London on September 3, 1860, he died there on April 9, 1948. He was educated at Dulwich College and studied art in London and Paris, being a pupil of Jules Dalou and W.S. Frith. He exhibited at the Royal Academy from 1886 onwards and was elected F.R.B.S. in 1938. He worked in London as a sculptor of portraits and genre figures.

FAGEL, Léon 1851-1913
Born at Valenciennes on January 30, 1851, he died in Paris on March 10, 1913. He studied under Cavelier and was runner-up in the Prix de Rome of 1875 with his bas-relief of Homer reciting his poems in a Greek town. He won the Prix de Rome in 1879, with a group of Tobias restoring sight to his Father. During his sojourn in Rome he continued to produce bas-reliefs of biblical and classical subjects, mainly in plaster. He exhibited regularly at the Salon, winning a third class medal in 1882 and a second class the following year, and gold medals at the Expositions of 1889 and 1900. His best known work is the bronze statue of Dupleix at the battlefield of Landrecies. His minor works include The Registrar, Abel's First Offering, A Soldier of Wattignies and a number of portrait busts.

FAGERBERG, Carl Vilhelm 1878-
Born in Sweden, he studied at the Stockholm Academy and also in Paris at the turn of the century. He sculpted portraits and exhibited in Stockholm and the Paris Salons in the early 1900s.

FAGGI, Alfeo 1885-
Born in Florence on September 11, 1885, he later emigrated to the United States and settled in Chicago where he sculpted figures and bas-reliefs for various churches. His best known work is the Pietà war memorial. He also produced a large number of busts and relief portraits.

FAILER, Peter 1870-
Born at Jungnau, Germany on May 28, 1870, he studied under Marmon at Sigmaringen and Lenz at Beuron. As Brother Fidelis he became a lay brother of the Benedictine Abbey of Beuron and worked on religious figures and reliefs for the Benedictine monasteries of Beuron, St. Gabriel (Prague) and Monte Cassino.

FAILLOT, Edmé Nicolas 1810-1849
Born in Auxerre on August 5, 1810, he died in Paris on June 9, 1849. He exhibited at the Salon from 1838 and won a medal in 1843. Despite his brief career he produced a wide range of sculpture in plaster and bronze, including genre groups, statuettes of saints and contemporary figures, classical groups, such as Combat of Gladiator and Lion and portrait medallions and plaques of his contemporaries.

FAINMEL, Charles fl. 20th century
Of French origin, he became a naturalised Canadian and specialised in nude statuettes in the inter-war period.

FAINO, Alfred fl. 20th century
Born in Bergamo, Italy at the turn of the century, he exhibited in Milan, Venice and Paris in the 1920s and produced portraits and genre figures.

FAIRBANKS, Avard Tennyson 1897-
Born in Provo, Utah on March 2, 1897, he attended the Art Students' League of New York and then studied at the École des Beaux Arts under Injalbert. He became a member of the National Sculpture Society and the American Federation of Artists. He produced many monuments and statues for public and private commissions and is best known for the fountain and sculptural doors of the Tabernacle Cathedral of Eugene, Oregon.

FAIRLEY, George 1920-
Born in Dunfermline, Fife on December 16, 1920, he studied at Edinburgh College of Art and now lives in Horsham, Sussex where he works as a painter and sculptor. His work has been exhibited at the Leicester Gallery and other galleries in the London area.

FAIVRE, Ferdinand 1860-
Born in Marseilles on October 8, 1860, he studied under Cavelier and exhibited at the Salon des Artistes Français, winning several medals and a travelling scholarship (1892) and a bronze medal at the Exposition Universelle of 1900. He sculpted genre and neo-calssical figures. His ornamental fountain is in the Museum of Sete.

FAKITS, Ernö 1883-
Born in Budapest on January 30, 1883, he studied at the School of Arts and Crafts in that city, and later worked in Vienna. He specialised in busts and figures of historical and contemporary Hungarian celebrities, and is best known for his monument to the war heroes Branyiszko and Szepesvaralja.

FALCINI, Louis fl. 20th century
Born in Buenos Aires, he studied there and in Paris and exhibited figures at the Nationale in the 1920s.

FALCONET, Étienne Maurice 1716-1791
Born in Paris on December 1, 1716, he died in Paris on January 24, 1791. Of very humble birth, he was at first apprenticed to a carpenter but some of his clay figures attracted the attention of J.B. Lemoyne in whose studio he subsequently produced his Milo of Croton which secured his admission to the Academy of Fine Arts in 1744. He became an academician ten years later and a professor in 1761. He made his début at the Salon in 1745 with a plaster version of his Milo, sculpted in marble ten years later. During the early part of his career he produced numerous models, classical, allegorical and genre, including the Genius of Sculpture, Science, Music, the Four Seasons, and Pygmalion at the feet of his Statue. In 1758 he was appointed director of sculpture at Sèvres where numerous figurines by him were reproduced in biscuit porcelain which captured the impression of warmth and humanity for which he was renowned. He is best remembered for his elegant renderings of nymphs and similar subjects in the light taste of the 18th century and his immense popularity resulted in the enormous number of inferior casts and outright copies of his works which persisted into the 19th century. His delicate charm and distinctive personality was matched by a powerful and articulate intellect and he helped to break down the rigid classicism of the period in his own voluminous writings, notably *Réflections sur la Sculpture* (1761). His more serious work included both sacred and secular subjects of great power and originality. Among his major works was the colossal statue of Peter the Great which he sculpted and cast in bronze for Catherine the Great in 1766, but he was dissatisfied with working arrangements in Russia and returned to Paris in 1781. Although most of his sculptures were in marble or *biscuit de Sèvres*, he also produced numerous bronze statuettes and many of the latter were also gilded.

Falconet, E.M. *Oeuvres litteraires* (originally published in Lausanne, 1781-82 in eight volumes and since reprinted many times in various editions).

FALCONNIER, Léon 1811-1876
Born at Ancy le Franc on March 10, 1811, he died in 1876. He studied at the École des Beaux Arts under Dumont and Ramey and exhibited at the Salon from 1841 to 1874. He produced numerous figures and groups of biblical and allegorical subjects and also did a number of genre studies of provincial types. His best known work work was a group celebrating the Emancipation of Slaves by Abraham Lincoln. His works were sculpted mainly in marble or plaster.

FALGUIÈRE, Jean Alexandre Joseph 1831-1900
Born in Toulouse on September 9, 1831, he died in Paris on April 19, 1900. He studied under Jouffroy at the École des Beaux Arts and began his career in the conventional classical mould. This is evident in his earliest works, notably The Child Theseus with which he made his début at the Salon of 1857. He won the Prix de Rome two years later with The Wounded Mézence saved by Lausus. On a second visit to Rome in 1864 he did the bronze group Victory in the Cockfight which subsequently won him first prize at the Salon. He also won a gold medal three years later with his figure of Tarcisius the Christian Boy-Martyr. Both of these sculptures are now in the Luxembourg. Tarcisius in particular marked the turning point for Falguière, from classicism to realism, and this was followed by such figures as The Egyptian Dancer (1872) and the statues of Corneille and Cardinal Lavigerie. In his later years, however, he secured too many public commissions and his work tended to degenerate into bombastic allegory, of which The Triumph of the Republic for the Arc de Triomphe was typical. His other major works include the Lafayette monument in Washington and statues of Lamartine, St. Vincent de Paul and Balzac. He also sculpted numerous smaller genre and allegorical works, including Eve, Cicada (silvered bronze) and busts of his artistic contemporaries. He also produced a number of genre paintings, several of which are in the Musée du Luxembourg.

Bénédite, Léonce *Alexandre Falguière* (1902).

FALIZE, Pierre fl. 19th century
He worked in Paris in the late 19th century as a watercolourist and landscape painter who also worked in enamels and dabbled in the sculpture of genre figurines which he exhibited at the Nationale.

FALKENSTEIN, Claire 1909-
Born at Coos Bay, Oregon, she studied at Anna Head School and the University of California graduating B.A. and later teaching at Mills College in Oakland, and the California School of Fine Arts, San Francisco. She worked initially as a painter but turned to sculpture in 1942. At first she carved direct in stone and wood but by the end of the second world war she was also working in plastics, synthetic stone and bronze, producing abstracts used for architectural decoration. In 1950 she settled in Paris where she lived till 1959, and also had a studio in Rome from 1954 onwards. She has abandoned the conventional techniques of sculpture and now works in wire and sheet metal such as iron, brass, copper, and silver, often combined with glass. She has worked in New York since 1959.

FALLANI, Giuseppe fl. 19th century
Born in Rome in 1859, he studied under Ettore Ferrari and Ercole Rossa and won the Prix de Rome for a statue of St. Sebastian. He specialised in ecclesiastical sculpture and decorated many chapels and buildings in the Vatican.

FALLER, Karl 1875-1908
Born at Meggen, Switzerland on May 8, 1875, he died in Paris on November 30, 1908. He studied at the School of Industrial Arts, Lucerne and later the Munich Academy and the École des Beaux Arts, Paris. He exhibited at the Paris Salons from 1900 to 1908 and also in Munich, where he won a silver medal in 1899. He produced numerous figures and groups, including Christ on the Cross, for the choir of the Franciscan church in Lucerne, Adam and Eve (1900), The Prodigal Son, Slaves of Labour, A Poor Woman, Homeless, Adam and similar genre subjects. His sculptures are in the museum of Berne and Geneva.

FALLSTEDT, Ingel 1848-1899
Born in Copenhagen in 1848, he died in Stockholm in 1899. He studied at the Stockholm Academy and then in Munich and Paris. He specialised in busts and bas-reliefs, mainly in marble, but including bronze busts of his contemporaries, such as H. Salmon, G. von Rosen and A. von Becker.

FAMIN, Auguste Pierre fl. 19th century
Born in France in the early years of the 19th century, he studied under David d'Angers and exhibited at the Salon from 1842 to 1852. He specialised in genre figures and classical groups, portrait busts and medallions of historical and contemporary figures.

FANDA, J. fl. 19th century
He originated in Silesia, but studied under Rauch in Berlin and later settled in that city. He exhibited in Berlin, Munich and London, showing a wooden statuette of Shakespeare at the Great Exhibition of 1851.

FANNIÈRE, Auguste François 1818-1900
Born at Longwy on November 20, 1818, he died in Paris on November 29, 1900. He enrolled at the École des Beaux Arts in 1838 and studied under Drolling. He exhibited at the Salon in 1841-76 and specialised in portrait reliefs, medallions and busts. His brother François Joseph Louis Fannière assisted him in this work. Much of his smaller work was used in jewellery.

FANTACCHIOTTI, Cesare 1844-1922
Born in Florence on December 1844, he died there in 1922. He was the son and pupil of Odoardo Fantacchiotti. He was a very prolific artist in every medium of sculpture. He produced numerous portrait busts of people in many parts of the world, classical and allegorical groups, historic statuettes, such as Dante, Leonardo, Savonarola, Molière, etc., and genre figures such as The Thorn, The Shepherdess, The Goatherd and other pastoral subjects. He exhibited in Munich, Venice, Berlin, Florence, Turin, Paris and London.

FANTACCHIOTTI, Odoardo 1808-1877
Born in Rome in 1808, he died in Florence in 1877. He built up a reputation at a very early age, recognised by his admission to several Italian academies. He produced figures and groups in the classical tradition, including allegorical works such as the Angel of Prayer (Cincinnati) and Eve (Museum of Modern Art, Turin) and historical figures such as Boccaccio.

FARAFONTIEV, Michael Jacovlevich fl. 18th century
He was the son of the painter Jacob Gerassimovich Farafontiev and studied at the School of Sculpture in St. Petersburg. He received many awards for his sculptures which were based on his close study of nature. He also sculpted a number of Russian historical figures and groups.

FARAGO, Jozsef fl. 19th century
Born at Ujbanya in Hungary in 1822, he worked in Budapest and studied under Ferenczy. Later he moved to Esztergom where he collaborated with Casagrandi in decorating the basilica. He began exhibiting in Budapest in 1840 with his group Armenia and later he also exhibited such works as The Genius of Hungary in Vienna and Munich. In the latter part of his life he returned to his native town for whom he sculpted the group of St. Stephen, St. Helena and St. Ladislas with the Holy Virgin.

FARAILL, Gabriel Emmanuel 1838-1892
Born at St. Marsal in 1838, he died in Paris in 1892. He studied under Oliva and Farochon and exhibited at the Salon from 1866 to 1882. He specialised in busts and portrait medallions, mainly in marble or plaster, but sometimes also cast in bronze. His bronze genre groups and figures include The Young Flautist. Most of his works are preserved in the Perpignan Museum.

FARAONI, G. fl. 19th century
He worked in Italy in the mid-19th century on genre figures and groups. The museum at Puy-en-Velay has a standing figure by him.

FARINOS, Carmelo fl. 19th century
Born in Valencia he produced genre busts and statuettes including Slave, The Surprise and Gipsy.

FARNUM, Suzanne 1898-
Born at Maeseych, Belgium on May 29, 1898. She studied in Brussels and won a prize in 1927 and the Prix de Rome the following year. She specialised in portrait busts of Belgian royalty and contemporary celebrities. She also sculpted the baptismal font for a church in Cincinnati.

FAROCHON, Jean Baptiste Eugène 1812-1871
Born in Paris on March 10, 1812, he died there on July 1, 1871. He is best known as a medallist, and won the Prix de Rome in this medium in 1835. He also produced quite competent sculpture in the round, including statuary in the Palais de Justice at Chalons and a great number of bronze or marble portrait busts.

FARRELL, James 1821-1891
Born in Dublin in 1821, he died there on November 20, 1891. He was the eldest son and pupil of Terence Farrell and was employed on church decoration. His more important works include the Annunciation in the Church of St. Francis Xavier, Dublin, the Sacred Heart (Sion Hill Convent) and Our Lady of Refuge and Christ in the Temple (Rathmines). He exhibited at the Royal Hibernian Academy from 1846 and showed portrait busts and genre figures. He showed Hunter at Rest at the Dublin Exhibition of 1853 and his Return of the Favourite Pigeon won a prize of the Royal Irish Art Union.

FARRELL, John 1829-1901
Born in Dublin in 1829, he died there in 1901. He was a son and pupil of Terence Farrell and worked mostly on church decoration and ecclesiastical statuary. His best known work, The Holy Virgin, was often reproduced in bronze. He exhibited at the Royal Hibernian Academy from 1839 to 1896. His genre figures and groups include The Bard, Regards by the Sea and Saved from Shipwreck.

FARRELL, Michael 1834-1855
Born in Dublin in 1834, he died there in 1855. The youngest son of Terence Farrell, he worked with his brothers on ecclesiastical statuary and is best known for his figure of Prudence in the Marlborough Street Church in Dublin.

FARRELL, Terence 1798-1876
Born at Creve, Longford in 1798, he died in Dublin on March 19, 1876. He studied under Edward and John Smyth and Thomas Kirk in Dublin and specialised in monuments and memorials in the Dublin area. He also sculpted miniature busts and statuettes of contemporary Irish celebrities. He exhibited at the Royal Hibernian Academy from 1826.

FARRELL, Thomas 1827-1900
Born in Dublin in 1827, he died in Redesdale on July 2, 1900. He was a son of Terence Farrell and studied under Panormo at the Royal Dublin Society School. He won prizes from the Royal Irish Art Union in 1843-46 with his genre and classical groups. Later he exhibited at the Royal Academy and the Royal Hibernian Academy and also travelled in Italy. Several of his statues and monuments may be found in and around public buildings and churches in Dublin. His smaller works include Young Boys with a Dog, Young Boys with a Goat, Nisus and Euryalus and Young Bather Surprised.

FARRELL, William fl. 19th-20th centuries
Yet another son of Terence Farrell, who worked in Dublin at the turn of the century.

FASANINO, Emile Dominique 1851-1910
Born at Sostogno on July 10, 1851, he died in Geneva on January 15, 1910. He studied at the School of Arts and Crafts in Geneva and later studied in France and Italy before settling in Geneva. He worked as a decorative sculptor on public buildings in that city as well as Lausanne and Berne. The Conservatory of Arts and Crafts, Geneva has a number of models, projects, maquettes and other minor works by this artist.

FASSBINDER, Wilhelm 1858-
Born in Cologne on April 20, 1858, he studied under his father-in-law, J. Nothon at Cologne and sculpted numerous monuments and memorials in the cemeteries, churches and parks of Rhenish Prussia. He also produced a number of busts of his contemporaries in Dortmund, Cologne and other cities of the Rhineland.

FASSIN, Adolphe Ferdinand 1828-1900
Born at Seny near Liège on July 14, 1828, he died near Brussels in 1900. He won a medal for his sculpture at the Centennial Exposition, Philadelphia in 1876. His group Acqua sala is in the Brussels Museum.

FASSNACHT, Joseph 1873-
Born at Mittelstreu, Germany on June 11, 1873, he worked for a wood-carver in Wurzburg and studied at the Munich Academy under Eberle and Schmitt. He won the Prix de Rome and later settled in Munich. His works include Maternal Joy, St. Barbara, Young Bacchus and an allegorical female statuette entitled Blossoming. These works were all sculpted originally in marble, but several were later copied in bronze. Other bronzes by him include Young Sparrowhawk, Mother of the Saviour and Ecce Agnus Dei.

FATH, Richard fl. 20th century
Born in Paris at the turn of the century, he studied under J. Boucher and exhibited figures and groups at the Salon des Artistes Français from 1925 onwards, winning an honourable mention in 1925.

FAUCHER, Guillaume fl. 19th century
Born in Paris in 1827, he studied under Dumont and Meusmer and exhibited medallions and relief portraits at the Salon in 1868-70.

FAUDOT, Bernard fl. 20th century
Born in Flogny at the end of the last century, he exhibited statuettes and portraits at the Salon des Artistes Français from 1921 onwards.

FAUGINET, Jacques Auguste 1809-1847
Born in Paris on April 22, 1809, he died there in 1847. He studied under Gatteaux and exhibited at the Salon from 1831 till his death. He produced a large number of portrait busts, religious statuettes and small groups and bas-reliefs of animal subjects, particularly racehorses.

FAURE, Antoine Ferdinand fl. 19th century
Born in Marseilles in the mid-19th century, he studied at the School of Fine Arts in that city and later was a pupil of Cavelier at the École des Beaux Arts, Paris. He exhibited at the Salon from 1882 to the end of the century and specialised in genre and classical bronze figures including Young Mother and her Child, Childhood of Bacchus, Youth (third class medal and a travelling scholarship, 1893). His larger works were sculpted in marble and he was employed on the restoration of sculpture in the Court of Honour at the Palace of Versailles, 1888. Many of his works were designed as decoration for the museum of Egyptian Antiquities, Cairo, inaugurated in 1897.

FAURE DE BROUSSÉ, Vincent Desiré fl. late 19th century
Born in Paris, he studied there under Salmson and exhibited at the Salon from 1876. He was one of the so-called Florentine group of sculptors in Paris whose statuettes of females were strongly influenced by the Florentine Renaissance. He also sculpted various classical subjects and genre busts.

FAURE-VINCENT, Julien fl. 20th century
Born at Cervières, he studied under Niclausse and exhibited at the Salon des Artistes Français in the 1930s, specialising in genre and allegorical works, such as The Call.

FAUSTA VITTORIA, Nicoletti Mengarini fl. 20th century
Born in Rome where he worked in the 1920s as a sculptor of statuettes featuring dancers and small boys. His bronzes were exhibited in Rome and at the Salon des Artistes Français.

FAUTEPEAU DE LA CARTE, Arthur Vicomte de fl. late 19th century
Born at Montmoillon, France in the mid-19th century, he produced a number of female busts and exhibited at the Salon in 1878-79.

FAUTRAS, Albert fl. 19th century
Born at Tours on July 25, 1832, he studied under Préault and exhibited figures at the Salon from 1864 onwards.

FAUTRIER, Jean 1898-
Born in Paris in 1898, he worked mainly as a painter and dabbled in sculpture in the late 1920s and again, for a brief period, in 1943-44. His sculptures are comparatively rare and consist of several Expressionist works, such as Woman with Bare Breasts (cire perdue), Torso (sand-cast), Hostage and a few heads.

FAUVEAU, Félicie de 1799-1886
Born in Florence of Breton parents in 1799, she died in Paris in 1886. One of the great Romantic sculptors of the early 19th century, her work has also been termed neo-Gothic because of its strong penchant for medieval subjects. Her father, a banker, was ruined by the Napoleonic wars and moved from Italy to Besançon where he got a civil service post. Following his death in 1822, she came to Paris and had a studio in the Rue la Rochefoucauld. She modelled in wax and was largely self-taught though she had some advice from Delaroche and Ingres and worked for a time with Hersent. Her figures, groups, bas-reliefs and busts, in plaster and bronze, included a wide range of subjects, from Descent from the Cross to her portrait of King Charles X. Her political sympathies are evident in many of her works. She was a fanatical Royalist like her father and was a staunch supporter of the Bourbon regime. She was a close friend of the Duchess of Berry and was imprisoned late in 1830 when the Bourbons attempted a counter-coup against the Orleanist July Monarchy. She spent seven months in Fontenay Jail but later returned to her painting and sculpture which she had abandoned during the political upheavals of that year. While in prison awaiting trial she did a mural symbolising the political situation in terms of medieval imagery. She was eventually brought to trial at Poitiers but acquitted. She returned to Paris and spurned Delaroche and her erstwhile friends who had espoused the Orleanist cause. She returned to La Vendée in 1832 when there was a second Bourbon uprising and took part in the armed revolt which was easily crushed. With her friend, the Countess of Rochejacquelin she fled to Belgium and was condemned to life imprisonment in her absence. Later she returned to Paris in disguise, secured her personal effects, and moved on to Florence where the Bourbons held court. She purchased a disused convent and established her studio there. She was an extremely talented artist, producing stained glass for the Château d'Ussé and carving wood panels to symbolise the Mirror of Vanity. Many of her sculptures in this period had a strong political bias and included St. George and the Dragon, Judith (the Duchess of Berry) holding up the head of Holophernes (Louis Philippe) which she exhibited at the Salon of 1842. She herself did not return to France till 1852, by which time the Orleanists had been overthrown, the ephemeral Second Republic had suffered a similar fate, and Napoleon III had seized power. During the late 1840s she continued to send sculptures from abroad to the Salon and had her bronzes cast in Paris, though she frequently fell foul of the Marseilles Customs. Relatively few of her works are to be found in France and the majority of them are in Italian museums. Her bronzes include portrait busts of the Duke of Bordeaux and the Duchess of Berry, statuettes of St. Dorothy and St. Elisabeth, the group To the Glory of Dante, Angel trying to purify the Air (Douai Museum), Virgin and Child (Hyères) and the monument to Baron Gros (Toulouse). Her marble group Lamp of St. Michael is the ultimate in the symbolic and allegorical sculpture of the mid-19th century. Her younger brother Hippolyte was a sculptor and architect who studied under her.

FAVERO, Antonio dal fl. 19th century
Born at Ceneda, Italy in 1844, he studied at the Academy of Venice and received many awards for his sculpture. His early works were mostly reliefs of an ecclesiastical nature, but later he did religious statues for Italian churches, such as figures of saints and The Conception. His chief works, however, were the monuments to Garibaldi and Victor Emmanuel II, for which he was awarded the Cross of the Crown of Italy. He was also a painter of some note.

FAVIN, Roger fl. 20th century
Born at Deauville in the early years of this century, he specialised in female busts which he exhibited at the Nationale from 1929 onwards.

FAVRE, Maurice fl. 19th-20th centuries
Born in Paris in the late 19th century, he exhibited figures and portraits at the Salon des Artistes Français, winning an honourable mention in 1896 and a second class medal and a travelling scholarship in 1907.

FAVRE-BERTIN, Charles Maurice 1887-
Born in Paris on November 13, 1887, he studied under G. Greber and C. Monnin and exhibited at the Salon des Artistes Français from 1920 onwards, winning a gold medal in 1929. He specialised in portrait medallions and bas-reliefs.

FAWCETT, Emily Addis fl. late 19th century
She exhibited figures and busts at the Royal Academy in the 1880s.

FAYARD, Georges fl. 20th century
Born in Algiers in the late 19th century, he exhibited at the Salon des Artistes Français in the early years of this century and produced figures and groups.

FAYRAL fl. 20th century
Sculptor of Art Deco bronzes, bronze and ivory figures and silvered or gilt-bronze statuettes of nude and semi-nude females, working in France in the inter-war years.

FAZZI, Arnaldo fl. 19th-20th centuries
Born in Lucca, in the mid-19th century, he studied under Giovanni Dupré and worked in Florence. His chief work was the Garibaldi monument in Genoa (1910), but he also sculpted numerous statuettes in marble and bronze, both portraits and genre subjects.

FAZZINI, Pericle 1913-
Born at Grottamare, Italy he worked in the studio of his father, a wood-carver and cabinet-maker, but later he attended private art schools in Rome from 1929 onwards. He took part in an exhibition in Paris (1934) and the following year exhibited two high reliefs at the Rome Quadrennial – Dance and Storm. Much of his earlier work was carved direct in stone or wood and was noted for its lyrical realism. In 1946, however, he began sculpting figures and groups that explored the movement of bodies and executed works of a novel, but invariably graceful, rhythmic pattern. His bronzes include Gymnast (1948), Woman's Face (1948), Dancer (1948), Dancing Girl (1951), Sibyl (1949) and various versions of Acrobats (1947-52). He had his first one-man shows in Rome in 1943 and 1951 and since the war has exhibited in New York, Venice, Antwerp and Sao Paulo.

FEART, Adrien fl. 19th century
Born at Sedan on April 11, 1813, he studied under Dantan and worked as a designer, medallist and sculptor. He exhibited at the Salon from 1845 to 1879 and worked exclusively in bronze. His works include The Marriage of the Virgin (bas-relief based on the painting by Raphael), and such bas-reliefs as Summer, Autumn, Winter, Spring, Feasting, Dancing and Music. He also produced an ornate Ewer and Basin in silvered bronze.

FEDERLIN, Karl fl. late 19th century
Born in Württemberg, he became sculptor to the Royal Court at Ulm. He is best known for the statues of St. Matthew and St. Batholomew and A.H. Franke, but he also sculpted busts of the Württemberg royal family and various religious statuettes.

FEDI, Pio 1816-1892
Born at Viterbo in 1816, he died in Florence on June 1, 1892. He was apprenticed to a jeweller in Florence and later worked for a copperplate engraver in Vienna. On his return to Florence he studied sculpture. He exhibited in Rome and established a reputation for his religious statuary. He also sculpted neo-classical and genre figures such as The Rape of Policene, The Florentine (Walker Gallery, Liverpool) and Poesy (Verona Civic Museum).

FEER, Cambon fl. late 19th century
She worked in Paris in the 1880s and sculpted historical and allegorical figures.

FEHR, Henry Charles 1867-1940
Born at Forest Hill, London on November 4, 1867, he died in London on May 13, 1940. He studied at the Royal Academy schools, winning several medals and an Armitage scholarship. He exhibited at the Royal Academy from 1887 and was one of the few English sculptors to participate in the Libre Esthétique Exhibition in Brussels. His bronze of Perseus rescuing Andromeda was purchased in 1894 under the Chantrey Bequest and is now in the Tate Gallery. He was a founder member of the Royal Society of British Sculptors in 1904. He also sculpted genre and allegorical bronzes, such as Morning.

FEHRLE, Wilhelm 1884-
Born in Schwäbisch-Gmund on November 27, 1884. He studied at the Academies of Berlin and Munich and later worked for a time in Rome and Paris. He participated in the Great Berlin Exhibitions of 1907-8 and later exhibited also in Stuttgart and at the Salon d'Automne in Paris. He did wood-carvings of religious subjects and bronze animal figures and groups.

FEICHTINGER, Carl 1838-1877
Born at Stubenberg, Styria on November 1, 1838, he died at Wiltern on January 15, 1877. He studied under Gschiel at Graz and later worked in Vienna, Munich and Wiltern. He sculpted religious figures, groups and bas-reliefs and is best known for the statue of St. Joseph and the high altar in the parish church of Graz (1865).

FEINBERG, Hirsch Bernarovich fl. 19th-20th centuries
Born at Georgenburg, Russia, in the mid-19th century he moved to Paris where he became naturalised and worked there at the turn of the century on genre figures and groups.

FEIST, Otto 1872-
Born at Karlsruhe on November 18, 1872, he studied at the Karlsruhe School of Arts and Crafts. He specialised in busts, heads and bas-reliefs, mostly in bronze. His works include busts of professors Göhler, Groh, and F.L.S. Meyer, bas-reliefs of the Grand Duke Frederick I and Grand Duchess Louise, and female statuettes. His works in other materials include an alabaster figure of Rübezahl, busts of children in wood and allegorical and genre figures in marble, such as Dream. He exhibited in Berlin and at the Crystal Palace, Munich from 1904 onwards.

FEITU, Pierre Luc 1868-
Born at Mur de Bretagne on April 16, 1868, he worked in Brest and sculpted monuments, memorials, busts, bas-reliefs and allegorical figures. His bronzes include Glory, Salome and Sisyphus. His chief work was the monument to Albert I of Belgium. He exhibited at the Salon des Artistes Français, the Nationale and also in New York, Philadelphia, Pittsburgh and Mexico City. Many of his works are in American museums.

FELDER, Katharina Maria 1816-1848
Born at Ellenbogen, near Bezau on January 15, 1816, she died in Berlin on February 13, 1848. She studied design in Constance and sculpture at the Munich Academy and for a time worked in the studio of Schwantaler where she executed the stone group of Faith, Hope and Charity. She later settled in Berlin where she did the equestrian statue of St. George. Her minor works consist mainly of religious figures, such as St. Sebastian and Virgin kneeling before the Infant Christ.

FELDERHOFF, Reinhold 1865-
Born at Elbing on January 25, 1865, he studied under Begas at the Berlin Academy and went to Italy in 1885 to complete his studies. He later had a studio in Berlin where he sculpted neo-classical figures and groups, such as Diana (Berlin Museum).

FELICI, Augusto fl. late 19th century
Born in Rome in 1851, he studied at the Institute of Fine Arts there and exhibited in Rome and Venice in the 1880s. He specialised in genre busts and heads but one of his most notable works was the series of six marble bas-reliefs bearing allegories of the sciences, which he sculpted for the Palazzo Franchetti in Venice. Later he went to India and became sculptor to the Maharajah of Baroda (1892), producing many bas-reliefs, statues and busts in bronze and marble for his palace. His works in this period include Crouching Violinist, Brahmin and Hunt with a Tame Leopard. He also worked in Buenos

Aires for some time and sculpted the monument to Argentinian Poets. His monument to St. Anthony stands in Padua. He also sculpted a number of modernistic allegories, such as Turbine (Gallery of Modern Art, Rome).

FÉLON, Joseph 1818-1896
Born at Bordeaux on August 21, 1818, he died in Nice in 1896. He was self-taught and worked as a painter and lithographer as well as sculptor. He exhibited at the Salon from 1840 to 1882, producing a number of busts and bas-reliefs in marble and bronze bas-reliefs and statuettes of classical subjects such as Galatea, Andromeda and Amphitrite.

FENOSA, Apel'les 1899-
Born in Barcelona on May 16, 1899, he studied under Casanovas in Barcelona and went to Paris where he lived for eight years. He returned to Barcelona in 1929 but in the closing months of the civil war he left Spain for good and has spent the rest of his life in Paris. He was a prominent member of the Spanish artistic colony in Paris and has had numerous important State commissions, producing large-scale monuments of which the most notable was the memorial to the victims of the Nazi destruction of Oradour-sur-Glane, commissioned by the Museum of Modern Art. Among his other large works are the Three Reigns fountain and a group of the Four Seasons. His earliest works (1920-39) were carved direct in stone and marble, but since then he has worked almost exclusively in bronze. Apart from his large monuments, he has sculpted numerous portrait busts of his artistic contemporaries, including Colette, François Poulenc, Tristan Tzara and Henri Michaux, Jean Cocteau, Paul Eluard, Dora Maar and Jean Marais among others. Since the second world war he has also sculpted a number of statuettes, mainly allegorical nudes and draped female figures such as Storm driven away by Fine Weather (1958).

FENTON, Beatrice 1887-
Born in Philadelphia in 1887, she studied at the School of Industrial Art and the Pennsylvania Academy of Fine Arts. She sculpted bronze allegories and statuettes. Her best known work is the Seaweed fountain in Fairmount Park, Philadelphia.

FEO, Luigi di fl. early 20th century
Born in Lombardy in the mid-19th century, he sculpted genre figures and groups and worked in Venice in the early years of this century. He exhibited in Venice, Turin and Paris bronzes such as Adolescent (1909).

FERBER, Herbert 1906-
Born in New York in 1906, he trained as a dentist before studying sculpture at the National Academy of Design where he held his first exhibition in 1930. He sculpted abstracts with a deep psychological or allegorical meaning and worked in lead and bronze. He has had a number of one-man shows at the Midtown Gallery since 1937 and since exhibited in many other American galleries. He also took part in the Jeu du Paume exhibition in Paris, 1938 and the New York World's Fair, 1939-40. His chief work is the large abstract for the Millburn synagogue (1952). Since 1950 his works have become entirely abstract with a feeling of lightness and airiness.

FERECZY, Istvan 1792-1856
Born at Rimaszombat, Hungary on February 23, 1792, he died there on July 4, 1856. He studied in Budapest and also at the Vienna Academy before going to Rome where he worked with Canova and Thorwaldsen. He specialised in marble busts and statues, many of which were subsequently cast in bronze. On his return to Hungary, he settled in Budapest where he played an important part in the revitalising of sculpture as an art in Hungary.

FERGUSON, Duncan 1901-
Born in Shanghai on January 1, 1901 of American parents, he works in Newark, New Jersey as a sculptor of portraits and figures.

FERGUSON, Eleanor M. 1876-
Born in Hartford, Connecticut on June 30, 1876, she studied under C.N. Flagg in Hartford and under Daniel Chester French and G.G. Bernard in New York. She produced figures and groups of genre subjects.

FERIGOULE, Claude fl. late 19th century
Born in Avignon on April 20, 1863, he studied under Falguière at the École des Beaux Arts. He collaborated with Félix Charpentier in sculpting the colossal monument commemorating the annexation of Venaissin to France. He was the curator of Arles Museum and also Director of the drawing school in that town. His sculptures include various busts and genre groups, such as The Woodcutter (1892), Thanks (1894) and A Negro of Guinea fighting a Snake.

FERLET, Adolphe Auguste fl. 19th-20th centuries
Born in Paris on March 9, 1867, he studied under Carlus, Hiollin and Claudis Mariston. He specialised in bas-reliefs, medallions and plaques and exhibited at the Salon des Artistes Français at the turn of the century.

FERNAND-DUBOIS, Émile 1869-
Born in Paris on July 27, 1869, he studied under Sul-Abadie and Dalou. He specialised in genre figures and groups, in marble, terra cotta and bronze. He exhibited at the Salon des Artistes Français from 1902, winning a third class (1910), second class (1911) and first class (1922) medals.

FERNANDES DE SA, Antonio fl. late 19th century
Born in Portugal in the mid-19th century, he produced portraits and neo-classical figures and groups such as The Raising of Ganymede (1898).

FERNANDEZ DE LA OLIVA, Manuel fl. 19th century
Born in Madrid in the first half of the 19th century, he studied at the Academy of San Fernando and late became professor of sculpture at the School of Fine Arts in Cadiz and Seville. He collaborated with his father Nicolas in sculpting a number of important monuments in Madrid. His minor works consist mainly of genre and neo-classical statuettes, such as Andromeda (1862) and First Disenchantment.

FERNANDEZ DE LA OLIVA, Nicolas fl. 19th century
Born in the early years of the 19th century in Madrid, he studied at the Academy of San Fernando and became one of the creators of the artistic circle in Madrid in the middle of the century. He is best known for his monumental statuary, notably the statues of Cervantes and Columbus in Valladolid, but he also sculpted a number of statuettes and groups of historical, allegorical and genre subjects.

FERNANDEZ GUERRERO, José fl. 19th century
Born in Spain, he studied at the School of Fine Arts in Cadiz and became an honorary member of the Academy of San Fernando, Madrid in recognition of his work as a sculptor of monuments, notably the statue of Queen Maria Isabella de Braganza. His minor works include busts, portraits reliefs and statuettes of classical subjects.

FERNANDEZ PATTO, Lucien fl. 19th-20th centuries
Born in Paris, where he worked as a sculptor of busts, reliefs and figures at the turn of the century. He became an Associate of the Artistes Français in 1902 and got an honourable mention four years later.

FERNKORN, Anton Dominik Ritter von 1813-1878
Born in Erfurt, Thuringia in 1813, he died in Vienna in 1878. He specialised in busts and portrait reliefs of the nobility and royalty of Austria and southern Germany.

Aurenhammer, H. *Anton Dominik Fernkorn* (1959).

FERRAN, Adriano fl. 18th-19th centuries
He studied at the School of Fine Arts in Barcelona and settled in Palma de Majorca where he specialised in statues of saints and bas-reliefs for altars and church ornament. He was awarded the Prize of Honour at the Barcelona Exhibition of 1815.

FERRAN, Augusto 1813-1879
Born at Palma de Majorca in 1813, the son and pupil of Adriano Ferran, he died in Havana, Cuba on June 28, 1879. He specialised in portrait reliefs and busts which he regularly exhibited in Madrid.

FERRAND, Ernest Justin fl. late 19th century
Born in Paris on November 6, 1846, he studied under Levasseur and Mathurin Moreau. He exhibited genre and allegorical works, such as By the Sword and By the Plough and Morning at the Salon des Artistes Français, of which he became an Associate in 1891.

FERRANT, Angel 1891-
Born in Madrid, the son of a painter. He taught himself the elements of sculpture and completed his education in Germany, Italy and France. He settled in Barcelona in 1928 and became a member of the avant-garde art movements, Els Evolucionistes and Amics de l'Art Nou. He taught modelling and drawing in a Barcelona school and specialised in mobiles and bas-reliefs, the latter being developed since 1950.

FERRARI, Bartolomeo 1780-1844
Born at Marostica en Vicenza on July 18, 1780, he died in Venice on February 8, 1844. He studied sculpture under his uncle Giovanni Ferrari and worked as a decorative sculptor in various churches and public buildings in Ferrara and Vicenza and also sculpted the ornament on the triumphal arch in Milan. His minor works include a number of portrait bas-reliefs and busts of Venetian society.

FERRARI, Ettore fl. 19th century
Born in Rome on March 25, 1849, he was the son of Filippo Ferrari. He sculpted numerous monuments and statues of contemporary celebrities on both sides of the Atlantic. His figure of Abraham Lincoln is in the Metropolitan Museum of Art, New York. He was awarded a Grand Prix at the Exposition Universelle of 1889.

FERRARI, Febo fl. late 19th century
Born at Pallanza on December 4, 1865, he studied at the Royal Academy in Turin and emigrated to the United States where he specialised in architectural decoration.

FERRARI, Filippo 1819-1897
He spent his entire life in Rome where he worked as a decorative sculptor on public buildings, churches and palaces. He produced a number of statues, notably Rebecca (1880). His minor works include maquettes and projects for a monument to Victor Emmanuel II and a series of bas-reliefs for the façade of the Palace of Arts in Rome.

FERRARI, Gaetano fl. 19th century
Born in the late 18th century, the son of Giovanni Ferrari, he studied under Rinaldo Rinaldi in Venice. He sculpted numerous ornaments for churches and public buildings in Venice, particularly the bronze lion beside the main window of the façade of St. Mark's. He also sculpted heads of nymphs and a bas-relief of Christ crowned with Thorns. He also produced a number of portrait busts, mainly in marble, of Venetian celebrities.

FERRARI, Giovanni (or Torretti) 1744-1826
Born in Crespano in 1744, he died in Venice in 1826. He was also known as Torretti, the surname of his uncle, Giovanni Torretti who first taught Canova. He worked in Mantua, Modena, Bologna, Rome and finally Venice, sculpting public monuments and statuary, mainly in marble. His minor works, however, include bronze statuettes and bas-reliefs and plaster or terra cotta figures for church decoration, mostly in Venice.

FERRARI, Giuseppe 1773-1864
He spent his entire life in Ferrara and studied under Ténerani. He became professor of sculpture at Ferrara University and sculpted numerous memorials for Ferrara cemeteries. His other work includes various statues, allegorical groups and bas-reliefs

FERRARI, Juan M. 1874-1916
Born in Montevideo on May 21, 1874, he died in Buenos Aires on October 31, 1916. He was one of the most important Latin American sculptors at the turn of the century. He won a travelling scholarship which took him to Europe in his youth and enabled him to study under Ettore Ferrari and Ercole Rosa in Italy. He produced numerous high-reliefs, statues and busts of his contemporaries, and monuments in the classical style in stone and bronze. His chief works were the monument to Mendoza, commemorating the Passage of the Andes, and the memorial to General San Martin.

FERRARI, Luigi 1810-1894
Born in Venice on June 21, 1810, he died there on May 13, 1894. He was the son and pupil of Bartolomeo Ferrari and established a reputation while still in his youth, with such figures as The Virgin and his group of Laocoon. He became professor at the Venice Academy in 1851 and produced a large number of bas-reliefs and busts of historic and contemporary personalities, as well as classical groups, such as David and Goliath and Endymion.

FERRARINI, Agostino fl. 19th century
Born at Moletolo, Parma in 1828, he studied under Tomas Bandini when he was only nine years old. He became professor at the Academy of Parma in 1865 and sculpted numerous ornaments on the public buildings of Parma and various statues and groups, mainly in marble. His works include the monument to the physician Guglielmo da Saliceto and allegories of Charity and Courage.

FERRARY, Desiré Maurice 1852-1904
Born at Embrun in 1852, he died at Neuilly-sur-Seine in 1904. He studied under Cavelier and exhibited at the Salon des Artistes Français from 1879 onwards, winning the Prix de Rome in 1882 and a silver medal at the Exposition Universelle of 1889. His works include Narcissus, Snake Charmer, Belluaire provoking a Panther, Mercury and Cupid and similar neo-classical groups.

FERRAT, Charles Hippolyte Marcelin 1830-1882
Born at Aix on April 26, 1830, he died there on February 27, 1882. He studied at the École des Beaux Arts under Duret and specialised in bronze statuettes and groups of classical and historical subjects. Aix Museum has his group of Cyparissa mourning the death of her deer.

FERRAT, Jean Joseph Hippolyte Romain 1822-1882
Born at Aix on August 9, 1822, he died there on October 24, 1882. He studied at the École des Beaux Arts under Pradier and was runner-up in the Prix de Rome of 1850. He exhibited at the Salon from 1849 to 1870. His works include Fall of Icarus, The Death of Achilles and similar bronze statuettes, allegorical groups and portrait busts of historical and contemporary personalities, in marble or bronze. His works are in various museums in Paris and Aix.

FERRAUDY, Berthe 1878-
Born in Paris on April 15, 1878, she studied under Coutan, Moreau-Vauthier and Max Blondat and exhibited figures and small groups at the Salon des Artistes Français from 1906 onwards.

FERRER, Alberto fl. early 20th century
Born in Florence in 1870, of Neapolitan origin, he studied in Naples. With Pellegrino he worked on the two sphinxes for the University of Florence. He specialised in genre and neo-classical bronzes, such as Misanthrope (1901) and Serenetta (1907). He exhibited in Florence and Munich in the early years of this century.

FERRERI, José fl. 19th century
Born at Lerida, Spain, he studied at the School of Fine Arts in Barcelona and specialised in ecclesiastical ornaments which may be found in the churches, cathedrals and monasteries of Barcelona and Montserrat.

FERRIER, André Pierre fl. 20th century
Born in Paris, he exhibited figures and groups at the Nationale before the second world war.

FERRIÈRES, Armand de 1873-
Born in Paris on July 14, 1873, he was the son and pupil of L.F.G. Ferrières and Maillol. He exhibited statuettes and animal groups at the Salon des Artistes Français from 1905.

FERRIÈRES, Louis François Georges, Comte de fl. 19th century
Born in Paris on November 10, 1837, he exhibited at the Salon from 1865 to 1893 and specialised in animal figures and groups, particularly of dogs and horses.

FERRU, Félix 1831-1877
Born at Limoges in 1831, he studied at the École des Beaux Arts, Paris and exhibited at the Salon from 1866 to 1877. His works include numerous busts in marble and bronze and genre figures such as Disdainful Girl, Love taming the Sphinx, Snake Charmer and Young Athenian watering Myrtle.

FERRU, Marceau fl. 20th century
Born in Algiers, he studied in Paris under Landowski and exhibited figures at the Salon des Artistes Français from 1933 onwards.

FERRY, Adrien fl. 19th century
He worked at Auch and died there some time before 1885. He may have been the son of Vincenzo Ferri, an Italian ecclesiastic decorator. He worked on a statue of Vice Admiral de Villaret-Joyeuse, and various models and maquettes by him survive, though the monument itself was actually sculpted by E. Nelli in 1885, after Ferry's death.

FERVILLE-SUAN, Charles Georges fl. late 19th century
Born at Le Mans, he specialised in medallions and statuettes of genre subjects, such as The Village and the Snake, Dancer of the 17th Century and The Cicada. He exhibited at the Salon in the 1870s.

FESQUET, Jules fl. 19th century
Born at Charleval on July 11, 1836, he studied at the École des Beaux Arts under Dantan the Elder and was runner-up in the Prix de Rome of 1862 with his classical group The Shepherd Aristeus stung to Death by Bees. He exhibited at the Salon from 1861 to 1867 and won third class medals in 1861 and 1863. He specialised in neo-classical bronze statuettes and groups, such as Young Faun playing with a Buck, Biblis, The Infant Bacchus, Cassandra in the Palace of Agamemnon, an allegory of the City of New York, and genre groups, such as Aragonese Smugglers (Victoria and Albert Museum).

FESSARD, Madeleine Henriette Louise 1873-
Born at Fécamp on October 7, 1873, she studied under Ségoffin, Gauquié, Sicard and Carli and exhibited statuettes at the Salon des Artistes Français in the 1920s.

FESSARD, Pierre Alphonse 1798-1844
Born in Paris on July 10, 1798, he died there on February 16, 1844. He studied at the École des Beaux Arts under Stouf, Bridan and Bosco and exhibited at the Salon from 1822 to 1843. He specialised in portrait busts of his contemporaries and Italian and French celebrities. His figure of Adonis is in the Grenoble Museum.

FESSLER, Johann 1803-1875
Born in Bregenz on August 29, 1803, he died in Vienna on March 14, 1875. He was the father of the sculptor Leo Fessler. He studied at the Vienna Academy under Anton Peter and Anton Schaller and specialised in busts and religious groups, many of which may be found in Viennese churches.

FESSLER, Leo 1840-1893
Born in Vienna on November 22, 1840, he died in Budapest on November 14, 1893. He studied under Bauer at the Vienna Academy and later worked under Melnitzky. He specialised in portrait busts of his contemporaries.

FEUCHÈRE, Jean Jacques 1807-1852
Born in Paris on August 26, 1807, he died there on June 25, 1852. He studied under Cortot and Ramey and exhibited at the Salon from 1831 to 1852, winning a second class medal in 1834. He became a Chevalier of the Legion of Honour in 1846. He produced a large number of statues and groups with classical, biblical and allegorical themes, many of them cast in bronze, including Saturn and Benvenuto Cellini. He also did a series of bronzes illustrating heroes of French history, including Joan of Arc at the Stake, Simon de Montfort, Comte Jacques de Douglas and Marie Adelaide de France.

FEUERHAHN, Hermann 1873-
Born in Heldesheim on May 20, 1873, he studied under Gundlach in Hanover and Behrens in Breslau and later also in France, Italy and the United States before settling in Berlin. He is best known for the ornament on the façade of the German National Library but he also sculpted numerous small figures and groups in the classical manner.

FEUERSTEIN, Georg 1840-1904
Born at Hinterreuthe near Bezau on October 16, 1840, he died at Bregenz on October 26, 1904. He studied at the Academy of Munich under Knabl and specialised in ecclesiastical sculpture, mostly wood-carving.

FEUERSTEIN, Noël fl. 20th century
Born at Sceaux, France in the early years of this century, he studied under Debarre and exhibited portraits and genre figures at the Salon des Artistes Français in the 1930s.

FEUGÈRE DES FORTS, Vincent Émile 1825-1889
Born in Paris on November 17, 1825, he died there in March, 1889. He studied under Heim and Duseigneur and exhibited at the Salon from 1849 to 1870, winning medals in 1864 and 1866 and also at the Exposition Universelle of 1867. He specialised in busts and genre statuettes, in marble and bronze, including Negress, Archer and Christian Martyr. He also sculpted the ornament in the church of Villette. Chartres Museum has his group The Death of Abel.

FEUILLATRE, Eugène 1870-1916
Born in Dunkirk on April 30, 1870, he died there on September 17, 1916. He exhibited figures and portraits at the Salon des Artistes Français from 1899 onwards, winning medals in 1904-5.

FEVENS, Augustin Joseph 1789-1854
Born at Turnhout in 1789, he died in Brussels on November 6, 1854. He studied at Antwerp Academy and was a pupil of Godecharles. He made his début at the Brussels Salon in 1811 with a bust of Napoleon and five years later his figure of Ariadne Abandoned excited favourable notice. Later he worked in Paris on the statue of Henri IV on the Pont Neuf and on bas-reliefs for the Arc de Triomphe. His minor works include numerous portrait busts of historic and contemporary personalities.

FÉVOLA, Félix Pascal 1882-
Born at Poissy on September 16, 1882, he studied in Paris under Thomas and Injalbert and exhibited romantic and allegorical figures at the Salon des Artistes Français in the early part of this century, winning a gold medal in 1927.

FICHET, Jean 1822-c.1889
Born in Lyons on April 17, 1822, he died about 1889. He studied under Legendre Héral at the Lyons School of Fine Arts (1835-37) and exhibited drawings, paintings and sculpture at Lyons in 1842-43. He worked on ecclesiastical decoration, including bas-reliefs, enamels and mosaics. He did not really come into prominence until the Exposition des Arts Décoratifs in Lyons, 1884. Most of his works are in churches in Lyons and Paris. The Musée des Tissus at Lyons has a number of his maquettes.

FICHTEL, J.N. fl. 19th century
He worked in Nüremberg in the mid-19th century and specialised in portrait busts and reliefs of his artistic contemporaries, as well as statuettes of French officers and soldiers of the Grand Armée.

FIELDSKOV, Niels Voldemar 1826-1903
Born in Copenhagen on April 2, 1826, he died there in 1903. He studied at the Copenhagen School of Fine Arts and worked for a time with H.V. Bissen. He was employed mainly on copying antique sculptures but his original works include figures of King Christian IV and Thor and various allegorical groups such as The Four Seasons. He also did the sculptural ornament on several churches and public buildings in and around Copenhagen.

FIERLAND, Herman de 1835-1872
Born in Antwerp on April 4, 1835, he died in Lyons on February 9, 1872. He studied under Geerts and spent many years in Rome. He specialised in biblical and classical groups, such as Ruth in the Wake of the Gleaners (Lyons Museum).

FIERO, Emilie fl. 20th century
Born at Joliet, Missouri in the late 19th century, she studied in Paris under Injalbert and exhibited at the Salon des Artistes Français in the 1920s. She specialised in bronze and plaster figures of animal and genre subjects, such as Leopard, Cock, Dog, and Father and Daughter.

FIERS, Édouard 1826-1894
Born at Ypres on May 27, 1826, he died near Brussels on December 23, 1894. He studied under Geefs and Simonis at their Brussels art school. He was one of the most prolific and fashionable of sculptors working in Belgium in the 19th century and was awarded the Order of Leopold for his services. He won many important State commissions and sculpted numerous monuments and memorials. Among his minor genre and allegorical works were The Night, Satyr and Cupid, The Infant Bacchus, Sciences and Arts, Commerce and Industry, Innocence, Negress, Slave, Cupid with a Sea-shell, Painting, Sculpture, Architecture, Poetry and Music, Young Neapolitan Fisherman, Child playing with a Dog, The Past, Present and Future and Young Girl. He also sculpted numerous busts of contemporary Belgian personalities.

FIEUZAL, Pierre Léonce Narcisse Félix 1768-1844
Born in Paris on September 20, 1768, he died in Valenciennes in 1844. He was the son of Madeleine Fieuzal, a famous actress whose stage name was Durancy. He studied under Godecharles and was professor of sculpture at Valenciennes Academy from 1809 to 1840. He specialised in portrait busts but also did monumental statuary in marble and plaster.

FIGUERAS Y VILA, Juan 1829-1881
Born in Gerona on July 15, 1829, he died in Madrid on December 28, 1881. He studied under José Piquer y Duart at the Academy of San Fernando, Madrid. He won the Prix de Rome in 1858 with his figure Suzanne in the Bath. He took part in the Madrid International Exhibition of 1860. He specialised in busts and heads, of which he did a vast number. The Museum of Modern Art, Madrid has several of his classical and genre works, including Conversion of an Indian Woman to Catholicism and Hymeneus.

FILEPOVIE, A. fl. 19th-20th centuries
This signature is found on genre bronze statuettes of the turn of the century.

FILHASTRE, Paul Louis Georges fl. 19th century
Born at St. Bazeille on September 18, 1859, he studied in Paris under Chapu and Puech. He exhibited figures and portraits at the Salon des Artistes Français from 1884.

FILIPPI, Paris 1836-1874
Born in Cracow in 1836, he died in Warsaw in 1874. He studied under his father, a genre painter, and then studied sculpture at the Munich Academy. He specialised in memorials, bas-reliefs and portrait busts.

FILIPPOTES, Demetrios fl. 20th century
Sculptor of genre figures and peasant groups, working in Athens in the mid-20th century.

FILLANS, James 1808-1852
Born at Wilsontown, Lanarkshire in 1808, he died in Glasgow on September 27, 1852. He was apprenticed to a weaver in Paisley and then to a stone-mason, but later he went to Glasgow where he taught himself to sculpt figures and busts and bas-reliefs for architectural decoration. His portraits were modelled in wax and then cast in plaster or bronze. In 1835 he went to Paris where he copied various works in the Louvre. The following year he was in London and modelled the bust of Allan Cunningham there. Cunningham introduced him to Chantrey who, in turn, brought him a number of patrons, notably Archibald Oswald whom he accompanied to Vienna and Italy in 1840-41. He later had a studio in Baker Street, London for a time and also worked in Paisley. He returned to Glasgow in 1850 and died there two years later of rheumatic fever, leaving a widow and eight children. He was buried in Paisley where the figure of Grief (designed for his father's grave) was placed over him. He exhibited at the Royal Academy from 1837 to 1850 and at the British Institution in 1847. His numerous busts include those of William Walkinshaw, Mrs. Charles Tennant, John Burnet, Robert Napier, Archibald Campbell, Professor Wilson ('Christopher North'), Colonel Mure and other contemporary Scottish worthies. His monument to William Motherwell (1851) is in the Glasgow Necropolis.

FILLEUL, Charles Alexandre fl. late 19th century
Born at Le Mans, he studied under Cavelier and A. Millet and exhibited figures and reliefs at the Salon des Artistes Français in the 1880s.

FILLEUL, Louis 1891-
Born at Le Mans on March 5, 1891, he was the son and pupil of Charles Filleul with whom he worked on portraits and genre figures.

FILLON, Tony fl. 20th century
Born at St. André du Cubzac at the turn of the century, he studied in Paris under Coutan and exhibited figures and groups at the Salon des Artistes Français and the Tuileries in the 1920s.

FILSJEAN, Roger Victor fl. 20th century
Born at St. Mande, he studied under Niclausse and specialised in nude statuettes, which he exhibited at the Salon des Artistes Français in 1934-36.

FINELLI, Carlo 1786-1853
Born in Carrara on April 25, 1786, he died in Rome on September 6, 1853. He studied under Canova and worked on the decoration of the Apostolic Palace in Rome and the Royal Palace in Turin. He was a painter of historical subjects but also did sculpture, such as the bronze Caryatids on the main altar of Novara Cathedral. He also sculpted a number of busts of Italian historical personalities such as Petrarch and Ariosto and various classical figures such as Juno and the young Mars.

FINNE, Augusta 1868-
Born in Bergen, Norway on March 11, 1868, she studied in Christiania (Oslo) and Copenhagen. The Copenhagen Museum has two portrait busts by her.

FINOT, Alfred 1876-
Born in Nancy on October 13, 1876, he studied under Barrias and exhibited at the Salon des Artistes Français from 1908 till the second world war. He specialised in genre statuettes and small groups, mainly in bronze.

FINTA, Alexander 1881-
Born at Tuckeve in Hungary on June 12, 1881, he emigrated to the United States and became a member of the American Federation of Arts. He specialised in monuments, fountains and statues for public parks and his works may be found in Brooklyn, Rio de Janeiro and Czechoslovakia.

FIORE, Georgia Eleanora fl. 20th century
Born in Philadelphia at the turn of the century, she studied under Frank B. Linton. She specialised in bronze portrait busts and exhibited in Philadelphia, New York and Paris in the 1930s.

FISCHER, Adam fl. 20th century
Born in Copenhagen in the late 19th century, he studied in Copenhagen and Paris and worked there in the inter-war period as a sculptor of bronze busts and portrait reliefs. He was a member of the Salon d'Automne and exhibited at the Tuileries from 1921 to 1931.

FISCHER, Bruno 1860-
Born in Dresden on April 30, 1860, he was the son of the painter Ernest Fischer. He worked in Stuttgart and later in Dresden under Schilling. For some years he also worked in Italy before settling in Dresden where he sculpted a number of monuments and statues distinguished for a sort of classic naturalism.

FISCHER, Carl 1838-1891
Born at Hüttenort Rotehütte on December 8, 1838, he died in Munich on February 22, 1891. He studied under Knabl in Munich and specialised in ecclesiastical statuary and decoration.

FISCHER, Ferdinand Auguste 1805-1866
Born in Berlin on February 17, 1805, he died there on April 2, 1866. He studied at the Berlin Academy, of which he became a member in 1847 and became a member of the Academic Senate the following year. He specialised in portrait bas-reliefs and medallions.

FISCHER, Martin Johann 1741-1820
Born at Bebele on November 2, 1741, he died in Vienna on April 27, 1820. He studied under Tabota and J. Schletterer in Vienna and became a member of the Academy of Fine Art and then, in 1815, the director of the School of Design. Most of his work was done in Vienna and consisted of allegorical, biblical and classical statuary for churches and public buildings.

FISCHER, Povl Gustaf 1860-
Born in Copenhagen on July 22, 1860, he worked as a painter and sculptor of genre subjects from the streets of Copenhagen.

FISHER, Alexander fl. 20th century
Author of a bronze bas-relief at Newcastle-upon-Tyne.

FITA Y ROVIRA, Magin fl. 19th century
Born in Barcelona about 1850, he studied at the School of Fine Arts in that city and exhibited in Barcelona, winning medals in 1871 and 1875 and also participating in the Madrid Exhibition of 1876. He sculpted bas-reliefs and statuettes of allegorical and religious subjects.

FITE-WATERS, George fl. 20th century
Born in San Francisco, he studied under Frank Elwell and then went to Paris, where he worked with Rodin at the beginning of this century. He later returned to the United States and specialised in busts and bas-reliefs.

FITZGERALD, Florence fl. 19th-20th centuries
She was the wife of the sculptor, W. Follen Bishop, and exhibited figures and groups at the Royal Academy, the Royal Society of British Artists and the main London galleries from 1887 until her death in 1927.

FITZRANDOLPH, Grace fl. 20th century
Born in New York at the turn of the century, she studied under Alden Weir and Augustus Saint-Gaudens in New York, and went to Paris, where she was a pupil of Constant, Girardot and Puech. She worked in South Hadley in the early 1900s, sculpting figures and busts.

FIVET, Alphonse Émile 1872-
Born at Noyers-Pont-Maugis on December 27, 1872, he studied under Xavier-Mathieu and exhibited statuettes and reliefs at the Salon des Artistes Français in the 1920s.

FIX, Yvonne fl. 20th century
Born at St. Mande, she sculpted figures and groups and exhibited at the Nationale in the late 1930s.

FIZELIÈRE-RITTI, Marthe de la fl. late 19th century
Born in Paris on April 21, 1865, she studied under Eugène Levasseur and Charles Colas and exhibited at the Salon des Artistes Français from 1890 onwards.

FJELDE, Paul 1892-
Born in Minneapolis on August 12, 1892, he studied at the Minneapolis School of Art, the Beaux-Arts Institute of New York and the Art Students' League. He also worked under Lorado Taft in Chicago and completed his studies at the Royal Copenhagen Academy and the École des Beaux Arts, Paris. He specialised in monuments and memorials in Scandinavia and America, his chief work being the Abraham Lincoln monument in Oslo. His minor works include a number of bronze bas-reliefs and portraits of American contemporaries.

FJELDSKOV, Niels Valdemar 1826-1903
Born in Copenhagen on April 2, 1826, he died in Paris in 1903. He studied under H.V. Bissen and also at the Copenhagen Academy. He worked mainly in wood and made copies of works by Thorwaldsen.

FLACHAT, Jean Baptiste 1828-1896
Born in Lyons on July 15, 1828, he died there on January 19, 1896. He studied at the École de la Martinière in Lyons and worked for a decorative sculptor in Lyons. He became a noted interior designer of the 19th century and was responsible for the furnishings of many châteaux and villas in France.. He also did minor sculpture in the medieval and Renaissance manner, mainly for the ornamentation of furniture. He was professor of decorative art at the Lyons School of Fine Arts in 1894-95 and was awarded the Legion of Honour in the latter year. He won gold medals at the Expositions of 1878 and 1889.

FLADAGER, Ole Henriksen 1832-1871
Born at Nordre Aurdal in 1832, he died in Rome in 1871. He specialised in classical statuettes, such as David and Theseus, and portrait busts of Norwegian contemporary personalities.

FLANAGAN, John fl. 19th and 20th centuries
Born in Newark, New Jersey, in the late 19th century, he studied under Saint-Gaudens in New York and then went to Paris, where he attended the Académie Julian under Chapu and the École des Beaux Arts under Falguière. He won a silver medal at the Exposition Universelle of 1900. Subsequently he worked in Paris for a time before returning to the United States. He specialised in memorials and monuments, bronze and marble bas-reliefs and architectural sculpture. His minor works include a number of bronze portraits and medallions of American celebrities.

FLAXMAN, John 1755-1826
Born in York on July 6, 1755, he died in London on December 3, 1826. He was an infant prodigy, winning the Society of Arts medal at the age of twelve, and began exhibiting at the Royal Academy at the age of fifteen. In the same year (1770) he enrolled at the Royal Academy schools and won the Silver Medal. To this early period belong a number of statuettes, busts and medallions modelled in wax. In 1775 he entered the employment of Josiah Wedgwood and eventually became chief modeller in basaltes and jasperware. At the same time he also sculpted large-scale memorial bas-reliefs in marble and plaster. In 1787 he and his wife went to Rome to superintend the Wedgwood works there and stayed for seven years, copying antique statuary. He became A.R.A. in 1797 and R.A. three years later. He was appointed professor of sculpture at the Royal Academy in 1810. In the ensuing years he sculpted an enormous number of bas-reliefs and friezes, mainly in marble for monuments and memorials. In the last years of his life, however, he also modelled figures and reliefs for interpretation in gold, silver and bronze – presentation pieces, cups and trophies. Apart from his portraits, his work was largely allegorical and classical in subject.
Colvin, S. *Essay on the Life and Genius of Flaxman* (1876).
Constable, W.G. *John Flaxman, 1755-1826* (1927).

FLEISCHMANN, Arthur John 1896-
Born in Bratislava, Slovakia, on June 5, 1896, he studied in Prague, Vienna and Rome and eventually settled in London, where he exhibited at the Royal Academy. He sculpted figures and reliefs in terra cotta, wood, cement and stone, as well as bronze.

FLETCHER, Rosamund M.B. 1914-
Born in Dorking, Surrey, on August 5, 1914, she was the daughter of the painter, Blandford Fletcher, and studied at the Ruskin School, Oxford (1935-37) and the Slade School of Art (1937-39). She exhibited at the Royal Academy, the Royal Scottish Academy, the R.B.A. and other leading British galleries and won the Feodora Gleichen Prize in 1948. She lives in Oxford and sculpts reliefs and figures in stone and bronze.

FLIGHT, W. Claude 1881-1955
Born in London on February 16, 1881, he died in Shaftesbury, Dorset, on October 10, 1955. He worked as an engineer, librarian and farmer for many years before taking up art shortly before the first world war and worked as a landscape painter, watercolourist and engraver, as well as sculptor. He was elected to the Royal Society of British Artists in 1923 and exhibited widely in Europe and America, Australia, South Africa and India, as well as the major British galleries. He worked for several years in the 1930s near Paris and later in London and Shaftesbury. He also wrote several books on engraving and printing.

FLINT, Robert 1880-
Born at Shoreham, Sussex, in 1880, he studied at Putney School of Art (1929-39) and the City and Guilds School, Kennington (1939-41). He exhibited at the Royal Academy and worked on reliefs and portraits, mainly in wood and stone.

FLOCKEMANN, August Christoph Friedrich 1849-1915
Born at Hiddersdorf on April 6, 1849, he died at Radebeul, near Dresden, on July 17, 1915. He studied under H. Martin in Hanover and collaborated with him in the restoration of the sculptures in Güstrow Cathedral. Later he studied under F. Eggers in Berlin and Schilling in Dresden. He specialised in allegorical statues, portrait reliefs, medallions, busts and statuettes of famous contemporary personalities.

FLODIN-RISSANEN, Hilda Maria 1877-
Born in Helsinki on March 16, 1877, she studied at the Helsinki School of Fine Arts before going to Paris in 1900. She exhibited at the Paris Salons from 1901 till the 1920s and specialised in bronze busts and genre statuettes.

FLORIO, Salvator Erseny 1890-
Born in Messina in 1890, he emigrated to the United States and studied at the National Academy of Design. Later he was assistant to Hermon A. MacNeil, A. Stirling Calder and James B. Fraser. His works include the bronze statuette Queen of Atlantis and the polychrome bronze relief The Tribute.

FLOSSMANN, Joseph 1862-1914
Born in Munich on March 19, 1862, he died there on November 20, 1914. He specialised in genre and neo-classical figures and groups and exhibited in Munich, Berlin and Paris at the turn of the century. His group Barbarian Mother hugging her Children to her Breast is in the Munich Glyptothek.

FOCARDI, Giovanni 1842-1903
Born in Florence on May 7, 1842, he died there in September 1903. He spent many years in London, only returning to Florence shortly before his death. He specialised in sculpture in a humorous vein and drew his inspiration from the ordinary people of London. Apart from his genre statuettes he also sculpted figures of Shakespearean characters, such as Othello and Desdemona, and a number of portrait busts. He exhibited at the Royal Academy at the turn of the century.

FOCHT, Frédéric 1879-
Born in Paris on July 17, 1879, he studied under Falguière and exhibited at the Salon des Artistes Français at the turn of the century, winning the medal of honour in 1900. He specialised in portrait busts and reliefs, but also sculpted a number of war memorials in Lor and Carcassonne after the first world war. He was also an opera singer of note.

FODOR, Madeleine fl. 20th century
Born in Budapest, she studied there and in Paris, where she exhibited statuettes at the Salon d'Automne in the inter-war years.

FOERSTER, Charles H. fl. early 20th century
Born in Lwow of Austrian parents in the late 19th century, he later settled in France and became naturalised after the first world war. He studied under Coutan and exhibited at the Salon des Artistes Français, winning a third class medal in 1914.

FOGELBERG, Bengt Erland 1786-1854
Born in Göteborg, Sweden, in 1786, he died in Trieste in 1854. He studied at the Stockholm Academy and went to Rome in 1820. On his return to Sweden he became Sculptor to the Court. He specialised in historic subjects and groups influenced by classical antiquity and Scandinavian mythology, and had a tremendous following in Sweden. Poor health obliged him to return to the warmer climate of the Adriatic, but he died on the journey. The museums of Göteborg and Stockholm have numerous examples of his works, including Venus, Apollo, Helena and Psyche from the classical world and Odin, Thor and Baldur from Norse mythology. He also sculpted busts of Swedish celebrities.

FOIT, Franta (Francis) Wladimir fl. 20th century
Born in Bohemia at the turn of the century, he studied in Prague and Paris, where he settled after the first world war. He specialised in portrait busts, heads and reliefs, which he exhibited at the Salon des Tuileries in the 1920s. He also sculpted a bronze group, The Lost Centuries.

FOLDES, Lenke 1899-
Born in Ujpest, Hungary, on August 12, 1899, she studied in Budapest and Paris and specialised in genre and allegorical figures, mainly carved direct in marble. Her works include Marbles and Stones (1928) and Maternity (1925).

FOLEY, John Henry 1818-1874
Born in Dublin on May 24, 1818, the son of a grocer, he died on August 27, 1874 in Hampstead, London. He had little formal education but followed his brother Edward in the Royal Dublin Society's schools in 1831-33 and in the latter year won the first prize for modelling and drawing. In 1834 he joined his brother in London and later studied at the Royal Academy schools, where he won the large silver medal. He exhibited at the Royal Academy from 1839 to 1861, becoming an A.R.A. in 1849 and R.A. in 1858. His first important commission came in 1840, when he did the group of Ino and Bacchus for Lord Ellesmere. In 1844 he exhibited Youth at the Stream, which was widely acclaimed, and in the same year he was commissioned to do the statues of John Hampden and Selden for the Houses of Parliament. Subsequently he was a prolific sculptor of statuary and monuments in England, Ireland and India. He became a member of the Royal Hibernian Academy in 1861 and an Associate of the Belgian Academy of Arts two years later. His chief works include the statue of Prince Albert and the group of Asia for the Albert Memorial in London, Stonewall Jackson (Richmond, Virginia) and the statue of Sir James Outram in Calcutta. His minor works in bronze include Winter, Summer, Egeria and Norseman and he also designed presentation pieces and trophies for execution by silversmiths, and the Great Seal of the Confederate States of America.
Monkhouse, W. Cosmo *The Works of J.H. Foley* (1875).

FOLGUERAS Y DOIZTUA fl. 19th-20th centuries
Born in Oviedo about 1860, he worked in Madrid as a sculptor of genre figures and groups. He was awarded a silver medal at the Exposition Universelle of 1900. The Museum of Modern Art, Madrid, has his group The Tooth Extraction.

FOLKARD, Edward 1911-
Born in London on May 16, 1911, he was the son of the painter

Charles James Folkard and studied at the Goldsmiths' College School of Art and the Royal Academy schools. He has exhibited at the Royal Academy and the other leading British galleries and was elected R.B.A. (1950) and F.R.B.S. (1955). He works in London as a sculptor of figures and portraits.

FOLLIN DE LA FONTAINE, Octave, Comte de fl. late 19th century
Born at Lude, France in the mid-19th century, he exhibited at the Salons of Paris from 1880 onwards. He specialised in genre statuettes and groups in marble or bronze, such as Intoxication (1880) and Bather (1882).

FOLTZ, Ludwig the Younger 1809-1867
Son of the painter Ludwig Foltz the Elder, he was born at Bingen on March 23, 1809 and died at Munich on November 10, 1867. He studied sculpture under Scholl at Mainz and later attended the Munich Academy. He worked in the studio of Schwanthaler in 1832 and later specialised in monumental sculpture and did the ornament for the throne room of Munich Castle. He also sculpted numerous memorials and portrait reliefs. At the other extreme he produced a large number of statuettes in bronze or ivory, and tiny humorous figures intended as chess pieces.

FONDERIE, Henri fl. 19th century
Born in The Hague in 1836, he studied under A. Toussaint in Paris and worked in Alsace-Lorraine on the decoration of churches at Lodebach, near Colmar. He exhibited at the Paris Salons allegorical works in marble, such as the Muse of Memory (1861), but specialised in bronze and terra cotta bas-reliefs, plaques and medallions.

FONFREIDE, Victor fl. 20th century
Born at Volvic, France in the late 19th century, he worked as an engraver and painter as well as a sculptor of genre figures and portraits. He was a member of the Société Nationale des Beaux Arts and exhibited at that Salon in 1922-24.

FONQUERGNE, Marcel 1873-
Born in Paris on September 23, 1873, he studied under Falguière and Perrin and exhibited figures and groups at the Salon des Artistes Français from 1923 onwards.

FONQUERNIE, Jean Paul fl. 20th century
Born in Toulouse at the turn of the century, he studied at the École des Beaux Arts in Paris and exhibited statuettes and reliefs at the Salon des Artistes Français in the 1920s.

FONT, Constantin 1890-
Born at Auch on January 11, 1890, he studied under Cormon in Paris and won the Prix de Rome in 1921. He exhibited at the Paris Salons, winning silver and gold medals in 1921-22. He was made a Chevalier of the Legion of Honour in 1935. He worked as a painter and engraver as well as a sculptor of medallions and bas-reliefs.

FONTAINE, A. Victor fl. 19th century
He worked at St. Amour, France in the 1860s, specialising in allegorical medallions and genre figures, such as Regret.

FONTAINE, Emmanuel fl. 19th-20th centuries
Born at Abbeville on December 8, 1857, he studied under Jouffroy and exhibited at the Salon from 1877 to 1882 and at the Salon des Artistes Français from 1887 to 1904. He won a silver medal at the Exposition Universelle of 1900 and numerous awards at the Salons from 1893 to 1904. He was made a Chevalier of the Legion of Honour in 1910. He specialised in genre figures and groups, such as The Shipwreck, Woodcutter of Grève-Coeur, To the Water, Porthos!, Fascination, and First Thrill.

FONTAINE, Gustave Adolphe fl. 20th century
Born in Brussels in the late 19th century, he studied in Brussels and Paris and exhibited busts of children, genre figures and masks at the Salon d'Automne in the 1920s.

FONTAINE, Henriette Marie fl. 20th century
Born in Bordeaux at the turn of the century, she worked in Paris in the inter-war period. She studied under Févola and specialised in genre figures and portraits.

FONTAINE, Jean Adolphe fl. 19th-20th centuries
Sculptor of Belgian origin, working in Paris at the turn of the century. He became an Associate of the Artistes Français in 1901.

FONTANA, Carlo 1865-

Born at Carrara on October 20, 1865, he studied in Carrara and Rome and worked as a watercolourist and etcher as well as sculptor of bas-reliefs and historical figures. His bronze of The Water Carrier is in the Museum of Modern Art, Paris.

FONTANA, Giovanni Giuseppe 1821-1893

Born in Carrara in 1821, he died in London in 1893. He exhibited at the Royal Academy (1852-86) and also the British Institution and the New Water Colour Society. As a sculptor, he specialised in classical and allegorical groups, including Cupid captivated by Venus, Hero, Capture of Love, Patrocles and Achilles, The Sleepwalker and Antique Vase.

FONTANA, Lucio 1899-

Born in Santa Fé, Argentina, in 1899, he was brought to Italy by his parents in 1905 and studied at the Academia Brera in Milan. He broke away from the academic conventions in 1930 and joined the Abstraction-Création movement four years later. During the second world war he worked in Argentina and returned to Italy in 1946, where he has since developed his ideas on Spatialism, striving to break down the barriers between painting and sculpture.

FONTANA, Luigi 1827-1908

Born at Monte San Petrangeli in 1827, he died in Rome at the end of December 1908. He studied under Palmaroli in Macerata and Minardix in Rome and worked as a painter and architect as well as a sculptor. He specialised in ecclesiastical ornament, his best known work being the tomb of Minardi. He also sculpted a number of portrait busts.

FONTANA, Luigi fl. 19th century

Born in Milan, he studied at the Academy in that city before emigrating to Argentina. He worked as a sculptor in Buenos Aires and Rosaria and produced a number of monuments to Argentine national heroes, notably General San Martin (Buenos Aires). He also sculpted the Columbus monument in Rosario. His minor works include genre figures and groups, such as The Orphans.

FONTENELLE, Charles Claude 1815-1866

Born at St. Marcel de Félines on June 16, 1815, he died in Paris on May 29, 1866. He studied under David d'Angers and exhibited at the Salon from 1843 to 1851. He sculpted bas-reliefs and ecclesiastical ornament, mainly in stone.

FORAND, Antony fl. early 20th century

Born at La Rochelle in the late 19th century, he attended the École des Beaux Arts, Paris, and specialised in genre figures. The museum at La Rochelle has his Young Beggar.

FORANI, Madeleine Christine 1916-

Born in Arlon, Belgium in 1916, she trained as an archaeologist before studying art at the Brussels Academy in 1942 and working in the studio of Marnix d'Haveloose, but was arrested by the Gestapo and sent to Dachau concentration camp. After she was freed in 1945 she returned to Brussels and studied under Zadkine at the Académie de la Grande Chaumière. She first exhibited her sculpture in Naples in 1949 and had her first individual show in Brussels in 1952. She represented Belgium in the competition of 1953 for the Unknown Political Prisoner and participated the same year in the Salon de le Jeune Sculpture. In 1954 she won a travelling scholarship which took her to the Congo, where she studied primitive art. This influenced her development away from her earlier figurative work to pure abstract, and this was reinforced by her sojourn in Central America in 1958-59. Since then her abstracts have been executed in hammered iron, glass paste, enamels and plastics. Her work in more conventional materials belongs to the period 1948-55.

FORCEVILLE-DUVETTE, Gédéon Alphonse Casimir 1799-1886

Born at St. Maulvis on February 12, 1799, he died in Amiens on January 30, 1886. He exhibited at the Salon from 1845 to 1880 and produced a wide range of sculpture, including busts, statues and monuments in the classical idiom, mainly in marble. His bronzes include portrait busts of his contemporaries, a statuette of St. Cecilia and a figure of The Barber. Some of his smaller works were also reproduced in Sèvres porcelain.

FORD, Edward Onslow 1852-1901

Born in Islington, London on July 27, 1852, he died in London on December 23, 1901. He studied painting at the Antwerp Academy (1870) and sculpture in Munich (1871-74), where he married Anne Gwendolen, daughter of Baron Franz von Kreuzer. He returned to England in 1874 and settled in Blackheath. He made his début at the Royal Academy in 1875 with a bust of his wife which attracted favourable notice. He continued to exhibit at the Royal Academy till his death and became A.R.A. in 1888 and R.A. in 1895. He sculpted a number of monuments, notably those of Sir Rowland Hill (Royal Exchange), Sir Henry Irving as Hamlet (Guildhall, 1883), General Gordon (Khartoum and Chatham, 1890), Shelley (Oxford, 1892) and Lord Strathnairn (Manchester, 1895). His works were characterised by great force and expression. Many of his larger works were published as bronze reductions and his minor work also includes a large number of busts of his contemporaries and genre statuettes. Among the busts which he modelled may be mentioned those of Millais, Alma-Tadema, Sir Walter Armstrong, Huxley, Herbert Spencer and the Duke of Norfolk. Among the statuettes are Folly, The Singer, Applause, Peace, Echo and Head of a Young Girl. His works are in many public collections in Britain and other countries. He was one of the pioneers of polychrome sculpture, decorating his bronzes with champlevé enamels to heighten their exotic appearance.

FORD, George Henry 1912-

Born on July 13, 1912, he studied at the Hornsey School of Art under Harold Youngman and has exhibited figures and heads at the Royal Academy, the Royal Scottish Academy and leading provincial galleries. He was elected A.R.B.S. in 1944 and F.R.B.S. in 1955. He works in the London area.

FORESTIER, fl. 20th century

Born in Paris at the turn of the century, he exhibited figures at the Salon des Artistes Français in the 1920s.

FORESTIER, Antonin Clair 1865-1912

Born in Cannes on October 18, 1865, he died in January 1912. He studied under Gauthier and Charpentier at the École des Beaux Arts and specialised in busts and portrait medallions. He worked in Victoria, Australia, for some time and sculpted portraits of Melbourne society.(1891-93). His genre works include Sea Wolf, Bacchante, The Hurricane and the Leaf, and First Desire.

FORESTIER, Gabriel fl. early 20th century

Born at Eymet in the late 19th century, he studied in Paris and won a travelling scholarship in 1922. He exhibited at the Nationale from 1922 to 1935, winning a silver medal in 1925 and a gold medal in 1934. He specialised in genre statuettes.

FORESTIER, Roland 1806-1885

Born in Moirans on May 15, 1806, he died at Lons-le-Saunier on June 14, 1885. He studied under J.J.C. Bourgeois at Lons and specialised in statues and bas-reliefs for churches and parks.

FORESTIER-BARBÉ, Andrée fl. 19th-20th centuries

Born at Liverdun, where she worked as a sculptor of figures and bas-reliefs at the turn of the century.

FORETAY, Alfred Jean 1861-

Born at Morges on January 12, 1861, he studied under Falguière and exhibited statuettes and portraits at the Salons at the turn of the century, winning an honourable mention in 1891 and a third class medal in 1904.

FORGEOT, Claude Édouard fl. 19th century

Born at Moule, France, in 1826, he studied under Rude in Paris and exhibited at the Salon from 1853 to 1877 and the Salon des Artistes Français in the 1890s. He produced a number of portrait busts of his celebrated contemporaries, such as Knight in Armour and Bohemian Girl.

FORMILLI, Attilio 1866-1933

Born in Alexandria, Egypt, on June 8, 1866, he died in Italy in 1933. He studied under Rivalta at the Florence Academy and settled in that city, where he specialised in busts. His portraits include Schopenhauer (Berlin, 1899) and Moise Supino, founder of the Pisa municipal museum. At the Florence exhibition of 1896 he showed a figure of Christ on the Cross.

FORNANDER, Andreas 1820-1903
He studied at the Stockholm Academy and worked in Sweden as a sculptor of animal subjects. The Stockholm Museum has the original model of his Roe-Deer.

FORNEY, Clarisse fl. late 19th century
Born in Paris, she studied under Madame Léon Bertaux and exhibited at the Salon in 1881-82. She specialised in bronze portraits of her contemporaries.

FORRES, Agnes Freda fl. 20th century
Born in Weybridge, Surrey, at the turn of the century, she studied painting and sculpture under Charles Jagger. She produced portrait busts in bronze and plaster and exhibited in London and Paris in the inter-war period.

FORREST, Norman John 1898-1972
Born in Edinburgh on September 30, 1898, he died there in 1972. He studied at the Edinburgh College of Art and also worked under Thomas Good. He exhibited at the Royal Scottish Academy, the Glasgow Institute and other galleries in Scotland and England, and was elected A.R.S.A. in 1943. He is best remembered for his bas-reliefs in the Cunard liners *Queen Mary* and *Queen Elizabeth*, but he also sculpted bronze busts of his artistic contemporaries, notably that of Sir Robert Helpman. A retrospective exhibition of his sculpture was held at the Royal Scottish Academy, Edinburgh, in 1974.

FORSBERG, P. William fl. 20th century
Born in Sweden at the turn of the century, he studied in Paris under M.E. Fernand-Dubois and exhibited figures and portraits at the Salon des Artistes Français in 1927-32.

FORSELLES, Sigrid Maria Rosina 1866-
Born at Evois in Finland on May 4, 1866, she settled in Paris and worked as a sculptress of genre figures. Her bronze statuette of Youth and a bas-relief, The Combat, are in the Helsinki Museum.

FORSMANN, Alma fl. 19th century
Born at Lojo, near Helsinki, in 1845, she worked in Helsinki as a sculptress of portrait busts, reliefs and roundels, in marble, plaster and bronze, particularly of musicians, singers and composers.

FÖRSTER, Richard 1873-
Born in St. Petersburg on September 25, 1873, he studied at the Städel Institute, Frankfurt and the Frankfurt Academy and was a pupil of Rümann. He settled in Munich and exhibited at the Crystal Palace from 1904 onwards. He was a member of the Munich Sezession and also exhibited at the Paris Salons. He specialised in statuettes, busts and medallions in bronze, silvered bronze and marble.

FÖRSTER, W. fl. 20th century
Sculptor working in East Berlin and Leipzig since the second world war. He specialises in figures of athletes and portrait busts of international celebrities of the sporting world.

FORSYTH, James 1826-1910
Born in London in 1826, he died there in 1910. He exhibited at the Royal Academy from 1864 to 1889 and specialised in genre and classical statuettes. His figure of Andromeda is in the Sydney Museum.

FORSYTH, James Nesfield fl. 19th-20th centuries
Born in London on October 11, 1841, he studied at the Royal Academy schools and the École des Beaux Arts. He exhibited at the Royal Academy, the Salon des Artistes Français and other galleries on both sides of the Channel and produced portrait busts and statuettes.

FORT, Louis Pierre Gustave fl. 19th century
Born in Bordeaux in the first half of the 19th century, he studied in Paris and exhibited at the Salon from 1868 onwards, specialising in figures and bas-reliefs.

FORTIN, Josephine (née Thierry) fl. 19th century
Born at Caen, she worked there as a sculptor of busts and statuettes, specialising in French historical and contemporary heroines. She exhibited at the Salon from 1864 to 1873.

FORTINI, Edoardo fl. 20th century
Florentine sculptor, working in the first half of this century. He exhibited figures in Florence, Milan, Rome and Paris before the first world war.

FORTNER, Andreas 1809-1862
Born in Prague on June 16, 1809, he died in Munich on March 14, 1862. He worked in Munich from 1840 onwards and sculpted memorials, bas-reliefs and portraits.

FOSCHINI, Pedro Maria fl. early 19th century
Born in Lisbon, he was the son of the painter Arcangelo Forchini and studied sculpture under J.J. de Aguiar, the Portuguese Court Sculptor. He was employed on the decorative sculpture of Ajuda castle in 1822 and also sculpted reliefs and statuary. His name is sometimes given as Fosquini.

FOSHKO, Josef fl. 20th century
American sculptor of Russian origin, he worked in Worcester, Massachusetts, in the first half of this century. The Worcester Museum has a collection of his figures and reliefs.

FOSSÉ, Athanase 1851-1923
Born at Allonville on January 7, 1851, he died there on June 18, 1923. He studied under Cavelier and exhibited at the Salon from 1876. He produced numerous busts of his contemporaries and various figures, such as Joan of Arc as a Prisoner, The Woodcutter and The Wave, and an allegorical group, The Night of December 4, 1851, symbolising the Bonapartist coup.

FOSSE, Desiré 1862-1913
Born at Nantillois on January 10, 1862, he died there in December, 1913. He exhibited statuettes and busts at the Salon des Artistes Français, winning a third class medal and a travelling scholarship in 1890.

FOSSES-MENGELLE, Pierre Émile fl. early 20th century
Born at Bagnères de Bigorre in the late 19th century, he exhibited figures and groups at the Salon des Artistes Français from 1903 onwards.

FOSTER, Enid 1896-
Born in San Francisco on October 28, 1896, she studied under Chester Beach and sculpted portrait reliefs and busts.

FOUACE, Guillaume Romain 1827-1895
Born at Réville in May 1827, he died in Paris in 1895. He worked in Paris as a painter and sculptor and studied under Yvon. He exhibited at the Salon from 1870 onwards, paintings of still life and genre figures.

FOUGÈRE, Germaine fl. 20th century
Sculptor of statuettes working in Paris before the second world war.

FOULONNEAU, Charles fl. 19th century
He worked at Quintin, France, in the late 19th century, sculpting portraits in marble and bronze.

FOUQUES, Henri Amédée 1857-1903
Born in Paris in 1857, he died there in 1903. He exhibited at the Salon from 1881 and specialised in hunting scenes and genre groups, such as The Siesta and Five o'Clock.

FOUQUET, Émile François 1817-
Born in Paris on June 13, 1817, he studied under Foyatier and exhibited at the Salon from 1865 to 1879, specialising in busts and bas-reliefs in wax and bronze.

FOURAUT, Célénie fl. 19th century
Born in Paris, where she worked in the late 1880s as a sculptor of figures and portraits.

FOURCADE, Dominique Philippe Jean fl. early 20th century
Born at Plan in France in 1871, he studied in Paris and exhibited at the Salon des Artistes Français from 1899 onwards, winning a second class medal in 1908. He specialised in medallions and bas-reliefs.

FOURCADE, F. de fl. 19th century
Portrait sculptor working in Dieppe in the late 19th century. He specialised in busts and portrait reliefs of his artistic contemporaries. His portrait of Saint-Saens is in the Saint-Saens Museum.

FOURDRIN, Adrien fl. 19th century
Born in France in the early 19th century, he exhibited at the Salon from 1849 and specialised in genre heads, roundels and small groups, such as Memory of Childhood, Study of a Head with Flowers and various heads of children.

FOURIÉ, Albert Auguste 1854-
Born in Paris in 1854, he studied under Gautherin and exhibited at the Salon from 1877 onwards, mainly as a painter. In the early part of his career, however, he sculpted heads of girls.

FOURNIER, Édouard fl. 19th century
Born in either Orleans or Dijon in the mid-19th century, he studied under Georges Lemaire and exhibited at the Salon des Artistes Français (third class medal 1889).

FOURNIER, Louis fl. 19th century
Born at St. Donat in the first half of the 19th century, he exhibited bronze and marble plaques and medallions of contemporary French celebrities at the Salon from 1864 to 1872.

FOURNIER, Paul 1856-
Born in Paris in 1856, he was better known as a playwright and drama critic, but he also sculpted busts and figures of theatrical personalities and Shakespearean characters. His bust of Ophelia is in Nice Museum and his statue of Shakespeare stands on the Boulevard Haussmann in Paris. He also sculpted the statue of Balzac at Tours.

FOURNIER, Pierre Émile fl. 19th century
Born in Paris on May 20, 1829, he studied painting under Couture and Émile Lecomte and sculpture under Barye and Frémiet. He exhibited at the Salon from 1866 to 1878 and worked as an Animalier, supplying zoos and veterinary colleges with anatomical drawings and models.

FOURNIER DES CORATS, Pierre 1884-
Born at Moulins near Paris, he studied under Coutan and exhibited figures and genre groups at the Salon des Artistes Français in the inter-war period, winning a bronze medal (1928), silver (1929) and gold medal (1933). He was made a Chevalier of the Legion of Honour in 1934.

FOURNIER-SARLOVÈZE, M. de fl. 19th century
Born in Paris in 1845, she exhibited watercolours, medallion portraits and bas-reliefs at the Salon from 1868 to 1880.

FOURNIER-SARLOVÈZE, Raymond Joseph de fl. 19th century
Born at Moulins on January 9, 1836, he exhibited portrait busts and bas-reliefs at the Salons of Paris. He was an Associate of the Artistes Français from its inception and an Officier of the Legion of Honour.

FOURQUET, Léon Charles fl. 19th century
Born at St. Forget on December 20, 1841, he studied under Jouffroy and exhibited at the Salon from 1866 to 1880. He specialised in statues and statuettes of classical and allegorical subjects, mainly in wood, plaster or marble.

FOURQUET, Napoleon fl. 19th century
Born at Dôle on August 15, 1807, he studied at the École des Beaux Arts in 1934-35 and was a pupil of David d'Angers. He exhibited portrait busts at the Salon from 1842 to 1857.

FOURREAU, Jacques François 1736-1795
Born about 1736, he died in Paris in 1795. He exhibited at the Salon in 1791 only, showing a bronze bas-relief of the Fall of the Bastille and a project for the tomb of Mirabeau.

FOURRIER, Odette fl. 20th century
Born in Paris at the turn of the century, she studied at the École des Beaux Arts and exhibited statuettes at the Salon des Artistes Français in the 1930s.

FOUSSEDOIRE, Émile J. fl. 19th-20th centuries
He worked at Pierrelage at the turn of the century and exhibited figures and reliefs at the Salon des Artistes Français from 1888 onwards.

FOWKE, Thomas fl. mid-19th century
He exhibited portraits and genre figures at the Royal Academy from 1851 to 1877.

FOYATIER, Denis 1793-1863
Born at Bussière on September 22, 1793, he died in Paris on November 19, 1863. He studied under Marin at the Lyons School of Fine Arts and came to Paris on a scholarship. He studied at the École des Beaux Arts in 1817-20. He was regarded as an infant prodigy, modelling animals in clay or carving them in wood from a very early age. He later did a number of sensitive animal groups, but worked mainly as a sculptor of ecclesiastical statuary and friezes, Virgins and crucifixes. He exhibited at the Salon from 1820 onwards, winning a gold medal for his Young Faun. His most important work is the statue of St. Mark for Arras Cathedral. Later he studied in Rome and from there he submitted to the Salon of 1827 his figure of Spartacus breaking his Chains. Subsequently he produced a number of large monuments and public statues, but also sculpted portrait busts and genre statuettes.

FRACASSI, Patrizio fl. late 19th century
He worked in Siena, where he died early in 1904. He studied at Siena Academy and specialised in genre groups, such as Work and Humanity.

FRACCAROLI, Innocenzo 1805-1882
Born at Castel Rotto, Italy in 1805, he died in Milan in 1882. He studied in Venice, Milan and Rome and became professor of sculpture at Florence Academy in 1842. He was also a member of the academies of Milan and Venice. His works include various portrait busts and statuettes and classical groups such as Venus de Milo (Walker Gallery, Liverpool), Wounded Achilles (Milan Modern Gallery), Cyparis mourning the Death of her Stag (Milan) and Slaughter of the Innocents (Belvedere Palace in Vienna).

FRAGONARD, Antonin fl. 19th century
The grandson of the painter Honoré Fragonard, he died in the asylum of Charenton in 1887. He exhibited statuettes of a Dancer and Aurora at the Salon of 1882.

FRAIKIN, Charles Auguste 1817-c.1890
Born at Herenthals, Belgium, on June 14, 1817, he died at Schaerbeek near Brussels about 1890. He studied at Antwerp Academy and exhibited there and in Brussels from 1846 and also at the Royal Academy, London in 1879. He became a Chevalier of the Order of Leopold in 1848 and an Officier ten years later. He was a member of the Belgian Royal Academy from 1847 and a member of the Academic Council from 1882. He produced a number of busts of Belgian celebrities, including Queen Marie-Henriette and King Leopold I (Ypres) and many genre and classical figures and groups, such as The Mother of Moses (Antwerp Museum) and Venus and Cupid (Brussels).

FRAISSE, Édouard 1880-
Born at Beaune on May 14, 1880, he specialised in groups and reliefs with a sporting theme. He exhibited at the Salon des Artistes Français, the Nationale and the Salon d'Automne. He was made a Chevalier of the Legion of Honour in 1929 and won a gold medal at the Exposition Internationale of 1937. His works are in various museums, mainly in the Burgundy region of France.

FRALEY, Laurence K. 1897-
Sculptor working in Portland, Oregon, in the early part of this century.

FRAMPTON, Sir George James 1860-1928
Born in London on June 16, 1860, he died there on May 21, 1928. He studied under W.S. Frith at the Lambeth School of Arts, soon after the modelling and sculpture course was introduced, and later at the Royal Academy schools from 1881 to 1887, winning the gold medal and a travelling scholarship. He finished his studies in Paris under Mercié and became strongly influenced by the Symbolist movement and also by the Arts and Crafts movement and the teachings of Ruskin and Morris. He exhibited at the Royal Academy from 1884, becoming A.R.A. ten years later and R.A. in 1902. He was knighted in 1908 and was President of the Royal Society of British Sculptors in 1911-12. He exhibited internationally and received many awards including Grand Prix at the Expositions Universelles of 1889 and 1900. He eventually became the most prominent English sculptor of his time and a leading figure in the Arts

and Crafts movement. His earlier work, from 1884 to 1893, followed the conventional pattern and was dominated by portrait busts and classical figures in marble or plaster. Then he began experimenting with polychrome or tinted plaster and later turned to combinations of different metals and techniques, such as *répoussage* and enamelling, which he used to great effect at the turn of the century. To this period belong his most interesting works such as the polychrome plaster Mysteriarch, or the Lamia in ivory, bronze, marble and gemstones. He experimented with decorative sculpture combining many different materials and strove to associate the fine arts (sculpture) with the applied arts. This is illustrated vividly in his bronze, beaten copper and silver panels of allegorical subjects in the Art Nouveau style. In the last phase of his career he produced a number of large monuments, not only for Britain but for many parts of the Commonwealth, from Winnipeg to Calcutta, and he sculpted the controversial monument to Edith Cavell in London. He is best remembered for the naturalism of such statues as Peter Pan in Kensington Gardens. There were various bronze reductions of the figure of Peter and a companion (though less well-known) figure of Wendy. His statuettes of Music and St. Mungo are in the Glasgow Museum and Art Gallery and La Belle Dame sans Merci in the Museum of Modern Art, Venice.

FRANCE, Raphael 1877-
Born in Amsterdam on July 13, 1877, of French parents, he studied in Amsterdam, The Hague, Brussels and Paris and exhibited at the Brussels and Paris salons in the early years of this century. Examples of his statuettes and busts are in the museums of The Hague, Ixelles and Lyons.

FRANCE DE SOUZA, Francisco fl. 20th century
Born in Madeira, where he worked in the early years of this century as a sculptor of portraits and genre figures.

FRANCESCHETTI, Giovanni 1816-1845
Born at Brescia in 1816, he died in Milan in 1845. He worked as a decorative sculptor on the Appiani monument in Milan and the statues on the Arco Sempione.

FRANCESCHI, Alessandro 1789-1834
Born in Bologna in 1789, he died there in 1834. He studied under G. di Maria and specialised in memorials and tombs, the tomb of Berilacqua at Ferrara being his best known work. He also sculpted a number of figures such as Venus and Birth of Christ.

FRANCESCHI, Emilio 1839-1890
Born in Florence in 1839, he died in Naples in 1890. He worked mainly as a wood-carver, though late in his career he sculpted in marble and bronze. His bronzes include the portraits of Eulalia Christiania and Fossor (both in the Galeria Moderne, Rome).

FRANCESCHI, Jean Paul Paschal 1826-1894
Born at Bar-sur-Aube on March 26, 1826, he died at Besançon on March 18, 1894. He was the younger brother of Jules Franceschi. He won first prize for sculpture at Besançon, where he studied from 1839 to 1841. Later he attended the École des Beaux Arts in Paris and studied under Rude and Carpeaux. On his return to Besançon he worked on statues and bas-reliefs for the churches in that district. He also produced a number of busts, medallions and portrait reliefs, memorials and tombs.

FRANCESCHI, Jules 1825-1893
Born at Bar-sur-Aube on January 11, 1825, he died in Paris on September 1, 1893. He studied under Rude and exhibited at the Salon from 1848, winning medals in 1861-69 and becoming a Chevalier of the Legion of Honour in 1874. He worked in marble or stone on statues and bas-reliefs, but his minor works include a large number of bronzes, including Young Shepherd bleeding his Sick Dog, Young Huntress teasing a Fox, The Awakening, Religion, War and Art, Painting, Fortune and similar allegorical figures, the statue of Kamineski and portrait busts of Princess Solovoy and Albert Wolff.

FRANCESCHI, Marguerite (Madame Poire) fl. 19th century
The daughter and pupil of Jules Franceschi, she exhibited at the Salon in 1883-85 and specialised in portrait busts.

FRANCEYS, Samuel 1762-1829
Born in Liverpool in 1762, he died there in 1829. He had a statuary company in Liverpool, producing chimney pieces, ornaments and statuettes in marble, stone and bronze. He dissolved his partnership with his brother Frank in 1819 and his place was taken by W. Spence and the firm continued under the name of Franceys & Spence till 1844. The company produced a large number of monuments, memorials, medallions, bas-reliefs and busts portraying Lancastrian worthies.

FRANCHINA fl. 19th century
This signature appears on statuettes of French historical personalities, apparently produced by a sculptor working in Troyes in the mid-19th century.

FRANCHINA, Nino 1912-
Born in Palmanova di Udine in 1912 of Sicilian parents, he spent his youth in Palermo before moving to Milan in 1936. He studied there and later in Rome, and after war service joined the Fronte Nuove delle Arte. He lived in Paris from 1947 to 1950 and exhibited at the Venice Biennale from 1948 onwards. His pre-war figurative work was strongly influenced by Arturo Marini, but since 1950 he has abandoned figurative sculpture and concentrated on abstracts such as his monumental Order Number 60124 (1959). Many of his post-war works, such as Metallurgy and Aerodynamic (both 1953) are executed in sheet metal, but others, notably New Reality (1949) and Trinacria (1955) are cast in bronze.

FRANCI, Agostino fl. 19th century
After completing his studies at the Milan Academy (1860-65) he went to work in Seville and Regla near Cadiz, where he sculpted bas-reliefs and statuary till 1867.

FRANCIA, Angelo fl. 19th century
He worked in Rodez (died 1883) and specialised in bronze portrait medallions, reliefs and busts of French celebrities of the late 19th century. He exhibited at the Salon from 1867 to 1882.

FRANCILLON, René 1876-
Born in Geneva on December 28, 1876, he studied under A. Martin at the School of Industrial Arts in that city. He is best known for his paintings and watercolours, but he also produced portraits and genre figures, which he showed at the Munich Exhibition in 1909.

FRANCIN, Guillaume 1741-1830
Born in Paris in 1741, he was the son and pupil of the monumental sculptor Claude Francin (1702-67). Later he studied under the Coustou brothers and specialised in busts and allegorical groups, mainly in marble. He exhibited at the Salon from 1793 to 1800.

FRANCISCO, Antonio fl. 18th century
He died in Lisbon about 1795. He studied under José d'Almeida and worked in the royal bronze foundry in Lisbon on classical figures, such as Mars and Vulcan.

FRANCISQUE fl. 20th century
Art Deco bronzes bearing this signature were produced by a sculptor working in Marseilles in the 1920s.

FRANCK, Jean François fl. 19th century
Born in Ghent, Belgium on November 30, 1804, he studied under his father, who was an ornamental sculptor, and later he went to Paris where he was a pupil of David d'Angers. He became professor of sculpture at Louvain and produced historical, romantic and genre figurines and portrait busts.

FRANCKE, Rudolf 1860-
Born in Nantschutz, Germany, on August 6, 1860, he studied at the Berlin Academy and settled in that city. He paid several visits to the German colonies in Africa and the Pacific, studying wild life and native types. Though mainly known for his drawings and sketches of German colonial life, published in books and magazines, he also modelled statuettes of the same subjects. His chief work as a sculptor was the monument to G. Hagenbeck.

FRANÇOIS, Auguste fl. 19th century
Born at Neuville-sur-Orne at the beginning of the 19th century, he studied under David d'Angers and Rude in Paris and exhibited at the Salon from 1848 onwards. He specialised in allegorical, heroic and biblical groups, in marble, plaster or bronze.

FRANÇOIS-CURILLON fl. 19th-20th centuries
Bronzes bearing this signature were produced by a sculptor working in Tournus at the turn of the century.

FRANK, Bernhard 1770-1836
Born at Etlingen in 1770, he died in Stuttgart on November 29, 1836. He studied in Heidelberg, Karlsruhe and Stuttgart and became sculptor to the Württemberg Court. He produced bas- and high-relief portraits in lead and bronze for tombs and memorials. His bronze relief of Friedrich Schiller was shown at the Schiller Exhibition, Weimar, in 1884.

FRANK, Theresia fl. 18th-19th centuries
Born in Lucerne in the mid-18th century, she died there on August 18, 1810. She was the wife and assistant to Friedrich Schafer and collaborated with her son on monumental statuary. Her own works include a statuette of William Tell and the figure of a Milkmaid.

FRANKENSTEIN, John d. 1881
Sculptor and painter of German origin, working in Cincinnati, Philadelphia and New York.

FRANKLIN, Ben 1918-
Born in Petworth, Sussex on February 7, 1918, he studied under R.H. Marlow at the Croydon School of Art and under H. Wilson Parker at the Goldsmiths' College School of Art. He has exhibited at the Royal Academy and other leading galleries in Britain and works in Farnham, Surrey, where he sculpts figures and portraits in stone, wood and concrete as well as bronze.

FRANOZ, François Charles c.1850-1908
He worked in Paris as a sculptor of figures and groups which he exhibited at the Salon des Artistes Français from 1889 to 1904.

FRANTZ, Julius 1824-1887
Born in Berlin in 1824, he died there on December 16, 1887. He studied at the Academy under Wichmann the Younger and F.A. Fischer and later worked in the studios of Wredow and Rauch. The Leipzig Museum has his statuette of Clio and the group Shepherd attached by a Panther.

FRASER, Elizabeth Bertha (née Marks) 1914-
Born in Teddington, Middlesex, in 1914, she studied at the Birmingham School of Art, the Central School of Art, Westminster School of Art and Edinburgh College of Art. She specialises in heads, busts and relief portraits and exhibits regularly at the Society of Portrait Sculptors. Her works are modelled in wax, plaster and bronze.

FRASER, James Earle 1876-
Born in Minnesota in 1876, he studied in Paris under Falguière. He produced numerous portraits, reliefs, figures and memorials and received many awards at the exhibitions of the various American art societies. Among his works are the John Ericsson statue and various portrait busts of American presidents in the Senate, Washington, and the figure of Benjamin Franklin in the Franklin Institute, Philadelphia. Minor works include Head of a Faun and At the End of the Trail.

FRASER, Laura Gardin 1889-
Born in Chicago on September 14, 1889, she studied sculpture at the Art Students' League under James E. Fraser (1907-10) and later married him. She became a member of the National Academy of Design in 1916 and won the Julia Shaw prize four years later for her bronze of a Baby Goat. She specialised in animal studies and her other bronzes include Snuff (a bronze puppy) and Young Porker. She also designed the bicentenary medal commemorating George Washington, 1932.

FRATIN, Christophe c.1800-1864
Born in Metz about 1800, he died at Raincy on August 16, 1864. He was the son of a taxidermist, from whom he acquired a sound knowledge of animal anatomy. Later he studied painting under Pioche and Géricault from whom he picked up his affinity for horses and equestrian subjects. He began exhibiting at the Salon in 1831, showing wax models of the English Thoroughbred 'Farmer' and a study of Two Bulldogs fighting over a Hare. He worked exclusively as an Animalier and produced numerous small bronzes of dogs, horses, domestic animals and wild creatures and their prey. He exhibited at the Salon from 1831 to 1839 and from 1850 to 1864. The principal collection of his works, in plaster, terra cotta and bronze is in Metz, but his works are also strongly represented in the Wallace Collection (London), the Eisler Collection (Vienna) and the Peabody Institute (Baltimore). Among his best known works is the group of Two Eagles guarding their Prey in New York's Central Park.

FRECCIA, Pietro 1814-1856
Born at Castelnuovo di Magra on July 24, 1814, he died in Florence on July 22, 1856. He specialised in genre and allegorical figures, such as Love (Prato Gallery).

FRECOURT, Maurice 1890-
Born at Charenton in 1890, he studied under Valton and J. Boucher and worked as an Animalier, exhibiting figures and groups at the Salon des Artistes Français in the inter-war years.

FRÉDÉRIC-TOURTE, Pierre Marc 1873-
Born at Cazères on July 11, 1873, he studied under Falguière and exhibited at the Salon from 1899 onwards. He was awarded a gold medal in 1925 and a silver medal at the Exposition Internationale of 1937. He sculpted genre figures and groups.

FRÉDIC, S. fl. 20th century
Born in Paris at the turn of the century, she sculpted statuettes and small groups which she exhibited at the Salon des Artistes Français in the 1920s.

FREDRIKSEN, Stinius 1902-
Born in Oslo in 1902, he studied there and in Copenhagen and worked in Norway before the second world war in stone, plaster and bronze on portraits and figures.

FREEBORNE, Zara Malcolm c.1861-1906
Born in Allentown, Pennsylvania about 1861, she died in Boston on May 31, 1906. She was primarily a portrait painter and studied under William Rimmer of Boston, before travelling to Italy in the late 19th century. While in Florence she turned to sculpture and established quite a reputation for genre figures and portraits.

FREESE, Ernst 1865-
Born at Nauen, Germany on January 24, 1865, he studied at the Berlin Academy from 1885 to 1894 under Albert Wolff, F. Schaper and E. Herter. He continued his studies in Italy in 1895-96 and later settled in Berlin. He specialised in portrait busts of his contemporaries and genre figures. His group Girls in the Bath is in the Berlin Museum.

FREI, Hans 1868-
Born in Basle on April 30, 1868, he studied at the School of Industrial Arts under Joseph Hollubetz. Later he studied in Vienna, Berlin, Cologne, Geneva and Paris. He produced portraits and genre figures and won a bronze medal at the Exposition Universelle of 1900.

FREITAG, Rudolf 1805-1890
Born in Breslau on February 1805, he died in Danzig in May 1890. He studied in Vienna under Schaller and Kasamann and worked with Thorwaldsen in Rome where he subsequently lived for many years. He specialised in portrait busts of German royalty and aristocracy.

FRÉMIET, Emmanuel 1824-1910
Born in Paris on December 6, 1824, he died there on September 10, 1910. He was the nephew and pupil of Rude and exhibited at the Salon from 1843. His early career was as a lithographer and he held the position of painter of cadavers at the Paris morgue. Later, however, he built up a formidable reputation for his large-scale monuments and equestrian statuary, but, at the same time, he also produced numerous small figures and groups of animals. He became a member of the Academy in 1892 and an honorary member of the Royal Academy in 1904. He succeeded Barye as professor of animal drawing at the Natural History Museum. Apart from his numerous animal studies he sculpted historical figures, including several versions of Joan of Arc, St. George, Velasquez, Colonel Howard, Duguesclin and Louis d'Orleans.

Beiz, Jacques de *E. Frémiet, un Maitre Imagier* (1896).
Faure-Frémiet, Philippe *Frémiet* (1934).

FREMONT, L. Charles fl. 19th century
Sculptor working in Paris at the turn of the century, on romantic and genre figures and groups.

FREMY, Édouard Pierre Desiré 1829-1888
Born in Paris on January 17, 1829, he died there on July 15, 1888. He exhibited at the Salon from 1865 to 1879 and specialised in bronze medallions, plaques and reliefs portraying his contemporaries. Some of these profiles are also known in terra cotta.

FRENCH, Daniel Chester 1850-1931
Born at Exeter, New Hampshire on April 20, 1850, he died in 1931. He studied under Dr. William Rimmer in Boston (1870-71) and then went to Italy where he studied under Thomas Ball in Florence (1874-76). He also studied at the Massachusetts Institute of Technology and worked in the studio of John Q.A. Ward. His first major work was the statue of The Minute Man, erected at Concord, Massachusetts shortly before the Centennial celebrations in 1875. His best known work is the allegorical group of Death staying the Hand of the Sculptor which he produced for the tomb of the sculptor Martin Milmore in the Forest Hills cemetery, Boston. Thereafter he sculpted numerous monuments and memorials, from the colossal Republic at the Chicago Exposition of 1893 and the Lincoln Memorial in Washington (1920) to the American First Division war memorial in Washington (1924). He exhibited regularly in Rome and Paris and won a third class medal at the Salon of 1892 and the Grand Prix at the Exposition Universelle of 1900. Among his other public statues are Spirit of Life, Alma Mater (Columbia University) and Memory (Metropolitan Museum of Art, New York). His minor works include numerous portrait busts of his distinguished contemporaries and historical political personalities for the Senate in Washington.
French, Mrs. W.H. *Memories of a Sculptor's Wife* (1928).

FRENCH, David M. 1827-1910
Born in New Market, in 1827, he died in Newburyport, Massachusetts on April 19, 1910. He worked in Boston as a sculptor of monuments and memorials, portraits and reliefs, mainly in plaster and marble.

FRENER, Johann Baptist 1821-1892
Born in Lucerne, Switzerland on December 10, 1821, he died in Guatemala on May 1, 1892. He studied under Franz Schlatt in Lucerne and Antoine Bovy and Pradier at the École des Beaux Arts, Paris. He specialised in plaques and medallions, but also sculpted a number of busts of contemporary poets and dramatists. He travelled widely in Italy, France and Germany before settling in Guatemala in 1854. He was awarded a gold medal at the Exposition Internationale of 1878.

FRENET, Jean Baptiste 1814-1889
Born in Lyons on January 31, 1814, he died at Charly on August 12, 1889. He attended the Lyons School of Fine Arts and studied under Bonnefond, before enrolling at the École des Beaux Arts, Paris in 1834. From there he went to Rome and then established a studio in his native town. He exhibited at the Salon from 1937 onwards. Deeply religious and mystical by nature, he later espoused advanced republican politics which influenced his painting and sculpture. His work includes groups and statuettes with strongly political or religious overtones.

FRENGUELLI, Giuseppe fl. late 19th century
Born in Perugia, he studied at the Academy in that city and later became professor of sculpture there. He is best remembered for his monument to Garibaldi at Todi, but he also sculpted historical and contemporary figures and portraits.

FRENSCH, Jakob 1832-1864
Born at Hesselbach, Germany on July 25, 1832, he died in Berlin in 1864. He studied under Launitz at Frankfurt-am-Main and specialised in figures and bas-reliefs for church decoration.

FRERE, Jean Jules 1851-1906
Born in Cambrai on October 1, 1851, he died in Paris in 1906. He studied under Cavelier and Cordier and exhibited at the Salon from 1874 to 1880 and subsequently at the Salon des Artistes Français. He won a third class medal in 1878 and a second class medal in 1883 and bronze medals at the Expositions of 1889 and 1900. He specialised in busts of contemporary celebrities and genre figures (often with an Oriental flavour). His best known work is the statuette of Cinderella.

FRESE, Heinrich 1794-1869
Born in Bremen on May 27, 1794, he died there on July 20, 1869. He studied under Andreas Steinhäuser and specialised in portrait busts, figures and reliefs.

FRESNAYE, Marie Alphonsine fl. 19th-20th centuries
Born at Magenta, Italy, she studied in Paris and exhibited at the Salon from 1874 to 1882 and subsequently at the Salon des Artistes Français, winning an honourable mention in 1884 and a bronze medal at the Exposition of 1900. She specialised in medallions and bas-reliefs, mainly of genre and classical subjects. Her works include Daughter of Apollodorus, Sibyl, Cherubs, The Little Possessor and The Little Flyer.

FRETTE, Auguste A. fl. late 19th century
Born in Grenoble, where he worked as a sculptor of memorials and portraits at the turn of the century.

FREUND, Christian Dan fl. 19th-20th centuries
Genre sculptor working in Copenhagen at the turn of the century. The Copenhagen Museum has several of his bronzes including Boccia-player, Horse drinking and Woman picking Flowers.

FREUND, Georg Christian 1821-1900
Born in Altona on February 7, 1821, he died in Copenhagen on April 6, 1900. He was the nephew and pupil of Hermann Ernst Freund and later studied under H.V. Bissen at the Copenhagen Academy. Many of his statuettes and groups are in the Copenhagen Museum.

FREUND, Hermann Ernst 1786-1840
Born at Uthlede, Denmark on October 15, 1786, he died in Copenhagen on June 13, 1840. He worked as a decorative sculptor on churches and public buildings in Copenhagen. He also produced a series of portrait reliefs of the kings of Denmark. Many of his minor works are in the Copenhagen Museum.

FREUNDLICH, Otto 1878-1943
Born in Stolp, Pomerania on July 10, 1878, he died in Auschwitz concentration camp in 1943. He studied art history under Woelfflin in Berlin and continued his studies in Munich and Florence. He moved to Paris in 1909 and worked in the Rue Ravignan near Picasso. He began exhibiting his sculpture in Paris in 1910 and participated in exhibitions in Amsterdam (1911) and Cologne (1912). He was influenced to some degree by Cubism in his painting and sculpture at this time. After the first world war he returned to Germany and exhibited at the Novembergruppe in Berlin (1919) but he returned to Paris again in 1924. He produced a number of monumental abstracts (1929-33) and was successively a member of the Cercle et Carré and the Abstraction-Création movements. He had his first retrospective show at the Galerie Jeanne Boucher in 1938. His sculptures were banned by the Nazis and after the collapse of France in 1940 he was hunted by the Gestapo. He was arrested in a Pyrenean village in 1943 while trying to escape into Spain and deported to Poland. His work, both painting and sculpture, 'remains as a very pure testimonial of serene spiritual strength that resists every encroachment' (Herta Wescher in *A Dictionary of Modern Sculpture*). His bronzes include Head (1910), Mask (1912), Female Bust (1910) and Great Mask (1912).

FREY, Erwin F. 1892-
Born in Lima, Ohio on April 21, 1892, he studied in Paris under Landowski and became a member of the National Sculpture Society of the United States.

FREY, Hans Konrad 1877-
Born at Wald in Switzerland on August 14, 1877, he studied under Peter Breuer at the Berlin Academy and went to Italy before settling in Zürich where he sculpted figures and portrait reliefs.

FREY, Johann Evangelist 1840-1909
Born at Hundham, Germany on October 17, 1840, he died in Munich on March 8, 1909. He worked in Munich and sculpted statues, busts, memorials and plaques.

FREYSS, Simone fl. 20th century
Born in Strasbourg at the turn of the century, she worked in Paris and exhibited at the Salon des Artistes Français in the 1920s.

FRIBERT, Charles Wilhelm 1868-
Born in Malmö, Sweden on April 15, 1868, he studied at Stockholm Academy and later attended the École des Beaux Arts, Paris where he was a pupil of Falguière. He emigrated to the United States and settled in Philadelphia at the turn of the century. He specialised in bronze and silver statuettes of contemporary personalities.

FRICK, Adolf 1870-
Born at Weilburg on December 25, 1870, he studied under Eberle in Munich and later settled there. He specialised in genre and classical statuettes, such as Echo (Leipzig).

FRIEDEMAN, L. fl. 18th century
He studied at the academies of Berlin and Vienna before settling in St. Petersburg where he died in 1802. He specialised in portrait busts and figures of Russian nobility and the Imperial family.

FRIEDL, Theodor 1842-1899
Born in Vienna on February 13, 1842, he died there in 1899. He specialised in monuments, memorials and public statuary in Hamburg, Budapest, Augsburg and Vienna.

FRIEDLANDER, Leo 1889-
Born in New York City in 1889, he studied at the Art Students' League, New York, the École des Beaux Arts in Paris and the Brussels Academy. He specialised in genre and allegorical bronzes, which include Potential America, Mother and Infant Hercules and various equestrian statuettes.

FRIEDMAN, Mark fl. 20th century
Born in New York in the late 19th century, he studied in Paris under Niclausse and exhibited in Paris and New York in the 1930s, specialising in statuettes and portraits.

FRIEDRICH, André 1798-1877
Born at Rappaltsweiler, Alsace on January 17, 1798, he died in Strasbourg on March 9, 1877. He studied in Stuttgart, Munich and Vienna and worked for many years in Paris and then in Germany before settling in Strasbourg. He produced a number of portraits and genre figures.

FRIEDRICH, Nicolaus 1865-
Born in Cologne on July 17, 1865, he studied at the Berlin Academy and was a pupil of Karl Begas from 1897 to 1901. He was employed as a decorative sculptor at the Chicago Exposition of 1893 and travelled extensively in Italy, Britain, Belgium and France. He won the Prix de Rome in 1896 and an honourable mention at the Exposition Universelle four years later. The Berlin Museum has his statuettes Man tying his Sandals and Stretching the Bow.

FRIEDRICK, André 1798-1877
Born in Ribeauville on January 15, 1798, he died in Strasbourg in 1877. He enrolled at the École des Beaux Arts in 1821 and studied under Bosio. Later he worked with Schadow in Berlin and then settled in Strasbourg. He exhibited at the Salon in 1835-42 and specialised in monuments, memorials and statuary for churches and cemeteries, mainly in marble. His minor works in bronze include a statuette of a monumental sculptor (Colmar Museum) and Sleep (Strasbourg Museum).

FRIES, Hans 1872-
Born in Heidelberg on April 8, 1872, he studied at the Berlin Academy and then settled in his native town, where he produced a great deal of statuary and decorative sculpture, mainly for churches and cemeteries.

FRIES, Pankraz fl. 18th century
Born at Baunach, Bavaria, he died at Bamberg in 1781. He was a decorative sculptor who worked on Birkenfeld Castle and churches in that area. His six sons worked with him and all of them modelled portraits, reliefs and statuettes as well as friezes and bas-reliefs. They were Adam Philipp (born 1768), Andreas, Anton (1764-1834), Christoph (died 1810), Friedrich (died 1810) and Johann Georg (1764-84).

FRINK, Elizabeth 1930-
Born in Thurlow, Suffolk, in 1930, she studied at the Guildford School of Art (1947-49) and the Chelsea School of Art (1949-53). She held her first exhibition in London in 1952 and thereafter took part in the open-air exhibitions in London, Sonsbeek and Middelheim (1954-59). She was short-listed in the competition for the monument to the Unknown Political Prisoner (1953). Since then she has had numerous public commissions and her larger works may be found outside many of the new high-rise office blocks and the public places of England's New Towns. Her work is largely drawn from nature, but there is a world of difference between the traditional Animalier school and the animals and birds she sculpts which verge on the abstract, particularly in her bronzes in which the surfaces are coruscated brutally. She conveys the emotions and character of birds and animals rather than attempting a realistic depiction of them as nature intended, and in her more recent works, such as Warrior Bird, Winged Figure and Bird Man, even the distinctions between human and bird figures have become blurred.

FRIOLI, Ligurio fl. 19th century
He worked in Rimini in the late 19th century as a portrait sculptor. His busts of Cavour and Luigi Pani are in Rimini Town Hall.

FRISCHE, Arnold 1869-
Born in Düsseldorf on December 19, 1869, the son of the landscape painter Heinrich Ludwig Frische, he worked as a genre sculptor in the Rhineland, Westphalia, Alsace and Bremen.

FRISENDAHL, Karl fl. 20th century
Born in Sweden in the late 19th century, he died in Paris in 1948. He settled in France before 1914 and studied under Bourdelle. He exhibited at the major Paris Salons and also in Rome, Munich, Edinburgh, Helsinki and Stockholm. He produced nude statuettes, portrait busts and animal figures and groups, particularly bears, bisons and horses.

FRISHMUTH, Harriet Whitney 1880-
Born in Philadelphia on September 17, 1880, she worked in New York under MacNeil and G. Borglum and later studied in Paris under Rodin and Injalbert. She belonged to the leading American art societies and won numerous prizes for her portraits and genre figures. Her bronzes include The Hunt, Globe Sundial, Nymph and Satyr and Fantasie.

FRISON, Barthélemy 1816-1877
Born in Tournai on September 21, 1816, he died in Paris on May 3, 1877. He studied at the École des Beaux Arts under Ramey and A. Dumont and became a naturalised Frenchman in 1848. He exhibited at the Salon from 1847 to 1877 and won second class medals in 1851 and 1863. He specialised in portrait busts, in marble or bronze, but also sculpted statues in marble and granite.

FRITEL, Pierre fl. 19th-20th centuries
Born in Paris on July 5, 1853, he worked there as a painter, engraver and sculptor. He studied under Millet and Cabanel and exhibited at the Salon in 1876-79. He specialised in religious figures and reliefs for ecclesiastical decoration, but also produced a number of statuettes in the classical idiom. His work was very highly regarded and he won numerous prizes, including a second class medal (1879), a bronze medal at the 1889 Exposition, the Belin-Dollet prize (1909) and a gold medal (1920).

FRITH, William S. 1850-1924
Born in London in 1850, he studied sculpture in South Kensington and at the Lambeth School of Art (1878-80), becoming a teacher of modelling there from 1880 onwards. He exhibited at the Royal Academy from 1884 to 1892 and specialised in religious figures, reliefs and portrait busts.

FRITSCH, Josef fl. 19th century
Born at Selzdorf, southern Germany, in 1840, he studied in Vienna and worked as a decorative sculptor in Ulm.

FRITSCH, Willibald 1876-
Born in Berlin on May 16, 1876, he studied under Manzel and specialised in heads, busts and portrait reliefs.

FRITZ, Heinz 1873-
Born in Cologne on June 12, 1873. he studied under Karl Janssen at the Dresden Academy.

FRITZ, Hermann 1873-
Born at Neuhaus on July 13, 1873, he worked in the Dresden area, and sculpted figures, groups and bas-reliefs for churches and public buildings in Saxony.

FRITZSCHE, Theobald Otto Wilhelm 1832-1899
Born in Altenburg on March 1, 1832, he died in Dresden on September 9, 1899. He studied in Dresden and settled there, specialising in monuments, memorials, statues, portrait busts and bas-reliefs.

FRIZON, Auguste Joseph Xavier fl. 19th century
Born at Crest, France, on November 12, 1839, he studied at the École des Beaux Arts and exhibited at the Salon from 1859 to 1882. He specialised in portrait busts and genre figures, such as The Pigeon and the Ant, The Fifer, The Widow, Remorse. His group of Hercules and Antaeus is in the Ajaccio Museum.

FROC-ROBERT, Desiré fl. 19th century
He worked as a decorative sculptor in Clermont, France, during the 19th century.

FRODMAN-CLUZEL, Boris fl. 20th century
Born in St. Petersburg, he moved to Sweden at the Revolution and worked there as a sculptor of portraits and genre figures in the inter-war period.

FROGER, Albert fl. late 19th century
Born in Paris in the mid-19th century, he exhibited at the Salon from 1881 onwards and won an honourable mention in 1889 for his genre figures.

FROGET, Pierre Marie fl. 19th century
Born at Panisières on May 24, 1814; he studied at the École des Beaux Arts under A. Dumont and Ramey and exhibited at the Salon from 1847 to 1855. He specialised in religious figures and bas-reliefs.

FROLICH, Finn Häkon fl. 19th-20th centuries
Born in Oslo on May 13, 1869, he emigrated to the United States and studied under Daniel Chester French in New York. Later he studied under Barrias in Paris and won a silver medal at the Exposition Universelle of 1900. He specialised in memorials, public statuary and portrait busts.

FROLOFF, Jakob fl. 19th century
He worked as a decorative sculptor in Moscow and later St. Petersburg.

FROMANGER, Alexis Hippolyte 1805-1892
Born in Paris on June 20, 1805, he died there in 1892. He studied at the École des Beaux Arts under Lemaire and exhibited at the Salon from 1835 to 1870. He specialised in classical and religious figures, mainly in stone or marble.

FROMEN, Agnes Valborg 1868-
Born in Valdemarsvik, Sweden, on December 27, 1868, she emigrated to the United States and studied under Lorado Taft and Charles Mulligan at the Chicago Art Institute. Her genre and allegorical figures were produced in bronze or bronzed plaster and include The Arrow's Flight.

FROMENTAL, Maximilien fl. 19th-20th centuries
Sculptor working in Paris at the turn of the century on genre and historic figures and portraits.

FROMENT-MEURICE, Jacques Charles François Marie 1864-1948
Born in Paris in 1864, he died there in January 1948. He studied under Chapu and exhibited at the Salon des Artistes Français at the turn of the century, winning an honourable mention in 1892. He was an Animalier, specialising in dogs and horses. The Bayonne Museum has his Dog of Montargis and Meissonier on his horse Rivoli.

FROMM, Kaspar fl. 19th century
He worked in Weissentheid, Germany, as a sculptor of religious figures, groups and reliefs.

FROST, Julius H. 1867-
Born in New Jersey on July 11, 1867, he was largely self-taught as a painter and sculptor. He was a member of the Society of Independent Artists and the American Federation of Artists and produced portrait busts and reliefs, monuments and statues.

FROUCHAUD, Auguste fl. early 19th century
Genre sculptor working in France in the 1830s. Aix Museum has his figure of a Young Girl crowned with Plants.

FRULLINI, Luigi 1839-1897
Born in Florence on March 25, 1839, he died there in July 1897. He exhibited in Florence from 1861 onwards and later also at the Paris Salons, the Royal Academy and the Vienna Academy. He specialised in portrait reliefs, medallions and busts.

FRUMERIE, Agnes de (née Kjellberg) 1869-
Born at Sköfde, Sweden, on November 20, 1869, she studied in Stockholm and later worked in Italy and Germany for many years. She specialised in portraits and genre figures.

FRY, Samuel fl. late 19th century
He worked in London in the late 19th century as a painter and sculptor and exhibited figures and portraits at the Royal Academy from 1877 to 1890.

FRY, Sherry Edmundson 1879-
Born in Creston, Iowa, on September 29, 1879, he studied under Taft at the Chicago Art Institute and then went to Paris, where he continued his studies at the Académie Julian and the École des Beaux Arts under Frederick MacMonnies and Verlet. He exhibited at the Salon des Artistes Français, winning an honourable mention (1906) and a third class medal (1908). In the latter year he also won the Prix de Rome and spent the ensuing three years at the American Academy in Rome. His works include numerous statues and fountains in American towns, public buildings and museums.

FRYDAG, Bernhard 1879-1916
Born in Münster, Germany on June 18, 1879, he died in April 1916. He sculpted portraits and genre figures, as well as a number of memorials in the Münster area.

FUCHS, Alois fl. 19th century
Born at Berwang, Austria in 1838, he studied under Renner and sculpted decorative works for public buildings and churches.

FUCHS, Carl 1842-1883
Born at Innichen, Austria on November 26, 1842, he died there on June 27, 1883. Examples of his works are in the Merano Museum.

FUCHS, Emil fl. 19th-20th centuries
Born in Vienna in 1866, he studied under Victor Tilguer and later attended the Vienna and Berlin academies. He won a travelling scholarship in 1890 which enabled him to continue his studies in Italy. He worked in Rome till 1899 and during this period he executed his group Mother Love. He moved to London at the turn of the century and worked as a painter and sculptor of portraits, his best known work being the profile of King Edward VII for the coins and stamps of 1902. Later he settled in the United States and exhibited both painting and sculpture in New York. His bronzes include the figure of La Pensierosa (Metropolitan Museum of Art), busts of Gari Melchers, Sir Johnston Forbes-Robertson, Sir David Murray and other artistic contemporaries, and a half-figure of an artist.

FUCHS, Félix Cajetan Christoph 1749-1814
Born at Rapperswil, Switzerland in 1749, he died in St. Gall on March 14, 1814. He studied in Augsburg and Rome and specialised in paintings and sculptures depicting characters from Shakespeare.

FUCHS, Gustave fl. 19th-20th centuries
Painter and sculptor of Austrian origin who committed suicide in New York on November 10, 1905.

FUCHS, Hermann 1871-
Born at Hochdahl, Germany in 1871, he studied under Schaper and worked in Berlin as a sculptor of historical, allegorical and genre figures and portrait busts.

FUCHS, Johann 1812-1895
Born in Hopfgarten, Bavaria on October 7, 1812, he died there in 1895. He studied at the Munich Academy and specialised in ecclesiastical decorative sculpture, mainly in his native town.

FUCHS, Peter 1829-1898
Born in Mülheim, Germany on September 27, 1829, he died there on July 31, 1898. He worked in Cologne, Hamburg and Frankfurt-am-Main and specialised in religious figures and groups.

FUCIGNA, Ceccardo fl. 19th century
Born in Carrara in the early 19th century, he worked there and in Pisa as a monumental sculptor.

FUETSCH, Karl 1823-1902
Born in Mitteldorf on November 3, 1823, he died in Patriasdorf on November 23, 1902. He studied under B. Gasser and worked on ecclesiastical figures and reliefs for Tyrolean churches. His best known work is the group of Joseph and the Holy Infant in Linz Museum.

FUGÈRE, Henry 1872-
Born at St. Mande, France on September 7, 1872, he studied in Paris under Cavelier and exhibited portraits and statuettes at the Salon des Artistes Français in the 1920s.

FÜGLISTER, Wilhelm fl. 19th-20th centuries
Born in Vienna on May 27, 1861, he worked as an ornamental sculptor in the Palace of the Grand-Duke of Baden, Karlsruhe at the turn of the century.

FÜHRER, Richard 1873-
Born in Budapest on July 18, 1873, he studied under Strobl and Loranfi and later worked in Italy and France. He won a bronze medal at the Exposition of 1900 for his statuettes and genre groups.

FULCONIS, Louis Guillaume 1817-1873
Born in Avignon in 1817, he died there on May 11, 1873. He studied at the School of Fine Arts in Avignon and exhibited at the Salon from 1857 to 1872. He specialised in religious and classical statuary and busts, mainly in marble, but several portraits (notably that of Dr. Camille Raspail) are recorded in bronze.

FULCONIS, Victor Louis Pierre 1851-1913
Born in Algiers in 1851, he died at Oran in October 1913. He studied painting and sculpture under his father L.G. Fulconis and also worked in the studios of Jouffroy and Bonnassieux in Paris and exhibited at the Salon in 1873-80 and subsequently the Salon des Artistes Français. He specialised in ecclesiastical statues and groups, but also produced a number of portrait busts and reliefs.

FULLER, Charles Francis 1830-1875
Born in England in 1830, he died in Florence on March 10, 1875. He exhibited at the Royal Academy from 1859 till his death and specialised in heads, portrait reliefs and busts.

FULPIUS, Elizabeth Caroline 1878-
Born in Geneva on January 16, 1878, she studied at the Schools of Fine Arts in Geneva and Paris. She exhibited at the Salon des Artistes Français, winning an honourable mention in 1906. She specialised in female busts and statuettes.

FUMADELLES, Augustin 1844-
Born in Agen, France in 1844, he sculpted figures and busts. He got an honourable mention at the Salon of 1884.

FUMIÈRE, Adolphe fl. 19th century
Belgian sculptor of the mid-19th century working in Tournai on memorials and portraits of local worthies, genre figures and groups.

FUNCH, Hermann Frederik fl. 19th century
Born at Rendsburg, Denmark on November 4, 1841, he studied under H.V. Bissen in Copenhagen. He worked as a landscape painter and also sculpted animal figures.

FUNEV, Ivan fl. 20th century
Born in Bulgaria in the early years of this century, he studied under Despiau, Bouchard and Wlérick. He returned to Bulgaria from Paris at the end of the second world war and has since become one of Bulgaria's leading sculptors of proletarian subjects. His genre figures and groups depict Bulgarian workers and peasants and include such bronzes as Third Class Carriage and Engineer.

FUNK, Friedrich 1804-1882
Born in Leipzig on August 11, 1804, he died there on December 15, 1882. He studied under Franz Pettrichs in Dresden before settling in his native town where he sculpted many monuments and statues. His chief works are the statues of J.A. Hiller and the singer Thekla Podleska. He also sculpted a number of portrait busts.

FURSTENBERGER, Michel fl. 20th century
Born in Warsaw in the late 19th century, he studied in Paris and exhibited figures and groups at the Salon des Artistes Français before the first world war.

FUSS, Heinrich 1845-1913
Born at Guntramsdorf, Austria on July 6, 1845, he died in Innsbruck on December 10, 1913. He was the son of an architect and studied at the Vienna Academy. He specialised in busts and reliefs depicting mythological and historical subjects.

GAAL, Nandor c.1885-1915
Born in Hungary about 1885, he died in Budapest on November 2, 1915. He sculpted a number of portrait busts of contemporary and historical Hungarians and is chiefly remembered for his statue of Lajos Kossuth.

GAALON, Jacques de fl. 19th-20th centuries
Born at Moutiers-en-Singlais, he studied at the School of Fine Arts in Caen and worked in that town at the turn of the century. He exhibited at the Salon from 1876 and became one of the earliest Associates of the Artistes Français in 1883.

GABO, Naum 1890-
Born in Briansk, Russia in 1890, he changed his original surname of Pevsner to avoid confusion with his elder brother, Antoine. He was sent to Munich to study medicine but opted for a career in science instead. At the same time, however, he attended Woelffflin's classes in the history of art and a visit to his brother in 1913, when he was working as a painter in Paris, convinced him that his true metier was art. During the first world war he lived in Copenhagen, then Oslo and did not return to Russia till after the Revolution in 1917. By that time he had taken up sculpture and was strongly influenced by Archipenko. His earliest works were constructed in plastic materials and were based on the principle of the open hollow. After his return to Russia he was preoccupied with the problems of conveying movement in space and many of his metal sculptures of the early 1920s incorporated electric motors. Soviet regimentation of art forced him to leave Russia and he then lived in Berlin till 1932. He collaborated with his brother in designing costumes and sets for Diaghilev's ballets. He had his first one-man show of sculpture at the Kestnergesellschaft in Hanover (1930). He subsequently worked in Paris (1932-35), London (1935-46) and New York (since 1946). He had a retrospective show at the Metropolitan Museum of Art in 1948 and has since taught at various American universities and now lives in Connecticut. At various times he has been a member of the Constructivist group in Russia, the Abstraction-Création movement in Paris and the non-figurative movements of the post-war period. Apart from his colossal works in steel, such as the Bijenkorf monument in Rotterdam, he has produced numerous small abstracts, such as the Linear Constructions in Space and Suspended Constructions of 1951-52, which combine bronze with other materials, such as glass, aluminium, steel, gold wire, cellon and nylon.
Joray, Marcel *Naum Gabo.*

GABOVICH, Josef fl. 19th-20th centuries
Born at Kolno in Russia in the mid-19th century, he studied in Paris under Thomas and worked there at the turn of the century on genre figures and portraits. He exhibited at the Salon des Artistes Français and also won a bronze medal at the 1900 Exposition.

GABRIEL, Edith M. fl. 20th century
She studied at Heatherley's and also at the École des Beaux Arts, Paris and worked in London from about 1925 to 1960. She exhibited at the Royal Academy, the Salon des Artistes Français and provincial galleries in Britain.

GABRIELLE-DUMONTET, Madame fl. 19th-20th centuries
Born at Bourg-sur-Gironde, she exhibited figures and portraits at the Salon des Artistes Français at the turn of the century. She got an honourable mention at the Exposition of 1900.

GABRIELLI, Giuseppe fl. late 19th century
Italian sculptor of portraits and genre figures, who exhibited at the Royal Academy from 1863 to 1880.

GADOWSKY, Valery fl. 19th century
Born in Cracow in 1833, he studied drawing under Stisler and modelling under Kossovsky at the Cracow art school and then spent two years at the Vienna Academy. He was appointed professor of sculpture at Cracow in 1877. He produced genre and biblical figures and groups and portrait busts of his contemporaries. Cracow Museum has Herodiad and a portrait of Countess Potocki by him.

GAGE, Merrell 1892-
Born in Kansas City, he studied at the Art Students' League, New York. He became a member of the Californian Art Club and won its gold medal. In 1921 he was appointed professor of art at the Kansas City Institute. He has sculpted monuments and memorials, portrait busts and reliefs.

GAGGINI, Giuseppe III 1791-1867
Born in Genoa on April 25, 1791, he died there on May 2, 1867. He came of a long line of sculptors and was himself a pupil of Canova in Rome. He worked in Milan and Rome before settling in Turin, where he executed a number of monuments for the Kings of Piedmont-Savoy. His minor works include portrait busts and historical figures.

GAGNE, Paul Auguste fl. 19th century
Born in Paris, he studied under his father, the painter Jacques Gagne, and later became a pupil of Roger. He exhibited at the Salon from 1861 onwards and specialised in bas-reliefs of classical subjects.

GAGNEUR DE PATRONAY, Ange Marie Maurice
fl. 19th-20th centuries
Born in Paris in the mid-19th century, he studied under Peynot and exhibited figures and groups at the Salon des Artistes Français at the turn of the century.

GAHAGAN, Charles fl. early 19th century
Probably a son of Lawrence Gahagan, he worked as an assistant to Flaxman in the late 1820s and exhibited busts at the Royal Academy in 1831-36. His most ambitious work, an allegorical group symbolising the three countries of Great Britain, was shown at Westminster Hall in 1844 but panned by the critics.

GAHAGAN, Edwin d. 1858
Son and pupil of Lawrence Gahagan, he exhibited portrait busts and figures at the Royal Academy in 1831-37 and a statue of Sir Isaac Newton at Westminster Hall, 1844.

GAHAGAN, Lawrence fl. 1756-1820
Born in Ireland, he changed his name from Geoghegan when he left Dublin in 1756. In that year he won the prize of the Royal Dublin Society for a statuette of Rubens and was encouraged to try his luck in England. He came to London and had a long period of unrewarding struggle before gaining recognition. In 1777 he won the prize of the Society of Arts for his large relief showing Alexander exhorting his Troops. Later he turned to small bronze portrait busts and statuettes and built up a considerable reputation in this field. He exhibited at the Royal Academy from 1798 to 1817 and also at the British Institution in 1809. His bronzes include the busts of Sir Thomas Paisley, Nelson, the Duke of Wellington, Romilly, Dr. Hawes, Tsar Alexander I, Parry, Blücher and Madame Catalini, statuettes of Lady Hood, Princess Cariboo and Hannah Moore, and groups of Gillingham the Murderer and his Victim Maria Bagnell, the Death of Spencer Perceval and Missionary Preaching to the South Sea Islanders.

GAHAGAN, Lucius d. 1866
Son of Lawrence Gahagan, he settled in Bath in 1820 and lived in a house named Lo Studio. He is best known as a stone carver of busts and statues, mainly in the Bath area. He sculpted the medallion plaque of Wellington at Stratfield Saye (1832). It is now considered that many of the portrait bronzes attributed to his father were actually sculpted by him. He also produced a number of allegorical figures, such as Commerce and Genius, and a number of medallions, plaques and bas-reliefs.

GAHAGAN, Sarah d.1866
Sister of Lucius with whom she worked in Bath after working on her own in Bristol for some years. She exhibited the bust of a child at the Royal Academy in 1817.

GAHAGAN, Sebastian fl. early 19th century
Brother of Lawrence Gahagan whom he followed from Dublin to London. He worked for Nollekens for many years but was poorly paid and exploited by him. Nollekens bequeathed £100 to him but several years of poverty elapsed before he finally received the money from Nollekens's executors. He was dogged by ill-luck and had to fall back on a small grant from the Royal Academy in 1835. He exhibited at the Royal Academy from 1802 to 1835, specialising in portrait busts. His best known work was the bust of Dr. Hutton (1832) of which a large number of casts were made for Hutton's friends. He also produced a number of large memorials and statues, such as those of Sir Thomas Picton in St. Paul's Cathedral (1815) and Dr. Charles Burnley in Westminster Abbey (1819).

GAHAGAN, Stephen 1832-1858
Born in London in 1832, the son of Edwin Gahagan (q.v.), he died in 1858. He attended the Royal Academy schools in 1850 and exhibited at the Academy in 1857-58. He specialised in portrait busts and medallions.

GAHAGAN, Vincent fl. early 19th century
Brother of Lawrence and Sebastian, he exhibited at the Royal Academy from 1804 to 1833 and was killed when a statue of George Canning (on which he was working) collapsed on top of him in 1832. He produced a number of equestrian statues and models for them.

GAIASSI, Vincenzo 1801-1861
He spent his entire life in Rome where he specialised in medallions and portrait reliefs. He sculpted the statue of Palladio on the Piazza Maggiore in Vicenza.

GAILLARD, Léon Jacques fl. 19th-20th centuries
Born in Preignac, he was killed in action in the first world war. He studied under Falguière and exhibited at the Salon des Artistes Français before 1914.

GAILLIOT, Geneviève Elisabeth 1896-
Born in Paris in 1896, she attended the École des Beaux Arts and exhibited figures at the Salon des Artistes Francais in the 1920s.

GAIRAD, Paul fl. 19th century
Spanish sculptor of the late 19th century. The Gallery of Modern Art in Madrid has a marble group of children by him.

GAIRAL DE SEREZIN, Eugène 1873-
Born at Lyons in 1873, he studied under Verlet and exhibited at the Salon des Artistes Français from 1905 to the 1930s, specialising in plaques, reliefs and medallions.

GAJARINI, Francesco fl. 19th century
Born at Contea, Italy, he studied under Ulisse Cambi in Florence and later worked with Lorenzo Bartolini. He exhibited in Florence, Milan and Paris in the 1860s and produced portraits and figures.

GALAN Y SANCHEZ, Rafael fl. 19th century
Born in Madrid where he worked as a sculptor of genre figures and groups, such as At School.

GALARD Fils fl. 19th century
Born in Marseilles in 1846, the son of Georges Galard the painter. He specialised in portrait busts.

GALATERI, Annibale, Conte di Genola, 1864-
Born at Savigliano, Italy, he studied in Rome and Turin and produced a number of memorials and monuments, such as that to General Arimondi, as well as portrait busts and reliefs.

GALIE, Gaston d. 1911
Sculptor working in Paris at the turn of the century on genre figures and portraits.

GALITZIN, Leo fl. 19th century
He studied under Ramassanoff and worked in Moscow as a sculptor of genre figures and portraits.

GALLE, Jean Joseph 1884-
Born in Rennes, he studied under Coutan and exhibited at the Salon des Artistes Français. He produced a number of monuments and statues and specialised in portrait busts and medallions.

GALLE, Oswald 1868-
Born in Dresden on April 26, 1868, he worked in Dresden and Berlin as a painter and sculptor, mainly in wood.

GALLET, Louis 1873-
Born at La Chaux-de-Fonds, Switzerland on November 16, 1873, he exhibited figures and groups at the Salon of the Société Nationale des Beaux Arts, Paris from 1904 to the first world war.

GALLETTI, Francesco fl. 19th century
Born at Cento, Italy on July 14, 1833, he studied under Baruzzi in Bologna and began exhibiting at the Italian galleries in 1870. He sculpted portrait busts and is best remembered for the statue of St. Lawrence in the Campo Varano, Rome.

GALLETTI, Stefano 1833-1900
Twin brother of Francesco, he died in Rome in 1900. He worked mainly in Cento, Bologna and Ferrara and sculpted the Cavour monument in Rome (1895).

GALLHOF, Wilhelm 1878-1918
Born in Iserlohn on July 24, 1878, he died in June 1918. He studied under Herterich the Elder at Munich and exhibited in Berlin, Munich, Bremen and Mannheim at the turn of the century. His smaller sculptures are in the museums of Weimar and Elberfeld.

GALLI, Alberto fl. 19th century
Born in Rome in 1843, he was Director of the Museum of Sculpture at the Vatican.

GALLI, Antonio 1862-
Born in Milan, he studied under Somaini and Thorwaldsen in Rome and specialised in portrait busts and figures and groups derived from classical mythology.

GALLI, Fortunato fl. 19th-20th centuries
Born at Leghorn in the mid-19th century, he died in Florence on April 19, 1918. He specialised in figures and reliefs, mainly of religious subjects, for ecclesiastical decoration. His chief work is the statue of Pope Gregory VII in Florence Cathedral.

GALLI, Riccardo fl. 19th century
Born in Nice in 1839, he began exhibiting in Naples in 1877 and subsequently worked in Milan as a painter and sculptor, specialising in portrait busts and heads. He also exhibited his portraiture in Rome and Turin. A head of a woman by him is in the Amsterdam Museum.

GALLARD, Sansonetti 1865-
Born in Nancy in 1865, he studied under Raphael Collin and Geoffroy. He specialised in classical figures, in marble and bronze, such as Orpheus, Hero and Leander, and Medea. He also modelled animal groups, especially various breeds of dogs.

GALLMETZER, Valentin 1870-
Born at Hintereggenthal, Austria, on February 9, 1870. He worked as a decorative sculptor for the churches of the Tyrol at the turn of the century.

GALLO, Ignacio fl. 20th century
Born in Valladolid, Spain in the late 19th century, he worked in Madrid and Paris in the inter-war years and specialised in statuettes of bathers, dancers, nudes and pagan goddesses.

GALLOIS fl. 19th century
Bronze statuettes of religious subjects bearing this signature were produced by an otherwise unknown sculptor working in Paris in the mid-19th century.

GALLORI, Emilio fl. 19th century
Born in Florence on April 2, 1846, he studied at the Academy of Fine Arts in Florence and later worked in Naples. He exhibited in Turin, Milan and Rome, as well as the Royal Academy, London (1875-78) and the Paris Salon. He was awarded a gold medal at the Exposition Universelle of 1900. He produced a wide range of sculpture, from busts and plaques to statuary.

GALLWEY, Antoinette Celestine fl. 19th century
Born at Le Havre in the first half of the 19th century, she studied under Barye and exhibited animal figures and groups at the Salon in 1867-70.

GALLWEY, Emmeline Henriette fl. 19th century
Sister of the above, she also worked as an Animalier in Paris and exhibited figures of domestic and farmyard animals at the Salon from 1864 to 1877.

GALMES, Guillermo fl. 19th century
He worked at Palma de Majorca in the mid-19th century as a decorative sculptor.

GALT, Alexander 1827-1863
Born in Norfolk, Virginia in 1827, he died at Richmond in March 1863. He specialised in portrait busts of historical and contemporary American political figures.

GALY, Hippolyte Marius fl. 19th-20th centuries
Born in Algiers, he studied in Paris under Dumont and Cormon and exhibited at the Salon des Artistes Français at the turn of the century. He was made a Chevalier of the Legion of Honour in 1900.

GAMBA, Giovanni Battista fl. 19th century
Born at Binago, Italy in 1846, he studied at the Brera Academy in Milan and was a pupil of Vela. He decorated many of the palaces in Bergamo, Rome and Nice and exhibited figures, groups and reliefs of classical, genre and historical subjects in Naples, Milan and Rome. He was regarded as one of the finest Italian sculptors of the late 19th century.

GAMBIER D'HURIGNY, Maurice fl. 20th century
Born in Paris, he studied under Henri Bouchard and won many medals at the Salons of Paris in the early years of this century for his figures and portraits.

GAMBLE, James fl. late 19th century
Sculptor of figures and busts working in London in the late 19th century. He exhibited at the Royal Academy in the 1890s.

GAMEIRO, Alfredo Roque fl. 19th century
Born in Lisbon, where he worked as a painter and sculptor of portraits and genre figures. He won an honourable mention at the Exposition Universelle of 1900.

GAMLEY, Henry Snell 1865-1928
Born at Logie Pert, Montrose in 1865, he died in Edinburgh in 1928. He studied at the Edinburgh Royal Institution and worked in the studio of D.W. Stevenson. He exhibited at the Royal Scottish Academy and was elected A.R.S.A. in 1908, R.S.A. in 1920 and F.R.B.S. in 1926. His works include Inspiration and Achievement, The Whisper, A Message to the Sea, and the statue of Robert Burns in Cheyenne, Wyoming.

GAMOT Y LLURIA, José fl. 19th century
Born in Barcelona, he died there in 1890. He studied under Novas at the School of Fine Arts, Barcelona and exhibited busts and historical figures at Madrid from 1876.

GAMP, Ludwig 1855-1910
Born in 1855, he died in Munich on May 23, 1910. He studied under Widmann at the Munich Academy and sculpted portraits, genre and historical figures and groups.

GAMSARAGAN, Doria fl. 20th century
One of the outstanding Egyptian sculptors of the early 20th century, she studied at the École des Beaux Arts in Paris and exhibited statuettes and busts at the Salon d'Automne and the Tuileries in the inter-war years.

GANDARIAS, Justo de fl. 19th century
Born in Barcelona in the mid-19th century, he worked in Barcelona and Madrid as a sculptor of genre statuettes. He exhibited in Madrid and also the Paris Salons from 1881 onwards, and was awarded an honourable mention at the Exposition Universelle of 1878. His bronzes of Child and Duck and Love and Interest are in the Madrid Museum.

GANDOLFI, Democrito 1797-1874
Born at Bologna in 1797, he died there in 1874. He was the son of the painter Mauro Gandolfi and studied at the Milan Academy. He produced a number of important monuments for various Italian cities, but also sculpted genre bronzes, such as The Beggar and The Woman who Weeps.

GANDRI, Simon François fl. 19th century
Born at St. Jean les deux Jameaux, he studied under Hardouin and Perrault and exhibited portrait medallions and busts at the Salon from 1875 to 1879.

GANESCO, Constantin 1864-
Born in Bucharest in 1864, he worked there as a painter and sculptor before settling in France. He continued his studies under Ziem at Nice and specialised in Romanesque subjects. His sculptures belong to the period from about 1900 to 1914, when he reverted to painting. He exhibited statuettes at the Salon des Artistes Français and also at the Nationale in the early 1920s.

GANGAND, Arthur fl. 19th-20th centuries
Sculptor of statuettes and portraits, working in Paris at the turn of the century. He became an Associate of the Artistes Français in 1901.

GANGERI, Lio 1844-1913
Born at Messina in 1844, he died in Salerno on February 4, 1913. He exhibited in Rome, Turin and Milan from 1880 till his death and specialised in portrait busts of Italian royalty and contemporary celebrities.

GANIÈRE, George Étienne fl. 20th century
Born in Chicago of French parents, he studied at the Art Institute and the École des Beaux Arts, Paris. He became head of the sculpture department at the Art Institute and specialised in busts and statues of American political personalities, especially Abraham Lincoln.

GANSER, Anton fl. 19th century
Born at Munich in 1811, he studied under Schwanthaler. His sculptures are in the Munich Museum.

GANUCHAUD, Paul 1881-
Born in Paris, he exhibited at the Salon d'Automne and the Tuileries in the 1920s.

GAPP, Alois 1838-1906
Born at Telfs in the Austrian Tyrol on June 21, 1838, he died in Graz on April 10, 1906. He was a pupil of Renn and later studied in Munich where he settled as a sculptor of portrait reliefs and busts and historical and allegorical figures.

GARAFULIC, Lily 1914-
Born in Chile of Serbian parents, she enrolled at the Art School of Santiago in 1934 and has taught there since 1951. She participated in art exhibitions in Santiago from 1936 and later won prizes in exhibitions in Buenos Aires and Valparaiso. She was awarded a Guggenheim scholarship in 1944 and this enabled her to study in the United States. Her earlier work was mainly carved direct in stone and ranged from heads, busts, torsos and small bas-reliefs to colossal statues and monuments. In the 1950s, however, she turned away from figurative to abstract sculpture and has since worked in plaster, clay and bronze.

GARAMENDI, Bernabé de fl. 19th century
Born in Bilbao, he studied there and exhibited figures and portraits in Madrid from 1865 to 1900. He was awarded a gold medal at the Bilbao exhibition of 1882.

GARBE, Louis Richard 1876-1957
Born in London on October 26, 1876, he died at Westcott near Dorking on July 28, 1957. He studied at the Central School of Arts and Crafts and the Royal Academy schools and exhibited at the Royal Academy from 1908. He was elected F.R.B.S. in 1920, A.R.A. in 1929 and R.A. in 1936. He taught sculpture at the Central School (1901-29) and was professor of sculpture at the Royal College of Art (1929-46). He sculpted animal and genre subjects in marble and ivory as well as bronze. His works include the bronze Song of the Sea and the ivory and bronze Dryad.

GARBERS, Karl 1864-
Born in Hamburg on May 11, 1864, he studied at Dresden Academy under Hähnel. He worked in Hamburg as a sculptor of portraits, and genre and allegorical figures.

GARCES, Salvador Domingo fl. 19th century
Born in Cadiz in the late 18th century, he died at Corunna in 1857. He was professor of modelling at the Corunna Academy of Fine Arts.

GARCIA, Feliciano fl. 19th-20th centuries
Born in Spain, he worked in Paris at the turn of the century and specialised in portrait reliefs and busts. He exhibited at the Salon d'Automne in 1905.

GARCIA Y ALONSO, Celestino fl. late 19th century
Born at Siguenza, Spain in the mid-19th century, he studied at the School of Fine Arts in Madrid and exhibited there from 1871 onwards.

GARCIA Y BAS, Mariano fl. 20th century
Born in Valencia in the late 19th century, he was awarded a travelling scholarship in 1922 and completed his studies in Rome. He specialised in portrait busts and statuettes of religious subjects, including a series of portraits of the popes.

GARCIA Y TORREBESANO, Petronila fl. 19th century
Born in Cordoba at the beginning of the 19th century, she exhibited figures and groups there from 1839.

GARDEL, Louis fl. 19th century
French sculptor of the first half of the 19th century, he exhibited plaques and medallions at the Salon in 1837 and 1849.

GARDET, Antoine 1861-1891
Born in Paris on February 22, 1861, he died there on February 24, 1891. He was the son of Joseph Gardet with whom he worked as a genre sculptor. His statuettes are in Roanne Museum.

GARDET, Georges 1863-1939
Born in Paris on October 11, 1863, he died there in 1939. He worked with his father and studied under Aimé Millet and Frémiet and became one of the leading Animalier sculptors of the late 19th century. He exhibited at the Salon des Artistes Français from 1883 and won a number of major awards including a medal at the Exposition of 1889 and the Grand Prix at the Exposition of 1900. He was appointed Chevalier (1896) and Officier (1900) of the Legion of Honour. Many of his animal figures were carved direct in marble and subsequently published as bronze or porcelain reductions. He produced a number of monumental works, including the Tiger and Bison at the entrance to the Laval Museum and the group of a Panther and Python in the Parc Mountsouris.

GARDET, Joseph c.1830-1914
Born in Paris about 1830, he died there in April 1914. He was the father of Antoine and Georges. He worked mainly on historic and allegorical figures.

GARDIE, Louis fl. mid-19th century
Sculptor of French origin working in London in the mid-19th century and exhibiting at the Royal Academy in 1850-4. He specialised in portrait busts of his contemporaries. At the Great Exhibition he showed a bronze of Sir Robert Peel. His terra cotta bust of John Speke is in the National Portrait Gallery, London.

GARDNER, Mabel fl. 20th century
Born at Providence, Rhode Island in the late 19th century, she studied in New York and settled in Paris in 1922. She produced statuettes and portraits, which were exhibited at the Paris Salons of the inter-war period.

GARDOS, Aladar 1878-
Born in Budapest on April 12, 1878, he studied in Munich and Paris before settling in Budapest. He sculpted portrait reliefs and busts as well as genre and historical figures.

GARDY, Gauderic fl. late 19th century
Born at Bagnères-de-Bigorre in the mid-19th century, he exhibited figures and groups at the Salon des Artistes Français from 1889 to the end of the 19th century.

GARELLA, Antonio fl. 19th-20th centuries
Born in Bologna, he worked in Florence at the turn of the century.

GARELLI, Franco 1909-
Born at Diano d'Alba, Italy in 1909, he trained as a surgeon but now teaches sculpture at the Albertina Academy in Turin. He began as an amateur painter and sculptor, but gradually turned to art and away from medicine. He had his first one-man show in the Stampa Salon,

Turin in 1936. After the second world war he concentrated on art alone and has since become one of Italy's leading sculptors of architectural decoration. He has participated in many international exhibitions, from the Venice Biennale of 1948 onwards and was awarded the Carnegie Prize in Pittsburgh, 1958. His abstracts are sculpted in iron or bronze. His works in the latter medium include The Host.

GARGALLO, Pablo 1881-1934
Born in Mailla, Spain in 1881, he died at Reus in 1934. When his family moved to Barcelona he began studying art there and later he visited Paris in 1906 and 1911 where he was influenced by Picasso, though in the end he was content to work in the manner of Maillol. He returned to Barcelona in 1914 and became a teacher at the School of Fine Arts (1917-23). Thereafter he spent the rest of his working life in Paris. He originally carved heads and busts in stone but in 1913 he began producing masks and statuettes in beaten copper, lead and iron. In the 1920s he sculpted figures and heads in bronze, including The Violinist, Christ on the Cross, Dancer, Harlequin and Bacchante. His chief work in this medium was The Prophet (1933), now in the Musée d'Art Moderne, Paris.

GARLAND, H. fl. late 19th century
Born in London, where he worked in the second half of the 19th century as a sculptor of memorials, portraits and genre figures. He exhibited at the Royal Academy from 1867 to 1878.

GARNAUD, Achille Charles fl. 19th century
Born in Paris on January 26, 1830, he studied under A. Toussaint and exhibited at the Salon from 1861 to 1873. He specialised in genre figures and groups, particularly featuring children. His bronzes include The Child and the Bacchante and Child with a Toy Boat.

GARNELO Y ALDA, Manuel fl. 19th-20th centuries
He worked in Madrid at the turn of the century and exhibited figures and groups in Madrid and Rome.

GARNIER, Gustave Alexandre fl. 19th century
Born near Sarthe on August 15, 1834, he studied at the École des Beaux Arts, Paris from 1854 to 1857 and was a pupil of Duret and Yvon. He began exhibiting at the Salon in 1859 and specialised in classical allegorical and genre figures and groups. His works include The Captive of Love, The First Education, David and Goliath, Springtime, The Sleeping Fisherman. He also sculpted portrait busts in marble and stone of distinguished French contemporaries.

GARNIER, Henri Adolphe fl. 19th century
Born in Paris in 1803, he exhibited at the Salon in 1831-35. He produced a number of portrait busts, roundels and plaques and classical, historical and genre figures and groups. His classical statuettes include Ajax, and Mucius Scaevola before Porsenna. Among his busts is that of Mlle. Elisabeth Taylor. His chief work was a colossal statue of the Nymph Echo.

GARNIER, Jean fl. late 19th century
Born at Monzeuil, he worked in Paris and exhibited statuettes at the Salon des Artistes Français in the 1890s.

GARNIER, Jean François Marie 1820-1895
Born in Lyons in 1820, he died in Paris in 1895. He worked in Lyons on classical and historical figures and groups. Lyons Museum has his Inferno of the Luxurious, after Dante.

GARNIER, Maurice fl. 20th century
Born in the early years of this century, he was killed in action at Vaux-sur-Mer, 1945. He specialised in curious animated figures, a collection of which is in the Museum of Popular Arts and Traditions in Paris.

GARNIER, R. fl. 19th-20th centuries
Sculptor working in Paris at the turn of the century, producing Art Nouveau decorative bronzes, such as oyster shells decorated with winged nymphs.

GARRARD, George 1760-1826
Born in London on May 31, 1760, he died in Brompton on October 8, 1826. He studied painting under Sawrey Gilpin and attended the Royal Academy schools in 1778. He exhibited animal paintings at

Burlington House from 1781 to 1795. In the latter year he switched to sculpture and quickly established a reputation for reliefs and accurate small-scale models of animals, especially dogs and cattle, in both plaster and bronze. There are large collections of his animal sculptures at Woburn Abbey, Southill and Burghley and he also made animal figures for Lord Petre and Sir John Soane. A vivid description of his studio is given in Ackerman's *Views of London* (1816). He exhibited at the Royal Academy till 1826 and at the British Institution from 1801 to 1825 - over 200 works of sculpture being exhibited. He was made A.R.A. in 1800. He also sculpted numerous portrait busts and several monuments between 1799 and 1816. His bronzes include Two Pointers (1799), reliefs of sporting scenes (c.1805), Eagle and Thunderbolt (1811) and an equestrian statuette of General Sir John Moore (1812).

GARRIER, A. fl. 19th-20th centuries
Sculptor of bronze statuettes of classical, medieval and historical genre figures, knights in armour and small decorative groups, working in France at the turn of the century.

GARRY, Augustin Marie Joseph fl. 19th-20th centuries
He worked at Maisons Lafitte at the turn of the century and exhibited bronzes at the Salon des Artistes Français.

GARTHWAITE, Josette fl. 20th century
Born in Paris of English origin, she produced genre statuettes in the inter-war period.

GASBARRA, Giuseppe fl. late 19th century
Born in Rome in 1849, he began exhibiting in 1877 and showed sculpture in Naples, Turin, and Venice as well as Rome.

GASCH, Antonio fl. early 20th century
Sculptor of genre and allegorical figures, working in Valencia in the early years of this century.

GASPAR, Jean Marie 1864-
Born at Arlon in 1864, he trained as an engineer and was self-taught as a painter and sculptor. He produced a number of genre figures and animal studies. He was awarded a medal at the Exposition Universelle of 1889 for his group The Abduction. His bronze of a Panther is in the Brussels botanic gardens. Other works include The Adolescents.

GASPARY, Eugène de fl. 19th-20th centuries
He won an honourable mention at the Salon des Artistes Français in 1894, but is otherwise unknown.

GASPIRINI, Luigi fl. late 19th century
Born at Zenon de Pavia, Italy in the mid-19th century, he exhibited figures and portraits in Turin and Venice in the 1880s.

GASQ, Paul Jean Baptiste fl. 19th-20th centuries
Born in Dijon on May 31, 1860, he studied at the Dijon School of Fine Arts and the École des Beaux Arts, Paris under Jouffroy and Hiolle. He won the Prix de Rome in 1890 and a Grand Prix at the Exposition Universelle of 1900. He became a member of the Institut in 1935. He specialised in figures and bas-reliefs of classical and allegorical subjects.

GASSER, Hanns 1817-1868
Born at Eisentratten, Austria on October 2, 1817, he died in Budapest on April 24, 1868. He studied painting and sculpture under Klieber and Kahssmann at the Vienna Academy and was a pupil of Schwanthaler in Munich. He worked mainly in Vienna and eventually became a professor at the Academy. He specialised in colossal statues - usually very hastily executed, since most of them crumbled or decayed a few years later.

GASSER DE VALHORN, Josef 1816-1900
Born at Praegratten, Austria on November 22, 1816, he died there on October 28, 1900. He worked mainly as a sculptor of ecclesiastical decoration, but is best known for his group The Seven Liberal Arts, in the Vienna opera house.

GASSETTE, Grace fl. 20th century
Born in Chicago at the turn of the century, she studied painting under Mary Cassatt and sculpture in Paris where she settled in the 1920s. She exhibited genre and idealised statuettes at the Paris Salons.

GASTON-BROQUET fl. 20th century
Born in Paris, in the late 19th century, he studied under Injalbert and won a travelling scholarship in 1912. He exhibited at the Paris Salons in the 1920s, winning a gold medal in 1921 and becoming a Chevalier of the Legion of Honour six years later. He specialised in groups, allegorical figures and reliefs and war memorials.

GASTON-GUITTON, Victor Edouard Gustave 1825-1891
Born at La Roche-sur-Yon in 1825, he died in Paris in 1891. He studied under Rude and Ménard and exhibited at the Salon from 1853 to 1877, winning a second class medal in 1857. He specialised in genre figures and groups, sculpted in marble or bronze. His bronzes include The Wayfarer and The Pigeon.

GATCHEV, Vasil fl. 20th century
Bulgarian sculptor of genre and allegorical figures and groups.

GATE, Camille 1856-1900
Born at Nogent le Rotrou in 1856, he died there on August 21, 1900. He exhibited figures and portraits at the Salon des Artistes Français and won a bronze medal at the Exposition Universelle of 1889.

GATELET, Eugène 1874-
Born in Nancy on March 9, 1874. He exhibited statuettes at the Salon of the Société Nationale in 1920s.

GATES, William Henry fl. early 20th century
Painter and interior designer as well as sculptor, working in London and Combe Martin, Devon in the 1920s. He studied at the Royal College of Art and exhibited statuettes and groups at the Royal Academy, the Royal Scottish Academy and provincial galleries. He was the author of *The Art of Drawing the Human Figure Simplified*.

GATLEY, Alfred 1816-1863
Born in Cheshire in 1816, he died in Rome on June 28, 1863. He was the son of a quarry owner and began his artistic career as a monumental mason. He came to London in 1857 and worked in the studio of E.H. Baily and attended the Royal Academy schools two years later. He exhibited at the Royal Academy from 1841 to 1862. In 1843 he became assistant to M.L. Watson and nine years later went to Rome where John Gibson introduced him to Greek art. He spent the last decade of his life in Rome, though he visited England periodically. His best known work was the bas-relief of Pharaoh and his Hosts, shown at the International Exhibition of 1862. He produced a large umber of statues and busts in marble, but many of his works were later published as bronze reductions, especially his bust of Hebe and a series of four recumbent animals, which were edited by the Art Union.

GATTEAUX, Jacques Édouard 1788-1881
Born in Paris on November 4, 1788, he died there on February 8, 1881. He studied under Moitte and exhibited at the Salon from 1814 to 1855. He became an Officier of the Legion of Honour and a member of the Institut. He specialised in bas-reliefs, plaques and medallions, but also sculpted busts and statues in marble. His bronzes include a bust of Michelangelo and a statuette of the Chevalier d'Assas.

GATTEAUX, Nicolas Marie 1751-1832
Born in Paris on August 2, 1751, he died there on June 21, 1832. He was the father of J.E. Gatteaux and also specialised in medallions and medals. He invented a machine used by medallic engravers for achieving very fine intricate work. He was mainly known as an engraver of dies for security printing, including assignats and lottery tickets. Among the bronzes are The Genius of History, now in the Louvre.

GATTI, Geraldo fl. 19th-20th centuries
Sculptor of Italian origin, working in Paris at the turn of the century. He exhibited historical and genre figures at the Salons of Paris in 1881-87.

GATTI, Gesualdo 1855-1893
Born in Naples on February 11, 1855, he died there in 1893. He exhibited figures and groups in Naples, Munich and Vienna.

GATTO, Carmelo fl. 19th century
Sculptor of memorials and portrait busts, who died at Reggio di Calabria in 1895.

GATTO, Saverio 1877-
Born at Reggio di Calabria on August 15, 1877, the son of Carmelo Gatto. He studied under Achille d'Orsi and exhibited in Naples and Paris at the beginning of this century.

GATTOZUNI, Paolo fl. 19th century
Italian sculptor working in St. Petersburg in the 1820s on monuments and memorials.

GAUBERT, Albin fl. 19th century
Born at Saverdun in the early 19th century, he died in Paris in October 1895. He studied under Falguière and exhibited at the Salon des Artistes Français till 1895.

GAUCHER, Emile 1860-1909
Born at Blois in 1860, he died at Challans in 1909. He exhibited statuettes and small groups at the Salon des Artistes Français in the 1890s.

GAUDEZ, Adrien Étienne 1845-1902
Born in Lyons on February 9, 1845, he died at Neuilly on January 23, 1902. He studied under Jouffroy and began exhibiting at the Salon in 1864, winning a third class medal that year and a first class medal in 1881. He specialised in monuments and large groups of statuary, but also sculpted portrait reliefs and busts.

GAUDI Y CORNET, Antonio 1852-1926
Born at Reus near Tarragona in June 1852, he died in Barcelona in June 1926. He was the foremost architect of Art Nouveau and the leading exponent of this style in the applied arts of Spain at the turn of the century. He brought a sculptural quality to bear on his architecture, and most of his sculpture was designed as decoration for villas, palaces, churches, public buildings and parks in the Barcelona area. His decorative sculptures may be found in the Palau Güell (1884-89). the church of the Sagrada Family (1903), the Casa Milà and the Casa Batllo (both 1905) and the Park Güell (1900).

GAUDIER-BRZESKA, Henri 1891-1915
Born at St. Jean de Braye near Orléans on October 4, 1891, the son of a carpenter and wood-carver, he was killed in the battle of Neuville St. Vaast on June 5, 1915. He won several scholarships, including one which took him to England in 1906, and another two years later which enabled him to study at University College, Bristol. He worked with a firm of coal contractors in Cardiff, but devoted more and more of his time to sketching and painting. In 1909 he went to Nuremberg and from there to Paris where he had an office job and studied art at the St. Geneviève Library in his spare time. It was here that he met Sophie Brzeska, a Polish woman twenty years his senior, and together they led a strange nomadic life. They lived in London from 1910 till the first world war and with the help of Major Haldane McFall he was introduced into London literary and artistic circles. During this period he first turned to sculpture, carving in stone and modelling in clay. He produced a number of portrait busts and bas-reliefs and allegorical groups, while also experimenting with Cubism, Vorticism and other transient abstract styles. In this period he was influenced by Picasso and Brancusi, but he also produced a number of figures and groups of animals which he studied in Richmond Park and London Zoo. He exhibited sculpture at the International Society of Sculptors, Painters and Gravers in the Grosvenor Gallery, 1913 and portrait busts at the London Salon in the Albert Hall the same year. He exhibited animal figures at the Alpine Gallery and London Salon in 1914. A retrospective exhibition of his work was held at the Leicester Galleries in 1918. Though most of his work was carved in stone, a number of the animal figures were cast in bronze by the *cire perdue* process. He was regarded as the most promising sculptor in England at the time of his death and it is idle to speculate what this 23 year-old might have done had the first world war not claimed him.

Pound, Ezra *Gaudier-Brzeska: His Life and Work.*

GAUDISSARD, Emile 1872-
Born in Algiers in 1872, he studied in Paris and won a travelling scholarship to Rome in 1904. He exhibited at the Salon des Artistes Français at the turn of the century and won a third class medal in 1904 and a second class medal two years later. He specialised in portrait busts and genre groups.

GAUDRAN, Louis Gustave fl. 19th century
Born in Paris in 1829, he studied under Toussaint and exhibited religious statuettes and reliefs at the Salon from 1870 to 1887.

GAUGUIN, Jean René 1881-
Born on April 12, 1881, he was the son of the painter and sculptor Paul Gauguin. He moved to Copenhagen with his mother in 1884, after his father abandoned them to devote his life to art. J.R. Gauguin became a Danish citizen in 1909 and worked in Copenhagen as a sculptor of portraits, reliefs and figures.

GAUGUIN, Paul 1848-1903
Born in Paris on June 8, 1848, he died at Atuana in the Marquesas group (French Polynesia) on May 6, 1903. He served as a French naval officer between 1865 and 1871 and then worked for a Paris stockbroker. In 1876 he began painting as a pastime and seven years later he turned to art full-time. Thereafter he commuted between Paris and Brittany, spent a year in Martinique (1887) and worked at Pont-Aven and Arles (1888) and then in Paris till 1891 when he departed for the South Pacific. He worked in Tahiti for two years and after a brief sojourn in France again he settled in the Marquesas where he died in 1903, destitute and alone. The importance of his work as a leading figure of Post-Impressionist painting, the Synthesists and the Pont-Aven group, his influence on Toulouse-Lautrec and Edvard Munch, and his revolutionary contribution to the development of the poster and other forms of graphic art, have over-shadowed his work as a sculptor. He produced sculptural ceramics during his Pont-Aven period and also a considerable number of wood-carvings and terra cotta figures during his years in Tahiti and the Marquesas and many of his pagan deities were subsequently cast in bronze.

Gauguin, Paul *Noa Noa* (1924). Morice, Ch. *Paul Gauguin* (1919). Rotonchamp, Jean de *Paul Gauguin* (1925).

GAUL, August 1869-1921
Born at Gross Anheim near Hanau on October 22, 1869, he died in Berlin in 1921. He was the son of a stone-mason from whom he learned the techniques of direct carving. He studied in Hanau and later at the Berlin Academy (1893-94). He worked in the studio of Reinhold Begas and won the prize of the Paul Schultze foundation in 1897. He completed his studies in Italy in 1898-99 and then settled in Berlin. He was strongly influenced by Tuaillon and von Marees and became a member of the Secession in 1902. He specialised in animal figures and groups, and was Germany's leading Animalier in the early years of this century, working in a mixture of realism and impressionism. Many of his figures were carved from stone, but others were modelled in clay and cast in bronze. The Hamburg Museum has a dozen of his animal bronzes and other works in this medium include Two Pelicans, Sheep at Rest, Dancing Bear, Ostrich and Owls.

GAULARD, Lucien fl. 20th century
Born in Marseilles in the late 19th century he worked there before the first world war as a sculptor of portraits and figures. He became an Associate of the Artistes Français in 1902.

GAULLE, Edmé 1762-1841
Born in Langres on January 4, 1762, he died in Paris in January 1841. He studied under Devosges in Djon and was runner-up in the Prix de Rome in 1799 but won the prize four years later with his group of Ulysses recognised by his Nurse Euryclea. He exhibited at the Salon from 1808 to 1827 and produced monuments, memorials, bas-reliefs and portrait busts in marble and bronze.

GAUMONT, Marcel 1880-
Born at Tours on January 27, 1880, he studied under Sicard and Coutan and won the Prix de Rome in 1908. He exhibited at the Paris Salons in the inter-war years, winning a gold medal in 1935 and a Grand Prix at the Exposition Internationale two years later. During the first world war he won the Croix de Guerre and became successively Chevalier (1925) and Officier (1938) of the Legion of Honour. He sculpted a number of statues and large monuments, but also did statuettes and bas-reliefs of a religious nature.

GAUPILLAT, Jenny (née Cheilley) fl. 19th century
She worked in Paris and died there in 1892. She exhibited figures and busts at the Salons from 1884 to 1891.

GAUQUIÉ, Henri Desiré 1858-1927
Born at Flers-les-Lille on January 16, 1858, he died in Paris in 1927. He studied under Cavelier and exhibited at the Salon from 1881, winning a third class medal and a travelling scholarship in 1886, second and first class medals in 1890 and 1896, and bronze and silver medals at the Expositions of 1889 and 1900. He became a Chevalier of the Legion of Honour in the latter year. He specialised in portrait medallions and busts of his contemporaries, but also did bas-reliefs and groups of classical subjects.

GAUTHERIN, Jean 1840-1890
Born at Ouroux on December 28, 1840, he died in Paris on September 21, 1890. He studied at the École des Beaux Arts under Gumery and A. Dumont. He began exhibiting at the Salon in 1865 and won medals in 1868, 1870 and 1873. He was made a Chevalier of the Legion of Honour in 1878. He specialised in portrait busts and allegorical figures and also sculpted several monuments in Paris.

GAUTHEROT, Claude 1729-1802
He spent his entire life in Paris, where he studied painting under Jean Louis David. Though best known as a painter, he also modelled a number of portrait busts of his artistic and literary contemporaries, such as Voltaire, Rousseau, Turgot, Bailly and Gluck.

GAUTHIER, Antoine fl. late 19th century
Born at Louhans in the mid-19th century, he exhibited figures at the Salon des Artistes Français and got an honourable mention in 1896.

GAUTHIER, Charles fl. 19th century
Born at Chauvirey le Chatel on December 7, 1831, he enrolled at the École des Beaux Arts in 1854 and studied under Jouffroy. He was runner-up in the Prix de Rome of 1861 and exhibited at the Salon from 1859 to 1892, winning medals in 1865-69 and the Legion of Honour in 1872. He specialised in figures sculpted in stone, plaster and bronze. His works in the latter medium include Charlemagne (on the high altar of the collegiate chapel of St. Quentin), Angel playing the Trumpet, The Preacher and Sin, Episode from a Shipwreck and other genre groups.

GAUTHIER, Joseph fl. 20th century
Born at Carcassonne in the early years of this century, he exhibited at the Paris Salons in the 1920s.

GAUTIER, Jacques fl. 19th century
Born in Paris on December 13, 1831, he studied under Rude and exhibited figurines and small groups at the Salon from 1855 to 1868

GAUTIER, Paul Albert 1884-
Born at Cayenne, French Guiana on September 19, 1884, he studied in Paris under Coutan and exhibited at the Salon des Artistes Français, winning a second class medal in 1921 and a first class medal five years later. He specialised in busts and heads of children.

GAUVIN, Albert fl. 19th century
He specialised in bas-reliefs and medallions in bronze, examples of which are in Rouen Museum.

GAUVIN, Alfred 1830-1892
Born at Hericourt-en-Caux on May 5, 1830, he died in Paris on December 27, 1892. He produced portrait busts and statuettes and examples of his work are in the museums of Rouen, Versailles and Paris (Musée Galliéra).

GAWEN, Joseph fl. late 19th century
He worked in London during the second half of the 19th century, exhibiting figures and portraits at the Royal Academy from 1850 to 1882.

GAY, Lydia (later Madame Gay-Guillet) fl. 19th century
She worked in Paris as a sculptor of portrait medallions, bas-reliefs and busts.

GAYRARD, Paul Joseph Raymond 1807-1855
Born at Clermont on September 3, 1807, he died at Enghien les Bains on July 22, 1855. He studied under his father Raymond Gayrard and exhibited at the Salon from 1831 to 1855, winning a second class medal in 1834 and a first class medal in 1846. He specialised in portrait busts of contemporary celebrities, but also produced a number of figures of allegorical and religious subjects. Like his father, he dabbled in animal sculpture such as the bronzes of The Monkey Steeplechase (1846) and Harnessed Horse (1847).

GAYRARD, Raymond 1777-1858
Born at Rodez on October 25, 1777, he died in Paris on May 4, 1858. He studied under Boizot, Taunay and Geoffroy and exhibited at the Salon from 1814 to 1851. He specialised in portrait medallions and busts, but also sculpted a number of marble portrait statues and genre and classical groups, such as Cupid counting his Arrows and Justice protecting Innocence and punishing Crime. He sculpted several equestrian statues, including those of Henri IV (1814) and General Tarayre (1857) and these were later published as bronze reductions. His importance as a precursor of the Animalier school, developed by Barye and Fremiet, is seen in such groups as Child playing with a Young Hare and Sleeping Lioness.

GECHTER, Jean François Theodore 1796-1844
Born in Paris in 1796, he died there on December 11, 1844. He studied under Bosio and Gros and exhibited at the Salon from 1827 to 1844, becoming a Chevalier of the Legion of Honour in 1837. He sculpted numerous heroic figures and bas-reliefs for public statuary and also portrait busts of his contemporaries. He was a friend of Barye and towards the end of his career dabbled in Animalier sculpture, producing statuettes of greyhounds and equestrian subjects, such as English Thoroughbred and a group showing Charles Martel in combat with Abderame, King of the Saracens.

GECKLE, Albert fl. late 19th century
Born in Stuttgart on August 25, 1853, he studied in Vienna, Munich and Paris before settling in his native city, where he worked on decorative sculpture for churches and public buildings.

GEEFS, Alexandre 1829-1866
Born in Antwerp on January 1, 1829, he died at Schaerbeek on August 27, 1866. He sculpted a number of portrait busts.

See Geefs Family Tree.

GEEFS, Aloysius 1817-1841
Born in Antwerp, he died at Auteuil on August 31, 1841. He worked in Flanders as a painter and genre sculptor.

GEEFS, Charles fl. 19th century
Belgian sculptor working in Brussels in the mid-19th century. It has not been ascertained whether he was related to Willem Geefs and his brothers. He exhibited at the Royal Academy in 1858.

GEEFS, Jan 1825-1860
Born in Antwerp on April 25, 1825, he died in Brussels on May 4, 1860. He specialised in mythological and allegorical statuettes and groups.

GEEFS, Joris 1850-
Born in Antwerp in 1850, the son and pupil of Willem Geefs. He studied at the Antwerp Academy and later became professor there and a member of the Academic Council in 1892. He was awarded medals at the Antwerp (1876), Brussels (1878) and Paris (1878) Expositions for his classical figures and groups. Antwerp Museum has his bust of his father and a group Leander dying on the Banks of the Hellespont.

GEEFS, Josef 1808-1885
Born in Antwerp on December 23, 1808, he died in Brussels on October 19, 1885. He studied under his brother Willem and won the Prix de Rome in 1836. He was appointed professor of sculpture at Antwerp Academy in 1841 and a member of the Académie Royale the following year. He was awarded the Order of Leopold and became a member of the Academic Council. He specialised in portrait busts, historical figures and genre groups, such as Fisherman seduced by the Siren (Antwerp Museum).

GEEFS, Theodore 1827-1867
Born in Antwerp on February 15, 1827, he died in London on January 1, 1867. He studied under his brother Willem and worked in Brussels and London, specialising in figures and bas-reliefs of religious subjects.

GEEFS, Willem 1805-1883
Born in Antwerp on September 10, 1805, he died in Brussels on January 24, 1883. He was the eldest of six brothers, all of whom became sculptors of note. He studied at the Antwerp Academy, winning the Grand Prix in 1828. Later he was a pupil of Ramey in Paris and was admitted a member of the Academic Council in 1852. He collaborated with his brother Josef on the column of Congress, representing Belgian sculpture at its zenith and very much in tune with the Belgian middle class taste of the period. He sculpted numerous monuments and memorials, but his minor works include a large number of historical figures - the medieval heroine Genèvieve de Brabant being a favourite subject. Many of his smaller bronzes are in the Antwerp Museum. One of his more interesting works is the statue and decorative bas-reliefs of General Belliard in Brussels.

GEEL, Johannes Franciscus van 1756-1830
Born in Malines on September 17, 1756, he died in Antwerp on January 20, 1830. He studied under Pieter Valk and was successively professor of sculpture at Malines (1784-1817) and Antwerp (1817-1830).

GEEL, Johannes Ludovicus van 1787-1852
Born in Malines on September 28, 1787, he died in Brussels on April 10, 1852. He was the son and pupil of J.F. van Geel and went to Paris in 1809 where he studied under David and Roland. He won first prize for sculpture in 1811. On his return to Brussels in 1815 he became Sculptor to the Prince of Orange. His best known work is the Lions on the battlefield of Waterloo.

GEENE, Henri Gysbert 1865-
Born in Roermond, Holland in 1865, he studied in Düsseldorf and later settled in St. Gall, Switzerland where he sculpted portraits and classical figures.

GEERTS, Edouard 1846-1889
Born in Brussels on January 10, 1846, he died at Ixelles on November 24, 1889. He worked in Brussels as a sculptor of historical and classical statuettes and portraits. He won an honourable mention at the Exposition Universelle of 1889.

GEERTS, Karel Hendrik 1807-1885
Born in Antwerp on August 10, 1807, he died in Louvain on June 16, 1885. He studied under J.B. van Hool and J.A. van der Ven and became professor of sculpture at Louvain Academy. He specialised in religious figures and reliefs and is best known for the statues in the stalls of Antwerp Cathedral. Many of his minor works are in the museums of Brussels and Bruges.

GEFLOWSKI, E. Edward fl. 19th century
Sculptor of Polish origin, working in London in the second half of the 19th century. He exhibited at the Royal Academy and the British Institution from 1867 and specialised in portrait busts of contemporary celebrities, both British and foreign. His statuette of Garibaldi is in the Liverpool and Salford museums.

GEIBEL, Herman 1889-
Born at Freiburg-im-Breisgau on May 14, 1889, he studied in Dresden and settled in Munich where he sculpted memorials, bas-reliefs and portraits in the 1920s.

GEIGER, Maurice Raphael fl. 20th century
Born at Nantes in the early years of this century, he exhibited statuettes at the Nationale in the 1930s.

GEIGER, Nicolaus 1849-1897
Born at Laningen on December 6, 1849, he died in Berlin on November 27, 1897. He studied at the Munich Academy and afterwards worked in the studio of Knabl, before settling in Berlin. He exhibited both painting and sculpture in Munich and Berlin in 1884-88. His sculptures consist of busts and heads of women and young girls and genre and classical groups such as After the Fall and Centaur and Nymph.

GEISER, Karl 1898-1957
Born in Berne in 1898, he died in Zürich in 1957. As a sculptor he was largely self-taught though he studied in Berlin for two years after the first world war before settling in Zürich in 1922. He specialised in heads and figures of young boys, but later did a series of figures of

women which occupied him from 1943 till his death. His one and only individual show was held in Winterhur in 1941, but a retrospective was staged in Basle in 1958. He had several major public commissions, including David (Soleure, 1944) and Monument to the Glory of Labour (incomplete at the time of his death).

GEISSBUHLER, Arnold fl. 20th century
Swiss sculptor working in the first half of this century and specialising in portrait reliefs, heads and busts.

GELDER, J.V. van fl. 19th century
Portrait sculptor working in Rotterdam in the 19th century. The Boymans Museum has his bust of the painter Koekkoek.

GELERT, Johannes Sophus fl. 19th-20th centuries
Born at Nybel in Denmark on December 19, 1852, he studied at the Copenhagen Academy and won a scholarship from the Danish government that enabled him to study in Rome. Later he emigrated to the United States where he worked on monuments and portraits. He exhibited in New York, St. Louis, Buffalo, Philadelphia and Paris and received a number of awards at the turn of the century.

GELEYN, Joseph fl. 19th-20th centuries
Belgian sculptor working in Brussels at the turn of the century on historical and allegorical figures.

GELL, Ada Evershed (Mrs. Freeman) fl. late 19th century
She worked in Brighton in the late 19th century and exhibited figures and groups at the Royal Academy and Suffolk Street from 1887 onwards.

GELLE, Jules fl. 19th century
Born at Anzin, France in the mid-19th century, he studied at the School of Fine Arts, Valenciennes and exhibited figures at the Salon from 1868 to 1880.

GELLES, Karl fl. 19th-20th centuries
He worked in Vienna at the turn of the century and exhibited genre figures and portraits in Vienna, Paris and Madrid up to the first world war.

GEMIGNANI, Ulysse fl. 20th century
Born in Paris at the turn of the century, he studied under Injalbert and won the Prix de Rome in 1933. He exhibited figures and reliefs at the Salon des Artistes Français before the second world war.

GEMITO, Vincenzo fl. 19th-20th centuries
Born in Naples on July 16, 1852, he was the brother of Stanislas Lista. He spent a number of years in France and exhibited at the Salon from 1879 to the end of the century, winning a third class medal in 1879 and a second class medal the following year. He was awarded Grand Prix at the Expositions of 1889 and 1900. His work was very highly regarded in France and Italy at the turn of the century and his genre sculpture was distinguished by its grace, delicacy and simplicity devoid of vulgarity. His bronzes include The Water-carrier, Nurse, The Fisherman, Japanese Conjurer, Narcissus, The Philosopher, Seated Woman and various heads and portrait busts.

GENDROT, Felix Albert 1866-
Born in Cambridge, Massachusetts on April 28, 1866, he studied in Boston where he subsequently worked as a painter and sculptor. He also studied painting under Laurens and Constant and sculpture under Puech and Verlet in Paris.

GENEVIEVE (Geneviève Pezet) 1918-
Born in Sandpoint, Idaho in 1918, she studied classics at Pullman State College, Washington and Columbia University and took up painting as an amateur. Later she attended classes at the Art Students' League, New York and then taught drawing in a New York school. After the second world war she went to Paris where she worked with André Lhote and then in the studio of Zadkine where she remained till 1956. She was pre-occupied with sculpture which sought to relate the human form to nature and worked in plaster and clay. From ceramic sculpture she moved on to casting in bronze at the Salon de la Jeune Sculpture from 1954 onwards and had her first individual show at the Galerie de l'Institut in 1957.

Editions Glachant *Genevieve* (1957).

GENIES, Joseph Antoine fl. 20th century
Born at Figeac, France, he produced portraits and statuettes before the second world war.

GENNA, Carmine fl. early 20th century
Born in Sicily in the late 19th century, he studied in Palermo and exhibited figures and reliefs in Rome and Milan in the early part of this century.

GENNARELLI, Amedeo fl. 20th century
Born in Naples in the late 19th century, he exhibited statuettes in Naples and Paris in 1913-14.

GENTILE, Tommaso fl. late 19th century
Born at Chieti, Italy in 1853, he began exhibiting in Naples in 1877 and also took part in the art exhibitions of Turin and Venice at the turn of the century.

GENUTAT, Wilhelm fl. 19th century
Born in Berlin, where he worked as a decorative sculptor. He also exhibited at the Royal Academy and produced portraits and genre figures.

GEOFFROY, Adolphe Louis Victor 1844-1915
Born in Paris on February 27, 1844, he died there in 1915. He studied under his father Geoffroy de Chaume and began exhibiting at the Salon in 1861. He was one of the original Associates of the Artistes Français (1883) and won third class (1875) and second class (1889) medals. He is best remembered for the bronze bas-reliefs on the doors of Strasbourg Cathedral.

GEOFFROY, Alexandre François fl. 19th century
Born at Loguyon in 1849, he studied under Hugoulin and exhibited at the Salon des Artistes Français at the end of the century.

GEOFFROY, Edouard fl. 19th century
Born in Paris, he studied under Franceschi and exhibited at the Salon from 1861, and became an Associate of the Artistes Français in 1886.

GEOFFROY, Henry Jules Jean 1853-1924
Born at Marennes on March 1, 1853, he died in Paris in 1924. He studied under Levasseur and exhibited at the Salon from 1874 and the Artistes Français from 1883, winning a third class medal in 1886 and a gold medal at the Exposition Universelle of 1900. He was also a Chevalier of the Legion of Honour. Although better known as a painter of children's portraits he also sculpted genre groups featuring children with naive charm.

GEOFFROY DE CHAUME, Adolphe Victor 1816-1892
Born in Paris on September 29, 1816, he died at Valmondois on August 25, 1892, enrolled at the École des Beaux Arts in 1831 and studied under David d'Angers. He was appointed a Chevalier of the Legion of Honour in 1862 and became an Officier in 1880. He specialised in portrait sculpture. The Museum of Modern Art has his mask of Beranger and the bust of the painter Corot.

GEORGE, Alfred fl. 19th century
Born in Paris on November 22, 1838, he studied under Jouffroy and exhibited at the Salon in 1864, 1866 and 1874.

GEORGE, Edmond Samuel fl. 19th century
Born in Paris on April 25, 1833, he enrolled at the École des Beaux Arts in 1848 and was a pupil of Nanteuil. He exhibited classical and genre figures at the Salon intermittently from 1864 onwards.

GEORGE, Helen Margaret fl. 20th century
Born in Blandford, Dorset at the turn of the century, she studied under Bourdelle in Paris and exhibited at the Royal Academy, the Royal Society of British Sculptors, the Salon des Artistes Français and American galleries in the inter-war period. She specialises in figures and groups with the theme of motherhood and works in Blandford Forum.

GEORGES, Eduard François fl. 19th century
Born in Amsterdam on March 14, 1817, he studied under Louis Royer and worked in Utrecht as a sculptor of figures and busts. His statue of Episcopius is in the Rotterdam Museum, while his bust of the architect Kramm is in the Utrecht Museum.

GEORGESCU, Ioan c.1857-1899
Born in Bucharest in 1856 or 1857, he died there in March 1899. He studied in Paris and exhibited at the Salon, winning an honourable mention in 1881 and a bronze medal at the Exposition Universelle of 1889. He specialised in portrait figures and busts. Examples of his work are in the Simu Museum, Bucharest.

GEORGET, Henri C.L. fl.19-20th centuries
Painter and sculptor working in Paris, where he died in 1905. He exhibited figures at the Salon des Artistes Français in 1901-5.

GEORGII, Theodor 1883-
Born in Shdani, Russia on April 30, 1883, of German ancestry, he studied in Munich and produced genre figures and portrait busts.

GEORGII-HILDEBRAND, Irene 1880-
Wife of the above, she was born in Florence and worked with her husband in Munich.

GERARD, Calixte Marius fl. late 19th century
Born in Paris about 1850, he studied under A. Dumont and exhibited at the Salon from 1869, winning a second class medal in 1881. He produced genre, allegorical and classical figures and groups.

GERARD, François Antoine 1760-1843
Born in Paris in 1760, he died there on September 16, 1843. He studied under Moitte and won the Prix de Rome in 1789. He exhibited at the Salon from 1808 to 1833 and specialised in allegorical groups and bas-reliefs, many of which were erected in public parks and places in Paris. His best known work is the Bastille fountain, but his decorative reliefs may be seen at the Carrousel, the Louvre and the Arc de Triomphe.

GERDUR - see HELGADOTTIR, Gerdur

GERENDAY, Antal 1818-1887
Born in Hungary in 1818, he died at Piszke on August 7, 1887. He spent most of his working life in Budapest, where he sculpted portraits, statues and bas-reliefs.

GERENDAY, Bela 1863-
Born in Budapest, he was the son of Antal Gerenday with whom he worked on monuments in Budapest.

GERENTE, Alfred 1821-1868
Born in Paris on March 11, 1821, he died there on November 11, 1868. He studied under Feuchères and Geoffroy de Chaume, but gave up his career as a sculptor on the death of his brother, the glass-painter Henri Gerente (1849). Thereafter he took over the family business and concentrated on stained glass. His sculptures consist mainly of genre and classical figurines.

GERGONNE, Dominique François fl. 19th century
Born in Paris about 1840, he died there in 1883. He studied under Chambard and Jobbé-Duval and exhibited figures and groups at the Salon from 1869 till his death.

GERHARD, Wilhelm Christoph Leonhard 1780-1858
Born in Weimar on November 29, 1780, he died in Heidelberg on October 2, 1858. He worked in Leipzig and Switzerland as a painter and sculptor of genre subjects.

GERHARDT, Heinrich 1823-1915
Born in Cassel on August 14, 1823, he died there on October 24, 1915. After a short period in Rome, where he had followed his master Henckeel, he returned to Cassel where he sculpted memorials, bas-reliefs and busts.

GERHART, Emmanuel 1857-
Born in Vienna on November 22, 1857, he worked as a decorative sculptor in Reichenberg.

GÉRICAULT, Jean Louis André Théodore 1791-1824
Born in Rouen on September 26, 1791, he died in Paris on January 26, 1824 as a result of a riding accident. His career as one of the most prominent Romantic painters of the early 19th century has overshadowed his importance as a sculptor, but he played a significant part in the Romantic movement, paving the way for the work of Barye. He studied painting under Vernet and Guérin and shocked the academic world by his realistic interpretation of nature. He was in Rome from 1816 to 1819 and on his return exhibited his most

famous painting The Raft of the Medusa at the Salon. The hostility with which this work was greeted forced him to work in London for two years where he produced a number of paintings and a series of prints illustrating famous horses. He returned to Paris at the end of 1822 and began modelling horses in wax as a preliminary study for an ambitious monumental project, and maquettes of an *écorché* horse for an equestrian statue. His untimely death abruptly terminated what might have been a most promising career in sculpture and bronze casts were not made of his models till almost a century later, when Valsuani edited a small edition of them.

Clément, Charles *Th. Géricault, Étude biographique et Catalogue raisonné* (1879).

GERIN, Michel fl. 18th-19th centuries
Born in France, where he worked in the late 18th century. He accompanied the Napoleonic armies and sculpted portraits of many personalities in other European countries at the beginning of the 19th century.

GERMAIN, Alphonse Joseph fl. late 19th century
Born in Paris, where he worked in the second half of the 19th century. He exhibited statuettes at the Salon from 1874 onwards.

GERMAIN, Gustave 1843-1909
Born at Fismes in 1843, he died in Paris on April 27, 1909. He studied under Gumery and A. Dumont and exhibited at the Salon from 1881 onwards. He won a bronze medal at the Exposition Universelle of 1889 and was later made a Chevalier of the Legion of Honour. He specialised in genre, allegorical and classical figures, such as Love Asleep (Sete Museum).

GERMAIN, Jean Baptiste d. 1910
Born at Fismes, he studied under Dumont and Gumery and worked with his brother Gustave in producing classical and historical statuettes and groups. He exhibited at the Salon from 1866 to 1879 and later at the Salon des Artistes Français, of which he became an Associate in 1889. He won a third class medal in 1883 and got an honourable mention at the Exposition of 1900. His bronzes include Joan of Arc and a group of Dido and Aeneas.

GERMAIN, L. fl. 19th century
French sculptor specialising in busts of his contemporaries. He exhibited at the Salon from 1812 onwards.

GERMAIN, Marguerite fl. 20th century
Born in Rouen where she works as a sculptor and painter. She exhibited statuettes at the Paris Salons in the 1930s.

GERMAIN, Raymond Albert fl. 19th-20th centuries
Born in Paris in the late 19th century, he studied under Coutan, Peter and Peynot and exhibited at the Salon des Artistes Français before the first world war, winning a third class medal in 1911.

GÉROME, Jean Léon 1824-1904
Born at Vesoul on May 11, 1824, he died in Paris on January 10, 1904. He was one of the more prominent French painters and engravers of the 19th century, and also worked as a sculptor. He came to Paris in 1841 and entered the studio of Paul Delaroche the following year. He made his début at the Salon in 1847 with the painting Cockfighting which won him a third class medal. Subsequently he produced many paintings of genre and classical subjects. His extensive travels in Italy, Turkey and the Danubian principalities were reflected in his paintings and engravings. He became a member of the Institut in 1863 and a Commandeur of the Legion of Honour in 1878. After a lifetime devoted to painting he switched to sculpture and produced genre, heroic and classical figures, such as Bonaparte, Bellona and Omphalos, Tanagra, Girl playing Bowls and similar subjects.

GERSTEIN, Noémi 1910-
Born in Buenos Aires in 1910, she studied under Bigatti in 1934, after taking a degree in science and fine art. In 1950 she came to Paris where she worked with Zadkine for a year. She belongs to the Argentine groups Twenty Painters and Sculptors and Arte Nuevo and taught sculpture till 1956. She has participated in many Argentine art exhibitions, as well as the Venice Biennale. Her work developed slowly from the charming figurative sculpture, such as Maternities

(1952-53) to the abstract and now tends towards the monumental. Her earlier works were modelled in clay and plaster, but more recently she has worked in iron (both cast and wrought) as well as bronze and silver.

GERTH, Fritz fl. late 19th century
German sculptor working in Rome in the late 19th century. He specialised in genre groups, many of which are to be found in museums in Scandinavia, the Netherlands and Germany, and include The Two Sisters (Amsterdam), The Little Musician (Bremen), Musical Reunion (Cologne) and Christmas Morning (Oslo).

GEYER, Otto 1843-1914
Born in Charlottenburg on January 8, 1843, he died there in March 1914. He sculpted statues and bas-reliefs for churches and public buildings in the Berlin area.

GHEEST, Maurice David Gabriel de fl. late 19th century
Born in Paris of Belgian parents, he worked there as a genre sculptor and exhibited statuettes at the Salon from 1878 onwards.

GHEZZI, Pasquale 1825-1890
Born in Lamone in 1825, he died in Rome in 1890. He studied in Paris and sculpted bas-reliefs, medallions and portrait busts.

GHIDONI, Domenico fl. 19th century
Born in Brescia, he studied in Milan and exhibited figures and groups in Milan and Turin in the late 19th century.

GHILONI, Pedro fl. 19th century
Portrait sculptor working in New Orleans in the late 19th century.

GHILONI MOLERA, Alejandro 1860-
Born in Barcelona in 1860, he exhibited figures and bas-reliefs in Madrid from 1881.

GIACOMETTI, Alberto 1901-
Born in Stampa, Switzerland, the son of the painter Giovanni Giacometti, he studied at the School of Arts and Crafts in Geneva, and worked in Rome for a year (1920-21) before settling in Paris. Here he attended Bourdelle's classes at the Académie de la Grande Chaumière (1922-25). His early works were influenced by Cubism and are typified by Woman-spoon (1926). Then he joined the Surrealists and executed what he termed Objects and Cage-constructions, such as Point in the Eye and Disagreeable Object (both 1932), the Invisible Object (1934), Palace at Four in the Morning (1932-33). In the mid-Thirties he turned back to figurative sculpture and specialised in human figures of unusually elongated proportions. During the second world war he lived in Geneva but returned to Paris following the liberation. He had his first one-man show at the Galerie Pierre Colle, Paris in 1934 and since the war has exhibited in France, Britain, Switzerland, Italy and the United States. Among his post-war figurative bronzes are The Hand (1947), Seven Figures and One Head (1950), Man walking across a Square in Sunshine (1948), City Square (1948-49), Female Figure (1948) and Man Painting (1947).

Selz, Peter *Alberto Giacometti* (1965).

GIACOMETTI, Diego 1902-
Born in Stampa, Switzerland, the younger brother of Alberto. His career has paralleled that of his brother's, but always in a secondary role. He has concentrated entirely on sculpture, whereas Alberto has also painted. Though indebted to Alberto to some extent, he is an important sculptor in his own right. He specialises in 'Objects, lustres, bodies of a baroquism, chimeras and salamanders fashioned in the flame', to use his own words.

GIANI, Vincenzo 1831-
Born in Como in October 1831, he studied under Vela at the Albertina Academy and settled in Turin where he sculpted decorative bas-reliefs and statuary. He exhibited in Turin, Milan and Rome in the late 19th century.

GIANNELLI, J.G. fl. 1808-1829
Son of the stone-mason and monumental sculptor J.B. Giannelli, he worked in London in the early 19th century and exhibited at the Royal Academy from 1809 to 1820. He specialised in bronze busts of his contemporaries. His bronze of Professor Porson (1809) is in the College Library, Eton. The Victoria and Albert Museum has a wax bust by him of an unknown man.

GIANSONE, Mario fl. 20th century
Painter and sculptor working in marble and bronze in Rome during the first half of this century. He specialised in allegorical works in a modernist idiom.

GIARRIZZO, Salvatore fl. late 19th century
Born in Piazza Armerina, Italy in 1853, he studied art under his father, the painter and interior designer Michelangelo Giarrizzo. He exhibited decorative sculpture in Messia and Palermo in the 1880s.

GIBELLI, Cesare fl. late 19th century
Born in Bologna where he worked as a sculptor of monuments and portrait busts.

GIBERT Y RAIG, Pablo fl. late 19th century
Born in Tarragona, he studied under Andreas Aben and began exhibiting statuettes in Barcelona in 1876 and in Madrid in 1881.

GIBSON, James Brown 1880-
Born in Glasgow on November 26, 1880, he studied at the Glasgow School of Art and worked in Glasgow, Milngavie and Killin, Perthshire. He is better known as a painter of landscapes, portraits and genre subjects, but he also worked as an engraver and lithographer and sculpted portrait busts and genre statuettes. He exhibited at the Royal Scottish Academy, the Glasgow Institute and various overseas exhibitions.

GIBSON, John 1790-1866
Born near Conway, North Wales in 1790, he died in Rome on January 27, 1866. He was the son of a market gardener and was self-taught, but in October 1817 he went to Rome where he studied under Canova. His first exhibited work in marble was the figure of a Sleeping Shepherd and this excited favourable comment. He established his own studio in the Via Fontanella and spent the rest of his life in Rome, though he frequently visited England and exhibited at the Royal Academy, becoming R.A. in 1836. Gibson has been favourably compared with Canova and Thorwaldsen, seldom descending to the sugary level of the one and sometimes surpassing the strength and quality of the other. Most of his genre and allegorical works were executed in marble or tinted plaster (the latter being a technique which he perfected), but several of his works were cast in bronze or edited as bronze reductions. His best known work is the group of Queen Victoria supported by Justice and Clemency (Houses of Parliament) and he also sculpted the statue of Huskisson in the Royal Exchange. His speciality, however, was the bas-relief which he used to great effect in the depiction of equestrian subjects. He bequeathed the contents of his studio to the Royal Academy, but an important collection of his works is also at Hafod in Denbighshire.
Eastlake, Lady *Life of John Gibson,R.A.* (1870). Matthews, T. *The Biography of John Gibson* (1911).

GIES, Ludwig 1887-
Born in Munich on September 3, 1887, he studied there at the School of Arts and Crafts and worked in that city for several years before moving to Berlin. He was a member of the Munich and Berlin Secession movements. He sculpted reliefs, mainly in wood or ivory, but also did a number of plaques and medallions cast in bronze. During the first world war he became one of Germany's leading exponents of the art of the satirical propaganda medal.

GIESE, Benjamin 1705-1755
Born in Berlin in 1705, he died in Potsdam in 1755. A bronze-founder as well as a sculptor, he did the ornaments in bronze and lead for the Prussian royal palaces at Potsdam, the best known being the bronze bas-relief in the Marble Salon at Potsdam. Many of his allegorical and classical groups were cast in bronze or gilt-lead for Sans Souci Park, including Flora, Pomona, Centaur and Bacchante.

GIESECKE, Wilhelm Christian Andreas 1854-1917
Born in Altona on April 2, 1854, he died at Barmen (now Wuppertal) on October 15, 1917. He was a genre painter and sculptor, specialising in busts and figures of Moors and Mamelukes. He exhibited in Munich and Hamburg at the turn of the century.

GIESSMANN, Friedrich Ernst fl. 19th century
Sculptor of historical and genre figures, working in Leipzig in the late 19th century.

GIGNOUX, Charles fl. 19th century
Animalier sculptor of the second half of the 19th century. The Museum of St. Etienne has his group of a Lion and Lioness at Play.

GIGON, André 1924-
Born at Biel, Switzerland in 1924, he studied at the applied arts department of Biel technical college. From 1945 to 1954 he worked in clay and produced abstracts in terra cotta. Since 1954 he has worked exclusively in stone and concrete.

GILABERT Y PONCE, Luis fl. 19th century
Born in Valencia on June 21, 1848, he studied at the local School of Fine Arts and began participating in the Valencia art exhibitions in 1876. He specialised in classical and modern figures, particularly athletes.

GILBAULT, Ferdinand fl. 19th-20th centuries
Born in Brest on March 20, 1837, he exhibited at the Salon des Artistes Français at the turn of the century, winning honourable mentions in 1890 and 1900 and a third class medal the following year. He specialised in bas-reliefs, plaques and roundels portraying contemporary figures and genre subjects of Breton interest.

GILBERT, Sir Alfred 1854-1934
Born in London on August 12, 1854, he died there on November 4, 1934. He studied at Heatherley's School from 1872, was a pupil of Boehm at the Royal Academy schools, and studied at the École des Beaux Arts, Paris (1875-78) and in Rome (1878-84). He began exhibiting at the Royal Academy in 1882 and rapidly established a reputation, becoming A.R.A. (1887), R.A. (1892) and professor of sculpture at the Royal Academy schools (1900). He was made bankrupt in 1903, subsequently resigned from the Royal Academy and lived in self-imposed exile in Bruges, Belgium until 1926. He was re-admitted to the Royal Academy in 1932 and knighted the same year. His best known work is the statue of Eros (1888), but he sculpted many other monuments and memorials in the London area and for the magnificent tomb of the Duke of Clarence at Windsor (in Mexican onyx, bronze, silver and ivory) he was appointed a Member of the Royal Victorian Order in 1897. Apart from his monumental works he produced numerous busts and genre statuettes, from The Kiss of Victory (1882) and Perseus Arming (1883) to Victory and the statuette of Comedy and Tragedy (National Gallery, Edinburgh). Among his other small bronzes are the head of a fisherman of Capri, Icarus and portrait busts of Cyril Flower, G.F. Watts, Sir Henry Tate, Sir George Grove and Sir Richard Owen. He sculpted a number of figurines cast in gold or silver, including Victory, St. Michael, St. George, as well as mayoral insignia, seals, fobs, chains and epergnes.
Bury, Adrian *Shadow of Eros* (1954). Hatton, Joseph *The Life and Work of Alfred Gilbert R.A., M.VO., LL.D.* (1903). McAllister Isabel *Alfred Gilbert* (1929).

GILBERT, Charles Web 1869-1925
An Australian sculptor, orphaned at an early age. He worked for a pastrycook and at the tender age of nine began modelling figures and animals which were then moulded in icing sugar. From this humble beginning he gradually became one of the foremost Australian sculptors of the early 20th century. He began exhibiting at the Royal Academy in 1914 and his bronze head The Critic was purchased by the Academy in 1917. His chief works include the statue of The Digger at Broken Hill, the statue of the explorer Matthew Finders (Melbourne), the monument to the Second Australian Division (St. Quentin) and the Australian Light Horse memorial (Port Said). He sculpted numerous busts, heads and small figures, and his works are in the Tate Gallery and various Australian museums.

GILBERT, Dennis Vivian 1922-
Born in London on January 7, 1922, he studied at St. Martin's School of Art from 1946 to 1951 and works as a painter and sculptor. His wife is the painter Joan Gilbert (née Musker) and they live in London. He has exhibited figures and portraits at the Royal Academy, the Royal Society of British Artists and the Salon des Artistes Français as well as various British provincial galleries.

GILBERT, Donald 1900-1961
Born in Burcot, Worcestershire on November 29, 1900, he died in Pulborough, Sussex on June 17, 1961. He was the son of the sculptor Walter Gilbert and was educated at Rugby. Later he studied sculpture

under his father and Sir Alfred Gilbert and also at the Birmingham Central School of Art, the Royal College of Art and the Royal Academy schools. He exhibited genre and allegorical figures and groups, in stone, marble, wood and bronze, at the Royal Academy, the Royal Hibernian Academy, the Glasgow Institute and the Paris Salons. His chief works are Destiny and Inspiration to Flight.

GILBERT, François Ambroise Germain 1816-1891
Born at Choisy le Roi on April 1, 1816, he died in Marseilles in 1891. He studied under Cortot and exhibited at the Salon from 1845. He specialised in marble monumental sculpture for churches and public buildings, mainly in the Marseilles area, but his minor works include bronze bas-reliefs, portrait busts and groups, illustrating heroic events in French history and allegories such as Commerce, Navigation, Industry and Agriculture. His statuette of Accursed Cain is in Niort Museum.

GILBERT, Stephen 1910-
Born in Fife on January 15, 1910, he was the grandson of Sir Alfred Gilbert. He studied architecture at the Slade School of Art (1929-32), but on the advice of Tonks he switched to painting. He exhibited at the Leicester Galleries from 1933 and the Royal Academy from 1936. He moved to Paris in 1938, returned to Britain on the outbreak of war, and resettled in Paris at the end of the war. He gave up painting in 1953 and has since concentrated on sculpture, producing abstracts in plastic, aluminium, steel and other metals. He has exhibited at the Salon des Réalités Nouvelles since 1956 and the Salon de la Jeune Sculpture since 1959.

GILI, Marcel 1914-
Born at Thuir, France on February 12, 1914, he studied under Gustave Violet in Perpignan and was influenced by Maillol in the 1930s. Later he joined the Abstraction-Creation movement and was associated with Robert Delaunay, Lipchitz, Zadkine and Laurens. In 1935 he rejected abstract art, destroying many of his works, and turned to figurative sculpture. He worked at first in terra cotta but worked in stone in the immediate postwar years and then turned to bronze as well as hammered copper and aluminium about 1950. He was a founder member of the Salon de Mai (1943) and won the Casa Velasquez Prize in 1946. He exhibits at the Salon de la Jeune Sculpture and is a member of its committee. He had his first one-man show at the Galerie Pierre Maurs in 1948.

GILIBERT, Jules
Sculptor specialising in portraits during the Second Empire. He also produced animal bronzes very infrequently, his best known work being the figure of the Bloodhound Druid, belonging to Napoleon III, which he sculpted about 1850.

GILIOLI, Émile 1911-
Born in Paris on June 10, 1911, he worked as a blacksmith from an early age, but took up sculpture in 1928 and attended classes at the School of Decorative Arts in Nice. In 1931 he enrolled at the École des Beaux Arts, Paris. He had his first one-man show at the Galerie Breteau, Paris in 1945 and two years later joined the abstract group exhibiting at the Galerie Denise René. He has participated in the Salon de la Jeune Sculpture since its inception in 1949. He works in a wide variety of materials, from copper and bronze to marble, granite, agate, and glass. His works are in many important public collections, including the Musée d'art Moderne, the Tate Gallery and the Museum of Modern Art, New York.

GILL, Henri fl. 19th century
Born at Carcassonne in the first half of the 19th century, he studied under Perrin and Jalabert and exhibited figures and busts at the Salon from 1868.

GILLES, Paul George 1875-
Born in Paris in 1875, he studied under Rollard and Injalbert and exhibited at the Salon des Artistes Français.

GILLES, Philippe Émile François fl. 19th century
Sculptor of portraits and genre figures, he exhibited at the Salon from 1850.

GILLET, André Joseph 1768-1832
Born in Valenciennes in 1768, he died there in 1832. He studied at Valenciennes Academy and was the pupil of his father Joseph Pierre Gillet. He was appointed municipal architect of Valenciennes in 1823 and specialised in decorative sculpture and bas-reliefs. The Valenciennes Museum has his statuette of Milo of Croton, based on the well-known figure by Falconet.

GILLET, Joseph Pierre 1734-1810
Born in Valenciennes on February 15, 1734, he died there on December 1, 1810. He specialised in ecclesiastical sculpture and worked on the decoration of churches in Valenciennes, and memorials for the cemeteries in that area.

GILLET, Lucien E. fl. 19th-20th centuries
He worked in Paris at the turn of the century and became an Associate of the Artistes Français in 1897.

GILLET, Nicolas François 1709-1791
Born in Metz on March 2, 1709, he died in Paris on February 7, 1791. He became an Academician in 1767 and then went to Russia where he founded an academy of painting and sculpture. He worked in Moscow and St. Petersburg and became director of the Academy of Fine Arts. He returned to France in 1787. Many of his portrait busts and statuettes in marble and bronze of members of the Russian Imperial family are in the museums of Leningrad and Moscow.

GILLET-DUVAL, Lucienne fl. early 20th century
Born in Paris in the late 19th century, she worked in Saumur and exhibited at the Nationale, becoming an associate in 1910. She produced portrait busts, genre figures and reliefs.

GILLI, Alexander fl. 19th century
He worked in Berlin, where he died in 1880, and specialised in portrait busts of historical and contemporary celebrities.

GILLICK, Ernest George 1874-1951
Born in Bradford in 1874, he died in London on September 25, 1951. He studied under Thomas Meldrum at the evening classes of Nottingham Art School and won a scholarship which took him to the Royal College of Art, where he studied modelling under Oliver Sheppard. He won a travelling scholarship in 1902 which enabled him to study in Rome for two years. He exhibited at the Royal Academy, and was elected A.R.A. in 1935 and F.R.B.S. in 1938. He became Master of the Art Workers' Guild in 1935 and worked with his wife Mary on medals, coinage, plaques and medallions. Among his bronze bas-relief portraits are those of Thomas Miller and Robert Millhouse.

GILLICK, Mary G. (née Tutin) c.1880-1965
She was the wife of Ernest Gillick and died in London on January 27, 1965. She studied at the Royal College of Art and exhibited paintings and bas-relief portraits at the Royal Academy and leading London and provincial galleries. Her best known work was the profile of Queen Elizabeth used for the coinage of 1953.

GILLIERON-OLTREMARE, Hélène 1864-
Born in Geneva on March 10, 1864, she worked there as a potter and sculptor of genre figures.

GILLOT, Anatole 1865-1911
Born at Éligny in 1865, he died in Paris in February, 1911. He specialised in statues and statuettes of contemporary and historical personalities.

GILLOT, Gustave 1888-
Born at Le Havre on April 26, 1888, he studied under Landowski and exhibited figures and groups at the Salon des Artistes Français from 1913.

GILLY, Seraphin fl. 20th century
Born at Aix-en-Provence at the turn of the century, he exhibited figures and engravings at the Salon d'Automne in the 1930s.

GIMMI, Karl 1870-
Born in Heilbronn on October 13, 1870, he studied in Stuttgart, Berlin, London and New York and specialised in bas-reliefs and statuettes of peasant subjects.

GIMOND, Marcel Antoine 1891-1961
Born in Tournon on April 27, 1891, he died in October, 1961. He studied at the School of Fine Arts in Lyons and was later a pupil of Maillol. He eventually became professor of sculpture at the École des Beaux Arts, Paris. He was the first sculptor of the anti-academic

school to have the honour of sculpting the official bust of the French President — Vincent Auriol. He spent many years in Cagnes, working with Renoir, but settled in Paris in 1920 and exhibited at the Indépendants and the Salon d'Automne in the inter-war period. He became the leading sculptor of the Fourth Republic in his latter years. He originally concentrated on figures, mainly of nudes, but later devoted his attention mostly to heads and busts.

GINER Y VIDAL, Vicente fl. 19th century
The brother of Carlos Ginery Vidal, the historic painter, he sculpted statuettes and busts of historical and contemporary celebrities and exhibited in Madrid in the 1850s.

GINES, José 1768-1823
Born at Polap, Spain in 1768, he died in Madrid in 1823. He studied at the Academy of San Carlos in Valencia and the Academy of San Fernando in Madrid, becoming a member of the latter in 1814 and its director three years later. He produced a number of monuments and allegorical, religious and classical figures, such as Religion, Venus, Venus and Cupid and the Four Evangelists.

GINOTTI, Giacomo 1837-1897
Born at Caravagliana in 1837, he died in Turin in 1897. He specialised in classical figures and modern genre subjects and exhibited these statuettes and groups in Turin, Milan and Venice. Examples of his sculptures are in the Museum of Modern Art in Rome.

GIORDANI, Giuseppe fl. late 19th century
Born in Piedmont in the mid-19th century, he exhibited figures in Turin and Venice in the 1880s.

GIORGI, Bruno 1908-
Born in Mococa, Brazil in 1908, he lived for many years in Italy and France. He studied under Maillol and exhibited at the Salon des Tuileries and the Salon d'Automne in the 1950s. He also participated in various Brazilian national exhibitions and had his first one-man show in Rio de Janeiro in 1948. He won several prizes at the Sao Paulo Biennale and the Venice Biennale (1950-52). Much of his work has been intended for the decoration of public buildings, but he has also sculpted numerous minor bronzes. Prior to 1947 his work was strongly influenced by Maillol in the academic tradition, but since then he has tended to simplify the outlines of his figures. His best known work is the Youth Monument in the gardens of the Ministry of Education in Rio.

GIORGIOLI, Gaetano de Meride fl. 19th century
Born in Switzerland in the late 18th century, he collaborated with Ferroni in ecclesiastical decorative sculpture in the 1820s.

GIOT, Marius Antoine fl. 20th century
Born at Étoges, France in the late 19th century, he studied under J. Boucher and exhibited figures at the Salon des Artistes Français, winning a second class medal in 1929.

GIOT, Maurice F. fl. 19th-20th centuries
French sculptor working from about 1890 to the second world war. He became an Associate of the Artistes Français in 1896 and won a bronze medal at the Exposition Universelle of 1900.

GIOVANNETTI, Giovanni fl. 19th century
He studied at the School of Fine Arts in Florence where he later worked as a sculptor of portraits and figures. He exhibited in Florence and Venice in the late 19th century.

GIOVANNI, Giuseppe de fl. 19th century
Born in Naples on April 21, 1825, he studied at the School of Fine Arts in that city but later worked in Malta and Ireland before settling in London. He specialised in glass sculpture, working in chipped and deep-cut crystal. He exhibited a large number of his glass figures in Turin in 1880. No bronzes have been recorded by him.

GIOVANNOZZI, Luigi fl. 19th century
He worked as an architect and sculptor in Florence in the second half of the 19th century and specialised in ecclesiastical decoration and memorials for Florentine churches and cemeteries. He became a member of the Florence Academy in 1870.

GIOVANNOZZI, Ottavio fl. 19th century
A decorative sculptor, he worked in Florence in the early 19th century and was engaged on the ornament of the Pitti Palace in

1828-29. He produced a series of portrait busts of famous Tuscans and also sculpted the lions on the San Andres fountain in the Boboli Gardens.

GIRARD, Noël Jules 1816-1886
Born in Paris on August 22, 1816, he died there in 1886. He enrolled at the École des Beaux Arts in 1837, and studied under David d'Angers and Petitot. He exhibited at the Salon from 1849 to 1873 and won a second class medal in 1852. He specialised in allegorical works, such as Charity sheltering the Suffering, Science attempting to cure the ills of Mankind, Comedy and Drama, and also statues of saints for various Parisian churches. His genre bronze of the Vineyard-worker is in Dijon Museum.

GIRARDET, Auguste Giorgio fl. 19th century
Born in Rome about 1830, he studied at the Institute of Fine Arts in Rome and later emigrated to Brazil, becoming professor at the Rio School of Fine Arts in 1892. He specialised in plaques and medallions and won a medal at the Exhibition of Industrial Arts, Rome in 1866 for a medallion portraying the Italian royal family. He produced a great number of portrait busts and medallions portraying prominent Brazilians of the turn of the century.

GIRARDET, Berthe (née Imer) 1869-
Born in Marseilles on April 8, 1869, she studied under A. Carlès and exhibited at the Salon des Artistes Français till 1933. She specialised in genre and religious groups, such as Virgin and Child, The Sick Child, The Grandparents' Blessing and Old Woman. She was awarded a gold medal at the Exposition Universelle of 1900.

GIRARDET, Pierre 1864-
Born in Lausanne, Switzerland, in 1864, he studied at the Académie Julian and later turned from painting to sculpture. He was then a pupil of Salmson in Geneva and Chapu in Paris and also spent three years in Rome. He specialised in portrait busts of Swiss contemporary personalities. Many of his works were produced in miniature form.

GIRARDIN, Émile fl. 19th century
Portrait sculptor of busts and figures working in Puy-en-Velay in the late 19th century. His statuette of Marie de Rolle (exhibited at the Salon of 1891) is in Puy Museum.

GIRARDIN, Eucher c.1859-1899
Born at St. Vincent de Boisset about 1859, he died in Roanne in 1899. He exhibited figures and portraits at the Salon des Artistes Français in the 1890s.

GIRAUD, Henri fl. 19th century
Born in Termonde, Belgium, of French parents, he studied in Paris under Rousseau and settled there as a painter and sculptor of genre subjects. He exhibited at the Salon of 1870.

GIRAUD, Jean Baptiste 1752-1830
Born at Aix on June 21, 1752, he died in Bordeaux on February 13, 1830. He studied art under the jeweller Collin and later attended the old Académie de St. Luc before going to Rome. On the death of an uncle he inherited a large fortune which enabled him to spend many years in Rome modelling the great treasures of classical sculpture. He was elected Academician in 1789 and was renowned for his mastery of human and animal anatomy. He created his own museum in the Place Vendôme. Several of his works are in the Aix Museum.

GIRAUD, Pierre François Gregoire 1783-1836
Born at Luc on March 19, 1783, he died in Paris on February 19, 1836. He was a nephew and pupil of J.B. Giraud and later studied under Ramey. He won the Prix de Rome in 1806 with a group of the Wounded Philoctetus on the Isle of Lemnos. He produced relatively little, but what work he did was of the highest quality, and he exhibited at the Salon in 1814 and 1827 alone. His marble figure of a Dog Lying Down (in the Louvre) was later published as a bronze reduction. Among his other works is a *cire perdue* equestrian statuette of Napoleon and various classical figures and maquettes in wax.

GIRAUD-BAILLIF, Renée 1904-
Born in Paris in 1904, she exhibited statuettes at the Paris Salons in the inter-war period.

GIRAULT, Eugène 1886-
Born at Toulon in 1886, he studied under Coutan and exhibited at the Salon des Artistes Français and the Tuileries in the 1930s.

GIRAULT, P. fl. 19th century
Genre sculptor working in Bourges in the late 19th century. He specialised in statuettes of sportsmen and athletes.

GIROLA, Stefano fl. 19th century
Born in Milan, he sculpted decoration for churches in Milan and Novara. He also did the series of thirteen historic figures on the iron gates of the Palazzo Cavriani in Mantua.

GIRSCHNER, Albert Ernst Eduard fl. 19th century
He studied under Wichmann and exhibited at the Berlin Academy from 1830 to 1840, specialising in portrait busts and genre groups.

GISCARD, Henri 1895-
Born in Toulouse in 1895, he studied under Carlus and exhibited at the Paris Salons in the 1920s.

GISCLARD-CAU, Yvonne fl. 20th century
A member of the Société des Femmes Peintures et Sculpteurs, she specialises in figures and nudes characterised by an exaggerated play on volumes.

GISLER, Hans 1889-
Born in Zürich on May 17, 1889, he studied under R. Kissling in that city before going to the École des Arts Décoratifs in Paris and then Rome. He returned to Zürich in 1914 and subsequently produced a number of monuments and public statuary for that district. His best known works are the bas-reliefs in Zürich High School and the statues of Bodmer and Gessner in the Central Library. The Swiss Confederation purchased his bronze Young Girl Crouching.

GIUDICE, Giuseppe 1794-
Born in Cremona on November 7, 1794, he studied under Camille Pacetti at Milan and Ignazio Maria in Turin. He specialised in ecclesiastical sculpture, tombs and monuments in the Cremona area.

GIUDICE, Luigi 1826-1892
Born in Genoa on September 1, 1826, he died in Brazil in 1892. He studied at the Academy of Fine Arts in Genoa and emigrated to Brazil in 1854, where he sculpted a number of monuments, statues and portraits.

GIUDICE, Primo fl. 19th-20th centuries
Born in Lodi in the mid-19th century, he died there in 1905. He spent much of his working life in Milan, where he sculpted figures and groups and exhibited there and also in Turin and Venice.

GIUDICE, Tommaso fl. 19th century
Genre sculptor working in Lodi in the 19th century. He exhibited in Milan, Rome and Turin.

GIULIANETTI, Filippo 1852-1903
Born in Genoa in 1852, he died in Rome on March 5, 1903. He began exhibiting in Turin and Rome in 1880. He studied under Varni and Scanzi in Genoa and specialised in genre, classical and heroic figures. His works include portraits of Columbus and Mazzini, Liberty, Faun and Under the Water.

GIUSTI, Guido fl. 19th century
Sculptor of busts and genre groups, working in Venice in the late 19th century. His works include Saved from Drowning (Venice, 1888), Lovers on A See-saw (Milan, 1894), Nude Odalisque (Berlin, 1900) and various portrait busts of Pope Pius X.

GJEDROYTZ, Prince Romuald fl. 19th century
Russian sculptor of the late 19th century, he studied under J. Jouant in Paris. He specialised in portrait busts of the Russian imperial family and the aristocracy. His works are in the Rumiantzev Museum in Moscow.

GJÖBEL, Selma fl. 19th-20th centuries
Born at Närke, Sweden in 1843, she studied under F. Kjellberg and M.E. Winge at the Stockholm Academy and later studied in South Kensington and in Paris and Rome. She was instrumental in founding the Stockholm art exhibition, Svensk Kunstslojd S. Gjöbel, with the aim of encouraging the plastic and applied arts in Sweden. She exhibited bas-reliefs and figures in Sweden and internationally and was awarded medals in the Expositions of 1889 and 1900 and in the American and Belgian world fairs at the turn of the century.

GLANTZLIN, Eugène fl. late 19th century
He worked in Paris as a genre sculptor in the 1890s.

GLÄNZ, Franz Sales 1810-1855
Born at Freiburg-im-Breisgau in 1810, he died there on May 12, 1855. He was the son and pupil of J.D. Glänz and worked in his father's studio for many years, specialising in ecclesiastical sculpture and ornamental work, with a bias towards neo-gothic panelling and statuary for castles and palaces in Germany, France, the Netherlands and England.

GLÄNZ, Joseph Dominik 1778-1841
Born in Freiburg-im-Breisgau in 1778, he died there on August 10, 1841. He is best known for the numerous decorative sculptures in Freiburg Cathedral.

GLASSBY, Robert Edward fl. 19th century
Born in Mexborough, he died there on August 3, 1892. He studied under Boehm and produced genre, allegorical and classical statuettes and groups. Sheffield Museum has his Cupid stung by a Bee.

GLASSBY, Roland c.1870-1908
Born in London about 1870, he died there in 1908. He specialised in portrait busts of European royalty and aristocracy. His best known work is the portrait of Grand Duke Ludwig of Hesse for the Royal Mausoleum at Frogmore.

GLAUFLÜGEL, Otto fl. 19th century
Born in Lipke, Germany on April 24, 1853, he died in the United States. He studied in Munich and Berlin and was also a pupil of Hähnel in Dresden and Chapu in Paris. He specialised in portrait busts, genre statuettes and animal groups.

GLEESON, Joseph Michael 1861-
Born at Dracut, New York on February 8, 1861. He studied in Paris under Bouguereau, Dagnan-Bouveret and Robert-Fleury but spent most of his working life in New York where he specialised in animal figures and groups. He was also a painter and illustrator.

GLEICHEN, Lady Feodora von 1861-1922
Born in London on December 20, 1861, she died there on February 22, 1922. She was the daughter of Prince Victor Hohenlohe-Langenburg and sister of Lady Helena Gleichen. She studied at the Slade School of Art under Legros and exhibited at the Royal Academy from 1892. She was a prolific sculptress of figures and portrait busts and also did numerous etchings. She was one of the foremost women sculptors of her day, and the Gleichen Award of the Royal Academy is named after her.

GLENNY, Alice (née Russell) 1858-
Born in Detroit in 1858, she was the wife of the painter John Glenny and worked in Buffalo, New York. She studied under Chase in New York and under Jules Lefebvre and Boulanger in Paris. She sculpted genre figures.

GLIBER, Jakob 1825-1917
Born at Ainet in the Tyrol on September 1, 1825, he died there on February 1, 1917. He studied at the Munich School of Design and the Vienna Academy and worked in the studio of J. Gasser. He is best known for the two colossal plaster statues for the Vienna World Fair of 1872. He sculpted figures and busts of saints for Viennese churches and the statues of Marco Polo and Albertus Magnus for the Vienna Court Museum. He carved a wood panel showing the Way of the Cross for the town of Admont in Styria.

GLID, N. fl. 20th century
Yugoslav sculptor working since the second world war. He specialises in portrait busts and figures of Yugoslav and international communist leaders and proletarian genre groups.

GLINSKY, Vincent fl. 20th century
American sculptor working in the first half of this century. He specialised in female nudes and allegorical statuettes, such as The Flower.

GLODINON, Émile fl. late 19th century
Born in Besançon in the mid-19th century, he studied under Rapin and exhibited at the Salon in 1881-82. He specialised in animal figures, such as Normandy Cattle, Limousin Bull, Normandy Bull and Dutch Cow.

GLOSIMODT, Olav Olavsen 1821-1901
Born at Siljord, Norway, in 1821, he died in Copenhagen in 1901. He spent most of his working life in Copenhagen, where he specialised in portrait medallions, reliefs and busts of his contemporaries.

GLOSS, Ludwig 1851-1903
Born in Wiener Neustadt on January 30, 1851, he died at Mödling on March 23, 1903. He studied at the academies in Vienna and Munich and was assistant to Zumbusch, collaborating with him on the Maria Theresa monument. He sculpted a number of statues for Vienna's new Town Hall. His minor works include several portraits and genre figures.

GLUMER, Hans Weddo von 1867-
Born at Pyritz, Germany, on August 18, 1867, he studied in Berlin and settled there. He exhibited at the Berlin Academy in 1890-92 and at the Crystal Palace, Munich from 1893 onwards. His chief work was the monument to Kaiser Wilhelm I with Bismarck and Moltke at Zeitz. He also sculpted figures of Frederick the Great (for Letschin and Prenzlau) and Kaiser Friedrich (Magdeburg and Prenzlau). His minor works include statuettes of female nudes and dancers.

GNACCARINI, Filippo 1804-1875
Born in Rome in 1804, he died there in 1875. He studied at the Academy of St. Luke and became a member in 1840. He specialised in statues of popes and allegorical statuary for public buildings and places in Rome.

GOBBO, Romulo del 1858-1912
Born at Ascoli Piceno on February 6, 1858, he died there on February 1, 1912. He studied at the Academy of Fine Arts in Rome at a very early age and made his reputation while still a youth for his allegorical group Pax Triumphabit and a statue of St. Sebastian. He specialised in medieval heroic figures, like Francesca da Rimini, and Ophelia, and portrait busts of contemporary Italian royalty and political figures.

GOBINEAU, Joseph Arthur, Comte de 1816-1882
Born at Ville d'Avray, France, on July 14, 1816, he died in Turin on October 13, 1882. He was a diplomat, historian and poet as well as a talented amateur sculptor. In his youth, he was a close friend of Ary Scheffer and was strongly influenced by the Renaissance and the cult of medievalism. He studied sculpture in Athens and was a pupil of Carpeaux in Paris. He specialised in busts, medallions and statuettes of such subjects as Dante and Beatrice and Wagnerian themes like the Valkyries. The principal collection of his works is in the Library of Strasburg University.

GOBO, George fl. 20th century
Born in San Francisco, he worked in Paris in the 1930s as a painter, illustrator and sculptor. He exhibited at the Nationale and won the Cottet Prize in 1945.

GODCHAUX, Roger 1878-
Born at Vendôme on December 21, 1878, he studied under Gérome and Adler and exhibited at the Salon des Artistes Français from 1905, winning a silver medal in 1928. He specialised in animal figures and groups.

GODDARD, Ralph Bartlett 1861-
Born at Meadville, Pennsylvania, on June 18, 1861, he studied at the National Academy of Design, New York and the Art Students' League. Later he studied under Jean Dampt in Paris but returned to New York, where he specialised in statuettes of 19th century literary and artistic personalities, such as Carlyle and Tennyson.

GODDE, Charles Joseph c.1821-1852
Born in France about 1821, he died in Paris in 1852. He studied under Pradier and won the Prix de Rome in 1841 for a bas-relief of the Death of Demosthenes. He studied at the Académie de France in Rome and specialised in classical statuettes and groups.

GODEBSKI, Cyprian 1835-1909
Born of Polish parents at Méry-sur-Cher in 1835, he died in Paris in 1909. He studied under Jouffroy and exhibited at the Salon from 1857, gaining mentions in 1880, 1884 and 1886. He specialised in bronze busts of celebrities, mainly Polish, but also did genre and allegorical statuettes such as Persuasion, Brute Force stifling Genius.

His wife Mathilde (née de la Fresnaye), who died in 1888, was also a genre sculptor and an Associate of the Artistes Français.

GODECHARLES, Gilles Lambert 1750-1835
Born in Brussels on December 30, 1750, he died there in February 1835. He studied under Delvaux and later became professor at the Brussels Academy and official sculptor to Napoleon and the King of Holland. He specialised in busts of Napoleonic personalities, but also did allegorical statuettes, such as Month and Time.

GODECKI, Teofil fl. 19th century
Born in Warsaw in 1847, he studied at the Warsaw School of Fine Arts and spent many years in Italy. He specialised in ecclesiastical sculpture, but also exhibited in Warsaw numerous portrait busts, maquettes and models for tombs and statuettes of historic and contemporary personages.

GODET, Henri 1863-
Born in Paris on March 5, 1863, he studied under Mathurin-Moreau and exhibited medallions and bas-reliefs at the Salon des Artistes Français.

GODIN, Eugène Louis 1823-1887
Born in Melun on August 25, 1823, he died in Paris in April 1887. He studied at the École des Beaux Arts under Toussaint and exhibited at the Salon from 1852. He specialised in busts and statues of contemporary personalities for monuments in various parts of France.

GODMER, Émile Jean Baptiste 1839-1892
Born in Mayenne on October 23, 1839, he died in 1892. He exhibited figures at the Salon of 1870.

GODWIN, Keith 1916-
Born in Warsop, Nottinghamshire, on April 17, 1916, he studied at Mansfield Art School (1934-35), Nottingham College of Art (1935-36), Leicester College of Art (1936-39) and the Royal College of Art (1946-48). He has exhibited at the Royal Academy and other leading London galleries and was elected R.B.A. in 1950. He works at Bollington Cross, Cheshire, and sculpts figures and portraits in plaster, cement, stone, terra cotta and bronze.

GOELZER, Albert Charles Julien fl. late 19th century
Born in Meauffe, France, in the mid-19th century, he exhibited at the Salon in 1881-83.

GOERITZ, Mathias 1915-
Born in Danzig in 1915, he studied in Berlin and became a Doctor of Philosophy. He studied the history of art and gradually became more and more engrossed in the practice of art itself. He enrolled at the Charlottenburg School of Arts and Crafts, studied painting and sculpture, and then moved to Paris, where he was influenced by Arp and Klee (1936-38). During the second world war he lived in Tetuan, Spanish Morocco and taught languages there. After the war he worked in Andalusia and Madrid and founded the School of Altamira at Santillana del Mar (1948), which has since played a prominent part in the development of the arts in Spain In 1949 he went to Mexico and taught architecture and sculpture at Guadalajara University. He was director of the School of Plastic Arts in the Hispano-American University of Mexico from 1955 to 1959. Goeritz has been linked to the polymaths of the Renaissance, excelling as an architect, poet, writer and painter as well as sculptor. His earlier sculpture was monumental and architectural but since 1950 he has produced smaller works, carved in wood or modelled in clay, often derived from biblical subjects.

GOESCHL, Heinrich 1839-1896
Born in Munich on June 24, 1839, he committed suicide there on December 16, 1896. He studied under M. Widnmann and followed his master to Rome in 1870. He specialised in genre statuettes and groups.

GOETZ, Johannes 1865-
Born at Fürth on October 4, 1865, he studied at the School of Fine Arts in Nuremberg and was a pupil of Schaper and Reinhold Begas at the Berlin Academy. He specialised in genre figures, such as Young Boy balancing a Ball, Young Girl pouring Water (both in the Berlin Museum), Water-carrier (Düsseldorf) and Bust of a Woman (Nuremberg). He exhibited in Berlin and Munich at the turn of the century and won a bronze medal at the Exposition Universelle of 1900.

GOETZ-GLEISTEIN, Elisabeth 1881-
Born in Hamburg on October 13, 1881, she worked in Berlin, where she made a reputation for her tiny sculptures and wax relief portraits. A number of her genre statuettes were also reproduced in porcelain. She exhibited in Cologne in 1914.

GÖHRING, Wilhelm 1876-
Born in Munich on July 8, 1876, he studied at the Munich Academy from 1905 to 1911. He had a studio at Moosach, near Munich, where he worked chiefly as a wood-carver of friezes, panels and figures for Bavarian churches. He also sculpted the reliefs on the doorway of Munich police headquarters.

GOIS, Edmé Étienne François 1765-1836
Born in Paris in 1765, he died at St. Leu-Taverny in 1836. He was the son and pupil of Étienne Gois and later studied at the Académie Royale, being runner-up in the Prix de Rome of 1788 and winning the prize three years later, with a biblical bas-relief. The prize was actually won by Bridan but Gois' colleagues petitioned Louis XVI to give him another. He exhibited at the Salon from 1798 to 1837. His works include The Three Horaces, the statue of Joan of Arc at Orléans and many portrait busts of personalities of the Napoleonic era, in marble and bronze.

GOIS, Étienne Pierre Adrien 1731-1823
Born in Paris on January 1, 1731, he died there on February 3, 1823. He studied under Jeaurat and Michel-Ange Slodtz and won the Prix de Rome in 1757. He became an Academician in 1770 and exhibited at the Salon from 1767 to 1804. He was a very prolific sculptor of historic figures, in marble, wax and bronze.

GOLDWITZ, Georg fl. 19th century
Son of Johann Leonard Goldwitz, he worked in Bamberg in the mid-19th century, specialising in bas-reliefs and statuettes of religious subjects.

GOLDWITZ, Jakob fl. 19th century
Son of Georg Goldwitz and pupil of F. Dietz, he later studied at the academies of Munich and Vienna. Like his father, he specialised in ecclesiastical sculpture, but also did many garden statues and groups for the princely house of Seehof.

GOLDWITZ, Johann fl. 18th-19th centuries
He worked on the decorative sculpture of Bamberg Cathedral in 1767.

GOLDWITZ, Johann Leonhard fl. 18th century
Probably born in Augsburg, he spent his working life in Bamberg, where he was employed by the Carmelites to sculpt the statues in their church. He also sculpted friezes and statues for the churches of Our Lady and St. Peter in Bamberg. He was the father of Georg and Stephan Goldwitz.

GOLDWITZ, Stephan fl. 19th century
The son and pupil of Johann Leonhard Goldwitz, he did decorative sculpture for the churches and public buildings in the Bamberg area and the castles of the Margrave Friedrich at Bayreuth.

GOLEJEWSKI, Nathalie fl. 20th century
Born in Vilna at the turn of the century, she studied in Paris under Rodin and exhibited at the Nationale in the 1920s. She specialised in figures of horses.

GOLFARELLI, Tullo fl. 19th-20th centuries
He worked in Bologna at the turn of the century and is best known for his large monumental sculptures of historic figures, particularly Garibaldi. He also produced a number of bronze statuettes and allegorical figures, such as New Ills (Crystal Palace Exhibition, Munich 1897). He also sculpted portrait busts of his contemporaries.

GÖLLNER, Kurt Eberhard 1880-
Born in Hanover on November 24, 1880, he studied painting at the Dresden Academy and later turned to sculpture. He worked at Söbrigen on the Elbe. The Albertinum in Dresden has his head of a Negress and a model of a fountain statue.

GOLUBKINA, Anna Semionova 1864-1927
Born in Moscow in 1864, she died there in 1927. She studied in Paris under Rodin and exhibited at the Nationale from 1899 onwards and at the Salon d'Automne in 1908. On her return to Moscow she took part in the annual exhibitions of the Society of Artists. She specialised in busts and heads, sculpted in marble, wood and bronze. Her works are in the Tretiakoff Gallery and the Moscow Literary and Artistic Club.

GOLOVINE, Alexander fl. 20th century
Born in Odessa in the early years of this century, he came to France after the Revolution and settled in Paris, where he exhibited figures and busts at the Salon des Indépendants from 1937.

GOMANSKY, Edmund 1854-
Born in Stettin on November 6, 1854, he worked as a decorative sculptor in Friedenau.

GOMEZ, Francisco Javier fl. 19th century
Born in Lograno, Spain, in the early 19th century, he studied under José Piquer and exhibited figures in Madrid from 1866 onwards.

GOMEZ Y LANZUELA, Antonio 1818-1877
Born in Cadiz on October 18, 1818, he died in Madrid on December 17, 1877. He studied at the San Fernando Academy and exhibited in Madrid from 1840 till his death. He specialised in portrait busts and reliefs and was one of the most fashionable portrait sculptors and painters in Spain in the 1860s.

GOMY, Paul fl. 19th century
Born in Chauvigny in the mid-19th century, he studied under A. Dumont and exhibited at the Salon from 1876. He specialised in figures and groups of biblical subjects.

GONON, Eugène 1814-1892
Born in Paris on August 16, 1814, he died there in 1892. He studied under Pradier and Blondel at the École des Beaux Arts. His father was the noted bronze founder Honoré Gonon, who cast many of his works *cire perdue*. He exhibited animal and genre figures at the Salon from 1852 to 1873. His works include The Consequences of a Storm (Tournus Museum), an equestrian statuette of Charles VII (Bordeaux Museum) and Combat of Lion and Snake (Tuileries Gardens).

GONTAUT-BIRON, Raoul de fl. 19th-20th centuries
He worked in Paris at the turn of the century, and exhibited figures at the Salon des Artistes Français, winning a third class medal in 1905.

GONTCHAROVA, Natalia 1881-1962
Born in Moscow on June 4, 1861, she died in Paris on October 1962. She studied at the School of Fine Arts in Moscow and took part in the Russian Art Exhibition in Paris, 1906. She settled in Paris in 1914 and exhibited at the Salon d'Automne, the Tuileries and the Indépendants. She is best known for her work as a designer of costumes and sets for the Ballets Russes and for her book illustrations, but she also sculpted portrait busts and genre figures.

GONYN DE LIRIEUX, A. Yvanhoe Rambosson fl. 19th century
The sister of the genre painter Louis Gonyn, she specialised in portrait reliefs and busts, which she exhibited at the Salon des Artistes Français at the turn of the century.

GONZALEZ, Julio 1876-1942
Born in Barcelona in 1876, he died in Arcueil, near Paris, in 1942. His father and grandfather were jewellers and silversmiths and he served his apprenticeship in this trade before coming to Paris with his brother in 1900. He worked as a painter and illustrator and it was not until his brother died in 1908 that he turned to sculpture as a form of consolatory therapy. It was not until 1927, however, that he devoted himself seriously to sculpture and for some time (1930-32) he worked with Picasso, whom he taught the techniques of sculpture in iron. He had one-man shows at the Galerie le Centaure, Brussels (1931) and the Galerie Percier, Paris (1934) and the Galerie des Cahiers d'Art (1935). His chief work was La Montserrat, shown in the Spanish pavilion at the Exposition Internationale of 1937. Retrospective exhibitions of his sculpture were held in the museums of modern art in New York, Paris and Amsterdam and he was also featured posthumously in the Catalan Art Exhibition in Paris, 1946. He worked mainly in wrought iron, but his bronzes include Gothic Man (1937), Cactus Man – various versions (1939) and various forms of La Montsarrat (1937-42).

GONZALES, Lorenzo fl. 19th-20th centuries
Born in Caracas, Venezuela, in the late 19th century, he studied in Paris under Belloni and exhibited figures and reliefs at the Salon des Artistes Français at the turn of the century.

GONZALES, Paul fl. 19th-20th centuries
Born in Marseilles on January 10, 1856, he studied under Carli and exhibited portrait bas-reliefs and busts at the Salon des Artistes Français, of which he became an Associate in 1902.

GONZALEZ, Simon fl. 19th-20th centuries
Born in Santiago, Chile, he studied in Paris under Injalbert and Roubaud. He sculpted statues, monuments, bas-reliefs and figures and was awarded a gold medal at the Exposition Universelle of 1900.

GONZALEZ GOYRI, Roberto 1924-
Born in Guatemala in 1924, he studied at the National Academy and exhibited there. He became an assistant curator in the department of ceramics in the National Museum of Archaeology. In 1948 he won a travelling scholarship, which enabled him to study in New York. He had one-man shows at the Clay Club (1949) and the Roko Gallery in 1950-51 and won the Central American Prize for Sculpture in New York, 1959. He gradually switched from academic to Expressionist sculpture in the 1950s and since 1954 has concentrated on non-figurative sculpture. His earlier works were sculpted in tin and bronze and include genre figures and animal groups, such as Cock Fight (1950).

GONZALEZ Y FERNANDEZ, Victorino fl. 19th century
Born at Monteboy, Spain, in 1855, he specialised in relief portraits and medallions.

GONZALEZ Y GARCIA, Blas fl. 19th century
He worked in Valladolid as a painter and sculptor of portraits, the latter being busts and reliefs. He began exhibiting in Madrid about 1866.

GONZALEZ Y GARCIA, Isidoro 1843-1879
Born in Valladolid on May 15, 1843, he died there on May 17, 1879. He studied at the Valladolid School of Fine Arts and exhibited there from 1859 onwards. He painted and sculpted genre subjects, strongly influenced by Goya. His sculptures are in the Valladolid Museum.

GONZALEZ Y JIMENEZ, José fl. 19th century
Born in Granada, he studied there and later in Rome. He was regarded as one of the finest Spanish sculptors of the 19th century and produced a number of monuments, statues, figurines and small groups in the classical idiom.

GONZALEZ DE SEPULVEDA, Mariano 1774-1842
Born in Madrid in 1774, he died there in 1842. He was the son of Pedro Gonzalez de Sepulveda, with whom he worked on portrait medallions and bas-reliefs.

GONZALEZ DE SEPULVEDA, Pedro 1744-1815
Born in Badajoz in 1744, he died in Madrid in 1815. He sculpted portrait busts, bas-reliefs and medallions of contemporary personalities.

GOOD, John Willis fl. 19th century
Sculptor of animal figures and portrait busts, working in London in the 1870s. He exhibited at the Royal Academy from 1870 to 1878, mainly bronze or terra cotta statuettes of race-horses, hunters and dogs.

GOODELMAN, Aaron 1890-
Born in Russia in 1890, he emigrated to the United States and worked in Philadelphia as a sculptor of figures and reliefs and a book-illustrator.

GORALCZYK, Jan 1877-
Born in Musczyna, Poland, on December 21, 1877, he studied at the School of Fine Arts in Cracow and the Vienna Academy. He specialised in animal figures and groups, particularly horses, and exhibited in Cracow from 1896 onwards.

GORDIN, Sidney 1918-
Born in Chelyabinsk, Russia, in 1918, he emigrated to the United States at the age of four. He studied at the Cooper Union Art School, New York, and later taught in several American art schools. He has had several one-man shows in New York, notably at the Borgenight Gallery and has participated in many museum exhibitions in the United States. His sculpture consists largely of purely geometrical abstracts stripped to the sheer horizontal and vertical lines, in steel, bronze and silver. He works in New York.

GORDINE, Dora 1906-
Born in St. Petersburg on April 13, 1906, she studied under Maillol and exhibited at the Paris Salons from 1926. Two years later she moved to England and began exhibiting at the Royal Academy and the Leicester Galleries in 1928. She married the Hon. Richard Hare in 1936 and designed their house and studio in Richmond. Her first major commission was to sculpt the decorative bronzes for Singapore Town Hall (1930-35). In 1947 she went to Hollywood, where she designed film sets and lectured on art. She specialises in portrait busts and statuettes, usually in bronze, and also paints occasionally. Her work is represented in many public collections in Britain and America.

GORDON-BELL, Joan Ophelia
see COOPER, Joan Ophelia Gordon

GORI, Georges fl. 20th century
Born in Paris at the turn of the century, he studied under Injalbert and exhibited figures at the Salon des Artistes Français from 1929, winning a bronze medal in 1931.

GORI, Lorenzo fl. 19th century
Born at Leghorn, Italy, in 1842, he worked there as a sculptor of memorials and genre figures. He exhibited in Italy and occasionally in Paris from 1868 onwards.

GORIA, Lamberto 1863-
Born in Tortona, Italy, in 1863, he studied design in Rome under Allegretti and later turned to sculpture. He won an honourable mention in 1886 for his project for a monument to Pietro Costa and was also commended at the Fine Arts Exhibition in Rome four years later for a bas-relief of the Virgin and Child. He subsequently specialised in monuments, bas-reliefs and portrait busts and was very fashionable at the turn of the century.

GORIELOFF, Ivan fl. 20th century
Russian sculptor of genre figures and groups working in Moscow in the early years of this century.

GORIN, Jean Albert 1899-
Born at St. Émilien de Blain, France, in 1899, he studied at the Académie de la Grande Chaumière, Paris and then the Nantes School of Fine Arts. He worked as a painter and sculptor and moved to Paris in the mid-twenties, where he came under the influence of Picasso and the Cubists. He turned from figurative sculpture to abstract works in 1926 and, influenced by Piet Mondriaan, produced polychrome wood panels and bas-reliefs. He had his first one-man show at the Galerie de l'Étrave, Nantes, in 1927. Later he was a member of the Cercle et Carré and Abstraction-Création groups. He travelled in Germany, Poland and Russia and was deported by tne Nazis during the war. After his release in 1945 he went to live in the south of France, where he experimented with spatial constructions. He has also sculpted a number of bas-reliefs. His work is represented in many public collections in France, Italy and South America.

GÖRITZ, Eduard fl. 19th century
He studied under Albert Wolff and worked in Berlin in the second half of the 19th century. He exhibited classical and allegorical statuettes at the Berlin Academy in 1860-64 and became a professor at the Academy in 1875.

GÖRLING, Felix 1860-
Born in Leipzig on May 18, 1860, he studied at the Berlin Academy. He is best known for his series of sculptures commemorating the reign of Frederick the Great (Friedrichshaven) and Wilhelm I (Berlin – Schöneberg). He exhibited at the Berlin Academy from 1884 onwards and specialised in genre figures of sporting subjects and portraits of Prussian royalty.

GORNIK, Friedrich fl. 20th century
Born in the Austrian province of Carinthia in the late 19th century, he studied at the Vienna School of Arts and Crafts and worked in that city. He specialised in animal studies for reproduction in porcelain,

but also sculpted groups of carnivores, horses and cattle, cast in bronze by A. Rubinstein. In his later years he also turned to genre groups, such as Quarrel between Young People, The Wounded Combatant and Departure of the Dragoons.

GORSKI, Belle Silveria 1877-
Born in Erie, Pennsylvania, on September 21, 1877, she studied under John Vanderpool, W.M. Chase and Frederick Richardson and worked in Chicago as a sculptor of portraits and genre figures.

GORST, Hester Gaskell (née Holland) 1887-
Born in Liverpool in 1887, he studied under Tonks at the Slade School of Art (1904-6) and then in Brussels. She exhibited at the Salon des Artistes Français and other galleries in Paris and Brussels and also in London. She lives in London and works as a painter and sculptor of genre figures and portraits.

GOSEN, Philipp Theodor von 1873-
Born in Augsburg on January 10, 1873, he studied under Wilhelm von Rümann in Munich and became professor at the School of Fine Arts, Breslau. He specialised in statuettes of violinists, musicians and athletes as well as portraits of German poets and other cultural personalities.

GÖSSER, Wilhelm 1881-
Born at Mühltal, near Leolien, in Styria, on May 6, 1881, he studied in Graz and at the Vienna Academy, where he won gold medals in 1908-9 for genre plaquettes and drawings. Later he sculpted several colossal statues, such as Oedipus, for the school at Hellmer. He won the Prix de Rome in 1913 but his studies there were cut short by the entry of Italy into the first world war. He won the Austrian State Prize in 1918 for his group of Pegasus and a gold medal the following year for Springtime (now in the Johanneum, Graz). He worked mainly in marble.

GOSSIN, Étienne d. 1900
Brother of Louis Gossin, with whom he worked on genre figures.

GOSSIN, Louis fl. 19th-20th centuries
Genre sculptor working in Paris at the turn of the century. He exhibited at the Salon from 1877 onwards and won bronze medals at the Expositions of 1889 and 1900. Toulouse Museum has his statuette Ame.

GÖTHE, Erik Gustav 1779-1838
Born in Stockholm in 1779, he died there in 1838. He specialised in portrait busts of Swedish royalty, nobility and contemporary celebrities, but also produced statuettes and groups of classical subjects, such as Sleeping Bacchante, Bacchus, Venus and Cupid. His works are in the museums of Stockholm, Göteborg and Oslo.

GÖTTING, Johann Peter von 1795-1865
Born in Aachen in 1795, he died there in 1865. He studied at the Düsseldorf Academy and worked there and in Aachen, as a painter and sculptor of historical subjects. He exhibited in Berlin, Hanover and Leipzig.

GOTTO, Basil 1866-1954
Born in London on August 10, 1866, he died there on October 19, 1954. He was educated at Harrow and studied art in Paris under Bouguereau and the Royal Academy schools (1887-90), winning the Landseer scholarship. He exhibited at the Royal Academy from 1892 and also at the Salon des Artistes Français. He was a war artist for the Daily Express during the South African campaign of 1899-1902. His best-known work is the Army and Navy Club war memorial, but he also sculpted a number of genre and classical statuettes, such as Bacchus and Beggar Man. He lived in Twyford, Middlesex for many years.

GOTTSCHALK, Alfred 1872-
Born at Stolp, Pomerania, on September 22, 1872. He studied at the academies of Berlin and Munich and is best known as a portrait painter, though he also sculpted bronze bas-reliefs of genre subjects, such as dancers and wrestlers.

GOTTSCHALK, Ernst 1877-
Born in Düsseldorf on October 15, 1877, he worked in that area on monuments and decorative sculpture for public buildings. His minor works include Mother and Child, Man walking into the Wind and a number of statuettes in the Düsseldorf Art Collection.

GÖTZ, Hermann 1848-1901
Born at Donaueschingen on September 28, 1848, he died in Karlsruhe on July 28, 1901. He studied at Karlsruhe Academy and later became director of the School of Arts and Crafts in that city. As such, he directed numerous exhibitions in Germany and abroad, including the German pavilions at the Chicago Exposition (1893) and Paris (1900). Although better known as a painter and lithographer, he also did bas-reliefs and ornamental sculpture for interior decoration.

GÖTZE, Wilhelm 1881-
Born at Friedensau on August 26, 1881. He studied in the academies of Hanau and Berlin and also at the School of Arts and Crafts in Munich. He worked in Darmstadt and specialised in memorials, bas-reliefs and portrait busts.

GOUÉZOU, Achille d. 1901
Born at St. Brieuc, he studied under his brother, the genre and historical painter Joseph René Gouézou, and worked in Paris in the late 19th century. He produced a number of genre figures and groups.

GOUGET, Emile Joseph Alexandre fl. 19th century
Born at Bray-sur-Seine, he studied under Barye and exhibited animal figures at the Salon from 1868.

GOULDEN, Richard Reginald 1877-1932
Born in London in 1877, he died there on August 6, 1932. He studied at the Royal College of Art and worked in London as a sculptor of portrait busts, reliefs and monuments. His best-known work is the bronze memorial to Margaret Macdonald in Lincoln's Inn Fields, London.

GOURBEILLON, Dom Eugène (known as Jehan de Solesmes) 1814-1895
Born at Chaumont on August 6, 1814, he died at Liguge in 1895. He became a Benedictine monk at Solesmes and specialised in ecclesiastical sculpture for various French churches and cathedrals. His statuettes were mainly carved direct in stone.

GOURDEL, Julien Jean 1804-1846
Born at Veneffles on November 5, 1804, he died in Paris on March 13, 1846. He exhibited at the Salon from 1835 to 1845 and was runner-up in the Prix de Rome in 1834. He specialised in portrait busts and classical and historical groups and figures, such as Niobe, Anaxagoras, The Little Savoyard, Little Girl, and Little Girl with a Dog.

GOURDEL, Pierre fl. 19th century
Born in Châteaugiron, he died there in 1892. He studied under his father, Julien J. Gourdel, and was also a pupil of Bonnassieux. He exhibited at the Salon from 1861 and became one of the first Associates of the Artistes Français. Originally a jeweller and goldsmith, he later turned to sculpture and was extremely versatile and prolific. One of his specialities were tiny figures of Breton men and women in the style of the Flemish sculptors of the 17th century. He also produced heads and busts of mothers and their children, portrait busts and reliefs of historic French and Breton characters and allegorical figures, such as Spring.

GOURDON, Pierre fl. 19th century
Born at Beaune in the early 19th century, he studied under Ramey the Younger and A. Dumont and exhibited portrait busts of classical and contemporary figures at the Salon from 1849 to 1865.

GOURGOUILLON, Henri 1858-1903
Born at Olliergues on January 16, 1858, he died in Paris in 1903. He exhibited figures and portraits at the Salon des Artistes Français.

GOURNAY, Louis fl. 19th-20th centuries
Sculptor of genre figures working in Paris at the turn of the century.

GOUTE, Suzanne fl. 20th century
Born in Toul at the turn of the century, she studied under Fougerat at Nantes and Despiau in Paris, and sculpted genre figures and groups.

GOUVEIA, Francisco Pereira de Silva fl. late 19th century
Born in Oporto, Portugal, he worked in Paris in the late 19th century and studied under Rodin, Falguière, Injalbert, Puech and Rolard. He won a silver medal at the Exposition Universelle of 1900.

GOYERS, Égide 1796-1847
Born in Louvain on September 12, 1796, he died there on November 18, 1847. He was the son and pupil of Pierre Goyers and worked with his father on decorative sculpture in Louvain. He also restored the façade of Louvain Town Hall (destroyed by enemy action during the first world war). He worked on the decoration of churches in Belgium, France, Holland and England in the early 19th century. His sons, Henri and Pierre, also worked in Louvain as decorative sculptors.

GOYERS, Pierre fl. 18th-19th centuries
Professor of sculpture at Louvain Academy, he died in 1814. He was the father of Égide Goyers.

GRABICHLER, Alok 1839-1886
Born in Rosenheim, Bavaria, on August 15, 1839, he died in Munich on August 18, 1886. He studied at the Munich Academy and worked in the studio of J. Halbig. Much of his work consisted of wood carving for churches in Bavaria, often working from models by other artists. Among his original works, however, were the bust of General Baron von Aufsees and the equestrian statue of Crown Prince Frederick William of Prussia.

GRABOWSKY, Felix 1817-1889
Born in Angers on March 26, 1817, he died in Paris in July 1889. He enrolled at the École des Beaux Arts in 1839, and studied under Ramey and Dumont. He exhibited at the Salon from 1855 to 1878 and won a second class medal in 1857. He specialised in statuettes of classical subjects.

GRADENIGO, Antonio 1806-1884
Born in Padua on September 25, 1806, he died there in 1884. He worked under Japelli and specialised in ornamental sculpture in churches and public buildings in Padua, usually carved direct in marble or wood.

GRADLER, Otto 1836-
Born in Possneck, Thuringia, on October 21, 1836, he worked in Charlottenburg and modelled statuettes of genre and allegorical subjects.

GRAEFF, Engelhardt 1807-1878
Born in Frankfurt-am-Main on December 24, 1807, he died there on July 16, 1878. He was a pupil of the Städel Institute and is best known as a wood-engraver of book illustrations (mainly scientific works), but he also sculpted a large number of portrait busts of his contemporaries.

GRAF, Paul Henri 1872-
Born in Bourgogne on December 2, 1872, he studied under Ponscarmé and specialised in portrait and allegorical reliefs and medallions. He exhibited at the Paris Salons and won a second class medal in 1920.

GRAFLY, Charles 1862-1929
Born in Philadelphia on December 3, 1862, he died there on May 5, 1929. He studied at the Pennsylvania Academy of the Fine Arts, the École des Beaux Arts, Paris, and also in the studios of Dampt and Chapu. He exhibited Mauvais Presage at the Salon of 1891, winning an honourable mention and this work is now in the Detroit Museum of Fine Arts. Thereafter he worked in Philadelphia, becoming an instructor at the Pennsylvania Academy, the Drexel Institute, Philadelphia, and the Boston Museum of Fine Arts. He received many important commissions and the high quality of his work was recognised by silver medals in Chicago (1893) and Atlanta (1895) and gold medals at the Pennsylvania Academy exhibition (1899), the Exposition Universelle (1900), the Pan-American Exposition (1901), Charleston (1902). He was a member of the jury at the St. Louis World's Fair (1904) and was elected an Associate of the National Academy of Design the following year. His major works include such monuments and memorials as those of General Reynolds (Fairmount Park), The Pioneer Mother (San Francisco) and the Meade Memorial (Washington). He also sculpted the allegorical series From Generation to Generation, Symbol of Life, Fountain of Man, Vulture of War, England and France for the New York Customs House. His minor works include numerous portrait busts and genre and classical statuettes such as Aeneas and Anchises. Grafly was one of the few American sculptors of his generation to follow the techniques and ideals of Rodin.

GRAGERA Y HERBOSO, José fl. 19th century
Born in Laredo, Spain, he died in Madrid in 1898. He became one of the most distinguished Spanish sculptors of the 19th century, specialising in busts of his artistic contemporaries, historical personalities and Spanish royalty.

GRAHAM, Dr. C. Honora fl. late 19th century
Amateur sculptress working in London in the late 19th century. She exhibited portraits and genre figures at the Royal Academy and Suffolk Street from 1888 onwards.

GRAILLON, Pierre Adrien 1809-1872
Born in Dieppe in 1809, he died there in 1872. He came from an old family of ivory carvers, but diversified into other media and studied modelling under David d'Angers, Ferel and Blard. He was an acute observer of nature and mankind but without any sense of malice, and specialised in genre figures and groups portraying ordinary people. Apart from his ivory statuettes the Dieppe Museum has portrait busts of his contemporaries and genre groups in terra cotta and bronze. These feature beggars, seamen, fisherfolk and children. His more noteworthy statuettes are The Last Day of the Condemned Man, Rustic Cabaret, The Smoker, The Prayer and The Four Ages of Life.

GRAMZOW, Karl Heinrich fl. 19th century
Born in Berlin in 1808, he studied under Wichmann and also at the Berlin Academy. He travelled in Italy and the United States and specialised in genre figures, such as The Genius of Peace (Berlin Museum).

GRANDE, Heinrich 1864-
Born in Berlin on January 20, 1864, he sculpted historical and genre figures at the turn of the century.

GRANDET, Joseph Maurice 1877-
Born in Rodez on December 17, 1877, he studied under Puech in Paris and exhibited at the Paris Salons at the beginning of this century.

GRANDFILS, Laurent Séverin 1810-1902
Born in Paris on November 24, 1810, he died at Chatou in 1902. He studied at the École des Beaux Arts and was a pupil of Ramey the Younger and Dantan the Elder. From 1832 to 1838 he was successively a student and associate professor at the Free School of Design in Paris, and later became professor of sculpture at the Valenciennes School of Fine Arts. He exhibited at the Salon from 1831 to 1869 and specialised in statuettes and busts of his contemporaries as well as historic French personalities.

GRANDGIRARD, Constant fl. 19th century
Sculptor of memorials, monuments and ecclesiastical statuary, working in Gray.

GRANDI, Giuseppe 1843-1894
Born at Val Grana on October 17, 1843, he died there on November 30, 1894. He studied in Milan and exhibited there and in Turin. He specialised in statuettes and groups of classical subjects. His figure of Odysseus drawing his Bow is in the Brera Museum, Milan.

GRANDIGNEAUX, Georges 1869-
Born in Versailles on September 4, 1869, he specialised in bas-reliefs, plaques and medallions.

GRANDIN, Léon Jean Baptiste 1856-1901
Born in Paris in 1856, he died at Versailles in 1901. He specialised in portrait busts and figures of contemporary and historical personalities, and exhibited at the Salon des Artistes Français, of which he was an Associate. His bust of Corneille is in Rouen Museum.

GRANDJEAN, Eugène Joseph Nicolas fl. 19th century
Born in Paris on August 14, 1842, he studied under Chardigny and exhibited portrait reliefs, medallions and busts at the Salon from 1861 to 1876.

GRANDMAISON, Charles Georges Paul Millin de fl. 19th century
Born in Paris in 1857, he studied under Doublemard and exhibited at the Salon from 1877 onwards. He specialised in portrait busts and statuettes of classical, historical and contemporary figures. His chief work was the equestrian statue of Louis XI. Puy Museum has his bust of Albert Coustou and The Departure of Telemachus.

GRANDMAISON, Nicolas fl. 19th-20th centuries
Born in Toulouse in the mid-19th century, he studied under Jouffroy, Falguière and Mercié. He exhibited genre and allegorical figures at the Paris Salons at the turn of the century and won third class and second class medals in 1899 and 1908 respectively, and a bronze medal at the Exposition Universelle of 1900.

GRANET, Pierre 1843-1910
Born at Villeneuve-Dornon on December 17, 1843, he died in August 1910. He studied under Dumont and Perraud and exhibited at the Salons from 1874 to 1910. He was regarded as a 'powerful and energetic' sculptor of allegorical subjects and received many awards in the late 19th century, including a second class medal (1874) and gold medals at the Expositions of 1889 and 1900. He was made a Chevalier of the Legion of Honour in 1900. His best known works are Hope, The Seine, The Marseillaise, Pegasus and Glory on the Alexander III Bridge.

GRANGÉ, Claude fl. 20th century
Born in Vienne at the turn of the century, he studied at the Lyons School of Fine Arts and under Injalbert in Paris. He was a member of the jury and Vice President of the Council of the Artistes Français, winning a gold medal in 1926 and the medal of honour in 1937. He became an Officier of the Legion of Honour in 1918. He produced a number of war memorials and monuments after the first world war, notably those at Vienne, Verdun and Lyons, and sculpted the bas-reliefs on the gates of the Exposition Internationale in 1937. He became a member of the French Academy in 1950.

GRANGER, Geneviève 1877-
Born at Tulle on February 1, 1877, she studied under Massoulle and Henri Dubois and exhibited medallions, plaques and portrait busts at the Salon des Artistes Français at the turn of the century.

GRANIER, Marie Jeanne fl. early 20th century
Born in Paris in the late 19th century, she exhibited portrait busts, reliefs and medallions at the Salon des Artistes Français in 1913. She also worked as a miniaturist.

GRANT, Peter 1915-
Born in Pomeroy, Co. Tyrone, on December 5, 1915, he studied at the National College of Art, Dublin (1933-39) and now lives in Dublin where he sculpts portraits, reliefs and figures in stone and wood as well as bronze. He has exhibited at the Royal Hibernian Academy and in Europe and the United States.

GRANUCCI, Bartolomeo fl. 18th century
He studied under L. Vaccaro and was assistant to Solimena in Naples. He worked as a decorative sculptor on many of the churches and palaces in the Neapolitan area. His best known work is the bronze ornament in the Church of the Apostles, and the two figurative candelabra in Naples Cathedral. He also carved bas-reliefs in marble.

GRARD, Georges 1901-
Born in Tournai, Belgium, in 1901, he studied at the Academy in his native town and settled in 1931 at St. Idesbald on the Belgian coast. Before the war he produced a number of statuettes in terra cotta but since 1945 he has sculpted larger figures and groups in stone and bronze, specialising in female nudes which are sensual in the grand manner.

GRAS, Jean Pierre fl. 20th century
Born at Villeneuve-les-Avignon, he exhibited statuettes and portrait reliefs at the Nationale in the inter-war period.

GRASEGGER, Georg 1873-
Born at Partenkirchen on November 28, 1873, he studied in that town and later at the Munich Academy. He participated in the major German sculpture exhibitions at the turn of the century. He specialised in ecclesiastical work, especially in Cologne. His best known works are the bronze statue of Charlemagne and a bronze bas-relief of Wilhelm I. He also sculpted several fountains and public statues in Cologne and Gelsenkirchen.

GRASES Y ROSELLO, José fl. 19th century
Decorative sculptor, working in Port Mahon, Minorca, in the mid-19th century.

GRASS, A. fl. 19th century
Sculptor of ornaments and portraits, working in London in the mid-19th century. He exhibited at the Royal Academy between 1859 and 1867.

GRASS, Philippe 1801-1876
Born at Molsheim in Alsace-Lorraine on May 6, 1801, he died in Strasburg on April 9, 1876. He attended the École des Beaux Arts, Paris, in 1822 and studied under Ohmacht and Bosio. He exhibited at the Salon from 1831 to 1873 and won a second class medal in 1834. He was made a Chevalier of the Legion of Honour in 1865. He specialised in marble portrait busts of contemporary personalities, but also did statues and genre groups in bronze, such as The Suppliant Slave. His best known work is the figure of General Kléber in Strasburg. He also sculpted portrait reliefs and medallions.

GRASSET, Edmund 1852-1880
Born at Preuilly in 1852, he died in Rome on November 15, 1880. He studied under A. Dumont in Paris and exhibited at the Salon from 1875 till his death, making his début with a group of a Young Man and a Tortoise. He won the Prix de Rome in 1878, but died there two years later.

GRATE, Eric 1896-
Born in Stockholm in 1896, he studied at the School of Fine Arts there before going to France, where he came under the influence of the *avant-garde* sculptors of the 1920s. He exhibited abstracts at the Salon d'Automne and the Indépendants in the inter-war years and later exhibited in Scandinavia, the Netherlands, Germany and major international exhibitions. He was represented in the Exhibition of Swedish Art in Paris (1945) and the exhibition at the Swedish Institute in London (1945). His best known work is the spatial abstract The Cave of the Winds.

GRATH, Anton 1881-
Born in Vienna on October 18, 1881, he studied at the School of Arts and Crafts and the Vienna Academy, and later worked in Berlin, Zürich, Moscow and Olmutz (Olomuc). He specialised in religious sculpture and commemorative monuments, medallions and plaques portraying German, Russian and Austrian celebrities of the 19th and early 20th centuries.

GRAVEN, Joseph fl. 19th century
German sculptor who died in Holland on January 9, 1877. He studied in Munich and later worked in Hertogenbosch and Rotterdam. He specialised in ecclesiastical sculpture and his works may be found in the churches of these towns. His chief work is the statue of Admiral Piet Hein at Delfshaven, but he also sculpted a large number of portrait busts and plaques in terra cotta, marble and bronze.

GRAVES, Jean fl. 20th century
Born at St. Maurice, France in the early years of this century, he exhibited animal figures and groups at the Salon des Indépendants and the Nationale in the 1920s.

GRAVILLON, Arthur Antoine Alphonse de 1828-1899
Born in Lyons in 1828, he died at Écully in 1899. Originally trained as a lawyer, he later turned to sculpture and studied under Fabisch and spent three years in Italy. He exhibited at the Salon from 1874, mainly marble busts and allegorical groups.

GRAY, James fl. early 20th century
Sculptor working in Glasgow at the beginning of the century. He exhibited intermittently at the Royal Academy, making his début in 1903 with a bronze statuette entitled Dreams. At the Annan Gallery (1913) he exhibited a large bronze group The Rhythm of Life, showing the strong influence of the Belgian sculptor Meunier. He also produced a number of portrait busts of his contemporaries.

GRAY, Thomas U. fl. late 19th century
He exhibited figures at the Royal Academy in 1893.

GRAY, William fl. 19th century
Painter of landscapes and portraits who also sculpted genre subjects and portrait busts. He worked in Ventnor, Isle of Wight, and London, and exhibited at the Royal Academy from 1835 to 1883.

GRAY, William Everatt 1892-1957
Born in Hull on July 24, 1892, he died in Hook, Surrey on February 24, 1957. He studied at the Regent Street Polytechnic, London, under Harold Brownsword and C.E. Osborne and exhibited figures and groups at the Royal Academy and other leading galleries in London and the provinces.

GRAZZINI, Gaetano 1786-1858
Born in Florence in 1786, he died there on August 22, 1858. He became a member of the Florence Academy in 1841 and specialised in busts and statues, many of which may be found in Florentine churches and palaces. He produced a number of historical statuettes such as Lorenzo the Magnificent, Amerigo Vespucci and Cavalcanti.

GREBEL, Alphonse 'Pock' 1885-
Born in France in 1885, he studied at the École Boulle, the École des Arts Décoratifs and the École des Beaux Arts in Paris. He was employed as a war artist in 1914-1918 and did many paintings of soldiers in the trenches. Later he did landscapes in Corsica and the South of France, where he settled. His sculptures include The Bather at Juan les Pins and the Capron monument at Cannes. He exhibited genre figures at the Salon d'Automne and the Indépendants and was awarded a gold medal at the Exposition des Arts Décoratifs, 1925.

GREBER, Henri Léon fl. 19th-20th centuries
Born at Beauvais on May 28, 1855, he studied under Frémiet and Mercié and exhibited at the Salon des Artistes Français, winning many prizes including a gold medal in 1903. He was made a Chevalier of the Legion of Honour. His works include genre groups, such as Fire-damp, classical statuettes like Narcissus and portrait busts of his contemporaries.

GREBIN, J.F. fl. 18th century
Sculptor working in Berlin the late 18th century, carving in ivory and modelling in wax for bronze-casting. His works include statuettes and busts of Venus, Minerva, Mercury and other classical subjects, which he exhibited at the Berlin Academy in 1793-95.

GRECO, Emilio 1913-
Born in Catania, Italy, in 1913, he served his apprenticeship in the studio of a monumental sculptor. Later he attended classes at Palermo Academy of Fine Arts while serving in the Army. After the war he settled in Rome and held his first one-man show at the Galleria Cometa (1946), and since then he has taken part in many exhibitions in Italy and other countries. His figurative sculpture has a refined and spiritual elegance. He was professor of sculpture at Naples Academy but now lives in Rome. His works include Large Bather (various versions, 1956-57), Pinocchio (1956), Portrait of a Woman and Joy of Living.

GREEN, Charles fl. late 19th century
Sculptor of genre subjects working in Sheffield in the late 19th century. He exhibited at the Royal Academy in 1889.

GREENHALGH, Victor 1900-
Born in Ballarat, Victoria, in 1900, he is one of Australia's leading sculptors of monuments, memorials, portrait busts and genre figures.

GREENOUGH, Horatio 1805-1852
Born in Boston, Massachusetts, on September 6, 1805, he died in Somerville, Massachusetts, on December 18, 1852. He began studying modelling in Boston at the age of twelve but later went to Harvard University. In 1825 he became the first American sculptor to visit Rome and on his return he worked in Washington, Baltimore and Philadelphia. He made a second visit to Italy in 1851 and studied under Bartolini in Florence. He specialised in portrait busts of European and American personalities of the first half of the 19th century and many of these works are in American museums. He also sculpted genre figures and groups in the neo-classical idiom but with a liveliness and naturalism which helped to pioneer romanticism in America. His chief works were the monument to Washington (1841) and his group entitled Deliverance — a fight between an Indian and a Paleface representing the triumph of civilisation.

GREENOUGH, Richard Saltonstall fl. 19th century
Born in Boston in the early 19th century, he died in Rome on April 23, 1904. He was the younger brother and pupil of Horatio Greenough and studied in Paris. On his return to the United States he settled in Newport, Rhode Island, but from 1874 onwards he made frequent trips to Europe. He was renowned for his portrait busts, but also sculpted figures and groups, such as The Child and the Eagle (Boston Athenaeum) and the Young Carthaginian (Boston Museum of Fine Arts). He also sculpted the statue of Benjamin Franklin in Boston Town Hall.

GREENWOOD, Ethan Allen 1779-1856
Born at Hubbardstown, Massachusetts, in 1779, he died there in 1856. He worked mainly as a painter but also sculpted some genre figures and portrait busts. His works are in the Boston Museum of Fine Arts.

GRÉGOIRE, Alice fl. 19th century
Born in Aachen of French parents, she died in Paris in 1903. She studied under Jacquard and Haussmann and exhibited busts and portrait reliefs at the Salon from 1861.

GRÉGOIRE, Émile fl. 19th-20th century
Genre sculptor working in Brossac, France, at the turn of the century.

GRÉGOIRE, Jean Louis 1840-1890
Born in Paris on December 13, 1840, he died there in 1890. He studied under Samson and exhibited at the Salon from 1867. He was one of the first Associates of the Artistes Français. He specialised in allegorical bronzes such as Truth.

GRÉGOIRE, René 1871-
Born in Saumur on June 4, 1871, he studied under Dubois and Thomas and won the Prix de Rome in 1899 and was made a Chevalier of the Legion of Honour in 1924. He specialised in bas-reliefs, plaques and medallions commemorating contemporary events.

GREGORY, Angela 1903-
Born in New Orleans in 1903, she worked in Paris and New York and produced genre figures and portraits.

GREGORY, Christine fl. 20th century
Born in London at the turn of the century, she taught modelling at Hammersmith (1918-1937) and lived in London where she worked as a potter and sculptor till about 1960. She exhibited figures at the Royal Academy and the Paris Salons of the inter-war period.

GREGORY, John 1879-
Born in London in 1879, he was a pupil of J. Massey Rhind for three years and then worked under George Gray Barnard and Hermon A. MacNeil at the Art Students' League, New York. Subsequently he spent three years at the École des Beaux Arts, Paris, then worked in the studio of Mercié and completed his studies at the American Academy in Rome, having won the Prix de Rome in 1912. At various times he also worked with Gutzon Borglum and Herbert Adams. He became director of sculpture at the Beaux-Arts Institute of Design and associate professor of modelling at Columbia University. Though he worked in marble mainly, he also modelled figures for bronze-casting. One of his best known works is the bronze figure of Philomela in the bird garden at Manhasset, Long Island.

GREGORY, Katherine 1897-
Born in the United States in 1897, she studied in Paris under Bourdelle and later worked in New York, sculpting figures and reliefs. She was a member of the Society of Women Painters and Sculptors of New York.

GREIL, Theodore Antoine 1826-
Born in Paris on April 4, 1826, he studied under Rude and exhibited statuettes at the Salon from 1865 to 1870.

GREINER, Daniel 1872-
Born in Pforzheim on October 27, 1872, he specialised in bronze reliefs, plaques and medallions of historical personages and events in Germany.

GREINWALD, Thomas 1821-1875
Born at Gseng on January 1, 1821, he died in Vienna on October 19, 1875. He studied at Munich Academy and specialised in busts and statues of historical figures ranging from Roman deities and biblical characters to saints and the Austrian royal family. He also produced a number of genre and classical groups such as Roman Gladiators.

GRELLETY SAINT-AVIT, Marguerite 1883-
Born in France in 1883, she studied in Paris and exhibited statuettes at the Salon des Artistes Français in the 1920s.

GREPPI, Ambrosio fl. 19th century
Portrait sculptor of Italian origin, working in St. Petersburg in the 19th century.

GRESLAND, Camille 1872-
Born in Paris on April 21, 1872, he studied under J. Thomas and specialised in genre figures and groups. He exhibited at the Paris Salons, winning a bronze medal in 1926. His figure of Love is in the Luxembourg Museum.

GRESNICHT, Carl 1877-
Born at Hilversum on November 4, 1877, he entered the Benedictine monastery of Maredsous in France in 1898 and was known as Father Adalbert. He worked as a painter, architect, medallist and sculptor. He studied art in Rome and worked on the decoration of the monastery of St. Gabriel in Prague. He also studied under Father Desiderius Lenz at Monte Cassino, where he produced maquettes for friezes and did the decorative sculpture on the grand staircase of that monastery. He also produced various roundels and medallions of religious subjects.

GRETER, Robert 1885-
Born in Lucerne on July 15, 1885, he studied at the schools of arts and crafts in Lucerne and Zürich and also at the Milan Academy. He participated in the Milan Exhibition of 1906 with an allegory of Old Age. He specialised in portrait busts, masks, bas-reliefs, plaques and animal figures.

GREVENICK, François Alfred 1802-1847
Born in Paris in 1802, he died there on August 25, 1847. He exhibited at the Salon from 1831 to 1847 and specialised in genre and historical figures, such as Episode from the July Days, Tanneguy-Duchâtel saving the Dauphin, The Great Condé and Cleopatra.

GRICCI, Filippo fl. 18th century
Born in Naples in the early 18th century, he died in Madrid in 1802. He was the son and pupil of Giuseppe Gricci and went to Spain in 1759 to become the first master modeller at Capodimonte and Buen Retiro. Although most of his figurines were produced in porcelain, a bronze group of Golgotha in the Laiglesia Collection, Madrid has been attributed to him.

GRICCI, Giuseppe d. 1770
Neapolitan sculptor working in Madrid where he died in 1770. He was Sculptor to the Spanish Court and director of the Madrid Academy. He worked for Capodimonte and modelled numerous figures and small groups. He also did portrait busts and reliefs of the Spanish royal family. His sons Filippo and Stefano assisted him in the modelling of reliefs, animal groups and decorative sculpture, mainly chinoiseries and rococo ornament. His works include a statuette of David (Madrid Academy) and a bracket decorated with monkeys and birds (Sèvres Museum).

GRIESSFELDER, Frau 1877-c.1930
Born in Vienna in 1877, she died in Budapest about 1930. She was the pupil, and later the wife, of Janos Griessfelder-Darazs and studied at the Vienna Academy. She specialised in portrait busts and commemorative plaques. Several of her sculptures are in the Museum of Antiquities at Aquincum near Budapest.

GRIESSFELDER-DARAZS, Janos 1877-1908
Born in Budapest in 1877, he died there on April 21, 1908. He studied at the Vienna Academy and worked in Budapest, where he specialised in genre figures, portrait busts and projects for memorials.

GRIESSINGER, François fl. 19th century
Sculptor of figures and portraits working in Oran, Algeria at the turn of the century.

GRIFFITH, Lillian 1877-
Born in Monmouth on July 14, 1877, she studied under Alfred Gilbert and Alfred Drury and exhibited at the Royal Academy, the Salon des Artistes Français (1911) and leading provincial galleries. She lived in Hengoed, Glamorganshire, and specialised in portrait busts

and statuettes in marble and bronze. Her works include Child on his Mother's Death-bed, Griselda, Galatea and Little Boy.

GRIFFO-SAPORITO, Francesco fl. late 19th century
Born in Palermo in 1851, he studied under Nunzio Morello and exhibited figures and busts in Palermo, Naples and Messina from 1875 onwards.

GRIFONI, Riccardo fl. late 19th century
Born in Florence on June 5, 1845, he studied under Giovanni Dupré at the Academy of Fine Arts in Florence. He specialised in genre groups, such as First Disappointment (Quirinal, Rome) and various busts of Italian royalty. He exhibited in Florence, Rome and Milan.

GRIMALDI, Salvadore fl. 19th century
Sicilian sculptor working in Florence in the late 19th century. He specialised in busts and statuettes, mainly in glazed earthenware but also known as bronze casts, notably his bust of King Victor Emmanuel II.

GRIMALDI DEL POGGETTO, Stanislas Count fl. 19th century
Italian cavalry officer who painted and sculpted equestrian subjects. He was commissioned in 1850 to produce a series of engravings illustrating the principal events in the Italian War of 1848-49 and this series was published in lithographic form in 1851-55. Later he was commissioned by King Victor Emmanuel II to paint horses and scenes from the war of 1848-49 and the Crimean campaign. His chief work as a sculptor is the equestrian statue of General La Marmora in the Piazza Bodoni, Turin. His minor works include bronzes of horses, notably Trotting Horse (1883-86).

GRIMAUD, Marguerite (née Trebuchet) fl. late 19th century
French sculptress working in the late 19th century. She exhibited genre figures at the Salon des Artistes Français from its inception in 1883.

GRIMES, Frances 1869-
Born in Braceville, Ohio, in January 1869, she studied at the Pratt Institute in Brooklyn and worked under Herbert Adams (1894-1900) and Augustus Saint Gaudens (1900-07). She was a member of the Association of Women Painters and Sculptors of New York and the American Federation of Arts. She produced figures and groups, in marble, plaster and bronze, and won prizes at the Pacific-Panama Exposition, San Francisco in 1915 and the A.W.P.S. prize the following year.

GRINLING, Antony Gibbons 1896-
Born in Wiltshire on January 6, 1896, he was educated at Harrow and exhibited figures and reliefs at the Royal Academy and provincial galleries. He now lives near Chippenham, Wiltshire.

GRINSDALEN, Anne fl. 20th century
Norwegian sculptress of genre figures and portraits, working in the period up to the second world war.

GRIS, Juan (José Victoriano Gonzalez) 1887-1927
Born in Madrid on March 23, 1887, he died in Boulogne on May 11, 1927. Destined for an engineering career, he turned instead to art and studied at the School of Arts and Crafts in Madrid. He began illustrating periodicals in 1904 and moved to Paris two years later. He was a close friend of Picasso and a founder member of the Cubist movement. Though best known for his paintings and theatre décor he also sculpted figures and reliefs.

GRISSEMANN, Johann 1831-1892
Born at Imst, Tyrol, on May 15, 1831, he died in Sebarn on June 22, 1892. He studied at the academies of Vienna and Munich and then went to Florence and Rome. On his return to Imst he became director of the state school of wood-carving. Although many of his works were carved in this medium, he also produced a number of bronze statues of religious subjects and public figures for Cologne, Brünn, Innsbruck and other towns in Austria and Germany. His best known work is the statue of Grand Duke Rudolph IV on the Rudolph Fountain in Innsbruck. He also sculpted a number of portrait busts and bas-reliefs.

GRITA, Salvatore fl. 19th-20th centuries
Born at Caltagerona, Italy, in the mid-19th century, he died in Rome in 1912. He produced genre and allegorical figures and exhibited in Naples and later in Turin and Milan.

GROBMER, Josef Anton 1812-1882
Born at Bruneck in the Tyrol, 1812, he died in Munich on September 21, 1882. He studied under Schwanthaler and specialised in large monumental marbles in Vienna and Munich as well as religious sculpture in Tyrolean churches. In addition, however, he also sculpted a number of portrait busts, statuettes and maquettes for monuments and these are preserved in the Ferdinandeum in Innsbruck.

GROETAERS – see also GROOTAERS

GROETAERS, François fl. 19th century
The son and pupil of Rombout Groetaers, he worked in Malines where he exhibited genre and classical figures and groups from 1814 to 1827. His works include Psyche Deserted, Orpheus and Hebe with Jupiter's Eagle.

GROETAERS, Rombout fl. 1762-1807
He worked in Malines in the late 18th century and exhibited models and maquettes for monuments at Malines from 1777 to 1783.

GROFF, Guillelmus de c.1680-1742
Born in Antwerp about 1680, he died in Munich on August 16, 1742. He studied art in Paris in 1700 and entered the service of Louis XIV in 1708 and became Sculptor to Maximilian Emanuel, Elector of Bavaria, in 1714. He specialised in decorative sculpture *bronzes d'ameublement* and bas-reliefs and also worked as a bronze founder. Many of his bronze statuettes and reliefs are in former royal residences in Bavaria. He introduced the style of Girardon and Bouchardon to Bavaria. His bronze statuette of Maximilian Emanuel, Conqueror of the Turks, is in the National Museum in Munich.

GROFF, Karl de 1712-1774
Born in Paris in 1712, he died in Munich on September 20, 1774. He was the son and pupil of Guillelmus, who sent him to Vienna to complete his artistic education. Later he succeeded his father as Sculptor to the Bavarian Court and was also a member of the academies of Venice and Rome. He produced a number of marble statues and monuments at Nymphenburg and Munich, as well as bronze statuettes, busts and medallions.

GRONE, Heinrich Georg 1864-
Born in Dresden on March 11, 1864, he studied at the Academy in that city and specialised in genre and classical groups in plaster and bronze. His works include Remorse, Sunbath, The Fisherman, Cain, Vulcan forging the Arrows of Cupid and numerous decorative sculptures for Saxon churches. He was awarded the silver medal of the Dresden Academy.

GROOT, Guillaume de fl. 19th century
Born in Brussels in 1839, he studied at the Belgian Royal Academy, of which he later became a member. He exhibited widely and won gold medals in Brussels (1872), Berlin (1877), Munich (1879), Paris (1881) and Vienna (1888). He specialised in allegorical works, such as The Genius of the Arts, Music, Youth and various monuments to prominent Belgians of the late 19th century.

GROOTAERS (or GROETAERS), Louis 1788-1867
Born in Malines in 1788, he died in Nantes in 1867. He studied under Cartellier and F. Lemot in Paris and settled in Nantes. He sculpted the bas-reliefs for the doorway of Nantes Town Hall in 1808. Other works include statues of St. Louis and St. Joseph in Nantes churches and various ecclesiastical figures and reliefs.

GROOTAERS, Louis Guillaume 1816-1882
Born in Nantes on August 19, 1816, he died at Montaigu in 1882. He was the son and pupil of Louis Grootaers and became a naturalised Frenchman in 1837. He also studied under Pradier in Paris and exhibited at the Salon from 1845 to 1882. He specialised in marble busts and stone façades for public buildings in the Nantes region, but also sculpted a series of eight bronze spirits for the fountain in the Place Royale, Nantes. Among his other bronzes are several portrait busts of French celebrities.

GROOTAERS, Philippe Jean fl. 19th century
Belgian sculptor of the early 19th century, specialising in genre busts and classical figures. He exhibited in Antwerp from 1813 and Brussels in 1818.

GROSJEAN, Jules Aimé d. 1906
Born in Vesoul in the mid-19th century, he died there in 1906. He exhibited at the Salon des Artistes Français, winning a second class medal and a travelling scholarship in 1899. The Gray Museum has his bust of the poet Grandmougin and a statuette of Liberty.

GROSS, Juliet White fl. 20th century
Born in Philadelphia at the turn of the century, she studied at the Pennsylvania Academy and later at the École des Beaux Arts, Paris. She produced portraits and genre statuettes in the late 1920s.

GROSS, Karl 1869-
Born at Fürstenfeldbruck near Munich on January 28, 1869, he studied at the School of Arts and Crafts in Munich and later became professor at the School of Arts and Crafts in Dresden. He specialised in pewter and spelter vases with decorative reliefs, but also did projects for furniture, stained glass windows and maquettes and bas-reliefs for ecclesiastical sculpture. He was a member of the Munich and Dresden Secession movements at the turn of the century.

GROSS, Wilhelm 1883-
Born at Schlawe, Pomerania, on January 12, 1883, he studied under Otto Lessing in Berlin and then attended the Karlsruhe Academy. Later he worked in the studio of L. Tuaillon and August Gaul in Berlin. He exhibited at the Secession in Munich and Berlin and also at the exhibitions of the Association of German Artists in Bremen and Mannheim. His works include Head of a Sabine, Sabine Woman, Discus-thrower and various portrait busts, in bronze or terra cotta.

GROSSI, Angelo 1854-
Born in Naples on February 8, 1854, he studied at the School of Fine Arts in Naples and was a pupil of Alvino and Lista. He exhibited figures and groups in Turin and Rome in the late 19th century.

GROSSMANN, Christian fl. 19th century
Born in Copenhagen in 1849, he studied under H.V. Bissen and also attended classes at the Royal Copenhagen Academy, where he exhibited portrait medallions, plaques, statuettes and busts from 1870 onwards.

GROSSMANN, Peter 1808-1847
Born at Brienz, Switzerland, in 1808, he died there on December 1, 1847. He studied locally under Christian Fischer and worked in Rome under Thorwaldsen. He sculpted neo-classical and genre figures, mainly in marble.

GROSSONI, Orazio fl. 19th-20th centuries
Born in Milan, where he worked at the turn of the century on genre and allegorical figures and groups. He exhibited in Italy and also won a silver medal at the Exposition Universelle of 1900.

GROSSOT DE VERCY, Camille fl. 19th century
Born in Paris on October 26, 1838, he studied at the École des Beaux Arts and was a pupil of Bonnassieux and A. Dumont. He exhibited statuettes at the Salon in 1865-67.

GROUILLET, Marcel fl. 19th-20th centuries
Born in Paris, he studied under Falguière, Delorme, Moreau, Mercié and Vital Cornu and exhibited figures and portraits at the Salon des Artistes Français, winning a third class medal in 1907.

GROUX, Henri Jules Charles Corneille de 1867-1930
Born in Brussels in 1867, he died in Marseilles in 1930. He was the son and pupil of the painter Charles de Groux and was himself a painter, lithographer and sculptor of historical and allegorical works. He studied under Portaels at the Academy of Fine Arts in Brussels and exhibited there from 1886. He was best known for his large and sometimes controversial allegorical paintings during the first world war. As a sculptor, he also produced numerous portrait busts of European literary and artistic contemporaries, such as Balzac, Baudelaire, Tolstoi and Wagner.

GRUBER fl. 19th-20th centuries
Bronzes bearing this signature were the work of a sculptor in Munich at the turn of the century. The Hanover Museum has a group of Cupid with a Lion.

GRUBER, Jakob 1864-
Born at Hallein, near Salzburg, on July 23, 1864, he studied at the School of Arts and Crafts and the Academy of Vienna and won the Fröhlich prize three times. He specialised in genre groups, such as The Shipwrecked Mariners, Springtime of Love and Buried Miners, the latter winning him the Prix de Rome in 1900. He also did portrait reliefs and medallions.

GRUBERSKI, Ladislas fl. early 20th century
Born in Warsaw in the late 19th century, he worked there as a genre sculptor before the first world war.

GRÜBLER, Florian 1746-1813
Born at Kilbnitz, Carinthia, on March 21, 1746, he died in Vienna on April 2, 1813. He studied at the academies of Mannheim and Munich and did decorative sculptures for the Nymphenburg Park and various public buildings in Vienna and Munich. He worked mainly in marble.

GRUN, Samuel fl. 20th century
Born in Reval, Estonia, at the beginning of this century, he worked in London and Paris and exhibited portrait reliefs and medallions at the Salon des Artistes Français and the Royal Academy in the inter-war period.

GRUND, Johann Gottfried 1733-1796
Born in Meissen on April 28, 1733, he died in Copenhagen on September 20, 1796. He studied in Dresden and Berlin and went to Copenhagen in 1757. He became Sculptor to the Danish Court and chief modeller at the Royal Copenhagen Porcelain Manufactory. Though best known for his porcelain figurines he also sculpted garden statuary and memorials in marble, lead and bronze.

GRUPP, Karl Heirich 1893-
Born in Rochester, New York, in 1893, he was a member of the National Society of Sculptors and studied at the Antwerp Academy and the Art Students League under Karl Bitter. He produced memorials, bas-reliefs, portraits and genre figures.

GRUPPELLO, Gabriel de 1644-1730
Born in Gramont, Belgium, on May 23, 1644, he died in Brussels in 1730. He was the son of a Spanish artillery officer stationed in what was then the Spanish Netherlands. He studied under Arthur Quellinus and became a master sculptor in Brussels in 1674 and later Sculptor to King Charles II of Spain. He produced a number of important monuments and statues of biblical, classical and allegorical subjects for churches and public buildings in Brussels. A number of his works are known as bronze reductions and the Bavarian National Museum in Munich has his bronze statuette of St. Bartholomew.

GRÜTER, Kaspar 1811-1865
Born in Raswil, Switzerland, in 1811, he died in Lucerne on December 17, 1865. He produced a large number of bronze statuettes and small groups, many of which are in the municipal museum of Soleure.

GRÜTTNER, Richard fl. 19th century
Born in Breslau on April 7, 1854, he worked in Berlin as a sculptor of portrait busts, reliefs and monuments.

GRUYER, Henri Julien Desiré fl. 19th-20th centuries
He worked in Paris at the turn of the century and exhibited at the Salon des Artistes Français, of which he became an Associate in 1887.

GRUYER-CAILLEAUX, Marie fl. late 19th century
Born at Soissons in the mid-19th century, she studied under Injalbert and exhibited genre statuettes at the Salon des Artistes Français at the turn of the century. She was probably the wife of H.J.D. Gruyer.

GRŽETIĆ, A. fl. 20th century
Yugoslav sculptor of monuments, public statuary, portrait busts and genre figures, working since the second world war. His chief work is the Kragujevac monument to the victims of Nazi atrocities.

GUACCI, Luigi 1871-
Born at Lecca, near Otranto, Italy on January 8, 1871. He studied at the Academy of St. Luke in Rome and won first prize in a national competition for his group of Sappho and Phaon. He specialised in classical and contemporary busts and groups in marble, plaster and bronze.

GUARNERIO, Pietro 1842-1881
Born in Milan in 1842, he died there in 1881. He specialised in allegorical and genre groups and statuettes, such as Vanity. The Stockholm Museum has his statuette Young Boy at Prayer.

GUASTALLA, Giuseppe 1867-
Born in Florence in 1867, he worked in Rome at the turn of the century under Ettore Ferrari and produced statuettes and portrait reliefs.

GUASTALLA, Hélène 1903-
Born in Paris on November 8, 1903, she studied under Sicard, Patey and Graf. She was an Associate of the Artistes Français and exhibited at that Salon and also the Salon d'Automne in the late 1920s, producing statuettes.

GUDJAN, Akzap fl. early 20th century
Born in Stockholm of Armenian origin in the late 19th century, he sculpted memorials, monuments, portraits and figures in the first half of this century.

GUÉDROÏTZ – See GJEDROYTZ, Prince Romuald

GUÉNIOT, Arthur Joseph 1866-
Born at Bournezeau, France, on May 1, 1866, he studied in Paris under G. Moreau and Delorme. He exhibited portrait busts, reliefs and statuettes at the Salon des Artistes Français till 1933, winning a first class medal in 1927 and becoming a Chevalier of the Legion of Honour two years later.

GUÉNOT, Auguste 1882-
Born in Toulouse on October 25, 1882, he was a most prolific sculptor of statues and memorials and worked in every medium from direct carving in stone and wood to modelling in clay, plaster and bronze. He exhibited at all the major Paris Salons in the inter-war period. His bronzes include Draped Woman with a Child and other genre groups, many of which are in the Luxembourg Museum and other museums in Paris and Brussels.

GUÉNOT, Ferdinand fl. early 20th century
Born in Paris in the late 19th century, he worked at Joinville le Pont and exhibited figures at the Salon des Artistes Français, getting an honourable mention in 1906 and becoming as Associate a year later.

GUEORGUIEVA, Mara fl. 20th century
Bulgarian sculptress of genre figures working in the inter-war period.

GUÉRARD, Georges Louis fl. 20th century
Born at St. Denis, France, in the early years of this century. He studied under Jean Boucher and exhibited portrait medallions, plaques and bas-reliefs at the Salon des Artistes Français, winning a third class medal in 1932.

GUÉRARD, Jean Baptiste 1811-1875
Born at Rantigny in 1811, he died there in 1875. He specialised in religious sculpture for church decoration and worked in wood, ivory, mother of pearl, precious metals and bronze. Amiens Museum has a small bas-relief by him showing Jesus expelling the Moneylenders from the Temple.

GUÉRIN, Albert Louis Joseph fl. 19th-20th centuries
Born at Caen in the late 19th century, he studied under Barrias and Coutan and worked in Paris. He specialised in portrait statuettes and busts of his contemporaries, and genre figures, such as The Last Friend. He won a third class medal at the Salon des Artistes Français in 1903.

GUÉRIN, Lucien Georges 1882-
Born in Paris on June 7, 1882, he studied under Falguière and exhibited figures and portraits at the Salon des Artistes Français.

GUÉRIN, Narcisse fl. 19th century
He worked in Paris in the second half of the 19th century, and was a pupil of Guillouette and Delagrange. He exhibited at the Salon in 1868-70.

GUÉRLAIN, Eugène fl. 19th century
Born at St. Pierre-lès-Calais, he studied under Cordier and exhibited statuettes at the Salon from 1857 to 1872.

GUERRA, Gabriel fl. late 19th century
Mexican sculptor of memorials, monuments, public statuary and portraits. He won a silver medal at the Exposition Universelle of 1889.

GUERRAZZI, Temistocle 1806-1884
Born in Leghorn in 1806, he died there on February 16, 1884. He was a member of the Florence Academy and sculpted a number of public statues and memorial reliefs in Florence, Pisa and Leghorn. His minor works include busts of historic Italian personages (many of them in the Leghorn Public Library) and maquettes for tombs and monuments.

GUERRINI, Lorenzo 1914-
Born in Milan in 1914, he moved to Rome at the age of sixteen and attended classes at the Academy and the Arts Museum. Later he studied in Breslau, the School of Arts and Crafts in Berlin and the École des Beaux Arts, Paris. He travelled widely in Europe and Latin America before settling in Italy. He pioneered abstract medallions in 1949 and many of these were subsequently used as emblems for art exhibitions and congresses. He has exhibited his sculptures all over Italy, won a major award at the first International Exhibition of Sculpture in Carrara, 1957, and has had one-man shows in Milan and Rome since 1947. Many of his more recent works have been sculpted in sheet metal or carved direct in stone, but his earlier reliefs and abstracts were cast in bronze.

GUERSANT, Pierre Sébastien 1789-1853
Born in Déols on January 20, 1789, he died in Paris on April 5, 1853. He studied under Cartellier and exhibited at the Salon from 1814 to 1850, winning a second class medal in the latter year. He specialised in classical and biblical statues and bas-reliefs, many of which may be found in the churches and cemeteries of Paris. His minor bronzes include busts of historic French personalities and the series of eight trophies of arms for the great staircase in the Palais du Luxembourg.

GUERSEY, Eleanor Louise 1878-
Born in Terre Haute, Indiana, on March 9, 1878, she studied at the Art Institute of Chicago and later settled in that city where she sculpted memorials, genre figures and portraits. She won the Wallon prize in 1909.

GUÉTANT, Gustave 1873-
Born in Marseilles on May 25, 1873, he studied under Barrias and Coutan and exhibited genre figures at the Salon des Artistes Français, winning a medal in 1931. He also worked as an illustrator of books and periodicals.

GUÉTROT, François René 1810-1871
Born at Melle in 1810, he died at Niort in 1871. He studied under Calmels and exhibited at the Salon in 1864-70. He specialised in portrait reliefs and busts, of contemporary celebrities and genre subjects, mainly women and children. The main collection of his works is in Blois Museum.

GUGLIELMI, Lange 1839-
Born in Toulon in 1839, he studied under Jouffroy and Courdouan and exhibited at the Salon from 1867 to 1882. He specialised in allegorical and classical works, mainly in marble or plaster but including such bronze statuettes as Follower of Bacchus.

GUGLIELMI, Luigi 1834-1907
Born in Rome in May 1834, he died there in 1907. He studied at the Academy of St. Luke and exhibited from 1855 onwards in Rome, Turin, Milan, London and Paris. He specialised in busts and statues, mainly in marble. The Museum of Modern Art, Rome, has his bronze portrait of Terenzio Mamiani.

GUHR, Richard fl. 20th century
Painter of frescoes, working in Dresden in the early years of this century, he also dabbled in genre and religious sculpture.

GUIBOURGÉ, Roger 1881-
Born in Paris on November 10, 1881, he studied under Barrias and exhibited figures at the Salon, winning a third class medal in 1910.

GUICHARD, fl. 19th century
Bronzes bearing this signature in the Roman and Cyrillic alphabets were the work of a sculptor born in Paris in the 18th century. He studied under Pajou and Vincent and exhibited at the Salon from 1802 to 1822, winning a medal in 1814. He specialised in busts, statuettes and bas-reliefs portraying the Bourbon dynasty. He also sculpted several monuments, of which the best known is his bas-relief of Money and Medals on the Bastille fountain. Later he moved to Russia where he became sculptor to the Imperial family. Many of his portrait busts and plaques of Russian celebrities are now in Soviet museums.

GUIGNARD, Pierre d. 1876
Parisian sculptor of the mid-19th century, specialising in portrait busts, mainly in bronze. His works include the bust of A. Soumet (1846) in the Palais de l'Institut, and Bossuet at the Ministry of the Interior.

GUIGNIER, Fernand 1902-
Born at Montpellier on August 29, 1902, he studied under Injalbert and exhibited statuettes and portraits at the Paris Salons in the inter-war period.

GUIGUES, Louis Jacques 1873-
Born in Bessèges, France, on April 30, 1873, he studied under A. Boucher and exhibited neo-classical and genre statuettes at the Salon des Artistes Français at the turn of the century. His figure of Diana is in the Museum at Gray.

GUILBAUD, Gustave 1842-1912
Born in Nantes on June 7, 1842, he died in Paris in 1912. He exhibited figures and small groups at the Salon from 1868 onwards.

GUILBAULT, Ferdinand fl. 19th-20th centuries
Born in Brest, where he worked as a decorative sculptor at the turn of the century.

GUILBERT, Charles fl. early 20th century
Born in Paris in the late 19th century, he studied under Valton and specialised in genre and animal figures. He became an Associate of the Artistes Français in 1909.

GUILBERT, Ernest Charles Demosthenes fl. late 19th century
Born in Paris on October 13, 1848, he studied under A. Dumont and Chapu and exhibited at the Salon from 1867, winning a third class medal (1873) and a second class medal two years later. He was awarded gold medals at the Expositions of 1889 and 1900 and was a Chevalier of the Legion of Honour. He specialised in marble portrait busts of French personalities, religious figures and allegorical bas-reliefs for public monuments.

GUILLAUME, Jean Baptiste Claude Eugène 1822-1905
Born at Montbard, France, on July 4, 1822, he died in Rome in 1905. He studied at the École des Beaux Arts under Pradier and won the Prix de Rome in 1845 for his group Theseus finding his Father's Sword under a Rock. He exhibited at the Salon from 1852 to 1882 and won a first class medal in 1855. He was awarded a medal of honour at the Exposition Universelle of 1867 and became a Commandeur of the Legion of Honour in 1875 and a member of the Institut in 1882. He was appointed director of the École in 1864 and became Director-General in 1879. Guillaume represented the classical rearguard against the Romantics and the disciples of Rodin right to the end of the 19th century. Much of his work was sculpted in marble, but his bronzes include the statues of Colbert (Rheims), Rameau (Dijon) and Philippe de Girard (Avignon) and a bust of Ingres at Bayonne. His figure of a Reaper and a group, The Brothers Gracchi, are in the Louvre.

GUILLAUME, Victor fl. late 19th century
Born in Toulon he studied under Courdouan and Vian de Pignans and exhibited busts and statuettes at the Salon from 1879.

GUILLAUMET, Henriette A. fl. late 19th century
She worked in Paris in the 1890s and sculpted genre figures and groups.

GUILLAUMOT, Charles Axel fl. 18th century
Parisian architect who died in 1807, he specialised in reliefs, roundels and medallions and completed the unfinished works of Poquet after his death in 1782. The Museum of Sens has his models and maquettes for portraits of the Royal family. He was also the Administrator of the Gobelins carpet factory.

GUILLEMIN, Émile Coriolan Hippolyte 1841-1907
Born in Paris on October 16, 1841, he died there in 1907. He studied under his father, the painter Émile Marie Guillemin, and was also a pupil of Salmson. He exhibited at the Salon from 1870 onwards and won an honourable mention in 1897. He specialised in biblical figures and groups, and portrait busts of his contemporaries.

GUILLEMIN, G. fl. 19th-20th centuries
He worked in Paris and Cambrai as a sculptor of portrait reliefs and busts and exhibited at the Salon des Artistes Français from 1883 to 1911.

GUILLEMIN, Nicolas fl. 19th century
Born in Dijon on January 12, 1817, he studied under David d'Angers and Devosges. He exhibited at the Salon from 1845 and produced historical and classical figures, many of which are preserved in Rochefort Museum.

GUILLET, fl. early 19th century
Bronze statuettes with this signature were the work of a French sculptor who exhibited at the Salon in 1833-34.

GUILLOIS, François Pierre fl. 18th-19th centuries
Born in Paris in 1764, he was self-taught and exhibited at the Salon from 1793 to 1834, winning a medal in 1819. His works include Child feeding a Snake (St. Cloud) and various statues and bas-reliefs of allegorical subjects in the Musée Royale and on the Arc de Triomphe.

GUILLON, Auguste Louis fl. late 19th century
Born in Paris in the mid-19th century, he exhibited at the Salon from 1876, winning a third class medal in 1884 and getting an honourable mention at the Exposition Universelle of 1889.

GUILLOT, Anatole 1865-1911
Born at Étigny in 1865, he died in Paris in February 1911. He studied under Gautherin and Falguière and became an Associate of the Artistes Français in 1892. He won a third class medal in 1889 and a second class medal in 1901, and a bronze medal at the Exposition of 1900. He specialised in genre and animal figures, in terra cotta and bronze.

GUILLOT, Arthur fl. early 19th century
Born in Lyons at the end of the 18th century, he worked in that town as a portrait sculptor. Many of his busts of contemporary personalities are in the museums of Lyons and Versailles.

GUILLOUX, Albert Gaston 1871-
Born in Rouen on October 9, 1871, he studied under Coutan and exhibited at the Salon des Artistes Français, winning a first class medal in 1906 and the Prix National in 1903. He specialised in bronze plaques and historical groups. The Bayonne Museum has a silvered bronze relief by him commemorating the millenary of Rouen. His group of Eve discovering the Corpse of Abel is in the Rouen Museum.

GUILLOUX, Alphonse Eugène fl. 19th-20th centuries
Born in Rouen on June 2, 1852, he studied under Falguière and exhibited at the Salon des Artistes Français till 1928, winning a gold medal at the Exposition Universelle of 1889. His major works, such as The Dying Orpheus, were carved in marble, but is also known in plaster and as a bronze reduction. He also produced a number of bronze portrait busts of his contemporaries.

GUILLOUX, Benjamin fl. late 19th century
He worked in Rouen in the last quarter of the 19th century and exhibited at the Salon from 1878 onwards.

GUILMART, Maurice 1903-1948
Born in 1903, he died in Paris in 1948. He studied under Coutan and exhibited at the Salon des Artistes Français, the Salon d'Automne and the Indépendants in the inter-war period. He was professor of design to the City of Paris and specialised in portrait busts of historic figures.

GUIMARD, Hector 1867-
Born in Paris on March 10, 1867, he studied architecture under Genuys at the School of Decorative Arts and under Raulin at the École des Beaux Arts. He was professor at the School of Decorative Arts from 1894 to 1898. He is best known as one of the leading French architects of the Art Nouveau style and also designed furniture in the same genre. He also worked as a decorative sculptor, in wrought iron, beaten copper and bronze and exhibited at the Salon des Artistes Français and the Nationale at the turn of the century. He is best remembered in this context for his curious decorative arches and gateways to the stations of the Paris Metro, derived from plant motifs.

GUIMBERTEAU, Raymond fl. 19th-20th centuries
Born in Angoulême in the mid-19th century, he died there in January, 1905. He studied under Cavelier and Barrias and exhibited at the Paris Salons from 1882 to 1903. He specialised in portrait reliefs and busts and also did the memorial to President Carnot at Annecy.

GUINO, Michel 1928-
Born in Paris in 1928, he was the son of the Catalan sculptor Richard Guino, but was largely self-taught. He attended the Académie de la Grande Chaumière and the École des Beaux Arts and was influenced by Despiau. In 1951 he discovered the work of Gonzalez and henceforth he gave up stone carving and figurative modelling and has concentrated on abstracts in iron or bronze ever since. He exhibits at the Salon de Mai and the Salon de la Jeune Sculpture and won prizes at the Paris Biennial (1959) and the Marseilles Exhibition (1960).

GUINO, Richard 1890-
Born in Gerona, Spain, on May 26, 1890, of French descent, he moved to Paris and later became a naturalised Frenchman. He studied under Maillol and was strongly influenced by Renoir, whose style he has interpreted in his figures and groups.

GUINZBURG, Frederick Victor 1897-
Born in New York City in 1897, he studied at the Art Students' League and was later a pupil of Victor D. Brenner (1915-17). After the first world war he continued his studies in Paris and Rome. On his return to America he became a member of the National Society of Sculptors and later was professor of sculpture in New York. His bronzes include a group The Bride of the Man Horse, inspired by a story of Lord Dunsany.

GUIONNET, Alexandre fl. 19th century
Sculptor of genre and classical figures, working in Paris. He exhibited at the Salon from 1831 to 1859.

GUMERY, Charles Alphonse Achille 1827-1871
Born in Paris on June 14, 1827, he died there on January 19, 1871. He studied under Toussaint and won the Prix de Rome in 1850 with his group The Death of Achilles. He exhibited at the Salon from 1855 to 1871 and won medals on many occasions up to 1863. He was a prolific sculptor of statues in marble and bronze and also did decorative sculpture in the new Opera House and many other public buildings in Paris. His minor bronzes include Harvester; Fountain of Love (marble and silvered bronze); President Favre (Chambéry); the bust of the surgeon Lapeyronie in the Faculty of Medicine, Montpellier; Science and Jurisprudence (Chambéry); Temperance (on the St. Michel fountain); Agriculture and Industry (Place des Arts et Métiers).

GUNDELACH, Karl 1856-1920
Born in Lindau on June 16, 1856, he died in Hanover on January 19, 1920. He studied under W. Engelhardt at the Berlin Academy and worked in Hanover from 1885 till his death. He specialised in architectural sculpture and also did many busts of Hanoverian personalities.

GUNTERMANN, Franz 1881-
Born at Steele in the Ruhr on August 22, 1881, he studied at the School of Arts and Crafts and the Academy of Munich and became a member of the Deutsche Werkbund. He specialised in classical and genre groups, often involving animals, such as St. Bernard Dog with two Children, Ulysses recognised by his Dog. Other genre groups related to the Ruhr district, such as Miners, Coming out of the Mine-shaft, etc. He also sculpted portrait busts of German royalty and contemporary celebrities.

GÜNTHER-GERA, Heinrich 1864-
Born in Gera on September 15, 1864, he studied at the Academy of Fine Arts, Berlin (1883-88) and worked in Charlottenburg. He exhibited at the Berlin Academy from 1894 and also participated in the Crystal Palace exhibitions, Munich, in 1897-98. He specialised in public statuary and monuments which may be seen in Gera, Graudenz, Darmstadt and Elberfeld, but also produced small allegorical figures and groups.

GUNTHORP, Henry fl. 19th-20th centuries
Born at Herne Hill, London, in the mid-19th century, he was a member of the Society of British Sculptors and exhibited figures at the Royal Academy from 1884.

GURADZE, Hans 1861-
Born in Kottulm, Silesia, on December 5, 1861, he studied at the academies of Berlin and Dresden and worked in Berlin. He exhibited at the Academy in the 1890s and also at the Munich Crystal Palace in 1898. He specialised in equestrian statuettes, of which the best known is Kaiser Wilhelm II as a Uhlan.

GURDJAN, Akop fl. 20th century
Born in Armenia at the turn of the century, he studied in Paris and settled there after the first world war. He specialised in genre figures and portrait busts of Armenian subjects. He took part in the Salon of Free Armenian Artists in Paris, 1945.

GURRI, Salvador fl. 18th-19th centuries
Born in Barcelona, where he worked from 1756 till 1819. He was an honorary member of the Academy of San Fernando in Madrid and specialised in classical, allegorical and biblical figures and bas-reliefs, many of which decorate Barcelona's churches and public buildings.

GURSCHNER, Gustav 1873-
Born at Mühldorf, Bavaria, on September 28, 1873, he studied in Bolzano and at the School of Arts and Crafts in Vienna. Later he worked in Paris for a time before settling in Vienna. He originally sculpted portrait busts but later concentrated on bronze statuettes and miniature groups, plaques, medallions and ornamental lamps.

GUTFREUND, Otto fl. 20th century
Born in Bohemia at the turn of the century, he became one of the leading Czech sculptors of the inter-war period, producing genre figures and groups, such as Business, in the Expressionist idiom.

GUTIERREZ DE LEON, Antonio fl. mid-19th century
He studied under his father Raphael de Leon (d.1855) and became professor of modelling at the Academy of Fine Arts in Malaga. He sculpted portraits and classical figures, mainly in marble.

GUTIERREZ Y CANO, Manuel fl. mid-19th century
Sculptor of ornament and classical figures, working in Seville in the 1850s.

GUTTMANN, Jakob 1811-1860
Born at Arad in Romania in 1811, he died in Vienna on April 28, 1860. He studied at the Vienna Academy from 1837 to 1840 and later established a studio in that city. He won a travelling scholarship to Rome and also worked for a short time in Paris. He specialised in portrait reliefs and busts in marble, wax and bronze, particularly of members of the Rothschild family and contemporary Viennese literary and artistic figures.

GÜTTNER, Vittorio 1869-
Born in Trieste on April 24, 1869, he worked in Munich and exhibited at the Crystal Palace. He specialised in bronze statuettes and portrait busts of genre subjects. His head of a Moor is in the Albertinum, Dresden.

GUY, Jean Baptiste Louis 1814-1888
Born in Lyons on March 8, 1834, he died there on February 17, 1888. He studied at the School of Fine Arts in Lyons from 1839 to 1846, and worked under Bonnefond and Duclaux. He exhibited in Lyons from 1840 onwards and also at the Paris Salon from 1868 till his death. He worked as a painter and etcher as well as a sculptor, and specialised in statuettes and groups depicting the people and animal life of Algeria, where he travelled extensively. He was appointed professor at the Lyons School of Fine Arts in 1871, but, when this appointment was unfairly revoked soon afterwards, he left Lyons and settled in Paris. In 1882 he was re-instated and later became Director of the Lyons School of Design.

GUYOT, Georges Lucien 1885-
Born in Paris on December 10, 1885, he worked as a sculptor, painter and engraver of animal subjects. He had a one-man show at the Salon des Indépendants in 1943 and exhibited regularly at that salon, as well as the Artistes Français and the Salon d'Automne. He is best known as an illustrator of animal books, but his sculptures include various lions, tigers, panthers, deer and pheasants.

GUYSKI, Marcell 1830-1893
Born in Krzyvostsynce, Ukraine, in 1830, he died in Cracow on May 6, 1893. He studied in Bologna, Florence and Rome, being a pupil of Amici in the last-named city, and was professor of sculpture at the Cracow School of Fine Arts. He produced statuettes and busts of historical and contemporary Polish celebrities and allegorical figures, such as The Angel of Death.

GUZMAN, Aleth Jeanne Antoinette 1904-
Born in Dijon on April 13, 1904, she was the daughter of a music professor and was originally trained as a musician. Later she attended the École des Beaux Arts and won the Prix de Rome in 1929. She specialises in portrait medallions and bas-reliefs.

GWOZDECKI, Gustav c.1880-
Born in Poland about 1880, he studied at Cracow Academy and exhibited paintings and sculpture at the Cracow Artists Society shows. At the turn of the century, he went to Paris and settled there. He exhibited at the Nationale, the Indépendants and the Salon d'Automne from 1904 and took part in international exhibitions in Leipzig, Venice, and New York before and after the first world war. He specialised in busts and statuettes of female nudes, in marble, plaster and bronze.

GWYN-JEFFREYS, Miss fl. 19th-20th centuries
Sculptress of allegorical figures and reliefs, working in London at the turn of the century.

GYDE-PETERSON, Hans F. 1863-
Born at Lindeballe, Denmark, on November 7, 1863, he studied at the Copenhagen Academy and specialised in biblical figures and groups, such as Adam and Eve in front of the Corpse of Abel (Copenhagen Museum) and Adam and Eve at the Grave of Abel (Aarhus Museum).

GYLDEN, Eva Maria 1885-
Born in Viborg (Wiipuri) on July 15, 1885, she studied at the design school of the Society of Fine Arts in Helsinki and then at the Berlin School of Arts and Crafts shortly before the first world war. Later she studied under Bourdelle in Paris. She specialised in bas-reliefs, medallions and cameos which she exhibited in Helsinki, Stockholm, Copenhagen and Paris in the inter-war period.

GYÖNGYÖSSY, Berta 1873-
Born at Nagykallo, Hungary, on March 13, 1873, she studied at the School of Arts and Crafts in Budapest. She specialised in bronze statuettes and busts of genre subjects, mostly children.

HA, Jean William Henri du fl. 20th century
Born in Bordeaux in the late 19th century, he studied under Jouffroy, Delaplanche and Falguière and exhibited figures at the Salon des Artistes Français in the 1920s.

HAAG, Carl 1867-
Born in Sweden in 1867, he emigrated to the United States and worked in New York. He produced numerous fountains and decorative sculptures, noted for their symbolic and poetical character. His allegory of Accord is in the Metropolitan Museum of Art.

HAAG, Franz 1865-
Born in Vienna on December 9, 1865, he studied at the School of Arts and Crafts and the Academy of Vienna. He specialised in classical, genre and allegorical statuettes such as Bacchante, Reverie and Teasing.

HAAREN, Franz, Baron von 1856-1879
Born in the Baltic province of Courland on January 11, 1856, he died in Stuttgart on February 18, 1879. He studied under Adolph Donndorf and specialised in portrait medallions and bas-reliefs of famous Germans.

HAAS, Hermann Georg 1864-1912
Born at Kircheim near Nuremberg on February 10, 1864, he committed suicide on September 3, 1912. Most of his work was done in Hamburg at the turn of the century and ranged from monuments and memorials to portrait busts, masks and plaques portraying his contemporaries as well as historic figures such as Goethe and Bismarck.

HAAS, Xaver fl. 19th century
Born in Horw, Switzerland at the beginning of the 19th century, he died in Lucerne about 1880. He studied under Franz Schlatt in Lucerne and exhibited statuettes and reliefs in Lucerne.

HAASE-ILSENBURG, Hermann 1879-
Born in Ilsenburg, Germany on February 14, 1879, he worked in Berlin and specialised in allegorical and genre groups, such as Spring and Tales.

HAASENBERGER, Wilhelm fl. 19th century
Born in Berlin at the beginning of the 19th century, he settled in St. Petersburg in 1825 and specialised in animal sculpture, particularly horses. He was awarded the diploma of the Imperial Academy in 1832 for his Uhlan on Horseback. He exhibited equestrian statuettes at the Berlin Academy from 1839 onwards.

HABER, Shamai 1922-
Born in Lodz, Poland in 1922, he emigrated with his family to Palestine in 1935 and studied art at the Tel Aviv Academy. He fought in the war of 1948 and then moved to Paris where he has worked ever since. At first he was strongly influenced by the work of Bourdelle and Despiau and his figurative modelling belongs to this period. Since 1952, however, he has abandoned this form of sculpture and concentrated on abstracts carved direct in stone. He has taken part in the Salon des Réalités Nouvelles and the Salon de la Jeune Sculpture since 1953.

HABERSTOCK, Franz fl. early 19th century
Viennese decorative sculptor working from 1816 to about 1835.

HABERT, Alfred Louis 1824-1893
Born in Paris in 1824, he died there in 1893. He studied under Pradier and exhibited portraits and reliefs at the Salon in 1850.

HABICH, Wilhelm 1840-c.1900
Born on October 20, 1840, he worked in Brunswick till the end of the 19th century. He studied at the Polytechnic School in Hanover and specialised in busts and equestrian statuettes, mainly of the Hanoverian royal family (the Duke of Cumberland) and contemporary German personalities.

HABICHT, Well 1884-
Born on July 7, 1884, he studied architecture in Darmstadt and later attended the Dresden Academy. He exhibited in Dresden from 1911 and specialised in statuettes, busts and animal figures. Many of his works are known in terra cotta and majolica.

HABLITSCHEK, Franz 1824-1867
Born in Nuremberg on March 2, 1824, he died there on March 30, 1867. He studied under Pappel in Munich and is better known as an illustrator and steel engraver. He sculpted decoration for the libraries, churches and other public buildings in Munich and Nuremberg.

HABS, Ernst fl. 19th century
Born in Magdeburg, he studied at the Berlin Academy and exhibited there and at the Great Berlin Exhibition of the 1890s. Apart from his busts of contemporary German celebrities he also sculpted the large monuments to Kaiser Wilhelm I at Burg and the Friesen memorial in Magdeburg.

HACHE, Louis 1893-
Born in Paris in 1893, he worked as a painter, engraver and sculptor of bas-reliefs in the inter-war period, exhibiting at the Salon des Indépendants.

HACHENBURGER, Etienne fl. early 20th century
Born in Paris in the late 19th century, he exhibited figures and portraits at the Salon des Artistes Français in the early 1900s.

HACKSTOCK, Karl 1855-1919
Born at Fehring in Styria on October 31, 1855, he died in Vienna in 1919. He won many prizes at the Vienna Academy and spent five years as an assistant and pupil of Tanagra. He specialised in memorials, monuments, reliefs, plaques, busts and small decorative sculptures and also worked as a portrait painter.

HADL, Richard 1877-
Born in Hungary on January 11, 1877, he studied at the Vienna Academy and won a Rothschild bursary which took him to Florence. He worked in Budapest, Vienna and later Berne and is best known as an engraver, but also sculpted portrait busts and reliefs.

HAE, see also HA

HAEN, Jacques de 1831-1900
Born in Brussels in 1831, he died at Schaerbeek on June 21, 1900. He studied under Simonis and specialised in genre and allegorical statuettes, such as Love in Chains.

HAERT, Hendrik Anna Victoria van der 1790-1846
Born in Louvain in 1790, he died in Ghent on October 8, 1846. He studied under Jacquin in Brussels and later under David (painting) and Rude (sculpture) in Paris. He became Director of the Ghent Academy of Fine Arts and worked as a painter, designer, engraver and sculptor of genre figures and bas-reliefs.

HAERTEL, Carl August Robert 1831-1894
Born in Weimar in 1831, he died in Breslau in 1894. He worked in Dresden and Breslau and specialised in high-reliefs, such as his epic triptych on the Life of Hermann (Arminius) who decisively defeated the Roman legions at the battle of the Teutoburger Wald.

HAESE, Oscar François d' 1870-
Born in Ghent on July 8, 1870, he worked in Paris at the turn of the century and exhibited genre statuettes at the Salon des Artistes Français.

HAESELER, Adeline von fl. early 20th century
Born in Boulogne of German parents, she studied in Paris under Gauquié. She exhibited statuettes at the Salon des Artistes Français and the Indépendants in the inter-war years.

HAFNER, Charles Andrew 1888-
Born in Omaha on October 28, 1888, he studied at the Art Students' League, New York and specialised in theatrical décor. He also sculpted a number of allegorical groups of which the best known is The Golden Age.

HAGBOLT, T. 1773-1849
Born in London in 1773, he died there in 1849. He exhibited at the Royal Academy from 1826 to 1833 and specialised in portrait reliefs and busts in wax and bronze. His statuette of Caroline Gordon is in the Victoria and Albert Museum, and his bust of James Rennell (1830) is in Westminster Abbey. Other portraits by him include those of Lady Cust (1826), John Sullivan (1830) and William Tassie (1833).

HAGEMANN, C. Friedrich 1773-1806
Born in Berlin in 1773, he died there in 1806. He studied under Schadow and worked in Rome for several years. He was a member of the Berlin Academy and specialised in portrait busts of his contemporaries.

HAGEN, Hugo c.1818-1871
Born in Berlin in 1818 or 1820, he died there on April 14, 1871. He studied under Wichmann in Berlin and was Rauch's assistant about 1840, finishing his works after his master's death. He produced a number of monuments in Berlin and Leipzig including a bronze figure of the Count of Brandenburg, but he worked mainly in marble and plaster.

HAGENAUER, Johann Baptist 1732-1810
Born in Strass, Bavaria on June 22, 1732, he died in Vienna on September 9, 1810. He studied at the academies of Vienna, Rome and Florence and began exhibiting in Salzburg. He worked mainly in marble or wood and sculpted friezes, bas-reliefs and decoration for many of the public buildings all over Austria. He also sculpted garden statuary in bronze or lead and his work may be seen in the Nymphenburg Park. Many of his minor works, including portrait busts and models for his larger monuments, are in the museums of Salzburg and Vienna. The Museum of the History of Art, Vienna has his lead figures and groups, such as Prometheus Enchained and Pieta with Mary Magdalene and St. Peter.

HAGER, Charles fl. 19th-20th centuries
Animalier sculptor working in Brussels at the turn of the century. He exhibited figures and groups at the Brussels Triennale and the World Fair of 1910.

HAHN, Hermann 1868-1942
Born at Kloster Weilsdorf, Thuringia on November 28, 1868, he died in Munich in 1942. He studied at the School of Arts and Crafts and later the Academy in Munich under Rümann and after travelling widely all over western Europe settled in Munich at the end of the last century. He did a number of monuments of historic personalities, such as Goethe (Chicago), Liszt (Weimar) and von Moltke (Chemnitz – now Karl Marx Stadt) and numerous busts of 19th century Germans, many of these works being preserved in the museums of Hamburg and Munich. He worked in Paris for a time and was an Associate of the Société Nationale des Beaux Arts and won a silver medal at the Exposition of 1900. Later he specialised in architectural sculpture and is best remembered for his Charioteer (1928-31) in front of the Munich Technical High School.

HAHN, Nancy Coonsman 1892-
Born in St. Louis, Missouri on August 28, 1892, she was a prolific sculptress of busts, portrait reliefs and memorials in the United States before the second world war.

HÄHNEL, Ernst Julius 1811-1891
Born in Dresden on March 9, 1811, he died there on May 22, 1891. He studied architecture in Dresden and then went to Munich about 1830, but returned to his native city to study sculpture. He was appointed professor of modelling at the Dresden Academy in 1849. He specialised in classical and mythological groups and portrait busts of historic and contemporary personalities. He lived in London for a time and exhibited at the Royal Academy from 1854 to 1881. He was one of the most important and influential of the Dresden school of sculptors in the 19th century and his works may be found in the museums of Basle, Berlin, Leipzig, Munich, Vienna and Weimar as well as Dresden.

HÄHNEL, Ernst Moritz Xaver 1846-1868
Born in Dresden on March 1, 1846, he died in Davos, Switzerland on December 18, 1868. He was the son and pupil of Ernst Julius Hähnel and produced a number of relief portraits and tableaux before his untimely death.

HÄHNEL, Julius Heinrich 1823-1909
The younger brother of Ernst Julius Hähnel, he was born in Dresden on December 21, 1823, and died there in 1909. He specialised in statuettes and small groups of animal subjects. Nine of his animal bronzes are in the Arts and Crafts Collection in Dresden and others are preserved in the Albertinum. Many of his works bear the signature 'J. Haehnel'.

HAID, Josef Anton 1801-1860
Born at Taufers in Vintschgau in 1801, he died at St. Johann, Tyrol in 1860. He worked as an ecclesiastical sculptor, mainly in stone and plaster, for churches in the Tyrol. His statuettes and bas-reliefs are also preserved in the Ferdinandeum in Innsbruck.

HAINGLAISE, Jean Fleury fl. late 19th century
Born at Toulon-sur-Arroux in the first half of the 19th century, he studied under Prauha and exhibited figures and portraits at the Salon from 1866. He won a third class medal in 1883 and became an Associate of the Artistes Français ten years later.

HAJDU, Stefan (Etienne) 1907-
Born in Turda, Romania in 1907, of Hungarian descent, he studied art in Bucharest, Vienna and Paris, attending classes at the École des Arts Décoratifs under Niclausse and the Académie de la Grande Chaumière under Bourdelle. He became a naturalised Frenchman in 1930. After a brief spell in the army during the 'phoney' war he moved to the Pyrenees where he worked as a marble-mason. After the war, however, he turned from direct carving in marble to bas-reliefs in plaster, and from there graduated to abstracts in bronze, lead, hammered copper and aluminium. Since then he has emerged as one of the most original sculptors at work in France today. He has exhibited at the Salon de Mai, the Salon de la Jeune Sculpture and galleries in Paris, New York, Basle and Berne.
Ganzo, Robert *Hajdu* (1958).

HAJEK, Otto Herbert 1927-
Born at Kaltenbach, Czechoslovakia in 1927, he studied at the Stuttgart Academy after the second world war and continued his studies in Paris, London and Rome, before settling in Stuttgart. He specialised in ecclesiastical sculpture but more recently has been experimenting with *Raumknoten* (spatial nexus abstracts). His bronzes are characterised by the deliberately roughened texture of the surface, contrasting with polished areas.

HAKOWSKI, Jozef Naticz 1834-1897
Born in Warsaw in 1834, he died in Koscienko in 1897. He studied at the Warsaw School of Fine Arts and later worked in Cracow where he specialised in marble, bronze and silver busts and bas-reliefs of his contemporaries. The principal collection of his work is in the Cracow Museum.

HALASZ, Läszlö c.1820-1882
Born in 1820, he died in Budapest in 1882. He worked in Szekesfehervar and Debreczen and came to Budapest in 1864 where he worked on the decoration of churches and public buildings, particularly the Academy of Sciences. He also did some sculptural work for the Serbian government. His minor works include a number of genre bronzes, such as Blind Beggar and his Daughter.

HALASZ-HRADIL, Rezsö 1875-1918
Born in Miskolcz on August 22, 1875, he died in Rome on July 20, 1918. He studied in Miskolcz, Munich and Paris and exhibited genre figures and busts in Miskolcz and Budapest at the turn of the century.

HALBIG, Andreas 1807-1869
Born at Donnersdorf, Franconia on April 24, 1807, he died in Penzing, near Vienna, on May 3, 1869. He studied under K. Eberhard at the Munich Academy and worked mainly on the decoration of churches in Franconia and the Cathedral of Bamberg. He moved to Vienna in 1857 and subsequently produced bas-reliefs and statuary for churches there and also in Olmutz and Budapest.

HALBIG, Johann von 1814-1882
Born at Donnersdorf in 1814, he died in Munich in 1882. He was one of the leading exponents of classicism in the 19th century, following in the footsteps of Canova and reacting against the romanticists led by Schwanthaler. His works include Nymphs entering a Bath, Emancipation (New York), the Passion (Oberammergaù) and numerous masks, busts and bas-reliefs portraying Russian and Austrian royalty and celebrities.

HALBREITER, Adolph 1839-1898
Born in Rosenheim on May 13, 1839, he died in Munich on June 28, 1898. He studied at the School of Arts and Crafts in Munich and later at the Academy before going to Paris where he worked in the studio of the Fannière Brothers and also with the goldsmith and jeweller Cristophle. He founded a workshop in Munich in 1871, specialising in bijouterie and presentation pieces. Most of his figures and groups were executed in silvered bronze, silver or silver-gilt.

HALE, Mary Powell 1862-
Born at Kingston, New York on April 12, 1862, she enrolled at the classes of the Art Students' League and became a member of the American Federation of Artists. She worked in New York as a painter and sculptor of genre subjects.

HALE, Owen fl. late 19th century
He worked in London in the late 19th century and exhibited figures at the Royal Academy in 1884. He was also an Associate of the Society of British Artists.

HALEPAS, Ioannis fl. 20th century
Sculptor of genre figures working in Athens in the first half of this century. He sculpted female nudes and statuettes such as Girl Sleeping.

HALÉVY, Leonie d. 1884
Born in Paris about 1850, she died at St. Germain-en-Laye on July 16, 1884. She studied under Frémiet and exhibited busts and statuettes of actors, actresses and contemporary celebrities at the Salon from 1877 till her death.

HALKIN, Jules 1830-1888
Born in Liège in 1830, he died there in 1888. He specialised in heads and busts of his contemporaries. Many of his works are in the Liège Museum.

HALL, Thomas Victor 1879-
Born in Indiana on May 30, 1879, he studied at the Cincinnati Academy and was a member of the Salmagundi Club.

HALLAGER, Jacob fl. 19th century
Born in Copenhagen on April 30, 1822, he studied at the Academy and took part in the annual Copenhagen art exhibitions from 1844 to 1853. He sculpted classical and allegorical figures in the style of Thorwaldsen, mainly in marble.

HALLAIS, Georges fl. early 20th century
Born in Paris in the late 19th century, he exhibited figures and reliefs at the Nationale before the first world war.

HALLBERG, Samuel Friedrich Ivanovich 1787-1839
Born in Haljal, Sweden in 1787, he died in St. Petersburg on October 22, 1839. He studied at the St. Petersburg Academy and also travelled widely, working in Berlin, Dresden, Vienna, Venice and Rome (where he was strongly influenced by Canova and Thorvaldsen). He sculpted various monuments in Novgorod and St. Petersburg (Leningrad) and also executed numerous portrait busts of early 19th century Russian celebrities, many of them being cast in bronze.

HALLE, Elinor fl. 19th-20th centuries
English sculptress of medallions and bas-reliefs, working at the turn of the century. She studied under Legros and exhibited at the Grosvenor Gallery, making her début in 1884 with a bas-relief of Music. Two years later she showed a relief portrait of Cardinal Newman at the Royal Academy. She exhibited at the Salon de la Société Nationale des Beaux Arts, Paris from 1898 to 1905 and also at the Society of Medallists.

HALLER, Hermann 1880-1950
Born in Berne on December 24, 1880, he died in Zürich in 1950. He studied architecture and painting in Munich, Rome and Stuttgart and took part in the Great Exhibition, Dresden in 1904. The following year he went to Rome where he took up sculpture and then lived in Paris from 1907 till 1914 when he returned to Switzerland and settled in Zürich. He exhibited at the Paris salons from 1909 to 1915 and the Mannheim International Exhibition in 1907. After the first world war he exhibited internationally, winning the gold medal of the Florence Academy at the Venice Biennale of 1934 and the year before he died Zürich awarded him its Grand Prix. He specialised in figures of young girls and heads and busts, in stone, pottery, cement and bronze. His best known works are Warrior throwing Stones (a bas-relief from the Morgarten battle memorial) and the bronze figure Enchained.

HALLER, Johann Nepomuk 1792-1826
Born in Innsbruck on March 1, 1792, he died in Munich on July 23, 1826. He studied at Innsbruck and then Munich and was sent to Rome by King Maximilian Joseph of Bavaria. He sculpted numerous statues and monuments for Crown Prince Ludwig at the Glyptothek and classical figures for Nymphenburg Park. His minor works include historical statuettes and busts of his contemporaries.

HALLEUX, Jean Joseph 1817-1876
Born at Battice, Belgium in 1817, he died at Dinant in 1876. He studied at Liège School of Fine Arts and specialised in genre, classical and biblical statuettes, such as Genie and Cain.

HALLGASS, Matyas fl. 19th century
Born near Budapest in 1827, he worked in that city and specialised in classical busts and statuary, such as Plato (1843) and Action of Graces (1844).

HALNON, Frederick James 1881-1958
Born in London on March 8, 1881, he died there on March 12, 1958. He studied at the Goldsmiths' College School of Art under Alfred Drury and exhibited at the Royal Academy from 1904 onwards. He was elected F.R.B.S. in 1906. He worked in London as a sculptor of neo-classical and genre figures, such as Mother and Child, The Laurels of Youth, Perseus and Bacchante.

HALONEN, Émile 1875-
Born in Finland in 1875, he studied in Helsinki and Paris. He worked in wood, marble and bronze and his figures, groups and bas-reliefs were inspired by the Finnish people, their history and folklore.

HALOU, Alfred Jean 1875-1939
Born at Blois on June 20, 1875, he died in Paris in 1939. He studied under Rodin and was a founder member of the Salon d'Automne, though he also exhibited at the other Paris Salons. One of the great French sculptors of the early 20th century, he produced a number of monuments and memorials to the Franco-Prussian war of 1870-71, but specialised in female statuettes. The principal collections of his work are in Blois Museum and the Museum of Modern Art, Paris.

HALOU, Alfred Jean Baptiste fl. 19th century
Born at Blois on March 23, 1829, he studied under Husson and Duret and attended the École des Beaux Arts in 1847-50. He exhibited at the Salon from 1853 and specialised in portrait busts, bas-reliefs and medallions of historical and contemporary figures.

HALSE, Emmeline c.1850-1930
She worked at Chalfont St. Giles, Buckinghamshire and studied at the Royal Academy schools and the École des Beaux Arts, Paris. She exhibited at the Royal Academy from 1878 onwards and specialised in classical figures and bas-reliefs. Her high-relief of The Pleiades is in the Glasgow Art Gallery and Museum.

HALTIO, Kaarlo 1863-
Born in Finland in 1863, he sculpted statuary and figurines in marble, bronze and plaster. He got an honourable mention at the Exposition Universelle of 1889.

HAMARD, Georges 1874-
Born at Villévêque, France, on March 9, 1874, he studied under Injalbert and exhibited statuettes at the Paris salons in the 1920s.

HAMBRESIN, Albrecht fl. 19th-20th centuries
Born at Willebraeck, Belgium in 1850, he worked in Brussels and specialised in genre figures and groups, such as The Bough (Antwerp Museum) and The Night Watchman (Simu Museum, Bucharest).

HAMILTON, Lilian V. (née Swainson) 1865-
Born in Mitcham, Surrey on July 9, 1865, she studied at the Slade School of Art in 1884 and married the painter Vereker M. Hamilton. She exhibited figures, bas-reliefs and medallions at the Royal Academy and the Salon des Artistes Français and worked in Cowden, Kent.

HAMLET, T. fl. early 19th century
Author of a small bronze bust of the Duke of Sussex, dated 1826, at Ombersley Court, Warwickshire.

HAMM, Henri 1871-
Born in Bordeaux in 1871, he studied at the local School of Fine Arts and worked in the studio of Magnesi. At the turn of the century, he founded the Société d'Art Moderne in Bordeaux and exhibited at the Exposition Universelle of 1900. He settled in Paris in 1902 and was a founder member of the Salon d'Automne. He was strongly influenced by Cezanne and Gauguin and was in the forefront of the Cubist movement. He taught in various Parisian art schools from 1918 and was appointed to the School of Applied Arts in 1925. He was on the committee of the Exposition Internationale of 1937. He worked in a wide variety of media, from glass, silver, ivory and horn to clay, plaster and bronze. Since the second world war, he exhibited at the Salon des Réalités Nouvelles and, at the age of 82, participated in the Salon de la Jeune Sculpture. Despite his advanced years, Hamm was one of the more avant-garde sculptors working in the 1950s.

HAMMAR, Carl Elias 1853-
Born at Karlskrona, Sweden on March 12, 1853, he exhibited in Stockholm and Paris at the turn of the century, and produced portrait busts and statuettes.

HAMMELEFF, Frederik Uncas Andreas 1847-1916
Born in Copenhagen on November 9, 1847, he died there on March 16, 1916. He studied at the Copenhagen Academy and exhibited there from 1868. He specialised in decorative sculpture and his architectural works may be seen in New York, the Carlsberg Glyptothek and various Copenhagen churches. He sculpted the series of ten medallions on the face of the Copenhagen Museum of Fine Arts. He also produced numerous portrait busts and genre groups. His Boar Hunt is in the National Museum, Frederiksborg.

HAMMER, Trygve 1878-
Born in the United States on September 6, 1878 of Norwegian descent, he studied under A.S. Calder and worked as a decorative and portrait sculptor in New York at the turn of the century.

HAMMERAN, Philipp Johann 1825-1876
Born in Frankfurt on October 3, 1825, he died there on March 2, 1876. He studied at the Städel Institute in Frankfurt and specialised in statuary and bas-reliefs for churches and public buildings. His minor works included numerous busts of historic and contemporary personalities in the arts. He is best known for the numerous statuettes of people in period costume, reproduced by the Zimmermann galvanoplastic studios in Hanau and Frankfurt.

HAMMERSCHMIDT, Joseph 1873-
Born in Münster on May 3, 1873, he studied at Düsseldorf Academy and was a pupil of Janssen with whom he worked on decorative sculpture for Düsseldorf. He produced a large number of monuments, fountains, portrait busts, bas-reliefs and genre statuettes.

HAMMOND, Jane Nye 1857-1901
Born in New York on March 3, 1857, she died in Providence, Rhode Island on October 23, 1901. She studied under Injalbert and Bartlett in Paris and specialised in portrait busts. She took part in the Chicago Columbian Exposition (1893) and the Pan-American Exposition, Buffalo (1901).

HAMPTON, Herbert 1862-1929
Born at Hoddesdon on August 31, 1862, he died in London on February 11, 1929. He studied at the Lambeth, Westminster and Slade schools of art and the Julian and Cormon academies in Paris and exhibited at the main galleries in London from 1886, particularly the Royal Academy. He specialised in genre and classical figures, such as Orpheus and The Broken Bow.

HANAK, Anton 1875-1934
Born in Brünn (Brno) on March 22, 1875, he died in Vienna in 1934. He studied at the Vienna Academy and exhibited figures and busts in Vienna, Munich, Düsseldorf and Berlin. He was a close friend of Josef Hoffmann and a member of the Vienna Secession in 1911. He taught sculpture at the School of Decorative Arts, Vienna from 1924 and latterly at the Vienna Academy. His works fall into the transitional period between the classical conventions of the 19th century and the modern sculpture of the period after the first world war. His works include Creator and Transfiguration (both 1914) Sphinx (Wiener Staatsgalerie), The Future (Muchner Neue Staatsgalerie), Great Grief (1917) and Burning Man (1922).

HANCOCK, John 1825-1869
Born in London in 1825, he died there on October 17, 1869. He was largely self-taught, though he did attend classes at the Royal Academy in 1842. He exhibited at the Royal Academy from 1843 to 1864 and specialised in classical, biblical and medieval subjects. At the Great Exhibition of 1851 he showed a plaster figure of Beatrice, later sculpted in marble for Baroness Burdett Coutts. His bronzes include Prodigal Son, Chaucer, Ariel released from the Tree (1858), Entry into Jerusalem (relief commissioned by the Art Union), The Crucifixion (1853) and various busts and portrait medallions of his artistic contemporaries.

HANCOCK, Walker 1901-
Born in St. Louis, Missouri on June 28, 1901, he studied at the St. Louis School of Fine Arts under Victor Holm and the Pennsylvania Academy. He won the Prix de Rome in 1925 and also the Widener prize and gold medal of the Pennsylvania Academy. He is a member of the Pennsylvania Academy, the National Sculpture Society and the Arts Club of Philadelphia. His speciality is garden statuary, fountain ornaments and allegorical statuettes. The main collection of his work is in the Academy of Fine Arts, Philadelphia.

HÄNDLER, Anton Theodor 1830-1878
Born at Freiburg-am-Breisgau on May 16, 1830 he died in Chemnitz on November 24, 1878. He studied at the Dresden Academy and worked under E. Rietschel on the decoration of the new Dresden Museum. Later he settled in Chemnitz and did statues and bas-reliefs for churches in that area. He also produced portrait medallions, reliefs and statuettes of contemporary German celebrities.

HANDLEY, F. Montague fl. late 19th century
He studied in Rome from 1873 to 1880 and subsequently exhibited statuettes and reliefs at the Royal Academy.

HANNAUX, Emmanuel fl. 19th-20th centuries
Born in Metz on January 31, 1855, he studied in Paris under A. Dumont, Thomas and Bonnassieux. He was runner-up in the Prix de Rome of 1880 and made his début at the Salon in 1878 and became an Associate of the Artistes Français in 1884. He won third class (1884), second class (1889) and first class (1894) medals and major awards at the Exposition of 1900. He was made a Chevalier of the Legion of Honour that year and won the medal of honour at the Salon of 1903. He specialised in busts, classical figures and allegorical groups, such as Dying Orpheus, The Poet and The Siren and Flowers of Sleep.

HANNIG, Robert 1866-
Born in Liegnitz, Saxony, on July 7, 1866, he studied at the academies of Dresden and Berlin and exhibited genre figures and busts at the Great Berlin Exhibitions from 1894 to 1913.

HANNOT, M. fl. 19th century
Sculptor of historic and contemporary figures, in terra cotta and bronze, working in Alsace-Lorraine in the first half of the 19th century. The Museum of Metz has his statuette of Bonaparte on the Bridge of Arcoli.

HANNOTIN, Simone 1906-
Born in Paris on March 19, 1906, she studied under Allouard and exhibited statuettes at the Salon des Artistes Français and the Indépendants.

HÄNNY, Karl 1879-
Born at Twaun, Switzerland in 1879, he studied at Biel School of Arts and Crafts and worked for a time in Munich and Vienna before

settling in Berne. He taught at the School of Arts and Crafts and went to Paris in 1903. He exhibited figures and groups at the salons of Lausanne, Berne and Paris in the early 1900s.

HANSEN, Aksel Christian Henrik fl. late 19th century
Born in Odense, Denmark on September 2, 1853, he studied at Copenhagen and exhibited there and at the Exposition Universelle of 1900. He specialised in portrait busts of his contemporaries as well as genre figures and biblical groups, such as The Mocking of Christ (Copenhagen Museum).

HANSEN, Alfred 1875-1902
Born in Flensburg on May 31, 1875, he died there on September 17, 1902. He specialised in portrait busts, bas-reliefs and plaques.

HANSEN, Hans 1821-1858
Born in Oslo in 1821, he died there in 1858. He specialised in portrait busts of Scandinavian royalty and celebrities and his works are in the museums of Oslo, Copenhagen and Stockholm.

HANSEN-JACOBSEN, Niels 1861-
Born at Vegen, Denmark in 1861, he studied in Aarhus and Copenhagen and also for a time in Paris in the 1890s. He produced genre figures, such as A Shade, The Mother's Death, and Baccia-player and groups based on Scandinavian folklore, such as Loki Enchained. He also sculpted numerous portraits of his contemporaries.

HANSEN-REISTRUP, Karl Frederik Christian 1863-
Born in Valby, near Copenhagen on April 22, 1863, he studied under Chapu at the Académie Julian in Paris (1885) and became a modeller and painter at the Royal Copenhagen Porcelain Manufactory. He made his début as a sculptor at the Copenhagen Exhibition of 1889 with a group of Lions. He specialised in historic tableaux, mainly rendered in pottery and porcelain. The main collections of his work are in the Sèvres Museum and the Swedish National Museum, Stockholm.

HAPPENBURGER, Frank 1859-
Born in San Francisco on October 21, 1859, he studied at the Munich Academy and worked for some time in Bavaria before returning to San Francisco. He exhibited at the Society of Artists from 1882 onwards. His best known works are the memorial to President Garfield in San Francisco and the California Monument in the same city. His minor works include genre and romantic figures such as The Archer.

HARBOE, Rasmus Gunnerson 1868-
Born at Skelsor, Denmark on October 25, 1868, he worked in Copenhagen and Paris at the turn of the century. He specialised in genre figures, such as Young Boy playing the Flute. Copenhagen Museum has his group of Combat of Jacob and the Angel.

HARBOE, Rolf 1860-
Born in Nyborg, Denmark in 1860, he studied at the Copenhagen Academy and specialised in classical statuettes in coloured marble and bronze.

HARDENBERG, B.F. fl. early 19th century
Sculptor of German origin, working in London from 1800 to 1823. He specialised in portrait busts of classical and contemporary personalities, such as Marshal Blücher (1817), Princess Charlotte (1818), Lord Ellenborough (1820), General Morgan (1821) and the second Earl of Liverpool. He also sculpted a series of portraits of the Roman emperors Nero, Vespasian and Claudius. His bronze statuette of the Duke of Wellington is at Stratfield Saye. He had a studio in Mount Street, London and was in partnership with P. Nicoli in the latter part of his career.

HARDIMAN, Alfred Frank 1891-1949
Born in London on May 21, 1891, he died there on April 17, 1949. He studied at the Royal College of Art under Lanteri from 1912 to 1916 and later at the Royal Academy schools and the British School in Rome. He exhibited at the Royal Academy and was elected A.R.A. in 1936 and R.A. in 1944. He won the R.B.S. medal in 1939. He specialised in memorial tablets and bas-reliefs, the best known being that to Earl Haig in Whitehall. He worked at Stoke Poges in Buckinghamshire.

HARDIN, Adlai fl. 20th century
American sculptor working before the second world war. His bronzes include Good Samaritan.

HARDING, George Frederick Morris 1874-1964
Born in Stevenage, Herts. in 1874 he died at Holywood, Co. Down in 1964. He studied art under his uncle Harry Bates and later also under J. Macallan Swan and Herbert Hampton. After war service (during which he was severely wounded at Ypres, 1917), he became a member of the Society of Animal Painters. He sculpted animal figures and groups.

HÄRDTL, Hugo 1846-1918
Born in Vienna on November 22, 1846, he died there on February 16, 1918. He studied under F.V. Melnitzky at the Vienna Academy and finished his works for him after his death. He specialised in decorative sculpture of Viennese public buildings and also produced a large number of portrait busts.

HARE, David 1917-
Born in New York in 1917, he studied in New York, Arizona, Colorado and California and worked as a biologist, chemist and colour photographer from 1938 to 1943. He turned to sculpture in 1944, using a blow-lamp technique in forming metal figures. Later he turned to modelling and uses the *cire perdue* technique of bronze casting. He worked as a magazine illustrator during the war but gradually sculpture became more important. He has had numerous one-man shows in New York since 1944, mainly at the Kootz Gallery. He took part in the 'Fourteen Americans' exhibition at the Museum of Modern Art, New York in 1946 as well as in the 'New Decade' exhibition at the Whitney Museum, 1955. He is also a prolific writer on the subject of art and has published many articles on the subject in America and France. He spends much of his time in Paris where he belongs to the Surrealist movement. His works have been described as eccentric abstracts and are cast in bronze or lead.

HAREL, Armand Pierre fl. 19th century
Born at Fourgères in the mid-19th century, he died in Paris in 1885. He studied under Perraud and Carpeaux and exhibited at the Salon from 1872 to 1885. He specialised in portrait busts, many of them in marble.

HAREL, Edmond fl. late 19th century
Born at Nantes on May 13, 1854, he studied under Ménard and exhibited figures in Nantes and Rennes.

HAREL, Louis 1831-
Born in Paris on June 17, 1831, he exhibited figures and portraits at the Salon from 1852 onwards.

HARKAVY, Minna fl. 20th century
Born in Estonia at the turn of the century, she emigrated to the United States and was a pupil of the Art Students' League of New York. Later she studied under Bourdelle in Paris. She exhibited in Russia, France and the United States and specialised in busts of French and American personalities of the inter-war period.

HARLEY, Charles Richard 1864-
Born in Philadelphia on March 25, 1864, he studied in Philadelphia and was a pupil of Chapu, Falguière and Dampt in Paris. He was awarded a bronze medal for his allegorical figures and groups at the Pan-American Exposition, Buffalo in 1901.

HARNISCH, Albert E. fl. 19th century
Born in Philadelphia, he studied under Joseph Bailly and spent eight years in Rome before returning to Philadelphia. He sculpted numerous memorials and monuments, such as that to General Robert E. Lee at Richmond, and his minor works include many statuettes and portrait busts.

HARPER, J.R. fl. late 19th century
Sculptor of figures and portrait busts, working in London. He exhibited at the Royal Academy from 1877.

HARRISON, Thomas Erat fl. 19th-20th centuries
He worked in London as a painter and engraver. Though best known for engraving the dies of postage stamps, banknotes and security documents, he also sculpted portrait busts and reliefs and exhibited at the Royal Academy from 1875 onwards.

HARRISSON, Henry C. fl. late 19th century
He worked in London in the late 19th century, specialising in genre figures and portrait reliefs and busts.

HART, Joel T. 1810-1877
Born at Clark City, Kentucky on February 10, 1810, he died in Florence on March 2, 1877. He was originally apprenticed to a stone mason, but began modelling in clay as a pastime. After completing his apprenticeship he tried watercolours and drawing but later turned seriously to sculpture. He went to Italy and settled in Florence where he studied the great masters of the Renaissance. He produced numerous busts and statues in marble and bronze. He continued to work as a watercolourist and was also a poet of some note.

HARTLEY, Jonathan Scott 1845-c.1910
Born in Albany, New York on September 23, 1845, he died in New York City about 1910. He studied under E.D. Palmer and completed his studies in London at the Royal Academy schools, and also in Germany, Paris and Rome. He settled in New York City and was a founder member of the Salmagundi Club. He exhibited at the Royal Academy in 1884 and won a silver medal five years later. He was awarded a bronze medal at the Buffalo Exposition of 1901 and became a member of the National Academy in the same year.

HARTMANN, Lucy fl. 20th century
She worked in Paris in the first half of this century as a painter and sculptor of genre subjects and exhibited at the Salon de la Société Nationale.

HARTUNG, Hans Heinrich Ernst 1904-
Born in Leipzig on September 21, 1904, he studied at the academies of Leipzig, Dresden and Munich from 1924 to 1928. He moved to Paris in 1935 and became a naturalised Frenchman. He exhibited at the Salon des Surindépendants in 1936-38 and in 1945 and has also exhibited in Oslo, Dresden, Berlin and London since the war. He abandoned figurative art in 1922 and has produced abstracts ever since, which he exhibits at the Salon des Réalités Nouvelles and the Salon de Mai. He also works as a painter and engraver.

HARTUNG, Johann fl. mid-19th century
Born at Coblenz in the early 19th century, he studied under Rude in Paris and worked there for several years as an ecclesiastical sculptor before settling in Berlin in 1850.

HARTUNG, Karl 1908-
Born in Hamburg on May 2, 1908, he served his apprenticeship as a wood-carver (1923-25) and studied at the Hamburg School of Fine Arts (1925-29). Later he worked in Paris (1929-32) and was influenced by Maillol and Despiau; then Florence (1932-33) and Hamburg (1933-36), eventually settling in Berlin. He was appointed professor at the Berlin School of Fine Arts in 1951. He produced his first abstracts in 1933 and has since participated in many major national and international exhibitions. He now lives in Berlin-Wilmersdorf and works in marble, granite, wood and polished bronze. His bronzes include Monument (1955) and Koré (1953).

HARTVIG, Berendt Jakob 1824-1892
Born in Copenhagen on June 8, 1824, he died there on March 26, 1892. He studied under H.V. Bissen and sculpted neo-classical and genre figures.

HARTWELL, Charles Leonard 1873-1951
Born in Blackheath, London on August 1, 1873, he died at Aldwick Bay, Sussex on January 12, 1951. He studied at the City and Guilds School, Kennington (where he was awarded the silver medal for sculpture) and the Royal Academy schools from 1896, winning bronze and silver medals. He was also a pupil of Onslow Ford and Hamo Thornycroft. He exhibited at the Royal Academy from 1900, becoming A.R.A. in 1915 and R.A. in 1924. His bronze figure The Goatherd's Daughter won him the R.B.S. silver medal in 1929. He specialised in genre bronzes, such as Bathers and The Chorister.

HARTZER, Ferdinand 1838-1906
Born in Celle, Hanover on June 22, 1838, he died in Berlin on October 27, 1906. He studied under Widnmann in Munich and Hähnel in Dresden and worked for a time in Italy before settling in Berlin. He specialised in busts, statuettes and memorials.

HARVEY, Eli 1860-1957
Born in Ogden, Ohio on September 23, 1860, he died in 1957. He studied drawing, painting and sculpture at the Cincinnati Academy of Fine Arts under Noble, Lentz and Rebisso. He went to Paris in 1889 and studied painting at the Académie Julian under Constant, Lefebvre and Doucet and was a pupil of Frémiet at the Jardin des Plantes where he learned to model animal figures. He exhibited in many American shows, and was awarded a bronze medal at the Pan-American Exposition of 1901. He was a member of the American Federation of Arts. His animalier sculpture includes Young Gorilla, Dinah, and Greyhound. His works are known in bronze and bronzed plaster.

HARZÉ Leopold 1831-1893
Born in Liège on July 29, 1831, he died there on November 20, 1893. He specialised in genre and allegorical figures, in bronze and terra cotta. Several of his works are in the Liège Museum.

HASELTINE, Henry James fl. 19th century
Born in Philadelphia in the early 19th century, he served in the Union Army during the civil war, after which he went to Italy and settled in Rome in 1867. He worked there as a sculptor of classical and genre figures for many years, and exhibited at the Centennial Exposition, Philadelphia in 1876.

HASELTINE, Herbert 1877-1962
Born in Rome on April 10, 1877, the son and pupil of Henry James Haseltine, he studied at the Munich Academy, the Collegio Romano, Harvard University and the École des Beaux Arts, Paris. He exhibited at the Salon des Artistes Français and the Royal Academy, as well as the great international exhibitions in Vienna, Venice, Rome, Brussels and Ghent. Over a period of fifty years he sculpted domestic animals, mainly horses, cattle, pigs and sheep and ranged from equestrian statuettes to colossal monuments. Many of his works depicted famous race-horses. During the first world war he served as a camouflage officer with the American Army and later sculpted war horses and pack ponies as well as equestrian statuettes of famous generals. After the first world war he specialised in figures of champion cattle, pigs and sheep. He also worked in India and carried out numerous commissions from Indian princes. Many of his equestrian monuments were later published as bronze reductions. Apart from his figures and groups he also sculpted horses' heads, including sumptuous portraits of the horses Indra and Lakshmi richly ornamented with gold and precious stones. Haseltine's animal sculptures are to be found in the Tate Gallery, Victoria and Albert Museum and Imperial War Museum (London), the Smithsonian Institution (Washington) and the Metropolitan Museum of Art (New York).

HASEMANN, Arminius 1888-
Born in Berlin on September 6, 1888, he worked in Karlsruhe and spent many years in Italy and Spain where he produced allegorical and religious figures and groups.

HASENFRATZ, Amilcar (pseudonym of F.A. Bartholdi, q.v.)

HASENOHR, Hermann fl. late 19th century
Born in Zwickau on January 7, 1855, he studied at the Dresden Academy and worked in that city on ecclesiastical sculpture.

HASEROTH, Max fl. late 19th century
Sculptor working in Berlin on bas-reliefs and portrait medallions.

HASSELBERG, Karl Peter 1850-1894
Born at Hasselstadt, Sweden on January 1, 1850, he died in Stockholm on July 27, 1894. He specialised in allegorical statuettes and groups, as well as portrait busts of his contemporaries. He exhibited at the Paris Salon in 1881-83, winning a third class medal.

HASSELBLATT, Adolf 1823-1896
Born at Roethel, Estonia on June 19, 1823, he died at Winnenden, Germany, on August 7, 1896. He worked in Italy and Germany as a sculptor of memorials and portrait reliefs.

HASSENPFLUG, Karl 1824-1890
Born in Cassel on January 5, 1824, he died there on February 18, 1890. He studied under Schaller in Munich and specialised in genre groups and portrait busts.

HASTINGS, William Granville c.1868-1902
Born in England about 1868, he died at Mount Vernon, U.S.A. on June 13, 1902. He studied in London and Paris from 1885, and

specialised in ceramic modelling. He went to the United States in 1891 where he specialised in commemorative statues and monuments in New Jersey and Cincinnati.

HASWELL, Ernest Bruce 1887-
Born in Kentucky in 1887, he studied at the Cincinnati Art Academy under Clement Barnhorn and the Académie Royale in Brussels under Paul Dubois and Victor Rousseau. He produced portraits and genre figures and animal and bird studies for fountains.

HAUSMANN, Hermann 1865-1907
Born in Hanau on June 10, 1865, he died at Bad Salzhausen in July, 1907. He was the son of the painter Friedrich Karl Hausmann and worked in Berlin where he specialised in historical statuettes and busts.

HAUTOT, Rachel Lucy 1882-
Born at Fermanville, U.S.A. on September 20, 1882, she studied in New York and Paris, under Marqueste. She exhibited figures and reliefs at the Salon des Artistes Français before the first world war.

HAUTTMAN, Anton 1821-1862
Born in Munich on June 20, 1821, he died in Florence on December 1, 1862. He was the son of Joseph Hauttman and studied under Schwanthaler at the Munich Academy.

See Hauttman Family Tree

HAUTTMAN, Carl Kaspar 1813-1905
Born in Munich on January 6, 1813, he died there on February 16, 1905. He was the son of Georg Michael Hauttman and taught at the Munich Academy.

HAUTTMAN, Dominikus 1738-1789
Born at Waldsassen about 1738, he died there on April 20, 1789. He specialised in ecclesiastical and ornamental sculpture.

HAUTTMAN, Georg Michael 1772-1868
Born at Waldsassen on October 24, 1772, he died in Munich on March 17, 1868. The son of Dominikus Hauttman, he worked on decorative sculpture in Munich.

HAUTTMAN, Georg Peter 1731-
Born at Waldsassen on May 19, 1731, he was the eldest son of Johann Michael Hauttman and worked with him on ecclesiastical sculpture.

HAUTTMAN, Heinrich 1770-1830
Born in Waldsassen on December 12, 1770, he died in Munich on May 30, 1830. He was the son of Dominikus Hauttman and worked on figures and bas-reliefs of religious subjects.

HAUTTMAN, Hippolyt Matthias 1802-1887
Born in Munich on February 21, 1802, he died there on July 23, 1887. He was the son of Georg Michael Hauttman and studied at the Munich Academy. He sculpted allegorical and historical figures.

HAUTTMAN, Johann Georg 1735-1814
Born in Waldsassen on August 4, 1735, he died there on April 20, 1814. The second son of Johann Michael Hauttman, he worked on ecclesiastical decoration in Waldsassen.

HAUTTMAN, Johann Nepomuk 1820-1903
Born in Munich on April 21, 1820, he died there on January 30, 1903. He studied under Schwanthaler and Eberhard at the Munich Academy and sculpted romantic figures and groups as well as portrait reliefs and busts.

HAUTTMAN, Joseph 1796-1878
Born in Waldsassen on September 11, 1796, he died in Munich on September 28, 1878. He was the son and pupil of Heinrich Hauttman.

HAUTTMAN, Philipp Jakob 1744-
Born in Waldsassen on July 20, 1744, he was the fourth son of Johann Michael Hauttman and worked on religious sculpture.

HAVELOOSE, Marnix d' 1882-
Genre sculptor working in Brussels in the early years of this century.

HAVERKAMP, Wilhelm 1864-
Born at Senden, Germany on March 4, 1864, he studied in Münster and worked as a genre and portrait sculptor in Berlin at the turn of the century.

HAVERMAET, Jan Frans van 1828-1899
Born at St. Nicholas, Belgium in 1828, he died there in 1899. He was a brother of the painter Piet Havermaet and studied at the Antwerp Academy. He specialised in portrait busts of his contemporaries.

HAVRANEK, Anton the Elder fl. 19th century
Born in Szekesfehervar, Hungary in the early 19th century, he worked in Germany, particularly the Munich area, as a sculptor of memorials, statues and allegorical figures.

HAVRANEK, Anton the Younger fl. late 19th century
Born in Hungary, the son of the above-named with whom he worked in Hungary and Bavaria.

HAWKS, Rachel Marshall 1879-
Born at Port Deposit, near Baltimore, Maryland, in 1879, she studied at the Rinehart School of Sculpture under Ephraim Keyser and Charles Pike. She specialised in bust and portrait bas-reliefs but also sculpted genre bronzes intended mainly for fountain decoration, such as Sixteen, The Secret, The Goldfish Girl and Bobbie's Smile.

HAYMAN, Laure fl. 19th-20th centuries
Chilean sculptor, born in Valparaiso, who settled in Paris and exhibited busts at the Salon d'Automne in the early 1900s.

HAYS, Austin 1869-1915
Born in New York in 1869, he died there on July 24, 1915. He studied under Mercié in Paris and produced genre and historical figures.

HAYWARD, A. fl. mid-19th century
Sculptor of genre figures working in London. He exhibited at the Royal Academy in 1857-59.

HEBER, Carl Augustus 1874-
Born in Stuttgart on April 5, 1874, he studied in Paris before emigrating to the United States. He continued his studies at the Chicago Arts Institute and was a member of the National Sculpture Society of New York. He had a high reputation for his monumental work and received numerous official commissions in the New York area.

HÉBERT, Henri fl. 20th century
Born in Montreal, Canada, he studied in Paris under Thomas and Injalbert and exhibited figures at the Salon des Artistes Français in 1907.

HÉBERT, Louis Georges fl. 19th century
Born in Caen on April 23, 1841, he studied at the Caen Municipal School and later worked under Lechesne. He exhibited portrait busts and medallions at the Salon from 1867 to 1880.

HÉBERT, Louis Philippe fl. 19th-20th centuries
Born at St. Sophie, Halifax, Canada on January 27, 1850, he settled in Paris where he worked as a decorative sculptor. He was awarded a bronze medal and a silver medal at the Expositions of 1889 and 1900 respectively and became a Chevalier of the Legion of Honour in 1901.

HÉBERT, Pierre 1804-1869
Born at Villabé, France on October 31, 1804, he died in Paris on September 15, 1869. He studied under Jacquet and exhibited at the Salon from 1839 to 1869. He specialised in genre and classical figures and busts, mainly in marble. His bronzes include portraits of Olivier de Senes, Parmentier, Vauquelin, Admiral Duperre and Comte de Gasparin.

HÉBERT, Pierre Eugène Émile 1828-1893
Born in Paris on October 12, 1828, he died there on October 20, 1893. He was the son and pupil of Pierre Hébert and worked in the studio of Feuchère. He exhibited genre and classical groups and bas-reliefs at the Salon from 1849.

HÉBERT, Théodore Martin 1829-1913
Born in Paris on July 29, 1829, he died there in 1913. He exhibited classical figures and groups at the Salon from 1848 to 1880. His group The God Pan instructing a Faun is in the Rochefort Museum.

HEBERT-STEVENS, Adeline fl. 20th century
Glass-painter and sculptor of religious subjects, working in Paris in the early years of this century.

HECHT, Friedrich August Richard 1865-1915
Born in Dresden on June 27, 1865, he died there on November 16, 1915. He studied at the Dresden Academy and spent some time in Rome before returning to his native city. He specialised in religious statuary and ecclesiastical ornament.

HEDLEY, Percival M.E. 1870-
Born in England, he worked in Vienna and later returned to London where he specialised in paintings and portrait sculpture of the British royal family.

HEDLINGER, Johann Karl 1691-1771
Born in Schwyz, Switzerland on March 28, 1691, he died there on March 14, 1771. He spent much of his life in Stockholm, where he was medallist and sculptor to the Swedish Court. He produced numerous portrait busts, medallions and bas-reliefs of Swedish celebrities of the 18th century, and many of them are preserved in the Stockholm Museum.

HEER, Adolf 1849-1898
Born at Vöhrenbach, Württemberg on September 13, 1849, he died in Karlsruhe on March 29, 1898. He travelled in Italy before settling in Karlsruhe and specialised in monuments and memorials in that city.

HEER, August 1867-1922
Born in Basle on June 7, 1867, he died at Arlesheim in March, 1922. He studied in Berlin from 1881 to 1891, apart from a year (1887) spent in Munich. He also worked with Falguière in Paris for a year before returning to Basle in 1892, but moved to Munich in 1901. He specialised in genre bronzes, such as My Grandfather (Basle Museum) and Farm Boy (Rath Museum, Geneva).

HEGENBART, Fritz 1864-
Born in Salzburg on September 15, 1864, he spent his youth in Prague and later settled in Munich. Though mainly known as a painter and engraver he also sculpted genre figures and portraits.

HEGENBARTH, Ernst 1867-
Born at Ulrichstal, Austria on March 5, 1867. He studied under Otto König and worked as a genre and portrait sculptor in Vienna.

HEGGELUND, Georg Andreas 1860-1916
Born at Lödingen on July 26, 1860, he died in Oslo on October 21, 1916. He studied in Berlin before settling in Christiania (Oslo) where he worked as a decorative sculptor.

HEIDA, Wilhelm 1868-
Born in Vienna on May 26, 1868, he studied under Lefebvre in Paris and exhibited figures and bas-reliefs in Vienna, Berlin, Dresden and Düsseldorf. He specialised in memorials.

HEIDEL, Edith Ogden fl. 20th century
Born in St. Paul, Minnesota, she worked in Minneapolis as a sculptor of figures and portraits and exhibited at the Washington Arts Club.

HEIDEL, Hermann 1810-1865
Born in Bonn on February 20, 1810, he died in Stuttgart on September 29, 1865. He studied under Schwanthaler and worked as an architect, designer and ornamental sculptor.

HEIDEPRIEM, Johannes fl. late 19th century
Born in Charlottenburg, he studied under Albert Wolff in Berlin and worked in that city as a sculptor of memorials and bas-reliefs in the late 19th century.

HEILIGER, Bernhard 1915-
Born in Stettin (now Szczeczyn, Poland) in 1915, he studied at the Stettin School of Arts and Crafts and then the Berlin Academy. He worked in Paris for some time, where he was influenced by Maillol and Despiau. He began exhibiting in Berlin after the second world war and has taught sculpture at the Charlottenburg School of Art since 1949. He won the Berlin Arts prize in 1950 and has taken part in major international exhibitions, such as the Venice Biennale (1956) and the Documenta exhibitions at Kassel (1955 and 1959). His work has gradually moved from the figurative towards the purely abstract, but he has also produced a number of portrait busts of contemporary German personalities. His bronzes include Seraphim (1953), Plant Figure (1955), Metamorphosis (1957), Two Related Figures (Darmstadt) and Ferryman (on the Neckar Bridge near Esslingen). His

portrait busts include those of the painter Hofer, the politican Ernst Reuter and the art historian Kurt Martin.

HEINEMANN, Fritz 1864-
Born in Altona on January 1, 1864, he studied in Nuremberg and settled in Dahlem near Berlin where he worked mainly in marble on bas-reliefs and allegorical figures.

HEISE, Josef 1885-
Born in Münster on February 3, 1885, he studied at the Cassel Academy and specialised in monuments and memorials in that area.

HEIZLER, Hippolyte 1828-1871
Born in Paris on April 19, 1828, he died there on October 20, 1871. He exhibited figures at the Salon from 1846 to 1871.

HELBIG, Friedrich Traugott 1859-1886
Born at Blasewitz, Germany on April 16, 1859, he died there on November 10, 1886. He studied under Johann Schilling at the Dresden Academy and specialised in allegorical figures and groups.

HELD, Charles fl. late 19th century
American sculptor of genre figures working in the late 19th century.

HELGADOTTIR, Gerdur 1928-
Born at Neskaupstadur, Iceland in 1928, she studied at the Reykjavik Art School from 1945 to 1947, then the Florence Academy (1948-49). She worked in Zadkine's studio in Paris in 1950-52 and worked in various media, including stone, wood, plaster and clay, but since 1953 she has worked almost exclusively in iron wire and metal tubing, producing non-figurative sculpture. She has exhibited at the Salon de Mai (since 1950), the Salon de la Jeune Sculpture (since 1952) and the Salon des Réalités Nouvelles (since 1953). She had a major individual show in Reykjavik in 1956.

HELLER, Hermann 1866-
Born in Vienna on August 22, 1866, he worked there as a painter and sculptor of genre and allegorical subjects at the turn of the century.

HELLMER, Edmund fl. 19th-20th centuries
Born in Vienna in November, 1850, he worked there as a genre sculptor and also taught at the Academy. He won many important public commissions and was awarded a gold medal at the Exposition Universelle of 1900.

HEMMERSDORFER, Hans 1870-
Born at Menzig, Germany on October 7, 1870, he worked in Munich and Berlin.

HENDERSON, Ann 1921-1976
Born in Edinburgh in 1921, she died there in 1976. She studied at the Edinburgh College of Art and exhibited at the Royal Scottish Academy, being elected R.S.A. She specialised in female statuettes and reclining figures.

HENDERSON, Elsie M. (Baroness de Coudenhove) 1880-c.1960
Born in Eastbourne on May 28, 1880, she studied at the Slade School of Art (1903-5) and then went to Paris where she developed an interest in lithography. Later she studied under Ernest Jackson at the Chelsea Polytechnic and was a member of the Senefelder Club. She married Baron de Coudenhove in 1928 and lived in Guernsey till 1946, then at Hadlow Down, Sussex till her death. Though best known as a painter and lithographer of animal subjects, she also sculpted figures and groups in the same genre.

HENDERSON, Robert fl. early 19th century
Sculptor working in London in the early 19th century. He exhibited at the Royal Academy from 1820 to 1832 and at the British Institution from 1825 to 1828. He specialised in bronze statuettes of royalty, including King George IV and the Duke of York. His statuette of King George III (1821) is in the Victoria and Albert Museum. He also sculpted bronzes of animals, including the racehorses Risk and Sober Robin.

HENG, Auguste 1891-
Born at La Chaux de Fonds, Switzerland on April 15, 1891, he became a member of the Swiss Society of Painters, Sculptors and Architects and was on the committee of the New Salon. He also participated in various international exhibitions and the Paris Salons of the 1920s where he showed figures, groups and portraits.

HENGSTENBERG, Georg 1879-
Born at Merano on July 13, 1879, he studied in Munich and later worked in Berlin.

HENINGSEN, Albert 1860-
Born in Santiago, Chile in 1860, he came to Paris in the 1890s and worked there before the first world war. He won an honourable mention for his allegorical figures at the Exposition Universelle of 1900.

HENN, Rudolf fl. 19th century
He studied under Waderé in Munich and worked as a decorative sculptor in that city.

HENNEBERGER, August 1873-
Born at Kötzting, Bavaria on January 15, 1873, he studied under Eberlé and Bradl at the Munich Academy.

HENNING, Gerhard 1880-
Born in Sweden, he studied in Stockholm and worked as a modeller at the Royal Copenhagen Porcelain factory. He produced genre figures and groups which were reproduced in terra cotta and bronze as well as porcelain. He was represented in the Exhibition of Swedish Art held in Paris in 1929.

HENNING, John 1771-1851
Born in Paisley, Scotland, on May 2, 1771, he died in London on April 8, 1851. He was the son of Samuel Henning, a carpenter and builder. He was encouraged by an exhibition of waxworks in Paisley in 1799 to try wax modelling and sculpted a number of profiles and busts. He was not very successful in this, but the failure of his father's business forced him to take up sculpture as his main occupation. In 1800 he went to Glasgow and set himself up as a modeller of wax portraits and was fortunate to secure the patronage of the Duke of Hamilton. Later he moved to Edinburgh, where he sculpted the portraits of many Scottish celebrities of the period. In 1803 he began studying at the Trustees' Academy and eight years later moved to London. He was inspired by the Elgin Marbles (then exhibited at Burlington House) and spent the ensuing twelve years making a copy of them, which he then marketed as plaster reductions. He subsequently did the friezes for the Athenaeum (1830) and the Royal College of Surgeons (1838). He continued to produce wax profiles and busts and also executed them in enamels, bronze and ceramics, the latter being for Wedgwood. His bronze portraits include that of Princess Charlotte (1813). He exhibited at the Royal Academy (1821-28) the British Institution (1816-23), the Edinburgh Society of Artists (1808-13) and the Royal Scottish Academy (1827-29) and was a founder member of the Society of British Artists.

HENNINGER fl. early 20th century
Bronzes bearing this signature were produced by a sculptor working in Paris in the early years of this century. He studied under Niclausse at the École des Beaux Arts.

HENRY, Claude fl. early 20th century
Born in Toulouse in the late 19th century, he studied under Maurice Bauval and exhibited figures and groups at the Salon des Artistes Français before the first world war.

HENSCHEL, Johann Werner 1782-1850
Born in Cassel on February 14, 1782, he died in Rome on August 15, 1850. He studied under L.D. Heyd in Cassel and worked as an ornamental sculptor. His chief works were the friezes and decorative sculpture in Wilhelmshohe Castle and the tomb of Count Wilhelm von Reichenbach.

HENTSCHEL, Konrad 1872-1907
Born in Meissen on June 3, 1872, he died there on July 9, 1907. He worked in Munich and Dresden and specialised in portrait busts and genre statuettes.

HENZE, Robert Edouard 1827-1906
Born in Dresden on July 8, 1827, he died there on April 3, 1906. He studied under Rietschel, Schilling and Hähnel in Dresden and sculpted several monuments and memorials in that district. His best known works are the monument to Henry I at Meissen and the memorial to Prince Wolfgang of Anhalt at Bernburg.

HEPWORTH, Barbara 1903-1975
Born in Wakefield, Yorkshire, on January 10, 1903, she died in a fire at her house in St. Ives, Cornwall on May 20, 1975. She studied at Leeds College of Art (1920) and the Royal College of Art (1921-24). Having won a travelling scholarship she went to Rome (1924-25). She was twice married, first to the sculptor John Skeaping and second to the painter Ben Nicholson; both marriages ended in divorce. She worked in London till the outbreak of the second world war, but then moved to St. Ives. She had her first exhibition in London in 1928 and since then participated in many of the major international exhibitions, both before and after the second world war. She had numerous important public commissions including the Festival of Britain (1951). Two years later she won second prize in the international competition for the monument To the Unknown Political Prisoner. Her smaller sculpture is represented in many leading art collections in Britain, Europe and America. Her figurative work belongs to the period up to 1934, but thereafter she tended towards the geometric and eventually the purely abstract, though she returned to human figures and busts in the 1950s before concentrating on spatial abstracts, often of considerable size, in the last years of her career. She worked in wood, stone, plaster and bronze.
Hammacher, A.M. *Barbara Hepworth* (Thames and Hudson, London).
Joray, Marcel *Barbara Hepworth*.

HÉRAIN, Jean Marie fl. late 19th century
Born in Louvain, Belgium, on October 24, 1853, he worked mainly in Brussels as a sculptor of genre figures. His figure The Captive is in the Antwerp Museum.

HERANT-BENDER, Mariene fl. early 20th century
Born in Egypt in the late 19th century, he studied in Paris under G.J. Thomase and G. Tonnelier. He exhibited figures at the Salon des Artistes Français in the early 1900s.

HERAS, Gaetano de las fl. 19th-20th centuries
Born in Seville in the late 19th century, he worked in Paris in the early 1900s and got an honourable mention for his figures at the Salon des Artistes Français in 1902.

HERAS VELASCO, Maria Juana 1924-
Born in Santa Fé, Argentina, in 1924, she taught science till 1945, when she decided to take up art. She attended classes at the independent school of Altamira and later worked in the studios of Lucio Fontana and Emilio Pettoruti. She has taken part in exhibitions in Buenos Aires since 1955 and won the prize of the Mar del Plata Salon two years later. She works in plaster, clay, concrete, aluminium and bronze in producing spatial abstracts.

HERBAUX, Maurice fl. 20th century
Born at Lannoy, France, at the turn of the century, he studied in Paris under Injalbert and exhibited statuettes at the Salon des Artistes Français from 1921.

HERBAYS, Jules 1866-
Born at Ixelles on March 25, 1866, he studied at the Antwerp Academy and began exhibiting at Ghent in 1891 and later took part in the Belgian Triennials and also the Salon of the Société Nationale des Beaux Arts in Paris.

HERBEMONT, Gaston 1883-
Born in Paris on August 28, 1883, he studied under Grebar and Mercié and exhibited statuettes at the Salon des Artistes Français.

HERBERT, Barbara fl. 20th century
Born in New York at the turn of the century, she studied in Paris under Segoffin and Peynot and exhibited at the Salon des Artistes Français in the inter-war period. She specialised in busts of pre-war celebrities and nudes in the academic style.

HERCULE, Benoit-Lucien 1846-1913
Born in Toulon in July 1846, he died in Paris on November 6, 1913. He studied under Jouffroy and exhibited at the Salon from 1874 onwards. He rapidly won a high reputation and was awarded honourable mentions at the Salons of 1883-85, and third class (1886), second class (1891) and first class (1904) medals, as well as major awards at the Expositions of 1889 and 1900. He became an Associate of the Artistes Français in 1885. He specialised in allegorical and genre figures and portrait busts of his contemporaries.

HERDTLE, Eduard 1821-1878
Born in Stuttgart on December 16, 1821, he died there on November 10, 1878. He was the brother and pupil of the landscape painter Hermann Herdtle and studied sculpture under Weitbrecht. He produced genre and allegorical figures and portraits.

HERGESEL, Frantisek fl. late 19th century
Genre sculptor working in Prague in the 1890s.

HERING, Elsie Ward fl. 19th-20th centuries
Sculptress of genre figures and portraits, working in New York at the turn of the century. She was the wife of Henry Hering.

HERING, Henry 1874-
Born in New York on February 15, 1874, he studied under Augustus Saint-Gaudens in Paris and sculpted numerous monuments and memorials. His minor works included portrait busts, plaques and medals.

HERITIER, Isidore Lucien fl. early 20th century
Born in Paris in the late 19th century, he studied under Auban and exhibited figures and groups at the Salon des Artistes Français in the period before the first world war.

HERKOMER, Sir Hubert von 1849-1914
Born at Waal in Bavaria on May 26, 1849, he died at Budleigh Salterton, Devon, on March 31, 1914. He was brought to England by his father, a wood-carver of considerable talent, and from him learned the art of wood-carving and engraving. He studied at the Southampton School of Art (1864-66) and South Kensington (1866-69) and settled in London. He made his début at the Royal Academy in 1869 and became A.R.A. in 1879 and R.A. in 1890. He was appointed Slade professor at Oxford in 1885 and founded the Herkomer Art School at Bushey in 1883 and directed it until 1904. He was knighted in 1907. He is best known as a genre and historical painter, but also worked in enamels, and was a prominent etcher, engraver and mezzotint draughtsman. Very little is known about his sculpture, but he modelled genre figures and bas-reliefs which were executed in bronze and silver.
Baldry, A.L. *Hubert von Herkomer, R.A.* (1901). Courtney, W.L. *Professor Hubert Herkomer, Royal Academician, His Life and Work* (1892). Herkomer, Sir Hubert von *My School and My Gospel* (1908); *The Herkomers* (1910).

HERMAN, Lambert fl. 19th century
Born in Liège in 1802, he specialised in portrait busts of Belgian contemporaries. His bust of Louis Jamme is in the Liège Museum.

HERMAN, Lambert 1837-84
Born in Liège, the son and pupil of the above, he died at Uccle in 1884. He specialised in classical figures and groups, such as Diana the Huntress (Liège Museum).

HERMANN, Joseph the Elder 1772-1818
Born in Dresden on January 21, 1772, he died there on October 25, 1818. He studied under Wiskottschill and sculpted monuments and decorative ornament.

HERMANN, Joseph the Younger 1800-69
Born in Dresden on March 12, 1800, he died in Loschwitz on November 7, 1869. He was the son and pupil of the above and worked for many years in Rome before becoming Sculptor to the Royal Saxon Court. He produced numerous monuments and memorials, genre and classical figures and portrait busts.

HERMANNS, Ernst 1914-
Born at Münster, Germany in 1914, where he works to this day. He studied at the Aachen School of Arts and Crafts and the Düsseldorf Academy, rounding off his studies in France, Italy and Greece. He turned from figurative to abstract sculpture in 1950 and became a member of the Junger Westen group. He has taken part in many art exhibitions in Germany and the Netherlands since 1951 and produces strange, amorphous masses in bronze and stone.

HERMANT, Louis J. fl. 19th century
He died in Paris in 1905 and worked in that city as a genre sculptor. He was an Associate of the Artistes Français.

HERMES, Erich 1881-
Born in Ludwigshafen, Germany, on January 18, 1881, he studied in Geneva and settled there, becoming naturalised Swiss in 1915. He produced a number of monuments in Geneva and the surrounding locality and also sculpted figures and portraits.

HERMES, Gertrude Anna Bertha 1901-
Born at Bickley, Kent, on August 18, 1901, she studied at Beckenham School of Art (1919-20) and Léon Underwood's School of Painting and Sculpture (1922-26). She has exhibited at the Royal Academy and was elected A.R.A. (1963) and R.A. (1971), as well as the Leicester Galleries and other art exhibitions in Britain. She taught at the Royal Academy schools and the St. Martin's School of Art and Central School. She works in London and specialises in portrait sculpture, but also works as a wood engraver and book illustrator.

HERNANDEZ, Mateo 1885-1949
Born in Bejar, Spain, on September 21, 1885, he died at Meudon, France on November 25, 1949. He began sculpting figures at the age of twelve and later studied at the School of Art and Industry in Bejar, working mainly in stone. At the age of seventeen he sculpted his first life-sized statue. He won a scholarship which took him to Madrid, where he continued his studies and carved direct in stone and wood. He moved to Salamanca and did several monuments, including the equestrian statue of Charro. He settled in France in 1913 and had a private zoo and workshop at Meudon. He exhibited at the Paris Salons from 1918, participated in the Exposition des Arts Décoratifs in 1925 and had a one-man show in 1928, sponsored by the Spanish government. He specialised in animal figures and groups and worked in a wide variety of different stones and timbers, but no bronzes have been recorded by him so far. He also sculpted portrait busts and did paintings, frescoes, drawings and lithographs. A retrospective exhibition of his work was held at the Salon des Indépendants in 1950.

HEROLD, Anton fl. 19th century
He worked in Munich, Vienna and Paris and died in Prague in 1867. He studied under Emmanuel Max and produced portraits and genre figures.

HEROLD, Gustav Karl Martin fl. 19th century
Born in Liestal, Germany, on February 23, 1839, he worked mainly in Frankfurt and Munich, specialising in statuettes and busts of historical and contemporary celebrities in the art world, such as Goethe and Mozart.

HÉRON, Armand fl. 19th-20th centuries
He worked in Paris as a genre sculptor at the turn of the century and exhibited figures and groups at the Salon des Artistes Français from 1900 onwards.

HERPICH, Victor Frédéric 1843-1872
Born in Paris on December 22, 1843, he died there in 1872. He studied under A. Dumont and exhibited statuettes and reliefs at the Salon from 1868.

HERRING, Mabel C. fl. late 19th century
Born in Boothlay, U.S.A., in the second half of the 19th century, she studied in New York and then under Merson and Collin in Paris. She exhibited at the Exposition Universelle of 1900. She specialised in portrait medallions, plaques and bas-reliefs.

HERTZBERG, Halfdan 1857-1890
Born in Christiania (Oslo) on February 7, 1857, he died at Naerstrand, near Stavanger, on July 5, 1890. He specialised in genre figures, such as Whistling Urchin.

HERTZOG, Frederik Gottlieb 1821-1892
Born in Copenhagen on January 6, 1821, he died there on March 13, 1892. He was employed as an ornamental sculptor on the decoration of Roskilde Cathedral and also sculpted figures and bas-reliefs for the Ny Carlsberg Glyptothek in Copenhagen.

HERXHEIMER, Dora fl. early 20th century
Born in London in the late 19th century, she studied there and in Paris where she settled at the turn of the century. She exhibited statuettes at the Nationale in the period up to the first world war.

HERZEL, Paul 1876-
Born at Tillowitz, Silesia, in 1876, he emigrated to the United States and studied at the St. Louis School of Fine Arts and the Beaux-Arts Institute of New York. He specialised in bronze or bronzed plaster animal figures and groups such as The Toad, and Lioness and Cubs.

HERZIG, August Albert Theodor 1846-1919
Born in Hamburg on August 3, 1846, he died in Darmstadt on July 11, 1919. He sculpted genre and classical figures and portrait busts. His best work is the Darmstadt war memorial (1918).

HERZOG, Georg fl. 19th century
Sculptor of classical figures, working in Vienna in the mid-19th century.

HERZOG, Leonhard fl. 19th-20th centuries
Born in Schweinau, Bavaria, on April 2, 1863, he worked as a sculptor of memorials and portraits in Nuremberg at the turn of the century.

HESS, Georg fl. 19th century
Born in Pfungstadt, Germany, on September 29, 1832, he studied in Munich and then emigrated to the United States where he worked in New York as a sculptor of portrait busts and reliefs, mainly in marble.

HESSELINCK, Abraham 1862-
Born at Eelde or Paterwolde in Holland on July 19, 1862. He studied at the Brussels Academy and sculpted monuments and statuary in Belgium and Holland at the turn of the century. His minor works include portrait busts, models and maquettes for his statues, some of which are preserved in the museums of Amsterdam and other Dutch cities.

HETHERINGTON, Irene 1921-
Born in Yorkshire on September 11, 1921, she studied at Leeds College of Art and the Royal College of Art, London. She works in Carlisle and was elected R.B.A. in 1949.

HETTE, Richard fl. 20th century
Born at Jassy, Romania in the late 19th century, he studied in Paris under Bourdelle and exhibited figures and portraits at the Paris Salons in the 1920s.

HETTLER, Carl fl. early 19th century
He worked in Breslau in the 1820s and specialised in portrait busts.

HETTNER, Otto 1875-
Born in Dresden on January 27, 1875, he settled in Paris at the turn of the century and worked there as a painter, engraver and sculptor of genre subjects. He became an Associate of the Nationale in 1903, and took part in the Paris Exhibition of German Artists in 1929.

HEU, Joseph 1876-
Born in Marburg, Germany, on February 21, 1876, he studied under Hellmer at the Vienna Academy and settled in that city, where he worked as a sculptor of genre and historical figures.

HEUMANN, Augustin 1885-1919
Born in Münster on November 11, 1885, he died in Cologne on February 1, 1919. He studied under Schmiemann in Münster and later worked on statuary and bas-reliefs in Munich.

HEURTEBISE, Lucien Eugène Olivier 1867-
Born at Le Mans on February 12, 1867, he studied in Paris under Carlus and T. Barrau and became an Associate of the Artistes Français in 1889.

HEUVELMANS, Lucienne Antoinette 1885-
Born in Paris in 1885, she won the Prix de Rome in 1911 and exhibited figures at the Salon des Artistes Français from about 1907 onwards.

HEXAMER, Frédéric fl. late 19th century
He was born in Paris in the mid-19th century and studied under Dumont and Lecomte-Vernet. He began exhibiting at the Salon in 1869 and was made an Associate of the Artistes Français in 1888. He won a third class medal in 1886 and silver medals at the Expositions of 1889 and 1900. He produced genre and allegorical figures and portrait sculpture.

HEYDORN, Richard 1858-1888
Born at Pirneberg, Denmark, on April 27, 1858, he died there on August 9, 1888. He studied in Copenhagen and worked as a decorative sculptor.

HEYMANN, Jules fl. 19th century
He worked in Viannes as a decorative sculptor and exhibited bas-reliefs and figures at the Salon des Artistes Français, becoming an Associate in 1889.

HEYNE, Heinrich 1869-
Born at Ohlau, Germany, on June 16, 1869, he worked in Berlin, Karlsruhe, Stuttgart and Rome as a decorative sculptor.

HEYNERT, Johann Friedrich 1857-1888
Born in 1857, he died at Schandau on June 6, 1888. He studied at the Dresden Academy and specialised in portrait bas-reliefs and busts.

HIBBARD, Frederick Cleveland 1881-
Born in Canton, Missouri, on June 15, 1881, he studied under Lorado Taft at the Art Institute of Chicago and became a member of the Federation of American Artists. He specialised in portrait busts, monuments and statuettes, mainly of military subjects, though his work also included such genre bronzes as The Moulder.

HICKHOLTZ, G. fl. 19th-20th centuries
German sculptor specialising in exotic wildlife figures. His bronzes include Bull Elephant.

HICKMAN-SMITH, Eileen fl. 1940-1965
Born in London in the early years of this century, she was the daughter of the painter D. Hickman-Smith. She studied at the Regent Street Polytechnic under Harold Brownsword and worked as an oil painter as well as sculpting figures and reliefs in stone and bronze. She exhibited at the Royal Academy, the Royal Society of British Artists and leading galleries in London and the provinces.

HIDDING, Hermann 1863-
Born at Nottnen, Germany, on May 9, 1863, he studied in Düsseldorf and Berlin and exhibited figures at the Berlin Academy in the 1890s.

HIERHOLTZ, Gustave 1877
Born in Lausanne, Switzerland, of French parents, on August 5, 1877. He studied painting and sculpture under Lugeon, Deléphine and Auhan, and exhibited genre paintings and sculpture at the Salon des Artistes Français, winning a third class medal in 1908 and being elected Associate the following year.

HIESZ, Géza fl. 20th century
Born in Budapest at the turn of the century, he studied at the Budapest School of Fine Arts and exhibited in Hungary, Austria and Paris in the 1920s.

HIGGINS, Eugène 1874-
Born in Kansas City in February 1874, he worked in New York and later studied in Paris under Gérôme and J.P. Laurens. He exhibited at the Salon des Artistes Français and the Nationale in the 1920s and was a member of many American associations, including the Federation of American Artists and the Salmagundi Club. He worked in New York as a painter and sculptor of genre subjects.

HIGUERAS Y FUENTES, Jacinto fl. 20th century
Born at Santisteban del Puerto, Spain, in the late 19th century, he worked in Madrid as a sculptor of figures and portraits and exhibited there from 1906 onwards.

HILBERT, Georges 1900-
Born in Algeria on March 22, 1900, he is an Animalier sculptor of great repute, working mainly in life size. He won the Blumenthal prize in 1927 and has exhibited figures and groups widely in Europe and America.

HILDEBRAND, Adolf Ernest Robert von 1847-1921
Born in Marburg, Germany, on October 6, 1847, he died in Munich on January 1, 1921. He studied at the Nuremberg School of Fine Arts and under Karl von Zumbusch at the Munich Academy and Siemering in Berlin. He was in Rome in 1867-68 and returned to Italy six years later, eventually settling near Florence. He built himself a house in Munich in 1897 and thereafter commuted between Florence and Bavaria. He specialised in portrait busts of his distinguished

contemporaries and also sculpted numerous fountains, monuments and public statues. His chief works were the fountains dedicated to Bismarck at Jena (1895), the Wittelsbachs in Munich (1895) and the River Rhine at Strasburg (1903). He also sculpted the equestrian statue of Prince Regent Luitpold in Munich. His book *The Problem of Form* (1893) analysed the optical laws underlying the artistic representation of form and exercised enormous influence on the German sculptors at the turn of the century.

Heilmeyer, A. *Adolf Hildebrand* (1902).

HILDEBRAND, Bernard fl. 19th century
Born at Montoillet, France, in the mid-19th century, he died in Paris in 1903. He exhibited statuettes and reliefs at the Salon des Artistes Français in the 1890s.

HILDEBRAND, Otto 1874-
Born in Metz on November 16, 1874, he studied under Dujardin and specialised in bronze bas-reliefs. Examples of his work are preserved in the Metz Museum.

HILDEBRANT, ? fl. 19th century
Marble, terra cotta and bronze portrait busts bearing this signature were produced by a sculptor working in Bayreuth in the early part of the 19th century.

HILGERS, Karl fl. 19th century
Born in Düsseldorf on January 17, 1844, he studied at the Düsseldorf Academy and spent three years in Italy before returning to his native town. He was one of the most fashionable German sculptors at the turn of the century and is best known for his colossal statue of Wilhelm I at Stettin (1894) and Friedrich Wilhelm I at Düsseldorf. He was appointed Court Sculptor to Kaiser Wilhelm II. His work was characterised by a cold formality, though not without elegance. His minor statuettes and busts are in the museums of Berlin and Düsseldorf.

HILL, Amelia Octavius (née Paton) fl. 19th century
Born in Dunfermline, she was the wife of the painter and pioneer photographer, David Octavius Hill. She exhibited portrait busts, animal figures and genre statuettes at the Royal Academy from 1870. Her best known work is the statue of Robert Burns in Dumfries (1882).

HILL, Caroline fl. 20th century
Born in Boston, Massachusetts, at the turn of the century, she studied under Bourdelle in Paris and exhibited at the Salon des Tuileries in 1929. She also worked in New York and produced genre figures and portrait reliefs.

HILL, Edith fl. late 19th century
Born in Edinburgh in the mid-19th century, she studied art in that city and exhibited figures and portraits at the British Institution in 1883.

HILL, Vernon 1887-
Born in Halifax, Yorkshire, in 1887, he worked as an etcher and engraver as well as a sculptor of genre statuettes and classical figures. His works include Winged Figures, Roaring Flame, Anemone, Twilight - Pan Piping. He worked at Headley Down in Hampshire and exhibited at the Royal Scottish Academy and leading provincial galleries.

HILLER, Anton 1893-
Born in Munich in 1893, he studied sculpture there and also in Italy (1924 and 1927) and France (1926). He was strongly influenced by the work of Rodin and Maillol but latterly has worked in wood and bronze, reducing the human figure to its essential plastic elements. He became professor of sculpture at the Munich Academy in 1946 and has since taken part in exhibitions in Munich, Berlin, Hamburg, Rome and Milan.

HILTUNEN, Eila 1922-
Born in Sortavala, Finland, in 1922, she studied at the Helsinki Art School and travelled widely in Scandinavia, France, Austria and the United States. Her earlier work conformed to the realist academic conventions and consisted mainly of portrait busts, bas-reliefs, monuments and war memorials. Since the late 1950s, however, she has experimented with welded steel in place of the bronze and stone she previously favoured and has become increasingly non-figurative.

She has had several scholarships from Finland, France and the United States and has exhibited in Scandinavia, Paris, London and New York. Examples of her bronzes are in the National Museum of Finland in Helsinki and also the Lahti Museum.

HIMMELSTOSS, Karl 1878-
Born in Breslau on July 12, 1878, he studied in Berlin and Munich and worked as a modeller in porcelain.

HINCKELDEY, Ernst Paul 1893-
Born in Arnstadt, Germany, on April 12, 1893, he studied in Berlin and specialised in portrait busts and genre figures.

HINDER, Margaret fl. 20th century
Born in the United States in the early years of this century, she worked as a decorative sculptor in Boston, Massachusetts, but emigrated to Australia in 1934 and has since produced abstracts in steel and bronze, mainly for the decoration of public buildings, such as Western Assurance in Sydney.

HINGRE, Louis Théophile fl. 19th-20th centuries
Born at Écouen, France, in the mid-19th century, he died in Paris in 1911. He studied under Gervais and Passot and exhibited at the Salon from 1881, winning a third class medal in 1902. At the Expositions of 1889 and 1900 he won bronze and silver medals respectively and was elected an Associate of the Artistes Français in 1909. He specialised in bas-reliefs, plaques, medallions and medals.

HINTERHOLZER, Andreas 1875-
Born in Lazsfons, Hungary, on July 18, 1875, he studied under Georg Werbas in Munich. He worked as a decorative sculptor in Hamburg, Münster, Nuremberg and Berlin before settling at Pradl near Innsbruck.

HINTERSCHER, Josef 1878-
Born in Munich on March 16, 1878, he studied in Italy and then worked as a portrait and decorative sculptor in Paris and Berlin.

HINTNER, Michael 1842-1900
Born at Pichl, Germany, on September 28, 1842, he died in Munich on December 14, 1900. He specialised in ecclesiastical figures and bas-reliefs, particularly of Christ and the Virgin Mary. He was the brother of the painter Johann Hintner.

HINTON, Charles Louis 1869-
Born at Ithaca, New York, in 1869, he studied under Low at the National Academy of Design and worked in the studios of Gérôme and Bouguereau in Paris before going to the École des Beaux Arts where he completed his studies under Gumer. He worked as a painter and sculptor and his bronzes include Diana with her Dogs, Atlanta, Tying the Sandal, Venus on a Shell, Vanity and Decorative Figure for a Fountain.

HINTON, Erwald Stuart 1866-
Born in New York on January 3, 1866, he worked as a sculptor of memorials, bas-reliefs and portrait busts in Chicago at the turn of the century.

HIOLIN, Louis Auguste 1846-1910
Born at Sept-monts, France, on March 18, 1846, he died at Silly-la-Poterie in May, 1910. He studied under Perray and Jouffroy and exhibited at the Salon from 1874, winning a third class medal in 1879. He became an Associate of the Artistes Français in 1885 and won a second class medal the same year. He was awarded bronze and silver medals at the Expositions of 1889 and 1900 respectively. He specialised in decorative sculpture for churches and public buildings.

HIOLLE, Ernest Eugène 1834-1886
Born in Paris on May 5, 1834, he died at Bois le Roi on October 5, 1886. He studied under Jouffroy and Granfils and was runner up in the Prix de Rome of 1856, taking the prize itself six years later. He was made a Chevalier of the Legion of Honour in 1873. He exhibited at the Salon from 1866 and won medals from 1867 to 1870 and the medal of honour at the Exposition Universelle of 1878. He specialised in classical and allegorical figures in plaster or bronze, but also sculpted numerous portrait busts of his contemporaries. His chief works are the statues of General Foy (Ham) and Lafayette (Puy-en-Velay).

HIOLLE, Maximilien Henri 1843-
Born at Valenciennes on April 4, 1843, he studied under Jouffroy and exhibited at the Salon from 1869, winning honourable mentions in 1882 and at the Exposition Universelle of 1900. He produced genre figures and portraits.

HIPPIUS, Natalia Nicolaievna 1880-
Born at Nieshin, Russia, on October 13, 1880, she produced allegorical and genre figures, many of which are preserved in the Gorky Museum.

HIQUILY, Philippe 1925-
Born in Paris, he attended art classes in Orleans, but enlisted in the Army at the Liberation and fought in the closing campaigns of the second world war and also in Indo-China. Following his demobilisation in 1947 he enrolled at the École des Beaux Arts and worked in the studio of Jeanniot. From 1951 onwards, he turned away from figurative sculpture towards abstracts, which he produces in wrought iron. His earlier figures were sculpted in clay, plaster and bronze. In recent years he has also worked in brass, copper, aluminium and stainless steel. He has exhibited at the Salon de Mai and the Salon de la Jeune Sculpture since 1956.

HIRNÉ – See LE RICHE, Henri

HIRON, Antoine fl. 19th century
Born at Ris-Orangis, France, on March 14, 1823, he worked as a genre sculptor in Paris and exhibited at the Salon from 1848.

HIRON, Ernest Marie 1850-1900
Born in Paris on January 5, 1850, he died there in December, 1900. He studied under Aimé Millet and Bastet and became an Associate of the Artistes Français in 1889. He was awarded a bronze medal at the Exposition Universelle of that year. He specialised in statuettes and portrait busts of his contemporaries.

HIROU, Jeanne fl. late 19th century
She exhibited genre and classical figures at the Salon des Artistes Français, winning an honourable mention in 1886.

HIRSCHAUTER, Joseph 1801-1859
Born in Vienna on May 6, 1801, he died there on April 26, 1859. He sculpted portrait busts, statuettes and ornamental bas-reliefs.

HIRT, Johann Christian 1836-1897
Born in Fürth on March 4, 1836, he died in Munich on August 19, 1897. He specialised in classical statuettes and groups. His figure of Andromeda is in the Simu Museum, Bucharest.

HIRT, Johannes 1859-1917
Born in Worms on April 27, 1859, he died in Karlsruhe in October, 1917. He studied under Schaper in Berlin and worked in Worms and Karlsruhe, mainly on portrait busts and monumental statuary.

HITCH, Frederick Brook 1877-1957
Born in London on November 7, 1877, he died there on April 30, 1957. He was the son and pupil of Nathaniel Hitch, a monumental mason, and collaborated with his father on memorials and monuments. He also studied at the Royal Academy schools and produced portrait reliefs and busts as well as allegorical statuettes and memorials. He spent most of his working life in London and was elected F.R.B.S.

HITZBERGER, Otto 1878-
Born in Munich on October 2, 1878, he studied in Partenkirchen and worked as a decorative sculptor in Munich and Stuttgart.

HJORTH, Bror 1894-1968
Born in Sweden in 1894, he studied at the School of Fine Arts in Copenhagen and under Bourdelle in Paris. He worked in many media, from coloured plaster and marble to carved wood and stone and painted bronze. His works include heads, busts and figures in which the features and limbs have been simplified. He took part in the Swedish Art Exhibition in Paris (1929) and at the Swedish Institute, London (1945). His works include Girl's Head and Nude Woman Reading.

HOARD, Margaret fl. 19th century
Born in Iowa in the mid-19th century, she worked in New York and later San Francisco at the turn of the century, producing genre figures, heads and busts.

HOBBIS, Charles Wilfred 1880-
Born in Sheffield on February 25, 1880, he studied at the Sheffield School of Art (1893-1902) and the Royal College of Art (1902-7) and exhibited at the Royal Academy and provincial galleries. He was the head of Norwich School of Art from 1919 till 1946 and worked as a painter, watercolourist, silversmith and sculptor of portraits and figures.

HOCHMANN, Henryk 1881-
Born in Lublin, Poland, in 1881, he studied under Rozen and Laszczka and produced monuments, memorials and genre figures in the early years of this century.

HODGE, Albert Hemstock 1875-1918
Born in Scotland in 1875, he died in London on January 27, 1918. He studied at the Glasgow School of Art and worked in London as a genre sculptor. He exhibited at the Royal Academy in the early 1900s, and was elected F.R.B.S.

HOEF, C.J. van der fl. early 20th century
Born in Amsterdam about 1875, he carved bas-reliefs and roundels in wood, and also produced statuettes and medallions in bronze.

HOEFER, Alexander 1877-
Born at Keuern in Saxony on January 16, 1877, he worked in Dresden where he studied under Epler and Diez at the Academy. He exhibited in Berlin in 1909 and specialised in portrait busts and heads as well as animal studies.

HOEFFLER, Josef 1879-1915
Born at Kaiserslautern on March 18, 1879, he died in Bergzabern on March 28, 1915. He studied under Schwert at Kaiserslautern and travelled widely in France, Austria and Germany. He worked in Hamburg for many years, sculpting memorials, portrait busts and allegorical figures.

HOEFLEIN, Otto 1840-1899
Born in Pforzheim in 1840, he died there on January 1, 1899. He studied in Munich and Stuttgart and sculpted genre and allegorical figures.

HOEG, Niels 1858-
Born in Sorring, Denmark, on December 6, 1858, he studied at the Copenhagen Academy and specialised in portrait reliefs and busts.

HOEGER, Otto 1881-1918
Born in Hamburg on May 27, 1881, he died in Rastatt on December 4, 1918. He studied under Olde and Hofmann at the Weimar Academy and spent many years in Denmark, where he worked as an engraver and sculptor of genre subjects.

HOEGLER, Franz 1802-1855
Born in Vienna on January 25, 1802, he died there on May 12, 1855. He studied at the Vienna Academy and specialised in busts and statuettes particularly of the imperial family.

HOELBE, Rudolph fl. 19th century
Born at Lemgo, Saxony, on October 6, 1848, he studied in Dresden and Leipzig and was a pupil of Schilling. He worked in Dresden, specialising in genre statuettes, busts and religious figures.

HOELZEL, Moritz 1841-1902
Born in Prague on January 1, 1841, he died at Bardelov on July 24, 1902. He studied at Prague Academy and specialised in statuettes and groups of religious and genre subjects.

HOENE, Max 1884-
Born in Rudolstadt on December 22, 1884, he studied in Munich and specialised in portrait busts and monuments.

HOENERBACH, Margarete fl. late 19th century
Born at Köln Deutz, Germany, on September 9, 1848, she studied under Rethel and travelled in France and Italy. She specialised in memorials, portrait reliefs and busts.

HOERBST, Baptist fl. 19th century
Born in Zürich on December 1, 1850, the son of Georg Hoerbst, he studied under J.C. Dielmann in Frankfurt and also worked for a time in Austria and Italy.

HOERBST, Georg 1823-1876
Born in Tannheim, Tyrol, in 1823, he died in Zürich in 1876. He worked as a sculptor of secular and religious ornament, bas-reliefs and statuary.

HOERBST, Hans fl. 19th century
Born in Zürich on April 29, 1859, the younger son of Georg Hoerbst, he worked in the United States and sculpted a number of portrait busts and memorials in the Chicago area before returning to Zürich at the turn of the century.

HOERMANN, Franz Xaver 1822-1896
Born in Burg on November 29, 1822, he died at Traunstein on April 1, 1896. He studied under Schwanthaler in Munich.

HOERSTEN, B. van fl. early 19th century
Austrian sculptor of Dutch origin, working in Vienna and Oldenburg in the early years of the 19th century. Examples of his statuettes and portraits are in the Oldenburg Museum.

HOESEL, Oskar Erich 1869-
Born in Annaberg, Germany, on April 5, 1869, he studied under Schilling and W. Diez at the Dresden Academy and became professor there in 1898. He was awarded gold medals in Berlin (1896) and Paris (1900). He specialised in equestrian statuettes.

HOETGER, Bernhard 1874-1949
Born at Hörde, Westphalia on May 4, 1874, he died in Interlaken, Switzerland in 1949. He was apprenticed to a stone-mason in Detmold and later studied in Bunzlau, Dresden, Düsseldorf and Berlin. He worked in Paris from 1900 to 1907 and was strongly influenced by Rodin. He was one of the founders of the Salon d'Automne and exhibited there in 1905. In 1911 he moved to Darmstadt to head the artists' colony there and worked as an architect, designer and sculptor. He moved to the artists' colony at Worpswede in 1919 but fled from Germany in 1933 when the Nazis came to power. Subsequently he worked in France, Spain, Portugal and Switzerland. His early work, influenced by Rodin and Meunier consisted mainly of statuettes and female torsos in bronze. Later, however, his style became more eclectic and combined elements of the Gothic, Jugendstil and Cubism. Towards the end of his career he returned to figurative work, and sculpted figures illustrating the wretchedness and misery of the human condition.

HOFER, Ludwig von 1801-1887
Born in Ludwigsburg on June 20, 1801, he died in Stuttgart on March 8, 1887. He studied in Rome under Thorvaldsen and sculpted many busts and statues in marble, inspired by classical mythology. Several works are known as bronze reductions.

HOFF, George Raynor 1894-1937
Born in Sydney, New South Wales in 1894, he studied at the Royal College of Art, London and won the Prix de Rome in 1922. The following year he was appointed professor of Sculpture at Sydney Technical College. His best known work is the Anzac memorial in Hyde Park, Sydney. His minor figures and portraits are in Sydney Art Gallery.

HOFFART, Johannes fl. late 19th century
Born in Mannheim on January 22, 1851, he studied at the Munich Academy and sculpted monuments and memorials in Baden, notably the tomb of Prince Karl Friedrich of Baden.

HOFFMAN, Malvina 1887-1966
Born in New York on June 15, 1887, she died there in 1966. She studied under Gutzon Borglum in New York and Rodin in Paris and was a member of many American art associations. She specialised in genre statuettes, such as Russian Dancer, Woman of Martinique, Offrande, Bacchanale Russe and Boy and Panther Cub, and heads such as The Modern Crusader. Her best known work was the series of figures illustrating Races of the World, begun in 1930. She also sculpted portrait busts of her contemporaries.

HOFFMAN, Wilmer 1889-
Born at Catonsville, Maryland on August 1, 1889, he studied at the Pennsylvania Academy of Fine Arts and won a travelling scholarship which took him to Paris, where he exhibited at the Salon d'Automne and the Tuileries. He specialised in American genre figures, particularly of Indians and Negroes.

HOFFMANN, Arthur 1874-
Born in Potsdam on July 20, 1874, he exhibited in Berlin from 1909 onwards. His works include genre statuettes, Shakespearean characters and medieval knights in armour.

HOFFMANN, Heinrich 1859-
Born in Cassel on August 30, 1859, he studied under Kolitz and Knackfuss. Though best known as a landscape painter, he also sculpted genre figures and busts.

HOFFMANN, Heinrich Bernhard Martin Johannes 1844-1920
Born in Schleswig on July 17, 1844, he died in Copenhagen on June 20, 1920. He studied under H.V. Bissen at Copenhagen and went to Italy in 1874. He worked in Rome for many years before retiring to Copenhagen. He specialised in genre, allegorical and classical statuettes, such as Youth and Psyche. Examples of his work are in the museums of Basle and Copenhagen.

HOFFMANN, Israel fl. 20th century
Argentine sculptor of monuments, bas-reliefs and portrait busts, working in Buenos Aires in the first half of this century.

HOFFMANN, Johann Joseph fl. 18th-19th centuries
Born at Guhlau, Austria, on March 17, 1762, he studied under Stein and Prokop and specialised in busts and heads.

HOFFMANN, Karl 1816-1872
Born in Wiesbaden in 1816, he died there about 1872. He settled in Paris in 1837, but later worked in Rome where he was strongly influenced by Thorvaldsen. He specialised in ecclesiastical ornament, mainly in marble.

HOFFMANN VON VESTENHOF, August fl. late 19th century
Born at Olmütz on June 18, 1849, he worked in Munich as a painter, illustrator and sculptor of genre and historical subjects. He exhibited in Munich and Berlin at the turn of the century.

HOFFMEISTER, Heinz 1851-1894
Born in Saarlouis on June 24, 1851, he died in Berlin on March 5, 1894. He studied under Cauer at Kreuznach and travelled in North Africa, Spain and the Levant. He specialised in religious and genre statuettes, many of them for churches and public buildings in the Berlin area.

HOFFMEISTER, Samuel 1765-1818
Born in 1765, he died in Stockholm in 1818. He studied under Sergel and specialised in relief portraits, busts and medallions of late 18th century international celebrities.

HOFFSTADT, Friedrich 1802-1846
Born at Amsbach in 1802, he died in Aschaffenburg on September 7, 1846. He studied painting, engraving and sculpture in Munich and specialised in ecclesiastical decoration.

HOFLEHNER, Rudolf 1916-
Born in Linz, Austria in 1916, he studied at the School of Mechanical Engineering in Linz where he learned the techniques of welding, forging and turning. Later he studied art at the Vienna Academy and taught at the Linz School of Arts and Crafts from 1945 to 1951, before establishing a studio in Vienna. His works are carved in wood or welded in iron and steel and no bronzes have so far been noted. He has taken part in many international exhibitions since 1954, including the Venice Biennales and the Middelheim and Cassel Documenta exhibitions.

HOFMAN, Alfred 1879-
Born in Vienna on November 28, 1879, he studied under Anton Brenek and travelled in Naples, Florence and Rome studying classical sculpture. He worked in Vienna and specialised in portrait busts.

HOFMAN VON ALPERNBURG, Edmund 1847-
Born in Budapest on November 2, 1847, he studied under F. Bauer in Vienna. He specialised in classical figures and groups, such as Orestes pursued by a Fury.

HOFMANN, Jakob 1876-
Born in Brunswick on December 17, 1876, he studied in Munich and worked in Aschaffenburg and Neuburg, specialising in portrait busts and religious groups.

HOFNER, Otto 1879-
Born in Vienna on March 29, 1879, he studied under Stephen Schwartz and completed his studies in France, Germany, England and the Low Countries. He specialised in busts and allegorical figures for monuments, and exhibited regularly in Vienna, Hamburg, Berlin and Rome.

HOFSESS, Georg fl. 19th century
Born in Frankfurt-am-Main on October 3, 1826, he specialised in animal figures and groups.

HOFSTOETTER, Franz 1871-
Born in Munich in 1871, he studied under Hackl at the Munich Academy and produced paintings and sculpture of genre subjects.

HOGAN, John 1800-1858
Born in Dublin in 1800, he died there in 1858. He exhibited at the Royal Hibernian Academy and specialised in portrait busts and statues of contemporary celebrities, such as Father Mathew and Rowan Hamilton. Examples of his portraits are in the National Library, The National Museum and Trinity College, Dublin.

HOGG, Isobel 1887-
Born in Montreal, Canada on February 8, 1887, she studied in Birmingham and Paris and has exhibited sculpture at the Royal Academy, the Royal Scottish Academy and other galleries in Britain, Canada and the United States. She worked in London and specialised in genre figures, such as The Dancer, Spring of Life, Youth and Summertime.

HOLBECH, Carl Frederik 1811-1880
Born in Denmark on February 27, 1811, he died in Rome on July 23, 1880. He was Thorvaldsen's assistant for several years in Rome and worked in marble on neo-classical figures and groups. Bronze reductions of his allegorical works are known.

HOLBEIN, Friedrich Wilhelm fl. early 19th century
He worked in Berlin in the 1830s and sculpted historical and classical figures.

HOLLAIN, Louis fl. 19th century
Born at Iwuy, France on July 14, 1813, he studied at the École des Beaux Arts, Paris and specialised in neo-classical and genre figures. His statuette of a Young Slave is in the Cambrai Museum.

HOLLISTER, Antoinette B. 1873-
Born in Chicago on August 19, 1873, she studied at the Chicago Arts Institute and worked under Rodin in Paris at the turn of the century. She specialised in genre figures and portraits.

HOLLO, Barnabas 1866-1917
Born in Also-Hangony, Hungary on May 16, 1866, he died in Budapest on November 2, 1917. He studied under Aloyse Strohl and was awarded a silver medal at the Exposition Universelle of 1900.

HOLM, Jesper Johansen 1748-1828
Born in Copenhagen in 1748, he died in Copenhagen on January 7, 1828. He studied under Wiedewelt and specialised in bas-reliefs and medallions, which were produced in porcelain, silver and bronze.

HOLM, Niels 1860-
Born in Slagelse, Denmark on February 14, 1860, he specialised in portrait busts and genre statuettes.

HOLM, Victor S. 1876-
Born in Copenhagen on December 6, 1876, he emigrated to the United States and studied under Lorado Taft at the Chicago Arts Institute, the Art Students' League, New York and in the studio of Philip Martiny. He produced a large number of monuments and memorials, public statuary and architectural sculpture, particularly for American universities and hospitals. Many of his statuettes were intended as models for larger works and include the figures of Leif Ericsson and The Spirit of France and the bust of Harlan Frazer. He also produced numerous plaques and medallions commemorating American events and personalities.

HOLMAN, George Alfred 1911-
Born in London on June 13, 1911, he studied at Hackney School of Art (1925-27) and Hornsey School of Art (1927-34). He has exhibited figures and portraits at the Royal Academy and the principal galleries in London and the provinces. He was elected A.R.B.S. in 1942 and F.R.B.S. in 1955. He now works in Leigh-on-Sea, Essex.

HOLMES, Majorie Daingerfield fl. 20th century
Born in New York at the turn of the century, she was a member of the National Arts Club and exhibited genre statuettes and portraits in the inter-war years.

HOLMGREN, Martin 1921-
Born at Hallnas, Sweden in 1921, he studied in Stockholm and went to Paris in 1952. On his return to Sweden he settled in Vaxholm where he still lives. At first he modelled figures of acrobats, toreadors, motorcyclists — 'men in terror, confusion and revolt', and gentler subjects such as ballet dancers. He turned to abstract sculpture in 1956, to register protest against the tragedy of the Hungarian Uprising and the Dutch floods of that year. His bronzes include the series of Forms seeking a Common Centre (1955-60), preserved in the Museum of Modern Art, Stockholm.

HOLROYD, Sir Charles 1861-1917
Born in Leeds on April 9, 1861, he died in Weybridge, Surrey on November 17, 1917. He studied under Legros at the Slade School of Art and won a travelling scholarship to Italy (1889-91) and paid a second visit in 1894-97. He was the first keeper of the Tate Gallery (1897-1906) and was subsequently Director of the National Gallery (1906-16). He was knighted in 1903. He exhibited at the Royal Academy from 1885 onwards and painted genre and religious subjects. He was also a prolific etcher and illustrator of architectural and landscape subjects. He also sculpted portrait busts, statuettes and reliefs.

HOLSMAN, Elizabeth Tuttle 1873-
Born in the United States on September 25, 1873, she studied at the Chicago Arts Institute and worked as a painter and sculptor of portraits.

HOLT, Gwynneth 1909-
Born in Wednesbury, Staffordshire on January 18, 1909, she studied at Wolverhampton School of Art from 1925 to 1930 and has since exhibited at the Royal Academy, the Royal Scottish Academy and the chief London and provincial galleries. She married the painter T.B. Huxley-Jones and now lives in the Isle of Man. She sculpts figures and groups in wood, ivory, terra cotta and bronze.

HOLT, Winifred fl. 19th-20th centuries
She studied under Trentanove and Saint-Gaudens in the late 19th century and worked in New York, Rome, Florence and London, sculpting portraits and genre figures.

HOLWECK, Louis fl. 19th-20th centuries
Born in Paris in the mid-19th century, he studied under Charles Gauthier and Thomas and exhibited at the Salon des Artistes Français, winning third class (1888) and second class (1893) medals and a travelling scholarship in 1891. He was also awarded bronze medals at the Expositions of 1889 and 1900. He produced portrait busts and reliefs and allegorical figures.

HOMS, Marcel fl. 20th century
French sculptor working before the second world war and sculpting figures and groups.

HONDRIESAR, Frédéric fl. late 19th century
Genre sculptor working in Paris, where he died in 1906. He was an Associate of the Artistes Français.

HONORÉ, Pierre fl. 20th century
Born in Paris in the late 19th century, he studied under Coutan and exhibited figures and busts at the Salon des Artistes Français in the 1920s.

HOOL, Johannes Baptista van, the Elder 1769-1837
Born in Antwerp on March 1, 1769, he died there on June 14, 1837. He studied under F. van Ursel and was appointed professor at Antwerp Academy in 1812. He specialised in religious sculpture, mainly for churches in Holland — Rotterdam, Amsterdam, Arnhem, Bosch and Breda.

HOOL, Johannes Baptista van, the Younger 1812-1883
Born in Antwerp in 1812, he died there on December 16, 1883. He studied under his father at the Antwerp Academy and succeeded him as professor of sculpture. He specialised in genre and neo-classical figures and groups, as well as portraits of contemporary celebrities.

HOOPER, Grace fl. 19th-20th centuries
Born in Boston, Massachusetts in November, 1850, she studied under Cyrus Dallin in Boston and Injalbert in Paris. She worked as a genre and portrait sculptress in Boston at the turn of the century.

HOPE-PINKER, Henry Richard fl. 19th-20th centuries
Sculptor working in London at the turn of the century, he was a member of the Society of British Sculptors and specialised in portrait busts of contemporary personalities. His bust of Henry Fawcett is in the National Portrait Gallery.

HOPFGARTEN, Emil Alexander 1821-1856
Born in Berlin on April 3, 1821, he died in Biebrich on September 12, 1856. He studied under L. Wichmann and exhibited portrait busts and classical groups at the Berlin Academy from 1844 till his death.

HOPKINS, John fl. late 19th century
Portrait sculptor working in London at the end of the 19th century. Two bronze busts by him are in the Boulogne Museum.

HOPKINS, Mark 1881-
Born in Williamstown, U.S.A. on February 9, 1881, he studied under MacMonnies and was a member of the Artistes Français and the International Union of Fine Arts. He worked in Giverny, France and Williamstown on genre figures and portraits.

HOPPENSACH, Alfred Valdemar 1854-1886
Born in Copenhagen on September 16, 1854, he died there on October 27, 1886. Though mainly a landscape painter, he also modelled genre figures and portraits.

HOPPIN, Thomas Frederick fl. 19th century
Born in Providence, Rhode Island on August 15, 1816, he was the brother of the engraver Augustus Hoppin and studied in Philadelphia. Later he went to Paris where he was a pupil of Delaroche. He returned to the United States in 1837 and settled in New York where he specialised in bas-reliefs and statuary of religious subjects. He also worked as a painter, engraver and illustrator.

HORCHERT, Joseph 1874-
Born in Hechingen, Germany on May 4, 1874, he studied at the Frankfurt Institute of Arts and the Munich Academy before emigrating to the United States. He sculpted the figures on the Friedrich Bridge in Berlin and the Guggenheim Memorial Fountain in America. His minor works include genre figures and portrait busts.

HOREJC, Jaroslav 1886-
Born in Prague on June 15, 1886, he specialised in bas-reliefs, plaques and medallions.

HORMANN, Sophie Fessy fl. late 19th century
Born at Blisholz Scharnbeck, Germany in the mid-19th century, she worked as a sculptor and painter mainly in the Munich area, but also exhibited figures and groups in the Paris Salons from 1893 to 1896.

HORN, Paul 1876-
Born in Merseburg on July 22, 1876, he studied under Topfmeyer in Hanover and worked on memorials and portrait figures and busts at Halle-Gröllwitz.

HORNBERGER, Wilhelm 1819-c.1880
Born at Ilbesheim, Germany on February 21, 1819, he died about 1880. He worked as a decorative sculptor in Mannheim and Ludwigshafen.

HORNO-POPLAWSKI, S. fl. 20th century
Sculptor of genre figures, such as workers and peasants, working in Poland since the second world war.

HORSETSKY, Mélaine von 1882-
Born in Vienna on April 7, 1882, she studied under Rodin in Paris and sculpted statuettes and portraits in the inter-war period.

HORVAI, Janos 1873-
Born in Pecs, Hungary in 1873, he studied in Budapest and specialised in monuments, memorials and portrait busts. He is best known for the Kossuth Monument in Budapest.

HORVATH, Adorian 1874-
Born in Gyor, Hungary on February 15, 1874, he studied in Munich, Rome and Paris before settling in Budapest where he sculpted bas-reliefs, portrait busts and genre figures.

HORVATH, Géza 1879-
Born at Marosvasarhely, Hungary in 1879, he studied under Strobl at the Budapest Academy. He specialised in bas-reliefs, plaques and medallions.

HOSAEUS, Kurt Hermann 1875-
Born in Eisenach, Germany on May 6, 1875, he studied under Herter and Begas and worked in Dresden, Nuremberg and Munich. He specialised in genre and heroic figures and was awarded a gold medal at the Berlin Exhibition of 1908 for After the Combat.

HOSE, Heinrich 1765-1841
Born at Tannroda, Germany in 1765, he died in Eisenach in 1841. He worked as a decorative sculptor on Weimar Castle, but also did portrait busts of Saxon royalty.

HOSEL, Erich fl.
Genre sculptor working in Berlin. His bronzes include a figure of a Hun.

HOSKINS, James d. 1791
With his partner Samuel Euclid Oliver he began working for Wedgwood in 1770 as a modeller of bas-reliefs of classical subjects. Two years later he modelled two figures for Mersham Hatch in Kent – Apollo (plaster) and Mercury (lead). In 1775 he began a series of busts of English historical and contemporary celebrities, which were subsequently produced commercially by Wedgwood in basalts. He was official moulder and plaster-caster to the Royal Academy from its inception till his death. His bronzes include eight statuettes, made originally for Lord Delaval's house in Portland Place, London.

HOSMER, Harriet Goodhue 1830-1908
Born at Watertown, Massachusetts on October 6, 1830, she died there on February 21, 1908. She was a poetess as well as a sculptress and studied art under Lenoe in Boston. Later she studied anatomy at St. Louis Medical College before going to Rome where she worked under the English sculptor Gibson from 1852 to 1859 and produced neo-classical figures and groups, mainly carved direct in marble, though maquettes and reductions are also known in bronze. Her best known work is the statue of Thomas Benton in the Roman style (St. Louis), but other works include Zenobia (1862), Beatrice Cenci (St. Louis Public Library), Puck and Faun.

HOUDON, Jean Antoine 1741-1828
Born at Versailles on March 18, 1741, he died in Paris on July 16, 1828. He was an infant prodigy who later became the most famous portrait sculptor of the late 18th century. He entered the old École Royale de Sculpture at the age of twelve and studied under Slodtz and Pigalle. Eight years later he won the Prix de Rome – the youngest winner ever – and worked in Italy till 1770. To this period belong the statues of saints and neo-classical figures, such as Morpheus (1771), many of which were commissioned by Pope Clement XIV and other church dignitaries. Thereafter he concentrated on portrait figures and busts, most of the leading men and women of Europe (and later America) being his sitters. At the time of the Revolution he switched from genre and religious figures to statues which embodied the philosophy of the Convention; thus the figure of St. Scholastica was hastily reworked as the allegory of Philosophy. Though he received few commissions in the Napoleonic period he sculpted busts of the Emperor and Empress Josephine and was made a Chevalier of the Legion of Honour, and sculpted the colossal bas-reliefs of the Grand Army, intended for a monument at Boulogne but never completed. Many of his marble figures and busts were also edited in plaster and bronze.

Diercks, Hermann *Houdons Leben und Werke* (1887). Giacometti, Georges *Le Statuaire J.H. Houdon et son Époque* (1918-19, 3 vols.). Hart, C.H. and Biddle, E. *Life and Works of Jean Antoine Houdon* (1911).

HOURSOLLE, Pierre 1853-1877
Born in Bordeaux in 1853, he died there in 1877. He studied under Jouffroy and Delaplanche and specialised in genre and allegorical figures, such as This Age is Without Pity (now in the Bordeaux Museum). He exhibited at the Salon in 1869 only.

HOUSSAYE, Frédéric 1827-1899
Born in Paris on February 2, 1827, he died there in June, 1899. He studied under Luc and exhibited genre figures at the Salon from 1869 onwards.

HOUSSIN, Edouard Charles Marie 1847-1917
Born in Douai on September 13, 1847, he died in Paris on May 15, 1917. He studied under Jouffroy, Aimé Millet and various sculptors in Douai. He exhibited at the Salon from 1873, winning numerous awards and bronze medals at the Expositions of 1889 and 1900. He produced a number of portrait busts of his contemporaries as well as genre and classical groups. There are many monuments and memorials in the Nord *departement* sculpted by him.

HOUZELOT, Alphonse Alexandre 1802-1857
Born in Troyes on April 8, 1802, he died there on February 2, 1857. He was the son and pupil of the stonemason J.B.T. Houzelot and later worked in the studio of Bosio in Paris. He became professor of drawing at Brienne Military Academy and specialised in portrait reliefs and busts.

HOVE, Johannes Hubertus van 1827-1881
Born in The Hague on March 7, 1827, he died there on November 3, 1881. He was the brother of the landscape painter Hubertus van Hove and himself worked as a painter and sculptor of genre subjects.

HOWARD, Cecil de Blaquière 1888-
Born in Clifton, Canada on April 2, 1888, he studied at the Buffalo School of Art, New York under James Earle Fraser and the Académie Julian, Paris (1905-6). He exhibited at the Salon des Tuileries from 1905 onwards and also participated in American exhibitions. He was a member of the National Society of Sculptors. A sculptor in the classical tradition, he specialised in monumental statuary, but his minor works included numerous nude statuettes, portrait busts and animal figures. Though his larger work was mainly carved direct in stone and marble, many of his smaller figures, maquettes and models were cast in bronze.

HOWARD, Isaac fl. early 18th century
Sculptor working in London and the Midlands in the late 17th and early 18th centuries. He made 'brass' figures of a Tartar horseman, Mercury and a head of Oliver Cromwell for Thomas Coke of Melbourne Hall, Derbyshire.

HOWARD, Walter 1910-
Born in Jena in 1910, he studied at the Berlin Kunsthochschule in 1946-50 and later at the Academy of Arts of the German Democratic Republic under F. Cremer and G. Seitz. He worked in Berlin from 1955 to 1961 and since then has taught at the Technical University in Dresden. He has produced a number of important monuments and memorials in East Germany, of which the Marx-Engels monument in Karl Marx Stadt (Chemnitz) is the best known. He has also modelled bronze portrait busts and statuettes of historical and contemporary personalities in eastern Europe.

HOWES, Edgar Allan 1888-
Born at East Dereham, Norfolk on January 10, 1888, he studied at the Royal Academy schools (winning the Landseer scholarship) and the Slade School of Art and exhibited at the Royal Academy, the Salon des Artistes Français and the Glasgow Institute as well as leading London galleries. He worked in Hammersmith and later in Saffron Walden, Essex and sculpted figures and portraits in stone, marble, wood, glass and bronze.

HOWLAND, Edith fl. 20th century
Born in Auburn, New York in the late 19th century, she studied at the Art Students' League under Daniel C. French and Augustus Saint-Gaudens. Later she worked in Paris under Gustave Michel and exhibited at the Salon des Artistes Français, winning an honourable mention in 1913. She specialised in portrait busts and neo-classical figures, in marble or bronze. Her best known work is the fountain group Tamed Pegasus.

HOYAUX, Émile Joseph fl. 19th century
Born in Mons, Belgium on June 14, 1823, he specialised in portrait busts and bas-reliefs.

HOYER, Wolf von 1806-1873
Born in Dresden in 1806, he died there in 1873. He was employed as a decorative sculptor on the Prussian royal palace of Sans Souci as well as many castles in Saxony. His minor works consist of statuettes and bas-reliefs.

HSIUNG, Ping Ming 1922-
Born in Nanking, China in 1922 he studied philosophy at Peking University and went to Paris in 1947 on a French state scholarship, but abandoned his studies to concentrate on sculpture. He studied at the Académie Julian and worked in the studio of Marcel Gimond. Later he studied at the Académie de la Grande Chaumière and worked with Jeanniot. Up to 1953 his sculpture followed a fairly classical style, influenced by ancient Chinese bronzes of the Han dynasty as well as the work of Rodin. Since then, however, he has experimented with spatial abstracts. He has exhibited at the Salon d'Automne and latterly at the Salon de Mai and the Salon de la Jeune Sculpture. He is primarily an Animalier and has produced numerous figures and groups of birds and animals in plaster, iron and bronze.

HUB, Émil 1876-
Born at Frankfurt-am-Main on February 2, 1876, he studied at the Académie Julian in Paris before settling in his native city. He produced monuments, allegorical figures and portraits and exhibited in Wiesbaden, Munich, Stuttgart and Darmstadt.

HUBACHER, Hermann 1885-
Born in Biel, Switzerland on August 14, 1885, he studied in Geneva and Vienna and worked in Berne, Munich and Paris. His sculptures are in many Swiss public collections, notably the museums of Zürich and Winterthur.

HUBATSCH, Hermann 1878-
Born in Berlin on May 16, 1878, he studied under Manzel and Haverkamp and specialised in portrait busts.

HUBER, Anton 1763-1840
Born in Fügen, Austria in 1763, he died there in 1840. He specialised in religious figures and bas-reliefs, several of which are preserved in Innsbruck Museum.

HUBER, Émil 1858-1896
Born in Lucerne on April 24, 1858, he died at Sarnen on July 25, 1896. He studied under Amlehn and produced portrait busts and statuettes.

HUBER, Jozsef fl. early 19th century
Born at Porsony, Hungary on April 27, 1777, he studied under Franz Reindl in Vienna and worked there, mainly as a decorative sculptor.

HUBER, Karl Georg 1872-
Born in Munich on February 13, 1872, he worked there as a decorative sculptor at the turn of the century.

HUBERT, ? fl. mid-18th century
Statuettes of nymphs and deities from classical mythology, in bronze or terra cotta, bearing this signature were the work of a sculptor working in Paris in the mid-18th century. He was a councillor of the old Académie de St. Luc and exhibited at the Salon in 1752-56.

HUBERT, Raphael 1884-
Born in Paris on June 19, 1884, he studied under Barrias and Coutan and exhibited figures at the Salon des Artistes Français.

HUBRICH, Paul 1869-
Born at Gebhardsdorf, Germany on November 9, 1869, he worked as a decorative sculptor at Friedenau and exhibited figurines, bas-reliefs and portraits at the Berlin Exhibition of 1909.

HUDE, Paula van der 1874-
Born in Berlin on March 15, 1874, she worked in Berlin, Munich and Paris.

HUDELET, Henry Paul 1849-1878
Born in Langre on December 20, 1849, he died in 1878. He studied under A. Dumont and exhibited at the Salon in 1876-78. He

specialised in bas-reliefs, medallions and statuettes, mostly of classical subjects. His bronzes include Fisherman finding the Head of Orpheus on the Banks of the Hebron and The Discus Thrower.

HUDLER, August 1868-1905
Born in Odelzhausen, Germany on December 12, 1868, he died in Dresden on November 21, 1905. He studied under W. von Rümann and Diez at Munich and produced allegorical figures and groups.

HUE, Ernest fl. 19th-20th centuries
Sculptor of genre subjects, working in Paris at the turn of the century. He was a founder member of the Artistes Français in 1883.

HUENERWADEL, Arnold 1877-
Born at Lenzburg, Germany on December 10, 1877, he studied at the École des Beaux Arts, Paris under Barrias and modelled genre figures, mainly in terra cotta.

HUET, Félix Victor fl. late 19th century
Born at St. Pierre les Elbeuf on March 1, 1861, he studied under Decorchemont and exhibited figures and portrait busts at the Salon des Artistes Français. He won honourable mentions in 1885-86 and became an Associate in 1893. He was awarded a bronze medal at the Exposition Universelle of 1889.

HUETTER, Elias 1775-1863
Born in Vienna in 1775, he died there in 1863. He studied under Grassi and was employed as a modeller at the Vienna porcelain factory. His figurines are known in bronze, and he also sculpted portrait busts and reliefs.

HUETTIG, Paul Gottfried 1865-
Born in Leipzig on December 10, 1865, he studied at the Dresden Academy and later settled in Berlin.

HUEVOES VON BOTGA, Laszlo 1883-
Born in Budapest in 1883, he worked in Paris where he sculpted portrait busts, mainly of musicians and composers.

HUF, Fritz 1888-
Born in Lucerne on August 14, 1888, he worked in Berlin after completing his studies in Italy. He specialised in portrait reliefs and busts.

HUGGLER, Arnold 1894-
Born in Brienz, Switzerland on February 12, 1894, he specialised in figures and groups in the neo-realist and stylised forms fashionable in the 1920s. He exhibited in Switzerland and also at the Salon d'Automne as well as the Exposition des Arts Décoratifs, 1925.

HUGHES, John fl. 20th century
Born in Dublin in the late 19th century, he worked there and also for a time in Paris as a sculptor of religious figures and groups, portrait busts and bas-reliefs. He exhibited at the Royal Hibernian Academy from 1915 to 1945.

HUGHES, Robert Ball 1804-1868
Born in London in 1804, he died in Boston, Massachusetts in 1868. He attended the Royal Academy schools in 1818-22, winning silver medals in 1819 and 1822 and the gold medal in 1823 for a bas-relief of Pandora brought to Earth by Mercury. His version of the Barbarini Faun won him the silver medal of the Society of Arts in 1820. He worked as assistant to E.H. Baily (1822-29) and then emigrated to the United States. His marble statue of Alexander Hamilton for the Merchant's Exchange in New York was the first portrait statue erected in the United States. His seated figure of Nathaniel Bowditch the navigator was the first ever to be cast in bronze in the United States. His minor works include numerous portrait busts and genre statuettes.

HUGO, Leopold Armand fl. late 19th century
Born in Paris in the mid-19th century, he studied under Vernet and exhibited figures at the Salon from 1874.

HUGO, Melchior von 1872-
Born in Usingen, Germany on March 23, 1872, he studied under Carrière in Paris and worked in Stuttgart and Nuremberg on memorials and public statuary.

HUGO-KLINGSEISEN Gustave fl. 19th-20th centuries
Born in Vienna, he worked in Paris at the turn of the century and produced genre and idealised statuettes and reliefs.

HUGOULIN, Émile fl. late 19th century
Born at Aix on April 8, 1848, he studied under A. Dumont and exhibited portrait busts and fantasy statuettes at the Salon from 1876, winning a second class medal that year. He also sculpted the series of medallions on the friezes in Toulon Museum.

HUGUENIN, Auguste 1886-
Born in Haute Saône on May 5, 1886, he studied under Patey and Peter and exhibited figures at the Salon des Artistes Français.

HUGUENIN, Jean Pierre Victor 1802-1860
Born in Dôle on February 21, 1802, he died in Paris on January 8, 1860. He studied under Ramey the Younger at the École des Beaux Arts and exhibited busts, statuettes and groups at the Salon from 1835 to 1859, specialising in historical figures. His works are in the museums of Angers, Bourg, Cambrai, Lille and Versailles.

HUJER, Ludwig 1872-
Born in Wilhelmshöhe, Germany on July 2, 1872, he worked in England, France and Germany and specialised in bas-reliefs and medallions.

HUKAN, Karol 1888-
Born near Kolomyio, Poland in 1888, he worked in the Cracow area as a decorative sculptor.

HULIN, Ernest 1882-1915
Born in Coutances on September 29, 1882, he was killed in action during the first world war. He exhibited figures at the Salon des Artistes Français and won an honourable mention in 1908.

HULTZSCH, Hermann 1837-1905
Born in Dresden on April 20, 1837, he died at Blasewitz on December 17, 1905. He worked as a portrait sculptor in the Dresden area.

HUMBEECK, Pierre van 1891-
Born in Brussels on April 27, 1891, he settled in Louvain and specialised in portrait painting and sculpture.

HUMBERT, A. fl. mid-19th century
He worked in Metz in the mid-19th century on genre and historical figures, groups and bas-reliefs. Metz Museum has a plaster version of his Knights in Combat (1852).

HUMPHREYS, Albert d. 1922-
Born in Cincinnati in the mid-19th century, he died in New York in 1922. He studied under Gérome and Robert-Fleury in Paris and worked as a painter and sculptor of genre subjects.

HUMPLIK, Josef 1888-
Born in Vienna on August 17, 1888, he specialised in portrait busts, reliefs and medals.

HUND, Cornelius fl. 20th century
Dutch sculptor of monuments, memorials and architectural decoration active since the second world war. He won the Prix de Rome for the Netherlands in 1947.

HUNDRIESER, Émil 1846-1911
Born at Königsberg on March 13, 1846, he died in Berlin on January 30, 1911. He exhibited at the Berlin Academy and was awarded a gold medal in 1888. He specialised in statuettes and busts portraying German royalty and aristocracy.

HUNOLD, Friedemann 1773-1840
Born at Seebergen on April 30, 1773, he died in Dessau on November 20, 1840. He was a pupil of Schadow and worked as a modeller for a porcelain factory. His genre statuettes are also recorded in bronze and terra cotta.

HUNT, Clyde du Vernet fl. 20th century
One of a well-known American family of architects, he has produced decorative sculpture and bronze statuettes of genre subjects, which he exhibited in France and America before the second world war.

HUNT, F.H. fl. mid-19th century
Sculptor of portraits and genre subjects, working in London in the mid-19th century. He exhibited at the Royal Academy in 1854.

HUNTER, Mary Sutherland 1899-
Born at Holytown, Scotland in 1899, she studied at the Edinburgh College of Art and the Royal Scottish Academy schools where she received the Chalmers Jervise prize in 1922. She worked in Edinburgh, Cornwall and the south of France, mainly as a painter of landscapes and portraits, but also sculpting heads and busts and genre statuettes. She has exhibited at the Royal Scottish Academy.

HUNTINGTON, Anna Hyatt 1876-
Born in Massachusetts on March 10, 1876, she was a member of the National Sculpture Society and the Federation of American Artists and sculpted portraits and genre subjects.

HUNTON, Charlotte fl. late 19th century
Born in Torquay, she exhibited figures and portraits at the Royal Academy in 1892-93.

HUNTON, Edith fl. late 19th century
Sister of the above, with whom she worked as a portrait sculptor in Torquay in the 1880s.

HUPE, Martial E.L. fl. 19th-20th centuries
An Associate of the Artistes Français (1887), he worked as a genre sculptor in St. Pierre-lès-Nemours at the turn of the century.

HUPMANN, A. fl. 19th century
German sculptor of genre bronzes, of which the best known is the statuette of Don Quixote on Rosinante.

HUPPE, Henri fl. late 19th century
Born in Paris in the mid-19th century, he exhibited figures and reliefs at the Salon from 1874 onwards.

HURUM, Per 1910-
Born in Oslo, he has sculpted memorials, monuments and public statuary in and around that city since the 1930s.

HUSSET, Henri Robert 1907-
Born in Mantes, France on June 11, 1907, he studied at the School of Decorative Arts in Paris and was a pupil of Camille Lefèbvre, Hector Lemaire and Pierre Séguin. He exhibited at the Salon des Artistes Français from 1936 onwards, winning a silver medal in 1936 and a gold medal three years later. He became a member of the Institut in 1941 and won a travelling scholarship the following year. Although best known for his classical figures in marble, he has also modelled animal groups, such as panthers, lions and vultures, in plaster, terra cotta and bronze.

HUSSEY, Henry James 1913-
Self-taught sculptor born in London on October 27, 1913. He has exhibited at the Royal Academy and the main London and provincial galleries.

HUSSMANN, Albert Heinrich fl. 20th century
Sculptor born in Germany in 1874, but working in Britain since the 1930s. He is an Animalier specialising in horses. His bronzes include Last Curve, Walter Dear, Finish, Young Stag and Deutsche Wehr.

HUSSON, Honoré Jean Aristide 1803-1864
Born in Paris on July 1, 1803, he died at Bellevue-Meudon on July 30, 1864. He studied under David d'Angers and was runner-up in the Prix de Rome in 1827 but won it three years later. He exhibited at the Salon from 1837, winning a second class medal that year and a first class medal in 1848. He was one of the most fashionable sculptors in France in the latter years of the Monarchy and sculpted many monuments and portraits of royalty and contemporary celebrities. He also produced a number of figures and groups of religious subjects.

Examples of his work may be seen in the museums of Auch, Rodez and Versailles.

HUSZAR, Adolf fl. 19th century
Born at Jakabfalva, Hungary in the early 19th century, he died in Budapest on January 21, 1885. He studied in Vienna and Budapest and settled in the latter city, where he worked as a decorative sculptor.

HUTCHISON, John 1833-1910
Born in Lauriston, Edinburgh in 1833, he died there on May 23, 1910. He was apprenticed to a wood-carver but also studied at the Antique and Life School of the Trustees' Academy, Edinburgh and went to Rome in 1863. He exhibited at the Royal Scottish Academy from 1856, being elected A.R.S.A. in 1862 and R.S.A. five years later. He also exhibited at the Royal Academy from 1861 onwards. He sculpted numerous monuments and memorials in the Edinburgh area and worked in wood, marble and bronze. His best known work is the statue of John Knox in Edinburgh.

HUTER, Andreas 1838-1910
Born in Kannserberg, Austria on November 13, 1838, he died there on May 4, 1910. He specialised in figures and bas-reliefs of religious subjects.

HUXLEY-JONES, Thomas Bayliss 1908-1969
Born in Staffordshire on March 14, 1908, he died at Broomfield, near Chelmsford, Essex in 1969. He studied under R.J. Emerson at the Wolverhampton School of Art (1924-29) and under Ledward, Garbe and Moore at the Royal College of Arts (1929-33). He exhibited statuettes and reliefs in ivory, terra cotta and bronze at the Royal Academy, the Royal Scottish Academy and the leading British galleries. Examples of his sculptures are in several public collections.

HUYBRECHTS, R. fl. 20th century
Sculptor of Belgian origin working in Paris since the second world war. He exhibited at the Salon des Indépendants in 1945 a group entitled Pensée.

HYATT, Anna Vaughn 1876-
Born in Cambridge, Massachusetts on March 10, 1876, she studied under Henry Hudson Kitson in Boston and MacNeil and Gutzon Borglum in New York. She continued her studies in Paris and worked there for many years, exhibiting animal figures at the Salons and becoming an Officier of the Legion of Honour in 1922. She was appointed Curator of Sculpture at the French Museum, New York. She exhibited at the St. Louis World's Fair (1904) and won a bronze medal. Her bronzes include Diana, Jaguar and Reaching Panther (a set of figures intended for gate-posts) and Fighting Elephants. She also produced garden statuary and fountain groups.

HYETT, John Edward 1867-1936
Born in Gloucester in 1867, he died at Sutton-on-Sea, Lincolnshire on November 18, 1936. He studied under Lanteri at the Royal College of Art and graduated in 1910. He exhibited at the Royal Academy and the major London galleries and was elected F.R.B.S. in 1915. He worked in London and Cheltenham before retiring to Sutton-on-Sea. He specialised in portrait busts, reliefs and heads.

HYNES, Gladys 1888-1958
Born in Indore, India in 1888, she died in London in 1958. She studied at the London School of Art under Stanhope Forbes and exhibited at the Royal Academy and the Salon des Artistes Français. She worked in London as a painter and sculptor of figures and portraits.

IAKIMOV, Igor von 1885-
Born in Russia on March 8, 1885, he studied in Paris under Colarossi and in Munich under Hollosy. Later he worked in Paris with Matisse and Bourdelle but settled in Berlin at the end of the first world war and exhibited at the Secession. He specialised in animal groups, genre figures and portrait busts and statuettes, in plaster, wood, pottery, terra cotta and bronze. He was also an accomplished watercolourist.

IANCHELEVICI fl. 20th century
Belgian sculptor working in the mid-20th century, specialising in portrait busts and figures of distinguished Belgians, also allegorical studies, such as Captive Hands.

IANNELLI, Alfonso 1888-
Born at Andretta, Italy on February 17, 1888, he emigrated to the United States and studied under Gutzon Borglum in New York. He specialised in figures and bas-reliefs of religious subjects.

I'ANSON, Charles 1924-
Born in Birmingham on October 28, 1924, he works in Bradford and sculpts portraits, figures, bas-reliefs and decorative work. He has taken part in many British and European exhibitions since 1950 and his work is represented in several leading public collections.

ICARD, Honoré 1845-1917
Born at Tourtouse, France in 1845, he died in St. Germain-en-Laye in 1917. He studied under Dumont and A. Muller and exhibited at the Salon from 1875 to 1882 and the Salon des Artistes Français from 1887, winning a second class medal in 1890 and a first class medal two years later. He was awarded a silver medal at the Exposition Universelle of 1900. He specialised in religious and genre figures and groups, his best known work being The Foolish Virgins.

ICHÉ, René 1897-1955
Born at Sallèles d'Aude, France in 1897, he died in Narbonne in 1955. After seeing voluntary service in the first world war he was apprenticed to a restorer of historical monuments and studied bronze casting under Gravelle and architecture with Auguste Perret. He began exhibiting at the Paris Salons in 1926 and was responsible for many public monuments, notably the series of bas-reliefs at the Exposition Internationale in 1937, and the statue of Joan of Arc in the church of Boulogne-Billancourt. He was awarded second prize at the Paris Peace Festival in 1945. His minor works include numerous portrait busts, reliefs and heads. He was president of the sculptors' union founded by him.

IDRAC, Jean Antoine Marie 1849-1884
Born in Toulouse on April 14, 1849, he died in Paris in 1884. He studied under Guillaume and Falguière and won the Prix de Rome in 1869. He exhibited at the Salon from 1877, winning a first class medal two years later. He also participated in international exhibitions, notably Munich in 1885 where his works were shown posthumously. His best known work is Salambo, of which there are casts in the Chicago and Copenhagen museums, and Wounded Love (casts in the Museum of Modern Art, Paris and the museums of Lille and Quimper). He also sculpted numerous portrait busts.

IELMONI, Charles fl. early 20th century
Born in Viterbo, Italy in the late 19th century, he studied in Paris and later settled there. He specialised in heads and busts, in plaster and bronze.

IERACE, Francesco fl. late 19th century
Born at Polistena, Italy in 1854, he studied under Francesco Morani and became one of the leading Italian sculptors of the 19th century. He exhibited in Naples, Milan and Paris at the turn of the century and was an honorary professor of the Naples School of Fine Arts and the academies of Milan and Bologna. His works include genre and allegorical bronzes, such as Mystique (Havana Museum of Modern Art) and various groups and busts in marble.

IERACE, Vincenzol 1862-
Born at Polistena in 1862, the younger brother and pupil of Francesco Ierace. He exhibited animal figures and groups in Naples, Bologna and Munich at the turn of the century.

IEVSTAFIEFF, Vassili Ivanovitch fl. 19th century
Born in Moscow in 1838, he studied at the St. Petersburg Academy and won numerous awards for his neo-classical bas-reliefs. Later he turned to portraiture and produced busts of his contemporaries.

IFFLAND, Franz fl. 19th century
German sculptor working in Berlin in the late 19th century. He exhibited at the Berlin Academy and the Great Exhibitions of the 1890s, specialising in bronze statuettes inspired by classical and Teutonic mythology, as well as genre groups and busts.

IGHINA-BARBANO, Mary 1865-
Born in Genoa in 1865, he exhibited in Turin from 1884 onwards, and specialised in portrait busts of Dante, Brunelleschi and other medieval Italian personalities.

IGUEL, Charles François Marie 1827-1897
Born in Paris on January 3, 1827, he died in Geneva on December 29, 1897. He studied at the École des Beaux Arts, Paris and worked in Rude's studio. He exhibited at the Salon from 1848 to 1872 and won medals in 1864, 1868 and at the Exposition Universelle of 1889. He specialised in busts of his contemporaries and allegorical figures, in marble and bronze.

ILARIOLI, Antonio fl. 19th century
Born at Cisano, Italy on May 25, 1825, he specialised in marble portrait busts.

ILIENKO, Ievgeni Mihailovich fl. 19th century
He studied at the St. Petersburg Academy and exhibited there from 1870 onwards. He specialised in portrait busts and reliefs. His bronzes include maquettes for monuments to Glinka at Smolensk (1873) and Pushkin in St. Petersburg (1874). His statuette of a Sorcerer won him a silver medal in 1877.

ILKKA, Elias 1869-
Born at Jalasjarvi, Finland on June 25, 1869, he studied at the Helsinki Athenaeum and at the Académie Colarossi in Paris. He carved panels in wood but later did numerous monuments and war memorials and a large number of portrait busts in plaster, marble and bronze.

ILLIERS, Gaston d' 1876-
Born in Boulogne on June 26, 1876, he studied under the Comte de Ruillé and G. Busson and exhibited at the Salon des Artistes Français from 1899. He specialised in animal sculpture, particularly horses, and produced a number of bronze groups of hunters, plough-horses, cavalry chargers and artillery horses from the first world war. He was equally versatile in modelling racehorses, many of which were edited in bronze.

ILLINGWORTH, Nelson fl. 19th-20th centuries
Australian sculptor, working in Sydney at the turn of the century. He specialised in genre subjects, particularly featuring aboriginal life. Sydney Museum has several of his bronzes, including The Father of Islam, Aboriginal Boy, Aboriginal Chief, Aboriginal Woman.

ILLITSCH, Alexander 1860-
Born in Vienna on March 23, 1860, he studied at the Vienna Academy and won a travelling scholarship to Rome. He took part in the exhibitions of the Vienna Artists' Circle and specialised in classical and religious figures, mainly carved in wood or stone, such as Cupid and Venus and Christ on the Cross. He also sculpted busts, genre statuettes and memorial plaques, mainly in bronze.

ILMARI, Johannes fl. 20th century
Born in Breslau in the early years of this century, he studied in Paris and exhibited figures at the Salon des Indépendants and the Salon d'Automne in the 1920s.

IMBAULT, Lucien 1878-1916
Born in Malakoff near Paris on April 3, 1878, he was killed in action in 1916. He specialised in portrait reliefs, medallions and busts, which he exhibited at the Salon des Artistes Français from 1898 till 1914.

IMBERT, Carlos 1870-
Born in Vitoria, Spain in 1870, he was employed as a decorative sculptor on the town halls of Vitoria and Pamplona.

IMHOF, Heinrich Maximilian 1798-1869
Born at Burglen, Switzerland on May 14, 1798, he died in Rome on May 4, 1869. He studied under Franz Abart at Kerns and Dannecker in Stuttgart and travelled in Greece and Italy. He also exhibited at the Royal Academy in London. He specialised in figures and bas-reliefs of biblical subjects, mainly in plaster or marble, but he also sculpted bronze portrait busts of his contemporaries.

IMHOFF, Franz Xaver Bernhard 1766-1824
Born in Cologne on July 14, 1766, he died there on February 24, 1824. He was the son and pupil of Johann Joseph Imhoff.

IMHOFF, Johann Joseph 1739-1802
Born in Cologne on April 9, 1739, he died there on April 13, 1802. He was the son and pupil of Alexander Wilhelm Imhoff, a stone-mason, and executed a number of marble statues and reliefs for buildings in the Cologne area, notably the Cathedral. He also sculpted portrait busts of famous persons in terra cotta and bronze.

IMHOFF, Wilhelm Joseph 1791-1858
Born in Cologne on March 23, 1791, he died there on February 27, 1858. He was the son and pupil of Franz Xaver Bernhard Imhoff and studied at the Berlin Academy. He exhibited at the Berlin Academy and the Cologne Society of Artists, busts, maquettes of a monument to Beethoven and allegorical and classical figures, such as Anatomy, and Venus Bathing.

INDENBAUM, Leon fl. 19th-20th centuries
Sculptor of busts, heads and neo-classical groups, mainly in stone, marble and terra cotta, working in Paris at the turn of the century. He exhibited at the Salon des Indépendants and the Tuileries.

INDONI, Gottardo fl. late 19th century
Born at Ligornetto, near Mendrisio, Switzerland on October 7, 1858, he studied under Vincenzo Vela and worked in London in the late 19th century, exhibiting portraits and genre statuettes at the Royal Academy from 1887 onwards.

INGELS, Frank Lee 1886-
Born in the United States on January 2, 1886, he studied at the Chicago Arts Institute and was a member of the Society of Artists of Chicago. He specialised in figures and reliefs with an agricultural theme. Many of his larger works adorn American universities and agricultural colleges.

INGHAM, Allen fl. 20th century
Born in New Zealand, he studied in London and worked as assistant to Henry Moore for several years. He now teaches sculpture in Australia and has produced a number of monuments and memorials, as well as portrait busts and figures.

INGHAM-SMITH, Elizabeth fl. 20th century
Born in Easton, Pennsylvania in the early years of this century, she studied at the Academy of Fine Arts, Philadelphia under Henry Snell and also studied painting under Whistler in Paris. She is best known for her watercolours and oil paintings, but has also modelled busts and genre figures.

INGRAHAM, Natalie fl. 19th-20th centuries
American sculptress working in New York at the turn of the century. She studied under Aimé Millet and Marcilly in Paris.

INGRAM, Archibald Bennett 1903-
Born in Nottingham on October 4, 1903, he studied art under his father, the lithographer Charles A. Ingram, and then attended the Nottingham School of Art and the Royal College of Art. He was runner-up in the Prix de Rome of 1927. He works as a sculptor and painter in Nottingham.

INGRAM, Walter Rowlands fl. 19th century
He worked in Brussels for several years and exhibited genre figures there, as well as at the Royal Academy and the Grosvenor Gallery from 1862.

INGRES, Théophile fl. 19th century
Born at Ecouen, France on November 19, 1832, he was a cousin of the famous painter. He studied under Possot and Daumas and produced genre and romantic figures.

INJALBERT, Jean Antoine 1845-1933
Born in Béziers on February 23, 1845, he died in January 1933. He was one of the most influential sculptors at the turn of the century and a distinguished member of the French cultural establishment. He made his début at the Salon in 1872 and won the Prix de Rome two years later. Among his many awards were a second class medal (1877), a gold medal at the Exposition Universelle of 1878 and the Grand Prix at the Exposition of 1889. He was a member of the Jury at the Exposition of 1900 and became a member of the Institut five years later. He was appointed successively Chevalier (1887), Officier (1897) and Commandeur (1910) of the Legion of Honour. He took part in many of the major international exhibitions of the period. He was a versatile artist whose work ranged from heads and busts of his contemporaries to genre figures and groups and biblical, classical and allegorical works. He received many important State commissions and sculpted a number of monuments as well as decorative works.

INNOCENTI, Bruno 1906-
Born in Florence in 1906, he worked in that city and also in Rome. Examples of his figures and groups are in the Gallery of Modern Art in Rome.

IOUCHKOFF, S.I. fl. 19th century
Russian sculptor of equestrian statuettes, working in St. Petersburg in the mid-19th century. Examples of his work are in the Russian Museum, Leningrad.

IPOUSTÉGUY, Jean Robert 1920-
Born at Dun-sur-Meuse, France in 1920, he worked entirely as a painter of frescoes and designer of stained glass until 1954 when he turned to sculpture. Under the influence of Adam, Picasso and Brancusi he has concentrated on abstracts modelled in clay and plaster, wrought in iron and carved direct in wood and marble. His abstracts have been exhibited at the Salon de Mai, the Salon des Réalités Nouvelles and the Salon de la Jeune Sculpture since 1956.

IRDI, Salvatore fl. early 19th century
Sculptor working in Naples in the first half of the 19th century. He studied at the Institute of Fine Arts, Naples and won a travelling scholarship to Rome in 1842. He exhibited in Naples from 1837 to 1851 and specialised in classical groups and reliefs, such as Daedalus and Icarus, Samson and Delilah, The Brothers of Joseph bringing the bloody Coat to their Father and Religion Triumphing over Anarchy with the Help of Pope Pius IX and King Ferdinand II.

IRELAND, Raymond Charley 1882-
Born at St. Cloud, France on July 23, 1882, he exhibited figures and groups at the Nationale in the 1920s and later at the Salon des Artistes Français.

IRIMSESCU, Ioan fl. 20th century
Romanian sculptor working in Bucharest since the second world war. He specialises in genre figures and groups illustrating the present-day life in Romania, such as Furnaceman.

IRVOY, Aimé Charles 1824-1898
Born in Vendôme on November 25, 1824, he died at Grenoble on March 18, 1898. He studied under Ramey and Dumont and was runner-up in the Prix de Rome of 1854. He exhibited at the Salon from 1849 to 1879 and is best known for the statue of Ronsard at Vendôme (1872). He was director of the school of sculpture at Grenoble from 1856. His minor works include portrait busts and classical groups, such as Hector begging from the Gods.

ISCHINGER, Hans 1891-
Born in Munich on April 7, 1891, he studied at the Academy and specialised in animal figures, particularly bird-life.

ISELIN, Georges 1874-
Born in Claire-Goutte, France on December 6, 1874, he studied under Mercie and Hector Lemaire. He exhibited at the Salon des Artistes Français, winning a third class medal in 1909. He specialised in genre subjects, such as Filial Love (Gray Museum).

ISELIN, Henry Frédéric 1825-1905
Born at Claire-Goutte on December 14, 1825, he died there in March 1905. He studied under Rude, and exhibited at the Salon from 1844, winning a third class medal in 1852 and a second class medal in 1861. He also won a bronze medal at the Exposition Universelle of 1855 and was made a Chevalier of the Legion of Honour in 1863. He specialised in portrait busts of his contemporaries, mainly in marble. He also sculpted various allegorical works, such as the Spirit of Elegance, in the New Opera House, Paris.

ISELIN, Louis Edouard fl. late 19th century
Born at Claire-Goutte in the mid-19th century, he studied under Millet, Dumont and Cordier and exhibited at the Salon in 1873-74. He specialised in portrait busts. His portrait of Prosper Merimée is in the Museum of Ajaccio.

ISELLA, Louisa fl. early 20th century
Born in Buenos Aires in the late 19th century, she studied in Paris and exhibited genre and allegorical figures at the Salon des Artistes Français in the early 1900s.

ISELLA, Pietro 1812-1871
Born at Morcote, Italy in 1812, he died there in 1871. He studied at the Brera Academy in Milan and later worked with Bianchi in Naples and Pompeii. He specialised in the restoration of ancient and ecclesiastical sculpture and worked on the renovation of Vercelli and Novara Cathedrals.

ISENBERG, Constantin Vassilievitch 1859-1911
Born in St. Petersburg on November 25, 1859, he died there in September 1911. He studied at the Academy in 1882-85 and sculpted a number of monuments in St. Petersburg at the turn of the century, the best known being that dedicated to the crew of the torpedo boat *Steregovchy*, sunk at Port Arthur in March 1904.

ISLER, Ladislaw fl. 20th century
Polish sculptor of portrait busts and figures, both contemporary and historical, working in Warsaw in the early years of this century.

ISOPI, Antonio fl. 18th-19th centuries
Born in Rome in the mid-18th century, he died in Ludwigsburg, Germany on October 2, 1833. He was director of the Institute of Artists at the Ludwigsburg porcelain factory in the late 18th century and professor of the Academy of Fine Arts, Stuttgart. He did a considerable amount of ornamental sculpture in stucco for the castles and palaces in Stuttgart, Ludwigsburg and other towns in the kingdom of Württemberg. He also sculpted vases, groups, figures and bas-reliefs in marble, alabaster and plaster and animal figures in plaster and bronze in addition to the figurines modelled in porcelain.

ISSAKOFF, Vassili Ivanovich 1819-1879
Born in St. Petersburg in 1819, he died there on March 17, 1879. He specialised in portrait busts and reliefs of Russian celebrities.

ISTÓK, János 1873-
Born in Budapest on June 16, 1873, he studied at the academies of Budapest and Munich. He specialised in statues and bas-reliefs of Hungarian celebrities, but also did a number of biblical, allegorical and animalier works, such as David, Energy and the Dog Caesar.

ITASSE, Adolphe 1830-1893
Born in Loumarin, France in 1830, he died in Paris in 1893. He studied under Belloc and Jacquot and exhibited at the Salon from 1864 to 1893. He specialised in busts, portrait reliefs and heads of contemporary personalities. He also sculpted a number of genre and allegorical works, such as The Kiss, The Birth of Love, Astronomy and Science, mainly in marble or plaster.

ITASSE-BROQUET, Jeanne 1867-
Born in Paris on September 25, 1867, she was the daughter and pupil of Adolphe Itasse. She exhibited at the Salon from 1881 and won honourable mentions in 1888 and at the Exposition Universelle of 1889. Later she got a travelling scholarship (1891), a third class medal (1896) and a silver medal at the Exposition of 1900. She did numerous busts and decorative sculpture for the New Opera House and the Trocadéro, Paris.

ITTEN, Johannes 1888-
Born at Herrliberg, near Zürich on November 11, 1888. He studied at the School of Fine Arts, Geneva and concentrated originally on painting and lithography. After the first world war, he moved to Weimar in Thuringia and turned to sculpture, producing architectural statuary and bas-reliefs. He exhibited these works and genre figures, such as The Smoker, in Vienna (1919), Berlin (1922) and Munich (1925).

ITZENPLITZ, Adolf 1821-1883
Born in Magdeburg in 1821, he died in Berlin on March 24, 1883. He specialised in portrait busts of his contemporaries, but also modelled various figures and genre groups intended for public display. His best known work is the group of Children in the Tiergarten, Berlin.

IVANOFF, Anton Andreievich 1815-1848
Born in St. Petersburg on January 28, 1815, he died there on July 15, 1848. He studied at the St. Petersburg Academy and won silver medals in 1832 and 1835 and a gold medal in 1835. He specialised in bas-reliefs and groups of religious subjects, but also produced a series of secular bas-reliefs and genre figures of young boys for the Leningrad Academy of Fine Arts and the Academy Museum.

IVANOFF, Arkip Matveievich 1749-1821
Born in St. Petersburg in 1749, he died there on October 10, 1821. He studied at the Academy in St. Petersburg and won the large gold medal in 1769 for a bas-relief of the Baptism of St. Olga. Later he studied in Paris and worked in the studio of Pajou before going on to Rome where he did allegorical studies and copies of classical works. On his return to Russia he was elected to the St. Petersburg Academy for his statues of Pluto and St. Petersburg Triumphant.

IVANOFF, Michael Ivanovich c.1772-1847
He specialised in portrait busts, mainly of Russian celebrities, but also including such international figures as Schiller.

IVANOFF, Sergei Ivanovich 1828-1903
Sculptor working in St. Petersburg in the 19th century. He specialised in genre figures, examples of which are in the Leningrad museum and the Tretiakoff gallery in Moscow.

IVANOFF, Sinovi Ivanovich fl. 19th century
Born in St. Petersburg in 1816, he sculpted numerous busts and relief portraits of minor Russian personalities of the mid-19th century.

IVATCHEFF, Nasar Adrianovich fl. 19th century
Born in Tomsk in October 1843, he studied at the Academy of St. Petersburg and won a large silver medal in 1868 and a small gold medal two years later. He specialised in genre and classical figures, such as Woodcutter (1870) and Discobolus (1871) — the latter earning him the Russian title of Free Artist.

IVEL, Madame Karl fl. 19th century
Born in Nancy in the mid-19th century, she died there in 1899. She studied under Burdy and exhibited portrait busts at the Salon in 1879-80. She was a Chevalier of the Legion of Honour.

IVES, Chauncey B. 1810-1894
Born in Hartford, Connecticut in 1810, he died in New York in 1894. He worked in Rome for many years, but sculpted monuments and memorials for the United States, notably the statue of Trumbull for the New State House in Hartford. He also sculpted genre figures such as The Little Flower-girl and Rebecca (both in the Metropolitan Museum of Art, New York) and The Savant (Corcoran Gallery, Washington).

IZSO, Miklos 1831-1875
Born at Disznoshorvat, Hungary on September 9, 1831, he died in Budapest on May 29, 1875. He studied under H. Gasser in Vienna and later at the Munich Academy. He specialised in genre and character studies of the Hungarian people, but also did many portrait busts and commemorative reliefs and monuments. His monuments to the poets Csokonai and Petöfi were completed posthumously by A. Huszar.

JABOEUF, Robert A. fl. early 20th century
Born in Paris in the late 19th century, he exhibited figures and groups at the Salon des Artistes Français in the early 1900s.

JABOUIN, Bernard fl. 19th century
Born in Bordeaux on December 7, 1810, he worked there as a mosaist and decorative sculptor. His patron was the Cardinal Archbishop of Bordeaux who commissioned him to decorate many churches in Bordeaux, Paris and Perigeueux.

JACKSON, Charles d'Orville Pilkington 1887-1973
Born at Garlenick, Cornwall on October 11, 1887, he died in Edinburgh on September 20, 1973. He studied at the Edinburgh College of Art (1905-10) and the British School in Rome (1910-11) and exhibited at the Royal Academy, the Royal Scottish Academy, the Glasgow Institute and other galleries in England and Scotland. He was president of the Scottish Society of Arts from 1942 to 1945. He was a prolific sculptor in stone, wood and bronze, and produced a number of monuments in Scotland, the best known being the equestrian statue of Robert Bruce, King of Scots on the battlefield of Bannockburn. He also sculpted numerous portrait busts and reliefs and his work is represented in the major public collections of England and Scotland.

JACKSON, Georges Simeon fl. 19th century
Genre and portrait sculptor working in Paris in the late 19th century. He was elected an Associate of the Artistes Français in 1889.

JACKSON, Harry 1924-
Born in Chicago in 1924, he attended the children's classes at the Chicago Art Institute and worked as a cowboy in Wyoming for four years before enlisting in the U.S. Marine Corps in 1942. At the age of 20 he was appointed the youngest official war artist with the American forces. He also broadcast from the Pacific and narrated the documentary film on the Battle of Iwo Jima. After demobilisation he worked as a cowboy and radio actor in California and Wyoming, but in 1946 he went to New York to study art under Tamayo and Hans Hoffmann. Later he worked for some time in Mexico and designed and painted theatrical sets. In 1950 he met Lipchitz and became an abstract expressionist painter, but returned to more figurative work in 1952. He had his first one-man show of paintings at the Tibor de Nagy Gallery, New York that year. In 1954 he went to Europe and eventually settled in Italy where he has lived since 1961. He was commissioned to paint a series of large murals for the Whitney Museum in Cody, Wyoming (1957-58) and this led him to model scenes from the Wild West which were subsequently cast in bronze. He learned the techniques of modelling and bronze-casting at the Vignali-Tommasi foundry in Pietrasanta. His bronzes were exhibited at Knoedler's Gallery in New York in 1960. He has also been a regular contributor to exhibitions in Europe. His works range from the complex groups entitled Stampede, The Range Burial and The Plantin' to single figures of cowboys and Indians on foot or horseback. These include Bronc Stomper, Setting Perty, Steer Roper, Ropin', To the Gods and Lone Hand and various Pony Express riders. Since 1960, he has also produced figures and groups of peasants, dancers and musicians of Europe and Mexico. Many of his bronzes are painted, using polychrome techniques derived from the classical Greek and Roman traditions.
Getlein, Frank *Harry Jackson.*

JACKSON, John Adams 1825-1879
Born in Bath, Maine in 1825, he died at Pracchia, Tuscany in 1879. He studied in Boston and the Académie Suisse in Paris, specialising in human anatomy. He began exhibiting portrait busts in 1851 and two years later moved to Florence where he studied classical and Renaissance sculpture. He returned to Paris the following year and sculpted a bust of the American Ambassador, Mr. Mason, before going back to Boston at the end of that year. He settled in New York in 1858, but thereafter commuted between America and Florence. His chief works include Musidora (1873) and the monument to American volunteers in the Franco-German war, erected at Lyons in 1874 with its figures of The City, Justice and The War. He sculpted many other allegorical figures, such as Aurora, Peace and Autumn, genre statuettes, bas-reliefs, such as Morning Glory and the series of bronze figures which decorate the gate of the South Reservoir in New York's Central Park. His minor works are in the museums of Boston and New York.

JACOBI, Wilhelm 1863-
Born in Neubrandenburg on December 6, 1863, he studied at the Berlin Academy and specialised in ecclesiastical bas-reliefs and statuary. His minor works include many genre statuettes in bronze, such as Reverie, Coquetry and the Knucklebones Player.

JACOBS, Constant fl. 19th century
Belgian sculptor of the second half of the last century, specialising in busts and statuettes of historical personalities. He took part in the exhibition of the History of Belgian Art, Brussels in 1880. The Plantin-Moretus Museum in Antwerp has his bust of the printer Cornelis van Kiel.

JACOBS, Edouard 1859-
Born in Amsterdam in 1859, he studied at the Brussels Academy and won the Prix de Rome in 1888. He settled in Laren, North Holland in 1909 and specialised in genre figures of Dutch peasants. His best known work is the statue of Navigation at the Peace Palace in The Hague.

JACOBS, Michel 1877-
Born in Montreal on September 10, 1877, he studied under E.M. Ward at the National Academy of Design, New York and the École des Beaux Arts and Académie Julian, Paris under J.P. Laurens. He was a member of the Salmagundi Club and worked in New York and Montreal. His bronzes include heads and busts of distinguished contemporaries, such as Fritz Kreisler and Admiral Peary, and statues and groups such as Rock of all Nations and In Flanders Field.

JACOBSEN, Carl Ludwig 1835-1923
Born at Moss, Norway in 1835, he died in Oslo on December 18, 1923. He was strongly influenced by Torvaldsen and was employed as Sculptor to the King of Denmark. As well as his decorative sculpture and monumental statuary he modelled portrait busts of Scandinavian personalities at the turn of the century.

JACOBSEN, Flora Josepha Christian 1863-
Born in Frederikssund, Denmark on June 17, 1863, she studied at the Copenhagen Academy and specialised in portrait busts and genre bas-reliefs. Her best known work is the memorial to Madame J. Blicher Clausen. She exhibited in Copenhagen from 1906 to 1920.

JACOBSEN, Robert 1912-
Born in Copenhagen in 1912, he was self-taught as a sculptor, though influenced by the work of Rodin and Henri Laurens, Nolde, Klee and Ernst Barlach in the 1920s. He began carving in wood in 1930 and gradually moved towards Surrealism, joining the Danish group of artists, Host, in 1941. The influence of Arp finally converted him to abstract art. After the war, he turned from wood to stone and in the 1950s, began experimenting with metalwork. He exhibits regularly at the Salons de Mai, des Réalités Nouvelles and de la Jeune Sculpture and has had several one-man exhibitions in Belgium, Holland and Denmark.

JACOBSON, Albert 1780-1836
Born in Copenhagen in 1780, he died there on November 28, 1836. He studied at the Copenhagen Academy and exhibited there from 1817 to 1834. He specialised in busts and portrait medallions, particularly of the Danish royal family.

JACOBSON, Lili Angelique Vilhelmine (Mrs. Havell)
fl. 19th-20th centuries
Born in Copenhagen on November 25, 1859, she studied at the Academy from 1889 to 1893 and married the English writer Ernest B. Havell with whom she settled in London. She sculpted numerous portrait busts at the turn of the century.

JACOMETTI, Ignazio 1819-1883
Born in Rome in 1819, he died there on April 22, 1883. He studied at the Academy of St. Luke (1855-58) and became Director of the Papal Collections in 1870. He specialised in ecclesiastical groups and reliefs, mainly in marble, such as The Judas Kiss, and Ecce Homo, both in the Church of San Salvatore in Rome. He produced numerous other religious statues and statuettes for churches in Rome and other Italian towns.

JACOPIN, Achille Emile 1874-
Born at Chateau Thierry, France on November 2, 1874, he studied under Falguière, Carlès and Mercié and exhibited figures at the Salon des Artistes Français, winning a third class medal in 1910.

JACQUEMART, Henri Alfred Marie 1824-1896
Born in Paris on February 22, 1824, he died there on January 4, 1896. He studied at the École des Beaux Arts and worked in the studios of Delaroche and Klagmann. He exhibited animal figures at the Salon from 1847 to 1879. He covered a wide range of subjects, mainly dogs and horses, but including Nubian Dromedary (1879), Camel-driver of Asia Minor (1877) and various Lions, the result of his extensive travels in Turkey, Egypt and the Middle East. Among his non-Animalier works was the colossal statue of Mehemet Ali in Alexandria and various portrait busts of late 19th century personalities. He also modelled figures interpreted in precious metals by Christophle.

JACQUEMART, Nicolas fl. 19th century
Sculptor working in Paris in the mid-19th century. He exhibited statuettes, bas-reliefs and medallions at the Salon in 1849-50.

JACQUEMIN, Etienne 1823-1897
Born at Trois-fontaines-la-Ville on August 6, 1823, he died in 1897. He studied under Brion and exhibited portrait busts in bronze, wax and plaster at the Salon des Artistes Français. His busts include those of Claude Lorrain (Nancy Museum) and Voltaire (St. Dizier Museum).

JACQUES, André 1880-
Born in Paris on May 31, 1880, he studied under Jean Escoula and worked in Chambery, Annecy, Geneva, Paris and London as a painter, engraver, watercolourist and genre sculptor.

JACQUES, E.F. fl. 19th-20th centuries
Sculptor of portrait busts, statuettes and medallions, working in Paris at the turn of the century. He exhibited at the Salon des Artistes Français intermittently from 1889 to 1905.

JACQUES, Marcel fl. 19th-20th centuries
Born in Cherbourg in the mid-19th century, he died there in 1921. He studied under Aubé and Thomas and specialised in heads and busts, mainly in marble. He won a silver medal at the Exposition Universelle of 1900.

JACQUES, Pierre Narcisse 1849-1904
Born at Cousenvoyes, France on October 29, 1849, he died in Geneva on December 17, 1904. He studied under Carpeaux and became professor at the School of Industrial Arts, Geneva. He exhibited there in 1896, and also at the Paris Salon in 1875 and sculpted mainly in stone and wood.

JACQUES, Theodore Joseph Napoleon 1804-1876
Born in Paris on May 12, 1804, he died there on March 30, 1876. He enrolled at the École des Beaux Arts in 1818 and studied under Cartellier and Cortot. He was runner-up in the Prix de Rome of 1828 with his group showing The Death of Hercules. He exhibited at the Salon from 1831 to 1875. He is best known for his colossal bronze allegory of the River Neva in Leningrad. He produced several other monuments in St. Petersburg and Kronstadt and decorative sculpture for The Hermitage.

JACQUIER, Charles François Marie fl. early 20th century
Born at St. Loup-sur-Semeuse in the late 19th century, he studied under Dumont and Perraud and specialised in portrait busts of historical and contemporary personages. He became an Associate of the Artistes Français in 1908.

JACQUIN DE MARGERIE fl. late 19th century
Bronzes thus signed were produced by a sculptor working in Paris in the late 19th century. He was born in Paris on January 16, 1855 and studied under Puech.

JACQUOT, Charles 1865-
Born at Bains (Vosges) on January 12, 1865, he studied under Falguière and Aubé. He exhibited at the Salon des Artistes Français, winning an honourable mention in 1887, a third class medal in 1889 and a silver medal at the Exposition Universelle of that year. He was awarded a travelling scholarship in 1893 and won a further silver medal at the Exposition of 1900 and a first class medal five years later. He specialised in genre and neo-classical statuettes, such as Prayer in the Fields, Joan of Arc on the Eve of Battle and Nymph and Satyr.

JACQUOT, Georges 1794-1874
Born in Nancy on February 15, 1794, he died in Paris on November 25, 1874. He studied under Bosio at the École des Beaux Arts and was runner up in the Prix de Rome of 1817. He won the prize three years later and exhibited at the Salon from 1817 to 1857. He specialised in busts of royalty and contemporary celebrities, classical figures and religious statuary for churches, mainly in marble. His bronzes include The Law of Grace and a bas-relief The Sermon on the Mount. His works are in the museums of Amiens, Bourges, Nancy and Paris.

JADDOULLE, Marin Nicolas 1736-1805
Born in Rouen on April 16, 1736, he died there on March 22, 1805. He studied at the Academy of Rouen and became a member of the Arts Commission in Paris, 1793. He specialised in ecclesiastical ornament, but also sculpted small groups and statuettes of allegorical and classical subjects in terra cotta and bronze.

JADOUIN, Eugène Paul fl. late 19th century
Born in Paris on September 1, 1856, he worked in that city as a decorative sculptor and exhibited at the Salon des Artistes Français in the 1890s.

JAECKLE, Charles 1872-1923
Born in Serienz, Alsace on April 26, 1872, he died in Basle on February 15, 1923. He studied at the School of Arts and Crafts in Munich and worked in that city. He exhibited at the Crystal Palace (1896-1923) and also in Berlin, Dresden and Düsseldorf, and at the Salon des Artistes Français from 1905 to 1912. He specialised in portrait busts in marble and bronze and female statuettes.

JAEGER, Ernst Gustav 1880-
Born in Berlin on May 3, 1880, he specialised in nude figures of young men, portrait busts and animal groups (mainly of monkeys, horses, bulls, deer and dogs). He was strongly influenced by the prehistoric art of the Dordogne and is best known for his statue The First Man (copies in the museums of Magdeburg and Hanover).

JAEGER, Gothilf 1871-
Born in Cologne on June 29, 1871, he studied at the Schools of Arts and Crafts in Iserlohn and Karlsruhe, and the Städel Institute, Frankfurt. He specialised in classical groups and statues, allegorical bas-reliefs, such as War and Peace, and commemorative monuments. His bronzes include Bowls-player, Centaur, Repose after the Fight and Wrestler.

JAEGERS, Albert 1868-
Born in Elberfeld, Germany on March 28, 1868, he was self-taught and emigrated to the United States with his family while still a boy. He was apprenticed to his father, a wood-carver, and worked on ecclesiastical sculpture in Cincinnati. Later he studied sculpture at the Cincinnati Art Academy under Louis J. Rebisso and architecture in the office of Lucien Plymton. In his later years he was able to continue his studies in London, Paris and Rome. He received many commissions for decorative sculpture, statues and monuments in the United States, especially for the great World's Fairs. He was awarded a bronze medal at St. Louis in 1904. Among his minor sculptures were genre bronzes and reliefs, such as Sun-Dial.

JAEGERS, Augustine 1878-
Born in Barmen on March 31, 1878, she was a younger sister of Albert Jaegers. She studied at the Art Students' League and the National Academy of Design, New York and the École des Beaux Arts, Paris under Mercié and sculpted genre figures.

JÄGER, Hans fl. 19th-20th centuries
Born in Teschen (now part of Czechoslovakia) on August 19, 1844, he worked in Aussig, Bohemia as a heraldic sculptor. His best known works were the decorative sculpture for the Leipzig Central Station (1911-12) and the Schicht Factory in Aussig. His minor works included busts, statuettes and bas-reliefs.

JAGGER, Charles Sargeant 1885-1934
Born at Kilnhurst, Yorkshire on December 17, 1885, he died in London on November 16, 1934. He was the brother of the painters David and Edith Jagger and studied at the Sheffield School of Art and the Royal College of Art under Lanteri. After winning a travelling scholarship he worked in Venice and Rome and won the Rome scholarship in sculpture in 1914. During the first world war he served in France and Gallipoli, was wounded three times and awarded the Military Cross. He recorded his war experiences in a bronze bas-relief No Man's Land (now in the Tate Gallery). He was elected F.R.B.S. in 1921 and A.R.A. in 1926 and won the R.B.S. gold medal in 1926 and 1933. His best known work is the Artillery Memorial at Hyde Park Corner. His bronzes include the portrait of Sir Ernest Shackleton (Royal Geographical Society) and the figure of Christ for the Society of the Sacred Mission, Kelham.

JAHN, Adolf 1858-
Born in Stettin on December 17, 1858, he studied at the academies of Berlin and Vienna. He worked in Berlin and exhibited at the Academy from 1891 to 1918 and also at the Great Exhibition of Fine Arts. He specialised in statuettes, groups, busts and bas-reliefs portraying contemporary German personalities, historic cultural figures and Shakespearean characters. He also sculpted a number of allegorical female busts.

JAHN, Adolf Moritz 1803-1881
Born in Kiel on July 25, 1803, he died in Copenhagen on September 24, 1881. He studied at the academies of Copenhagen and Berlin and assisted Thorvaldsen in Rome on his statue of the Apostle Thomas. On his return to Denmark he worked on the decoration of Frederiksborg Castle. His minor works include busts and bas-reliefs of classical subjects.

JAHN, Carl Ernst Albrecht 1844-1912
Born in Berlin on January 27, 1844, he died in Helsinki on January 9, 1912. He studied at the Berlin Academy and worked in London and Dresden. He exhibited at the Royal Academy from 1868 to 1873 and sculpted medallion portraits of Beethoven and Martin Luther and English literary personalities, such as Dickens and Tennyson. The Helsinki Athenaeum has a number of the original wax models for his plaques and medallions.

JAHN, Gustav 1850-1904
Born at Kreutzen, Austria on August 22, 1850, he died in Vienna on September 26, 1904. He studied at the Vienna Academy and worked on fountains, colonnades and façades in the Vienna area.

JAKIC, Richard 1872-
Born in Graz, Austria on March 2, 1872, he studied under Kundmann and worked as a decorative sculptor in Prague and Vienna.

JALEA, Joan 1887-
Born in Bucharest, Romania in 1887, he studied at the Bucharest Academy and the Académie Julian in Paris. He worked for many years in Paris and specialised in classical and allegorical figures and groups, such as Hercules wrestling with the Centaurs, Faun playing the Flute and Peace. He sculpted the war memorial at Dieuze (Moselle) in 1920.

JALEY, Jean Louis Nicolas 1802-1866
Born in Paris on January 27, 1802, he died in Neuilly on May 30, 1866. He studied under Cartellier at the École des Beaux Arts and was runner-up in the Prix de Rome of 1824, winning the prize three years later. He exhibited at the Salon from 1824 to 1863 and won a first class medal in 1827. He became a Chevalier of the Legion of Honour in 1837 and a member of the Institut in 1856. He specialised in allegorical statuary, such as Shame, Painting, Force and Justice, and also sculpted numerous portrait busts of Napoleonic heroes and celebrities of the Second Empire, in marble and bronze.

JAMAIN, Emile Theodore fl. 19th-20th centuries
Born at Fumay, France in the mid-19th century, he specialised in ivory and bronze statuettes, reliefs and medallions. He exhibited at the Salon des Artistes Français, winning an honourable mention in 1890 and a third class medal in 1907.

JAMPOLSKY, Michael 1874-
Born in Kiev on December 13, 1874, he emigrated to France and was later naturalised.

JANACOPOULOS, Adrienne fl. 20th century
Born in Buenos Aires of Greek parentage, she studied in Paris and exhibited statuettes at the Salon d'Automne in the inter-war years.

JANCIĆ, Olga 1929-
Born in Bitola, Yugoslavia in 1929, she studied at the Belgrade Academy and worked in the studio of Tomo Rosandic. She has exhibited abstracts, mainly in stone, in Belgrade, Ljubljana, Zagreb, Trieste and London since 1952 and has participated in international exhibitions in Milan, Warsaw, Brussels and Vienna. She is one of the most prominent Yugoslav sculptors to emerge in the post-war period.

JANDA, Johannes 1827-1875
Born in Breslau on January 3, 1827, he died there on November 14, 1875. He studied at the School of Fine Arts in Breslau and went to Rome in 1867. He exhibited in Berlin from 1852 to 1874 and specialised in religious sculpture, mainly in wood and ivory. His secular work included a number of portrait busts and statuettes of horses and hunting dogs, in terra cotta and bronze.

JANENSCH, Gerhard Adolf 1860-
Born in Berlin on April 24, 1860, he exhibited romantic, genre and heroic figures at the Berlin exhibitions, winning a gold medal in 1892.

JANETSCHEK, Hans 1892-
Born in Salzburg on January 27, 1892, he studied locally and later attended classes at the Institute of the Conservatory of Arts and Crafts. He worked in Berlin and specialised in animal and human figures, heads and busts.

JANKOVITS, Gyula 1865-
Born in Budapest in 1865, he studied at the School of Arts and Crafts and later went to the Munich Academy. He won the Franz Josef I Prize in 1888 for his group of The Virgin and repentant Magdalene. Later he studied at the Vienna Academy for six years before returning to Budapest where he sculpted many statues and monuments. His minor works include Flight of Birds, Deluge and Fighting Amazons.

JANNIOT, Alfred Auguste 1889-
Born in Paris on June 13, 1889, he specialised in the painting of frescoes and the sculpting of bas-reliefs and friezes, the best known being the decorations in the Musée des Colonies at Vincennes. He exhibited at the Salon des Artistes Français and the Tuileries and was a Chevalier of the Legion of Honour.

JANSON, Louis Charles 1823-1881
Born at Arcis-sur-Aube on November 4, 1823, he died in Paris on March 26, 1881. He studied under Ramey and Dumont and exhibited at the Salon from 1850 to 1880. He produced bas-reliefs and statues in plaster and stone, and also allegorical statuettes and groups in bronze, such as Grief (casts in Bergues and Epinal museums). Many of his works were inspired by medieval history and classical mythology.

JANSONS, Karlis 1896-
Born in Nitaure, Latvia, in 1896, he studied under K. Ronczewski and attended the Academy of Fine Arts, Riga in 1925-28. He produced a number of monuments in Riga, and specialised in heads, busts and relief profiles. He was represented in the Exhibition of Lettish Art, Paris, 1939.

JANSSEN, Karl fl. 19th-20th centuries
Born in Düsseldorf on May 29, 1855, he was the younger brother of the painter Peter Johann Janssen. He studied at the Düsseldorf Academy and went to Rome in 1881. Later he became professor of

sculpture at the Düsseldorf Academy. He took part in the annual Berlin exhibitions and won a medal in 1902. His bronzes include The Stone-breaker and various classical groups.

JANSSEN, Marie Hermione 1876-
Born in Paris on January 30, 1876, she worked at Herrsching-am-Ammersee, Bavaria. She began as a sculptor in a general way, sculpting fountain ornaments and statuary, reliefs, portrait busts and medallions, but later concentrated on marionettes and eventually turned to ceramics. She exhibited in Nuremberg, Munich, Ghent and Sao Paulo.

JANSSEN, Ulfert 1878-
Born in Silesia on December 11, 1878, he studied at the Munich Academy and settled in Stettin. He specialised in monuments and public statuary, fountains and bas-reliefs in the classical tradition. His best known work is the tomb of Wagner at Zweibrucken. He produced a large number of portrait busts of German and Scandinavian celebrities in marble, granite, basalt, iron, wax and bronze.

JANSSENS, François Joseph 1744-1816
Born in Brussels in 1744, he died there on December 22, 1816. He studied in Brussels and Rome and specialised in statuettes of classical and biblical figures. Many of his models have been preserved in Brussels museums.

JANSSENS, Jean Martin 1764-1856
Born in Brussels in 1764, he died there on February 11, 1856. He worked as a decorative sculptor in the Brussels area.

JANSSON, Viktor Bernhard 1886-
Born in Helsinki on March 1, 1886, he studied at the School of Fine Arts in Helsinki and spent three years in Paris where he worked under Injalbert. His best known work is the granite figure of an athlete in Helsinki and he also sculpted bronze memorials in Tammerfors and Lahti. His minor bronzes consist of busts and masks of Finnish celebrities.

JANUSZKIEWICZ fl. 20th century
Genre bronzes of workers and peasants with this signature are the work of a sculptor working in Poland.

JANVIER, Lucien Joseph René 1878-
Born in Paris on August 17, 1878, he studied under Puech and exhibited genre figures and portraits at the Salon des Artistes Français at the turn of the century.

JAQUET, Désiré Alfred 1873-
Born in Paris on June 28, 1873, he studied under Falguière, Mercié and Guilbert and exhibited figures and groups at the Salon des Artistes Français in the period before the first world war.

JAQUET, Jacques 1830-1898
Born in Antwerp in 1830, he died there in July 1898. He studied under Geefs and was appointed professor at the Academy of Fine Arts at the relatively early age of 40. He sculpted many official monuments and statues and was one of the leading Belgian sculptors of the period. His minor works include portrait medallions and busts.

JAQUET, Jan Jozef 1822-1898
Born in Antwerp in 1822, he died in Brussels on June 9, 1898. He studied under Geefs and became a professor at the Brussels Academy. He specialised in allegorical groups and busts, mainly in marble.

JAQUET, Jean 1765-1839
He worked in Geneva and specialised in portrait busts of Swiss and French celebrities of the early 19th century. His works are in the Rath Museum.

JARA, Antonio de la fl. 19th century
Born at Veley near Malaga, he worked there and also in Santiago and Benamargosa as a decorative sculptor.

JARAY, Sandor 1870-
Born in Temesvar, Hungary (now Timisoara, Romania) on January 11, 1870, he worked as a sculptor of genre and allegorical figures. He took part in the Berlin Exhibition of 1909.

JARDELLA, Aristide fl. early 20th century
Born in Carrara in the late 19th century, he studied in Paris under Alfred Boucher and exhibited figures and portraits at the Salon des Artistes Français, winning a third class medal in 1906.

JARL, Otto 1856-1915
Born in Uppsala, Sweden on April 10, 1856, he died at Dornbach, near Vienna on November 16, 1915. He studied at the Stockholm Technical School and was a pupil of Björnsterne Björnsen before going to the Vienna Academy. At first he sculpted portrait reliefs and busts, but later he specialised in animal figures. He is best known for the figure of a Polar Bear, which is known in porcelain as well as bronze. The Fire Brigade Museum, Vienna has a group of firemen by him.

JARL, or JÖRGENSEN, Viggo Hieronimus 1879-1965
Born in Copenhagen on November 28, 1879, he died at Cannes in March 1965. He studied in Paris under Victor Ségoffin and won the Prix de Rome. He exhibited at the Salon des Artistes Français and won an honourable mention in 1905. He specialised in genre and allegorical groups and figures, such as Broken Wings and Evil Thought.

JAUZION, Jeanne fl. 19th-20th centuries
Born in Paris on April 19, 1851, she studied under Rouland, Rolard and Injalbert and exhibited busts and allegorical statuettes at the Salon des Artistes Français at the turn of the century.

JAYET, Clément 1731-1804
Born in Langres on February 27, 1731, he died in Lyons in 1804. He specialised in portrait busts, reliefs and medallions.

JAYEZ, Léon 1878-
Born in Besançon on January 1, 1878, he sculpted genre figures and portraits in the early years of this century.

JEAN, Auguste Toussaint fl. 19th century
Born at Rocanval-Amencourt in the early 19th century, he studied in Paris under Dubray and Lebourg and exhibited busts, bas-reliefs and medallions at the Salon in 1861-63.

JEANNERET, Charles Edouard (known as Le Corbusier) 1887-1965
Born in La Chaux de Fonds, Switzerland on October 6, 1887, he died in Roquebrune-Cap-Martin on August 27, 1965. His pre-eminence as an architect, designer and writer have tended to overshadow his work as a painter and sculptor of abstracts in the Cubist idiom. He studied in Paris and Berlin and exhibited watercolours and sculpture in Zürich in 1916.

JEANNEST, Louis François fl. early 19th century
Born in Paris in the late 18th century, he studied under Rolland and exhibited at the Salon in 1812-15. He specialised in medallions and bas-reliefs in wax and ivory, and bronze statuettes of French historic figures.

JEANNIN, René Félicien fl. late 19th century
Born in Paris in the mid-19th century, he exhibited figures at the Salon des Artistes Français in the 1890s.

JEAUSENNE fl. mid-19th century
Bronzes bearing this signature were produced by a sculptor, working at Avignon in the 1850s.

JEFFERSON, Robert d. 1870
English sculptor specialising in high-reliefs and portrait statuettes of prominent English personalities of the early 19th century. He exhibited at the Royal Academy from 1853 to 1860. His works include a high-relief of the Entry of the Duke of Wellington to Madrid and a statuette of The First Prince of Wales.

JEFFS, James Gunyeon (Tim) 1904-1975
Born in Dumfries, Scotland on April 25, 1904, he was drowned in a boating accident on Loch Ken on September 28, 1975. He was educated at Dumfries Academy and served his apprenticeship as a motor mechanic, later working for Arrol-Johnston and building his own car which he raced at Brooklands. For several years he taught metalwork and woodwork at Dumfries High School, and was also Curator of the Burgh Observatory Museum. In 1945 he settled in Kirkcudbright and practised a wide range of crafts. Though entirely self-taught, he worked as a painter, draughtsman, wood-carver and

weaver. While best known for his freedom caskets and illuminated burgess tickets commissioned by many Scottish burghs, he also sculpted portraits and bas-reliefs, even doing the bronze-casting himself. His bronzes include heads of Sir Harry Fildes (1930) and the actor John Laurie, portrait reliefs of G.W. Shirley (Ewart Library) and the Rev. Harold Cockburn (St. Michael's Church), the Bruce memorial plaque at Castledykes and the bas-relief of 18th century Dumfries on the Mid-Steeple.

JEGOU, Jean 1899-
Born in Paris on February 14, 1899, he studied at the École des Beaux Arts and won a travelling scholarship in 1924. He exhibited figures and groups at the Salon des Artistes Français in the inter-war years.

JÉHOTTE, Louis 1803-1884
Born in Liège on November 7, 1803, he died in Brussels on February 3, 1884. He was the son of the engraver Léonard Jéhotte and studied under Kessel and Thorvaldsen in Rome. He settled in Brussels in 1830 and sculpted genre, religious and historic statuettes and busts of 19th century Belgians.

JELOVSEK, David 1879-
Born in Zagreb on December 25, 1879, he studied at the School of Arts and Crafts in Munich and later established a studio in that city. He specialised in decorative sculpture and monuments and did the bas-reliefs of St. George at Schloss Babenhausen. He also sculpted a number of portrait busts in the 1920s.

JELTSEMA, Frederik Engel 1879-
Born in Uithuizen, Holland on October 4, 1879, he studied at the Academy of Amsterdam and won the Prix de Rome in 1903. Later he studied under J.C. Champlain in Paris and settled at Scheveningen near The Hague. He specialised in busts and statues in bronze and marble of Dutch celebrities as well as classical and allegorical figures such as Morning and Bacchante.

JENDRITZKO, Guido 1925-
Born in Kirchhain, Silesia (now in Poland) in 1925, he studied at the Berlin School of Art in 1950-56 and worked in the studio of Karl Hartung, winning a travelling scholarship and the Critics' Prize in the latter year. He had his first one-man show in 1953, in Berlin and Frankfurt and took part in the Cassel Documenta and Middelheim exhibitions of 1959. His earliest works were carved direct in marble, then he turned successively to slate and sheet metal before favouring stone and bronze. His works are purely abstract, originally geometric but derived from plant forms in more recent years.

JENKINS, F. Lynn fl. 20th century
Born in Devon, he studied at the Royal Academy schools and later worked in Paris and Rome. He specialised in portrait busts, decorative sculpture, garden statuary and fountains. His minor bronzes include neo-classical statuettes, such as Diana and Daphne, portrait busts and allegorical heads, such as Peace in Exile.

JENNER, Anton Detlef fl. early 18th century
He died in Brunswick on June 26, 1732, having worked in that city as an ornamental sculptor and wood-carver, specialising in the decoration of churches.

JENNEWEIN, Carl Paul 1890-
Born in Stuttgart on December 2, 1890, he emigrated to the United States and studied at the National Academy of Design and the Art Students' League, New York. He specialised in ornamental sculpture for theatres, shops and hotels in New York, but also did several monuments and memorials and the bronze group on the Darlington memorial fountain. His minor bronzes include neo-classical groups, such as Cupid and Gazelle and Nymph and Fawn and allegorical statuettes, such as Comedy.

JENNINGS, Benjamin fl. 19th century
English sculptor working in Rome in the late 19th century, specialising in busts and neo-classical statuettes, mainly in marble.

JENNINGS, Leonard 1877-1956
Born in Acton, London on November 10, 1877, he died in London on October 5, 1956. He studied at the Lambeth and Glasgow Schools of Art and the Royal Academy schools and was employed by the Indian government on decorative sculpture for public buildings (1907-9).

Among his best known works are the statues of King Edward VII at Bangalore and the Prince of Wales in Bombay. After serving in France and Belgium in 1916-19 he settled in London.

JENSEN, David Ivanovich 1816-1902
Born in Copenhagen on November 9, 1816, he died in St. Petersburg in 1902. He studied at the Copenhagen Academy from 1832 to 1841 and won a silver medal (1837) and a gold medal (1841), the latter being awarded for his group of Jesus at the Home of Martha and Mary. Princess Maria Nicolaievna invited him to St. Petersburg where he spent the rest of his life. He sculpted the decoration on the imperial palaces and also executed a number of public statues in the classical tradition in St. Petersburg and Moscow. In 1845 he founded a ceramics factory in St. Petersburg which produced many bas-reliefs, busts, statues, fountain groups and vases.

JENSEN, Georg 1866-1935
Born at Raavad near Copenhagen on August 31, 1866, he died there in 1935. He studied at the Copenhagen Academy from 1887 to 1892 and sculpted portrait busts and genre figures, such as The Boar Hunt (1894) and Springtime. His work as a sculptor, however, was completely overshadowed by his activities as a jeweller and silversmith, specialising in the design of table wares in the modern Scandinavian idiom.

JENSEN, Laurits fl. late 19th century
Born in Viborg on August 22, 1859, he studied in Copenhagen and specialised in animal figures and groups, especially of hunting dogs, equestrian statuettes of Danish royalty and genre figures. Randers Museum has his group Two Christians in the Arena.

JENSEN, P. Marius 1883-
Born in Fredericia, Denmark on February 8, 1883, he went to Germany in 1901 and worked in Dresden and Berlin, latterly as assistant to C. Bernewitz. He specialised in neo-classical bronzes, such as Psyche, Icarus, Warriors after Combat, and bas-reliefs and statuary in stone, the latter mainly in the Cassel area.

JÉRAMEC, Gabriel fl. early 20th century
Born in Paris in the late 19th century, he studied under Marc Robert and exhibited statuettes at the Salon des Artistes Français, winning an honourable mention in 1910.

JERICHAU, Jens Adolf 1816-1883
Born at Assens in 1816, he died at Neder Draaby in 1883. He studied in Copenhagen before becoming Thorvaldsen's assistant in Rome. On his return to Denmark he became one of that country's leading sculptors and produced many public monuments and bas-reliefs of classical and biblical subjects. His minor works include genre figures and groups, particularly featuring young girls, and allegorical figures, such as Angel of Death and Resurrection.

JERMAN, Karl 1868-
Born in Berlin on December 29, 1868, he exhibited at the Academy from 1892 to 1915, and specialised in genre and allegorical works, such as Death Throes (Albertinum, Dresden).

JERNDAHL, Aron fl. late 19th century
Born in Sweden in 1858, he specialised in genre figures, busts, reliefs and masks in bronze. His works include Mask of the Carnival of Life (Stockholm Museum) and Young Peasant (Göteborg Museum).

JESPERS, Emile Louis 1862-
Born in Antwerp in 1862, he specialised in genre figures and portrait busts, many of which are preserved in the museums of Brussels and Antwerp and the Simu Museum, Bucharest. He exhibited at the Brussels and Paris salons from 1893 and took part in the Brussels Exposition of 1910.

JESPERS, Oscar 1887-
Born at Borgerhout, Belgium in 1887, he was the son and pupil of Emile Louis Jespers. Later he attended the Academy and the Institute of Fine Arts in Antwerp where he studied under Thomas Vincotte. At first he was strongly influenced by Rik Wouters but later turned to Cubism. After the first world war he joined the Sélection group and tended towards Expressionism and from 1937 onwards he abandoned the abstract altogether in favour of figurative sculpture. He was exceedingly versatile in his use of materials such as polychrome wood,

beaten copper, carved stone and bronze. He was elected to the Flemish Royal Academy in 1941 and in more recent years was Chairman of the commission on sculpture for the Royal Fine Arts Museums of Belgium. He participated in the major international exhibitions in Brussels and Paris (1935-37) and was represented in the International Exhibition of Contemporary Sculpture at the Rodin Museum, Paris in 1956.

JETOT, Ernest Charles Molière fl. 19th century
Born in Paris on January 16, 1845, he specialised in bronze medallions and bas-reliefs which he exhibited at the Salon in 1870-73.

JEUNOT, Charles 1836-1888
Born in Vevey, Switzerland in 1836, he died at Estavager on May 18, 1888. He studied at Lons-le-Saulnier and Paris and worked as a decorative sculptor of public buildings and churches. His best known work is the memorial to French Internees at Estavager.

JEVRIC, Olga 1922-
Born in Belgrade in 1922, she studied at the Academy and the Conservatory of Fine Arts and has exhibited sculpture in Yugoslavia and internationally since 1948, including the Venice Biennales, Middelheim, Brussels (World's Fair, 1958), Milan and Turin. Prior to 1954 she concentrated largely on portrait busts but since then has produced increasingly non-figurative works, in iron as well as bronze.

JEWETT, Maude Sherwood 1873-
Born at Englewood, New Jersey on June 6, 1873, she was a pupil of the Art Students' League, New York and also worked in the studios of various sculptors for several years. She became a member of the American Federation of Arts and sculpted memorials, monuments, fountain statuary and sundials. She also produced a large number of portrait statuettes.

JIMINEZ ASTORGA, Gumersindo fl. 19th century
Spanish sculptor working in Seville, where he exhibited from 1858 onwards. He produced a number of historical figures, bas-reliefs and portraits. His best known work is the Murillo monument (1861).

JIMINEZ SARABIA, Rafael fl. 19th century
Genre sculptor, working in Cordoba in the second half of the 19th century. He exhibited figures and groups in Madrid from 1878 onwards.

JOACHIM, Joseph (known as Superi) fl. 19th-20th centuries
German sculptor working in Paris at the turn of the century. He was elected Associate of the Artistes Français in 1906.

JOAS, Joseph 1807-1857
Born in Gais, Tyrol in 1807, he died in Vienna in 1857. He produced genre, neo-classical and equestrian statuettes, such as Greek Archer, Paris and St. George and the Dragon, and an equestrian bas-relief of Prince Windischgrätz. His works are in the Ferdinandeum, Innsbruck.

JOBBAGY DE TUR, Miklos 1882-
Born in Budapest on May 13, 1882, he worked in that city as a sculptor of portrait busts of Austro-Hungarian royalty and aristocracy and genre figures, particularly of male and female harvesters and farm-workers. He exhibited at the Crystal Palace, Munich from 1907 and also the International Art Exhibition in Mannheim.

JOBST, Heinrich 1874-
Born at Schönlind, Bavaria on October 6, 1874, he studied at the Munich Academy and did many public statues and fountains in that city in the neo-classical idiom. In 1906 he went to Darmstadt at the behest of Grand-Duke Ernst Ludwig, and sculpted the two bronze lions at the Hesse National Museum, Darmstadt. He sculpted numerous busts of the Hesse royal family and German celebrities of the period. He belonged to both the Munich and Berlin Secessions and also exhibited in Cologne in 1907. He was awarded a gold medal at the Munich International Exhibition of 1909.

JOCHEMS, Franz fl. 19th-20th centuries
Belgian sculptor, working in Brussels at the turn of the century. He showed genre figures at the Brussels Exhibition of 1910.

JOCHUMSEN, Peter Niels 1795-1866
Born in Copenhagen on November 1, 1795, he died there on February 2, 1866. He studied at the Copenhagen Academy and won silver medals in 1817 and 1820. He worked as a decorative sculptor on Fredensborg Castle and specialised in marble reliefs.

JOENSSON, Anders 1883-
Born in Malmö, Sweden on December 30, 1883, he studied in Stockholm and Paris and won an honourable mention at the Salon des Artistes Français in 1909. He specialised in female busts and torsos, examples of which are in the museums of Malmö and Stockholm.

JOFFRE, Félix 1903-
Born in Marcille on March 26, 1903, he studied in Paris under Jean Boucher and won the Prix de Rome in 1929. He specialised in allegorical statuettes and groups, such as Summer.

JOHANSEN, Nanna Viga 1888-
Born in Copenhagen on May 2, 1888, she studied at the Academy in 1912-14 and won a gold medal in 1916 for a bas-relief of the Daughter of Pharaoh finding Moses. She exhibited regularly in Copenhagen from 1911 onwards, specialising in portrait busts and classical and biblical groups, such as Tobias and the Fish and Venus and Cupid.

JOHMANN, Eugène Félix 1852-1884
Born in Nancy in 1852, he died there in 1884. At the Salon des Artistes Français in 1883 he won an honourable mention for genre figures. His Sleeping Child is in the Nancy Museum.

JOHN, Sir William Goscombe 1860-1952
Born in Cardiff on February 21, 1860, he died in London on December 15, 1952. He studied at Cardiff School of Art, the City and Guilds School and the Royal Academy schools, winning gold medals and a travelling scholarship which took him to Paris (1890-91) where he studied under Rodin. He gained an honourable mention at the Salon of 1892 and a gold medal at the Exposition Universelle of 1900. He was elected a corresponding member of the Institut de France. He travelled widely in Europe and the Middle East and this was reflected in his portrait sculpture and genre figures. He exhibited at the Royal Academy from 1884 and was elected A.R.A. in 1899 and R.A. in 1909. He was knighted two years later, at the Investiture of the Prince of Wales at Caernarvon. He was awarded a first class medal at the Salon des Artistes Français in 1901 and the R.B.S. gold medal in 1942. He received numerous important public commissions and sculpted many monuments, memorials and statues, including King Edward VII (Cape Town), Sir Stanley Maude (Baghdad) and Viscount Wolseley in Horse Guards Parade, London. His minor bronzes include numerous portrait busts, including many of children, plaques, bas-reliefs and medallions, and the Silver Jubilee medal of 1935. His genre figures include The Elf (Glasgow Museum), Morpheus (Cardiff Art Gallery), St. John the Baptist, and The Boy at Play (Tate Gallery).

JOHNSEN, Sverre 1884-
Born in Oslo on December 19, 1884, he studied painting at the Oslo Academy and later worked on humorous wood-engravings and caricatures done in the style of Japanese woodcuts. He also sculpted ecclesiastical decoration in Norway and Sweden, but no bronzes have been recorded so far.

JOHNSON, Adelaide fl. 20th century
Born in Plymouth, Illinois in the late 19th century, she studied under G. Monteverde and Falbi-Altini in Rome before settling in Washington, D.C. where she specialised in portrait busts and statues. Her best known work is the monument in the Capitol, Washington honouring the pioneers of women's suffrage in America, Lucretia Mott, Elizabeth Cady Stanton and Susan B. Anthony. Many of her portrait sculptures are in the Metropolitan Museum of Art, New York and the Chicago Historical Society.

JOHNSON, Blucher 1816-1872
Born in Dublin in 1816, he died there in 1872. He worked as a decorative sculptor and interior designer in Dublin.

JOHNSON, Eli c.1850-1881
Born about 1850, he died in Northampton on January 14, 1881. He exhibited at the Royal Academy in 1878-80 and specialised in portrait busts, in marble, terra cotta and bronze.

JOHNSON, Grace Mott 1882-
Born in New York City on July 28, 1882, she was a pupil of the Art Students' League under Hermon A. MacNeil and Gutzon Borglum and later studied in Paris, exhibiting at the Salon des Artistes Français in 1910. She participated in the Panama-Pacific Exposition, San Francisco in 1915 and at the Whitney Studio Club exhibitions in the 1920s. She specialised in animal figures, groups and bas-reliefs. Her bronzes include Chimpanzees, Gunda, and White-tailed Deer walking (bas-reliefs); Calf Stretching, Mare and Foal, Old Lion, Zebra, Greyhound Pup, Goat, Colt walking, Mongolian Wild Horse, Orang Outang, Elephants and Zebu Bull. She also did wooden reliefs of giraffes, kangaroos and circus horses.

JOHNSON, James C. fl. 20th century
American sculptor of the post-war period. He trained under Zadkine in Paris and sculpts abstracts.

JOHNSSON, Ivar Viktor 1885-
Born at Schonen, Sweden on February 12, 1885, he studied at the Stockholm Academy and travelled in France and Italy before settling at Hälsingborg. He became a member of the Stockholm Academy in 1922. He did the decorative sculpture on the façade of Stockholm Technical High School. His minor works include bronzes of David, Aphrodite and the Dying Adonis. Examples of his work are in the Göteborg Museum.

JOHNSTON, Thomas Vincent 1923-
Born in Dannevirke, New Zealand in 1923, he studied in Wellington and the Royal Academy schools, London and served in the R.N.Z.A.F. during the second world war. He founded the Palmerston North Art Gallery and has taught sculpture there since 1956. He has exhibited figures and portraits at the Royal Academy, the Glasgow Institute, as well as galleries in New Zealand and Australia.

JOINDY, Joseph François 1832-1906
Born in Paris in 1832, he died there in 1906. He exhibited at the Salon from the 1860s onward and was made a Chevalier of the Legion of Honour in 1900. He produced genre and romantic figures, portrait busts and reliefs. Examples of his work are in the Musée des Arts Décoratifs, Paris.

JOIRE, Jean 1862-
Born in Lille on September 5, 1862, he specialised in animal figures which he exhibited at the Salon des Artistes Français at the turn of the century, winning a third class medal in 1909.

JOLLO, Domenico fl. 19th-20th centuries
Italian sculptor working in Naples at the turn of the century. He exhibited in Naples, Milan, Rome and Turin and also at the Salon des Artistes Français. He was awarded a bronze medal at the Exposition Universelle of 1900. He produced genre and neo-classical bronzes, examples of which are in various European museums.

JOLLY, Adolphe Gustave fl. 19th century
Born in Paris on September 26, 1826, he studied under Dantan the Elder and exhibited garden statuary and romantic bronzes at the Salon from 1848 to 1870.

JOLY, René Charles Paul 1885-
Born at Courbevoie on June 10, 1885, he worked at Choisy le Roi as a sculptor, lithographer and engraver. He exhibited portrait busts, reliefs and medallions at the Salon des Artistes Français from 1912 to 1921.

JOMANTAS, Vincas 1922-
Born in Lithuania in 1922, he emigrated to Australia at the end of the second world war and works there as a sculptor of monuments, memorials, statues and portrait busts.

JONAS, Siegfried 1909-
Born in Geneva in 1909, he studied under James Vibert at the Geneva School of Fine Arts. He went to Paris in 1931 and continued his studies there for two years but did not take up sculpture seriously again till 1940 when he produced figurative work influenced by Maillol. In 1945 he turned to abstracts and the following year he left Switzerland and settled in Paris. He has exhibited abstract bronzes at the Salon de la Jeune Sculpture and the Salon des Réalités Nouvelles since 1949. In addition to cast bronzes he also works in sheet metal

and more recently has been using plaster. His best known work is the colossal Signal for the Church of the Sacred Heart, Mulhouse (1960).

JONCHERY, Charles 1873-
Born in Paris on June 27, 1873, he exhibited figures and portraits at the Salon des Artistes Français and the Salon des Indépendants at the turn of the century.

JONDET, Henri Michel 1862-1922
Born in Rouen in 1862, he died in Paris on March 20, 1922. He specialised in genre figures and groups, such as Death of a Tramp. He exhibited at the Salon des Artistes Français, winning an honourable mention in 1892 and being elected Associate the following year. Examples of his sculpture are in the Rouen Museum.

JONES, Adrian 1845-1938
Born in Ludlow, Shropshire on February 9, 1845, he died in London on January 24, 1938. He served in the Army as a veterinary officer for 23 years and took part in several African campaigns. Later he studied art under C.B. Birch and exhibited at the Royal Academy and leading London galleries from 1884 onwards. His best known work is Peace in her Quadriga on Constitution Hill, London, but he sculpted a number of other monuments in the London area. His minor works consist of models and maquettes for these monuments, equestrian statuettes and portrait busts.

JONES, Arne 1914-
Born in Medelpad, Sweden in 1914, he was apprenticed to a stone-mason with whom he worked for five years. During that time he studied art at the Stockholm Technical High School and continued his studies at the Stockholm Academy till 1947. He began as a figurative sculptor, gradually simplifying line and form until he had evolved a purely abstract style. His sculpture is produced in bronze and silver, often combining both metals, and includes Fountain (1948), Cathedral (1948), Spiral Space (1953), Andante (1959) and Within and Without (1959).

JONES, Dan Rowland 1875-
Born in Wales on September 21, 1875, he studied at the London School of Art, the Royal College of Art and the Académie Julian in Paris. He settled in Aberystwyth and worked there as a painter, etcher and sculptor of genre subjects.

JONES, Ernest Yarrow 1872-
Born in Liverpool on July 13, 1872, he studied at the art schools of Westminster and South Kensington and the Colarossi and Julian academies in Paris. He exhibited at the Royal Academy, the Paris Salons and the main British galleries. He worked at Hythe in Kent and also in Paris for many years as a watercolourist, oil-painter and sculptor of genre subjects.

JONES, John Edward 1806-1862
Born in Dublin on May 2, 1806, he died at Finglas near Dublin on July 25, 1862. He was the son of Edward Jones the miniaturist and was trained as an engineer. He was responsible for the construction of Waterford Bridge and many other public works. In 1840 he came to England and took up sculpture in which he rapidly made a reputation. He exhibited at the Royal Academy and the Royal Hibernian Academy from 1842 to 1862, more than 100 works, mainly portrait busts of his celebrated contemporaries. At the Great Exhibition of 1851 he showed bronze groups of children and animals.

JONES, Thomas D. 1808-1881
American sculptor working in New York. He specialised in portrait busts of American personalities and became an Associate of the National Academy of Design in 1853.

JONES, Thomas J. fl. 20th century
Born in Bideford, Devon in the late 19th century, he studied at the Royal College of Art and graduated in 1902. He exhibited at the Royal Academy and the Salon des Artistes Français and worked as a watercolourist, oil-painter, etcher and sculptor of historical and genre figures. He was Principal of the Tunbridge Wells School of Arts and Crafts for several years.

JONSSON, Adolf Sven August 1872-
Born in Småland, Sweden on July 7, 1872, he studied under Injalbert and Rolland and at the Académie Colarossi in Paris, then studied in

Rome from 1904 to 1914. He exhibited in Stockholm, Paris and Rome and specialised in allegorical and biblical groups and portrait busts of contemporary Scandinavian personalities, such as Bissen, Holmström and Branting.

JONSSON, Anders 1883-
Born in Sweden in 1883, he studied in Munich and Paris and exhibited in Stockholm and Paris in the 1920s.

JONSSON, Einar 1874-
Born in Iceland on May 11, 1874, he studied in Copenhagen and Berlin and exhibited there from the beginning of this century. His best known work is The Outcast, which won him a travelling scholarship to Rome. From 1905 to 1907 he produced abstracts entitled Antique, Typhoon and Aurora but later did monuments and memorials in Canada and the United States. His minor bronzes include statuettes and busts of Danish and Icelandic personalities. Many of his works are in the Reykjavik Museum, including Evolution, New Times, The Night, the Birth of Psyche, Thorfinnur Karlsefni (also in Philadelphia), and The King of Atlantis.

JONZEN, Karin (née Lowenadler) 1914-
Born in London on December 22, 1914, she studied at the Slade School of Art (1933-36), the Stockholm Academy and Kennington Art School and exhibited at the Royal Academy, the Leicester Galleries and other leading British galleries. She was elected R.B.A. in 1948. She works in London and sculpts figures in terra cotta, stone and bronze.

JOOS, Henri fl. 19th-20th centuries
Sculptor of genre figures and portraits working in Brussels at the turn of the century.

JORDAN, Julius Gotsch 1864-1907
Born in Bloemfontein, Transvaal on March 28, 1864, he died in Germany on August 9, 1907. He studied in Hanover and Berlin and the Académie Royale in Brussels. He worked in Munich (1891-1900) and in Frankfurt from 1900 till his death, specialising in genre and allegorical groups in marble and bronze. He exhibited at the Crystal Palace (1890 and 1899), the Great Berlin Exhibition and the Salon des Artistes Français (1895). His bronzes include Murmurs of Love, statuettes such as Faun and Sparrow, Two Golfers and David, and portrait busts of German artists and scientists working at the turn of the century.

JORDANESCU, Joan 1881-
Born in Bucharest in 1881, he studied in Bucharest, Paris and Naples and specialised in allegorical and genre groups, such as Maternal Goodwill, The Blind, Inquietude and various memorials and monuments.

JOREL, Alfred fl. 19th-20th centuries
He worked in Paris as a genre sculptor and died there on April 3, 1927. He became an Associate of the Artistes Français in 1896 and won a third class medal in 1907.

JORGENSEN, Jorgen 1871-
Born in Denmark on December 6, 1871, he emigrated to the United States and was a member of the League of American Artist Professors. He specialised in monuments and memorials, but also sculpted genre figures and portraits.

JORGENSEN, Marius Erik Jakob 1870-
Born in Copenhagen on July 18, 1870, he studied at the Academy from 1889 to 1907 and exhibited there from 1906 onwards. He won the Neuhausen Prize in 1911 for his group of Wrestlers, and a travelling scholarship two years later. He specialised in genre groups and portrait busts.

JORGENSEN, Viggo Hieronimus see JARL, Viggo Hieronimus

JORGES, Alexandre fl. late 19th century
Genre sculptor working in Paris in the 1890s.

JÖRIN, Jean 1888-
Born in Basle on August 5, 1888, he exhibited in Switzerland and at the Salon d'Automne in Paris, specialising in genre statuettes and portrait busts.

JORIS, Edgard 1885-1916
Born in Antwerp on September 7, 1885, he died there in 1916. He exhibited figures at the Brussels International Exhibition of 1910.

JORIS, Franz Josef 1851-1914
Born at Deurne in 1851, he died in Antwerp on October 23, 1914. He studied under J. Geefs at the Antwerp Academy and specialised in genre groups, such as My Cavalier and The Little Mother.

JOSEPH, Mely 1886-1920
Born in Pforzheim on March 6, 1886, he died in Berlin on January 14, 1920. He worked as a painter, lithographer and sculptor of genre subjects. His bronzes include Mother and Child, exhibited at Wiesbaden in 1920.

JOSEPH, Samuel 1791-1850
Born in London in 1791, he died there on July 1, 1850. He studied under Peter Rouw and attended the Royal Academy schools in 1811, winning silver medals in 1811-12 and a gold medal in 1815 for a group Eve Supplicating Forgiveness. In 1823 he moved to Edinburgh and was a founder member of the Royal Scottish Academy three years later. His portrait busts were regarded as superior to anything else in Scotland prior to that time. He returned to London in 1828 and spent the rest of his life there. Although very prolific, he never got the recognition he deserved and went bankrupt in 1848. His bronze busts include those of Flaxman (1830), Professor Donald Stewart (c.1825).

JOSSAND, Henri fl. 19th century
Born in Bourges in the mid-19th century, he studied at the local School of Fine Arts and was a pupil of M. Petre. He exhibited at the Salon des Artistes Français at the turn of the century and specialised in genre figures, such as the Vineyard Worker, and portrait busts, mainly in wood or plaster.

JOSSET, Raoul 1892-
Born at Fours, France on December 9, 1892, he studied under Injalbert and became an Associate of the Artistes Français. He won a travelling scholarship in 1923 and later emigrated to the United States where he specialised in genre figures, particularly athletes and sportsmen, in bronze and aluminium.

JOST, Josef 1875-
Born at Heckendalheim, Germany on August 6, 1875, he studied in Strasbourg and Munich and exhibited busts, genre figures and animal groups at the Crystal Palace, Munich from 1903 onwards.

JOUANDOT, Amédée 1831-1884
Born in Bordeaux on September 2, 1831, he died there on March 9, 1884. He studied under Jouffroy and exhibited at the Salon from 1867, specialising in religious figures and ecclesiastical bas-reliefs. His group Eternal Rest is in Bordeaux Museum.

JOUANT, Jules fl. late 19th century
Born in Paris, he worked in Neuilly-sur-Seine and exhibited at the Salon des Artistes Français and the Nationale from 1885 onwards. He specialised in genre statuettes and busts. His chief work is the memorial to the Franc-Tireurs (guerrillas) of Ternes in the Place, St. Ferdinand, Paris.

JOUBERT, Henri 1873-
Born in Paris on May 14, 1873, he worked there as a sculptor and painter of genre and allegorical subjects. He exhibited at the Salon des Indépendants from 1902.

JOUFFROY, François 1806-1882
Born in Dijon on February 1, 1806, he died in Laval on June 25, 1882. The son of a baker, he enrolled at Dijon School of Fine Arts in 1817 and studied under Anatole Devosges and Nicolas Bornier. In 1824 he won first prize and went to the École des Beaux Arts, Paris. He was runner-up in the Prix de Rome of 1826 and won the prize in 1832. He returned from Rome in 1835 and exhibited at the Salon from then until 1877. He was one of the most prominent and influential French sculptors of the second half of the 19th century. He won second class medals in 1838 and 1848 and a first class medal in 1839. He was made a Chevalier of the Legion of Honour in 1848 and an Officier in 1861. He was appointed professor at the École des Beaux Arts in 1863. He had many official commissions and

specialised in monumental figures of saints, such as St. Bernard (in the Church of St. Geneviève), St. John (St. Gervais Church, Paris) and the monument to St. Bernard in Dijon. His most ambitious work was the colossal relief of Christ and the Twelve Apostles on the façade of St. Augustin Church. His minor works include many classical and genre statuettes and groups in Dijon Museum, such as The Disillusion, Erigone, The Dream, Death of Orion, Prometheus, First Secret Confided to Venus, Philomela and Progné, St. Benedict, St. Bruno; and portraits of Bonaparte as First Consul, Louis Dietsch and Gaspard Monge.

JOUKOFF, Innocenti Nikolaievich 1875-
Born in Russia he studied at the University of St. Petersburg and moved to Paris at the turn of the century, where he studied sculpture under Bourdelle. He produced genre figures and groups and portrait reliefs and busts in the 1920s and 1930s.

JOUNEAU, Prosper fl. late 19th century
Born in Parthenay, France in the mid-19th century, he studied under Dumont and exhibited at the Salon from 1874. Later he became Director of Montpellier School of Fine Arts. He specialised in busts and allegorical statuettes.

JOUNIEAU, Alfred Aimé d. 1896
Genre and allegorical sculptor working in Paris, where he died in 1896. He was an Associate of the Artistes Français.

JOURAKOVSKY, Michel (Mihail Zhurakovsky) fl. 20th century
Born in the Ukraine in the early years of this century, he studied at the Moscow Academy and moved to France at the Revolution. He exhibited figures at the Nationale from 1926 onwards.

JOURDAIN, Jules 1873-
Born in Namur on December 30, 1873, he worked in Brussels and took part in the International Exhibition of 1910.

JOURJON, Toussaint François 1809-1857
Born at St. Genest Lerp in 1809, he died in Rennes in 1857. He was the son of an armourer and learned the techniques of metalwork from his father. Later he studied under Dumont and was runner-up in the Prix de Rome of 1836. He exhibited portrait paintings and sculpture at the Salon from 1844 to 1849.

JOUSSELIN, Stéphane A. fl. late 19th century
Portrait and genre sculptor working in Paris in the late 19th century. He was elected Associate of the Artistes Français in 1888.

JOUTSAYTIS, Antoine 1868-
Born in Lithuania on October 30, 1868, he studied in Odessa, Munich and Paris, settling in the latter city. He exhibited at the Nationale in 1912 and 1922 and the Salon d'Automne in 1921. He specialised in heads, busts, statuettes and decorative reliefs, in granite, marble and bronze.

JOUVRAY, Madeleine fl. late 19th century
Born in Paris in the mid-19th century, she specialised in busts of classical subjects and allegorical works, such as La Pensée, The Source, etc. She won an honourable mention at the Salon des Artistes Français in 1889 and was an Associate of the Société Nationale des Beaux Arts.

JOVINO, Felix fl. 20th century
Born at San Paolo Belnito, Italy in the late 19th century, he studied at the Naples Academy and worked in that city and Paris. He exhibited at the Salon des Artistes Français in 1910 and in 1920-22. He specialised in monuments and memorials, the best known being the war memorial at Thiviers, Dordogne. His minor works include portrait busts of historical and contemporary cultural celebrities and neo-classical figures and bas-reliefs, such as Bacchante and Dance of Love.

JOYEUX, Pierre 1881-
Born in Angoulême on July 11, 1881, he studied under Coutan and exhibited figures at the Salon des Artistes Français.

JOZON, Jeanne 1868-1946
Born in Paris on July 15, 1868, she died there in July, 1946. She studied at the Bourges School of Fine Arts and was later a pupil of Denys Puech. She exhibited statuettes at the Salon des Artistes

Français, getting an honourable mention in 1897 and being elected Associate in 1906.

JUCH, Ernst 1838-1909
Born in Gotha on April 25, 1838, he died in Vienna on October 5, 1909. Though best known as a painter and caricaturist, he also worked as a sculptor, specialising in statuettes, reliefs, small busts and groups. Many of his works featured his colleague L. Anzengruber and were executed in painted terra cotta, plaster and bronze.

JUCKOFF-SKOPAU, Paul 1874-
Born in Merseburg, Germany on August 2, 1874, he studied at the Leipzig Academy and settled in Skopau near Merseburg in 1901. He specialised in commemorative statuary, particularly monuments to Bismarck and Scharnhorst. His minor bronzes include busts of Prussian royalty and celebrities. He took part in the Great Berlin Exhibitions of 1904, 1907 and 1910.

JUHASZ, Gyulia 1876-1912
Born in Eger, Hungary in 1876, he died in Budapest on January 6, 1912. He studied at the academies in Budapest, Vienna and Florence and settled in Budapest where he specialised in bas-reliefs and plaques. A bronze statuette of a woman by him is in the Museum of Fine Arts, Budapest.

JUILLERAT, Eugène 1856-
Born in Paris on April 17, 1856, he worked as a sculptor and lithographer and studied under Carolus-Duran. He was elected an Associate of the Artistes Français in 1888 and won third class (1895) and second class (1899) medals. He was awarded a silver medal at the Exposition of 1900 and became a Chevalier of the Legion of Honour in 1909.

JUILLIOT, Louis Laurent fl. 19th century
Born in Paris in 1827, he studied under Langlois and Cezanne and exhibited genre figures at the Salon in 1852-59.

JUKES, Edith Elizabeth 1910-
Born in Shillong, Assam on December 19, 1910, the daughter of a tea-planter, she was educated in England and studied at the Royal College of Art (1928-32) under Garbe, Moore and Palliser. She has exhibited at the Royal Academy and leading British galleries and was elected F.R.B.S. in 1948. She has taught sculpture at the Sir John Cass College School of Art since 1947 and now lives in London. She has produced figures and portraits in clay, wood and stone.

JULIA, Jean Baptiste fl. 18th century
Born in Toulouse in the mid-18th century, he died there in 1803. He studied at the Toulouse Academy of Fine Arts and worked as an ornamental sculptor on the Versailles opera house with Pajou, and also did ecclesiastical sculpture for the churches of Toulouse.

JULIEN, Georges Jules 1872-
Born in Paris on February 20, 1872, he studied under Thomas and Larche and exhibited figures at the Salon des Artistes Français.

JULIEN, Pierre 1731-1804
Born at St. Paulien near Puy on June 20, 1731, he died in Paris on December 17, 1804. He studied under G. Samuel in Puy and A.M. Perrache in Lyons and won the medal for sculpture in 1753. Five years later he came to Paris and worked in the studio of Guillaume Coustou. In 1760 he was awarded the gold medal of the Académie Royale and won the Prix de Rome five years later. He worked with L.M. Vanloo (1765-68) and studied in Rome from 1768 to 1773. He was admitted to the Académie in 1778, his *morceau de réception* being the figure of The Dying Gladiator (now in the Louvre). He lodged at the Louvre from 1790 and became a member of the Institut in 1801. He was one of the finest sculptors of his age and never succumbed to the extremes of classicism. His works consisted mainly of subjects from classical mythology and were executed in marble, plaster, terra cotta and bronze. His minor works include numerous maquettes, models and sketches. He was appointed one of the first Chevaliers of the Legion of Honour in 1804.

JULLIEN, Hippolyte André fl. 19th century
Born at Gap, France in 1840, he worked with Duret, Guillaume and Lequestre and exhibited at the Salon from 1866 to 1876. He specialised in portrait busts and neo-classical figures, in marble and bronze. He was professor of sculpture at Winterthur, Switzerland from 1875 to 1887.

JUNCK, Ferdinand fl. 19th century
German figure sculptor working in London in the mid-19th century. He exhibited at the Royal Academy and the British Institution from 1858 onwards.

JUNCK, Oscar Alexander fl. late 19th century
Probably a brother of Ferdinand Junck, he worked in London and exhibited figures at the Royal Academy from 1880.

JUNGBLUT, Emil 1888-
Born in Düsseldorf on June 11, 1888, he studied at the local School of Arts and Crafts before going to Paris where he worked for several years. On his return to Düsseldorf he specialised in portrait busts, masks and statues of contemporary celebrities. He did the German war memorial in Thiaucourt Cemetery.

JUNGBLUTH, Alfred L. fl. 19th-20th centuries
Born at Trémentines, France in the mid-19th century, he died in Paris in May, 1914. He exhibited at the Nationale from 1898 to 1909 and at the Indépendants in 1907. He specialised in genre statuettes, mostly dancers and Parisian demi-mondaines, in plaster, terra cotta and bronze.

JUSSERAND, Antoine Louis fl. 19th century
Born at Issoudun, France in 1838, he studied under Dumont and Bonnassieux. He exhibited statuettes and busts at the Salon from 1858 to 1877. His figure of an Amazon is in the museum at Châteauroux.

JUSTUS, Elisabeth fl. 20th century
She worked as a sculptress of historical and genre figures in Hamburg in the early years of this century and exhibited in Berlin in 1909.

JUSZKO, Jeno (Jean) 1880-
Born in Ungvar, Hungary in 1880, he studied at the National School of Ceramics, Budapest, under Edmund von Hellmer at the Vienna Academy, and G.J. Thomas at the École des Beaux Arts, Paris. He emigrated to the United States and settled in New York. He exhibited in Paris (1904), Milan (1905) and the United States (1909-14), mainly at the Pennsylvania Academy, the National Academy of Design and the Salmagundi Club. He was a very versatile sculptor, producing numerous portrait medals and plaques, monuments and memorials (notably that to Archbishop Lamy at Santa Fé), portrait busts of his contemporaries, fountain statuary and genre groups, especially of dancers.

KAAN, Arthur 1867-
Born in Klagenfurt, Austria on February 24, 1867, he studied under Zajouk in Vienna and specialised in portraits, particularly busts of children. He also sculpted a statue of the Emperor Franz Josef, subsequently edited as a bronze reduction.

KADO, Eduard 1875-
Born in Memel, Lithuania on August 15, 1875, he studied at the Académie Julian in Paris and travelled all over Europe before settling in Königsberg. He specialised in figures and bas-reliefs of religious subjects.

KAEHR, Jakob 1865-
Born in Berne on May 27, 1865, he studied under Lorenti in Berne and later attended the Academia de la Brera in Milan and worked for a time under Sartorio in Geneva. He worked as a portrait and genre sculptor in Lyons, Berne and Zürich.

KAELHER, Heinrich 1804-1878
Born in Rostock on February 22, 1804, he died in Güstrow on April 5, 1878. He studied under Schadow at the Berlin Academy and later worked as a genre sculptor in Italy, Germany and England. He exhibited at the Royal Academy from 1837 to 1844.

KAERNER, Theodor 1884-
Born at Holenberg, Germany on January 10, 1884, he worked in Munich, mainly as a modeller of figurines for a porcelain factory.

KAESBACH, Rudolf 1873-
Born in Munich on July 22, 1873, he worked in Paris, Düsseldorf and Brussels and specialised in classical and allegorical figures. He was very strongly influenced by classical mythology.

KAESSMANN, Josef 1784-1856
Born in Vienna on September 3, 1784, he died at Fischau on January 18, 1856. He was the son and pupil of the ecclesiastical stonemason Franz Kaessmann and studied under Thorvaldsen in Rome. He later became professor of sculpture at Vienna Academy and specialised in classical groups and statues, such as Jason and Medea. His minor works are in the Belvedere Museum, Vienna.

KAFFSACK, Josef 1850-1890
Born in Ratisbon on October 21, 1850, he drowned at Wannsee on September 7, 1890. He studied under Hähnel in Dresden and specialised in portrait busts and statuettes of German royalty and celebrities.

KAFKA, Bohumil 1878-
Born at Nova Paka, Bohemia on February 14, 1878, he studied in Prague and Vienna and worked in London, Berlin and Rome before settling in Prague. He specialised in animal bronzes, such as The Foal.

KAFKA, Viacheslav Antonovich fl. 19th century
Born in Russia in the early 19th century, he died in 1889. He exhibited genre figures at the Paris Salon in 1888, winning an honourable mention, and a silver medal at the Exposition Universelle the following year.

KAHLE, Anna von 1853-1920
Born in Germany on February 17, 1853, she died in Berlin in June, 1920. She studied under F. Schaper in Berlin from 1876 to 1880 and specialised in portrait busts and statuettes of mythological subjects.

KALAND, Moriz Jan 1869-
Born in Bergen, Norway on September 30, 1869, he worked as a painter, lithographer and sculptor of Norwegian genre subjects. He was Curator of Bergen Museum.

KALCKREUTH, Count Karl Walter Leopold 1855-1927
Born in Düsseldorf on May 15, 1855, he died in Munich in 1927. He was the son and pupil of the landscape painter Stansilaus Kalckreuth and studied at the Munich Academy. He was appointed professor at Weimar School of Fine Art and settled in Munich in 1890. He worked there as a painter of portraits and genre subjects and also as a lithographer and sculptor, specialising in portrait busts of his contemporaries. He exhibited in Munich, Berlin, Dresden and Weimar and won a medal at Munich in 1888. A retrospective exhibition of his work was staged at the Staatsbibliothek in 1928.

KALIDE, Theodor Erdmann 1801-1863
Born in Königshütte on February 8, 1801, he died at Gleiwitz on August 26, 1863. He worked initially as a foundryman but after studying sculpture under Schadow he went to Italy and learned the techniques of direct carving in marble. He specialised in genre and neo-classical figures and groups, in marble and bronze. His Bacchante on a Panther is in the Berlin Museum.

KALISH, Max 1891-
Born in Poland on March 1, 1891, he emigrated to the United States where he studied under Adams and Calder and became a member of the American Federation of Arts.

KALLIO, Kyösti 1873-1940
Born in Finland in 1873, he died in Helsinki on December 19, 1940. Originally a farmer, he became a member of the Finnish Diet in 1904 and a senator in 1917. He held various cabinet appointments and became prime minister (1922-24, 1925-26, 1929-30 and 1936-37). Subsequently he was President of Finland until a month before his death and successfully prosecuted the Winter War with Russia in 1939-40. He was a talented amateur painter and sculptor, producing plaques, medallions and bas-reliefs.

KALLOS, Ede 1866-
Born at Hodmezovasarhely, Hungary on February 22, 1866, he studied at the School of Decorative Arts, Budapest and was a pupil of Chapu in Paris. He worked in Budapest as a decorative sculptor and produced heroic and allegorical bas-reliefs and statuary. He sculpted the decoration of the Hungarian pavilion at the Exposition Universelle of 1900.

KÄLLSTRÖM, Arvid 1893-
Born in Sweden on February 17, 1893, he studied in Paris, Rome, London and Copenhagen and won the Ester Lindahl scholarship. He specialised in religious and secular monuments, memorials and statuary.

KALMSTEINER, Johann fl. 19th century
Born at Samtheim, Germany on September 23, 1845, he studied in Dresden and Munich and worked in Vienna, Berlin and Bremen, specialising in portrait busts.

KALTENHEUZER, Charles fl. 19th century
Born in Barmen, Westphalia at the beginning of the 19th century, he worked as a genre and allegorical sculptor. He exhibited in Paris, winning an honourable mention in 1859.

KAMENSKY, Fiodor Fiodorovich 1838-1913
Born near St. Petersburg in 1838, he died in the United States in 1913. He specialised in genre figures and portrait busts, in marble and bronze. Examples of his work in the Leningrad Museum include The First Step and a bust of T.A. Brouny.

KAMINSKA, Sophia fl. early 20th century
Born in Warsaw in the late 19th century, she worked as a painter and sculptor of portraits and genre subjects in the early years of this century.

KAMPF, Léopold Eugène fl. 19th century
Born at Clairvaux in the early 19th century, he worked in Dunkirk, specialising in figures, groups and reliefs of military subjects. He exhibited at the Salon in the 1860s.

KANE, Julius fl. 20th century
Born in Budapest, he emigrated to Australia after the second world war and works as a sculptor of monuments and memorials, portrait busts and reliefs.

KANN, Frederick 1884-
Born at Gabloz (now Jablonec, Czechoslovakia) on May 25, 1884, he emigrated to the United States and became a member of the Artists' Professional League. He returned to Europe after the first world war and settled in Paris where he joined the Abstraction-Création group and exhibited abstracts at the Salon des Surindépendants, the Tuileries and the more avant-garde galleries.

KANN, Léon fl. early 20th century
Born at Damboch in the late 19th century, he studied in Paris and exhibited figures and groups at the Salon des Artistes Français, winning a third class medal in 1908.

KAPLAN, Michel fl. 19th-20th centuries
Born in Odessa in the mid-19th century, he studied at the Schools of Fine Arts in Odessa and Paris and worked under Falguière. He got an honourable mention at the Exposition Universelle of 1900.

KAPLICKY fl. 20th century
Czechoslovak sculptor working in Prague and Paris since the second world war. He has moved from figurative to abstract sculpture under the influence of modern French artists. He took part in the Exhibition of Czech Art at the Orangerie, Paris in 1946.

KAR, Chintamoni 1915-
Born in Bengal, India on April 19, 1915, he studied at the Indian Society of Oriental Art School, Calcutta and the Académie de la Grande Chaumière, Paris in 1938-39. He now works in London as a painter and sculptor, working in stone, terra cotta and bronze. He has exhibited at the Royal Academy, the Paris Salons and the Royal Society of British Artists and was elected A.R.B.S. in 1947.

KARCHER, Eugène Henri 1881-
Born at Angers on November 17, 1881, he exhibited genre figures at the Salon des Artistes Français.

KARLEBYE, Jens 1730-1812
Born at Thorsager, Denmark in 1730, he died in Copenhagen on November 21, 1812. He specialised in portrait busts of Danish royalty and contemporary celebrities.

KARSCH, Joachim 1897-
Born in Breslau on June 20, 1897, he settled in Berlin in 1919 and won the national prize for sculpture in 1920. He specialised in portrait busts, plaques and bas-reliefs of contemporary figures and characters from German and Russian literature.

KASPER, Ludwig 1893-1945
Born in Gurten, Germany in 1893, he died in Brunswick in 1945. The son of a Viennese labourer he was fortunate enough to have his artistic genius recognised early by a wealthy patron of the arts whose generosity enabled him to study at the Munich Academy from 1912 to 1923 under Hermann Hahn. Later he spent a year in Paris (1928) and settled in Berlin in 1933. He visited Greece in 1937 and taught at the Brunswick School of Art from 1943 till his death. A retrospective exhibition of his work was held in Munich in 1952. He was the last of the Munich classicists under the influence of Hildebrand and was innately conservative in his work. He specialised in statuettes of men and women, standing, sitting or walking, but also sculpted a few portrait busts of his family.

KASSIN, Joseph fl. 19th century
Born near Klagenfurt, Austria in 1856, he studied under Kundmann in Vienna and won the Prix de Rome in 1885 with a bronze group of Samson and Delilah.

KASTELEYN, Gustave 1848-1900
Born in Ghent on July 15, 1848, he died there on April 20, 1900. He specialised in genre figures and groups, such as The Prisoners and The Sleeping Child, both in Ghent Museum.

KATCHAMAKOFF, Atanas 1898-
Born at Leskovetz, Bulgaria on January 18, 1898, he studied in Sofia and worked there and in Berlin, Rome and the United States. He won

the prize of the American Federation of Arts for a figure of an Indian Woman (1931) and also did numerous portrait busts and architectural decoration in America, Germany and Bulgaria.

KATSCH, Arnold 1861-
Born in Cassel on May 25, 1861, he studied in Rome and worked in Berlin, specialising in portrait busts.

KAUBA, Carl fl. early 20th century
American sculptor of genre and animal bronzes, particularly horses.

KAUBA, G. fl. 19th century
Austrian sculptor of genre bronzes, especially American Indians.

KAUFFMANN, Jean 1866-1924
Born in Lucerne on November 27, 1866, he died there on March 24, 1924. He studied at the Lucerne School of Fine Arts (1882-88) and in Geneva (1888-89) and worked in Germany and Paris till 1893 when he settled in Lucerne. He specialised in bas-reliefs, plaques and medallions.

KAUFMAN, John François 1870-
Born at Uznach, Switzerland on October 31, 1870, he studied under Gérome at the École des Beaux Arts, Paris and won an honourable mention at the Nationale in 1927. Though best known as a painter he also sculpted portrait busts and reliefs and after emigrating to the United States he did ecclesiastical sculpture in Richmond, Virginia.

KAUFMANN. Eugénie (née Hiller) 1867-1924
Born in Esseg, Austria on May 15, 1867, she died in Vienna on July 1, 1924. She studied in Karlsruhe and worked mainly in Weimar and Mannheim, specialising in portrait busts, heads and reliefs.

KAUFMANN, Hugo 1868-1919
Born at Schotten, Germany on June 29, 1868, he died in Munich on May 14, 1919. He studied in Hanau and also at the Städel Institute, Frankfurt. Later he was a pupil of W. von Rümann at the Munich Academy and settled in Berlin. He specialised in busts and medallions of historical German personalities. He exhibited in Munich (1897) and Paris (1900). His works are in the Bremen Museum.

KAULBACH, Karl fl. 19th century
Born in Arolsen, Bavaria on March 5, 1808, he studied under Schwanthaler in Munich and worked in Würzburg as a painter and sculptor of portraits.

KAUPERT, Gustav 1819-1897
Born in Cassel on April 4, 1819, he died there on December 4, 1897. He studied under Wehrmuth, Werner Henschel and Ruhl and travelled all over Germany and Italy before returning to his birthplace. He specialised in figures and groups depicting classical subjects, but always imbued with naturalism. He also did some statuary for the Capitol, Washington.

KAUTSCH, Heinrich 1859-
Born in Prague on January 28, 1859, he studied under Injalbert and Roubaud and exhibited at the Salon des Artistes Français at the turn of the century, winning a silver medal at the Exposition Universelle of 1900. He specialised in portrait busts.

KAVANAGH, John F. 1903-
Born in Birr, Co. Offaly, Ireland on September 24, 1903, he studied at the Liverpool School of Art (1920-21) and the Royal College of Art (1925-30) under Henry Moore. He worked at the British School in Rome (1930-33) after winning the Prix de Rome. He was elected F.R.B.S. in 1935 and taught at Leeds College of Art from 1934 to 1939. After war service he emigrated to New Zealand and became senior lecturer at Elam Fine Art School, Auckland University in 1951. He specialised in portrait busts, heads and reliefs.

KECK, Charles 1875-
Born in New York on September 9, 1875, he was a pupil of the Art Students' League and later studied in Greece, Florence and Rome. A member of the Federation of American Arts, he won the gold medal of the Archaeology League of New York in 1926. He is best known for his monument to General Jackson in Charlottesville and the statue of Tom Tyler in the Virginia State Capitol. His minor figures and busts are in many American museums.

KEIL, Carl fl. 19th-20th centuries
Genre sculptor working in Berlin in the second half of the 19th century, he died about 1910. He won a gold medal at the Berlin Exhibition of 1868.

KEIL, Christian 1826-1890
Born in Siegritz, Germany on June 4, 1826, he died in Munich on June 19, 1890. He studied in Ratisbon and worked as a decorative sculptor on churches in Landshut, Dingelstadt and Munich.

KEISER, Johann Albert 1825-1905
Born in Zug, Switzerland on January 13, 1825, he died there on July 19, 1905. He studied under Ludwig Schwanthaler in Munich and specialised in memorials and monuments in the Zug area.

KEISER, Johann Ludwig 1816-1890
Born in Zug on December 14, 1816, he died in Zürich on January 8, 1890. He studied under the painter Moas in Zug but later turned to sculpture. He worked in Munich, latterly with Schwanthaler (1837-52) and then settled in Zürich. He was professor of sculpture and modelling at the Zürich Polytechnic. His best known work is the statue of St. Agatha in a Zug chapel, but he also sculpted portrait busts and genre figures.

KELDER, Toon 1894-
Born in Rotterdam in 1894, he studied at the academies of The Hague and Rotterdam and then travelled in Spain, Belgium and France in the late 1920s. Since the second world war, he has commuted between Paris and The Hague. His early career was as a painter and he did not turn to sculpture till after the war, beginning with masks and figures and abstracts using iron wire, executed two-dimensionally like drawings in space. In the 1950s, however, he began sculpting figures and busts in the round. His speciality is carved wood covered with hammered copper sheet, but he has also produced sculpture in more conventional forms.

KELLER, Alfred 1877-
Born in Vienna on February 1, 1877, he worked in Rome and later settled in Munich where he sculpted memorials and portrait busts.

KELLER, Heinrich 1771-1832
Born in Zürich on February 17, 1771, he died in Rome on December 21, 1832. He specialised in busts of contemporary Swiss personalities, and classical groups, such as Electra at the Tomb of Agamemnon and statuettes, such as Ariadne.

KELLER, Johan 1863-
Born in The Hague on November 13, 1863, he studied in The Hague and Rotterdam and was appointed professor of sculpture at the Glasgow School of Art in 1895. He produced portraits and allegorical figures, such as Sculpture, now in the Boymans Museum, Rotterdam.

KELLER, Josef fl. late 19th century
Born at Nesselwang, Germany on March 31, 1849, he worked in Frankfurt-am-Main as a sculptor of memorials, monuments and public statuary. His minor works include portrait busts of contemporary figures and classical statuettes.

KELLER, L.G. fl. 20th century
Genre sculptor working in Paris before the second world war. He gave up sculpture in 1939 to concentrate on lacquered screens and tableaux.

KELLER, Laurent Friedrich 1885-
Born in Monaco on May 3, 1885, he studied in Paris and worked in Zürich as a genre and portrait sculptor. His works are in the museums of Soleure and Olten.

KELLY, James Edward fl. 19th-20th centuries
Born in New York on July 30, 1855, he worked as an illustrator for various magazines, but also did heads and busts of famous Americans, such as Edison and General Sheridan.

KELZ, Franz Xaverius 1826-1876
Born in Rettenbach, Austria on December 18, 1826, he died in Graz on December 24, 1876. He specialised in ecclesiastical statuary and bas-reliefs, especially in Graz and Styria.

KEMENY, Zoltan 1907-
Born in Banica, Romania in 1907, he was apprenticed to a cabinet-maker but later studied architecture in Budapest and designed fashion models before turning to painting and sculpture. He worked in Paris from 1930 till 1940 and then moved to Zürich where he lives to this day. After the war, he held several one-man shows in Zürich, London, Berlin and Paris. His abstracts are usually constructed from pieces of scrap metal, often using sheet metal, hammered, cut and welded. He has also experimented with various metals used in more conventional techniques, and includes lead, tin, iron, zinc, copper and bronze to produce abstract reliefs.

KEMEYS, Edward 1843-1907
Born in Savannah, Georgia on January 31, 1843, he died in Washington on May 11, 1907. He was educated in New York but trained as an engineer and worked in the iron industry. He served in the Union Army during the civil war, attaining the rank of captain in the artillery. At the end of the war, he transferred to the civil engineering corps and was responsible for the layout of New York's Central Park. This gave him the opportunity to display his talents as a sculptor of American wildlife, though he was self-taught. Thereafter he spent much of his time travelling all over America, studying the Indians and the animals of the Wild West. He visited Paris and exhibited Bison and Wolves at the Exposition Universelle of 1878. In the ensuing years, he executed monumental statuary of animals for a number of American parks and public buildings, notably the bronze lions at the Art Institute Chicago and decorative works at the Columbian Exposition of 1893. He also exhibited at the Centennial Exposition, Philadelphia in 1876 and the Royal Academy in 1877. His small bronzes of American wildlife are in many public collections, the best being the group of more than fifty bronzes in the National Gallery in Washington.

KEMPER, Georg 1880-
Born at Oelde, Germany on November 20, 1880, he worked in Munich and exhibited genre figures and portraits in Munich and Berlin.

KENDALL, William Sergeant 1869-
Born at Spuyten Duyvil, New York on January 20, 1869, he was a pupil of the Art Students' League and later studied under Eakins in Philadelphia and Merson in Paris. He won an honourable mention at the Salon of 1891 and worked as a painter and sculptor. He participated in the Columbian Exposition (1893), the Exposition Universelle, Paris (bronze medal), the Pan-American Exposition, Buffalo (silver medal) and the St. Louis World's Fair (gold medal). He was elected an Associate of the National Academy of Design in 1901, and an Academician four years later.

KENDRICK, Flora fl. early 20th century
Sculptress and watercolourist working in Hampstead, London in the 1920s. She studied at the Royal College of Art and exhibited genre figures and portraits at the Royal Academy and the Salon des Artistes Français.

KENNARD, Miss E.C. fl. 19th century
She exhibited figures at the Royal Academy in 1866 and 1869.

KENNET, Lady Kathleen 1878-1947
Born at Carlton-in-Lindrick, Nottinghamshire on March 27, 1878, she died in London on July 24, 1947. She studied at the Slade School of Art and the Académie Colarossi and worked with Rodin in 1905-6. In 1908 she married Captain Robert Falcon Scott, R.N. who perished at the South Pole in 1912. She remarried in 1922, her second husband being Sir Edward Hilton Young, later created 1st Baron Kennet. She exhibited at the Royal Academy in 1913 and was elected A.R.B.S. in 1928 and F.R.B.S. in 1946. She travelled all over the world and drew on her experiences in modelling portrait busts and figures as well as statues and memorials. She lived in London and Great Yarmouth.

KENNINGTON, Eric Henri 1888-1960
Born in Chelsea on March 12, 1888, he died in Reading on April 13, 1960. He was the son of the painter T.B. Kennington and studied at the Lambeth School of Art and the City and Guilds School. He exhibited at the Royal Academy from 1908 and was elected A.R.A. in 1951 and R.A. in 1959. He served in France in 1914-15, was wounded in action and later appointed official war artist (1916-19) and also during the second world war. He worked as a painter and sculptor of portraits and lived in Ipsden, Oxfordshire.

KERCKHOVE FAMILY of Belgium
Twelve sculptors of this surname were active in the 19th century and their inter-relationship is uncertain. They are listed briefly below:
Antoine van den fl. in Antwerp in the mid-19th century and exhibited in Brussels in 1851.
Antoine Joseph Born in Brussels on May 1, 1849, the son of Auguste van den Kerckhove, worked in London and Paris.
Antonia exhibited at the Brussels Salon in 1848.
Arthur exhibited genre figures in Brussels and Antwerp in 1872-73.
Auguste was born in Antwerp in 1825 and died in Brussels in 1895. He worked in Brussels and exhibited at the Royal Academy, London.
Ernest worked as a painter and sculptor and exhibited in Brussels from 1840 to 1879.
Godefroid was born in Antwerp in 1841 and died in Brussels in 1913. He was professor of modelling at Schaerbeeck Academy.
Jean Baptiste worked in Brussels and exhibited allegorical and classical statuettes, such as Eve (1866), at the Brussels Salon.
Jean François was born in Antwerp about 1815 and died at St. Josse, near Brussels on November 29, 1885. He exhibited figures at the Brussels Salon from 1848 to 1872.
Jean Ives specialised in portraits, and exhibited busts at the Brussels Salon in 1873.
Louis was born in Antwerp in 1814 and died in Brussels. He specialised in genre and neo-classical figures. His Outraged Cupid is in the Ypres Museum.
Paul was born at St. Josse on October 23, 1876, presumably a son of Jean François, and studied at the École des Beaux Arts, Paris. Later he worked in England.

KERCKX, Jean Baptiste fl. late 19th century
Born in Antwerp on May 1, 1853, he studied at the Antwerp Academy and became a professor there in 1883.

KERN-LOFFTZ, Marie fl. early 20th century
Sculptress of genre and portrait subjects, working in Munich at the beginning of this century. She exhibited in Berlin in 1909.

KESEL, Charles Louis de 1849-1922
Born at Somergem, Belgium on August 11, 1849, he died at Erlangen, Germany on November 20, 1922. He studied in Paris, Berlin and Rome and worked as a decorative sculptor mainly in Ghent. His best known work is the façade of the Palais de Justice in Ghent. The Ghent Museum has his group of Two Painters.

KESSLER, Adolf Josef 1859-1903
Born at Kronstadt on April 7, 1859, he died in Budapest in 1903. He studied at the Vienna Academy and worked with Huszar and Feszler in Budapest.

KESSLER, François Nicolas 1792-1882
Born in Tavel, Switzerland on October 10, 1792, he died in Fribourg on February 25, 1882. He studied under David d'Angers in Paris and sculpted romantic figures and bas-reliefs.

KEYSER, Ephraim fl. late 19th century
Born in Baltimore, Maryland in October, 1850, he studied under Widmann at the Munich Academy and Wolff at the Berlin Academy. He worked in Munich from 1872 to 1876 and won the Michael Beerche prize in Berlin for his figure of Psyche. He then went to Rome for a year and on his return to the United States, was appointed professor at the Maryland Institute of Art. He did numerous memorials and monuments in America, as well as portrait busts of his contemporaries.

KEYSER, Ernest Wise 1875-
Born in Baltimore in 1875, he was a pupil of the Maryland Institute of Art, the Art Students' League, New York and the Académie Julian, Paris. He also worked with Saint-Gaudens in New York. He specialised in fountain statuary and memorials and won many commissions for monuments and tombs in the United States. He won a gold medal in New York in 1923. Among his works are the bronze figures of Sir Galahad on the Harper Memorial, Ottawa and the bronze and marble memorial to the Twelfth Infantry in New York.

KEYSER, Franz 1804-1883
Born in Stans, Switzerland in 1804, he died there in 1883. He studied at the Munich Academy and worked in that city and also in Rome. He sculpted bronze and terra cotta statuettes, examples of which are in the Rath Museum, Geneva.

KEYSER, Jean Baptiste de fl. late 19th century
Born at Curreghem, Belgium on April 22, 1857, he exhibited statuettes in Brussels and Paris in the 1880s.

KEYSER, Michel de fl. late 19th century
Portrait sculptor working in Paris in the 1880s.

KHNOPFF, Fernand 1858-1921
Born at Grembergen, Belgium on September 12, 1858, he died in Brussels on November 12, 1921. He studied painting under X. Mellery at the Brussels Academy and worked under Jules Lefebvre in Paris. He worked as a painter, pastellist, lithographer and sculptor and was strongly influenced by the English Pre-Raphaelites and the French Symbolists. He exhibited widely, winning silver medals at the Expositions Universelles of 1889 and 1900 and a medal in Munich in 1905. He also had a one-man show at the New Gallery, London in 1902. He produced portrait busts, heads and masks, in ivory, wood, plaster and bronze.
Dumont-Wilden, L. *Fernand Khnopff* (1907).

KHUEN, Theodor Franz Marie 1860-
Born in Vienna on July 13, 1860, he studied under Hugo Härdtl, Tilgner and Hans Gasser. He specialised in portrait busts, statues and memorials and is best known for the equestrian statue of the Prince of Liechtenstein.

KIEFER, Karl 1871-
Born at Jettenbach on February 9, 1871, he studied under W. von Rümann and worked in Munich.

KIEFER, Oscar Alexander 1874-
Born in Offenbach, Germany on February 26, 1874, he worked mainly in Karlsruhe and specialised in architectural sculpture and decoration. He also sculpted monuments to Bismarck, Goethe and Liszt.

KIELLAND, Valentin Axel 1866-
Born in Stavanger, Norway on July 21, 1866, he studied under Léon Bonnat in Paris and was strongly influenced by Rodin. His statuettes and groups were mainly of religious subjects.

KIELLBERG, Johannes Frithiof 1836-1885
Born in Jonkoping, Sweden on February 5, 1836, he died in Stockholm on February 16, 1885. He exhibited in Copenhagen, Stockholm, Berlin, Paris and Rome and specialised in portrait busts and groups based on classical and Scandinavian mythology.

KIEMLEN, Émil 1869-
Born in Kannstatt, Germany on January 1, 1869, he worked as a decorative sculptor in Heilbronn, Stuttgart and other towns in Württemberg. He specialised in portrait busts and statues of German royalty and political figures, such as Bismarck.

KIENAST, Anna Baumann 1880-
Born in Horgen, near Zürich on November 18, 1880, he exhibited busts and statuettes regularly in the Swiss salons.

KIENERK, Giorgio 1869-
Born in Florence on May 5, 1869, he worked as a painter and sculptor of portraits.

KIENHOLZ, Hans fl. late 19th century
Born in Brienz, Switzerland in 1856, he worked there and later in Paris where he taught at the School of Decorative Arts. He returned to Switzerland and became professor at the School of Fine Arts, Brienz.

KIESER, Richard 1870-
Born in Coburg, Germany on March 15, 1870, he worked as a decorative sculptor in Krefeld and Dessau.

KIESER, Walter 1894-
Born in Krefeld on August 27, 1894, he was the son and pupil of Richard Kieser and worked on figures and bas-reliefs in Dresden and Dessau.

KIESEWALTER, Heinrich fl. 19th century
Born in Breslau on November 14, 1854, he studied under Wolff in Berlin and specialised in equestrian statuettes.

KIETZ, Gustav Adolph 1824-1908
Born in Leipzig on March 26, 1824, he died near Dresden on June 24, 1908. He had a great reputation at an early age for his mythological figures and groups. Later he sculpted a number of monuments for Dresden, Cassel, Leipzig and Berlin.

KIETZ, Theodor Benedikt 1829-1898
Born in Leipzig on September 27, 1829, he died near Dresden on July 26, 1898. He specialised in portrait busts of German royalty and celebrities.

KILBANIKOV, ? fl. 20th century
Sculptor of portrait busts, statues and reliefs, mainly of political figures in the Soviet Union since about 1930.

KILENYI, Julio 1885-
Born in Hungary in 1885, he emigrated to the United States and studied in New York. He was a member of the American Federation of Arts and specialised in medallions and bas-reliefs portraying contemporary and historical American celebrities.

KILLER, Karl 1873-
Born in Munich on August 30, 1873, he studied under F. von Müller and specialised in public statuary and memorials.

KILPATRICK, Dereid Gallatin 1884-
Born in Uniontown, Pennsylvania on September 21, 1884, he studied under Lucien Simon, A. Bourdelle and Collin in Paris. He specialised in portrait busts, reliefs and statues of historic Americans, such as Washington and Lincoln.

KIMBALL, Isabel Moore fl. 20th century
Born in Wentworth, Iowa at the beginning of this century, she studied under Herbert Adams and was a member of the American Federation of Arts. She specialised in fountains and ornamental sculpture for parks and public places. She also sculpted several memorials after the first world war.

KIND, Georg 1897-
Born in Dresden on January 24, 1897, he worked as an engraver and sculptor and specialised in busts and statuettes of dancers and animals.

KINDLER, Ludwig 1875-
Born in Strasbourg on March 16, 1875, he worked in Munich and specialised in busts of Bavarian royalty.

KING, Inge fl. 20th century
Sculptress of European origin who emigrated to Australia in 1951 and has since produced portrait busts and reliefs, genre figures, memorials and monuments, mainly in Sydney, Canberra and Melbourne.

KING, John Crookshanks 1806-1882
Born in Scotland in 1806, he died in Boston, Massachusetts in 1882. He emigrated to New Orleans in 1829 and later settled in Boston where he sculpted portrait busts and statues of prominent American politicians.

KING, William Charles Holland 1884-
Born in Cheltenham on October 5, 1884, he studied at the Slade School and the Royal Academy Schools where he won the Landseer scholarship. He exhibited at the Royal Academy from 1910 onwards and also the Royal Scottish Academy and major galleries in Britain and western Europe. He was awarded the R.B.S. gold medal for distinguished services to sculpture and was President of that Society from 1949 to 1954. He worked in London and Ventnor, Isle of Wight as a sculptor of portrait busts, heads and reliefs.

KINLOCH, George W. fl. late 19th century
Born in Perthshire in the mid-19th century, he worked in Edinburgh as a sculptor of portraits and genre figures. He exhibited three works at the Royal Academy in 1884.

KINSBOURG, L. fl. 20th century
Portrait sculptress working in Paris before the second world war.

KINSBURGER, Sylvain fl. 19th-20th centuries
Born in Paris on January 21, 1855, he studied under A. Dumont and D. Thomas and exhibited genre figures at the Salon from 1878. He was one of the earliest Associates of the Artistes Français and won third class (1888) and second class (1899) medals, as well as bronze medals at the Expositions of 1889 and 1900.

KIRCHEISEN, Eugen Victor 1855-1913
Born in Johanngeorgenstadt, Hanover on August 21, 1855, he died in Brunswick on December 13, 1913. He studied under Schilling and sculpted numerous busts and monuments of German celebrities, notably that of Bismarck at Holzminden.

KIRCHHOFF, Theodor Johann Friedrich fl. 19th century
Born in Moscow on March 8, 1837, he settled in Dresden where he had studied at the Academy. He sculpted busts of Saxon society.

KIRCHMAYER, Friedrich 1813-1871
Born in Munich in 1813, he died there in 1871. He produced statues of Bavarian royalty and celebrities and ornamental sculpture in Munich.

KIRCHMAYR, Johann fl. 19th century
Born in Oberperfuss, Tyrol in the late 18th century, he died there in 1846. He worked as a decorative sculptor, particularly in the churches of the Tyrol.

KIRCHMAYR, Joseph 1775-1845
Born in Rockersing, Bavaria on March 8, 1775, he died in Munich in 1845. He specialised in busts of his contemporaries. Many of his works are in the Hamburg Museum.

KIRCHNER-MOLDENHAUER, Dorothea 1884-
Born near Poznan on September 19, 1884, she studied under Zügel and worked on animal figures and groups, many of which were subsequently reproduced in porcelain.

KIRSCH, Hugo Franz 1873-
Born in Hainsdorf, Germany on July 15, 1873, he was employed as a modeller in a porcelain factory.

KIRSTEIN, Edith 1881-1926
Born in Sagnitz, Germany on August 24, 1881, she died in Berlin in October, 1926. She produced statuettes and portrait busts.

KIRSTEIN, Joachim Friedrich 1805-1860
Born in Strasbourg in 1805, he died there on January 22, 1860. He worked as a jeweller and sculptor of figurines and presentation pieces and exhibited at the Salon in 1838-42.

KISELEWSKI, Joseph fl. 20th century
American sculptor of Polish origin working in the first half of this century. He sculpted portrait busts and reliefs, memorials and statues, allegorical and animal figures and groups.

KISFALUDI-STROBL, Zsigmond 1884-
Born at Also Rajk, Hungary on July 1, 1884, he studied in Budapest and Vienna and became professor of sculpture at the Budapest Academy in 1923. He sculpted portraits and genre figures and, in more recent years, allegorical and political figures and groups, such as The Wheel Turns Round Again.

KISS, August Karl Eduard 1802-1865
Born at Paprotzah, Prussia on October 11, 1802, he died in Berlin on March 24, 1865. He studied at the Berlin Academy under Rauch, Tieck and Schinkel and produced portrait busts, allegorical groups, such as Faith, Hope and Charity, and hunting groups, such as Amazon defending herself against a Tiger, Fox-hunt, End of the Hunt and Return from the Hunt.

KISS, Gyorgy 1852-1919
Born in Szasvhar, Hungary on August 17, 1852, he died in Budapest on September 24, 1919. He specialised in allegorical and religious figures and ecclesiastical decoration, notably in Esztergom Cathedral. He was awarded a silver medal at the Exposition Universelle of 1900.

KISS, Jozsef 1875-
Born in Budapest on March 6, 1875, he studied there and in Vienna and at the Académie Julian in Paris. He produced genre and allegorical figures at the turn of the century.

KISSLING, Ernst 1890-
Born in Zürich on August 12, 1890, he specialised in heads and busts.

KISSLING, Leopold 1770-1827
Born in Schönleben, Austria on October 8, 1770, he died in Vienna on November 26, 1827. He sculpted classical figures and allegorical statuary, mainly in marble. His best known work is the marble group in the Belvedere Palace, Vienna, depicting Mars, Venus and Cupid to symbolise the marriage between Napoleon and Marie Louise of Austria.

KISSLING, Richard 1848-1919
Born at Wolfwyl, Switzerland on April 15, 1848, he died in Zürich on July 19, 1919. He studied under Ferdinand Schloth and later attended classes at the Academy of St. Luke, Rome from 1870 to 1883 before settling in Zürich. He sculpted monuments, memorials and fountains in Zürich, Coize and St. Gall. He exhibited statuettes at the Royal Academy in 1887 and got an honourable mention at the Exposition Universelle of 1889.

KISSNER, Erwin 1885-
Born in Berlin on December 13, 1885, he specialised in animal figures and groups.

KITSON, Henry Hudson 1865-
Born in Huddersfield, Yorkshire on April 9, 1865, he studied at the École des Beaux Arts, Paris under Bonnassieux and won a bronze medal at the Salon of 1889. He later emigrated to the United States and settled in New York where he sculpted numerous monuments. He took part in the principal American exhibitions from the Columbian Exposition of 1893 onwards.

KITSON, Samuel James 1848-1906
Born in Huddersfield on January 1, 1848, he died in New York on November 9, 1906. He Studied at the Academy of St. Luke, Rome under Todesti and Jacometti. He emigrated to the United States in 1878 and worked in Boston and New York as a decorative sculptor. He worked for William Vanderbilt and did the decorative sculpture on his New York mansion. He also sculpted a number of monuments and memorials, such as the Sheridan monument in Arlington National Cemetery and the bas-relief honouring sailors and soldiers on the Hartford War Memorial. He produced a number of portrait busts of contemporary American politicians and society celebrities.

KITSON, Thea Alice (née Ruggles) 1876-
Born in Brookline, Massachusetts, she was the pupil and later the wife of Henry Hudson Kitson. She studied in Paris under Dagnan Bouveret and exhibited at the Salon des Artistes Français, winning an honourable mention in 1899. She was awarded a bronze medal at the St. Louis World's Fair (1904). She specialised in allegorical figures and equestrian statues and did many monuments and memorials in Massachusetts.

KITTLER, Hermann 1866-
Born in Leipzig on February 20, 1866, he worked in Berlin from 1887 as a landscape painter and sculptor of heads and busts.

KITTLER, Philipp 1861-
Born at Schwabach near Nuremberg on June 18, 1861, he enjoyed a high reputation for his tombs and memorials. He also sculpted public statuary and genre figures.

KLAGMANN, Jean Baptiste Jules 1810-1867
Born in Paris on April 14, 1810, he died there on January 18, 1867. He studied at the École des Beaux Arts and was a pupil of Feuchère and Ramey the Younger. He was employed by the Gobelins, Beauvais and Sèvres factories as a designer and modeller. He was made a Chevalier of the Legion of Honour in 1853 and specialised in decorative sculpture, notably in the theatres of Avignon and Toulon. The museums in these towns possess various models and maquettes by him. He also sculpted portrait busts and statuettes of contemporary and historical figures.

KLAUER, Ludwig fl. early 19th century
Born in Weimar, Saxony on January 9, 1782, the son of Martin Gottlieb Klauer, he specialised in portrait busts of German celebrities, such as Herder, Schiller and Goethe.

KLAUER, Martin Gottlieb 1742-1801
Born at Rudolstadt on August 29, 1742, he died in Weimar on April 4, 1801. He specialised in portrait busts of Saxon celebrities and royalty and also classical friezes, bas-reliefs and murals.

KLEEFT, Henry William Brouwer van der 1778-1862
Born in Dordrecht, Holland in 1778, he died in Hamburg on July 26, 1862. He spent many years in Russia and later worked as a decorative sculptor in London and Hamburg.

KLEIN, Franz fl. early 19th century
Born in Vienna on April 27, 1779, he studied under Martin Fischer in Vienna and then went to Rome. He returned to Vienna in 1820 and specialised in portrait busts and memorials.

KLEIN, Karl 1898-
Born at Nymburk, Bohemia on May 25, 1898, he settled in Paris after working in Prague and Berlin. Though mainly known as a landscape painter he also dabbled in genre sculpture.

KLEIN, Max 1847-1908
Born at Gönc, Hungary on January 27, 1847, he died in Berlin on September 6, 1908. He exhibited romantic and genre figures in Paris, Munich and Berlin in the late 19th century.

KLEIN, Richard 1890-
Born in Munich on January 7, 1890, he studied at the Academy and worked as a painter and sculptor, specialising in portrait reliefs and busts.

KLEM, Theophil 1849-1923
Born in Colmar in 1849, he died there on November 20, 1923. He studied at the Vienna Academy and specialised in ecclesiastical sculpture in Switzerland and Alsace-Lorraine.

KLEMENS, Emil 1866-
Born in Berlin on October 5, 1866, he specialised in monuments to Kaiser Wilhelm I all over Germany.

KLETT, Hans 1876-
Born at Saalfeld, Thuringia on May 30, 1876, he lived for many years in Italy and travelled in Egypt and the Near East. This is reflected in his work, which consisted of figures and groups illustrating the peoples and wildlife of the Mediterranean. He took part in the Berlin Exhibition of 1909.

KLEY, Louis 1833-1911
Born at Sens on March 17, 1833, he died there on March 8, 1911. He studied under Lequien and exhibited at the Salon from 1853, winning a silver medal at the Exposition of 1889 and many other prizes. He produced allegorical and neo-classical groups and statuettes as well as portrait busts of contemporary Frenchmen in bronze and terra cotta.

KLIEBER, Josef 1773-1850
Born in Innsbruck on November 1, 1773, he died in Vienna on January 11, 1850. He studied under Straub and Fischer and specialised in monuments and memorials.

KLIEBER, Urban c.1740-1803
Born in Innsbruck about 1740, he died there on March 25, 1803. He did many public statues and monuments in the Innsbruck area, as well as church decoration and memorials and tombstones.

KLIMSCH, Fritz 1870-
Born in Frankfurt-am-Main on February 10, 1870, he studied under Schaper in Berlin and also worked in Vienna, Paris and Rome. He participated in the major international exhibitions at the turn of the century and won a gold medal in Berlin in 1907. He specialised in genre statuettes of athletes and dancers.

KLINCKERFLUSS, Bernhard 1881-
Born in Stuttgart on May 23, 1881, he studied under Landenberger and worked mainly as a landscape painter. He travelled in France, England and Italy and also sculpted genre statuettes.

KLINGER, Max 1857-1920
Sculptor in marble, ivory and bronze working in the Leipzig area on portrait busts and statues of historic and contemporary Germans. He was born in Leipzig on February 18, 1857 and died there on July 5, 1920. He studied in Karlsruhe (1874-75) and Berlin and exhibited

paintings and etchings at the Academy, but for much of his career his work was regarded as highly controversial. He studied in Paris from 1883 to 1886 and then visited Italy, returning to Leipzig in 1893. From 1886 onwards he concentrated more on sculpture, aiming at grim impressionism of traditional subjects derived from classical mythology and the Bible. He was a pioneer of chryselephantine bronzes in the original Greek sense of using gilding and ivory to enhance bronze. His sculptures in this genre include figures of Cassandra, Salome, Christ and Beethoven. His chief work was the colossal monument to Richard Wagner which remained incomplete at the time of his death. Many of his smaller sculptures, paintings and etchings are in the Leipzig Museum, in a hall which he designed himself.
Schmid, Max *Max Klinger* (1926)

KLINT, Gustav Adolf 1775-1822
Born in Stockholm in 1775, he died there in 1822. He studied under Sergel and specialised in portrait busts, bas-reliefs and medallions in plaster and bronze.

KLIPPEL, Robert 1920-
Born in Sydney, Australia in 1920, he studied art there and has sculpted numerous monuments and memorials, public statuary and portrait busts and heads since the second world war.

KLODT, Baron P.K. von Jurgensburg 1805-1867
Born in Russia in 1805, he died there in 1867. He was an Animalier, specialising in figures and groups of horses and equestrian statuettes of Russian royalty. Many of his bronzes are preserved in the Russian Museum, Leningrad and the Tretiakoff Gallery, Moscow.

KLOSS, Karl 1849-1881
Born in Warsaw on February 19, 1849, he died there on May 29, 1881. He studied under Marconi and specialised in portrait busts and memorials and neo-classical statuettes.

KLOTZ, Edmund fl. 19th century
Born at Inzing, Austria on December 25, 1855, he studied in Italy before settling in Breitenfeld where he specialised in religious statuary and friezes.

KLOTZ, Gottlieb 1780-1834
Born at Imst, Austria on March 3, 1780, he died there on February 13, 1834. He specialised in classical figures and groups, such as Orestes and Pylades before Iphigenia (Innsbruck Museum).

KLOTZ, Hermann fl. late 19th century
Born in Imst on June 11, 1850 he was the nephew of Gottlieb and studied under Karl Kaiser in Vienna. He specialised in polychrome plaster figures.

KLOUCEK, Celda fl. late 19th century
Born in Senomaty, Bohemia on December 6, 1855, he studied in Vienna and Frankfurt and settled in Prague where he did many public statues and monuments. His minor works include portrait busts and bas-reliefs.

KLUGE, Kurt 1886-
Born in Leipzig on April 29, 1886, he studied under Sterl and Dorsch in Dresden. He settled in Berlin where he became professor of sculpture at the Academy. He specialised in busts and figures of a religious nature.

KLUGT, Hugo 1879-
Born in Hamburg on December 14, 1879, he studied in Berlin and Munich and specialised in bas-reliefs and allegorical figures. He sculpted the war memorial at Volksdorf in 1925.

KNABL, Josef 1819-1881
Born in Fliess, Germany on July 17, 1819, he died in Munich in November 1881. He studied under Franz Renn and settled in Munich. He was a very prolific sculptor of religious works, mainly for churches in Augsburg, Eichstatt, Marienberg and Passau.

KNAPPE, Karl 1884-
Born in Kempten, Germany on November 11, 1884, he settled in Munich where he produced Expressionist figures and groups with a strong religious influence.

KNAUR, Emmanuel August Hermann 1811-1872
Born in Leipzig on April 3, 1811, he died there on April 1, 1872. He specialised in portrait busts, reliefs and statuettes of his distinguished contemporaries and also allegorical works, such as the statuette representing Lipsia the embodiment of Leipzig. His chief work was the Gellert monument, maquettes for which are in the Leipzig Museum.

KNECHT, Richard 1887-
Born in Tübingen on January 25, 1887, he studied under Erwin Kurz at the Munich Academy and was strongly influenced by Rodin in his earlier statuettes and groups.

KNEELAND, Horace fl. 19th century
American sculptor, working in New York in the 1860s. He did the bust of the marine engineer and inventor John Ericsson now in the Stockholm Museum.

KNEULMAN, Carel 1915-
Born in Amsterdam in 1915, he studied at the Academy of Fine Arts (1940-43) and has taken part in all the major Dutch exhibitions since 1949, as well as the Antwerp Biennale since 1953. He has travelled widely, in Britain, Belgium, France, Germany, Switzerland and the Iberian peninsula and has had many important public commissions in the Netherlands. Much of his work shows religious inspiration and includes Jacob and the Angel (1956), The Resurrection of Lazarus (1957). Occasionally his work takes on a more symbolic and Expressionist note, such as Warning against Destruction (1956) and Icarus Falling (1956). He lives in Amsterdam.

KNIEBEBE, Walter 1884-
Born in Dortmund on June 22, 1884, he worked mainly in Düsseldorf and Elberfeld on female statuettes, busts and torsos.

KNIEKE, Heinrich fl. late 19th century
Born in Mackstum, Germany on March 5, 1855, he worked in Hildesheim and Berlin and assisted Schaper on the Goethe monument. His minor works include portrait busts and allegorical statuettes.

KNOOP, Guitou 1909-
Born of Dutch parentage in Moscow in 1909, she became a naturalised Frenchwoman in 1933. Prior to 1927 she wandered all over Europe in the aftermath of the Revolution but then settled in Paris and studied under Bourdelle. She began exhibiting in 1932, at the Galerie Cardo. Later she was influenced by Despiau and concentrated on portrait busts in clay for bronze casting. She exhibited at the Wildenstein Gallery in New York in 1936 and 1939 and stayed in the United States during the second world war but has commuted between Paris and New York since 1945. Since 1949 her work has become increasingly abstract, influenced by Arp, and since then she has exhibited at the Salon de la Jeune Sculpture, working in brass, lead and latterly in stone.

KOB, Anton 1822-1895
Born near Merano on September 7, 1822, he died at Bozen (Bolzano) on December 29, 1895. He specialised in ecclesiastical decoration and worked in the churches of Kastebrut and St. Nicholas, Bozen.

KOBELT, Johann 1861-1903
Born at Marbach on March 10, 1861, he died in St. Fiden in 1903. He worked in Munich under Widmann and then went to Vienna where he studied under Lax and Weyr. He is best known for the four large figures decorating the Parliament Building in Vienna. In 1886 he moved to Berlin and subsequently did numerous portrait busts. He returned to Switzerland about 1890 and settled in St. Gall where he did many memorials and a number of genre figures and groups.

KOCH, Franz 1832-1922
Born in Tarrenz, Tyrol on September 12, 1832, he died in Vienna on May 12, 1922. He specialised in monumental sculpture and decorated the façades of the Museum of the History of Art, the Finance Ministry and the Parliament Building.

KOCH, Georg Moritz 1885-
Born in Berlin on December 21, 1885, he studied under Bruno Wiese and became one of the leading members of the German Expressionist school, specialising in busts, heads and relief portraits.

KOCH, Gottlieb von 1849-1914
Born in Hirschberg, Germany on October 15, 1849, he died at Alsbach on November 21, 1914. He worked as an Animalier in Jena and Darmstadt.

KOCH, Leopold fl. late 19th century
Born at Klein Mangelsdorf, Germany on June 28, 1857, he worked in Berlin and exhibited at the Academy from 1881. He is best known for the monument to King Frederick William I of Prussia, formerly in Nauen.

KOCH, Paul Francesco 1845-1886
Born in Hamburg on March 31, 1845, he died in Augsburg on August 19, 1886. He studied at the Berlin Academy and produced genre and historic figures.

KOCIAN, Quido 1874-
Born at Usti in Bohemia in 1874, he became professor of sculpture at Horice School of Art and specialised in statues and groups inspired by biblical characters.

KOELLE, Fritz 1895-
Born in Augsburg on March 10, 1895, he travelled in Italy and France and worked as a decorative sculptor in Munich, Berlin, Münster and Baden-Baden.

KOELMAN, Johann Philip 1818-1893
Born in The Hague on March 11, 1818, he died there on January 16, 1893. He studied architecture under his father and drawing under C. Kruseman, but later turned to sculpture and exhibited a plaster bust at The Hague in 1866. He is best known for the statuary at the Netherlands Bank in Amsterdam, of which bronze reductions also exist.

KOENIG, Fritz 1924-
Born in Würzburg, he studied at the Munich Academy from 1946 to 1952 under Anton Hiller. In 1951 he studied in France and visited Belgium, Italy, Greece and Egypt. He won a prize in the international competition of 1952 for the monument To The Unknown Political Prisoner and the Böttcherstrasse Prize of Bremen in 1957 and the Villa Massimo scholarship the same year. He has exhibited in Antwerp, Arnhem and Munich since 1957. He works in bronze and produces elongated figures and groups, bas-reliefs, such as Calvary, and various interpretations on the theme of a Herd of Bulls. Quadriga (1957) is a semi-abstract in which the horse, man and chariot have been merged into one.

KOENIG, Gustav 1880-
Born in Rudolstadt on November 17, 1880, he moved to Paris in 1898 and then to Berlin in 1912 where he won the Prix de Rome. Later he settled in Berlin-Wilmersdorf where he sculpted monuments, memorials and portraits.

KOGAN, Moissej 1879-
Born in Orgieieff, Russia on May 24, 1879, he worked in Germany and Paris and was influenced by Rodin and Maillol. Later he became a member of the Munich Artists' Circle. He specialised in female statuettes and torsos, in terra cotta and bronze.

KOHLER, Rose fl. 20th century
Born in Chicago, she studied under Duveneck at the Cincinnati Academy and worked as a painter and sculptor of portrait and genre subjects. She was a member of the American Professional Artists League.

KOHN, Gabriel 1910-
Born in Philadelphia in 1910, the son of an engraver, he studied at the Cooper Union under Gaetano Cecere. From 1930 to 1934 he studied at the Beaux-Arts Institute of Design, modelling figures and busts from life. From then until 1942 he worked mainly in Hollywood, modelling for cinema and theatre sets and worked as a camouflage officer during the war. In 1947 he went to Paris and worked with Zadkine and later worked in Rome (1948-49) and studied in Paris and at the Cranbrook Academy till 1954. He was a prize-winner in the competition for the monument To the Unknown Political Prisoner. He has exhibited in American galleries, the Sao Paulo Biennial and other international shows since 1953 and his sculpture is represented in the collections of the Museum of Modern Art, New York, the

Whitney Museum and the Albright Art Gallery. His earlier work was done in stone, terra cotta and bronze, but since 1959 he has preferred laminated wood.

KOKOLSKY, Hermann fl. 19th century
Born in Berlin on April 12, 1853, he did numerous monuments of German royalty, especially in the Osnabrück area and decorated churches in Berlin, Dessau and Leipzig.

KOLBE, Georg 1877-1947
Born in Waldheim, Germany on April 15, 1877, he died in Berlin in 1947. He worked originally as a painter, but after meeting Rodin and Tuaillon in 1898 he turned to sculpture. He settled in Berlin in 1903 and worked in Munich, Paris and Rome at various times. He also spent some time in Florence (1905), Greece (1913) and Egypt (1931). He was awarded the Goethe Prize of Frankfurt in 1936. He specialised in figures which were highly distinctive and exerted a great influence on the development of German sculpture in the 1920s and 1930s. Later, however, he tried to conform to the heroic ideal laid down by the Nazis, but this never succeeded in stifling his distinctive style. His works include Dancer (1912), Slave (1917), Annunciation (1924), Seated Woman (1928), Pietà (1929), Zarathustra (1933), Discobolus (1933), Young Girl (1934) and Young Standing Woman (1937). The main collection of his bronzes is in the Georg Kolbe Museum, Berlin-Charlottenburg, founded after his death.

KÖLBEL, Rudolf 1826-1910
Born in Berlin, he died in Oldenburg on January 7, 1910. He was sculptor to the Grand Duke of Oldenburg and specialised in portrait busts, heads, bas-reliefs and medallions of German royalty and society.

KOLBERG, Andreas Johnsen 1817-1869
Born in Copenhagen on November 25, 1817, he died there on August 10, 1869. He specialised in biblical figures and groups, such as Ruth and Boaz (1843).

KOLLMAR, Wilhelm 1872-
Born in Zweibrücken on March 15, 1872, he studied at the Karlsruhe Academy from 1896 to 1903 and exhibited figures there in 1906.

KÖLLÖ, Miklos 1861-1900
Born in Gyergyo-Csomafalva, Hungary in 1861, he died in Budapest on September 17, 1900. He studied under Knabl and Hess at the Munich Academy and specialised in figures and groups of historic and heroic subjects. His chief work was the statue of Lajos Kossuth at Maros Vasarhely.

KOLLWITZ, Käthe 1867-1945
Born in Königsberg on July 8, 1867, she died in Moritzburg near Dresden on April 22, 1945. She studied painting in Berlin under Stauffer-Bern in 1885 and then sculpture under Herterich in Munich in 1888-89. In 1891 she married Karl Kollwitz, a doctor working in the Berlin slums, and she worked with him for many years, apart from the periods in 1904 and 1907 when she trained as a sculptor in Paris and Rome. She produced paintings and etchings of historic and contemporary subjects, such as the Weavers Rebellion and the Peasants' War and the social message was an underlying theme of her sculpture as well. Her first sculpture was exhibited in 1916. Her son Peter was killed in action in 1914 and she worked for years on a memorial, not only to him but to all the volunteers who had fallen in the war. The memorial was eventually completed in granite in 1932 and erected in Essen cemetery near Dixmude. Many of her later works, such as Circle of Mothers (1937), Pietà (1938) and Indictment (1939) were strongly pacifist and critical of the Nazi regime. She was banned by the Berlin Academy and constantly intimidated by the Gestapo, but she refused to leave Germany and spent the remaining years of her life in circumstances of great privation.

KOLP, Engelbert 1840-1877
Born at Flirsch, Austria on October 28, 1840, he died in Innsbrück on August 21, 1877. He specialised in ecclesiastical sculpture in Upper Bavaria.

KOLTZOFF, Serge 1892-
Born in Moscow on September 17, 1892, he studied at the Moscow School of Fine Arts and won its gold medal. He began as a Realist but turned to Constructivism in the 1920s.

KOMPATSCHER, Andreas 1864-
Born in Bozen (Bolzano) in 1864, he specialised in figures and groups of religious subjects, mainly in polychrome marble.

KONCZEWSKA, Madame fl. 19th-20th centuries
Polish sculptress working in France at the turn of the century on Art Nouveau bas-reliefs and statuettes.

KONDRUP, Catinka fl. 19th century
Born near Aalborg, Denmark on December 11, 1851, she studied in Copenhagen and London and exhibited figures at the Royal Academy in 1880-86.

KONENKOV, S. 1874-
Born in New York in 1874, he worked as a sculptor of memorials and portraits in the early years of this century.

KONIECZNY, Wladimir 1886-1916
Born in Jaroslav, Poland in 1886, he died on July 5, 1916. He worked as a decorative sculptor in Cracow and later also in Paris and Italy.

KÖNIG, Benedikt 1842-1906
Born at Gruberberg, Württemberg on April 11, 1842, he died in Munich on July 9, 1906. He specialised in statues and busts of prominent Germans. His statue of Leibniz is in Stuttgart Polytechnic.

KÖNIG, Richard fl. late 19th-20th centuries
Born at Leobschütz, Saxony on February 7, 1863, he studied at the academies of Dresden and Berlin and worked in Dresden, and Chemnitz on religious figures and bas-reliefs and monumental statuary.

KONIONKOFF, Sergei Timofeievich 1874-
Born in Smolensk, Russia on July 10, 1874, he worked in Moscow and St. Petersburg and specialised in busts and bas-reliefs. After the Bolshevik Revolution he moved to Italy and later settled in the United States.

KONNERT, Michel 1875-
Born in Paris on April 29, 1875, he studied under Moreau-Vauthier and exhibited figures at the Salon des Artistes Français.

KONTI, Isidore 1862-
Born in Vienna on September 9, 1862, he studied at the Vienna Academy under Kundmann and won several scholarships which enabled him to continue his studies in Rome. In 1890 he emigrated to the United States and worked for two years on the decoration of the buildings for the Columbian Exposition in Chicago. Later he was associated with Karl Bitter in New York and specialised in architectural sculpture. He established his own studio in New York in 1900 and did decorative work for the Pan-American Exposition, Buffalo. His minor bronzes include genre figures, such as Will-o-the-Wisp and Dying Melodies. He won a gold medal at the St. Louis World's Fair in 1904 and was elected Academician the following year. He also produced a large number of portrait busts.

KOORT, Jaan 1883-
Born at Pupaswere near Dorpat, Estonia on November 6, 1883, he studied in St. Petersburg and Paris and settled there about 1907. He exhibited figures and busts at the Nationale from 1908.

KÖPF, Josef 1867-1915
Born in Schongau, Bavaria in 1867, he died in Munich in December 1915. He worked as a decorative sculptor in Munich, and specialised in religious figures and bas-reliefs.

KÖPF, Joseph von 1827-1903
Born in Unlingen, Württemberg on March 10, 1827, he died in Rome on February 2, 1903. He was self-taught, but went to Rome in 1852 and later worked with Martin Wagner in Wurzburg in the mid-1850s. He worked for a time in Rome and then settled in Baden-Baden. He won a medal at the Munich exhibition of 1888 and took part in the Paris Exposition of 1900. He specialised in busts and statues of German royalty and allegorical figures, such as Piety, The Dance, Music, Winter and Summer.

KÖPF, Professor T. fl. 19th century
Genre sculptor working in Rome in the second half of the 19th century. He exhibited at the Royal Academy from 1869 to 1897.

KOPITS, Janos 1872-
Born at Kaposvar, Hungary on September 9, 1872, he specialised in ecclesiastic sculpture.

KOPMAN, Benjamin 1887-
Born at Vitebsk, Russia on December 25, 1887, he emigrated to the United States in 1900 and studied at the National Academy of Design, New York. He worked as a painter and sculptor of genre and portrait subjects and exhibited at the National Academy of Design from 1912 and had a one-man show in Chicago in 1920.

KOPP, Karl 1825-1897
Born at Wasseralfingen, Germany on October 24, 1825, he died in Stuttgart on March 1, 1897. He worked as a decorative sculptor at Wilhelma Castle, Stuttgart.

KORALUS, Paul 1892-
Born at Widminnen, East Prussia in 1892, he worked as a decorative sculptor in Königsberg.

KORBEL, Mario J. 1882-
Born in Gosik, Bohemia on March 23, 1882, he studied in Munich and Paris and emigrated to the United States. He became a member of the Society of Arts, Chicago and specialised in allegorical statuettes, such as Night (a seated female figure), and dancers.

KORMIS, Fred J. 1894-
Born in Frankfurt-am-Main on September 20, 1894, he studied at the local High School and emigrated to England in the 1930s. He has since exhibited at the Royal Academy and works in London, sculpting figures and portraits in stone, wood, terra cotta and bronze.

KORN, Halina 1902-
Born in Warsaw on January 22, 1902, she married the painter Marek Zulawski and settled in London in 1940. She was largely self-taught but works as a painter and sculptor of portraits and genre subjects. She has exhibited at the Royal Academy and the Leicester Galleries and has had several individual shows.

KORN, Johann Robert 1873-1921
Born in Salzungen, Germany on February 15, 1873, he died in Berlin on September 24, 1921. He exhibited figures and groups in Berlin in 1909.

KÖRNENDI-FRIM, Jeno 1886-
Born in Budapest on October 21, 1886, he worked as a monumental sculptor. His best known work is the memorial to the war against the Turks, at Jaszbereny.

KORNER, Henrietta 1892-
Born in Tarnow, Poland on February 23, 1892, she studied under Anton Hanak in Vienna and worked in Paris from 1938 onwards. She exhibited at the Exposition Internationale of 1937 and at the Salon d'Automne and the Tuileries and showed terra cotta figures at the Birmingham Exhibition of 1950. She produced statuettes and reliefs in bronze and ceramic materials.

KOROLEV, B. 1884-
Born in Russia in 1884, he produced figures and bas-reliefs in the early years of this century.

KORSCHMANN, Charles 1872-
Born in Brno, Bohemia on July 23, 1872, he studied at the Schools of Fine Arts in Vienna, Berlin and Paris, settling in the latter in 1894. He exhibited at the Salon des Artistes Français from then onwards and was awarded a bronze medal at the Exposition of 1900. He specialised in portrait busts in marble and bronze.

KORTHALS, Claudie Fréderique fl. 20th century
Born in Frankfurt-am-Main in the late 19th century, she settled in Holland and specialised in animal figures and groups.

KOSSOWSKI, Henryk the Elder c.1815-c.1870
Born in Cracow about 1815, he died there about 1870. He worked in Berlin and Warsaw and specialised in busts of German and Polish celebrities and royalty.

KOSSOWSKI, Henryk the Younger fl. 20th century
Born in Cracow about 1855, he came to Paris in 1882 and exhibited at the Salon des Artistes Français. He won a bronze medal at the Exposition Universelle of 1900. He specialised in gilt-bronze medieval and historical figures, such as The Armourer.

KOTTLER, Moses 1896-
Born in Germany in 1896, he emigrated with his family to South Africa at the turn of the century and lived in Cape Town. He studied in Jerusalem, Tel Aviv, Munich and Paris after the first world war and settled in Johannesburg where he has sculpted a number of monuments and memorials, and the decorative bas-reliefs in Johannesburg Public Library. He has sculpted South African celebrities, past and present, such as General de Wet and President Burgers of the former Orange Free State. He also sculpts genre figures illustrating the Afrikaaner way of life, in stone, wood and bronze.

KOURITSINE, Vladimir fl. 20th century
Born in Sebastopol at the beginning of this century, he emigrated to France after the Revolution and exhibited statuettes at the Salon des Indépendants, the Salon d'Automne and the Nationale from 1926 onwards.

KOWALCZEWSKI, Karl 1876-
Born at Schwanzenau, Germany on December 31, 1876, he worked in Berlin and took part in the Great Exhibition of 1909.

KOWARZIK, Joseph 1860-1911
Born in Vienna on March 1, 1860, he died in Cannes on March 13, 1911. He worked in Frankfurt-am-Main where he specialised in memorials, tombs and monumental statuary.

KOWARZIK, Rudolf 1871-
Born in Vienna on March 13, 1871, he became professor of sculpture at Pforzheim and later Baden. He specialised in portrait bas-reliefs and medallions.

KOWNATZKI, Hans 1886-
Born in Königsberg (now Kaliningrad) on November 26, 1886, he studied under Heide, Koner and Lefebvre before emigrating to the United States. He won first prize for sculpture in Washington in 1929.

KOZARIC, Ivan 1921-
Born in Petrinja, Yugoslavia in 1921, he studied under Krsinič in the Zagreb Academy and spent some time in Paris studying the work of Arp, Brancusi, Zadkine and Giacometti. On his return to Yugoslavia he settled in Zagreb and has exhibited there and in Belgrade and Dubrovnik since 1956. He has taken part in international exhibitions since 1956, in Germany, Italy, France and Austria and has exhibited at the Salon de la Jeune Sculpture since 1960. He has done wood-carving for churches in Croatia, notably the Stations of the Cross for Senj, but since 1960 he has tended more and more towards the abstract. His earlier work includes a number of bronzes, such as Torso and The Man of Lika (head).

KOZMA VON KEZDI-SZENTELEK, Erzsebet 1879-
Born in Neumarkt, Hungary on May 30, 1879, she worked in Budapest and sculpted bas-reliefs and friezes for the castles in that city and its environs.

KOZUBEK fl. 19th century
Romantic bronzes bearing this signature were produced by a Polish sculptor in the second half of the 19th century.

KRAAHT, Constantin 1868-
Born in Moscow on April 22, 1868, he settled in Paris at the turn of the century and exhibited figures and busts at the Salon d'Automne from 1905.

KRALS, Anton 1900-
Born in Zagorica on August 23, 1900, he worked mainly in Prague and Ljubljana on figures and bas-reliefs of symbolic and religious significance.

KRALS, Franz 1895-
Born in Zagorica on September 26, 1895, he was the founder and chief exponent of the Slovene school of Expressionist sculpture. He worked in Ljubljana and specialised in religious sculpture.

KRÄMER, Albert 1889-
Born in Frankfurt-am-Main on September 1, 1899, he worked in Berlin on portrait busts, reliefs and heads.

KRAMER, Joseph von 1841-1908
Born in Augsburg on May 26, 1841, he died in Munich on May 28, 1908. He worked as a decorative sculptor in Kaiserslautern.

KRANE, Josef Hermann 1849-1901
Born in Paderborn on July 23, 1849, he died there on January 28, 1901. He studied in Munich and specialised in busts and memorials mainly in the Paderborn district.

KRATINA, Joseph 1872-
Born in Prague on February 26, 1872, he studied at the École des Beaux Arts and the Académie Julian in Paris and sculpted busts and genre figures.

KRATZ, Paul 1884-
Born in Coblenz, Germany on May 1, 1884, he specialised in animal figures and groups.

KRATZENBERG, Albert 1890-
Born at Clerf, Luxembourg on April 8, 1890, he studied in Karlsruhe and worked in Walferdingen in the grand duchy of Luxembourg, specialising in ecclesiastical sculpture. Many of his works decorate Luxembourg Cathedral.

KRAUS, Adolph F.A. 1850-1901
Born in Zeulenroda, Saxony on August 5, 1850, he died in a mental hospital in Denver, Colorado on November 7, 1901. He won the Prix de Rome and emigrated to the United States in 1881. He specialised in monuments and statues of famous Americans including Theodore Parker and Crispus Attucks and sculpted decoration for the Columbian Exposition in 1893.

KRAUS, August 1868-
Born in Ruhrort, Germany on July 9, 1868, he worked in Rome and Berlin, and specialised in genre statuettes, such as Woman in Sandals (Düsseldorf Museum) and The Bowls-player (Berlin). He won a gold medal at the Berlin Exhibition of 1907.

KRAUS, Fritz 1874-1918
Born in Ruhrort on May 24, 1874, he was killed in action in April 1918. He studied in Strasbourg and Berlin and specialised in monuments and memorials, mainly in Berlin and Kiel.

KRAUS, Gerhard Franz 1871-1910
Born in the duchy of Courland on April 6, 1871, he died in St. Petersburg in September 1910. He studied under Jules Aurèle l'Homeau in Paris and sculpted genre and historic figures.

KRAUS, Valentin 1873-
Born in Mulhouse on August 23, 1873, he specialised in ecclesiastical decoration, mainly in the Munich area.

KRAUSE, Max Reinhold 1875-1920
Born at Filehne, Germany on October 5, 1875, he died in Berlin on November 13, 1920. He worked in Berlin, Brussels and New York and did decorative sculpture for the town halls of Charlottenburg and Allenstein (Olzstyn).

KRAUSS, Karl 1859-1906
Born in Munich on May 14, 1859, he died in Aachen on November 30, 1906. He specialised in portrait busts, particularly of German royalty and political figures, such as Bismarck and von Moltke.

KRAUSSER, Johann Konrad 1815-1873
Born in Nüremberg on March 31, 1815, he died there on January 25, 1873. He sculpted the reliefs on the altar in Rottweil Church, and also did a series of twenty bronze statuettes of historic Bavarian personages.

KRAUTH, Jakob 1833-1890
Born in Mannheim on July 4, 1833, he died in Merano on December 30, 1890. He worked on the decoration of the castles of Heidelberg, Karlsruhe and Mannheim.

KREBS, Hulda fl. 20th century
Sculptor of genre figures and busts, working at Marienhöhe, Germany in the early years of this century.

KREIS, Henry fl. 20th century
American sculptor of portrait medallions and bas-reliefs.

KREITAN, Wilhelm Ferdinand fl. 19th century
Born at Friedrichshamm, Germany in 1833, he worked in St. Petersburg and studied at the Academy, specialising in portrait busts and neo-classical groups.

KRELING, August von 1819-1876
Born in Osnabruck on May 23, 1819, he died in Nuremberg on April 23, 1876. He studied under Cornelius and became director of the Nuremberg School of Fine Arts in 1853 and an honorary member of the Munich Academy in 1876.

KREMER, Joseph fl. 19th century
Born at Tromborn in the first half of the 19th century, he died about 1909. He studied in Paris under Poitevin and began exhibiting at the Salon in 1867 and the Royal Academy five years later. He won a medal for sculpture at the Munich exhibition of 1883.

KRESS VON KRESSENSTEIN, Gustav Karl Christoph 1838-1898
Born in Offenbach on December 30, 1838, he died in Frankfurt-am-Main on July 20, 1898. He studied at Karlsruhe Academy and later worked at Frankfurt as assistant to his father, George Ludwig Kress, the painter and engraver. He himself produced portrait busts and bas-reliefs.

KRESTOVSKI, Vassili 1889-1914
Born in Tashkent in 1889, he died in France in 1914. He was deported to Siberia for political activities and later emigrated to France where he studied sculpture under J.P. Laurens and Maurice Denis.

KRETSCHMANN-WINCKELMANN, Frieda 1870-
Born in Berlin on October 23, 1870, she worked in Paris and London and exhibited in Munich and Berlin, specialising in busts and portrait reliefs.

KRETSCHMER, Karl fl. 20th century
Genre and portrait sculptor working in Berlin in the early years of this century.

KRETZ, Leopold 1907-
Born in Lwow, Poland in 1907, he studied at the Cracow School of Art and worked as a monumental sculptor in that city until 1931 when he came to Paris and began studying at the École des Beaux Arts and worked under Landowski, but turned away from academic teaching by 1933 and joined the modernist group of Carton, Couturier and Yencesse. He had his first one-man show at the Galerie Pièrre Loeb in 1933. In the late 1930s he executed monuments for several French towns, notably Reims and Poitiers. After service in the second world war he taught modelling and sculpture at the Académie de la Grande Chaumière from 1945 to 1951. Since the war he has gradually given up stone-carving in favour of bronze and worked in that medium through the 1950s. He has exhibited at the Salon de Mai since 1933, and also at the Salon de la Jeune Sculpture. In more recent years he has taught at the School of Fine Arts in Reims. His greatest work was the monument to Marcinelles in 1959.
Editions Lesourd *Nudes de Leopold Kretz* (1946)

KRETZSCHMAR, Fritz 1863-1915
Born in Plauen on September 9, 1863, he died in Dresden in 1915. He exhibited in Berlin from 1893 to 1912 and specialised in portrait busts and genre groups, often including animals.

KRICKE, Norbert 1922-
Born in Düsseldorf in 1922, he served as a pilot in the Luftwaffe and began studying at the Berlin Academy after the second world war. He specialised in architectural sculpture composed of steel, copper, bronze and nickel wire and tubes but has also produced small decorative abstracts in the same genre. He had his first one-man show at the Ophir Gallery, Munich in 1953 and has since exhibited in Düsseldorf and Paris.

KRIEGER, Franz Xaver 1861-1907
Born in Munich on March 17, 1861, he died in Frankfurt-am-Main on November 9, 1907. He specialised in religious and historical statuettes and exhibited at the Crystal Palace, Munich in 1899.

KRIEGER, Wilhelm 1877-
Born in Germany on June 2, 1877, he worked at Herrsching near Munich, specialising in animal figures and groups.

KRIEGHOFF, Johann Carl Christian fl. 19th century
Born in Hamburg on June 7, 1838, he spent some time in South America in the 1850s and later became professor of sculpture in Zürich. He exhibited busts and bas-reliefs at the various Swiss exhibitions in the second half of the 19th century.

KRIMOV, Stefan fl. 20th century
Born in Bulgaria, he works in Sofia and sculpts monuments, memorials, portrait busts and genre figures and groups, often with strong political overtones, such as Refugees.

KRINOS, Pierre A. fl. 19th-20th centuries
Born in Syra, Greece in the second half of the 19th century, he studied in Athens under Sochos and settled in Paris at the turn of the century. He got an honourable mention at the Exposition of 1900.

KRISCHER, Otto 1899-
Born in Bendorf, Germany on May 7, 1899, he specialised in busts and very realistic statuettes of genre subjects.

KRISMAYR, Anton 1810-1841
Born in Telfs, Tyrol on April 4, 1810, he died in Albano on July 27, 1841. He studied under Schwanthaler in Munich and worked in Innsbruck on portraits and genre figures. The main collection of his work is in the Innsbruck Museum.

KRIZEK, Jan 1919-
Born in Dobromerice, Czechoslovakia in 1919, he studied at the local Technical High School and went to the Prague Academy in 1938. His studies were interrupted by the war but on completing his training in 1946 he went to Paris where he has lived ever since. He has concentrated on stone sculpture, with lines incised in the form of simple emblems derived from Greek, Cretan and Sumerian art. No bronzes have so far been recorded by him.

KROL, Abraham 1919-
Born at Pabianice near Lodz, Poland in 1919, he studied locally and came to France in 1938, enlisting in the Foreign Legion the following year. After the war he studied at the École des Beaux Arts, Avignon and has since worked as a painter, engraver and sculptor of subjects with the theme of the liberation of the Jewish mystique.

KRONER, Kurt 1885-
Born in Breslau on October 23, 1885, he worked in Paris and was influenced by Rodin. Later he settled in Berlin where he specialised in portrait busts, though he is best known for his large statues, such as Adam or Victory, in the Impressionist manner.

KROP, Hildo J. 1884-
Born in Steenwijk, Holland on February 26, 1884, he studied at the Heatherley Art School, London and the Académie Julian under J.P. Laurens and joined the Amsterdam Academy in 1908. Subsequently he visited Berlin, Rome and Paris and settled in Amsterdam in 1916 where he was appointed sculptor to the municipality. In this capacity he sculpted many monuments and architectural decoration, at first in the Expressionist manner but later varying his technique considerably. Though much of his municipal work was carved direct in stone and wood he also modelled figurines in clay and produced an astonishing array of genre figures illustrating every aspect of Dutch life as well as animals, grotesqueries and imaginery creatures. Many of these statuettes were produced in terra cotta or bronze. Apart from his prolific output in this medium he was also a weaver of considerable distinction.

KROPP, Diedrich Samuel 1824-1913
Born in Bremen on December 11, 1824, he died there on May 15, 1913. He specialised in the sculptural decoration of ships at Rostock and Bremen but also did architectural work and monumental statuary in the latter town.

KRSINIC, Frane fl. 20th century
Yugoslav sculptor active since the second world war. He has produced many monuments, notably the Revolution Monument in Titovo Uzice, portraits of Marshal Tito, Nicola Tesla and other celebrities and genre and allegorical works such as Fettered and Mother's Play.

KRÜCKEBERG, Hans 1878-
Born at Treuenbritzen on March 12, 1878, he specialised in bas-reliefs, monuments and figures depicting animal subjects.

KRÜGER, Arthur 1866-
Born in Berlin on August 21, 1866, he studied under Schultz and Uhlmann and specialised in portrait reliefs and busts.

KRÜGER, Franz Ludwig August 1849-1912
Born in Berlin on July 12, 1849, he died at Frankfurt-am-Main on July 17, 1912. He studied under Albert Wolff and worked in Copenhagen and Paris, specialising in allegorical and neo-classical figures, reliefs and monuments.

KRÜGER, Friedrich Heinrich 1749-1815
Born in Dresden in 1749, he died there in 1815. He specialised in figures and groups portraying contemporary and historical German personalities. He sculpted monuments of Peter the Great, King Frederick III of Saxony and other European rulers.

KRUSE, Bruno Friedrich Emil fl. 19th century
Born in Hamburg on June 1, 1855, he specialised in portrait busts in marble and bronze.

KRUSE, Carl Max fl. late 19th century
Born in Berlin on April 14, 1854, he originally trained as an architect, but later took up sculpture, studying under Wolff and Fr. Schaper. He went to Italy in 1881-82 and settled in Berlin. He won gold medals at the Berlin Exhibition (1899) and the Exposition Universelle (1900) and specialised in portrait busts and classical figures.

KRYLOFF, Michael Grigorievich 1786-1850
Born in Russia on June 3, 1786, he died in St. Petersburg in 1850. After studying at the St. Petersburg Academy he went to Rome where he worked with Thorvaldsen. On his return to St. Petersburg he specialised in busts of Russian royalty and the nobility.

KUBANEK, Ludwig 1877-
Born in Graz, Austria on February 3, 1877, he worked in Munich, Donaueschingen and Ofingen on decorative sculpture.

KUBOVSKY, Eduard 1866-
Born in Graz on November 24, 1866, he worked as a decorative sculptor and did the statuary and bas-reliefs in the Franciscan church in Marburg.

KÜCHLER, Rudolf 1867-
Born in Vienna on September 20, 1867, he specialised in portrait busts and statuettes. His chief work was the monument at Halle to the German emperors William I and Frederick I.

KÜFFER, Johannes Samuel Friedrich 1844-
Born in Berne on May 17, 1844, he worked there and also in Ammergau and Geneva before emigrating to South America in 1886. He specialised in religious statuettes, crucifixes and bas-reliefs, in plaster, terra cotta and bronze.

KUGEL, Georg fl. 19th century
Born in Erfurt, Thuringia on January 4, 1848, he worked in Nuremberg, Munich and Eisenach and specialised in ecclesiastical and public decorative sculpture. His work graced the town hall and cathedral of Erfurt.

KUGLER, Pal Ferenc 1836-1875
Born in Ödenburg (now Sopron), Hungary on March 11, 1836, he died in Vienna on April 11, 1875. He worked in Budapest and Sopron and produced statuettes, bas-reliefs, portraits and groups of secular and religious subjects.

KÜHL, Karl 1864-
Born in Altona on November 17, 1864, he worked in Hamburg and collaborated with Aloys Denoth in producing decorative sculpture, mainly in wood.

KÜHN, Gottlob Christian 1780-1828
Born in Dresden on June 16, 1780, he died there on December 20, 1828. He studied under Franz S. Pettrich and spent many years in Italy. On his return to Dresden he specialised in portrait busts and bas-reliefs and also did a number of statues and monuments.

KÜHNE, August 1845-1895
Born at Königslutter on July 29, 1845, he died at Graz on August 15, 1895. Though better known as a jeweller and tapestry weaver he also produced genre statuettes.

KÜHNELT, Hugo 1877-1914
Born in Vienna on October 4, 1877, he was killed in action on September 8, 1914. He studied under Hellmer at the Vienna Academy and worked in Italy for some time.

KULLRICH, Wilhelm 1821-1887
Born in Dahme, Germany on December 18, 1821, he died in Berlin on September 1, 1887. He studied under K. Fischer and worked in London, Paris, Brussels and Munich before settling in Berlin.

KUMM, Wilhelm 1861-
Born in Hamburg on April 3, 1861, he specialised in genre figures and busts, many of which are preserved in the Hamburg Museum. He exhibited in Munich and at the Paris Salons in the 1890s.

KÜMMEL, Heinrich August Georg 1810-1855
Born in Hanover on February 2, 1810, he died in Rome on December 31, 1855. He studied under Hengst and was one of the most fashionable portrait sculptors of his day, producing numerous busts of European royalty and aristocracy. He also sculpted genre and allegorical statuettes, such as Boy Fishing, Nymph, Penelope and The Education of Bacchus.

KUNA, Henri 1885-
Born in Warsaw on November 16, 1885, he moved to Paris in 1911 and specialised in allegorical female statuettes, such as Rhythm, which he exhibited at the Salon d'Automne.

KUNDMANN, Carl 1838-1919
Born in Vienna on June 15, 1838, he died there on June 9, 1919. He exhibited internationally, being made a Chevalier of the Legion of Honour for his contribution to the Exposition Universelle of 1878 and winning gold medals in Berlin in 1879 and 1888. He produced statues, busts and bas-reliefs portraying German, French and Austro-Hungarian notables of the late 19th century.

KÜNNE, Arnold fl. 19th century
Born in Altona, he worked mainly in Charlottenburg and did portrait busts and statues of German royalty and celebrities.

KUNTZ, Gustav Adolf 1843-1879
Born at Wildenfels, Saxony on February 17, 1843, he died in Rome on May 2, 1879. He studied under Schilling in Dresden and worked in Italy, France, England and the Netherlands. He won a gold medal in Berlin in 1877. He specialised in portraits, both as a painter and as a sculptor. He sculpted the marble figure of Daniel on the mausoleum of Prince Albert at Frogmore.

KUNTZE, Edward J.A. 1826-1870
Born in Pomerania in 1826, he died in New York on April 10, 1870. He emigrated to the United States and became an Associate of the National Academy of Design in 1869. He also exhibited at the Royal Academy in 1860 and 1863 and specialised in historical and contemporary portrait busts and statuettes, such as those of Shakespeare and Abraham Lincoln.

KUNTZE, Reinhold 1886-
Born in Leipzig on June 23, 1886, he studied there and in Dresden and worked as a painter and sculptor of biblical, classical and allegorical figures. His statue of Salome is in the Poznan Museum.

KUNZ, Paul 1890-
Born in Berne on December 15, 1890, he studied in Munich, Vienna and Florence and did numerous busts, heads and relief portraits. His best known work is the equestrian statue of General Wille. Various bronzes are in the museums of Berne and Winterthur. He also sculpted genre figures, such as Seated Woman.

KUÖHL, Richard Emil 1880-
Born in Meissen on May 31, 1880, he was employed as a modeller at the Meissen porcelain works, but also sculpted genre figures for bronze-casting. He also worked as a decorative sculptor in Coburg and Lübeck.

KUOLLA, Ladislas fl. 20th century
Genre sculptor working in Poland. His works include figures and groups of children with birds and animals.

KUOLT, Karl Joseph 1879-
Born in Spaichingen, Germany on April 3, 1879, he specialised in memorials and monumental statuary in Spaichingen and other German towns, particularly war memorials.

KUPFER, Johann Michael 1859-1917
Born at Schwabach on June 4, 1859, he died in Vienna on June 20, 1917. He was assistant to Goess at Nuremberg and then, in 1880, moved to Vienna where he concentrated on painting.

KÜPPERS, Albert Hermann fl. 19th century
Born in Koesfeld, Germany on February 22, 1842, he worked in Bonn and specialised in portrait busts of his distinguished contemporaries.

KURCZYNSKI, Sigismund 1886-
Born in Lwow in 1886, he studied in Paris under Rodin and specialised in portrait busts and genre statuettes.

KÜRLE, Adolf fl. 20th century
German sculptor of genre subjects working in Grunewald in the early years of this century.

KURZAWA, Antoine 1843-1898
Born in Podhale, Poland in 1843, he died in Cracow on February 10, 1898. He specialised in figures and portraits and is best known for the Mickiewicz monument in Cracow.

KUSTER, Nicodem 1826-1884
Born in Engelberg, Switzerland on July 18, 1826, he died there on January 31, 1884. He studied in Basle and Munich and on his return to Switzerland he worked mainly in Lucerne, specialising in statues of the Apostles in the churches of that district.

KÜSTHARDT, Friedrich the Elder 1830-1900
Born in Göttingen on January 30, 1830, he died in Hildesheim on October 8, 1900. He specialised in ecclesiastical sculpture and examples of his work may be seen in the Church of St. Lambert and the Cathedral, Hildesheim.

KÜSTHARDT, Friedrich the Younger 1870-1905
Born in Hildesheim on May 13, 1870, he died in Freiburg-im-Breisgau on April 29, 1905. He specialised in heads, busts and portrait reliefs.

KÜSTHARDT, Georg 1863-1903
Born in Hildesheim on October 23, 1863, he died in Hanover on October 13, 1903. He specialised in portrait busts and statues of contemporary German celebrities and royalty and did the bust of Kaiser Wilhelm II and the statue of Kaiser Wilhelm I at Emden.

KÜSTHARDT-LANGENHAM, Gertrud 1877-
Born in Gotha on July 13, 1877, she studied under Friedrich Küsthardt the Younger whom she subsequently married. She worked as a painter and sculptor of portraits. Her best known work is the memorial after the first world war, in Hildesheim.

LABARRE, Jean Georges fl. 19th-20th centuries
Born in Paris, he exhibited figures at the Salon from 1877 and became an Associate of the Société Nationale des Beaux Arts in 1898.

LABASQUE, Yvon fl. 20th century
Born in Paris at the turn of the century, he specialised in allegorical figures which he exhibited at the Salon des Indépendants from 1930. His chief work was the monument to the Pioneers of Aviation.

LABATUT, Jules Jacques fl. 19th century
Born in Toulouse on July 31, 1851, he studied at the École des Beaux Arts under Jouffroy and Mercié and won the Prix de Rome in 1881. He exhibited at the Salon from that year and also at the Salon des Artistes Français, winning third class (1881), second class (1884) and first class (1894) medals. He also won silver medals at the Expositions of 1889 and 1900 and was made a Chevalier of the Legion of Honour in 1894. His works include the statue of Roland at Toulouse (cast in the Bayonne Museum), Moses (Toulouse Museum), The Apple of Discord (Narbonne Museum), The Infant Martyr (Musée Galliera, Paris) and the Tapestry Weaver (Nantes Museum).

LABBÉ, Henry Charlemagne 1870-
Born in Paris on July 7, 1870, he studied under A. Descatoire and exhibited figures at the Salon des Artistes Français.

LABORD, Ernest fl. 19th century
Born in Bédarieux, France, in 1834, he studied under Adalbert and specialised in portrait busts of his contemporaries.

LABOUESSE, Jeanne fl. 20th century
Born at Gusset, France in the late 19th century, she studied under Sicard and Carli and exhibited neo-classical heads, busts and statuettes at the Salon des Artistes Français.

LA BOULAYE, René de 1874-
Born in Paris on November 7, 1874, he exhibited figures at the Salon des Artistes Français.

LABOURET, Mathilde Marie de fl. late 19th century
Born in Angoulème, she studied under M. Schroeder and exhibited portrait busts at the Salon from 1879.

LABOUREUR, Francesco Massimiliano 1767-1831
Born in Rome on November 10, 1767, he died there on March 6, 1831. He was the son and pupil of Maximilien Laboureur, a Flemish stonemason who worked in Rome on garden statuary. In 1783 he won the Prize of the Academy of St. Luke and was elected a member in 1802 and president in 1820. He specialised in busts of historic Italian artists of the Renaissance period, but also sculpted a number of allegorical and classical figures and groups. He produced a colossal bust of Napoleon and a statue of him clad in the toga of a Roman senator. The Quirinal Palace in Rome also has several bas-reliefs by him. He worked mainly in marble, but some of his works were cast in bronze.

LABRAISE, Joseph fl. 18th-19th centuries
Born in Nancy in the mid-18th century, he died there in 1835. He was a member of the Nancy Academy and specialised in classical and allegorical figures, such as The Spirit of France (1808) and Diana and Apollo (Lorraine Museum). He also sculpted the statue of Duke Stanislas in Nancy and the figure of St. Nicolas in the Garden of the Doctrine.

LABRIARE, Albert de fl. 19th century
Sculptor of genre subjects working in Paris in the mid-19th century. He exhibited figures and bas-reliefs at the Salon from 1848.

LABUS, Giovanni Antonio 1806-1857
Born in Brescia in 1806, he died in Milan in 1857. He is best known for the colossal statue of the mathematician B. Cavalieri in Milan. He sculpted a number of memorials in Brescia cemetery and ecclesiastical statuary and bas-reliefs for churches in northern Italy. His bas-relief, The Apotheosis of Canova, is in the Museum of Modern Art, Milan.

LACAVE, Desiré fl. 19th century
Born at Neuilly-sur-Seine in the mid-19th century, he specialised in figures and busts portraying his artistic contemporaries. He exhibited at the Salon from 1877.

LACAZE-DORY, Louise J. fl. 19th century
Sculptress of neo-classical statuettes and portraits working in Paris in the late 19th century. She was an Associate of the Artistes Français and died in 1904.

LACHAISE, Gaston 1866-1935
Born in Paris on May 19, 1866, he died in New York in 1935. He studied under Thomas at the École des Beaux Arts and worked with Lalique for a time before emigrating to the United States in 1906. He worked under Henry Hudson Kitson in Boston, then moved to New York in 1912 where he sculpted his bronze Standing Woman (not completed till 1927). He assisted Paul Manship in a number of memorials and monuments and first exhibited his work at the Bourgeois Gallery, New York in 1920 and had a one-man show at the Intimate Gallery in 1927. He specialised in bronze statuettes of women, both portraits of female celebrities, such as Ruth St. Denis doing a Hindu dance, and neo-classical, allegorical and genre figures. His bronzes were highly polished and given an almost unnatural lustre. His work had a certain affinity with Maillol. His best known work is The Seagull, the national Coastguard memorial.

LACHAISE, Sylvain fl. 19th century
Born in Foecy, France, he studied under Comoléra and exhibited animal figures at the Salon from 1865 to 1875.

LACHER, Karl 1850-1908
Born at Uttenhofen near Nuremberg on May 23, 1850, he died in Graz, Austria on January 15, 1908. He studied at the School of Arts and Crafts in Nuremberg and did numerous bronze busts of historic figures, such as Rembrandt, Titian and Raphael. He also sculpted a series of twelve portrait medallions for the Prince of Liechtenstein and various relief portraits of Austrian emperors.

LACKNER, Janos fl. 19th century
Born in Hungary in 1834, he studied at the Vienna Academy and exhibited at the Viennese Society of Artists. He settled in Pest in 1852 and specialised in fountain and garden statuary. His classical figures and groups are known in terra cotta and bronze.

LACOMBE, Georges 1868-1916
Born at Versailles in 1868, he died in Alençon in 1916. He was the son of the painter Laure Lacombe and learned the rudiments of art from her. He later carved wooden bas-reliefs and then went on to model portrait busts of French cultural celebrities and statuettes for the Ranson marionette theatre. He was a member of the Nabis group at Pont-Aven.

LACOMBLÉ, Eugène 1828-1905
Born in Brussels on March 5, 1828, he died in Arnhem on November 17, 1905. He studied at the Brussels Academy and was a pupil of Léon Cogniet in Paris. He was appointed professor of sculpture at The Hague in 1859 and specialised in portrait busts. Examples of his busts are in the Boymans Museum, Rotterdam.

LACOSTE, Charles fl. late 19th century
Born in Toulouse, he studied under Dorval and Mulatier de Merat and exhibited figures at the Salon from 1875.

LADD, Anna Coleman 1878-
Born in Philadelphia in 1878, she studied drawing and sculpture for ten years in Paris and Rome and later in Boston, under Gallori, Rodin and Grafly. She organised the first open-air sculpture exhibitions in Boston and Philadelphia and founded the American Red Cross studio

of portrait masks for disfigured servicemen in Paris, 1917. Her bronzes include Lady (Gardner Collection), Roman Lady, Psyche and several figures of American soldiers used for the American Legion memorials at Manchester and Hamilton, Massachusetts.

LAERUM, Gustav 1870-
Born at Felsund, Norway, in 1870, he worked as an illustrator and painter and sculptor of portraits. He also produced statuettes, busts and medallions.

LAESSLE, Albert 1877-1945
Born in Philadelphia on March 28, 1877, he died there in 1945. He studied in New York, at the Spring Garden Institute, Drexel Institute and Pennsylvania Academy, Philadelphia and Paris before returning to his birthplace and specialised in animal figures and groups. Examples of his Animalier bronzes are in the Pennsylvania Academy, Carnegie Institute, Pittsburg and Metropolitan Museum of Art, New York. His works include Billy (bronze goat), Turning Turtle, Victory (bronze eagle), First Effort, Frog and Caryatid, Chanticleer (bronze cock).

LAETHIER, Georges 1875-
Born in Besançon on April 23, 1875, he studied under Thomas and exhibited figures and groups at the Salon des Artistes Français, winning a third class medal in 1903.

LAFAUCHE, Leon 1876-
Born at Moutier-en-Deran on October 17, 1876, he studied under Falguière and exhibited busts and reliefs at the Salon des Artistes Français, winning a third class medal in 1906.

LAFAURIE, Marceau 1876-
Born in Toulouse on April 3, 1876, he exhibited figures at the Salon des Artistes Français.

LAFORESTERIE, Louis Edmond fl. 19th-20th centuries
Born at Port au Prince, Haiti in the mid-19th century, he studied under Jouffroy and Bourg and exhibited portrait busts at the Salon from 1876.

LAFORET, Alessandro fl. 19th-20th centuries
Born in Milan, he studied at the Royal Academy there and exhibited at the Paris Salons, winning a bronze medal at the Exposition Universelle of 1900.

LAFRANCE, Jules Isidore 1841-1881
Born in Paris in 1841, he died there on January 16, 1881. He studied under Maillard, Duret and Cavelier and won the Prix de Rome in 1870. He exhibited at the Salon from 1860 and won a first class medal in 1874. Four years later he became a Chevalier of the Legion of Honour. He specialised in religious figures, in stone, marble, plaster and bronze.

LA FRESNAYE, Roger Noel François de 1885-1925
Born in Le Mans on July 11, 1885, he died at Grasse on November 27, 1925. He worked as a painter, illustrator and sculptor and was a prime exponent of Cubism. He studied at the Julian and Ranson academies under Serusier and Denis and exhibited Cubist figures at the Salon d'Automne in 1910-13.

LAGAE, Jules 1862-
Born in Roulers, France on March 15, 1862, he studied under Van der Stappen and Jef Lambeaux. He won the Prix de Rome in 1888 and settled in Brussels in 1892. He exhibited in Brussels, Ghent, Dresden, Munich and Paris, winning a gold medal at the Exposition of 1900. He specialised in busts of his contemporaries, and genre figures, such as Young Fisherman, Silenus, The Aged Philosopher and Expiation. His chief works are the Monument to Franco-Belgian Friendship (Le Havre) and the Independence Monument (Buenos Aires).

LAGARE, Eugène fl. early 20th century
Born at Lodève in the late 19th century, he became a member of the Société Nationale des Beaux Arts in 1908 and exhibited figures and portraits at that Salon.

LAGARRIGUE, Carlos fl. late 19th century
Born in Valparaiso, Chile in the mid-19th century, he studied there and in Paris and exhibited at the Salon des Artistes Français, getting an honourable mention in 1888 and a third class medal in 1891.

LAGNEAU, Raphael fl. 19th century
Sculptor of genre subjects, working in Paris in the 1890s.

LAGRANGE, Jean 1831-1908
Born in Lyons on November 6, 1831, he died in Paris in 1908. He studied under J. Vibert in Lyons and Bonnassieux in Paris and was Chief Medallist at the Paris Mint, 1880-96. He specialised in bas-reliefs and medallions in bronze and also stone roundels in public buildings.

LAGRIFFOUL, Henri Albert 1907-
Born in Paris on May 9, 1907, he studied at the École des Beaux Arts and specialised in portraits and genre groups. His works in the Museum of Modern Art, Paris include the Magicians and Marie-Jeanne.

LAHEUDRIE, Edmond de 1861-
Born in Trévières on October 23, 1861, he studied under Cavelier, Barrias and Mercié. He exhibited at the Salon des Artistes Français and won a second class medal in 1901. He specialised in figures, bas-reliefs and groups of religious subjects, such as Christ Entombed (Rouen Museum).

LAHNER, Karl fl. 19th century
Born in Vienna on October 16, 1842, he worked as an illustrator of humorous magazines, but also did a certain amount of portrait sculpture of his contemporaries. Many of his busts are preserved in various Austrian museums. He also sculpted the Cherubim on the Court Opera, Vienna.

LAINÉ, or LENET, Jean fl. early 19th century
Russian sculptor of French descent, working in St. Petersburg. He did the bas-reliefs for the Alexander Column in St. Petersburg and also bronze and plaster caricatures of French and Russian celebrities of the early 19th century. His statues of Justice and Fidelity lined the grand staircase in the Winter Palace.

LAITIÉ, Charles René 1782-1862
Born in Paris in 1782, he died there on December 13, 1862. He studied under Dejoux and was runner-up in the Prix de Rome of 1803, but won the prize the following year. He exhibited at the Salon from 1812 to 1838 and won a medal in 1824. He specialised in public statuary and bas-reliefs for the façades of public buildings, such as the Louvre and the Paris Bourse. His minor works include statuettes, groups and bas-reliefs of historical and religious subjects, such as Departure of the Armies (Liseux Museum), Passage of the Great St. Bernard Pass (Versailles, 1800), Death of Desaix at the Battle of Marengo (1800) and busts of James Stuart, Earl of Buchan, Pierre Corneille and Cardinal Fleury.

LALAING, Jacques de fl. 19th century
Belgian painter and sculptor working in the 1870s, he specialised in monuments and memorials, such as the monument to the British soldiers killed at the Battle of Waterloo in Evere cemetery near Brussels, regarded as one of the finest Belgian sculptures of the late 19th century. He also sculpted the statue of the Chevalier de la Salle in Chicago and genre figures and groups, such as The Wrestlers (Brussels).

LALIBERTE, Albert 1878-
Born in Ste. Elisabeth, Canada, in 1878, he studied in Paris under Thomas and exhibited at the Salon from 1905. He specialised in neo-classical, allegorical and genre statuettes and groups, such as The First Kiss. The main collection of his bronzes is in the Ottawa National Museum.

LAMASSON, Joseph Jean Jules Germain 1872-
Born in Toulouse on May 11, 1872, he studied under Falguière, Mercié and A. Dubois and won the Prix de Rome in 1902 and a bronze medal at the Exposition of 1925. He specialised in bas-reliefs and medallions.

LAMB, William fl. 20th century
Scottish portrait sculptor, active before the second world war. He exhibited bronze busts and heads at the Royal Scottish Academy and was elected A.R.S.A. His bust of Robert Burns is in the Sunderland Museum. He worked in Montrose, Angus.

LAMBEAUX, Joseph Marie Thomas ('Jef') 1852-1908
Born in Antwerp on July 13, 1852, he died in Brussels on June 6, 1908. He studied under Joseph Geefs at the Antwerp Academy and

won a gold medal at the Brussels Exposition of 1881. He became the leading exponent of Realist sculpture among the Belgian artists of the late 19th century. His figures and groups were noted for their rustic simplicity, the creations of his tormented genius imbuing his work with obscure symbolism without losing their essential character. He was influenced by Jordaens in his penchant for gross Flemish women. His genre and neo-classical bronzes include The Kiss, The Human Passions, The Wrestlers, Vengeance, Wounded Faun and Nymph, Woman with a Cygnet, The Murdered Faun, Prometheus, Venus and The Merry Song. His many awards and decorations included the Grand Prix at the Belgian Colonial Exhibition of 1900.

LAMBERECHTS, Frans 1909-
Born at Molenbeek-lès-Bruxelles in 1909, he ran away from home to France in 1924 and worked in Paris till 1932, learning the rudiments of sculpture by working with a group of craftsmen on the restoration of public monuments and ecclesiastical decoration. He then enrolled at the Brussels Academy and won the Triennial Prize in 1935. He has exhibited regularly in Brussels since 1936 and won the Young Belgian Sculpture prize in 1942. For several years he lived in Flanders (1947-51) and spent some time in Mexico and Guatemala in 1959-60 but now lives in Brussels. His earlier figurative work was superseded by abstracts, in bronze and stone, intended for architectural decoration. His more recent works include the war memorial at Jemappes and the decoration at the entrance to the pavilion of banking and insurance at the Brussels Exposition of 1958.

LAMBERT, Adolphe 1880-
Born in Brussels on July 21, 1880, he became professor at the École de Bijouterie, Brussels in 1920 but later worked in La Paz, Bolivia and Paris. He specialised in figurines executed in precious metals as well as bronze.

LAMBERT, Arsène Louis Marie fl. 19th century
Born at Carhaix in the mid-19th century, he studied under Guilbert and exhibited figures at the Salon from 1876.

LAMBERT, Emile Placide 1828-1897
Born in Paris on December 2, 1828, he died there on April 27, 1897. He studied under Franceschi and exhibited at the Salon from 1867, specialising in bronze portrait busts and statues of contemporary and historical personalities. His works include the bust of Louis Favre (Geneva, 1894), the statue of Voltaire at Ferney and the figure of Voltaire as a young man in the Court of the Mairie of the 9th *arrondissement* Paris.

LAMBERT, Ferdinand fl. late 19th century
Born in Paris in the mid-19th century he exhibited portraits at the Salon des Artistes Français, winning an honourable mention in 1894.

LAMBERT, Gustave Alexandre fl. 19th-20th centuries
Born in Paris on April 5, 1856, he studied under Bissinger and exhibited at the Salon from 1879. He became an Associate of the Artistes Français in 1899 and won third class (1900) and first class (1908) medals.

LAMBERT, Jules Gabriel fl. 19th-20th centuries
Parisian sculptor of genre subjects at the turn of the century, he became an Associate of the Artistes Français in 1901.

LAMBERT, Léon Eugène 1865-
Born in Sèvres on August 20, 1865, he studied in Paris and exhibited statuettes at the Salon des Artistes Français, winning a third class medal in 1908 and a second class medal the following year.

LAMBERT, Maurice 1901-1964
Born in Paris on June 25, 1901, he died in London in 1964. He was the son of the painter George Washington Lambert and studied sculpture under Derwent Wood. He had his first one-man show at the Claridge Gallery, London in 1927 and exhibited at the Royal Academy, becoming A.R.A. in 1941 and R.A. in 1952. He sculpted portraits and genre figures in bronze and stone.

LAMBERT, Noel Marcel fl. 19th-20th centuries
Born in Paris on May 12, 1847, he exhibited figures and portraits at the Salon des Artistes Français and the Nationale in the early years of this century.

LAMBERTON, Joseph Louis fl. early 20th century
Born at St. Jean-en-Royans, France, he studied under Falguière and exhibited figures at the Salon des Artistes Français, getting an honourable mention in 1910.

LAMBERT-RUCKI, Jean 1888-
Born in Cracow on September 17, 1888, he studied at the School of Fine Arts in Cracow and emigrated to France, becoming naturalised in 1932. He exhibited at the major Paris Salons of the 1930s and specialised in polychrome sculptures and mosaics of religious subjects.

LAMI, Alphonse 1822-1867
Born in Paris on June 2, 1822, he died in Alexandria in 1867. He studied under Abel, Pujol and Duret and exhibited figures at the Salon from 1851-64, specialising in anatomical studies, such as Écorché plastique. He became a Chevalier of the Legion of Honour in 1859.

LAMI, Stanislas 1858-1944
Born in Paris on November 30, 1858, he died there in 1944. Best known as a prolific writer on art and the compiler of dictionaries of sculptors, he also produced a number of bronzes in his own right and exhibited at the Salon from 1882 onwards, winning honourable mentions at the Salon of 1887 and the Exposition of 1889 and a second class medal in 1891. He was made a Chevalier of the Legion of Honour in 1900. His works include the mask of Berlioz (Paris Opera), Cain, The First Fault, The Silence of the Tomb and Great Dane (bronze dog).

LAMMEN, J. fl. early 19th century
Dutch sculptor of genre subjects and portraits, working in Amsterdam in the 1820s.

LA MONACA, Francis 1882-
Born in Catanzaro, Italy on February 10, 1882, he studied in Paris under Thomas and Injalbert and exhibited in Rome, London and Paris. He was made a Chevalier of the Legion of Honour and specialised in portrait busts of international celebrities, such as Pope Pius IX, George Bernard Shaw, Alfred Cortot and other artists and literary figures. His chief work is the monument to the Spaniard, Blasco Ibanez.

LAMOURDEDIEN, Raoul Eugène 1877-
Born at Fouguerolles on February 2, 1877, he exhibited at the Salon d'Automne and the Nationale and became a professor at the École des Beaux Arts, Paris. He was a Chevalier of the Legion d'Honneur. Though best known for his portrait medallions, such as those commemorating Santos Dumont and marking the inauguration of President Poincaré, he also did portrait busts and monumental statuary. His minor works are in the museums of Agen, Perigueux, Vitré and Paris.

LAMY-LNADI, Eugène fl. 19th century
Portrait sculptor who exhibited busts and statuettes at the Salon in 1849-50.

LANCELOT-CROCE, Marcelle Renée fl. 19th century
Born in Paris on January 26, 1854, she studied under her father, the illustrator Dieudonné Lancelot and the medallist Ponscarme. She made her début at the Salon in 1878 and got an honourable mention ten years later, a travelling scholarship in 1889, a second class medal in 1891 and a gold medal at the Exposition of 1900. She specialised in portrait medals, bas-reliefs, heads, busts and genre groups, such as The Family and Woman and her Destiny. She sculpted portraits of Clemenceau, Foch and other outstanding political figures of the turn of the century.

LANCERAY, Yevgeni Alexandrovich 1848-1886
Born in St. Petersburg in 1848, he died there in 1886. He spent much of his life in Paris (where his name was often rendered as Lanceré) and specialised in bronzes featuring horses. His works include Peasant on a Mule, Tribesman on a Donkey, Troika, Cossack on a Pony with Packhorse and Boy with Three Donkeys. His bronzes, cast at the Chopin foundry, bear his signature in Cyrillic.

LANCHELEVICI fl. early 20th century
Bronzes bearing this signature were produced by a Belgian sculptor, specialising in portrait busts and statuettes of his distinguished contemporaries.

LANÇON, Auguste André 1836-1887
Born at St. Claude in 1836, he died in Paris in March 1887. He was originally trained as a lithographer but later attended classes at the Lyons School of Fine Arts and then went to Paris where he studied sculpture under Picot. He was strongly influenced by Barye and worked at the Jardin des Plantes on animal figures, drawings and engravings. He exhibited at the Salon from 1861 to 1870 under the name of André Lançon, but thereafter used his full name. He served as an infantry sergeant in the war of 1870 and took part in the Paris Commune, for which he was sentenced to be shot but served six months in Satory prison camp before being acquitted by court-martial. He resumed work in 1871 and used his full name from 1872 onwards. He was a war correspondent for *L'Illustration* during the Russo-Turkish War of 1877. His animal bronzes consist mainly of lions, tigers and deer.

LANCRY, Auguste fl. 19th century
Born in Lyons in the first half of the 19th century, he studied under Fabisch and exhibited figures and groups at the Salon from 1868.

LANDA fl. 20th century
Czech sculptor of the early 20th century, specialising in Expressionist figures.

LANDEIRA Y IGLESIAS, Luis 1861-1924
Born at Santiago de Compostella on May 19, 1861, he died there on June 26, 1924. He was professor at Baeza (1917-20) and Santiago (1920-24) and specialised in altars and ecclesiastical sculpture. He also designed stained glass windows.

LANDER, Abraham Louis Theodore fl. 19th century
Born in Geneva on March 23, 1807, he studied under Grosclaude in Geneva and went on to the Academy of St. Luke in Rome, where he won first prize for sculpture in 1830. He worked in the Vatican, sculpting bas-reliefs and statuary, mainly in marble.

LANDGREBE, Gustav Adolf 1837-1899
Born in Berlin on December 27, 1837, he died there on June 11, 1899. He studied at the Berlin Academy under E. Fischer and won the National Grand Prix in 1865. He exhibited at the Academy from 1886 to 1895 and specialised in busts and statuettes of German composers and musical celebrities, such as Beethoven, Mozart and Wagner. He also sculpted the decoration in the Berlin National Gallery.

LANDORI, Vilmos 1872-1923
Born in Pecs, Hungary, on August 6, 1872, he died in Budapest on January 19, 1923. He worked for some time in Gardone but many of his monuments and statues were destroyed during the first world war. His minor works include a number of bronze statuettes of female nudes.

LANDOWSKI, Paul Maximilien 1875-1961
Born in Paris on June 1, 1875, he died in Boulogne in April, 1961. He studied under Barrias at the École des Beaux Arts, Paris, and won the Prix de Rome in 1900 with his Fighting David. He exhibited at the Salon des Artistes Français from 1906, winning a first class medal for his Daughters of Cain. He was one of the youngest Chevaliers of the Legion of Honour and had a highly successful, if somewhat controversial, career. He became Director of the École in succession to Barrias. He received many public commissions, including a number of war memorials in the early 1920s. The most notable were The Phantoms (1923), the Moroccan Victory Monument and the National Memorial, Algiers. His numerous minor works include The Boxer (a portrait of Georges Carpentier), Dancer with Snakes, The Hero, Hymn to the Dawn (Petit Palais), The Sons of Cain (Copenhagen Museum) and numerous portrait busts of his contemporaries.

LANDRÉ, Mary fl. 18th century
A modeller for Wedgwood, whose accounts record various payments from 1769 to 1774 for models and groups of allegorical, biblical and classical subjects. She also sculpted genre figures and groups of boys in bronze.

LANDRY, Fritz Ulysse 1842-1927
Born in Locle, Switzerland, on September 26, 1842, he died there in 1927. He studied in Neuchatel, Geneva and Paris and became professor of design at Neuchatel in 1872. He specialised in portrait

medallions and busts, but also did a number of genre and allegorical bronzes, such as Sic fugit Tempus, Springtime and Young Girl.

LANDSBERG, Max 1850-1906
Born in Rawitsch on July 11, 1850, he died in Berlin on August 16, 1906. He studied at the Berlin Academy and specialised in busts of German royalty and contemporary celebrities.

LANDSEER, Sir Edwin Henry 1802-1873
Born in London on March 7, 1802, he died in St. John's Wood, London, on October 1, 1873. He was the third son of the engraver and art historian John Landseer, under whom he received his artistic training. He was a child prodigy, as his drawings at the age of eight (now in the Victoria and Albert Museum) demonstrate. His first major work was a drawing of a St. Bernard dog, at the age of thirteen, and this was subsequently engraved by his brother Thomas. He made his début that year at the Royal Academy with two animal paintings. He had a distinguished and highly fashionable career as a painter of humanoid animals, being elected R.A. in 1831 and knighted in 1850. He refused the presidency of the Royal Academy on the death of Sir Charles Eastlake in 1865. At the Exposition Universelle of 1855, he was awarded the large gold medal. A retrospective exhibition held at the Royal Academy in 1874 included 461 paintings, drawings and maquettes. His chief work as a sculptor was the group of lions for the base of Nelson's Column in Trafalgar Square.

Graves, Algernon *Catalogue of the Works of the late Sir Edwin Landseer* (c.1874). Stephens, Frederick G. *Sir Edwin Landseer* (1880). Monkhouse, Cosmo *The Studies of Sir Edwin Landseer* (undated).

LANDSHEER, E. 1834-1876
Born in London in 1834, he died there on May 21, 1876. He exhibited genre statuettes and busts at the Royal Academy and British Institution between 1863 and 1870.

LANE, John Edmund fl. 19th century
Genre and portrait sculptor working in London in the mid-19th century.

LANE, Katharine Ward 1899-
Born in Boston, Massachusetts, on February 22, 1899, she studied under Charles Grafly and Putnam and later worked in France, exhibiting at the Salon des Artistes Français in the late 1920s and winning a number of medals for her statuettes.

LANE, Richard James 1800-1872
Born in London in 1800, he died there in 1872. He was the grand-nephew of Gainsborough and worked as a lithographer, engraver and sculptor. He was elected A.R.A. in 1827 and became Lithographer to the Queen in 1837. He modelled statuettes of genre subjects. His figure of his brother, the Arabic scholar Edward William Lane, in Egyptian costume, is the National Portrait Gallery.

LANÉRY, Auguste fl. 19th century
Born in Lyons at the beginning of the 19th century, he studied under Fabisch and worked as his assistant when he moved to Paris. He exhibited at the Salon in 1868-70 and specialised in portrait reliefs and busts.

LANFRANCHI, Angelo 1832-1873
Born in Ajaccio in 1832, he died in Paris in 1873. He studied under Toussaint and Barre and exhibited at the Salon in 1863-64. He produced genre figures, such as Meditation and Springtime (both in the Ajaccio Museum) and portrait busts of his contemporaries.

LANG, Hermann 1856-1916
Born at Heidenheim, Württemberg, on August 13, 1856, he died in Munich on October 8, 1916. He worked as an ecclesiastical sculptor in Heidenheim and Ulm and decorated public buildings in Nuremberg. His minor works include numerous portrait busts.

LANG, Johann Georg 1889-
Born in Oberammergau, Bavaria, on August 27, 1889, he specialised in religious statuary and memorials.

LANG, Otto 1855-
Born in Oberammergau on September 5, 1855, he was trained at the Nuremberg School of Arts and Crafts and later studied at the Munich Academy and also in Berlin and Rome. He exhibited at Munich from

1881 onwards. His chief work was the monument to Alfred Krupp at Essen, but he also sculpted numerous portrait reliefs and busts.

LANGE, Arthur 1875-
Born in Röhrsdorf, near Chemnitz, on March 9, 1875, he worked as a modeller for the Meissen porcelain factory. His sculpture includes the equestrian statue of King Albrecht at Meissen, the war memorial at Dresden Technical High School and semi-nude figures in the Albertinum, Dresden.

LANGE, Eleanor fl. 20th century
Australian sculptress of German origin, working in Melbourne and Sydney since the second world war.

LANGE, Max 1868-
Born in Cologne on March 29, 1868, he worked in Göttingen, specialising in bronze bas-reliefs, plaques and busts of his distinguished contemporaries. He also sculpted a number of memorials in Leipzig and statuettes, such as Lucifer, Seaman, Fantassin, and Young Man. Examples of his work are in the museums of Leipzig and Dresden.

LANGEBAHN, August A. 1831-1907
Born in Germany on August 28, 1831, he died in Buffalo, New York, on June 7, 1907. He emigrated to the United States in 1852 and worked in New York State on monuments and memorials, portrait busts and bas-reliefs. Examples of his work are in the Buffalo Museum.

LANGENEGGER, Rosa fl. late 19th century
Born in Schwyz, Switzerland, in the mid-19th century, she worked in Geneva and Paris and was an Associate of the Société Nationale des Beaux Arts.

LANGER, Ignac 1857-1927
Born in Hungary in 1857, he died in Budapest on May 26, 1927. He worked as a decorative sculptor on the public buildings of Budapest and also did the bronze and gilt panels and bas-reliefs for the furniture in the throne-room of the Royal Castle in Budapest, in connection with the Millenary celebrations of 1896.

LANGER, Richard 1879-
Born in Nordhausen, Harz, on November 28, 1879, he studied under Brausewetter, Böse and Janetsch in Berlin and worked as a sculptor of portraits and bas-reliefs in Ascona.

LANGERON, Laure 1882-
Born in Nîmes on January 22, 1882, she studied under Marqueste and Michel and exhibited figures at the Paris Salons from 1905 onwards.

LANGIE-PERRIN, Amélie 1833-1887
Born at Payenne, Switzerland on June 4, 1833, she died there on October 17, 1887. She studied in Paris under Herbert for painting and Sansel for sculpture and exhibited statuettes in Lausanne in 1882-85.

LANGLOIS, Théodore Hippolyte Victor fl. early 20th century
Born in Bordeaux in the late 19th century, he studied under Carlier and exhibited at the Salon des Artistes Français, becoming an Associate in 1909.

LANGMAN, Sigismund 1860-1924
Born in Cracow in 1860, he died there on December 10, 1924. He studied under Wiedeman and Knabl in Munich and Monteverelli in Rome and worked in Paris on genre and allegorical figures and groups.

LANGRAND, Jean Apollon Léon fl. late 19th century
Born in Cambrai in the mid-19th century, he studied under Barrias and Coutan and exhibited figures at the Salon des Artistes Français, getting an honourable mention in 1899.

LANGTON, Berenice fl. 19th-20th centuries
Born in Erie County, Pennsylvania, she studied under Saint-Gaudens in 1891 and later worked in Paris for two years, receiving some tuition from Rodin. She specialised in portrait bas-reliefs and medallions in marble and bronze.

LANIEL, Marguerite fl. 19th century
Genre sculptress who exhibited at the Salon des Artistes Français in the 1890s and died in Paris in 1905.

LANSON, Alfred Désiré 1851-1898
Born in Orleans on March 11, 1851, he died in Paris in 1898. He studied at the École des Beaux Arts, Paris, and was a pupil of Rouillard, Jouffroy and Aimé Millet. He exhibited at the Salons from 1870 to 1898, winning the Prix de Rome in 1876 and many medals, culminating in the Grand Prix at the Exposition of 1889. He became a Chevalier of the Legion of Honour in 1882. He specialised in allegorical works, such as Geography (Limoges Museum), Force leaning on Justice (Orleans Museum) and The Age of Iron (the Louvre).

LANTERI, Edward 1848-1917
Born in Auxerre, Burgundy, on November 1, 1848, he died in London on December 22, 1917. He studied at the École des Beaux Arts, Paris and emigrated to England in 1872. He joined the staff of the Royal College of Art in 1874 and was professor of sculpture from 1880 to 1910. He exhibited at the Royal Academy from 1876 and specialised in portrait busts, statuettes and genre groups. His allegory of Peace (1896) is in the Salford Museum.

LANYI, Dezso 1879-
Born at Baan, Hungary, on January 23, 1879, he studied in Paris and Brussels before settling in Budapest. He specialised in genre and portrait busts which were renowned for their realistic treatment of the subject. He was a prominent member of the so-called Neo-Baroque School in Hungary.

LANZ, Karl Alfred 1847-1907
Born at La Chaux de Fonds, Switzerland, on October 25, 1847, he died in Berne on May 1, 1907. He originally trained as an engineer but turned to sculpture in 1872 and went to Paris where he studied under Cavelier. Later he worked for a time in Italy and England. Following his return to Paris he was appointed Commissioner for the Swiss Art exhibits at the Expositions of 1889 and 1900. His best known work is the equestrian statue of General Dufour in Geneva. His minor works include many busts of Swiss contemporaries and allegorical figures of Posts, Telegraphs, Navigation and Railways (Lucerne Head Post Office).

LANZIROTI, Antonio Giovanni fl. 19th century
Born in Palermo, Sicily, on May 9, 1839, he studied there and in Paris and specialised in neo-classical and genre figures. His Greek Slave is in the Nice Museum.

LANZIROTI, Giovanni fl. 19th century
Born in Naples in the early 19th century, he worked in Paris and exhibited figures at the Salon in 1859.

LAOUST, André Louis Adolphe fl. late 19th-20th centuries
Born in Douai on September 16, 1843, he studied under Jouffroy and exhibited at the Salon from 1868, winning third class medals in 1873-74 and a first class medal in 1910. He became an Associate of the Artistes Français in 1885 and was awarded a silver medal at the Exposition Universelle of 1889. He specialised in portrait busts and statuettes of historical and contemporary French celebrities. He also sculpted statuettes of genre and classical subjects, such as A Future Advocate, The Young Pastor, Amphion and Moonlight.

LAPAYRE, Eugène fl. 19th century
Born at Boulages, France, in the first half of the 19th century, he studied under Jouffroy and exhibited at the Salon from 1870, winning an honourable mention in 1883. He produced portrait busts of international celebrities of the period and genre and neo-classical statuettes, such as Fisherman casting his Net, and the curious group in Troyes Museum showing a French Sailor and a German Soldier fighting in the nude.

LAPLAGNE, Guillaume fl. late 19th century
Born at Ervy, France, in the mid-19th century, he studied under Barrias and exhibited genre figures at the Salon des Artistes Français in the 1890s.

LAPLANCHE, Pierre fl. 19th century
Born in Lyons, he died in Paris in 1873. He studied under Rouillard and exhibited animal figures and groups at the Salon from 1857 to 1869.

LA PORTE, Alexandre Gabriel 1851-1904
Born in Toulouse in 1851, he died there on June 27, 1904. He studied under Jouffroy and Falguière and exhibited figures at the Salon in 1875-80.

LA PORTE, Émile 1858-1907
Born in Paris on November 18, 1858, he died there in 1907. He studied under Dumont and Thomas and exhibited at the Salon des Artistes Français from 1883, winning a third class medal in 1885, a travelling scholarship the following year, a second class medal in 1897 and a silver medal at the Exposition Universelle of 1900. He specialised in portrait reliefs and busts.

LA PORTE, Émile Henri 1841-1919
Born in Paris on January 26, 1841, he died there in January, 1919. He studied under Glayre and Pils and exhibited at the Salon from 1864 and the Salon des Artistes Français from 1885. He won a bronze medal at the Exposition of 1889 and a silver medal at the Exposition of 1900. He worked as a painter and sculptor of portraits and genre subjects, but also produced neo-classical groups, such as Venus mourning the death of Adonis.

LAPORTE-BLAIRSY or BLAISIN, Léon M.V. 1865-1923
Born in Toulon on April 5, 1865, he died in Paris in 1923. He studied under Falguière and Mercié and exhibited at the Salon des Artistes Français, winning a third class medal (1894), a travelling scholarship (1896), a second class medal (1898) and a first class medal (1904). He was awarded a silver medal at the Exposition of 1900 and became a Chevalier of the Legion of Honour in 1903. He is best remembered for his Art Nouveau bronze lamp stands modelled as dancing girls, such as Cléo de Mérode and Lòie Fuller. He also sculpted genre and neo-classical figures, such as Caresse de Faune (Gray Museum).

LAPRET, Pierre Alexandre fl. 19th century
Born in Besançon about 1820, he worked in that town as an engraver and sculptor of animal subjects, particularly dogs.

LAQUIS, Dominique fl. 19th century
Born in Guebviller, France, on April 20, 1816, he studied under Ramey and A. Dumont and exhibited animal figures at the Salon from 1852 to 1868.

LARA, Manuel de fl. 20th century
Spanish sculptor specialising in statues and reliefs portraying saints and biblical subjects.

LARCH, Hans fl. 19th century
Born in Sterzing, Tyrol, on August 4, 1851, he died in Bozen (Bolzano). He studied under König in Vienna and settled in Bozen, where he specialised in heads, busts and portrait reliefs.

LARCHE, François Raoul 1860-1912
Born at St. André de Cubzac on October 22, 1860, he was killed in a car crash on June 2, 1912. He enrolled at the École des Beaux Arts in 1878 and studied under Falguière, Jouffroy and Delaplanche. He was runner up in the Prix de Rome of 1886 and exhibited at the Salon des Artistes Français from 1881 till his death, winning a third class medal and travelling scholarship in 1890, and a first class medal in 1893. He was awarded a gold medal at the Exposition of 1900 and the medal of honour in 1903. He became a Chevalier of the Legion of Honour in 1900. He is best remembered for his bronze and glass lamps modelled in the form of famous dancers, such as Loie Fuller and Isadora Duncan, but also employed Art Nouveau females in other forms of the applied arts. He specialised in religious figures and groups, of which Jesus with the Doctors is the most prominent. Other works include The Loire and its Tributaries (Carrousel) and Meadow and Stream (Senate).

LARCHEVEQUE, Pierre Hubert 1721-1778
Born in Paris in 1721, he died there on September 26, 1778. He was a pupil of Edmé Bouchardon and won first prize for sculpture in 1745. He was admitted to membership of the Academy ten years later. He lived in Sweden from 1760 to 1776 and sculpted many important monuments and statues there, of which the figure of Victory and the equestrian statue of Gustavus Adolphus are the best known.

LARDERA, Berto 1911-
Born in La Spezia, Italy, in 1911, he studied sculpture in Florence and then went to Paris in 1947 where he has lived ever since. Most of his work consists of constructions in copper, iron, bronze and aluminium, hammered and welded together, but prior to 1942 he modelled and sculpted figurative works, the best known of which is the monument to the partisans of Plan Albero in Tuscany. His post-war abstracts are conceived as two dimensional works of art which he has exhibited at the Salon de Mai, the Salon des Réalités Nouvelles and the Salon de la Jeune Sculpture.

LARDILLIER, Auguste 1871-
Born in Aubusson on October 3, 1871, he studied under Cavelier and Barrias and exhibited statuettes at the Salon des Artistes Français, winning a second class medal in 1922.

LARIVIÈRE, Alice (née Monod) fl. 19th-20th centuries
Born at Gien, France, in the mid-19th century, she exhibited figures and groups at the Salon des Artistes Français at the turn of the century and won bronze medals at the Expositions of 1889 and 1900.

LARMIER, Pierre Philibert 1752-1807
Born in Dijon in 1752, he died there on August 7, 1807. He studied under Coustou and exhibited at the Salon from 1791 to 1793. He specialised in portrait busts of his contemporaries, many examples being in the Dijon Museum.

LAROQUE, Léon fl. late 19th century
Born in Argentat in the mid-19th century, he exhibited genre figures and groups at the Salon des Artistes Français and got honourable mentions in 1884-85. Tulle Museum has The Music Lesson.

LARREGIEU, Fulbert Pierre fl. 19th century
Born in Bordeaux in the first half of the 19th century, he studied under Maggesi and A. Dumont and exhibited figures and portraits at the Salon from 1868 to 1880.

L'ARRIVÉ, Jean Baptiste c.1870-1928
Born in Lyons about 1870, he died in Liège on March 20, 1928. He studied under Barrias and exhibited at the Salon des Artistes Français, winning a third class medal in 1901 and the Prix de Rome three years later. He was appointed Director of the National School of Fine Arts in Liège.

LARROUX, Antonin fl. late 19th century
Born in Toulouse on June 3, 1859, he studied under Maurette, Idrac and Falguière and exhibited at the Salon des Artistes Français, winning a travelling scholarship in 1888, a third class medal in 1890 and a second class medal in 1893. He was awarded bronze medals at the Expositions of 1889 and 1900. He specialised in neo-classical and allegorical works, such as Nymph and Dolphin, and Idyll (Petit Palais, Paris).

LARSEN, Hans Vilhelm 1887-
Born in Copenhagen on September 8, 1887, he studied at the Academy and sculpted memorials, figures and portraits.

LARSEN, Jorgen 1851-1910
Born at Lellinge, Denmark, on July 28, 1851, he died on September 6, 1910. He sculpted genre figures and groups. The Copenhagen Museum has his Italian Mandolin-player.

LARSEN, Wilhelm 1861-1913
Born in Germany on February 23, 1861, he died in Oldenburg on July 5, 1913. He worked as a painter in Munich but also did genre figures and groups in Berlin, Copenhagen and Oldenburg.

LARSEN, William Peter 1884-
Born in Copenhagen on May 15, 1884, he worked in Germany and Romania and sculpted neo-classical, allegorical and biblical figures.

LARSEN-STEVNS, Niels 1864-
Born in Gaevbo, Denmark, on July 9, 1864, he was a painter and sculptor of genre and religious subjects and did bas-reliefs and statuary for Viborg Cathedral. He exhibited his work in Charlottenburg, Stockholm, Malmö and Brighton.

LARUE, Jean Denis fl. 19th century
Born in Paris, where he also died in 1884. He studied under Klagmann and exhibited figures at the Salon from 1845 to 1852.

LA RUSSA, Rosco 1825-1894
Born at Villa San Giovanni on September 24, 1825, he died in Rome on October 16, 1894. He studied at the School of Fine Arts, Messina, and the Albertine Academy in Turin. He sculpted monuments and memorials, portrait busts and genre figures and was honorary professor of the Institute of Fine Arts, Naples.

LASAR-SEGALL 1890-
Born in Vilna, Lithuania, in 1890, he studied in Germany and emigrated to Brazil in 1913, settling in Sao Paulo. He worked in Europe in 1917-22 and became an Expressionist before returning to Brazil in 1923. He specialised in genre and allegorical figures and groups in which there was a strong Judaic-Slavonic element.

LASSAW, Ibram 1913-
Born in Alexandria, Egypt, on May 4, 1913, of Russian parents, he lived a nomadic existence as a small boy. His family moved all round the Mediterranean area and also Istanbul and the Crimea before emigrating to the United States in 1921. He was naturalised in 1928 and in the same year enrolled at the Clay Club of New York where he studied modelling till 1932. He was a co-founder of the American Abstract Artists group in 1936 and was its president in 1946-49. He was one of the first American sculptors to work in a purely abstract style (1931) and produced many large individual pieces in connection with architecture. He has had numerous one-man shows since the second world war and has taken part in international exhibitions such as the Venice Biennales since 1954. He taught at the American University, Washington and has a studio in New York. His smaller bronzes include Moons of Saturn (1954), Nebula in Orion (1951), Zodiac Horse (1958) and Galactic Group (1958). Many of these works combine bronze with iron, nickel and silver.

LAST, Clifford 1918-
Born in England in 1918, he emigrated to Australia and has sculpted monuments, memorials, statues and busts. His works are represented in several museum collections.

LASZCZKA, Konstanty 1865-
Born in Kalisch, Poland, on September 8, 1865, he studied in Warsaw under Krynski and in Paris under Falguière. He was appointed professor of sculpture at the School of Fine Arts, Cracow, in 1899. He specialised in portrait busts and allegorical statuettes in plaster, terra cotta and bronze. His Enchanted Princess is in the Cracow Museum.

LATORRE, Jacinto 1905-
Born in Irun, Spain, in 1905, he was largely self-taught, but after fleeing from Spain during the civil war he attended classes at the Académie de la Grande Chaumière for three years and was taught by Wlérick and Despiau. In 1942 he abandoned realism for the abstract and was influenced by Laurens and Brancusi. He was one of the prize winners in the competition for the monument To the Unknown Political Prisoner in 1952 and has since been exhibited in the Salon de La Jeune Sculpture, the Salon de Mai and the Salon des Réalités Nouvelles and has had several one-man shows in Paris since 1956. His later work has been carved direct in marble or wood, but his earlier figurative works were sculpted in iron, copper and bronze.

LATOUCHE, Gaston de 1854-1913
Born in St. Cloud on October 29, 1854, he died in Paris on July 12, 1913. A founder member of the Société Nationale des Beaux Arts in 1890, he became an Associate of the Artistes Français in 1883. His many awards included a bronze medal at the Exposition of 1889 and a gold medal at the Exposition of 1900. He became a Chevalier of the Legion of Honour in 1900 and an Officier nine years later. He worked as a painter, engraver and sculptor of portrait and genre subjects.

LATOUR, Louis Marie Blaise c.1860-
Born in Algiers about 1860, he studied in Paris under Falguière and Paul Dubois and exhibited busts, figures and bas-reliefs at the Salon des Artistes Français at the turn of the century.

LATT, Hans fl. late 19th century
Born in Breslau on May 3, 1859, he studied at the Berlin Academy and exhibited there in the late 19th century. He produced figures of contemporary and historical celebrities and genre and classical subjects. He sculpted the monument to Frederick the Great at Samotschin.

LATTEUR fl. 19th century
Signature found on bronze portrait busts of the mid-19th century. This artist studied under Godecharles and also spent some time in Rome. Examples of his work are in the Valenciennes Museum.

LATTEUR, Karel 1873-
Born in Heule-lez-Courtrai, Belgium, in 1873, he studied under Lagae and worked in Bruges, specialising in allegorical bronzes, such as Equity, Truth and Justice. He sculpted the allegorical decoration on the façade of Bruges Palais de Justice.

LAUBMANN, Friedrich (known as COLORETTO) fl. 19th century
Born in Hof, Germany, in 1829, he studied in Rome and worked in Hof as a sculptor of ecclesiastical decoration. He sculpted the seven large statues in the Church of St. Michael in Hof.

LAUDY, Jean fl. 20th century
Belgian sculptor of animal figures working in the first half of this century.

LAUFFS, Leon 1883-
Born in Dürler, Germany on October 24, 1883, he worked in Italy and Belgium and specialised in genre groups and portrait busts and bas-reliefs.

LAUGIER, Marius François fl. 19th-20th centuries
(known as SALOMON)
Born in Marseilles, he studied under Jouffroy and exhibited genre figures of peasants and fishermen at the Salon from 1869 onwards.

LAUMANS, Jean André 1823-1902
Born at Heyopden Berg, Belgium, on November 7, 1823, he died in Brussels on November 29, 1902. He studied under Geefs and exhibited figures at the Brussels Salon in 1902.

LAUMONNERIE, Théophile fl. 19th-20th centuries
Born at Dournazac, France, in the mid-19th century, he studied under Jules Lefebvre and Cormon and became an Associate of the Artistes Français in 1896. He worked as a painter and sculptor of portraits and genre subjects and won a third class medal in 1903 and a second class medal in 1911.

LAUNITZ, Eduard 1797-1869
Born at Grobin near Libau, Courland, on November 23, 1797, he died in Frankfurt-am-Main on December 12, 1869. He studied in Göttingen and Rome before settling in Russia. His chief works are the statues of Kutusov and Prince Barclay de Tolly for St. Petersburg Cathedral.

LAUNITZ, Robert E. von der 1806-1870
Born in Riga, Latvia, on November 4, 1806, he died in New York on December 13, 1870. He was the son and pupil of a stone-mason and emigrated to the United States in 1830. Three years later he became a member of the National Academy of Design and sculpted numerous monuments, statues and busts of prominent Americans in the mid-19th century, many of them for Greenwood Cemetery. He did the statue of General Thomas at Troyes.

LAURANT, François 1762-1821
Born in Malines in 1762, he died there in 1821. He specialised in figures and groups of religious and mythological subjects.

LAURENS, Henri 1885-1954
Born in Paris on February 18, 1885, he died there on May 8, 1954. He worked originally as an interior decorator but was later influenced by Rodin and joined the Cubist movement in 1911 after meeting Braque. His early work consisted of polychrome reliefs and semi-abstracts which used geometric forms that gradually developed into figures. He never became an abstract sculptor in the strict sense. After 1930, he tended towards sculpture in the round and he specialised in female figures of monumental proportions. Later he turned towards classical and mythological themes and executed the very poetical Sirens and the figure of Amphion (Caracas). He also did numerous collages and illustrated volumes of poetry. He made his début at the Salon des Indépendants in 1913 and had several one-man shows in the late 1940s. He took part in the Venice Biennales of 1948 and 1950 and was represented in the exhibition of Seven Pioneers of Modern Sculpture, Yverdon, Switzerland, in 1954. His bronzes include L'Adieu (1941), Winged Siren (1938), The Little Siren

(1944), Mermaid (1945), The Great Amphion (1952), Reclining Woman with Mirror, Draped Woman (1927), Woman with Mirror, Kneeling Woman, Caryatid, Ondines, Seated Woman, The Negress, The Mother, The Forest, Metamorphosis, Summer, Morning, Allegory, The Moon, Small Amphion (1937), Group of Sirens, Deep Night (1951), Bather (1947), Sleeping Woman (1943), Crouching Figure (1941), Musician (1938) and Life and Death (1937).

LAURENS, Suzanne fl. 20th century
Born in Verdun in the late 19th century, she exhibited figures at the Salon des Artistes Français in the 1920s, winning a bronze medal and the Prix de Longchamps in 1929.

LAURENS-DIETERLE, Yvonne 1882-
Born in Paris on March 7, 1882, she studied under Hannaux and exhibited figures at the Salon des Artistes Français.

LAURENT, Albert 1877-
Born in Paris on February 26, 1877, he studied under Gauthier and exhibited at the Salon des Artistes Français.

LAURENT, Blanche fl. 19th century
Parisian sculptress of genre subjects working in the late 19th century, she studied under Puech and got an honourable mention at the Salon des Artistes Français in 1901.

LAURENT, Charles fl. 19th century
Born in Paris, he studied under Drolling and exhibited portraits and figures at the Salon in 1852-53.

LAURENT, Ernest fl. 19th century
Sculptor of figures and groups working in Paris in the mid-19th century. He exhibited at the Salon in 1847 and 1849.

LAURENT, Eugène 1832-1898
Born in Gray on April 29, 1832, he died in Paris in 1898. He studied under Coinchon and exhibited at the Salon from 1861. He specialised in portrait busts and figures of contemporary and historical French celebrities. He sculpted the monument to Jacques Callot in Nancy and the statue of François Boucher in Paris town hall.

LAURENT, Jean Jules César 1800-1877
Born in Paris on November 30, 1800, he died in Épinal on May 16, 1877. He enrolled at the École des Beaux Arts in 1820 and worked as a painter and sculptor of genre and neo-classical subjects. He was Curator of the Vosges Museum, Épinal, which has many of his works.

LAURENT, Pierre Antoine 1868-
Born at Montluçon on July 8, 1868, he studied under Cavelier, Chapu and Barrias and exhibited at the Salon des Artistes Français, winning a third class medal in 1897, a second class and a travelling scholarship in 1899 and a first class medal in 1903. He produced statuettes of historical, classical and contemporary figures.

LAURENT, Robert 1890-
Born in Concarneau on June 29, 1890, he studied under Maurice Sterne and worked in the Arts Institute of Chicago and the museums of New York and Brooklyn. He was professor of sculpture at the Art Students' League, New York.

LAURENT-BERBUDEAU, Blanche 1877-
Born in Paris on April 10, 1877, she studied under Puech and exhibited figures and portraits at the Nationale at the turn of the century.

LAURENTI, Adolfo fl. 19th century
Born in Rome, he worked there and exhibited in Turin, Milan and Rome as well as the Exposition Universelle of 1889.

LAURIE, Lee 1877-
Born in Germany in 1877, he worked in the studios of many sculptors until 1904, when he emigrated to the United States. He taught sculpture at Yale University from 1908 to 1919 and at Harvard Architectural School in 1910-12. He specialised in neo-Gothic ecclesiastical sculpture and did a bronze bas-relief for the National Academy of Sciences in Washington.

LAUTH-BOSSERT, Louise Aline 1869-
Born in Barr (Bas-Rhin) on May 3, 1869, she studied under Icard and Ducrot-Icart and exhibited genre and romantic figures at the Salon des Artistes Français. Her works are preserved in various museums of eastern France.

LAVALETTE, Jean fl. 19th century
Born at Ainay-le-Vieil, he died in Paris in 1878. He studied under Bonnassieux and Jouffroy and exhibited at the Salon from 1867 to 1877. He specialised in portrait busts and figures of historic and contemporary personalities. His statue of St. Peter is in the Church of Notre Dame de Bercy, and a bust of General Piat is in the museum of Clamecy.

LAVALETTE-D'EGISHEIM, fl. 19th century
Jacques Martin Jean Guillaume
Born in Heidelberg of French parents, he studied in Paris and exhibited at the Salon in 1848-52. He specialised in statues and busts of French celebrities, the main collection of which is in the Colmar Museum.

LAVALLEZ, Pierre fl. 20th century
Born in Lyons in the late 19th century, he won the Prix de Rome and founded the School of Fine Arts in Rabat, Morocco, in 1939. He specialised in portraits and genre figures and wildlife studies of North Africa.

LAVÉE, Adolphe J. fl. 19th century
Sculptor of medallions and portrait reliefs working in Paris in the late 19th century. He was an Associate of the Artistes Français and died in 1904.

LAVERETZKY, N.A. 1837-1907
Born in Russia in 1837, he died there in 1907. He worked in St. Petersburg and specialised in genre figures and groups. The Russian Museum, Leningrad, has Cupid and Psyche and The Old Jew. Other works include a group of Children (Rumianzeff Museum) and Young Italian with a Monkey (Tretiakoff Gallery, Moscow).

LAVERGNE, Adolphe Jean fl. 19th century
Born in Hautefort, France, in the early 19th century, he studied under Jouffroy and exhibited at the Salon from 1863 to 1876. He produced portrait busts, classical and genre figures and groups, such as The Quoit-player, Diomedes, Bacchante.

LAVEZZARI, Vittorio fl. 20th century
Born in Genoa in the late 19th century, he worked in Genoa, Rome and Florence and produced Realist figures and groups.

LAVIGNE, Hubert 1818-1882
Born in Cons la Granville on July 11, 1818, he died in Paris on January 12, 1882. He studied under Ramey and Dumont and was runner-up in the Prix de Rome in 1843. He exhibited at the Salon, winning medals in 1861-63. The main collection of his work is in the Nancy Museum and includes medallions and portrait reliefs of historical and contemporary celebrities and classical and genre figures such as Young Flautist, Death of Epaminondas and Mercury inventing the Lyre. He sculpted a series of portrait roundels for the Bibliothèque Nationale, including those of Montaigne, Bacon, Descartes, Newton, Voltaire and Goethe.

LAVRILLIER-COSSACEANU, Marguerite fl. 20th century
French sculptress working in the early part of this century. She exhibited Realist figures with allegorical titles, such as Space, at the Salon d'Automne and the Salon des Femmes Peintres et Sculpteurs.

LAVROFF, Georges 1895-
Born in Siberia on April 19, 1895, he studied in Moscow and emigrated to France after the Revolution. He exhibited figures and portraits in the major Paris Salons of the inter-war period.

LAW, Edward 1798-1838
Born in Sheffield on December 9, 1798, he died there on June 30, 1838. He was the son and grandson of silversmiths and designers of ornamental, but utilitarian articles for brass and iron foundries. He himself worked as a modeller and designer in the same field and produced a hexagonal bronze stove with ormolu mountings for the old Register House in Edinburgh. He was employed as a modeller of figures by Hoole and Robson and produced a number of wax medallions, subsequently cast in bronze, with portraits of Shakespeare, Canning and other historic and contemporary figures. He exhibited at the Royal Academy in 1829 and 1832. Many of his portrait busts and reliefs were of Sheffield worthies.

LAWES-WITTERONGE, Charles Bennett 1843-1911
Born in Teignmouth on October 3, 1843, he died in London on October 6, 1911. He exhibited figures at the Royal Academy, British Institution and Salon des Artistes Français and won an honourable mention at the Exposition Universelle of 1878.

LAWLOR, John 1820-1901
Born in Dublin in 1820, he died in London in 1901. He studied in Dublin and then emigrated to the United States but after a few years came to London and executed several statues for the Houses of Parliament. He exhibited at the Royal Academy in the late 19th century.

LAWRENCE, Mervyn 1868-
Born in Dublin on September 16, 1868, he studied at the Royal College of Art and exhibited at the Royal Academy and various provincial galleries. He worked in London as a painter and sculptor of portraits and genre subjects. He was vice-president of the South London Group and deputy head of Westminster School of Art.

LAWRIE, Leo Oskar 1877-
Born in Rixdorf, Germany, on October 16, 1877, he studied under Martiny and Saint-Gaudens in Chicago and became professor of sculpture at Harvard University. He did decorative sculpture for Westpoint Military Academy.

LAWSON, George Anderson 1832-1904
Born in Edinburgh in 1832, he died in London on September 23, 1904. He studied under Handyside Ritchie and Robert Scott Lauder and exhibited at the Royal Scottish Academy from 1860 onwards. Later he went to London and thence to Italy, where he worked with Gibson in Rome. He produced a number of statues, such as those of the Duke of Wellington (Liverpool) and Robert Burns (Ayr) but is best known for his genre bronzes, such as Dominie Sampson (1868) and The Bard (Edinburgh Museum), and neo-classical figures such as Callicles (1879). The Burns statue is also known as a bronze reduction, casts being in Ayr Old Church and the British Institute, Paris.

LAWSON-PEACHEY, Jess 1885-
Born in Edinburgh in 1885, he studied at the Edinburgh College of Art and the Royal College of Art and specialised in classical statuettes in bronze or bronzed plaster. His works include Daphne, the spirit of Belgium, 1914, and Galatea.

LAZAROV, Ivan fl. 20th century
Sculptor of genre figures, mainly of workers and peasants, working in Bulgaria since the second world war. His best known work is the Yavorov Monument.

LAZON, Lucien fl. 19th century
Genre sculptor working in Cambrai at the turn of the century. He was made an Associate of the Artistes Français in 1905.

LAZZARINI, Pietro fl. 19th century
Born in Carrara on January 5, 1842, he studied at the Florence Academy and exhibited in Milan, Berlin and Paris at the turn of the century. He specialised in genre figures such as Coquetry (Madrid Modern Art Gallery).

LAZZERINI, Alessandro 1860-
Born in Carrara on November 7, 1860, he studied at the Carrara Academy and was a pupil of Carusi, Giuseppe Lazzerini and Pelliccia. He produced genre and allegorical figures and won an honourable mention and a bronze medal at the Exposition Universelles of 1889 and 1900 respectively.

LAZZERINI, Giuseppe the Elder d. 1801
Italian portrait sculptor of the 18th century who died in Carrara in 1801. He studied in Munich and spent several years in England before settling in Bavaria. He specialised in neo-classical portrait busts, mainly in marble.

LAZZERINI, Giuseppe the Younger 1831-1895
Grandson of the above, born in Carrara on December 15, 1831. He died in Carrara on December 3, 1895. He spent most of his working life in Rome and Carrara and was Director of the Carrara Academy. His figures and portraits are in the Museum of Modern Art, Carrara, and Narbonne Museum.

LAZZERINI, Pietro 1842-1918
Born in Carrara on January 5, 1842, he died there on June 4, 1918. He worked in Berlin and sculpted portrait reliefs and busts of the German imperial court. He also exhibited busts at the Royal Academy in 1875.

LEA, Sheila (née Maclagan) 1901-
Born in London on March 16, 1901, she studied at Bournemouth School of Art and the Regent Street Polytechnic School and exhibited plaster and bronze figures at the Royal Academy and the Salon des Artistes Français. She worked in Bournemouth.

LEBARQUE, Albert Léon fl. late 19th century
Genre sculptor working in Paris in the 1890s.

LE BAS, Émile P.L. 1864-
Born in Pontoise on August 25, 1864, he studied under Chapu and Barrias and exhibited figures at the Salon des Artistes Français in the 1890s.

LE BAS, Molly 1903-
Born in London on June 13, 1903, she studied at the École des Beaux Arts, Paris, and has exhibited at the Royal Academy, the Glasgow Institute and various provincial galleries. She worked in London and now lives at Angmering in Sussex.

LEBAUDY, Gabrielle 1866-
Born in Paris on May 29, 1866, she studied under Max Blondat and exhibited genre and allegorical figures at the Salon des Artistes Français from 1907 onwards.

LE BEAU, Maurice 1885-
Born in Beauvais on March 11, 1885, he exhibited figures and groups at the Salon des Artistes Français from 1909.

LE BÈGUE, Adolphe Paul fl. late 19th century
Born in Paris in the mid-19th century, he specialised in busts and portrait reliefs which he exhibited at the Salon from 1876 onwards.

LEBEL, A. fl. 19th century
Portrait sculptor working in Auch in the mid-19th century. He specialised in bas-reliefs and medallions of contemporary celebrities.

LEBER, Pietro 1829-1892
Born in Lugano on November 25, 1829, he died at Como on May 8, 1892. He studied at the Academia Brera in Milan and then went to the United States, where he worked as a decorative sculptor on buildings and churches in the Louisville area.

LE BLANC, Maurice fl. 19th century
Born at Braine-sur-Vesle, France, in the mid-19th century, he exhibited figures at the Salon des Artistes Français and got an honourable mention in 1887.

LEBOEUF, Louis Joseph fl. 19th century
Born at Lons-le-Saulnier in the early 19th century, he died in Paris in 1867. He exhibited figures and groups at the Salon from 1857 till 1867. He sculpted the two stone statues at the entrance to the Fire Brigade Headquarters in Paris.

LEBORGNE, Émile fl. 19th century
Born at Marcilly le Hayer on April 30, 1832, he specialised in genre and classical figures and groups, such as The Enchained Prisoner and Philoctetes on the island of Samos (Troyes Museum).

LEBOSSÉ, Henri Victor Gustave fl. 19th-20th centuries
Born in Paris, he studied under Salmson and exhibited at the Salon from 1872 and the Salon des Artistes Français at the turn of the century.

LEBOURG, Charles Auguste 1829-1906
Born in Nantes on February 20, 1829, he died in Paris in February 1906. He studied under Rude and Amédeé Ménard and exhibited at the Salon from 1852, winning medals in 1853, 1859 and 1868. He specialised in religious and classical bas-reliefs and groups and also did busts and portrait medallions of contemporary French celebrities.

LE BOUVIER, Eugénie fl. 19th century
Genre and portrait sculptress working in Besançon in the late 19th century. She exhibited at the Salon from 1878.

LEBROC, Jean Baptiste 1825-1870
Born in Paris on November 9, 1825, he died there in 1870. He studied at the École des Beaux Arts and exhibited classical and mythological statuettes at the Salon from 1844 to 1867.

LECAVELIER, Charles fl. 19th century
Born in Caen in the early 19th century, he studied under Rude and worked as a decorative sculptor in Paris. He exhibited bas-reliefs and figures at the Salon of 1859.

LECERF, Émile Louis fl. 19th century
Sculptor working in Paris, where he died in 1892. He was an Associate of the Artistes Français.

LECHEREL, Alphonse Eugène fl. 19th century
Born in Paris in 1850, he studied under Henri François and exhibited engravings, cameos, gemstones and relief portraits at the Salon des Artistes Français from 1883, winning a third class medal in 1888. He won bronze and silver medals at the Expositions of 1889 and 1900 respectively.

LECHESNE, Auguste fl. 19th century
Born in Le Mans, he died in Paris on March 18, 1861. He studied under his father, Auguste Jean Baptiste Lechesne, and Duret, and was runner-up in the Prix de Rome of 1856. He exhibited figures at the Salon from 1861.

LECHESNE, Auguste Jean Baptiste 1815-1888
Born in Caen in 1815, he died there on November 2, 1888. He exhibited at the Salon from 1848 to 1878 and won a second class medal in 1848. He became a Chevalier of the Legion of Honour in 1855 and specialised in portrait busts and genre groups.

LECHESNE, Henry fl. 19th century
Son and pupil of Auguste Lechesne, he exhibited genre statuettes and portraits at the Salon from 1869 to 1878.

LECLERC, Alexandre Joseph Hippolyte fl. 19th century
Born in Beauvais at the beginning of the 19th century, he died in Paris on August 12, 1864. He studied under David d'Angers and Famin and exhibited genre figures and portraits at the Salon of 1863. When his work was rejected by the Salon the following year he committed suicide in Montmartre cemetery.

LECLERC, Constant E. fl. 19th century
An Associate of the Artistes Français, he exhibited at that Salon in the 1880s.

LECLERCQ, F. fl. 18th-19th centuries
Portrait sculptor working in Namur in the late 18th and early 19th centuries. He specialised in busts and bas-reliefs of contemporary personalities and died in 1826.

LECLERCQ, Julien Gabriel 1805-1882
Born in Ghent on February 22, 1805, he died in Brussels on February 23, 1882. He studied under David d'Angers in Paris and worked in Brussels as a decorative sculptor, mainly on churches. He also sculpted portrait reliefs and medallions.

LECOINTE, Léon Aimé Joachim 1826-1913
Born in Paris on April 9, 1826, he died there in 1913. He studied under Klagmann and Toussaint and exhibited genre, allegorical classical and biblical figures and groups at the Salon from 1850 onwards, making his début with The Execution of John the Baptist. He got an honourable mention in 1882 and a bronze medal at the Exposition Universelle of 1889.

LECOMTE, Félix 1737-1817
Born in Paris on January 16, 1737, he died there on January 11, 1817. He studied under Falconet and Antoine Vassé and was three times runner-up in the Prix de Rome, finally winning it in 1758. On his return from Rome he was elected to the Academy in 1771, became a professor in 1792 and a member of the Institute in 1810. His chief work was the mausoleum of King Stanislas of Poland and Lorraine at Nancy (1774). He exhibited at the Salon from 1769 to 1793 and specialised in classical figures and groups, but also did busts and statuettes of contemporary celebrities, such as Marie Antoinette, Fénelon and Laharpe.

LECOQ, Fernand fl. 19th-20th centuries
Born in Paris in the late 19th century, he exhibited figures and groups at the Salon des Artistes Français, getting an honourable mention in 1897 and becoming an Associate in 1903.

LECORDIER, Madame Paul fl. 19th century
Parisian sculptress of genre figures and groups, who exhibited at the Salon des Artistes Français from 1884 onwards.

LECORNET, Nicolas fl. 19th century
Born at Gourgeon, France, in the mid-19th century, he exhibited figures and portraits at the Salon in 1880-84.

LECOURTIER, Prosper 1855-1924
Born at Gremilly in 1855, he died in Paris in 1924. He studied under Frémiet and Coutan and exhibited at the Salons of Paris at the turn of the century, winning a third class medal in 1880, a second class medal in 1879 and a first class medal in 1902. He also won a bronze medal at the Exposition Universelle of 1900. He specialised in Animalier sculpture and his works include Great Dane suckling her Young (Provins Museum), The Forgotten One - a sensitive study of a braying donkey (Tourcoing Museum), and Stalking Lion (1898).

LECREUX, Paul (known as 'Jacques France') 1826-1894
Born in Paris about 1826, he died there on July 3, 1894. He specialised in bronze portrait busts and allegorical statuettes of the republic.

LECUIRE, Alfred fl. 19th century
Born at Tournans in the early part of the 19th century, he studied at the École des Beaux Arts and exhibited bas-reliefs at the Salon in 1861-63.

LECUYOT, Lucien Stanislas fl. 19th century
Born at Montigny-Lecoup in the mid-19th century, he studied under Madrassi and exhibited figures and groups at the Salon from 1878.

LEDERER, Hugo 1871-
Born in Znaim, Germany, on November 16, 1871, he studied at the Znaim Ceramic School and the Erfurt School of Art. Later he worked in the studio of the Bieler brothers in Dresden. He exhibited at the Berlin Academy and specialised in bas-reliefs, figures and groups of biblical subjects, such as The Good Samaritan and Baptism in the Jordan.

LEDERER, Karl fl. 18th-19th centuries
Sculptor of neo-classical figures and groups who died in Prague about 1811.

LEDEVIN, Édouard René fl. late 19th century
Born in Paris in the mid-19th century, he specialised in bas-reliefs and medallions which he exhibited at the Salon des Artistes Français from 1883.

LE DOUBLE, Frédéric Marie Auguste Aimé fl. 19th-20th centuries
Born in Grigny, France, in the mid-19th century, he studied under Géorges Lemaire and Georges Tonnelier and exhibited at the Salon des Artistes Français, winning a third class medal in 1900. He got an honourable mention at the Exposition of the same year and became a Chevalier of the Legion of Honour in 1906.

LEDRU, Auguste 1860-1902
Born in Paris in 1860, he died there on November 5, 1902. He was an Associate of the Artistes Français and exhibited figures and portraits at that Salon.

LEDRU, Eve Léonie fl. 19th century
Wife of the above, with whom she worked in Paris in the 1890s.

LEDUC, Arthur Jacques 1848-1918
Born in Torigny-sur-Vire on March 27, 1848, he died in Antibes on February 29, 1918. He studied under Lenordez, Guillard, Dumont, Barye and Carolus Duran and exhibited at the Salon from 1878 onwards. He won a third class medal in 1879 and got silver medals at the Expositions of 1889 and 1900. He became a Chevalier of the Legion of Honour in 1906 and an Associate of the Société Nationale des Beaux Arts in 1893. He specialised in animal and genre groups, such as Familial Piety, Standing Stag and Mare and Foal.

LEDUC, Celestine Marie (née Lecomte) 1860-
Born in Caen on March 8, 1860, she was the pupil and later the wife of the above. She worked as a genre sculptress in Paris and became an Associate of the Artistes Français in 1883.

LEDUC, Marcel Michel Édouard Marie 1876-
Born at La Louvière-en-Hainault, Belgium, on August 28, 1876, he studied in Paris under Mercié and Peter and exhibited in Brussels and Paris in the early years of this century.

LEDWARD, Gilbert 1888-1960
Born in Chelsea on January 23, 1888, he died in London on June 21, 1960, and received his early artistic education from his father, the stone-carver Richard Arthur Ledward. Later he studied at Chelsea Polytechnic, the Goldsmiths' College School of Art and the Royal College of Art under Lanteri and the Royal Academy schools. He won the first scholarship of the British School in Rome in 1913 and the Royal Academy gold medal and travelling scholarship the same year. During the first world war he served with the Royal Garrison Artillery and resumed his studies in 1919. He was appointed professor of sculpture at the Royal College of Art in 1926, became an A.R.A. in 1932 and R.A. in 1937. He was President of the Royal Society of British Sculptors in 1954-56, and a trustee of the Royal Academy in 1956-57. He worked in London, specialising in portraits and figures in marble, stone and bronze.

LEE, Arthur 1881-
Born in Trondhjem, Norway, on March 4, 1881, he studied in Paris, Rome and London and emigrated to the United States. He exhibited in New York from 1921 onwards. He specialised in allegorical figures in plaster, concrete and bronze, such as Dawn and Voluptuousness (Metropolitan Museum of Art).

LEE, Erica fl. 20th century
Born in Manchester in the late 19th century, she studied under E. Whitney Smith and Sir William Dick and exhibited at the Royal Academy, the Royal Scottish Academy, the Glasgow Institute and other provincial galleries, and the Salon des Artistes Français. She specialised in heads, busts and portrait reliefs, in terra cotta and bronze and was a member of the Society of Portrait Sculptors. She was active in the inter-war period.

LEE, Rupert Godfrey 1887-1959
Born in Bombay in 1887, he died at San Roque, Spain, on August 2, 1959. He studied at the Royal Academy schools and the Slade and was a member of the Leicester Galleries and the Friday Club from 1920 onwards. He was Chairman of the first International Surrealist Exhibition, 1936, and lectured at the Westminster School of Art and worked as a painter and sculptor. He lived at Pulborough, Sussex, for many years.

LEE, Thomas Stirling 1857-1916
Born in London on March 16, 1857, he died there on June 29, 1916. He studied at the Royal Academy schools, winning the gold medal and a travelling scholarship in 1880. He studied under Cavelier and also at the École des Beaux Arts (1880-81) and completed his studies in Rome (1881-83). He is best remembered for his portrait busts and heads, many of them cast by the *cire perdue* process, but he also did figures, such as Dawn of Womanhood (1883) and bas-reliefs, such as those in St. George's Hall, Liverpool.

LEEB, Arthur Johann 1790-1863
Born in 1790, he died in Munich on July 5, 1863. He studied in Lindau and worked in Winterthur, Lausanne, Geneva and Paris, where he was assistant to Thorvaldsen for some time. He settled in Munich in 1826 and produced neo-classical figures and reliefs.

LEEMANS, Philippe Alexis de 1827-1885
Born in Brussels on January 12, 1827, he died there on June 10, 1885. He did many statues and reliefs for Brussels University in 1866-69.

LEENHARDT, Michel Maximilien fl. 19th century
Born in Montpellier on April 2, 1853, he studied under Michel and Cabanel and became an Associate of the Artistes Français in 1883. He won a third class medal in 1884 and a bronze medal at the Exposition Universelle of 1889. He specialised in statuettes of genre and religious subjects.

LEENHOFF, Ferdinand Carl Adolph Constantin 1841-1914
Born at Zalt Bonnel, Holland, on May 24, 1841, he died in Nice on April 25, 1914. He studied under Mazzara and Alphonse François and exhibited at the Paris Salons, winning a second class medal in 1872 and a gold medal at the Exposition of 1889. He became a Chevalier of the Legion of Honour in 1872. His works include the statue of Josef Israels in the Amsterdam Municipal Museum and Warrior at Rest (Angers Museum).

LEEUW, Henri 1866-1918
Born in Roermond, Holland, on October 7, 1866, he died in Nimwegen on June 12, 1918. He worked in Paris and Barbizon as a painter and figure sculptor in the neo-impressionist style.

LE FAGUAYS, Pierre fl. 20th century
French sculptor of Art Deco bronze and ivory figures and groups. He worked as a sculptor of statuary and reliefs for film sets.

LEFEBURE fl. 19th century
Signature found on portrait busts by a sculptor working in Paris in the early 19th century.

LEFEBVRE, Camille fl. 19th-20th centuries
Born at Issy-sur-Seine on December 31, 1853, he served his apprenticeship with a wood-carver and then attended classes at the École des Arts Décoratifs and the École des Beaux Arts and worked as assistant to Cavelier. He was runner-up in the Prix de Rome of 1878 and exhibited at the Salon from 1879, winning a third class medal in 1884 and a second class four years later. He was founder-member of the Société Nationale des Beaux Arts in 1890 and exhibited at that Salon from then onward. He was awarded a silver medal at the Exposition of 1889 and a gold medal at the Exposition of 1900, and became a Chevalier of the Legion of Honour the following year. He specialised in genre groups, such as In the Street, The Ford and Good Luck.

LEFEBVRE, Eugène Peter fl. 19th century
Born in Paris in the early 19th century, he studied under Rude and exhibited figures and groups at the Salon from 1848 to 1872.

LEFEBVRE, Hippolyte Jules 1863-
Born in Lille on February 4, 1863, he studied at the local School of Fine Arts before going to Paris in 1882 where he studied under Cavelier, Coutan and Barrias. He won the Prix de Rome in 1892 and exhibited at the Salon des Artistes Français from 1893, winning a second class medal in 1896, a first class in 1898 and the Medal of Honour in 1902. He was awarded a gold medal at the Exposition Universelle of 1900 and became a Chevalier of the Legion of Honour in 1902 and an Officier in 1925. He specialised in figures of biblical, allegorical and classical subjects, such as Niobe, Sadness, Christ, The Young Blind People, The Pardon, Summer and Winter.

LEFEBVRE-VALAY, Charles Georges 1885-
Born in St. Omer on May 22, 1885, he was apprenticed to a wood-carver at the age of fourteen. Later he won a scholarship from St. Omer to Paris and studied at the École des Beaux Arts. He exhibited at the Salon des Artistes Français and got an honourable mention in 1910.

LEFEVER, Edmond Florimond 1839-1911
Born in Ypres on February 25, 1839, he died in Brussels on April 18, 1911. He studied under H. Thoris at the Ypres Academy and produced decorative sculpture in that area, notably the five statues which at one time decorated the Cloth Hall (destroyed by enemy action in the first world war). He specialised in genre and allegorical figures, such as First Sorrow.

LEFEVRE-DESLONCHAMPS, Louis Alexandre 1849-1893
Born in Cherbourg on November 22, 1849, he died in Paris on February 23, 1893. He studied under A. Dumont and exhibited figures, in marble, plaster and bronze, at the Salon in 1873. The main collection of his works is in Cherbourg Museum.

LEFEVRE-DEUMIER, Marie Louise (née Rouleaux-Dugage) 1829-1877
Born in Argentan in 1829, she died in Paris in 1877. She exhibited at the Salon from 1850 to 1877 and her works include Morning Star, The Child Virgil and portraits of Louis-Napoleon and General Paixhaus.

LEFRANC, Gustave Clement fl. 19th century
Born in Döle, he died in 1900. He studied under Dumont and Perraud and exhibited at the Salon from 1870 to 1892.

LE GALIENNE, Gwenn 1900-
Born in Paris on November 5, 1900, she studied in Paris and Boston and became a painter of landscapes as well as an engraver and sculptor. She specialised in busts and heads of contemporary American and French personalities, including Joyce and Hemingway. She exhibited at the Salon d'Automne and the Tuileries.

LEGASTELOIS, Julien Prosper fl. 19th century
Born in Paris on May 24, 1855, he studied under Carlier, Levasseur and G. Tonnelier and exhibited at the Salon des Artistes Français, winning a third class medal in 1899 and a bronze medal at the Exposition of 1900. He became a Chevalier of the Legion of Honour. He specialised in portraits and allegorical figures. His statuette of Youth is in Limoges Museum.

LEGASTELOIS, Marcel 1883-1916
Born in Paris on December 5, 1883, he was killed in action during the first world war. He studied under Mercié and Lemaire and exhibited figures and groups at the Salon des Artistes Français.

LEGENDRE-HÉRAL, Jean François 1796-1851
Born in Montpellier on January 21, 1796, he died in Marcilly on September 13, 1851. He studied under Chimard at Lyons School of Design and exhibited at the Salon from 1817. He was appointed professor at the Lyons School of Fine Arts in 1818. Apart from a short sojourn in Rome he spent the early part of his career in Lyons, working on decorative sculpture for public buildings in that city. He moved to Paris in 1839 and worked as a decorative sculptor then till shortly before his death.

LÉGER, Fernand 1881-1955
Born in Argentan in 1881, he died at Gif-sur-Yvette in 1955. Though he only turned to sculpture relatively late in life he had always had a deep interest in this medium and it strongly influenced his paintings, mosaics and stained glass. During the second world war he lived in the United States and worked with Mary Callery, combining his painting with her sculpture. From this he developed architectural and decorative sculptures of his own, including abstracts, bas-reliefs, female heads and large compositions in which outlines were in relief, painted to contrast with their background. The sculptures produced in his lifetime were invariably in fire-clay or some other ceramic material, but he left instructions for them to be cast in bronze and various editions have been produced since 1955. The main collection of his work is in the Musée Fernand Léger at Biot.

LÉGER, René fl. 19th-20th centuries
Born in Paris, he was killed in action during the first world war. He studied under Louis Gossin and won a third class medal at the Salon of 1911.

LE GOFF, Élie Jules 1858-
Born at St. Brieuc on March 1, 1858, he studied under Chapu and Guibé and exhibited at the Paris Salons, winning a medal in 1929. St. Brieuc Museum has his group Happy Age and portrait busts of C. Baratoux and Grand Master Villiers de l'Isle Adam of the Knights of Malta.

LEGOUT, Auguste Eugène fl. 19th century
Born in Valenciennes, he exhibited figures at the Salons from 1882 to 1894.

LEGRAIN, Edmond 1821-1871
Born in Vire on April 24, 1821, he died there on February 11, 1871. He studied under Paul Huet and Gaillard and exhibited at the Salon from 1861. He was better known as a painter, but also sculpted portrait busts.

LEGRAIN, Emile Desiré Louis c.1837-1892
Born at Aizy about 1837, he died in Paris on March 3, 1892. He studied under Vigneron and specialised in monuments, memorials and bas-reliefs.

LEGRAIN, Eugène c.1837-1915
Born in Paris about 1837, he died there on January 10, 1915. He studied under Carpeaux and exhibited at the Salon from 1872 to

1912. His best known works are the equestrian statue of St Joan of Arc and a globe decorated with the signs of the zodiac for the fountain of the Paris Observatory.

LEGRAND, Auguste Ernest 1872-1912
Born in Lesmont in 1872, he died there in 1912. He studied under Thomas and A. Boucher and won a third class medal and a travelling scholarship in 1895. He specialised in portrait busts and genre figures, such as The Orphan and The Fallen Angel.

LEGROS, Alphonse 1837-1911
Born in Dijon on May 8, 1837, he died in Watford, Hertfordshire, on December 8, 1911. He was the youngest child in a very large and poor family and was illiterate till he began his apprenticeship as a ship's painter at the age of eleven. In 1851 he moved from Lyons to Paris, where he worked under the scene-painter Cambon. He studied painting, engraving and modelling under Lecocq and Boisboudran and began exhibiting at the Salon in 1857. He took part in the first Salon des Refusés in 1859, with Fantin Latour and Whistler, the first of the secessions from the official Salon. Disappointed at the lack of recognition he moved to England in 1863. He exhibited at the Royal Academy from 1864 and also showed his works at the Grosvenor and New Galleries. He taught at the Slade School and was appointed professor in 1876 in succession to Paynter, holding this position till 1892. Though better known for his paintings and etchings, Legros was a powerful and original force in the revival of interest in cast bronze medals in Britain in the late 19th century. He also sculpted a number of bronze bas-reliefs and neo-classical torsos and nudes. His bronzes are in the Luxembourg and various British galleries.

LEGUEULT, Eugène fl. 19th century
Born at St. Sever, France in 1858, he specialised in portrait medallions and bas-reliefs.

LEHARIVEL-DUROCHER, Victor Edmond 1816-1878
Born at Chanu, France, on November 20, 1816, he died there on October 9, 1878. He enrolled at the École des Beaux Arts in 1838 and exhibited at the Salon from 1846. He specialised in ecclesiastical sculpture in Paris, and also decoration for the Louvre and the Théâtre Française. His minor works are in the museums of Alençon and Vire. He became a Chevalier of the Legion of Honour in 1870.

LEHMANN, Kurt 1905-
Born in Coblenz in 1905, he studied at the academies of Cassel and Berlin from 1924 to 1929 and then worked in France and Belgium. He was also awarded a state scholarship enabling him to complete his studies at the Villa Massimo in Rome. He worked in Berlin from 1931 to 1933 and returned to Cassel in 1934. He served in the Wehrmacht from 1940 to 1945 and became professor of sculpture at the Hanover Technical High School in 1949. He has taken part in many international exhibitions since the war, including the Cassel Documenta (1955), the Exposition Internationale de Sculpture, Paris (1956) and the Middelheim and Arnhem exhibitions of 1958. His earlier figurative work includes bronze figures of Bather, Exhausted Man, Prostrate Boys, Little Shepherd and Crouching Woman, but later he tended towards the abstract, typified by Mother and Child (1957).

LEHMANN-BORGES, Hans 1879-
Born in Berlin on July 20, 1879, he worked as a decorative sculptor in Berlin and Zürich.

LEHMBRUCK, Wilhelm 1881-1919
Born at Meiderich, near Duisburg, on January 4, 1881, he committed suicide in Berlin on March 25, 1919. He studied at the School of Decorative Arts and the Academy of Düsseldorf (1901-07) and was strongly influenced by Meunier and Rodin. From 1910 to 1914 he worked in Paris and was closely associated with Archipenko and Brancusi, though it was to Maillol that he turned for guidance, and this is evident in the architectural qualities of his figures. Most of his figures have an air of repose, exemplified by Nude Woman Standing (1910) and Kneeling Woman (1911), Young Man Standing (1913) and Young Man Seated (1918). His Fallen Warrior (1915-16) reveals something of that depression which led him to take his own life. A confirmed pacifist, he worked in Berlin as a nurse in a military hospital and had a nervous breakdown which was only temporarily assuaged by a period of convalescence in Switzerland (1917-18). His female figures show great sensitivity, and include Female Figure

(Duisburg), Female Torso (The Hague), Frau Lehmbruck (Essen) and Knieende (Mannheim). He also sculpted several portraits, notably that of Fritz von Unruh in Frankfurt, Portrait of Mademoiselle B. (1918) and Head of a Thinker (1918). In his last works the simplification of line was taken to extreme lengths, as in Woman Praying (1918). The main collections of his bronzes are in the Duisburg Museum and the Museum of Modern Art, New York.

Westheim, Paul *W. Lehmbruck* (1919). Hoff, August *Wilhelm Lehmbruck* (1969).

LEHNERT, Adolf 1862-
Born in Leipzig on July 20, 1862, he specialised in portrait busts in marble and bronze. The Leipzig Museum has his bust of the singer Hedwig Reicher-Kindermann.

LEHR, Christian Wilhelm Jacob fl. 19th century
Born in Berlin on March 25, 1856, he worked mainly in Berlin, Aachen and Merano as a decorative sculptor.

LEHUÉDÉ, Marcel Pierre 1886-1918
Born at Pouliguen, France, on January 21, 1886, he died at Cempuis on April 16, 1918. He studied under Coutan and Peynol and was runner-up in the Prix de Rome in 1913.

LEIFCHILD, Henry Stormont 1823-1884
Born in London in 1823, he died there on January 11, 1884. He exhibited figures and portraits at the Royal Academy from 1844 to 1882.

LEIGHTON, Frederick, Lord 1830-1896
Born in Scarborough, Yorkshire on December 3, 1830, he died in London on January 25, 1896. His father was a physician who held many appointments abroad and took his family with him. Frederick Leighton had a very disjointed education, and owed much of his artistic training to Edward Steinle, at the Institut Städel in Frankfurt, though he also studied in Italy under F. Meli in Rome and Hiram Powers and Zanetti in Florence. Later he worked in Brussels and Paris under Ary Scheffer and Robert-Fleury. He did not settle in London till 1860, though he exhibited paintings at the Royal Academy from 1855 onwards and was elected A.R.A. in 1864 and R.A. in 1868 and became President ten years later in succession to Grant. He took up sculpture in the 1870s and was greatly influenced by Greek and Renaissance styles. He is better known as a fashionable painter of the late 19th century, receiving a knighthood in 1878, a baronetcy in 1886 and a barony shortly before his death. Though his classical paintings completely eclipsed his sculpture at the time, in retrospect he is regarded as the father of the New Sculpture in England. His bronze Athlete Wrestling with a Python (1877) is interesting on two counts: its anatomical accuracy and generalised treatment of surfaces broke with English tradition and showed a keen awareness of contemporary developments in France, and it was conceived primarily as a statuette in clay, cast in bronze (as an aid to one of Leighton's paintings), rather than as a bronze reduction made as an afterthought to a larger work carved in marble, as was hitherto the custom in Britain. This was later reinforced in his figure of The Sluggard (1886), now in the National Gallery.

Barrington, Mrs. Russell *The Life, Letters and Work of Frederick Leighton* (1906). Rhys, Ernest *Frederick, Lord Leighton* (1898, revised 1900).

LEINFELLNER, Heinz 1911-
Born in Steinbrück, Austria in 1911, he studied at the School of Arts and Crafts, Graz, and learned the techniques of wood- and stone-carving and pottery. He studied at the Vienna Academy from 1933 to 1939 under Hanak and also worked as a restorer of decorative sculpture. After the war he was assistant to Wotruba for four years (1947-51) and since 1959 has taught ceramics at the School of Decorative Arts in Vienna. He is a founder member of the International Art Club in Vienna and has participated in many of their exhibitions at home and abroad, as well as the Venice and Sao Paulo biennials and the Cassel Documenta exhibition of 1959. His Cubist figures and abstracts have been produced in many materials, from carved wood and limestone to clay and bronze.

LEINS, Anton 1866-1925
Born at Vollmaringen, Germany, on May 27, 1866, he died at Horb on the Neckar on February 24, 1925. He specialised in religious figures and reliefs, many of which are in the churches of Württemberg, Baden and Bavaria.

LEINWEBER, Leopold 1861-1909
Born in Hamburg on October 11, 1861, he died there on December 18, 1909. He studied under E. Pfeiffer and worked in Paris and the French Midi, as a painter and engraver as well as sculptor, specialising in portrait and allegorical reliefs and medallions.

LEIRNER, Felicia fl. 20th century
Sculptress of abstract and non-figurative bronzes, working in Brazil since the second world war.

LEISEK, Georg 1869-
Born in Vienna on June 30, 1869, he worked as a decorative sculptor in churches and public buildings, notably Florisdorf Town Hall. He also sculpted the monument to Kaiser Franz Josef at Pruchatitz.

LEISTNER, Albrecht 1887-
Born in Leipzig on November 6, 1887, he worked as a sculptor and engraver and specialised in heads and busts of his artistic contemporaries, such as Richard Wagner and Max Klinger.

LEITAO, José Joaquim fl. 18th century
Born in Mafra, Portugal, he died there in 1805. He sculpted the statue of King José I at Lisbon.

LEITHERER, Hans 1885-
Born at Frankenthal, Germany, on December 13, 1885, he studied at the Munich Academy and worked in Bamberg where he sculpted many public statues and monuments.

LEJEUNE, Louis Aimé 1884-
Born at Livet-sur-Authon on January 22, 1884, he studied under Thomas and Injalbert and won the Prix de Rome in 1911. He exhibited at the Salon des Artistes Français, winning a third class medal (1911), second class (1913) and first class (1920). He was a Chevalier of the Legion of Honour. He specialised in portrait busts of his contemporaries as well as statuettes of religious and neo-classical subjects, such as St. Theresa (Brooklyn Museum) and Ephebus (Museum of Modern Art, Paris).

LE KERMADEC, Eugène Nestor 1899-
Born in Paris on May 21, 1899, he was a painter and sculptor whose work was largely ignored in his lifetime. He specialised in female figures, characterised by their coldness and lack of compromise, but with powerful rhythmic qualities. He exhibited sporadically at the Salon des Indépendants.

LELEU, Jules Emile 1883-
Born in Boulogne on June 17, 1883, he studied under Deman and exhibited figures at the Salon des Artistes Français.

LELIBON, Philibert fl. 19th century
Born in Bayonne, he studied under Jouffroy and exhibited at the Salon from 1868 to 1877.

LELIÈVRE, Eugène fl. 19th century
Born in Paris on March 13, 1856, he exhibited at the Salon des Artistes Français, winning a first class medal.

LELIÈVRE, Octave Georges 1869-
Born in Paris on August 8, 1869, he studied under Barrau and Mayeux and won a medal at the Salon of 1902.

LELIÈVRE, Philippe 1731-1815
Born at Nivelles, Belgium in 1731, he died there in 1815. He worked as an ornamental sculptor, specialising in candelabra, balustrades and bas-reliefs for the public buildings in the Nivelles area.

LE LORRAIN, Robert 1666-1743
Born in Paris on November 15, 1666, he died there on June 1, 1743. He studied under Girardon. He was admitted to the Academy in 1701, his *morceau de réception* being a figure of Galatea. He exhibited from 1704 onwards, showing classical and allegorical figures. His bronzes include a group of Vertumne, Pomona and Cupid and a figure of a Bacchante. He also sculpted the tomb of Girardon in the Church of St. Landry.

LEMAIRE, Ferdinand fl. late 19th century
Born at Chars on May 10, 1851, he studied under Steiner and became an Associate of the Artistes Français in 1890.

LEMAIRE, Georges Henri 1853-1914
Born in Bailly on January 19, 1853, he died in Paris in 1914. He studied under M.J. Perrin and worked as a gem-cutter and sculptor. He was an Associate of the Artistes Français and won third class (1885), second class (1886) and first class (1894) medals. At the Expositions of 1889 and 1900 he was awarded silver and gold medals respectively and was also a Chevalier of the Legion of Honour (1896). He won the medal of honour in 1908 for his classical and historical figures and groups.

LEMAIRE, Hector Joseph fl. 19th century
Born in Lille on August 15, 1846, he studied under Dumont and Falguière and spent four years working in Rome. He exhibited at the Salon from 1869 and became an Associate of the Artistes Français in 1883. He also exhibited at the Nationale from 1892 till the end of the century. His numerous awards include gold medals at the Expositions of 1889 and 1900 and the Legion of Honour in 1892. He was professor of sculpture at the School of Decorative Arts, Paris. His works include Roman Charity, Young Mother, Lover of the Good Things of Nature, Lover of Truth, Morning, The Wave, The Merchant of Love, The Folding Star, The Antique Marriage, Profane Music, Sacred Music, Mother Love and other genre and allegorical groups. He also sculpted portrait busts of French historical and contemporary personalities.

LEMAIRE, Philippe Joseph Henri 1798-1880
Born in Valenciennes on January 9, 1798, he died in Paris on August 2, 1880. He studied under Cartellier and Milhomme and won the Prix de Rome in 1821. He exhibited at the Salon from 1831 and won a first class medal in 1837. He was made a Chevalier of the Legion of Honour in 1834 and an Officier in 1843 and became a member of the Institut in 1845. His chief work is the decorative sculpture on the façade of the Madeleine, but he did many other statues and reliefs for public buildings and gardens in Paris, Versailles, Lille and Valenciennes, the last-named having many maquettes of his works in its museum. His minor works include Head of a Virgin (Museum of Modern Art, Paris), Duke of Bordeaux, Young Girl with a Butterfly, Young Girl Frightened by a Snake and Resignation (Valenciennes Museum) and various busts and statuettes of French historical personages (Versailles Museum).

LEMAITRE, Aline M. fl. 19th century
French sculptress who died in 1907. She exhibited figures and portraits at the Salon des Artistes Français at the turn of the century.

LE MEUR, Pierre 1886-
Born in Callac, France on August 12, 1886, he studied under Mercié and exhibited figures at the Salon des Artistes Français and the Salon des Indépendants.

LEMMERS, Ferdinand Georges fl. 19th-20th centuries
Born in Antwerp, he studied at the Antwerp Academy and worked as a painter and sculptor of genre subjects. He was awarded a bronze medal at the Exposition of 1900.

LEMOINE, Charles fl. 19th century
Born in Paris in 1839, he studied at the École des Beaux Arts and exhibited figures at the Salon in 1865 and 1868-69.

LEMOT, Baron François Frédéric 1772-1827
Born in Lyons on November 4, 1772, he died in Paris on May 6, 1827. He studied under Dejoux and won the Prix de Rome in 1790. He was awarded a medal at the Salon of 1804 and became a member of the Institut the following year and professor at the École in 1810. He interrupted his studies in Rome to return to France when the Revolution broke out and subsequently served in the Army of the Rhine. He returned to sculpture in 1795, producing a colossal allegorical composition symbolising the French people. He sculpted many other allegorical and classical monuments and statues for government buildings during the Directory period, notably the Arc de Triomphe du Carrousel. His smaller works include statues of Apollo, Jean Bart, Murat and Henri IV.

LEMOYNE, Paul 1784-1873
Born in Paris in 1784, he died in Rome on May 23, 1873. He won third prize in the Prix de Rome competition of 1808 and exhibited at the Salon from 1814 to 1837, winning a second class medal in 1817. He became a Chevalier of the Legion of Honour in 1837. He specialised in portrait busts and neo-classical groups, such as Bacchante and Young Faun, in the palace of Compiegne and Bordeaux Museum respectively.

LEMPEREUR, François fl. 19th century
Born in Rupt, France, he died in Switzerland in 1904. He studied under Fourdrin and attended classes at the Schools of Fine Arts in Paris and Geneva. He exhibited at the Salon of 1874 alone.

LENARTOWICZ, Teofil 1822-1893
Born in Warsaw on February 27, 1822, he died in Florence on February 3, 1893. He was a poet and sculptor and worked in Brussels, Fontainebleau and Florence. He exhibited in Cracow from 1873 to 1889 and specialised in busts, groups and bas-reliefs. His best known work is the bronze door and bas-relief in a chapel of the Church of the Holy Cross in Florence, in memory of Captain Bechi, an Italian officer executed by the Russians during the Polish Uprising of 1863. He also sculpted a number of portrait medallions.

LENDECKE, Otto Friedrich Carl 1886-1918
Born in Lemberg (Lwow) on May 4, 1886, he died in Vienna on October 17, 1918. At the Salon des Artistes Français of 1910 he showed a bust of the painter Katherina de Szabo-Hindi whom he married. He specialised in busts and statuettes, many of which were reproduced in porcelain at Carlsbad as well as being cast in bronze. He also worked as an illustrator of Austrian art and fashion magazines.

LENGLET, the Elder fl. 19th century
Brother of C.A.A. Lenglet, he exhibited figures at the Salon in 1848-49.

LENGLET, Charles Antoine Armand fl.19th century
Born at Levergies, France in 1791, he studied under Cartellier and exhibited at the Salon from 1846 to 1855, winning a second class medal in 1848.

LENNGREN, Carl Emil Edward 1842-1903
Born in Helsinki on April 7, 1842, he died there on December 25, 1903. He studied in Stockholm, Paris and Rome. His works include Sleeping Bacchante and Andromeda in Chains.

LENOIR, Alfred Charles 1850-1920
Born in Paris in 1850, he died there on July 27, 1920. He studied under Guillaume and Cavelier and exhibited at the Salon from 1874, winning second class medals in 1874 and at the Exposition of 1878 and gold medals at the Expositions of 1889 and 1900. He became a Chevalier of the Legion of Honour in 1886 and an Officier in 1900. He specialised in busts of his contemporaries, but also sculpted allegorical and genre works, such as the frieze The Joys of Childhood and the group Young Faun watching a Cock-fight (Nice Museum).

LENOIR, André Alfred Alexandre fl. early 20th century
Born in Paris in the second half of the 19th century, he exhibited figures at the Salon des Artistes Français and the Nationale and won a travelling scholarship in 1905.

LENOIR, Auguste Henri 1885-1915
Born in Nancy on September 29, 1885, he died of war wounds in 1915. He studied under Injalbert and exhibited at the Salon des Artistes Français, getting an honourable mention in 1910.

LENOIR, Charles Joseph 1844-1899
Born in Paris on December 6, 1844, he died in Rennes on June 17, 1899. He studied under Jouffroy, Cogniet, Carpeaux and Farochon and exhibited at the Salon from 1870, winning a third class medal in 1874. His works include Idyll, Cock-fight (casts in the museums of Nantes, Nice and Rennes), Wounded Cupid and a bust of J.L. Duc (Versailles).

LENOIR, Pierre Charles 1879-
Born in Paris on May 22, 1879, he was the son and pupil of C.J. Lenoir, and also studied under Chaplain and Peter Mercié. He exhibited at the Salon des Artistes Français, winning second class medals in 1905 and 1907 and a travelling scholarship in 1911. He was

a very prolific sculptor of monuments and memorials, but also did several portrait busts, including those of Stendhal and Charles le Goffic. His bronze plaques include Bucolique, Childhood of Bacchus, Seated Girl (Museum of Modern Art, Paris) and numerous medallions.

LENORDEZ, Pierre fl. 19th century
Born in Vaast (Manche) in the early 19th century, he worked in Caen and exhibited at the Salon from 1855 to 1877, making his début with a wax model of the stallion Le Baron of the imperial stud at the Bois de Boulogne. He specialised in animal sculpture and concentrated largely on figures and groups of famous racehorses. Other works include Welsh Pony, Blacksmith shoeing a Horse, Episode from the Surrender of Sedan, Huntsman sounding his Horn, and Slave and Sultan on Horseback.

LENORMAND, Pierre Jules Augustin fl. 19th century
Born in Paris, he exhibited figures and portraits at the Salon des Artistes Français in the 1890s.

LENTELLI, Leo 1879-
Born in Bologna on October 29, 1879, he emigrated to the United States at the turn of the century. He worked as a painter and sculptor of religious subjects, but also did ornamental bas-reliefs and friezes in American theatres. His best known work is the façade of the Steinway Building in New York.

LENZ, Alfred David 1872-1926
Born at Fond du Lac, Wisconsin in 1872, he died in Havana, Cuba, on February 16, 1926. Originally apprenticed to a jeweller, he studied engraving, chasing and bronze-casting and eventually mastered every technique of metalwork associated with the applied arts. He specialised in the sculpting of figures involving five or six different metals and his most sumptuous works in this manner included The Orchid Pearl and Aphrodite. His bronzes in the more traditional vein include Desha, The Elusive Witch Pavlova, Susette and Señorita Hootch. He also modelled the Lawn Tennis Trophy in bronze.

LENZ, Maximilien 1860-
Born in Vienna on October 4, 1860, he studied under Wurzinger and Eisenmenger at the Vienna Academy. He produced allegorical and classical bronzes, such as The World (Budapest) and Sea Centaur and Sirens (Leipzig).

LENZ, Oscar 1874-1912
Born in Providence, Rhode Island in 1874, he died in New York on June 25, 1912. He studied at the Rhode Island School of Design, and the Art Students' League, New York before going to Paris. His best known work is the ornamental sculpture on the new bridge of Buffalo, but he also did the decorative sculpture for the Pennsylvania Station in New York.

LENZ, Peter (Brother Desiderius) 1832-1928
Born at Haigerloch, Bavaria on March 12, 1832, he died at Beuron Monastery on January 28, 1928. He studied at the Munich Academy and became the founder and head of the Beuron School. He was a member of the Benedictine order of Beuron Monastery and specialised in religious painting, sculpture and architecture.

LÉONARD, Agathon (pseudonym of Van Weydeveldt)
fl. 19th century
Born in Lille in 1841, he studied under Delaplanche and at the School of Fine Arts in Lille. Later he moved to France and was naturalised. He became an Associate of the Artistes Français in 1887 and an Associate of the Société Nationale in 1897. He won third class (1879) and second class (1895) medals and was awarded silver and gold medals at the Expositions of 1889 ana 1900 respectively. He became a Chevalier of the Legion of Honour in 1900. His bronzes include the bas-relief of St. Cecilia (Abbeville Museum) and a bust entitled The Plunderer of Shipwrecks (Nantes Museum).

LEONARD, Charles fl. late 19th century
Born in Lille he exhibited figures at the Salon des Artistes Français and got an honourable mention in 1891.

LÉONARD, Lambert Alexandre fl. 19th century
Born in Paris on March 18, 1831, he studied under Jacquot, Rouillard and Barye and specialised in Animalier sculpture which he exhibited at the Salon from 1851 to 1873. Many of his groups depicted birds, such as Heron, Fox and Partridge, Fighting Thrushes, Sparrows and

Thrushes, Foraging Chickens, Wounded Bittern and Eagle guarding its Prey. Other works include After the Hunt (1868) and Arab surprised by Lions (1869). His works were executed in plaster, wax or wax with a silver finish as well as bronze. His works are usually signed 'A. Léonard'.

LÉONARD, (Leonard Schwartz) 1923-
Born in Cincinnati on August 10, 1923, he was orphaned at the age of two and moved to Detroit where he was adopted by a sculptor who specialised in anatomical figures in the classical style. He studied philosophy at Detroit University for four years, then served in the United States Navy in the second world war. He took up the study of art in 1945 and was awarded a Veterans' travelling scholarship which took him to Paris in 1946. He worked with Zadkine and was influenced by Laurens. He won a Guggenheim scholarship in 1949 and subsequently participated in the major Paris exhibitions. His art is an interesting blend of American and Latin styles.

LEONCILLO (Leonardo Leonardi) 1915-
Born in Spoleto, Italy in 1915, he studied at the Institute of Art,Perosa Argentina and settled in Umbertide but moved to Rome in 1942 where he has since taught ceramics and modelling. From Expressionism and figurative work he gradually moved towards Cubism and the abstract and was strongly influenced by Picasso. He went through phases of geometric art before evolving his 'concretions' derived from the world of fantasy. He has taken part in the major Italian exhibitions since 1956.

LEONE, Giustino fl. early 19th century
Neapolitan sculptor of the period 1837-51, specialising in genre and classical statuettes and bas-reliefs. He exhibited at the Bourbon Museum, Naples from 1837 till his death. His works include Diomede, Pericles and Slaughter of the Innocents (Naples Institute of Fine Arts).

LEORNARDY, Henri Charles fl. 19th century
Born in Forbach in the mid-19th century, he studied at the École Nationale de Dessin and exhibited figures at the Salon from 1876 to the end of the century.

LEPAGE, Céline 1882-1928
Born in Warsaw in 1882, she died in Paris in 1928. She worked as a decorative sculptor for the Pomona Pavilion at the Exposition des Arts Décoratifs in Paris, 1925.

LEPELTIER, Odette 1914-
Born in Paris in 1914, she studied under J.P. Laurens and specialised in ceramic modelling. Her Coquette is in the Museum of Modern Art, Paris.

LEPÈRE, Alfred Adolphe Édouard 1827-1904
Born in Paris on May 15, 1827, the son of François Lepère, he died at Bourg-la-Reine in 1904. He studied under Ramey, Dumont, Toussaint and Gleyre. He won the Prix de Rome in 1852 and exhibited at the Salon, winning a third class medal in 1859 and a second class medal at the Exposition Universelle of 1878. He was awarded the Legion of Honour in 1870. He was a painter and sculptor of classical, mythological and hunting subjects.

LEPÈRE, François 1824-71
Born in Paris on September 7, 1824, he died there in 1871. He studied under Rude and exhibited at the Salon from 1863 to 1870. Chartres Museum has five terra cotta statuettes by him.

LEPETIT, Napoleon Victor fl. 19th century
Born in Metz on September 20, 1806, he specialised in genre figures and groups such as Father and Mother of the Artist, The Artist in his Workshop and A Family of Bohemians.

LEPIC, Ludovic Napoleon, Vicomte 1839-c.1890
Born in Paris on September 17, 1839 he died there in either 1889 or 1890. He studied under Verlet, Wappers, Gleyre and Cabanel and worked as a painter, engraver and sculptor of genre and allegorical subjects. He exhibited at the Salon from 1869 and won a third class medal in 1877.

LEPINE, Louis fl. 19th century
Parisian sculptor of the second half of the 19th century, he studied under Levasseur and Osbach and exhibited figures at the Salon from 1880 onwards.

LEPKE, Ferdinand 1866-1909
Born in Coburg on March 23, 1866, he died in Berlin on March 13, 1909. He studied at the Berlin Academy and worked in the studio of the Begas Brothers. His works, mainly carved direct in stone, consist of classical and mythological subjects.

LEPLA fl. 19th century
Polish sculptor of Impressionist and genre statuettes working in Warsaw at the end of the 19th century.

LEPLAE, Charles 1903-
Born in Louvain, Belgium at the beginning of this century, he worked in Liège and specialised in busts. He exhibited his work in 1948 at the Salon d'Art Moderne et Contemporain, Liège. He studied at the Louvain Academy and Oxford University before taking a law degree at Louvain. Thereafter, however, he took up sculpture and settled in Etichove where he sculpted busts and figures in the manner of Despiau. An interesting feature of his bronzes is the amount of afterwork, hammering and chiselling, which he does on the bronze following casting. His Young Girl Kneeling forms a pair with one by Grard for the outside of the Banque Nationale in Brussels. He has also worked on bronze plaques and medallions, using punches and burins to achieve an engraved effect.

LEQUESNE, Eugène Louis 1815-1887
Born in Paris in 1815, he died there in 1887. He studied under Pradier and exhibited at the Salon from 1842, winning the Prix de Rome in 1844 and a first class medal in 1851. He was made a Chevalier of the Legion of Honour following his participation in the Exposition Universelle of 1855. He sculpted statues for several Paris churches and did the statue of Laennec at Quimper. His Dancing Faun is in the Luxembourg gardens. His allegories include Industry and Sculpture (both in Amiens Museum) and his classical groups include Priestess of Bacchus and Vercingetorix conquering the Romans (Chartres). He also sculpted a number of busts and statuettes of his contemporaries.

LEQUIEN, Alexandre Victor 1822-1905
Born in Paris on January 17, 1822, he died there in 1905. He studied under Devaux and exhibited at the Salon in 1853. He produced busts of French contemporary personalities, such as d'Ornano, Palissy and Napoleon III.

LEQUIEN, Justin 1826-1882
Born in Paris on November 1, 1826, he died there on June 2, 1882. He studied under Taunay and Bosio and exhibited figures at the Salon in 1875.

LEQUIEN, Justin Marie 1796-1881
Born in Paris on December 9, 1796, he died in Villevoyer on November 18, 1881. He studied under Bosio and was runner-up in the Prix de Rome of 1819. He exhibited at the Salon from 1831 to 1857 and became a Chevalier of the Legion of Honour in 1863. He specialised in portrait busts of French historical personalities.

LEQUINE, Claude François fl. 19th century
Born in Paris, he went to Berlin and studied under Rauch. On his return to Paris he exhibited at the Salon from 1848 to 1864. He produced medallions, busts and portrait statuettes in plaster, terra cotta and bronze and was a practising bronze founder.

LERCHE, Hans S. fl. early 20th century
Born in Düsseldorf of Norwegian parents in the late 19th century, he learned the rudiments of art from his father, the genre painter Vincent Lerche. He exhibited genre figures and groups at the Nationale in Paris from 1901 onwards.

LE RICHE, Henri 1868-
Born in Grenoble on April 12, 1868, he studied under Bouguereau and Robert-Fleury and won the Prix de Rome in 1888. He exhibited pastels, oils and watercolours at the Salon des Artistes Français from 1894 but also did genre and portrait statuettes under the pseudonym of Hirne.

LE RICHE, Marc 1885-1918
Born in Roanne on December 1, 1885, he died in Lyons on October 15, 1918. He studied under Injalbert and won the Prix de Rome in 1914.

LE ROLLE, Alphonse fl. 19th century
Born in Paris about 1830, he studied under Pradier and exhibited figures at the Salon in 1852-54.

LEROLLE, Édouard Louis Henri 1868-
Born in Paris on May 20, 1868, he studied under Larche and Gauquié and exhibited genre figures at the Paris Salons, winning a medal in 1924.

LEROUGE, Maurice fl. early 20th century
Born at Mantes in the late 19th century, he studied under Thomas Injalbert and Peynot and exhibited figures at the Salon des Artiste Français, winning an honourable mention in 1906.

LEROUX, Frédéric Etienne 1836-1906
Born in Ecouché on August 3, 1836, he died in Paris in 1906. He studied under Jouffroy and enrolled at the École des Beaux Arts in 1859. He exhibited at the Salon from 1863 and won medals in 1866-67, 1870 and 1878, also receiving the Legion of Honour in the latter year. He won silver medals at the Expositions Universelles of 1889 and 1900. His classical works include Achilles and Thetis, and Demosthenes, while his allegories include Somnolence and Victory. His genre figures and groups are typified by The Young Mother, The Violet-seller and The Little Flower-seller. He also sculpted busts and statuettes of historical and contemporary figures such as Joan of Arc, Georges Sand, Rachel, Renan and l'Abbé Croquet.

LEROUX, Gaston Veuvenot fl. 19th century
Born in Paris on September 14, 1854, he studied under Jouffroy and C. Deloye and became a member of the Société des Artistes Français in 1883. He won a third class medal and a travelling scholarship in 1885 and bronze medals at the Expositions of 1889 and 1900. He specialised in busts and statuettes of artistic contemporaries including Rosa Bonheur, Paul Sébilleau and Lionel Bonnemère.

LEROY, Dominique fl. early 20th century
Sculptor of genre subjects, working in Nancy in the early 1900s.

LEROY, Émile André 1899-
Born at St. Armand-Montrond on September 25, 1899, he studied under Jean Boucher and exhibited portrait busts and genre subjects at the Salon des Artistes Français in the 1920s, winning a bronze medal in 1927. His best of a Young Haitian is in the Museum of Modern Art, Paris.

LEROY, Hippolyte fl. 19th century
Born in Liège on April 4, 1857, he studied at the Ghent Academy and was a pupil of Falguière in Paris. He specialised in portrait medals, busts and statuettes and won bronze and silver medals at the Expositions of 1889 and 1900 respectively. The museums of Amiens and Verviers have his figures of Hero and Salambo.

LEROY, Marie fl. 19th century
Parisian sculptress of the late 19th century. She was made an Associate of the Artistes Français in 1889.

LEROY, Pierre François 1739-1812
Born in Namur on January 14, 1739, he died in Brussels on June 27, 1812. He studied under Laurent Delvaux and attended the Paris Académie Royale from 1762 to 1766 and then the Académie Bridan before going to Italy. Later he sculpted religious figures for Belgian convents, but also did portrait busts, bas-reliefs and medallions of his contemporaries.

LESCHNITZER, Georg 1885-
Born in Tamovitz, Silesia on January 27, 1885, he specialised in statuettes and small groups of dancers, and portrait busts and decorative reliefs for the Berlin Opera.

LESCORNEL, Joseph Stanislas 1799-1872
Born in Langres on September 16, 1799, he died in Paris on April 18, 1872. He studied under Cartellier and Petitot and exhibited at the Salon from 1831 to 1870, winning medals in 1836 and 1848. He specialised in busts of biblical, historical and contemporary figures and classical statues, such as Ariadne (Dijon Museum).

LESCORNEL, Nicolas 1806-1879
Born in Langres in 1806, he died in Roanne in 1879. He specialised in busts and statuettes of his contemporaries, many examples being preserved in the museums of Langres and Roanne.

LESIEUX, Augustin fl. early 20th century
Born at Sombrin, France in the late 19th century, he studied under Barrias and Coutan and exhibited figures at the Salon des Artistes Français, getting an honourable mention in 1902.

LESLIE, Alexander J. 1873-1930
Born in London on November 27, 1873, he died in Lynton, Devon on June 12, 1930. He studied at the Royal Academy schools and exhibited figures and portraits at the Royal Academy from 1901 onwards.

LESLIE, Cecile Mary 1900-
Born in Surrey on March 23, 1900, she worked as a painter, etcher, engraver and sculptor and exhibited at the Royal Academy, the Royal Scottish Academy, the Royal Cambrian Academy, the Glasgow Institute and other galleries, both in Britain and abroad. She lived in West Byfleet for many years and now works in Blakeney, Norfolk.

LE SOUDIER, Jane 1885-
Born in Le Mans on February 18, 1885, she worked as a sculptor and pastellist of genre subjects and exhibited at the Salon des Artistes Français and the Salon des Indépendants.

LESSING, Otto 1846-1912
Born in Düsseldorf on February 24, 1846, he died in Berlin on November 22, 1912. He studied under his father, the painter Karl F. Lessing and later studied sculpture in Karlsruhe and worked in the studio of A. Wolff in Berlin. He became a member of the Berlin Academy in 1884. From 1872 onwards he concentrated on sculpture and decorated many of the public buildings and parks in Berlin. His smaller works include numerous busts in marble and bronze of contemporary Germans. He also sculpted the funerary mask of Von Moltke.

LESSORE, Frederick 1879-1951
Born in Brighton, Sussex on February 19, 1879, he died in London on November 14, 1951. He was the son of the painter Jules Lessore and studied art in London and Paris, winning the medal of the Royal Academy schools in 1906. He became a member of the Art Workers' Guild and worked in London as a sculptor of portrait busts and statues.

LESTACHE, Pierre c.1688-1774
Born in Paris about 1688, he died in Rome in 1774. He studied at the Académie Royale, Paris from 1712 to 1715 and became a state pensionary at Rome (the former equivalent of the Prix de Rome), where he studied at the Académie de France till 1721. He sculpted figures and bas-reliefs for the French church in Rome and also did numerous portrait busts of his contemporaries following his return to Paris.

LESTRADE, Gabriel Theodore fl. 18th-19th centuries
Sculptor working in Paris till his death in 1825. He studied under P. Julien and exhibited figures and reliefs at the Salon from 1793 to 1819.

LESUEUR, Jacques Philippe 1757-1830
Born in Paris in 1757, he died there on December 4, 1830. He won the Prix de Rome in 1780 and exhibited at the Salon from 1791 to 1824. He became a Chevalier of the Legion of Honour and a member of the Institut, and specialised in monumental statuary and memorials. His minor works include classical figures, such as Hippomenes and Atalanta and genre groups, such as Flower Festival.

LESZKOVSKY, György 1891-
Born in Budapest on March 21, 1891, he worked there as a painter and sculptor, specialising in ecclesiastical decoration. His frescoes, stained glass windows, figures and bas-reliefs decorate churches in Budapest and Marosvasarhely.

LETELLIER, Arsène fl. 19th century
Born in Rouen, he died in Paris in 1884. He studied under Duret and Dehay and exhibited at the Salon from 1869 onwards.

LETOURNEUR, René 1898-
Born in Paris on November 26, 1898, he studied at the École des Beaux Arts and won the Prix de Rome in 1925. He exhibited figures and reliefs at the Salon des Artistes Français, winning a third class medal. With Jacques Zwobada he shared the prize for the Bolivar Monument.

LETTIERI, Giuseppe 1860-
Born in Naples on June 24, 1860, he worked in that city as an ecclesiastical sculptor and did the figures of saints on the façade of Naples Cathedral and statues of angels in Sorrento cemetery. His minor works include numerous statuettes in Naples University and churches in the Naples area.

LEU, Max 1862-1899
Born in Soleure, Switzerland on February 26, 1862, he died in Basle on February 4, 1899. He studied in Soleure and Basle and worked in the studio of Gürtler. In 1880 he went to Lyons and the following year to Paris where he studied under Cavelier at the École des Beaux Arts. He returned to Switzerland in 1898 after travelling all over Europe but died a few months later. He sculpted the monument to Daniel Richard at Locle and various portrait busts, including those of Bishop Fiala (Soleure) and Councillor Frey (Berne).

LEUCH, Karl Joseph 1871-1913
Born in Zürich on September 17, 1871, he died there in 1913. He worked as a decorative sculptor on the Parliament Buildings in Berne and exhibited figures and bas-reliefs of allegorical and historical subjects at the Zürich and Basle exhibitions of 1897-98.

LEUCHTWEISS, Karl Gottfried 1814-1888
Born in Frankfurt-am-Main on January 28, 1814, he died in Hanau on August 15, 1888. He was appointed professor of design at Hanau in 1840 and sculpted a number of monuments, memorials and statues in that town, including the war memorial of 1871 and the bas-relief of Venus and Adonis.

LEULIE, Charles Achille fl. 19th century
Born in Paris on November 12, 1826, he exhibited figures at the Salon in 1848-69.

LEURS, Godefroid 1829-1904
Born in Antwerp on April 13, 1829, he died there on November 3, 1904. He studied at the Antwerp Academy from 1848 to 1852 and specialised in busts and genre groups.

LEUTHNER, Johann Georg 1725-1785
Born in Graz, Austria on March 28, 1725, he died in Vienna on September 6, 1785. He sculpted monuments and memorials, notably the lead bas-relief of the Body of Christ and the Praying Angel in the Kaiser Friedrich Museum, Berlin.

LEUZINGER, Johannes 1845-1881
Born in Netstal-Glarus on March 1, 1845, he died in Kappel on May 2, 1881. He studied at Glarus Art College which has the main collection of his works, including Satyr playing the Flute, Charity (group), St. Mark (bas-relief) and a bust of J. Blumer.

LEVASSEUR, Henri Louis 1853-
Born in Paris on April 16, 1853, he studied under Dumont, Thomas and Delaplanche and exhibited at the Salon des Artistes Français, winning a third class (1885), second class (1888) and first class (1898) medal. He was awarded bronze and silver medals at the Expositions of 1889 and 1900 respectively. His works include the bas-reliefs After the Battle and Delaplanche on his Death-bed.

LEVASSEUR, Jules Clément 1831-1888
Born in Paris about 1831, he died there on April 18, 1888. He studied under Michel Pascal and exhibited figures and groups at the Salon from 1874.

LEVÉ, Louis Charles fl. 19th century
Born in Paris on April 4, 1828, he studied under Pomateau and exhibited figures at the Salon from 1859 to 1870.

LE VÉEL, Armand Jules 1821-1905
Born in Bricquebec on January 26, 1821, he died in Cherbourg on July 21, 1905. He studied under Rude and exhibited at the Salon from 1850, becoming a Chevalier of the Legion of Honour in 1863. His best known work was the equestrian statue of Napoleon at Cherbourg. He specialised in busts and statuettes of contemporary celebrities, including Napoleonic and Bourbon royalty, and historic groups, particularly of the 16th century and the Revolutionary period.

LEVEL, Hélène fl. late 19th century
Born in Rio de Janeiro in the mid-19th century, she came to France,

married there and exhibited at the Salon des Artistes Français, getting an honourable mention in 1896.

LEVEN, Hugo 1874-
Born in Benrath near Düsseldorf on March 15, 1874, he worked in Düsseldorf and Bremen before becoming the Director of the Academy of Hanau in 1910. He was an Animalier sculptor, specialising in bas-reliefs. His works are in the museums of Düsseldorf, Bremen and Stuttgart.

LEVEQUE, Auguste Maurice François Giuslain 1864-1921
Born in Nivelles in 1864, he died in Brussels in 1921. He worked as a painter and sculptor and was a prominent member of the various artistic movements of the 1890s. He headed the Flemish movement back to nature in art and specialised in figures, groups and bas-reliefs with agricultural and peasant subjects, such as Vision Païenne (Antwerp Museum) and Triumph of the Vine (Liège Museum). He exhibited at the Paris Salons at the turn of the century, winning a third class medal in 1900 and the medal of honour two years later.

LEVEROTTI, Julian 1844-1915
Born in Italy in 1844, he died in 1915. He specialised in portrait reliefs and medals of European celebrities. His bas-relief portraying Robert Owen is in the National Portrait Gallery.

LEVI, Max 1865-1912
Born in Stuttgart on September 27, 1865, he died in Berlin on June 5, 1912. He studied at the Berlin Academy and specialised in busts of his contemporaries, such as Strindberg (Berlin Museum), Agnes Soma and Councillor Schmidt (Albertinum, Dresden).

LEVI, Pietro 1874-
Born in Mendrisio, Switzerland in 1874, he specialised in memorials and commemorative plaques. He took part in the Swiss national exhibitions and was awarded medals in 1894 and 1903.

LEVICK, Ruby (Mrs. Gervase Bailey) fl. 19th-20th centuries
Portrait and genre sculptress working in London at the turn of the century. She exhibited at the Royal Academy from 1894 to 1909.

LEVILLAIN, Ferdinand 1837-1905
Born in Passy in 1837, he died in Paris in January, 1905. He studied under Jouffroy and exhibited at the Salon from 1861, winning a silver medal at the Exposition Universelle of 1889 and becoming a Chevalier of the Legion of Honour three years later. He sculpted numerous bas-reliefs, plaques and medallions of historic and genre subjects. Examples of his gilt-bronze vase, with reliefs illustrating the story of Diogenes, are in the Lyons Museum and the Museum of Modern Art, Paris.

LEVY, Albert 1864-
Born in Paris on May 4, 1864, he studied under Etienne Leroux and exhibited at the Salon des Artistes Français from 1886. Gray Museum has his group A Discovery in Pompeii.

LEVY, Clarisse 1896-
Born at St. Maurice, France on July 31, 1896, she studied under Segoffin and Sicard and exhibited statuettes at the Salon des Artistes Français, winning a second class medal in 1929.

LEVY, Vaclav 1820-1870
Born in Nebreziny, Bohemia on September 14, 1820, he died in Prague on April 30, 1870. He studied in Prague, Munich and Rome and sculpted genre, religious and neo-classical figures as well as memorials and decoration on the public buildings of Prague and Vienna. His works include Adam and Eve (Beseda Umelecka, Prague) and figures of various saints for the churches and monasteries of Prague.

LEVY-DHURMER, Lucien 1865-1953
Born in Algiers on September 30, 1865, he died in Paris in 1953. He studied under Collin, Vion and Wallet and exhibited at the Salon des Artistes Français. He won a bronze medal at the Exposition Universelle of 1900 and became a Chevalier of the Legion of Honour two years later. He was elected an Associate of the Société Nationale des Beaux Arts in 1906. He specialised in paintings and sculpture of genre subjects, and busts and reliefs of females of different races.

LEWANDOWSKY, Stanislas Roman 1859-
Born in Poland on February 28, 1859, he studied under Gadomsky

and then attended classes at the Vienna Academy under Zumbusch. He was awarded the gold medal of the Vienna Academy and settled in that city in 1894. He specialised in portrait busts of his contemporaries, and allegorical bronzes, such as Slave breaking his Chains (Cracow Museum).

LEWIN-FUNKE, Arthur Wilhelm Otto 1866-
Born in Dresden on November 9, 1866, he worked in Charlottenburg and studied in Berlin, Rome and Paris. The Berlin Museum has his bronze of a Child Running, while the museum in Karl Marx Stadt (Chemnitz) has Young Girl tying her Sandal.

LEWIS, Charles Walter Edward 1916-
Born in Southsea on July 18, 1916, he studied at Portsmouth College of Art (1932-36) and the Royal College of Art (1936-39) under Garbe. After war service he became head of the sculpture department at Kingston Polytechnic and works mainly in stone and wood.

LEWIS, Edmonia fl. 19th century
Born in New York State in 1843, of mixed Negro, Indian and European blood which was reflected in her works. She was self-taught but after exhibiting her sculpture in Boston, in 1865 she rapidly built up a major reputation in America.

LEXOW-HANSEN, Sören 1845-1918
Born in Norway in 1845, he died there in 1918. Oslo Museum has his bronze figure entitled Vala (exhibited in 1886).

LEYGUE, Louis 1905-
Born in Bourg-en-Bresse in 1905, he studied under Wlérick at the École Germain Pilon (1921-23) and then at the Schools of Fine and Decorative Arts. During a prolonged period of ill health (1924-26) he was temporarily forced to abandon sculpture and concentrated on painting instead. He returned to his sculpture studies in 1938 and won the Prix de Rome in 1941. His early work was influenced by Rodin, but by the late 1930s he had turned to Maillol and Despiau. In 1928 he spent some time in Canada working on large-scale sculpture in metal though he never developed this technique till 1950. During the war he was a member of the Resistance, but following his arrest by the Gestapo he was deported to Germany. At the end of the war he became a lecturer at the École des Beaux Arts and had his first exhibition at the Galerie de Berri in 1946. His earlier sculpture was a curious blend of the baroque and the modern and consisted of nudes, studies of horses and bas-reliefs. In more recent years, however, he has tended towards expressionism and architectural conceptions and exhibits regularly at the Salon de la Jeune Sculpture.

LEYRITZ, Jeanne Hélene de (née Vesques d'Ourches) 1885-1940
Born in Paris on August 21, 1885, she died there on May 31, 1940. She studied under Marqueste and exhibited at the Salon des Artistes Français from 1910, specialising in portrait and allegorical busts and heads.

LEYRITZ, Léon Albert Marie de 1888-
Born in Paris on January 7, 1888, he studied under J.P. Aubé and Mercié and won the Prix Chenavard in 1914. He exhibited at the Salon des Artistes Français, the Salon d'Automne and the Salon des Artistes Décorateurs winning many medals and prizes between 1912 and 1931. He was very prolific and highly versatile in different sculptural media. He worked in many different metals as well as bronze and his works include the lead figure of Serge Lifar, an aluminium bust of Comtesse d'Indy-Becdelièvre, the gilt-lead Arms of Castilleja and decorative sculpture in stone and ceramic materials. He specialised in theatrical decor and produced numerous busts and bas-reliefs of theatrical personalities.

LEYSALLE, Pierre Émile fl. 19th century
Born in Paris in 1847, he studied under Mathurin Moreau and J.B. Carpeaux. He became professor of sculpture at the School of Industrial Arts, Geneva and exhibited at the Paris Salons from 1873 to 1905. He specialised in allegorical works, such as Time protected by the Truth and The Runner (Lyons Museum).

LEYSNER, Sebastian Johann 1728-1781
Born at Veitshöchleim, Germany on January 27, 1728, he died in Angers, France in 1781. He worked as a decorative sculptor in Angers from 1759 till his death.

L'HOEST, Eugène Léon 1874-
Born in Paris on July 12, 1874, he studied at the École des Beaux Arts under Thomas, and later worked with A. Lanson. He exhibited at the Salon des Artistes Français from 1893 and at the Indépendants in the 1920s. He specialised in portrait busts and allegorical figures, mainly in bronze. His works include Pro Patria, The Souvenir and Meditation. He won a third class medal in 1900 and a travelling scholarship in 1906 and was a Chevalier of the Legion of Honour.

L'HOMME, Louis Jean 1879-
Born in St. Romain-en-Viennois, France on December 28, 1879, he studied under Louis Martin and exhibited at the Salon des Artistes Français. His figures and groups are preserved in the Musée Calvet at Avignon.

L'HOMME DE MERCEY, Bernard 1820-1907
Born in Autun on July 30, 1820, he died in 1907. He studied under David d'Angers and Rude and exhibited at the Salon from 1848 to 1865, winning a third class medal in 1849. He specialised in busts and figures of his contemporaries. Dijon Museum has The Demon of Day by him.

L'HOMMEAU, Jules Aurèle fl. 19th-20th centuries
Born at Le Mans in the second half of the 19th century, he studied under Barrias and worked in Paris from 1897 to 1916. He specialised in busts, plaques and medallions.

LHUILLIER, Nicolas François Daniel fl. 18th century
Decorative sculptor working in Paris in the 18th century, where he died on June 8, 1793. He was employed by F. Belanger in the decoration of the Hotel de Brancas and later worked under Pajou on the fountain of the Innocents and the châteaux of Maison-Lafitte and Bagatelle. Copies of antique bronzes in the Louvre and the Wallace Collection have been attributed to him.

LIARDO, Filippo 1840-1917
Born in Leonforte, Sicily on May 14, 1840, he died in Asnières, France on February 9, 1917. He studied in Paris under Gérome and worked as a painter and etcher as well as a sculptor of figures and portrait busts of his contemporaries. He also did many magazine illustrations in Paris.

LIBERAKI, Aglaia 1923-
Born in Athens in 1923, she studied at the Athens Art School under Tombros. She settled in Paris in 1955 and has exhibited at the Salon de la Jeune Sculpture and the Salon des Réalités Nouvelles since 1957. She had her first individual show at the Galerie Iris Clert in 1957. She had produced figurines, birds and animals in plaster and wax since 1946. She also did a series of semi-abstract works with the theme of shipwrecks, in wax and sand, but more recently she has done marine abstract bas-reliefs in bronze and antimony.

LIBERALI, Giulio Angelo 1874-
Born in Trieste on July 20, 1874, he studied at the academies of Vienna and Munich and travelled widely in Italy, the Balkans, the Middle-East and Russia producing landscape and genre paintings. He also sculpted busts and figures of racial and peasant types.

LIBERICH, Nicolai Ivanovich 1828-1883
Born in 1828, he died in St. Petersburg on May 29, 1883. He studied at the St. Petersburg Academy and specialised in animals, particularly horses. Many of his statuettes were cast in silver as well as bronze.

LIBONIS, Léon Charles c.1847-1901
Born in Paris about 1847, he died there on June 30, 1901. He studied under Dumont, Bonnassieux and Chambard and exhibited figures at the Salon from 1866.

LIE, Emil 1897-
Norwegian sculptor of genre and portrait subjects.

LIEBERMANN, Ferdinand 1883-
Born in Munich on January 15, 1883, he was employed as a modeller at the KPM factory, Berlin and the Rosenthal pottery, but also sculpted busts, heads and nude statuettes in bronze for monuments and fountains. The main collection of his work is in the Lenbach Gallery, Munich.

LIEBICH, Curt 1868-
Born in Wesel, Germany on November 17, 1868, he worked at Gutach in the grand-duchy of Baden as a painter, etcher, magazine illustrator and sculptor. He studied at the academies of Dresden and Berlin and the Weimar School of Art. He sculpted many war memorials in southern Germany in the 1920s. His minor works were characterised by a keen study of costumes and landscape.

LIEBL, Simon 1873-
Born in Munich on December 1, 1873, he specialised in memorials and tombs and did a number of war memorials in Bavaria.

LIEBMANN, Hans Harry 1876-
Born in Berlin on September 18, 1876, he worked at Bad Homburg vor der Höhe on statuettes, relief portraits, tombs and war memorials. His bronzes include Diana, Youth and Plaiting Straw.

LIENARD, Michel Joseph Napoleon fl. 19th century
Born at La Bouille near Rouen on September 17, 1810, he worked as a designer of jewellery for Froment-Maurice and also did ecclesiastical sculpture. He exhibited at the Salon in 1864-66 showing a female bust, a group entitled At the Fountain and a figure of a Bather.

LIENARD, Paul 1849-1900
Some confusion exists over the identity of this sculptor. Benezit, for example, considers that Paul and M.J.N. Lienard were one and the same person - a mistake caused no doubt by the fact that they both exhibited at the Salon in 1864 and 1866, though Paul is also recorded as being an exhibitor in 1890. It is more likely that they were father and son. Paul Lienard studied under Duret and sculpted portrait busts and statues of historical and contemporary personalities. His statue of Lord Brougham is at Cannes and a bust of Fragonard by him is in the Cannes public gardens. He died at Cannes in December, 1900.

LIENARD, P.G. fl. 19th century
Engraver and sculptor working in Paris in the early 19th century, specialising in portraits of personalities of the Revolutionary and First Empire periods.

LIGETI, Miklos 1871-
Born in Budapest on May 19, 1871, he studied in Budapest, Vienna and Paris and was influenced by Rodin. His chief works were the monuments to Queen Elizabeth of Hungary at Szeged and Crown Prince Rudolph at Buda. He also sculpted many genre statuettes and portrait busts.

LIIPOLA, Yrjö 1881-
Born at Koskis, Finland on August 22, 1881, he studied in Helsinki, Florence, Rome, Paris and Berlin before returning to Helsinki. He produced biblical, allegorical and portrait figures and busts. His works include The Daughter of Jairus (Abo Museum), and Awakening of Energy (Helsinki Athenaeum).

LIISBERG, Carl Hugo 1896-
Born in Denmark on June 23, 1896, he specialised in figures, such as Man and Woman and Young Man (Museum of Fine Arts, Copenhagen).

LILIEN-WALDAU, Karl von 1875-
Born in Munich on October 20, 1875, he studied at Karlsruhe Academy and specialised in portrait busts. He also sculpted bronzes for the castles of Hirschberg and Neu-Egling.

LIMBURG, Josef 1874-
Born in Hanau on July 10, 1874, he worked in Berlin and specialised in religious groups and statues, many in bronze, as well as busts of his contemporaries. His portraits include those of Cléo de Mérode, the Prince of Wedel, Bornes, Baron Munchhausen and other German literary characters. He also produced monuments and memorials for various towns in Germany.

LINDAU, Paul 1881-
Born in Dresden on October 23, 1881, he studied at the Academy and specialised in portrait busts and allegorical compositions, such as Melancholy.

LINDBERG, Johan Adolf 1839-1916
Born in Stockholm in 1839, he died there in 1916. He specialised in portrait bas-reliefs, plaques and medallions of his contemporaries.

LINDBERG, Johan Erik 1873-
Born in Stockholm in 1873, the son and pupil of J.A. Lindberg. He studied at the Stockholm School of Fine Arts before going to Paris. Later he became a member of the Swedish Academy. He specialised in medallions and relief portraits.

LINDBERG, Vilhelm Maurits Gustaf fl. 19th century
Born in Stockholm in 1852, he specialised in genre and allegorical statuettes, such as The Wave, The Mist and Lovers playing with a Snail. His works are preserved in the museums of Göteborg and Stockholm.

LINDEN, Erich 1898-
Born at Alfter near Bonn in 1898, he studied at the Aachen School of Arts and Crafts and later worked in that city as a genre painter and sculptor.

LINDEN, Franz 1873-
Born in Aachen on December 2, 1873, he studied at the Academy of Düsseldorf and specialised in ecclesiastical statues and memorials, mainly in Düsseldorf.

LINDEN, Gerard van der 1830-1911
Born in Antwerp on February 8, 1830, he died in Louvain on June 6, 1911. He studied at Antwerp Academy and specialised in large public statues, mainly in stone, for the Liège, Antwerp and Louvain districts. His minor works include classical bronzes such as Calistes hesitating in his choice between Paganism and Christianity.

LINDER, Henry 1854-1910
Born in Brooklyn, New York on September 26, 1854, he died there on January 7, 1910. He studied under Knabl in Munich. He specialised in allegorical works, such as Medieval Art (Metropolitan Museum of Art, New York) and Oriental Art (St. Louis).

LINDERATH, Hugo fl. 19th century
Born in Düsseldorf in 1828, he became a Franciscan monk and specialised in religious figures and bas-reliefs, decorating the Warendorf Monastery and the Franciscan church in Düsseldorf.

LINDGREN, Greta fl. 20th century
Born at Björkäng, Sweden in the late 19th century, she studied in Paris under Bourdelle and exhibited statuettes at the Salon des Artistes Français in 1928.

LINDL, Hans 1885-
Born in the Rhineland Palatinate in 1885, he studied at the Munich Academy and was a pupil of Jank and Kurz. He settled in Munich and worked as a sculptor of figures, bas-reliefs and medallions.

LINDNER, Doris 1896-
Born in Llanyre, Radnor on July 8, 1896, she studied at Frank Calderon's School of Animal Painting, St. Martin's School of Art, London and the British School in Rome. She exhibited at the Royal Academy, the Royal Society of British Sculpture, the Leicester Galleries, the Glasgow Institute and other British galleries and specialised in figures of animals and birds, in stone, concrete, plaster and bronze. Many of her figures have been reproduced in porcelain by Royal Worcester. She worked in London for many years before moving to Gloucestershire.

LINDNER-LATT, Hedda 1875-
Born in Stralsund, Germany on May 30, 1875, she studied in Paris under J. Dampt, A. Roubard and J. Heinemann. She married the sculptor Hans Latt in 1910 and worked with him in Berlin.

LINDSTRÖM, Charles Victor Peter 1867-
Born in Copenhagen on January 11, 1867, he studied at the Copenhagen Academy and specialised in portrait busts.

LINNING, Christian Arvid 1781-1843
Born in Stockholm in 1781, the son of a furniture maker, he died there in 1843. He studied at the Stockholm Academy and produced portraits and allegorical works, such as his group of King Gustav Adolf IV crowned by the Spirit of Glory.

LINZINGER, Ludwig Max 1860-1929
Born in Munich on June 18, 1860, he died in Linz, Austria on February 14, 1929. He specialised in ecclesiastical decoration which may be found in St. Stephen's Cathedral, Vienna and churches in the Linz area.

LIONETTI, Edoardo 1862-1912
Born in Naples in December 1862, he died there on March 26, 1912. He exhibited in Turin, Rome and London from 1884 onwards and specialised in genre figures and groups, such as On the Lido.

LIOTARD DE LAMBESC, Pascal 1805-1886
Born at Lambesc, France, in 1805, he died in Paris in 1886. He studied under David d'Angers and exhibited at the Salon from 1835 to 1875.

LIPA 1907-
Born in Grodno, Poland on July 10, 1907, he came to France as a boy and later became naturalised. He studied painting at the École des Beaux Arts but later turned to sculpture and was influenced by Rodin. He worked in Toulouse, concentrating on the translation of movement and expression into sculpture. His works are in the Grenoble Museum.

LIPCHITZ, Jacques 1891-
Born at Druskieniki, Lithuania on August 22, 1891, he studied art in Vilna and moved to Paris in 1909 where he continued his studies at the École des Beaux Arts and the Académie Julian. He worked in the studio of an industrial sculptor and exhibited for the first time in 1912. In the same year he came under the influence of Cubism and joined the movement in 1913. He also worked in a bronze foundry for some time before going to Spain in 1914. Apart from a brief sojourn there, and a period of military service in Russia in 1912-13, he spent most of his life in France till he was forced to flee the country in 1941 and moved to the United States where he has remained ever since. He had his first one-man show in Paris in 1920 and a major retrospective, featuring over 100 of his works, was staged at the Galerie La Renaissance in 1930. He first exhibited at the Brummer Gallery, New York in 1935 and had an entire room devoted to his sculpture in the Exposition des Maîtres d'Aujourd'hui at the Petit-Palais in 1937. After moving to the United States, he settled at Hastings-on-the-Hudson. Since 1943 he has participated in many American exhibitions and had a retrospective at the Museum of Modern Art, New York in 1954. His bronzes include Head (1915-16), Guitarist (1918-19), Ploumarach (1926), Musical Instruments (1924), The Joy of Living (1927), The Couple (1928), Figure (1926-30), Woman with Guitar (1927), Head of a Woman (1930), The Song of the Vowels (1930-31), Spring (1942), Barbara (1942), Prometheus and the Eagle (1943-44), Mother and Child (1941-45), The Rescue (1945) and Aurelia (1946) — the last two being in gilt-bronze.

Hammacher, A.M. *Jacques Lipchitz* (undated, but c.1960). Hope, Henry R. *The Sculpture of Jacques Lipchitz* (1954).

LIPMAN-WOLF, Lucie 1878-
Born in Berlin on April 29, 1878, she worked as a potter, engraver and sculptor, specialising in table centrepieces and presentation items. Her brother Peter was a wood-carver.

LIPPELT, Julius August Martin 1829-1864
Born in Hamburg in 1829, he died there on August 17, 1864. He is best remembered for the statue of Schiller in Hamburg, but he also sculpted busts of his artistic contemporaries and allegorical and genre statuettes and groups, such as Inspiration, Eve and her Children, Young Girl and Dancer.

LIPPMANN, Alphonse fl. 19th century
Born in Besançon in the early 19th century, he died there some time after 1875. He studied under Oliva and exhibited figures at the Salon from 1870 to 1875.

LIPPOLD, Richard 1915-
Born in Milwaukee, Wisconsin in 1915 of German parentage, he studied at the University of Chicago (1933-37), taking a course in industrial design simultaneously at the Art Institute of Chicago. He worked as a designer for the Cherry-Burrell Corporation in 1937-38, then had a studio in Milwaukee from 1938 to 1941 and taught at Layton School of Art (1940-41) and the University of Michigan (1941-44). He took up sculpture in 1942 and had his first one-man show in 1947. Since the war he has held a number of teaching posts in New York and New Jersey and participated in many major

exhibitions in America and Europe since 1950. He was commissioned by Walter Gropius to sculpt The World Tree (1950) and was one of the prize-winners in the competition for the monument To the Unknown Political Prisoner (1953). Though self-taught as a sculptor he brought his training as an industrial designer to bear on his sculpture which is largely abstract and spatial in concept.

LIPSCHITZ, Israel 'Lippy' 1903-
Born in Lithuania on May 8, 1903, he emigrated to South Africa with his family in 1908 and settled in Johannesburg. Later he studied in Paris and exhibited at the Salon des Indépendants, the Salon d'Automne and the Tuileries before the war. Since the war he has worked in South Africa as a graphic artist and sculptor of abstracts.

LIPSI, Morice 1898-
Born in Lodz, Poland in 1898, he followed his brother to Paris in 1913 and later became a naturalised Frenchman. He studied under Coutan, Mercié and Injalbert and worked in wood and ivory at first, but later turned to stone, cement and bronze. He had his first one-man show, of ivory carvings, in 1922 at the Galerie Hébrard, and first exhibited bronzes five years later at the Galerie de l'Art Contemporain. He exhibited at the major Paris salons in the inter-war period and won a gold medal at the Exposition Internationale in 1937. His bronzes from this period include a group of Standing Sirens, Young Girl Crouching, Brothers, Girl playing with a Child and Ball-player. Since the war, however, he has concentrated on abstracts carved direct in stone, particularly lava.

LIPTON, Seymour 1903-
Born in New York, he studied at the City College (1922-23) and Columbia University (1923-27) and qualified as a dentist. He turned to sculpture in 1932 as a hobby and was entirely self-taught. From 1935 to 1945 he carved direct in wood but after the war he began working in various metals and has produced abstracts in iron, bronze, nickel and other metals, often silver-plated. He taught at the Cooper Union Art School, New Jersey State Teachers' College and the New School for Social Research (since 1946). His works include Sea King (1955), Sorcerer (1957) and various ritual figures for synagogues in Oklahoma and Indiana.

LISBOA, A.F. fl. 20th century
Brazilian sculptor of figures and busts, of biblical, historical and contemporary personalities.

LISTA, Stanislas 1824-1908
Born in Salerno on December 8, 1824, he died in Naples on February 12, 1908. He studied under Tamburini in Bologna and exhibited in Naples, Rome, Parma and Paris from 1845 onwards. His works include Rocco Beneventano (Naples Museum).

LITKE, Theodor 1847-1902
Born in Berlin on July 19, 1847, he died there on November 18, 1902. He sculpted figures and groups of genre and historical subjects.

LIVOFF or LWOV, Piotr Ivanovich 1882-
Born in Tobolsk, Russia on January 16, 1882, he studied in Moscow and St. Petersburg and worked as a painter, draughtsman and sculptor. His works are in the Tretiakoff Gallery in Moscow.

LJUNGH, Ernst Adolf 1854-1892
Born in Ostra Broby, Sweden, on June 2, 1854, he died at Lund on June 6, 1892. He is better known as a silhouettist, but Malmö Museum has his statuette Kraka.

LLABRÉS, Antonio fl. 18th-19th centuries
Born at Sansellas, Majorca, in the mid-18th century, he died at Palma in 1826. He worked as a decorative sculptor for the churches in Majorca.

LLACER Y VIANA, Bernardo fl. 19th century
Spanish sculptor of religious subjects, working in Valencia.

LLADÓ, José fl. 19th century
Born in Palma de Majorca about 1810, he worked in that town in the mid-19th century as a sculptor of portrait and genre subjects. The main collection of his work is in the Palma Academy.

LLANECES, Jose 1863-1919
Born in Madrid in 1863, he died there on December 11, 1919. He studied in Paris and worked there for many years, specialising in large murals and frescoes. Little is known of his work as a sculptor, but he did the statue of Goya for the staircase in the Prado.

LLONGARRÍU, Salvador fl. 19th-20th centuries
Born in Madrid about 1860, he exhibited figures in that city from 1884 to 1917.

LLUCH Y PRAT, Joaquin fl. 19th century
Born in Barcelona, where he exhibited sculpture in 1866-70.

LOBACH, Walter 1863-
Born at Klein-Waldeck, Germany, on May 7, 1863, he studied under Jouvray in Paris and exhibited in Berlin at the turn of the century. He specialised in busts and statuettes of his distinguished contemporaries. Casts of his statuette of Mommsen are in the Berlin Museum and the Museum of Modern Art, Paris.

LOBER, George John 1892-
Born in Chicago on November 7, 1892, he studied under A.S. Calder at the National Academy of Design and Hermon MacNeil at the Beaux-Arts Institute, New York. He did a number of monuments and specialised in portrait busts of his contemporaries, in bronze or bronzed plaster. He also modelled genre bronze statuettes, such as Snake Charmer.

LOBO, Balthazar (Baltasar) 1911-
Born in Zamora, Spain, in 1911, he studied in Valladolid and Madrid, but fled to France in the closing phase of the Civil War and was befriended by Picasso. For some time he worked with Laurens but did not exhibit anything till 1945, when he sent abstracts to the Galerie Vendôme exhibition of Masters of Contemporary Art. Thereafter he exhibited regularly at the Salon de Mai. His best-known works are the colossal monument to Spanish resistance fighters at Anneçy (1952) and the large bronze Maternity for the University of Caracas. In more recent years he has taken part in international exhibitions and had a retrospective at the Galerie Villard-Galanis in 1957. He works in marble and granite as well as bronze. His works include Reclining Nude, The Shepherdess, Woman and Child, Forms at Rest, The Peasants, The Idol.

LOCHER, Axel Thilson 1879-
Born in Copenhagen on September 11, 1879, the son of the painter Carl Locher, he sculpted a series of eight large statues for Christiansborg Castle, the bronze relief vases in the tower and the decorative sculpture on the gates and grilles. He specialised in busts, statues and statuettes, particularly of actors in their most characteristic roles.

LOCK, Michel 1848-1898
Born in Cologne on April 27, 1848, he died in Berlin on February 20, 1898. He specialised in monumental groups and friezes, but is best remembered for the west face of the old Reichstag building.

LOEHR, Alois 1850-1904
Born in Paderborn, Germany, in 1850, he died at Silver Springs, U.S.A., in June 1904. He settled in New York in 1883 and moved to Milwaukee six years later. His major works include the Siegfried monument and statue of Arion in New York and the Fritz Reuter monument in Chicago. He also sculpted portrait reliefs and busts of his contemporaries.

LOEWENTAL, Arthur Immanuel 1879-
Born in Vienna on August 28, 1879, he produced bronze portrait busts, such as that of Beethoven for the Moscow Philharmonic in 1912, various portrait reliefs, plaques and medallions and the Austrian medals struck during the first world war.

LOGANOVSKI, Alexander Vassilievich 1810-1855
Born in Moscow on March 11, 1810, he died in St. Petersburg on November 18, 1855. He attended classes at the Moscow Academy and won a state scholarship which took him to Rome. He specialised in reliefs and statues of saints for Moscow churches and the Isaac Cathedral in St. Petersburg. His group of the Angel and St. George is in the Alexander Room in the Kremlin.

LÖHR, Franz 1874-1918
Born in Cologne in 1874, he died there on January 30, 1918. He studied at the Hanau Academy of Design and also in Paris, where he was influenced by Rodin. He specialised in busts, nude statuettes and small plaques and exhibited them in Paris from 1905 to 1911. His works are represented in the museums of Cologne, Freiburg and Düsseldorf.

LOISEAU-BAILLY, Georges Philippe Eugène 1858-1913
Born at Faix-Sauvigny-les-Bois on February 16, 1858, he died in Paris on June 2, 1913. He studied under A. Dumont at the École des Beaux Arts and exhibited at the Paris Salons from 1879 to 1913, winning a second class medal in 1886 and silver medals at the Expositions Universelles of 1889 and 1900. He won a travelling scholarship in 1890 and travelled widely in Italy and Tunisia. He specialised in busts, statuettes and groups of historical, neo-classical and genre subjects. His works are in the museums of Bourges and Auxerre.

LOISEAU-ROUSSEAU, Paul Louis Émile 1861-1927
Born in Paris on April 20, 1861, he died there in 1927. He studied under Barrau and exhibited at the Salon des Artistes Français, winning a third class medal in 1892, a second class in 1895 and a first class in 1898. He was awarded a gold medal at the Exposition of 1900 and the Legion of Honour the following year. His works include Negro Salem, Baby Amusing Itself, Victim of Cleopatra, Toreador, Negro of the Sudan, Andromeda, The Beggar, Picador and Bull, Panther Hunt and Negro Musicians.

LOISON, Pierre 1816-1886
Born at Mer, France, on July 5, 1816, he died in Cannes in February 1886. He studied under David d'Angers and exhibited at theSalon from 1845, winning a third class medal that year and first class medals in 1853 and 1859. He became a Chevalier of the Legion of Honour in the latter year. He specialised in ecclesiastical sculpture, mainly in Parisian churches, but also did decorative work for the Tuileries and the Louvre. He did a number of classical statuettes, such as Sappho, and Daphnis and Chloe, as well as busts and statues of his contemporaries.

LOMBARD, Henri Édouard 1855-1929
Born in Marseilles on January 21, 1855, he died in Paris on July 23, 1929. He studied under Cavelier and exhibited at the Salon from 1878, winning the Prix de Rome in 1883. He was appointed a professor at the École des Beaux Arts and won a gold medal at the Exposition Universelle of 1900. He was made a Chevalier of the Legion of Honour in 1894. He specialised in busts and statues, in marble, plaster and bronze, mainly for museums and public buildings in Paris and Marseilles.

LOMBARDI, Eugenio fl. late 19th century
Born in Milan in 1853, he exhibited figures in Turin, Milan and Venice from 1875.

LOMBARDI, Giovanni Battista 1823-1880
Born in Brescia in 1823, he died there in 1880. He specialised in monuments, tombs and memorials in Brescia and Rome. He also sculpted genre and biblical figures in marble and bronze, such as the statue of a Sulamite and the figure of a Woman with Cupid (both in Melbourne National Gallery).

LOMBARDI, Giovita 1837-1876
Born at Rezzato, near Brescia, in 1837, he died in Rome in 1876. He was an Animalier, specialising in marble figures and groups.

LOMBARDINI, Gaetano 1801-1869
Born in St. Arcangelo, Italy, in 1801, he died in Rome in 1869. He studied in Rome under Canova and produced genre and biblical figures, mainly in marble, such as Christ (Cesena cemetery) and The Old Paralytic.

LOMMEL, Friedrich Eugen 1883-
Born in Erlangen, Germany, on May 26, 1883, he specialised in decorative sculpture and monumental statuary which may be found on public buildings in Jena, Bremen, Prien and Munich.

LONG, John Kenneth 1924-
Born in Liverpool on March 2, 1924, he studied at Manchester Regional College of Art and has exhibited paintings and sculpture at the Royal Academy, the Royal Society of British Artists and other galleries. He works mainly in terra cotta and lives in Barnsley, Yorkshire.

LONGEPIED, Léon Eugène 1849-1888
Born in Paris on August 10, 1849, he died in Paris on October 13, 1888. He studied under Cavelier, Moreau and Coutan and exhibited at the Salon from 1870, winning a third class medal in 1880 and a first class medal two years later. He was awarded the Prix de Salon in 1882 for his Fisherman recovering the Head of Orpheus from his Net. He became a Chevalier of the Legion of Honour in 1887. His chief works consist of decorative sculpture in Paris Town Hall and the Sorbonne. His minor works include various portrait busts and allegorical and genre statuettes, such as Immortality (cast in the Museum of Modern Art, Paris and the Épinal Museum), Spring, Summer and Neapolitan Harpooner.

LONGMAN, Evelyn Beatrice 1874-
Born in Winchester, Ohio, on November 21, 1874, she studied under Lorado Taft at the Art Institute of Chicago and worked as assistant to Daniel Chester French from 1901 to 1904. She was a member of the American Federation of Arts and received many awards at American exhibitions, including the St. Louis World's Fair (1904). She received many public commissions and sculpted monuments and symbolic statuary. Her chief works include the bronze doors of the chapel at the U.S. Naval Academy, Annapolis, the bronze doors of the Library at Wellesley College, Wellesley, Massachusetts. Minor works include symbolic statues of Victory, The Future (both Metropolitan Museum of Art) and Beyond, various torsos, heads and busts, such as those of N.H. Batchelder and Louise.

LONGUET, Karl Jean 1904-
Born in Paris on November 9, 1904, he studied under Niclausse at the School of Decorative Arts and under Jean Boucher at the École des Beaux Arts. Later he worked under Despiau and Matteo Hernandez and exhibited at the Salon des Artistes Français, the Salon des Indépendants and the Salon des Tuileries. He specialised in war memorials and allegorical bas-reliefs. His minor works, including portrait busts and maquettes, are in the Museum of Modern Art, Paris, and the museums and art galleries of Algiers, Berlin, Bordeaux, Dresden, Grenoble, Lille, Moscow, New York and Vienna. Many of his portrait reliefs and medallions were cast or hammered in lead as well as bronze.

LOOS, Adolf 1830-1879
Born in Iglau, Austria, in 1830, he died in Brünn (Brno) in 1879. He sculpted many statues in Bohemia, especially Brno.

LOPES, E.A. fl. 20th century
Portuguese sculptor of figures and groups, working in the mid-20th century.

LOPEZ, Charles Albert 1869-1906
Born in Matamoros, Mexico, in 1869, he died in New York in 1906. He became an Associate of the National Academy of Design shortly before his death.

LORÁNFI, Antal 1856-1927
Born in Kecskemet, Hungary, on September 5, 1856, he died in Budapest on April 16, 1927. He specialised in statuettes, bas-reliefs and medallions of genre subjects.

LÖRCHER, Alfred 1875-
Born in Stuttgart on July 30, 1875, he studied in Stuttgart, Karlsruhe and Kaiserslautern and was a pupil of W. von Rümann at the Munich Academy (1898-1902). He also worked in Italy for some time before settling in Berlin in 1908. After the first world war he was appointed head of the ceramics department at the Stuttgart Academy and worked there until he retired in 1945. The Württemberg State Gallery held a retrospective exhibition of his works in 1950, while his most recent works were the subject of a one-man show by the Cologne Art Union in 1959. His sculpture was influenced by Hildebrand and Maillol and was characterised by serenity and tranquillity. He specialised in female nudes but later in his career he turned to bas-reliefs featuring a large number of figures and animals, such as Horses, Revolution and Spectators at a Swimming Pool. His individual works include such figures as Girl Sleeping and Girl Lying Down.

LORENSEN, Carl 1864-1916
Born in Dent, U.S.A., about 1864, he died in Chicago on January 17, 1916. He produced a wide range of sculpture, figures, groups, bas-reliefs and friezes. He sculpted decorative friezes for the former Royal Palace in Bucharest. The main collection of his works is in the Field Museum, Chicago.

LORENZ, Franz Anton 1853-1891
Born in Munich on November 25, 1853, he died on October 2, 1891. He produced numerous figures and reliefs of saints and biblical scenes for churches in Bavaria.

LORENZANI, Arthur E. 1885-
Born in Carrara in 1885, he studied at the Reale Accademia di Belle Arti in Carrara and the Istituto di Belle Arti in Rome before emigrating to the United States. He specialised in portraiture and fountain figures for the garden and indoor decoration. Among his portraits are the bas-relief of the Children of Mrs. Fairbanks, Young Mother, Youth and other quasi-allegorical subjects.

LORIEUX, Julien Auguste Philibert 1876-1915
Born in Paris on December 31, 1876, he died of wounds at Tout on the western front, April 30, 1915. He studied under Falguière, Prinet and Mercié and exhibited at the Salon des Artistes Français, winning a travelling scholarship in 1902 and a first class medal in 1907. He specialised in portrait busts and genre figures, such as the statuette of a Young Alpinist.

LORMIER, Édouard 1847-1919
Born at St. Omer in 1847, he died in Paris on June 7, 1919. He studied under Jouffroy and exhibited at the Salon from 1866. He specialised in busts and statues of contemporary personalities and classical statuettes, such as Academia, Sappho and Historia.

LORRAIN, Fernand fl. late 19th century
Born in Nancy about 1850, he studied under M.C. Lebourg and exhibited figures at the Salon from 1876.

LORRAIN, Jenny 1876-
Born in Virton, France, on December 30, 1876, she studied under Mercié, Injalbert and Dampt and worked in Brussels, where she specialised in bronze portrait busts and heads of Belgian personalities.

LORTA, Jean Pierre 1752-1837
Born in Paris on September 17, 1752, he died at Versailles on February 20, 1837. He studied under Bridan and exhibited at the Salon de Correspondance in 1780-81 and the Salon from 1791 to 1819, being runner-up in the Prix de Rome of 1779. He specialised in classical figures and groups, such as Diana Surprised, Cupid, Virgin (Sens Cathedral), Nude Girl stroking a Dog; and portraits of Louis XIV and Gui de Chapelier.

LOSIK, Thomas 1849-1896
Born in Poland in 1849, he died in Cracow in 1896. He was a painter and sculptor of portrait busts and genre groups.

LOSSOW, Arnold Hermann 1805-1874
Born in Bremen in 1805, he died in Munich in 1874. He studied under Schwanthaler and was employed by King Ludwig I of Bavaria, specialising in friezes and statuary. Much of his decorative sculpture is preserved in the Munich Staatsbibliothek.

LOTSCH, Christian Johann 1790-1873
Born in Karlsruhe in 1790, he died in Rome in 1873. He worked in Rome under Thorvaldsen and specialised in medallions and allegorical groups mainly in alabaster.

LOUIS, Hubert Noel fl. 19th century
Born in St. Omer on April 1, 1839, he studied under Jouffroy and exhibited at the Salon from 1863, winning a second class medal in 1873 and a silver medal at the Exposition Universelle of 1889. He became a Chevalier of the Legion of Honour in 1880. He sculpted various statues for public buildings in Paris and also a number of memorials and tombs in Père Lachaise cemetery. His minor works include busts portraying historic and contemporary celebrities.

LOURMAND, Hippolyte fl. 19th century
Born in Nantes in the first half of the 19th century, he studied under Pradier and exhibited romantic and genre figures at the Salon from 1868 onwards.

LOUTCHANSKI, Jakob 1876-
Born in Vinnitza, Poland, on December 8, 1876, he emigrated to France and was later naturalised. He studied under Mercier and exhibited at the Salon d'Automne and the Indépendants. He specialised in heads of young girls and allegorical figures, such as Maternity.

LOUTCHIANOV, Dino fl. 20th century
Bulgarian sculptor of historical and allegorical figures and portrait busts.

LOVETT-LORSKI, Boris 1891-
Born in Russia, he studied at the St. Petersburg Academy before emigrating to the United States. He has exhibited in the United States and also at the Salon d'Automne and the Salon des Indépendants in Paris. He specialised in busts and heads of contemporary American artists, and genre and allegorical figures, such as Effort and Spring Folly.

LÖW, Jakob 1887-
Born at Stanislau, Galicia, on May 4, 1887, he studied under Barwig and Strnad in Vienna and worked as a decorative sculptor in Austria and Poland.

LOYAU, Marcel François 1895-
Born at Onzain, France, on September 11, 1895, he settled in Boulogne and specialised in busts and heads of children. He exhibited at the Salon des Artistes Français, winning a third class medal in 1823, a second class in 1927 and the Prix National in the latter year.

LOYAU-MORANCE, Jeanne Marie Eugènie 1898-
Born in Paris on April 18, 1898, she is a painter and sculptor of portraits and genre subjects.

LUCA, Luigi de fl. 19th century
Born in Naples in 1857, he studied there and in Rome. He began exhibiting in Rome in 1883 and in Turin the following year. He specialised in genre figures, such as At School and Fish-net (1886) and portrait busts and statuettes, such as those of the celebrated actress Lalla playing the leading role in Zola's The Dram Shop, and General Rocca.

LUCAS, François 1736-1813
Born in Toulouse in 1736, he died there on September 17, 1813. He was the son and pupil of the 17th century stone sculptor Pierre Lucas and also studied at the Toulouse School of Fine Arts, winning the gold medal and Grand Prix in 1761. He went to Rome in 1774 and worked for some time in Carrara, where he sculpted a large-scale marble relief symbolising the Junction of Two Seas, later erected at the confluence of the Languedoc Canal and the River Garonne. His minor works include a number of maquettes in terra cotta and bronze, such as Virgin Mary and Child, Flagellation of a Martyr, and Christ, Sybil and the Apostles.

LUCAS, Georg 1893-
Born in Paderborn, Germany on January 8, 1893, he worked as a painter and sculptor of animal subjects. A bronze Cock by him is in Münster Museum.

LUCAS, Richard Cockle 1800-1883
Born in Salisbury, Wiltshire, on October 24, 1800, he died at Chilworth on May 18, 1883. He was apprenticed to his uncle, a cutler in Winchester, and learned to carve knife-handles in wood, bone and ivory. From this he turned to sculpture and attended the Royal Academy schools, winning silver medals in 1828-29. He exhibited at the Royal Academy from 1829 to 1859 and also participated in the Westminster Hall exhibition of 1844 and the Great Exhibition of 1851, where he displayed carved ivories and bronze statuettes. Among his chief works are the scale models of the Parthenon before and after the explosion of 1687 and his quasi-historic or romantic figures and groups such as Lilla and Edwin, and King Canute. His minor works include statuettes and bas-reliefs in bronze, imitation bronze, ivory and wax. He was granted a Civil List Pension of £150 per annum in 1865.

LUCAS DE MONTIGNY 1747-1810
Born in Rouen in 1747, he died in Paris in 1810. He specialised in statuettes and busts portraying contemporary personalities. His bust

of Mirabeau and a statuette of the actress Antoinette Chavel in the role of Dido are in the Louvre.

LUCCA, Flaminio fl. 19th century
Milanese sculptor of the second half of the 19th century, producing portrait and genre subjects. He exhibited in Naples and Turin from 1877 onwards.

LUCCARDI, Vincenzo 1811-1876
Born in Gemona, Italy, in 1811, he died in 1876. He studied in Venice and worked in Rome, where he was professor at the Academy of St. Luke. He did classical and mythological figures, groups and reliefs for buildings in Venice and the Vatican.

LUCCHESI, Andrea Carlo 1860-1925
Born in London on October 19, 1860, he died there on April 9, 1925. He studied at the West London School of Art and the Royal Academy schools and exhibited at the Royal Academy from 1881 till his death. He also exhibited in provincial galleries and in major international exhibitions, winning gold medals in Dresden (1897), and the Exposition Universelle (1900), and Turin (1911). He specialised in bronze portrait busts and heads of historic and contemporary personalities.

LUCCHESI, Urbano 1844-1906
Born in Lucca in 1844, he died in Florence in January 1906. He sculpted a number of monuments, including those to Garibaldi (Lucca), Shelley (Viareggio) and Donatello (Florence). His minor works, including statuettes and busts of historic and contemporary personalities, are in the Lucca Pinacothek.

LUCCHETI, Giuseppe fl. 19th century
Born in Urbania, Italy in 1823, he studied at the academies of Perugia and Rome. He exhibited in Rome and Turin from 1850 onwards and specialised in busts and figures of the popes and Italian historical personages. Many of his works are preserved in the Vatican and the museums of Perugia and New York.

LUCIBEL-DELANDRE, Alfred fl. 19th century
Born in Bordeaux in 1842, he studied under A. Dumont and exhibited figures at the Salon in 1867-69.

LÜDECKE, Karl 1897-
Born in Erfurt, Germany, on February 10, 1897, he worked in Dresden-Lochwitz as a portrait sculptor. Examples of his heads and busts are in the municipal museum of Erfurt.

LUGEON, David 1818-1895
Born in Lausanne in 1818, he died there in 1895. He studied in Geneva, Lyons and Paris and worked as an ornamental sculptor, specialising in neo-Gothic work and the restoration of sculpture in various French cathedrals. He retired to Lausanne in 1876 and spent the last years of his life working on the decoration of Lausanne Cathedral.

LUGEON, Raphael 1862-
Born in Poissy, France, in 1862, he was the son and pupil of David Lugeon, with whom he collaborated on ecclesiastical restoration. He studied at the School of Decorative Arts, Paris, and exhibited at the Salon des Artistes Français from 1898 onwards. He worked on the decoration of Paris Town Hall and the Church of Sacré Coeur.

LUGINBÜHL, Bernhard 1929-
Born in Berne in 1929, he studied at the School of Arts and Crafts in that city. He specialises in abstracts, wrought, cast or hammered in iron. His work has been shown in the Venice Biennales since 1956 and also in Antwerp and other major international exhibitions since 1959.

LUGINBÜHL, Christian 1788-1837
Born in Berne in 1788, he died there on April 7, 1837. He sculpted the heads of animals and worked mainly in wood and marble. He exhibited animal sculpture at Berne in 1830.

LUINI, Costanzo 1886-
Born in Milan on October 31, 1886, he emigrated to the United States and studied under Aitken and MacCartan, becoming a member of the American Federation of Arts. He specialised in plaques, bas-reliefs, medallions and busts portraying contemporary American celebrities.

LUKEMAN, Henry Augustus 1872-
Born in Richmond, Virginia, on January 28, 1872, he studied in New York and at the École des Beaux Arts, Paris. He was awarded a bronze medal at the St. Louis World's Fair in 1904. He specialised in memorials, commemorative bas-reliefs and portrait busts of contemporary celebrities.

LUKIC, Zivojin 1883-
Born in Belgrade on January 29, 1883, he worked in Rome, Moscow and Belgrade as a decorative sculptor. His best known works are the allegories of Commerce and History in the Parliament building, Belgrade.

LUKITS, Theodore Nikolai fl. 20th century
A member of the American Professional Artists League, he has sculpted monuments, public statuary and portraits in many parts of the United States.

LUKSCH, Richard 1872-
Born in Vienna on January 23, 1872, he worked in Hamburg and Vienna as a sculptor of portraits, specialising in bas-reliefs, medallions, busts and heads of Austro-Hungarian royalty, German celebrities and European nobility.

LUKSCH-MAKOWSKY, Elena 1878-
Born in St. Petersburg on November 13, 1878, she studied in Hamburg, where she met and married Richard Luksch. She sculpted bas-reliefs and groups of mothers and children and also worked as a painter and wood-engraver of similar subjects.

LUMB, Frank 1910-
Australian sculptor of monuments, statues, genre figures and portraits, working in Sydney.

LUND, Georg 1861-
Born near Flensburg on June 14, 1861, he studied under Schaper and worked in Paris, Rome and Berlin. He produced allegorical, genre and neo-classical bronzes, such as Psyche Lamenting (Berlin Museum) and Children Singing (Stuttgart Museum).

LUND, Jens 1873-
Born near Ringköbing, Denmark, on February 6, 1873, he studied in Copenhagen and worked there as a decorative sculptor. He sculpted the ornament on the central Railway Station and the Institute of Technology. His minor works include a number of portrait busts and genre figures, preserved in the museums of Copenhagen and Frederiksborg.

LUNDBERG, Jakob 1792-1893
Born in Sweden in 1792, he died in Rome in 1893. He produced genre and biblical statuettes and bas-reliefs, examples of which are preserved in the National Museum in Stockholm.

LUNDBERG, Theodor Johan 1852-1925
Born in Stockholm in 1852, he died in Rome in 1925. He was the son and pupil of Jakob Lundberg and produced various portrait busts and statues as well as genre figures and groups such as Brothers in Arms, Brothers of Milk, Art and Craft, Affliction, and The Shore and the Wave.

LUNDGREN, Tyra fl. 20th century
Born in Sweden in the early years of this century, she works as a painter, potter and sculptor. For many years she was employed as a modeller at the Sèvres porcelain factory but since 1945 has sculpted bas-reliefs and abstracts, mainly in stoneware.

LUNDING, Calle 1930-
Born in Sweden in 1930, he became something of a child prodigy, producing abstracts in the late 1940s, culminating in the series of Compositions of Floating Spaces (1953) which mark him out as one of the outstanding exponents of spatial abstract sculpture in recent years.

LUNDQVIST, John 1882-
Born in Sweden in 1882, he studied in Copenhagen and Paris and exhibited statuettes at the Salon des Indépendants in the 1920s.

LUNG, Rowena Clement 1905-
Born in Tacoma, Washington, on March 27, 1905, she studied under Marshall, Herter and Cooper and is a member of the Society of

Independent Artists in New York. She works as a painter and sculptor of portrait and genre subjects.

LUPPI, Ermenegildo 1877-
Born in Italy in 1877, he worked in Florence, where the Gallery of Modern Art has the main collection of his works.

LURJE, Victor 1883-
Born in Vienna on July 28, 1883, he worked as a painter and architect as well as an ornamental sculptor working mainly in stucco.

LÜRSSEN, Eduard August 1840-1891
Born in Kiel on November 11, 1840, he died in Berlin on February 18, 1891. He studied at the Berlin Academy and specialised in decorative sculpture for public buildings, fountains, bridges and parks in Berlin and Kiel.

LUSINI, Giovanni 1809-1889
Born in Siena, Italy, on June 20, 1809, he died in February 1889. Though mainly known as a wax modeller, some of his portrait reliefs were also cast in bronze. He sculpted the statue of Alberti in Florence.

LUSSMANN, Anton 1864-
Born in Frankfurt-am-Main on April 12, 1864, he sculpted a series of stone statues for the Municipal History Museum and the Town Hall in Frankfurt. His minor works include portrait busts and reliefs.

LÜTHI, Johann Georg 1813-1868
Born in Olten in 1813, he died in Soleure in 1868. He worked in Switzerland as a sculptor of classical, mythological and biblical subjects for public buildings and churches, mainly in stone and plaster.

LUX, Elek 1884-
Born in Budapest on December 18, 1884, he studied in Budapest, Munich and Brussels before returning to his home town. He specialised in busts and statuettes of dancers and boxers, in terra cotta and bronze.

LUXMOORE, John M. 1912-
Born in England on May 12, 1912, he is a member of the Manchester Academy of Fine Arts and lives in Hale, Cheshire where he sculpts portraits and figures. He has exhibited at the Royal Academy, the Royal Society of British Artists and provincial galleries since the second world war.

LUZANOWSKY-MARINESCO, Lydia 1899-
Born in Kiev, Russia, on August 30, 1899, she studied at the Budapest School of Fine Arts and won the prize of the Romanian Salon, Bucharest, in 1924. She studied under Zadkine in Paris and exhibited statuettes and groups at the major Paris Salons in the inter-war years.

LYCE DE BELLEAU, Manette de 1873-
Born at Courrières on November 4, 1873, she exhibited marble, terra cotta and bronze statuettes of classical and biblical subjects at the Salon des Artistes Français and the Indépendants in the early years of this century.

LYNN, Samuel Ferris fl. 19th century
Born in Ireland, he died in Belfast in 1876. He studied at the Royal Academy schools and worked as an ornamental sculptor for his brother, an architect.

LYNN-JENKINS, Frank 1870-1927
Born in Torquay in 1870, he died in New York in 1927. He studied at the Lambeth School of Modelling and the Royal Academy schools and exhibited at the Royal Academy, the Salon des Artistes Français and various international exhibitions from 1895 onwards. He was awarded a silver medal at the Exposition Universelle in 1900 and received many public commissions for statuary and monuments. He was a prominent member of the Art Workers' Guild and a founder member of the Royal Society of British Sculptors. His minor works include many portrait busts.

LYON, Edwin fl. 19th century
Born in Dublin in 1836, he sculpted portrait reliefs and statuettes, mainly in wax.

MABERLEY, Diana 1903-
Born in London on August 20, 1903, she studied under Hannak in Vienna.

MABILLE, Jules Louis fl. 19th century
Born in Valenciennes on August 14, 1843, he studied under Jouffroy and exhibited at the Salon from 1868 onwards, specialising in busts and genre statuettes, neo-classical groups and medallion portraits of his contemporaries. He won a third class medal in 1877 and a bronze medal at the Exposition Universelle of 1889.

MABRU, Raoul 1888-
Born in Clermont-Ferrand on October 22, 1888, he became professor of sculpture at the School of Fine Arts in that city. He specialised in war memorials and genre statuettes, particularly of peasant subjects.

MACALISTER, Molly fl. 20th century
New Zealand sculptress working in Auckland. Her bronzes include figures of Maori warriors.

McBRIDE, John Alexander Paterson 1819-1890
Born in Liverpool in 1819, he died there on April 10, 1890. He was the son of Archibald McBride of Campbeltown and trained under William Spence. In 1841 he went to London and made his début three years later at Westminster Hall with a group of Margaret of Anjou and her Son. This brought him to the attention of Samuel Joseph, who was so impressed with his work that he took him on as a pupil without charging the customary fee of 50 guineas. Subsequently McBride became Joseph's chief assistant. He returned to Liverpool in 1852 and became a leading protagonist of the Pre-Raphaelite movement and an enthusiastic supporter of Holman Hunt and Millais. He exhibited at the Royal Academy from 1848 to 1853 and specialised in portrait busts and statues. His statuette of Lady Godiva (1850) was subsequently cast by the Art Union and presented as prizes.

MACCAGNANI, Eugenio fl. 19th century
Born at Lecca, Italy, in 1852, he exhibited genre and classical figures in Milan, Rome and Turin from 1880 onwards, winning many prizes. He was awarded gold medals at the Exposition Universelles of 1889 and 1900.

McCANCE, William 1894-
Born in Glasgow on August 6, 1894, he studied at the Glasgow School of Art under Greiffenhagen and Anning Bell and worked in London and Reading as a painter and sculptor of portraits, landscapes and genre subjects. He exhibited at the Glasgow Institute and various provincial galleries. His wife was the painter Agnes Miller Parker.

McCANN, Minna fl. 20th century
Born in London, she studied at the Manchester Municipal School of Art and the Royal College of Art, London. She specialises in portrait busts, genre statuettes, garden statuary and fountains and decorative figures.

McCARTAN, Edward 1878-
Born in Albany, New York, in 1878, he studied at the Art Students' League, New York, and the École des Beaux Arts, Paris. He produced a large number of small decorative, genre, neo-classical and allegorical bronzes, including Pan, Diana, Nymph and Satyr. Examples of his works are in various American museums.

MACCARTHY, Carlton W. fl. 19th century
English portrait sculptor, born in 1817, the younger son of John

James MacCarthy. His statuette of Sarah Bernhardt is in the Sydney Museum.

MACCARTHY, Hamilton fl. 19th century
Born in 1809, the eldest son of John James MacCarthy, a stone-mason. Hamilton collaborated with his younger brother Carlton in the modelling of small figures of racehorses commissioned by their owners, including Colonel Copeland, Lord William Beresford, Lady Dallas and Count Batthiany. Other works by the MacCarthy Brothers include Red Deer, A Horse in a Lassoo and an equestrian figure of Charles XII. At the Great Exhibition of 1851 he showed an inkstand decorated with animal figures, including a stag surmounting a concealed envelope compartment. Hamilton MacCarthy exhibited at the Royal Academy from 1838 to 1867 and also produced a number of portrait busts in the latter part of his career.

MACCARTHY, Hamilton Patrick fl. late 19th century
Son of Hamilton MacCarthy, with whom he worked on portrait sculpture in the second half of the 19th century. He himself sculpted numerous portraits in the late 19th century.

MACCARTHY FAMILY fl. 19th century
As well as Carlton and Hamilton MacCarthy, John James MacCarthy had a son Sexon and two daughters, Amelia and Gertrude, all of whom exhibited portrait busts and statuettes at the Royal Academy in the mid-19th century.

McCAUSLEN, W.C. fl. 19th century
American portrait sculptor of the mid-19th century. His bust of President Andrew Johnson is in the Senate Gallery, Washington.

McCHEYNE, John Robert Murray 1911-
Born in Scotland on June 2, 1911, he studied at the Edinburgh College of Art (1930-35), the Copenhagen Academy (1936-37) and completed his studies in Athens and Florence shortly before the second world war. He has exhibited at the Royal Scottish Academy and provincial galleries in Scotland and the north of England. He works in stone, wood, terra cotta and bronze and lives at Gosforth, Northumberland.

MACDONALD, Alessandro fl. late 19th century
Born in Rome on August 17, 1847, the son and pupil of Lorenzo Macdonald, he worked as a portrait and figure sculptor in Italy and Britain in the late 19th century.

McDONALD, James Wilson Alexander 1824-1908
Born in Steubenville, New York, on August 25, 1824, he died at Yonkers, N.Y., on August 14, 1908. He studied in St. Louis and New York and specialised in portrait busts and statues of contemporary celebrities, mainly in the New York area. His best known work is his statue of General Custer at Westpoint Military Academy.

MACDONALD, Lawrence (Lorenzo) 1799-1878
Born in Scotland on February 15, 1799, he died in Rome on March 4, 1878. He founded the British Academy in Rome and specialised in busts, portrait reliefs and medallions, many of which are preserved in the National Portrait Galleries in London and Edinburgh.

McDOWELL, Patrick 1799-1870
Born in Belfast in 1799, he died in London in 1870. He exhibited at the Royal Academy and sculpted biblical and classical figures. Casts of his Eve are in the museums of Salford and Melbourne.

MACÉ, Émile Louis fl. 19th century
Portrait sculptor working in Angers in the late 19th century. He studied under Cavelier in Paris and exhibited busts and medallions at the Salon des Artistes Français from 1883 to 1896.

MACFALL, David Bernard 1919-
Born in Glasgow on December 21, 1919, he studied in Birmingham at the Junior School of Arts and Crafts (1931-34) and the College of Arts (1934-39) under Charles Thomas. He went to London in 1940 and studied at the Royal College of Art (1940-41) and the Kennington School of Art (1941-45) under Jacob Epstein. He began exhibiting at the Royal Academy in 1943 and was elected A.R.A. in 1955 and R.A. in 1963. He has taught sculpture and modelling at the Kennington School of Art since 1956. His work, in bronze and stone, consists mainly of portrait busts, heads, figures and animal groups.

MCGEOCH, Anderson James 1913-
Born in Paisley, Renfrewshire, on February 1, 1913, he studied at the Glasgow School of Art under W.O. Hutchison (1932-37) and the École des Beaux Arts, Paris (1938). He has exhibited at the Royal Scottish Academy, the Glasgow Institute and the Salon des Artistes Français and works as a painter and sculptor in clay, wood and stone, in Paisley.

MACGILL, David fl. late 19th century
Scottish sculptor working in London in the late 19th century. He exhibited portraits and figures at the Royal Academy from 1889 onwards and got an honourable mention at the Exposition Universelle of 1900.

MACGILLIVRAY, James Pittendrigh 1856-1938
Born in Inverurie, Aberdeenshire, in 1856, he died in Edinburgh on April 29, 1938. He worked in the studio of William Brodie and studied at the Edinburgh College of Art, before becoming assistant to John Mossman in Glasgow in 1876. He moved to Edinburgh in 1894 and sculpted a number of statues and monuments in that city at the turn of the century. He exhibited at the Royal Academy from 1891 and also at the Royal Scottish Academy, being elected A.R.S.A. in 1892 and R.S.A. in 1901. He was the Sculptor Royal for Scotland. He is best known for his portrait busts, notably that of Thomas Carlyle, but also sculpted the figure of Historia for the Gladstone Memorial in Edinburgh.

MACHADO, Antonio fl. 18th century
Born in Lisbon about 1740, he died there on April 1, 1810. He sculpted a number of statues for public buildings and parks in Lisbon, notably the figure of Venus for the Janelles-Verdes fountain and the statue of St. Peter on the façade of the Church of St. Paul. His minor works, consisting mainly of figures of saints, were largely derived from models by N. Villela.

MACHADO DE CASTRO, Joaquim fl. 18th-19th centuries
Born in Coimbrà in the mid-18th century, he died in Lisbon on December 3, 1822. He was Sculptor to the Portuguese Court and Director of the nude school at the Academy of Sao José. He sculpted many statues and monuments, in marble and bronze, in Lisbon. His minor works include allegorical groups, portrait medallions and bas-reliefs in terra cotta and carved wood for churches.

MACHAULT, Paul Émile 1800-1866
Born in Paris on September 1, 1800, he died there in 1866. He studied under Francin and exhibited figures and portraits at the Salon from 1833 to 1879.

MACHAULT, Paul François fl. 19th century
Born in Paris in 1835, he studied under Simart and exhibited figures at the Salon from 1864 onwards.

MACHIN, Arnold 1911-
Born in Stoke-on-Trent on September 30, 1911, he studied at Stoke School of Art, Derby School of Art and the Royal College of Art, winning a silver medal and a travelling scholarship. He has exhibited at the Royal Academy since 1940 and was elected A.R.A. 1947, A.R.B.S. 1953, F.R.B.S. 1955 and R.A. 1956. He has sculpted figures and groups, busts, heads and relief portraits, notably the profile of Queen Elizabeth used on British postage stamps since 1967.

MACHO, Victorio 1885-
Born in Palencia, Spain, in 1885, he worked in Madrid and sculpted monuments, fountains and statues for public places. His minor works include busts of his family and contemporaries.

MACHOLD, Ernest fl. 19th century
Born in Coburg in 1814, he studied in Bamberg and Gotha and worked on the restoration of Bamberg Cathedral in 1835-37. He specialised in ecclesiastical statuary and ornamental sculpture for buildings in the Stuttgart and Tübingen area.

MÄCHTIG, Carl Andreas 1797-1857
Born in 1797, he died in Breslau in 1857. He studied in Dresden and exhibited there from 1823 to 1855. He specialised in busts and portrait reliefs, statuettes of biblical and classical subjects, and figures of animals. He also sculpted many statues for buildings in Breslau from 1825 to 1847.

MACK, Lajos 1876-
Born in Przemysl, Galicia, on May 13, 1876, he worked in Pecs, Hungary and sculpted the decoration for Debreczen Town Hall. He specialised in memorials, tombs and portrait busts and is best known for the portrait of Johann Gutenberg at Pecs printing works. His genre figure, The Orphan, is in Pecs Museum.

MACK, Ludwig 1799-1831
Born in Stuttgart on October 22, 1799, he died there on August 8, 1831. He produced classical figures and groups, such as Cupid and Psyche (Stuttgart Museum).

MACKAIN-LANGLOIS, Marguerite fl. 20th century
Born in Paris at the beginning of this century, she exhibited statuettes at the Nationale and the Royal Academy in the inter-war years.

MACKAY, Helen Victoria 1897-
Born in Cardiff on April 2, 1897, she studied at the Regent Street Polytechnic School of Art, London, and has worked in that city ever since. She has exhibited at the Royal Academy, the Royal Scottish Academy and the Glasgow Institute and was elected A.R.B.S. in 1938 and F.R.B.S. in 1952. She sculpts figures and portraits in stone and wood as well as bronze.

MACKENNAL, Sir Bertram 1863-1931
Born in Melbourne, Australia, on December 6, 1863, he died in Torquay on October 11, 1931. He came to England in 1882 and studied in London and Paris, spending five years in the latter city and coming under the influence of French Symbolism and Romanticism. He spent the rest of his life working in London, though he frequently visited Australia and sculpted the portraits of many famous Australians of the early 20th century. He exhibited at the Royal Academy from 1886, and was elected A.R.A. in 1909 and R.A. in 1922. He was knighted in 1921. Apart from his heads and busts he sculpted portrait reliefs and did the coinage profiles of King George V used for coins, medals and postage stamps. His bronzes include a number of statuettes in the Symbolist manner, such as Circe (honourable mention at the Salon of 1893) and She sitteth on a Seat in the High Places of the City, as well as more conventional classical figures like The Metamorphosis of Daphne and The Wounded Diana.

McKENZIE, R. Tait 1867-
Born in Almonte, Canada, on May 26, 1867, he worked as a painter and did not take up sculpture till 1902, when he produced a series of four masks illustrating the progress of fatigue, and a statuette The Sprinter. He lectured on artistic anatomy at Montreal Art School and Harvard University and later became professor of physical education at the University of Pennsylvania. Most of his sculpture reflects his life-long interest in sport and athletics. His bronzes include portrait busts and reliefs, statuettes of Hyperion, The Plunger (swimmer), Boy Scout and various figures of athletes. He sculpted the bas-relief Joy of Effort for the wall of the Stockholm Olympic stadium, 1912, and was awarded a special Olympic gold medal by the King of Sweden for his services to athletic art.

MACKENZIE, Roderick D. 1865-
Born in London on April 30, 1865, he studied under Constant, Jules Lefebvre, Chapu and attended classes at the École des Beaux Arts. He travelled widely, becoming a member of the American Federation of Arts. His paintings and sculpture reflect his travels in India and the Middle East.

McKINSTRY, Grace E. fl. 20th century
Born in Fredonia, U.S.A. at the turn of the century, she studied at the Art Students' League, New York and the Julian and Colarossi academies in Paris, under Raphael Collin. She was a member of the Professional Artists' League and specialised in portrait busts, heads and reliefs.

MACKLIN, Thomas Eyre 1867-1943
Born in Newcastle upon Tyne in 1867, he died there on August 1, 1943. He studied at the Royal Academy schools and won the R.A. silver medal in 1888. Later he worked for a time in Paris and exhibited at the Royal Academy and the Salon des Artistes Français from 1889 onwards. He worked mainly as a magazine illustrator, and was on the staff of the *Pall Mall Budget* from 1888 to 1892. Many of his oil paintings are landscapes which he produced during his long

sojourn in France. As a sculptor, he is best remembered for the Northumberland War Memorial, Newcastle, but also sculpted portrait busts and allegorical figures.

MACLEARY, Bonnie fl. 20th century
Born in San Antonio, Texas, at the beginning of this century, she studied at the Académie Julian and was also a pupil of James Earle Fraser in New York. She is a member of the American Professional Artists League. She has sculpted portraits and allegorical figures, such as Aspiration (Metropolitan Museum of Art, New York).

MACLEARY, Thomas Nelson 1845-94
Born in London in 1845, he died there in 1894. He exhibited figures and portraits at the Royal Academy and the British Institution from 1870 till his death. Examples of his work are in Bradford Museum.

McMILLAN, William 1887-
Born in Aberdeen on August 31, 1887, he studied at Gray's School of Art, Aberdeen, and the Royal College of Art (1908-12). He exhibited at the Royal Academy from 1917 and was elected A.R.A. in 1925 and R.A. in 1933. He taught at the Royal Academy sculpture school from 1929 to 1940. He specialised in figures and groups and lived for many years in London.

MACMONNIES, Frederick William 1863-1937
Born in Brooklyn, New York, on September 20, 1863, he died there in 1937. He entered the studio of Augustus Saint-Gaudens in 1880 and also studied at the National Academy of Design and the Art Students' League. Later he studied in Munich and was a pupil of Falguière at the École des Beaux Arts, Paris. He exhibited at the Salon in 1889 and won an honourable mention for a figure of Diana and two years later was awarded a second class medal — the highest award ever given to foreigners, and the first American to win it. Later he won a gold medal in Antwerp (1894) and the Grand Prix d'Honneur at the Exposition Universelle, Paris (1900). He became a Chevalier of the Legion of Honour in 1896. He received many important public commissions at the turn of the century, his larger works including the statues of Nathan Hale (New York City Hall Park), the group of Three Angels (St. Paul's Church, New York), the Columbian Fountain at the Chicago Exposition of 1893, the Memorial Arch to Soldiers and Sailors (Brooklyn Prospect Park), Winged Victory (Westpoint Military Academy), the Pioneer Monument (Denver), the bronze door of the Library of Congress and Civic Virtue for the fountain at New York Civic Hall (1919). His minor works include maquettes and models for these monuments and memorials, with a predilection for military subjects, and such neo-classical bronzes as Diana, Young Faun and Heron, Pan of Rohallion, Pax Victrix, and Bacchante and Infant Faun.

MACNEIL, Carol Brooks 1871-
Born in Chicago on January 15, 1871, she studied at the Art Institute under Lorado Taft and worked under MacMonnies and Injalbert in Paris. She exhibited at the Salon des Artistes Français, winning an honourable mention in 1900, but also getting a silver medal at the Exposition Universelle the same year. Her bronzes include statuettes such as Spring Song and Anitra's Dance, Betty (head), and Elizabeth (bust). She was the wife of Hermon MacNiel or MacNeil.

MACNIEL, or MACNEIL, Hermon Atkins 1866-1947
Born at Everett, Massachusetts, on February 27, 1866, he died in New York on October 2, 1947. He taught industrial art at Cornell University from 1886 to 1889 before going to France, where he studied sculpture under Chapu and Falguière. On his return to the United States he assisted Martiny in the preliminary decorative sculptures for the Columbian Exposition and three years later (1896) he won the Rinehart scholarship, which enabled him to continue his studies in Rome for four years. Subsequently he taught at the Art Institute of Chicago and the Pratt Institute, Brooklyn, and was elected to the National Academy in 1906. He won a silver medal at the Exposition Universelle of 1900 among his many other awards, and the Saltus gold medal in 1923. He received many public commissions and his most important works were the President McKinley Memorial Arch at Columbus, Ohio, the frieze for the Missouri state capitol, the war memorial at Flushing, Long Island, and the Soldiers' and Sailors'

Monument in Albany. His smaller bronzes include many figures and groups illustrating the life of the American Indians, such as The Moqui Runner, Moqui praying for Rain, Primitive Song, Vow to the Sun, A Primitive Chant, but he also sculpted female busts, such as those of Agnese and Beatrice.

MACPHERSON, George Gordons, 1910-
Born in London on May 10, 1910, he studied at the Liverpool College of Art (1927-32) and the Central School of Art (1936-38) and exhibited at various London and provincial galleries. He was head of the sculpture department at Liverpool College of Art from 1945 till 1971 and now lives at Birkenhead, Cheshire. He has sculpted figures and portraits in wood, clay and bronze and also painted in oils and watercolours.

MACPHERSON, Hamish 1915-
Born in Hartlepool, Co. Durham, on February 20, 1915, he studied at Elam School of Art, Auckland, N.Z. (1930-32) and the Central School of Arts and Crafts, London (1934-39). He has exhibited figures and portraits in British and overseas galleries and now works at Studham in Bedfordshire.

McWILLIAM, Frederick Edward 1909-
Born in Banbridge, County Down, on April 30, 1909, he studied painting in Belfast and at the Slade School of Art under Tonks and Schwabe (1928-31) and then worked for a year in Paris before turning to sculpture. He was influenced by Surrealism and worked with a British Surrealist group in the late 1930s. He had his first one-man show at the London Gallery in 1939. He served with the Royal Air Force in the Far East during the second world war. He has exhibited regularly at the Royal Academy since the war and was elected A.R.A. in 1959 and made C.B.E. in 1966. He sculpts portraits and figures in stone, terra cotta, wood, brass and bronze and his work is represented in several public collections. In recent years he has turned away from portraiture and explored the abstract forms of sculpture which held his interest before the war.

MADARIAGA, Emilio de 1887-1920
Born in Corunna, Spain, on November 24, 1887, he died in Madrid on March 18, 1920. He studied in Paris and settled in Madrid in 1914, where he specialised in statues of saints and other religious subjects.

MADEYSKI, Anton 1862-
Born in Poland on October 16, 1862, he studied at the School of Fine Arts in Cracow under Szynalevski and Jablonski and at the Vienna Academy under Hellmer. He worked in St. Petersburg from 1893 to 1898 and then settled in Rome. He did the ornamental sculpture for Wawel Cathedral, noted for its realism. Other works include the bronze figure of Stephen Batory, and busts of his contemporaries. Cracow Museum has a marble figure of a Hunting Dog by him.

MADRASSI, Luca fl. late 19th century
Born in Tricesimo, Italy in the mid-19th century, he studied in Italy and Paris, and was a pupil of Cavelier. He exhibited at the Salon des Artistes Français from 1881 to 1896 and at the Nationale from 1896, specialising in busts, statuettes and allegorical groups.

MADSEN, Sören 1861-1890
Born in Denmark on May 15, 1861, he died on June 22, 1890. He worked in Copenhagen and Berlin and exhibited there from 1881 till his death. He specialised in biblical and classical figures, such as Telemachus tying his Sandals, Joseph interprets his Dreams (gold medal, 1886) and Ulysses and Nausicaa, and also sculpted a number of portrait medallions.

MAES, Jules Albert fl. 19th-20th centuries
Born at Clichy-la-Garenne in the mid-19th century, he died in Paris in 1916. He studied under M. Delorme and exhibited figures at the Salon from 1873 onwards.

MAES, Jules Oscar 1881-
Born in Lille on November 12, 1881, he studied under Coutan and exhibited at the Salon des Artistes Français, the Nationale, the Salon d'Automne and the Tuileries from the early years of this century. He specialised in landscape paintings and genre figures and groups. The main collection of his work is in Tourcoing Museum.

MAESTRE, Joseph fl. 19th century
Spanish sculptor of Flemish origin working on ecclesiastical decoration in Seville.

MAFAI, Antoinette Raphael 1900-
Born in Vilna, Lithuania in 1900 she was brought to London as a child and then emigrated to Italy in 1925. She studied at the Academy of Fine Arts in Rome and produced figures and portraits, several of which are in the Gallery of Modern Art.

MAFFEI, Charles fl. 19th-20th centuries
Italian sculptor working at the turn of the century on contemporary portraiture. He studied at the Academy of St. Luke, Rome and is best known for his busts of Rossini and Verdi.

MAGARINOS RODRIGUEZ DE BENDANA, Maximino 1869-1927
Born in Santiago de Compostella on November 18, 1869, he died there in March 1927. He is best known for his ecclesiastical sculpture, memorials and tombstones in the Pontevedra area, but also sculpted figures and animals, such as the two lions in the throne room of the Capitania General in Santiago.

MAGGESI, Domenique 1807-1892
Born in Carrara, Italy, in 1807, he died in Bordeaux in 1892. He became a naturalised Frenchman and settled in Bordeaux in the 1830s. He exhibited at the Salon from 1838 to 1857 and specialised in portrait busts of contemporary celebrities, mainly in marble.

MAGNI, Pietro 1847-1877
Born in Milan in 1847, he died there on January 10, 1877. He produced statues and monuments of contemporary and historic Italian celebrities, his best known works being the statue of Leonardo da Vinci in the Piazza della Scala, Milan, and the statue of Count Cavour in the Galeria Vittore Emmanuele. Trieste Museum has the main collection of his works, which include Nymph Anrisina, Piercing the Isthmus of Suez, Angelique, Negroes, The Corporal's Family and a bust of Baron Revoltella.

MAGNIANT, Jacques Henri 1821-1866
Born in Paris on January 9, 1821, he died there in 1866. He studied under Rude and exhibited at the Salon from 1861. He specialised in French historical subjects, mainly carved direct in stone. His minor works, however, include plaster and bronze maquettes of portrait busts and genre groups, such as Les Amours (Angoulême Museum).

MAGNIER, Jules fl. 19th century
Born at Crèpy-en-Valois on July 12, 1857, he studied under Geoffroy and exhibited paintings and sculpture at the Salon des Artistes Français.

MAGNUSSEN, Harro 1861-1908
Born in Hamburg on May 14, 1861, he died in Berlin on November 2, 1908. He was the son of the painter C.K. Magnussen and studied painting and wood engraving under his father. Later he attended classes at the Munich Academy, then turned to sculpture and settled in Berlin, where he worked under Reinhold Begas. He sculpted numerous statues of Bismarck, the Kaisers and German generals for many German towns, but also produced portrait busts and reliefs.

MAGNUSSEN, Rikard 1885-
Born in Copenhagen on April 2, 1885, he studied under Sinding and sculpted numerous monuments and statues in Copenhagen and other Danish towns. His minor works include portrait busts and allegorical figures.

MAGROU, Jean Marie Joseph 1869-
Born in Béziers, France, on October 22, 1869, he studied under Thomas and Injalbert and exhibited at the Salon des Artistes Français, winning a third class medal in 1895 and a first class medal in 1926. He was also a Chevalier of the Legion of Honour. Béziers Museum has his groups of Orphans and Faun awakened by Nymphs.

MAHLKNECHT, Dominique 1793-1876
Born at Gröden, Tyrol, on November 13, 1793, he died in Paris on May 17, 1876. He emigrated to France in the 1820s and became a naturalised Frenchman in 1848. He studied in Rome under Canova before settling in Paris. He exhibited at the Salon from 1831 to 1857 and won a second class medal in 1831. He specialised in biblical and classical figures and groups, such as Venus and Cupid, Venus and

Adonis, Mars and Jupiter, and French historical subjects, such as Duguesclin, Louis XVI and A Vendean Chief.

MAHOUX, F. fl. 19th century
Born in Rodez, France, in the first half of the 19th century, he died there in 1901. He was employed by the Rodez Museum to sculpt busts and statuettes of contemporary French personalities.

MAHOUX, Paul fl. 19th century
Sculptor working in Rodez in the mid-19th century.

MAILLARD, Auguste 1864-
Born in Paris on June 15, 1864, he studied under Dalou, Falguière and Gaudez. He exhibited at the Salon des Artistes Français, winning third class (1894), second class (1898) and first class (1924) medals, as well as a bronze medal at the Exposition Universelle of 1900. He was a Chevalier of the Legion of Honour and specialised in busts, statues, memorials and portrait medallions.

MAILLARD, Charles 1876-
Born in Cholet on June 29, 1876, he studied under Barrias and Coutan and exhibited figures and bas-reliefs at the Salon des Artistes Français at the turn of the century. He worked mainly in earthenware and terra cotta.

MAILLARD, Louis fl. 19th century
Born at Châlons-sur-Marne in the early 19th century, he exhibited at the Salon in the late 1860s and specialised in birds, modelled in wax.

MAILLER, Alexander fl. 19th century
Born in Vienna on February 14, 1844, he studied under Radnitzky and Blazer. He specialised in portrait busts, but also did the decorative sculpture for the Museum of Natural History and other Viennese buildings.

MAILLOL, Aristide Joseph Bonaventure 1861-1944
Born at Banyuls-sur-Mer in 1861, he died at Perpignan in October, 1944. He studied painting in Perpignan and worked in the studio of Cabanel in Paris, executing paintings and tapestries. He did not take up sculpture until 1900 and first exhibited in 1905. His earliest work was carved direct in wood without any preliminary clay models but later he produced terra cottas which Vollard cast in bronze. He quickly developed a style which remained constant for more than thirty years, and he is regarded as the most classical figurative sculptor of modern times. He spent some time in Greece in 1906 and this influenced his figures, combining Greek restraint and French grace. A calmness and dignity characterise all his work. His best known works are the female nudes entitled The Mediterranean, The Mountain, The Expression, The Night, Chained Action, The River, L'Ile de France and Pomona. His minor works include maquettes for the larger figures, casts of the early terra cottas and a number of portrait busts.
Georg, Waldemar *Maillol* (1965). Mirbeau, Octave *Aristide Maillol* (1922). Lafargue, Marc *Aristide Maillol* (1925). Rewald, John *Maillol* (1939).

MAILLOS, André Jean Marie 1871-
Born in Paris on May 14, 1871, he worked as a painter and sculptor of genre and allegorical subjects and exhibited figures and groups at the Salon des Artistes Français, the Indépendants and the Salon d'Automne.

MAILLOT, Pauline fl. 19th century
Born at Flushing, Holland, in the mid-19th century, she died in Paris on January 1, 1897. She exhibited figures and groups at the Salon des Artistes Français and got an honourable mention in 1890.

MAINDRON, Étienne Hippolyte 1801-1884
Born at Champtoceaux, France, on December 16, 1801, he died in Paris on March 21, 1884. He enrolled at the École des Beaux Arts in 1827 and studied under David d'Angers. He exhibited at the Salon from 1834 onwards and became a Chevalier of the Legion of Honour in 1874. He specialised in busts and statues, mainly in marble and stone. His bronzes include Christ on the Cross (Church of St. Sulpice) and a figure of General Travot (La Vendée, 1838).

MAINONI, Luigi 1804-c.1850
Born in Modena in 1804, he died there in either 1850 or 1853. He studied under Tenerani and Sanquiricos and specialised in portrait busts and funerary monuments in Rome and Modena.

MAIOLI, Luigi 1819-1897
Born in Ravenna in 1819, he died in Rome in 1897. He studied under Giovanni Dupré and sculpted busts and statues of historic and contemporary artistic celebrities. His best known work is the figure of Canova in the Palace of Fine Arts Rome.

MAIRE, Anna fl. 19th century
Born in Besançon, the daughter and pupil of Jean Baptiste Maire, with whom she worked on portrait sculpture. Besançon Museum has a medallion of Liberty by her.

MAIRE, Jean Baptiste 1789-1859
Born at Gerné-Fontaine, near Besançon on August 15, 1789, he died there on December 18, 1859. He studied at the École des Beaux Arts, Paris, from 1816 to 1820 under Lemot and exhibited at the Salon from 1819 to 1824. He specialised in portrait busts, bas-reliefs and figures, particularly of biblical figures and religious subjects, including contemporary church dignitaries, in marble and bronze.

MAISON, Rudolf 1854-1904
Born in Regensburg, Germany, on July 29, 1854, he died in Munich on February 12, 1904. He studied in Regensburg and Munich and exhibited in Munich, Berlin and Paris, getting an honourable mention at the Exposition Universelle of 1900. He sculpted many statues all over Germany in the Romantic tradition. His minor bronzes include various portrait busts of historic and contemporary personalities and statuettes of Siegfried, Roman Augur and Wounded German Knight.

MAKAROV fl. 20th century
Russian sculptor of monuments, memorials, statues and portrait busts, working in the post-revolutionary period. His best known work is the monument to the 26 Commissars of Baku, shot by the British in 1918.

MAKRISZ, Antal fl. 20th century
Hungarian sculptor working in Budapest since the second world war, specialising in portraits and figures of political and historical subjects. His best known work is the memorial to the victims of Nazi oppression at Mauthausen concentration camp.

MALACAN, Jean Baptiste 1875-
Born in Béziers, France, on September 19, 1875, he studied at the École des Beaux Arts and exhibited classical and allegorical works at the Salon des Artistes Français. Béziers Museum has his group The Kiss of the Siren.

MALAISE, Charles 1775-1836
Born in Brussels in 1775, he died there on May 31, 1836. He studied under Godecharles and produced monuments and memorials for the Brussels area. His minor works include portrait busts, bas-reliefs and maquettes for his monumental statuary.

MALAN, Marius 1872-
Born at Mané, France, on May 19, 1872, he exhibited figures and groups at the Salon des Artistes Français and got an honourable mention in 1926.

MALCHOW, Friedrich fl. 19th century
Portrait and figure sculptor working in Berlin in the mid-19th century. He studied under Kalide and exhibited at the Academy in 1836, 1842 and 1844.

MALCOURONNE, Paul 1883-
Born at Authie, France, on December 22, 1883, he studied under F. Jacquier and exhibited sculpture at the Salon des Artistes Français and the Salon d'Automne.

MALEMPRÉ, Louis Auguste fl. 19th century
Sculptor of French origin working as assistant to Theed in London in the mid-19th century. He exhibited bas-reliefs and medallions at the Royal Academy from 1848 to 1879.

MALFATTI, Andrea 1830-1917
Born at Mori, near Naples, in 1830, he died at Trent on February 7, 1917. He specialised in memorials and monuments, religious and classical figures, and won a silver medal at the Exposition Universelle of 1900. His Pietà is in the Revoltella Museum, Trieste.

MALFRAY, Charles Alexandre 1887-1940
Born in Orleans on July 19, 1887, he died in Dijon on May 28, 1940. He came from a long line of stone-masons and studied at the Orleans School of Fine Arts, where he won the Lardureau Prize. His work was influenced at first by a local sculptor Lançon, but in 1907 he went to Paris and studied at the École des Beaux Arts under Coutan. He served in the infantry during the first world war and was severely gassed three times. He was invalided out of the army and suffered from ill health throughout the 1920s which periodically prevented him from working. He was runner-up in the Prix de Rome in 1920, and won the Blumenthal Prize the same year, but most of his work of this period was controversial and often misunderstood. Long neglected, fame came late to him. In 1930 he was designated by Maillol as his successor at the Académie Ranson and exerted a great influence on the present generation of French sculptors during his nine years there. He broke his self-imposed seclusion in 1931 when he exhibited his works at the Galerie Paquereau in Paris. This led to a re-appraisal of his work and official recognition came four years later when he began to get official commissions. The City of Paris organised a retrospective exhibition of his work in 1947. His chief works were the colossal bronze war memorials at Orleans and Pithiviers executed in the early 1920s, entitled To Glory and Fear respectively. His minor works include numerous torsos, nudes, bathers, dancers, seated nudes, allegories of Spring and Summer and classical figures such as the Triptych of the Dance, and Leda.

MALINSKY, Josef 1756-1827
Born at Brnan near Doksan, Bohemia, on July 10, 1756, he died in Prague on July 9, 1827. He specialised in monuments, memorials and portrait reliefs in various Bohemian towns.

MALINSKY, Paul fl. 19th century
Born in Bohemia in the late 18th century, he died in Warsaw in 1853. He studied under Thorvaldsen and spent three years in Rome, Florence and Naples before settling in Warsaw, where he specialised in statues and bas-reliefs for churches and public buildings.

MALISSARD, George 1877-
Born at Anzin, France, on October 3, 1877, he was an Animalier, specialising in equestrian subjects. He received many important state commissions after the first world war to produce statues of Marshals Foch, Lyautey and Pétain. He also sculpted equestrian statues of Albert I, King of the Belgians, and King Alfonso XII of Spain. His small bronzes were edited by Valsuani using the *cire perdue* process and consisted of cavalrymen.

MALLET, Pierre Louis Nicolas fl. 19th century
Born at Grand Quevilly, France, in the early 19th century, he exhibited at the Salon from 1839 and won a third class medal in 1843. He produced allegorical works, such as The Love that Passes, the Love that Lasts, statues of saints and figures and groups of birds.

MALMBERG, V, 1867-
Born at Napharleby, Finland, on June 20, 1867, he specialised in busts of his artistic contemporaries and genre and classical statuettes, such as Nostalgia and Diana.

MALMQUIST, Georg fl. early 20th century
Swedish sculptor of portrait busts, heads and reliefs, working in Stockholm in the early years of this century. He specialised in portraits of contemporary Scandinavian celebrities.

MALRIC, Charles Louis 1872-
Born in Bordeaux on August 19, 1872, he studied under Falguière, Marqueste and Mercié and exhibited busts and statuettes at the Salon des Artistes Français, winning third class (1902), second class (1904) and first class (1921) medals. He was a Chevalier of the Legion of Honour.

MALTESE, Giovanni fl. late 19th century
Born in Naples in the mid-19th century, he exhibited figures in Naples and Turin from 1875 onwards.

MALTHE, Rasmus Secher 1829-1893
Born in Randers, Denmark, on November 21, 1829, he died there on May 6, 1893. He studied in Copenhagen under Vilhelm Bissen and decorated the Royal Theatre in Frederiksborg. His minor works include portrait busts, classical statuettes and genre groups.

MALVAUX, François 1846-1914
Born at Estenne-Haulchin, France, on September 23, 1846, he died in Brussels on March 3, 1914.

MANAUT, Paul fl. 20th century
Born in France in the late 19th century, he studied under Coutan and exhibited at the Salon des Artistes Français, getting an honourable mention in 1908. Later he also exhibited genre and allegorical works, such as Tenderness and The Source at the Salon d'Automne.

MANCINI, Emilio fl. 19th century
Born in Florence in 1844, he studied under Benelli and Pazzi and sculpted genre and allegorical figures, mainly in marble.

MANDOV fl. 20th century
Bulgarian sculptor of portraits and figures, working in Sofia in the first half of this century.

MANERA, Domenico fl. 19th century
Born in Asolo, Italy, at the beginning of the 19th century, he worked in Rome and studied under his cousin Canova. He specialised in portrait busts of Italian celebrities of the mid-19th century.

MANÈS, Pablo Curatella 1891-
Born in La Plata, Argentina, in 1891, he studied under Arturo Dresco and enrolled at the National Academy of Art, Buenos Aires. Later he worked for a time with Lucio Correa Morales. He won a state scholarship in 1911, enabling him to continue his studies in Europe, particularly in Florence and Rome. He settled in Paris in 1914 and worked under Bourdelle. He exhibited at the Salon des Indépendants in 1924 and won a silver medal at the Exposition des Arts Décoratifs the following year. In 1926 he joined the Argentinian diplomatic service, being secretary to the ambassador in Paris till 1947, holding consular posts in Oslo and Athens and becoming head of the Department of Culture in 1950. He continued to combine his artistic and diplomatic careers and was represented in many of the post-war exhibitions, notably the Sao Paulo Biennale and the Venice Biennale (1952-53). His bronzes include figures of guitarists and dancers, acrobats and saints, torsos and nudes and portrait busts of his contemporaries. His best known works are the semi-figurative Rugby and the Dance.

MANFREDINI, Gaetano fl. 19th century
Born in Milan in the early 19th century, the son and pupil of Luigi Manfredini, he died in Milan in 1870. He sculpted biblical and classical figures, his best known work being the figure of David on the façade of the Church of San Fidele, Milan.

MANFREDINI, Luigi 1771-1840
Born in Bologna on September 17, 1771, he died in Milan on June 22, 1840. He specialised in portrait reliefs, plaques and medallions of royalty and European celebrities. He was also a practising bronze-founder.

MANGLIER, Charles fl. 19th century
French sculptor of allegorical bronzes, working in the second half of the 19th century. His group entitled Fortune is in Aurillac Museum.

MANIGLIER, Henri Charles 1825-1901
Born in Paris on October 11, 1825, he died in Paris on March 17, 1901. He enrolled at the École des Beaux Arts in 1843, and studied under Ramey and Dumont. He was runner-up in the Prix de Rome of 1856 and exhibited at the Salon from 1850 to 1868, becoming a Chevalier of the Legion of Honour in 1878. He specialised in busts and statues of saints, mainly in marble. His bronzes include classical and medieval statuettes, such as 15th Century Armourer, Penelope and Wounded Achilles.

MANNEBACH, Peter 1797-1842
Born in Germany in 1797, he died in Cologne on March 1, 1842. He specialised in memorials and portrait bas-reliefs.

MANNEVILLE, André de fl. 19th century
Born in Paris in the second half of the 19th century, he studied under Puech, Patey, Injalbert and Rolard and exhibited at the Salon des Artistes Français, getting an honourable mention in 1894. He specialised in genre figures and bas-reliefs, such as A Halt and Death of a Traveller.

MANNONI, Gérard 1928-
Born in Bastia, Corsica, in 1928, he studied at the École des Metiers d'Art in Paris in 1945-48 and then at the Académie Julian under Marcel Gimond and the École des Beaux Arts (1949-50) under Yencesse and Saupique and the Académie de la Grande Chaumière under Zadkine. In the period up to 1956 he worked in clay and plaster, often as preliminary maquettes for works cast in bronze and concrete, or carved direct in stone and wood. Since 1956 he has worked mainly in iron both wrought and cast to produce abstracts. Since 1957 he has exhibited at the Salon de la Jeune Sculpture and also with the Espace Group.

MANNUCCI, Edgardo 1904-
Born in Fabriano, Italy, in 1904, he was at first influenced by the archaism of Arturo Martini, but when he settled in Rome in 1930 he turned to Expressionism. He developed his present abstract style in the 1950s, using wrought metal and twisted wire to achieve a distinctive effect. His bronzes mainly belong to the earlier part of his career and range from the melancholy allegories of the 1930s to the more natural forms of the 1940s. He produced the monument to the International Red Cross at Solferino (1959) but his minor works also include medals and bas-reliefs. He has taken part in many post-war exhibitions, notably the Exhibition of Twentieth Century Italian Sculpture in Messina, Rome and Bologna (1957).

MANOLO (Manuel Martinez Hugué) 1872-1945
Born in Barcelona in 1872, he died in Briquetes, Catalonia, in December 1945. The son of a Spanish general, he himself deserted from the army and fled to France, eventually settling in Paris, where he was befriended by Picasso. Later he moved to Céret in the Pyrenees and then took up sculpture. He was influenced by Cubism to some extent but nevertheless clung to figurative sculpture derived from peasant art; notably the series of comic figures exhibited at the Galerie Simon in Paris (1923) and the E. Weyhe Gallery, New York (1926). His chief work The Catalan was erected in Céret. He returned to Spain in 1928 and produced a large number of portrait busts, nudes and genre figures, such as the Bull-fighter, Mother and Child. His 'Mediterranean' style and penchant for Junoesque figures suggest an affinity with Maillol.

Pia, Pascal *Manolo* (1930).

MANSHIP, Paul 1885-
Born in St. Paul, Minnesota, on December 25, 1885, he studied at St. Paul Institute of Art and the Pennsylvania Academy of Fine Arts. He won the Prix de Rome and studied at the American Academy in Rome from 1909 to 1912. He exhibited in the United States and France, earning two gold medals at the Philadelphia Sesquicentennial Exposition of 1926 and the Légion d'Honneur three years later. He specialised in portrait busts, heads, bas-reliefs, medals and figures and groups featuring nymphs and fauns. Other bronzes include Dancer among the Gazelles, Indian and Antelope, Centaur and Dryads, Mother and Child, Centaur and Nymph, Indian Hunter with his Dog, Girl with Owls, Little Brother, Faun and Dryad, Playfulness and Diana. He sculpted the bronze figure of the Duck Girl for the fountain in Fairmount Park, Philadelphia.

MANSION, Simon 1773-1854
Born in Paris in 1773, he died there in 1854. He exhibited at the Salon from 1810 to 1822 and won a first class medal at his début. He specialised in classical figures and groups, mainly in marble, and portrait busts such as those of Rembrandt, Teniers and Michelot.

MANTEL, Julius 1820-1896
Born in Berlin on September 20, 1820, he died there on January 22, 1896. He was employed as a modeller at the Royal Porcelain Factory, Berlin. Some of his genre figures are also known in bronze.

MANTYNEN, J. fl. 20th century
Finnish sculptor of portraits and genre figures, working in the early years of this century.

MANUELA, (Marie Adrienne Anne Victorienne Clémentine de Rochechouart-Mortemart, Duchess of Uzès) 1847-1933
Born in France in 1847, she died in Paris on February 3, 1933. She exhibited at the Salon des Artistes Français and got an honourable mention in 1887. She specialised in monuments and figures of French

historical personalities. She was President of the Union of Women Painters and Sculptors and was also a prolific writer on art and politics.

MANUILOFF, Alexander Michailovich fl. 19th century
Born in Russia on June 16, 1841, he worked in St. Petersburg as a decorative sculptor. He also sculpted portrait busts and classical figures. His works are preserved in the Leningrad Museum.

MANZEL, Ludwig fl. late 19th century
Born in Kagendorf, Germany, on June 3, 1858, he studied under F. Schaper at the Berlin Academy and worked in Paris in 1886-89. Following his return to Berlin he became a professor at the Academy and succeeded Begas as director of a sculpture studio. His group Song of Evening is in the Berlin Gallery.

MANZÙ, Giacomo 1908-
Born in Bergamo in 1908, he worked for a stucco-decorator and attended evening classes in his native town. During his military service he attended classes at the Verona Academy of Fine Arts and was influenced by the Renaissance sculptors such as Donatello. He spent some time in Paris in 1933 and 1936 and came under the influence of Rodin's work. He moved to Milan in 1930 and had his first one-man show there in 1932. He returned to Bergamo in 1933 and achieved fame four years later when his work was exhibited at the Cometa Gallery in Rome. He was appointed professor of sculpture at the Albertina Academy, Turin, in 1941, and now lives in Milan. He has exhibited at the Venice Biennales since 1948 and the following year won the competition to sculpt the bronze door for St. Peter's in Rome. More recent commissions have included the decoration of Salzburg Cathedral. Many of his works are religious in context but always imbued with realism. His Crucifixions, sculpted at the end of the war, depict the executioners as German soldiers. His bronzes include numerous portrait busts and figures of skaters, cardinals, dancers and the series depicting Maternity.
Rewald, John *Giacomo Manzù* (1968).

MARAI, Luigi fl. late 19th century
Milanese sculptor of portraits and figures, exhibiting in Turin, Milan and Venice from 1880 onwards.

MARAINI, Adelaide fl. 19th century
Born in Milan in 1843, she worked in Lugano and Rome and exhibited figures in Italy and France from 1870 onwards.

MARAINI, Antonio 1886-
Born in Rome on April 5, 1886, he was a writer, art critic and sculptor who sculpted decoration for one of the bronze doors in St. Peter's, Rome. He specialised in genre and allegorical figures and groups, such as Maternity (National Gallery, Rome) and Intimacy (Modern Gallery, Venice).

MARATKA, Josef 1874-
Born in Prague on May 25, 1874, he spent three years in Rodin's studio and collaborated with him on the Victor Hugo monument. He sculpted the monument to Alberto Santos-Dumont in Buenos Aires, and statues for the new Town Hall, Prague. He organised the exhibitions honouring Rodin (1903) and Bourdelle (1909).

MARBOUTIN, Germaine 1899-
Born in Paris on March 6, 1899, she studied under Sicard and exhibited figures and portraits at the Salon des Artistes Français, winning medals in 1927 and 1929.

MARC, Fanny fl. 19th-20th centuries
Born in Paris on May 22,1858, she studied under Falguière, Barrias and Georges Lemaire. She exhibited at the Salon des Artistes Français, getting an honourable mention in 1895 and third class (1904) and second class (1906) medals. Her best known work is the Franco-Prussian war memorial at Ferté-sous-Jouarre.

MARCEL-JACQUES, Alphonse fl. 19th-20th centuries
Born in Cherbourg in the mid-19th century, he exhibited at the Salon des Artistes Français from 1889 to 1925 under the name of Marcel. He specialised in busts and heads of genre subjects, particularly peasants.

MARCELLIN, Jean Esprit 1821-1884
Born at Gap, France, on May 24, 1821, he died in Paris on June 22,

1884. He enrolled at the École des Beaux Arts in 1844 and studied under Rude. He began exhibiting at the Salon in 1845 and won numerous medals between 1851 and 1859. He became a Chevalier of the Légion d'Honneur in 1862.

MARCH, Elsie fl. early 20th century
Sculptress working in clay and bronze, and exhibiting at the Royal Academy, the Glasgow Institute and other British galleries from 1920 till 1955. She worked in Farnborough, Kent.

MARCH, Sydney fl. early 20th century
English portrait sculptor, active in the early years of this century. He sculpted bronze busts and heads of British royalty and nobility and contemporary celebrities.

MARCHAND, Jean Baptiste Ernest fl. 19th century
Born in Paris, he studied under Doublemard and exhibited busts and genre groups at the Salon from 1878 onwards.

MARCHAND, Xaver 1759-1834
Born in Salem, Baden, on March 21, 1759, he died in Karlsruhe on August 4, 1834. He sculpted historic and neo-classical figures and bas-reliefs and decorative sculpture in the grand-duchy of Baden.

MARCHANT, Édouard François fl. 19th century
Born in Antwerp on April 29, 1813, he studied under Matthieu van Bree and attended classes at the academies of Antwerp and Brussels. He specialised in busts and monumental statuary.

MARCHANT, Gaston 1843-1873
Born at Sables d'Olonne on December 14, 1843, he died in Rome on November 14, 1873. He produced busts and classical figures and groups.

MARCHEGAY, Gustave Émile fl. 20th century
Born at St. Germain de Prinçay, France, in the early years of this century, he specialised in sculpture depicting fishes and exhibited at the Salon d'Automne. His works include bronze Trout and Perch (Museum of Modern Art, Paris).

MARCHESI, Luigi fl. 19th century
Born at Saltrio, near Como, at the beginning of the 19th century, he worked as a decorative sculptor on Milan Cathedral from 1823 to 1863.

MARCHESI, Chevalier Pompeo 1789-1858
Born near Como on August 11, 1789, he died in Milan on February 7, 1858. He studied under Canova and sculpted numerous statues of Italian royalty, nobility and European celebrities, such as Volta (Como), Goethe (Frankfurt Staatsbibliothek) and Kaiser Franz I (Graz and Vienna). His minor works include historic and contemporary busts and statuettes, mainly of Italian celebrities.

MARCINKOVSKY, Vladislav fl. 19th-20th centuries
Born in Mieszkov, Poland, in 1858, he studied under Chapu in Paris and also attended classes at the Berlin Academy. He worked in Paris and Berlin and became Director of the Poznan Military Museum in 1925. He specialised in portrait busts of famous Poles.

MARCKS, Gerhard 1889-
Born in Berlin on February 18, 1889, he studied painting under Richard Scheibe and sculpture under August Gaul and Georg Kolbe. In 1918 he was appointed to a teaching post at the Berlin School of Arts and Crafts, then taught at the Weimar Buhaus (1920-25) and the Halle School of Arts and Crafts. He was dismissed by the Nazis in 1933 and four years later his works were banned. After the war he was appointed to the Central Art School in Hamburg, where he taught until 1950. Since then he has lived in Cologne. Retrospective exhibitions of his work were held in 1949 in Hamburg, Stuttgart and Munich. He exhibited in New York in 1951 and was represented at the Venice Biennale (1954) and the Cassel Documenta (1955 and 1959). He carried on the tradition instituted by Barlach and as influenced by ancient Greek art, producing many bronze nudes. After the war he sculpted nudes and animal figures.

MARCO, Michele de fl. 19th century
Born in Naples on December 26, 1832, he travelled extensively all over Europe before settling in Naples, where he did monuments, memorials and decorative sculpture for the Cathedral of Amalfi.

MARCONI, Leonard 1836-1899
Born in Warsaw in 1836, he died in Lwov on April 4, 1899. He studied at the Warsaw School of Fine Arts and the Rome Academy and became professor of architecture at Lwov Polytechnic. Cracow Museum has models and maquettes for a monument to Kosciuszko.

MARCOV, Marco fl. 20th century
Born in Bulgaria, he studied at the Sofia School of Fine Arts before going to Paris, where he was influenced by Despiau, Bouchard and Wlérick. He sculpted many monuments and memorials in Sofia. His minor works include statuettes and portraits of Bulgarian contemporary personalities.

MARCUSE, Rudolf 1878-
Born in Berlin on January 15, 1878, he studied at the Berlin Academy and specialised in portraits. His chief works were the monuments to Moses Mendelssohn (Berlin) and Carl Hagenbeck (Stellingen).

MARÉCHAL, Ambroise René 1818-1847
Born in Paris on February 1, 1818, he died in Rome in October 1847. He studied under Ramey and Dumont at the École des Beaux Arts and was runner-up (1841) and winner (1843) of the Prix de Rome. He died while working on his scholarship in Rome. He exhibited classical figures and groups at the Salon from 1842 to 1847.

MARENT, Franz 1895-1918
Born in Basle in 1895, he died there in December, 1918. He specialised in nude statuettes and busts.

MAREY, Charles Gustave de 1878-
Born at Verneuil-sur-Avre on March 22, 1878, he studied under Puech and Marc Robert in Paris and exhibited figures at the Salon des Artistes Français from 1900 to 1914.

MARGAT, André 1903-
Born in Paris on April 8, 1903, he is a painter, engraver of woodcuts and sculptor of animal subjects. He has exhibited at the Salon d'Automne, the Indépendants, the Nationale and the Salon de la Société des Animaliers.

MARGOULIES, Berta fl. 20th century
American sculptress of genre figures, groups and bas-reliefs. Her chief work is Mine Disaster.

MARIE, Désiré Pierre Louis fl. 19th century
Born in Calvados in the early 19th century, he studied under A. Toussaint and exhibited at the Salon in 1861-63. His works include genre and classical bronzes, such as St. Veronica and Suzanne in the Bath.

MARIE, René fl. 20th century
French sculptor of the mid-20th century. He studied under Maillol and has exhibited torsos, busts, nudes, heads and human and animal figures at the Salon des Surindépendants since 1945.

MARIE CHRISTINE d'ORLEANS 1813-1839
Grand Duchess of Württemberg
Born in Palermo on April 12, 1813, she died at Pisa on January 2, 1839. She was the daughter of Louis Philippe, King of France and studied under David d'Angers and Ary Scheffer. Her sculpture consists mainly of statuettes of French historical personalities, notably Joan of Arc, of whom she produced several versions at Fontainebleau, Orleans and Chantilly.

MARIN, Filip 1865-1928
Born in Bucharest in 1865, he died there in 1928. He sculpted heads and busts of Romanian celebrities and classical and genre figures. His works are represented in the Simu Museum.

MARIN, Jacques 1877-
Born in Brussels on June 6, 1877, he studied under Van der Stappen and attended classes at the Brussels Academy. He exhibited at Brussels and Antwerp in the 1890s and won a gold medal at Liège in 1905. He produced several memorials after the first world war. His minor works consist of statues and busts of historic and contemporary personalities. Antwerp Museum has a group of Danaides, a maquette for his Danaides fountain in Brussels.

MARIN, Joseph Charles 1759-1834
Born in Paris in 1759, he died there on September 18, 1834. He studied under Clodion and won the Prix de Rome in 1801. He became professor of sculpture at the Lyons Academy and exhibited at the Salon from 1791 to 1831. He specialised in busts of young girls, statuettes of bacchantes and other classical subjects, and figures and groups of French historical personalities.

MARIN Y TORRES, Miguel fl. 19th century
Born in Granada, Spain, about 1830, he sculpted many monuments and statues in that district, especially the figures of Ferdinand the Catholic and Queen Isabella, of which several versions exist.

MARINAS Y GARCIA 1866-
Born in Segovia in 1866, he specialised in classical figures sculpted in a realist or impressionist manner. The Gallery of Modern Art, Madrid, has his figure of Velasquez and the group The Second of May.

MARINI, Luigi fl. 19th century
Venetian sculptor of figures and portraits working in the late 19th century. He exhibited in Milan, Rome, Turin and Venice.

MARINI, Marino 1901-
Born in Pistoia, Italy, in 1901, he studied painting and sculpture at the Florence Academy and taught at the Villa Reale Art School, Monza (1929-40). Subsequently he was appointed professor of sculpture at the Brera Academy, Milan. He travelled widely in Europe and North America and worked in Paris from time to time between 1919 and 1938. During the second world war he lived in Ticino, Switzerland. He has exhibited internationally since 1950 and had one-man shows in London, New York, Basle, Zurich and Berne, as well as participating in the Venice Biennales. He now lives in Milan. His earlier work included bronze groups, such as People (1929) and numerous portraits of his cultural and artistic contemporaries, but from 1936 to 1952 he concentrated on the extensive series of horses and horsemen. Other bronzes include The Miracle (1953-54), Warrior (1956), Pomona (1949) and The Monument (1957-58).
Busignani, Alberto *Marini* (1971). Joray, Marcel *Marino Marini* (1968).

MARINI, Raffaele 1868-
Born in Naples on May 29, 1868, he studied at the Institute of Fine Arts, Naples, and exhibited there from 1888 onwards. He specialised in figures and groups derived from Roman history.

MARIOTON, Claudius 1844-1919
Born in Paris on February 2, 1844, he died there on April 26, 1919. He studied under Dumont and also attended the École des Beaux Arts. He exhibited at the Salon from 1873 to 1881 and subsequently at the Salon des Artistes Français, winning third class (1883), second class (1885) medals and silver and gold medals at the Expositions of 1889 and 1900 respectively. He became a Chevalier of the Legion of Honour in 1895. He specialised in portrait busts, medallions and statues of contemporary celebrities and figures and groups of fantasy subjects, such as Chactas (Rouen Museum).

MARIOTON, Eugène fl. 19th-20th centuries
Born in Paris in 1854, he studied under Dumont, Bonnassieux and Thomas and exhibited at the Salon des Artistes Français from 1882 to 1922, winning Bronze medals at the Expositions of 1889 and 1900, and a travelling scholarship in 1888. He specialised in portrait medallions, bas-reliefs and busts.

MARJOLIN, Cornelia (née Scheffer) fl. 19th century
Daughter and pupil of Ary Scheffer, she married and settled in England in the late 19th century where she worked as a portrait sculptress. Her bust of her father is in the Boymans Museum.

MARK – see MATVEÉVICH

MARKLUND, B. fl. 20th century
Swedish sculptor of abstracts and expressionist groups, such as Figure in a Storm.

MARKOV, Marko – see MARCOV, Marco

MARKS (Markowski), Albert 1870-1941
Born in Paris of Polish parents in 1870, he died in Angoulême on December 4, 1941. He studied under Auguste Dujardin and became a landscape painter. He also sculpted genre figures and groups, examples of which are in the Metz Museum.

MARKUP, Bela 1873-
Born in Budapest on August 23, 1873, he worked as a decorative sculptor in that city and sculpted figures and bas-reliefs for the Parliament building.

MARLET, Jérome 1731-1810
Born in Dijon on August 28, 1731, he died there on November 14, 1810. He was Curator of the Dijon Museum, 1806-10, and most of his sculpture is preserved there. He produced portrait busts, religious figures and ornamental sculpture and also decorated Autun Cathedral.

MARMON, Franz Xaver 1832-1878
Born in Haigerloch, southern Germany, on February 1, 1832, he died in Offenburg on August 1, 1878. He specialised in altar reliefs and religious figures and decorated churches in Baden and Württemberg, notably Freiburg Cathedral.

MARNEUF, Antoine André 1796-1865
Born in Paris on March 31, 1796, he died there in March 1865. He studied under Bridon at the École des Beaux Arts and worked as an ornamental sculptor, decorating the Madeleine, Paris Town Hall, Rouen Customs-house, Boulogne Column and the Marseilles Arc de Triomphe.

MAROCHETTI, Baron Charles 1805-1867
Born in Turin in January, 1805, he died in Paris on December 29, 1867. He studied under Bosio at the École des Beaux Arts and later became a naturalised Frenchman. He exhibited at the Salon in 1827 and 1831 and concentrated initially on genre groups in marble and plaster. Later he turned to monumental statuary and bas-reliefs of French historical subjects, mainly carved direct in marble, though bronze maquettes and reductions of several are known. Among his full-size bronzes are the statue of La Tour d'Auvergne for the town of Carhaix, the equestrian statue of the Duke of Orleans for the Louvre courtyard and the equestrian statue of Queen Victoria for George Square, Glasgow.

MAROLA, Giuseppe fl. 18th-19th centuries
Italian sculptor of biblical subjects who exhibited at the Academy of St. Luke from 1805 till his death in 1823. His works include Lot and his Daughters, and the Prophet Nathan reproaching David.

MAROTI, Geza 1875-
Born in Vorosvar, Hungary, on March 1, 1875, he studied in Budapest and Vienna and sculpted decoration for buildings in Budapest and Mexico City, notably the Teatro Municipal.

MARQUALDER, Hans 1882-
Born at Weiningen, Switzerland, in 1882, he worked as a decorative sculptor on public buildings, monuments and parks in Switzerland.

MARQUE, Albert 1872-
Born in Nanterre, France, on July 14, 1872, he exhibited at the Nationale from 1899 to 1904 and later at the Indépendants and the Salon d'Automne. He specialised in studies of women and girls, such as Woman combing her Hair, and busts of children in the Museum of Modern Art, Paris.

MARQUESTE, Laurent Honoré 1848-1920
Born in Toulouse on June 12, 1848, he died in Paris on April 5, 1920. He studied under Jouffroy and Falguière and won the Prix de Rome in 1871. He exhibited at the Salon from 1874 onwards, winning a third class medal with his first work, a plaster bas-relief of Jacob and the Angel. Two years later he won a first class medal and at the Expositions Universelles of 1878, 1889 and 1900 he was awarded silver and gold medals and the Grand Prix respectively. He became a Chevalier of the Légion d'Honneur in 1884 and was promoted to Officier and finally, in 1903, to Commandeur. He became a member of the Institut in 1900. He produced a large number of allegorical and classical works, including Centaur raising up a Nymph, Galatea, Perseus wrestling with Medusa, Cupid, and busts and statues of historical and contemporary figures like Rousseau, Casimir-Perrier and Delibes.

MARQUET, Alix 1875-
Born at Oudan, France, on January 8, 1875, he exhibited genre and portrait figures at the Salon des Artistes Français, winning numerous prizes, including a travelling scholarship in 1903 and third (1901), second class (1903) and first class (1905) medals. He became a Chevalier of the Légion d'Honneur in 1910.

MARQUET, René Paul 1875-
Born in Port Louis on July 5, 1875, he studied painting and sculpture under Emmanuel Fontaine and Jean Falguière respectively and exhibited figures at the Salon des Artistes Français, getting an honourable mention in 1909.

MARQUET DE VASSELOT, Anatole Comte 1840-1904
Born in Paris on June 16, 1840, he died in Neuilly in April 1904. He studied under Jouffroy and exhibited at the Salon from 1866 onwards, winning a third class medal in 1873 and a second class medal in 1876 for a bas-relief of Liszt. Later he turned to allegorical subjects, such as Inspiration, Poverty, Purity triumphing over the Vices and similar groups. He also sculpted busts and statuettes of biblical and contemporary figures, such as Corot, Balzac and Lamartine.

MARQUIS, Lucien fl. 19th century
Born in Brébières in the early 19th century, he specialised in portrait busts of his artistic contemporaries.

MARS-VALLETT, Marius fl. 19th-20th centuries
Born at Leinenc, France, in the mid-19th century, he worked in Paris and at Charmettes in Savoy. He exhibited at the Salon de la Société Nationale from 1897 to 1922 and specialised in medallions, bas-reliefs and statuettes of historical and contemporary personalities. He also sculpted the statue of Rousseau at Chambèry.

MARSCHALKO, Janos 1819-1877
Born at Hörse, Hungary, in 1819, he died in Budapest in 1877. He worked as a decorative sculptor in Budapest and sculpted statuary and friezes for public buildings, churches and palaces. His minor works include statuettes, busts and bas-reliefs portraying Hungarian artists, writers and poets.

MARSCHALL, Rudolf 1873-
Born in Vienna on December 3, 1873, he studied there and in Paris and became Director of the State School of Engineering, Vienna, in 1905. He produced portrait medallions, medals and bas-reliefs.

MARSHALL, William Calder 1813-1894
Born in Edinburgh on March 18, 1813, he died in London on June 16, 1894. He was educated at Edinburgh Academy and the Royal Academy schools (1834) and was a pupil of Chantrey and Baily. He won the Royal Academy silver medal and spent two years in Rome before settling in London as a classical sculptor. He exhibited at the Royal Academy from 1835 and was elected A.R.A. in 1844 and R.A. in 1852. He was also a member of the Royal Scottish Academy. He specialised in statues and groups, such as Sabrina (Liverpool Museum), The Prodigal Son (Tate Gallery) and Oenone (Sydney Museum).

MARSILI, Emilio fl. 19th century
Born in Venice on February 9, 1841, he specialised in portrait busts of contemporary Italian celebrities and exhibited in Turin, Venice and Rome. He won a bronze medal at the Exposition Universelle of 1889. The Gallery of Modern Art, Rome has his bronze group Sad Motherhood.

MARSON, Eugène Hippolyte fl. 19th century
Born in Troyes in the early 19th century, he studied under Moynet and Vendeuvre. He specialised in bas-reliefs and medallions portraying his contemporaries.

MARSTRAND, Julie 1882-
Born in Copenhagen on June 26, 1882, she specialised in busts of children.

MARTEGNANI, Alexandra fl. 19th century
Born in Milan in the early 19th century, she began exhibiting there in 1863 and later also in Turin and Naples. She specialised in figures and reliefs of saints and sculpted some of the decoration in Milan Cathedral.

MARTEL, Jan and Jöel 1896-
Twin brothers, born at Mollin, France, on March 5, 1896. They have exhibited figures, portraits and reliefs at the Salon des Indépendants, the Salon d'Automne and the Tuileries.

MARTENS, Jean Baptiste fl. 19th century
Born at Wonterghem, Belgium, in the early 19th century, he studied at the École des Beaux Arts, Paris, and exhibited figures at the Salon from 1861 to 1870.

MARTIGNY, Florent 1863-
Born in Marcy, France, on August 13, 1863, he studied under Fossé and exhibited figures and busts at the Salon des Artistes Français at the turn of the century.

MARTIN, Auguste 1828-1910
Born at Dun-le-Roi, France, on September 14, 1828, he died in 1910. He studied under Jouffroy and Rude and exhibited busts and statuettes at the Salon from 1852 to 1859. He specialised in statuettes of saints and biblical figures, many of which are in Bourges Museum, but also produced secular works, such as bathers and genre subjects. He also produced a number of portrait busts of his contemporaries.

MARTIN, Charles Marie Félix 1844-1916
Born in Neuilly on June 2, 1844, he died in Paris in 1916. He studied under Guillaume Duret, Loison and Cavelier and exhibited at the Salon from 1879. He became a Chevalier of the Legion d'Honneur in 1879. He specialised in bronze statuettes of French historical figures, many of which are in the museums of Rouen, Senlis and Evreux. His works include the statuette of Louis XI at Peronne and a bronze group portraying the Abbé de l'Epée.

MARTIN, Etienne 1913-
Born at Dröme in 1913, he has produced figurative and abstract works imbued with the mysticism of the East. He has exhibited his sculpture at the Salon de Mai.

MARTIN, François fl. 18th-19th centuries
Born in Grenoble in the mid-18th century, he died in Lyons in December 1804. He enrolled at the Grenoble School of Design in 1778 and was a close friend of Marat, whose portrait he sculpted, as well as those of other revolutionary figures. He produced allegorical figures and groups imbued with revolutionary fervour but later sculpted busts and statuettes of papal functionaries. The latter part of his life was spent in obscurity and great poverty.

MARTIN, Frank Graeme 1914
Born in Portsmouth, Hampshire, on December 27, 1914, he studied at the Portsmouth School of Art and the Royal Academy schools and became head of the sculpture department at St. Martin's School of Art, London. He now lives on Hayling Island, Hampshire, and sculpts figures and portraits in stone, wood, wrought metal and bronze.

MARTIN, Jacques Marie 1885-
Born in Marseilles on August 7, 1885, he studied under Coutan, Patey and Carli and exhibited figures at the Salon des Artistes Français, winning a medal in 1925.

MARTIN, Kenneth 1905-
Born in Sheffield on April 13, 1905, he studied at the Sheffield School of Art (1927-29) and the Royal College of Art (1929-32). He began exhibiting at the Leicester Galleries in 1936 and became a member in 1949, and had his first one-man show there in 1943. He now works in London as an abstract painter and sculptor specialising in constructions in bronze and steel.

MARTIN, L. fl. late 19th century
Sculptor working at Aix-en-Provence in the late 19th century. He exhibited statuettes at the Salon des Artistes Français and won a bronze medal at the Exposition of 1889.

MARTIN, Louis 1866-
Born at Aix-en-Provence on March 18, 1866, he studied under Jouffroy and Mercié and exhibited at the Paris Salon from 1875 to 1894, winning a third class medal in 1875 and a second class medal in 1881. He was awarded a bronze medal at the Exposition Universelle of 1889. He specialised in classical and historical statuettes, examples of which are in Aix Museum and Paris Town Hall.

MARTIN, Marie Auguste fl. late 19th century
Born at Dan-sur-Auron, France, in the mid-19th century, she studied under Rude and Jouffroy and became Associate Curator of Sens Museum, which has the main collection of her works. She specialised in genre groups, busts and bas-reliefs.

MARTIN, Mary Adela (née Balmford) 1907-
Born in Folkestone, Kent, on January 16, 1907, she studied at the Goldsmiths' College School of Art (1925-29) and the Royal College of Art (1929-32) and married her fellow student Kenneth Martin in 1930. Originally a painter of landscapes and still life, she turned to abstracts in 1950 and has also produced abstract sculpture. She has exhibited at the Leicester Galleries since 1932.

MARTIN, Milo 1893-
Born at Morges in the Swiss canton of Vaud on February 6, 1893, he exhibited figures and portraits at the Swiss Society of Painters and Sculptors in the first half of this century.

MARTIN, Priska von 1912-
Born in Fribourg, Switzerland in 1912, the daughter of the eminent sociologist Alfred von Martin. She studied under Fernand Léger in Paris and later attended classes at the Munich Academy under Wackerle. She married the sculptor Toni Stadler in 1942 and now lives in Munich, which awarded her its civic cultural prize in 1958. She has taken part in major national and international exhibitions since the second world war, notably the Middelheim exhibitions. She specialises in animal figures, mainly cast in bronze by the *cire perdue* process.

MARTIN, Raymond fl. 20th century
Born in Paris in the late 19th century, he collaborated with Wlérick on the equestrian statue of Marshal Foch at the Palais de Chaillot. He has exhibited animal and human figures and equestrian subjects at the Salon d'Automne and the Salon des Tuileries.

MARTIN, Raymonde 1887-
Born in Marseilles on January 15, 1887, she studied under Marqueste and exhibited figures at the Salon des Artistes Français from 1913 onwards, winning the Longchamps Prize in 1920.

MARTIN-HANSEN, Carl 1877-
Born in Kolding, Denmark, on July 8, 1877, he did many statues in that neighbourhood. He also modelled figures for the Royal Copenhagen porcelain factory.

MARTIN-LAUREL, Eugène fl. 19th century
Spanish sculptress of French origin, working in Madrid in the mid-19th century. She specialised in genre and biblical figures in plaster and bronze.

MARTIN Y RIESCO, Elias 1839-1910
Born in Aranjuez, Spain, on July 20, 1839, he died in Madrid in 1910. He studied under Sabino de Medina and became President of the Academy of San Fernando. He produced statuary and decorative sculpture for public buildings and squares in Madrid.

MARTINCOURT fl. 18th century
Associate Professor of Sculpture at the Académie de St. Luc from 1764, he was a bronze-founder as well as a sculptor and produced statuettes and decorative articles such as the pair of magnificent candelabra in the Wallace Collection, London.

MARTINELLI, Jeno 1886-
Born in Budapest on October 3, 1886, he studied under Loranfi and Radnai and specialised in portrait busts and memorials. Examples of his work are in the New Gallery, Budapest.

MARTINET, Aimé Achille fl. late 19th century
Born in Paris, he studied under Gautherin and Echerac and exhibited figures and busts at the Salon from 1880 onwards.

MARTINET, Henri 1893-
Born at Bercenay-le-Hayer, France, in 1893, he studied under Coutan and exhibited portrait busts at the Salon des Artistes Décorateurs (1921-), the Indépendants (from 1922), the Salon d'Automne in 1923 and the Tuileries since 1926. His bust of François Pompon (1933) is in the Museum of Modern Art, Paris.

MARTINEZ, Gaetano 1892-
Born at Galatina, Italy, in 1892, he worked in Rome. Examples of his figures and groups are in the Gallery of Modern Art in Rome.

MARTINEZ, Prospero 1885-
Born in Caracas, Venezuela, in 1885, he studied painting and sculpture under Emilio Maury and Herrera Toro. He was awarded first

prize for sculpture at the Venezuelan Academy of Fine Arts in 1908 and was a founder member of the Circle of Fine Arts.

MARTINEZ TORREZ, Ricardo 1892-
Born in Valencia, Spain, in 1892, he is a writer and sculptor of figures and portraits.

MARTINI, Arturo 1889-1947
Born in Treviso, Italy, in 1889, he died in Milan in 1947. He studied ceramics in Faenza and worked originally as a potter but turned to sculpture in 1905 and went to Paris in 1907 and 1911 to study. He attended the nude classes at the Venice Academy and studied under Adolf Hildebrand in Munich in 1909. He served in the Italian Army during the first world war and had his first one-man show in Milan in 1920. After the war he worked in Rome, where he belonged to the Valori Plastici group. Later he moved to Vado Ligure, near Genoa. His early ceramic training influenced his work and much of his sculpture was executed in terra cotta. His style, which derives from Etruscan statuary and Roman classicism, has exerted considerable influence in Italy. His bronzes include The Gypsy (1934), Heroic Group (1935), Cow, and Rape of the Sabine Women (both 1940).

MARTINI, Quinto 1908-
Born at Seano, near Florence, in 1908, he has produced genre bronzes, such as The Cook.

MARTINI, Wilhelm 1880-
Born in Bielefeld, Germany, on April 30, 1880, he studied at the Düsseldorf Academy and worked in that city. He is best known for the public fountain in Gelsenkirchen. His figure of Death is in the Düsseldorf Museum.

MARTINIE, Berthe fl. early 20th century
Born at Nérac in the late 19th century, she exhibited animal paintings and sculpture at the Salon des Tuileries and the Salon d'Automne. Her Foal is in the Museum of Modern Art, Paris.

MARTINO, Giovanni de 1870-
Born in Naples on January 3, 1870, he became a member of the Institute of Fine Arts, Naples. Examples of his figures and portrait sculpture are in the Gallery of Modern Art in Rome.

MARTINO, Michele 1889-
Born in Alvignano, Italy, on February 22, 1889, he emigrated to the United States and studied under Lee Lawrie and Henry Hudson Kitson and taught sculpture at the Strong School in New Haven.

MARTINOLI, Silverio fl. 19th century
Born at Bederio Valcalia, Italy, in the mid-19th century, he exhibited figures in Naples and Milan from 1877 onwards.

MARTINS, Maria (known as 'Maria') 1906-
Born in Campanha, central Brazil, in 1906, she studied music in Petropolis and Paris and intended originally to have a career as a concert pianist. She took up painting and then wood-carving and turned to ceramics while living in Japan in 1936-39. She visited Brussels in 1939 and, on the advice of Oscar Jespers, began to concentrate on sculpture. She moved to Washington, D.C. and had her first exhibition there in 1940. Six years later she exhibited at the Museum of Modern Art, New York, her works being largely inspired by her travels in the Amazonian forests. She had her first European exhibition in Paris in 1949 at the Galerie René Drouin and has since had many exhibitions in both Paris and New York. She also took part in the Surrealist Exhibition at the Galerie Maeght (1947) and now lives in Rio de Janeiro. Her bronzes include I dreamed for a long time that I was Free (1945), Prometheus (1950) and Ritual of Rhythm (1958).

MARTINY, Philip 1858-
Born in Alsace on May 10, 1858, he emigrated to the United States and settled in New York, where he studied under Eugene Dock and Augustus Saint-Gaudens. He specialised in medallions, bas-reliefs and plaques, but his larger works include the bronze door of St. Bartholomew's Church, New York, and the Jersey City war memorial.

MARUCELLI, Angelo (known as 'Canapino') fl. 19th century
Ecclesiastical sculptor working in Florence, where he died in 1889. Many of his works are in Florence Cathedral.

MARVAL, Jacqueline 1866-1932
Born at Quaix, France, in 1866, she died in Grenoble in 1932. She studied under the painter E. Flandrin and eventually married him. She worked as a painter, lithographer and sculptor of genre subjects and exhibited at the Salon d'Automne, the Nationale and the Tuileries in the early years of this century.

MARX, Maurice Roger 1872-
Born at Fontainebleau on April 1, 1872, he studied under Barrias and exhibited at the Salon des Artistes Français, winning third class (1901), second class (1904) and first class (1921) medals. He was a Chevalier of the Légion d'Honneur. He specialised in genre and animalier figures and groups in marble and bronze. His figure The First Tooth is in the Luxembourg Museum.

MARX-VALLET, Marius 1867-
Born in Chambéry in 1867, he worked in Paris as a portrait sculptor. His chief work is the monument to the Archbishop of Chambéry (1892).

MARYE, Simone fl. 20th century
Born in Paris, where she worked as an Animalier before the second world war. She exhibited figures of animals and birds, many in gilt-bronze, at the Salon des Indépendants, the Salon d'Automne and the Tuileries from 1926 onwards.

MARYON, Edith fl. 19th-20th centuries
English sculptress of neo-classical bronze statuettes, active at the turn of the century. She exhibited at the Royal Academy from 1899 onwards and her works are in various public collections, notably the Liverpool Art Gallery.

MARZAROLI, Cristoforo 1836-1871
Born in Salsomaggiore, Italy, in 1836, he died in Parma on February 23, 1871. He worked as a decorative sculptor in the Parma area, but also produced portrait busts, genre figures and biblical groups, examples of which are preserved in the Parma Gallery and the Parma History Museum.

MARZOLFF, Alfred 1867-
Born in Strasbourg in 1867, he studied under W. von Rümann in Munich and exhibited at the Salon des Artistes Français at the turn of the century, getting an honourable mention in 1893. He produced portrait busts of his contemporaries, genre and neo-classical figures, such as The Archer, and projects for a Marseillaise monument.

MASCARELLI 1835-1896
Born in Nice in 1835, he died in Italy in 1896. He specialised in portrait busts and figures and groups of Italian contemporary and historic figures. His best known work is the group showing Garibaldi at Aspremonte (Nice Museum).

MASCHERINI, Marcello 1906-
Born in Udine, Italy, in 1906, he studied in Trieste and took part in the main Italian exhibitions since 1931, including the Venice Biennale, the Milan Triennale and the Rome Quadrennale. He has also had numerous one-man shows in Italy and abroad. For some years now he has been striving to give his work its definitive aspect, combining elegance of form with the irony of movement to produce a delicate sensuality. His bronzes include Awakening of Spring (1954), Rhythms (1955), Kneeling Woman (1957), Woman Bather (1957), Faun (1958), Sappho (1960), Corrida (1960) and Chimera (1960).

MASCRÉ, Louis 1871-1929
Born in Brussels on June 21, 1871, he died there on October 15, 1929. He won the Grand Prix of the Brussels Academy in 1898 and was runner-up in the Prix de Rome in 1903. He produced portrait busts of Belgian royalty and political figures, genre groups such as The Kiss, and various medallions and plaques.

MASELLI, Giacomo 1883-
Born at Cutrofiano, Italy, in 1883, he studied at the Academy of Fine Arts in Bologna and sculpted figures and decorative groups in that city.

MASEREEL, Frans 1882-1972
Belgian sculptor of portraits and genre subjects, working mainly in wood.

MASI, Tommaso fl. early 19th century
Ecclesiastical sculptor who worked on the decoration of Pisa Cathedral in the early 19th century. He also sculpted memorials and portrait medallions.

MASINI, Girolamo 1840-1885
Born in Florence on December 29, 1840, he died there in 1885. He studied under Costoli and exhibited in Turin, Milan, Bologna and Carrara. The Museum of Modern Art in Rome has his figure of Fabiola.

MASKOS, Fritz 1896-
Born in Dresden on July 8, 1896, he produced portrait busts and heads of his artistic and literary contemporaries, and genre figures and groups, such as Mother and Child, and The Dreamer.

MASSARENTI, Alessandro fl. 19th century
Portrait sculptor working in Ravenna in the second half of the 19th century. He specialised in busts of theatrical personalities and exhibited in Naples, Milan, Rome, Turin and Venice in the 1880s.

MASSARI, Bernardino 1827-1913
Born in Piacenza in 1827, he died there in 1913. He executed figures of saints and biblical subjects for the churches in Piacenza.

MASSAU, P. Félix fl. 19th-20th centuries
Born in Lyons in the mid-19th century, he won a travelling scholarship in 1879 and exhibited figures and groups at the Salon des Artistes Français at the turn of the century. He was awarded a silver medal at the Exposition Universelle of 1900 and the Légion d'Honneur in 1907.

MASSON, Auguste Jean 1802-1870
Born in Paris on April 6, 1802, he died towards the end of 1870. He studied under the Famières Brothers and exhibited portrait medallions and busts at the Salon from 1842 till his death.

MASSON, Clovis Edmond 1838-1913
Born in Paris on March 7, 1838, he died there in 1913. He studied under Santiago, Barye and Rouillard and exhibited at the Salon from 1867 to 1881 and subsequently at the Salon des Artistes Français, winning an honourable mention in 1890. He was an Animalier, best known for his group Goats at Market (Château-Thierry Museum).

MASSON, François 1745-1807
Born at Vielle-Lyre, France, in 1745, he died in Paris on December 18, 1807. He studied under Guillaume Coustou and exhibited at the Salon from 1793. He worked as a decorative sculptor in Metz, but also executed monumental statuary in Paris, notably the tombs of Vauban (Les Invalides) and Rousseau. His minor works include small allegorical groups and statuettes, such as Flora, and portrait busts of Napoleon and his Court.

MASSON, Jean Augustin Alfred fl. 19th century
Born at Palaiseau in the early 19th century, he died in Paris in 1897. He studied under Bonnassieux and Delorme and exhibited portrait busts at the Salons from 1866 to 1895.

MASSON, Jules Edmond 1871-
Born in Paris on June 3, 1871, he was the son and pupil of Clovis Masson. He exhibited at the Salon des Artistes Français and gained an honourable mention in 1890 and medals in 1922 and 1928. He specialised in bas-reliefs and medallions.

MASSON, Sebastian 1817-1881
Born in Rheims on January 24, 1817, he died at Châlons-sur-Marne on October 29, 1881. He exhibited at the Salon from 1866-1870 and specialised in busts and statuettes, many of which are preserved in the museums of Rheims and Châlons.

MASSOULE, André Paul Arthur 1851-1901
Born in Epernay on November 5, 1851, he died in Paris on June 19, 1901. He studied under Salmson and Cavelier and exhibited busts and medallions at the Salon in 1878-81. He also sculpted two allegorical bronzes for the Pont Alexandre III.

MAST, Louis Jean 1857-1901
Born in Ghent, Belgium, on August 21, 1857, he died there on July 15, 1901. He exhibited in Brussels and Paris and specialised in portrait busts of Belgian royalty and contemporary celebrities, as well as genre figures and groups. His chief work is The Wounded Gladiator in the Place du Comte de Flandre, Ghent.

MASTRODONATO, Luigi fl. 19th century
Born in Naples on June 17, 1846, he specialised in ornamental figures and bas-reliefs for interior decoration.

MASTROIANNI, Umberto 1910-
Born at Fontana Liri, near Rome, on September 21, 1910, he was a child prodigy descended from a long line of famous artists. He was influenced by the art of Greece and the Etruscans and began sculpting at a very early age. In 1926 he settled in Turin and had his first one man show at the age of 21 in Genoa. Since then he has had many others, and also participated in the major national and international exhibitions, from the Venice Biennale of 1940 to the Brussels Exhibition of Fine Arts in 1957. He lives in a sculpturally designed house in Turin, often attributed to him but actually designed by the architect Enzo Venturelli. He is a leading exponent of the geometric approach to abstract sculpture. Though he prefers to carve direct in marble he has also worked in metal and his bronzes include Rhythm (1955), Martyrdom (1956), Winged Apparition (1957), Cavalcade and Solomon (both 1959). His best known work is the colossal monument dedicated to the Resistance Partisans of Cuneo, the commission for which he won in open competition in 1945.

MATABON, Charles fl. 19th century
Born in Lyons in the early 19th century, he died in Paris in May 1887. He studied under Duret, Bontour and Caillouette and exhibited figures at the Salon from 1864 onwards.

MATAOANU, D. 1888-1929
Born at Campulung, Romania, in 1888, he died in Bucharest in 1929. He studied in Bucharest and Paris and specialised in busts and neo-classical statuary.

MATARÉ, Ewald 1887-
Born in Aachen, he studied painting under Corinth and did not take up sculpture till 1920, when he began carving in wood. He lived in Berlin till 1931 but then moved to Düsseldorf where he taught art until dismissed by the Nazis. He was re-instated in 1946. Recognition came after the war, and in 1953 a retrospective exhibition of his work was held in the Hamburg Museum of Arts and Crafts. The following year he won the gold medal of the Mainz Triennial and since then has taken part in all the major German exhibitions, especially the Cassel Documenta exhibitions of 1955 and 1959. Mataré is first and foremost an Animalier in the modern idiom, following the tradition of Pompon. Although finely polished wood continued to be his chief medium he has also carved figures of animals in stone and cast them in bronze. During the lean years of the Third Reich he worked as a metal craftsman and executed numerous commissions for church plate, door handles and knobs, candelabra, fonts and medallions. He has continued to produce ecclesiastical sculpture and metalwork since the war, notably the tripartite bronze door of the south portal of Cologne Cathedral (1954) and bronze doors for the memorial chapel in Hiroshima and churches in Aachen and Salzburg. His other major works in bronze include the Cleves war memorial, the Stephan Lochner fountain for the Wallraf-Richartz Museum in Cologne and the colossal figure of the Sphinx for the Düsseldorf provincial parliament building.

MATARÉ, Josef 1880-
Born in Aachen on March 19, 1880, the brother of Ewald. He studied under von Rümann, Raup and Corinth and worked as a painter and sculptor in Aachen, where the museum has examples of his work.

MATELLI, Metello fl. late 19th century
Milanese sculptor of portraits and genre figures, active in the late 19th century.

MATHÉ, Vassily 1856-1917
Born at Wirballen, Russian Poland, on February 23, 1856, he died in St. Petersburg on April 9, 1917. He studied at the School of Design and the Academy in St. Petersburg and won a travelling scholarship which enabled him to continue his studies in Paris in 1880-83. He studied there under Pannemaker and Ferdinand Gaillard. He is best known as a medallic engraver but also sculpted historical and allegorical reliefs.

MATHET, Louis Dominique fl. 19th-20th centuries
Born at Tarbes, France, in the mid-19th century, he studied under A. Dumont and exhibited at the Salon des Artistes Français from 1884 to 1914. He was elected an Associate and got an honourable mention in 1887 and won a third class (1888) and second class (1890) medals. At the Expositions Universelles of 1889 and 1900 he was awarded bronze and silver medals respectively. He specialised in genre and allegorical figures and groups, such as Hesitation, The First Prayer, Oreade the Mountain Nymph. His works are represented in the collections of the museums of Amiens, Avignon and Tarbes.

MATHEY, Georges 1887-1915
Born at Crèches-sur-Saone on May 15, 1887, he was killed in action on the Western Front. He studied under Injalbert and Hannaux and exhibited figures at the Salon des Artistes Français, winning a medal in 1911. He was runner-up in the Prix de Rome of 1909.

MATHIEU, Charles J.M. 1876-
Born at Monesquieu-Lauraguais, France, on May 7, 1876, he studied under Falguière and Mercié and exhibited figures and groups at the Salon des Artistes Français, winning a third class medal in 1900.

MATHIEU, Justin 1796-1864
Born at St. Justin in 1796, he died in Paris in 1864. He produced neo-classical figures and bas-reliefs and exhibited at the Salon from 1846 to 1861, winning a third class medal in 1851. His bas-relief of The Foundations of Marxile is in the Nice Museum.

MATHIEU, Justin fl. 19th century
Born at St. Justin in the early 19th century, he was the son and pupil of Justin Mathieu. He exhibited figures and bas-reliefs at the Salon in 1855 and 1857.

MATHIEU-MEUSNIER, Roland 1824-1876
Born in Paris on April 1, 1824, he died there on January 31, 1876. He studied under Dumont and C. Desains at the École des Beaux Arts and exhibited at the Salon from 1843, winning a third class medal in 1844. He specialised in portrait busts and medallions of his contemporaries, mainly in marble and stone. He also sculpted a number of statuettes of saints and historical personalities.

MATHON, Edmund Constant 1835-1891
Born in Arras in 1835, he died there in 1891. Arras Museum has various busts and profiles by him in terra cotta. His bronzes include such genre figures as Young Bather and Reaper.

MATISSE, Henri 1869-1954
Born at Cateau-Cambrésis, France, on December 31, 1869, he died in Nice on November 3, 1954. His career as a sculptor has been overshadowed by his work as a painter, but though he is best known as the leader of the Fauvist school of painting he also executed almost 70 bronze sculptures from 1899 onwards. Curiously enough, this artist, whose paintings emphasised colour and virtually ignored volume, was one of the great masters of three-dimensional art. He was influenced by Rodin and later by Maillol, with whom he collaborated in 1905. Subsequently his work became more Expressive, typified by Serpentine (1909), but this was followed by increasing severity and conciseness, as shown in the series of Backs from 1909 to 1929 and culminated in the stark Venus with Shell of 1930. He abandoned sculpture three years later and thereafter concentrated on the development of his painting. He sculpted numerous heads of women and little girls between 1908 and 1933, often derived from the culture of other lands, from Negro to Polynesian art. His bronzes include Jaguar Eating a Hare (1899), The Horse (1901), Madeleine, The Slave (both 1903), Negresses (1908), Reclining Nude (1907), Torso (1906), Heads of Jeannette (1910-13), Small Torso (1929) and Tiaré (1930). His last work in this medium was the crucifix for the chapel at Vence (1950).
Basler, A. *Henri Matisse* (1924). Faure, E. *Henri Matisse* (1920). Sembat, Marcel *Henri Matisse: une étude critique* (1920).

MATISSE, Jean Gérard 1899-
Born in Toulouse on January 10, 1899, he worked originally as a painter but turned to sculpture and specialised in memorials and monumental statuary. His best-known work is the fountain Femmes à la Coquille. His exhibited figures and groups at the Salon des Indépendants and the Salon d'Automne.

MATRAI, Lajos 1875-
Born in Budapest in 1875, he studied there and in Paris and collaborated with his father L.G. Matrai, on monuments in Schweidel and Szeged.

MATRAI, Lajos Gyorgy 1850-1906
Born in Budapest on March 6, 1850, he died there on October 15, 1906. He studied in Vienna and Paris and sculpted numerous memorials, fountains and monuments in Györ, Sopron, Szeged and Budapest, his best known work being the tomb of the sculptor Izso in Budapest. His minor works include busts and relief portraits of his contemporaries.

MATTE, Nicolas Augustin 1781-1837
Born in Paris in 1781, he died there in May 1837. He studied under Monot and Dejoux and was runner-up in the Prix de Rome of 1807. He exhibited at the Salon from 1810 to 1835 and won a second class medal in 1817. He specialised in portrait busts, mainly in marble.

MATTEIS, Francesco de fl. 19th century
Born at Lecca, Italy, on February 25, 1852, he worked in Naples and specialised in small bronze groups and statuettes of people in national costume, from Neapolitan singers to Bulgarian peasants and Spanish bull-fighters. He exhibited in Turin and Venice from 1884 onwards.

MATTELIN, Maurice de fl. 19th-20th centuries
Born at Lintigny, Belgium, on July 31, 1854, he studied under Drion and specialised in bronze figures, notably the statues in gilt-bronze for the Head Post Office and the University of Liège.

MATTHAI, Ernest 1779-1842
Born in Meissen on June 14, 1779, he died in Dresden on April 19, 1842. He studied in Rome under Thorvaldsen (1805-17) and produced neo-classical figures and groups, notably the Venus for Rothenstein Castle near Stuttgart.

MATTHAI, Johann Gottlob 1753-1832
Born in Meissen on July 17, 1753, he died in Dresden on June 4, 1832. From 1779 onwards he was employed as a modeller of statuettes, bas-reliefs and portrait busts at the Meissen porcelain works. Some of his figurines were also reproduced in bronze.

MATTHEW, Charles fl. 19th century
English portrait sculptor of the mid-19th century, examples of whose bas-reliefs are in the National Portrait Gallery.

MATTHEWS, Anna Lou fl. 20th century
Born in Chicago, she studied at the Art Institute under Lorado Taf and then attended classes at the École des Beaux Arts, Paris, unde Simon, Max Bohn and Garrido, and worked with Sir Frank Brangwyn in London.

MATTHIÄ, Wilhelm 1807-1888
Born in Berlin in 1807, he died in Rome on February 24, 1888. He studied under Thorvaldsen and specialised in portrait busts, especially of historical musical celebrities.

MATTON, Arsène 1873-
Born at Harlebeke, Belgium, on December 15, 1873, he studied in Brussels and worked in the Congo, where he specialised in medallions and bas-reliefs.

MATTON, Ida 1863-
Born in Gèfle, France, on February 24, 1863, she studied in Paris and settled there. She exhibited busts and groups of historical subjects at the Salon des Artistes Français, getting an honourable mention in 1896. Much of her portrait work was done in Sweden in the early years of this century.

MATTUCCI, Luigi fl. late 19th century
Born in Florence in the mid-19th century, he exhibited figures and portraits in Naples, Milan and Turin in the last quarter of the century.

MATVEËVICH, Mardoukh Matysovich Antokolski 1843-1902
(known as 'Mark')
Russian sculptor, best known for his colossal marble statues of Peter the Great and Ivan the Terrible. His minor works, in bronze as well as marble, include numerous figures and groups depicting pagan, Jewish and Christian martyrs.

MATVEIEFF, Alexander Terentjevich 1878-
Born in Saratov, Russia, on August 13, 1878, he studied under Prince Paul Trubetzkoy and became professor of sculpture at the Academy of Fine Arts, Petrograd (1918). He worked mainly in pottery and porcelain. He abandoned his earlier Impressionism and evolved his own monumental style, influenced by Maillol.

MATZDORF, Paul 1864-
Born at Altrüdnitz, Germany on March 7, 1864, he specialised in medallions and bas-reliefs.

MATZEN, Hermann N. 1861-
Born in Denmark on July 15, 1861, he studied at the academies of Berlin and Munich and later emigrated to the United States, working in Cléveland, Ohio. He produced numerous busts, and statues of historic personalities, as well as allegorical and classical figures, such as Law and Justice, War and Peace, Moses and Gregory the Great.

MAUBERT, Louis 1875-
Born in Toulon on May 18, 1875, he studied under Barrias and Puech and exhibited figures at the Salon des Artistes Français at the turn of the century.

MAUCH, Max von 1864-1905
Born in Vienna on February 6, 1864, he died in Chicago on February 15, 1905. He settled in New York in 1891, but went to Chicago two years later and worked with Karl Bitter on the decorative sculpture for the Columbian Exposition. Later he collaborated with Bell on a number of allegorical works and monuments.

MAUDE, Alice C. (Mrs. Stewart) 1879-
Born in Horsmonden, Kent, in 1879, she studied at the Chelsea, Lambeth and Hammersmith Schools of Art and the Central School of Arts and Crafts. She exhibited paintings, etchings and sculpture at the Royal Academy and various provincial galleries and worked in Swanage, Dorset.

MAUDER, Josef 1854-1920
Born in Prague, on December 1, 1854, he died there on November 15, 1920. Many of his works are preserved in the Prague Modern Gallery.

MAUER, Hans 1879-
Born in Vienna on February 28, 1879, he specialised in heads and busts of German and Austrian cultural celebrities and royalty. He sculpted the decoration for the Schubert Festival at Graz in 1907.

MAUGENDRE-VILLERS, Édouard fl. 19th-20th centuries
Born at Gournay-en-Bray in the mid-19th century, he studied under Dumont and exhibited figures at the Salon from 1879 to 1921.

MAUGSH, Gyula 1882-
Born at Neusohl (now Besztercebanya, Hungary) on June 1, 1882, he was an Animalier specialising in zoological sculpture. His works include the group of Lions at Budapest Zoo and Elephants at the Water-hole (Budapest Museum). He also sculpted the war memorial at Tapolea.

MAULMONT, Marcel de 1882-c.1916
Born in Perigueux on August 4, 1882, he was killed in action during the first world war. He studied under Injalbert and won an honourable mention at the Salon des Artistes Français in 1914.

MAUQUOY, Alphonse 1880-
Born in Antwerp on October 28, 1880, he studied under Thomas Vincotte and specialised in memorials, notably the war memorials at Westmalle and Louvain University. His minor works include patriotic bronzes, such as Defence of the Fatherland (1922).

MAURACHER, Hans 1885-
Born at Kaltenbach, Tyrol, on July 1, 1885, he specialised in busts of Austrian personalities.

MAURETTE, Henri Marie 1834-1898
Born in Toulouse on September 21, 1834, he died there on June 6, 1898. He studied under Duret and Jouffroy and was appointed professor of sculpture at the École des Beaux Arts. He exhibited genre figures at the Salon from 1861 to 1873, in marble and bronze.

MAURS, Richards 1888-
Born in Riga, Latvia, on January 13, 1888, he studied under August Volz in Riga and H. Engelhardt in Berlin. He worked mainly as a wood-carver and examples of his sculpture are in various Riga museums.

MAUSKE, Paul 1871-
Born in Küstrin, Germany, on June 14, 1871, he studied in New York and worked in Berlin. His best known work is the marble Christ in the Evangelical House, Potsdam

MAX, Emmanuel, Ritter von Wachstein 1810-1901
Born at Bürgstein, Tyrol, on October 19, 1810, he died in Prague on February 22, 1901. He studied under Bergler, Waldherr, Führich and Kupelwieser and won a travelling scholarship to Rome in 1847. He settled in Prague three years later and received many public commissions in Bohemia. He was raised to the nobility in 1896. He specialised in busts and statues of historic personalities, mainly in marble, though bronze reductions and casts of his maquettes are known.

MAX, Joseph Calasanza 1804-1855
Born at Bürgstein on January 16, 1804, he died in Prague on June 18, 1855. He sculpted numerous statues and memorials, and is best remembered for the series of eight warriors on the Radetzky Monument in Prague. His statue of Radetzky was edited as a bronze reduction.

MAX, Joseph Franz 1765-1838
Born in Bürgstein in 1765, he died there on October 7, 1838. He produced memorials and portrait busts in the Tyrol, and was the father of Emmanuel and J.C. Max.

MAX-CLAUDET fl. 19th century
Born at Fécamp, he died in Salins, France, on May 28, 1893. He studied under Darbois at the École des Beaux Arts, Dijon, and then went to Paris, where he studied under Jouffroy and worked in the studio of Perrault. He travelled in Spain, Italy and Algeria before settling in Salins. He was a painter, ceramic modeller and portrait sculptor, and also wrote a treatise on modelling and biographies of Perrault and Coubret. As a sculptor, his chief work is the statue of a Vineyard-worker in Salins market place. His minor works, including bronzes, are in the museums of Lons and Geneva.

MAXWELL, Coralee Delong 1878-
Born in Ohio on September 13, 1878, she studied under Herman Matzen and became a member of the American Federation of Arts. She produced portraits and genre figures.

MAY, Beulah 1883-
Born in Hiawatha, U.S.A., on June 26, 1883, she worked as a portrait and figure sculptress in Santa Ana, California.

MAY, Karl 1884-
Born in Frauenaurach, Germany, on January 31, 1884, he studied under Edwin Kurz and specialised in memorials and monumental statuary. He produced a number of allegorical war memorials in the 1920s.

MAY, William Charles 1853-1931
Born in Reading, Berkshire, in 1853, he died in London on December 28, 1931. He studied at the Royal Academy schools and was a pupil of R. Monti in Paris. He exhibited at the Royal Academy from 1875 to 1894 and produced numerous classical and genre figures as well as busts of his contemporaries. His works include the memorial to the Hon. C.S. Rolls (1911) and the bronze group The Vision of St. Cecilia (Reading Museum).

MAYER, Éduard 1812-1881
Born in Trier on August 17, 1812, he died at Aibling, Bavaria, on October 12, 1881. He studied under Rietschel in Dresden and Rauch in Berlin before going to Paris, where he was a pupil of David d'Angers (1840-42). He exhibited at the Paris Salon of 1841 and the following year went on to Rome, where he completed his studies before settling in Aibling. He specialised in allegorical works, such as Science and Industry, and classical groups, such as Mercury slaying Argus.

MAYER, Eduard 1857-1908
Born in Vienna in 1857, he died in Budapest on March 10, 1908. He studied under König and Zumbusch and sculpted neo-classical figures and groups.

MAYER, Emil 1880-
Born in Cannstadt, Germany, on February 10, 1880 he studied under Donndorf and von Rümann and worked in Stuttgart.

MAYER, Ernst 1776-1844
Born in Ludwigsburg, Bavaria, on June 24, 1776, he died in Munich on January 22, 1844. He studied under Isopi and worked with Thorvaldsen from 1821 to 1825. He specialised in bas-reliefs and colossal statuary of classical subjects.

MAYER, Josef Gabriel 1808-1883
Born at Gebrazhofen, Bavaria, on March 18, 1808, he died in Munich on April 16, 1883. He produced memorials, statues and portrait busts, mainly in the Munich area.

MAYER, Louis 1869-
Born in Milwaukee, Wisconsin, on November 26, 1869, he studied under Benjamin Constant and J.P. Laurens in Paris and under Max Thedy in Weimar and P. Höckes in Munich. He worked as a painter and sculptor in New York, specialising in bronze portrait reliefs, busts and heads of contemporary and historical figures, including Abraham Lincoln, Julia Lindemann and Eliot Norton. Examples of his work are in the Art Institute of Milwaukee and the National Museum, Washington.

MAYER, Nicolas fl. 19th-20th centuries
Born in Paris in the mid-19th century, he studied under Cordier and exhibited genre and allegorical figures at the Salon des Artistes Francais, getting an honourable mention in 1887 and becoming an Associate in 1904. His group The Dream is in Roanne Museum.

MAYER, Rudolf 1846-1916
Born in Niedeck, Silesia, on June 12, 1846, he died in Karlsruhe on June 24, 1916. He studied under Otto König in Vienna and became professor at the School of Industrial Arts, Karlsruhe. He specialised in portrait reliefs and medals.

MAYER-FASSOLD, Eugen 1893-
Born in Munich on July 19, 1893, he studied under H. Hahn and sculpted figures and portraits in Bavaria.

MAYERHOFER, Johannes 1859-1925
Born in Baden, near Vienna, on November 14, 1859, he died in Vienna on April 9, 1925. He studied at the Vienna Academy and worked as a painter, illustrator, medallic engraver and decorative sculptor, specialising in religious subjects.

MAYERL, Adolf 1884-
Born at Eger, Austria, on August 28, 1884, he specialised in busts and statuettes of contemporary personalities. He also sculpted statues of the Kaiser Franz Josef for Metzling and Gablonz (now Jablonec in Czechoslovakia).

MAYOR, Harriet Hyatt 1868-
Born in Salem, Massachusetts, on April 25, 1868, she studied under Henry Hudson Kitson and Dennis Bunker at Cowles Art School in Boston. She taught modelling at Miss Fine's School in Princeton, New Jersey, and was a member of the American Federation of Arts. She won a silver medal at the Atlanta Exhibition, 1895, and specialised in commemorative medals and plaques. She also sculpted bronze busts of her distinguished contemporaries.

MAYR, Franz 1866-1920
Born in Munich in 1866, he died there on August 4, 1920. He produced genre and classical figures and portrait sculpture.

MAZAROZ, Jean Paul fl. 19th century
Born at Lons-le-Saunier on December 6, 1823, he was a sculptor and art critic. His works in Lons Museum include a study of a Head, Angel with a Book and The Four Seasons.

MAZETTI, Joseph Bernard fl. 18th-19th centuries
Born in Avignon in the mid-18th century, he died there on September 19, 1828. He specialised in portrait busts of his contemporaries.

MAZILIER, Carmen 1891-
Born in Buenos Aires on May 6, 1891, she studied under Marqueste in Paris and became a naturalised Frenchwoman. She exhibited statuettes at the Salon des Artistes Français in the 1920s.

MAZUR, Vladislav 1874-
Born at Jaslo, Poland, on May 3, 1874, he studied at the Vienna Academy before emigrating to the United States, settling in Cincinnati. He produced portrait busts and genre statuettes, examples of which are in museums in Ohio and Cracow.

MAZZACURATI, Marino 1908-
Italian sculptor of memorials and monuments, notably The Four Days of Naples and the Monument to the Resistance at Parma (1955). He was born at Gallina near Bologna and studied at the Academy of Fine Arts, Rome, under Scipione and Mafai. He now works in Paris.

MAZZEI, Corrado Alberto 1885-
Born in Carrara, Italy on January 9, 1885, he belonged to a Futurist group in Berlin (1913) but moved to Paris a year later and settled there. He exhibited at the Salon d'Automne since 1919, the Indépendants from 1920 and the Nationale from 1927. Though better known as an Animalier, his figure of The Sleeper, shown at the Salon d'Automne in 1946, aroused considerable interest.

MAZZOTTI, Pellegrino 1785-1870
Italian sculptor of portrait busts and neo-classical figures.

MAZZUCHELLI, Alfonso fl. 19th century
Born in Milan in the first half of the 19th century, he exhibited figures in Milan, Turin and Venice.

MAZZULLO, Giuseppe 1913-
Born at Graniti, near Messina, Italy in 1913, he studied at the Perugia Academy and has had numerous one-man shows in Italy since 1945. He has taken part in all the principal Italian art events and now lives in Rome. His bronzes include female figures such as Woman Jumping (1957).

MEAD, Larkin Goldsmith 1835-1910
Born in Chesterfield, Derbyshire, on January 3, 1835, he died in Florence on October 15, 1910. He studied under Brown (1853-55) and went to Florence in 1862. Many of his works were destined for the United States and include the allegorical figure of the Mississippi in Minneapolis and the Lincoln Monument in Springfield.

MEADMORE, Clement 1929-
Born in Melbourne in 1929, he has sculpted memorials, portrait busts and statuary in Australia since the second world war.

MEADOWS, Bernard 1915-
Born in Norwich on February 19, 1915, he studied at Norwich School of Art (1934-36), and the Royal College of Art (1938-40 and 1946-48). He also worked in the studio of Henry Moore and served in the Royal Air Force during the second world war. He had his first one-man show at Gimpel Fils in 1957, and has exhibited internationally since the Venice Biennale of 1952. He taught at the Chelsea School of Art from 1948 to 1960 and is now professor of sculpture at the Royal College of Art. His commissions have included a bronze for Hertfordshire County Council (1954) and a large group for the Trades Union Congress building in London (1958). His minor bronzes include Surrealist figures of birds, insects, animals, marine life and vegetation.

MEARES, Gerald A. 1911-
Born in Woodford, Essex, in 1911, he studied at the Regent Street Polytechnic School of Art and exhibits sculpture in stone, wood and terra cotta mainly at the Royal Academy. He lives in Tenterden, Kent.

MEARS, Helen Farnsworth 1878-1916
Born in Oshkosh, Wisconsin, in 1878, she died in New York on February 17, 1916. She studied under Saint-Gaudens and specialised in portrait figures and busts. Her best known work is the statue of Frances Willard in the Capitol, Washington.

MEDEM, Heinrich fl. mid-19th century
A pupil of Rauch, he worked in Berlin and specialised in animal figures and groups.

MEDEN, Max 1882-
Born in Copenhagen on September 15, 1882, he specialised in portrait busts of his contemporaries. His bust of Carl Petersen (1921) is in the Copenhagen Museum.

MEDGYESSY, Ferenc 1881-
Born in Debrecen on January 10, 1881, he studied medicine in Budapest but later went to Paris to study painting under J.P. Laurens and J.C. Chaplain before concentrating on sculpture. He did the war memorials in Vaskut and Isaszeg. His minor works, including bronzes, are in various Hungarian museums.

MEDICI, Ulderigo fl. 19th century
Born in Florence in 1828, he studied under Gresci and Costali and began exhibiting about 1850. He specialised in decorative sculpture for palaces and public buildings, as well as monumental statuary.

MEDINA Y PENAS, Gabino de 1814-1888
Born in Madrid on December 20, 1814, he died there on May 10, 1888. He specialised in portrait busts and statues, mainly in marble. Examples of his work are in the Prado and the Chamber of Deputies in Madrid.

MEDREA, Constantin fl. 20th century
Romanian sculptor of allegorical compositions, such as Constructive Socialism. His minor works include portrait busts and genre statuettes.

MEGGITT, Marjorie (Mrs. Jones) 1906-
Born in Sheffield on February 27, 1906, she studied at the Sheffield College of Art and the Royal Academy schools before going to the British School in Rome (1932-35). She has exhibited at the Royal Academy and various provincial galleries and was elected A.R.B.S. in 1956. She works in Fulham, London, and sculpts portraits and figures, mainly in terra cotta.

MEGRET, Louis Nicolas Adolphe 1829-1911
Born in Paris on November 1, 1829, he died there in 1911. He studied under Jouffroy and Duret and exhibited at the Salon from 1863 to 1874, winning an honourable mention in 1874 and a bronze medal at the Exposition Universelle of 1889. He produced portrait medallions, busts and statuettes of historic and contemporary personalities, and allegorical figures and groups.

MEHNERT, Ernest Julius Wilhelm 1823-1878
Born in Germany on October 30, 1823, he died in St. Petersburg on March 12, 1878. He studied at the Berlin Academy and later worked as a decorative sculptor in Russia.

MEIER, Wilhelm 1880-
Born at Embach, near Zurich, on August 29, 1880, he studied under A. Bösch and worked in Munich as a sculptor of portraits and genre figures.

MEIER-DENNINGHOFF, Brigitte 1923-
Born in Berlin, she studied at the Berlin School of Art (1943-45) and the Munich Academy (1945-48) and then worked in Henry Moore's studio. Later she studied under Pevsner in Paris (1949-50). On her return to Germany she worked as a designer of theatrical sets in Darmstadt (1953-54), then taught at Cassel Academy (1957-58). She has exhibited in Berlin, Munich and Düsseldorf and won the Bourdelle Prize in 1959. Originally carving direct in stone and wood, she later turned to concrete and bronze, producing abstracts, such as Gust of Wind (1959), Pallas Athene, Angel and Planet.

MEIKOFF, Alexander Friedrich Karlovich 1827-1854
Born in Russia in 1827, he died in Moscow on March 13, 1854. He studied at the School of Fine Arts, Moscow, and sculpted figures and bas-reliefs.

MEINTEL, Johann Nepomuch 1816-1872
Born at Horb in Württemberg, on March 5, 1816, he died there on December 14, 1872. He studied painting under Schott at Horb and sculpture in Munich under Eberhard and Riedmiller. He had a studio in Horb specialising in figures and bas-reliefs of religious subjects.

MEISEN, Karl 1867-
Born in Cologne on July 22, 1867, he studied at the Munich Academy (1890-94) and later worked as a decorative sculptor in Berlin. His minor works include portraits and genre groups.

MEISSNER, Max 1859
Born in Berlin on November 7, 1859, he studied under Lessing and Siemering and produced busts, statuettes, statues and monuments of famous Germans.

MEISSONIER, Jean Louis Ernest 1815-1891
Born in Lyons on February 21, 1815, he died in Paris on January 31, 1891. He studied under Léon Cogniet and exhibited at the Salon in 1834. He was a painter and engraver as well as a sculptor and his works include Wounded Horse (Bayonne Museum), Herald of Murcia, The Gladiators, Dancer, Duroc at Castiglione, Dancing Muse and Caryatid (Grenoble Museum).

MEISTER, Eduard 1837-1867
Born at Billigheim, Germany, on October 13, 1837, he died in Freiburg-am-Breisgau on October 12, 1867. He studied at the Institut Städel in Frankfurt and the School of Fine Arts in Stuttgart. He specialised in statuettes of historic personalities and decorative reliefs. Many of his works were executed for the castles of Mainau and Eberstein in the grand-duchy of Baden.

MEIXNER, Johann 1819-1872
Born at Rothfoss, Bohemia, on January 3, 1819, he died in Gleichenberg, Styria, on October 23, 1872. He studied at the Vienna Academy (1947-48) and in Rome (1854-55) and specialised in religious figures and portrait busts of Austro-Hungarian celebrities.

MELCHIOR, Carl Theodor 1826-1898
Born in Copenhagen on March 13, 1826, he died there in 1898. He studied at the Copenhagen Academy in 1839-40 and worked in that city as a painter and sculptor of genre subjects.

MELCHIORRE, Luigi fl. 19th century
Piedmontese sculptor of figures and bas-reliefs, working in Rome, Turin and Milan.

MELDERS, Emils 1889-
Born in Latvia on May 27, 1889, he studied under Baron Stieglitz at St. Petersburg and worked in Paris in the 1920s. He is best known for the war memorial in Riga.

MELI, Giosué 1807-1893
Born at Luzzano, Italy, in 1807, he died in Rome in 1893. He studied in Rome under Thorvaldsen and Tenerani and specialised in religious figures and groups.

MELIDA Y ALINARI, Arturo 1848-1902
Born in Madrid in 1848, he died there on December 15, 1902. He was professor of modelling at Madrid School of Architecture and is best known for the Columbus monuments in the Madrid Hippodrome and Seville Cathedral. His minor works include portrait busts and statuettes of contemporary and historic Spaniards.

MELIN, Paul fl. late 19th century
Born at Fontainebleau in the mid-19th century, he exhibited figures and portraits at the Salon des Artistes Français, winning a third class medal and a travelling scholarship in 1895 and a second class medal in 1899.

MÉLINGUE, Étienne Marin 1808-1875
Born in Caen on April 16, 1808, he died in Paris on March 27, 1875. He studied under Odelli and Bochard and exhibited at the Salon in 1852-55, winning a third class medal. He specialised in busts and statuettes of playwrights and actors, he himself being an actor of some note. His works are in the museums of Caen, Le Havre and Rouen.

MELIODON, Jules André 1867-
Born in Paris on June 1, 1867, he studied under Falguière, Frémiet, Barrou and Message in Paris and was an Associate of the Artistes Français. Later he emigrated to the United States and became a member of the Professional Artists' League. He specialised in figures and statuettes of contemporary personalities.

MELLANVILLE, Germain de fl. 19th-20th centuries
Born in the late 19th century, he was killed in action on September 27, 1915. He studied under Falguière and Mercié and exhibited figures at the Salon, winning an honourable mention in 1909 and a third class medal in 1911.

MELLGREN, Karl Magnus 1806-1886
Born at Marstrand, Norway, in 1806, he died in Helsinki in 1886. He produced figures and portraits of Scandinavian personalities.

MELLI, Roberto 1885-1958
Born in Ferrara in 1885, he died in Rome in 1958. He studied in Ferrara and came to Rome in 1911 where he played a prominent part in the renaissance of Italian art, both as a painter and sculptor and as an art critic and writer. The main period of his sculpture was from 1906 to 1914 and includes such bronzes as Profile of a Young Girl in Relief (1911), Small Mask (1912), Woman with a Black Hat (1913), Portrait of the Artist's Wife and Portrait of Vincenzo Constantini (1914). Many of his works are in the Gallery of Modern Art, Rome. His work was banned by the Fascists, but a major retrospective exhibition was held at the Barberini Palace, Rome, shortly before his death.

MELLINGER, Ludwig Karl Kasimir 1865-
Born in Mainz on April 14, 1865, he studied under Goebel, A. Burger and Steinle in Frankfurt and worked in Florence from 1891 to 1895 before settling in Freiburg-am-Breisgau.

MELLON, Eleanor M. 1894-
Born in Narberth, Pennsylvania on August 18, 1894, she studied under V.D. Salvatore, McCartan and Robert Aitken and became a member of the American Federation of Arts. She specialised in bronze statuettes of neo-classical subjects.

MELNIK, Woldemar 1887-
Born in Purtse, Estonia, on May 11, 1887, he studied under Baron Stieglitz at St. Petersburg and attended classes at the Academy from 1914 to 1918. He specialised in portrait busts, tombs and war memorials. Reval Museum has his Head of a Woman.

MELNITZKY, Franz 1822-1876
Born at Schwamberg, Bohemia, in 1822, he died in Vienna in 1876. He studied under J. Klieber and produced decorative sculpture, portraits and genre figures.

MELOT, Egide Hyacinthe 1817-1885
Born in Antwerp on August 16, 1817, he died at Schaerbeek on April 19, 1885. He specialised in portrait busts of contemporary and historical personalities of the art world, such as Napoleon Godecharles (Antwerp Museum) and Jan van Eyck (Brussels Museum).

MELVILLE, Carl 1875-
Born in Mitau, (now Jaunjelgava, Latvia), on October 29, 1875, he studied in Berlin, Cassel and Brussels and became professor at the School of Industrial Art in Erfurt. His figure of a Dancing Bear is in Erfurt Museum.

MELZER, Julius 1823-1853
Born at Bürgstein, Bohemia, on February 21, 1823, he died in Rome on November 8, 1853. He was the pupil and later assistant of J.C. Max in Prague and settled in Rome in 1849 where he produced decorative sculpture and religious figures.

MEMMINGER, Friedrich Jakob 1813-1848
Born in Mainz on July 14, 1813, he died there on July 7, 1848. He studied in Munich and went to Rome in 1839, working there for three years. He collaborated with Cornelius Schleidt on decorative sculpture at Mainz in 1846-48.

MENANT, Julien Michel 1880-1915
Born at Château, near Cluny, on August 10, 1880, he was killed in the battle of Neuville St. Waast on May 22, 1915. He studied under Barrias, Coutan and Louis Convers and exhibited figures and groups at the Salon des Artistes Français getting an honourable mention in 1907 and a third class medal in 1913.

MÉNARD, Amédée René 1806-1879
Born in Nantes on October 16, 1806, he died there on October 22, 1879. He enrolled at the École des Beaux Arts, Paris, in 1829, and studied under Ramey. He exhibited at the Salon from 1837 to 1852 and won a third class medal in 1837. He specialised in decorative sculpture for public buildings, but his small bronzes include Morning Prayer, Evening Prayer and the series of five figures on the Billault Memorial in Nantes.

MENDÈS DA COSTA, Joseph 1863-1939
Born in Amsterdam of Jewish parents, he learned the techniques of sculpture from his father, a monumental mason and carver of tombstones. He attended part-time classes at the Quellinus School

(1879-81) and later studied at the School of Applied Arts in Amsterdam and worked with Zijl for three years. He began modelling figurines in 1898 and worked in terra cotta till about 1910, when he turned to more ambitious works on a larger scale. Many of his figures were derived from the Old Testament, but he also sculpted animals, notably the pair of Jaguars commissioned by the architect Berlage for a building in Soerabaya, Indonesia. Among his later works are portrait busts, many in bronze. His chief work is the monument to General de Wet in Amsterdam. Many of his works are preserved in the Kröller-Müller Museum. He received many awards in international exhibitions, notably Turin (1902), St. Louis World's Fair (1904) and the Exposition des Arts Décoratifs, Paris (1925). He is today regarded as the Maillol of Holland.

MÊNE, Pierre Jules 1810-1871
Born in Paris on March 25, 1810, the son of a metal-turner, he died there in 1871. Apart from a few tips from René Compaire, Mêne was self-taught as a sculptor but built up a large reputation as an Animalier, producing figures which he cast in bronze himself. He established his own foundry in 1838 and thereafter had a thriving business in turning out small *bronzes d'ameublement* by the sand-cast process. He exhibited at the Salon from 1838 onwards, making his début with a group entitled Dog and Fox. He won a second class medal in 1848 and first class medals in 1852 and 1861, receiving also the Légion d'Honneur in the latter year. He also exhibited at the Great Exhibitions of 1851 and 1862 in London and many of his groups were designed with the British market in mind. After Barye, Mêne is probably the best known of the French Animalier school and his bronzes are today among the most highly prized in this genre. Many of his bronzes were edited posthumously by his son-in-law, Auguste Nicolas Cain. A catalogue of his bronzes is appended to *The Animaliers* by James Mackay (1973).

MÉNESTRIER, Edmond fl. 19th century
Born in Langres in the early 19th century, he died there on September 6, 1884. He studied under Gérôme and exhibited at the Salon in 1880-84. Langres Museum has a study of a Woman by him.

MENGES, Joseh Wilhelm 1856-1916
Born at Kaiserslautern in 1856, he died in Munich in November 1916. He spent his working life in Munich and specialised in portrait busts, statuettes and groups. His larger works include such monuments as those of Bismarck at Kaiserslautern, Krupp at Essen and Scheffel in Säckingen.

MENGIN, Charles Auguste 1853-1933
Born in Paris on July 5, 1853, he died on April 3, 1933. He studied under Gecker and Cabanel and exhibited at the Paris Salons from 1876 to 1927, winning a third class medal in 1876, a travelling scholarship in 1883 and a second class medal in 1890. He was awarded a silver medal at the Exposition Universelle of 1900. He worked mainly as a painter, but his sculpture includes genre and classical figures, represented in museum collections in Bergues, Dinant, Ixelles and Manchester.

MENGIN, Paul Eugène fl. 19th-20th centuries
Twin brother of Charles Auguste Mengin, he studied under Millet and Dumont and exhibited at the Salon from 1874 onwards, winning a travelling scholarship (1875), an honourable mention (1877) and a third class medal (1885). He also got a bronze medal at the Exposition of 1900. He specialised in animal figures, but also did several genre groups, such as Maternity (Narbonne Museum).

MENGUE, Jean Marie fl. 19th-20th centuries
Born at Bagnères de Louchon on December 31, 1855, he studied under Meynier and exhibited at the Salons from 1876 to 1925, becoming an Associate of the Artistes Français in 1894. His numerous awards included bronze and silver medals at the Expositions of 1899 and 1900 respectively and the Légion d'Honneur. He specialised in biblical and classical figures such as Cain and Abel (Luxembourg Gardens) and Icarus (Montpellier Museum).

MENN, Charles Louis 1822-1894
Born in Geneva on March 16, 1822, he died there on May 10, 1894. He studied under Pradier and Etex in Paris and exhibited at the Paris Salon from 1852 to 1859. He specialised in busts of personalities in classical mythology and contemporary poets and playwrights.

MENNICKEN, Hubert fl. 19th-20th centuries
German sculptor of religious subjects who died in Berlin on July 3, 1916.

MENSER, Karl 1872-1929
Born in Cologne on July 19, 1872, he died in Bonn in 1929. He qualified as a doctor of medicine but later turned to sculpture. He sculpted decorative statuary and friezes in Cologne and did the monument to Lacombe in Père Lachaise cemetery, Paris. He specialised in portrait busts of contemporary and historical French and German personalities.

MENTZEL, Otto Moritz 1838-1901
Born in Dresden on August 6, 1838, he died in Prague on February 27, 1901. He studied under Hähnel and later worked for some time in Rome (1862-64). He was Director of the School of Jewellery, Prague, from 1874 to 1885 and produced numerous marble and bronze busts of his contemporaries.

MERABISHVILI, K fl. 20th century
Georgian sculptor of historic and contemporary portraits.

MÉRARD, Pierre fl. 18th century
He studied under Edmé Bouchardon and became associate professor at the Academy of St. Luke. He exhibited portrait busts and bas-reliefs there in 1774 and at the Salon of the Louvre in 1795-99.

MERCHI, Gaetano 1747-1823
Born in Brescia in 1747, he died at Agen, France, on October 23, 1823. He was self-taught but won a high reputation and was invited by Catherine the Great to St. Petersburg, where he sculpted busts of Russian royalty and the nobility. He went to Paris in 1777 and stayed there till 1795, when he moved to Madrid. In 1892 he moved to Bilbao and ten years later settled in Agen.

MERCIÉ, Marius Jean Antonin 1845-1916
Born in Toulouse on October 30, 1845, he died in Paris on December 14, 1916. He studied under Jouffroy and Falguière and won the Grand Prix de Rome at the age of 23. He established his reputation four years later (1872) with his bronze figure of David, now in the Luxembourg, and his medallion Gloria Victis earned him the medal of honour of the Salon at the age of 30. Other highly popular works included the bas-relief Genius of the Arts (1877), a cast of which is in the Tuileries and another on the tomb of Michelet in Père Lachaise. His larger works include The Souvenir (1885), the monument to Louis Philippe and Queen Amelie for their tomb at Dreux, and the figure of Justice for Paris Town Hall. His smaller bronzes include Oriental Dancers, Hope, and various heads and busts of genre subjects in the Florentine manner. Mercié was appointed professor at the École des Beaux Arts and became a member of the Institut in 1891. He was also President of the Société des Artistes Français and one of the few sculptors to attain the rank of Grand Officier in the Légion d'Honneur.

MERCIÉ GANTRAGO, Charles fl. late 19th century
Born in Madrid in the mid-19th century, he became a naturalised Frenchman and exhibited figures and portraits at the Salon from 1881 onwards.

MERCIER, Michel Louis Victor 1810-1894
Born at Meulan, France, on May 24, 1810, he died in 1894. He studied under Pradier at the École des Beaux Arts and exhibited at the Salon from 1835 to 1848, winning a third class medal in 1835 and a first class medal in 1841. He produced many statues and busts of French historical personalities, in marble, plaster and bronze. Many of his works are preserved in Versailles Museum.

MERCULIANO, Giacomo fl. 19th century
Born in Naples on September 29, 1859, he studied at the Institute of Fine Arts, Naples, and exhibited there and in Palermo in the 1880s. Later he moved to Paris and became a naturalised Frenchman. He got an honourable mention at the Exposition Universelle of 1889. He specialised in animal figures and portrait busts.

MEREDITH-WILLIAMS, Gertrude Alice (née Williams)
fl. 19th-20th centuries
Born in Liverpool in the mid-19th century, she died in Edinburgh on March 3, 1934. She studied at the School of Architecture and Applied Art, Liverpool, and the École des Beaux Arts, Paris, and married the painter Morris Meredith-Williams. She worked as a decorative painter, stained-glass artist and sculptor of neo-classical and renaissance figures, and exhibited at the Royal Academy, the Royal Scottish Academy, the Salon des Artistes Français and various British provincial galleries. Her best known work is The Spirit of the Crusaders, sculpted for the Paisley war memorial.

MEREL, Félix Eugène 1894-
Parisian sculptor of portraits and figures.

MERELLE, René fl. 20th century
French sculptor active in the mid-20th century. His best known work is the Monument to the Deportees at Meaux. He exhibited at the Salon des Indépendants in 1945, showing projects for the statue of King Henri IV at St. Germain-en-Laye.

MERGEHEN, Ludwig 1884-
Born at Mornhausen, Germany, on July 14, 1884, he worked as a decorative sculptor in Frankfurt-am-Main.

MERIGNARGUES, Marcel 1884-
Born in Nimes on March 17, 1884, he studied in Paris under Mercié and exhibited figures at the Salon des Artistes Français from 1906, winning medals in 1926-7.

MÉRITE, Édouard Paul 1867-1941
Born at Neubourg on March 7, 1867, he died in Paris in 1941. He studied under Frémiet, Morot and Barrias and exhibited at the Salon des Artistes Français, winning third class medals for painting (1896) and sculpture (1901). He became professor of animal drawing at the Museum of Natural History. He specialised in animal sculpture, such as Seated Hare and a group of Partridge in a Snow-field.

MERKER, Paul fl. 18th-19th centuries
Sculptor of medallions and bas-reliefs working in Brunswick in the early 19th century. He became a member of the Berlin Academy in 1806 and died at Brunswick in 1823.

MERLEY, Louis 1815-1883
Born at St. Étienne on January 7, 1815, he died in Paris on September 17, 1883. He studied under Pradier, David d'Angers and Galle and won the Prix de Rome in 1843. He exhibited at the Salon from 1840 onwards, winning medals in 1851 and at the Exposition Internationale of 1867. He was awarded the Légion d'Honneur in 1866. He specialised in classical and allegorical works and decorative sculpture.

MERLIER, Pierre 1931-
Born in Toutry, France, in 1931, he was apprenticed to a stone carver and later studied at the Académie de la Grande Chaumière in Paris, where he was strongly influenced by Zadkine. His earliest work, carved direct in stone, was abstract and polychrome, but since 1954 he has produced more figurative work, influenced by both classical and primitive art. His work has so far been mainly in terra cotta.

MERLIEUX, Louis Parfait 1796-1855
Born in Paris on November 27, 1796, he died there on September 8, 1855. He enrolled at the École des Beaux Arts in 1812, and studied under Roman and Cartellier. He exhibited at the Salon from 1824 to 1837 and specialised in portrait busts. His chief work is the Triton and Nereid on the fountain in the Place de la Concorde.

MÉRODACK-JEANNEAU, Alexis fl. 19th-20th centuries
Painter, designer and sculptor of the Synthesist school, working in Angers, where he died in 1919.

MÉROT, Julien Louis 1876-
Born in Tanville, France, on June 14, 1876, he studied under Barrias, Chaplain, Bottée and Coutan and won the Grand Prix de Rome in 1905. He exhibited figures and groups at the Salon des Artistes Français from 1893 onwards and won a third class medal in 1926.

MERRIFIELD, Leonard Stanford 1880-1943
Born at Wick Rissington, Gloucestershire, on April 14, 1880, he died in London on April 25, 1943. He studied at the Cheltenham School of Art, the City and Guilds School, Kennington, and the Royal Academy Schools, where he won the Landseer scholarship and the Armitage Prize. He exhibited at the Royal Academy and the leading

British galleries from 1906 onwards and also at the Salon des Artistes Français, where he won an honourable mention in 1925. He specialised in portrait bas-reliefs and busts and worked in London.

MERSCH, Karl 1887-1916
Born in Elberfield, Germany, on June 27, 1887, he was killed in the battle of the Somme on September 28, 1916. He sculpted portraits and genre figures.

MESNARD, Jules fl. 19th century
Parisian sculptor of figures and portraits, exhibiting at the Salon in 1859-61.

MESSINA, Francesco 1900-
American sculptor of Italian origin, specialising in portrait busts and statuettes of historical, contemporary, classical and literary figures.

MESSMER, Josef 1839-1886
Born at Oberdorf, Carinthia, on February 7, 1839, he died there on September 8, 1886. He studied in Vienna under Hans Gasser and produced religious and genre figures.

MESTER, Jens Eugen 1882-
Born at Maklar, Hungary, on July 11, 1882, he studied under E. Telcs and worked in Budapest from 1906 to 1913, later moving to Copenhagen. Budapest Museum has his genre statuette Lost in Dreams.

MESTROVIC, Ivan 1883-
Born in Vrpolje, Slavonia (now part of Yugoslavia), on August 15, 1883, he was taught the elements of wood-carving by his father. At the age of 13 he was apprenticed to a stone-mason at Split and in 1899 enrolled at the Vienna Academy, studying under König and von Hellmer until 1904. He exhibited at the Vienna Secession, the Austrian Exhibition in London, (1906) and in Munich, Venice and Paris. The last-named exhibition brought him to the notice of Rodin and he subsequently studied under him, and later Bourdelle and Maillol. He also worked in Rome in 1911-14 and took part in the Rome International Exhibition of 1911. With Rosandic and Penic he was responsible for the revival of the sculptural arts in Croatia and staged an exhibition at Zagreb in 1910. He personified the medieval and renaissance style of sculpture which was strongly developed in post-war Yugoslavia and is exemplified in his Temple of Kosovo, which commemorated a 14th century battle against the Turks. He specialised in Serbo-Croat historical subjects and undertook a number of important state commissions, including the nomument to the Unknown Soldier of the first world war at Avala Mount near Belgrade, and the statue of the Victor, erected in memory of the partisans after the second world war. An exceedingly versatile sculptor in wood, stone and bronze, he has sculpted portraits, both busts and reliefs, figures and decorative sculpture, statues of saints and contemporary figures such as Herbert Hoover, Thomas Masaryk, Pope Pius XI and Lenin, two equestrian figures of American Indians for the city of Chicago, and genre figures and groups, such as Widow and Child, Reminiscence, and The Artist's Mother at Prayer.

Curcin, M. *Ivan Mestrovic, a Monograph (1919);* Schmeckebier, Laurence *Ivan Mestrovic: Sculptor and Patriot (1959).*

MÉSZÉROS, Andor 1900-
Born in Budapest in 1900, he studied architecture there before studying sculpture at the Académie Julian in Paris and won the Franz Josef Prize for sculpture in Vienna. He emigrated to Australia in 1939 and has since produced a wide variety of sculpture in the South Pacific area, ranging from decorative sculpture in Adelaide Cathedral and the Brisbane Shrine of Remembrance and the altar in Canterbury Cathedral, New Zealand, to commemorative plaques, portrait bas-reliefs and the Australian Olympic medals of 1956.

METCALF, James 1925-
Born in New York in 1925, he studied at the Philadelphia Academy (1947-48) and the Central School of Arts and Crafts, London (1950-52), where he learned the techniques of working in bronze and precious metals. He taught at the Central School after graduating there, then won the Clark scholarship which enabled him to continue his studies in Spain (1953-55), where he had his first one-man exhibition, in Barcelona. He settled in Paris in 1955. Since then he has tended more and more towards Surrealism and prefers to work in hammered lead and wrought iron and now brass. Nevertheless several of his abstracts in recent years have been cast in bronze, such as the Phoenix-Mutation series of the late 1950s.

METCALFE, Percy 1895-1970
Born in London on January 14, 1895, he died there in 1970. He studied at the Royal College of Art and worked in London as a portrait sculptor and medallist. He exhibited at the Royal Academy for many years.

METCHNIKOFF, Olga fl. 19th-20th centuries
Russian sculptress working in Paris at the turn of the century. She studied under Injalbert and won a bronze medal at the Exposition Universelle of 1900.

METEIN-GILLIARD, Valentine 1891-
Born in Geneva on February 7, 1891, she was the daughter and pupil of Eugène Gilliard and also studied under J. Vibert and the ceramicist E. Mayor. She has produced figures and portraits in terra cotta and bronze.

METTLER, Walter 1868-
Born at Herisau, Switzerland, on December 14, 1868, he studied under Chapu, Cavelier and Barrias in Paris. His works include The Water-carrier, Young Man bending his Bow, Hero and Eve.

METZ, Gustav 1817-1853
Born in Brandenburg on October 28, 1817, he died in London on October 30, 1853. He studied under Rauch in Berlin and Rietschel in Dresden and is best known for his genre and historical paintings, though he also sculpted figures of the same subjects.

METZ, P. fl. 19th century
Ecclesiastical sculptor working at Gebratshofen, Württemberg, in the mid-19th century.

METZGER, Christian 1874-
Born at Simbach, Germany, on July 18, 1874, he worked in Ratisbon and did monuments in Berne, Platting and Waldsassen.

METZGER, Franz 1861-
Born at Möhlin in the Swiss canton of Argau in 1861. He studied in Milan and Florence and worked in the latter city as a decorative sculptor.

METZNER, Franz 1870-1919
Born at Wscherau near Pilsen, Bohemia, on November 18, 1870, he died in Berlin on March 24, 1919. He worked in Berlin from 1892 to 1903 and became professor at the School of Industrial Arts, Vienna (1903) but returned to Berlin in 1906. He produced monuments, mainly for towns in Austria, though his chief work was the group of thirteen figures on the battle memorial at Leipzig, sculpted between 1906 and 1913. His minor works include genre groups and portrait busts.

MEUNIER, Constantin Émile 1831-1905
Born at Etterbeek, Belgium, on April 12, 1831, he died at Ixelles on April 4, 1905. He learned the rudiments of painting from his father and elder brother and then studied at the Brussels Academy under Fraikin, but decided to concentrate on painting and it was not until 1885 that he returned to sculpture. He was a pioneer of socialism in Belgium and his political ideals were reflected in his paintings of workers and peasants. He was appointed professor at the Louvain Academy in 1886, and exhibited in Brussels and Paris, winning Grand Prix at the Paris Expositions of 1889 and 1900 for sculpture. He was awarded the Order of Leopold (1875) and the Légion d'Honneur in 1889. His best known work is the large bas-relief The Glorification of Labour with figures personifying the various trades. His bronzes include Sower, Reaper, Puddler, Metal-worker, Mineworkers, Firedamp Explosion, Mother Love, Prodigal Son, The Victim, Dock Labourer, Ecce Homo, An Old Colliery Horse, Miner, Puddlers at the Furnace (bas-relief), The Ancestor, The Glebe and Hammerer. Many of his works are preserved in the museums of Belgium and Paris. His house in Brussels, whence he moved in 1900, is now a museum.

Lemonnier, *Constantin Meunier* (1904). Scheffler, K. *Constantin Meunier* (1908).

MEUNIER, Louis fl. 19th century
Born at Solesmes, France, in the first half of the 19th century, he died in Paris in 1886. He studied under Belloc, Guillaume and Viollet-le-Duc and exhibited at the Salon from 1868 till his death. He specialised in marble and bronze busts and medallions of his contemporaries and also did groups and bas-reliefs of allegorical subjects.

MEURISSE, Josef 1868-
Born in Aachen in 1868, he worked there as a sculptor of busts, bas-reliefs and medallions of historic and contemporary personalities.

MEUSE, Jane de fl. early 20th century
Sculptress of genre figures, working in Brussels before the first world war.

MEYENBERG, John Carlisle 1860-
Born at Tell City, Indiana, on February 4, 1860, he learned the art of wood carving from his father, a Swiss immigrant woodworker, and studied drawing and modelling under Thomas Noble and L.F. Rebisso at the Cincinnati Art Academy. Later he enrolled at the École des Beaux Arts, Paris, and studied sculpture under Jules Thomas. He worked in Cincinnati as a sculptor of monumental statuary. His minor works, in plaster and bronze, include portrait busts of his contemporaries.

MEYENBERG, Viktor von 1834-1893
Born at Schaffhausen on September 25, 1834, he died in Dresden on February 16, 1893. He studied under J.J. Ochslin and Hugo Hagen and worked as a decorative sculptor in Zurich, notably on the provincial museum and the Polytechnic. He also sculpted busts and heads of his contemporaries.

MEYER, Adolf 1867-
Born in Basle on October 21, 1867, he studied under Reinhold Begas and was strongly influenced by Adolf Hildebrand. He worked at Zolliken, near Zurich, where the House of the Arts has various bronze busts by him.

MEYER, Alvin William 1892-
Born in Bartlett, Maryland, in 1892, he studied at the Maryland Institute and the Rinehart School of Sculpture, Baltimore, and the Pennsylvania Academy. He was visiting professor at the American Academy in Rome for a year and now works in Baltimore, sculpting busts, figures and reliefs in plaster and bronze.

MEYER, Carl Viktor 1811-1830
Born in Minden on June 26, 1811, he died there on November 12, 1830. He studied under Rauch and Schadow in Berlin and produced busts of historical and contemporary celebrities.

MEYER, Daniel fl. 20th century
Genre and portrait sculptor working in Nancy in the early years of this century.

MEYER, Emil 1872-
Born in Cassel on December 5, 1872, he studied under Carl Janssen and worked in Düsseldorf as a decorative sculptor.

MEYER, Julius 1825-1913
Born in Luseringen, Hanover, on June 1, 1825, he died in Brunswick on September 29, 1913. He studied under Wessel and Howaldt and worked in the United States from 1849 to 1858 before returning to Germany and settling in Brunswick. His works include numerous heads and busts, a memorial in the Brunswick garrison cemetery and genre statuettes, such as Mischief.

MEYER-DEYK, Tonio 1875-
Born in Cologne on July 31, 1875, he studied under von Rümann and worked in Munich as a painter and sculptor of genre subjects. His sculptures are preserved in the museums of Cologne and Munich.

MEYER-PYRITZ, Martin A.R. 1870-
Born in Pyritz, Germany, on November 6, 1870, he studied under Breuer and Herter and worked in Berlin on bronze portrait busts and animal figures.

MEYER-STEGLITZ, Georg Renatus 1868-1929
Born in Pyritz on June 27, 1868, the elder brother of Martin Meyer-Pyritz, he died in Berlin on October 11, 1929. He studied

under Johan Böse and specialised in historic figures, bas-reliefs and monuments to German royalty and political figures, such as Bismarck. He also sculpted the first world war memorial at Saarlouis.

MEYERHOF, Agnes 1858-
Born at Hildesheim on June 2, 1858, she worked in Frankfurt as a painter, engraver and sculptor. She studied under Küsthandt the Elder and J.M. Welsch and specialised in animal painting and sculpture, particularly birds.

MEYERHUBER, Karl August 1874-
Born in Karlsruhe on October 26, 1874, he studied under Dujardin and worked in Metz as a decorative sculptor.

MEYERS, Ferdinand 1836-1858
Born in Berbourg in the grand-duchy of Luxembourg on December 20, 1836, he died in Rome on March 20, 1858. He produced portraits and genre figures.

MEYLAN, 1920-
Born at Saint-Imier, Switzerland, in 1920, he studied at the School of Fine Arts in La Chaux de Fonds, training as a silversmith and jeweller. Later he studied painting and theatrical design in Paul Collin's studio, Paris, and returned to Switzerland in 1940, where he took up modelling. At the end of the war he returned to Paris and worked in the independent schools, notably the Académie de la Grande Chaumière under Zadkine. His earlier work was modelled in clay, but after 1950 he turned more and more towards direct carving in stone, only to reject this technique since it was impossible to achieve the light, airy effect for which he strove. In recent years he has worked in plaster, bronze and wrought iron to produce spatial constructions, evolving a kind of spatial calligraphy. He had exhibitions at the Drian Gallery, London, in 1958 and 1960.

MEYNIER, Samuel fl. 19th century
Born in Uzès, France, in the early 19th century, he died in Paris in 1881. He exhibited portrait busts and medallions at the Salon from 1868 to 1879.

MEZZARA, Joseph fl. 19th century
Born in New York in the early 19th century, he studied under Granger at the École des Beaux Arts, Paris, and exhibited at the Salon from 1852 to 1875, specialising in portrait busts. He also sculpted the figure of the Madonna in the church of Clamart.

MHATRO, fl. 19th century
Bronzes thus signed were the work of two brothers working in England in the late 19th century.

MIAULT, Henry 1881-
Born at Breuil-sur-Argentan on December 31, 1881, he exhibited figures and groups at the Salon des Artistes Français from 1910 onwards, winning medals in 1910 and 1926. In the 1920s he also exhibited statuettes and reliefs at the Indépendants, the Tuileries and the Salon d'Automne and won a Grand Prix at the Exposition des Arts Décoratifs in 1925. He was a Chevalier of the Légion d'Honneur.

MICH, Jean fl. early 20th century
Born in Luxembourg in the late 19th century, he studied in Paris under Thomas and F. Charpentier and exhibited figures and portraits at the Salon des Artistes Français and the Nationale before the first world war, winning a third class medal in 1912.

MICHAELIS, Hermann fl. 19th century
Sculptor of figures and portraits working in Breslau, where he died on April 28, 1889.

MICHAN, Jeanne fl. 20th century
The wife of the French sculptor Cognasse, she sculpted portraits in her own right.

MICHAUD, Claude fl. 19th century
Born in Paris on October 29, 1822, he studied under Rude and exhibited figures and bas-reliefs at the Salon from 1848 to 1857.

MICHAUD or MICHAUT, Auguste François 1786-1879
Born in Paris on September 29, 1786, he died in Paris in December 1879. He studied under Moitte, Lenot and Gallé and worked as an

engraver and sculptor of portrait busts and medallions. He sculpted the bronze statue of the Abbé de L'Epée in St. Louis Church, Versailles.

MICHEL, Gustave Frédéric 1851-1924
Born in Paris on September 29, 1851, he died there in 1924. He studied under Jouffroy and exhibited at the Salon from 1875, winning a second class medal that year, a travelling scholarship in 1883, and a first class medal in 1889. He was awarded gold medals at the Expositions of 1889 and 1900 and the medal of honour in 1896. He rose through the grades of the Légion d'Honneur to the rank of Officier in 1905. He specialised in classical and allegorical works, mainly monuments and public statuary. His minor bronzes include busts, statuettes and medallions.

MICHEL, Pierre 1728-1809
Born at Puy on October 27, 1728, he died in Madrid on November 15, 1809. He studied under Bonfils and settled in Madrid in 1750, succeeding his brother Robert as Court Sculptor. He produced small decorative bronzes, bas-reliefs and portraits of the Spanish royalty and nobility.

MICHEL, Robert 1721-1786
Born in Puy on November 8, 1721, he died in Madrid on January 31, 1786. He was appointed Sculptor to the Spanish Court in 1740 and produced numerous statues and groups in Madrid, mainly in marble and stone.

MICHEL, Sigisbert François 1728-1811
Born in Nancy on September 24, 1728, he died in Paris on May 21, 1811. He was a member of the Academy of St. Luke and went to Berlin at the invitation of the King of Prussia. He produced many classical and allegorical monuments and statues there, especially in and around the palace of Sans-Souci at Potsdam. He returned to Paris in 1774 and began exhibiting at the Academy, and later the Salon de Correspondence (1791-1800). He specialised in small groups showing Venus and Cupid.

MICHEL-MALHERBE, Ernest Jules fl. 19th-20th centuries
Born at Ay, France, in the mid-19th century, he exhibited figures at the Salons from 1887 to 1910.

MICHEL-THOMAS, Alexandre Louis fl. 19th century
Born in Nantes on April 16, 1830, the son and pupil of Louis Michel-Thomas, he worked in that city as a decorative sculptor.

MICHEL-THOMAS, Louis 1792-1856
Born in Poitiers in 1792, he died in Nantes in February, 1856. He worked mainly as a decorative sculptor but also produced busts, memorials and bas-reliefs.

MICHELENA, Bernabé 1888-
Born in Durazno, Uruguay, in 1888, he studied drawing and modelling in Montevideo under the Italian artist Filipe Morelli and travelled in Europe in 1908, 1916 and 1927, on state scholarships. His sojourn in France in the 1920s brought him under the influence of Rodin, Maillol, Bourdelle and Despiau. He exhibited sculpture at the Galerie Zak in Paris (1928) and won first prize in the Uruguayan centenary exhibition of 1930 and the Grand Prix in the Uruguayan National Salon the same year. Since then he has sculpted many monuments and public statuary in Montevideo, working in clay, plaster, marble and granite. His minor works include a large range of portrait busts of Uruguayan and Latin American celebrities in the various fields of the arts. He has continued to exhibit in Europe, and won the Grand Prix at the Salon de la Société Nationale des Beaux Arts, Paris, in 1942.

MICHELET, Firmin Marcelin 1875-
Born in Tarbes, France, on September 20, 1875, he studied under Falguière, Mercié and Marqueste and exhibited at the Salon des Artistes Français (second class medal, 1907), the Salon d'Automne and the Salon des Tuileries. He produced classical and allegorical figures and reliefs, notably the two angels for the Marne Memorial Chapel. Other works include a bust of a young girl and a statuette La Sportive (Museum of Modern Art, Paris), Youth and Les Parques (Toulouse Museum).

MICHELI, Aurelio fl. 19th century
He studied at the Berlin Academy from 1860 to 1870 and worked in Rome in 1862-63 before returning to Berlin, where he specialised in busts portraying German royalty and political personalities.

MICHELON, Auguste 1827-1872
Born in Auxerre in 1827, he died there in 1872. Auxerre Museum has various heads, busts and allegorical figures by him.

MICHELSEN, Hans 1789-1859
Born at Mehlus, Norway, in 1789, he died in Oslo on June 20, 1859. He studied in Stockholm and then went to Rome where he worked under Thorvaldsen. He specialised in ecclesiastical decoration and worked on the sculpture for Trondheim Cathedral. His works, regarded by his contemporaries as second-rate, include statuettes and medallions of the Apostles.

MICHIELI, G fl. late 19th century
Venetian sculptor of the late 19th century, exhibiting figures and reliefs in Turin, Milan, Rome and Venice from 1880 onwards.

MICOTTI, Ignazio fl. 19th century
Born in Milan in the early 19th century, he died there on May 5, 1886. He worked as a decorative sculptor and produced portraits, statues and bas-reliefs of saints and other religious figures. His chief work is the statue of St. Cyril in Milan Cathedral.

MIDDELTHUN, Julius 1820-1886
Born in Kongsberg, Denmark, on July 3, 1820, he died in Oslo on May 5, 1886. He studied under Bissen in Copenhagen and was influenced by Thorvaldsen with whom he worked in Rome for eight years. He specialised in busts in the realist manner of his times. He also did a series of statuettes illustrating various trades and occupations.

MIEDEMA, Simon 1860-
Born in Harlingen, Holland, on July 13, 1860, he studied at the Rotterdam Academy and specialised in medallions, plaques and allegorical figures. Rotterdam Museum has his allegorical group of Carving and Engraving.

MIESTCHANINOFF, Oscar 1886-
Born in Vitebsk, Russia, on April 22, 1886, he studied at Odessa School of Fine Arts in 1905-6 and went to Paris in 1907 where he was a pupil of Mercié and Joseph Bernard. He exhibited at the Salon d'Automne from 1912 and later also at the National and the Indépendants. His bronzes include heads and busts of women and girls and the figure Woman doing her Hair (Museum of Modern Art, Paris).

MIGLIARO, Vincenzo fl. late 19th century
Born in Naples on December 8, 1858, he studied at the Institute of Fine Arts and was a pupil of Stanislas Lista and Domenico Morelli. He worked as a painter, engraver and sculptor of genre subjects and exhibited in Turin, Venice, Naples and Paris.

MIGLIORETTI, Pascal (Pasquale) 1823-1881
Born at Ossiglia on January 17, 1823, he died in Milan on February 17, 1881. He studied at the Milan Academy and exhibited there and in Paris, winning a gold medal at the Exposition Internationale of 1855. He specialised in classical figures and groups, his works including Bacchus and Ariadne, Zeus as a Bull taking off Europa, Joseph interpreting his Dreams to Pharaoh, the Sacrifice of Abraham, Cain fleeing after the Death of Abel and Cimon in Prison, fed by his daughter Pero.

MIGNON, Léon 1847-1898
Born in Liège on April 9, 1847, he died in Brussels on September 30, 1898. He worked in Rome, Florence and Paris, and studied under Paul de Vigne. He specialised in groups showing bull-fights, but also sculpted more exotic figures such as Bison, Dromedary and Lady Godiva, and busts of Belgian personalities. His minor works include maquettes and projects for decorative and monumental sculpture. His bronze Man with Bull stands in one of the public squares in Liège.

MIKA MIKOUN fl. 20th century
Born in Warsaw, he emigrated to France before the first world war and studied under Bourdelle. He specialised in the production of clay, bronze and enamelled copper masks and exhibited them regularly in France and the United States.

MIKECHIN, M.O. 1836-1896
Russian sculptor of historical and genre figures. His Centurion is in the Tretiakoff Gallery, while the Russian Museum in Leningrad has a bronze maquette for his monument to Catherine the Great.

MIKLOS, Gustave 1888-
Born in Budapest on June 30, 1888, he emigrated to France in 1909 and was subsequently naturalised. He studied painting and sculpture under Kimnach at the Royal School of Decorative Arts in Budapest. He specialised in architectural sculpture in the modernist style.

MIKULA, Ferenc Janos 1861-
Born in Debrecen, Hungary, in 1861, he studied under Hellmer in Vienna and worked in Budapest as a decorative sculpture.

MILANESE, Rocco fl. 19th century
Born at Melicocca, Italy, on November 11, 1852, he studied at Naples School of Fine Arts and was a pupil of Monteverde in Rome. He exhibited figures and reliefs in Turin and Naples in the late 19th century.

MILANI, Umberto 1912-
Italian sculptor of genre and allegorical figures and abstracts, such as Mode (1959).

MILIONE. Louis 1884-
Born in Padua in 1884, he emigrated to the United States and studied at the Philadelphia School of Industrial Art (1900-04) and the Pennsylvania Academy (1904-08). He became an instructor in modelling at the Pennsylvania Museum and School of Industrial Art and specialised in decorative work, mainly in stone.

MILLER, Alec 1879-
Born in Glasgow on February 12, 1879, he studied at the Glasgow School of Art and went to Florence in 1908. He exhibited at the Royal Academy and in various parts of the United States. He taught at Camden School of Arts and Crafts (1902-14) and at Oxford City School of Art from 1919 to 1923 before emigrating to the United States. The latter part of his career was spent in Monterey, California. He sculpted in stone, marble and wood, and no bronzes by him have been recorded.

MILLER, Burr C. fl. 19th-20th centuries
American portrait and genre sculptor working at the turn of the century. He exhibited at the Salon des Artistes Français, getting an honourable mention in 1907.

MILLER, Felix Martin fl. 19th century
Sculptor of classical and allegorical figures, working in London. He exhibited at the Royal Academy from 1842 to 1880.

MILLER, Joseph Maxwell 1877-
Born in Baltimore, Maryland, in 1877, he studied at the Maryland Institute, the Rinehart School of Sculpture, the Charcoal Club, Baltimore and the Académie Julian under Verlet. He received an honourable mention at the Paris Salon in 1902 and specialised in portrait busts, bas-reliefs, memorials and monuments, in plaster and bronze.

MILLES, A.C.V. fl. 19th-20th centuries
Born in Stockholm in the second half of the 19th century, he studied in Paris under Injalbert and Rolard and exhibited figures at the Salon. He was awarded a silver medal at the Exposition of 1900.

MILLES, Carl Vilhelm Emil 1875-1955
Born in Lagga, near Uppsala, Sweden on June 23, 1875, he died in Stockholm in 1955. He studied in Paris under Puech and Puvis de Chavannes, Barye and Rodin and exhibited at the Salon des Artistes Français from 1899 onwards. At the Exposition Universelle of 1900 he got an honourable mention and subsequently exhibited at the Salon of the Société Nationale des Beaux Arts. He visited Munich in 1904 and came under the influence of Hildebrand. On his return to Sweden, however, he cut loose from the classicism of his mentors and developed his own fantasy style, which he used most effectively in fountains and monuments. His studio, the Millesgarden, became a museum to his work during his lifetime. He won a high reputation in Scandinavia, and at the Malmö Exhibition of 1913 he had an entire gallery devoted to his sculpture. After the first world war he exhibited in many parts of the world, from the Tate Gallery (1920), Paris, Germany and Sweden to the United States, where he settled in 1930. Although he spent the latter part of his career in Cranbrook, near Detroit, and became an American citizen, he returned to Sweden on his retirement and died there. His style varied considerably during his long career, from the Art Nouveau of the 1890s and the neo-Baroque of the early 1900s, through the synthesis of medievalism and Expressionist realism of the 1920s and the formalised classicism of his American period. He received many public commissions in Scandinavia and America and his chief works include the colossal Gustavus Vasa in the Nordiska Museet, Stockholm (1904-27), Solglitter (1926), the Jonas Fountain (1932), Orpheus Fountain (1936), Peace Monument (1936), Man and Nature (for the Time-Life Building, New York, 1940), the Rudbeckius monument at Westeras, Europa and the Bull (Halmstad) and the National Monument at Helsingborg. His minor works include genre and animal figures and groups, such as Little Girl with her Cat, The Struggle for Life, Archer and groups of dancers and elephants.

MILLES, Ruth 1873-
Born in Wallentuna, Sweden, in 1873, she worked in Stockholm and Paris and exhibited figures at the Salon des Artistes Français.

MILLET, Aimé 1819-1891
Born in Paris on September 28, 1819, he died there on January 14, 1891. He was the son of the miniaturist, Frédéric Millet, and enrolled at the École des Beaux Arts in 1836 where he studied under David d'Angers and Viollet-le-Duc. He exhibited at the Salon from 1840 and won a first class medal in 1857 and the Légion d'Honneur two years later. He produced many portrait busts and statuettes in marble, plaster and bronze, mainly of classical and historical subjects. He also secured commissions for a number of monuments to contemporary French celebrities.

MILLET DE MARCILLY, Édouard François fl. 19th century
Born in Paris on October 2, 1839, he was the son and pupil of Édouard Gustave Louis Millet de Marcilly and later studied under Carrier-Belleuse and Cheret. He specialised in monuments and memorials and sculpted several memorials to the Franco-German war of 1870-71, notably that at Villefranche. His minor works include bronze statuettes, groups and bas-reliefs portraying French generals, such as Bosquet and Bourbaki, and battle scenes.

MILLET DE MARCILLY, Édouard Gustave Louis 1811-1885
Born in Paris on September 11, 1811, he died there in 1885. He studied under Lequien and produced neo-classical figures and groups.

MILLS, Clark 1815-1883
Born in Onondaga, New York, on December 1, 1815, he died in Washington, D.C. on January 12, 1883. He worked in Charleston and specialised in portrait busts of his contemporaries. His chief work is the statue of Andrew Jackson in Washington.

MILLS, Theodore Augustus 1839-1916
Born in Charleston, South Carolina, in 1839, he died in Pittsburgh, Pennsylvania, in December, 1916. He was the son of Clark Mills and worked with him in his monumental sculpture. He sculpted a number of portrait busts and reliefs in his own right.

MILMORE, Martin 1844-1883
Born in Sligo, Ireland, in 1844, he died in Boston, Massachusetts, on July 21, 1883. He emigrated to the United States with his family during the Hungry Forties and later worked under T. Ball (1860-64) before going to Rome to study classical sculpture. While there he sculpted a bust of Pope Pius IX and subsequently made a reputation in America for portrait sculpture, his best known busts being those of Emerson and Webster. His chief work, however, was the Boston memorial to the dead.

MINAZZOLI, Edward A. 1887-
Born in Momo, Italy, on August 16, 1887, he emigrated to the United States and enrolled at the Art Students' League in New York. Later he attended classes at the École des Beaux Arts, Paris, and won an honourable mention at the Salon of 1929. He specialised in statuettes and bas-reliefs of religious subjects and also sculpted several monuments.

MINEUR, François Édouard fl. 19th century
Born in Paris in the first half of the 19th century, he studied under Simon the Younger and Fauginet and exhibited medallions and plaques at the Salon in 1863-68.

MINGHETTI, Giovan Battista fl. 19th century
Genre and portrait sculptor working in Bassano, Italy, in the second half of the 19th century. He exhibited figures in Turin and Venice in the 1880s.

MINGUZZI, Luciano 1911-
Born in Bologna in 1911, the son of a stone-mason who taught him the elements of sculpture. Later he studied at the Fine Arts Academy in Bologna and began exhibiting at the Venice Biennale and the Rome Quadriennials in 1933. Since the war he has participated in all the major national and international exhibitions in Europe, the United States and Brazil and now teaches sculpture at the Brera Academy in Milan. He exhibited in the New York Museum of Modern Art (1955) and in the Exhibition of Twentieth Century Italian Sculpture held in Messina, Rome and Bologna in 1957. His bronzes include The Shadow in the Wood (1957), Two Shadows (1957), Six People (alternatively known as The Stag Beetles), Contortionists (1950), The Echo and various maquettes for his monument To the Unknown Political Prisoner (1953).

MINNE, Georges 1866-1941
Born in Ghent on August 30, 1866, he died at Laethem St. Martin, Belgium, in 1941. He studied at the Ghent Academy (1882-84) before going to Paris in 1890. On his return to Belgium in 1895 he enrolled at the Brussels Academy but was expelled. His striking originality was sometimes regarded as verging on blasphemy and offended the narrow-minded pillars of the Belgian establishment at the turn of the century. He had a struggle to become established, but persevered to become one of the outstanding Belgian sculptors of the early 20th century. The turning point came in 1897 with his Kneeling Figure, the thin angular figure of a young man with his head bowed in submission. This was to become a recurrent theme in much of his later work, along with the subject of a mother weeping over her dead child. He moved with his family to Laethem St. Martin in 1899 and became the leader of the artists' colony there. After attending the anatomy lectures at Ghent University (1910), he tended towards greater realism in his figurative work. He became a teacher at the Ghent Academy in 1912 and during the first world war he lived as a refugee in Wales, returning to Laethem in 1919. In the 1920s he became the leading figure of Symbolist sculpture in Belgium and exerted great influence on the development of sculpture not only in the Low Countries but also in Germany. His works include The Wrestler, The Bearer of Relics, Nun at Prayer, The Mason, Young Girl Smiling, Mother and Dying Child and various portrait busts.

MINOT, Paul Louis fl. 19th century
Born at Mézières, France, on February 3, 1839, he exhibited figures and reliefs at the Paris Salon in 1887-88.

MIRA, Salvatore fl. 19th century
Sculptor of decorative and ecclesiastical bas-reliefs and figures, working in Palermo, Sicily, in the second half of the 19th century.

MIRANDA Y CASELLAS, Fernando 1842-1925
Born in Valencia in 1842, he died in New York in 1925. He studied in Valencia and Madrid and was a pupil of J. Piquer. He specialised in monuments, memorials, portrait busts and bas-reliefs.

MIREA, Dumitru D. 1868-
Born in Campulung, Romania, in 1868, he worked in Bucharest and Campulung at the turn of the century. He specialised in genre and allegorical figures and groups, such as Peasant of Campulung and Sad Thoughts (Simu Museum, Bucharest). He was awarded a bronze medal at the Exposition Universelle of 1900.

MIRKO – See BASALDELLO, Mirko

MIRÖ, Joan 1893-
Born in Tarragona, Spain, in 1893, he studied at the Barcelona School of Art (1907) and the Gali Academy (1910-15) and went to Paris in 1919. He joined André Breton's Surrealist movement from its beginning in 1924 and began sculpting Surrealist objects about 1930.

Although principally a painter, he decorated pottery for Artigas in 1942 and thereafter turned to ceramics himself. Mirö and Artigas collaborated closely on this combination of ceramics and paintings, working in Catalonia in the mid-1940s. His sculpture uses a wide variety of materials, including wood, cork, shells, stone, pebbles, tiles and even egg-shells. He has also had several bronzes cast, notably the Bird series of 1944-46. He now lives at Montroig in Spain.

Dupin, Jacques *Joan Mirö* (undated, but c.1965).

MISEREY, Albert Ernest 1862-
Born at Ménilles, France, on July 31, 1862, he studied under Thomas and Gauthier and exhibited genre figures at the Salon des Artistes Français, winning third class (1894), second class (1901) and first class medals (1913). He specialised in statuettes depicting different racial types.

MISZFELDT, Heinrich 1872-
Born in Kiel, Germany, on December 20, 1872, he studied under P. Schnorr, Janensch, Herter and Breuer and worked in Berlin as a sculptor of portraits and genre figures, such as The Bowls-player (Bremen Museum).

MITCHELL, Guernsey 1854-1921
Born in Rochester, New York, on October 1, 1854, he died there on April 1, 1921. He spent 21 years working in Paris and exhibited at the Salon des Artistes Français, getting an honourable mention in 1890. He produced portrait busts and figures.

MITCHELL, Maggie (née Richardson) fl. 20th century
Born in London in the late 19th century, she died in Somerset on February 21, 1953. She studied at the Goldsmiths' College School of Art and the Royal College of Art and married the painter George J. Mitchell. She exhibited portrait busts and heads at the Royal Academy, the Royal Scottish Academy and the Salon des Artistes Français and was elected RBA in 1929. She worked at Norton-sub-Hamden, Somerset.

MITFORD-BARBERTON, Ivan 1896-
Born in Somerset East, Cape Province, on February 1, 1896, he was educated at St. Andrews College, Grahamstown, and served in both world wars in the South African armed forces. He studied at the Royal College of Art, London, and also in Paris and Italy in the mid-1920s and worked as a coffee planter in Kenya for fifteen years before concentrating on sculpture. He taught at the Michaelis Art School, Cape Town, and lived at Hout Bay, Cape Province. He sculpted portraits and figures as well as memorials and public statuary, working in wood, ivory, stone and bronze.

MITRIC, Nikola fl. 20th century
Yugoslav sculptor working in Belgrade since the second world war and specialising in portrait busts and statues of historic and contemporary personalities, particularly from the world of politics.

MITSCHERLICH, Frieda 1880-
Born in Berlin on April 6, 1880, she worked in Munich and produced portrait busts of her artistic contemporaries. Her portrait of Janensch is in the Berlin National Gallery.

MITTERER, Josef 1880-
Born in Munich on April 2, 1880, he produced decorative sculpture and memorials in Bavaria.

MITTERLECHNER, Franz fl. 19th century
Born in Austria about 1830, he worked in Vienna and studied at the Academy. He is best remembered for the five allegorical statues at the Vienna Nordbahnhof.

MOCQUOT, Magdaleine fl. 20th century
French sculptress, working in Paris in the early years of this century. She exhibited figures at the Salon des Indépendants.

MODEL, Jean Louis fl. 20th century
French painter, poster-artist and sculptor of genre figures, working in Paris in the first half of this century.

MODIGLIANI, Amadeo 1884-1920
Born in Leghorn, Italy, on July 12, 1884, he died in Paris on January 24, 1920. His father was a Jewish banker and his mother was born in Marseilles of Italian descent. His father went bankrupt when he was

still quite young and the family led a rather nomadic existence, living in Rome, Naples, Florence, Venice and Paris at the turn of the century. He began sculpting about 1908 and was befriended by Brancusi, who introduced him to the work of Picasso and Lipschitz. Later he was strongly influenced by Nadelmann and also derived inspiration from the Negro art which became fashionable in the 1920s. His earliest sculpture was carved in wood and little has survived from that period. He spent some time in Leghorn in 1909-11, but then settled in Paris and exhibited heads and maquettes for caryatids at the Salon d'Automne in 1912. Thereafter he abandoned sculpture and concentrated on painting.

MODROW, Philipp 1882-1925
Born in Frankfurt-am-Main on May 8, 1882, he died in Davos, Switzerland, on December 6, 1925. He studied under Emil Cauer and produced portrait and genre figures. His best known work is the Spengler monument in Davos (1923).

MOEST, Friedrich fl. 19th century
Born at Gernsbach, Germany, on March 26, 1838, he studied under Des Coudres and Schirmer and produced monuments, war memorials and public statuary for many German towns. His minor works include allegorical statuettes and portrait busts of his contemporaries.

MOEST, Josef 1873-1914
Born in Cologne, the son of Richard Moest, on January 13, 1873, he died at Rath-Heumer on May 25, 1914. He specialised in figures and bas-reliefs of religious subjects and sculpted the Shermondt monument at Aachen.

MOEST, Richard 1841-1906
Born in Horb, Germany, on February 20, 1841, he died at Cologne on August 1, 1906. He studied under J.N. Meintel, A. Kreling and P. Lenz and specialised in religious figures and bas-reliefs and altar decoration.

MOFFITT, John M. 1837-1887
Born in England in 1837, he died in New York in 1887. He specialised in tombstones, memorials and religious figures and is best known for The Four Ages of Life in Greenwood cemetery, Brooklyn.

MOGLIA, Domenico 1780-c.1862
Born in Cremona, Italy, on September 26, 1780, he died some time after 1862. He studied under F. Rodi and worked as a decorative sculptor in Milan, producing decoration reliefs for the Peace Arch in that city.

MOHOLY-NAGY, Laszlo 1895-1946
Born in Bacsbarsod, Hungary, in 1895, he died in Chicago in 1946. He served in the Austro-Hungarian Army during the first world war and was severely wounded in 1917. He took up drawing and painting during his long convalescence and in 1920 went to Berlin, where he began painting abstracts under the direction of the Russian school, especially Lissitsky. This led him to Constructivism and the work of Pevsner and Gabo, and he produced a series of constructions using wood, aluminium, copper, nickel, bronze and steel. He had an exhibition of his work at the Sturm Gallery in 1922 and this brought him to the attention of Gropius, who invited him to join the Bauhaus, where he subsequently taught metalwork. His later constructions anticipated Calder's mobiles and used both manual and mechanical devices to produce the element of movement. He also experimented with plexiglas and other transparent plastics, and used electric light projected through slits and holes in his sculptures. He left the Bauhaus in 1928 and went to Berlin where he began experimenting with photography as an artistic medium and then moved to Paris where he worked with the Abstraction-Création group. After the Nazis came to power in Germany he moved to England for a time (1935-37) before settling in the United States. He founded the New Bauhaus in Chicago (1938) and the School of Drawing, which he continued to direct till his death. His metallic sculpture belongs to the period up to about 1932; thereafter he experimented with Space Modulators in which transparent plastic became predominant.

MOHR, Christian 1823-1888
Born at Andernach, Germany, on April 18, 1823, he died in Cologne on September 13, 1888. He specialised in religious sculpture and produced the four Evangelists and 59 angels which decorate the south door of Cologne Cathedral. He also sculpted seven figures of saints in the Church of St. John the Baptist in Aachen.

MOHR, Claus 1868-
Born at Lutzhorn, Holstein, on February 9, 1868, he studied under J. Grünewald, Herterich and A.V. Donndorf. He specialised in bas-reliefs and figures of genre and literary subjects. Stuttgart Museum has his bronze group Sun Bath. He was greatly influenced by the writings of Schiller and sculpted his monument at Marbach, which bears a series of eleven bas-reliefs derived from his works.

MOHR, Johannes Matthäus 1831-1903
Born in Frankfurt-am-Main on May 30, 1831, he died in Rudolstadt on March 5, 1903. He studied at the Institut Städel and worked at the Nymphenburg porcelain factory as a modeller.

MOIGNIEZ, Jules 1835-1894
Born at Senlis in 1835, he died there in 1894. He studied under Coméléra and worked as an Animalier. He made his début at the Salon of 1855 with a plaster group of a Setter seizing a Pheasant, and exhibited there regularly till 1881. His father was a metal-gilder who established a bronze foundry in 1857, and cast his son's works. After his death Moigniez had his bronzes cast by A. Gouge. Like Mène, Moigniez was particularly fashionable in Britain and many of his figures and groups of game-birds and hunting dogs were aimed at the English and Scottish market. It has been estimated that more than half of his considerable output was exported to Britain between 1862 and 1894 and this accounts for the number of bronzes by him which turn up in British salerooms. He participated in the Great Exhibition of 1862 and won a medal. A list of bronzes by Moigniez is appended to *The Animaliers* by James Mackay (1973).

MOINE, Antonin Marie 1796-1849
Born at St. Étienne on June 30, 1796, he committed suicide in Paris on March 18, 1849. He studied under Girodet and Gros at the École des Beaux Arts and exhibited at the Salon from 1831 till 1848, specialising in busts and heads of the Orleanist royal family and contemporary celebrities.

MOIRET, Ödön (Edmund) 1883-
Born in Budapest on March 2, 1883, he studied in Budapest, Vienna and Brussels and produced bas-reliefs and plaquettes.

MOIRIGNOT, Edmond 1913-
Born in Paris on October 21, 1913, he studied under Jean Boucher and exhibited at the Salon d'Automne and the Tuileries. He had a one-man show in Paris in 1950, and specialised in portrait busts, reliefs and heads.

MOITTE, Jean Guillaume 1746-1810
Born in Paris on November 11, 1746, he died there on May 2, 1810. He was the son and pupil of Pierre Etienne Moitte and also studied under Pigalle. He won first prize for sculpture in 1786, with his group of David carrying in triumph the Head of Goliath. He exhibited at the Salon from 1783 to 1814 and became a member of the Institut in 1795 and a Chevalier of the Légion d'Honneur in 1805. He sculpted many public monuments and statues in Paris, notably the equestrian statue of Bonaparte in the Tuileries Gardens, a popular subject as a bronze reduction. His minor works include the statuette of Minerva (The Louvre).

MOLEAU, Calixte Désiré fl. 19th century
Born at Cerdon, France, on May 26, 1841, he studied under Bonnassieux, Dumont and Delorme and won a high reputation for his allegorical and classical figures. He became a member of the Institut. His figure of Charity is in the Orleans Museum.

MOLGAARD, Johannes 1854-1927
Born at Tondern, Denmark, on May 5, 1854, he died in Copenhagen on October 11, 1927. He studied at the academies of Copenhagen and Berlin and specialised in portrait busts of his Danish contemporaries.

MOLIN, C. Gunnar fl. 20th century
Born in Stockholm, he emigrated to the United States and enrolled at the classes of the Art Students' League in New York. He produced monuments, portraits and figures and became a member of the American Professional Artists League.

MOLIN, Johann Peter 1814-1873
Born in Göteborg on March 17, 1814, he died at Ekudden, near Vaxholm, on July 27, 1873. He studied in Copenhagen, Paris and Rome and produced numerous statues for Swedish towns. His minor works include many busts, bas-reliefs and medals of Scandinavian royalty and contemporary celebrities, and classical figures such as Triton, and Sleeping Bacchante.

MOLINARI, Giuseppe fl. mid-19th century
Figure and portrait sculptor working in Genoa in the mid-19th century. He studied under S. Varni and sculpted many statues and allegorical groups in Genoa, notably the poor asylum and the cemeteries of that city.

MOLINO, Antonio 1808-c.1839
Born in Vasto in the Abruzzi, Italy, on May 6, 1808, he died in Naples about 1839. He studied at the Naples Academy and worked as a decorative sculptor, specialising in religious subjects.

MOLINS BALLESTE, Enrique 1893-
Born in Barcelona in 1893, he studied at the School of Fine Arts in that city before settling in Paris. His sculpture is mostly in wood.

MOLITOR, Mathieu 1873-1929
Born at Piecklissem, Germany, on May 23, 1873, he died in Lèipzig on December 23, 1929. He studied at the Academy of Weimar and worked mainly in the Lèipzig area on public statuary, particularly at Lèipzig University. His Portrait of a Woman is in the Weimar Museum.

MOLKENBOER, W.B.G. 1844-1915
Born in Leyden, Holland, on June 8, 1844, he died in Amsterdam in December, 1915. He worked with Veneman at Hertogenbosch and later lived in Munich, Antwerp and Louvain where he sculpted busts and relief portraits.

MOLL, Margarete 1884-
Born in Mulhouse on August 2, 1884, she was the wife of the painter Oskar Moll. She studied under Corinth and was influenced by August Gaul. She spent her working life in Breslau, where she produced figures and busts expressing the suppleness of the human body.

MOLLER, Alexis Bernhard Thorvald 1879-
Born in St. Petersburg, Russia, on July 22, 1879, he studied at the Copenhagen Academy and worked in Denmark, where he specialised in busts of his contemporaries.

MÖLLER, Edmund 1885-
Born at Neustadt an der Heide, Germany, on August 8, 1885, he studied in Düsseldorf, Dresden and Rome and then settled in Dresden, where he specialised in heads and busts and genre figures.

MOLLER, Heinrich Hermann Christian 1835-1929
Born in Altona on August 20, 1835, he died at Linda, near Freiburg-am-Breisgau, on September 11, 1929. He studied under J. Schilling in Dresden and specialised in memorials, monuments and genre figures and groups.

MOLLER, Hermann 1870-
Born at Langewiesen, Germany, on August 13, 1870, he specialised in monuments and public statuary, particularly war memorials which may be found in many parts of Germany.

MOLOSTVOFF, Boris fl. 20th century
Born in Kazan, Russia, at the turn of the century, he came to France and studied under Bouchard and Landowski and exhibited figures at the Salon des Artistes Français, the Indépendants and the Salon d'Automne in the 1920s.

MOLTO Y LLUCH, Antonio 1841-1901
Born at Altea, Spain, in 1841, he died in Granada in 1901. He studied in Valencia and Rome and produced many monuments and ecclesiastical statuary for churches in Madrid.

MOMBUR, Jean Ossaye 1850-1896
Born at Enneyat, France, in 1850, he died in 1896. He studied in Paris under Dumont and Bonnassieux and exhibited at the Salon from 1878 onwards. He produced classical figures and genre groups, such as The Familial Kiss, as well as busts of his contemporaries.

MONARD, Louis de 1873-
Born in Autun on January 21, 1873, he worked as an Animalier, exhibiting at the Salons around the turn of the century. His best known work is Young Bucks in Combat, on the terrace of the Luxembourg Museum, while other animal groups by him may be found at Sèvres, Cahors and Paris Town Hall. He also sculpted the monument to fallen airmen of the first world war (Chapelle des Invalides). His minor bronzes include various studies of terriers and horses and several portrait busts.

MONARI, Carlo c.1832-1918
Born in Italy about 1832, he died in Bologna in 1918. He specialised in tombs, bas-reliefs and portrait busts and exhibited in Milan, Turin, Bologna and Paris from 1881 onwards.

MONASTERIO, Luis Ortez 1906-
Born in Mexico City in 1906, he studied at the San Carlos Academy in that city before moving to California in 1925. Two years later he was appointed to a teaching post in Mexico, but again went to California in 1928 and exhibited his sculpture in Los Angeles in 1929 and San Francisco in 1930. He returned to Mexico in 1931 on being given a professorship and thereafter undertook a number of important state commissions, including Call to Revolution (1932) and The Slave (1933). He has taken part in many international exhibitions since 1940 and has had a prodigious output in both stone and bronze. Many of his works are architectural and are designed for public squares and buildings in Mexico City, Puebla, Chapultepec and Jalapa. His work is strongly influenced by traditional Mayan sculpture and other pre-Columbian art forms but he has also derived inspiration from the art of Greece and Egypt. This eclecticism, however, has been harnessed to his own inimitable genius and the resulting figures are quite distinctive.

MONCASSIN, Henri Raphael 1883-
Born in Toulouse on April 3, 1883, he studied under Mercié and exhibited at the Paris Salons from 1905 onwards, being runner-up in the Prix de Rome in 1908. He produced a number of memorials after the first world war, but specialised in busts of children and contemporary figures. His work also includes genre bronzes, such as Youth (1911).

MONCEAU, Clovis Antoine fl. 19th century
Born in Orleans on November 29, 1827, he studied under Dantan the Elder and also attended classes at the École des Beaux Arts. He exhibited at the Salon in 1859 and 1861, showing terra cotta figures. He is best known for the Fourteen Stations of the Cross in Orleans Cathedral, bas-reliefs in stone. He won the Prix Robichon in 1874 and also sculpted numerous bronze plaques and portrait medallions.

MONCEL, Conte Alphonse Emmanuel de Moncel de Perrin 1866-
Born in Paris on September 7, 1866, he studied under Thomas and Mercié and exhibited at the Salon des Artistes Français from 1888 onwards, getting an honourable mention in 1889 and a travelling scholarship in 1895. He was awarded the Légion d'Honneur in 1903. He specialised in classical high-reliefs, genre figures and portrait busts. He sculpted the high-reliefs of Venus and Juno in the Petit Palais and allegorical compositions, such as Ivy, Verse of Love and Enigma, as well as small plaques and medallions.

MONCHANIN, Louis fl. 19th century
Born in Paris in the early 19th century, he studied under Legendre-Héral and exhibited figures and groups of animals at the Salon from 1853 to 1866.

MONCOURT, Henri de fl. 19th century
Born in Amiens in the mid-19th century, he studied under Millet and Fagel and exhibited figures at the Salon des Artistes Français in the 1880s.

MONETA, Girolamo fl. late 19th century
Portrait sculptor working in Milan from 1877 to 1894.

MONFRIED, Georges Daniel de 1856-1929
Born in Paris on March 14 1856, he died there on November 26, 1929. He was a close friend of Paul Gauguin and worked as a painter, engraver and sculptor of genre subjects.

MONGINOT, Charlotte 1872-
Born in Paris on December 18, 1872, she was the daughter and pupil of the painter Charles Monginot and studied under Puech, Verlet and

Marqueste. She exhibited paintings and sculpture of classical subjects at the Salon des Artistes Français, getting an honourable mention in 1895 and a third class medal in 1910.

MONIER, Émile Adolphe 1883-
Born in Paris on July 10, 1883, he studied under Ponscarme and specialised in medallions and plaques, many of which are represented in the Troyes Museum collection.

MONNIER, François Xavier 1831-1912
Born in Belfort about 1831, he died in Detroit, Michigan, on April 5, 1912. He emigrated to the United States in 1862 and worked in Michigan as a decorative sculptor.

MONOT, Martin Claude 1733-1808
Born in Paris in 1733, he died there in 1808. He was the grandson and pupil of Pierre Étienne, the sculptor, and won first prize for sculpture in 1760. He was admitted to the Académie Royale in 1769 and became an Academician ten years later. He was Sculptor to the Comte d'Artois and exhibited at the Salon from 1769 to 1798. He specialised in busts of his contemporaries and classical figures, mainly in marble.

MONSARAZ, Maria fl. 20th century
Portuguese sculptress of portrait busts and bas-reliefs, of historical and contemporary personalities.

MONSEGUR, Alexandre 1849-
Born in Belfort on April 7, 1849, he studied under Gérôme and Aimé Millet and exhibited plaques, bas-reliefs and medallions at the Salon from 1876 to 1880.

MONSERRAT Y PORTELLA, José fl. 19th-20th centuries
Born in Hospitalet de Llobregat, Spain, in the mid-19th century, he worked in Madrid and exhibited genre and allegorical figures there from 1879 to 1912. The Gallery of Modern Art, Madrid, has his figure of a Washerwoman and the group Love and Labour.

MONTAGNE, Émile Pierre de la 1873-
Born in Antwerp on October 22, 1873, he studied at the old Académie Royale and later at the Brussels Academy. He went for two years to Paris where he studied portrait painting and then worked in London for five years. Though better known as a painter he also sculpted portrait busts, heads and reliefs.

MONTAGNE, Pierre Marius 1828-1879
Born in Toulon on September 4, 1828, he died there on January 17, 1879. He spent many years in the sculpture workshop of the naval dockyard at Toulon before coming to Paris, where he studied under Rude and exhibited at the Salon from 1850 to 1875, winning medals in 1867 and 1869. He is best known for the decorative sculpture in the Grand Theatre, Toulon. Casts of the models for the six statues in the theatre are now in Toulon Museum. He also sculpted numerous portrait busts and classical figures, in marble and bronze.

MONTAGNY, Jean Pierre 1789-1862
Born at St. Étienne on July 31, 1789, he died at Belleville in 1862. He was the son and pupil of the engraver and medallist Clement Montagny and studied sculpture under Cartellier. He specialised in plaques and bas-reliefs.

MONTANA, Pietro 1890-
Born in Italy in 1890, he emigrated to the United States and studied at the Cooper Union and Mechanics Institute of New York. He produced a number of war memorials and monuments in the 1920s and 1930s, as well as genre figures and busts, and the bronze bas-relief My Parents.

MONTEVERDE, Giulio 1837-1917
Born at Bistagne, Italy, on October 8, 1837, he died in Rome on October 3, 1917. He studied at the Academy of Fine Arts in Rome and later became professor there. He is best known for neo-classical and historical figures and groups, such as Jenner experimenting with Vaccine (awarded a medal of honour at the Exposition Internationale of 1878), The Genius of Franklin, the monument to Victor Emmanuel II in the Rome Pantheon, Idealism and Materialism (Exposition Universelle, 1900). His minor works include genre groups, such as Children playing with a Cat (Genoa Museum). Casts of his statuette The Young Columbus, are in various American and Italian museums. He was one of the most fashionable Italian sculptors of the turn of the century and received many awards. He was made an Officier of the Légion d'Honneur in 1878 and an Italian Senator in 1889.

MONTFORD, Paul Raphael 1868-1938
Born in London on November 1, 1868, he died in Melbourne, Australia, in 1938. He was the son of Horace Montford, sculptor in marble, and studied under his father at the Lambeth School of Art and the Royal Academy schools, where he won the gold medal, the Landseer scholarship and a travelling scholarship in 1891. He exhibited portrait busts, heads and figures at the Royal Academy and the RBA from 1892. After the first world war he executed a number of commissions for monuments and public statuary in Australia.

MONTHIÈRES, Léon de fl. 19th-20th centuries
Born in Abbeville, France, in the mid-19th century, he exhibited figures at the Salon des Artistes Français at the turn of the century, getting an honourable mention in 1898.

MONTI, Federico fl. 19th century
Sculptor of memorials, tombs and monumental statuary working in Bologna in the mid-19th century.

MONTI, Gaetano 1776-1847
Born in Ravenna on March 13, 1776, he died in Milan on May 27, 1847. He was the father of Rafaello Monti and a cousin of Giovanni Monti. He specialised in religious sculpture and decorated churches in Milan, Ravenna, Brescia and Varese. His secular works include busts of Italian royalty and contemporary celebrities.

MONTI, Giovanni fl. 18th century
Ornamental sculptor working in Rome in the second half of the 18th century and a member of the Academy of St. Luke. He produced decorative reliefs and figures in plaster, bronze and gilt-bronze, especially for the Casino Borghese.

MONTI, Luigi fl. 19th century
Sculptor of religious subjects working in Rome, where he died in 1897. His best known work is the monument to Pope Gregory XVI in St. Peter's Basilica.

MONTI, Rafaello 1818-1881
Born at Iseo, Italy, in 1818, he died in London on October 16, 1881. He was the son and pupil of Gaetano Monti and specialised in neo-classical statuary. He won a gold medal in Milan for his equestrian statue of Alexander the Great on Bucephalus. He worked in Vienna from 1838 to 1842 and came to England in 1848 to execute decorative sculpture for the Duke of Devonshire. His Veiled Statue belongs to this period. When revolution broke out later that year he returned to Italy and enlisted in the army of Garibaldi. On the cessation of hostilities he returned to London, where he spent the rest of his life. He exhibited figures and bas-reliefs at the Royal Academy from 1853 to 1860.

MONTINI, Tullio 1878-
Born in Verona in 1878, he studied under C. Poli and R. Cristani. He worked as a decorative sculptor in Verona and produced several statues and monuments for public buildings, squares and parks in that city. His minor works include genre statuettes and heads.

MONTPELLIER fl. 18th-19th centuries
Bronzes of neo-classical and historical subjects with this signature were the work of a Parisian sculptor who studied under Lemoine and exhibited at the Salon of 1798. His chief work is the series of six bas-reliefs featuring trophies of arms, for the Arc de Triomphe du Carrousel in Paris.

MONTRESOR, Francesco fl. 19th century
Born in Verona in the early 19th century, he studied under Tenerani and specialised in portrait busts of contemporary personalities. His bust of Pope Gregory XVI is in the Pinacothec of Ascoli.

MONY, Adolphe Stéphane 1831-1909
Born in Paris on March 23, 1831, he died there in 1909. He studied under Guiton and Bartholdi and exhibited figures at the Salon from 1877, getting an honourable mention in 1892.

MOODY, Ronald 1910-
Born in Kingston, Jamaica, on August 12, 1910, he studied in London and Paris and has exhibited at the Royal Academy, the Paris Salons and various provincial and foreign galleries. He specialises in portrait busts, heads and figures and is a member of the Society of Portrait Sculptors. He now works in London.

MOORE, Henry Spencer 1898-
Born in Castleford, Yorkshire, on July 30, 1898, he served in the army in 1917-19 and studied at Leeds College of Art (1919-21), the Royal College of Art (1921-24) and also in France and Italy. He had his first one-man show at the Warren Gallery, London, in 1928 and was a member of the Leicester Galleries from 1930 to 1937. He belonged to the Seven and Five Society (1932-35) and Unit One (1933) and took part in the International Surrealists' Exhibitions of 1936 and 1938. He travelled widely and participated in many exhibitions both at home and abroad. His first public commission was a bas-relief for the London Underground headquarters in 1928. He taught at the Royal College of Art (1925-32) and the Chelsea School of Art (1932-39) and served as an official war artist in 1940-42, his sketches of refugees in the underground shelters being his best known work from this period. Since the war he has had many retrospective exhibitions in Britain, Europe and America and won prizes at the Venice and Sao Paulo Biennales and other major international exhibitions. His position as the leading British sculptor of this century has been recognised by the award of the Order of Merit in 1963. He lives in Much Hadham, Hertfordshire. Though best known for his variations on the theme of the reclining figure he has produced a wide range of sculpture, both carved direct in stone and cast in bronze. His numerous public commissions include Reclining Woman (1929), Madonna and Child (Northampton, 1943), Memorial Figure (Dartington Hall, 1947), Three Standing Figures (London, 1947), Family Group (Stevenage New Town, 1948), Draped Reclining Figure (Time-Life Building, London, 1952), King and Queen (Middelheim, Antwerp and Glenkiln, Galloway, 1953), Glenkiln Cross (Galloway, 1956) and Reclining Figure (UNESCO Headquarters, Paris, 1958). His minor works include portraits and maquettes for many of his larger commissions, such as Warrior with Shield and Mother and Child in a Rocking Chair.
Grohmann, Will *The Art of Henry Moore* (1960). James, Philip (ed.) *Henry Moore on Sculpture* (1967). Jianou, Ionel *Henry Moore* (1968). Melville, Robert *Henry Moore* (1970). Read, Herbert *Henry Moore: A Study of his Life and Work* (1965).

MOORE, Joan Augusta Munro (Mrs. Armitage) 1909-
Born in Eltham, Kent, on March 10, 1909, she studied at the Slade School of Art (1932-36) and has exhibited painting and sculpture, in stone, wood, terra cotta and bronze, at the Royal Academy and the leading British galleries. She lives in London.

MOOS, Leo von 1872-
Born in Mondsee, Austria, in 1872, he studied in Innsbruck and Vienna and worked in Salzburg, specialising in statues and busts of historic and contemporary German and Austrian personalities.

MORA, Domingo fl. 19th-20th centuries
Born in Catalonia in the mid-19th century, he died in San Francisco, California, on July 24, 1911. He studied in Barcelona and Madrid and worked in Montevideo, Uruguay, where he did statues and decorative sculpture for the Exchange and the Museum.

MORA, Joseph Jacopo 1876-
Born in Montevideo on October 22, 1876, the son of Domingo Mora. He studied under J. Decamp and J.C. Beckwith and specialised in genre figures and groups, memorials and commemorative plaques.

MORAHAN, Eugene 1869-
Born in Brooklyn, New York, on August 29, 1869, he studied under Saint-Gaudens and was a pupil of the Art Students' League. He produced monumental statuary, fountains and memorials, in Rhode Island, New York, and also in England.

MORALES Y GONZALEZ, Francisco fl. 19th century
Born in Granada, Spain, about 1845, he studied under Miguel Marin and worked as a painter and sculptor of religious subjects. Examples of his work may be found in the University and churches in Granada.

MORATILLA, Felipe fl. 19th century
Born in Madrid in 1827, he specialised in portrait busts of Spanish and papal personalities. The Gallery of Modern Art in Madrid has several allegorical, classical and genre bronzes by him, such as Hermes and Bacchus, Faith, Hope and Charity and Neapolitan Fisherman.

MORBIDUCCI, Publio 1889-
Born in Italy in 1889, he produced genre and allegorical figures, such as Fecondita (Gallery of Modern Art, Florence).

MORBLANT, Charles fl. 19th century
Born at Vitry-sur-Seine in the mid-19th century, he studied in Paris under Leroux and exhibited figures at the Salons from 1875 to 1886.

MOREAU, Auguste fl. 19th-20th centuries
Born in Dijon in the early 19th century, he studied under Mathurin Moreau and exhibited statuettes, mainly in marble, at the Salons from 1861 to 1910.

MOREAU, François Clement 1831-1865
Born in Paris on October 17, 1831, he died there on June 12, 1865. He attended the École des Beaux Arts in 1850-53 and was a pupil of Pradier, Simard and Mathurin Moreau. He exhibited busts and allegorical figures at the Salon from 1853 to 1865, winning a medal in the latter year.

MOREAU, François Hippolyte fl. 19th century
Born in Dijon in 1832, he studied under Jouffroy and worked in Paris. He exhibited at the Salon from 1863, winning a third class medal in 1877 and a bronze medal at the Exposition Universelle of 1900. He specialised in genre figures, such as Springtime and The Drinker (both in Dijon Museum).

MOREAU, Friedrich, Baron de 1814-1885
Born in Paris in 1814, he died in Bozen (Bolzano) on June 2, 1885. He spent most of his life in Austria, painting hunting scenes and modelling figures and groups of dogs and horses.

MOREAU, Jean Baptiste 1797-1855
Born in Dijon in 1797, he died there in 1855. He worked as a decorative sculptor of classical subjects. The Dijon Museum has marble bas-reliefs and a terra cotta of Mars and Venus by him.

MOREAU, Louis Auguste 1855-1919
Born in Paris on April 23, 1855, the son of Mathurin Moreau, he died there on October 18, 1919. He studied under his father, Aimé Millet, A. Dumont and J. Thomas and exhibited at the Salon, winning a third class medal in 1877 and a bronze medal at the Exposition Universelle of 1900. He specialised in allegorical and classical groups, statuettes of historic personalities and busts of his contemporaries.

MOREAU, Mathurin 1822-1912
Born at Côte-d'Or on November 18, 1822, the son of Jean Baptiste Moreau, he died in Paris on February 14, 1912. He studied under his father and enrolled at the École des Beaux Arts in 1841, where he was a pupil of Ramey and Dumont. He exhibited at the Salon from 1848 onwards and received numerous awards. He became an Officier of the Légion d'Honneur in 1885. He had many public commissions and his statues and monuments are to be found in many parts of Paris. His bronzes include numerous classical and allegorical figures and groups, the statuette of Marguerite of Anjou (1901) and the memorial to Gramme in Père Lachaise cemetery.

MOREAU-SAUVE, Edmond fl. early 20th century
Born in Paris in the late 19th century, he exhibited figures and portraits at the Salon des Artistes Français and got an honourable mention in 1908.

MOREAU-VAUTHIER, Paul Gabriel Jean 1871-
Born in Paris on November 26, 1871, he learned the techniques of sculpture from his father, the ivory carver Augustin Moreau-Vauthier and studied under Thomas at the École des Beaux Arts. He exhibited genre and allegorical figures at the Salon des Artistes Français, becoming an Associate (1895) and winning an honourable mention (1898), third class (1899), second class (1907) and first class (1928) medals. He was awarded a silver medal at the Exposition Universelle of 1900 and the Légion d'Honneur in 1910. He produced a number of memorials in the aftermath of the first world war. His figure of a Dead Cuirassier is in Beaufort Museum.

MOREIRA RATO fl. 20th century
Portuguese sculptor of genre figures, characterised by stark realism. His bronzes include Without a Hearth and Without Bread.

MOREL, Louis Fernand 1887-
Born at Essoyes, France on November 30, 1887, he studied under Injalbert and worked in Troyes whose museum has the main collection of his work, such as the Mask of Ephebus and other classical reliefs and figures in bronze, plaster and marble. He exhibited at the Salon des Artistes Français and won a second class medal in 1921.

MOREL-LADEUIL, Leonard 1820-1888
Born in Clermont-Ferrand in 1820, he died in Boulogne on March 15, 1888. He was the pupil and later the assistant of Antoine Vechte and exhibited figures at the Salon from 1853 onwards, winning a third class medal in 1874. He became a Chevalier of the Légion d'Honneur in 1878. His works are preserved in the Museum of Decorative Arts, Paris.

MORET, Alfred fl. 19th-20th centuries
Born in Tours in the mid-19th century, he died there in 1913. He exhibited portrait busts, reliefs and medals at the Salon from 1877 to 1892.

MORETON, Alice Bertha (née Tippin) 1901-
Born in Liverpool on March 23, 1901, she studied at Bootle and Liverpool Schools of Art and won a travelling scholarship in 1922 which enabled her to study in Rome and Paris. She completed her studies at the Royal Academy schools in 1924-28. She has exhibited figures and portraits at the Royal Academy, the Paris Salons and the main British galleries and has worked in Hooton, Cheshire for many years.

MORETTI-LARESE, Lorenzo 1807-1885
Born in Venice in 1807, he died there in 1885. He specialised in portrait busts of historic and contemporary Italian figures.

MOREY, Virgile fl. late 19th century
He studied under Hippolyte Moreau and worked as a sculptor of genre subjects in Paris, exhibiting at the Salon from 1883 to 1895.

MORGAN, Arthur C. fl. 20th century
Born at Riverton Plantation, Ascension, Louisiana, in the late 19th century, he studied under Borglum and Korbel and became a member of the American Federation of Arts. He specialised in portrait busts and statuettes of fictional heroes, such as Thais and Don Quixote.

MORGAN, George T. fl. 19th century
Born in Birmingham in 1845, he studied there and in London before emigrating to the United States where he worked as assistant to William Barber and Charles Barber at the Philadelphia Mint. He specialised in bas-reliefs, plaques and medallions.

MORGAN, Jane fl. 19th century
Born in Cork, Ireland in the early 19th century, she studied in Dublin under R.R. Scanlan and J.R. Kirk. She worked in Rome from 1855 to 1866 before emigrating to the United States. She sculpted monuments and memorials, portrait busts and genre figures and died in Livingston, Montana on April 4, 1899.

MORIA, Blanche Adèle 1859-1927
Born in Paris on May 7, 1859, she died there in 1927. She studied under Chapu, Chaplain and Mercié and exhibited at the Salon des Artistes Français, winning an honourable mention in 1892 and a third class medal in 1909. She was awarded a bronze medal at the Exposition Universelle of 1900. She specialised in medallion portraits and allegorical high-reliefs, such as Towards Infinity.

MORICE, Georges 1899-
Born in Paris on November 12, 1899, he studied under Coutan and exhibited figures at the Salon des Artistes Français, becoming an Associate in 1923.

MORICE, Léon 1868-
Born in Angers on January 25, 1868, he studied under Brunclair and F. Charpentier and exhibited portraits and figures at the Salon des Artistes Français, winning an honourable mention in 1910 and a second class medal in 1914.

MORICE, Léopold 1846-1920
Born in Nimes in 1846, he died in Paris in July 1920. He studied under Jouffroy and exhibited at the Salon from 1868, winning medals in 1875 and at the Expositions of 1878 and 1900. He became a Chevalier of the Legion d'Honneur in 1883. He specialised in religious works, particularly figures of saints and groups of the Holy Family. His secular works include the colossal allegory of the republic in the Place de la Republique, Paris. He also sculpted numerous portrait busts of his contemporaries.

MORIGGI, Josef c.1841-1908
Born in Nauders, Austria, about 1841, he died in Innsbruck on October 28, 1908. He studied under M. Stolz, O.J. Entres and Petz and became professor of sculpture at the School of Decorative Arts, Innsbruck. He produced bas-reliefs, monuments and decorative sculpture.

MORIN, Georges 1874-
Born in Berlin, he studied at the Academy and later in Paris and Italy. He produced monuments and statues for Berlin and Poznan, but his minor works include busts, statuettes and medallions.

MORIN, Louis Henri Ismael fl. late 19th century
Born at Lisieux in the mid-19th century, he exhibited portrait busts of contemporary figures at the Salons in 1878-84 and 1890.

MORIS, Louis fl. 19th century
Born in Paris in 1818, he studied under Lequien and Pradier and specialised in tombs and memorials. He exhibited bas-reliefs and roundels at the Salon from 1857 to 1869.

MORISON, David fl. mid-19th century
Portrait sculptor of Scottish origins, working in London from 1821 to 1850, during which period he exhibited at the Royal Academy. He was appointed miniature modeller to the Duke and Duchess of Gloucester in 1826 and also worked for the Duchess of Cambridge and Princess Augusta. He specialised in wax profiles, though some of his portraits are known to have been cast in bronze and precious metals. A series of four portraits of the Abadon family and a bust of King George IV by him are in the Victoria and Albert Museum.

MORISSE, Bernhard 1883-
Born in Olde, Germany in 1883, he studied in Düsseldorf and Munich and worked in the studio of Balthasar Schmitt and specialised in religious figures and reliefs.

MORITZ, Robert 1874-
Born in Geneva on August 7, 1874, he studied under Salmson and Jacques and worked as a portrait and figure sculptor in Switzerland.

MORLON, Alexandre 1878-
Born in Mâcon, France, on June 4, 1878, he studied under Falguière and Mercié and exhibited at the Salon in 1900. He specialised in allegorical figures and bas-reliefs and sculpted the standing figure of Victory used for the Allied Victory Medal (1918). He also modelled the plasters for the French base metal coinage of the 1920s and did numerous war memorials. Examples of his work are in the Mint Museum, Paris, and Ghent Museum.

MORMANN, Anton fl. 19th century
Born at Sünninghausen, Germany, on November 2, 1851, he specialised in religious figures, notably the series illustrating the Fourteen Stations of the Cross in Rochusberg Church near Bingen.

MORMANN, Julius 1886-
Born at Wiedenbrück, Germany, on June 23, 1886, he was the son and pupil of Anton Mormann and likewise produced religious figures and bas-reliefs. His statues of saints may be found in churches in Essen and Dortmund.

MORMANN, Wilhelm 1882-1914
Born in Wiedenbrück on August 2, 1882, he was killed in action at Dombrovice on the Eastern Front on November 15, 1914. He studied under Karl Janssen and sculpted monuments, fountains and statuary in the towns of Westphalia.

MORNY, Mathilde, Marquise de 1863-
Born in Paris on May 26, 1863, she studied under Comte. St. Cène and Millet de Marcilly and sculpted statuettes which bear her pseudonym of Yssim.

MORODER, Ludwig fl. 20th century
Born at St. Ulrich in Austria, he studied under his father, the wood-carver Josef Theodor Moroder, and produced religious figures and bas-reliefs for Austrian churches.

MOROS, Vicente 1860-1881
Born in Saragossa, Spain, in 1860, he died there on February 15, 1881. He sculpted statuettes and bas-reliefs.

MORREN, George 1868-
Born in Eeckeren, Belgium, on July 28, 1868, he studied under Carrière and Puvis de Chavannes in Paris. He worked as a painter and decorative sculptor, examples of his work being preserved in the Brussels Museum.

MORRIS, George L.K. 1906-
Born in New York in 1906, he studied at Yale University and went to Paris where he was a pupil of Fernand Léger in the 1930s. He became a founder member of the Association of American Abstract Artists in 1936, having turned from painting to sculpture in 1932 on the advice of his friend Gaston Lachaise. He has continued to produce one or two abstracts in marble or bronze each year ever since. He had his first sculpture exhibition at the Downtown Gallery, New York in 1945 and has since participated in several major exhibitions in America and France. He has travelled widely, with many periods spent in Paris. He is still one of the foremost exponents of abstract art in America and has written extensively on the subject. He now lives in New York.
Morris, George L.K. *The World of Abstract Art* (1957).

MORRIS, Paul Winters 1865-1916
Born at Du Quoin, U.S.A., on November 12, 1865, he died in New York on November 16, 1916. He studied under Saint-Gaudens and Daniel Chester French and worked in Paris under Injalbert and Roland, producing portraits and figures, memorials and monuments.

MORSE, Samuel Finley Breese 1791-1872
Born in Charlestown, Massachusetts, on April 27, 1791, he died in New York on April 2, 1872. He studied under W. Allston and travelled widely in Europe before settling in New York. Originally a painter, he turned to sculpture in 1838 and produced historical and contemporary portrait figures and busts, in marble and bronze. He was not content, however, to be a mere artist, but made his own moulds and castings and also invented a marble-cutting machine in 1823. In 1825 he founded the National Academy of Design and was its President till 1845. Morse's artistic career has been almost completely eclipsed by his scientific work, to which he increasingly devoted his life from 1832 onwards. His greatest achievements in this field were the invention of the electro-magnetic telegraph in 1830 (though this was also invented simultaneously and quite independently by Joseph Henry) and the code of dots and dashes which still bears his name. Morse won a series of lawsuits in the 1840s to defend his patents and it was not until 1858 that he received international recognition and monetary compensation for his telegraph system. He also experimented with marine telegraph cables and introduced the Daguerre system of photography to the Western Hemisphere. Examples of his sculpture are in the museums of Boston, Washington and New York.
Prime, Irenaeus *Life of S.F.B. Morse* (1875).

MORTENSEN, Carl Laurits Nikolaj 1861-
Born in Copenhagen on February 23, 1861, he was employed as a modeller of figurines at the Royal Copenhagen porcelain factory. Several of his works, notably figures of runners entitled Before and After the Race, were also cast in bronze. He got an honourable mention at the Exposition Universelle of 1900.

MÖRTH, Michael 1878-
Born at Fürnitz, Austria, on March 30, 1878, he studied under Breitner and Strasser in Vienna from 1896 to 1904 and worked as a sculptor and potter of genre figures.

MORTON, Mary fl. early 20th century
She studied at the Bristol School of Art and the Royal College of Art from 1911 to 1913 and exhibited at the Royal Academy, the Royal Scottish Academy, the Salon des Artistes Français and other leading galleries in Britain and France up to 1950. She worked as a watercolourist and sculptor of genre subjects in London.

MORYCE-LIPSZYC (Lipchytz) 1897-
Born in Lodz, Poland, on May 22, 1897, he studied in Paris under Coutan and Mercié and exhibited portrait busts at the Salon d'Automne, the Tuileries and the Salon des Indépendants from 1922 onwards.

MOSCOTTO, Giovanni fl. mid-19th century
Sculptor of busts, heads and allegorical bas-reliefs working in Trieste in the 1850s. He produced decorative sculpture for the Trieste Museum and Town Hall.

MOSE, Carl C. 1903-
Born in Copenhagen on February 17, 1903, he emigrated to the United States where he studied under Lorado Taft, Albin Polasek and Leo Lentelli. He is a member of the American Federation of Arts and specialised in busts and bas-reliefs.

MOSEBACH, Rudolf 1860-
Born in Zwickau, Germany, on October 23, 1860, he studied under Schilling and Hähnel in Dresden and produced religious figures and reliefs for Zwickau Cathedral and churches in Saxony.

MOSELAGE, Fritz 1881-
Born in Düsseldorf on June 20, 1881, he studied under Clement Buscher and Ignaz Wagner.

MOSER, Josef fl. 20th century
Austrian sculptor specialising in religious figures and reliefs decorating churches in the Merano area. He has also sculpted portrait busts of his contemporaries.

MOSER, Karl Adalbert Julius 1832-1916
Born in Berlin on July 14, 1832, he died there in January 1916. He studied at the Academy and was a pupil of August Fischer and Drake. He specialised in figures and busts portraying German celebrities and also sculpted allegorical groups, such as Love Disarmed.

MOSSMAN, George 1823-1863
Born in Edinburgh in 1823, he died in Glasgow in 1863. He studied under his father, William Mossman the Elder, Behnes and Foley and produced statues and busts of contemporary figures, mainly in marble.

MOSSMAN, John G. 1817-1890
Born in London in 1817, the son of the stone-mason and marble sculptor William Mossman, he died in Glasgow in 1890. He studied under his father and spent his entire working life in Glasgow where he sculpted a number of statues, fountains and bas-reliefs, notably the statue and bas-reliefs commemorating David Livingstone (1877), the Robert Stewart fountain (1872) and the bronze figure of The Lady of the Lake for the Loch Katrine commemorative fountain in Kelvingrove Park. His minor works include many portrait busts of Scots worthies and a number of allegorical statuettes. He exhibited at the Royal Scottish Academy (1840-86) and the Royal Academy (1868-79).

MOSSMAN, William the Elder fl. 19th century
Stone-mason, marble-cutter and sculptor of portraits and monumental statuary, he spent much of his working life in London and died there in 1884.

MOSSMAN, William the Younger 1843-1877
Son and pupil of John Mossman, he was born and died in Glasgow. He collaborated with his father in various statues and monuments. His own works include historic busts, such as that of Shakespeare in the Glasgow Art Gallery.

MOTA, Antonio Augusto da Costa 1862-1930
Born in Coimbra on February 12, 1862, he died in Lisbon on March 26, 1930. He studied under Simoens d'Almeida and V. Bastos and sculpted monuments, statues and decorative works, notably the monument to Alfonso de Albuquerque in Lisbon. Examples of his statuettes, busts and reliefs are in the museums of Coimbra and Lisbon.

MOUCHERON, Eugène Louis Vicente de fl. 19th century
Born in the château of Maison Maugis, France, in the first half of the 19th century, he died in Paris in 1903. He studied under Frémiet and produced allegorical and historical figures and groups. He exhibited at the Salon from 1870 to 1890.

MOUCHON, Louis Eugène 1843-1914
Born in Paris on August 30, 1843, he died at Grand Montrouge, near Paris, on March 3, 1914. He was the son and pupil of Louis Claude Mouchon, the painter, and himself worked as a painter, graphic artist, medallist, engraver and sculptor. He exhibited at the Salon from 1876 onwards and became an Associate of the Artistes Français in 1888. His many awards included the Légion d'Honneur (1895) and a silver medal at the Exposition Universelle of 1900. He specialised in portrait and allegorical reliefs and medallions. He was for many years employed at the Paris Mint as a designer and engraver of the dies for coins and postage stamps and is best known for the Peace and Commerce stamps of 1876 and the Rights of Man series of 1900. He also engraved the dies of the Sower series of 1903, designed by another well-known sculptor, Oscar Roty.

MOULIN, Eugène Émile 1880-1914
Born at Châlons-sur-Marne on March 9, 1880, he was killed in the first battle of the Somme in October, 1914. He studied under Falguière, Mercié and Hector Lemaire and exhibited figures and groups at the Salon des Artistes Français from 1904 till 1914, winning medals in 1906 and 1912. Examples of his sculpture are in the Châlons Museum.

MOULIN, Hippolyte Alexandre Julien 1832-1884
Born in Paris on June 12, 1832, he died at Charenton in June 1884. He studied at the École des Beaux Arts (1855-58) and exhibited at the Salon from 1857 to 1878 and also at the Exposition Internationale of the latter year. He specialised in classical and genre groups and busts of his contemporaries.

MOULINET, Eugène Alfred fl. 19th century
Born in Paris in the mid-19th century, he studied at the Imperial School of Design and exhibited groups and bas-reliefs at the Salon from 1870 to 1877.

MOULINE, Jean Pierre fl. 19th century
Sculptor of portrait busts in marble, plaster and bronze, working in Paris in the first half of the 19th century. He was runner-up in the Prix de Rome of 1838.

MOULLET, Paul 1878-
Born in Lyons on December 27, 1878, he studied under C. Dufresne and Barrias and worked in Fribourg and Geneva, as a decorative sculptor.

MOULY, François Jean Joseph 1846-1886
Born at Clermont-Ferrand on September 22, 1846, he committed suicide in Bordeaux on October 25, 1886. He studied under Jouffroy and exhibited busts and medallions at the Salon from 1876 till his death. The museum of Clermont-Ferrand has his figure of a Young Faun.

MOURGES, François 1884-
Born in Marseilles on September 21, 1884, he studied under Coutan and exhibited figures at the Salon des Artistes Français, becoming an Associate in 1913 and winning medals in 1920 and 1926.

MOURIER, Pierre 1890-1918
Born in Paris in 1890, he was killed in action on the Western Front on March 31, 1918. He exhibited portraits and figures at the Salon des Indépendants and the Nationale in 1910-14.

MOUSRY, Edmond fl. 19th century
Born in Valenciennes in the first half of the 19th century, he studied under Jouffroy and Lemaire and exhibited portrait busts at the Salon from 1864 to 1869.

MOUTIER, Ferdinand fl. 19th century
Born in Rouen about 1840, he studied under Dupré and Lecomte and exhibited portraits at the Salon in 1867, 1869 and 1870.

MOUTON, Antoine fl. 18th-19th centuries
Born in Lyons in 1765, he specialised in decorative sculpture, with a penchant for military and heroic subjects. His minor works include statuettes and bas-reliefs of classical and historic personalities. He sculpted decoration for the Arc de Triomphe and the Vendôme column and exhibited at the Salon in 1810-17.

MOUTON, Pierre Martin Désiré Eugène fl. late 19th century
Born in Marseilles in the mid-19th century, he exhibited figures at the Salon in 1874.

MOYE, Paul 1877-1926
Born at Nordhausen, Germany, on August 24, 1877, he died in Weimar, on September 2, 1926. He studied under Robert Diez and produced genre and classical figures. His Stone-thrower is in the Albertinum, Dresden.

MOYNIHAN, Frederick 1843-1910
Born in Guernsey in 1843, he died in New York on January 9, 1910. He produced figures and busts of historic and contemporary personalities, as well as monumental bas-reliefs and statuary. His chief work is the colossal allegorical group of the Confederate Army in Chickamauga Park, Georgia.

MOZIER, Joseph 1812-1926
Born in Burlington, Vermont, in 1812, he died in Faido, Switzerland, on May 13, 1926. He settled in Rome in 1848 and spent the rest of his long career there, though many of his works were destined for the United States. He specialised in genre figures such as The Thinker (National Museum, Washington), and The Prodigal Son (Museum of Fine Art, Philadelphia).

MUCHINA or MUKHINA, Vera Ignatievna 1889-
Born in Riga, Latvia, on June 19, 1889, she studied art under Juon and Machkoff in Moscow and sculpture under Bourdelle in Paris. She was appointed professor at the Institute of Fine Arts, Moscow, in 1927, and produced portraits of Soviet celebrities as well as genre figures illustrating the working classes. Examples of her work are in the Tretiakoff Gallery, Moscow, and the Russian Museum, Leningrad.

MUESCH, Leo 1846-1911
Born in Düsseldorf on February 26, 1846, he died there on January 6, 1911. He studied under Bayerle, C. Mohr and A. Wittig and worked as a decorative sculptor.

MUGUET, Georges 1903-
Born at Moissy-Cramayel, France, on July 3, 1903, he has exhibited figures and portraits at the Salon des Indépendants and the Tuileries.

MÜHLBACHER, Joseph 1868-
Born at St. Margarethen, Austria, on March 4, 1868, he studied at the Vienna Academy and specialised in figures and bas-reliefs of saints and biblical subjects, monuments, tombs and fountains in the churches of Austria.

MÜHLBAUER, Ludwig 1875-
Born in Munich on January 7, 1875, he studied at the Munich Academy and worked in that city as an architect and decorative sculptor.

MUHLENBECK, Georges Émile 1862-
Born at Rigny-le-Ferron, France, on May 25, 1862, he studied under Falguière and Aimé Millet and exhibited figures and bas-reliefs at the Salon des Artistes Français from 1884 to 1910, winning a third class medal in 1898 and a bronze medal at the Exposition Universelle in 1900.

MULINEN, Eleonore de fl. 20th century
Swiss sculptress of genre figures and portraits working in the early part of this century.

MÜLLER, Albert 1897-1926
Born in Basle in 1897, he died at Orbino, near Mondrisio, Switzerland, on December 14, 1926. He worked in Basle as a painter, engraver and sculptor of genre and neo-classical subjects. Examples of his work are in the Basle Museum.

MULLER, Alfred 1882-
Born in Paris on September 29, 1882, he studied under Burdif and exhibited figures and portraits at the Salon des Artistes Français from 1903 to 1926 and later at the Salon d'Automne.

MULLER, Carl fl. 19th century
German sculptor working in Paris and England in the mid-19th century. He exhibited romantic and neo-medieval statuettes and groups at the Salon of 1848-49. His group The Curse of Menestrel is in Bradford Museum.

MÜLLER, Ernst 1823-1875
Born in Göttingen in 1823, he died in Düsseldorf on April 20, 1875. He studied under W. Henschel and worked in Rome, Munich, Paris, Brussels, Bonn, Cologne and Düsseldorf as a decorative sculptor.

MÜLLER, Ferdinand 1815-1881
Born in Meiningen in 1815, he died in Bavaria on September 6, 1881. He studied under Schwanthaler in Munich and executed many statues and portrait busts for towns in Bavaria.

MÜLLER, Friedrich Dominicus Nicolaus fl. 19th century
Berlin portrait sculptor of the late 19th century.

MÜLLER, Georg 1880-
Born in Munich on February 23, 1880, he studied under von Mauch in Chicago and von Rümann and E. Kurz in Munich. He was a prominent member of the Munich Secession and sculpted figures and portraits of women and children. The Munich Glyptothek has his bust of a Child, head of an Athlete and figure of Silene.

MÜLLER, Hans 1873-
Born in Vienna on January 10, 1873, he studied under Kühne and Hellmer and specialised in genre bronzes, such as Sower, and Water-carrier (both in the Simu Museum, Bucharest).

MÜLLER, Heinz 1872-
Born in Münster on July 20, 1872, he studied at the Düsseldorf Academy and was a pupil of K. Janssen. He produced genre figures, such as Young Woman, Traveller and Sower. Examples of his work are in the museums of Munich and Stuttgart.

MÜLLER, Hermann fl. 19th century
Born at Seefeld, Tyrol, in the early years of the 19th century, he worked in Munich from 1839 and specialised in genre and biblical figures and bas-reliefs. The Ferdinandeum, Innsbruck, has his relief of Jesus and the Good Samaritan.

MÜLLER, Joachim fl. 19th century
Born at Heiterwang, Tyrol, in the early 19th century, he studied at the Munich Academy and worked as a sculptor of religious figures in Innsbruck.

MÜLLER, Johann fl. 19th century
Born at Schurz, Austria, on August 29, 1824, he studied at the Vienna Academy and worked as an ornamental sculptor in that city. He decorated the Opera, Burgtheater and Imperial Museum.

MÜLLER, Johann Eduard 1828-1895
Born at Hildburghausen, Germany, on August 9, 1828, he died in Rome on December 29, 1895. He started life as a scullion in the ducal kitchens at Coburg, then went to Antwerp, where he studied at the Academy (1850-54) and thence to Rome, where he eventually became professor at the Academy of St. Luke. He produced numerous portrait busts, classical groups and genre statuettes, examples of which are in the museums of Berlin, Gotha and Berne.

MÜLLER, Josef Cassian 1809-1882
Born at Pettnau, Tyrol, on May 20, 1809, he died in Innsbruck on February 1, 1882. He studied under F.X. Renn and specialised in religious figures and reliefs. Examples of his work are in the Mariahilf Church in Munich. His Pieta is in the Ferdinandeum, Innsbruck.

MULLER, Juana 1911-1952
Born in Santiago, Chile, of German parentage, she died in Paris in 1952. She studied at the Santiago School of Art and came in 1937 to Paris, where she was a pupil of Zadkine at the Académie de la Grande Chaumière. Under the influence of Brancusi she moved away from realism and figurative work to abstracts in elemental volumes carved direct in stone or wood. After the war she began sculpting totemic forms in plaster and bronze. She exhibited her work at the Salon de Mai and, from 1949 till her death, at the Salon de la Jeune Sculpture. Her later work was inspired by a mixture of symbolism and pre-Colombian Indian art. Following her death after a long illness, the Salon de la Jeune Sculpture held a retrospective exhibition of her sculpture.

MÜLLER, Karl Friedrich fl. 19th century
Born in Berlin in 1812, he studied under Wichmann and Rauch and later worked at the Munich Academy and in Paris, where he produced decorative and portrait sculpture.

MÜLLER, Karl Hubert Maria fl. 19th century
Born at Remagen, Westphalia, on August 15, 1844, he was the son of the painter Andreas Müller and studied under Wittig in Düsseldorf. He produced genre, allegorical and neo-classical groups, such as Expulsion from Paradise (Munich Academy Museum).

MÜLLER, Martin 1885-
Born in Cologne on April 29, 1885, he studied under W. Schwarzburg and L. Manzel and travelled in America and India before settling in Berlin. He sculpted busts and figures of contemporary celebrities.

MULLER, Olga Popoff 1883-
Born in New York on December 1, 1883, she studied in Russia, Munich and Paris, and won a medal of honour at the Paris Exhibition of Women's Works in the 1920s for her statuettes.

MÜLLER, Paul 1843-1906
Born at Mergelstetten, Württemberg, on March 12, 1843, he died in Stuttgart on April 24, 1906. He studied under T. Wagner and Johann Schilling and worked as a sculptor of classical statuary in Stuttgart. His minor works are preserved in the Stuttgart Museum.

MÜLLER, Robert 1920-
Born in Zurich in 1920, he studied under Germaine Richier and Charles Banninger (1940-44) and then worked at Morgues on Lake Geneva and later in Genoa and Rome. In 1950 he went to Paris and has exhibited at the Salon de Mai since 1953. Much of his work is Surrealist, consisting of collages of bits and pieces of stray ironmongery, but in more recent years he has constructed fantasy figures in brass, bronze and wrought iron, such as Crayfish, Knot, Larva, Saba, Stele for a Termite, Ex-voto, Arrum, Rübezahl and The Spit.

MÜLLER-BRAUNSCHWEIG, Ernst 1860-
Born at Oelper, Germany, on January 23, 1860, he was a businessman who turned to sculpture merely as a form of relaxation. Though entirely self-taught he produced some creditable portrait busts of his contemporaries and rather hackneyed genre groups, such as In the Tempest and Faith.

MÜLLER-ERFURT, Hermann 1882-
Born in Erfurt, Germany, on November 9, 1882, he studied at the Munich Academy and worked under Kurz and Hildebrandt. He produced modernist figures and reliefs.

MÜLLER-KREFELD, Adolf 1863-
Born in Krefeld on April 7, 1863, he studied at the Antwerp Academy (1879-82) and sculpted portraits and figures.

MÜLLER-LIEBENTHAL, Moritz Otto 1876-
Born in Mittweida, Germany, on September 30, 1876, he studied at the academies of Dresden and Berlin and worked as an Animalier, specialising in figures and groups of rabbits and cats. He also sculpted a number of biblical figures.

MÜLLER-ÖRLINGSHAUSEN, Berthold 1893-
Born at Örlingshausen, Germany, on February 10, 1893, he studied at the Bielefeld School of Decorative Arts and was a pupil of Perathoner in Berlin. He specialised in ecclesiastical sculpture, much of which was designed for churches in Hagen and Küppersteg, near Cologne.

MULLIGAN, Charles J. 1866-1916
Born at Aughnachy, Ireland, on September 28, 1866, he died in the United States in 1916. He studied in Chicago and was a pupil of Falguière in Paris. His chief work is the group of Three Sisters of Lincoln in Springfield. He sculpted a number of portrait busts, statuettes and reliefs of American personalities at the turn of the century.

MULLINS, Edwin Roscoe 1849-1907
Born in London in 1849, he died at Walberswick on January 9, 1907. He specialised in neo-classical, genre and biblical figures. His bronze of Cain is in the Glasgow Art Gallery.

MÜLLNER, Josef 1879-
Born in Baden, near Vienna, on August 1, 1879, he studied under Zumbusch and Hellmer and won the Prix de Rome in 1903. Later he became a professor at the Vienna Academy. He sculpted numerous monuments, statues and tombs as well as decorative sculpture in and around Vienna.

MULOTIN DE MERAT, Blanche fl. 19th century
Born in Paris in the mid-19th century, the daughter of Edmond Mulotin de Merat, she exhibited portrait busts, reliefs and medals at the Salons from 1873 to 1889.

MULOTIN DE MERAT, Edmond fl. 19th century
Born in Reims on January 1, 1840, he studied under Devaulx and Ciappori and exhibited busts and heads at the Salons from 1859 to 1885.

MULOTIN DE MERAT, Ernestine fl. 19th century
Born in Luneville, France, in the early 19th century, she studied under Ciappori and exhibited portrait busts at the Salon in 1869-70.

MÜNCH, Otto 1885
Born in Meissen on October 23, 1885, he studied at the School of Decorative Arts in Dresden and was a pupil of Karl Gross. He settled in Zurich in 1912 and worked as a sculptor decorating the public buildings of that city.

MUNCH-KHE, Willi 1885-
Born in Karlsruhe on January 19, 1885, he studied under L. Schmid-Reutte and Hans Thoma. He worked as a painter, engraver and sculptor of dancers, animals and genre groups set on the shores of lakes.

MUNN, George Frederick 1852-1907
Born in Utica, New York, in 1852, he died in 1907. He studied at the National Academy of Design and emigrated to England, where he studied at the Royal College of Art and the Royal Academy schools. He exhibited at the Royal Academy, the Grosvenor Gallery and Suffolk Street from 1875 till his death, and worked in London and Brittany as a marine landscape painter and sculptor of genre subjects.

MUNRO, Alexander 1825-1871
Born in Sutherland, Scotland, in 1825, he died in Cannes on January 1, 1871. The son of a stone-mason on the Sutherland estates, his artistic talent came to the attention of Harriet, 2nd Duchess of Sutherland, who helped him to get an education and brought him to London in 1848. She introduced him to Sir Charles Barry, who employed him on the sculpture for the new Houses of Parliament. Subsequently he turned to portrait sculpture and produced a number of busts. He sculpted busts of the children of a number of families, including those of the Ingram, Hardy, Gathorne-Hardy, Gladstone, Matheson, and Compton Roberts families between 1853 and 1865. Examples of these child portraits were shown at the Royal Academy. His genre bronzes include The Sleeping Child, the original plaster model being now in the Birmingham Art Gallery, along with the maquette for a head of James Watt. He also sculpted a series of portraits of great British inventors for the University of Oxford.

MUNSTERHJELM, Johan Hjalmar 1879-1925
Born in Tuulois, Finland, on December 11, 1879, he died in Helsinki on August 16, 1925. He studied in Berlin and produced fountains, memorials and monuments for various Finnish towns, notably the Tammerfors fountain and the statues of Presidents Svinhufvud and Mannerheim outside Vaasa Town Hall. His minor works include portrait busts and bas-reliefs of contemporary celebrities.

MUNTZ, Elizabeth 1894-
Born in Toronto, Canada, in 1894, she studied at Ontario College of Art and the Académie de la Grande Chaumière in Paris. She was also a pupil of Frank Dobson for some time. She settled in England and works at Chaldon Herring, Dorset. She has exhibited paintings and sculpture in stone, wood and bronze in England, France and North America.

MURAI, Stefania 1872-
Born in Budapest in 1872, she specialised in portrait reliefs, busts and heads.

MURALT, Martin von 1773-1830
Born in Zurich on March 28, 1773, he died there on December 5, 1830. He studied under J.A.M. Christen and P.J. von Scheffauer at Stuttgart and in 1816 established a studio in Zurich, where he specialised in busts and bas-reliefs of classical subjects such as Cleopatra, and portraits of contemporary minor German royalty.

MURANTI, Gyula 1881-1920
Born in Budapest on March 26, 1881, he died there on February 21, 1920. He studied in Budapest, Paris and Vienna and produced romantic and genre figures and groups.

MURGEY, François Théophile fl. 19th-20th centuries
Born in Dijon in the mid-19th century, he died in Paris on March 13, 1907. He worked as an ornamental sculptor on the Lyric Theatre and the New Louvre and also decorated other public buildings in Paris. He worked mainly in stone and no bronzes have so far been recorded.

MURGUE, Pierre fl. 19th century
Born at St. Étienne in the mid-19th century, he specialised in statuettes of allegorical and historical subjects, in terra cotta and bronze.

MURMANN, Joszef Arpad 1889-
Born at Przemysl, Galicia, on March 5, 1889, he studied in Vienna and Paris and specialised in genre and allegorical figures. His bronze of Hope is in the Brooklyn Museum, New York.

MURPHY, Seamus 1907-
Born at Mallow, in County Cork, in 1907, he studied at Cork School of Art and in Paris. He has exhibited at the Royal Hibernian Academy (elected R.H.A., 1954) and galleries in Britain and Europe and sculpts figures and monuments in stone, marble and bronze.

MURPHY, Thomas 1867-
Born in Bantry, County Cork, on November 24, 1867, he studied in London, Paris and Italy. He emigrated to the United States and settled in Chicago, where he specialised in portrait busts and bas-reliefs.

MURPHY, Thomas Joseph 1881-
Born in Cork on February 20, 1881, he studied at the Kennington School of Art and the Royal Academy schools and exhibited portrait sculpture and paintings at the Royal Academy. He had a studio in Windsor.

MURRAY, Samuel 1870-
Born in Philadelphia on June 12, 1870, he studied under Thomas Eakins, whose portrait statuette he later produced in bronze for the Metropolitan Museum of Art, New York. He specialised in genre bronzes, particularly of sportsmen and athletes, and also sculpted a number of statues and memorials in Pennsylvania and New York.

MUSCHWECK, Albert 1857-1919
Born at Roth, near Nuremberg, on January 10, 1857, he died in Strasbourg on October 12, 1919. He studied in Nuremberg and Munich under von Widemann and was appointed professor of sculpture at Strasbourg Academy. He produced numerous portrait reliefs and busts and classical and genre figures, with a predilection for national costumes of different countries.

MUSETTI-FAIVRE, Auguste 1896-
Born in Paris on July 22, 1896, he studied under Coutan and exhibited figures and groups at the Salon des Artistes Français, becoming an Associate in 1923 and winning a Bronze Medal in 1931.

MUSSELMANN-CARR, Myra V. 1880-
Born in Georgetown, Kentucky on November 27, 1880, she studied in Paris under Bourdelle and worked as a portrait and genre sculptress in New York.

MUSSINO, Giuseppe 1857-
Born in Turin in 1857, he studied under Cerutti, Bauducco and Grosso and specialised in portrait reliefs and busts, often using a caricaturist style of interpretation.

MUSSO, Ricardo J. 1897-
Born in Buenos Aires of Italian parentage on December 12, 1897, he won first prize at the Buenos Aires National Exhibition of 1929 and also exhibited figures in Paris at the Salon d'Automne (1927-) and the Independants (from 1928).

MUSSOT, Jean Baptiste fl. 19th century
Born at Varennes, France, in the mid-19th century he studied at the Dijon School of Fine Arts and he specialised in genre figures, such as The Flute-player (Langres Museum).

MUTH, Georg fl. 19th century
Born in Leipzig on February 10, 1859, he studied at the Leipzig Academy under M.A. Zur Strassen. He worked as an ecclesiastical sculptor in Berlin.

MUTSCHELE, Georg Josef 1759-1817
Born in Bamberg on May 18, 1759, he died there in 1817. He was the son and pupil of Martin Mutschele and worked in Strasbourg and Paris before returning to his native town. He sculpted decoration in the churches and castles of the Bamberg area.

MUTSCHELE, Joseph Bonaventura 1728-c.1780
Born in Bamberg in 1728, he died in Moscow about 1780. He was the son and pupil of Johan Georg Mutschele, an Austrian ecclesiastical sculptor. He travelled in France and worked in Fürth and Nuremberg before becoming Court Sculptor to Catherine the Great in 1774. He worked in Moscow with his brother Martin.

MUTSCHELE, Martin 1733-1804
Born in Bamberg in 1733, he died there on October 21, 1804. He was the son of Johan Georg Mutschele and elder brother of Joseph B. Mutschele and worked on ecclesiastical monuments, altars, memorials and tombs in the Bamberg area and also in Moscow in the 1770s.

MUTTER, Leopold 1827-1887
Born at Unteralpen, Bavaria on December 22, 1827, he died in Munich on May 27, 1887. He studied in Munich under Johann Petz and Ferdinand Preckle and specialised in portrait reliefs, busts and religious figures.

MUXEL, Franz Joseph 1745-1812
Born in Bezau in 1745, he died in Munich on April 26, 1812. He studied in Mannheim, Strasbourg and Holland before settling in Munich where he sculpted figures of saints, lions and allegorical subjects, and bas-reliefs for Bavarian churches.

MUZAUNE, Suzanne 1876-
Born in Savignes, France on March 17, 1876, she studied under Hannaux and Jean Boucher and exhibited figures at the Salon des Artistes Français from 1913, winning a medal in 1926.

MYRTEK, Thomas 1888-
Born at Beuthen, Prussia on December 28, 1888, he studied at the Breslau Academy and was a pupil of Werner and von Gosen. He settled in Breslau where he specialised in figures and groups illustrating the way of life of the Silesian miners.

MYSLBEK, Josef Vaclav 1848-1922
Born in Prague on June 20, 1848, he died there on June 2, 1922. He studied in Prague and Vienna and became the leading Czech exponent of romantic sculpture at the turn of the century. His numerous bronzes of historic and religious figures are preserved in the museums of Prague and other Czech towns, the main collection being in the Museum of Modern Art in Prague. His best known works are the bronze and granite statue of Saint Wenceslas in the square of that name in Prague, and the allegory of Music.

NAAGER, Franz 1870-
Born in Munich on March 25, 1870, he studied under Strähuber, F. Barth, Hackl and Seitz and settled in Munich where he worked as a painter, designer, architect, engraver, art critic, writer and art connoisseur as well as sculptor. He produced frescoes, mosaics and bas-reliefs for monuments, particularly in Berlin.

NACHREINER, Hans fl. 19th century
Born in Munich on December 3, 1858, he studied at the Munich Academy and worked for some time in Rome. He specialised in portrait busts and bas-reliefs.

NACKE, Carl 1876-
Born in Hanover on August 2, 1876, he studied at the Berlin Academy and worked as a decorative and portrait sculptor in Berlin.

NADELMAN, Elie 1885-1946
Born in Warsaw on October 6, 1885, he died in the United States in 1946. He studied in Warsaw and Munich and in 1906 settled in Paris, where he came under the influence of Rodin and continued his studies at the Académie Colarossi. He concentrated on the nude figure and gradually combined elements from primitive and classical Greek art in his work. He was an accomplished draughtsman and engraver and published portfolios of his figural work, such as *Towards a Sculptural Unity* (1914), and exhibited his figures at the Galerie Drouot in 1909. He had his first one-man show in New York in 1914 and emigrated there three years later. Though best known for his figures reduced to an abstract expression and highly polished, he also produced a series of humorous mannikins, based on the famous doll collections he had seen in Munich, and also sculpted animal figures. His bronzes in this field include Deer at Rest, Wounded Deer, Wounded Bull and Standing Bull.

NADORP, Franz Johann Heinrich 1794-1876
Born in Anhalt, Germany, on June 23, 1794, he died in Rome on September 13, 1876. He studied under Joseph Bergler in Prague (1814) and worked in Dresden, Vienna and Rome, settling in the latter in 1828. Though best remembered as a landscape and portrait painter he also modelled portrait busts and small genre figures.

NADZOV, Alexis 1907-
Born in Valparaiso, Chile, on July 23, 1907, he worked as a book illustrator and sculptor of classical and religious subjects. He also produced friezes and decorative sculpture for theatres in Latin America and had a one-man show in Paris in 1933.

NAGEL, Anton 1882-
Born at Bulach, near Karlsruhe, in 1882, he studied there and at the Leipzig Academy. He specialised in religious figures and also sculpted a number of memorials after the first world war.

NAKTAN, Reuben 1896-
Born in New York, he now works in Stamford, Connecticut. He produced traditional figures and groups until the early 1940s, when he began experimenting with abstracts, worked in plaster and subsequently cast in bronze. Since 1953 he has used canvas sacking on chicken wire, dipped in glue and plaster, as the basis for his bronzes.

NAMUR, Emile Jean François 1852-1908
Born in Brussels in 1852, he died there on March 2, 1908. He specialised in bronze busts and genre statuettes and won a silver medal at the Exposition Universelle of 1889.

NANNANI, R. fl. 19th century
Italian sculptor of genre figures, particularly featuring Albanian, Greek and Italian peasantry.

NANTAR, Maria fl. early 20th century
Born in Lyons in the late 19th century, he exhibited figures at the Salon des Artistes Français and got an honourable mention in 1907.

NANTEUIL-LEBOEUF, Charles François 1792-1865
Born in Paris on August 9, 1792, he died there on November 1, 1865. He studied under Cartellier and won the Prix de Rome in 1817. He exhibited at the Salon from 1824 to 1852 and received many public commissions. He became an Officier of the Légion d'Honneur in 1865 and member of the Institut in 1831. He produced numerous marble and bronze busts of contemporary celebrities and many classical and allegorical figures and groups.

NAOUM-ARANSON, Madame fl. 19th-20th centuriess
Russian sculptress, born at Kreslavka in the mid-19th century. She sculpted portraits and genre figures and won a silver medal at the Exposition Universelle of 1900.

NAPOTNIK, Ivan 1888-
Born in Zavodnje, Serbia, in 1888, he studied under Bitterlich and J. Müller, J. Hellmer and J. Horvai in Vienna and did memorials, monuments and decorative sculpture in Belgrade. His minor works include allegorical and neo-classical figures.

NARVAEZ, Francisco 1908-
Born at Porlamar, Venezuela, on October 4, 1908, he studied at the Caracas Academy and the School of Plastic Arts and had his first exhibition in Caracas in 1928. Then he went to Paris and studied at the Académie Julian for three years (1929-32) and following his return to Venezuela was appointed professor at the School of Plastic Arts (1936), becoming Director in 1954. He has produced many public monuments and statues in Caracas and has exhibited in New York, Brussels, Sao Paulo and Venice. Most of his work is carved direct in stone, but he has also produced bronze abstracts and reliefs, notably the works preserved in the library of Caracas University.

NAST, Gustave Louis fl. 19th century
Born in Paris on April 3, 1826, he exhibited busts and allegorical statuettes at the Salon from 1852 to 1881.

NATORP, Gustav fl. 19th century
Born in Hamburg on June 20, 1836, he studied under Legros and Rodin and worked in London from 1884 to 1898. He produced portrait busts of contemporary celebrities in the world of the arts and literature, and genre statuettes, such as Knucklebone Player.

NATTER, Christoph 1880-
Born at Kulm-an-der-Weser, Germany, on May 1, 1880, he studied at the Berlin Academy and settled in Jena, where the museum has the main collection of his figures and portraits.

NATTER, Maximilian 1880-
Born in Reutlingen, Germany, in 1880, he studied at the Stuttgart Academy and the Académie Julian in Paris. The Stuttgart Museum has his figure of a Woman.

NAUBEREIT, Christiana 1901-
Born in Heilsberg, Germany, on February 13, 1901, she studied at the academies of Königsberg and Berlin and worked in the latter city.

NAUWENS, G.J. fl. 19th century
Born in Antwerp in the early 19th century, he died there on September 25, 1873. He sculpted portraits, figurines, medallions and decorative work used in jewellery.

NAVA, Fidencio Lucano 1872-
Born in Jalapa, Mexico, on October 30, 1872, he studied under Norena and Puech in Paris and sculpted figures and bas-reliefs. He was awarded a bronze medal at the Exposition Universelle of 1900.

NAVARRE, Henri Édouard 1885-
Born in Paris on April 4, 1885, he exhibited at the Nationale, the Salon d'Automne and the Salon des Artistes Décorateurs, as well as participating in international exhibitions in Brussels, Cairo, Stockholm, Copenhagen, Oslo, Athens and New York. He sculpted many monuments, statues and decorative sculptures in Paris, (notably for theatres and the Bibliothèque Nationale), as well as portrait busts, bas-reliefs and medals.

NAVARRO, Juan Carlos Oliva 1888-
Born in Montevideo, Uruguay, in 1888, he subsequently became a citizen of Argentina. He has sculpted many monuments for Buenos Aires, but is best known as an Animalier specialising in the wildlife of the pampas.

NAVARRO Y RUMERO, Vicente 1889-
Born in Valencia, Spain, in 1889, he studied there and in Rome and settled in Barcelona, where he sculpted figures and bas-reliefs.

NAVELLIER, Édouard Felicien Eugène 1865-1945
Born in Paris in 1865, he died there in 1945. He was the son of the engraver Narcisse Navellier and grand-nephew of Jouffroy, and studied under Truphème, J.P. Laurens and B. Constant. He gave up painting at the turn of the century and concentrated on sculpture, specialising in animal figures and groups, such as Il Passe..... (a group of an elephant and pelican), Old Stag on the Watch, Lying Stag, Cat, Lying Hind and Zebu Bull of Madagascar. He exhibited at the Salon from 1895 onwards and the Salon d'Automne organised a retrospective exhibition for him in 1945 shortly after his death.

NAVLET, Gustave André fl. 19th century
Born in Châlons in 1832, he was the brother of the painters Joseph and Victor Navlet and studied under Bonnassieux. He exhibited at the Salon from 1866 to 1877 and specialised in genre figures and bas-reliefs, such as The Interrupted Rest, Shipwreck and The First Success, historical subjects, such as Jacques Callot and Joan of Arc and classical reliefs of Greek heroes, Thyestes, Egisthus and Pelopea.

NAYEL, Auguste François Joseph fl. 19th century
Born at Lorient, France, on May 16, 1845, he studied under Mélin and exhibited genre statuettes at the Salon from 1875 onwards.

NEAL, Grace Prudence 1876-
Born in St. Paul, Minnesota, on May 11, 1876, she studied in Munich and Paris and worked in New York on memorials and portraits.

NEANDROSS, Sigurd 1871-
Born in Stavanger, Norway, in 1871, he studied under P.S. Kroyer and Stefan Sinding in Copenhagen, and was a pupil of the Cooper Union in New York. He specialised in portrait heads and busts of American personalities, in bronze or bronzed plaster.

NEBEL, Berthold 1889-
Born in Switzerland in 1889, he studied at the Mechanics Institute and the Art Students' League in New York. He won the Prix de Rome in 1914 and studied at the American Academy in Rome till 1917. He has produced portraits and allegorical figures in plaster and bronze.

NEBLE, Étienne 1820-1840
Born at Sète in 1820, he died there in 1840. He studied under David d'Angers and died suddenly while competing for the Prix de Rome. Sète Museum has two of his works, The Force and The Secret.

NEGRET, Edgar 1920-
Born in Popayan, Colombia, in 1920, he studied at the Cali Art School and in 1950 went to New York, where he now teaches sculpture at the New School. He has had several one-man shows there and also in Paris, Cali and Madrid. His early figurative work, such as Young Girl at the Window and Head of a Baptizer, was superseded after 1954 by geometric abstracts in various metals. In recent years he has concentrated on polychrome iron, as in Masks and Magic Instruments.

NEGRI, Mario 1916-
Born in Tirano, Italy, in 1916, he studied at the School of Architecture in Milan. He served in the Italian army during the war but was captured by the Germans in 1943 and sent to a concentration camp for two years. He took up sculpture while in prison and studied from 1945 to 1954. During this period he undertook a number of important commissions and also wrote extensively on art criticism. He had his first one-man shows at the Borgenight Gallery, New York, and the Galleria del Milione, Milan, in 1957. Since then he has taken part in many major national and international exhibitions, including the Venice Biennales. He is the art critic for the Italian review *Domus* and now works in Milan. His bronzes include Little Allegory and Large Multiple Figure (1956-57).

NEGRO, Pietro fl. late 19th century
Born in Milan in the mid-19th century, he specialised in portrait busts and religious figures, and exhibited in Parma and Milan from about 1870 onwards.

NEHER, Dora 1879-
Born in Schaffhausen, Switzerland, on March 28, 1879, she studied in Vienna and Paris. She settled in Zurich and produced portraits and figures. Examples of her sculpture are in the Museum of Art and Industry, Vienna, and the Schaffhausen Cantonal Museum.

NEJBERG, Johanne fl. 19th century
Born in Copenhagen, she studied there and in Paris and exhibited figures at the Salon, getting an honourable mention in 1893.

NELE, E.R. 1932-
Born in Berlin in 1932, she studied under Hans Uhlmann in Berlin and produced small bronzes and gold pendants in fantasy shapes, and exhibited in Amsterdam in 1956. She moved to Munich in 1959 and was influenced by Hans Platschek and the Spur Group. She exhibited bronzes at the Brussels World's Fair (1958).

NELSON, Alphonse Henri fl. 19th century
Born in Paris on January 12, 1854, he exhibited figures at the Salon from 1882 onwards and got an honourable mention at the Exposition Universelle of 1889.

NEMES, György 1885-
Born in Temesvar, Hungary, on March 22, 1885, he studied in Budapest and Paris and worked as a decorative and portrait sculptor in Budapest.

NEMON, Oscar 1906-
Born in Osijek, Slavonia (now part of Yugoslavia), on March 13, 1906, he studied there and in Brussels and Paris before settling in England before the second world war. He has had many important commissions since 1945 and his work may be found in the House of Commons, Windsor Castle, the Guildhall, London, and the Oxford Union. He lives in Oxford and specialises in portrait figures, bas-reliefs and busts. His subjects have included British royalty, political figures, such as Winston Churchill, Harold Macmillan and Lord Beaverbrook, and international celebrities like Sigmund Freud, Sir Max Beerbohm, President Eisenhower and Field Marshal Montgomery.

NEMTH, M. fl. 20th century
Hungarian sculptor of historic and contemporary portrait busts and figures, mainly of Hungarians.

NEPPEL, Hermann 1882-
Born in Munich on May 8, 1882, he studied under Pruska, Waderé and Widmer and became professor of design at Munich in 1919. He produced several war memorials and monuments, decorative sculpture and bas-reliefs. His minor works include portrait busts and medallions.

NERODA fl. 20th century
Portrait busts and bas-reliefs bearing this signature in Cyrillic were the work of a sculptor working in Russia in the early post-revolutionary period.

NESTI, Vittorio fl. mid-19th century
Florentine sculptor active between 1825 and 1844 and specialising in bas-reliefs, plaques and portrait medallions. He sculpted the allegorical group of Charity for the Fate-bene-Sorelle Hospital in Milan.

NETOLISZKA, Oszkar 1897-
Born at Kronstadt in the Siebenbirge district of Transylvania (now Romania), in 1897, he studied in Dresden and specialised in ecclesiastical sculpture for the churches of Hungary.

NETZER, Hubert 1865-
Born at Isny, Württemberg, on October 5, 1865, he studied under J. Hoffart and von Rümann and worked in Munich and Düsseldorf. He did statuary for fountains, war memorials and monuments, mainly in the classical style. His Fountain of Narcissus is in the Bavarian National Museum, Munich.

NEUBER, Fritz 1837-1889
Born in Cologne in 1837, he died in Hamburg on August 10, 1889. He studied under Stephan and Lippelt and specialised in figures and reliefs of religious subjects.

NEUGEBAUER, Rudolf 1892-
Born in Münster on May 11, 1892, he studied at the Berlin Academy and was later a pupil of Habermann in Munich. He worked as a painter, engraver and sculptor and produced portrait busts and bas-reliefs.

NEUHAUS, Carl 1881-
Born at Witzenhausen, near Cassel, on September 9, 1881, he worked in Dresden and Düsseldorf as a decorative sculptor.

NEUHAÜSER, Franz 1828-1848
Born in Dresden on October 12, 1828, he died there on June 20, 1848. He was the son and assistant of Johann Neuhaüser and studied sculpture under Rietschel.

NEUHAÜSER, Johann Christoph 1793-1843
Born in St. Pankraz, Bohemia, on October 29, 1793, he died in Dresden on February 8, 1843. He studied under F.S. Pettrich and worked on ecclesiastical and decorative sculpture in Saxony.

NEUJD, Axel Herman 1872-
Born in Adelöf, Sweden, on August 1, 1872, he studied in Paris and worked in Stockholm. Examples of his neo-classical and genre figures are in the museums of Stockholm, Göteborg, Budapest and Liverpool.

NEUMANN, Richard Gustav fl. 19th century
Born in Berlin on October 9, 1848, he studied under Hagen, Siemering and Keil and produced a number of war memorials in Berlin and Magdeburg after the Franco-German war of 1870-71. He also sculpted portrait busts and statues of contemporary personalities.

NEUPER, Christian 1876-
Born in Weissenstadt, Bavaria, on March 17, 1876, he studied at the Nuremberg Academy and in Carrara and sculpted neo-classical monuments and allegorical groups.

NEUSTÜCK, Johann Heinrich 1802-1868
Born in Basle in 1802, he died there in July, 1868. He worked as a decorative sculptor.

NEUWIRTH, Rosa 1883-
Born in Prague on October 25, 1883, she studied in Paris under Maillol and produced genre and allegorical statuettes.

NEVEU, Edmond Joseph 1885-
Born at Pouilly-sur-Loire on February 25, 1885, he exhibited figures at the Salon des Artistes Français before the first world war and at the Salon des Indépendants in the 1920s.

NEVIN, Blanche 1841-1925
Born in Mercersburg in 1841, she died in Lancaster, Pennsylvania, in 1925. She studied under J.A. Bailly and specialised in portrait sculpture. Her best known work is the statue of Peter Mühlenberg in the Washington Capitol Museum.

NEWMAN, Allen George 1875-
Born in New York on August 28, 1875, he studied under J.Q.A. Ward (1897-1901) and the National Academy of Design. He worked in New York as a decorative sculptor and produced many monuments, statues and portrait busts of historic and contemporary figures.

NEY, Elisabeth 1830-1907
Born in Münster in 1830, she died in Austin, Texas, on June 30, 1907. She studied under J.R. Berdellé and Rauch and settled in Texas

in 1870. She produced numerous portrait busts of German and American celebrities of the late 19th century.

NICHOLS, Peggy Martin 1884-
Born in Atchison, Kansas, on March 22, 1884, she studied under Cecilia Beaux and W.M. Chase, and worked in Los Angeles as a painter, sculptor and architectural designer.

NICHOLSON, Ben 1894-
Born in Denham, Buckinghamshire, in 1894, he is best known as a painter, but has also produced abstract sculpture. He was a member of the group Seven and Five and the Abstraction-Création Movement in Paris between the wars, and was influenced by Juan Gris and Georges Braque.

NICK, Ludwig 1873-
Born in Münster on January 30, 1873, he worked at Meissen as a porcelain modeller, but later moved to Berlin where he sculpted figures and bas-reliefs in other materials. He sculpted the war memorial at Berlin-Schargendorf.

NICLAUSSE, Paul François 1879-1958
Born in Metz on May 26, 1879, he died in Paris in 1958. He studied at the École des Beaux Arts but was forced to retire to the country on grounds of ill health. This led him to sculpt peasant subjects and develop an unpolished direct style which was utterly different from the mannered techniques then practised at the École. This resulted in figures and portrait busts with a refreshing realism. He received many awards later in life and was a member of the Institut. He sculpted portraits of most of the famous Frenchmen of his period and did the war memorial in Metz.

NICOLADZE see NIKOLADZE

NICOLET, Fina fl. 19th century
Born in Paris in the early 19th century, she studied under Ottin and Caudron and exhibited busts, medallions, figures and groups in marble, plaster and bronze at the Salon from 1863 to 1879.

NICOLINI, Giovanni 1872-
Born in Palermo in 1872, he studied under Vincenzo Ragusa and L. Monteverde and produced monuments in Palermo and Rome. His minor works include historical figures and classical bronzes, such as Faun and Nymph.

NICOLINI, Guiseppe fl. late 19th century
Born in Palermo on March 4, 1855, he worked as a decorative sculptor in Sicily.

NICOLOV see NIKOLOV

NICOT, Louis Henri 1878-c.1944
Born in Rennes on February 12, 1878, he disappeared in 1944, possibly killed in a Nazi concentration camp. He studied at the Rennes School of Fine Arts and the École des Beaux Arts, Paris, and was runner-up in the Prix Chenavard. He was an Associate of the Artistes Français and won many prizes, including a first class medal and the Prix Hors Concours. He sculpted many war memorials in the early 1920s and exhibited at the Salon des Indépendants from 1906 to 1912, and the Salon d'Automne in 1922. He was a Chevalier of the Légion d'Honneur and an Officier de l'Instruction Publique. His minor sculpture includes busts and heads, nude statuettes and figures of boxers and other sportsmen.

NIEDER, Adolf 1873-
Born in Hamburg on April 5, 1873, he studied under Janssen and worked in Düsseldorf, specialising in religious statuary and bas-reliefs.

NIEDERHÄUSERN-RODO, Auguste de 1863-1913
Born at Vevey, Switzerland, on April 2, 1863, he died in Munich on May 21, 1913. He studied under Barthelemy, Menn, Pignolat and Salmson in Geneva and also under Falguière at the École des Beaux Arts, Paris. He collaborated with Rodin for eight years and exhibited at the Salon from 1885, becoming an Associate of the Société Nationale. He won a gold medal at the Exposition Universelle of 1900 and was recognised as one of the leading Swiss sculptors of the period. He is best known for his colossal memorial to Paul Verlaine in the Luxembourg Gardens, Paris. He had many commissions for decorative sculpture in Berne and Geneva, but also sculpted numerous busts,

allegorical figures and groups and statuettes of women, dancers, singers and nudes.

NIEHAUS, Charles Henry fl. late 19th-20th centuries
Born in Cincinnati on January 24, 1855, he studied at the McMichen Art School, the Munich Academy and the Royal Academy, London, and also in Rome. He worked in New York where he settled in the late 19th century, and became a member of the Salmagundi Club in 1908. He produced numerous bronze busts, half-figures and statuettes of contemporary and historical figures. His genre and classical figures include bronzes of Caestus the Athlete and The Goose-Boy.

NIELSEN, Madame A.M. Carl (née Brodersen) fl. 19th-20th centuries
Born at Sönder Stenderup, Denmark, on June 21, 1863, she was the wife of the composer Carl Nielsen. She studied in Slesvig and Copenhagen, where she worked as an Animalier and classical sculptress. Her works include Two Calves, Young Centaur, Lying Horse, Bull dragging his Chain, Calf scratching itself, Calf licking itself, Bull pawing the Ground, Ewe and Foal feeling the Cold.

NIELSEN, Kai 1882-1924
Born in Svendborg, Denmark on November 26, 1882, he died in Copenhagen on November 2, 1924. He was one of the leading Danish sculptors at the turn of the century and his works demonstrate a preoccupation with the simplification of forms in a decorative sense. He specialised in busts of his artistic contemporaries, classical figures such as Leda and the Swan and Venus with the Golden Apple, nudes and allegorical works, such as Reminiscence and The Awakening.

NIELSEN-ALLING, Niels fl. late 19th century
Born at Voldum near Randers, Denmark on September 15, 1861, he studied under P.J. Jensen-Klint and attended classes at the Copenhagen Academy.

NIENHAUS, Max 1891-
Born in Cologne on October 6, 1891, he studied at the Institut Städel in Frankfurt and the Berlin Academy under Scharff. He produced figures strongly influenced by Maillol.

NIESSEN, Wilhelm Joseph 1827-1903
Born in Cologne on June 29, 1827, he died in Munich on November 17, 1903. He studied under Christian Mohr and also attended the Munich Academy. He specialised in figures and bas-reliefs of religious subjects and worked mainly in the Munich area.

NIEUWERKERKE, Alfred Emile O'Hara, Comte de 1811-1892
Born in Paris on April 16, 1811, he died at Gattaiola near Lucca, Italy on January 16, 1892. He came from an aristocratic Dutch family and became one of the most influential figures of the French artistic establishment under the Second Empire. He was Director-General of Museums (1849-63), Superintendent of Fine Arts (1863) and Minister of the Fine Arts (1870), a Chevalier of the Légion d'Honneur and member of the Institut (1863) and a Senator (1864). He was responsible for the development of the Louvre in its present form. He exhibited at the Salon from 1842 onwards and produced portrait busts of historic and contemporary personages in marble and bronze. His most noteworthy bronzes of his early period were the equestrian statue of William the Silent and a figure of René Descartes. Later he produced numerous busts and statuettes portraying prominent personalities of the Second Empire.

NIKOLADZE, Jacques fl. 19th-20th centuries
Born at Kutaise in the Caucasus in the late 19th century, he studied in Paris under Rodin and became the leading sculptor of Georgia at the turn of the century. His chief work is the great bas-relief portraying the Georgian national poet, Shota Rustaveli in Tbilisi. Later he moved to Moscow and worked there before and after the Revolution, specialising in portrait busts.

NIKOLOV, Andrei 1878-
Born at Vratza, Bulgaria in 1878, he studied under Schatz at the Sofia Academy and won a travelling scholarship which took him to Paris where he worked in the studio of Antonin Mercié. Later he was appointed professor of sculpture at the Sofia Academy. He specialised in portrait busts of historic and contemporary figures, such as Alexander Stamboulisky, and female statuettes.

NILSSON, Gunnar 1904-
Born in Karlskrona, Sweden in 1904, he moved to France in 1928 and has lived there ever since. He studied under Despiau at the Academie Scandinave and under Niclausse at the Académie Julian and exhibited at the Salon des Indépendants and the Salon d'Automne from 1929 onwards. He has also participated in many national and international sculpture exhibitions since the second world war. He specialises in human figures characterised by 'a sinuous grace and sensuousness of linear composition' (Pierre Volboudt). His bronzes include Nymph of Spring (1954), The Family (1959), Birth of Eve (1955-60) and Young Girl (1960).

NIMPTSCH, Uli 1897-
Born in Berlin on May 22, 1897, he studied there and also in Rome and Paris. He settled in Britain in 1940 and had his first one-man show two years later at the Redfern Gallery. He has also exhibited bronze figures at the Royal Academy and was elected A.R.A. in 1958.

NIVELT, Roger Robert Charles 1899-
Born in Paris on August 30, 1899, he studied under J.P. Laurens, Pierre and Albert Laurens at the Académie Julian and worked as a painter, etcher and sculptor. He began exhibiting at the Salon des Artistes Français in 1923 and became an Associate in 1926 and a member of the jury in 1946. He won a silver medal and the West Africa Prize at the Exposition of 1925 and a gold medal in 1929. He has also exhibited at the Salon d'Automne (since 1924) and the Indépendants (since 1925), winning many prizes. He was made Laureate of the Academy of Fine Arts in 1944. He specialised in figures and groups illustrating the native types of French North and West Africa.

NIVET, Émile Ernest 1871-1948
Born at Levroux on October 7, 1871, he died at Chateauroux in February, 1948. He worked with Rodin, Maillol, Despiau and Pompon and exhibited at the Salon des Artistes Français from 1897, winning third class (1906), second class (1911) and first class (1923) medals. He specialised in figures and groups illustrating the peasant way of life.

NOBAS, Rosendo 1838-1891
Born in Barcelona in 1838, he died there on February 5, 1891. He studied under Vallmijana and Masriera and became a professor at the Barcelona Academy. He specialised in historical and classical figures and monumental statuary.

NOBLE, Matthew 1818-1876
Born at Hackness, near Scarborough, Yorkshire, in 1818, he died in London on June 23, 1876. He specialised in portrait busts of historical personalities, such as Cromwell and the Duke of Wellington as well as contemporary celebrities, and exhibited at the Royal Academy from 1845 till 1876.

NOBLE, William Clark fl. late 19th century
Born at Gardiner, Massachusetts, on February 10, 1858, he studied under Pierce, Greenough and Taft, and worked mainly in Boston as a portrait and figure sculptor.

NOBOLO, Silvio del fl. 19th century
Born in Florence in the early 19th century, he specialised in decorative sculpture, particularly miniature work associated with jewellery and presentation pieces. He produced numerous medallions, medals, regalia, chalices and religious decoration and is best remembered for the sumptuous Sword of Honour presented by the Italian Army to Crown Prince Umberto in 1870.

NOCQ, Henri Eugène 1868-
Born in Paris on January 13, 1868, he studied under Chapu and exhibited medallions and bas-reliefs at the Salon des Artistes Français, winning the Légion d'Honneur and a silver medal at the Exposition Universelle of 1900.

NOCQUET, Paul Ange 1877-1906
Born in Brussels on April 2, 1877, he died in Long Island, New York, on April 4, 1906. He studied under Jef Lambeaux and worked for a time in Paris where he was influenced by Rodin. He emigrated to the United States in 1903. He produced genre figures, such as Dying Slave (Ixelles Museum) and Man Grieving (Metropolitan Museum of Art, New York).

NOEL, Edmond Julien fl. 19th century
Born at Loches, France, in 1813, he studied under Chialli in Rome and exhibited neo-classical figures and groups at the Salon from 1850 to 1868.

NOEL, Ernest Hector fl. 19th century
Born at Ruminghem, France, in the early 19th century, he studied under Louis and Jouffroy and exhibited portrait busts at the Salon in 1868-70.

NOEL, Louis fl. 19th century
Born in St. Omer, France, in the mid-19th century, he specialised in portrait busts and was awarded the Légion d'Honneur. Examples of his work are preserved in the Sète Museum.

NOGENT, Joseph Comte de fl. 19th century
Born in Paris on November 29, 1813, he studied under Lequesne and exhibited busts of his contemporaries and allegorical groups at the Salon from 1853 to 1863.

NOGUCHI, Isamu 1904-
Born in Los Angeles, California, in 1904, the son of the Japanese poet and English scholar, Yone Noguchi, and Leonie Gilmore, a Scottish-American. He lived in Japan from 1906 to 1918, while his father taught at Keio University, then returned to California where he was apprenticed to a cabinet-maker. He first tried his hand at sculpture in the early 1920s when he was working as tutor to the son of Gutzon Borglum. He enrolled as a medical student at Columbia University in 1923, but the following year began attending classes at the Leonardo da Vinci and East Side Art Schools. A Guggenheim scholarship enabled him to continue his studies in Paris in 1927-28. He worked as assistant to Brancusi and was befriended by Giacometti and Calder. He returned to America in 1929 and then went to Peking and Japan to study ceramics and oriental drawing. He worked in London and Mexico in the 1930s and returned to the United States in 1938, winning the commission for the Associated Press bas-relief at the Rockefeller Center. He designed the fountain at the Ford pavilion in the New York World's Fair of 1939-40. In December 1941 he was sent to the internment camp at Poston, Arizona, and spent the rest of the war in captivity. Fortunately he was released in time to take part in the Fourteen Americans Exhibition at the Museum of Modern Art, New York, in 1946. Since then he has commuted between New York and Tokyo and is now one of the most versatile and accomplished of sculptors, successfully combining the old and the new, the occidental with the oriental. He works in every medium, from direct carving in stone and wood, to terra cotta, wrought iron and bronze, and specialises in interior design and landscape sculpture, notably for the UNESCO Headquarters in Paris.

NOGUES GARCIA, Anselmo 1864-
Born at Valls, Spain, in 1864, he studied under Rosendo Nobas and A. Vallmitjana in Barcelona, and worked there and in Madrid. Examples of his figures are in the National Library, Madrid, and the Museum of Fine Arts, Barcelona.

NONO, Urbano fl. 19th century
Born in Venice on January 5, 1849, he worked with his brother, the painter Luigi Nono, and turned to sculpture, producing genre and classical figures. He exhibited in Venice, Florence and Paris, winning a silver medal at the Exposition Universelle of 1889. Examples of his works are in the major Italian museums and galleries.

NORDENSKJOLD, Rosa Margareta 1890-
Born at Virkvarn, Sweden, on August 27, 1890, she studied under Marta Ameen, A. Bergström and K. Vilhelmson and later worked in Paris, Munich and Dachau as a painter and sculptor of animal subjects. She was confined to a lunatic asylum in 1917.

NORDHEIM, August von 1813-1884
Born at Heinrichs, near Suhl, Germany, on April 22, 1813, he died at Frankfurt-am-Main on August 13, 1884. He studied under Döll at Suhl and attended classes at the Düsseldorf Academy. He produced numerous portrait busts, tombstones and colossal monuments of contemporary and historic personalities. He sculpted the statues of Holbein and Dürer for the façade of the Institut Städel.

NORDIN, Alice Maria 1871-
Born in Stockholm on May 4, 1871, she sculpted figures and portraits. Examples of her work are in the Stockholm National Museum.

NORFINI, Giuseppe fl. late 19th century
Born in Florence about 1860, he studied at the Academy in that city and began exhibiting in Florence, Turin, Bologna and Paris in the 1880s. He got an honourable mention at the Exposition Universelle of 1889. Examples of his figures are in the Gallery of Modern Art, Rome.

NORTON, Elizabeth 1887-
Born in Chicago on December 16, 1887, she was a pupil of the Art Students' League in New York and became a member of the American Federation of Arts. She specialised in genre and neo-classical figures for fountains and parks.

NOSCH, Wenzel fl. mid-19th century
Austrian sculptor of wax figures, later cast in bronze, working in Vienna in 1843-50.

NOST, Jan (John) van, the Elder fl. 1686-1729
Born in Malines, Belgium, in the mid-17th century, he came to England in 1686 and worked as foreman to Quellin, on whose death he married his widow and took over the business in the Haymarket, London, where he specialised in lead figures and garden statuary, particularly putti, amorini and figures from classical mythology, such as Perseus, Andromeda, Mercury, and Psyche. He also did a steady line in ducks, swans, Indians and Blackamoors, reflecting English country taste at the beginning of the 18th century. Much of his work may be seen to this day at Melbourne Hall, where stands his famous Vase of the Seasons, supported by four monkeys, a group of playing children and allegories of the four seasons. Apart from the seasons, which was a popular theme, he produced metal figures of Apollo, Equity, Liberty, Secrecy and Truth, also fountain groups of mermaids, dolphins and other aquatic creatures. Similar figures were produced for sundials and pedestals. Examples of his garden statuary, mainly in lead, may be seen at Rousham (Oxon), Seaton Delaval (Northumberland), Chirk Castle (North Wales), Castle Howard (Yorkshire), Ampthill (Bedfordshire), Stonyhurst and Moulsham Hall (Essex). He did a series of six statues for Sir Robert Geffrye in 1723 and these are also known as bronze reductions. He also worked occasionally in marble, the best example in this medium being the baroque mausoleum of the Duke and Duchess of Queensberry at Durisdeer, Dumfriesshire.

NOST, John van, the Younger c.1710-1787
Born in London about 1710, the son of Jan van Nost, the Elder, he died in Dublin in 1787. He specialised in portrait busts and figures, in bronze and marble and worked in Dublin from 1750 till his death.

NOTER, Pierre François (Pieter Frans) 1779-1843
Born at Walhem, Belgium, on February 23, 1779, he died in Ghent on November 22, 1843. He was the son of an architect and studied sculpture under J.F. van Geel. He specialised in religious figures, but also worked as a painter, designer, wood-carver, engraver and etcher.

NOVAK, Raimund fl. 19th century
Born in Vienna in 1827, he studied under Fernkorn and sculpted historical and classical figures, examples of which are in the Vienna Arsenal.

NOVAK, Stefan fl. 20th century
American sculptor of portrait busts, bas-reliefs and medallions.

NOVANI, Giulio 1889-
Born in Massa, Italy, in 1889, he studied at the Royal Academy, Massa and the Beaux-Arts Institute of Design, New York. He produced genre figures, heads and busts in bronze and bronzed plaster. His works include the busts My Father and Portrait of a Negro.

NOVELLI, James 1885-
Born in Sulmona, Aquila, Italy, in 1885, he was brought to the United States at the age of five and studied under Julio Monteverde, Ettore Ferrari and Silvio Sbricoli at the Academia Reale, Rome. He exhibited at the Paris Salon and got an honourable mention in 1906. He specialised in religious sculpture and decorated many churches and cemeteries in the United States. His bronzes include the crucifix for the Holy Name cemetery, Jersey City, the bronze doors of the Sigman mausoleum and the Schmuck mausoleum at Woodlawn cemetery, New York, the bronze door of the Bigham mausoleum, Hawthorne, and the La Gioia mausoleum in Calvary cemetery, New York, the Rowan bas-relief, Woodlawn cemetery, and the bronze and granite memorial to Lamattina Guerriero in Calvary cemetery. His secular works include bronze busts of Thomas J. Stewart, Julius Berger, Irving Green, Margaret Lawson, Annita Novarra and portrait reliefs of Charlotte Brainard, Charles G. Brainard and Dorothy Langley.

NUNEZ DE IBARRA, M.P. fl. 20th century
Argentinian sculptor of historic and contemporary portrait busts, statuettes and monuments. His best known work is the statue of General San Martin in Buenos Aires.

NUSSY, Eric William Nussbaum de 1887-
Born in Paris on February 24, 1887, he studied under Injalbert, Verley and Decorchemont and exhibited at the Salon des Artistes Français, winning two second class medals. He served in the French army during the first world war and won the Croix de Guerre. He specialised in commemmorative figures and portrait busts, and is best remembered for having sculpted the first portrait busts of Charles Lindbergh at Le Bourget airfield, completing it within 48 hours of the avaiator's landing.

NYGAARD, Kaare fl. 20th century
Sculptor of allegorical groups and abstract forms, including the Refugees, United Nations building, New York.

NYLUND, Felix Arthur 1878-
Born at Korpo, Denmark, in 1878, he studied at the Copenhagen Academy and specialised in portrait busts and animal studies. Examples of his work are in the museums of Copenhagen, Abo and Helsinki.

NYSTRÖM, Gustaf Alfred 1844-1897
Born at Ny Västra, Sweden, on March 11, 1844, he died there on February 15, 1897. He studied under Johan P. Molins and specialised in busts and statuettes of Swedish contemporary figures, and also classical and allegorical statuettes. The main collection of his work is in the Göteborg Museum.

OAKLEY, Alfred James 1880-1959
Born in High Wycombe, Buckinghamshire, on March 3, 1880, he died in Newbury, Berkshire, on April 28, 1959. He studied at the City and Guilds School from 1903 to 1910 and was elected A.R.B.S. (1920) and F.R.B.S.(1938). He exhibited figures and portraits in bronze and wood at the Royal Academy from 1922.

OBICI, Giuseppe 1807-1878
Born in Italy in 1807, he died in 1878. He studied at the Carrara Academy and worked under Tenerani in Rome. He sculpted portrait busts, including that of Tenerani, and genre statuettes, such as The Wounded Soldier. His works are in the museums of Modena and Florence.

OBRIST, Hermann 1863-1927
Born at Kilchberg near Zürich, on May 23, 1863, he died in Munich on February 26, 1927. He trained as a scientist but later turned to art and studied at the School of Arts and Crafts in Karlsruhe, but the eclecticism of the teaching there did not appeal to him so he worked with a potter in Thuringia and became a prominent member of the German equivalent of the Arts and Crafts movement. He was greatly impressed by the Exposition Universelle of 1889 and three years later established an embroidery workshop in Florence. In 1894 he moved to Munich and became a founder member of the Deutscher Werkbund and a leading exponent of *Jugendstil* in many fields of the applied arts. As a sculptor he is of paramount importance as a pioneer of the abstract movement producing memorials, fountains, statuary and ornamental forms inspired by the waves of the sea, arabesques and plant-life. His philosophy as a sculptor is set out in his book *Neue Möglichkeiten der Bildenden Kunst* (New Ventures in the Plastic Arts), published in 1903.

OBSIEGER, Robert 1884-
Born in Lundenburg, Austria, on September 23, 1884, he studied at the Vienna School of Decorative Arts and later became professor there. He worked as a potter and sculptor of figures and bas-reliefs.

OCHSE, Louise fl. early 20th century
Born in Brussels, she worked there as a decorative and portrait sculptress in the early years of this century. She became an Associate of the Société Nationale des Beaux Arts, Paris, in 1905.

OCKELMANN, Robert fl. 19th century
Born in Hamburg on October 25, 1815, he studied under E.A. Larssen in Berlin and L. Schilling in Dresden, where he subsequently worked as a sculptor of figures and reliefs.

O'CONNOR, Andrew fl. 19th century
Born in Lanark, Scotland, on April 18, 1846, he came to the United States with his parents in 1851 and settled in Rhode Island. He studied art in Providence and Rome and settled in Holden, Massachusetts. He produced numerous allegorical and genre groups, such as The Republic and The Fisherman's Child, several monuments and many portrait busts and medallions in marble and bronze.

O'CONNOR, Andrew, Junior 1874-
Born in Worcester, Massachusetts, on June 7, 1874, the son of Andrew O'Connor under whom he studied. He later studied in Paris and won a second class medal at the Salon of 1906, the highest award open to a foreigner. He produced decorative bronzes for many churches and public buildings in the United States, including the central doors and tympanum of St. Bartholomew's Church, New York. His bronze figures include the statue of General Lawton in Indianapolis, a statuette of Commodore John Barry and a head of Lincoln.

OCTOBRE, Jeremie Aimé Delphin 1868-
Born at Angles-sur-Anglin, France, on May 13, 1868, he studied under Gauthier, Cavelier and Coutan, and exhibited at the Salon des Artistes Français, winning the Prix de Rome (1893), third class (1896), second class (1897) and first class (1899) medals and a silver medal at the Exposition Universelle of 1900. He became a Chevalier of the Légion d'Honneur in 1906 and an Officier in 1925. He specialised in allegorical and genre groups, such as Remorse, The Cicada, Painting and Nymph.

O'DOHERTY, William James 1835-1868
Born in Dublin in 1835, he died in Berlin in February 1868. He studied under Kirk at the Dublin Society School and went to England in 1854, where he exhibited figures at the Royal Academy and the British Institution from 1857 to 1864. The following year he went to Rome and thence to Germany but failed to establish himself there and died in a Berlin charity hospital.

OECHSLIN, Johann Jakob 1802-1873
Born in Schaffhausen, Switzerland, on February 19, 1802, he died there on April 28, 1873. He studied under Dannecker in Stuttgart and Thorvaldsen in Rome and specialised in memorials and figures of saints and historical personalities.

OECHSLIN, Johann Konrad 1845-1875
Born in Schaffhausen on February 10, 1845, he died in Berlin in 1875. He was the son and pupil of J.J. Oechslin and worked in Germany as a decorative sculptor.

OEHLER, Emmerich 1881-
Born in Meissen on July 14, 1881, he studied under Wrba and worked as a decorative sculptor in Hamburg.

OEHLMANN, Hermann 1834-1878
Born in Brunswick on February 21, 1834, he died in Munich in 1878. He studied at the Munich Academy and sculpted figures and portraits in Bavaria. Examples of his sculpture are preserved in the Munich Polytechnic and the New Town Hall.

OEMBERG, Charles van 1824-1901
Born at Limelette, Belgium, on October 11, 1824, he died at Mons in 1901. He studied at the Brussels Academy and specialised in busts of his contemporaries, examples of which are in the museums of Brussels and Malines.

OESER, Adam Friedrich 1717-1799
Born in Pressburg (Przemysl) on February 17, 1717, he died in Leipzig on March 18, 1799. He came to Vienna in 1730 but failed to get a teacher and returned to Galicia. Five years later he returned to Vienna and enrolled at the Academy, studying under Raphael Donner. In 1739 he moved to Dresden and painted miniatures. In 1756 he moved to Dahlem and thence to Leipzig in 1763 where he became Director of the Academy. He also held the posts of professor at Dresden Academy and Court Painter to the Saxon royal family. As a sculptor he did the decoration for several Saxon churches and a marble figure of Gellert.

OESTEN, Paul 1874-
Born in Berlin on September 19, 1874, he studied under Reinhold Begas and L. Manzel and worked as a decorative sculptor in Berlin.

OETTEL, Otto Hermann Paul 1878-
Born at Bügel, Thuringia, on June 8, 1878, he studied under Balthasar Schmitt and worked on figures and bas-reliefs in Gera.

OFFERMANN, Friedrich 1859-1913
Born in Hamburg on June 5, 1859, he died in Dresden on February 24, 1913. He studied under Hähnel and sculpted statues in Hamburg and Dresden. His bust of a Trooper of the Guard is in the Dresden Municipal Museum.

OGÉ, Pierre Marie 1817-1867
Born at Plérin, France, on December 3, 1817, he died at St. Brieuc on December 27, 1867. He studied under David d'Angers at the École des Beaux Arts in 1838-44 and exhibited at the Salon from 1844 to 1848. He specialised in religious sculpture, including figures of saints and the Apostles and did decorative sculpture for the churches, cathedrals and public buildings in St. Brieuc. The museum in St. Brieuc has his statuettes of a Bluebird and Spartacus.

OGÉ, Pierre Marie François 1849-1913
Born in St. Brieuc on March 24, 1849, the son of the above, he died in Paris in 1913. He studied under his father, Carpeaux and Eudes and exhibited at the Salon, winning honourable mentions in 1880, 1883, and 1885, and a bronze medal at the Exposition Universelle of 1900. He was professor of sculpture at the National Institution for Deaf Mutes and sculpted numerous busts, statues, and statuettes of his contemporaries. He also did several monuments and small genre groups, such as Pillar of the Sea and The Gallic Baptism.

O'HARA, Dorothea Warren fl. 20th century
Born at Malta Bend, Montana, in the early years of this century, she studied at the Royal College of Art, London, and the Munich School of Design. Her figures and groups are preserved in various American museums, including the Metropolitan Museum of Art, New York.

OHLSON, Karl Alfred 1868-
Born in Stockholm on February 13, 1868, he was self-taught and produced a number of religious figures and reliefs for churches in Stockholm and Skara. His secular work, including genre figures and portraits, are in the Stockholm National Museum.

OHLY, Ernst G. 1879-1916
Born in Milan of German parents on March 18, 1879, he was killed on the Somme in 1916. He studied under F. Haussmann and A. Varnesi and worked as a sculptor of figures and portraits in Frankfurt-am-Main.

OHLY, William F.C. 1883-
Born in Hull, Yorkshire, on August 31, 1883, the younger brother of Ernst Ohly. He studied in Germany under H. Lederer and worked as a decorative sculptor in Frankfurt. After the first world war he sculpted numerous war memorials and fountains in many parts of Germany.

OHMACHT, Landolin 1760-1834
Born at Dunningen, near Rottweil, on November 11, 1760, he died in Strasbourg on March 31, 1834. He studied in Rome and settled in Strasbourg and exhibited at the Paris Salon from 1822 till his death. He specialised in classical subjects, mythological statuettes and allegorical groups, such as Religion and Charity (Karlsruhe), Judgment of Paris (Nymphenburg Park) and numerous busts, bas-reliefs and plaques portraying his contemporaries.

OHMANN, Béla 1890-
Born in Budapest on March 6, 1890, he worked as a decorative sculptor in Debrecen and Szeged.

OHMANN, Richard 1850-1910
Born in Weimar on July 28, 1850, he died in Berlin on April 26, 1910. He studied under Reinhold Begas and worked on busts and statuary in Berlin.

OHNEN, Henri 1897-
Born in Paris on October 28, 1897, he exhibited pottery, paintings and sculpture at the Salon des Artistes Français, the Salon des Tuileries, the Salon d'Automne and the Salon des Artistes Décorateurs in the period between the world wars. He also produced decorative sculpture for the Colonial Exhibition of 1931. Examples of his work are in the Petit Palais, Paris.

OLAFSSON, S. fl. 20th century
Portrait sculptor working in Reykjavik, Iceland, he has produced a number of statues and monuments, notably that of Fridrik Fridriksson.

OLDEFREDI, Gerolamo fl. 19th century
Milanese sculptor of figures and portraits, exhibiting in Milan, Rome and Venice in the last quarter of the 19th century.

OLESZCZYNSKI, Ladislas 1807-1866
Born in Konskolwola, Poland, on December 17, 1807, he died in Rome on April 11, 1866. He studied in Paris under David d'Angers and worked for a time in Paris as an engraver of dies, medals and plaques as well as a sculptor in the round. He returned to Poland during the July Revolution of 1830 and became engraver at the Warsaw Mint, but was sent into exile by the Russians the following year and returned to Paris. He went back to Poland again at the time of the Uprising of 1863 but after its suppression he fled the country and spent the last years of his life in Florence and Rome. Most of his work was done in Paris and consisted of religious figures and groups,

memorials and tombs, portrait busts, plaques and medallions of his contemporaries.

OLIVA, Alexandre Joseph 1823-1890
Born at Saillagousc, France, on September 4, 1823, he died in Paris on February 23, 1890. He studied under Delestre and exhibited at the Salon from 1849, winning medals in 1852 and 1861 and at the Exposition of 1855. He was awarded the Légion d'Honneur in 1867. He specialised in portrait busts of his contemporaries, in marble and bronze, and also produced several portrait statuettes.

OLIVARI, Paolo fl. 19th century
Born in Genoa, he studied under his uncle the ecclesiastical sculptor and wood-carver Angelo Olivari. He himself specialised in portrait busts but is best remembered for his religious sculpture, including more than 30 groups of religious processions and a score of altars in churches of Liguria.

OLIVE, Antoine 1808-1883
Born in Biot, France, on March 8, 1808, he died at Aix on October 28, 1883. He studied under Monti and L.M. Clérian and became professor at the Superior School of Design, Aix. He produced numerous portrait busts, bas-reliefs, and medallions of his contemporaries.

OLIVIER, Henri 1895-
Born in Paris on October 28, 1895, he exhibited paintings and sculpture at the Salon des Artistes Français, the Tuileries and the Salon d'Automne in the 1920s.

OLIVIER, Joseph 1861-
Born in Paris on December 28, 1861, he studied under Perrin, Delépine and A. Boucher and exhibited figures at the Salon des Artistes Français, becoming an Associate in 1912.

OLRIK, Henrik Benedikt 1830-1890
Born in Copenhagen in 1830, he died there on January 2, 1890. He studied under Couture in Paris (1854) and worked in Rome in the late 1870s. He painted and sculpted portraits and genre subjects and also did portrait reliefs, plaques, busts and medallions. His son Povl (1878-1928) worked as a wood-carver and is not known to have produced any bronzes.

OLSEN, Christian Constantin 1829-1896
Born in Copenhagen on March 5, 1829, he died there on September 6, 1896. He studied under H.V. Bissen and completed many of Thorvaldsen's works after his death. He was also responsible for restoring and refurbishing the Thorvaldsen Museum.

OLSON, Anders 1880-
Born at Rinkaberg, Sweden, on April 9, 1880, he studied in Stockholm, Paris and Bruges and worked in Stockholm where he specialised in animal figures and groups.

OMS, Manuel 1842-1889
Born in Barcelona in 1842, he died there on June 27, 1889. He was the son and pupil of Vicente Oms the Elder and also studied in Rome. He specialised in portraits of historic and contemporary Spanish celebrities, his best known work being the monument to Isabella the Catholic in Madrid.

OMS, Vicente, the Elder fl. 18th-19th centuries
Born in Barcelona in the late 18th century, he died there about 1854. He worked as a decorative and ecclesiastical sculptor there.

OMS, Vicente, the Younger 1854-1885
Born in Barcelona in 1854, he died in Madrid in 1885. He was the son of Vicente the Elder and studied in Barcelona and Paris. He worked in Madrid and did numerous sculptures for the Faculty of Medicine.

ONDRUSCH, Paul 1875-
Born at Leobschutz, Germany, on June 4, 1875, he studied in Munich and was a pupil of Eberle and Balthasar Schmitt. He worked in Silesia as an ecclesiastical sculptor.

ONGHENA, Charles and Constant fl. early 19th century
Copper-plate engravers, medallists and sculptors working in Ghent in the early 19th century. They specialised in bas-reliefs and plaques of historic and contemporary personalities. Examples of their work are preserved in the Ghent Academy.

OPFERMANN, Karl 1891-
Born at Rödding, North Slesvig, on September 29, 1891, he studied at the Flensburg School of Industrial Arts and settled in Hamburg. He specialised in genre and allegorical groups, such as The Four Seasons (Deutscher Haus, Flensburg) and The Mandolin Players (Hamburg Crematorium).

OPPENHEIMER, Viktor 1877-
Born at Neu-Rausnitz, Germany, in 1877, he studied in Munich under Miller and Dasio and settled in Brno, Czechoslovakia where he sculpted busts, reliefs and medallions.

OPPERMANN, Theodor Carl Rudolf 1862-
Born in Copenhagen on October 8, 1862, he studied under Franz Schwarz, Vilhelm Bissen and K. Zahrtmann and became Inspector of the New Carlsberg Glyptothek and later (1921) Director of the Thorvaldsen Museum, Copenhagen. He produced neo-classical statuettes and reliefs.

OPPLER, Alexander 1869-
Born in Hanover on February 10, 1869, he worked in Paris and became an Associate of The Société Nationale des Beaux Arts in 1904.

ORBAN, Antal 1887-
Born at Pusztakalan, Hungary, on April 24, 1887, he studied in Budapest, Brussels and Paris and became professor of sculpture at the Budapest School of Fine Arts. He did a number of monuments and statues in Budapest.

ORDUNA LAFUENTE, Fructuoso 1893-
Born at El Roncal, Spain, on January 23, 1893, he studied under M. Benlliure and worked in Madrid where he sculpted the decoration for several public buildings, such as the Ministry of Fine Arts and the Palace of Justice. He also produced bronze bas-reliefs and plaques and decorated the doors of the School of Mines.

ORIAN, Lys fl. 20th century
Sculptor of figures and portraits working in France between the wars and exhibiting at the Salon des Indépendants.

ORIGONE, Giovanni Battista fl. 19th century
Italian sculptor of historic figures and reliefs. His chief work is the monument to Giuseppe Maragliano at Camposanto, Genoa.

ORLANDI, B. fl. 19th century
French sculptor, exhibiting figures and groups at the Salon from 1831 to 1847.

ORLANDINI, Antoine 1886-
Born at Seurrè, France, on May 16, 1886, he studied under Mercié and Bouchard and exhibited at the Paris Salons from 1921 onwards, winning silver and gold medals in 1925 and 1927 respectively.

ORLÉANS, Marie Princess of, Duchess of Württemberg
— See MARIE CHRISTINE D'ORLÉANS

ORLÉANS, Paul fl. late 19th century
French sculptor of figures and portraits, exhibiting at the Nationale in the late 19th century.

ORLOFF, Chana (working under the name of CHANA ORLOFF)
1888-
Born at Tsaré Constaninowka, Ukraine, in 1888, she left Russia in 1904 and went to Jaffa in Palestine, but settled in Paris in 1910 and became naturalised in 1926. In 1911 she enrolled at the School of Decorative Arts and began exhibiting sculpture the following year. She showed two portrait busts at the Salon d'Automne in 1913 and later also exhibited regularly at the Salon des Indépendants and the Tuileries. She was represented in the Exhibition of the Masters of Independent Art at the Petit Palais in 1937. She was intimately associated with the Fauvists and the Cubists and this is reflected in much of her work. She produced numerous portrait busts, female nudes, animals and birds, in which the forms became increasingly severe and reduced to an almost elemental geometry. She worked in many media, including wood, stone, marble, sandstone, cement, alabaster and bronze. Her works include Seated Woman, The Pigeons, Lady with Fan, Venus, Madonna, My Son, The Bird, The Family and many busts and heads.

ORLOVSKI, Boris Ivanovich 1796-1837
Born in St. Petersburg in 1796, he died there in 1837. He studied under Thorvaldsen in Rome and is best known for his colossal bust of Tsar Alexander I. His minor works include classical groups and figures and busts of Russian war heroes.

ORSI, Achille d' 1845-1929
Born in Naples on August 6, 1845, he died there on February 8, 1929. He studied at the Naples Academy and then went to Rome where he modelled figures and sculpted the statue of Salvatore Rosa. On his return to Naples he sculpted The Parasites, which roused enormous interest on account of its unusual subject. He later did many genre and allegorical works and exhibited in Venice, Turin, Florence and Naples. He was for some time professor of sculpture at the Milan Academy and won a bronze medal at the Exposition Universelle of 1900.

ORTEL, Johannes 1893-
Born at Liechtenstein, Franconia, Germany on April 24, 1893, he studied under Schwegerle and B. Blecker and settled in Rothenburg-am-Tauber where he worked as a decorative sculptor.

OSBACH, Joseph fl. 19th century
Born in Lunéville, France, in the mid-19th century, he died there in 1898. He studied under Jouffroy, Carpeaux and J.P. Laurens and exhibited busts and statues at the Salon from 1873 to 1882. Toul Museum has several of his works.

OSBORNE, Charlotte Ellen (née Gibson) 1902-
Born in Launceston, Cornwall in 1902, she studied at the Regent Street Polytechnic School of Art under Brownsword (1925-31) and the British School in Rome (1931-32). She married the painter J.T.A. Osborne and lives at Orsett in Essex. She has exhibited figures and portraits at the Royal Academy and various London and provincial galleries and was elected FRBS in 1951.

OSGOOD, Richard fl. 1691-1715
Sculptor employed at Hampton Court in 1700-01, renovating and repairing the garden statuary there. He also cast figures in lead and bronze from his own models and produced various heads and busts, antique figures of boys and Roman statuary for private customers, notably Colonel Childs who commissioned many works from him in 1704-06. He was again working at Hampton Court from 1709 to 1715 and cast two sea-horses and two Tritons for the fountains.

O'SHAUGHNESSY, Thomas A. 1870-
Born at Charlton, Montana on April 14, 1870, he studied under Maratta, Willits and Alfons Mucha and worked in Paris and Dublin at the turn of the century before returning to the United States. He specialised in stained glass and glass-painting, and the sculpture of reliefs and plaques.

OSLÉ SAENZ DE MEDRANO, Luciano 1880-
Born in Barcelona on November 13, 1880. With his brother Miguel (born October 7, 1879) he studied under J. Monserrat and both worked as genre painters and sculptors in Barcelona.

OSMOND, Maurice 1875-
Born at La Meauffe, France, on January 5, 1875, he exhibited figures at the Salon des Artistes Français in the early years of this century, becoming as Associate in 1920.

OSOUF, Jean c.1900-
Born in Paris, about 1900, he specialised in busts which were noted for the sensitivity of the portraiture. He also produced masks and heads, in terra cotta, bronze and gilt-bronze and exhibited at the Salon d'Automne and the Tuileries.

OSSWALD, Paul 1883-
Born in Zürich in 1883, he studied under von Rümann in Berlin and worked in Italy from 1904 to 1912. He specialised in heads and female statuettes.

OSTROWSKI, Stanislaw Kazmierz Waclaw 1879-
Born in Warsaw, on May 8, 1879, he studied at the Cracow Academy and later in Florence and Rome. He was greatly influenced by Rodin and worked in Russia during the first world war. His best known work is the Tomb of the Unknown Soldier in Warsaw, but he also sculpted numerous portrait busts of his contemporaries.

OTTAVIANI, Ottaviano fl. late 19th century
He studied under Tenerani and worked in Folignano as a decorative sculptor from about 1872 onwards.

OTTAVRY, Antoine Elie 1887-
Born in Lyons on November 26, 1887, he studied under Mercié and exhibited figures at the Salon des Artistes Français, winning a third class medal in 1920 and a second class medal in 1926.

OTTIN, Auguste Louis Marie 1811-1890
Born in Paris, on November 11, 1811, he died there in 1890. He studied under David d'Angers and was runner up in the Prix de Rome of 1833, winning the prize three years later. He exhibited busts and statuettes of historic personalities and classical statuary at the Salon, winning several medals and the Légion d'Honneur in 1867.

OTTO, Johann Einar 1872-1901
Born in Copenhagen on September 21, 1872, he died there on August 22, 1901. He studied under Bissen and sculpted memorials and portraits of Danish personalities.

OTTO, Martin Paul 1846-1893
Born in Berlin, on August 3, 1846, he died there on April 7, 1893. He studied under Tonden and Alfinger at the Berlin Academy and worked in Rome from 1873 to 1887, before returning to Berlin. He is best remembered for his monuments to Luther and Humboldt in Berlin. His minor works include portrait busts and neo-classical groups, such as Young Virgins in the Service of Vesta.

OTTO, Wilhelm 1871-
Born in Harzgerode, Germany, on May 15, 1871, he worked in Berlin and Stettin and did decorative and ecclesiastical sculpture. His work includes fountains, public statuary and portraits.

OUBAWKICH, ? fl. late 19th century
Sculptor of genre and historic figures, working in Belgrade in the late 19th century. He was awarded a bronze medal at the Exposition Universelle of 1889.

OUDINÉ, Eugène André 1810-1887
Born in Paris, on January 3, 1810, he died there on April 12, 1887. He studied under Galle, Petitot and Ingres and won the Prix de Rome in 1831. He exhibited at the Salon from 1837 and had numerous awards, including second class medals in 1837, 1848 and 1855 and first class medals in 1839, 1843 and 1855. He became a Chevalier of the Légion d'Honneur in 1857. He was employed at the Paris Mint as a medallist and coin engraver, but continued to sculpt busts and statues in marble and bronze, including historic and contemporary personalities, allegories and classical subjects.

OUDOT, Georges 1928-
Born in Chaumont in 1928, he studied at the École des Beaux Arts, Paris from 1946 to 1950 under Marcel Gimond and was influenced by Malfray and J.P. Laurens. He works in Besançon and has exhibited regularly at the Salon de la Jeune Sculpture since 1952, winning the Fenelon Prize for Sculpture in 1955. His work ranges from large-scale monuments, such as that in honour of the sociologist Proudhon at Besançon, to nudes, torsos and semi-figurative forms in plaster and bronze.

OURY, Germaine 1889-
Born in Valenciennes, on October 6, 1889, she exhibited statuettes at the Salon des Artistes Français from 1921 onwards and won medals in 1921 and 1927.

OURY, Louis fl. late 19th century
Born at Montauban, France, in the mid-19th century, he exhibited figures and portraits at the Salon des Artistes Français and got an honourable mention in 1898.

OVARNSTROEM, Charles Gustave 1810-1867
Born in Stockholm, in 1810, he died there in 1867. He studied for six years in Italy and two in Paris as well as in Munich and became Director of the Stockholm Academy. He sculpted busts, bas-reliefs, statuettes, plaques and medallions, mainly inspired by the characters and creatures of Norse mythology.

ÖXLEIN, Christian Daniel fl 18th century
Sculptor of bas-reliefs and portrait medallions, working in Nuremberg and Ratisbon between 1712 and 1759.

ÖXLEIN, Johann Leonhard 1715-1787
Born in Nuremberg on January 28, 1715, he died there on October 26, 1787. He was the son and pupil of Christian Daniel Öxlein and also studied under B. Richter and Sennaro and produced medallions, plaques and reliefs.

OZANNE-CEDERLUND, Frédérique 1881-
Born at Le Havre on September 23, 1881, she studied under Valton and worked as an Animalier, exhibiting bird and animal figures and groups at the Salon des Artistes Français and winning a third class medal in 1929. She also exhibited at the Salon des Femmes Peintres et Sculpteurs and the Salon d'Hiver.

PAASCH, Adèle (née Hillringhaus) 1868-
Born in Barmen (now Wuppertal), Germany, on June 16, 1868, she worked in Berlin. She was self-taught and sculpted figures and portraits. Examples of her work are in the Düsseldorf Museum.

PACCHIONI, Giuseppe fl. 19th century
Born in Bologna in the early 19th century, he died there in January, 1887. He sculpted many busts and tombs for the Carthusian monastery in Bologna.

PACETTI, Camillo 1758-1826
Born in Rome on May 2, 1758, he died in Milan on July 16, 1826. He studied at the Academy of St. Luke and became professor of sculpture at the Milan Academy. He sculpted many of the statues on the façade of Milan Cathedral and also specialised in portrait busts of Italian historic and contemporary personalities, particularly of the Napoleonic period.

PACETTI, Giuseppe 1782-1839
Born in Rome, on March 24, 1782, the son of Vicenzo Pacetti, he died in Rome on March 9, 1839. He studied under his father and Thorvaldsen (1821-24) and worked on classical and allegorical figures, mainly in marble.

PACETTI, Vicenzo c.1746-1820
Born in Rome about 1746, he died there on July 28, 1820. He was the brother of Camillo and father of Giuseppe and worked as a decorative and ecclesiastical sculptor on the churches and palaces of Rome, notably the Palazzo Borghese.

PACHT, Axel Frederik 1847-1898
Born in Copenhagen on June 16, 1847, he died there on October 28, 1898. He studied at the Copenhagen Academy and specialised in monuments, memorials and portrait busts of Danish celebrities.

PACI, Emilio 1809-1875
Born at Ascoli Piceno, Italy, on February 3, 1809, he died in Rome on September 23, 1875. He studied at the Academy of St. Luke and was a pupil of T. Minardi and P. Tenerani, with whom he worked on the tomb of Pope Pius VIII. He specialised in figures and bas-reliefs of religious subjects.

PACI, Giorgio 1820-1914
Born at Ascoli Piceno, Italy, on October 10, 1820, he died there on February 3, 1914. He was the younger brother of Emilio Paci and studied at the Rome Academy. He also worked with Tenerani in the decoration of many Roman churches and also sculpted portrait busts of his contemporaries, notably the series of singers for the Teatro Ventidio Basso.

PACIUREA, Dumitru 1873-1923
Born in Bucharest, Romania, on November 23, 1873, he died there in 1923. He studied in Paris and became the leading Impressionist sculptor in Romania at the turn of the century. His chief work is the group Death of the Mother of God. The Simu Museum has his Head of an Infant and two bronze bas-reliefs.

PADDOCK, Willard Dryden 1873-
Born in Brooklyn, New York, in 1873, he studied under Herbert Adams in New York and attended classes at the Pratt Institute in

Brooklyn. Later he studied under Courtois and Girardet in Paris. He sculpted numerous busts, figures, fantasies, sun-dials and statuettes in plaster and bronze.

PADIGLIONE, Agostino fl. 19th century
Neapolitan sculptor of the mid-19th century, who modelled figures and reliefs for the Sallust house and the Casa de Fauno.

PADIGLIONE, Domenico fl. 19th century
Classical sculptor working in Naples, he is best known for his models of the three temples of Paestum.

PADIGLIONE, Felice fl. 19th century
Neapolitan sculptor specialising in reproductions of figures and groups of classical sculpture, particularly those excavated at Pompeii.

PADRO Y PIJOAN, Ramon 1876-
Born at San Feliu de Llobregat, Spain, on August 17, 1876, he studied under D. Campeny and specialised in ecclesiastical sculpture for churches and cathedrals in Barcelona and Saragossa.

PAEFF, Bashka 1893-
Born in Minsk, Russia, on August 12, 1893, he emigrated to the United States and studied at the Massachusetts Normal School and the School of the Boston Museum of Fine Arts under Bela Pratt. He specialised in portrait busts, bas-reliefs and commemorative sculpture. His bronzes include portraits of William Dixon Weaver, Jane Addams (Hull House, Chicago), James Barr Ames (Law Building, Harvard University), Oliver Wendell Holmes, Louis Brandeis, Sherman L. Whipple, Ames Hersey Whipple (Town Hall, New London, Connecticut), Arthur Foote, and many other distinguished Americans of the early 20th century. He also sculpted bronze figures of animals, genre statuettes, sun-dials and fountain statuary.

PAERINO, Demetrio 1851-1914
Born in Genoa on October 13, 1851, he died there on October 20, 1914. He exhibited in Turin, Milan and Paris from 1880 onwards and won a bronze medal at the Exposition Universelle of 1889. He specialised in busts of historic and contemporary Italian celebrities, such as the portraits of Mazzini and Garibaldi in Genoa Town Hall, and also did much decorative sculpture in that city.

PAGANI, Louis fl. 19th century
Born in Bergamo in the early 19th century, he studied at the Milan Academy and exhibited in Parma, Milan, Naples, Rome and Turin from about 1870 onwards. His best known work is the group The Dead at the Gates of Paradise. He also sculpted portrait busts and genre statuettes.

PAGANO, Domenico fl. late 19th century
Born in Rome in the mid-19th century, he exhibited there and in Turin, Venice and Paris from 1880 onwards, winning an honourable mention at the Exposition of 1889.

PAGANUCCI, Giovanni fl. 19th century
He worked in Leghorn as a decorative sculptor, and exhibited figures and bas-reliefs at the Florence Academy from 1870.

PAGE, Norbert Joseph 1821-1870
Born in Mons, Belgium, on May 28, 1821, he died at Evere, near Brussels on November 30, 1870. He worked with Étienne Waucquier in the sculpture of the twenty caryatids in the Salle des Pasperdus at Mons.

PAGELS, Hermann Joachim 1876-
Born in Lübeck on September 11, 1876, he studied under Breuer and Herter at the Berlin Academy and then settled in Charlottenburg where he sculpted monuments, memorials and portraits of his artistic contemporaries. His genre statuettes include the figure of a Worker in a Steel Rolling Mill (Essen), the Little Fisherman fountain in Bremerhaven and The Chicken Stealer (Aachen Museum).

PAILLET, Charles 1871-
Born at Mouins-Engilbert, France, on March 30, 1871, he studied under Gardet and exhibited at the Salon des Artistes Français from 1897, winning third class (1902), second class (1904) and first class (1922) medals. His animal figures and groups were characterised by humanoid overtones, a typical example being the Two Friends in the Luxembourg Gardens.

PAINTER, Tom 1918-
Born in Wolverhampton on November 29, 1918, he studied at the Wolverhampton College of Art (1932-40) and at the Royal College of Art (1946-9) and in Italy. He now works in London.

PAINTI, Paul 1862-
Born at Olmütz (Olomuc in Czechoslovakia) on January 15, 1862, he studied under Weyr and worked in Vienna as a sculptor of allegorical figures. His chief works are the colossal statues of Song and Poetry in Vienna.

PAJOL, Charles Pierre, Comte de 1812-1891
Born in Paris on August 7, 1812 he died there on April 3, 1891. The son of Général-en-Chef, Comte de Pajol, he himself was a professional soldier attaining the rank of Major-General. He practised lithography and engraving as a hobby and was also a sculptor of portraits and military subjects and exhibited at the Salon from 1863 onwards. His chief work was the bronze statue of his father erected in Besançon. His minor bronzes include statuettes and busts of Napoleon and his generals. His figure The Dead Hussar is in Besançon Museum.

PAJOU, Augustin 1730-1809
Born in Paris on September 19, 1730, he died there on May 8, 1809. He studied under Lemoyne and won the Prix de Rome in 1748. Thereafter he worked in Rome till 1759 and on his return to Paris was admitted to the Academy. He exhibited at the Salon from 1759 to 1802 and became an Academician (1760), Professor (1762) and Rector (1792). He was a member of the Institut from its foundation and one of the first holders of the Légion d'Honneur (1804). His chief works were the decorations on the Paris Opera and the Palais-Bourbon, but he also sculpted numerous busts, bas-reliefs and figures of allegorical subjects and contemporary celebrities, mainly in marble and stone, though bronze reductions are known.

PALACIOS CABELLO, Eloy fl. 19th century
Born in Maturin, Venezuela on June 25, 1847, he studied in Munich and worked in Caracas where he specialised in busts and statues portraying South American heroes.

PALLANT, Charlotte von (de) fl. 20th century
Member of a Danish noble family, working in Paris in the inter-war period as a sculptress of genre statuettes and busts. She exhibited at the Salon des Tuileries in 1938.

PALLAVICINI, Petrus 1888-
Born in Korcula (now Yugoslavia) on June 15, 1888, he studied at the School of Sculpture, Horice (Bohemia), and the Prague Academy and became professor at the Belgrade School of Fine Arts after the first world war. He sculpted a number of memorials and tombs as well as busts of his contemporaries.

PALLENBERG, Joseph Franz 1882-
Born in Cologne on August 6, 1882, he studied at the Düsseldorf Academy and worked in the Lohausen district of Düsseldorf. He specialised in animal figures and groups, examples of which are in the Düsseldorf Municipal Museum.

PALLEZ, Lucien fl. 19th century
Born in Paris on May 22, 1853, he studied under Guillaume and A. Millet and exhibited at the Salon from 1873, winning a third class medal (1875), a travelling scholarship (1883), and a second class medal (1885). He became a Chevalier of the Légion d'Honneur in 1887 and won silver medals at the Expositions Universelles of 1889 and 1900. He produced allegorical figures and monuments in the neo-classical style, but also sculpted portrait busts of his contemporaries and the monument of Victor Hugo for the Palazzo Borghese in Rome.

PALLISER, Herbert William 1883-1963
Born in Northallerton, Yorkshire, on May 3, 1883, he died in London on October 9, 1963. He studied at the Central School of Arts and Crafts and the Slade School and exhibited figures and portraits at the Royal Academy and provincial galleries.

PALMELLA, Maria, Duchess de 1841-1909
Born in Lisbon on August 4, 1841, she died at Cintra on September 2, 1909. She studied under Calmels and exhibited figures in Lisbon and Paris, winning honourable mentions at the Salon in 1884 and 1886.

PALMER, Herbert Ralph 1916-
Born in Richmond, Surrey, on December 13, 1916, he was brought up in South Africa and studied at the Johannesburg Art School (1932-6). Subsequently he returned to England and studied under P.H. Jowett in London. He has exhibited paintings and sculpture in the main London and provincial galleries since the second world war and now works in London.

PAMPALONI, Luigi 1791-1847
Born in Florence on October 7, 1791, he died there on December 17, 1847. He studied under Bartolini and became a member of the Florence Academy in 1830. He sculpted many statues and monuments to historical personages in Florence and Pisa.

PAN, Marta 1923-
Born in Budapest in 1923, she studied painting and sculpture there and emigrated to France after the second world war, settling in Paris in 1947. She has exhibited at the Salon des Réalités Nouvelles since 1950 and became naturalised in 1952. Most of her sculptures are abstracts carved in wood, but about 1957 she began experimenting with Constructivist sculpture in metals, notably aluminium and more recently has modelled them for mass production.

PANCALDI, Francesco 1829-c.1869
Born in Ascona, Switzerland, on August 9, 1829, he died in Milan about 1869. He worked in Switzerland and Lombardy as a decorative sculptor.

PANDER, Pier 1864-1919
Born at Drachten, Holland, on June 20, 1864, he died in Rome in September 1919. He worked with Collinet in Amsterdam (1880-2) and studied at the École des Beaux Arts under Cavelier (1884-5). He returned to Amsterdam for three years then worked in Paris in 1887-9 and eventually settled in Rome. He specialised in classical and allegorical figures, such as Nymph, Music and Youth.

PANDIANI, Constantino fl. 19th century
Born in Milan on April 28, 1837, he worked there as a decorative sculptor and exhibited figures and bas-reliefs in Parma, Milan, Turin, Naples and Paris, getting an honourable mention at the Exposition Universelle of 1889.

PANDIANI, Giovanni 1809-1879
Born in Milan on January 6, 1809, he died there on January 26, 1879. He decorated the Church of San Carlo in Milan and sculpted figures and bas-reliefs illustrating the life of St. Francis.

PANDIANI, Innocent c.1820-1901
Born in Milan about 1820, he died there on February 4, 1901. He specialised in memorials and tombs in Milan, and also did decorative sculpture in the Victor Emmanuel II Gallery in Milan.

PANFILOFF, Ivan Pavlovich 1843-1876
Born in Serpurkov, Russia, in 1843, he died in Rome on October 16, 1876. He studied at the St. Petersburg Academy and specialised in genre figures, such as Gladiator and Child with a Goat.

PANICHI, Ugolino 1839-1882
Born at Ascoli Piceno, Italy, in 1839, he died in Rome on February 14, 1882. He studied under Paci and worked at the Florence Academy where he was a pupil of A. Costoli. He spent five years in Paris (1861-6) before settling in Rome where he specialised in religious figures and reliefs. He decorated the Gubbio and other Roman churches and sculpted the Leopardi monument in Recanati.

PANKOK, Otto 1893-
Born in Lülheim, Germany, on June 6, 1893, he studied at the Düsseldorf Academy and the Weimar School of Art and worked in Paris for some time before settling in Düsseldorf. He was a painter, engraver, writer and sculptor of the Impressionist school.

PANTA, Egisto da fl. 19th century
Born in Turin in the mid-19th century, he studied in Florence and won numerous awards. He specialised in genre works, such as Return from the Fête, Return of the Nurse, Silence, In the Sunshine, Dinner-time, I am Content, and his best known work, A Gust of Wind — a virtuoso study of diaphanous veils, lace and frills on a young lady struggling to regain her composure in a gale.

PAOLI, Luigi de fl. late 19th century
Born at Pordenone, Italy in the mid-19th century, he won a high reputation in the late 19th century for the quality of his portrait busts and his statuettes of nudes. His best known work is The Honeymoon (Milan, 1886), showing a pair of lovers kissing. He worked mainly in marble, but many of his figures were published as bronze reductions and these classical and genre statuettes were extremely popular in Italy at the turn of the century.

PAOLO, Cartaino S. 1882-
Born in Italy in 1882, he emigrated to the United States and worked in New York, where he specialised in portrait busts. Examples of his work are in State House and St. Patrick's Cathedral.

PAOLOZZI, Eduardo 1924-
Born in Edinburgh, Scotland of Italian parents on March 7, 1924, he studied at the Edinburgh College of Art (1942) and the Slade School (1943-7) and had his first one-man show at the Mayor Gallery in 1947. He worked in Paris from 1947 to 1950 and was influenced by Giacometti and Paul Klee. Subsequently he exhibited internationally and took part in the Venice Biennale of 1952. The following year he was commissioned by the Hamburg City Council to design a fountain for a public park and the same year he won the British Critics Prize. He has taken part in many exhibitions, including Sonsbeek (1958), New York and Sao Paulo. He taught at the Central School of Arts and Crafts, London (1950-5) and St. Martin's School (1949-58) and now lives at Thorpe-le-Soken, Essex. His earlier works were mostly in concrete or plaster but his more recent works have been cast in bronze and include The Cage (1950-1), Japanese War God (1958), Monkeyman, Little King and Saint Sebastian. His abstract figures are characterised by the complexity of their surfaces, covered with impressions of nuts, bolts and mechanical bits and pieces. They have been described as 'patched-up robots making their rickety way out of some atomic holocaust' (Michael Middleton).

PAPALE, Benedetto 1836-1913
Born in Caltagirone, Sicily, in 1836, he died there in 1913. He specialised in figures and bas-reliefs of religious subjects particularly Nativity scenes.

PARAYRE, Henri Ernest 1883-
Born in Toulouse on July 9, 1883, he studied at the School of Fine Arts in that city and became professor at the School of Decorative Arts, Paris. He exhibited at the Petit Palais in 1937 a number of figures including bronzes of an Athlete, Girl's Torso, Standing Woman and Seated Woman and a terra cotta of a Woman with Crossed Legs and a stone Head of a Young Boy. He sculpted the monument to Paul Lacombe in Carcassonne. His Young Girl in a Bath is in the Museum of Modern Art, Paris.

PARBURY, George fl. 1760-1791
Born in London, probably in 1738, the son of a Keeper of the Royal Academy, he won a prize in 1760 for a clay model of birds and a further prize the following year from the Society of Arts in whose records he is described as a metal chaser. He specialised in wax portraits, statuettes and small groups of classical subjects. He exhibited at the Royal Academy from 1772 to 1791 and at the Society of Artists from 1764 to 1771.

PARBURY, Kathleen Ophir Theodora 1901-
Born at Borehamwood, Hertfordshire on August 23, 1901, she studied at the Slade School under Tonks and Harvard Thomas (1920-4) and exhibited at the Royal Society of British Sculptors, being elected FRBS in 1966. She lives on the island of Lindisfarne.

PARFAIT, Henri Charles 1819-1873
Born at Chartres on September 5, 1819, he died there on April 27, 1873. He studied under Pradier and enrolled at the École des Beaux Arts in 1838. Later he was employed on the restoration of Chartres Cathedral, following the extensive fire damage of 1836. He sculpted reliefs for the west door. He also did busts, reliefs and medallions of his contemporaries.

PARINI, fl. 19th century
Professor of modelling at the Nice Municipal School of Art in the 1850s. Nice Museum has a bas-relief by him showing Lovers chasing a Boar (1859).

PARIS, Auguste 1850-1915
Born in Paris in 1850, he died at Colombes in March 1915. He studied under Jouffroy, Falguière and Doublemard and exhibited at the Salon from 1876, becoming an Associate of the Artistes Français in 1883. He won third class (1876), second class (1880) and first class (1882) medals and a gold medal at the Exposition Universelle of 1889. He was awarded the Légion d'Honneur in 1892. He is best known for his monumental work, including the Dantan memorial and the 1789 monument in Montsouris Park. His group of Orpheus and Eurydice is in the Belfort Museum.

PARIS, Gabriel Paulin 1882-
Born at Rethel, France on September 15, 1882, he studied under Barrias, Peter and Coutan and exhibited bas-reliefs and medallions at the Salon des Artistes Français.

PARIS, René 1881-
Born in Paris on November 26, 1881, he studied under Thomas, Gardet and Peter and specialised in animal figures and groups. He became an Associate of the Artistes Français in 1906 and won an honourable mention in 1907, a second class medal in 1944 and a first class medal in 1920.

PARK, R.H. fl. 19th century
Sculptor and painter of genre and neo-classical subjects working in New York and also for many years (1871-90) in Florence.

PARKER, Constance Anne 1921-
Born in London on October 19, 1921, she studied at the Polytechnic School of Art and the Royal Academy schools where she won four silver and three bronze medals for painting, engraving and sculpture. She has exhibited at the Royal Academy, the Royal Society of British Artists and other leading British galleries and lives in London.

PARKER, Harold 1873-
Born in Aylesbury, Buckinghamshire on August 27, 1873, he was taken to Australia by his parents as an infant and brought up in Brisbane, Queensland. He studied at the Brisbane Art School under R. Godfrey Rivers and came to London in 1896 to study at the City and Guilds School under W.S. Frith (1897-1902). He won a number of prizes and scholarships and exhibited at the Royal Academy from 1903 to 1929. He was a member of the Royal Society of British Sculptors (1906-26) and a founder member of the Australian Academy of Arts. He returned to Australia in 1930 and worked for some time in Melbourne and then in Brisbane. His portrait busts, statuettes and genre, classical and allegorical figures are represented in many public collections in Britain and Australia and include Ariadne (Tate Gallery) and First Breath of Spring (Brisbane National Art Gallery).

PARKER, Harold Wilson 1896-
Born in London on May 6, 1896, he studied at the Walthamstow School of Art, St. Martin's School of Art, the Central School of Arts and Crafts, Sir John Cass School of Art and the Royal College of Art, winning the Prix de Rome for sculpture in 1927. He has lived in London for many years and sculpts figures, reliefs and portraits in wood, stone and bronze.

PARKER, John F. 1884-
Born in New York on May 10, 1884, he studied under Robert Henri and then went to Europe where he studied in London and was a pupil of J.P. Laurens and Steinlen in Paris. He worked in the United States as a painter and sculptor of historical subjects. His figures and groups are in the National Gallery, Washington, the Museum of American History and the Valley Forge Museum.

PARKER, Lilian G. 1880-
Born in Bolton, Lancashire in 1880, she studied at the Royal College of Art and exhibited at the Royal Academy, the Salon des Artistes Français and various British galleries. She specialised in portrait busts and figures and worked in London.

PARKER, Richard Henry 1881-
Born in Dewsbury on August 30, 1881, he studied at the Royal College of Art and the British School in Rome and was Principal of Harrogate School of Art, and Plymouth School of Art, and a lecturer at the Royal College of Art. He sculpted bas-reliefs and portraits and architectural decoration, as well as working as a painter and etcher.

PARKER, Samuel fl. early 19th century
Decorative sculptor working in London in the Regency period. His best known work is the chimney piece for the saloon of the Royal Pavilion, Brighton, made of marble with niches containing ormolu Chinoiseries. This remarkable piece was subsequently removed to Buckingham Palace where it is now in the Yellow Drawing-room. He also worked on the decoration of Buckingham Palace in 1829-31. He specialised in small bronze busts, including those of Lord Brougham and King William IV (1831), both in the Scottish National Portrait Gallery, and Sir Thomas Lawrence (shown at the Great Exhibition of 1851).

PARKINSON, William Edward 1871-1927
Born in Chester on January 1, 1871, he died in York on May 26, 1927. He studied at Chester School of Art and the Royal College of Art where he won silver and bronze medals. He subsequently exhibited at the leading London and provincial galleries and the Paris Salons. He lived in York, where he was Principal of the Art School. He worked as a landscapist in oils and watercolours and sculpted portraits and genre figures.

PARMEGGIANI, Carlo fl. 19th century
Born in Bologna in the mid-19th century, he worked there as a decorative sculptor and exhibited figures and reliefs in Rome, Venice and Bologna.

PARMENTIER, Charles Isidore Gustave 1818-74
Born at Villejuif, France on October 23, 1818, he died in Paris on March 6, 1874. He exhibited animal figures in wax and bronze at the Salon from 1866 to 1872.

PARMENTIER, Marc fl. 19th century
Amiens Museum has his bust of Commandant J.F. Vogel.

PARMENTIER, Philippe 1787-1851
Born at Feluy near Nivelles on November 15, 1787 he died in Ghent in 1851. He worked with his father, Antoine Parmentier on the decoration of the Palais de Justice, the Theatre and the University of Ghent and also sculpted religious figures, mainly in marble, for Furnes Church.

PARR, Lenton 1924-
Born in Melbourne, Australia, he has sculpted figures and memorials, portraits and groups in various parts of Australia. He is also a writer and compiled the volume on sculpture in the Arts in Australia series.

PARS, Albert fl. mid-18th century
Born in London in the early 18th century, the son of a silver chaser and brother of William Pars the portrait painter and Henry Pars the Director of St. Martin's School of Art. He won prizes from the Society of Arts in 1759, 1764 and 1765 for wax models of classical figures subsequently cast in bronze.

PARSONS, Edith Barretto fl. 20th century
Born in Houston, Texas in the late 19th century, she was a pupil of the Art Students' League, New York under Daniel Chester French and George Grey Barnard. She specialised in classical and animal bronzes, including The Baby Goat, Baby Pan and The Big Duck.

PARTRIDGE, Roy 1888-
Born at Centralia, near Washington, D.C., on October 14, 1888 of English parentage, he studied at the National Academy of Design (1909-10) and in Paris (1911-14). He is best known as a landscape painter and magazine illustrator but has also sculpted figures and portraits. He worked mainly in Oakland, California.

PARTRIDGE, William Ordway 1861-1930
Born in Paris of American parents on April 11, 1861, he died in New York on May 22, 1930. He studied under Welonski in Rome and Elwell in New York and produced busts of 19th century American celebrities, many of which are in the Brooklyn Museum. He also sculpted the equestrian statue of General Grant (Brooklyn) and Alexander Hamilton (Columbia University). His marble head of Peace is in the Metropolitan Museum of Art, New York.

PARTSCH, Josef 1811-1886
Born at Engelsberg, Austria, in 1811, he died in Vienna in 1886. He worked as a decorative sculptor.

PASCAL, Anne Marie 1898-
Born in Lyons on June 1, 1898, she exhibited statuettes at the Salon des Artistes Français in the 1920s.

PASCAL, Ernest Emile fl. late 19th century
Born in Paris in the mid-19th century, he studied under Barye and exhibited portrait busts, medallions and animal figures at the Salon in 1881-82.

PASCAL, François Michel 1810-1882
Born in Paris on December 29, 1810, he died there on January 3, 1882. He studied at the École des Beaux Arts under David d'Angers and exhibited at the Salon from 1840 to 1880, winning a third class medal in 1847 and a second class medal a year later. He produced many busts and figures of his contemporaries and groups depicting incidents in French history, religious and genre figures and groups, such as the Seated Capuchin, Monk at Prayer, Capuchin and Children, Trappist Monk, Capuchin in Prayer, Nun with Children, and Trappist Praying. His best known work in this genre is the group Let the Little Children come unto Me.

PASCAL, Wilhelm fl. 19th century
Born in Berlin in 1813, he studied at the Academy and exhibited figures and portraits there, up to 1848.

PASCHE, Albert 1873-
Born in Geneva of French parents, on December 12, 1873, he studied in Paris under Falguière and Mercié and worked as a painter and sculptor of genre and mountain subjects. He exhibited at the Salon des Artistes Français, winning a second class medal in 1909 and a first class medal in 1926. He became professor at the School of Fine Arts, Besançon.

PASCOE, Ernest 1922-
He studied at Carlisle School of Art (1937-41) and the Slade School (1945-8) and has exhibited paintings and sculpture at the Royal Academy, the Royal Society of British Artists and the London Group. He now works in Bristol.

PASCUAL, Manolo fl. early 20th century
Born in Bilbao, he studied at the Academy of San Fernando, Madrid, and won the Prix de Rome. On his return to Spain in 1932 he began sculpting genre figures in the modern manner, his best known work from this period being The Motorcyclist. He was exiled after the Civil War and went first to France and then to the United States. He founded the School of Fine Arts in Ciudad Trujillo, Dominican Republic, and has produced heads and busts of Indians and West Indians as well as non-figurative work in wrought iron.

PASINATI Family fl. 19th century
Family of sculptors working on medallions, medals, plaques and bas-reliefs in Rome. They include Giuseppe (fl. 1814-15), Luigi (fl. 1823-56) and Paolo (fl. 1884-90).

PASMORE, Victor 1908-
Born in Chelsham, Surrey, in 1908, he studied painting in evening classes while working as a local government officer in London and then taught at the Euston Road School in 1937-39. After war service he taught at the Camberwell School of Art (1945-49) the Central School of Arts (1949-53) and at Durham University (since 1954). He has been a member of the London Group since 1932 and was created C.B.E. in 1959. His figurative work belongs to his early period, but gradually he tended towards the abstract and produced bas-reliefs and constructions since 1951, in addition to his better known work as an abstract painter.

PASQUALI, Antonio fl. early 19th century
Born in Verona about 1780, he worked on the decoration of Milan Cathedral from 1808 to 1847. His secular work includes portrait busts, such as that of Palladio at Vicenza.

PASQUANIN, Nikolaus 1810-c.1860
Born in Fiume in 1810, he died in Trieste about 1860. He studied under his uncle, Marc Cerigin, in Fiume and worked as a monumental sculptor in Fiume and Trieste.

PASQUIER, Antoine Léonard du 1748-1831
Born in Paris in 1748 he died there in 1831 or 1832. He exhibited at

the Salon in 1791 under the name of Pasquier and from 1808 onwards under the name of Dupasquier. He specialised in battle scenes, heroic groups inspired by Napoleon's campaigns, bas-reliefs and classical statuettes, such as Arion (Narbonne Museum).

PASSAGE, Arthur Marie Gabriel, Comte du 1838-1909
Born at Frohen, France, on June 24, 1838, he died there in February 1909. He studied under Barye and Mêne and exhibited at the Salon from 1865 onwards. He is better known as a painter of animal subjects, but he also sculpted a number of small bronzes, which bear the signature 'Ct. du Passage'. These include Dying Roe-deer, The Relay, The Last Effort, Hunter at the Trot, Mare harnessed by a Groom, Joan of Arc and Setter with Game.

PASSAGE, Charles Marie, Vicomte du 1843-
Younger brother of the Comte du Passage, he was a noted animal painter who also sculpted figures and groups, mainly of birds and hunting subjects. His bronzes include Bull Terrier tormenting a Martin trapped in a Snare, Falcon and Hare, Falcon attacking a Homing Pigeon, Cat and Dog, Goshawk seizing a Heron, Falcon in Flight, Rabbit Hunt, The Poacher, Fox strangling a Cock and Boars Fighting. He exhibited at the Salon from 1874 to the end of the 19th century.

PASSAGLIA, Auguste 1838-1918
Born in Lucca in 1838, he died in Florence on September 5, 1918. He was regarded as one of the finest Italian sculptors of the 19th century and received numerous commissions for monuments and public statuary. His best known works include the statues of Boccaccio and Victor Emmanuel II at Carrara. His minor works include figures and bas-reliefs of allegorical, historic and contemporary subjects.

PASSANI, I.A. fl. 19th century
Sculptor of neo-classical figures and statuettes in the manner of the 17th century Paduan School. Typical of his whimsical approach is the figure Satirino Freddoloso (the freezing little satyr) — a satyr shivering with cold, blowing on his fingers instead of his pipes of Pan.

PASSANI, Ulisse fl. 19th century
Born in Parma in 1848, he emigrated to Argentina in 1890 and sculpted historic and allegorical figures and bas-reliefs. Examples of his smaller works are in the Parma Museum.

PASSARIN, Domenico 1802-1867
Born at Bassano in 1802, he died in Venice in 1867. He worked in Lombardo-Venezia as a decorative sculptor.

PASTEUR, Édouard fl. 19th-20th centuries
Decorative and genre sculptor working in Paris at the turn of the century.

PASTINSZKY, Mihaly 1886-
Born at Peredmer, Hungary, on October 1, 1886, he studied in Budapest and worked in Györ on allegorical and neo-classical figures and groups, such as the Symbolist work The New Laocoon.

PASTOR Y JULIA, Modesto 1825-1889
Born at Albaida, Valencia, in 1825, he died in Valencia in 1889. He sculpted religious figures, mainly in painted wood, for churches in Valencia.

PASZTOR, Janos Job 1881-
Born in Gyoma, Hungary, on January 28, 1881, he studied in Budapest and Paris and worked in Budapest where he modelled genre statuettes, mainly illustrating the life of the gipsies and Hungarian peasantry. His allegorical works include Separation, Primavera, and his genre figures and groups include The Hunt, Cleopatra, Suzanne in the Bath, Young Girl carrying a Pitcher. He also sculpted several memorials after the first world war.

PATAKY, Ferenc 1850-1910
Born at Magyarovar, Hungary, on November 29, 1850, he died at Kecsemet on March 31, 1910. He worked as a sculptor and painter of genre subjects.

PATEY, Henri Auguste Jules 1855-1930
Born in Paris on September 9, 1855, he died there on May 17, 1930. He studied under Chapu, Jouffroy and Chaplin and exhibited at the Salon in 1877 and the Salon des Artistes Français from 1885 onwards. He won the Prix de Rome in 1881 and third class (1886),

second class (1887) and first class (1894) medals. At the Expositions Universelles of 1889 and 1900 he was awarded Bronze and Gold Medals respectively and the Légion d'Honneur in 1898. He was given the medal of honour in 1910. He was the Chief Medallist at the Paris Mint and engraved the 25-centime coin of 1896. His sculpture includes portrait busts, bas-reliefs and medallions.

PATIGIAN, Haig 1876-
Born in War, Armenia, on January 22, 1876 he studied in Paris under Alexandre Marquet (1906-7) and was an Associate of the Artistes Français. Later he emigrated to the United States and settled in San Francisco where he sculpted busts, portrait reliefs and a number of monuments, notably that honouring General Pershing.

PATRIARCHE, Louis fl. 20th century
Born in Bastia, Corsica, in the late 19th century, he studied in Paris under Barrias, Vernon and Hippolyte Lefebvre. He exhibited reliefs and medallions at the Salon des Artistes Français, getting an honourable mention (1903), third class (1906), second class (1910) medals, the Légion d'Honneur (1924) and the medal of honour (1932).

PATZAY, Pal 1896-
Born in Kapuvar, Hungary, on September 17, 1896, he studied in Budapest and won the Prix de Rome. He worked in Budapest as a sculptor of figures and portraits and examples of his work may be found in the museums of that city.

PATZO, Pal 1886-
Born in Budapest on January 15, 1886, he studied in Vienna and worked as a decorative sculptor in Budapest.

PAUFFARD, Jean Baptiste Auguste fl. 19th century
Born in Dijon on June 5, 1819, he worked with Ramey and Dumont and exhibited at the Salon from 1846 to 1877. The main collection of his works in Dijon Museum includes busts of his contemporaries. Semur Museum has his group of Socrates, Heraclitus and Democritus.

PAUGOY, Eugène fl. 19th century
Born in Marseilles in the mid-19th century, he studied under Loudon and exhibited bas-reliefs and medallions at the Salon in 1877-78.

PAUL, Ernst Wilhelm fl. 19th century
Born at Adorf, Saxony, on August 17, 1856, he studied under J. Schilling and worked in Dresden on genre figures (mostly of children) and historical figures. He sculpted the Luther monument at Döbeln and the Kaiser Wilhelm I monument at Naumburg.

PAUL, Léon fl. 20th century
Born at Bransat, France, in the late 19th century, he exhibited figures at the Salon des Artistes Français in the early years of this century and got an honourable mention in 1910.

PAUL, Louis Auguste Albert 1854-1922
Born at Béziers on June 5, 1854, he died there on May 9, 1922. He studied under his father, a stone-mason, and went to Paris, where he was a pupil of Cabanel and Millet. He exhibited portraits and landscape paintings at the Salon from 1879 onwards, but also sculpted busts and relief portraits of French historical personalities. He became a Chevalier of the Légion d'Honneur in 1898.

PAUL-MANCEAU, Dr. G. 1872-
Born at Loches, France, on November 6, 1872, he exhibited portraits and figures at the Salon des Indépendants in 1897 and the Nationale in 1900.

PAULDING, John 1873-
Born in Dark County, Ohio, on April 5, 1873, he worked as a figure and decorative sculptor in Chicago.

PAULIN, George Henry 1888-1962
Born at Muckhart, Clackmannanshire, Scotland, on August 14, 1888, he died in London in 1962. He studied at the Edinburgh College of Art under Percy Portsmouth and later studied in Rome, Florence and Paris. He exhibited at the Royal Academy, the Royal Scottish Academy and the Glasgow Institute and was elected A.R.S.A. in 1920. He specialised in portrait busts and figures of historic and contemporary personalities.

PAULIN, Paul fl. 19th-20th centuries
Born at Chamalières, France, in the mid-19th century, he exhibited at the Paris Salons from 1882 to 1922 and was a Chevalier of the Légion d'Honneur. He specialised in busts and reliefs portraying his artistic contemporaries, including Degas, Renoir, Monet (Rodin Museum), August Comte (Panthéon) and Degas and Paul Brissard (Pau Museum).

PAULSEN, Andreas Stephan Mygind 1836-1915
Born at Hadersleben, Denmark, on December 18, 1836, he died in Copenhagen on January 18, 1915. He studied under H.V. Bissen and specialised in busts and statues of Danish contemporary personalities, in Aalborg, Copenhagen and Odense.

PAULSEN, Carl E. 1897-
Born in Tonsberg, Norway, in 1897, he studied in Copenhagen and was a pupil of R. Tegner. He also worked in Paris for some time before returning to Oslo, where he sculpted genre and portrait subjects.

PAULUS, Eugène 1876-1930
Born at Châtelet, Belgium, on July 2, 1876, he died there on July 23, 1930. He studied under J. Dillens and C. van der Stappens and specialised in historic and allegorical figures, portrait busts and monuments. He sculpted the war memorial at Châtelet.

PAUTARD, Marc fl. 19th century
Born at La Bessière, at the beginning of the 19th century, he died there in 1855. He studied under Rude and exhibited statuettes, busts and portrait reliefs at the Salon from 1848 to 1855.

PAUTROT, Ferdinand fl. 19th century
Born in Poitiers, in the early 19th century, he exhibited at the Salon from 1861 to 1870. He was an Animalier, specialising in hunting themes. His bronzes include Setter and Teal, Setter and Partridge, Spaniel and Teal, Setter and Hare, Trapped Fox, Pheasant hunted by Pointers, Dog and Rabbit by a Warren, Snipe and Thrushes, Horse and Roe-deer, Group of Teal, Silver Pheasant, Partridge with Chicks, Seated Setter and Seated Pointer. Non-hunting subjects by him include Cat and Kitten (1870) and Fighting Stags.

PAUTROT, Jules fl. 19th century
Born at Vernon, in the mid-19th century, he studied under Ferdinand Pautrot, but it is not known what their relationship was. He was an Animalier, specialising in bird subjects, such as Combat of Falcons, Struggling Falcons, Heron and Snake. He exhibited at the Salon in 1874-75 only.

PAUW, Jean Baptiste 1786-1861
Born at Termonde, Belgium, on July 31, 1786, he died there on July 9, 1861. He studied under Dubois, Godecharle and Pletinke and worked in Ghent and was professor of sculpture at the Termonde Academy in the 1820s.

PAVELESCU-DIMO, Dumitru 1870-
Born at Calafat, in Romania, in 1870, he studied in Bucharest and worked for many years in Florence. He belonged to the Naturalistic school and sculpted many monuments in Braila, Craiova and other Romanian towns. He specialised in statuettes and bas-reliefs of Romanian historical subjects.

PAVLIN, Joseph 1875-
Born at Naklo, Slovenia, on March 6, 1875, he died near Przemysl. He studied under J. Vurnik and A. Gangl at the School of Art in Botzen and produced monuments, memorials and religious figures for various towns in Galicia.

PAVLOV, Yanko fl. 20th century
Born in Bulgaria, in the early years of this century, he studied under M. Vassiliev and specialised in statuettes imbued with a somewhat whimsical realism, inspired by the example of Prince Paul Trubetzkoy.

PAVOT, Vendémiaire 1883-
Born in Valenciennes, on September 30, 1883, he was grand-nephew of the historical and portrait painter Pierre Pavot. His father wanted him to be a musician but he showed an aptitude for sculpture from a very early age and was trained at the Valenciennes School of Fine Arts at the age of twelve, under Maugendre. He served in the army at the turn of the century and after his demobilisation in 1903 he studied at the École des Beaux Arts, Paris, under Barrias and Coutan. He won the Chenavard Prize on two occasions and exhibited at the Salon from 1904 onwards, winning a third class medal in 1910 and a second class medal and a travelling scholarship in 1913.

PAZZI, Enrico 1819-1899
Born in Ravenna, on June 21, 1819, he died in Florence, on March 28, 1899. He studied at the Ravenna Academy and was a pupil of Ignazio Sarti in Bologna. He exhibited in Rome, Florence and Bologna from 1840 onwards and specialised in portrait busts. He is best known for the colossal figure of Dante in the Church of the Holy Cross, Florence, and also sculpted decoration for the Massa-Lombarda Cathedral.

PEABODY, Amelia 1890-
Born in Marblehead Neck, Texas, on July 3, 1890, she studied at the Boston School of Art and was a pupil of Charles Grafly. She was a member of the American Federation of Arts and the Professional Artists' League and sculpted portraits and genre figures.

PEABODY, Polly — see CROSBY, Caresse

PEACEY, Jessie M. Lawson 1885-
Born in Edinburgh, on February 18, 1885, she worked as a portrait and figure sculptress in New York.

PEAU, Edmond 1837-1877
Born in Le Havre, on November 20, 1837, he died in Paris on January 15, 1877. He studied under Jouffroy and exhibited at the Salon from 1864 to 1877, specialising in portraits and genre figures. His works include portraits of Bernardin de St. Pierre and St. Sebastian, Moses and various heads and studies. His genre works include Harvest Dance and Neapolitan Fisherman.

PECH, Gabriel Édouard Baptiste 1854-1930
Born in Albi, on May 21, 1854, he died at St. Loup-Cammas, on December 2, 1930. He studied under Jouffroy, Falguière and Mercié and exhibited at the Salon des Artistes Français from 1905, winning a third class (1883), second class (1890) and first class (1908) medals, silver and gold medals at the Expositions of 1889 and 1900 and the Légion d'Honneur (Chevalier, 1900 and Officier, 1920). He produced many busts and statuettes of contemporary celebrities. Albi Museum has his genre group The Last Vision.

PECHE, Alexandre Mathurin 1872-
Born in Paris, on September 23, 1872, he studied under Aimé Millet, Gauthier and Moreau-Vauthier. He exhibited figures and reliefs at the Salon des Artistes Français, getting an honourable mention in 1903 and a third class medal in 1906.

PECHER, Jules Romain 1830-1899
Born in Antwerp, in 1830, he died there on June 30, 1899. He worked as a painter and sculptor, producing busts and statuettes of historic and contemporary personalities from the field of the arts.

PÉCHINÉ, Antide Marie fl. 19th century
Born in Langres on August 19, 1855, he studied under Dumont, Bonnassieux and G. Thomas and exhibited at the Salon from 1876 and subsequently the Salon des Artistes Français, getting honourable mentions in 1887 and at the Exposition Universelle of 1889. His works include busts of historic and contemporary figures, genre statuettes, such as The Archer (Langres Museum), medallions and bas-reliefs.

PECHSTEIN, Max Hermann 1881-
Born in Zwickau, Germany, on December 31, 1881, he studied under Otto Gussmann and worked in Italy (1907) before settling in Berlin. He is best remembered as an Impressionist painter, striving to create a most imaginative style. He joined the Brücke Group founded by Kandinsky and Klee in 1906, but left in 1912. He sculpted figures and portraits in the same style.

PECION, Georges fl. 19th century
Born in Paris, he studied under Bourg and Farochon and exhibited figures at the Salon from 1869 to 1875.

PECKARY, Karl 1848-1896
Born in Vienna, on June 18, 1848, he died in Graz, on April 29, 1896. He studied in Vienna under W. Pilz and was professor of sculpture at Czernowitz and Graz.

PECOU, Jean William Henri fl. 19th century
Born in Bordeaux, in 1854, he studied under Jouffroy, Delaplanche and Falguière. He exhibited portrait busts, reliefs and medallions of his contemporaries at the Salon from 1876, getting an honourable mention in 1885 and a bronze medal at the Exposition Universelle of 1889.

PEDERSEN, Michael Hans 1882-1918
Born in Copenhagen, on September 28, 1882, he died there on November 8, 1918. He worked as a modeller at the Royal Copenhagen Porcelain factory from 1913 till his death. Various models and maquettes by him are preserved in the Sèvres Museum and the Museum of Industrial Arts in Copenhagen. No bronzes are recorded so far.

PEDERSEN-DAN, Hans Peder 1859-
Born at Itzehoe, Slesvig, on August 1, 1859, he studied in Rome from 1881 to 1886 and worked at Hvidore, near Copenhagen, specialising in allegorical figures and bas-reliefs. He sculpted the war memorial at Ruiel, near Paris, in the 1920s.

PEDUZZI, Renato fl. 19th century
Born at Ramponio d'Intelvi, Italy, in the early 19th century, he died in Milan, on July 19, 1884. He specialised in ecclesiastical decoration in Milan and the Trentino district, but also sculpted portrait busts, historic statuettes and genre groups, such as Childish Amusement. He exhibited in Milan, Naples, Turin and Rome.

PEENE, Augustin 1853-1913
Born in Bergues, France, on May 20, 1853, he died at Meudon in May 1913. He studied under Dumont and Bonnassieux and exhibited at the Salon from 1880 onwards, getting an honourable mention in 1885 and a bronze medal at the Exposition Universelle of 1889. He was a decorative sculptor, specialising in classical subjects, and also sculpted statuettes and busts of his contemporaries and classical groups, such as Cupid and Psyche.

PEET, Constant Edouard 1888-
Born at Borgerhout, Belgium, on September 24, 1888, he studied at the Antwerp Academy and specialised in portrait busts, reliefs and medallions.

PEETERS, Alphonse fl. late 19th century
Belgian sculptor of historical figures, working in Antwerp in the late 19th century. He is best remembered for the six statues of the Dukes of Brabant for Antwerp Town Hall.

PEGHOUX, Albert A.J. fl. 19th-20th centuries
Sculptor of figures and groups, working in Paris at the turn of the century. He became an Associate of the Artistes Français in 1909.

PEGRAM, A. Bertram 1873-1941
Born in 1873, he died in London on January 14, 1941. He studied at the Royal Academy schools and the École des Beaux Arts, Paris, and exhibited figures at the main London and provincial galleries at the turn of the century.

PEGRAM, Henry Alfred 1862-1937
Born in London, on July 27, 1862, he died there on March 25, 1937. He studied at the Royal Academy schools (1881-87) then worked as assistant to Sir Hamo Thornycroft (1887-91). He exhibited at the Royal Academy from 1884 and was elected A.R.A. in 1904 and R.A. in 1922. He won bronze and silver medals at the Expositions Universelles of 1889 and 1900 respectively and a gold medal in Dresden in 1897. He specialised in portrait busts and figures, mainly of classical subjects.

PEGRASSI, Salesio 1812-1879
Born in Verona on November 21, 1812, he died there on December 6, 1879. He studied in Verona and sculpted monuments and memorials in that locality. His best known works are the war memorial at Monte Berico, near Vicenza, and the monuments on the battlefields of Solferino and Magenta. His minor works include portrait busts and genre statuettes.

PEIFFER, August Joseph 1832-c.1870
Born in Paris, on December 4, 1832, he died there in about 1870. He studied under Klagmann and exhibited classical figures at the Salon from 1865 to 1879. Angoulême Museum has his marble figure of Psyche.

PEIFFER, Engelbert Joseph 1830-1896
Born in Cologne, on May 14, 1830, he died in Hamburg on October 18, 1896. He produced bronze busts and statues of historic and contemporary artistic celebrities – actors, painters and writers – and also sculpted the Hansa fountain in Hamburg. His minor works include bas-reliefs, plaquettes and medallions.

PEINTE, Henri 1845-1912
Born in Cambrai on August 24, 1845, he died in Paris in December 1912. He studied under Duret and Cavelier and exhibited at the Salon from 1877, winning third class medal and the Prix de Salon at his début, a second class medal (1887) and the Grand Prix and the Légion d'Honneur (both in 1889). He specialised in classical figures and groups, such as Orpheus putting Cerberus to Sleep (casts in the Cambrai and Luxembourg Museums).

PELGRIN, Georges Joseph fl. late 19th century
Born in Lille in the mid-19th century, he studied under Cavelier, Barrias and Coutan and exhibited figures at the Salon des Artistes Français, getting an honourable mention in 1893.

PELITTI, Francesco 1830-1907
Born in Milan in 1830, he died there in 1907. He worked as a decorative sculptor.

PELLEGRINI, Isidor, the Elder 1841-1887
Born in Stabio, Italy, in 1841, he died in Basle, Switzerland, on April 16, 1887. He studied at the Brera Academy in Milan and worked in Alsace in 1867-68, before settling in Basle, where he produced decorative sculpture.

PELLEGRINI, Isidor, the Younger 1871-
Born in Basle in 1871, the son and pupil of the above. He sculpted memorials and bas-reliefs in Switzerland at the turn of the century.

PELLETIER, Michel fl. 19th century
Portrait sculptor of the mid-19th century. Semur Museum has his busts of Rousseau and Montesquieu.

PELLICCIA, Ferdinando 1808-1892
Born in Carrara on April 24, 1808, he died there on February 13, 1892. He studied in Rome under Tenerani and became a professor at the Carrara Academy in 1835 and Director in 1846. He sculpted marble statuary and ecclesiastical friezes. His decorative work may be found in Bastia Cathedral and the Admiralty building in Sevastopol, Russia. His minor figures, including bronzes, were mostly of biblical and classical subjects, such as Calliope and The Baptism of Christ.

PELLIER, Jules fl. 19th century
Born in Paris on July 11, 1836, he specialised in figures and groups of horses.

PELLINI, Eugène 1864-
Born at Marchiloro, Italy, in 1864, he worked in Milan and specialised in tombs, memorials and bas-reliefs. He won a silver medal at the Exposition Universelle of 1900.

PELTIER, Jules C. fl. 19th century
Sculptor of portraits and figures, working in Paris in the late 19th century. He exhibited at the Salon des Artistes Français and died in 1905.

PELTIER, Thérèse fl. early 20th century
Born in Orleans, she studied under Vital-Cornu and exhibited figures at the Salon des Artistes Français from 1900 to 1911 getting an honourable mention in 1902 and becoming and Associate in 1906.

PENA, Antonio 1894-1947
Born in Montevideo, Uruguay, in 1894, he died there in 1947. He studied at the classes of the Fine Arts Circle in Montevideo and won a travelling scholarship which took him to Europe. He was a pupil of Anton Hanak in Vienna and Antoine Bourdelle in Paris. He produced numerous portrait busts, medallions, statues and monuments in Uruguay. His allegorical works include the Cordiality of the Towns of the River Plate (Buenos Aires).

PENAS, Antonio c.1810-1872
Born in Granada about 1810, he died in 1872. He worked in Seville and Las Palmas in the Canary Islands and specialised in portrait busts, plaques and medallions.

PENALBA, Alicia 1918-
Born in Buenos Aires in 1918, she studied painting and won a state scholarship which took her to Paris in 1948. She turned to sculpture and studied under Zadkine for two years and subsequently settled in Paris. She has exhibited at the Salon de la Jeune Sculpture since 1952 and more recently has taken part in the Antwerp Biennial, the Salon des Réalités Nouvelles and other exhibitions in France and abroad. She has a penchant for columnar abstracts, such as Totems (1952), Plant Liturgy (1956) and Chrysalid (1956), cast in concrete or bronze. She has had numerous individual shows at the Galerie du Dragan and the Galerie Claude-Bernard in Paris.

PENDARIES, Jules Jean L. 1862-
Born at Carmeaux, France, on March 20, 1862, he studied under A. Millet, Falguière and Mercié and exhibited at the Salon des Artistes Français from 1891 onwards, winning third class medals in 1895 and 1897 and a silver medal at the Exposition Universelle of 1900. He specialised in classical and genre figures and groups, such as The Workers in the Fields (Narbonne Museum) and The Consoling Muse (Le Mans Museum).

PENDL, Anton Johann fl. 19th century
Born in Merano, Austrian Italy, on June 24, 1828, he was the son and pupil of Johann Baptist Pendl. He studied in Munich and Paris and emigrated to the United States.

PENDL, Emanuel 1843-1926
Born in Merano on February 23, 1843, he died in Vienna in October 1926. He was the son and pupil of Franz Xaver Pendl and father of Erwin Pendl the landscape painter. He is best known for the colossal statue of Justice in Vienna and a group of three statues in the Vienna Town Hall, five allegorical figures in the parliament buildings and many monuments in Vienna. His minor works include allegorical and historical statuettes and portraits.

PENDL, Franz Xaver 1817-1896
Born in Merano on May 5, 1817, he died there on June 23, 1896. He was the son of Johann Baptist Pendl and elder brother of Anton Johann, and studied in Vienna from 1838 to 1841 under Joseph Klieber and J.N. Schnaller. Later he studied under Eberhardt and Hess in Munich and specialised in figures, groups and reliefs of religious subjects. His chief works are the Twelve Apostles (Merano) and Pietà (Capuchin Church, Merano).

PENDL, Johann Baptist 1791-1859
Born at Ried, Austria, on June 22, 1791, he died in Merano on March 14, 1859. He studied under Franz Xaver Nissl and Franz Seraph Nissl in Ried and also at the academies of Dresden and Vienna before settling in Merano in 1815. He worked on the decoration of churches there and in Innsbruck and Bolzano (Bozen).

PENGOV, Johann 1879-1932
Born at Ihan, Croatia, on June 9, 1879, he died in Ljubljana on May 31, 1932. He studied under A. Rovsek and worked as a decorative sculptor in Ljubljana. His chief work is the series of statues of saints and bishops in the Cathedral, but he also sculpted portrait busts and genre figures.

PENIC, Dujan 1890-
Born in Split in 1890, he studied under Mestrovic and worked in Rome, Vienna, New York and Paris and specialised in busts of young girls.

PENNE, Francisco 1865-
Born in Naples on April 10, 1865, he studied at the Naples Institute of Fine Arts and exhibited figures in Italy, Australia and Latin America, where he worked for some time.

PENSART, Paul 1880-1916
Born in Paris on January 25, 1880, he was killed in action during the first world war. He studied under Mathurin Moreau and Injalbert and exhibited figures at the Salon des Artistes Français, winning an honourable mention in 1905.

PENZ, Ludwig 1876-1918
Born at Schwatz, Austria, on August 13, 1876, he died there on November 4, 1918. He studied under Kobald, A. Delug (Vienna) and Rümann (Munich) and worked as a sculptor of religious figures and bas-reliefs in the Tyrol.

PENZOLDT, Ernst 1892-
Born in Erlangen, Germany, on June 14, 1892, he studied under Egger-Lienz in Weimar and Olde at Cassel and worked in Erlangen as a genre and portrait sculptor.

PENZYNA, Gustave 1882-
Born in Poland of French parents in 1882, he studied in Paris and settled in France after the first world war. He is best known as a painter, but also exhibited genre and classical statuettes at the Salon des Indépendants in the 1920s, such as The Chimerist, Painter and a group of Leda between the Swan and the Serpent.

PEPE, Lorenzo 1912-
Animalier sculptor whose bronzes include Donkey (1956).

PÉPIN, Édouard Félicien Alexis 1853-
Born in Paris in 1853, he studied under Cavelier and exhibited at the Salon from 1878, winning a second class medal in 1884 and a first class medal in 1891, as well as silver medals at the Expositions of 1889 and 1900. He specialised in religious and genre statuettes and busts and statues of his contemporaries.

PEPPERNY, Richard 1867-
Born in Prague in 1867, he worked in Bohemia as a decorative sculptor.

PERABO, Giovanni Battista 1783-1836
Born in Milan in 1783, he died there on January 11, 1836. He was employed as a decorative sculptor in Milan and produced seven statues and 44 statuettes of saints and biblical figures for the Cathedral.

PERANTINOS, Nikolaos fl. 20th century
Portrait sculptor working in Athens in the first half of this century. His best known work is the statue of Emmanuel Pappas, but he also sculpted portrait busts, reliefs and statuettes.

PERATHONER, Hans 1872-
Born in the Tyrol on November 21, 1872, he studied at the Munich Academy and settled in Charlottenburg in 1914. He is best known for the fountain of the Linen Weavers in Bielefeld, but he also sculpted many statuettes and groups with the theme of Virtue, notably those in Charlottenburg Town Hall.

PERCK, Pierre Henri van 1869-
Born in Malines, Belgium, on July 24, 1869, he studied in Malines and Antwerp under Vinçotte. He received many public commissions and sculpted various monuments, notably the Boer War memorial at Bornhem and the memorial to the Comte de Merode. His bronze group Child with a Dog is in the Malines botanic gardens and a group of Greyhounds is in the Tervueren Museum. He also sculpted portrait busts and heads in terra cotta and bronze.

PERCOPO, Federico 1860-
Born in Naples on July 4, 1860, he studied under Toma and Lista and sculpted portraits and genre figures.

PERCY, John Francis fl. 19th century
Born in Dublin in 1801, the son of the painter H.G. Percy, he studied at the Dublin Society schools from 1816 to 1820 and then emigrated to England. He exhibited at the Royal Academy from 1827 to 1839, working as a designer and modeller for the silversmiths Elkington and Company. His neo-classical figures and groups are known in silver, silver-gilt and bronze. A wax relief of Bacchus and Ariadne, modelled in 1827, is in the Bethnal Green Museum.

PERDIGON, Jesus Maria 1888-
Born in Orotava, Canary Islands, in 1888, he studied under J. Samso and E. Blay and worked in Madrid as a painter and sculptor of portraits and an art critic. Examples of his sculpture are in the museums of Madrid, Cordoba and Las Palmas.

PEREDA, Raimondo 1840-1915
Born in Lugano, Switzerland, on September 29, 1840, he died there on October 10, 1915. He studied at the Milan Academy and exhibited in Munich from 1870 to 1884 and the Paris Salon in 1879-80, as well as in Parma and Milan, the Centennial Exposition Philadelphia (1876) and the Exposition Universelle of 1889. He specialised in genre bronzes, such as The Widow (Rath Museum) and The Prisoner of Love (Lugano Museum). Examples of his work are also in the Maison des Arts, Zurich.

PEREIRA, Antonio Joaquim Gonçalves 1839-1878
Born in Lisbon on July 23, 1839, he died there on October 2, 1878.
He sculpted monuments, memorials, bas-reliefs, portraits and religious
figures in that city.

PEREIRA, Antonio José fl. 19th century
Born in Vizeu, Portugal, in 1820, he worked there as a decorative
sculptor.

PEREIRA-ARNSTEIN, Louis, Marquis de 1803-1858
Born in Vienna in 1803, he died at Altenburg on September 8, 1858.
He studied under J. Schorr von Carolsfeld and practised painting,
lithography and sculpture as side-lines to his banking and commercial
interests.

PERÉNYI, Jozsef 1873-
Born in Györsziget, Hungary, on April 28, 1873, he studied in
Budapest and Paris and worked as a decorative sculptor in Budapest.

PERERA, Gino 1872-
Born in Siena, Italy, on August 2, 1872, he studied in Rome before
emigrating to the United States, where he became a pupil of Birge
Harrisson and a member of the Salmagundi and Boston Art Clubs. He
worked in that city as a painter and sculptor.

PEREZ, Augusto 1929-
Born in Messina, Italy, in 1929, he worked in Terracina and now
teaches at the Naples Academy. He had his first one-man show in
Rome in 1955 and has since participated in leading national and
international exhibitions, in Spoleto (1957), Milan (1958) and the
Rome Quadriennial (1960). He specialises in bronze figures with a
social and political message, such as Young Girl cutting Bread, King
and Queen, Mason, and Peasant Woman with a Hen. His more recent
work shows the influence of Germaine Richier and includes Masked
Man, Survivors and Tyrannicides.

PEREZ COMENDADOR, Enrique 1900-
Born at Hervas, Spain, on November 17, 1900, he studied in Seville
under J. Bilbao and also in Madrid, where he later worked on monu-
ments and memorials to Spanish royalty. His minor works include
allegorical groups, numerous female busts and historical statuettes.

PEREZ DEL VALLE, Francisco fl. 19th century
Born at Rivadesella, near Oviedo, in the early 19th century, he died in
Madrid in 1884. He studied at the San Fernando, Madrid, in 1838-40
and was appointed Court Sculptor to Isabella II in 1843. He later
became professor of sculpture at the School of Fine Arts, Madrid. He
specialised in portraits and allegorical works and examples of his busts
and figures are in the Senate, Chamber of Deputies and Madrid
museums.

PERFILIEF, Tatiana fl. 20th century
Born in Russia in the early years of this century, she worked mainly
as a wood-engraver and illustrator of scenes from China and
South-East Asia, where she travelled extensively. She also dabbled in
bas-reliefs and figures.

PERICOLI, Giovanni Battista 1810-1884
Born in Urbino, Italy, in 1810, he died there in 1884. He worked as a
decorative sculptor and also produced religious and genre figures.

PERILLO, Luigi fl. 19th century
Born in Naples on December 22, 1820, he studied at the Institute of
Fine Arts and decorated churches and public buildings in the Naples
area.

PERL, Karl 1876-
Born in Liezen, Austria, on March 3, 1876, he studied under Hellmer,
Zumbusch and Kundmann and worked as a sculptor of figures, busts,
bas-reliefs and medallions in Vienna.

PERMEKE, Constant 1886-1952
Born in Antwerp in 1886, he died in Jabbeke, near Ostend, in 1952.
He studied at the academies of Bruges and Ghent and worked as a
painter of the Flemish Expressionist school. He turned to sculpture
relatively late in life (1936), though this was but a logical extension of
his painting, in which forms were arranged sculpturally. He began
with bas-reliefs and rapidly developed sculpture in the round,
concentrating on the human figure. His bronzes include Marie-Lou,
Niobe and The Three Graces.

PERNOT, Henri fl. early 20th century
Born in Ghent, Belgium, in the late 19th century, he moved to Paris
and became a naturalised Frenchman. He exhibited figures at the
Salon des Artistes Français, getting an honourable mention in 1897
and third and second class medals in 1904 and 1909 respectively.

PERRAUD, François fl. 19th century
Born in Nantes on March 26, 1849, he worked in Paris from 1871 to
1879 and later worked with J.B. Barre in Nantes. He produced
portraits, bas-reliefs and genre figures.

PERRAUD, Jean Joseph 1819-1876
Born at Monay, France, on April 6, 1819, he died in Paris on
November 2, 1876. He enrolled at the École des Beaux Arts, Paris, in
1843 and studied under Dumont and Ramey. He specialised in
bas-reliefs and statuary in marble and stone, but also produced several
bronze statuettes, small classical groups and portrait busts of
celebrities of the musical world.

PERRAUD-HARRY, Émile 1878-
Born in Paris on August 9, 1878, he studied under Frémiet and
exhibited animal figures and groups at the Salon des Artistes Français,
winning a third class medal and a travelling scholarship in 1905 and a
first class medal in 1929. His bronzes include Fenecs, Young
Elephant, and Great Dane.

PERRETTE, Jacques 1718-1797
Born at Chassagne, France, in 1718, he died in Besançon in 1797. He
worked as a decorative sculptor in Besançon and is best known for the
statue of Doubs on the fountain in the Rue Rouchaux and the
allegorical group of Charity at the gate of Mont de Pieté in that town.

PERREY, Aimé Napoleon 1813-1883
Born in Damblin, France, on August 15, 1813, he died at Pont de
Roide on November 23, 1883. He exhibited at the Salon from 1848
and won a medal in 1868. He specialised in bas-reliefs and figures of
saints, mainly in marble or stone, and also sculpted The Harvester,
outside Rouen Town Hall.

PERREY, Léon Auguste 1841-1900
Born in Paris on August 24, 1841, he died there on March 19, 1900.
He was the son and pupil of Aimé Napoleon Perrey and studied under
Jouffroy at the École des Beaux Arts. He exhibited at the Salon from
1865 onwards, winning medals in 1866-67. He specialised in
allegorical and classical figures and bas-reliefs, but also sculpted genre
figures and busts of his contemporaries, in marble and bronze.

PERRIN, Jacques 1847-1915
Born in Lyons on July 30, 1847, he died in Paris on October 8, 1915.
He studied under M.A. Dumont and exhibited at the Salon in 1879
and at the Salon des Artistes Français from 1883 onwards, winning
third class (1888), second class (1892) and first class (1903) medals,
as well as bronze and silver medals at the Expositions of 1889 and
1900 and the Légion d'Honneur in 1908. He received many
commissions for monuments and public statuary. His minor works
include portrait busts and statuettes.

PERRIN, Léon Charles 1886-
Born at Locle, Switzerland, on November 19, 1886, he studied in
Florence, Vienna and Paris and worked as a decorative sculptor in La
Chaux de Fonds.

PERRODIN, Antoine fl. 19th century
Parisian sculptor of figures and bas-reliefs, he became an Associate of
the Artistes Français in 1891.

PERRON, Charles Théodore 1862-
Born in Paris on October 16, 1862, he studied under Falguière, Roy
and Hiollin. He exhibited at the Salon des Artistes Français and got an
honourable mention (1896), third class (1897), second class (1899)
and first class (1910) medals, as well as an honourable mention at the
Exposition Universelle of 1900. He specialised in genre figures and
groups, in marble and bronze.

PERRON, Philipp 1840-1907
Born in Frankenthal, Bavaria, on August 2, 1840, he died at Rottach
on July 16, 1907. He studied under Max and Widnmann and worked
on the decoration of various Bavarian castles, notably Herrenchiemsee
and Neuschwanstein. He also sculpted monuments, war memorials,
bas-reliefs and portraits.

PERRON, Walther 1895-
Born at Frankenthal on September 30, 1895, he studied under F. Böhie and Johann Sailer and worked as a painter and sculptor of landscapes and genre subjects.

PERROTTE, Philippe fl. early 19th century
Born at Brain sur l'Authion in the late 19th century, he studied in Paris under Cavelier and Barrias and exhibited figures at the Salon des Artistes Français, winning a third class medal in 1902 and a second class medal in 1930.

PERRY, Emilie S. 1873-1929
Born in New Ipswich, New Hampshire, on December 18, 1873, she died in Ann Arbor, Michigan, on July 16, 1929. She was a painter and sculptor of genre subjects.

PERRY, Roland Hinton 1870-
Born in New York on January 25, 1870, he was a pupil of the Art Students' League (1885-88) and went to Paris, where he studied at the École des Beaux Arts and the Académie Julian. He was a pupil of Gérôme, Delance, Callot, Chapu and Puech at various times and specialised in portrait painting. On his return to the United States, however, he also took up sculpture as a career and produced a wide range, including portrait busts and bas-reliefs, genre figures, such as Boy with Fish, fountain figures of Neptune and statues of contemporary and historical celebrities in Harrisburg and Louisville.

PERRY, Walter Scott fl. early 20th century
Born at Stonham, Massachusetts, in the late 19th century, he worked in New York as a painter, sculptor and writer and was director of various art schools in the state of New York.

PERTOIS, Jean fl. 18th century
Alsatian sculptor of memorials, tombs and religious figures, in marble and bronze. He sculpted decoration for Strasbourg Cathedral and Montbéliard Town Hall.

PERTSCHER, Johann fl. 19th century
He studied under Franz Bauer and died in Vienna on February 19, 1872. He produced statues and busts of contemporary and historical figures, many of which are in the Army Museum, Vienna.

PERUZZI, Augusto fl. 19th century
Born in Rome in the early 19th century, he studied at the Academy of St. Luke and won the Academy Prize in 1857. He produced memorials and tombs and ecclesiastical decoration in Rome.

PERUZZI, Svitoslav 1881-
Born at Lipe, near Ljubljana, Slovenia (now Yugoslavia), on October 7, 1881, he studied at the Vienna Academy and specialised in portrait busts and figures. His chief work was the monument to Kaiser Franz Josef, erected in Ljubljana in 1903.

PESCHIERA, Ignazio 1777-1839
Born in Genoa on February 14, 1777, he died there on June 18, 1839. He studied under Nicola Traverso and Francesco Ravaschio and became a member of the Academia Ligustica in 1811. He specialised in portrait busts of historic and contemporary personalities, such as Columbus and Alfieri (Genoa Town Hall), Charles Albert and Paul Balbi (Genoa University).

PESCI, Ottilio 1877-
Born in Perugia on September 24, 1877, he studied in Paris and exhibited in Rome, New York, London and Munich as well as at the Nationale, the Salon d'Automne and the Salon des Artistes Français. He specialised in busts, heads, portrait reliefs and decorative friezes.

PESETTI, Charles Antoine fl. 19th century
Born at Lorgues, France, on December 12, 1818, he studied under his father, Sebastien Pesetti, and specialised in busts of his contemporaries. Examples of his work are in the museum of Aix.

PESETTI, Sebastien 1779-1860
Born at Aix in 1779, he died there in 1860. He studied under Chardigny and worked as a decorative sculptor in Aix and Toulon. His chief work is the fountain in the Place St. Roch, Toulon. He also produced ecclesiastical sculpture and figures of French historic personalities.

PESKETT, Eric Harry 1914-
Born in Guildford, Surrey, on January 31, 1914, he studied at the Brighton College of Art (1929-35) and the Royal College of Art (1935-39) and has exhibited at the Royal Academy and the London Group since the war. He was elected A.R.B.S. in 1948 and F.R.B.S. in 1961 and works at Whyteleafe, Surrey, as a sculptor in wood, ivory, stone and bronze.

PESNE, Alexandre Auguste fl. late 19th century
Born in Argentan in the mid-19th century, he studied under Lequien and exhibited figures and groups at the Salon in 1877.

PETER, Hermann 1871-1930
Born in Soleure, Switzerland, on August 19, 1871, he died in Lucerne in November 1930. He studied in Switzerland and France and exhibited at the Salon des Artistes Français in 1905-07 and also at the Nationale, specialising in allegorical and genre works, such as Grief, and busts of his contemporaries.

PETER, Victor 1840-1918
Born in Paris on December 20, 1840, he died there in 1918. He studied under Vital-Cornu and Devaulx and is best known as a landscape painter. He also painted portraits and sculpted busts and medallions. Most of his small bronzes, however, were of animal subjects. He began exhibiting at the Salon in 1868 and showed animal bronzes and bas-reliefs from 1873 onwards. He won second class (1898) and first class (1905) medals as well as bronze and gold medals at the Expositions of 1889 and 1900 respectively and was awarded the Légion d'Honneur in the latter year. His chef d'oeuvre was the series of nine bas-reliefs of Goat, Lion, Bull, Percheron Horse, Hind, Horse, Bitch, Nanny Goat and Bulldog shown at the Salon of 1881. Other works include Zanzibar Lion (1875), Sow, Cow, Grazing Sheep and Cockerel. Examples of his work are in the Caen Museum.

PETER-REININGHAUS, Maria 1883-
Born in Graz, Austria, on November 24, 1883, she studied in Paris at the Académies Julian and Colarossi and the École des Beaux Arts and was a pupil of Bartholomé and Rodin. She worked in Eggenburg, near Graz, as a painter and sculptor and specialised in busts, heads and portrait reliefs. She also sculpted the war memorial at Radkersburg after the first world war.

PETERICH, Paul 1864-
Born at Schwartau, Germany, on February 2, 1864, he studied at the Schools of Fine Arts in Hamburg and Berlin and the Berlin Academy and specialised in portraits and genre figures, such as Standing Boy (Berlin National Gallery).

PETERS, Carl 1822-1899
Born in Copenhagen on July 26, 1822, he died there on September 17, 1899. He studied at the Academy and was a pupil of H.V. Bissen before going to Italy (1850-52). He was professor of sculpture at Copenhagen from 1868 to 1889 and produced numerous portrait busts and statuettes of Danish artists and writers, mythological statues and groups and genre statuettes, such as Child playing with Flowers, and Dancing Flute-player.

PETERSEN, Armand 1891-
Born in Basle on November 25, 1891, he studied in Switzerland and later moved to Paris, where he exhibited animal figures and groups at the Salon d'Automne and the Tuileries. He has also taken part in international exhibitions in Europe and the United States.

PETERSEN, Hans Christian 1853-1919
Born in Vejle, Denmark, on April 7, 1853, he died in Copenhagen on July 30, 1919. He studied under V. Fjeldskov at the Technical High School and the Academy of Copenhagen and worked as a decorative sculptor, mainly in the Hall of the Knights in Frederiksborg Castle. He sculpted the statues of Alexander the Great and Julius Caesar on the bridge in front of the castle. His minor works include statuettes of historic and contemporary celebrities.

PETERSEN, Hans Gyde 1863-
Born in Vejle on November 7, 1863, he studied at the Copenhagen Academy (1882-88) and worked in Paris (1895) and Italy (1897-99). His chief work is the bronze statue of King Christian IX in Tisted market place, but he also sculpted numerous busts of his contemporaries. Casts of his group Adam and Eve are in museums in Aarhus and Copenhagen.

PETERSEN, Julius Hans Henrik Johan Frederik fl. 19th century
Born at Aarhus on February 16, 1851, he studied at the Copenhagen Academy and worked as a landscape painter and decorative sculptor.

PETERSEN, Nielsine Caroline 1851-1916
Born at Nyrup, Denmark, on July 10, 1851, she died in Hellerup on November 26, 1916. She produced allegorical and genre figures, such as Dancing Faun, Crab Fisherman, and portrait busts and statuettes of Danish royalty and contemporary celebrities. Examples of her work are in the museums of Copenhagen, Frederiksborg and Ribe.

PETERSON, George D. 1862-
Born in Wilmington, Delaware, in 1862, he studied in Paris under Bartholdi, Chapu and Falguière and sculpted monuments and memorials in the United States. His minor works include portraits and allegorical figures.

PETIT, Gaston 1890-
Born at St. Jean des Vignes, France, on October 6, 1890, he studied under Injalbert and exhibited figures at the Salon des Artistes Français, winning second class and first class medals in 1925 and 1935 respectively.

PETIT, Georges 1879-
Born in Lille of Belgian parents on March 14, 1879, he studied in Liège and Paris and spent three years in Louvain working with F. Vermeylen and later (1906-11) worked in Italy. He worked in Liège and produced many busts of his artistic contemporaries, in marble and bronze, as well as allegorical and genre groups. He sculpted a number of war memorials in Belgium in the 1920s.

PETIT, Jean Claude 1819-1903
Born in Besançon on February 9, 1819, he died in Paris on March 6, 1903. He studied under David d'Angers and attended classes at the École des Beaux Arts. He exhibited at the Salon from 1844 to 1864, being runner-up in the Prix de Rome of 1839 and winning a third class medal in 1846. He sculpted marble and stone statuary for public places in Paris, but also produced bronze busts and bas-reliefs portraying his contemporaries. He sculpted a prodigious number of statuettes and small groups, bas-reliefs, plaques and roundels, many of them maquettes for his marble statuary, and these were mostly inspired by classical mythology.

PETIT, Louis Michel 1791-1844
Born in Paris on August 29, 1791, he died there on July 19, 1844. He enrolled at the École des Beaux Arts in 1809 and was a pupil of Simon and Cartellier. He exhibited at the Salon from 1824 and produced plaques, medallions and groups of allegorical subjects, such as Faith and Hope (Temple Church). He was a member of the Consultative Committee on French Coinage.

PETIT DE CHEMELLIER, Georges fl. 19th-20th centuries
Parisian sculptor of figures and portraits. He exhibited at the Salon des Artistes Français at the turn of the century and died in 1908.

PETITOT, Louis Messidor Lebon 1794-1862
Born in Paris on June 23, 1794, he died there on June 1, 1862. He was the son and pupil of Pierre Petitot and also studied under Cartellier. He was runner-up in the Prix de Rome of 1813 and won the prize the following year. He won a first class medal at the Salon of 1819 and became a Chevalier (1828) and Officier (1860) of the Légion d'Honneur. His chief work was an equestrian bronze statue of Louis XIV, but he also sculpted numerous genre and allegorical figures and busts of French historical and contemporary celebrities.

PETITOT, Pierre 1760-1840
Born at Langres on December 11, 1760, he died in Paris on November 7, 1840. He studied under Devosges and Caffieri and won the Grand Prix of the States of Burgundy in 1787. He exhibited at the Salon from 1793 to 1817 and specialised in classical figures, such as The Death of Pindar, allegories (Genius of Victory) and busts and statuettes of Napoleonic personalities.

PETRI, Lajos 1884-
Born in Szeged, Hungary, on June 10, 1884, he studied in Budapest and was a pupil of E. Telcs. Later he worked in Brussels from 1909 but returned to Budapest on the outbreak of the first world war. He specialised in figures, busts and heads of athletes, dancers and nudes.

PETRI, Otto 1860-
Born at Niederschönhausen, near Berlin, on April 15, 1860, he studied under L. Manzel and worked as a decorative sculptor in Berlin.

PETRIDES, Janos 1861-
Born in Lemberg (now Lwow, Poland) in 1861, he studied in Vienna and worked as a decorative sculptor in various towns in Galicia.

PETROVICS, Demeter 1799-1854
Born at Baja, Hungary, on February 18, 1799, he died in Vienna on December 25, 1854. He sculpted the monument to Kisfaludy-Strobl and produced classical figures and groups, such as Venus and Cupid, and Perseus.

PETRUCCI, Mario 1893-
Born at Rhodi, Ferrara, on March 25, 1893, he studied under Bitterlich at the Vienna Academy and settled in that city, where he sculpted portrait busts, notably a series in bronze featuring Viennese composers. His chief work is the monument to F. Lassalle, the German socialist leader. He also sculpted fountains and public statuary in Vienna and Zurich.

PETRY, Heinrich 1832-1904
Born in Frankfurt-am-Main on June 10, 1832, he died there on October 3, 1904. He studied under Zwerger and E.A. Hopfgarten and specialised in portrait busts of his contemporaries, notably those of Stenle and Brentano in the Institut Städel. His chief work is the group of four statues in the doorway of Frankfurt Cathedral.

PETRY, Marguerite 1897-
Born in Mulhouse on July 28, 1897, she studied under Raoul Vernet and Bourdelle in Paris (1910-11) and works in Mulhouse on figures, portrait busts and bas-reliefs.

PETSCHKE, Hanns 1884-
Born in Bautzen, Saxony, on April 8, 1884, he studied under H. Spieler, K. Grosz and W. Kreis and specialised in portrait busts of his contemporaries and statuettes of dancers. Examples of his work are in the Bautzen Museum.

PETSCHKE, Theodor Karl Friedrich fl. 19th century
He studied at the Berlin Academy (1826-30) and was a pupil of Wichmann. He was appointed professor of the School of Fine Arts, Danzig, in 1834 and also worked in Rome (1840-43). He produced classical and allegorical figures and groups.

PETSCHNER, Friedrich 1784-1853
Born in Vienna in 1784, he died there on July 14, 1853. He worked in Vienna as a decorative sculptor and also produced portrait busts and statuettes.

PETSCHNER, Paul fl. 18th century
Born in Vienna in 1730, he studied under J.B. Mutschele and worked as a decorative sculptor in Bamberg and Nuremberg.

PETTENA, Giovanni Battista 1828-1905
Born in Moena, Italy, on January 18, 1828, he died there on June 19, 1905. He studied at the Venice Academy and was a protégé of the Archduke Maximilian, later to become the ill-fated Emperor of Mexico. He specialised in statues and bas-reliefs of religious subjects.

PETTER, Raimund 1769-1834
Born in Vienna in 1769, he died there on February 2, 1834. He worked as a decorative sculptor.

PETTER, Veit 1725-1798
Born in Vienna in 1725, he died there on June 29, 1798. He specialised in ecclesiastical figures and groups.

PETTRICH, August 1832-c.1910
Born in Rome on December 21, 1832, he died there about 1910. He worked in Rome as a sculptor of memorials and religious figures.

PETTRICH, Ferdinand Friedrich August 1798-1872
Born in Dresden on December 3, 1798, he died in Rome on February 14, 1872. He studied at the School of Fine Arts and the Academy in Dresden and worked with his father, Franz Pettrich. Later he went to Rome and worked with Thorvaldsen and in 1835 went to the United States, producing religious sculpture for churches in Washington. Subsequently he worked in Rio de Janeiro and finally settled in

Rome, where he sculpted busts and statues of contemporary celebrities. He also produced allegorical groups and various figures of Christ.

PETTRICH, Franz 1770-1844
Born at Triebnitz, Saxony, on August 29, 1770, he died in Dresden on November 23, 1844. He worked in Rome for several years under Canova and restored the statuary in the Zwinger, Dresden. He worked in Venice and Vienna and sculpted monuments of 18th century personalities, notably Casanova, and also did the statue of Mars in Vienna.

PETTRICH, Oscar 1831-1873
Born in Rome on January 8, 1831, he died there on March 2, 1873. He was the son and pupil of Ferdinand Pettrich and worked with him on religious figures and portraits in Rome.

PEVEREDA, Erminegildo 1866-1900
Born in Locarno, Switzerland, on June 8, 1866, he died there in January 1900. He specialised in genre figures and groups, such as The Kiss (Rome), and exhibited in Rome and Turin in the 1890s.

PEVSNER, Antoine 1886-1962
Born in Orel, Russia, in October 1886, he died in Paris in June 1962. He was the elder brother of Naum Gabo and studied at the Kiev School of Fine Arts (1902-09) and the St. Petersburg Academy (1910), but learned more from Byzantine icons and statuary than the stereotyped classicism taught at the Academy. He went to Paris in 1911 but returned to Russia on the outbreak of the first world war. From 1915 to 1917 he lived in Oslo with his brother and it was then that he first turned from painting to sculpture, though he did not develop this seriously until 1923. After the downfall of the monarchy in Russia they returned to Moscow and took a leading part in the avant-garde art movements during the Revolution. The Pevsner brothers produced their famous Realist Manifesto in 1920 and laid the foundations of Constructivism, which dominated Soviet art in the early 1920s. Pevsner first exhibited paintings at the Russian Art Exhibition in Berlin in 1922 and, realising that the Soviet authorities had changed their policies on art, decided not to return to Russia. Gabo reached Berlin in late 1922 and Pevsner joined him there in January 1923. He moved to Paris the following October and settled there. The following year he took up sculpture seriously and exhibited with Gabo at the Galerie Percier in 1924. Three years later he designed the Constructivist sets for Diaghilev's ballet The Cat. He had his first major one-man show at the Galerie Douin in 1947 and in the postwar years exhibited in various parts of Europe and America. He took part in the Seven Pioneers of Modern Sculpture Exhibition at Yverdon (1954) and had a retrospective exhibition at the Museum of Modern Art, Paris, in 1957. His bronzes include Projection in Space (1938-39), Construction in the Egg (1948), Dynamic Projection in the 30th Degree (1950-51), Column Symbolising Peace (1954), Twinned Column (1947) and Spectral Vision (1959).

Joray, Marcel. *Antoine Pevsner*. Peissi, Pierre, *Antoine Pevsner* (1961).

PEYNOT, Émile Edmond 1850-1932
Born at Villeneuve-sur-Yonne on November 22, 1850, he died on December 12, 1932. He studied under Jouffroy and Robinet and exhibited at the Salon from 1873 onwards, winning the Prix de Rome in 1880 and numerous medals (1883-86), as well as gold medals at the Expositions Universelles of 1889 and 1900. He became a Chevalier of the Légion d'Honneur in 1891 and an Officier in 1903. He sculpted many monuments and statues all over France. His minor works include projects for monuments, notably those honouring Claude Gellée (Nancy) and Paul Bert (Sens).

PEYRANNE, Pierre Louis 1883-
Born in Béziers, France, on August 25, 1883, he studied under Injalbert and H. Lemaire and exhibited figures at the Salon des Artistes Français, winning an honourable mention in 1909 and a first class medal in 1921.

PEYRE, Jules Constant fl. 19th century
Born at Sedan in 1811, he studied under Barye and became a porcelain modeller at Sèvres. He exhibited portrait busts in terra cotta and bronze at the Salon from 1840 to 1870.

PEYRE, Raphael Charles 1872-
Born in Paris on June 1, 1872, he studied under Falguière, Mercié and T. Barrau. He exhibited figures and portraits at the Salon des Artistes Français at the turn of the century, winning an honourable mention in 1894, a third class medal in 1902 and a second class medal and a travelling scholarship the following year.

PEYRISSAC, Jean 1895-
Born in Cahors in 1895, he studied medicine in Paris and served in the French army during the first world war. He settled in Algiers in 1920 and turned to sculpture, experimenting with wrought iron, wood and rope to produce abstract constructions. He visited Paris on several occasions and also spent some time at the Bauhaus in Dessau, where he was influenced by Klee and Kandinsky. For much of the interwar period he concentrated on painting but from 1934 onwards he turned increasingly towards sculpture. After the second world war he abandoned his earlier constructions and produced abstracts wholly in metal. He left Algiers in 1957 and now lives in Paris. His works include Plastic Machines, Static Equilibrium and Dances.

PEYROL, François Auguste Hippolyte 1856-1929
Born in Paris on June 10, 1856, he died at Neuilly-sur-Seine on December 24, 1929. He married Juliette Bonheur, sister of Isidore and Rosa Bonheur, and cast their animal bronzes for them. He, himself, was an Animalier sculptor, specialising in domestic animals.

PEYRONNEL, Jean fl. 19th century
Born at Sauges, France, in 1850, he specialised in allegorical statuettes, such as Hope (Puy Museum).

PEYRONNET, Émile 1872-
Born in Rougnac, France, on June 14, 1872, he studied in Paris under Thomas and exhibited figures and reliefs at the Salon des Artistes Français from 1898 to 1938, getting an honourable mention at his début and winning third class (1906) and second class (1908) medals. He received the Légion d'Honneur in 1931.

PEZIEUX, Jean Alexandre 1850-1898
Born in Lyons on June 17, 1850 he died in Épinay in September 1898. He studied under Jouffroy, Fabisch, Tony Noel and attended classes at the École des Beaux Arts. He exhibited at the Salon of 1877 only. He specialised in classical and genre figures and groups, including Martyr (Rouen Museum), Daphnis (Sens), Oh Youth! (Musée Galliera, Paris) and Non omnes moriemur (Square Parmentier, Paris).

PEZOLD, Georg 1865-
Born in Mittweida, Germany, on May 5, 1865, he studied at the Munich School of Fine Arts (1884-87) and the Academy (1887-93) and worked with Eberle and Thiersch. He worked as a decorative sculptor in Munich and sculpted a number of war memorials in the 1920s.

PEZZOLI, Francesco fl. 19th century
Milanese sculptor of portraits and genre figures, exhibiting from 1883 onwards.

PFANNSCHMIDT, Carl Gottfried 1819-1887
Born at Mühlhausen in Thuringia, on September 15, 1819, he died in Berlin on July 5, 1887. He studied at the Berlin Academy and was a pupil of Daege (1835-41). Then he went to Munich for a year before settling in Berlin where he worked with Cornelius. He was appointed professor of sculpture at the Berlin Academy in 1863 and was a member of the Berlin, Munich and Dresden Academies. He was awarded a medal at the Berlin Exhibition of 1884. He worked as a painter and sculptor of historical subjects.

PFANNSCHMIDT, Friedrich Johann 1864-1914
Born in Berlin on May 19, 1864, the son of Carl Pfannschmidt, he was killed in the battle of Châlons on September 7, 1914. He studied under his father in Berlin and was a pupil of Schilling in Dresden. He produced historical and allegorical figures and reliefs and sculpted a number of monuments, notably that to Kaiser Wilhelm I at Wesel.

PFEIFER, Ernst 1862-
Born at Bibra, Germany, on February 15, 1862, he studied under C. Lessing and W. von Rümann and worked as a decorative sculptor in Munich. He sculpted fountains and monuments in Altenburg, Aschaffenburg and Munich, notably the decoration on the Prince Regent Bridge in the last-named.

PFEIFER, Felix Georg 1871-
Born in Leipzig on November 9, 1871, he studied at the Academies of Leipzig (1893-94) and Berlin (1894-95) and was a pupil of Breuer and Herter. He spent a year in Rome and then worked in Paris for some time, before going to Dresden in 1906 and on to Leipzig in 1911. He specialised in busts of musicians and composers, and sculpted several tombs. His minor works include numerous small genre bronzes, represented in the museums of Leipzig, Dresden and Hanover. His bronzes include First Love, The Kiss and Twilight.

PFLUGER, Joseph 1819-1894
Born in Soleure, Switzerland, on May 19, 1819, he died there on January 12, 1894. He studied under Knabl and specialised in portrait busts, twenty of them being preserved in the Casino at Baden-Baden. His daughter Hedwige (born 1848) was also a sculptor.

PFRETZSCHNER, Norbert 1850-1927
Born at Kufstein, Austria, on September 1, 1850, he died at Lana on December 27, 1927. He was the grandson of the painter Johann Pfretzschner and studied under Hellmer and Manzel in Vienna. He produced a number of monuments and war memorials for various towns in Austria and southern Germany. His minor works, in wood, stone and bronze, include numerous portrait busts of his contemporaries and European historical personalities.

PFUHL, Johannes 1846-1914
Born in Löwenberg, Silesia, on February 20, 1846, he died in Baden-Baden in May, 1914. He studied at the Berlin Academy and was a pupil of H. Schievelbein. He was influenced by Schadow and went to Italy in 1878 to pursue his classical studies. He later produced many classical and allegorical groups, statues of German royalty and outstanding figures in the world of science. He also sculpted figures of generals and military heroes in many parts of Germany in the late 19th century.

PHILIP, John Birnie 1824-1875
Born in London, on November 23, 1824, he died there on March 2, 1875. He studied under John Rogers Herbert and worked in Rome in 1848-49. He is best known for the statues and bas-reliefs on the Albert Memorial, notably the allegories of Geology and Geometry, but he also sculpted a series of eight statues for the Royal Gallery in Westminster Palace and the statues of famous artistes for the façade of the Royal Academy.

PHILIPP, Istvan 1870-
Born at Wag-Bistritz, Hungary, in 1870, he worked in Budapest as a sculptor of busts, heads, bas-reliefs, plaques and medallions.

PHILIPP, Karl 1872-
Born in Vienna on October 26, 1872, he studied at the Academy and specialised in busts, plaques and medallions portraying famous Austrians. He sculpted the monument to Adalbert Stifter.

PHILLIPS, Helen 1913-
Born in Fresno, California, in 1913, she studied sculpture at the California School of Fine Arts under Ralph Stackpole (1931-36), then worked in Paris (1936-39), London (1939-40) and New York (1940-50) before settling in Paris, where she has taken part in the Salon de Mai and the Salon de la Jeune Sculpture. She married the English painter S.W. Hayter. She had her first individual show at the Libraire La Hune, Paris in 1954 and collaborated with Chelimsky, Levée and Cousins in the Quatre Artistes Americains de Paris exhibition at the American Cultural Centre in Paris in 1958. She won the French prize for her entry in the competition of 1952 for the monument To the Unknown Political Prisoner and produces figurative sculpture in wood, stone, clay and bronze.

PHILPOT, Glyn Warren 1884-1937
Born in London on October 5, 1884, he died in London on December 16, 1937. He studied at the Lambeth School of Art from 1900 and attended classes under J.P. Laurens at the Académie Julian in 1905. He exhibited paintings and sculpture at the Royal Academy from

1904 and had his first one-man show at the Baillie Gallery in 1910. He was elected ARA in 1915 and RA in 1923. He worked from time to time in Spain and France and exhibited at the Venice Biennale of 1930. As a sculptor he produced portraits and figures and experimented with unusual techniques in interpretation.

PHITALIS, Giorgios fl. 20th century
Sculptor of portraits and genre figures, working in Athens. His works include busts and statues of historic and contemporary Greek personalities, such as Patriarch Gregory V, and genre figures of shepherds and Greek peasants.

PHYFFERS, Theodore fl. 19th century
Born in Louvain, Belgium, in the early 19th century, he studied under Karl Geert and worked in London from 1850 to 1864. He was employed on the decorative sculpture at the Great Exhibition of 1851 and sculpted many figures and groups of religious subjects, some of which are in Canterbury Cathedral.

PHYSICK Family fl. 19th century
Group of sculptors working in London in the 19th century, producing bas-reliefs, statuary and small figures. They included Charles (fl. 1832-34), Edward (c.1810-1842), Edward Gustavus (c.1822-1871), Edward James (c.1848-1863), Edward William (c.1836-1871) and Edward Robert (c.1836-1880).

PIAZZA CRARARA, A. fl. 19th century
Italian portrait sculptor of the mid-19th century. A marble bust by him of Jacques M. Delpech, professor of Montpellier Medical Academy, is in the Montpellier Museum.

PIBWORTH, Charles James 1878-1958
Born in Bristol on January 23, 1878, he died in London on November 8, 1958. He studied at the Bristol School of Art and the Royal College of Art, under Lanteri, and the Royal Academy schools. He was elected F.R.B.S. in 1907 and exhibited at the Royal Academy and the Paris Salon as well as provincial galleries in Britain. He worked as an oil painter, watercolourist and sculptor of figures and portraits in marble, stone, bronze and silver. His bronzes include Atalanta tying her Sandal, Euterpe and a bust of Beethoven.

PICASSO, Pablo 1881-1973
Born in Malaga, Spain, on October 25, 1881, he died in Mougins, near Cannes, on April 8, 1973. His father was a professor at the Barcelona Academy and under him Picasso had his earliest training as a painter. After many visits to Paris he settled there in 1903 and became one of the leading artists of the Post-Impressionist school, later evolving Cubism (1906-10) with Braque. Picasso's contribution was the use of collage in a three-dimensional form, and from this he progressed to sculpture. His earliest sculptures were executed about 1905 when he first began to appreciate primitive, and in particular, Negro art. He then produced figures, heads and reliefs which took up the classic themes of the Cubist painters. His bronzes of this early period include Buffoon (1905), Guitar (1912), Violin (1913), Absinthe Glass (1914), Guitar and Bottle (1914) and Mandoline (1914). In 1928 he became interested in wrought iron, influenced by Gargallo and Gonzalez, who helped him master this technique. He executed a series of constructions in this medium, but then reverted to more figurative forms, carved from cylindrical pieces of wood and then cast in bronze. During the second world war, he experimented with ready-made objects which he transformed into sculpture by giving them a new meaning; the classic example is the bicycle seat and handlebars which became a bull's head. In 1944 he sculpted Man with Goat, which now stands in the village square in Vallauris. Later works include Woman Reading, Monkey, Crane, Owl, She-goat and Diving Girl. For several years after 1947 he concentrated on ceramics at his studio in Vallauris, but returned to bronze with Woman Diving (1957) and Bather (1958). Goat's Head and Bottle (1951-52) were executed in bronze which he later painted. Picasso, though best known as a painter, also worked as an etcher, ceramicist, book illustrator, portraitist and stage designer - truly one of the greatest and most manifold talents of this century.

Barr, A. Picasso: Forty Years of his Art (1939). Cassou, J. Picasso (1940). Cocteau, Jean Picasso (1923). Penrose, Roland The Sculpture of Picasso (1967). Raynal, M. Picasso (1922). Salmon, A. L'Art Vivant (1920), Picasso (1920). Stein, Gertrude Picasso (1939).

PICAUD, Charles Louis fl. 19th-20th centuries
Born in Lyons in the second half of the 19th century, he studied under A. Miller and Crauk and exhibited at the Salon des Artistes Français, winning third class (1899) and first class (1910) medals as well as a bronze medal at the Exposition Universelle of 1900. He specialised in allegorical and genre works, which include The Wave (St. Etienne), The Poor (Roanne Museum), and various monuments, medallions and bas-reliefs in the Roanne area.

PICAULT, Émile Louis fl. 19th-20th centuries
Born in Paris about 1840, he studied under Royer and exhibited medallions and statuettes at the Paris Salons from 1863 to 1909. His bronzes include Archer and 14th Century Scholar.

PICCHI fl. early 19th century
Italian sculptor working in the 1830s. He produced portrait busts, statuettes and equestrian figures. His best known work is the statue of General Comte Le Marois at Bricquebec, France.

PICCIRILLI, Attilio 1866-
Born at Massa, Italy, in 1866, he studied at the Academy of St. Luke, Rome, and worked as a decorative sculptor in Rome and Paris at the turn of the century. His figures and bas-reliefs were mostly carved in marble or wood, but he also cast figures in plaster and bronze.

PICCIRILLI, Furio 1870-
Born at Massa, Italy, the younger brother of Attilio Piccirilli, he studied at the Academy of St. Luke and worked in Rome as a sculptor of monuments and memorials, mostly in marble. His bronze statuettes are of classical figures, such as Narcissus.

PICCIRILLI, Horace 1872-
Born at Massa, Italy, in 1872, he emigrated to the United States and studied in New York under Roiné. He produced portraits and human and animal figures, in marble, stone, majolica, bronzed plaster and bronze.

PICHERY, Albert 1908-
Born in Paris on January 13, 1908, he worked as a painter and sculptor of nude figures and exhibited at the Tuileries (1938-), the Salon d'Hiver (1943) and the Salon des Indépendants since 1945.

PICKERY, Gustave Marie François 1862-1921,
Born in Bruges, Belgium, on August 9, 1862, he died there on February 28, 1921. He specialised in portrait busts of Belgian royalty and his contemporaries and exhibited in Brussels and Paris, getting an honourable mention at the Salon of 1888.

PIÉ, Jean 1890-
Born at Vilabella, Spain, on June 11, 1890, he studied under Llimana at the Barcelona School of Fine Arts and worked in Paris from 1910 onwards. He works mainly in wood, but also produced numerous small bronzes and minor bijouterie, and became an Associate of the Salon d'Automne in 1920.

PIERART, Jean 1865-
Born near Avesnes, France, on August 11, 1865, he exhibited figures at the Salon des Artistes Français from 1902 to 1907.

PIERCE, Norman F. 1915-
Born in Lewisham, near London, in 1915, he studied at Reading University School of Art (1931-35) and the Royal College of Art (1935-38) and has exhibited at the Royal Academy and the Paris Salons. He is a member of the Society of Portrait Sculptors and lives in Winchester.

PIEROTTI, Francesco fl. 19th century
Born in the early 19th century, he died in Florence in 1850. He worked with his brothers Giuseppe and Pietro as a decorative sculptor and all three exhibited figures and bas-reliefs in Florence, Turin and Milan in the mid-19th century.

PIERRE, Louis fl. 19th century
Born in Paris about 1850, he died there in April, 1900. He studied under Granet and exhibited figures at the Salon from 1878 till his death.

PIETSCH, Jost 1896-
Born in Gablonz (Jablonec, Czechoslovakia), on December 12, 1896, he studied at the Academies of Prague and Dresden and specialised in figures. His Seated Woman is in the Prague Modern Gallery.

PIETTE, Olivier Maurice 1885-
Born in Ghent on December 25, 1885, he studied under J. van Biesbroeck, Devin and Metdepenninghen and worked with Vinçotte on the Congo Monument in Brussels. He sculpted historical and allegorical figures and examples of his work are in the Ostend Museum.

PIETZ, Adam 1873-
Born in Offenbach, Germany, on July 19, 1873, he studied in Germany before emigrating to the United States in 1899. He continued his studies at the Pennsylvania Academy of Fine Arts and the Art Institute of Chicago. He specialised in bronze portrait reliefs and medallions of contemporary celebrities.

PIFFARD, Jeanne 1892-
Born in Paris in 1892, she studied at the Académies Julian and de la Grande Chaumière and was a pupil of Navelier. She exhibited at the Nationale, the Salon des Artistes Français (honourable mention, 1913), and the Salon des Tuilieries (1938-40) and won a Grand Prix at the Exposition Internationale in 1937. She specialised in biblical and classical figures, but she also sculpted bird figures and groups and busts of her artistic contemporaries.

PIFFARETTI, Luigi fl. 19th century
The nephew of Vincenzo Vela, with whom he worked for several years in Switzerland.

PIFFRADER, Hans 1888-
Born in Klausen, Austria, on August 6, 1888, he was the nephew and pupil of Joseph Piffrader and also studied at the Vienna Academy under Hermann Klotz. He worked in Bozen (Bolzano) and also sculpted memorials and decorative sculpture in the Innsbruck and Gelsenkirchen districts.

PIFFRADER, Joseph 'Sepp' 1882-
Born in Klausen, Austria, on September 17, 1882, he studied under Hermann Klotz in Vienna and sculpted many monuments to famous people and war memorials all over Austria. His minor works include numerous portrait busts.

PIGALIO, Alexis Baptistin 1860-1895
Born in Marseilles in 1860, he died there on December 12, 1895. He studied under Falguière and specialised in allegorical figures and bas-reliefs, such as In the Name of the Father (Marseilles Museum).

PIGALLE, Jean Baptiste 1714-1785
Born in Paris on January 26, 1714, he died there on August 21, 1785. He was the fourth son of Jean Pigalle, the royal cabinet-maker, and was apprenticed to Robert le Lorrain and later worked with Lemoyne. He attended the Academy School in 1741 and won a third class medal but never quite lived up to his early promise. He failed to win the Prix de Rome, but undeterred, he set off on foot for Italy He incurred a serious illness on the way and almost died, but for the intervention of Guillaume Coustou the Younger. He had a hard struggle to make ends meet and went to Lyons and then back to Paris in 1744. He began exhibiting at the Salon that year, producing biblical and classical figures and groups, mainly in marble and plaster, though also including several in lead or bronze. His later works were mostly portrait busts and statues, in plaster, marble, terra cotta and lead. The turning point in his career came when he won the patronage of La Pompadour and as a result he obtained many important commissions. He became an associate professor (1751), professor (1752), associate rector (1770), rector (1777) and chancellor (1885) of the Academy and was awarded the Order of St. Michel.

PIGALLE, Jean Marie 1792-1857
Born in Paris on May 19, 1792, he died there in 1857. He was a pupil of Lemot and studied at the École des Beaux Arts. He exhibited at the Salon from 1814 to 1850, winning a first class medal in 1850. He specialised in bronze figures of literary personalities, such as Corneille, Racine, Molière, Pascal and La Fontaine.

PIGALLE, Jean Pierre 1734-1796
Born in Paris on December 4, 1734, he died there on January 4, 1796. He was the son of the painter Pigalle and a pupil of his uncle Jean Baptiste Pigalle at the Académie Royale. In 1751 he went to Italy and became a member of the Florence Academy. He later worked with his uncle on statuary and decorative sculpture in Paris. He also sculpted a number of memorials and monuments in his own right.

PIGNOL, Valentin 1865-1912
Born at Roquevaire, France, on November 20, 1865, he died in Marseilles on January 7, 1912. He studied under Cavelier and Lanson and exhibited bas-reliefs and genre groups at the Salon des Artistes Français, getting an honourable mention in 1903. His relief At the Piano is in the Marseilles Museum.

PILARTZ, Theodor Caspar 1887-
Born in Cologne in 1887, he worked in Darmstadt and Berlin as a decorative sculptor. His minor figures and bas-reliéfs are in the Wallraf-Richartz Museum, Cologne, and the Munich Kunsthalle.

PILET, Léon fl. 19th-20th centuries
Born in Paris in the first half of the 19th century, he died there in 1916. He studied under A. Toussaint and exhibited at the Salon from 1861 to 1914, winning honourable mentions in 1882-83, a third class medal in 1888 and a bronze medal at the Exposition Universelle of 1889. He specialised in busts of his contemporaries and genre groups, such as Slave for Sale (Niort).

PILLARS, Charles Adrian 1870-1920
Born at Rantoul, Illinois, in 1870, he died in Jacksonville, Florida, in 1920. He studied at the Art Institute of Chicago and became assistant to Lorado Taft, before settling in Jacksonville. He sculpted a number of monuments, notably the Dillon memorial in Jacksonville, and the bronze doors of the Leland Stanford Museum in California.

PILLET, Charles Philippe Germain Aristide 1869-
Born in Paris on July 20, 1869, he studied under Chapu and Chaplain and won the Prix de Rome in 1890. He exhibited portraits and figures at the Salon des Artistes Français, winning third class (1895), second class (1896) and first class (1905) medals, as well as a silver medal at the Exposition of 1900 and the medal of honour in 1923. He was made a Chevalier of the Légion d'Honneur in 1911.

PILLET, Edgar 1912-
Born at St. Christoly de Medoc, France, in 1912, he studied at the Schools of Fine Arts in Bordeaux and Paris and won a travelling scholarship in 1936. He won the Abd El Tif prize in 1938 and since the war has exhibited at the Salon de Mai and also in Belgium and Denmark. He has worked as a painter, abstract sculptor and film producer.

PILLHOFER, Josef 1921-
Born in Vienna in 1921, he studied at the School of Arts and Crafts in Graz and then, in 1947, attended classes at the Vienna Academy, where he was a pupil of Wotruba. He studied in Paris (1950-51) and met Brancusi, Laurens and Giacometti and from then until 1954 he was Wotruba's assistant. He has taught at the Vienna Academy since 1954. He has taken part in exhibitions in Vienna, Paris, Venice, Rome, Arnhem and Middelheim since 1951 and had a retrospective exhibition at the Santee Landwar Gallery in Amsterdam in 1959. He soon turned from his early abstract work to more figurative sculpture, though the influence of Brancusi can still be discerned in such bronzes as The Roof of the World (1958).

PILS, Ernest 1825-1871
Decorative sculptor working in Paris.

PILS, Paul 1883-1915
Born in Görlitz, Silesia, on November 4, 1883, he was killed in action on the Russian front on August 22, 1915. He studied at the Breslau and Dresden Academies and specialised in heads and busts. Examples of his work are in the Leipzig Museum.

PILZ, Otto 1876-
Born in Sonneberg, Thuringia, on April 30, 1876, he studied at the School of Decorative Arts in Dresden and the Berlin Academy. He specialised in animal figures, mainly for fountains and public parks. His Leopard is in the Leipzig Museum.

PILZ, Vincenz 1816-1896
Born at Warnsdorf, Austria, on November 14, 1816, he died in Vienna on April 26, 1896. He studied at the Vienna Academy and was a pupil of Bauer and J. Kässmann. He worked in Vienna as a decorative sculptor, notably on the Ring.

PIMENOFF, Nicolai Stepanovich 1812-1864
Born in Russia, on November 24, 1812, he died in St. Petersburg on December 5, 1864. He was the son and pupil of Stepan Pimenoff and specialised in religious and genre figures. His chief work was a monument to Tsar Nicholas I.

PIMENOFF, Stepan Stepanovich 1784-1833
Born in St. Petersburg, in 1784, he died there on March 22, 1833. He studied at the St. Petersburg Academy and did many statues in and around Leningrad.

PIMIENTA, François 1888-
Born in Paris, on August 1, 1888, he specialised in bronze statuettes of women. He took part in the exhibition of Mâitres de l'Art Indépendant at the Petit Palais in 1937. Examples of his dancers and nudes are in the Louvre, and the museums of Agen and Grenoble.

PINA, Alfredo 1883-
Born in Milan, on November 13, 1883, he studied at the Academia Brera and was a pupil of Rodin in Paris. He exhibited at the Salon des Artistes Français (Associate, 1911), the Salon d'Automne (1911), the Indépendants (1920) and the Tuileries. He specialised in portrait busts of European artistic and musical celebrities.

PINAZO, MARTINEZ, Ignacio c.1880-
Born in Valencia, about 1880, he worked in Madrid and sculpted monuments, statues and busts of Spanish royalty, nobility and contemporary celebrities.

PINCHES, John Robert 1885-
Born in London, on May 5, 1885, he studied at the Slade School of Art and the École des Beaux Arts, Paris, and worked as a landscape painter, medallist and portrait sculptor. He has exhibited at the Royal Academy and leading British galleries in London and the provinces. He was a director of John Pinches Ltd., medallists and engravers in London for more than a century, and recently renamed as the Franklin Mint's subsidiary in England.

PINGEL, Gustav Frederik Claudius 1849-1891
Born in Copenhagen, on October 6, 1849, he died insane in Caen on April 12, 1891. He studied at the Copenhagen Academy and exhibited figures in Copenhagen and Paris between 1872 and 1880.

PINGRET, Joseph Arnold 1798-1862
Born in Brussels in 1798, he died there on January 23, 1862. He studied under Bosio and Lenglet and was a member of the Institut and the Société des Beaux Arts. He exhibited figures and portraits at the Salon from 1821 to 1855.

PINKER, Henry Richard Hope 1849-1927
Born in London in 1849, he died there in December, 1927. He studied in London and Rome and produced a number of busts and statuettes portraying his contemporaries. Examples of his bronzes are in the National Portrait Gallery, London, and the Ashmolean Museum, Oxford.

PINTO, Antonio Alves fl. 19th-20th centuries
Born in Oporto, Portugal, in the mid-19th century, he studied under Antonio Soares dos Reis and worked as a decorative sculptor at the turn of the century. He won a silver medal at the Exposition Universelle of 1900 for his work on the Portuguese pavilion.

PINTO, Marie Thérèse 1910-
Born in Santiago, Chile, in 1910, of mixed Chilean and English parentage, she studied in Germany and Italy and settled in Paris, where she trained under Brancusi and Laurens. She was in Mexico when the second world war broke out and she stayed there for the duration of the war. She returned to Paris in 1945 and began exhibiting in 1950. Her figures have a Surrealist quality without, however, losing sight of their human derivation. She works in both stone and bronze.

PIOCHE, Charles Augustin 1762-1839
Born in Metz, on September 2, 1762, he died there on February 15, 1839. He was the son and pupil of Jean Baptiste Pioche and later went to Paris, where he studied at the old Académie Royale and was a pupil of Bridan. He won the Grand Prix for sculpture in 1789. He returned to Metz in 1794 and founded the School of Design there. He produced a large number of busts, bas-reliefs and statuettes, though his work deteriorated latterly as he became prematurely senile.

PIOCHE, Jean Baptiste fl. 18th century
He studied at the Academy of St. Luke in 1757 and worked in Metz as a decorative sculptor.

PIOCHE, Nicolas 1729-1764
Sculptor of small ornaments, figures and bas-reliefs, working in Paris.

PIPER, Carl fl. 19th century
Born in Stettin, Prussia (now Poland), on April 17, 1856, he studied under F. Schneider in Leipzig and also worked in Berlin and Rome. He worked as a decorative sculptor and is best known for the figures and reliefs on the Frederick and Moabit bridges in Berlin.

PIQUEMAL, François Alphonse fl. early 20th century
Born in Bordeaux, in the late 19th century, he studied under Cavelier and exhibited figures at the Salon des Artistes Français, becoming an Associate in 1904 and getting an honourable mention in 1909.

PIQUER Y DUART, José 1806-1871
Born in Valencia, on August 19, 1806, he died in Madrid on August 26, 1871. He was the son of José Piquer, an ecclesiastical sculptor working in the late 18th century. He specialised in figures and relief portraits of saints and Spanish royalty, in marble and bronze. Examples of his work are in the Madrid Gallery of Modern Art.

PIRCHSTALLER, Jakob 1755-1824
Born at Trens, near Sterzing, Tyrol, on July 3, 1755, he died at Merano on February 14, 1824. He studied under J. Gratl in Innsbruck and also at the Vienna Academy and specialised in ecclesiastical sculpture in the Tyrol. His secular work includes many relief portraits of contemporary figures.

PIRON, Eugène Désiré 1875-1928
Born in Dijon, in 1875, he committed suicide at Aix-en-Provence in November 1928. He studied under Barrias and Coutan and exhibited figures and portraits at the Salon des Artistes Français, winning the Prix de Rome in 1903 and a second class medal in 1907.

PISCHELT, Ferdinand 1811-1852
Born at Grafenstein, Austria, in 1811, he died in Prague on November 24, 1852. He studied under Wenzel Prachner in Prague, whose municipal museum has the main collection of his sculptures.

PISKORZ, Anton 1811-1856
Born in Moravia in 1811, he died at Mährisch-Weisskirchen on May 20, 1856. He studied at the Vienna Academy and worked as a decorative sculptor in Moravia.

PISTRUCCI, Benedetto 1784-1855
Born in Rome, on May 29, 1784, he died at Englefield Green, near Windsor, on September 16, 1855. He settled in London in 1815 and was employed as a designer and engraver of dies at the Royal Mint (1816-25). As such he was responsible for the modelling of the St. George and Dragon motif for the reverse of the crown and sovereign gold coins. He modelled figures and profiles in wax and also sculpted busts of his contemporaries.

PISTRUCCI, Camillo 1811-1854
Born in Rome on April 13, 1811, the son of Benedetto Pistrucci, he died there on August 27, 1854. He studied under his father and Thorwaldsen and specialised in tombs and ecclesiastical sculpture in Rome.

PIWOWARSKI, fl. 20th century
Polish sculptor of portraits and genre figures, working in Warsaw. His best known work is The Little Soldier.

PLACZEK, Otto 1884-
Born in Berlin on January 25, 1884, he studied at the Academy and specialised in statues, memorials and fountain figures.

PLANES PENALVER, José 1893-
Born in Espinardo, Spain, on December 23, 1893, he worked in Madrid as a designer and architectural sculptor.

PLANQUETTE, Albert 1894-
Born in Montrouge, France, on November 2, 1894, he exhibited figures at the Salon des Artistes Français from 1922 onwards.

PLATTNER, Christian 1869-1921
Born at Imst, Tyrol, on March 2, 1869, he died in Innsbruck on January 1, 1921. He studied under Hellmer and Zumbusch and produced numerous memorials and statues in the Tyrol.

PLÉ, Henri Honoré 1853-1922
Born in Paris on March 8, 1853, he died there on January 31, 1922. He studied under Gérault and Mathurin Moreau and worked as a painter and sculptor of portraits and bas-reliefs, mainly in stone. He exhibited figures and projects for memorials at the Salon from 1877, winning honourable mentions in 1879 and 1889, and third and second class medals in 1880 and 1898 respectively. He also received a bronze medal at the Exposition Universelle of 1900.

PLECNIK, Josef 1872-
Born in Ljubljana on January 23, 1872, he studied under Otto Wagner and became professor at the Ljubljana School of Art. He sculpted ornament for churches in Czechoslovakia, Slovenia and Croatia.

PLESSIS, Félix Auguste 1869-
Born in Paris on January 18, 1869, he studied under Barrias and Puech and exhibited figures at the Salon des Artistes Français, getting an honourable mention in 1900.

PLESSNER, Jakob 1871-
Born in Berlin on August 18, 1871, he studied under Janensch, Herter and Breuer. He specialised in busts and heads portraying Jewish celebrities, and also sculpted fountains and memorials.

PLESZKOVSKY, Anton (Antoine) 1859-1889
Born in Cracow in 1859, he died in Merano in January, 1889. He studied under Zumbusch in Vienna and specialised in genre and allegorical figures, such as Blind and Sadness.

PLETINCKX, Daniel fl. early 19th century
A pupil of Godecharle, he worked in Brussels in the early 19th century, and exhibited figures and portraits there in 1811-16.

PLISSON, Henry 1908-
Born in Paris on September 20, 1908, he studied under Lucien Simon at the École des Beaux Arts. He worked as a painter, designer and potter as well as a sculptor of military and genre figures. He exhibited at the Salon des Indépendants and the Salon d'Automne from 1932 onwards.

PLISSONIER, Julien fl. 19th century
Born in Louhans, France, in the first half of the 19th century, he studied in Paris under Pernez and Jouffroy and exhibited at the Salon from 1864 to 1874. He specialised in portrait reliefs and busts, in marble and bronze.

PLOCK, Christian fl. 19th century
Born at Aalen in the early years of the 19th century, he died there in 1882. He studied in Rome in 1842-43 and worked in various parts of Germany as a decorative sculptor.

PLOCSROSS, Ingeborg (Madame Irminger) 1872-
Born in Copenhagen on June 18, 1872, she studied at the Academy and married the painter Victor Irminger. She specialised in figures of children and busts of Danish artists.

PLOJOUX, John 1866-
Born in Tannay, France, on October 28, 1866, he studied under Salmson and won the Prize of the Société Nationale des Beaux Arts in 1894 with his bronze group The Age of Stone.

PLOMDEUR, Simone 1897-
Born in Liège on May 31, 1897, she studied under Adriaan de Witte, Joseph Rulot and O. Berchmans in Liège and H.L. Bouchard in Paris. She produced figures and groups, statues, tombs and memorials.

PLOQUIN, Jean 1860-
Born in Lyons on October 22, 1860, he studied under Thomas and Fabisch and exhibited figures and groups at the Salon des Artistes Français, getting an honourable mention in 1897.

PLYN, Charles de fl. 19th century
Decorative sculptor working in Antwerp in the mid-19th century, notably on the Antwerp Town Hall.

PLYN, Eugène de fl. late 19th century
He sculpted the figure of Justice in Antwerp Town Hall.

POBJOY, Derek Charles 1933-
Born in Cheam, Surrey, on June 26, 1933, the son of Ernest Pobjoy, he studied at the Central School of Arts and Crafts under Hughes and joined the family firm in 1949, working as a modeller and designer of sculptural jewellery, figurines, plaquettes, bas-reliefs and medallions, in plaster, bronze, brass, stainless steel and precious metals.

POBJOY, Edwin Charles 1876-1959
Born in London in September 1876, he died in Essex in March 1959. He was apprenticed to a plasterer and stuccator and worked as a decorative sculptor on houses and public buildings in the London area, notably Somerset House. For several years he worked in South Africa and Canada at the turn of the century, and this is reflected in his figures and bas-reliefs of native genre and wildlife subjects. His minor works include bijouterie cast in gold and silver as well as bronze.

POBJOY, Ernest 1905-
Born in London in April, 1905, the son of Edwin Charles Pobjoy, he studied at the Central School of Arts and Crafts and worked for Joseph and Peirce, learning the techniques of manufacturing jewellery. He produced miniature sculpture in precious metals, bronze, wood, alabaster and hardstones, filigree work and decorative mounts for clocks. He joined the family company (now Ernest Pobjoy Ltd.) in 1924. He has exhibited decorative and ecclesiastical sculpture in London and Paris.

POBJOY, Reginald 1903-
Born in London in 1903, the son of Edwin Charles Pobjoy, he studied in London and Peking and was a professor of science. He practised sculpture in bronze, precious metals and ivory. He also experimented with the use of glass and other translucent substances as a sculptural medium. He has also painted portraits and genre subjects.

POCOCK, Alfred Lyndhurst 1881-
Born in Sussex in 1881, the son of the painter Lexden L. Pocock, he studied at the Royal Academy Schools and exhibited pottery, watercolours and sculpture at the Royal Academy and provincial galleries. He worked in Slinfold, Sussex.

PODOSEROFF, Ivan Ivanovich fl. 19th century
Born at Gallitch, Russia, on February 24, 1835, he studied under D. Jensen at the Academy of St. Petersburg. He produced bronze busts of his contemporaries. The Russian Museum, Leningrad, has his bronzes of the sculptor N.S. Pimenoff and the architect A.I. Resanoff.

POELAERT, Denis Victor 1820-1859
Born in Brussels on September 28, 1820, he died there on September 29, 1859. He studied at the Brussels Academy and was a pupil of W. Geefs. He sculpted decoration and bas-reliefs in that city.

POELCHAU, Oscar 1835-1882
Born in Riga, Latvia, on February 28, 1835, he died there on May 9, 1882. He studied in Berlin under Franz Preller the Elder and worked as a painter and sculptor in Riga. His figures and bas-reliefs were preserved in the Riga Museum.

POELMANN, Heinrich fl. 19th century
Born at Scheventorf, near Iburg, Prussia, on October 24, 1839, he worked on architectural decoration, statues and memorials in Berlin.

POERTZEL, Otto 1876-
Born at Scheibe, Germany, on October 24, 1876, he worked as a decorative sculptor in Coburg.

POGANY, Vilmos Andras (William Andrew) 1882-
Born in Szeged, Hungary, on August 24, 1882, he studied in Munich and Budapest before emigrating to the United States where he settled in New York. He produced portraits and figures, both classical and genre. He won gold medals at the Leipzig and Budapest Exhibitions of 1915. Examples of his work are in the museums of Budapest and New York.

POGLIAGHI, Lodovico 1857-
Born in Milan on January 8, 1857, he worked as a painter, illustrator, sculptor and engraver, specialising in figures and bas-reliefs of religious subjects for public buildings in northern Italy. His minor works include bronze plaques and medallions.

POHL, Adolf Josef 1872-
Born in Vienna on April 27, 1872, he studied under Carl von Zumbusch and worked as a decorative sculptor. He won an honourable mention at the Exposition Universelle of 1900.

POHL, Wilhelm 1841-1908
Born in Aachen in 1841, he died there in 1908. He sculpted statues and ornament for churches in the Aachen area.

POHLE, Rudolf 1837-
Born in Berlin on March 19, 1837. He studied under F. Drake and sculpted many monuments and statues in Berlin. His minor works include maquettes for these projects and small bas-reliefs.

POIRIER, Charles Eugène 1892-
Born at Asnières, France, on December 27, 1892, he exhibited figures at the Salon des Artistes Français from 1913 onwards.

POISSON, Pierre Marie 1876-1953
Born in Niort on November 19, 1876, he died in Paris on January 11, 1953. He studied at the Toulouse School of Fine Arts and won a scholarship to the Villa Abd-el-Tif in 1908. He received several important state commissions and sculpted a number of war memorials in the 1920s. He is best known for his neo-classical nude figures and allegorical studies, including the portrait bust symbolising La République.

POITEVIN, Auguste fl. 19th century
Born at La Fère in the early 19th century, he died there on August 12, 1873. He studied under Rude and Maindron and exhibited at the Salon from 1845 to 1867, winning a third class medal in 1846. He specialised in allegorical groups, mainly in stone, and decorative reliefs on public buildings. His minor works, in terra cotta, marble, plaster and bronze, include projects for these works as well as portrait busts of his contemporaries.

POITEVIN, Auguste Flavien fl. 19th century
Born in Paris, he was the son and pupil of Auguste Poitevin and exhibited busts, heads and portrait reliefs at the Salon from 1865 to 1870.

POITEVIN, Philippe 1831-1907
Born at St. Maximin, France, on January 21, 1831, he died in Marseilles on September 15, 1907. He studied under Toussaint and Ramus and exhibited at the Salon from 1855 to 1872. He produced busts and heads and genre subjects, mainly in bronze. The Versailles Museum has his statuettes of The Billiards Player and the Spinning-top Player.

POITEVIN, Scipion 1830-1898
Born at Sète in 1830, he died at Montpellier in 1898. He studied at the Montpellier School of Fine Arts and worked in that town, specialising in busts and statues.

POKORNY, Josef 1829-1905
Born in Vienna on February 12, 1829, he died at Hinterbrühl on January 9, 1905. He sculpted portraits, figures and bas-reliefs for Viennese churches, the University and the Palace of the Archduke Ludwig Victor.

POKORNY, Karel 1891-
Born at Porlice, Moravia, on January 18, 1891, he has worked in Prague since the second world war. He specialises in allegorical figures and groups, such as Fraternization and The Earth, and genre studies.

POLASEK, Albin 1879-
Born at Frankstadt (now Frenstat, Czechoslovakia) on February 14, 1879, he emigrated to the United States and studied at the Pennsylvania Academy of Fine Arts under Charles Grafly and won the Prix de Rome of the American Federation of Arts in 1910. He finished his studies at the American Academy in Rome (1910-13) and exhibited at the Paris Salon in 1913, getting an honourable mention. He later became head of the sculpture department at the Art Institute of Chicago. He specialised in portrait busts, heads and medallions of contemporary American celebrities, but also produced a number of allegorical figures, such as Fantasy (Metropolitan Museum of Art, New York), Man Chiselling his own Destiny, Pan and The Maiden.

POLGE, Ferdinand fl. late 19th century
Portrait sculptor working in France in the 1880s. The Ajaccio Museum has his bust of Sampiero Corso.

POLI, Cesare fl. 19th century
Born in Verona about 1816, he worked in that city as a decorative sculptor and is best remembered for the statuary at the entrance to Verona cemetery.

POLLAK, Johann fl. 19th century
Born in Rain, Germany, on March 27, 1845, he studied at the Munich Academy and in Rome. He worked in Munich where he sculpted figures, portraits and allegorical groups.

POLLET, Joseph Michel Ange 1814-1870
Born in Palermo in 1814 of French parents, he died in Paris on December 31, 1870. He studied under Villareale, Thorvaldsen and Tenerani in Rome and worked in Paris, Brussels and Italy. He exhibited at the Salon from 1846 to 1856, and won third class (1847), second class (1848 and 1855) and first class (1851) medals. He was awarded the Légion d'Honneur in 1856. He produced a great deal of ecclesiastical, classical, allegorical and historical figures and groups, including The Night, The Dawn, Star of Evening and Bacchante.

POLLIA, Joseph fl. 20th century
American sculptor of monuments, memorials and statuary for fountains, parks and public buildings in the United States. His minor works include portrait busts, equestrian statuettes of George Washington and historical bas-reliefs.

POLLICE, Giuseppe fl. 19th century
Born in Naples in 1833, he studied at the Naples Institute of Fine Arts, and worked as a decorative sculptor and bronze-founder, producing many small ornamental bronzes. He took part in the Paris Exposition Internationale of 1878.

POLLOCK, Courtenay Edward Maxwell 1877-1943
Born in Birmingham on June 23, 1877, he died in London on June 7, 1943. He studied at the Birmingham School of Art and the Royal College of Art, and exhibited in the main galleries in Britain and overseas. He specialised in portraits and figures.

POMEROY, Frederick William 1856-1924
Born in London on October 9, 1856, he died at Cliftonville near Bristol, on May 26, 1924. He studied at the Lambeth School of Art under Dalou and the Royal Academy schools (1881-85), winning a gold medal and a travelling scholarship in 1885. He subsequently studied in Paris and Rome and exhibited at the Royal Academy from 1885, being elected A.R.A. in 1906 and R.A. in 1917. He was a founder member of the Society of Portrait Sculptors in 1911. He worked in London as a sculptor of heads, busts, portrait relief, figures and monuments.

POMMAY (Pommet), René Jean Modeste 1759-1848
Born in Orléans on August 2, 1759, he died at Neuville-aux-Rois on August 6, 1848. He was the Bursar of Neuville Hospital and an amateur sculptor, specialising in portrait busts of French royalty, the popes and contemporary celebrities. Examples of his portraiture are in the Orléans Museum.

POMMIER, Albert 1880-
Born in Paris on January 11, 1880, he studied under Frank Bail and Barrias and exhibited at the Salon des Artistes Français from 1905 onwards, winning medals in 1907 and 1912. He produced numerous plaques of combattants during the first world war and medallions featuring female native types of the French colonial empire. His sculpture in the round consisted mainly of seated and standing nudes.

POMODORO, Arnaldo 1926-
Born in Marciano di Romagno, Italy, in 1926, he was the brother of Gio and Giorgio Pomodori, with whom he formed the group known as 3P in Pesaro and later Milan. These three combined their talents as theatrical designers, painters, sculptors, goldsmiths and jewellers. Arnaldo and Gio later concentrated on sculpture, using a wide variety of materials. Arnaldo has exhibited in Venice, Amsterdam and the United States.

POMODORO, Gio 1930-
Born in Orciano di Pesaro, Italy, he studied painting, drawing and modelling in Florence, where he joined the Numero Gallery group. His work with 3P in the 1950s has done much to revive interest in precious metals as a sculptural medium. Since 1960, however, he has worked on his own and specialises in bas-reliefs combining the traditional with the avant-garde. He won first prize for sculpture at the Biennales des Jeunes Artistes in Paris, 1959.

POMPON, François 1855-1933
Born at Saulieu (Côte d'Or) on May 9, 1855, he died in Paris in 1933. He was apprenticed to a marble-cutter in Dijon at the age of fourteen and also attended classes at the Dijon School of Fine Arts. In 1875 he moved to Paris where he established himself as a marble-cutter and monumental mason. Through his friendship with the sculptor Caille he got admission to the School of Decorative Arts and later worked as assistant to Mercié (1880) and Rodin (1889), being greatly influenced by the latter. He exhibited at the Salon, winning a third class medal in 1888 for a statuette of a little girl Cosette, based on the character by Victor Hugo. In 1890, however, he turned from human to animal sculpture and continued to work in that medium long after the fashion for the Animaliers had declined. He adopted an Impressionist style which was at variance with the mainstream of Animalier sculpture and this explains why recognition was so slow in coming. His marble Polar Bear was shown at the Salon d'Automne in 1921 and thenceforward Pompon won wide acclaim. He exhibited at the Salon d'Automne from then until his death and was belatedly awarded the Légion d'Honneur shortly before he died in 1933. Between 1879 and 1890 he concentrated on heads and busts and portrait statuettes. Thereafter he sculpted animal figures, mainly carved direct from stone in static poses. Many of his works were also produced in terra cotta and bronze and cover a wide range of animals, both wild and domesticated. A complete list of his animal sculptures appears as an Appendix to *The Animaliers* by James Mackay (1973).
Des Courières, Édouard *François Pompon* (1926). Dijon Musée des Beaux-Arts, *François Pompon: Sculpteur animalier Bourgignon (1964).*

PONCET, Antoine 1928-
Born in Paris in 1928, the son of the Swiss painter Marcel Poncet and grandson, on his mother's side, of Maurice Denis. He studied at the Lausanne School of Art from 1942 to 1945 and collaborated with his father in mosaic and stained glass work. He visited Paris in 1947 and was influenced by Zadkine with whom he worked for a time. He worked with Arp from 1952 onwards and later (1955) with Stahly, Étienne—Martin and Delahaye with whom he collaborated on the decoration of the church at Baccarat. He has taken part in many international exhibitions, including the Venice and Antwerp Biennales and the International Exhibition of Contemporary Sculpture at the Rodin Museum in Paris. He works at St. Germain-en-Laye and has sculpted figures and abstracts in plaster, cement and stone, but now prefers polished bronze. His bronzes include Lunar Bird (1957) and Tripatte (1958).

PONCET, Antoine François fl. 19th century
Born in Paris in the first half of the last century, he exhibited portrait busts and medallions at the Salon from 1870 onwards.

PONCIN, Albert 1877-
Born in Lyons on March 17, 1877, he studied under Verlet and exhibited at the Salon des Artistes Français, winning a third class medal in 1923 and a first class medal in 1929. He also exhibited at the Nationale from 1910 onwards. He specialised in classical figures, groups of dancers and animals, such as the Panther in the Museum of Decorative Arts, Paris.

PONGRACZ, Siegfried 1872-1929
Born in Brno, Bohemia, on June 15, 1872, he died in Budapest on February 6, 1929. He studied in Budapest and Vienna and worked there as a decorative sculptor. His minor works, both statuettes and bas-reliefs, are in the Budapest National Gallery.

PÖNNINGER, Franz Xaver 1832-1906
Born in Vienna on December 29, 1832, he died there on August 6, 1906. He studied under A. von Fernkorn and specialised in bas-reliefs, plaques and medallions.

PONOMAREV, Sergei fl. 20th century
Russian sculptor of allegorical figures and groups. He exhibited his Paradise Lost at the Salon d'Automne in the 1920s.

PONS, Pierre 1806-1869
Born in Tonneins, France, on March 28, 1806, he died in Versailles on June 4, 1869. He studied under Caunois and Toussaint and exhibited portrait busts at the Salon from 1841 to 1869. He worked at Versailles as a restorer of sculpture in the Galleries there.

PONSART, Paul 1882-1915
Born at Raincy in 1882, he was killed in action at Vauquois on February 16, 1915. He studied under Injalbert and Mathurin Moreau and exhibited figures at the Salon des Artistes Français, getting an honourable mention in 1905.

PONSCARME, François Joseph Hubert 1827-1903
Born at Belmont-les-Monthureux on May 20, 1827, he died at Malakoff, near Paris, on February 27, 1903. He studied under Oudiné and A. Dumont and worked as an engraver of dies and medals, winning second prize for engraving in 1855 with his plaque Dying Warrior on the Altar of the Fatherland. He exhibited busts, portrait reliefs, medallions and medals at the Salon from 1857 onwards, winning third class medals in 1859, 1861 and 1863 and gold medals at the Expositions of 1867 and 1878.

PONSIN-ANDARAHY, Charles 1835-1885
Born in Toulouse on March 18, 1835, he died there in 1885. He studied under Jouffroy and exhibited genre figures at the Salon from 1865 onwards, winning a third class medal in 1876. His statuette of The Shoemaker Gregoire is in the Toulouse Museum.

PONTIER, Auguste Henri Modeste 1842-1927
Born in Aix on July 18, 1842, he died there in September, 1927. He studied under A. Dumont and exhibited genre and classical figures at the Salon from 1876. His works include The First Gudgeon of the Young Angler, Ixion and The Grief of Orpheus.

PONTILLER, Hans 1887-
Born at Jenback, Austria, on February 23, 1887, he studied at the Vienna Academy and was a pupil of Breitner and Bitterlich. He specialised in allegorical figures and portrait busts and worked as a decorative sculptor in the Salzburg area.

PONZANO Y GASCON, Ponciano 1813-1877
Born in Saragossa on January 19, 1813, he died in Madrid on September 15, 1877.

POOLE, Henry 1873-1928
Born in Westminster on January 28, 1873, he died in London on August 15, 1928. He studied at the Lambeth School of Art and the Royal Academy schools (1892-97) and worked under Harry Bates and G.F. Watts. He exhibited allegorical and classical figures and groups at the Royal Academy and was elected A.R.A. in 1920 and R.A. in 1927.

POPIEL, Antoni 1865-1910
Born at Szczakova, Galicia, in 1865, he died in Lemberg (Lwow) in 1910. He studied at the Cracow Academy and was a pupil of W. Gadomski and I. Jablonski. Later he worked under Hellmer and König in Vienna. He sculpted monuments to famous Poles in Lwow, Brody and Washington, D.C..

POPINEAU, François Émile 1887-
Born at St. Armand-Montrond, France, on October 2, 1887, he specialised in monuments and memorials, but also produced small allegorical figures and groups, such as Eve, Spring (Museum of Modern Art, Paris) and Bather (Petit-Palais). He exhibited at the Salon d'Automne, the Nationale, the Tuileries and the Indépendants in the inter-war years.

POPOFF, Mikhail Petrovich fl. 19th century
Born in St. Petersburg on August 23, 1837, he studied at the Academy and worked as a decorative sculptor in that city. The Russian Museum, Leningrad, has his statuette Young Italian playing the Mandoline.

POPP, Antonin 1850-1915
Born in Prague in 1850, he died there in 1915. He was the son and pupil of Ernst Popp and sculpted statuary and bas-reliefs in Prague and other Bohemian towns.

POPP, Ernst 1819-1883
Born in Coburg on March 8, 1819, he died in Prague on September 14, 1883. He studied under Schwanthaler and worked as a modeller at the Prague porcelain factory.

PÖPPELMANN, Peter 1866-
Born at Harsewinkel, Germany, on April 24, 1866, he worked in Münster and Dresden. He produced portrait busts and allegorical and genre figures and groups, mainly of children and girls, such as Girl Washing, Girl Crouching and Two Little Girls.

PORCHER, Eugène fl. 19th-20th centuries
Born at Fontevrault, France, in the late 19th century, he studied under Thomas and exhibited figures at the Salon des Artistes Français, getting an honourable mention in 1894, and becoming an Associate in 1906.

PORTALIS, Rodolphe Philippe Conrad, Baron de fl. 19th century
Born in Passy in the first half of the 19th century, he was a professional soldier and served in the Cuirassiers. He was an amateur sculptor of considerable talent and exhibited at the Salon from 1865, becoming an Associate of the Artistes Français in 1883 and getting an honourable mention at the Exposition Universelle of 1900.

PORTER, James Frank 1883-
Born in Tientsin, China, on October 17, 1883, the son of American missionaries. He studied under Robert Aitken and was a member of the Art Students' League, New York. He specialised in heads, busts and portrait reliefs.

PORTNOFF, Alexander 1887-
Born in Russia in 1887, he was brought to the United States as an infant and studied under Charles Grafly at the Pennsylvania Academy of Fine Arts. He worked as a painter and sculptor and taught at the Graphic Sketch Club in Philadelphia. He specialised in bronze heads and busts of his contemporaries, including those of Professor Alonzo Brown, Frederic Vaux Wistar and Professor Charles La Wall.

PORTSMOUTH, Percy Herbert 1874-1953
Born in Reading, Berkshire, on February 2, 1874, he died in Buntingford, Hertfordshire, on October 29, 1953. He trained as an engineer but then studied art under Walter Crane and Morley Fletcher and spent some time in Paris and Brussels at the turn of the century. Later he studied under Lanteri at the Royal College of Art. He exhibited portrait busts and allegorical statuettes at the Royal Academy and the Royal Scottish Academy (A.R.S.A. 1906; R.S.A. 1922) and lived for many years in Edinburgh before retiring to Buntingford. His best known works are Captive, Labour and Vision.

PORZIO, Francesco fl. 19th-20th centuries
Born at Vercelli, Italy, he worked in Rome and Naples as a decorative sculptor and also produced portraits and statuettes. He exhibited in Italy from 1875 and also at the Paris Salons at the turn of the century, getting an honourable mention in 1907.

POSCH, Eduard fl. 19th century
Born at Imst, Tyrol, on September 25, 1856, he studied under Johann Grisemann, Trenkwalder and Hellmer and specialised in religious figures and reliefs.

POSCH, Hans fl. early 20th century
Born at Imst at the beginning of this century, he specialised in bas-reliefs of religious subjects. Examples of his work are in various churches in Vienna and the Tyrol.

POSCH, Leonhard 1750-1831
Born at Finsing, near Eügen in the Tyrol on November 7, 1750, he died in Berlin on June 21, 1831. He studied in Salzburg and Vienna and settled in Berlin where he sculptured busts, bas-reliefs, plaques and medallions of the Prussian royal family and contemporary celebrities.

POSCHACHER, Maria Louise 1886-
Born in Vienna on April 1, 1886, she studied under Moritz Heymann and Benno Becker and worked in Java as a painter and sculptor of portraits of Dutch officials and local dignitaries.

POSSESSE, Albin François de 1888-
Born in Paris on April 19, 1888, he studied under Bourdelle and Lazerini and worked as a painter, watercolourist and sculptor of portraits and genre subjects. He exhibited at the Salon des Artistes Français and the Indépendants.

POTET, Louis 1866-
Born in Nantes in 1866, he was the son and pupil of Pierre Potet and also worked under Chapu.

POTET, Pierre fl. 19th century
Born in Nantes on July 6, 1824, he studied under Barrême, Michel-Thomas and Bonnassieux, and worked as a decorative sculptor in Nantes.

POTIEZ, Louis fl. 19th century
Born in Douai on September 11, 1816, he became professor of modelling at Douai Academy and Curator of the Museum, which has the main collection of his works, including Ecce Homo and various portrait medallions of his contemporaries.

POTTER, Edward Clark 1857-1923
Born in New London, Connecticut on November 26, 1857, he died there on June 22, 1923. He studied in Paris under Mercié and Frémiet and sculpted numerous statues and monuments in many parts of the United States. He worked as assistant to Daniel Chester French and first came to prominence in 1893 when he collaborated with French in sculpting the great Columbus Quadriga for the Chicago Exposition. Thereafter he worked with French on a number of other equestrian figures and groups and established a reputation as an Animalier specialising in horses. He also sculpted many portrait busts of historic and contemporary Americans and classical figures, such as The Sleeping Faun (Art Institute of Chicago). Many of his horses are known as bronze reductions.

POTTER, Louis 1873-1912
Born in Troy, Vermont, on November 14, 1873, he died in Seattle, Washington, on August 29, 1912. He studied under Flagg in Hartford, Connecticut, and Merson and Dampt in Paris, and specialised in Indian figures and groups.

POTTER, Nathan Dumont 1893-
Born in Enfield, Massachusetts, on April 30, 1893, he studied under Daniel Chester French and R. Reid and worked in New York as a painter, illustrator and sculptor of genre subjects.

POTTNER, Emil 1872-
Born in Salzburg, Austria, on December 10, 1872, he studied under Herterich and Höcker at the Munich Academy. He worked as a painter, engraver and sculptor, specialising in small figures and groups of birds.

POUCKE, Karel van 1740-1809
Born in Dixmude, Belgium, on July 18, 1740, he died in Ghent on November 12, 1809. He studied under Pulinck in Belgium and Pigalle in Paris and worked in Naples and Vienna, being employed by the Empress Maria Theresa. He sculpted decoration for Ypres Cathedral and did many statuettes and bas-reliefs of genre and allegorical subjects. Dixmude Museum has his figure of a Young Girl Sleeping.

POUNTNEY, Albert 1915-
Born in Wolverhampton on August 19, 1915, he studied at the Wolverhampton Art School (1931-35), the Royal College of Art (1935-38) and the British School in Rome (1938-39). He works as a figure and portrait sculptor at Bitteswell, near Rugby.

POUPELET, Jane 1878-1932
Born at St. Paul-Lizonne, France, in 1878, she died in Paris on November 19, 1932. She studied under L. Schneeg and Rodin and made her début at the Salon of 1900 with a decorative fountain. Later she exhibited at the Nationale and the Salon d'Automne, won a travelling scholarship in 1900 and later the Légion d'Honneur. Her works include Walking Cow, Bather, Woman at her Toilet, Woman admiring her Reflection in Water, On the Beach and Torso of a Seated Woman.

POUSETTE-DART, Nathaniel J. 1886-
Born in St. Paul, Minnesota, on September 7, 1866, he studied under Hermon MacNiel in New York and attended classes at the Pennsylvania Academy of Fine Arts. He worked in Paris for many years and exhibited figures at the Salon des Indépendants, receiving many awards.

POUYDEBAT, Onesime François fl. 19th century
He studied under M. Martin and worked as a decorative sculptor in the Sens district. Sens Museum has his study for a head, and a medallion portrait of Mademoiselle Bondier.

POWER, Albert George 1883-1945
Born in Ireland in 1883, he died in Dublin on July 10, 1945. He exhibited at the Royal Hibernian Academy and sculpted busts and heads of many prominent Irish figures.

POWER, Mary Elizabeth 1904-
Born in Dublin on September 11, 1904, the daughter of Albert G. Power, she studied under her father and also at the Dublin National College of Art. She has exhibited watercolours and portrait sculpture at the Royal Hibernian Academy since 1932. Her works are signed 'May Power'.

POWERS, Hiram 1805-1873
Born at Woodstock, Vermont, on June 29, 1805, he died in Florence on June 27, 1873. The family moved to Ohio in 1819 and he attended school there for about a year, before taking a succession of jobs, as a hotel porter and then as a store clerk in Cincinnati and finally as a mechanic in a clock factory. In 1826 he began to frequent the studio of Eckstein and became passionately interested in sculpture. His accomplishments as a modeller secured him the position of general assistant and artist to the Western Museum, Cincinnati, and he achieved recognition for his remarkable tableau of Dante's Inferno. He went in 1834 to Washington, where his talents were soon recognised and three years later he settled in Florence, from which he continued to send his works to America right up to the time of his death. Though the bulk of his bread and butter work consisted of portrait busts of contemporary worthies, he made his reputation on romantic and genre figures of the Florentine school, such as Eve, Greek Slave, Fisher Boy, Dying Gladiator, Il Penseroso, Proserpine, California and America (for the Crystal Palace, London) and The Last of his Tribe.

POWERS, Longworth c.1835-1904
Born in Washington, D.C., about 1835, the son of Hiram Powers, he died in Florence in 1904. He was the son and assistant of Hiram Powers and sculpted a number of portrait busts and allegorical figures in his own right.

POWERS, Preston fl. 19th century
Born in Florence in 1843, the son and pupil of Hiram Powers. He worked in Florence as a portrait sculptor before going to the United States and working in Washington and Boston as a sculptor of monuments, public statuary and allegorical figures.

POWNALL, Mary (Mrs. Bromet) fl. 19th-20th centuries
Born in Leigh, Lancashire, in the second half of the 19th century, she exhibited figures and groups at the Paris Salon in 1893-99 and the Royal Academy from 1897 to 1925.

POWOLNY, Michael 1871-
Born in Judenburg, Galicia, on September 18, 1871, he studied in Vienna and worked there and in Gmunden as a potter and modeller of statuettes and reliefs. He founded a ceramic workshop in Vienna and became head of the Austrian National Ceramic School.

See Pozzi Family Tree

POZZI Family fl. 18th-19th centuries
A family of sculptors and bronze-founders, originating in Milan in the 17th century and spreading north and south, into Italy, Switzerland and Austria over the ensuing two centuries. Francesco Pozzi (1700-1784) was born and died in Castello San Pietro and is best remembered for the master altar in Soleure Church, Switzerland. He sculpted small ornaments and bas-reliefs. He was the father of Carlo Domenico, Carlo Luca and Giuseppe Antonio Pozzi, all of whom worked as decorative sculptors. Carlo Domenico operated a bronze

foundry in Milan and established a line of ornamental sculptors which extended through five generations. His grandson, Francesco Pozzi (1779-1844) studied at the Florence Academy and produced many busts of the Italian nobility and minor royalty. His great-great-grandson Tancredi was born in Milan on October 14, 1864, and died in Turin on March 14, 1929. He specialised in figures and groups depicting horses. Giuseppe Antonio Pozzi (1732-1811) became Court Sculptor in Mannheim and worked on the decoration of Schwetzingen Castle and the surrounding gardens. Two of his three sons became sculptors and the third, Carlo Ignazio, was a painter. Of the sculptors, Francesco Antonio (born at Porrentruy in 1763, died Frankfurt-am-Main in 1807) worked with his father in Mannheim and Schwetzingen and produced bas-reliefs and allegorical figures in southern Germany. The youngest son, Maximilian Joseph (born on September 2, 1770, died March 12, 1842), studied at the Mannheim Academy and worked as a portrait sculptor there. Francesco Antonio's son Antonio (1792-1829) worked with his uncle Maximilian as a portrait sculptor in Mannheim.

PRACHTER, Karl 1866-
Born in Gramzow, Prussian Poland, on October 28, 1866, he worked in Berlin as a portrait sculptor and medallist.

PRACK, Wilhelm Oskar 1869-
Born in Melsungen, Germany, on February 4, 1869, he studied under J. Kowarzik and worked in Frankfurt-am-Main, where he sculpted portrait busts, bas-reliefs and medals.

PRADAL, Jacques Barthelemy Noé 1827-1903
Born in Castres on May 9, 1827, he died there on June 24, 1903. He specialised in relief portraits and medallions of local personalities. He was an Officier of the Légion d'Honneur.

PRADEL, Louis Robert 1888-
Born in Paris on July 22, 1888, he exhibited figures and reliefs at the Salon des Artistes Français from 1920 onwards, winning a third class medal in 1927 and a second class medal in 1929.

PRADEL Y PUJOL, Damian fl. 19th-20th centuries
Catalan sculptor, working in Barcelona at the turn of the century.

PRADIER, Jean Jacques 'James' 1792-1852
Born in Geneva on May 23, 1792, he died at Rueil, France, on June 4, 1852. He was descended from an old Huguenot family and studied art under Charles Wielandy and David Detalla. He won a scholarship which took him to Paris, where he enrolled at the École des Beaux Arts in 1811 and studied painting in the classical manner under Lemot. He won the Prix de Rome in 1812 for painting and the Grand Prix the following year. He worked in Rome from 1814 to 1819 and began exhibiting at the Salon on his return, winning a first class medal with his début. He concentrated on sculpture from 1820 onwards and specialised in busts of his contemporaries and neo-classical statuettes in the style of Clodion, but more erotic if anything. He won the Légion d'Honneur in 1824 and was advanced to the grade of Officier only seven years later. He was a member of the Institut and succeeded his old master Lemot as professor of sculpture at the École. He won many important public commissions and is best known for the decorative sculpture on the Arc de Triomphe, the Madeleine and Napoleon's tomb in Les Invalides. He was nicknamed 'the last of the Greeks' for his entrenched classicism. Many of his works in marble were also cast in bronze. These include the Niobe group (1822), The Three Graces (1821), Psyche (1824), Atalanta (1850) and Sappho (1852).

PRAEGER, Sophia Rosamond 1867-1954
Born in Holywood, County Down, Northern Ireland, on April 15, 1867, she died there on April 16, 1954. She studied at the Belfast School of Art and the Slade and exhibited at the Royal Academy, the Royal Hibernian Academy and the Paris Salons. She wrote and illustrated children's books and her sculpture tended to concentrate on children, as exemplified in The Waif, These Little Ones and The Philosopher.

PRAHAR, Renée 1880-
Born in New York City of Bohemian parentage in 1880, she studied in Paris under Bourdelle and exhibited at the Salon in the inter-war years. Her bronzes include Russian Dancer (Metropolitan Museum of Art, New York).

PRAMPOLINI, Enrico 1894-1956
Born in Modena, Italy, on April 20, 1894, he died in Rome in 1956. He exhibited widely in Italy, Switzerland, Germany and the United States from 1912 onwards and organised the first independent art exhibition in Rome in 1918. He tended towards Futurism, giving it a peculiarly Italian flavour, and had many state commissions under the fascist regime. His minor works include numerous female statuettes in the Art Deco idiom.

PRANTL, Albert 1892-
Born at Schwaz, Tyrol, on December 17, 1892, he studied under Franz Kobald and specialised in religious figures and reliefs. His chief work is the war memorial in Schwaz.

PRATI, Edmondo 1889-
Born in Paysandu, Uruguay, on April 17, 1889, he studied painting under his uncles Eugenio and Giulio Prati and studied sculpture at the Milan Academy. He had many public commissions in Uruguay and is best known for the decorative sculpture on the parliament building in Montevideo. He also produced genre figures and groups, of which Mother and Son is the best known.

PRATT, Bela Lyon 1867-1917
Born in Norwich, Connecticut, on December 11, 1867, he died in Boston, Massachusetts, on May 18, 1917. He studied in Boston and Paris and won an honourable mention at the Salon of 1897. He specialised in figures of nude women, bathers and dancers, but also produced some sensitive portrait busts and statues of American political personalities of the Revolutionary period, such as Nathan Hale and Alexander Hamilton. His minor works include numerous medallions and pendants, and he is best known for the 'emaciated Indian' reverse of the gold half- and quarter-eagle coins of 1908, unusual in having an intaglio, instead of relievo, design.

PRCHAL, Johann Wenzel 1744-1811
Born in Kremsier, Austria, on August 17, 1744, he died at Iglau on October 16, 1811. He worked as a decorative sculptor in Iglau, Kremsier and other towns in Moravia.

PREATONI, Luigi fl. late 19th century
Born in Novara in the mid-19th century, he exhibited figures and groups in Turin, Rome and Bologna in the last quarter of the 19th century.

PREAULT, Antoine Augustin 1810-1879
Born in Paris on October 6, 1810, he died there on January 11, 1879. He studied under David d'Angers and Moine and exhibited at the Salon from 1833 to 1879. During his long career he was a most prolific and versatile sculptor, producing religious, genre, allegorical and classical figures and groups as well as busts of historic and contemporary personalities. He received few honours, though, and won a second class medal in 1849 and became a Chevalier of the Légion d'Honneur in 1870.

PRECKEL, Friedrich fl. 19th century
Born at Warensdorf, Germany, on October 16, 1832, he settled in Stadtamhof in 1864 and sculpted statues, busts, medallions and bas-reliefs for public buildings, churches and the Palace in Ratisbon.

PRECKLE, Ferdinand 1823-1863
Born in Mindelheim, Bavaria, in 1823, he died in Munich on March 13, 1863. He worked as a decorative sculptor in Munich.

PREISS, Fritz 1883-
Born in Stettin (now Szczeczin in Poland) on October 9, 1883, he studied in Berlin and Paris and worked there in the inter-war years, where he built up a reputation as one of the foremost exponents of the chryselephantine bronze. His bronze and ivory statuettes, so long decried first as kitsch and then as high camp, have become immensely fashionable in recent years. His figures of long-limbed amazons, sportswomen, dancers, nudes and semi-nudes were often gilded or enamelled. Many of them are unnamed but the better known examples include The Sun Worshipper, Girl with Hoop, Con Brio and Balloon Girl.

PRELEUTHNER, Johann 1807-1897
Born in Vienna on December 27, 1807, he died at Glognitz on August 4, 1897. He studied under Schaller at the Vienna Academy and Schwanthaler in Munich, and specialised in religious figures and portrait busts.

PRELL, Hermann 1854-1922
Born in Leipzig on April 29, 1854, he died in Dresden-Loschwitz on May 18, 1922. He studied under Grosse at the Dresden Academy and became professor of sculpture there. He exhibited in Berlin and got honourable mentions in 1886 and 1893. He produced many small bronzes of classical and biblical subjects, such as Prometheus, Venus and Anadyomene.

PRENDERGAST, Charles E. 1868-
Born in Boston, Massachusetts, on May 27, 1868, he worked in America and Paris as an engraver and sculptor of portraits. He was a member of the Salon des Indépendants.

PREUSSER, Nelly 1889-
Born in Vienna on February 1, 1889, she settled in Graz and worked there as a sculptor of portrait busts, bas-reliefs and memorials.

PREVOST, Édouard Stanislas fl. 19th century
Born in Paris in the first half of the 19th century, he studied under Penez and Jouffroy and exhibited portrait busts, statuettes and medallions at the Salon from 1868.

PREVOT, Edmond 1848-1892
Born in Bordeaux in 1848, he died there in 1892. He studied under Jouffroy in Paris and settled in Bordeaux. He exhibited at the Salon from 1876 to 1892, getting an honourable mention in 1887. He specialised in statuary, portrait busts, heads, relief portraits and medallions of his contemporaries.

PREVOT, Joseph fl. 18th century
Born in Paris on October 6, 1706, he studied under Francin and worked from 1763 to 1775 on the decoration of the châteaux of Fontainebleau and Versailles as well as the Louvre. His minor works include classical figures and portrait busts.

PREZ DE LA VILLE TUAL, Édouard des 1869-
Born in Rheims on March 11, 1869, he studied under Dubois and Barrias and exhibited busts and medallions at the Salon des Artistes Français, getting an honourable mention in 1899.

PRIEUR-BARDIN, F. Léon fl. late 19th century
Sculptor of figures and genre groups, working in Paris in the late 19th century. He became an Associate of the Artistes Français in 1896.

PRINCETEAU, René Pierre Charles c.1844-1914
Born in Libourne about 1844, he died there on January 31, 1914. He studied under Maggesi, Dumont and Deloye and worked as a painter and sculptor of portraits and genre subjects. He exhibited at the Salon from 1868 and at the Salon des Artistes Français from 1881, getting a third class medal in 1883 and a first class medal in 1885. He won a bronze medal at the Exposition Universelle of 1900. He also produced figures of animals and historical subjects.

PRINNER, Anton 1902-
Born in Budapest in 1902, he began his artistic career as a painter and then in 1926 went to Paris, where he gave up art in favour of the occult but failed to make a success of it. He took up painting again in 1935 and turned to sculpture four years later. He dabbled with Abstract art, but it failed to satisfy his need to express his sense of the occult, so he reverted to figurative sculpture, much of which verged on the Surreal. He had one-man exhibitions at Galerie Jeanne Boucher (1942) and Galerie Pierre Loeb (1945) and settled in 1950 in Vallauris, where he has worked as a book illustrator, potter and sculptor of figures, groups, bas-reliefs and monuments.

PRINS, Albert de fl. 19th century
Born in Roubaix in the mid-19th century, he studied under M.H. Pluchart and exhibited figures at the Salon of 1879.

PRINSEP, Anthony Levett 1908-
Born in Shenstone, Staffordshire, in 1908, he trained as an architect but later turned to the fine arts and studied sculpture under John Skeaping at the Central School of Art (1931-35). He worked in Suffolk for several years but now lives in Denmark, where he works as a landscape painter and sculptor of panels and bas-reliefs, mainly in wood.

PRINTEMPS, Jules Louis fl. 19th century
Born in Lille in the mid-19th century, he died there in 1879. He studied under Jouffroy and exhibited busts and heads at the Salon from 1878 onwards.

PRINZI, Giuseppe 1833-1893
Born in Messina on September 11, 1833, he died in Frascati in July 1893. He studied under Aloysio Juvara in Rome and specialised in portrait busts, bas-reliefs and tombs.

PRIOR, Laurits Terpager Malling 1840-1879
Born in Stege, Denmark, on June 8, 1840, he died in Copenhagen on April 5, 1879. He studied at the Copenhagen Academy and was a pupil of H.V. Bissen and G. Hetsch. He specialised in busts of his contemporaries in the world of the arts, and classical statuettes, such as Narcissus, Ulysses and Calypso.

PROBST, Jakob 1880-
Born at Reigoldswil, Switzerland, on August 17, 1880, he studied in Paris under Bourdelle and worked in Basle and later Geneva. He specialised in portrait busts of his contemporaries. A retrospective exhibition of his work was staged at the Basle Kunsthalle in 1952.

PROBST, Josef 1839-1892
Born in Vienna on July 26, 1839, he died there in 1892. He studied at the Academy and sculpted many statues for the new Vienna Town Hall.

PROBST, Louis fl. early 20th century
Born in Lyons in the late 19th century, he studied under Barrias and Coutan and exhibited figures and groups at the Salon des Artistes Français, winning a third class medal in 1906.

PROCHASKA, Heinrich 1897-
Born in Graz, Austria, on July 24, 1897, he studied at the Munich Academy and settled in Bruck-an-der-Mur, where he worked on allegorical groups and decorative sculpture. He was also a painter and writer.

PROCTOR, Alexander Phimister 1862-1950
Born in Bozanquit, Ontario, in 1862, he died in the United States in 1950. His family moved to Des Moines, Iowa, in 1867 and later to Denver, Colorado, where he developed his twin passions for hunting and painting the wildlife of the West. He sold the family ranch in 1887 and moved to New York, where he enrolled at the National Academy of Design and later the Art Students' League. He worked on the animal sculpture decorating the Columbian Exposition of 1893 and won a medal and the Rinehart travelling scholarship. He went to Paris and worked under Saint-Gaudens, Puech and Injalbert, and took part in the Exposition Universelle of 1900, winning a gold medal for the colossal quadriga entitled The Goddess of Liberty on the Chariot of Progress and the pair of Panthers (now in Prospect Park, Brooklyn). He won many commissions for monumental sculpture incorporating both animal and human figures, but he was at his best when concentrating on animals on their own. His bronzes include Indian Warrior, Bronco-Buster, Bison, Timid Fawn, Pacing Lioness and the group of Bear-cub and Rabbit. Most of his animal figures were sculpted between 1887 and 1900 and cast by J.N.O. Williams. His later monumental work includes the lions on the McKinley Monument in Buffalo, and the Princeton Tiger.

Proctor, Hester E. *Alexander Phimister Proctor, Sculptor in Buckskin* (1970).

PROETORIUS, C fl. 19th century
Dutch sculptor working in London on bronze reliefs, plaquettes and medallions in the second half of the 19th century.

PROFILLET, Anne Marie fl. 20th century
Born in Rennes, she studied under Navelier and Pompon and exhibited at the Salon des Artistes Français and the Salon d'Automne in the early part of this century. Though best known for her ceramic figures of animals she also worked in bronze. Among her works in this medium is the figure of a Duck in the Museum of Modern Art, Paris.

PROGAR, Alois 1857-
Born in Dolenja Vas, Slovenia, in 1857, he studied in Vienna under Hellmer and Zumbusch and specialised in religious figures and bas-reliefs in Carinthia.

PROKOFIEFF, Ivan Prokofievich 1758-1828
Born in St. Petersburg on January 25, 1758, he died there on February 10, 1828. He studied at the Academy and was regarded as one of the greatest Russian sculptors of his time. He produced large monuments and small groups and statuettes in the classical idiom. The Russian Museum, Leningrad, has his bronze Actaeon and marble Morpheus.

PROKOP, Franz 1790-1854
Born in Vienna on September 2, 1790, he died there on October 4, 1854. He was the son and pupil of Philipp Jakob Prokop and worked mainly as an ecclesiastical sculptor, though he also sculpted busts of his artistic contemporaries.

PROKOP, Philipp Jakob 1740-1814
Born in Ronsberg, Austria, on May 1, 1740, he died in Vienna on October 16, 1814. He studied under Balthasar Moll and also at the Vienna Academy. He specialised in religious sculpture, particularly altar pieces and statues in Viennese churches and Steinamanger Cathedral. His secular work includes classical groups and busts. The Baroque Museum, Vienna, has his group of Aeneas, Anchises and Ascanius.

PRONASZKO, Zbigniew 1885-
Born in Zychlin, Poland, on May 27, 1885, he studied in Cracow under J. Melczevski and then went to Munich. He was a versatile artist, working as a theatrical producer, stage designer, painter, engraver and sculptor. The museums in Katowice, Poznan, Warsaw and Prague have examples of his portrait busts, heads, bas-reliefs and medallions. He exhibited a nude figure, portrait bust of a woman and landscape paintings at the Salon d'Automne in 1928.

PROST, Louis 1876-
Born in Lyons on April 7, 1876, he worked as a monumental and decorative sculptor in that city. He exhibited at the Salon des Artistes Français from 1906 onwards, winning a second class medal in 1935. He sculpted the war memorials at Lyons, Montbrison and St. Chamond in the 1920s. His minor works include portrait busts and allegorical statuettes.

PROST, Maurice 1894-
Born in Paris on March 13, 1894, he specialised in animal figures and groups. He exhibited at the Salon des Artistes Français, getting an honourable mention (1922) and a second class medal (1936). He was awarded the Légion d'Honneur in 1933.

PROSZOVSKI, Jozef Baltasar 1860-1906
Born at Przeczyce, Galicia, in 1860, he died in Czestochowa on December 9, 1906. He studied in Warsaw and Cracow and worked as a painter and sculptor of religious subjects.

PROTAT, Hugues fl. 19th century
Decorative sculptor working in Paris in the mid-19th century, he exhibited medallions and bas-reliefs at the Salon from 1843 to 1850.

PROTHEAU, François 1823-1865
Born at Fontaines, France, on July 30, 1823, he died there on September 9, 1865. He studied under Bonnassieux and exhibited classical and allegorical figures and groups at the Salon from 1853 to 1867, winning a medal in 1864.

PROUDFOOT, Alexander 1878-1957
Born in Liverpool on November 7, 1878, he died in Glasgow on July 10, 1957. He studied in Liverpool and was head of the sculpture department at the Glasgow School of Art from 1912 to 1928. He exhibited figures and portraits at the Royal Scottish Academy and was elected A.R.S.A. in 1920 and R.S.A. in 1932.

PROUHA, Pierre Bernard 1822-1888
Born at Born, France, in 1822, he died in Paris in July 1888. He studied under Ramey, Dumont and Toussaint and exhibited classical and allegorical figures, mainly in marble, at the Salon from 1855.

PROUVÉ, Victor Émile 1858-1943
Born in Nancy on August 15, 1858, he died at Sétif in 1943. One of the foremost influences in the development of Art Nouveau at the turn of the century, he worked as a designer of jewellery and furniture, interior decorator, lithographer, etcher, painter and sculptor of historical subjects and portraits. He was Director of the Nancy School of Fine Arts and exhibited at the Salon des Artistes Français, from 1885 onwards, winning many awards. He became a Chevalier of the Légion d'Honneur in 1891 and an Officier in 1925.

PRUD'HOMME, Georges Henri 1873-
Born at Cap Breton, France, on February 9, 1873, he studied under Falguière and Alphée Dubois and specialised in portrait busts, reliefs and medallions. He exhibited at the Salon des Artistes Français from 1894 onwards, getting an honourable mention in 1901 and a third class medal in 1904. He was awarded the Légion d'Honneur in 1923.

PRUGGER, Max fl. 19th century
Tyrolean sculptor of portrait busts, notably that of the patriot Andreas Hofer at Berg Isel near Innsbruck.

PRUSKA, Anton 1846-1930
Born at Goldbrunn, Bohemia, on June 1, 1846, he died in Munich on July 24, 1930. He studied in Prague and Munich and worked under Gedon. He sculpted numerous statues for churches, castles and private mansions in southern Germany and examples of his figures and bas-reliefs are in the Munich museums.

PRUSZYNSKI, Andrzei 1836-1895
Born in Warsaw on November 24, 1836, he died there on March 7, 1895. He studied in Warsaw and Rome and returned to his birthplace, where he sculpted religious figures and bas-reliefs, plaques and medallions. Examples of his work are in the Museums of Cracow and Warsaw.

PRYTKOFF, Alexei Pantelievich 1784-1813
Born in St. Petersburg in 1784, he died there on November 21, 1813. He studied under Leberecht and specialised in bas-reliefs, plaquettes and medallions.

PTAK, Johann 1808-1860
Born in Kruman, Bohemia, in 1808, he died there in July, 1860. He studied in Prague and Vienna and worked as a decorative sculptor in Bohemia.

PUCHEGGER, Anton 1890-1917
Born in Payerbach, Germany, in 1890, he died in Davos, Switzerland, in October 1917. He worked for some time in Berlin, where he sculpted animal figures and groups.

PUECH, Denys Pierre 1854-1942
Born at Gavernac, on December 16, 1854, he died in Paris in 1942. He studied under Jouffroy, Chapu and Falguière and exhibited at the Salon from 1875 onwards. He became an Associate of the Artistes Français in 1886 and won a third class medal and the Prix de Rome in 1884. His later awards included second class and first class medals in 1889-90 and a Grand Prix at the Exposition Universelle of 1900. He became a Chevalier of the Légion d'Honneur in 1892, and promoted to Officier (1899) and Commandeur (1908). He became a member of the Institut in 1905 and Director of the Villa Medicis, Rome, in 1933. He produced many portrait busts of contemporary celebrities, allegorical and neo-classical figures and groups, monuments, projects and maquettes. Many of his works are preserved in the Luxembourg Museum.

PUENTE, Luis de la fl. 18th century
Born at Santiago de Compostella in the mid-18th century, he died there in 1808. He studied under J. Gambino and J.A.M. Ferreiro and worked in Santiago as an ecclesiastical sculptor.

PUGET-PUSZET, Baron Ludwik de 1877-
Born in Cracow on June 21, 1877, he worked in Poland and France — hence the curious hyphenated version of his name, rendered in French and Polish. He studied at the Cracow Academy and worked as an Animalier, though he also sculpted a number of allegorical groups and busts of his contemporaries. The National Museum, Warsaw, has his Flock of Sheep.

PUGIN, François Michel c.1761-1820
Born in Berne about 1761, he died there on April 30, 1820. He worked in Paris till 1791 before returning to Switzerland, where he specialised in gilt-bronze figures.

PÜHRINGER, Hans 1875-
Born in Klosterneuburg, Austria, in 1875, he worked as a decorative sculptor in Vienna.

PUIFORCAT, Jean 1897-1945
Born in 1897, he died in Paris in October 1945. He began producing his distinctive style of jewellery and silverware in 1921 and revolutionised the art of religious jewellery. Relatively little is known of him as a sculptor, though he produced portraits and figures, and sculpted the statue of the Rugby-player at Colombes Stadium.

PUILLE, Maximilian 1816-1874
Born in Nymphenburg in 1816, he died at Landshut, Bavaria, on December 3, 1874. He was the son of the architect Karl Peter Puille and worked in Schwanthaler's studio before settling in Landshut. He is best remembered for a series of four statues in St. Martin's Church in that town, but he also sculpted classical and historical statuettes.

PUJOL, Jean Marie Guillaume Valentin 1781-c.1850
Born at Fronsins, France, in 1781, he died in Paris about 1850. He worked as a decorative sculptor and is best known for the bas-relief of The Dance on the Bastille fountain and the allegory of La Marne on the façade of the Temple. He exhibited figures and bas-reliefs at the Salon from 1817 to 1822, winning a medal in the latter year.

PULL, Jules Louis fl. late 19th century
Born in Paris, he studied under A. Dumont and exhibited bronze busts and statuettes at the Salon from 1875 to 1879 and became an Associate of the Artistes Français in 1886.

PURKARTHOFER, Mathias 1827-1893
Born in St. Johann, near Herbersteim, Austria, on September 30, 1827, he died in Vienna on December 6, 1893. He sculpted many statues and monuments for public places and churches in Vienna.

PÜSCHEL, Alfred 1834-1886
Born in Leipzig on May 12, 1834, he died in Munich on July 9, 1886. He specialised in small bronzes of animals.

PUTNAM, Arthur 1873-1930
Born at Waveland, Missouri, on September 6, 1873, he died at Ville d'Avray, France, on May 27, 1930. He worked as an Animalier, and examples of his figures and groups are in the Boston Museum of Fine Arts and the Metropolitan Museum of Art, New York.

PUTNAM, Brenda 1890-
Born in Minneapolis on June 3, 1890, she began studying sculpture at the age of twelve. In 1907 she studied drawing under Paxton and Hale at the Boston Art Museum School and then studied modelling and anatomy under Bela Pratt. She worked for two years under James Earle Fraser at the Art Students' League, New York, and then studied drawing under E.C. Messer at the Corcoran Art Gallery, Washington. She was a member of the American Federation of Arts and won numerous awards for her sculpture. Her bronzes include portrait busts of celebrities in the world of the arts and genre figures, such as Pigeon Girl.

PÜTS, Heinrich 1882-
Born in Roermond, Holland, on January 15, 1882, he studied in Roermond and Antwerp and became Director of the Wiedenrück School of Fine Arts, Germany. He sculpted portraits and figures.

PUTTEMANS, Auguste 1866-1922
Born in Brussels on April 8, 1866, he died there on January 28, 1922. He studied in Paris and was a pupil of Van der Stappen at the Brussels Academy. He produced genre and classical statuettes, such as Young Fleming (Brussels Museum) and Oedipus (Ixelles).

PUTTI, Massimiliano 1809-1890
Born in Bologna in 1809, he died there in 1890. He was the son and pupil of Giovanni Putti and worked with his father on religious sculpture for churches in the Bologna area. He himself also sculpted many busts of contemporary personalities and sculpted memorials and tombs in Bologna.

PUTTINATI, Allessandro 1801-1872
Born in Verona in 1801, he died in Milan on July 1, 1872. He was the son and pupil of Francesco Puttinati and studied at the Milan Academy. Later he worked under Thorvaldsen in Rome and sculpted numerous busts and figures of contemporary personalities. His chief work is the group of the romantic characters by Bernardin de St. Pierre, Paul and Virginia, in the Gallery of Modern Art, Milan.

PUTTINATI, Francesco c.1775-1848
Born in Verona about 1775, he died in Milan in 1848. He specialised in portrait busts, reliefs, plaques and medallions of contemporary celebrities.

PUVREZ, Henri 1893-
Born in Brussels in 1893, he was brought up in Spain and then studied at the Brussels Academy for a year. As a sculptor, he is largely self-taught and preferred direct carving in stone, simplifying human forms to the verge of the abstract. The Expressionism which influenced Belgian art in the mid-1920s turned him towards more figurative work and he was strongly influenced by Negro art, which was then becoming fashionable. In the 1930s he sculpted figures in wood and is best known for the colossal Naiad at the Liège Water Exhibition of 1939. A shortage of his usual materials during the second world war induced him to take up modelling in clay and he then concentrated on portrait busts, many of which were later cast in bronze. He taught at the Antwerp Institute of Art from 1946 to 1957, and is a member of the Royal Academy of Belgium.

PUYAU, Hignio Amado 1893-1936
Born in Argentina in 1893, he died there in 1936. He studied in Buenos Aires and exhibited figures and portraits there from 1922 till his death, receiving many awards, including a posthumous first class medal.

PUYENBROEK, Pierre 1804-1884
Born in Louvain on March 1, 1804, he died in Brussels on March 17, 1884. He worked as a decorative sculptor in Ypres, but many of his works were destroyed during the first world war, notably the series of statues formerly in the Cloth Hall. Various busts of his artistic contemporaries are preserved in the Brussels Museum.

PY, Denis Fernand 1887-
Born in Versailles on January 10, 1887, he exhibited at the Salon d'Automne (from 1922), the Indépendants (1923) and the Salon des Artistes Décorateurs (from 1925). His work was strongly influenced by religious mysticism and characterised by greatly simplified lines in the Art Deco idiom. He produced busts, statuettes, medallions and jewellery.

QUADRELLI, Emilio 1863-1925
Born in Milan on May 8, 1863, he died there on May 7, 1925. He specialised in genre and allegorical figures and groups and exhibited in Rome, Turin and Paris, getting an honourable mention at the Exposition Universelle of 1889.

QVARNSTROM, Karl Gustaf 1810-1866
Born in Stockholm on March 23, 1810, he died there on March 5, 1866. He studied under Masselgrem at the Stockholm Academy, where he subsequently became a Professor and eventually Director. He worked in Italy from 1836 to 1854 and worked as a painter, lithographer and sculptor, specialising in busts of his contemporaries.

QUATTRINI, Enrico 1863-
Born at Colle Valencia, near Todi, Italy, on December 24, 1863, he studied at the Perugia Academy and worked as a decorative sculptor in Perugia, Rome, Milan and Rappallo. His minor works include maquettes and projects for monuments, and allegorical statuettes.

QUENARD, Armand Pierre Louis 1865-
Born at Allones, France, in 1865, he studied under Vimont and Hiollin and sculpted statuettes, busts and medallions, examples of which are in the museums of Tourcoing and Château-Thierry.

QUEROL, Augustin 1863-1909
Born in Tortosa, Spain, on May 17, 1863, he died in Madrid on December 14, 1909. He studied under R. Cervera and D. Talaru and is best known for his tombs in the mèdieval and Renaissance styles. He also did historical statuettes, busts, medallions and bas-reliefs.

QUEVILLON, Madame E.H. fl. 19th-20th centuries
Sculptress of genre statuettes, working in Paris at the turn of the century. She was an Associate of the Artistes Français, and died in 1909.

QUILLIVIC, René 1879-
Born at Plouhinec, Brittany, on May 13, 1879, he studied in Paris under Mercié and exhibited at the Salon des Artistes Français, winning an honourable mention (1907), and a second class medal and travelling scholarship (1908). He also exhibited at the Royal Academy in the 1920s and the Salon d'Automne in 1945. He sculpted many war memorials in Brittany, as well as busts and figures illustrating the Breton way of life. He was an Officier of the Légion d'Honneur.

QUINCEY, Agenor Doynel, Comte de fl. 19th century
Born in Avranches, France, in the mid-19th century, he studied under Lavigne and exhibited at the Salon from 1872 to 1877. He specialised in allegorical and genre figures in marble and bronze, such as The Truth and The Error.

QUINN, Edmond T. 1868-
Born in Philadelphia in 1868, he studied under Thomas Eakins in Philadelphia and Injalbert in Paris. He sculpted numerous statues and monuments all over the United States and received a silver medal for his work in connection with the Panama-Pacific Exposition in San Francisco, 1915. His minor works include many bronze busts and heads of his contemporaries, such as Captain Allan Pollock, Vicente Blasco Ibanez and Fred Dana Marsh, and statuettes of allegorical and classical subjects.

QUINQUAND, Anna 1890-
Born in Paris on March 5, 1890, she studied painting and sculpture under her mother and B. Laurent, and exhibited portraits and genre subjects at the Salon des Artistes Français from 1910 onwards, winning a bronze medal in 1921 and the Légion d'Honneur.

QUINTON, Eugène fl. 19th century
Born at Rennes in the mid-19th century, he died there in June 1892. He studied under Cavelier and exhibited portrait busts, classical bas-reliefs and genre groups at the Salon from 1877 till his death.

QUINZIO, Tullio Salvatore 1858-1918
Born in Genoa, on February 22, 1858, he died there on December 3, 1918. He studied under his father, the painter Giovanni Quinzio, and then studied sculpture at the Academia Ligustica and later in Rome. He worked as a painter and sculptor of classical and genre subjects, examples of his work being in the Gallery of Modern Art, Genoa.

QVIST, Gerda 1883-
Born in Helsinki, Finland on August 14, 1883, she studied at the Helsinki Athenaeum and the Stockholm Academy and specialised in bas-reliefs, plaques and medallions.

QUITTSCHREIBER, August Ernst fl. 18th-19th centuries
Born in Berlin about 1770, he studied at the Academy and exhibited there from 1794 to 1808. He specialised in portrait busts of European royalty and artistic and literary figures.

RABAS, Vaclav 1885-
Born in Krusovice, Bohemia, on November 13, 1885, he studied under Schusiger and Max Svabinsky and worked in Prague as a landscape painter, engraver, lithographer and book illustrator. He was awarded the title of National Painter in 1945. He has also sculpted portraits and genre figures, examples of which are in the Prague Modern Gallery.

RABBI, Adriano 1833-1913
Born in Mantua in 1833, he died in Brescia, on February 17, 1913. He studied in Pisa, Rome and Carrara and specialised in busts of Italian historical personalities. Examples of his portraits are in the Mantua Museum.

RABY, Ekiel Rabinovich 1893-
Born in Lyadi, Russia, on October 18, 1893, he emigrated to France and became naturalised in 1925. He worked as a decorative sculptor and produced statuettes in ivory and bronze. He exhibited at the Nationale, the Indépendants, the Salon d'Automne and the Salon des Artistes Décorateurs in the 1920s, and won a Grand Prix at the Expositions des Arts Décoratifs in 1925.

RACHETTE, Antoine Jacques Dominique 1744-1809
Born in Valençay on December 22, 1744, he died in St. Petersburg, in 1809. He studied at the Copenhagen Academy and the Académie de St. Luc, Paris, and then settled in St. Petersburg in 1779. He produced portrait busts of Russian celebrities and classical figures. Examples of his work are in the Hermitage Museum, Leningrad.

RACHMANOV, I.F. 1883-
Born in Moscow in 1883, he studied under S. Konyonkov and sculpted genre figures and portraits. Examples of his sculpture are in the Tretiakoff Gallery.

RACHNER, Albert 1837-1900
Born at Trommelort, Germany, on June 4, 1837, he died in Breslau in February, 1900. He studied under von Widnmann and produced allegorical and genre figures and groups.

RÄDECKER, Johann – see RAEDECKER, John

RADNAI, Adalbert Beia 1879-1923
Born in Przemysl, Galicia, on May 25, 1879, he died in Budapest, on November 21, 1923. He worked as a decorative sculptor in Przemysl and Budapest and sculpted many monuments, statues and busts of contemporary and historical Hungarian celebrities. He won a bronze medal at the Exposition Universelle of 1900.

RADNITZKY, Karl 1818-1901
Born in Vienna on November 17, 1818, he died there on January 10, 1901. He was the son and pupil of the engraver Joseph Radnitzky and specialised in bas-reliefs, commemorative plaques and portrait medallions.

RADOS, Eugenio fl. 1840-50
Milanese decorative sculptor, working on Milan Cathedral in the mid-19th century.

RADOSLAVOV, Vassil fl. 20th century
Bulgarian sculptor of monuments, genre figures and portraits, working in the first half of this century.

RADTKE, Felix 1877-
Born in Königsberg, on June 15, 1877, he studied under W. Reusch and worked as a painter and sculptor of portraits.

RADTKE, Kurt 1895-
Born in Königsberg (now Kaliningrad, Russia) on July 28, 1895, he studied under H. Lederer, R. Scheibe and E. Scharff, and worked as a painter and decorative sculptor in what was formerly East Prussia.

RAEDECKER, John (Johann Anton) 1885-1956
Born in Amsterdam in 1885, he died there in 1956. He studied under his father, a stone-mason and ornamental sculptor, and attended classes at the Amsterdam Academy. He was in Paris in 1912-14 and came under the influence of Cubism, reflected in some of his early wood-carvings. He returned to the Netherlands in 1914 and worked there till his death in 1956. He was regarded as one of the leading Dutch sculptors of the first half of this century, adapting oriental and ancient Egyptian art and the romanticism of the turn of the century to produce his distinctive style. He produced numerous portrait busts, masks, torsos, animal figures and female statuettes and is best known for the Wassenaar memorial (1936) and the Waalwijk war memorial (1947). His chief work, the National Memorial to the Victims of the War (Amsterdam) was incomplete at the time of his death.

RAFFAELLI, Jean François 1850-1924
Born in Paris on April 20, 1850, of Italian parents, he died there on February 29, 1924. He studied under Gérôme and worked as a painter of landscapes, an engraver, etcher and lithographer of portrait and genre subjects, and an actor. He exhibited at the Salon from 1870 onwards and was a member of the Société Nationale des Beaux Arts, winning an honourable mention in 1885 and a gold medal at the Exposition Universelle of 1889. He became a Chevalier of the Légion d'Honneur in 1889 and an Officier in 1906.

RAFFEGEAUD, Sylvain fl. 19th century
Born in Nantes, he died there in 1891. He studied under Ottin and exhibited at the Salon in 1863. He specialised in portrait busts and statuettes of genre subjects.

RAFFEINER, Clemens 1848-1925
Born in Schnals, Tyrol, on May 13, 1848, he died at Schwarz on November 27, 1925. He sculpted figures and bas-reliefs for the churches in the Tyrol.

RAFFL, Ignaz 1828-1895
Born in Merano (then part of Austrian Italy) on December 17, 1828, he died in Menton on November 11, 1895. He studied in Vienna, Venice, Florence and Rome, and settled in 1857 in Paris where he specialised in portrait busts of royalty and European celebrities. He also produced genre and historical statuettes and small groups.

RAGGI, Giovanni Battista fl. early 19th century
Born in Carrara in the late 18th century, he studied at the Academy of St. Luke in Rome, and worked on the decoration of Milan Cathedral in 1810-15.

RAGGI, Mario 1821-1907
Born in Carrara in 1821, he died in Farnham, Surrey, on November 26, 1907. He studied under R. Monti and M. Noble and worked as a decorative sculptor in England, mostly in the Sheffield area. He produced a number of monuments, statues and bas-reliefs.

RAGGI, Nicolas Bernard 1791-1862
Born in Carrara on June 11, 1791, he died in Paris on May 24, 1862. He studied under Bartolini in Florence, winning the Elisabeth Bonaparte prize there in 1810, and Bosio at the École des Beaux Arts, and exhibited at the Salon from 1817 to 1842, receiving the Légion d'Honneur in 1825. He produced busts and statuettes of contemporary celebrities, historical and biblical groups, in marble and bronze.

RAGOCZY, Laura Johanne Wilhelmine (née Kandelsdorff) 1880-
Born in Aarhus, Denmark, on June 14, 1880, she studied under Elna Borch in Copenhagen and had a studio in Smidstrupöre, near Rungsted, where she sculpted female statuettes. Aarhus Museum has her Young Girl Asleep.

RAGONNEAU, Étienne Germain fl. 19th century
Born in Auxerre in the early 19th century, he studied in Paris under Lequien and David d'Angers and exhibited busts and statuettes at the Salon from 1844 to 1868.

RAGUSA, Vincenzo fl. 19th century
Born in Palermo on July 12, 1841, he studied under Morelli and exhibited in Milan from 1865. He was in Japan from 1876 to 1882, doing decorative sculpture for the Mikado.

RAHMSTORFF, Willy 1897-
Born in Mainz on January 2, 1897, he studied under H. Hahn and worked as a decorative sculptor in the Mommenheim area.

RAHR, Erik 1900-
Born in Odense, Denmark, on April 4, 1900, he studied under Anton Hanak in Vienna and also at the Copenhagen Academy. He has sculpted bas-reliefs and statues for public places and buildings in Copenhagen, as well as statuettes and portraits.

RAHTZ, Wilhelm 1881-
Born in Berlin on August 18, 1881, he worked in Berlin and specialised in religious sculpture, notably the series of bas-reliefs in the church of Völkingen in the Saarland.

RAINALTER, Anton 1788-1851
Born in Bozen (now Bolzano) on August 14, 1788, he died there on January 7, 1851. He was the son of a monumental mason, Andreas Rainalter, and later studied under Franz Schwanthaler in Munich and Kliber and Kässmann at the Vienna Academy. He specialised in religious figures and reliefs and decorated a number of churches in the South Tyrol.

RAINALTER, Franz 1820-1874
Born in Bozen on August 26, 1820, he died there on June 17, 1874. He was the son and pupil of Anton Rainalter and also studied under Ludwig Schwanthaler in Munich. He sculpted tombs, memorials and religious figures in Austria.

RAINER, Virgil 1871-
Born in Matrie, Austria, on November 27, 1871, he studied at the Vienna Academy and sculpted many tombs, statues and monuments, as well as several war memorials in the 1920s for towns in the Tyrol.

RAINOT, Alexandre François Claude fl. late 19th century
Born in Paris in the mid-19th century, he studied under Frémiet and exhibited at the Salon in 1880 and became an Associate of the Artistes Français in 1887.

RAISSIGUIER, Paul Émile Félix 1851-1932
Born in Oran, Algeria, on December 3, 1851, he died in Paris on September 7, 1932. He studied under Jouffroy, Cabanel and Rapin and exhibited painting and sculpture at the Salon from 1880 and the Salon des Artistes Français, getting an honourable mention in 1898 and becoming an Associate in 1902. Examples of his work are in the museums of Castres and Versailles.

RAITH, Bela 1885-1915
Born in Budapest in 1885, he was killed in action on the Galician front on March 29, 1915. He sculpted figures and portraits and worked in Budapest.

RAJKI, Jozsef 1894-
Born in Oroshava, Hungary, in February 1894, he studied in Budapest and specialised in genre and peasant figures and groups in terra cotta and bronze.

RAMASANOV, Nikolai Alexandrovich 1818-1867
Born in Russia on February 1, 1818, he died in Moscow in 1867. He studied at the Academy of St. Petersburg and specialised in classical figures, such as Milo of Croton, genre groups like Woman with Goat, and busts of his literary and musical contemporaries.

RAMASCHIELLO, Vincenzo fl. early 20th century
Sculptor of portraits and genre figures working in Rome in the early years of this century.

RAMCKE, Joachim Heinrich fl. 19th century
Born in Wedel, Germany, on March 26, 1839, he studied in Altona and Berlin and worked as a decorative sculptor in Chemnitz, Altona and Zwickau.

RAMEY, Claude 1754-1838
Born in Dijon, on October 29, 1754, he died in Paris, on June 4, 1838. He studied under Devosges and Gois and won the Grand Prix in 1782 with his Parable of the Good Samaritan. He exhibited at the Salon from 1793 to 1827 and was awarded the Légion d'Honneur in 1824. He produced numerous statues and busts, classical, allegorical and historical figures and bas-reliefs, monuments and decorative sculpture.

RAMEY, Étienne Jules 1796-1852
Born in Paris, on May 23, 1796, he died there on October 29, 1852. He was the son and pupil of Claude Ramey and was runner-up in the Prix de Rome of 1814 with his Wounded Achilles, but won the prize the following year. He exhibited at the Salon from 1822 to 1827 and became a member of the Institut in 1828. Like his father, he was a prolific sculptor of classical, biblical, allegorical and heroic figures and groups and bas-reliefs. He also produced a number of busts of his contemporaries.

RAMMELT, Walter 1890-
Born in Bischwiller, Germany, on March 20, 1890, he studied in Berlin and Munich and sculpted war memorials in the 1920s, notably that at Rostock.

RAMOUS, Carlo 1926-
Italian sculptor of allegorical and genre figures. His bronzes include Dance in the Full Moon (1960).

RAMPONI, Ferdinando c.1880-1917
Born in Tessin, Switzerland, about 1880, he settled in Milan and studied under Segantini. He was a painter and sculptor of genre subjects, reflecting his interest in Alpine subjects. He enlisted in the Italian army and was killed on the Austrian front in the first world war.

RAMSEYER, André 1914-
Born in Trameln, Switzerland, in 1914, he studied art in La Chaux de Fonds (1932-35) and Paris (1935-36) and was a pupil of Zadkine at the Académie Colarossi. He travelled in Italy in 1938 and then taught drawing and art history at the Lycée in Neuchâtel till 1936. He has sculpted memorials and monuments in many parts of Switzerland and has taken part in the Venice Biennales, the International Exhibition of Contemporary Sculpture in Paris (1956) and various Swiss national exhibitions since the war. Prior to 1955 he concentrated on figurative works following traditional styles, but since then he has experimented with more abstract forms. His bronzes include Consolation, The Couple, Eurhythmy and Atlantic.

RAMUS, Joseph Marius 1805-1888
Born in Aix, on June 19, 1805, he died in Nogent, on June 3, 1888. He studied under Cortot and was runner-up in the Prix de Rome in 1830. He began exhibiting at the Salon in 1831 and won a second class medal at his début and a first class medal in 1839. He became a Chevalier of the Légion d'Honneur in 1852. He produced statues and busts in marble and bronze portraying classical, biblical, historical and contemporary personalities.

RANDOW, Adolf von 1828-1911
Born in Schwednitz, Germany, in 1828, he died in Krefeld on March 9, 1911. He studied under Wichmann and worked in Rome from 1851 to 1855 before settling in Krefeld, where he sculpted decoration for public buildings.

RANGENIER, Carl 1829-1895
Born in Bernerode, Hanover, on December 17, 1829, he died at Bautzen, Saxony, on October 20, 1895. He studied under Hähnel in Dresden and later in Munich and Paris and worked in Hanover, Dresden and Bautzen as a decorative sculptor. His minor works in the Bautzen Museum include a project for a war memorial, a bust of Blücher and portraits of various contemporary musical celebrities, and genre figures, such as Sleeping Child and Bearded Man.

RANIERI, Aristide de fl. 19th-20th centuries
Born in Italy, he worked in Paris at the turn of the century and exhibited figures at the Salon, getting an honourable mention in 1899.

RANSOM, Frank 1874-
Born in Westminster on October 8, 1874, he studied at the Lambeth School of Art and the Royal Academy Schools and exhibited figures and reliefs at the Royal Academy, the Royal Scottish Academy and various provincial galleries.

RANTZ, August 1872-
Born in Graz, Austria, on June 28, 1872, he studied in Vienna under Hellmer and in Munich under Syrius Eberle. He worked in Paris from 1897 to 1900 and produced many tombs, memorials, portrait busts and genre figures in Graz. His chief work is the memorial to the Third Training Battalion at Graz University. His statuette Young Girl at her Mirror is in Graz Museum.

RANTZ, Theodor Karl Wilhelm 1820-1851
Born in Berlin on August 27, 1820, he died there on February 16, 1851. He worked as a decorative sculptor, and also sculpted portrait busts and reliefs.

RAPHAEL, France fl. 20th century
Born in Amsterdam in the early years of this century, she worked in Paris in the 1920s and exhibited statuettes at the Salon d'Automne (Associate), the Tuileries and the Nationale.

RAPHAEL-SCHWARTZ, 1884-
Born in Kiev on October 1, 1884, he settled in Paris at the turn of the century and worked as a painter and sculptor specialising in the nudity of woman in all its eloquent simplicity. He exhibited statuettes at the Nationale, the Tuileries and the Salon d'Automne in the 1920s.

RAPOLTI, Lajos 1880-
Born at Szekely-Vasarhely, Hungary, on March 15, 1880, he studied and worked in Budapest, though for several years he was employed as a decorative sculptor in Turkey and did the statue of Kemal Ataturk for the town of Coma.

RASBOURG, Antoine Joseph van 1831-1902
Born in Brussels in 1831, he died at Choisy-le-Roi in 1902. He studied under Carrière-Belleuse and worked as a decorative sculptor in Brussels. He collaborated with Rodin on the Loos monument in Antwerp and sculpted many busts of historic and contemporary Belgians.

RASMUSSEN, Otto fl. 19th century
Born in Berlin on May 2, 1845, he studied at the Academy there and worked in Dresden as an ornamental sculptor.

RASMUSSEN, Rasmus 1849-1883
Born in Aarhus, Denmark, on December 2, 1849, he died in Rome on August 3, 1883. He studied at the Copenhagen Academy (1873-78) and worked in Italy (1880-83), specialising in biblical and classical figures, such as The Prodigal Son, Ulysses and The First Step.

RASMUSSEN, Wilhelm Robert 1879-
Born at Skieus, Norway, on June 15, 1879, he was a pupil of Bergslien and Utne in Oslo and later studied in Berlin, Paris and Rome. He was appointed professor of sculpture at Oslo Academy in 1921 and succeeded Vigeland as sculptor on the decoration of Trondheim Cathedral, for which he produced numerous figures and reliefs.

RASSAU, Oskar 1843-1912
Born in Schulenberg, Germany, on July 29, 1843, he died in Dresden on December 6, 1912. He produced a number of monuments in many parts of Germany, notably those honouring Schläger (Hamelin), Stromeyer (Hanover), Schiller (Dresden-Loschwitz) and the Emperor Joseph II (Teschen).

RASUMNY, Felix 1869-
Born in Sevastopol, Russia, on April 20, 1869, he emigrated to France and was later naturalised. He studied under Aimé Millet, Gauthier and Tasset and exhibited figures at the Salon des Artistes Français from 1889 onwards and the Nationale from 1911. He got an honourable mention in 1891 and a second class medal in 1911 and was awarded the Légion d'Honneur in 1933.

RASZKA, Jan 1871-
Born at Ropice, near Teschen (now in Czechoslovakia) on May 2, 1871, he studied at the Vienna Academy under Berger, L'Allemand, Hellmer and Zumbusch. He worked in Paris (1900-02) and was then appointed professor at the Academy of Cracow, becoming its Director from 1922 to 1931. He produced many busts and figures of historic and contemporary Poles, war memorials and the monument to the 1863 Uprising at Bogucice.

RATH, Anton fl. 19th century
Ecclesiastical sculptor working in Graz and Vordernberg, Austria, in the 1830s.

RATHAUSKY, Hans 1858-1912
Born in Vienna on November 23, 1858, he died there on July 17, 1912. He studied at the Academy and worked as a decorative sculptor in Linz and Salzburg. He won a silver medal at the Exposition Universelle of 1900.

RATHGEBER, Johann Balthasar Jacob 1770-1845
Born in Gotha on April 14, 1770, he died there on May 22, 1845. He studied under Schadow and was appointed Court Sculptor in Saxony, 1820, and later professor of sculpture at the Gotha School of Art. He sculpted decoration for Weimar castle in 1836. His minor works consist mainly of portrait busts, examples of which are in the Weimar Museum.

RATHJE, Hans Christian 1767-1805
Born in Flensburg in 1767, he died in Naples on October 20, 1805. He studied under Jens Hjernoe at Horsens and later attended classes at the Copenhagen Academy. He produced monuments, bas-reliefs and allegorical figures.

RATHSACK, Svend 1885-
Born in Fredericia, Denmark, on September 8, 1885, he studied at the Copenhagen Academy from 1903 to 1907 and was a pupil of O. Bache and Viggo Johanson. He worked in Spain and North Africa (1909-11) and then in Paris (1914), Java (1921) and Greenland (1931), and sculpted portraits and statuettes of the native types he encountered in his travels. He also sculpted classical and biblical figures, such as Adam and Eve (Aarhus Museum).

RATO, Jose Moreira 1860-
Born in Lisbon on August 26, 1860, he studied under Alberto Nunes and V. Bastos, and then worked under A. Dumont in Paris for two years (1880-82). He sculpted figures, groups and portraits, examples of which are in the Museum of Modern Art, Lisbon.

RATTI, Adriano fl. 19th century
Born in Carrara on May 24, 1845, he studied at the Academy there and was a pupil of Carimini in Rome and Micheli in Florence. He worked as a decorative sculptor in Serravezza.

RAU, Ernst 1839-1875
Born in Biberach, Germany, on December 7, 1839, he died in Stuttgart on August 24, 1875. He studied under T. Wagner and worked in Berlin and Paris before settling in Stuttgart where he sculpted busts, statues and memorials of illustrious Germans.

RAU, Marcel 1886-
Born in Brussels in 1886, he studied under Dubois and won the Prix de Rome in 1911. He sculpted a number of war memorials in various parts of Belgium in the 1920s. His minor works consist of genre figures and groups, such as Maternal Happiness.

RAUBER, Max 1891-
Born in Olten, Switzerland, he studied at the Brera Academy, Milan, from 1908 to 1911, and then at the Académie Julian in Paris under Landowsky and Bouchard. He works as a sculptor of figures, portraits and bas-reliefs in Olten.

RAUCH, Christian Daniel 1777-1857
Born at Arolsen, Saxony, on January 2, 1777, he died in Dresden on December 3, 1857. He studied under Valentin in Arolsen and Ruhl in Cassel and then attended the Berlin Academy (1802-03) and worked in Rome (1804-11). On his return to Berlin he became a member of the Academy and was also an honorary member of the Institut de France. He was one of the great masters of 19th century German sculpture and received many commissions for monuments to German royalty in Berlin and Munich. His figure of Frederick the Great was immensely popular as a bronze reduction. His minor works include busts of contemporary and historic German celebrities.

RAUCH, Josef 1868-1921
Born in Baden Baden in 1868, he died in Berlin on February 12, 1921. He studied under Eberle in Munich and settled in Berlin where he was appointed professor of modelling at the Technical University. Examples of his figures and portraits are in the museums of Munich and Berlin.

RAUCHMANN, Matthaus 1822-1844
Born in Vienna in 1822, he died there on February 9, 1844. He
worked as a decorative sculptor and also produced figures and
bas-reliefs.

RAUFER, Aloys 1794-1856
Born at Lenzkirch, Baden, on August 16, 1794, he died in Karlsruhe
on February 4, 1856. He studied in Karlsruhe from 1819 to 1821 and
then worked under Thorvaldsen in Rome. He was appointed professor
at the Karlsruhe Institute in 1832 and sculpted many statues and
monuments in that area.

RAUL, Harry Lewis 1883-
Born in Easton, Pennsylvania, on October 2, 1883, he was a pupil of
Farrington Elwell and attended classes at the Art Students' League
under F.V. Dumond and the Pennsylvania Academy under Charles
Grafly. He produced numerous monuments and memorials, religious
and genre figures and busts of famous Americans. His bronzes include
the group Laughing Mermaids.

RAULT, Louis Armand 1847-1903
Born at Calais, in 1847, he died in 1903. He exhibited medallions and
plaques at the Salon of 1881. He later turned to figures and was one
of the first sculptors to work in iron and steel. He was a Chevalier of
the Légion d'Honneur.

RAUM, Alfred 1872-
Born at Bernau, Germany, on January 16, 1872, he studied at the
Berlin Academy and produced monuments, memorials and allegorical
groups in many parts of Germany.

RAUNER, Louis fl. early 20th century
Genre sculptor working in Paris. He exhibited figures at the Salon des
Artistes Français and got an honourable mention in 1904.

RAUSCHER, Michael 1875-1915
Born at Traberg, near Linz, on September 4, 1875, he died at Huszt,
Hungary, on March 21, 1915. He studied under Eberle in Munich and
worked as a decorative sculptor in Austria at the turn of the century.

RAUSCHER, Robert 1879-
Born in Strasbourg on March 29, 1879, he studied at the Munich
Academy and produced figures, groups and portraits.

RAVAIOLI, Gino 1895-
Born in Rimini in 1895, he studied at the Bologna Academy and was
a pupil of Adolphe de Karolis. He travelled extensively and worked as
a painter, architect and sculptor. He won a gold medal at Rimini in
1921 and a prize at the Milan Exhibition of 1923, and specialised in
religious and genre figures.

RAVASCHID, Francesco 1743-1820
Born in Genoa, on April 17, 1743, he died there on October 22,
1820. He studied at the Academia Ligustica (1793-1801) and
produced many allegorical and classical statues and groups in the
Genoa area.

RAVASCO, Cesare 1875-
Born in Milan in 1875, he worked there in the early years of this
century as an architectural sculptor.

RAVRIO, Antoine fl. 18th-19th centuries
He worked with his father, a decorative sculptor of Italian origin, for
the Bourbon monarchy, and produced ornamental sculpture in bronze
and precious metals. After the downfall of the monarchy he
continued to work for the Republic and specialised in large and rather
vulgar medals which were worn by the *Incroyables et Merveilleuses*,
the dandies of the Napoleonic era who went to the very limits of
fashion. His more serious work consisted of figures and bas-reliefs
symbolising the different political atmosphere in turn — the
Directorate, the Consulate and the Napoleonic Empire, and is said to
have become a millionaire on the sale of such trinkets. He is best
remembered for having left a sum of 3,000 frs. at his death in 1814 as
a prize to be awarded to the first person to invent a technique of
ormolu without its injurious side-effects (mercury poisoning). The
prize was won three years later by the bronze-founder and chemist,
Darcet.

RAWLINS, Darsie 1912-
Born in Kentmere on March 27, 1912, he studied at the Royal College
of Art (1930-34) and has a studio at Penn in Buckinghamshire where
he works in stone, wood and bronze. He has exhibited at the Royal
Academy and other leading galleries at home and abroad and was
elected A.R.B.S. (1947) and F.R.B.S. (1961).

RAY, Richard Archibald 1884-
Born in Camberwell, London, on September 10, 1884, he studied at
the Brighton School of Art and the Royal College of Art. After
graduating in 1912 he moved to Sunderland where he eventually
became Principal of the School of Art. He painted and sculpted
subjects inspired by the life and countryside in County Durham.

RAYBAUD, Henri Charles fl. 19th-20th centuries
Born in Marseilles, he worked there at the turn of the century as a
decorative sculptor. He exhibited figures and reliefs at the Salon des
Artistes Français and got an honourable mention in 1904.

RAYMONDI, Joseph fl. 19th century
Born in Nice in 1826, he studied at the Turin Academy and became
professor at the Albertine Academy. He produced portrait busts and
genre groups, examples of which are in the museums of Nice and
Turin.

RAYNAUD, Georges fl. 20th century
Genre and portrait sculptor working in Paris in the inter-war years. He
exhibited at the Salon des Artistes Français and got an honourable
mention in 1935.

REA, Constance (née Halford) fl. early 20th century
The wife of the painter Cecil Rea, she worked in London in the 1920s
and exhibited figures at the Royal Academy, the Glasgow Institute
and other galleries in Britain.

REA, John Lowra 1882-
Born in Beckmantown, New York, on January 29, 1882, he studied
under Hermon MacNiel and James Earle Fraser and worked on
memorials, portraits and genre figures in Plattsburg, New York.

REAL DEL SARTE, Maxime 1888-1954
Born in Paris, on May 2, 1888, he died there on February 15, 1954.
He specialised in monuments and memorials and won the Grand Prix
Nationale in 1921 for his nude study of a man and a woman entitled
The First Home. He sculpted numerous war memorials in the 1920s
and won medals at the Salon des Artistes Français in 1920 and 1927
and the Légion d'Honneur in 1940. He also sculpted the monument
to Joan of Arc on her Pyre at Rouen and genre and lyric groups, such
as The Man and his Dream.

REAM, Winnie (Mrs. Hoxie) 1847-1914
Born in Madison, Wisconsin, on September 25, 1847, she died in
Washington on November 21, 1914. She studied under Bonnat in
Paris and Maioli in Rome and produced a number of statues and
monuments in the United States, notably those of Abraham Lincoln
(Washington Capitol) and Admiral Farragut in Farragut Square
(1878). Her minor works include portrait busts and statuettes.

REBECK, Steven Augustus 1891-
Born in Cleveland, Ohio, on May 25, 1891, he studied at the
Cleveland School of Art under Karl Bitter and Carl Heber and later at
the National Academy and the Beaux-Arts Institute of Design, New
York. He specialised in portrait figures, reliefs and busts of
contemporary and historic celebrities. His chief work was the statue
of Shakespeare in Cleveland.

REBISSO, Louis Thomas 1837-1899
Born in Italy in 1837, he emigrated to the United States and died in
Cincinnati on May 3, 1899. He is best remembered for the
monuments to General Grant in Chicago, President Benjamin Harrison
in Cincinnati and the equestrian statue of General McPherson in
Washington. He sculpted many portrait busts and statuettes of
prominent Americans of the late 19th century.

REBOUL, Joseph fl. 19th century
Sculptor of classical and allegorical figures and portraits, working in
Draguignan where he died in 1866. Examples of his work are in the
Draguignan Museum.

RECCHIA, Richard H. 1885-
Born in Quincy, Massachusetts, on November 20, 1885, he studied at the Art School of the Boston Museum of Fine Arts, the Académie Julian in Paris and also in Italy. He was awarded a bronze medal at the Pan-Pacific International Exposition, 1915, for his decorative sculpture. He specialised in busts, heads, medallions, bas-reliefs and statuettes, particularly of military subjects. His genre bronzes include Siren and Dreamer.

RECIPON, Georges 1860-
Born in Paris on January 17, 1860, he studied under Dumont and Français and exhibited at the Salon in 1879. In 1888 he became an Associate of the Artistes Français and thereafter exhibited at that Salon, getting a third class medal in 1890 and a first class medal in 1901. He also had an honourable mention and a silver medal at the Expositions of 1889 and 1900 respectively, and received the Légion d'Honneur in the latter year. He worked mainly as a painter and illustrator, but he also sculpted classical subjects, notably the two bronze quadrigae on the Palace of Fine Arts and the nymphs representing the Seine and the Neva on the Pont Alexandre III in Paris.

RECKE-VOLMERSTEIN, Ariel Graf (Count) von der fl. 19th century
Portrait sculptor working in Berlin in the mid-19th century. He studied at the Berlin Academy from 1856 to 1864 and was appointed Sculptor to the Khedive of Egypt in 1867.

REDPATH, Norma fl. 20th century
Australian sculptress of figures, portraits and memorials, active since the second world war.

REDUZZI, Augusto 1862-
Born in Genoa in 1862, he studied under O. Tabacchi and worked as a decorative sculptor in Piedmont at the turn of the century. He won a bronze medal at the Exposition Universelle of 1900.

REDUZZI, Cesare 1857-1911
Born in Turin on September 24, 1857, he died there on May 9, 1911. He exhibited in Turin and Milan from 1880 onwards and also at the Salon des Artistes Français where he got an honourable mention in 1904. He specialised in memorials and tombs, but also sculpted figures of historical and contemporary Italian celebrities in marble and bronze. A fine example of the latter is his statuette of Tiberius Claudius in Turin Municipal Museum.

REGAZZONI, Ampellio 1870-
Born in Chiasso, Switzerland, on June 28, 1870, he studied under R. Pereda and worked in Fribourg where the museum has a number of portrait busts and genre figures by him. He also sculpted the Bernasconi family tomb in Chiasso cemetery.

REGL, Joseph 1846-1911
Born in Wildenau, Austria, on November 1, 1846, he died in Zürich on March 29, 1911. He studied under Werner David in Vienna and worked at Aspach, Austria, till 1878, when he was appointed professor at the Zürich School of Fine Arts. His best-known work is the bronze figure of a vineyard worker on a fountain in Zürich, but he also sculpted figures and bas-reliefs for many Swiss churches.

REGNIER, Hyacinthe Jean 1803-1870
Born in Paris on April 18, 1803, he died at Gambais on February 13, 1870. He worked at the Sèvres porcelain factory as a modeller and exhibited figurines at the Salon in 1840-41. He received the Légion d'Honneur in 1855.

REICH, Franz Xaver 1815-1881
Born at Hufingen, Baden, on August 1, 1815, he died there on October 8, 1881. He studied in Frankfurt-am-Main and was a pupil of Zwergert (1833-35) and then worked with Schaller in Munich and studied in Rome in 1842-43 before returning to Hufingen. He sculpted monuments honouring the grand-ducal family of Baden and various statues in the cathedrals and churches of Constanz and Karlsruhe. His minor works include allegorical and classical figures and groups, notably The Birth of the Danube, in Donaueschingen Park.

REICHEL, Alfred fl. 19th century
Born in Gnadenfeld, Saxony, on April 26, 1856, he studied at the Dresden Academy (1875-77) and the Berlin Academy (1877-81) and worked with Reinhold Begas. He settled in Berlin where he specialised in memorials and monumental statuary.

REICHENSTEIN, Robert fl. 20th century
French sculptor of figures and portraits working in the inter-war period. He won a third class medal at the Salon des Artistes Français in 1935.

REICHERT, Janina 1895-
Born in Stary Sambor, Poland, on June 22, 1895, she studied at the Lemberg (Lwow) School of Art (1915-18) and the Cracow Academy (1918-21) where she was a pupil of Laszczka. Her chief work is the Pilsudski monument at the Cracow military academy, but she also sculpted figures and reliefs for churches in Cracow and Lwow and genre statuettes, such as The Slave (Lwow Museum)).

REIMERS, Johan Manovich 1818-1868
Born in St. Petersburg, on February 3, 1818, he died there on November 25, 1868. He attended the Imperial Academy from 1835 to 1839 and worked in Rome in 1846-47 and 1857-62. He specialised in medallions, plaques and bas-reliefs, many of which are preserved in the Tretiakoff Gallery, Moscow.

REINECK, Georg 1848-1916
Born in Stuttgart, in 1848, he died there in July, 1916. He worked as a decorative sculptor in that city.

REINHART, William Henry 1825-1874
Born in Baltimore, Maryland, in 1825, he died in Rome in October 1874. He studied in Baltimore and went to Italy in 1855 where he produced classical and biblical figures, mainly of women. Examples of his works are in the Peabody Institute, Baltimore, the Corcoran Gallery, Washington, and the Metropolitan Museum of Art, New York.

REINHOLD, Bernhard 1824-1892
Born in Schönberg, Germany, on April 23, 1824, he died in Plauen-im-Vogtland, on November 22, 1892. He studied under Thorvaldsen and Bissen in Rome and Copenhagen respectively, and also worked in Munich in 1846. He was influenced by Kraus and Begas and settled in Dresden where he specialised in historical figures and bas-reliefs.

REINHOUD (Reinhoud D'Haese) 1928-
Born in Grammont, Belgium, in 1928, he is the brother of the sculptor Roel D'Haese and adopted his first name alone in order to avoid the confusion between them. He studied at the School of Decorative Arts in Brussels (1947-50) and has since taken part in many national and international exhibitions. His early work was modelled in plaster and clay for bronze casting or terra cotta firing and he had his first one-man show at the Taptoe Gallery in Brussels in 1956. He moved to Paris in 1959 and since then has worked mainly in sheet metal (usually copper or brass), producing baroque abstracts in which traces of his earlier figurative work can still be discerned.

REINITZER, Alois 1865-
Born in Prague, on February 20, 1865, he studied under Hellmer in Vienna (1883-85) and worked in Prague (1885-89) before coming to Paris where he continued his studies at the Académie Julian. He exhibited at the Paris Salons and won a bronze medal at the Exposition Universelle of 1900.

REISCHACH, Hans, Markgraf Von 1873-
Born in Ludwigsburg, Bavaria, on October 2, 1873, he worked in Munich and studied at the academies of Stuttgart and Munich and the Académie Julian in Paris. He produced classical and modernistic figures and portraits.

REISNER, Hans 1871-
Born at Granzin, Prussia, on May 15, 1871, he studied at the Berlin Academy and became professor of sculpture at the Hanau Academy of Design. He sculpted genre and neo-classical figures.

REISS, Albert 1874-
Born at Löbau, Saxony, on January 8, 1874, he worked as a decorative sculptor and medallist in Leipzig.

REISS, Anton Joseph 1835-1900
Born in Düsseldorf on October 25, 1835, he died there on January 31, 1900. He studied under Julius Bayerle and worked on ecclesiastical sculpture and allegorical groups for the churches and public buildings of Düsseldorf and Cologne.

REISSMANN, Gustav 1887-
Born in Neustadt, near Coburg, on March 17, 1887, he worked as a portrait and genre sculptor in Dresden.

REITER, Carl fl. early 19th century
Decorative sculptor working in Brunn (Brno) about 1839.

REMBOWSKI, Jan 1879-1923
Born at Wawyszew, near Warsaw, on January 12, 1879, he died in Warsaw on January 26, 1923. He studied at the Warsaw School of Design and the Cracow Academy and was a pupil of Laszczka and J. Mehoffer and E. Wyspianski. He worked in Warsaw (1916-23) and specialised in magnificent studies of girls and boys which he used in an ambitious series of portraits, depicting the Polish legionaries of the first world war in the Graeco-Roman style. He also produced paintings in the same genre.

REMINGTON, Frederic Sackrider 1861-1909
Born in Canton, New York, on October 1, 1861, the son of an officer in the U.S. Cavalry, from whom he inherited his deep love of horses. He was educated at a military academy and Yale University (1878-80) but dropped out of business school and went West, spending four years in Mississippi and Kansas City, sketching and painting frontier life. He worked as a magazine illustrator, often accompanying the Army in its punitive expeditions against the Indians. His paintings recorded a vanishing way of life on the plains of North America. He served in the Spanish American War of 1898-99 as an official war artist. His output as a painter and draughtsman was exceedingly prolific, some 2,700 drawings and paintings being reproduced in 41 periodicals and 142 books. He took up sculpture relatively late in his career, in 1895, when he took lessons in modelling from Frederick Ruckstull in New Rochelle. His first equestrian figure, The Bronco Buster, appeared in 1896 and was followed by a number of other groups illustrating the Indians and cavalrymen, the cowboys and frontiersmen of the Wild West. His bronzes include The Wounded Bunkie, The Stampede, The Scalp, The Fallen Rider and The Indian Dancer. Remington registered his bronzes for copyright purposes and a detailed list of them, together with his own descriptions, appears as an appendix in *The Animaliers* by James Mackay. Remington's bronzes were sand-cast by the Roman Bronze Works of New York in limited editions up to 1901, and then edited by the *cire perdue* process at the same foundry thereafter. Remington died of cancer at Ridgeway, Connecticut, on December 26, 1909.

McCracken, Harold *Frederic Remington: Artist of the Old West* (1947).

REMONDOT, Marius L.G. fl. 19th-20th centuries
Born at Montmirail, France, in the late 19th century, he exhibited figures and groups at the Salon des Artistes Français at the turn of the century, receiving a third class medal in 1908.

RÉMY, Julien fl. 20th century
Sculptor of figures and portraits working in Paris in the inter-war period. He was an Associate of the Artistes Français and won second and first class medals in 1928 and 1932 respectively and a silver medal at the Exposition Internationale of 1937.

RENARD, Edmond fl. 19th century
Sculptor of portrait busts, figures, statues and memorials, working in Cologne in the mid-19th century. He worked on the decoration of the tower of Cologne Town Hall.

RENARD, Léopold 1868-
Born in Paris on March 3, 1868, he worked in Lyons as a decorative sculptor. He won a gold medal at the Lyons salon, was a Chevalier of the Légion d'H onneur and an Officier of the Institut Publique.

RENARD, Lucie Gabrielle fl. 19th century
Born in Meaux in the mid-19th century, she studied under P. Aube and exhibited figures at the Salon from 1880 onwards.

RENARD, Marcel Claude 1893-
Born in Lyons on August 5, 1893, he was the son and pupil of Léopold Renard and also studied under Rost and J. Boucher. He exhibited at the Salon des Artistes Français (Associate) and the Salon des Artistes Décorateurs and won second and first class medals in 1925 and 1934 respectively. He specialised in bas-reliefs and medals.

RENAUD, Alexandre Charles 1756-1817
Born at Spix, near Dijon, in 1756, he died in Vienna in 1817. He studied under F. Devosge at the Burgundy Academy and won the Grand Prix of Burgundy in 1777, enabling him to continue his studies in Rome. He had an enormous reputation while still a young man, and is chiefly remembered on account of his marble copy of the Apollo of Belvedere (Dijon Museum). He sculpted many allegorical and classical monuments and small groups and bronzes are known of several of the projects and preliminary models. He left France at the Revolution and settled in Vienna where he sculpted portrait busts and figures of Austrian celebrities.

RENAUD, Francis 1887-
Born in St. Brieuc, France, on November 26, 1887, he studied in Paris and Rome and was a pupil of Cormon and Injalbert. He began exhibiting at the Salon des Artistes Français in 1921, winning second and first class medals in 1922 and 1932 respectively. He sculpted many war memorials in Brittany, characterised by simplicity of form but yet conveying powerful emotions.

RENAUDOT, Jules François Gabriel 1836-1901
Born in Paris, on May 2, 1836, he died there in 1901. He studied under Jouffroy and exhibited at the Salon from 1865 onwards, specialising in statues and groups of classical and allegorical subjects in stone and marble. His minor works include nude statuettes and busts in bronze.

RENDIC, Ivan 1849-1932
Born at Supetar, Croatia, on May 27, 1849, he died in Split on June 29, 1932. He studied under G. Moscotta and Giovanni Dupré and specialised in monuments and memorials, mainly in the Zagreb area.

RENKER, Emil 1887-
Born in Berlin on June 25, 1887, he studied under Haverkamp and Herter and won the Prix de Rome in 1913. He worked for the German Ambassador in St. Petersburg before the first world war and sculpted portraits and statuettes. Later he settled in Berlin where he worked as a decorative sculptor.

RENN, Franz fl. 19th century
Born at Imst, Tyrol, on December 7, 1821, he died in Vienna at the turn of the century. He studied at the Vienna Academy and worked there as a decorative sculptor.

RENN, Franz Xaver 1784-1875
Born in Imst, in 1784, the son and pupil of Josef Anton Renn, he studied architecture at the Vienna Academy and collaborated with his father in decorative sculpture and religious figures and bas-reliefs in Imst. He died there on January 5, 1875.

RENN, Gottfried 1818-1886
Born in Imst, on October 15, 1818, he died in Speyer, Germany, in 1886. He was the son of Franz Xaver Renn and studied under Schwanthaler in Munich. He sculpted statues, reliefs and decorative work in Speyer Cathedral.

RENN, Josef Anton 1715-1790
Born in Imst, on April 22, 1715, he died there on March 17, 1790. He studied in Vienna for six years and later worked as an ecclesiastical sculptor in Strasbourg, Berne and Constance before returning to the Tyrol.

RENN, Joseph 1820-1894
Born in Imst, on June 2, 1820, he died in Munich on June 16, 1894. He worked with his brother Gottfried.

RENOIR, Joseph Alexandre 1811-1855
Born at Gray, on May 9, 1811, he died in Paris in January 1855. He studied under Ramey and Pradier and exhibited at the Salon from 1847 till his death, winning a third class medal in 1852. He produced figures and groups of classical and biblical subjects in marble and bronze.

RENOIR, Pierre Auguste 1841-1919
Born in Limoges, on February 25, 1841, he died at Cagnes, in Provence, on December 17, 1919. He was apprenticed to a porcelain manufacturer at the age of thirteen and was employed as a painter of china, fans, screens, blinds and other decorative articles. Later he worked with Gleyre and was influenced by Sisley, Monet and Courbet, becoming one of the leading Impressionist painters of the late 19th century. He did not turn to sculpture till 1907, when his hands were too crippled by arthritis to continue painting. He found modelling therapeutic and produced unaided a portrait bust and a medallion portraying his son Coco. Six years later he formed a partnership with Guino which continued until the end of 1918 and produced a number of sculptures which wielded considerable influence on the development of French sculpture after the first world war. His chief works were Venus, The Washerwoman and Judgment of Paris. With Morel he produced a bas-relief of women dancing to the music of a piper. His sculptures have a mature serenity which places him on par with Maillol.
Fosca, F. *Renoir* (1924). Vollard, Ambroise *La Vie et l'Oeuvre de Pierre Auguste Renoir* (1919).

RENTSCH, Friedrich Carl Adolf 1836-1899
Born in Dresden on January 2, 1836, he died there on November 17, 1899. He was the son of the painter Friedrich Rentsch and father of the painter Fritz Rentsch. He studied under Hähnel, Hübner, Peschel and Ehrhang in Dresden and was appointed professor of ornamental design at Dresden Technical High School in 1873. He sculpted decoration for the Martinkirche and the Dresdner Hauptbahnhof.

RENVALL, E. fl. 20th century
Portrait sculptor working in Finland in the mid-20th century. He has sculpted portrait busts, reliefs and statues of prominent Finnish personalities, his best known work being the statue of the late President Paasikivi in Helsinki.

REPIC, Alois 1866-
Born at Vrhpolje, Slovenia, on March 11, 1866, he studied at the Vienna Academy and worked in Ljubljana as a sculptor of figures and portraits. His chief work is the statue of Cardinal Missia in Gorizia.

REPSOLD, Wilhelm 1885-
Born in Hamburg on March 19, 1885, he studied at the Dresden Professional School and the Académie Julian in Paris and was a pupil of Habisch in Stuttgart. He sculpted figures and groups illustrating episodes in the careers of such fictional heroes as Baron Munchhausen, Don Quixote and Till Eulenspiegel, as well as portraits of his contemporaries. He also worked as a potter, painter, watercolourist, engraver and sillhouettist.

RESEDAH, Georges fl. 19th century
Born in Angers in the mid-19th century, he exhibited figures at the Salon in 1878.

RETTENMAIER, Eduard Friedrich 1865-
Born in Schwäbisch-Gmund, Austria, on June 5, 1865, he studied under Eberle and Widemann in Munich and Kowarzik in Frankfurt-am-Main. The Städel Institute in Frankfurt has his bronze of a Seated Girl.

RETZLAFF, Carl Friedrich Wilhelm August 1863-
Born in Berlin on July 18, 1863, he studied under Manzel and H. Wefing and was professor of sculpture at the Detmold Technical School from 1896 to 1923. He produced many bronze statuettes, busts and groups in the Detmold area and sculpted the Jahn monument there.

REUSCH, Friedrich Johann 1843-1906
Born in Siegen, Germany, on September 5, 1843, he died at Agrigento, Italy, on October 15, 1906. He studied under A. Wolff in Berlin and became professor (and later Director of the Königsberg Academy). He sculpted numerous memorials after the Franco-Prussian War of 1870-71, and did the monuments to Prince Bismarck and the German Emperors formerly in Königsberg. His minor works include portrait busts of his contemporaries and genre and allegorical groups, such as The Market and The Demon of Smoking.

REUSER fl. 20th century
Abstract sculptor working in the Netherlands since the second world war. He was represented in the exhibition of modern Dutch art, held in Paris in 1945.

REVELLI, Salvatore 1816-1859
Born in Taggia, near San Remo, Italy, on September 1, 1816, he died in Rome on June 14, 1859. He studied under Tenerani and worked as a decorative sculptor in Rome and Genoa, where he sculpted many memorials, plaques, monuments and tombs.

REVILLON, Aimé Jean 1823-
Born in Paris on July 1, 1823, he studied under Lequien and exhibited medallions, plaques and bas-reliefs at the Salon from 1848 to 1882.

REVILLON, Ernest fl. 19th century
Born in Paris, he exhibited figures and reliefs at the Salon des Artistes Français, becoming an Associate in 1884 and getting an honourable mention in 1887.

REVILLON, Georges Jules fl. 19th century
Born in St. Petersburg of French parents, he worked in Russia as a portrait and figure sculptor.

REVILLON, Jean Baptiste 1819-1869
Born in Paris on January 8, 1819, he died there on December 22, 1869. He studied under Feuchère and exhibited at the Salon from 1840 to 1869, specialising in religious and allegorical figures and bas-reliefs and sculpted decoration on many Parisian buildings.

REVOL, Guy Charles 1912-
Born in Paris on October 3, 1912, he was runner-up in the Prix de Rome of 1937 and won a silver medal at the Exposition Internationale the same year and a prize at the International Exhibition of Medallists in Madrid, 1951. He sculpted decoration for the French pavilion at the Golden Gate Exposition, San Francisco, in 1939, and has decorated many public buildings, parks and fountains in France. He has exhibited portrait busts, reliefs and medallions of his illustrious contemporaries at the Salon d'Automne, the Indépendants and the Tuileries since the 1930s.

REYCHAN, Stanislas 1897-
Born in London on October 8, 1897, he studied at St. Martin's School of Art, and the Central School of Arts and Crafts and has exhibited at the Royal Academy and the Paris Salon, receiving third class and second class medals in 1958 and 1960 respectively. He works in London as a potter and sculptor of figures and portraits.

REYER, Hans fl. 20th century
Portrait sculptor working in Hamburg, producing busts, heads and bas-reliefs, often in collaboration with Hans Eckermann.

REYMOND, Auguste fl. Late 19th century
Born in Montélimar in the mid-19th century, he studied under Aimé Millet and Ponscarme and exhibited medallions and bas-reliefs at the Salon in 1881.

REYMOND, Casimir 1893-
Born at Vaulion, in Switzerland, in 1893, he studied at the Geneva School of Fine Arts and worked as a decorative sculptor in Vienna, Geneva and Lausanne. He has produced many portrait busts and reliefs and figures of religious and classical subjects.

REYMOND, Charles fl. 19th century
Born at Chardonne, in Switzerland, in the early 19th century, he died at Vevey, in 1871. He studied under Hector Lemaire and specialised in classical figures, such as Centaur and Nymph and sculpted the monument to Philippe Suchard at Serrières.

REYMOND DE BROUTELLES, J. Maurice 1862-
Born in Geneva, on April 25, 1862, he studied in Paris under Chapu and Barrias and exhibited at the Salon d'Automne, the Indépendants and the Salon des Artistes Français. He won a bronze medal at the Exposition Universelle of 1889 and a silver medal at the Exposition of 1900. He specialised in portrait busts and allegorical groups in marble and bronze. Examples of his sculpture are in the Rath Museum, Geneva, and the Winterthur cantonal museum.

REYNERSON, June 1891-
Born in Mound City, Illinois, on February 21, 1891, she studied at the Pratt Institute and became a member of the Pen and Brush Club. She works as a painter, lithographer and sculptor of figures and portraits.

REYNESY-GURGUI fl. late 19th century
Catalan sculptor of figures and groups, working in Paris in the late 19th century.

REYNOLDS, Bernard Robert 1915-
Born in Norfolk on June 2, 1915, he studied at the Norwich School of Art (1932-37) and the Westminster School of Art under Eric Schilsky and Blair Hughes-Stanton. He has exhibited at the Royal Academy and the principal London and provincial galleries since the war. He now lectures in sculpture at the Ipswich School of Art and works as a painter and sculptor of portraits.

REYNOLDS-STEPHENS 1862-
Born in England in 1862, he emigrated to the United States and settled in Detroit. He studied at the Royal Academy schools in 1884-87 and exhibited at the Academy and the Paris Salon, getting an honourable mention in 1892. Examples of his work are in the Tate Gallery.

RHADES, August 1886-
Born in Berlin on March 6, 1886, he studied under Erwin Kurz and worked on decorative sculpture in various Berlin churches.

RHEINECK, Georg 1848-1916
Born at Neckarsulm, Württemberg, on May 24, 1848, he died in Stuttgart, on July 4, 1916. He studied under Gnauth, in Stuttgart, and Bergmann, Schilling and Hähnel in Dresden, and worked in Leipzig (1881-84), Karlsruhe (1885-86) and Stuttgart (from 1886). He was a decorative sculptor and produced fountains, bas-reliefs, friezes and portrait busts. He is best known for the Fisherman's fountain in Heilbronn and a series of reliefs at the Academy of Stuttgart.

RHEINOLD, Hugo Wolfgang 1853-1900
Born in Obernlahnstein, Germany, on March 26, 1853, he died in Berlin, on October 2, 1900. He studied under M. Kruse and Herter and attended classes at the Berlin Academy. He also spent some time in Italy but worked mainly in Berlin. He specialised in allegorical figures and groups, such as Dynamite in the Service of Humanity (Hamburg).

RHIND, Alexander 1834-1886
Born in Banff, Scotland, in 1834, he died in Edinburgh, in 1886. He was a pupil of William Brodie and specialised in portrait busts of contemporary Scots.

RHIND, John 1828-1892
Born in Banff, in 1828, he died in Edinburgh, on April 5, 1892. He studied under A.H. Ritchie and specialised in classical figures and groups in marble and bronze. His chief work was the William Chambers memorial in Edinburgh (1891).

RHIND, John Massey 1860-1936
Born in Edinburgh, on July 9, 1860, he died in New York, on October 20, 1936. He was the son and pupil of John Rhind and studied in Paris where he worked under Dalou. He emigrated to the United States in 1889 and settled in New York. He won a gold medal at the St. Louis World's Fair, 1904, and continued to exhibit at the Royal Scottish Academy till his death, being elected R.S.A. in 1934 and A.R.B.S. in 1936. He produced portrait busts and statues of historic figures in Newark, Jersey City, Pittsburgh and Philadelphia.

RHIND, William Birnie 1853-1933
Born in Edinburgh, in 1853, he died there on July 9, 1933. He was the elder son of John Rhind and studied at the Edinburgh School of Design under Hodder and attended classes at the Royal Scottish Academy for five years. He exhibited at the Royal Scottish Academy and was elected A.R.S.A. in 1893 and R.S.A. in 1905. He sculpted numerous monuments and memorials in Edinburgh, notably the statues and bas-reliefs on the various regimental memorials after the Boer War, such as that honouring the Kings Own Scottish Borderers (1902), the Royal Scots Greys and the Black Watch (1908). He

sculpted the bronze Stag on the Queensberry monument and also produced numerous busts and statuettes of historical and contemporary Scottish personalities, notably Mary, Queen of Scots, in the Scottish National Portrait Gallery.

RIBAUPIERRE, François de 1886-
Born at Clarens, Switzerland, in 1886, he studied at the Geneva School of Fine Arts (1902-05) and in Paris (1907-08) and also spent some time in Florence. He worked in Switzerland as a painter, stained-glass artist and sculptor of religious figures and bas-reliefs.

RIBIER, Germain 1826-1865
Born in Montpellier in 1826, he died there on April 7, 1865. He specialised in portrait busts, bas-reliefs and tombs, mainly in marble.

RICCA, Aristide fl. 19th century
Born in Naples, in the mid-19th century, he exhibited figures in Naples, Turin and Milan from 1877 onwards.

RICCA, Claudio 1828-1892
Born in Rome, on November 9, 1828, he died in Naples, on January 3, 1892. He studied at the Institute of Fine Arts, Naples, and worked in Paris for some time, but returned to Naples in 1870 and worked on the decoration of many churches in that area. After the Franco-Prussian War he returned to Paris and sculpted the four Evangelists in the Church of St. Sernin, Toulouse.

RICCARDI, Eleuterio 1884-
Born at Rocca d'Arci, Italy, in 1884, he worked in marble, wood, terra cotta and bronze and specialised in portrait busts and allegorical groups. He exhibited internationally and won a gold medal in Munich (1909) and showed busts and figures at the Leicester Gallery, London, in 1921-22. Examples of his portrait sculpture are in the Tate Gallery and various Roman museums.

RICCI, Stefano 1765-1837
Born in Florence, on December 26, 1765, he died there on November 22, 1837. He studied under Carrodot and became professor at the Florence Academy (1802-37). He specialised in memorials and religious sculpture.

RICHARD, Alfred Pierre fl. 19th century
Born in Paris, in the first half of the 19th century, he died there in April, 1884. He studied under Cogniet and exhibited busts at the Salon in 1867.

RICHARD, Félix Pierre fl. 19th century
Born at La Tronche, near Grenoble, on November 28, 1848, he studied under Jouffroy and Carpeaux and exhibited at the Salon from 1875 onwards, getting honourable mentions in 1890 and also at the Exposition Universelle of 1889. He specialised in portrait busts and figures of religious subjects, mainly in marble.

RICHARD, Jules fl. 19th century
Born in Paris, in the mid-19th century, he studied under Donot and exhibited figures at the Salon of 1872.

RICHARD, Melanie (née Mozin) fl. 19th century
Parisian sculptress of bas-reliefs and medallions, she exhibited at the Salon from 1863 to 1876.

RICHARD-BOUFFE, Pauline fl. late 19th century
Born in Paris in the mid-19th century, she studied under Aimé Millet and Mlle. Dubois-Davesne and exhibited busts at the Salon of 1878.

RICHARDS, David 1829-1897
Born at Abergynolwyn, North Wales, in 1829, he died in Long Island, New York, on November 28, 1897. He emigrated to the United States in 1847 and worked in New York till 1854, but then spent three years in Rome. Subsequently he worked in New York and Chicago and sculpted many statues and memorials in New York and New Hampshire.

RICHARDS, Lee Greene 1878-
Born in Salt Lake City, Utah, on July 27, 1878, he studied under J.T. Harwood, J.P. Laurens and Bonnat and exhibited at the Paris Salons at the turn of the century, getting an honourable mention in 1904. He worked as a painter, illustrator and sculptor of genre subjects.

RICHARDSON, C. Douglas fl. 19th-20th centuries
Born in England, in the mid-19th century, he settled in Melbourne, Australia, and specialised in rather lugubrious allegorical groups, such as Grave, where is thy Victory? Death, where is thy Sting? He exhibited at the Royal Academy in 1884.

RICHARDSON, Edward M. 1812-1869
Born in 1812, he died in London in July 1869. He exhibited portrait busts and heads at the Royal Academy from 1835 to 1866.

RICHE, Louis 1877-
Born in Paris, on May 29, 1877, he studied under Gardet and Perrin and exhibited at the Salon des Artistes Français, getting an honourable mention (1897), third class (1903), second class (1905) and first class (1924) medals. He also exhibited at the Salon des Indépendants in 1923. He specialised in animal and genre groups. Valence Museum has his bronze of a Cat waylaying a Butterfly.

RICHEFEU, Charles Édouard 1868-
Born in Paris, on January 7, 1868, he studied under Puech and exhibited figures at the Salon des Artistes Français in the 1880s.

RICHER, Paul M.L. Pierre 1849-1933
Born in Chartres, on January 17, 1849, he died there in December, 1933. He exhibited at the Salon des Artistes Français from 1878 onwards, winning a third class medal in 1900. He got an honourable mention at the Exposition Universelle of 1889 and a bronze medal at the Exposition of 1900. He received a number of important public commissions and was professor of modelling and anatomy at the Academy of Medicine and an Officier of the Légion d'Honneur. He specialised in bronze figures of allegorical and genre subjects.

RICHETTI, Francesco fl. 18th century
Roman sculptor, specialising in statuettes and small groups in bronze based on ancient and medieval sculpture.

RICHIER, Germaine 1904-1959
Born at Grans, near Arles, in 1904, she died in Paris in 1959. She studied at the Montpellier School of Fine Arts (1922-25) and worked with Bourdelle in Paris (1925-29). She had her first individual show at the Galerie Max Kaganovich in Paris in 1934 and thereafter participated in many international exhibitions, the Paris Salons and numerous gallery shows. She spent the second world war in Switzerland and exhibited at the Basle Kunsthalle with Marino Marini and Wotruba. She married the writer Rene de Solier and was a member of the organising committee of the Salon de Mai. She developed her own highly distinctive, if often macabre form of figurative Surrealism and worked in clay, plaster and bronze. Her bronzes include busts, torsos and human figures in a more traditional form, but from 1940 onwards she produced strange creatures, often inspired by the insect world. Her works in this genre include The Spider (1946), The Storm (1948), Hurricane (1949), Bat Man (various versions, 1946-56), Ogre (1951), Don Quixote of the Forest (1951), Tauromachy (1953), The Eagle (1954), Mountain (1955-56), The Grain (1955) and Thistle Sun (1956-59). She was also a prolific painter and experimented with combinations of glass and lead, coloured plaster and painted bronze in the last years of her life.

RICHMOND, Sir William Blake 1842-1921
Born in London, on November 19, 1842, he died there on February 11, 1921. He was the son of the painter George Richmond and studied at the Royal Academy schools from 1857, winning two silver medals. He exhibited at the Royal Academy from 1861, being elected A.R.A. in 1888 and R.A. in 1895. He was knighted in 1897. He was Slade Professor at Oxford University from 1878 to 1883 and worked for some time in Italy, Greece and Egypt and this is reflected in his paintings and sculpture of Mediterranean subjects. He is best known, however, for his portraits of many of the leading European political figures of the late 19th century, including Gladstone and Bismarck.

RICHON, Henri Louis fl. late 19th century
Born at Seine Port, France, in the mid-19th century, he studied under Monceau and Dumont and exhibited portrait busts at the Salon from 1878 onwards.

RICHTER, Etha 1883-
Born in Dresden, on February 4, 1883, she worked in Ankara, Turkey, and specialised in animal subjects. Her works include Horses (Karl Marx Stadt Museum), Geese, Young Giraffe and Family of Cats (Dresden).

RICHTER, Otto 1867-
Born in Löbnitz, Saxony, on March 18, 1867, he studied at the Berlin Academy. He worked as a decorative sculptor in many parts of Germany and sculpted statues for the Ministry of Culture in Berlin, the fountain for Mannheim Town Hall and numerous figures and groups, represented in the collections of the museums in Leipzig, Brunswick and Nordhausen.

RICHTER-ELSNER, Fritz 1884-
Born in Köppelsdorf, Germany, on January 8, 1884, he studied in Munich and worked in Berlin. He sculpted portrait busts and figures of historical and contemporary personalities and did the Jahn monument in Perleberg and the Cuirassiers' war memorial in Brandenburg.

RICHTERS, Bernardus Jacobus 1888-
Born in Rotterdam, on March 27, 1888, he studied at the Academy there and also in Düsseldorf, Stuttgart, Munich and Venice. He worked as an architectural sculptor in Rotterdam and Amsterdam.

RICKARD, Stephen 1917-
Born in Carshalton, Surrey, on May 9, 1917, he studied art in Kingston-on-Thames (1936-39).

RICKERT, Arnold 1889-
Born at Zoppot, near Danzig, on July 10, 1889, he studied under Engelhard and attended the Munich Academy. He specialised in tombs and memorials but also sculpted busts, heads and portrait reliefs and worked in Freiburg-am-Breisgau, Karlsruhe and Stettin.

RICKETTS, Charles 1866-1931
Born in Geneva, on October 2, 1866, of English parentage, he died in London, on October 7, 1931. He spent his boyhood in France, Switzerland and Italy, but came to England in 1882 to receive his art training at the Lambeth School of Art. He became friendly with Charles Shannon with whom he edited *The Dial* (1889-97) and founded the Vale Press which he operated from 1896 to 1904. Though best known as a printer of fine books, he also painted in oils and watercolours and worked as a wood-engraver, sculptor and art critic. His sculpture developed from 1906 onwards and he exhibited figures at the Royal Academy, being elected A.R.A. in 1922 and R.A. in 1928. His works are represented in a number of museum collections. He wrote a number of books on art and bibliography, including *The Prado and its Masterpieces* (1903) and *Titian* (1906).

RICOURT, Charles fl. 18th century
Born in Lille, about 1749, he studied at the School of Design and later the Academy in Lille and worked as a jeweller and silversmith. He entered the Paris Académie Royale in 1778 and studied sculpture under Le Comte. He exhibited at the Salon in 1793-95, statues and various projects for monuments. His chief work was the decorative sculpture on the powder magazine at Grenoble. His minor works include portrait busts and maquettes.

RIDOLFI, Ettore 1861-1892
Born in Rome in 1861, he died there in 1892. He sculpted figures and portraits and is best known for the Victor Emmanuel II monument in Civita Vecchia.

RIEBER, Alois 1876-
Born in Petschau, Bohemia, in 1876, he studied under Myslbek and became professor of sculpture at the Technical University in Prague.

RIEDERER, Karl 1819-1884
Born in Munich, in 1819, he died there on June 5, 1884. He was employed by Ludwig II of Bavaria as a decorative sculptor and did the statue in memory of the ill-fated king of Bavaria at Herrenchiemsee.

RIEDISSER, Wilhelm 1870-c.1913
Born at Kisslegg, Germany, on September 21, 1870, he died in Italy some time after 1913. The Munich orphanage has a crucifix sculpted by him.

RIEDL, Josef 1884-
Born in Vienna, on March 12, 1884, he studied under Johann Benk, Bitterlich and Hellmer. He sculpted monuments, tombs, statues and war memorials in Austria and is best known for the monument to President Ebert in Vienna.

RIEDMULLER, Johann 1815-1895
Born at Heimertingen, Germany, on November 2, 1815, he died in Munich on February 11, 1895. He worked as an ecclesiastical and decorative sculptor in various parts of southern Germany and produced figures and bas-reliefs for Ratisbon Cathedral and Waldstetten Church, as well as the memorials after the Franco-German War in Zweibrucken, Worms and Lauingen. His minor works include allegorical figures and maquettes for his monuments.

RIEGEL, Theodor J. 1866-
Born in Munich, in 1866, he worked as a painter and sculptor of portraits and figures and did decorative sculpture on the Reichstag and buildings in many German cities.

RIEKER, Albert George 1890-
Born in Stuttgart, on October 18, 1890, he studied at the academies of Munich and Stuttgart and exhibited both at home and abroad, receiving many awards. He was a prolific sculptor of memorials, monumental statuary, portrait busts and allegorical bas-reliefs in the inter-war period.

RIES, Theresa Feodorovna 1874-
Born in Moscow, on January 30, 1874, she trained at the Moscow Academy and studied under Hellmer in Vienna where she settled. She produced genre and allegorical works, such as The Legislator, The Kiss, Eve and Lucifer, but also did portrait busts of Hellmer, Mark Twain and other 19th century personalities in the world of the arts. Her chief work was the Liszt monument in Vienna.

RIESZ, Ferdinand 1824-1871
Born in Gmünd, Austria, in 1824, he died there in 1871. He studied under Sickinger and did decorative sculpture for his brother, the architect and designer Karl Riesz.

RIETH, Otto 1858-1911
Born in Stuttgart, on June 9, 1858, he died there on September 10, 1911. He studied at the Technical University in Stuttgart and was a pupil of Wallot in Frankfurt, assisting him in the construction and decoration of the Reichstag from 1883 to 1886. He sculpted the Bismarck monument in Heilbronn and the Galatea fountain in Stuttgart.

RIETSCHEL, Ernest Friedrich August 1804-1861
Born at Pulsnitz, Saxony, on December 15, 1804, he died in Dresden, on February 21, 1861. He studied at the Dresden and Berlin academies and went to Italy in 1830. He was appointed professor at Dresden Academy in 1832 and became an honorary member of the Berlin and Vienna academies in 1836. He exhibited nationally and internationally and won a gold medal at the Paris Exposition of 1855. He was a most versatile and prolific sculptor, producing busts of his artistic contemporaries, historical German figures, animal figures and groups (Panthers and other exotic creatures), portrait bas-reliefs and medallions, allegories of Day, Night, Morning and Evening, and classical groups, such as Cupid and a Panther, casts of which are in the museums of Leipzig and Stockholm.

RIETZLER, Franz Xaver 1838-1900
Born in Bavaria, on December 2, 1838, he died in Munich, on March 10, 1900. He studied under Widnmann and specialised in ecclesiastical sculpture. He founded the Institute of Religious Art, Munich, in 1876.

RIFESSER, Josef fl. late 19th century
Decorative sculptor working at St. Ulrich, Austria, in the 1890s.

RIFFARD, Albert 1859-1915
Born in Nîmes, on September 4, 1859, he died in 1915. He studied under Jouffroy and Hiolle and exhibited figures at the Salon des Artistes Français in the 1890s.

RIGAL, André fl. 20th century
Born in Paris, in the early years of this century, he specialised in nude statuettes. His figure of a Young Girl, shown at the Salon d'Automne in 1945, attracted favourable attention from the critics.

RIGAVELLI, Augustin 1890-
Born in Buenos Aires, in 1890, he was self-taught and specialised in portrait busts, th ough he also sculpted many monuments in the latter part of his career. He took up sculpture in 1913 and, on being rejected by the official Salon in Buenos Aires, he organised a Salon of Rejects. He won admission to the official exhibition in 1916.

RIGELE, Alajos 1879-
Born in Przemysl, Galicia, on Février 8, 1879, he studied in Vienna under Bitterlich and Hellmer and then worked for a time in Rome before returning to Przemysl. He sculpted portrait busts, reliefs and statuary of contemporary and historical celebrities and is best known for the tomb of Cardinal Pazmany and the statues of St. Zita and St. Elisabeth of Hungary in Przemysl.

RIMANDO, Giacomo 1855-
Born in Caltagirone, Sicily, in 1855, he studied at the Naples Institute of Fine Arts and worked as a decorative sculptor in southern Italy.

RINALDI, Rinaldo 1793-1873
Born in Padua, on April 13, 1793, he died in Rome, on July 28, 1873. He learned the techniques of sculpture from his father, the wood-carver Domenico Rinaldi, but he himself worked in various media, including bronze. He produced bas-reliefs, statues and groups, mainly religious in content, with a penchant for the Madonna and Child theme. His other works include The Wise and Foolish Virgins (Liverpool), The Wrestler (Gallerie d'Arte Antica, Rome) and Adonis (Venice).

RINEHART, William Henry 1825-1874
Born at Union Bridge, Maryland, on September 13, 1825, he died in Rome, on October 28, 1874. He studied at the Maryland Institute, Baltimore, and went to Rome in 1858 where he was converted to classicism. His chief works were the elaborate bronze doors of the Senate and House of Representatives in Washington. His minor works include The Good Samaritan (Walters Gallery, Baltimore) and Latona and her Children (Metropolitan Museum of Art, New York).

RINGEL D'ILLZACH, Jean Désiré 1847-1916
Born at Illzach, Alsace, on September 29, 1847, he died in Strasbourg, on July 28, 1916. He studied under Jouffroy and Falguière and exhibited at the Salon from 1873 onwards and the Nationale from 1904, receiving many awards from 1884 onwards and silver medals at the Expositions Universelles of 1889 and 1900. He specialised in busts and medallions portraying his contemporaries. Nine large bronze medallions are in the Cette Museum and his bust of Léon Gambetta is in the Le Mans Museum. Casts of The Rakoczy March are in the Luxembourg Gardens and the museums of Amiens and Châteauroux.

RINGLER, Karl 1864-
Born in Lucerne on September 19, 1864, where he worked as a portrait and figure sculptor.

RINIBEZ, Zacharie fl. 19th century
Born in Pau, in the mid-19th century, he studied under Moreno and exhibited busts, heads and portrait reliefs at the Salon from 1878.

RIOLO, Salvator fl. 20th century
French sculptor of Italian origin, exhibiting statuettes and groups at the Salon des Artistes Français in the inter-war period. He got an honourable mention in 1931, and third and second class medals in 1935 and 1936 respectively.

RIPAMONTI, Riccardo 1849-1930
Born in Milan on October 1, 1849, he died there on September 15, 1930. He exhibited in Turin, Florence, Milan, Rome, Bologna and Vienna at the turn of the century. He served under Garibaldi in the campaign of 1866-67 and was elected to the Milan Academy, but frequently fell foul of the establishment of the period, on account of his anti-clerical tendencies, evident in such works as Cain (symbolising the evils of the human conscience), Dies Irae and Judicial Error - both inspired by the Dreyfus Affair. He sculpted a number of tombs for Milan cemetery. The Gallery of Modern Art in Milan has his bronzes, including Cain, The Water Carrier, Waterloo, Borgia and Ugo Foscolo.

RIPLEY, Lucy Perkins fl. 20th century
Born in Minnesota in the late 19th century, she studied under Saint-Gaudens, Daniel C. French and Rodin, and sculpted bronze allegorical figures, such as The Inner Voice.

RIPSZAM, Henrik 1889-
Born in Nemetboly, Hungary, in 1889, he studied in Budapest and settled in England. He had a studio in Ockley, Surrey, for many years and was a member of the Society of Portrait Sculptors.

RISPAL, Gabriel 1892-
Born in Bordeaux, on May 14, 1892, he studied under Jean Boucher and exhibited figures at the Salon des Artistes Français from 1923 onwards, winning a second class medal in 1925 and a gold medal at the Exposition Internationale of 1937.

RISPAL, Jules Louis fl. 19th-20th centuries
Born in Bordeaux in the second half of the 19th century, he died there in 1910. He studied under M. Thomas and exhibited figures and portraits at the Salon des Artistes Français, getting an honourable mention in 1899, and third class (1901), second class (1902) medals, as well as a medal at the Exposition Universelle of 1900.

RISQUE, Caroline Everett 1886-
Born in St. Louis, Missouri, in 1886, she studied at the St. Louis School of Fine Arts under George Zolnay and then went to Paris where she studied at the Académie Colarossi and was a pupil of Paul Bartlett and Injalbert. She exhibited at the Paris Salon in 1912. She specialised in decorative work and small bronzes, many of which are preserved in the New Orleans Museum.

RISTERUCCI, Denise fl. 20th century
Born in Bordeaux, in the early years of this century, she exhibited statuettes, busts and heads of her contemporaries at the Salon d'Automne and the Indépendants.

RISTORI, Tite Henri Clement fl. 19th century
Born in Naples, he emigrated to France and worked at Marzy in the mid-19th century. He founded a pottery there about 1850 and won a first class medal at the Exposition of 1855. As a sculptor, he specialised in historic figures, groups and busts and also sculpted animal groups, such as Boar warding off a Pack of Hounds (Avignon Museum).

RISWOLD, Gilbert P. 1881-
Born at Sioux Falls, South Dakota, on January 23, 1881, he worked in Chicago and sculpted portrait busts and figures. His chief works are the statue of Stephen A. Douglas in Springfield and the Mormon Pioneers monument in Salt Lake City.

RITCHIE, Alexander Handyside 1804-1870
Born in Musselburgh, Midlothian, in 1804, he died in Edinburgh, in 1870. He studied under S. Joseph in Edinburgh and Thorvaldsen in Rome and is best known for the Wallace monument near Stirling. He sculpted many memorials and statues in the Edinburgh area and exhibited at the Royal Scottish Academy. His minor works include portrait busts of classical personalities, such as Hippocrates (1845) and contemporary Scots worthies.

RITCHIE, John 1809-1851
Born in Musselburgh, in 1809, he died in Rome in 1851. He was the younger brother of A.H. Ritchie and worked with him on monumental statuary.

RITTWEGER, Ernst 1869-
Born in Frankfurt-am-Main, on July 22, 1869, he studied under Kaupert and Hausmann and sculpted the statues at the entrance to the Ring Church in Wiesbaden.

RIVALTA, Augusto 1838-1925
Born in Alexandria, Egypt, of Italian parents, he died in Florence on April 14, 1925. He studied in Genoa and Florence and became professor of sculpture at the Florence Academy in 1870 and one of the outstanding Italian sculptors of the late 19th century. He exhibited widely at home and abroad and won a silver medal at the Exposition Universelle of 1900. He produced classical figures and groups - fauns, centaurs, nymphs, heroes and deities, mostly in bronze. Examples are in the museums of Berlin, Bucharest and Florence.

RIVIÈRE, Jean fl. 19th century
Born in Toulouse, in the mid-19th century, he studied at the Toulouse School of Fine Arts and exhibited figures at the Salon des Artistes Français, getting honourable mentions in 1882 and 1887.

RIVIÈRE, Joseph 1912-
Born in Bordeaux. in 1912, he exhibited figures and portraits at the major Paris Salons, and won an honourable mention in 1935 and a second class medal in 1938.

RIVIÈRE, Théodore Louis Auguste 1857-1912
Born in Toulouse, on September 11, 1857, he died in Paris, on November 9, 1912. He studied under Jouffroy, Mercié and Falguière, and exhibited at the Salon from 1876, becoming an Associate of the Artistes Français in 1894. He sculpted numerous monuments in many of the French colonies, particularly in Indo-China and North Africa. He won many medals at the Salons and a gold medal at the Exposition Universelle of 1900. He became an Officier of the Légion d'Honneur in 1906. His minor works include figures and busts of French historical personalities, allegorical groups extolling the glory of France, and native and animal figures and groups.

RIVOIRE, Raymond Léon 1884-
Born at Cussel, France, on October 21, 1884, he studied under Injalbert and exhibited at the Salon des Artistes Français from 1905, winning second class and first class medals in 1921 and 1929 respectively. He sculpted genre and historical figures in marble and bronze and did decorative work on Moulins Cathedral. Examples of his sculpture are in the Trocadero, Luxembourg, and museums in Le Mans and New York.

RIZZATO, Servilio 1889-
Born at Este, near Padua, on May 24, 1889, he worked as a decorative sculptor in that area.

RIZZELLO, Michael 1926-
Born in London, in 1926, he won the Prix de Rome in 1951, and subsequently specialised in two-dimensional sculpture, bas-reliefs, plaques, medals and coins. He has worked for the Royal Mint and is best known for sculpting the official medals for the Prince of Wales's Investiture and the 900th Anniversary of Westminster Abbey. He has sculpted the coins for Bahrain, Bermuda, the Congo, Iraq, Iran, Paraguay and the East Caribbean Currency Authority. He became President of the Royal Society of British Sculptors in 1976 and was awarded the C.B.E. in 1977.

RIZZOLI, Pasquale c.1871-
Born in Bologna, about 1871, he studied under Salvini and specialised in tombs, memorials and monumental statuary in the Bologna area. His chief work was the monument to the victims of the uprising of August 8, 1848, in Bologna.

ROBERT, Eugène fl. 19th-20th centuries
Born in Pau in the mid-19th century, he died there in 1912. He studied under Mathurin Moreau and exhibited at the Salon from 1874, getting honourable mentions in 1880-81 and 1884-85 and at the Exposition Universelle of 1889. He also won a third class medal in 1888 and a silver medal at the Légion d'Honneur for his work at the Exposition of 1900. He sculpted genre figures and groups and portraits of his contemporaries. Examples of his work are in the Roubaix Museum.

ROBERT, Louis Valentin Elias 1821-1874
Born in Étampes, in 1821, he died in Passy, on April 28, 1874. He studied under David d'Angers and Pradier and exhibited at the Salon from 1845. He produced busts and heads of his contemporaries, allegorical groups and decorative sculpture for public buildings. His allegories include France crowning Art and Industry (Palais de l'Industrie) Agriculture and Industry, and Drama (Chatelet Theatre).

ROBERT, Marc Jean 1875-
Born in Agen, France, on March 26, 1875, he studied under Falguière and Mercié and exhibited figures and groups at the Salon des Artistes Français, getting a third class medal in 1906 and a first class medal in 1925.

ROBERT, Marie Melchior Auguste fl. 19th century
Born at Conflans St. Honorine, in the first half of the 19th century, he studied under Destriez and exhibited bas-reliefs and medallions at the Salon from 1870.

ROBERT, Philippe Alphonse 1909-
Born in Paris in 1909, he exhibited figures and portraits at the Salon des Artistes Français.

ROBERT CHAMPIGNY, Charles Hubert fl. 19th century
Born at Ancy-sur-Moselle, in the 19th century, he studied in Paris and exhibited genre figures, particularly featuring children, at the Salon des Artistes Français, winning an honourable mention in 1901.

ROBERTON, Adolphe fl. 19th century
Born in Paris in the mid-19th century, he died there in 1899. He studied under Fournier and Truphème and exhibited figures at the Salon from 1881 till his death.

ROBERTS, Phyllis Kathleen (née Aspden) 1916-
Born in London, on June 11, 1916, she studied at Hornsey College of Art and exhibited at the Royal Academy and other leading British galleries. She has also exhibited at the Paris Salon, winning a silver medal in 1959 and a gold medal in 1964. She lives in Enfield, Middlesex, and works as a painter and sculptor of portraits.

ROBERTS-JONES, Ivor 1916-
Born in Oswestry, Shropshire, on November 2, 1916, he studied at the Goldsmiths' College School of Art under Clive Gardiner (1932-34) and the Royal Academy schools (1934-38). After service with the Royal Artillery in Burma during the second world war, he joined the staff of the Goldsmiths' College in 1946. He had his first one-man show at the Beaux Arts Gallery in 1957 and was elected A.R.A. in 1969. He specialises in portrait sculpture, in bronze and concrete.

ROBERTSON, Richard Ross 1914-
Born in Aberdeen, on September 10, 1914, he studied at the Glasgow School of Art (1932) and Gray's School of Art, Aberdeen (1933-38) and works as a portrait and figure sculptor in Aberdeen. He has exhibited at the Royal Academy and the Royal Scottish Academy (A.R.S.A. 1969), and sculpts figures and groups in wood, stone, clay and bronze.

ROBIN, Honoré fl. 19th century
Parisian sculptor of genre figures, he exhibited at the Salon des Artistes Français in the 1890s.

ROBINET, Pierre Alfred 1814-1878
Born in Paris, in 1814, he died there on April 8, 1878. He studied under Pradier and was runner-up in the Prix de Rome of 1840. He exhibited at the Salon from 1835 to 1877, specialising in busts and statuettes of his contemporaries. He moved to Jersey for health reasons in 1871 and sculpted the monument to General Don, a former Governor of the bailiwick. His Genius of Commerce, exhibited in 1877, was part of a project for this monument.

ROBINET, Stephane 1799-1869
Born in Paris, on December 6, 1799, he died there in December 1869. He exhibited busts of his contemporaries at the Salon in 1831-34.

ROBINOT-BERTRAND, Charles Guillaume 1778-1840
Born in Nantes, on September 3, 1778, he died there on February 24, 1840. He was the son and pupil of the painter Charles Robinot-Bertrand and studied sculpture at the Nantes School of Fine Arts (1801) under Dejoux. He produced classical and allegorical figures.

ROBINSON, Helen Avery fl. early 20th century
Born in Louisville, Kentucky, she studied under Solon Hannibal Borglum and produced portraits and figures in marble, plaster and bronze.

ROBLOT, Armand François 1890-
Born in Paris, on May 16, 1890, he studied under Mercié and Fountaine and worked as a decorative sculptor in Rouen. He exhibited figures and bas-reliefs at the Salon des Artistes Français, becoming an Associate in 1914 and winning a third class medal in 1924.

ROBYN, Corneille Jean Louis 1835-1912
Born in Antwerp, in 1835, he died in Brussels, on October 13, 1912. He specialised in busts of his contemporaries.

ROCA REY, Joaquin 1923-
Born in Lima, Peru, in 1923, he studied at the National Art School and was a pupil of Victorio Macho. He had his first one-man show in Lima in 1948 and in the ensuing years he travelled extensively in western Europe. In 1950 he won the major prize at the Spanish-American Salon in Madrid and the following year he took part in exhibitions in Paris, Florence and Rome. He was one of the prize-winning entrants in the competition for the monument To the Unknown Political Prisoner (1952) and subsequently won a number of important commissions for monuments in Latin America. He has taught sculpture in Lima since 1957. His earlier work was carved in stone and wood, then he turned to clay, and in more recent years has worked in various metals such as iron, steel and bronze, using lamination and welding techniques as well as casting to create abstracts.

ROCAMORA Y BERNAT, Ramiro 1877-
Born at Reus, near Barcelona, in 1877, he worked as a painter and sculptor at Sarria and studied under Casals. Many of his bas-reliefs and figures are in Reus Town Hall.

ROCH, Clotilde 1867-
Born in Geneva, in 1867, she studied under Bovy and Bounal and exhibited at the Salon des Artistes Français in 1904. She specialised in busts and portrait reliefs of her contemporaries. Her bronze plaquette portraying Hugues Bovy is in the Rath Museum.

ROCH, Susi fl. 20th century
She exhibited statuettes at the Salon des Indépendants in the inter-war period.

ROCHAL fl. 20th century
Sculptor of monuments, statues, busts and allegorical figures, working in Buenos Aires. His chief work is the monument to General Belgrano.

ROCHARD, René fl. 20th century
An Associate of the Artistes Français, he won a bronze medal at their Salon in 1941.

ROCHE, Pierre (pseudonym of Fernand Massignan) 1855-1922
Born in Paris in 1855, he died there on January 18, 1922. He studied under Roll, Dalou and Rodin and exhibited at the Salon des Artistes Français, and the Nationale, winning a silver medal at the Exposition Universelle of 1900 and the Légion d'Honneur. He produced heads, busts and figures of religious, allegorical and historical subjects, bronze statuettes of nude women, plaques and medallions.

ROCHEBRUNE, Octave Guillaume de 1824-1900
Born at Fontenay le Comte, on April 1, 1824, he died there on July 1, 1900. He studied under J. Ouvrie and L. Petit and exhibited engravings, drawings and sculpture at the Salon from 1845. He was awarded the Légion d'Honneur in 1874.

ROCHET, Louis 1813-1878
Born in Paris, on August 24, 1813, he died there on January 21, 1878. He studied under David d'Angers and exhibited at the Salon from 1838 to 1897, winning a third class medal in 1841 and becoming a Chevalier of the Légion d'Honneur in 1856. He produced busts and figures of French historical personalities, from Francis I to Napoleon, but also sculpted celebrities of other countries, from Charlemagne to Dom Pedro of Brazil. He did a series of allegories for Rio de Janeiro. His best known work is the statue of William the Conqueror at Falaise.

ROCK, Helen Frazer fl. 19th-20th centuries
Figure and portrait sculptor and potter working in Wimbledon, London, where she died in 1932. She studied at the Royal Academy schools and exhibited at the Academy at the turn of the century.

ROCKLIN, Raymond 1922-
Born in Moodus, Connecticut, in 1922, he trained as an electronics engineer in the Army during the second world war and studied drawing and sculpture at the Educational Alliance Art School (1948-49) and the Cooper Union Art School (1949-51), winning a travelling scholarship which took him to Italy for a year. Since then he has taught sculpture at the American University, Washington, and the University of California, Berkeley. He had his first one-man show in New York in 1956 and has also participated in many national exhibitions in the United States. He sculpts abstracts, using a wide range of metals and techniques.

RODE, Eugénie C. fl. late 19th century
Born in Paris in the mid-19th century, she worked there as a painter and sculptress of genre subjects and exhibited figures at the Salon des Artistes Français in the 1880s.

RODER, André 1900-
Born in Vienna, on May 31, 1900, he studied under Paul Paintl and then Bitterlich at the Academy (1925-30). He was awarded the Prize of Honour in 1928 for his Mothers' Monument. His minor works include portrait busts and statuettes.

RÖDER, Karl fl. 19th-20th centuries
Born at Griez, Germany, in the mid-19th century, he died in Dresden on February 17, 1922. He studied under Hähnel in Dresden and worked for some time in Italy. He settled in Dresden where he worked as a decorative sculptor, specialising in genre figures. His bronze of The Oarsman is in the Dresden Museum, while Löbau Church has his group of The Four Evangelists.

RODIN, Auguste 1840-1917
Born in Paris in 1840, he died at Meudon on November 17, 1917. He was of humble origin and was given a religious education. Deeply affected by the death of his sister, he considered entering the priesthood but embarked on an artistic career instead. Turned down by the École des Beaux Arts, he became an ornamentalist, moulder and chiseller to earn a living. From 1864 to 1871 he worked in the studio of Carrier-Belleuse at the Sèvres porcelain works. From 1871 to 1878 he was in Belgium where he was greatly influenced by Meunier. He made copies of sculpture in museums and produced various works on a commission basis. His strong personality only began to express itself sculpturally after he had visited Italy in 1875 and culminated in his first work of major importance, The Age of Bronze (1877), which created a considerable furore at the time. Thenceforward his works were invariably the subject of violent controversy. He was deeply pre-occupied by the challenge of linking sculpture and architecture. In 1884 he began work on The Burghers of Calais, completed ten years later. Other monumental works of the late 19th century include Victor Hugo, Gate of Hell, The Thinker, The Kiss and, above all, the statue of Balzac, refused in 1898 by the Société des Gens de Lettres which had commissioned it, but finally erected at the Raspail-Montparnasse intersection in 1939 – 22 years after Rodin's death. At the Exposition Universelle of 1900 he had an entire pavilion devoted to him, and thereafter he became something of a national institution. He has the singular honour of having three museums devoted to him - the Rodin Museum (Hôtel Biron, Paris), the Rodin Museum, Meudon, and the Rodin Museum, Philadelphia (1929). He produced a wide range of heads, busts, figures and groups – portraits, allegories, historical and genre subjects. He exhibited at the Salon des Artistes Français till 1890 when he transferred his allegiance to the new Salon of the Société Nationale des Beaux Arts. His works are represented in many of the world's leading art collections. Of the vast literature on Rodin and his works, the following are among the more useful.
Alexandre, Arséne P. *Le Balzac de Rodin* (1898). Arts Council of Great Britain *Rodin* (1970). Benedite, L. *Rodin* (1926). Black, C. *Auguste Rodin: the Man, his Ideas and his Works* (1905). Cladel, J. *Auguste Rodin, the Work and the Man* (1917). Champigneulle, Bernard *Rodin* (1967). Descharmes, Robert and Chabrun, Jean François *Auguste Rodin* (1967). Hawkins, Jennifer *Rodin Sculptures* (1971). Maillard, L. *Rodin* (1899). Tirel, M. *Last Years of Rodin* (1925).

RODO Y SAMARACH, Pablo 1843-1894
Born at Tarrasa, near Barcelona, on December 25, 1843, he died in Barcelona on January 5, 1894. He studied under Cabanas and also in Rome and Paris and specialised in figures and reliefs of religious subjects.

RODRIGUES, Faustino José 1760-1829
Born in Lisbon, on February 15, 1760, he died there in 1829. He studied under J. Machado de Castro and worked as a painter and sculptor of genre subjects. He was professor at the Lisbon School of Fine Arts.

RODRIGUES, Francisco de Assis 1801-1877
Born in Lisbon on October 12, 1801, he died there on February 1, 1877. He was the son and pupil of F.J. Rodrigues and worked as a sculptor and writer. He became professor, and later director, of the Lisbon School of Fine Arts. As a sculptor he is best known for the decoration in the theatres and churches of Lisbon.

RODRIGUEZ, Andres fl. 19th century
Born at Santiago de Compostella, Spain, in the early 19th century, he worked in Madrid from 1848 to 1875, producing figures and groups of classical, historical and contemporary subjects.

RODRIGUEZ, E. fl. 20th century
Sculptor of genre figures and portraits, working in Havana, Cuba, in the mid-20th century.

RODRIGUEZ, José 1839-1909
Born at Santa Maria Villanueva, Spain, in 1839, he died in Cadiz in 1909. He worked as an architect and decorative sculptor in the Cadiz and Cordoba area and specialised in religious figures and bas-reliefs.

ROEDER-GARBE, Emy 1890-
Born in Wurzburg, Germany, on January 30, 1890, she studied under Bernhard Hoetger in Darmstadt (1912-14) and settled in Berlin. She was a founder member of the November Group and married the painter Herbert Garbe. She left Germany when the Nazis came to power in 1933 and lived in Florence for several years, but was interned by the Fascists. She returned to Germany in 1949 and taught at the Mainz Art School till 1955. A retrospective exhibition of her work was held in Darmstadt, Brunswick and Munich in 1959. Her figures and busts have been influenced by Gothic art and Expressionism but later she turned to Realism. Her works include portraits of her contemporaries, such as Heckel, Purrman and Schmidt-Rottluf, genre figures and groups, such as Pregnant Woman, Praying Boy (both 1919), Sisters (1933), Mother and Child (1939) and Three Women under a Shower, and various studies of horses, executed in the 1920s.

ROEDER, Wilhelm 1882-1926
Born at Heiligensee, Germany, on January 15, 1882, he died in Berlin on December 27, 1926. He studied under Widemann and sculpted genre and allegorical figures.

ROEMER, Georg 1868-1922
Born in Bremen on January 19, 1868, he died in Munich on January 25, 1922. He studied in Dresden, Berlin, Paris, Rome and Florence and was a pupil of Hildebrand. He is best known for the Franzius monument in Bremen and the fountain in Munich's exhibition park, but he also sculpted nudes and athletes, notably The Javelin Thrower (Munich University).

ROGER, François fl. 19th century
Born at Rambervillers, France, in the mid-19th century, he died in Paris in 1898. He studied under Dumont and Bonnassieux and exhibited at the Salon from 1873 onwards, winning a third class medal in 1880 and a second class medal in 1887. He also got a silver medal at the Exposition Universelle of 1889. His best known work is the monument to the National Guard of 1870, in Rambervillers Town Hall, but he also sculpted various classical and allegorical groups, such as Time discovering Truth (Cambrai Museum) and The Dream of Omphalus.

ROGERS, John 1829-1904
Born in Salem, Massachusetts, on October 30, 1829, he died in New Canaan on July 26, 1904. He studied under Spencer in Rome and became a member of the National Academy in 1863. His major works include the equestrian statue of General John F. Reynolds in Philadelphia and the Declaration of American Independence (Ariana Museum, Geneva), but he is best known for his small genre figures and groups, in bronze, terra cotta and other ceramic materials.

ROGERS, Randolph John 1825-1892
Born in Waterloo, New York, on July 6, 1825, he died in Rome, on January 15, 1892. He studied in New York, Rome and Florence, and was a pupil of Bartolini. His chief work is the bronze door for the Capitol in Washington, but he also sculpted many monuments after the American Civil War. His minor works include classical figures, such as Nydia, Psyche, Ruth and The Dead Pleiad, examples of which are in the museums of New York and Chicago.

ROGOZINSKI, Martin c.1825-1855
Born in Cracow, about 1825, he died there in 1855. He studied at the Cracow School of Fine Arts and worked in western Europe in the late 1840s. He specialised in religious figures and groups. His Temptation of Christ (1854) is in the Cracow Museum.

ROGUET, Louis 1824-1850
Born at St. Jumien, France, on December 24, 1824, he died in Rome, on September 24, 1850. He studied under Duret and was runner up in the Prix de Rome of 1848, winning the prize the following year. He died of an illness contracted while studying in Rome. His work, exhibited at the Salon of 1849-51, showed immense talent and promise. His allegorical and classical figures, groups and nudes are preserved in Orleans Museum.

ROHATSCHEK, Konrad 1872-
Born at Herrbaumsgarten, Bohemia, on February 8, 1872, he studied under Csadeck in Vienna (1885-89) and settled in Salzburg in 1895, where he specialised in ecclesiastical decoration.

ROHL-SMITH, Carl Wilelm Daniel 1848-1900
Born in Roskilde, Denmark, on April 3, 1848, he died in Copenhagen, on August 20, 1900. He studied at the Copenhagen Academy from 1865 to 1870 under H.V. Bissen and then worked in Berlin (1875-77) and Vienna (1877-81) before becoming a professor at the Copenhagen Academy. He worked in New York from 1886 to 1900 and sculpted monuments in St. Louis and Chicago as well as busts and statuettes portraying Indian chiefs and American military celebrities. He also sculpted classical figures, such as Ajax, and many busts and heads of his Danish contemporaries.

RÖHRER, Carl 1874-
Born in Braunau, Austria, on February 2, 1874, he studied under Erwin Kurz in Munich and specialised in busts of literary and artistic figures in the early years of this century.

RÖHRIG, Karl 1886-
Born at Eisfeld, Germany, on January 27, 1886, he worked as a potter and sculptor in Munich.

ROIDER, Maximilian 1877-
Born in Hörmannsdorf, Bavaria, on April 29, 1877, he studied under Romeis, Pruska, Hess and Eberle in Munich and worked in Ratisbon. He sculpted religious figures and monuments for various towns in southern Germany.

ROINÉ, Jules Édouard 1857-1916
Born in Nantes on October 24, 1857, he died in Paris on April 11, 1916. He studied under Chantron and Morice and worked in New York from 1886 to 1894, before settling in Paris. He worked as a decorative sculptor and produced figures and bas-reliefs for many theatres and churches in New York.

ROKSANDIE, Simeon G. 1874-
Born at Majska Poljana, Croatia, on April 1, 1874, he studied in Budapest and Munich and became professor at the School of Fine Arts in Belgrade. He is best known for the war memorial at Vranje and the Fishermen's fountain in Belgrade, but he also sculpted portraits and genre figures.

ROLAND, Philippe Laurent 1746-1816
Born at Marcq-en-Pévèle, near Lille, on August 13, 1746, he died in Paris, on July 11, 1816. He was the son of a stone-mason, and was apprenticed to a wood-carver in Lille while also attending drawing classes at Lille municipal school. Later he studied sculpture under Tiller and Guéret and came to Paris in 1764. He attended the Royal Academy School and spent five years in Rome, being elected to the Academy in 1782. He was a protégé of Pajou and worked with him on several of his most important commissions. He exhibited at the Salon from 1783 to 1814 and decorated various palaces and public buildings, including Fontainebleau and the Louvre. He became a professor at the Academy and a member of the Institut. He is best known for his Homer Singing and Playing the Lyre (the Louvre), but he also sculpted many busts of his contemporaries. Projects, models and bronze reductions of monuments and allegorical groups are in various French museums.

ROLARD, François Laurent 1842-1912
Born in Paris, on January 26, 1842, he died there in 1912. He studied under Jouffroy and Crauck and exhibited at the Salon from 1867. He sculpted monuments and public statuary in Paris. Many of his minor works portray his friend Dr. René Levasseur, and include busts, groups and bas-reliefs.

ROLEZ, Marie Émilie 1896-
Born at Verteuil, France, on September 12, 1896, she studied under Descatoire and exhibited figures at the Salon des Artistes Français from 1925, winning a medal in 1929.

RÖLL, Fritz 1879-
Born in Berlin, on March 16, 1879, he studied in Berlin (1909) and worked under Eberlin, J. Götz and L. Manzel. He won the Prix de Rome in 1910 and worked in Italy till 1914. He produced busts and statuettes depicting peasant subjects.

ROLLAND, Jane R.S. fl. 20th century
French sculptress of genre subjects, exhibiting at the Salon des Artistes Français, getting an honourable mention in 1941 and a second class medal the following year.

ROLLER, Jean 1798-1866
Born in Paris, on December 30, 1798, he died there on November 21, 1866. He began as a piano salesman, but later took up painting and sculpture and studied under Gautherot. He exhibited at the Salon from 1836 to 1866, getting a third class medal in 1840, a second class in 1842 and a first class medal in 1843. He became a Chevalier of the Légion d'Honneur in 1844. He was extremely fashionable during the second empire and sculpted many heads, busts and reliefs of his contemporaries as well as genre figures and groups.

ROLLIN, Ernest fl. late 19th century
Born at Blerville, France, in the mid-19th century, he exhibited statuettes at the Salon from 1878.

ROLLINS, John fl. late 19th century
Sculptor working in London in the late 19th century, he studied at the Royal Academy schools and exhibited at the Academy from 1887. His chief works are the colossal statue of Queen Victoria at the Royal Victoria Hospital, Belfast, and the Boer War memorial in Eton College Chapel.

ROMAGNOLI, Guiseppe 1872-
Born in Bologna, on December 14, 1872, he studied under Barbieri and became Director of the Medallists School in the Rome Academy in 1909. He specialised in bas-reliefs, plaques and medallions, but his sculpture in the round includes the marble busts of Youth in the Gallery of Modern Art, Rome.

ROMAIN fl. early 19th century
Bronzes bearing this signature are thought to have been the work of a Dutch sculptor named Christian Romain, working in Paris in the early years of the 19th century.

ROMAN, Jean Baptiste Louis 1792-1835
Born in Paris, on October 31, 1792, he died there on February 11, 1835. He studied under Cartellier and exhibited at the Salon from 1824 to 1831. He was runner-up in the Prix de Rome of 1812 and won the prize four years later. He became a Chevalier of the Légion d'Honneur in 1827 and a member of the Institut in 1831. He specialised in busts of his contemporaries and classical figures and groups.

ROMAN ROJAS, Samuel 1907-
Born in Rancagua, Chile, of peasant stock, he taught himself to model in clay and carve wood, and in 1924 came to Santiago where he enrolled at the School of Art and won a medal at the national Salon a year later. Thereafter he won numerous prizes in Chile, including the Humboldt scholarship (1937) which enabled him to continue his studies in Germany for two years. He exhibited in Berlin before returning to Latin America. He taught at the University of Santiago and later founded the School of Chilean Workshops, stimulating interest in the arts and crafts. Many of his statues are in Chilean parks and squares and he has also sculpted many busts of his contemporaries. A retrospective exhibition held in Santiago in 1950 included 82 pieces of sculpture in various media. He works in clay, plaster, bronze and granite.

ROMANELLI, Carlo 1872-
Born in Florence, on August 24, 1872, he worked in Rome and emigrated to the United States, settling in Los Angeles where he sculpted portrait medallions and busts.

ROMANELLI, Pasquale 1812-1887
Born in Florence, on March 28, 1812, he died there on February 11, 1887. He sculpted busts and statues, mainly in marble.

ROMANELLI, Raffaello 1856-1928
Born in Florence, on May 13, 1856, he died in 1928. He was the son and pupil of Pasquale Romanelli and exhibited in the major Italian salons as well as in Paris and London at the turn of the century. His chief works are the equestrian statue of Garibaldi in Siena and the Charles Albert monument in the Quirinal, Rome. His minor works include genre, historical and classical bronze statuettes, examples of which are in the Pitti Palace, Florence.

ROMANELLI, Romano 1882-
Born in Florence, on May 14, 1882, he was the son and pupil of Raffaello Romanelli. He travelled all over the world and worked as a sculptor, medallist and writer. His sculpture includes busts and statuettes of historical and contemporary celebrities, nudes and genre figures of women, bas-reliefs, plaques and medallions. He sculpted the original plaster for the Italian War Medal of 1918.

ROMANO, Nicholas 1889-
Born at Montoro, Italy, on December 6, 1889, he studied under Laessle and worked in Philadelphia as a painter and sculptor of portraits and genre subjects. Examples of his work are preserved in the Pennsylvania Academy of Fine Arts.

ROMBAUX, Egide 1865-
Born at Schaerbeek, Belgium, on January 19, 1865, he was the son and pupil of the stone-mason and monumental sculptor Felix Rombaux. Later he studied under Jef Lambeaux, Van der Stappen, Groot and Desenfans. He won the Prix de Rome in 1891 and became a professor at the Institut Supérieur des Beaux Arts, Antwerp and later the Brussels Academy. He sculpted monuments, statues, busts and bas-reliefs of contemporary personalities in marble and bronze, including figures of Gabrielle Petit and the monuments to Paul Jansen and Edith Cavell in Brussels. His minor works include statuettes of young girls, genre, classical and mythological figures such as First Morning (Tate Gallery, London).

RÖMER, Bernhard Wilhelm Erdmann 1852-1891
Born at Grosz-Strelitz, Mecklenburg, on February 21, 1852, he died in Berlin, on June 30, 1891. He studied under Wolff and worked in Rome from 1879 to 1881. He specialised in busts of Prussian and German royalty.

ROMER, Georg 1868-
Born in Bremen, on January 19, 1868, he studied at the Dresden Academy and worked in Berlin, Florence and Paris before settling in Munich in 1902. Bremen Museum has various busts, classical figures (Atalanta and Hippomenes), statuettes of dancers and plaquettes by him.

ROMOLI, Pietro fl. 19th century
Born about 1825, he worked as a decorative sculptor in Florence.

RONCEVSKIS (Ronczewski), Konstantins 1874-
Born in St. Petersburg, on December 31, 1874, of Polish parents, he studied architecture at Riga Polytechnic and settled in Latvia after studying in Munich and Paris (1905-11). He became professor of sculpture at the Riga Polytechnic and examples of his work are in the Riga Museum.

RONDONI, Alessandro fl. 19th century
Born in Rome, he exhibited there and also in Naples, Milan and Turin, specialising in busts and statuettes of historical cultural personalities, such as Raphael, Caracci and Andrea del Sarto.

ROOD, John 1902-
Born in Athens, Ohio, in 1902, he had a variety of jobs before he took up sculpture in 1933. He published a literary journal *Manuscript* (1933-36) and had his first one-man show in New York in 1937, followed by many others in various parts of the United States. He has also taken part in international exhibitions in Latin America and Europe since the second world war. He has taught sculpture at the University of Minnesota since 1944 and has had many public commissions, mainly for American churches. He works in wood, stone and various metals and has long been interested in the potential growth of forms, with specific reference to birth, growth, death and resurrection. His abstracts sculpted in this theme include Growth (1955). He lives in Minneapolis.

ROOS, August 1826-c.1893
Born in Rome, on September 24, 1826, he died some time after 1893. He studied at the Academy of St. Luke, Rome, and founded a sculpture studio there in 1861.

ROOSVAL VON HALLWYL, Ellen 1867-
Born in Södermanland, Sweden, on July 29, 1867, she studied under Carl Milles in Stockholm and Toussaint in Paris, and later founded the Hallwyl Museum in Stockholm, where the main collection of her sculptures is preserved. She sculpted genre and allegorical groups and bas-reliefs, such as The Dance, but is chiefly remembered for her religious figures and groups.

ROQUES, François Jules Alexandre fl. 19th-20th centuries
Born in Aurillac, France, in the mid-19th century, he worked there as a genre sculptor at the turn of the century and exhibited figures at the Nationale from 1904.

RORIMER, Louis 1872-
Born in Cleveland, Ohio, on September 12, 1872, he studied under Puech, Widemann and La Blanc in Paris and was a member of the Salmagundi Club.

ROSA, Ercole 1846-1893
Born at San Severino, Italy, on February 13, 1846, he died in Rome, on October 11, 1893. He was influenced by Vincenzo Vela and served under Garibaldi at Mentana. He sculpted the equestrian statue of Victor Emmanuel II in the Piazza Duomo, Milan. His minor works include heads, busts and statuettes of Garibaldi, Manzoni and other Italian celebrities, and classical figures, such as Diana.

ROSANDIC, Toma 1876-
Born in Belgrade, in September 1876, he studied under Mestrovic and produced genre and portrait figures. His bronze Abandoned is in the Boymans Museum, Rotterdam. Other bronzes include Auto-Portrait and The Sculptor.

ROSATI, James 1912-
Born in Washington, D.C. in 1912, he produces sculpture influenced by Brancusi and Arp. He has exhibited at the Whitney Museum, New York, since 1952 and teaches at the Cooper Union Art School and the Pratt Institute, New York. He had his first one-man show at the Peridot Gallery, New York, in 1954. His bronzes include Bull (1951).

RÖSCH, Wilhelm 1850-1893
Born at Neckarems, Germany, on October 29, 1850, he died in Stuttgart, on August 6, 1893. He studied under Donndorf and specialised in figures of historical and contemporary personalities and genre groups. His works include the statue of Kepler in Stuttgart Polytechnic and the Nauff and Möricke monuments in the same city. Stuttgart museum has his Boy with a Horse-fly.

ROSENBERG, Walter 1882-
Born in Königsberg, in 1882, he studied at the local Academy under Friedrich Reusch, and sculpted a number of monuments, memorials and statues in East Prussia.

ROSENBERGER, Michael fl. 19th century
Born at St. Johann, near Herberstein, Austria, in the early 19th century, he died in Graz, on June 30, 1875. He sculpted ecclesiastical decoration in Graz.

ROSENFALK, Carl Julius 1815-1878
Born in Copenhagen, on October 25, 1815, he died there on April 3, 1878. He studied at the Copenhagen Academy and sculpted monuments and statuary for various Danish towns.

ROSENTHAL, Adolf 1838-1866
Born in Osnabrück, on April 28, 1838, he died there on September 23, 1866. He studied under Rauch in Berlin and sculpted allegorical and genre figures, examples of which are in the museums of Osnabrück and Hanover.

ROSENTHAL, Bernard 1914-
Born in Illinois, in 1914, he studied at the University of Michigan and then worked with Carl Milles at Cranbrook Academy in 1939. He has taken part in many exhibitions and has had over a dozen one-man shows since the second world war. He was represented at the Brussels World's Fair (1958) and has won several major prizes in San Francisco and Los Angeles since 1950. His many architectural commissions have included bronze reliefs for Chicago and Beverly Hills, several fountains, notably those for the Museum of Science and Industry, Chicago (1941) and a Ballet group for the R.K.O. studios in 1952. His work is represented in many private and public collections, notably Illinois State Museum of Natural History and Art and the museum of the University of Arizona. He lives in Malibu, California.

ROSKAM, Édouard 1854-1912
Born in Amsterdam, in 1854, he died in Brussels, on February 26, 1912. He studied at the Louvain Academy and worked in Louvain, St. Gilles and Brussels as a decorative sculptor.

ROSLYN, Louis Frederick 1878-
Born in London, on July 13, 1878, he studied at the Royal Academy Schools, winning the Landseer scholarship. He specialised in portrait busts of contemporary celebrities and also produced bronze statuettes of classical subjects, such as Prometheus Bound (Liverpool Museum).

ROSS, Alfred fl. 19th century
Born at Tillières-sur-Aube, in the first half of the 19th century, he died in Paris, in 1880. He studied under Jouffroy and exhibited at the Salon from 1869. He specialised in portrait busts and medallions of literary and artistic figures, such as Baudelaire. His chief work is a bas-relief depicting a panoramic view of Valenciennes, commissioned by the Pharmacy School of that town.

ROSS, Franz 1858-1900
Born in Berlin, on November 10, 1858, he died there on October 5, 1900. He studied under Schaper in Hanau and Berlin. His best known work is the Kaiser Wilhelm I memorial in Rathenow.

ROSS, H. fl. 19th century
Portrait sculptor working in London from 1851 to 1867. He showed statuettes of Peel and Wellington at the Great Exhibition of 1851 and a group entitled Home Sweet Home at the International Exhibition of 1862. He exhibited at the Royal Academy from 1858 to 1867, specialising in portrait busts. A colossal bust of the Duke of Wellington by him was formerly displayed at the Crystal Palace, Sydenham.

ROSSI, Alessandro 1820-1891
Born in Lugano, in 1820, he died in Milan, on January 15, 1891. He was a professor at the Academy of Fine Arts, Milan, and exhibited portraits and allegorical figures there and in Turin.

ROSSI, Eduardo 1867-1926
Born in Naples, on September 20, 1867, he died there on May 1, 1926. He studied under Achille d'Orsi and worked as a decorative sculptor.

ROSSI, Egisto fl. 19th century
Born in Tuscany, he was regarded as one of the finest Italian sculptors of the 19th century. He sculpted numerous busts, statues and monuments.

ROSSI, Guiseppe 1823-1907
Born in Milan in 1823, he died in Novara, on August 7, 1907. Examples of his figures and groups are in the Galleries of Modern Art in Rome and Florence.

ROSSI, John Charles Felix 1762-1839
Born in Nottingham, on March 8, 1762, he died in London, on February 21, 1839. He was the son of a doctor who had come from Siena to work in Britain. He studied under G. Locatelli and also at the Royal Academy schools and was employed as a modeller at the Derby porcelain factory (1788-89) and then worked with Vulliamy, modelling ormolu mounts for clocks. Later he joined Coade and worked in terra cotta, eventually devising an improved formula for this substance. He was awarded the Academy gold medal in 1784 for his group Venus Conducting Helen to Paris, and the following year won the Academy's travelling scholarship, which enabled him to continue his studies in Rome for three years. During this period he carved direct in marble, though the Royal Academy advised him to concentrate on clay modelling. On his return to London he formed a partnership with J. Bingley for the manufacture of terra cotta figures. He was elected A.R.A. in 1798 and R.A. in 1802. He was Sculptor to the Prince of Wales, later King George IV, from 1797 to 1830, and Sculptor to William IV from 1830 to 1837, and was responsible for a number of friezes and statues in Buckingham Palace. His minor works include many tombs, memorials, busts and heads of contemporary celebrities. He exhibited at the Royal Academy from 1782 to 1834 and at the British Institution from 1806 to 1834. On his retirement in 1834 the contents of his studio were sold. Though mainly working in terra cotta and marble, Rossi produced bronze figures, the best known being his equestrian statuettes of the Duke of Wellington attended by Fame and Victory. His bronze bust of James Wyatt is in the National Portrait Gallery. He was married twice and had eight children by each wife.

ROSSI, Remo 1909-
Born in Locarno, Switzerland, in 1909, he studied in Milan and Paris and has taken part in many exhibitions in Switzerland and abroad since 1945. His chief work is the monumental fountain in Bellinzona. His minor works include series of Cats and Acrobats (1957-58) and a frieze of Horses (1957).

ROSSIGNOLI, Vincenzo 1856-c.1920
Born in Assisi, in 1856, he died in Florence, about 1920. He studied under Passaglia and worked as a decorative sculptor in Florence, mainly carving direct in wood.

ROSSMANN, Maximilian Georg 1861-
Born in Vohenstrauss, Germany, on May 10, 1861, he worked as a painter and decorative sculptor in Amorbach. He studied under Gagl, Löfftz, Benczur and Lindenschmitt and was influenced by Thoma. Examples of his work are in the Institut Städel in Frankfurt.

ROSSO, Medardo 1858-1928
Born in Turin, in 1858, he died in Milan, on March 31, 1928. Though intended for a career in the Civil Service, he rebelled against this and ran away from home. He went to work for a marble mason at the age of twelve and learned the rudiments of modelling and carving from him. Later he studied art at the Brera Academy but was expelled in 1884 for leading a student's revolt against the classicism of the teaching. He attempted to illustrate the life of the Milanese streets in his work, using the expressiveness of shadows to register human feelings and moods, such as tenderness, humility, grace and attentiveness. Though it has been said that he owed a great deal to Daumier his style was radically different. No sculptor, in fact, has ever come closer than Rosso, in sentiment and inspiration, to the Impressionist painters of the 1880s. From 1885 he worked in Paris in Dalou's studio and became acquainted with Rodin, Degas and the art connoisseur Rouard. He exhibited in Milan, Rome, Venice, Vienna, Paris and London and a major retrospective was staged in connection with the Venice Biennale in 1950. His bronzes include Sick Child (1895), Motherhood, Ecce Puer (1910) and numerous portrait busts. His work is represented in many European museums, as well as in the Medardo Rosso Museum at Barzio, Valsassina.

ROSSO, Mino 1904-
Born at Castagnole Monferrato, Italy, on January 24, 1904, he belongs to the Futuristic school of sculpture, producing busts and figures of exaggerated realism tending towards dramatic caricature. His bronzes include Portrait of Giovanni Arpino (1960).

ROSSOLIN, Agnes L. 1872-
Born in Denmark, on April 20, 1872, she studied under Rodin and Sabatte in Paris and became a naturalised French citizen. She exhibited at the Salon des Artistes Français from 1911 onwards and won a medal in 1923.

ROST, Otto 1887-
Born at Keuern, Germany, on June 16, 1887, he studied under Wrba and worked in Dresden. He produced a number of memorials after the first world war and various statues and monuments in southern Germany. The Albertinum, Dresden, has portrait busts and maquettes by him.

ROSZAK, Theodore 1907-
Born in Poznan, Poland, in 1907, he was brought to the United States by his parents in 1909. He was brought up in Chicago and moved to New York at the age of 24. He studied, then taught art in Chicago and began modelling figures in the early 1920s. After the second world war he abandoned figurative work for abstracts, experimenting with Constructivism before returning to a characteristically spiky style of semi-figurative work in various metals. His bronzes belong to the early period (1931-36) and from 1943 onwards, though since then he has also worked in steel. His more recent works include Spectre of Kitty Hawk (1945-47), Cradle Song (1956), Thorn Blossom, Sea Quarry (1956), Iron Gullet (1959) and projects for the monument To the Unknown Political Prisoner (1952-53).

ROTH, Christoph 1840-1907
Born in Nuremberg on July 22, 1840, he died in Munich on March 22, 1907. He studied under Sickinger and Knabl and produced busts, statues and monuments of local celebrities in Munich and other Bavarian towns.

ROTH, Frederick George Richard 1872-
Born in Brooklyn, New York, on April 28, 1872, he studied under Meyerheim and Hellmer at the Vienna Academy and later at the Berlin Academy. He became an associate member of the National Academy of Design, New York, in 1906 and taught modelling there in 1915-18. He was awarded a silver medal at the St. Louis World's Fair in 1904 and a gold medal at the Panama-Pacific Exposition of 1915. He specialised in genre and animal figures and groups. His bronzes include In Central Park, Morgan Horse, Jock (bronze dog), Puma and Akela (dog).

ROTHENBURGER, Adolf 1883-
Born in Frankfurt-am-Main, on January 24, 1883, he specialised in portrait reliefs and busts, examples of which are in the German Museum, Munich, and the Ratisbon Valhalla.

ROTHER, Richard fl. 19th century
Born in Kitzingen, Germany, he died at Bieber, on May 8, 1890. He studied under Max Hellmaier and Hermann Hahn and sculpted memorials and monuments in the Kitzingen area. He was also an engraver and book illustrator.

RÖTHLISBERGER, Paul 1892-
Born at Neuchâtel, Switzerland, on May 5, 1892, he studied under Bouchard, Landowski and Bourdelle in Paris, and worked at Thielle. He exhibited figures at the leading Swiss and Paris Salons from 1922 onwards.

ROTHMUND, Albert 1861-
Born in Inzighofen, Austria, on April 2, 1861, he studied at the Vienna Academy under Hellmer and Zumbusch and sculpted figures and portraits.

ROTTA, Antonio fl. mid-19th century
Born in Genoa, he exhibited figures and groups there and in Naples, and in Milan in the 1850s.

RÖTTGER, Johann 1864-
Born at Northeim, Germany, on March 1, 1864, he studied at the Berlin Academy and worked as a decorative sculptor in Berlin. He is best known for the monuments to Bismarck in Düsseldorf and Reuleaux in Berlin-Charlottenburg.

ROTY, Oscar 1846-1911
Born in Paris, on June 12, 1846, he died there on March 23, 1911. He studied under Dumont and Ponscarme and did much to revive the medallic art in the late 19th century. He exhibited at the Salon from 1873 and won the Prix de Rome in 1875. He received a Grand Prix at the Exposition Universelle of 1900 and was a member of the Institut and a Commandeur of the Légion d'Honneur. He is best known for the figure of La Semeuse (The Sower) which graces the obverse of French coins to this day. He sculpted numerous medals, medallions, plaques and bas-reliefs, commemorative, portrait and allegorical in concept. His works are represented in the museums of Paris, Sète and Bayonne and the Hamburg Kunsthalle.

ROUBAUD, François Félix the Elder 1825-1876
Born in Cerden, France, in 1825, he died in Lyons, on December 13, 1876. He studied under Pradier and exhibited at the Salon from 1853 to 1877. He specialised in allegorical bas-reliefs, such as Philosophy, Poetry, Sculpture, Painting, Justice, Force, Terpsichore and Euterpe, classical figures such as Cupid and Psyche, and busts of contemporary celebrities.

ROUBAUD, Louis Auguste 'the Younger' 1828-1906
Born at Cerdon on February 29, 1828, the younger brother of the above, he died in Paris on April 11, 1906. He studied under Flandrin and Duret and exhibited at the Salon from 1861, winning medals in 1865-66 and 1875. He specialised in allegorical figures and groups. His bronze The Vocation is in the Chateauroux Museum.

ROUBILIAC, or ROUBILLAC, Louis François 1695-1762
Born in Lyons in 1695, he died in London, on January 11, 1762. He was apprenticed to Balthasar Permoser, Sculptor to the Elector of Saxony, in Dresden and later assisted Nicholas Coustou in Paris. He came to England in 1732 and worked for Benjamin or Thomas Carter. Quite by chance he happened to find a wallet belonging to Sir Edward Walpole near Vauxhall Gardens and on returning it to its owner was rewarded for his honesty by getting Walpole's patronage. Walpole introduced him to Sir Henry Cheere whose assistant he bécame. In 1735 he married Catherine Helot and two years later got his first independent commission, the statue of Handel for Vauxhall Gardens (the original terra cotta model being in the Fitzwilliam Museum, Cambridge). He had a very successful career as a portrait sculptor from then on and had a studio in St. Martin's Lane, London. He executed numerous busts, monuments and statues, mostly in marble, plaster or terra cotta, though several are known as bronzes, notably the bust of Joseph Wilson at Burlington House (1760).
Sainte-Croix, Le Roy de *Vie et ouvrages de L.F. Roubillac, sculpteur lyonnais* (1882). Esdaile, Katherine A. *The Life and Works of Louis François Roubiliac* (1929).

ROUEN, Adolphe Jean Baptiste 1814-c.1878
Born in Montmartre in 1814, he died there about 1878. He exhibited genre and animal figures at the Salon from 1857 to 1877. Bagnols Museum has his group Quail caught in a Snare.

ROUFFIE, Marcille fl. 20th century
Born in Clermont-Ferrand in the early years of this century, she exhibited figures at the Nationale and Salon des Tuileries in the 1920s.

ROUGE, Bonabes Vicomte de fl. 19th century
Born in Paris in the early 19th century, he studied under Bonnassieux and exhibited at the Salon from 1859 onwards. He specialised in busts of the aristocracy of the Second Empire and the early years of the Third Republic.

ROUGELET, Benoit 1834-1894
Born in Tournus on September 17, 1834, he died in Paris in July, 1894. He studied under Duret and exhibited at the Salon from 1876, getting honourable mentions in 1887 and at the Exposition Universelle of 1889, and a third class medal in 1892. He produced numerous busts and medallions portraying historical and contemporary French celebrities. He also sculpted classical figures and groups, such as Cupid, Faun and Fauness and Promotion of the Eagle.

ROUGELET, Émilie Jeanne fl. 19th century
Born in Tournus in the first half of the 19th century, she studied sculpture under her brother Benoit Rougelet and exhibited busts and figures at the Salon from 1876.

ROUGERON, Christophe fl. 19th century
Born at Recour, France, in the mid-19th century, he studied under Cavelier and Aimé Millet and exhibited figures at the Salon from 1874.

ROUILLARD, Pierre Louis *1820-1881
Born in Paris on January 16, 1820, he died there on June 2, 1881. He studied under Cortot and exhibited at the Salon from 1837, winning a third class medal in 1842 and the Légion d'Honneur in 1866. He specialised in animal figures and groups, his best known work being the bronze Lion killing a Boar (La Rochelle).

ROUILLIÈRE, Marcel Alexandre 1868-
Born in Paris on October 11, 1868, he studied under J. Perrins and specialised in portrait reliefs, busts and architectural ornament.

ROULLEAU, Marcel fl. 20th century
Sculptress of figures and portraits working in Paris before the second world war. She exhibited at the Salon des Artistes Français, getting an honourable mention in 1935, and third and second class medals in 1936 and 1938 respectively.

ROULLET, Auguste fl. 19th century
Born in Angers in the early 19th century, he studied under Barème and Jean Debay and exhibited figures and groups at the Salon from 1866 onwards.

ROUSAUD, Aristide C.L. fl. 20th century
French sculptor of portraits and figures, which he exhibited at the Salon des Artistes Français in the inter-war period. He won a third class medal in 1921 and a gold medal at the Exposition Internationale in 1937.

ROUSSEAU, Jean Charles fl. 19th century
Born in Paris on December 31, 1813, he exhibited at the Salon from 1849 to 1874. Châlons Museum has his figure of Ulysses bending his Bow.

ROUSSEAU, Pierre 1802-1866
Born in Iseghem, Belgium, in 1802, he died in Bruges in 1866. He worked in Bruges as an ornamental sculptor and wood-carver.

ROUSSEAU, Victor 1865-
Born at Feluy-Ardennes, Belgium, on December 16, 1865, he studied under Van der Stappen at the Brussels Academy and travelled in France, Italy and England. He became a professor at the Brussels Academy and is best known for his monument to the Belgian Renaissance in London. His minor works include numerous busts and statuettes of famous Belgians and allegorical works in the Art Nouveau style, such as Sisters of Illusion (Brussels Museum), Confidence, Causerie, Encounter. He also sculpted many statuettes of children and dancing girls.

ROUSSEL, Léon 1868-
Born at Ourches, France, on November 25, 1868, he studied under J. Thomas and E. Peynot and worked in Paris. He exhibited at the Salon des Artistes Français, getting an honourable mention in 1898 and a second class medal in 1931. He sculpted a number of war memorials in the 1920s, but is best known for his portrait reliefs, busts and medallions of contemporary personalities. His allegorical and genre statuettes and groups are in the Petit Palais and the Bar le Duc Museum.

ROUSSEL, Marius Pascal 1874-
Born in Sète on September 7, 1874, he studied under Falguière and exhibited at the Salon from 1898, winning a first class medal in 1922. He worked as a portrait and genre sculptor in Paris and was awarded the Légion d'Honneur in 1935.

ROUSSEL, Paul René 1867-1928
Born in Paris on October 23, 1867, he died there on January 1, 1928. He studied under Cavelier, Barrias and Coutan and won the Prix de Rome in 1895 and a silver medal at the Exposition Universelle of 1900. He was a prolific sculptor of war memorials in the 1920s and became an Officier of the Légion d'Honneur. His minor works include numerous classical and genre statuettes, such as Apollo and Les Tout Petits, and busts of French celebrities of the 1920s.

ROUSSIL, Robert 1925-
Born in Montreal, Canada, in 1925, he trained at the Art Association of Montreal (1946-48) and had his first exhibition there. The frank realism of his nudes, however, was interpreted as an exercise in lewdness and obscenity and on several occasions since then his works have been attacked by outraged spectators or seized by the authorities. The narrow-minded atmosphere in Quebec forced him to leave Canada and settle in the south of France where his sculptures, displayed on the roadside, have had something of a mixed reception. Since the early 1950s, however, he has abandoned realism and opted for a less controversial abstract form in which, nevertheless, the sensuality of his figurative work continues to manifest itself.

ROUW, Peter 'the Younger' 1770-1852
Born in London on April 17, 1770, the son of Peter Rouw the Elder who specialised in wax profiles, he died in London on December 9, 1852. He himself produced wax portraits and was appointed sculptor-modeller of gems to the Prince of Wales in 1807. He exhibited at the Royal Academy from 1794 to 1840 and showed wax portraits at the Great Exhibition of 1851. He produced a large number of monuments from 1799 to 1840, often decorated by medallions cast in bronze. He designed medals and coinage for India (1823) and engraved gems and cameos. His bronzes include a series of busts executed in 1825-29 for Sir John Thorold's library at Syston Hall.

ROUX, Constant Ambroise 1865-
Born in Marseilles on April 20, 1865, he studied under Cavelier and Barrias and exhibited at the Salon des Artistes Français, getting an honourable mention in 1892 and third class (1898), second class (1902) and first class (1911) medals. He won the Prix de Rome in 1894, a bronze medal at the Exposition Universelle of 1900, the Légion d'Honneur in 1923 and the medal of honour in 1930. He produced numerous busts and relief portraits of historical and contemporary Frenchmen.

ROUX DE LUC, Félix fl. 19th century
Born at Bagnols, France, in 1820, he worked in Avignon where the museum has the main collection of his works. He produced busts of classical figures and French contemporary celebrities, medallions, plaques and portrait reliefs. His chief works include statues of Gutenberg and the poet Cassan.

ROUX, Julien Toussaint 1836-1880
Born at St. Michel-Chauveaux, France, on July 28, 1836, he died in Paris in 1880. He studied under Jouffroy and exhibited at the Salon from 1861. He specialised in allegorical and genre statuettes and busts of his contemporaries. Angers Museum has a large collection of his sculptures.

ROWE, Thomas William fl. 19th century
Portrait and allegorical sculptor working in London. He exhibited at the Royal Academy from 1862 to 1878.

ROYER, Lodenvyck (Louis) 1793-1868
Born in Malines, Belgium, on June 19, 1793, he died in Amsterdam on July 5, 1868. He studied under J.F. van Geol and J.B. Debay in Paris and became Director of the Amsterdam Museum. As a sculptor he is chiefly known for his classical groups, such as Mercury and the Infant Bacchus, and busts portraying European celebrities.

ROZE, Albert Dominique 1861-
Born in Amiens on August 4, 1861, he studied at the Amiens School of Design (1873-79) and won a travelling scholarship which took him to Paris where he continued his studies under Dumont and Bonnassieux. In 1891 he went to Rome and spent two years there before returning to Amiens. Later he became Director of the Amiens School of Fine Arts and Curator of the Picardy Museum. He was a prolific sculptor of statues, continuing to work up to 1945. He is best known for the gilt-bronze Virgin of the Albert Basilica. He sculpted many heroic and genre groups, decorative sculpture on public buildings in northern France, monuments, busts of his contemporaries, and war memorials after both world wars, notably the Resistance Memorial at Amiens (1945). He exhibited at the Salon, getting an honourable mention (1891), third class medal (1897), second class medal (1908) and a first class medal (1914). He was awarded the Légion d'Honneur in 1920 and became a member of the Institut.

ROZEK, Marcin 1885-
Born at Kosieczyn, near Zbaszyn, Poland, on November 8, 1885, he studied under P. Gimzicki in Poznan and then went to Germany where he trained at the academies of Berlin and Munich. He specialised in statues and busts of Polish contemporary and historic personalities, particularly Kosciuszko and the heroes of the 18th and early 19th centuries.

ROZET, Fanny 1881-
Born in Paris on June 13, 1881, she studied under Marqueste and exhibited figures at the Salon des Artistes Français from 1904, getting a third class medal in 1921.

ROZET, René 1859-
Born in Paris on May 14, 1859, he studied under Cavelier and Aimé Millet and exhibited at the Salon from 1876, getting a first class medal in 1927. He was an Associate of the Artistes Français, and received the Légion d'Honneur in 1912. He specialised in rather sentimental genre groups, such as Bonsoir Maman (Lyons Museum).

ROZNIATOVSKA, Antonina c.1860-1895
Born in the Ukraine about 1860, she died in Cracow on June 20, 1895. She studied under Guyski in Cracow (1886) and produced busts and statuettes of genre subjects. Cracow Museum has two female busts and a figure of an old Lithuanian priest by her.

ROZY, H.L. Bernardus fl. mid-19th century
Genre sculptor working in Ghent in the 1840s.

RUBATTO, Carlo 1810-1891
Born in Genoa in 1810, he died there in 1891. He studied under Ignazio Peschiera and worked in Genoa as a decorative sculptor. He also produced several memorials and monuments and a number of portrait busts.

RUBIN, Hippolyte fl. 19th century
Born in Grenoble on May 10, 1830, he worked in Paris and exhibited at the Salon from 1857 to 1868. He produced numerous statuettes, bas-reliefs and busts of his contemporaries. He sculpted the bas-relief of the Holy Family for the chapel of the Grande Chartreuse.

RUBINO, Édoardo 1871-
Born in Turin on December 8, 1871, he studied at the Academy and sculpted many busts of Italian personalities for tombs and mausolea. He also decorated public buildings in northern Italy. Examples of his figures and bas-reliefs are in the museums of Rome, Florence, Turin and Bologna.

RUBLETZKY, Géza 1881-
Born in Budapest on July 1, 1881, he studied there and specialised in genre figures and groups. His Mother and Child are in the Budapest National Gallery.

RUBSAM, Josep Jupp' 1896-
Born in Düsseldorf on May 30, 1896, he specialised in religious and allegorical figures and bas-reliefs and sculpted several war memorials in the Düsseldorf area.

RUCKSTULL, Frederick Wellington 1853-
Born in Breitenbach, Germany, on May 22, 1853, he was brought to the United States as a child and studied art in New York and Paris. He was a pupil of Boulanger and Lefebvre at the Académie Julian and Mercié at the Académie Rollins. He exhibited at the Salon in 1888, getting an honourable mention and on his return to the United States received many commissions to sculpt figures and monuments in New York and Washington. His minor works include many portrait busts and equestrian statuettes. Examples of his sculpture are in the Metropolitan Museum of Art, New York, and the St. Louis municipal museum.

RUCKTESCHELL, Walter van 1882-
Born in St. Petersburg on November 12, 1882, he studied under A. Jank and worked in Dachau as a decorative sculptor. He produced a number of war memorials and monuments in the 1920s and also worked as a painter and engraver.

RUDDER, Isidore de 1855-
Born in Brussels on February 3, 1855, he worked as a designer, decorator and sculptor at the turn of the century, and was a prominent member of the Belgian Art Nouveau movement. Antwerp Museum has his marble The Nest.

RUDE, François 1784-1855
Born in Dijon on January 4, 1784, he died in Paris on November 3, 1855. He studied under Devosges (1800) and Frémiet (who bought him out of the Army in 1805) and Denon and worked in Gaulle's studio on bas-reliefs for the Vendôme Column. He was runner-up in the Prix de Rome in 1810 and won the prize in 1812 but did not take it up as he was too busy by that time. He exhibited at the Salon from 1827 and won the gold medal of honour at the Exposition of 1855. He became a Chevalier of the Légion d'Honneur in 1833. He had many state commissions for statuary and bas-reliefs and sculpted monuments to his illustrious contemporaries. He executed numerous bronzes of Napoleonic marshals and is best known for the colossal group Le Depart on the Arc de Triomphe de l'Étoile, symbolising The Marseillaise. The main collection of his minor works is in the Rude Museum in Dijon, which published a catalogue and biography in 1955.

Quarré, P. *La Vie et l'oeuvre de François Rude* (1947).

RÜDISÜHLI, Hermann 1864
Born at Lenzburg, Switzerland, on June 10, 1864, he was the son and pupil of the landscape painter Jakob Lorenz Rüdisühli. He studied in Basle and Karlsruhe and was influenced by Böcklin. He worked as a painter and sculptor in Munich. Examples of his figures and portraits are in the museums of Mainz, Wuppertal and Zurich.

RUDOLF, Robert 1884-
Born in Selzach, Switzerland, on April 4, 1884, he studied under Richard Kissling and specialised in allegorical figures and monumental statuary, in Soleure and Laufen. His minor works and maquettes are in the Museum of Decorative Arts at Locle.

RUDOLFI, Pietro fl. early 19th century
Sculptor of tombs and memorials working in Udine in the early 19th century. He produced bas-reliefs and figures of the Habsburg family and religious sculpture for the Abbey of St. Paul, Carinthia.

RUDOLPH, Jakob 1887-
Born at Behlingen, Bavaria, on September 21, 1887, he studied at the Munich Academy under Balthasar Schmitt and produced war memorials, fountains and statuary in southern Germany.

RUDZKI, Jan Wezyk 1792-1874
Born at Witkovice, Poland, on March 11, 1792, he died in Florence, on January 31, 1874. He studied at the Academy of St. Luke in Rome and specialised in bronze portrait reliefs. He also worked as a painter and architect.

RUEHOT, A. fl. late 19th century
French sculptor of allegorical bronze statuettes in the 1890s. His figures of girls in the Art Nouveau style bear the names of flowers, such as Iris and Tulip.

RUEMANN, Wilhelm von 1850-1906
Born in Hanover on November 11, 1850, he died in Ajaccio, Corsica, on February 6, 1906. He studied at the Munich Academy and travelled extensively in England, Italy and France. He was appointed professor of sculpture at Munich in 1887 and produced numerous statues and monuments all over Germany at the turn of the century. His minor works include heads and busts in marble and bronze, statuettes of girls and genre groups. Examples of his works are preserved in the museums of Berlin, Hanover and Munich.

RUF, Heinrich 1837-1883
Born in Munich on March 10, 1837, he committed suicide there on January 23, 1883. He studied under Widemann and Schwanthaler and worked in Basle from 1867 to 1875, specialising in marble and bronze busts of his contemporaries.

RUFF, Andor 1885-
Born in Taksony, Hungary, on January 2, 1885, he studied in Budapest and Brussels and worked as a decorative sculptor in Baden.

RUFFIER, Noel fl. late 19th century
Born in Avignon in the mid-19th century, he studied under Guilbert d'Anelle and A. Dumont and exhibited at the Salon from 1878 to 1896. He produced portrait busts, several of which are in the Calvet Museum, Avignon, and genre figures and groups.

RUFFINI, C.
Sculptor of religious figures and groups, working in Rome. His works preserved in the Vatican include Doves, Christ Crucified and Angel with Lectern.

RUGA, Alessandro fl.19th century
Born in Milan in 1836, he studied under Vela and exhibited busts of his contemporaries in Turin and Milan.

RUGGERI, Quirino 1883-
Born at Albacina, Italy, on March 24, 1883, he sculpted busts and portrait reliefs, examples of which are in various Rome museums.

RUHL, Johann Christian 1764-1842
Born in Cassel on December 15, 1764, he died there on September 29, 1842. He worked as an etcher, lithographer and decorative sculptor, notably on the ornament and friezes in Wilhelmshöhe Castle in Cassel.

RÜHM, F. Oskar Adolf 1854-1934
Born at Hengelbach, Saxony, on March 3, 1854, he died at Hiltpoltstein in the summer of 1934. He studied under Schilling in Dresden and executed many busts, statues and fountains in the Dresden area.

RULOT, Joseph 1853-1919
Born in Liège on January 29, 1853, he died at Herstal on February 16, 1919. He studied at Liège Academy and produced statues, portrait reliefs, busts and decorative sculpture.

RÜMANN – see RUEMANN

RUMEAU, Jean Maurice 1915-
Born at Pussay, France, on December 1, 1915, he studied at the School of Decorative Arts, Paris (1933) and travelled in Italy, Greece, Egypt and North Africa. He served in the 1939-40 campaign and was captured at the fall of France. Following his release from prison camp in 1943 he began exhibiting painting and sculpture at the Salon des Indépendants and had a one-man show at the St. Placide Gallery. He specialises in genre figures.

RÜMELIN, Wilhelm 1876-
Born in Linz, Austria, on November 27, 1876, he studied under Rümann and worked as assistant to E. Pfeifer. He later settled in Nuremberg where he produced statuary and bas-reliefs as well as paintings.

RUMMEL, Peter 1850-
Born in Ratisbon (Regensburg), Bavaria, on July 12, 1850, he studied at the Munich Academy and then went to Vienna where he was the pupil and later assistant of Zumbusch.

RUMPF, Anton Karl 1838-1911
Born in Frankfurt-am-Main on March 24, 1838, he died there on May 9, 1911. He studied in Frankfurt, Munich and Nuremberg and sculpted allegorical groups and statuettes of historical German personalities, particularly members of the Goethe family.

RUMSEY, Charles Cary 1879-1922
Born in Buffalo, N.Y., in 1879, he died at Glen Head on September 21, 1922. He studied in Boston and was a pupil of Bartlett in Paris (1902-6) and was awarded a bronze medal at the Panama-Pacific Exposition of 1915. He specialised in genre and animal figures in bronze. His works include Dancing Figure, Fighting Horses, Leaping Deer, The Bull, St. George, The Pagan, The Centaur, Buffalo Cow and Calf, and Dying Indian.

RUNEBERG, Walter Magnus 1838-1920
Born in Borga, Finland, on December 29, 1838, he died in Helsinki on December 23, 1920. He studied in Paris and worked there for many years before returning to Finland. He specialised in busts of his contemporaries, classical and allegorical figures and groups, bas-reliefs for tombs and mausolea, medallions and portrait reliefs. His genre statuettes include Young Boy dancing with a Basque Drum.

RUNGALDER, Peter fl. 19th century
Born at St. Ulrich, Austria, in the early 19th century, he sculpted ecclesiastical figures and reliefs for various churches in the St. Ulrich area.

RUNGE, Otto Sigismund 1806-1839
Born in Hamburg on April 30, 1806, he died in St. Petersburg on March 16, 1839. He studied under Johan G. Matthai in Dresden and Thorvaldsen in Rome and worked in Germany and Russia as a genre sculptor. His group of a Girl teaching a Little Boy to Fish is in the Hamburg Kunsthalle.

RUPPE, Michael 1863-
Born in Schäflein, Carniola (now Yugoslavia), on March 24, 1863, he studied under H. Klotz and Adam Hölzel and worked in Salzburg and Laibach (now Ljubljana). The Ljubljana Museum has three bronze statuettes by him.

RUSCA, Antonio fl. early 19th century
Decorative sculptor working in Rancate, Italy. He studied under Camillo Pacetti and worked on the decoration of Milan Cathedral from 1808 to 1821, sculpting statues of the prophets and Apostles.

RUSCA, Gerolamo fl. 19th century
The son and pupil of Grazioso Rusca, he worked on the decoration of Milan Cathedral from 1823 to 1871.

RUSCA, Giuseppe fl.1789-1812
Sculptor of religious subjects, employed on the decoration of Milan Cathedral from 1789 to 1812. He sculpted the bas-reliefs on the south face.

RUSCA, Grazioso 1757-1829
Born in Rancate, Italy, in 1757, he died in Milan on June 18, 1829. He was the father of Gerolamo and uncle of Antonio Rusca. He studied under Stefano Salterio and worked on the decoration of Milan Cathedral from 1785 onwards. He also worked on Cremona Cathedral and churches in Piacenza and Altdorf. His minor works include religious statuettes and bas-reliefs.

RUSSELL, Charles Marion 1865-1926
Born in St. Louis, Missouri, on March 19, 1865, he died at Great Falls, Montana, on October 25, 1926. Though best known as a painter and illustrator of the Wild West, he also sculpted figures and groups in the same genre. In this medium he was almost entirely self-taught and modelled figures of cowboys and Indians, buffalo, wolves, bears and cougars in clay for casting in bronze. Most of the 250 known sculptures by Russell were cast in small editions not exceeding 24 in number and many of them were cast posthumously.

RUST, Karolina fl. 19th century
Born in Bodenmais on October 11, 1850, she studied under Rudolf Maison and sculpted genre figures in Austria in the late 19th century.

RUTELLI, Mario 1859-1941
Born in Palermo, Sicily, on April 4, 1859, he died in Rome in 1941. He worked in Palermo for many years before settling in Rome. He specialised in portrait busts and statuettes which he cast himself in bronze. He exhibited in the principal Italian salons and also at the Exposition Internationale in Paris, 1878.

RÜTGER, Christian 1821-1846
Born in Cologne on January 12, 1821, he died in Bensberg, near Cologne, on October 8, 1846. He studied under Schwanthaler and worked in the Cologne area as a decorative sculptor.

RUTLAND, Charles 1858-1943
Born in Cheltenham on April 27, 1858, he died in London in September 1943. He studied at the Kennington School of Art and exhibited figures and portraits at the Royal Academy and the leading London and provincial galleries. His works include Orpheus, Timid Nymph, Harp of Life and The Wise Woman.

RUTLAND, Marion Margaret Violet, Duchess of 1856-1937
Born in Wigan, Lancashire, on March 7, 1856, she died in London, on December 22, 1937. The daughter of Colonel the Hon. Charles Lindsay, she married Henry Manners, later Marquess of Granby, who succeeded to the dukedom of Rutland in 1906. She was a painter and sculptor of portraits and exhibited at the New Gallery from 1904 and the Royal Academy from 1925 to 1931, as well as in Paris and New York. She had an individual show in 1919 at the Fine Arts Society and was a member of the Leicester Society of Artists.

RUTZ, Gustav 1857-
Born in Cologne on December 14, 1857, he studied in Düsseldorf under Julius Geertz and in Munich under A. Hess. He sculpted public statuary and fountains for many German towns.

RUXTHIEL, Henri Joseph 1775-1837
Born at Lierneux, near Liège, Belgium, on July 4, 1775, he died in Paris on September 15, 1837. He began life as a shepherd boy but in his twenties he went to Paris and studied under Devandre, Houdon and David. He was runner-up in the Prix de Rome of 1804 and won the prize four years later. He exhibited at the Salon from 1814 to 1827 and produced classical and historical figures and groups, and busts of Napoleonic celebrities.

RYGIER, Theodor 1841-1913
Born in Warsaw on November 9, 1841, he died in Rome on December 18, 1913. His chief work is the Mickiewicz monument in Cracow, but he also sculpted genre figures and portrait busts of historical and contemporary Poles in marble and bronze.

RYLAND, Adolfine Mary 1903-
Born in Windsor, Berkshire, on March 14, 1903, she studied at Heatherley's School of Art (1920-25) and exhibited at the WIAC from 1927 to 1954. She sculpted figures and groups and her work is represented in the Tate Gallery.

RYNBOUT, Jan 1839-1868
Born in Utrecht on January 29, 1839, he died there on December 9, 1868. He worked as a decorative sculptor in Utrecht and Harmelen and produced a series of allegorical figures for the courts of justice in these towns.

SA, Aernance de fl. 19th-20th centuries
Born at Avintes, France, in the mid-19th century, he studied under Puech and Falguière and worked in Paris at the turn of the century as a decorative sculptor. He won a bronze medal at the Exposition Universelle of 1900.

SAABYE, August Vilhelm 1825-1916
Born at Skioholm, near Aarhus, Denmark, on July 7, 1825, he died in Copenhagen on November 12, 1916. He studied at the Copenhagen Academy and sculpted bas-reliefs and busts of Danish royalty and historical personalities, as well as classical and genre statuettes, such as Faun with the Infant Bacchus, Lady Macbeth and The Little Fisherman. Examples of his work are in the museums of Copenhagen and Frederiksborg.

SABIELLO, Parmen Petrovich fl. 19th century
Born at Monastyrchtchino, Russia, in 1830, he studied at the St. Petersburg Academy and specialised in busts and statuettes of historical and contemporary personalities.

SACCOMANNO, Santo 1833-1914
Born in Genoa in 1833, he died there in 1914. He studied under Varni at the Genoa Academy and worked as assistant to Giuseppe Gaggini. His chief work is the statue of Mazzini and his Disciples, but he also sculpted numerous medallions, plaques and busts, tombs and memorials, in Genoa.

SACHOT, Octave fl. 19th century
Born at Montigny-Lencoup, France, he studied under Petit and exhibited at the Salon from 1861 to 1878. He produced busts, heads, portrait reliefs and medallions of his contemporaries. Sens Museum also has a statuette of a Greek peasant woman of the island of Mytilene by him. He was a Chevalier of the Légion d'Honneur.

SACHSSE, Walter Max 1870-
Born in Bautzen, Saxony, on December 24, 1870, he studied under F. Offermann and A. Hudler in Dresden. He produced several war memorials in the Dresden area. His minor works include bas-reliefs and medallions portraying his contemporaries.

SAFF, Vojtech Eduard 1865-1923
Born at Policka, Bohemia, on June 17, 1856, he died in Prague on December 26, 1923. He studied under Kundmann at the Vienna Academy and specialised in monuments and bas-reliefs inspired by Bohemian mythology and history. His allegorical figures of Air and Earth are in the Prague Museum.

SAGET, Guillaume 1873-
Born at Réole, France, on September 17, 1873, he studied under Barrias and exhibited figures at the Salon des Artistes Français from 1904, getting an honourable mention in 1908.

SAILO, Leopold 'Albinus' 1877-
Born at Hämeenlinna, near Tavastehus, Finland, on November 17, 1877, he studied in Helsinki, Florence and Budapest and specialised in portrait busts and heads.

SAIN, Marius Joseph 1877-
Born in Avignon on October 18, 1877, he studied under Thomas, Félix Charpentier, Injalbert and Allouart and exhibited at the Salon des Artistes Français, getting an honourable mention in 1903 and second class medals in 1906 and 1910. He became a Chevalier of the Légion d'Honneur in 1926. He produced numerous tombstones, mausolea and war memorials, but his minor works include allegorical and genre statuettes, such as Harmony, Song of the Vine and Young Arab Herdsman.

ST. ANDRÉ, Ambroise de Lignereux 1861-
Born in Paris on July 6, 1861, he studied under Barrias and exhibited figures at the Salon des Artistes Français, getting medals in 1902 and 1908 and also the Légion d'Honneur.

ST. ANGEL, Pierre Charles Gabriel de fl. late 19th century
Born at Montbreton, France, in the first half of the 19th century, he studied in Paris under Dumont, Bonnassieux and Maggesi and exhibited figures and groups at the Salon from 1868 onwards.

ST. GAUDENS or SAINT-GAUDENS, Augustus 1848-1907
Born in Dublin, of mixed Gascon and Irish parentage, on March 1, 1848, he died at Cornish, New Hampshire, on August 3, 1907. His parents emigrated to the United States while he was still a baby and settled in New York. At the age of thirteen he was apprenticed to Louis Avet, a cameo and gemstone cutter. He studied sculpture at the Cooper Union Art School and the National Academy of Design, and then attended classes at the École des Beaux Arts, Paris, from 1867 to 1870. Following the outbreak of the Franco-Prussian War he moved to Rome and worked there for three years before returning to the United States. He received numerous commissions for monumental statuary and architectural sculpture in the neo-classical manner, but he also produced many portrait busts, bas-reliefs and statues of historical and contemporary American personalities. He was the most cosmopolitan of the American sculptors of the late 19th century, spending much of his time abroad. He was a member of the Jury for the Exposition Universelle of 1889 and a corresponding member of the French Académie des Beaux Arts. He was awarded the Grand Prix at the Exposition Universelle of 1900. His work represents the transition between the classicism of Canova and Thorvaldsen and the greater realism which animated sculpture at the turn of the century.
Cortissoz, Royal *Augustus Saint-Gaudens* (1907). Cox, Kenyon *Old Masters and New* (1905). Hind, C. Lewis *Augustus Saint-Gaudens* (1908). Saint-Gaudens, Homer *Reminiscences of Augustus Saint-Gaudens* (1913).

SAINT-GAUDENS, Louis 1854-1913
Born in New York on January 8, 1854, he died at Cornish, New Hampshire, on March 8, 1913. He was the younger brother and assistant of Augustus and studied at the École des Beaux Arts, Paris. Though mainly associated in the monumental commissions of his brother, he also sculpted medallions and genre and allegorical statuettes in his own right. His works include Pan playing the Flute (Metropolitan Museum of Art, New York) and an allegory of Painting (St. Louis Museum).

SAINT-GAUDENS, Paul 1900-
Born in Flint, Michigan, on June 15, 1900, he studied under Frank Applegate, G.L. Bachelder, C.A. Binns and Arnold Ronnebeck, and worked in New York as a painter and sculptor. He is a member of the American Federation of Arts.

ST. GERVAIS, Charlotte de, Countess de la Salle 1860-
Born in Nantes in April, 1860, she studied under Hélène Berteaux and exhibited figures at the Salon from 1876 onwards.

ST. JOLY, Jean fl. 19th century
Born in Toulouse in the first half of the 19th century, he died there at the end of 1904. He studied under Toussaint and exhibited at the Salon from 1863, getting an honourable mention in 1885. He worked as a decorative sculptor, mainly in the south of France, and sculpted the allegory of Marseilles for the façade of Paris Town Hall. His minor works include genre groups, such as The Archery Lesson.

ST. LANNE, Louis fl. late 19th century
Born at St. Sever, France, in the mid-19th century, he exhibited figures at the Salon des Artistes Français, getting an honourable mention in 1893.

ST. MARCEAUX, Charles René de 1845-1915
Born in Rheims on September 23, 1845, he died in Paris on April 23, 1915. He studied under Jouffroy and exhibited at the Salon from 1868 and became an Associate of the Artistes Français in 1885. He won numerous medals at the Salon from 1872 onwards and a gold medal at the Exposition Universelle of 1889. He became a Chevalier of the Légion d'Honneur in 1880 and an Officier in 1889, a member of the Jury of the 1900 Exposition and a member of the Institut in 1905. He had many public commissions and sculpted monuments, notably those honouring Dumas fils, Alphonse Daudet and the Universal Postal Union in Berne. His minor works include busts and heads in bronze, allegorical and genre figures and groups, such as The Communicant and Boyhood of Dante.

ST. MARCEAUX, Jean Claude de 1902-
Born at Cuy-St. Fiacre, France, on September 15, 1902, he exhibited figures at the Salon d'Automne and the Group of Twelve before the second world war.

ST. PAUL, Édouard fl. 20th century
French sculptor of genre and allegorical figures. He exhibited at the Salon d'Automne and the Tuileries before the second world war.

SAINT-PRIEST, Marguerite Cerval,
Comtesse de Lavergne, Vicomtesse de 1844-1883
Born at Sarlat, France, in 1844, she died in Paris in 1883. She studied under Robinet and Harel and exhibited genre and allegorical statuettes at the Salon from 1875 till her death. Examples of her work are in the Perigueux Museum.

ST. VIDAL, Francis de 1840-1900
Born in Milan of French parents, on January 16, 1840, he died in Paris on August 18, 1900. He studied under Carpaux and exhibited portrait busts and statuettes at the Salon from 1875 onwards. Bordeaux Museum has his bust of Beethoven, while Versailles Museum has his figure of Carpeaux.

SAJEVIC, Johann 1891-
Born in Staravas, Yugoslavia, on October 21, 1891, he studied under Müllner in Vienna and worked as a decorative sculptor in Croatia.

SALA, Elia 1864-1920
Born in Milan in April 1864, he died at Gorla Prescotta on January 10, 1920. He specialised in portrait busts and reliefs of his contemporaries.

SALADIN, Alphonse 1879-
Born in Epinal, France, on February 6, 1879, he studied under Mengue and became an Associate of the Artistes Français. He exhibited busts of artists and poets at the Salon, winning an honourable mention (1909), third class medal (1910) and second class medal (1920). He received the Légion d'Honneur in 1932.

SALAMON fl. 19th century
Toulouse Museum has eight busts in terra cotta of French heroic and historic celebrities bearing this signature.

SALATA, Achille fl. 19th century
Born in Milan in the mid-19th century, he exhibited there and in Turin and Leghorn. He specialised in genre bronze statuettes, distinguished by their realistic portraiture.

SALEMANN, Robert J. 1813-1874
Born in Reval, Estonia, on June 16, 1813, he died in St. Petersburg on September 12, 1874. He studied under Rietschel in Dresden and Schwanthaler in Munich and worked as a portrait and decorative sculptor in Russia. The Russian Museum in Leningrad has his busts and statues of the Tsarist family.

SALEMME, Antonio 1892-
Born in Gaeta, Italy, in 1892, he emigrated to the United States and studied painting at the Boston Museum of Fine Arts School. Later he turned to sculpture and went to Rome where he studied under Angelo Zanelli for seven years. He produced genre busts and statuettes, such as Prayer, Old Scotch Woman and various peasant subjects.

SALENDRE, Georges Maurice fl. 20th century
Born in Lyons in the early years of this century, he specialises in busts of his artistic contemporaries and genre figures, such as Young Girl with a Bird.

SALERNO, Vincent 1893-
Born in Sicily in 1893, he emigrated to the United States and studied at the National Academy of Design under A. Stirling Calder, and Hermon A. MacNiel at the Beaux-Arts Institute, New York. He won a silver medal at the Panama-Pacific Exposition, San Francisco, 1915, and has since produced numerous portrait busts and genre figures, in bronze and bronzed plaster.

SALES, André Pierre 1860-
Born in Perpignan on January 14, 1860, he studied under Dumont and P. Dubois and exhibited bas-reliefs, plaquettes and medallions at the Salon from 1876 onwards.

SALESSES, Jean Baptiste 1817-1873
Born in Toulouse on November 2, 1817, he died in Orleans on March 20, 1873. He worked as a painter, draughtsman and musician as well as a sculptor and specialised in busts and genre statuettes in plaster and bronze.

SALIÈRES, Sylvain 1865-
Born at Escorneboeuf, France, in 1865, he studied under Falguière and Marqueste and exhibited allegorical and genre figures and groups at the Salon des Artistes Français, winning a third class medal in 1896, a second class medal in 1901 and a bronze medal at the Exposition Universelle of 1900. The Museum of Fine Arts, Paris, has his group Romance of April.

SALIMBENI, Raffaello 1916-
Italo-American sculptor of figurative and abstract works in bronze, such as Space Man and Anna with a Fan.

SALIS-SOGLIO, Pietro von 1877-
Born in Coire, Switzerland, in 1877, he worked in Zurich in the early years of this century as a portrait and figurative sculptor.

SALLE, Adelin 1884-
Born in Liège, on April 21, 1884, he specialised in ecclesiastical sculpture and public statuary in that area. His minor works include statuettes, medallions and bas-reliefs.

SALLE, André Augustin 1891-
Born at Longueau, France, on September 9, 1891, he studied under Coutan and Carli and exhibited figures at the Salon des Artistes Français from 1923 onwards, winning a third class medal that year and a second class medal in 1931. He won the Prix de Rome in 1924.

SALLES, André fl. 19th century
Born in Perpignan in the mid-19th century, he studied at the École des Beaux Arts, Paris, and specialised in genre figures, dancers, bathers and nudes.

SALMON, Émile Frédéric 1840-1913
Born in Paris on June 15, 1840, he died at Forges-les-Eaux on June 12, 1913. He studied under Barye, Hédouin and Gaucherel and exhibited at the Salon from 1859. He produced many small bronzes of animals, but later gave up sculpture and concentrated on etching, and built up a major reputation as an illustrator.

SALMSON, Jean Jules 1823-1902
Born in Paris on July 18, 1823, he died at Coupvray on May 7, 1902. He studied under Dumont, Ramey and Toussaint and exhibited at the Salon from 1859, winning second class medals in 1863 and 1867 and becoming a Chevalier of the Légion d'Honneur in the latter year. He was Director of the School of Industrial Arts, Geneva, a corresponding member of the Institut de France (1891) and one of the leading exponents of portrait sculpture at the end of the 19th century. He did decorative and ornamental sculpture, busts and statuettes of historic and contemporary French and Swiss personalities, allegorical figures, bas-reliefs and medallions. His best known work is the Caryatids at the Paris Vaudeville Theatre. He published a book about his work in 1892.

SALO Y JUNQUET, José 1810-1877
Born at Mataro, Spain, on November 24, 1810, he died in Cordoba, on September 3, 1877. He was a pupil of Fr. Lopez, D. Campeny and S. Mayol and worked as a decorative sculptor. He was employed on the decoration of Cordoba Cathedral.

SALOUN, Ladislav 1870-
Born in Prague on August 1, 1870, he studied under B. Schnirch and T. Seidan and decorated public buildings in Prague. His chief work is the Hus monument in Prague, but he also sculpted bronze statuettes of Czech historic personalities.

SALTO, Axel Johann 1889-
Born in Copenhagen on November 17, 1889, he worked there as an engraver, sculptor, potter, lithographer and book illustrator. He studied under H. Grönvold, P. Rostrup, Borgesen and J. Paulsen.

SALVATORE (Messina Salvatore) 1916-
Born in Palermo, Sicily, in 1916, he studied at the Palermo Academy and worked in Trieste and Milan before settling in Venice after the second world war. He has taken part in the Venice Biennales since 1940 and the Rome Quadriennial and been represented in many overseas exhibitions. He began by sculpting figurative groups and bas-reliefs, such as The Family (1940) but gradually moved towards the abstract, under the influence of Arp and Brancusi. Many of his bronzes have the recurring theme of flight and movement in space.

SALVATORE, Victor D. 1885-
Born in Italy in 1885, he emigrated to the United States and studied under Charles Niehaus, Hermon A. MacNiel and A. Phimister Proctor. He was awarded a silver medal at the Panama-Pacific Exposition of 1915 and produced allegorical figures and reliefs in marble and bronze.

SALVATORI, Enrico 1852-
Born in Naples in 1852, he studied at the Academy there and exhibited figures and reliefs in the major Italian Salons, as well as in Paris and at the Royal Academy, London.

SALVIGNOL, Alfred Jules fl. 19th-20th centuries
Born in Pertuis, France, in the late 19th century, he exhibited figures at the Salon des Artistes Français and won a third class medal in 1903.

SALVINI, Mario fl. 19th century
Born in Reggio Emilio, Italy, in the mid-19th century, he exhibited figures and portraits in Venice, Florence and Bologna.

SALVINI, Salvino 1824-1899
Born in Leghorn on May 26, 1824, he died at Arezzo on June 4, 1899. He studied at the academies of Florence and Rome and exhibited statuettes and busts of historic and contemporary personalities in Florence, Naples, Bologna, Rome, Turin and Paris.

SAMAIN, Louis 1834-1901
Born in Nivelles on July 4, 1834, he died at Ixelles, near Brussels, on October 24, 1901. He worked in Brussels, Antwerp and Paris and exhibited portrait busts and genre figures at the Salons in these cities. He won a gold medal at the Exposition Universelle of 1889 and was a Chevalier of the Order of Leopold.

SAMARAIEV, Gavril Tochonovich 1758-1823
Born in Russia in 1758, he died in St. Petersburg in 1823. He studied at the Academy of St. Petersburg and worked with L.P. Mouchy in Paris.

SAMBUGNAK, Sandor 1888-
Born at Semlin, Hungary, on April 22, 1888, he studied in Budapest, Munich and Paris and worked in Budapest as a painter and sculptor of genre subjects.

SAMSO, Juan 1834-1908
Born in Gracia, Spain, in 1834, he died in Madrid in 1908. He specialised in religious figures and bas-reliefs and decorated churches in Madrid, Barcelona and Covadonga.

SAMUEL, Charles 1862-
Born in Brussels on December 29, 1862, he studied at the Académie Royale in Brussels and specialised in busts of Belgian royalty and contemporary celebrities, medallions and bas-reliefs of genre and allegorical subjects. He won silver and gold medals at the Expositions Universelles of 1889 and 1900 respectively.

SAMUEL, Kornel 1883-1914
Born at Szilagyköved, Hungary, on April 10, 1883, he was killed in action on October 2, 1914. He studied in Budapest and Munich and specialised in genre and allegorical statuettes, such as Fortune, Eve, Love and Nude Boy.

SANAVIO, Antonio fl. 19th century
Decorative sculptor working in Padua in the mid-19th century.

SANAVIO, Natale 1827-1905
Born in Padua on September 9, 1827, he died there on December 28, 1905. He was the brother of Antonio Sanavio and worked with him on the decoration of churches and public buildings in Padua.

SANCHEZ, Albert Ernest 1878-
Born in Paris on April 24, 1878, he studied under Falguière, Mercié and Gardet and exhibited figures at the Salon des Artistes Français, winning an honourable mention in 1904 and a third class medal in 1912.

SANCHEZ ARACIEL, Manuel 1851-1918
Born in Murcia, Spain, on October 21, 1851, he died in Madrid on May 24, 1918. He was the son and pupil of Francisco Sanchez Tapia and specialised in busts and figures of religious subjects. He sculpted the Way of the Cross in the Church of San Gaetano, Madrid.

SANCHEZ TAPIA, Francisco fl. 19th century
Born in Murcia in the first half of the 19th century, he died there on January 1, 1902. He studied under S. Baglietto and worked as a decorative and ecclesiastical sculptor in Murcia, Aljucer, Jumilla and Novelda.

SAND, Karl Ludwig 1859-
Born in Munich on May 10, 1859, he studied under Eberle and sculpted statues and busts of contemporary German celebrities.

SAND, Maurice, Baron Dudevant 1823-1889
Born in Paris on June 30, 1823, he died there in 1889. He was the son of George Sand, the novelist, and was himself a painter, draughtsman, sculptor, interior designer and writer. He illustrated many of his mother's works as well as the novels of other authors. As a sculptor he is best known for his decorative work in Parisian theatres. He also sculpted a series of statuettes portraying actors.

SANDBERG, Aron Simon 1873-
Born at Gränna, Sweden, on January 5, 1873, he sculpted portrait busts of his contemporaries and worked as a decorative sculptor.

SANDBERG, Gustaf Emil 1876-
Born in Gränna on January 12, 1876, he was the younger brother of the above. He sculpted many statues and monuments in the Stockholm area.

SANDBICHLER, Mathaüs 1877-
Born at Imst, Tyrol, in 1877, he sculpted tombs, monuments and war memorials in the Innsbruck area.

SANDERS, Adam Achod 1889-
Born in Sweden in June 1889, he emigrated to the United States and studied at the Beaux-Arts Institute of New York. He was a member of the American Federation of Arts and an Associate of the Salon des Indépendants. His chief work is the Lincoln monument in Washington, D.C., but he also sculpted many portraits of historical and contemporary American personalities.

SANDOZ, Édouard Marcel 1881-
Born in Basle on March 21, 1881, he studied under Injalbert and Mercié at the École des Beaux Arts, Paris, and exhibited in Brussels and Barcelona. He specialised in portrait busts and allegorical bas-reliefs.

SANFORD, Edward Field 1886-
Born in New York in 1886, he was a pupil of the Art Students' League and the National Academy of Design in New York, the Académie Julian in Paris and the Munich Academy. He later taught at the Rhode Island School of Design, Providence, which has his bronze statuette of Pegasus.

SÄNGER, Dominikus 1845-1897
Born in Munich on October 6, 1845, he died there on March 6, 1897. He sculpted figures and bas-reliefs and decorated buildings in the Munich area.

SANGIORGIO, Abbondio 1798-1879
Born in Milan on July 16, 1798, he died there on November 2, 1879. He studied under Pacetti and worked in Milan and Turin.

SANGIOVANNI, Benedetto 1781-1853
Born in Laurino, Italy, in 1781, he died in Brighton, Sussex, on April 13, 1853. He trained in Italy and settled in London in 1827, exhibiting at the Royal Academy from that year till 1847, showing figures and groups of animals and various works of a romantic nature, statuettes of the bandits, brigands and peasants of his native Calabria. His best known work is the Contadina of the province of Salerno (exhibited in 1845), described by the *Art Union* as 'perfect in costume and character and modelled with the utmost nicety of execution'.

SANGUINETTI, Alessandro fl. 19th century
Born in Carrara in 1816, he studied under Rauch in Berlin and settled in Florence in 1835 where he worked as a decorative sculptor.

SANGUINETTI, Carlo fl. mid-19th century
Genre sculptor of the 1850s. Nancy Museum has his bronze of a Young Neapolitan Fisherman.

SANGUINETTI, Francesco c.1800-1870
Born in Carrara about 1800, he died in Munich on February 15, 1870. He worked as a landscape painter and genre sculptor and studied in Munich where he then settled. He turned to sculpture relatively late in his career and studied in Milan, where his best work in this medium is preserved. He was an ardent art collector and immensely wealthy but his life was marred by great misfortune and scandal, notably the murder of his 19 year old daughter, and he died in great misery.

SAN MARTI Y AGUILO, Medardo fl. 19th century
Born in Barcelona in the early 19th century, he died there in 1891. He sculpted many busts, statues and monuments in Madrid and Barcelona and several of his sculptures are preserved in the Modern Museum in Madrid.

SANMARTIN DE LA SERNA, Juan 1830-1918
Born in Santiago de Compostela on April 21, 1830, he died in Madrid on November 11, 1918. He studied under Piquer and worked as a decorative sculptor in Madrid.

SANMARTINO, Giuseppe 1723-1793
Born in Naples in 1723, he died there on December 12, 1793. He studied under Felice Bottiglieri and was strongly influenced by the works of Bernini. He produced statuettes, bas-reliefs, groups and crèches for Neapolitan churches, and his work was characterised by an air of realism.

SANSON, Justin Chrysostome 1833-1910
Born in Nemours on August 8, 1833, he died in Paris on November 2, 1910. He studied under Lequien and Jouffroy and exhibited at the Salon from 1861, winning numerous awards and medals at the Expositions of 1867, 1878 and 1889. He specialised in allegorical figures and groups, notably those in the Palais de Justice, Amiens.

SANTAGATA, Antonio Giuseppe 1888-
Born in Genoa on November 10, 1888, he studied at the Genoa Academy and worked in that area as a decorative sculptor and painter. His minor works include bas-reliefs, plaquettes and medallions.

SANTANA, Raul 1893-
Born in Caracas, Venezuela, in 1893, he studied at the Caracas Academy of Fine Arts under Herrera Toro and went to Barcelona where he worked under Francisco Labarta. Though best known as a painter and caricaturist he has also produced figures and groups and won the sculpture prize of the Caracas Academy in 1928.

SANTANDREU, Pedro Juan 1808-1838
Born in Manacor, Spain, in 1808, he died at Palma on November 26, 1838. He studied under J. Llado and sculpted ornament and decoration for public buildings and churches.

SANTARELLI, Emilio 1801-1886
Born in Florence in 1801, he died there in November 1886. He was the son and pupil of Giovanni Santarelli and also worked under Thorvaldsen in Rome for some time. He produced busts and figures of historical and contemporary Italians.

SANTARELLI, Giovanni Antonio 1758-1826
Born in Monopello, Italy, on October 20, 1758, he died in Florence on May 30, 1826. He was a professor at the Florence Academy and sculpted busts and heads in stone, semi-precious stones and metals. He also engraved cameos and medallions.

SANTIFALLER, Anton 1894-
Born in Merano, South Tyrol, on December 14, 1894, he studied under O. Strnad, R. von Kenner and A. Hanak in Vienna and Bourdelle in Paris. He produced statues, tombs and bas-reliefs in Innsbruck and other Austrian towns. His minor works include bronze busts, heads and genre statuettes.

SANTIGOSA WESTRETEN, Francisco fl. 19th century
Born in Tortosa, Spain, on October 12, 1835, he worked under his brother José and sculpted religious figures and bas-reliefs in Valencia.

SANTIGOSA WESTRETEN, José fl. 19th century
Born in Tortosa in the early 19th century, he worked there and in Valencia as a decorative sculptor.

SANTINI, Vincenzo 1807-1876
Born in Pietrasanta, Italy, on July 2, 1807, he died there in 1876. He studied under Tenerani and became a professor at the Pietrasanta Art School.

SANTORO, Giovanni Battista 1809-c.1895
Born in Fuscaldo, Italy, on October 24, 1809, he died in Naples about 1895. He worked as a sculptor and lithographer in Naples.

SANZ, Roman fl. 19th century
Born in Sacedon, Spain, on February 28, 1829, he studied under J. Galvez, A. Brabo and F. Elias.

SANZ, Toribo fl. 19th-20th centuries
Born in Lenia, Peru, in the mid-19th century, he sculpted figures and bas-reliefs in Lima. He was awarded a gold medal at the Exposition Universelle of 1900.

SANZEL, Félix 1829-1883
Born in Paris on January 25, 1829, he died there in December 1883. He studied under Fromage and Dumont and exhibited at the Salon from 1849, getting a medal in 1868. He specialised in genre figures, such as Mischief (Orleans Museum) and busts of historic and contemporary French celebrities.

SAPIK, Vojtech Adalbert 1888-1916
Born in Polska Ostrava, Galicia, on April 8, 1888, he was killed in action on the Eastern front on July 4, 1916. He studied under Sucharda and specialised in bas-reliefs and medallions, many of which are preserved in the Prague Modern Gallery.

SAPONARO, Salvatore 1888-
Born at Sancesario di Lecce, Italy, on March 30, 1888, he studied in Lecce and Milan where he settled in 1921. He sculpted the war memorials in Padua and Milan as well as portraits and allegorical figures and reliefs.

SAPORETTI, Edgardo 1865-1909
Born at Bagnacavallo, Italy, on February 13, 1865, he died in Bellaria on October 4, 1909. He was the son and pupil of the genre painter Pietro Saporetti and was himself a painter but also sculpted figures and groups. He exhibited in Rome, Bologna and Florence.

SAPPEY, Pierre Victor 1801-1856
Born in Grenoble on February 11, 1801, he died there in 1856. He studied under Raggi and Ramey the Younger and exhibited at the Salon from 1831 onwards. He is best known for the monument to General de Boigne in Chambéry. Many of his sculptures are preserved in the Grenoble Museum, including allegories of the rivers Isère and Drac and neo-classical statues and groups, such as the Death of Lucretia.

SARGANT, Francis William 1870-1960
Born in London on January 10, 1870, he died in Cambridge on January 11, 1960. He was educated at Rugby and New College, Oxford, and then studied art at the Slade School (1895-96) and then in Florence and Munich from 1899 to 1903. He won a gold medal at the Crystal Palace Exhibition in Munich, 1904. With the exception of the first world war period he lived in Florence from 1899 to 1937 and was made a Cavaliere of the Crown of Italy in 1920. He received the O.B.E. for war services in 1919. He exhibited portrait and figure sculpture at the Royal Academy from 1919 onwards and his works are in several public collections.

SARGENT, John 1910-
Born in London on July 21, 1910, he was educated at Charterhouse and St. John's College, Cambridge. He has exhibited at the Royal Academy and the Paris Salon since the second world war and won a gold medal in 1962. He works as a figure and portrait sculptor at Wilbraham in Cambridgeshire.

SARGENT, Louis Augustus 1881-
Born in London in 1881, he worked as a painter and sculptor of portraits and genre subjects. He exhibited in the major British galleries and also took part in several international exhibitions, and had a one-man show at the Leicester Galleries in 1913.

SARI, Arsène Étienne 1895-
Born in Marseilles on October 7, 1895, he was self-taught and worked in Nice as a painter and sculptor of figures in the Impressionist manner.

SARKISOFF, Maurice 'Sarki' 1882-
Born in Geneva on January 3, 1882, he was a pupil of Auguste de Niederhäusen. Examples of his sculpture are in the museums of Soleure and Geneva.

SARLIN, Robert 1887-
Born in Paris on April 1, 1887, he studied under Hannaux and exhibited figures at the Salon des Artistes Français. He was a holder of the Légion d'Honneur and the Croix de Guerre for service in the first world war.

SARNIGUET, Emilio 1887-1943
Born in Buenos Aires in 1887, he died there in 1943. He won a travelling scholarship and went to Paris where he exhibited at the Salon des Artistes Français from 1910 to 1913. His genre figures and groups were characterised by a dramatic sense, strength and vigour.

SARRABEZOLLES, Charles 1888-
Born in Toulouse on December 27, 1888, he studied under Mercié and Marqueste and won the Prix de Rome in 1914. He exhibited at the Salon des Artistes Français till 1932 and won a second class medal in 1921 and the Prix National the following year. He was awarded two gold medals at the Exposition des Arts Décoratifs (1925) and a Grand Prix at the Exposition Internationale of 1937. He became a Chevalier of the Légion d'Honneur in 1932. He specialised in religious figures, commemorative monuments, statues, busts and bas-reliefs, and sculpted many war memorials in the early 1920s.

SARROCCHI, Tito 1824-1900
Born in Siena on January 5, 1824, he died there on July 30, 1900. He studied under Lorenzo Bartolini and Giovanni Dupré and became one of the leading Italian sculptors of the 19th century. He specialised in busts and monuments in the Siena and Florence districts.

SARTI, Pier Angelo fl. early 19th century
Figure sculptor and poet working in Vetriano and London in the early years of the 19th century.

SARTORIO, Antoine 1885-
Born in Menton on January 27, 1885, he studied under Injalbert and Hannaux and exhibited at the Salon des Artistes Français from 1911 onwards. He won a travelling scholarship in 1920, the Légion d'Honneur in 1926, a silver medal in 1934 and the Diploma of Honour at the Exposition Internationale of 1937.

SARTORIO, Girolamo fl. early 19th century
The grandfather of Giulio A. Sartorio, he worked in Rome from 1824 to 1830. His group of Deer and Hunting Dog is in the Ambrosiana Library, Milan.

SARTORIO, Giulio Aristide 1860-1932
Born in Rome on February 11, 1860, he died there on October 3, 1932. He was the son and pupil of Raffaele Sartorio and is best known as a painter, though he was also a prolific writer, architect, engineer and sculptor. In the last named medium he specialised in plaques, bas-reliefs and medallions of classical, allegorical and medieval subjects.

SARTORIO, Giuseppe 1854-
Born at Boccieleto, Italy, in 1854, he studied under Antonino and Tabacchi and later attended classes at the Academy of St. Luke, Rome. He worked in Turin and specialised in memorials, bas-reliefs and monuments. He exhibited in Turin and Milan.

SARTORIO, Jacqueline fl. 20th century
French sculptress of portraits and figures. She won a bronze medal at the Salon des Artistes Français in 1943.

SARTORIO, Raffaele fl. 19th century
Genre and neo-classical painter and sculptor working in Rome in the mid-19th century.

SARTORIO, Xavier fl. 19th century
Born at Calco Superiore, Italy, on December 26, 1846, he worked as a decorative sculptor and modeller of statuettes in Geneva.

SASSONE, Antonio 1906-
Born in Argentina in 1906, he studied at the Buenos Aires Art School and won the Argentinian national prize for sculpture in 1941. He sculpts figures and groups in the Expressionist manner.

SASSU, Aligi 1912-
Born in Italy in 1912, he specialises in animal figures, such as his bronze Rearing Horse (1958).

SATTLER, Josef Ignac 1852-1927
Born in Linz on February 1, 1852, he died there on February 12, 1927. He studied under Eugen Kolb in Munich and Kundmann in Vienna and specialised in figures and reliefs of religious subjects.

SATTLER, Thomas 'Gaudes' fl. early 19th century
He worked in Königswart, Austria, as a decorative sculptor in the 1830s. Königswart Museum has terra cotta statuettes of Luna and Mars and a bust of Prince Metternich by him.

SATZINGER, Karl 1864-
Born at Bubenheim, Germany, on July 6, 1864, he studied under W. von Rümann and worked as a decorative sculptor near Munich.

SAUDEK, Rudolf 1880-
Born in Kilin, Bohemia, on October 20, 1880, he studied at the academies of Leipzig, Prague and Florence and specialised in busts of distinguished contemporary figures, such as Nietzsche and Wagner.

SAUER, Wilhelm 1865-1929
Born at Odeshofen, near Kehl, Germany, on September 23, 1865, he died in Durlach on March 20, 1929. He studied in Paris and Rome and was a pupil of J. Kopf in Karlsruhe. He produced statues and fountains for the Karslruhe area.

SAULO, Georges Ernest 1865-
Born in Angers on September 16, 1865, he studied under Cavelier and Roubaud and exhibited figures at the Salon des Artistes Français, winning a travelling scholarship in 1891. He was awarded a silver medal at the Exposition Universelle of 1889. Examples of his work are in the museums of Angers, Brives and Beaufort.

SAULO, Maurice 1901-
Born in Paris on December 14, 1901, he was the son and pupil of the sculptor G.E. Saulo and also studied under Coutan. He exhibited sentimental and genre figures at the Salon des Artistes Français from 1919 onwards, getting an honourable mention in 1921, a travelling scholarship in 1925 and bronze and gold medals in 1927 and 1934 respectively. His works include Venetia (Petit Palais) and Resignation (Angers Museum).

SAUPIQUE, Georges Laurent 1889-
Born in Paris on May 17, 1889, he studied under Coutan, Lefebvre and Rousaud. He exhibited at the Salon des Artistes Français (1922-24 and 1945), the Tuileries (1926), the Salon d' Automne (1923), the Exposition des Arts Décoratifs (1925), the Exposition Coloniale (1931) and the Exposition Internationale (1937). He specialised in busts and heads of French colonial types, nude statuettes and allegories of the Fourth Republic.

SAUSSE, Honoré 1891-
Born in Toulon on January 31, 1891, he studied under Coutan and exhibited at the Salon des Artistes Français from 1911, winning a bronze medal in 1930, the Prix Magnan in 1931 and a silver medal in 1932. He sculpted war memorials at Toulon and Enghien and specialised in busts of cultural celebrities.

SAUTTER, Adolf 1877-
Born in Pforzheim, Germany, on October 30, 1877, he worked in Württemberg as a decorative sculptor.

SAUTTER, Hans 1877-
Born in Munich in 1877, he worked as a religious sculptor in Cassel. Examples of his work are in the Folkwang Museum, Essen.

SAUVAGE, Jean Pierre Armand 1821-1883
Born in Abbeville, France, on April 11, 1821, he died at Vichy on June 20, 1883. He produced busts and medallions portraying his contemporaries. Examples are preserved in the Abbeville Museum.

SAUVAGE, Zette fl. 20th century
Born in Nancy in the early years of this century, she exhibited figures at the Salon d'Automne in the inter-war period.

SAUVAGEAU, Louis 1822-c.1874
Born in Paris on July 22, 1822, he died some time after 1874. He studied under Lequien and Toussaint and exhibited at the Salon from 1848 to 1874. He tried his hand at every aspect of sculpture – genre, religious, mythological, classical, allegorical and Animalier and specialised in busts, bas-reliefs, plaques and medallions in terra cotta and bronze.

SAVAGE, Donald Percival 1926-
Born in Brisbane, Queensland, on October 12, 1926, he studied in Brisbane and Sydney and settled in Paris in 1949. He belonged to the Miya and Half-dozen Groups and was one of the most avant-garde of the younger Australian sculptors in the immediate post-war era. He sculpts abstracts.

SAVILL, Bruce Wilder 1893-
Born in Quincy, Massachusetts, on March 16, 1893, he studied at the Boston Museum School and was a pupil of Cyrus Dallin and Henry Hudson Kitson. A member of the American Federation of Arts, he specialised in portrait busts and reliefs, commemorative bas-reliefs and monumental statuary. He taught modelling at Ohio State University and Columbus Art School.

SAVINE, Léopold Pierre Antoine 1861-
Born in Paris on March 6, 1861, he studied under Injalbert and exhibited religious statuettes at the Salon des Artistes Français from 1888, getting an honourable mention in 1892 and a bronze medal at the Exposition Universelle of 1900.

SAVREAUX, Henri Eugène fl. 19th century
Born in Paris in the first half of the 19th century, he studied under Cogniet, Cornu and Jouffroy and exhibited figures at the Salon from 1869.

SAWYER, Edward Warren 1876-
Born in Chicago on March 17, 1876, he studied under J.P. Laurens, Injalbert, Verlet, Frémiet and Rodin and received many awards at the Salon from 1914 onwards. His figures and portraits are in the Museum of Modern Art, Paris, and several American museums.

SAXELLIN, Into 1883-1926
Born in Finland in 1883, he died in Paris on May 26, 1926. He specialised in genre and allegorical statuettes, examples of which are in the Helsinki Athenaeum.

SBRAVATI, Giuseppe 1743-1818
Born in Parma, Italy, in 1743, he died there on October 30, 1818. He studied under J.B. Boudard and was appointed professor at the Parma School of Painting. He sculpted figures and reliefs for the churches and chapels of Parma, mostly in marble and wood.

SBRICOLI, Silvio 1864-1903
Born in Rome in 1864, he died there on November 30, 1903. He studied under P. d'Epinay and exhibited figures in Turin Venice and Bologna.

SCAILLIET, Émile Philippe 1846-1911
Born in Paris in 1846, he died there in 1911. He studied under Lehmann, Jouffroy and Moreau-Vautier and exhibited figures at the Salon des Artistes Français from 1906, getting an honourable mention in 1907.

SCALVINI, Giuseppe 1908-
Born in Italy in 1908 he produces genre and allegorical bronzes, such as Offering (1957).

SCHAAF, Anton 1869-
Born in Milwaukee, Wisconsin, on February 22, 1869, he studied under Shirlaw, Cox, Beckwith and Saint-Gaudens and worked as a decorative sculptor in New York. His minor works include portrait reliefs and figures, mostly of military personalities.

SCHAAR, Pierre 1872-
Born in Schaerbeek, Belgium, on July 30, 1872, he studied at the Brussels Academy and specialised in figures and groups of dogs. He also sculpted medallions and bas-reliefs.

SCHAARSCHMIDT, Johann Gotthilf 1823-1850
Born a deaf-mute at Streckewalde, Saxony, on December 27, 1823, he died in Dresden in 1850. He studied under F. Funk and E. Rietschel and specialised in portrait busts and heads.

SCHÄDLER, August 1862-1925
Born at Ratzenried, Bavaria, on June 22, 1862, he died in Munich on September 28, 1925. He studied under Widnmann and worked as a potter and sculptor of portrait busts and figures of contemporary celebrities. His best known work is the statue of A. von Gegenbaur at Wangen.

SCHÄDLER, Rudolf fl. 19th-20th centuries
Sculptor of religious bas-reliefs and groups, working in Austria and Liechtenstein at the turn of the century.

SCHADOW, Johann Gottfried 1764-1850
Born in Berlin on May 20, 1764, he died there on January 27, 1850. He studied under P. Tassaert and went to Rome in 1785 where he was a pupil of Trippels. On his return to Berlin in 1787 he succeeded Tassaert as Prussian Court Sculptor and Secretary to the Berlin Academy and became Director in 1816. His keen interest in nature is reflected in his sculpture and he exerted considerable influence on the development of German naturalistic sculpture in the 19th century. He specialised in busts of German royalty and contemporary celebrities, but also sculpted many bas-reliefs, statues and monuments, the best known being the Quadriga on the Brandenburg Gate. His minor works include numerous statuettes of biblical, classical and genre subjects.

SCHADOW, Karl Zeno Rudolph 'Ridolfo' 1786-1822
Born in Rome on July 9, 1786, the eldest son of Johann Gottfried Schadow, he died in Rome on January 31, 1822. He studied under his father in Berlin and returned to Rome in 1810 where he worked under Canova and Thorvaldsen. He was extremely versatile, sculpting religious, classical and genre figures and portrait busts. He worked in London for some time, sculpting a series of bas-reliefs for the Duke of Devonshire and the Marquis of Lansdowne. His best known work was the colossal group, commissioned by the King of Prussia, of Achilles with the Body of Penthesilea.

SCHAEFER, Hans 1875-
Born in Sternberg, Germany, on February 13, 1875, he emigrated to the United States in 1919 and settled in Chicago. He specialised in busts, statuettes, bas-reliefs and medallions of contemporary American and European celebrities, particularly royalty.

SCHAEFER, Henry Thomas fl. 19th-20th centuries
Painter and sculptor of genre subjects working in London at the turn of the century. He exhibited at the Society of British Artists, the Royal Academy and the British Institution from 1873 to 1915.

SCHAEFFER, Heinrich 1818-1873
Born in Trier in 1818, he died in Rome on September 5, 1873. He specialised in portrait busts.

SCHAER-KRAUSE, Ida 1877-
Born in Berlin on February 13, 1877, she studied under H. Kokolsky and Adolf Brütt and settled in Zug, Switzerland, where she sculpted portraits and figures.

SCHÄFER, Adam Joseph 1798-1871
Born in Kronach, Bavaria, on March 6, 1798, he died in Bamberg on December 30, 1871. He studied under Georg Hoffmann in Bamberg and then enrolled at the Munich Academy. He worked as a decorative sculptor in Bamberg and sculpted many altars, tombs, memorials and fountains.

SCHÄFER, Bruno Otto 1883-
Born in Leipzig on September 5, 1883, he worked as a decorative sculptor in Frankfurt-am-Main.

SCHÄFER, Karl 1888-
Born in Geislingen, Germany, on June 30, 1888, he studied at the academies of Stuttgart and Munich and worked as an architectural sculptor in Berlin, Cologne and Ulm.

SCHÄFER, Philipp Otto 1868-
Born in Darmstadt on April 28, 1868, he studied under Ferdinand Keller, L. von Löfftz and F. Kirchbach and worked as a painter and sculptor of genre subjects.

SCHALLER, Johann Nepomuk 1777-1842
Born in Vienna on March 30, 1777, he died there on February 15, 1842. He was employed as a modeller at the Vienna porcelain factory, but also sculpted many busts of the Austrian Imperial family and classical figures and groups.

SCHALLER, Ludwig 1804-1865
Born in Vienna on October 10, 1804, he died in Munich on April 29, 1865. He was the nephew and pupil of Johann N. Schaller and later studied at the Vienna and Munich academies. He sculpted many statues in Vienna, Munich and Weimar. His minor works are represented in several German, Austrian and Hungarian museums.

SCHAMBERGER, Johann Nikolaus 1771-1841
Born in Erlangen in 1771, he died there on September 1, 1841. He sculpted many tombs, statues, fountains and religious figures for churches in the Erlangen area.

SCHAPER, Dorothea 1897-
Born in Berlin on May 5, 1897, the daughter of Fritz Schaper, she studied at the School of Decorative Arts, Berlin and specialised in busts and allegorical groups.

SCHAPER, Fritz 1841-1919
Born in Alsleben, Prussia, on July 31, 1841, he died in Berlin on November 28, 1919. He studied at the Berlin Academy and sculpted several important monuments to 19th century celebrities. His minor works include numerous busts and female nude statuettes.

SCHAPER, Gottfried Dietrich Christoph 1775-1851
Born in Hamburg on December 2, 1775, he died in Copenhagen on November 21, 1851. He sculpted memorials, tombs, and bas-reliefs in Copenhagen.

SCHAPER, Wolfgang 1895-1930
Born in Berlin on January 23, 1895, he died there in 1930. He was the son and pupil of Fritz Schaper and studied under Wolfsfeld and Janensch. He specialised in figures and groups of children and sportsmen.

SCHARFENBERG, Wilhelm von 1879-
Born in Bonn on July 19, 1879, he studied in Brussels under Van der Stappen, and then moved to Paris where he worked under J. Lefèvre and Verlet. He worked as a decorative sculptor in Wanfried-an-dem-Werra.

SCHARFF, Anton 1845-1903
Born in Vienna on June 10, 1845, he died at Brunn-am-Gebirge on July 5, 1903. He studied at the Vienna Academy and specialised in portrait busts, heads, bas-reliefs and medallions. He was awarded a Grand Prix at the Exposition Universelle of 1900.

SCHARFF, Cäsar 1864-1902
Born in Hamburg on December 22, 1864, he died at Allt-Rahlstedt on October 21, 1902. He worked as an architectural and ecclesiastical sculptor.

SCHARFF, Erwin 1887-1955
Born at Neu-Ulm on the Danube on March 21, 1887, he died in Hamburg in 1955. He studied painting at the Munich Academy and later took lessons in sculpting from Hackl and Herterich. He visited France in 1911-13 and had his first one-man show at the Gaspari Gallery in Munich in the latter year. He also became a founder member of the New Secession that year. He served in the German Army from 1915 to 1918 and was appointed to a teaching post at the Berlin School of Decorative Arts in 1923. He was dismissed by the Nazis in 1933 and though he managed to get a professorship in Düsseldorf the following year he was again dismissed in 1937. Many of his paintings and sculptures were seized by the Nazis and destroyed. After the second world war he became a professor at the Hamburg Academy, a post he held until his death. In 1956 an important retrospective was held at the Hamburg Kunsthalle. He produced many genre figures and groups, busts and heads of his contemporaries and a number of colossal works, such as the Neu-Ulm monument (1929-32) and the 23-feet high Horse Breaker in Düsseldorf's exhibition park.

SCHATZ, Boris 1867-1932
Born at Vorno, Russia, on December 23, 1867, he died in Denver, Colorado, on March 23, 1932. His family moved from Russia to Bulgaria in 1878 to escape the Jewish pogroms and later he studied in Warsaw and Paris and the Academy of Fine Arts in Sofia. He is regarded as the founder of modern sculpture in Bulgaria, profucing bas-reliefs, figures and groups of biblical subjects, such as The Scribe and The Mother of Moses. His works are represented in public collections in Bulgaria, Israel and the United States.

SCHAUSS, Martin 1867-1927
Born in Berlin on September 25, 1867, he died there in January 1927. He studied at the Berlin Academy and the Academy of St. Luke in Rome and specialised in genre figures, such as Siesta and Boy with Cock, busts of his contemporaries and medallions and plaques.

SCHECK, Gottlieb fl. 19th century
Born in Ruteshem, Germany, on March 15, 1844, he studied under Wagner and Jouffroy and worked in Stuttgart where he specialised in memorials, plaques and portrait medallions.

SCHEEL, Joseph 1853-1923
Born in Wäschenbeuren, Germany, on February 7, 1853, he died in Munich in August 1923. He studied under Eberle and worked as a decorative sculptor in Bavaria.

SCHEFFAUER, Philipp Jakob 1756-1808
Born in Stuttgart on May 7, 1756, he died there on November 13, 1808. He became Sculptor to the Württemberg Court at Stuttgart. The National Gallery in Stuttgart has many of his portrait busts, allegories, such as the Spirit of Death, medallion portraits and biblical groups, such as Jacob wrestling with the Angel.

SCHEFFER, Ary 1795-1858
Born in Dordrecht, Holland, on February 10, 1795, he died at Argenteuil, France, on June 15, 1858. He was the son and pupil of the painter J.B. Scheffer, a German who had settled in the Netherlands. He himself is best known as a painter, etcher, engraver and lithographer of historical, genre and portrait subjects and won the prize of the Antwerp Exhibition of 1816 for his paintings. He was appointed tutor to the children of the Duke of Orleans, who became King Louis Philippe of France in 1830. Thereafter he received many commissions for monuments, memorials, statues and bas-reliefs which he sculpted in the romantic idiom. He was very extravagant and died in great poverty. He became a Chevalier of the Légion d'Honneur in 1828 and an Officier in 1835. The main collection of his work is in the Scheffer Museum, Dordrecht.
Etex, A. *Ary Scheffer* (1859). Mrs. Grote *Life of A. Scheffer* (1860).

SCHEFFER, Cornelia (Madame Marjolin) 1830-1899
Born in Paris on July 29, 1830, she died there on December 20, 1899. She was the daughter of Ary Scheffer and produced busts of her contemporaries (including her father) and historical personalities. Examples of her work are in the Boymans Museum, Rotterdam and the Scheffer Museum, Dordrecht.

SCHEIBE, Richard 1879-
Born in Chemnitz (now Karl Marx Stadt) on April 19, 1879, he studied painting in Dresden and Munich but went to Rome in 1899 and took up sculpture. He worked in Frankfurt-am-Main and was appointed professor at the Berlin School of Fine Arts in 1935. He is best remembered for the Saarland Liberation monument at Höchst, sculpted in 1935.

SCHEIBER, Franz Paul 1875-
Born at Umhausen, Germany, on March 23, 1875, he studied under W. von Rümann and worked in Munich where he specialised in genre and religious figures. His statuette The Sheaf-binder is in the Ferdinandeum, Innsbruck.

SCHEIBLER, Carl Friedrich Heinrich fl. early 19th century
He studied under Bardou and exhibited figures and groups at the Berlin Academy from 1800 to 1838.

SCHELER, Heinrich Christoph Friedrich 1843-1900
Born in Coburg on June 6, 1843, he died there on March 1, 1900. He studied under T. Wagner and became Court Sculptor at Coburg. He produced many busts, statues and memorials in the Coburg area.

SCHELLHORN, Hans 1879-
Born in Kiel, Germany, on November 11, 1879, he studied at the Berlin Academy and worked there as a monumental and decorative sculptor. He sculpted the group of Tritons in the Berlin-Weissensee Park.

SCHENCKENHOFER, Christoph fl. 19th century
Born in Augsburg in 1830, he studied under Piloty and worked in Aarau from 1871 to 1875 and then in Munich. He was a painter and sculptor of portraits and genre subjects.

SCHERER, Hermann 1893-1927
Born in Rummingen, Switzerland, in 1893, he died in Basle in 1927. He studied under O. Roos and was influenced by Kirchner. He worked as a wood-engraver, painter and sculptor of genre figures and female statuettes.

SCHERPE, Johann 1855-
Born in Vienna on December 15, 1855, he studied under Carl Kundmann and attended classes at the Vienna Academy. He produced many busts of historical and contemporary personalities and genre and heroic figures and groups, such as The Dying Warrior.

SCHEURLE, Paul 1892-
Born at Rechberghausen, Germany, on June 18, 1892, he worked as a decorative sculptor in Munich.

SCHEWEN, Bernhard 1874-1907
Born in Münster in 1874, he died in Neuss on May 7, 1907. He studied at the Düsseldorf Academy and sculpted the war memorial at Steinhagen. He worked as a decorative sculptor mainly in the Wiedenbruck district.

SCHEY, Jean 1791-1843
Born in Paris on April 23, 1791, he died there in 1843. He studied under Lemot and Regnault and attended the School of Fine Arts in 1813. He exhibited figures at the Salon in 1839-40, getting a third class medal in the latter years.

SCHICHTMEYER, Johannes 1861-
Born in Danzig on May 2, 1861, he studied under Fritz Schaper and worked in Dresden as a sculptor of figures and portraits. He got an honourable mention at the Exposition Universelle of 1900.

SCHIERBECK, Christian Peter 1835-1865
Born in Copenhagen on March 31, 1835, he died in Rome on October 8, 1865. He studied under P. Petersen, H.V. Bissen and attended classes at the Academy. He went to Rome in 1863 to continue his studies there but died after a sudden illness. Although his career was very brief he produced many figures and groups, examples of which are in the museums of Copenhagen and Aalborg.

SCHIERBECK, F. fl. 19th century
Danish sculptor of the mid-19th century. The Copenhagen Museum has a marble group of Young Boys in the Bath.

SCHIERHOLZ, Friedrich Johann Georg 1840-1894
Born in Frankfurt-am-Main on April 27, 1840, he died there on February 2, 1894. He studied at the Institut Städel and was a pupil of Widnmann. He worked in Frankfurt as a monumental sculptor and executed many statues for churches, public buildings and parks in that city. His minor works include busts of his contemporaries in the Frankfurt Municipal Library.

SCHIES, Hermann 1836-1899
Born at Eltville, Germany, on July 29, 1836, he died in Wiesbaden on February 19, 1899. He studied under Hopfgarten and Drake in Berlin and became professor at the Wiesbaden School of Fine Arts. He sculpted a number of war memorials in Wiesbaden and the neighbouring towns in the aftermath of the Franco-German war of 1870-71.

SCHIESTL, Heinrich 1864-
Born in Wurzburg on February 22, 1864, he studied at the Munich Academy and was a pupil of Eberle. He settled in Wurzburg, where he specialised in religious figures and reliefs.

SCHIEVELBEINE, Hermann Friedrich Anton 1817-1867
Born in Berlin on November 18, 1817, he died there on August 6, 1867. He studied at the Academy and won the Grand Prix. He

worked as a painter, architect and sculptor in many parts of Germany and produced monuments to historic personalities, such as Luther, Melanchthon, Von Stein and heroes of the Napoleonic era. His minor works include portrait busts and allegories, such as Winter Evening, Summer Evening, and classical groups, such as Pallas Athene teaching a Young Man the use of Weapons.

SCHILD, Carl 1831-1906
Born in Vienna in 1831, he died there on July 22, 1906. He studied under F. Dobyaschovsky, F. Bauer, Josef Kässmann and Hans Gasser and worked as a painter and sculptor of portrait busts and reliefs.

SCHILLER, Franz Bernhard 1815-1857
Born at Ostritz on October 28, 1815, he died in Hamburg on May 13, 1867. He studied under Joseph Gareis in Ostritz, Schwanthaler in Munich and Rietschel in Dresden and then settled in Hamburg (1842), where he specialised in portrait busts, mainly in marble.

SCHILLING, Johannes 1828-1910
Born in Mittweida on June 23, 1828, he died at Klotzsch, near Dresden, on March 21, 1910. He enrolled at the Dresden Academy in 1842 and worked with Rietschel from 1845 to 1850. He later studied in Berlin and then went for three years to Italy, where he became influenced by classical sculpture. Following his return to Dresden he was appointed professor at the Academy and thereafter became one of the leading sculptors of the Idealist School in Dresden. He specialised in classical and allegorical figures and groups, typified by The Night with Sleep and Dreaming (Weimar Museum), Centaurs, Joyful Stars and similar works.

SCHILLINGER, Gyula 1888-1930
Born in Budapest on February 20, 1888, he died in Davos, Switzerland, on April 5, 1930. He won the Prix de Rome in 1913 and specialised in small figures and groups of animals. Many of his animal sculptures are in the Budapest National Museum.

SCHILSKY, Eric 1898-1974
Born in Southampton in 1898, he died in Edinburgh on April 29, 1974. He studied at the Slade School of Art and taught at the Central School of Arts and Crafts. After the second world war he became head of the sculpture department at the Edinburgh College of Art and retired in 1969. He was elected A.R.S.A. (1952), R.S.A. (1956) and A.R.A. (1957). He was best known as a portrait sculptor in stone and bronze, but also sculpted genre figures, such as Portrait Figure (1922) and Sleeping Child (1933).

SCHILT, Otto Heinrich 1888-
Born at Frauenfeld, Switzerland, in 1888, he studied under J. Vibert and worked as a decorative sculptor in Geneva.

SCHIMECK, Ludwig 1837-1886
Born in Prague on February 19, 1837, he died there on January 25, 1886. He studied at the Prague Academy under Joseph Max and was a pupil of Widnmann in Munich. He worked in Rome from 1864 to 1870 before returning to his native city. He specialised in busts and figures of German, Austrian and Bohemian historical personalities.

SCHIMKOWITZ, Ottmar 1864-
Born in Tarts, Hungary, of German parents, on October 2, 1864, he studied at the Vienna Academy under Hellmer and Kundmann and then emigrated to the United States. He worked in the studio of Karl Bitter in New York (1892-95) but then decided to return to Austria and established his own workshop there. He became a member of the Vienna Secession in 1898 and was its President in 1929-30. He worked at Kroisbach, near Graz, in the latter part of his career and sculpted monuments, public statuary, memorials and statuettes.

SCHIMSER, Anton fl. 18th-19th centuries
Born in Austria about the middle of the 18th century, he studied at the Vienna Academy and worked in Paris before settling in Lwow in 1812. He was strongly influenced by Canova and sculpted many monuments and statues in the classical idiom in Lwow, where he died in 1836.

SCHINDLER, Anna Margareta 1893-1929
Born in Kennelbach, Austria, on October 26, 1893, she died in Vienna on June 14, 1929. She studied at the Geneva School of Fine Arts and the Vienna Academy under J. Mullner and later worked for several years in Rome.

SCHINDLER, Ferdinand Hieronymus fl. 19th century
Prussian sculptor of figures and groups, he studied under Schievelbeine and worked in Rome in 1858-59. Nothing is known of him after 1867.

SCHINDLER, Franz Johann Alois 1808-1856
Born at Urmitz in 1808, he died in Rome on December 12, 1856. He settled in Rome in 1840 and sculpted figures and reliefs in the neo-classical manner.

SCHIRMER, Robert 1850-1923
Born in Berlin on July 11, 1850, he died there on September 23, 1923.

SCHIRRER, Albert fl. 19th-20th centuries
Portrait and genre sculptor working in Menton at the turn of the century. He exhibited figures at the Salon des Artistes Français and got an honourable mention in 1889 and a third class medal in 1901.

SCHLAFHORST, Maria 1865-1925
Born in München Gladbach on April 12, 1865, she died there on January 15, 1925. She studied under Wadere and worked in southern Germany, specialising in busts of German royalty and society celebrities.

SCHLAGETER, Arthur Charles 1883-
Born in Clarens, Switzerland, on December 11, 1883, he studied under A. Huguet, A. Cacheux, N. Jacques, B. Caniez and Carl Angst and worked as a decorative sculptor in Geneva, Roubaix and Denain. His minor works include genre figures and groups. He was also employed on the restoration of Lausanne Cathedral.

SCHLATT, Franz 1765-1843
Born in Lucerne on September 16, 1765, he died there on December 28, 1843. He sculpted decoration for the façade of Lucerne theatres and also produced portrait busts.

SCHLEE, Kaspar Johann Michael 1799-1874
Born in Beromunster on June 14, 1799, he died in Berne on December 12, 1874. He studied under Franz Schlatt and produced busts of contemporary celebrities in Berne, in clay and bronze.

SCHLEGELL, Martha von (née Schulz) 1861-
Born in Johanngeorgenstadt, Saxony, on January 12, 1861, she studied under A. Klamroth and worked as a portrait and genre sculptress in Chemnitz.

SCHLEIDT, Cornelius 1814-1868
Born in Mainz on February 20, 1814, he died there on March 31, 1868. He became professor of drawing at Mainz, but also modelled figures and groups.

SCHLEY, Paul 1854-
Born in Berlin on July 22, 1854, he was the son and pupil of the wood-carver Carl Schley. He studied at the School of Fine Arts in Berlin and worked in the studio of H. Naack in Berlin and later with A. Waagen in Vienna. He produced animal and human figures and groups.

SCHLIEPHACKE, Walter 1877-
Born in Ilsenburg, Germany, on October 12, 1877, he studied at the School of Industrial Arts in Hanover and also at the Munich Academy. He worked as a painter and sculptor of portraits and genre subjects in Cassel and Marburg.

SCHLIEPSTEIN, Gerhard 1886-
Born in Brunswick on October 21, 1886, he worked in Berlin, where he sculpted genre figures and groups. He was also employed as a modeller by the KPM and Rosenthal porcelain factories.

SCHLIESSLER, Otto 1885-
Born in Forbach, Germany, on October 18, 1885, he studied in Karlsruhe under H. Volz and spent some time in Rome and Florence before settling in Karlsruhe, where he worked as a decorative sculptor. Examples of his figures and reliefs are in the museums of Karlsruhe, Mannheim, Nuremberg, Wiesbaden and Worms.

SCHLITZ, Emil Friedrich Franz Maximilian Graf von
1851-1914
Born in Berlin on February 15, 1851, he died in Frankfurt-am-Main on October 9, 1914. He studied under Joseph Echteler in Munich and

was Director of the Weimar School of Fine Arts from 1885 to 1901. He produced historic and heroic figures, allegories and religious sculpture and decorated churches and public buildings in Berlin.

SCHLOSSER, Ernest fl. early 20th century
Born in Wiesbaden in the late 19th century, he studied under Injalbert and worked in Paris. He exhibited figures at the Salon des Artistes Français, getting an honourable mention in 1909.

SCHLÖTH, Achilles 1858-1904
Born in Basle on November 7, 1858, he died there on July 5, 1904. He was the nephew of Ferdinand Schlöth and assisted him in sculpting religious, allegorical and historical figures.

SCHLÖTH, Lukas Ferdinand 1818-1891
Born in Basle on January 25, 1818, he died in Thal on August 2, 1891. He studied in Basle and Munich before going to Rome, where he was strongly influenced by the work of Canova and Thorvaldsen. He worked in Basle and Neuchatel and was a prolific sculptor who had an enormous influence on the development of Swiss sculpture in the second half of the 19th century. Examples of his figures are in the museums of Basle and Neuchatel.

SCHLOTTER, Heinrich 1886-
Born in Hildesheim on June 16, 1886, he studied in Berlin under Schmarje and Haverkamp and worked in Hildesheim and Hanover as a decorative sculptor.

SCHLÜTER, Carl H.W. 1846-1884
Descendant of the great Prussian sculptor of the 17th century Andreas Schlüter, he was born at Pinneberg on October 24, 1846, and died in Dresden on October 25, 1884. He studied under Schilling at the Dresden Academy and then went to Rome to complete his studies. He specialised in genre figures in the classical idiom, such as Young Roman Shepherd, Nude Girl, Girl pouring Water and portrait busts of his family and friends.

SCHMARJE, Walter 1872-1921
Born in Flensburg on August 16, 1872, he died in Berlin on November 5, 1921. He studied under Reinhold Begas in Berlin and specialised in fountains, tombs and public statuary. His minor works include statuettes of classical subjects, such as Young Satyr (Brunswick Museum).

SCHMELZER, Josef fl. 19th century
Portrait and figure sculptor working in Budapest (1809-20) and Vienna (1820-24).

SCHMID, Adolf 1867-
Born in Stuttgart on July 15, 1867, he produced bronze statuettes, medallions and plaques portraying German royalty and contemporary figures.

SCHMID, Alexander 1833-1901
Born in Sonneberg, Germany, on February 14, 1833, he died in Coburg on March 7, 1901. He founded a school of design in Sonneberg and moved to Coburg in 1884. As a sculptor he is best known for the Victory monument in Meissen, but he also sculpted allegorical figures (Germania) and portrait busts.

SCHMID, Hans Sebastian 1862-c.1926
Born in Munich on June 22, 1862, he died there about 1926. He studied under Widnmann and worked as an art critic, author, painter and sculptor of genre figures and portraits.

SCHMID, Henry fl. 19th-20th centuries
Born in Paris in the second half of the 19th century, he studied under Thomas and became an Associate of the Artistes Français in 1893. He exhibited figures and portraits at that Salon, winning an honourable mention in 1896, a second class medal in 1897 and a third class medal in 1900. He also got an honourable mention at the Exposition Universelle of that year.

SCHMID, Joseph 1842-1914
Born in Bozen (Bolzano) on August 2, 1842, he died in Innsbruck on February 23, 1914. He studied at the Munich Academy (1864-66) and worked as an architect and decorative sculptor, mainly for the churches of the Tyrol.

SCHMIDGRUBER, Anton 1837-1909
Born in Vienna on March 26, 1837, he died there on April 18, 1909. He studied under Franz Bauer and worked in Rome for a year (1868) before returning to Vienna, where he sculpted figures and groups and bas-reliefs for public buildings.

SCHMIDT, August 1811-1886
Born in 1811, he died in Augsburg on January 24, 1886. He studied at the Munich Academy and worked as a decorative sculptor in Munich and Augsburg.

SCHMIDT, Christian 1869-
Born in Halle, Saxony, on June 11, 1869, he studied at the Dresden Academy and specialised in genre figures. His best known work is the bronze Archer in the Halle Zoo Park.

SCHMIDT, Fritz 1876-1935
Born in Munich on February 3, 1876, he died there on February 21, 1935. He studied under Fritz von Millers and succeeded him as professor at the Munich School of Industrial Arts. He specialised in small decorative sculpture.

SCHMIDT, Gustav Heinrich 1803-c.1846
Born in Königsberg in 1803, he died there about 1846. He studied under his father, Johann Heinrich Schmidt, and was a pupil of L.W. Wichmann in Berlin from 1822 to 1826, before going to the Vienna Academy (1827) and the Munich Academy (1828-29). He sculpted neo-classical figures and groups.

SCHMIDT, Johann Heinrich 1741-1821
Born in Derenthal, southern Germany, in 1741, he died at Ludwigsburg, Bavaria, on December 1, 1821. He was employed at the Ludwigsburg porcelain factory as a modeller of figurines, but he also produced small decorative bronzes.

SCHMIDT, Louise 1874-
Born in Frankfurt-am-Main on April 2, 1874, she studied under F. Haussmann and Puech. She worked on decorative sculpture in Frankfurt, Usingen and Eppstein, but her minor works include busts and statuettes of historical personalities.

SCHMIDT, Margaret 1899-
Born in London on June 17, 1899, she studied at the Goldsmiths' College School of Art and exhibited figures and portraits at the Royal Academy, the Royal Scottish Academy and the Paris Salons in the inter-war period.

SCHMIDT, Rudolf 1894-
Born in Vienna on April 19, 1894, he studied under Otto Hofner and attended classes at the Academy. He worked at Rodaun, near Vienna, and specialised in bronze busts, plaques and medallions, many of which are preserved in the museums of Vienna.

SCHMIDTCASSEL, Gustav 1867-
Born in Cassel on November 2, 1867, he studied under Herter and worked in the Baltic states. His chief work is the monument to Peter the Great in Riga. He produced numerous busts and statuettes of historical personalities.

SCHMIDT-ROTTLUFF, Karl 1884-
Born at Rottluff, near Chemnitz, on December 14, 1884, he studied in Dresden and became a founder member of the Brücke Movement in 1905. He travelled widely in India, the Balkans, Switzerland, France and Italy, working mainly as a landscape painter, lithographer and wood-engraver, though he also modelled figures which gradually changed from Impressionism to Expressionism in the 1920s.

SCHMIED, Friedrich 1893-
Born in Zurich on July 26, 1893, he studied under J. Vibert and specialised in portrait busts, genre and allegorical figures and groups in marble and bronze. Examples of his work are to be found in many Swiss museums.

SCHMIRGUELA, Nicolas fl. 20th century
Bulgarian sculptor of monuments, figures and bas-reliefs working before the second world war.

SCHMITT, Balthasar 1858-
Born in Aschach, Bavaria, on May 29, 1858, he studied under Michael Arnold in Kissingen, under Eberle in Nuremberg, and also worked in

Munich and Rome (1889-1902). He was appointed professor of sculpture at the Munich Academy in 1906. He sculpted a number of monuments, notably the colossal statue of Schwind in Munich and the Kilian fountain in Wurzburg. His minor works include maquettes and projects for monuments, portrait busts and religious figures.

SCHMITT, Jakob Ludwig 1891-
Born in Mainz on October 11, 1891, he was blinded in the first world war but continued to model genre figures and groups. His sculpture includes The Bowls-player (Essen), the statue of St. Theresa (Frankfurt-am-Main) and The Duck-seller on the fountain in the market-place, Mainz.

SCHMUTZER, Ferdinand (Senior) 1833-1915
Born in Vienna in 1833, he died there in April 1915. He was the son of Vincent Schmutzer, a stone-mason and monumental sculptor, and was the father of the genre painter Ferdinand Schmutzer, Junior. He studied under Franz Bauer at the Vienna Academy and specialised in animal figures and groups.

SCHNABEL, Day 1905-
Born in Vienna in 1905, she studied painting at the Academy, then architecture and sculpture in the Netherlands, Italy and France. She spent the second world war in New York and since 1947 has commuted between New York and Paris, where she has had numerous individual shows as well as taking part in national and international exhibitions, notably the Salon de Mai and the Salon de la Jeune Sculpture, the Antwerp Biennale and modern sculpture exhibitions in London, Amsterdam, New York, Madrid and Brussels. She has worked in plaster, wrought iron and bronze, producing abstracts and bas-reliefs. Her bronzes include Transformation (1955), Temple (1957), and The Wall (1959).

SCHNAUDER, Reinhard 1856-1923
Born in Plauen on December 9, 1856, he died in Dresden on October 14, 1923. He studied at the Dresden Academy and worked with Hähnel. His chief work is the decorative sculpture in the Hall of Memory at Görlitz, but he also sculpted allegorical statuettes.

SCHNAUDER, Richard Georg 1886-
Born in Dresden on January 12, 1886, he studied at the School of Industrial Arts and later worked for some time in Paris, modelling genre figures.

SCHNECKENDORF, Josef Emil 1865-
Born in Kronstadt, Romania, on December 29, 1865, he studied at the Munich Academy and settled in Bavaria where he worked as a decorative sculptor.

SCHNEGG, Lucien 1864-1909
Born in Bordeaux on April 19, 1864, he died in Paris on December 22, 1909. He exhibited at the Salon des Artistes Français, the Nationale and the Indépendants and won a gold medal at the Exposition Universelle of 1900. The Luxembourg Museum has his bust of a Young Girl (in fact a portrait of the sculptress, Jane Poupelet, as a child). His bronze statuettes of Young Man and Aphrodite are in the Petit Palais.

SCHNEIDER, Charles 1881-
Born at Château Thierry on February 23, 1881, he studied under Chaplain and exhibited figures at the Salon des Artistes Français from 1906, winning a silver medal in 1926 and the Legion d'Honneur the previous year.

SCHNEIDER, Josef 1876-
Born in Eslohe, Germany, on April 25, 1876, he worked in Düsseldorf and specialised in memorials, tombs, bas-reliefs and plaques.

SCHNEIDERHAN, Maximilian 1844-1923
Born at Rexingen, Bavaria, on May 19, 1844, he died in St. Louis, Missouri, on November 24, 1923. He studied under J.N. Meindel and attended classes at the Munich Academy under Knabl (1866-70) before emigrating to the United States. He worked in Louisville, Washington and St. Louis, specialising in ecclesiastical sculpture. Many of his figures and reliefs are in the Cathedrals of Lyons and Belleville, France, as well as churches in the mid-western and southern states of the U.S.A.

SCHNIER, Jacques fl. 20th century
American artist of French origin, working in California. He has modelled figures in bronze and carves reliefs in wood and stone. As a writer he is best known for his Sculpture in Modern America (1948).

SCHNIRCH, Bohuslav 1845-1901
Born in Prague on August 10, 1845, he died there on September 30, 1901. He studied under E. Grein, Franz Bauer and M. von Widmann and worked in Italy for two years (1871-73) before returning to Prague, where he was employed on the decoration of the Rudolphinum and the Bohemian Museum.

SCHNÖLLER, Josef Anton fl. 19th century
Born in Stockach, Bavaria, in the early years of the 19th century, he worked as a decorative and portrait sculptor in Munich from 1848 to 1877.

SCHNYDER, Anton 1823-1897
Born in Lucerne on May 30, 1823, he died there on January 17, 1897. He worked as a jeweller and sculptor, specialising in small bas-reliefs, plaques, statuettes and medallions of allegorical and genre subjects.

SCHOENEWERK, Alexandre 1820-1885
Born in Paris on February 18, 1820, he committed suicide there on July 22, 1885. He studied under David d'Angers, Jolliet and Triqueti and exhibited at the Salon from 1842 to 1885, winning a third class medal in 1845 and first class medals in 1861, 1863 and 1878. He became a Chevalier of the Légion d'Honneur in 1863. His chief works include statues of historic personalities and decorative sculpture in stone for public buildings in Paris. His minor works consist of portrait busts of his contemporaries and genre figures and groups, such as Morning, Young Fisherman with a Turtle, Hesitation, Young Girl at the Fountain. He enjoyed the patronage of Princess Mathilde and was very fashionable with Paris society during the Second Empire and the early years of the Third Republic. Despite his success, however, he was subject to fits of self-doubt, and the failure of his statue of Salome to win a medal at the Salon of 1885 caused a severe depression. He threw himself out of the third-floor window of his house and died the following day.

SCHOLL Family fl. 18th-19th centuries
A prolific family of artists, descended from a stone-mason of Obereurheim in southern Germany in the late 17th century. His four sons were all stone-masons and marble-cutters but no bronzes have been recorded so far by any of them. These sons were Georg Christoph, who died at Ansbach in 1805, Johann Valentin, who worked in Bamberg, Johann who worked in Bonn and Johann Adam who worked in Trier. The sculptors noted below are the three sons and descendants of Johann Valentin, who spread from Bamberg to Mainz, Darmstadt and Bremen in the 19th century.

See Scholl Family Tree.

SCHOLL, Anton Friedrich 1839-1892
Born in Mainz on September 27, 1839, he died there on April 7, 1892. He studied under Bläser in Berlin and also worked in Paris, London and Rome. He specialised in busts of his contemporaries, examples of which are preserved in the Mainz Museum.

SCHOLL, Hermann 1875-
Born in Darmstadt on March 27, 1875, the son of Karl and the nephew of Anton Scholl. He won a travelling scholarship which took him to Berlin where he studied from 1896 to 1900. He worked in Darmstadt as a decorative sculptor and sculpted many monuments and memorials to German celebrities of the early 20th century, notably that of Reichsrath (imperial counsellor) Ludwig at Heppenheim.

SCHOLL, Johann Baptist the Elder 1784-1854
Born in Bamberg in 1784, he died in Darmstadt on July 6, 1854. He studied under Johann W. Wurzer and became Court Painter to the Grand Duke of Hesse. He also sculpted many busts in the classical manner.

SCHOLL, Johann Baptist the Younger 1818-1881
Born in Mainz on April 6, 1818, he died in Limburg, Germany, on September 26, 1881. He studied under his father, Johann Baptist Scholl the Elder, then went to the Munich Academy (1832-40) and

worked in Frankfurt, Rodelheim and Darmstadt before settling in Limburg. Though best known as a painter he sculpted the Schiller monuments in Mainz and Wiesbaden and also produced a number of statuettes and busts of historical and allegorical subjects.

SCHOLL, Johann Georg 1763-1820
Born in Bamberg in 1763, he died in Mainz on October 22, 1820. He worked in the studio of Johann Bernhard Kamm and then, from 1787 to 1794, was assistant to Sebastian Pfaff at Mainz. He produced monuments and memorials in Mainz and sculpted a series of allegorical figures for Schönbusch near Aschaffenburg.

SCHOLL, Joseph Franz 1796-1842
Born in Mainz on December 4, 1796, he died there on April 7, 1842. He studied under his father, Johann Georg Scholl, and then went to Rome. He was a member of the Overbeck Circle (1829-30) and one of the leading sculptors in Mainz in the first half of the 19th century, being employed on the restoration of the sculpture in Mainz Cathedral. His minor works include many busts of contemporary figures.

SCHOLL, Karl 1840-1912
Born in Munich on July 11, 1840, he died in Darmstadt on January 12, 1912. He studied under his father, Johann Baptist Scholl the Younger, and also at the Frankfurt School of Art. He specialised in busts of Hessian royalty and celebrities, in marble and bronze.

SCHOLL, Peter Ignaz 1780-1825
Born in Bamberg in 1780, he died in Bremen in 1825. He worked in the Hanseatic cities as a decorative sculptor.

SCHOLL, Philipp Johann Joseph 1805-1861
Born in Bremen in 1805, he died in Copenhagen on October 7, 1861. He studied under his father Peter Ignaz and his uncle Johann Baptist the Elder and worked as a decorative sculptor in Denmark.

SCHOLZ, Belle K. fl. 19th-20th centuries
American sculptress of statues and busts of American celebrities, both historical and contemporary, notably the portraits of Andrew Jackson in the Rotunda and the Hall of Fame in the Capitol, Washington.

SCHOLZ, Heinrich Karl 1880-
Born in Mildenau, Bohemia, on October 16, 1880, he studied under Bitterlich and Hellmer in Vienna where he established his own studio. He specialised in monuments dedicated to musical personalities in various Austrian towns. He also sculpted medallions, several of which are preserved in the Museum of the History of Art, Vienna.

SCHOLZ, Leopold 1874-
Born in Vienna on December 6, 1874, he studied under Anton Brenek, Hellmer and C. Kundmann and worked in Athens as a decorative sculptor.

SCHÖNAU, Hermann 1861-1900
Born in Bollstedt, Thuringia, on April 20, 1861, he died in Nuremberg on July 7, 1900. He studied at the Nuremberg School of Art and the Dresden Academy and later worked for some time in Berlin and Rome before settling in Nuremberg in 1892 where he specialised in genre statuettes, such as Sicilian and Young Girl.

SCHÖNBAUER, Henry 1894-
Born at Güns, Hungary, on March 1, 1894, he studied at the academies of Budapest, Vienna and Munich before emigrating to the United States. He worked in New York as a portrait and figure sculptor.

SCHÖNESEIFFER, Peter Joseph 1856-1922
Born in 1856, he died in Marburg on February 26, 1922. He specialised in figures and bas-reliefs of religious subjects, and decorated the Elisabethkirche in Marburg and the Cathedral of Frankfurt.

SCHÖNHARDT, Henri 1877-
Born in Providence, Rhode Island, on April 24, 1877, he studied in Paris under Puech, Dubois and Verlet at the Académie Julian and under Chevignard and David at the School of Decorative Arts. He exhibited at the Salon des Artistes Français, getting an honourable mention in 1908. On his return to the United States he was appointed professor at the Rhode Island School of Design. He sculpted a number of monuments in Providence and Bristol, Rhode Island.

SCHÖNTHALER, Franz 1821-1904
Born in Neusiedl on January 21, 1821, he died in Gutenstein on December 26, 1904. He studied in Paris under Fourdinois and Lafrance and worked in France for some time before settling in Vienna where he decorated public buildings.

SCHOOP, Ulrich 1903-
Born in Cologne on October 17, 1903, he studied in Paris and exhibited at the Indépendants and the Salon d'Automne in the late 1920s. He also worked in Zurich for some time and specialised in animal figures and groups.

SCHÖPF, Peter 1804-1875
Born in Munich in 1804, he died in Rome on September 13, 1875. He was the son and pupil of Peter Paul Schöpf and also studied at the Munich Academy (1818) and worked with Schwanthaler in Rome (1832) and subsequently with Thorvaldsen. He returned to Munich in 1838 but went back again to Rome three years later and remained there till his death. He specialised in neo-classical figures and groups.

SCHÖPF, Peter Paul 1757-1841
Born in Imst, Tyrol, in 1757, he died in Munich on April 27, 1841. He worked for twelve years as assistant to J.A. Renn and then went to Munich in 1788 where he established his own studio two years later. He also worked in Augsburg for some time before returning to Munich in 1793. He specialised in statuettes and small groups, mainly of religious subjects.

SCHOTT, Walter 1861-
Born in Ilsenburg on September 18, 1861, he studied under C. Dopmeyer and F. Schaper and worked in Berlin. He produced a number of monuments and statues of the German Imperial family, decorative sculpture and genre figures, such as The Bowls-player, casts of which are in the National Gallery, Berlin, and the Düsseldorf Museum. He was awarded a gold medal at the Exposition Universelle of 1900.

SCHOTZ, Benno 1891-
Born in Arensburg, Estonia, on September 11, 1891, he came to Britain and studied engineering at the Glasgow Royal Technical College (now the University of Strathclyde), but gave this up in favour of sculpture which he studied at the Glasgow School of Art. He had his first one-man show at the Reid Gallery in Glasgow, 1926, and then had an exhibition at the Lefevre Galleries, London, in 1930. He was head of the sculpture and ceramic departments of the Glasgow School of Art from 1938 onwards and was elected R.S.A. in 1937. He is Her Majesty's Sculptor in Ordinary for Scotland and has had many important commissions, though best known for his portraiture. His busts and heads are represented in several public collections.

SCHRAM, Alois Hans 1864-1919
Born in Vienna on August 20, 1864, he died there on April 8, 1919. He studied at the Vienna Academy and won a silver medal at the Academy exhibition of 1892. He worked with L. Burger on the decoration of the Frinkel Palace and decorated several other public buildings in Vienna at the turn of the century. His minor works include genre figures and reliefs.

SCHRATT, Ferdinand fl. 18th century
Sculptor of classical and allegorical figures, working in Constance in the late 18th century. He sculpted the figures of Jupiter and Mercury for the fountain there.

SCHREIBER, Alfred fl. 19th century
Born in Vienna in the early years of the 19th century, he studied at the Academy in 1853-54 and exhibited there in 1860-61.

SCHREINER, Carl Moritz 1889-
Born in Barmen, Westphalia, on October 17, 1889, he was self-taught and worked as a decorative sculptor in Wuppertal and Düsseldorf. He specialised in figures of lions and cats in marble and bronze.

SCHREINER, Johann Baptist 1866-
Born in Munich on December 19, 1866, he studied under von Rümann and worked in Cologne from 1894 onwards. He sculpted architectural ornament for many buildings in that area, his chief work being the monument to Adolf Kolping. His minor works include bas-reliefs, plaquettes and medallions.

SCHREITMULLER, August 1871-
Born in Munich on October 2, 1871, he studied under Eberle and Robert Diez as well as his father, Johannes D. Schreitmuller. He worked in Dresden as a decorative sculptor and sculpted the Peace fountain at Mittweida. His minor statuettes and reliefs are preserved in the museums of Dresden and Bautzen.

SCHREITMULLER, Johannes Daniel 1842-1885
Born at Bruckberg, near Ansbach, on February 23, 1842, he died at Genthin on May 30, 1885. He studied under A. Kreling and became professor at the Dresden School of Fine Arts. He produced decorative sculpture in Munich.

SCHREYOGG, Georg 1870-1934
Born in Mittenwald on August 13, 1870, he died at Karlsruhe in July 1934. He studied under W. von Rümann and was appointed professor at Karlsruhe School of Art in 1909. He is best known for the Barbara fountain in Coblenz, but also sculpted figures and reliefs for the Victoria Monastery in Karlsruhe. His minor works include portrait busts in marble and bronze.

SCHRIKKER, Cornelis 'Kees' fl. 20th century
Born in Amsterdam at the turn of the century, he worked in Paris as a painter and sculptor of genre subjects and exhibited at the Salon d'Automne.

SCHRÖDER, Ivan Nikolaievich fl. 19th century
Born in Russia in 1835, he studied under Baron Klodt and attended Pimenoff's class at the St. Petersburg Academy. He worked in Latin America from 1865 to 1869 before returning to St. Petersburg. He specialised in busts, statues and relief portraits of Russian celebrities.

SCHRÖDER, Josef fl. 19th century
Sculptor of religious figures, working at Innsbruck in the early 19th century. He is best known for a portrait of Pope Pius VII, sculpted in 1824.

SCHRÖDL, Leopold fl. 19th century
Born at Währing, near Vienna, on July 7, 1841, he was the son and pupil of Norbert Michael Schrödl, the ivory carver. He himself worked in ivory, stone, wood and bronze.

SCHROEDER, Louis Jean Désiré 1828-1898
Born in Paris on December 24, 1828, he died there in 1898. He studied under Rude and Dantan the Elder and exhibited classical and genre figures at the Salon from 1848, winning a second class medal in 1852. His works include Falling Leaves (Tours Museum) and Oedipus and Antigone (Dijon Museum)).

SCHROEDTER, Anton 1879-
Born in Coblenz on February 9, 1879, he studied under L. Habich and worked in Rome from 1907 to 1914. After war service he settled in Cologne and did decorative sculpture there and in Darmstadt.

SCHROER, Rudolf 1864-
Born in Vienna on October 1, 1864, he studied under E. Hoffmann and worked in Vienna as an ecclesiastical and ornamental sculptor.

SCHROEVENS, Cesar 1884-
Born in Antwerp on February 25, 1884, he studied under Frans Joris and Jef Lambeaux. He specialised in heads, bas-reliefs and busts of cultural celebrities in marble and bronze and worked in Brussels.

SCHROTH, Andreas fl. early 19th century
Born in Vienna in 1791, he studied at the Academy (1809-14) and exhibited there from 1820 to 1850. He worked in Vienna as a painter and sculptor of genre and allegorical subjects.

SCHROTH, Jakob 1773-1831
Born in Pest (now Budapest) in 1773, he died in Vienna on February 22, 1831. He worked as a decorative sculptor in Vienna and Weilburg, but also sculpted statuettes and small groups.

SCHROTH, Johann the Elder 1789-1857
Viennese sculptor and architect.

SCHROTH, Johann the Younger fl. 19th century
Born in Vienna in 1819, the son of the above, he worked as a decorative and portrait sculptor.

SCHROTTA, Janos Frigyes 1898-
Born at Kispest, Hungary, on May 13, 1898, he worked in Budapest as a decorative sculptor and produced a number of monuments, statues and war memorials for various Hungarian towns in the 1920s.

SCHRUERS, Xavier fl. 19th century
Belgian portrait sculptor of the second half of the 19th century. He studied under G.L. Godecharles.

SCHTSCHADILOFF, Mikhail Nikolaievich 1815-1842
Born in St. Petersburg on September 12, 1815, he died there in 1842. He studied under Boris Orlovski and worked as a portrait and genre sculptor.

SCHTSCHEDRIN, Feodossi Feodoerovich 1751-1825
Born in St. Petersburg in 1751, he died there on January 19, 1825. He studied at the Academy and was appointed Rector of the sculpture department in 1818. He specialised in classical busts and statuary and also sculpted large decorative groups in the classical idiom, many of which are still in situ on the buildings of Leningrad.

SCHUBERT, Benjamin fl. 19th century
Decorative sculptor working in Dessau in the 1830s. His minor works include figures and groups for fountains.

SCHUBERT, Hermann 1831-1917
Born in Dessau on June 12, 1831, the son of Benjamin Schubert, he died in Dresden on January 24, 1917. He studied at the Munich Academy from 1849 to 1852 and worked in Rome from 1856 to 1872 before returning to Germany. He sculpted the Jubilee fountain in Dessau and various monuments and religious statuary in Dessau and Dresden. His minor works include many busts of his contemporaries.

SCHULENBURG, Adele 1883-
Born in St. Louis, Missouri, in 1883, she studied at the St. Louis School of Fine Arts under George J. Zolnay and worked under Charles Grafly in Philadelphia. She went to Berlin and studied under Lewin Funcke at the Secession School. She specialised in reliefs, busts and maquettes derived from Mexican peasant life.

SCHULER, Édouard 1806-1882
Born in Strasbourg on August 19, 1806, he died at Lichtenthal, near Baden-Baden, in 1882. He was the son of the engraver and designer Charles L. Schuler and studied in Paris under Baron Gros. He returned to Strasbourg and produced religious and genre figures and groups.

SCHULER, Hans 1874-
Born at Morange, Lorraine, on May 25, 1874, he studied at the Académie Julian and worked in Verlet's studio in Paris before emigrating to the United States where he continued his studies at the Maryland Institute, the Charcoal Club and the Rinehart School in Baltimore. He was appointed Director of the Maryland Institute in 1925. He exhibited at the Salon des Artistes Français, winning a third class medal in 1901 and subsequently took part in many American exhibitions. He produced a large number of bronze busts of French and American personalities, neo-classical groups, such as Ariadne (Baltimore) and Paradise Lost (St. Louis Museum) and memorials, such as the John Hopkins monument in Baltimore.

SCHULER, Karl 1847-1886
Born in Nuremberg on January 11, 1847, he died in Berlin-Friedenau on April 13, 1886. He studied in Nuremberg, Berlin, Rome and Dresden, and specialised in bronze busts, statues and monuments of historical and contemporary German celebrities.

SCHULTZ, Albert 1871-
Born in Strasbourg on April 15, 1871, he studied under W. von Rümann and worked as a decorative sculptor in Alsace-Lorraine, sculpting numerous statues of historic personalities and several war memorials in the 1920s. He sculpted the Gallic Cock on the Kehl bridge.

SCHULTZ, Julius Vilhelm fl. 19th century
Danish sculptor of classical, biblical and historical figures and groups, and busts of historical and contemporary Danish celebrities. Copenhagen Museum has his group of Adam and Eve and portraits of the Young Oehlenschlager and Jans Baggesen.

SCHULZ, Arthur 1873-
Born in Berlin on August 15, 1873, he studied under Janensch and worked as an architectural sculptor in Quedlinburg, Stettin and Copenhagen. He sculpted several monuments in memory of Kaiser Friedrich in the 1890s and also produced numerous statuettes and busts of German royalty.

SCHULZ, Moritz 1825-1904
Born at Leobschutz, Prussia, on November 4, 1825, he died in Berlin on December 17, 1904. He studied at the Poznan School of Art and was a pupil of Drake at the Berlin Academy. He worked in Rome for some time before returning to Berlin where he specialised in bas-reliefs of historic scenes, such as the Battle of Sadowa (1866) on the Siegesallee. His minor works include allegorical, classical and genre figures and groups, such as Mother Love.

SCHULZ, Paul 1868-
Born in Berlin on October 26, 1868, he studied under Herter and worked in Rome from 1898 to 1915, specialising in neo-classical and allegorical figures and groups.

SCHULZ, Paul 1875-
Born at Tschirnau, Germany, on January 13, 1875, he studied under C. Behrens in Berlin and under Rodin in Paris. He is best known for his monument to Martin Luther at Reichenbach, Silesia. His minor works consisted mainly of nude statuettes.

SCHULZE, Fritz 1838-1914
Born at Rendsburg, Schleswig-Holstein, on July 17, 1838, he died in Munich on December 23, 1914. He studied at the Copenhagen Academy (1856-63) and then went to Rome for a year before settling in Munich. He specialised in classical and historical figures and groups.

SCHULZE-THEWIS, Walter 1872-
Born in Berlin on January 3, 1872, he studied at the Academy and won the Prix de Rome for sculpture in 1903. He sculpted war memorials and public statuary.

SCHUMACHER, Max 1885-
Born at Lota in Chile on November 11, 1885, he studied in Berlin and settled there as a portrait and figure sculptor.

SCHUMANN, Daniel Johann 1752-c.1809
Born in Potsdam in 1752, he died some time after 1809. He studied under A.L. Kruger and the Räntz brothers in Potsdam and later went to the Copenhagen Academy.

SCHÜPPEL, Karl 1876-
Born at Oberwurschnitz, Germany, on November 25, 1876, he studied at the Dresden Academy and the Académie Julian in Paris and worked as a decorative sculptor in Oberlungwitz, Saxony.

SCHUSTER, Maximilian 1784-1848
Born at Oberdettingen, Wurttemberg, on October 10, 1784, he died there on December 10, 1848. He specialised in religious figures and reliefs.

SCHUSTER, Michael Johann fl. 18th-19th centuries
Brother of Maximilian Schuster, with whom he worked on ecclesiastical sculpture.

SCHUTTER, Jean Louis de 1910-
Born in Antwerp on February 14, 1910, he studied under A. Dupon and won first prize at the Antwerp Royal Academy. He began his career as a painter but turned to sculpture in 1931. He has exhibited in Antwerp, Brussels, Amsterdam and Ghent since 1938 and specialised in busts of children and figures of animals and birds. His portraits include those of his father and uncle, the Belgian poets Louis and Herman de Schutter.

SCHÜTZKY, Waldemar 1881-
Born in St. Petersburg on June 12, 1881, he studied under W. von Rümann and specialised in portrait busts, plaquettes and medallions.

SCHWAB, André Pierre 1883-
Born in Nancy on August 6, 1883, he studied under Chaplain and Mercié and exhibited portrait busts, reliefs and medallions at the Salon des Artistes Français, from 1905 onwards, winning a gold medal in 1926.

SCHWABE, Heinrich 1847-
Born in Wiesbaden on October 30, 1847, he studied at the Nuremberg School of Fine Arts under Kreling and was professor of sculpture there from 1875 to 1907.

SCHWABE, Leonhard fl. 18th century
Danish sculptor of portrait busts, statues and heads. He worked on the decoration of Frederiksborg and Rosenborg castles.

SCHWADE, Heinrich 1843-1899
Born in Erfurt, Thuringia, on November 27, 1843, he died in Munich on September 26, 1899. He studied under Widmann at the Munich Academy and sculpted religious figures, notably the Twelve Apostles for St. Michael's Church in Breslau.

SCHWANTHALER Family fl. 17th-19th centuries
Seventeen members of this family were sculptors in southern Germany and Austria over a period of three centuries. They were descended from the monumental sculptor Hans Schwanthaler (c.1600-56), who worked in the Austrian town of Ried. His son Thomas (1634-1707) had four sons, all of whom were marble-cutters and monumental masons. Of these Johann Franz (1683-1762) deserves separate mention, since he was the first of the family to produce bronze statuettes. All of the later Schwanthalers were directly descended from him.

See Schwanthaler Family Tree.

SCHWANTHALER, Franz Anton 1767-1833
Born in Ried on May 10, 1767, he died in Munich in 1833. He worked as a decorative sculptor with his father, Johann Peter the Elder, and settled in Munich in 1785.

SCHWANTHALER, Franz Jakob I 1760-1801
Born in Ried on July 3, 1760, he died there in 1801. He was the son and pupil of Franz Mathias and specialised in ecclesiastical sculpture decorating various churches in Austrian towns.

SCHWANTHALER, Franz Jakob II 1760-1820
Born in Ried on August 2, 1760, he died in Munich on December 4, 1820. He was the son of Johann Peter the Elder and became one of the greatest exponents of the classical style of sculpture from its inception. He worked in Ried and Salzburg before settling in Munich, where he introduced the classical idiom. He sculpted many statues and memorials in Munich, and his minor works include busts of Bavarian royalty and celebrities of the early 19th century.

SCHWANTHALER, Franz Mathias 1714-1782
Born in Ried on June 20, 1714, he died there on April 16, 1782. He was the son of Johann Franz and sculpted figures and bas-reliefs for churches in Waldzell and Ansbach.

SCHWANTHALER, Johann Ferdinand fl. 18th century
Born in Ried on October 19, 1722, he produced ecclesiastical and secular ornament in the rococo style and is noted for having worked on the decoration of Gurten church in 1775.

SCHWANTHALER, Johann Franz 1683-1762
Born in Ried on August 16, 1683, he died there on July 3, 1762. He was the youngest son of Thomas Schwanthaler and broke with the family tradition of religious sculpture by producing lively statuettes in the late baroque manner. Examples of his work are in the Linz Museum and the Baroque Museum, Vienna.

SCHWANTHALER, Johann Georg fl. 18th century
A son of Johann Franz Schwanthaler, he worked in Gmunden from 1773 to 1790 and sculpted bas-reliefs, groups, statuettes and crèches. Several of his works are preserved in Gmunden Museum.

SCHWANTHALER, Johann Peter the Elder 1720-1795
Born in Ried on June 20, 1720, he died there on July 20, 1795. He was the second son of Johann Franz and became one of the leading exponents of the rococo style in Austria. He specialised in decorative and ecclesiastical sculpture. His Pieta is in the Baroque Museum, Vienna.

SCHWANTHALER, Johann Peter the Younger 1762-1838
Born in Ried on July 2, 1762, he died there on June 10, 1838. The second son of Johann Peter the Elder he sculpted tombs, crèches and religious figures in Ried.

SCHWANTHALER, Ludwig Michael von 1802-1848
Born in Munich on August 26, 1802, he died there on November 14, 1848. He was the son of Franz Jakob II and studied in Munich and Rome. On his return to Munich in 1832 he received many important commissions and built up a reputation as the leading master of neo-classicism in southern Germany. He enjoyed the patronage of King Ludwig I and decorated the palaces, museums and public buildings which arose in Bavaria in the 1830s. The Pinakothek has 25 of his marbles commemorating historic painters. Many of his sculptures are preserved in the Munich Palace, notably the group of twelve gilt-bronze figures in the throne-room. Other works include 92 figures decorating the Ruhmeshalle, the colossal allegory of Bavaria and the decoration on the north pediment of the Valhalla at Ratisbon. His minor works include maquettes and projects for these monuments, and numerous busts and statuettes of historic and contemporary personalities, including Shakespeare, Goethe, Mozart and Richter. Schwanthaler bequeathed all his models, maquettes and studies to the Munich Academy and these formed the nucleus of the extensive collection of his works preserved in the Schwanthaler Museum. He won numerous awards, and was enobled by the King of Bavaria, hence the distinction of 'von' in his surname.

SCHWANTHALER, Rudolf 1842-1879
Born in Munich on April 4, 1842, the son of Franz Xavier Schwanthaler, he died there on April 27, 1879. He studied at the Academy and was a pupil of Widnmann and J. von Halbig. He sculpted portrait busts, statues and memorials.

SCHWARTZE, Georgine Elizabeth 1854-
Born in Amsterdam on April 12, 1854, she studied under von Stracke and F. Leenhoff and specialised in figures of children. The Amsterdam Museum has her statuette of a Choirboy and the group Sleeping Children. She got an honourable mention at the Exposition Universelle of 1900.

SCHWARZ, Philipp 1874-1924
Born in Darmstadt on February 12, 1874, he died there in December 1924. He worked as a decorative and portrait sculptor.

SCHWARZ, Rudolf 1856-1912
Born in Vienna in 1856, he died in Indianapolis on April 14, 1912. He studied at the Vienna Academy and emigrated to the United States where he sculpted busts, statues and memorials.

SCHWARZ, Rudolf 1878-
Born in Kaiserslautern on October 21, 1878, he studied under W. von Rümann and attended classes at the Munich Academy, afterwards establishing a studio in that city.

SCHWARZBECK, Fritz 1902-
Born at Wicklesgreuth, Germany, on December 23, 1902, he studied at the academies of Düsseldorf and Cassel and specialised in busts and heads.

SCHWARZBÖCK, Georg 1877-
Born in Vienna on April 5, 1877, he worked there as a decorative sculptor and medallist.

SCHWATHE, Hans 1870-
Born in Strachwitztal, Austria, on May 28, 1870, he sculpted tombs, portrait busts, altars and ecclesiastical ornament for churches in Vienna and other Austrian towns. His secular work includes plaquettes and medallions.

SCHWEDER, G.F. Theodor 1812-c.1880
Born in Magdeburg on February 23, 1812, he died in Valparaiso, Chile, about 1880. He studied under Josef Klieber in Vienna, Rauch in Berlin and Schwanthaler in Munich before emigrating to Chile, where he sculpted figures, bas-reliefs and monuments.

SCHWEGERLE, Hans 1882-
Born in Lübeck on May 2, 1882, he studied under W. von Rümann and attended the Munich Academy, later settling in that city, where he specialised in portrait busts of historic and contemporary German personalities.

SCHWEIGEL Family fl. 18th-19th centuries
Decorative sculptors working in Brno, Bohemia, descended from the stone-mason Anton Schweigel, who flourished in the late 17th century. His two sons, Andreas (1735-1812) and Thomas Stefan (1743-1814) worked together on the decoration of churches and public buildings in Brno and Troppau. The business was carried on by Thomas Stefan's sons, Josef (born 1775) and Johann (1786-1846).

SCHWEIKLE, Konrad Heinrich 1779-1833
Born in Stuttgart on March 28, 1779, he died there on June 2, 1833. He studied under Scheffauer in Stuttgart and also spent some time in Paris and Rome. He sculpted figures and portraits.

SCHWEINITZ, Karl Rudolf 1839-1896
Born in Charlottenburg on January 15, 1839, he died in Berlin on January 7, 1896. He studied under Schievelbeine in Berlin and then went to Paris, Rome and Copenhagen before settling in Berlin. He specialised in genre and allegorical groups, such as Love in Danger (Berlin Museum).

SCHWEITZER, Gaston Auguste 1879-
Born in Montreuil-sous-Bois on September 1, 1879, he studied under Falguière, Mercié, Auban and Peter and exhibited allegorical and classical figures and portraits at the Salon des Artistes Français from 1903 onwards. He received many state commissions, particularly for war memorials in the 1920s.

SCHWEIZER, J. Otto 1863-
Born in Zurich on March 27, 1863, he studied at the School of Fine Arts in that city and later was a pupil of Tuiller in Paris and Schilling in Dresden. He also spent some time in Florence and Rome (1889-94) before emigrating to the United States and settling in Philadelphia (1895). He sculpted many busts and heads of American celebrities, as well as statuary, fountains and memorials.

SCHWENZER, Karl 1843-1904
Born in Löwenstein on February 26, 1843, he died in Stuttgart on November 29, 1904. He studied under Kreling at Nuremberg, P. Tasset in Paris and William Wyon in London and became Court Medallist at Stuttgart. He sculpted bas-reliefs, plaquettes and medallions of Wurttemberg royalty and contemporary celebrities.

SCHWERDTFEGER, Kurt 1897-
Born in Köslin, Germany, on June 20, 1897, he studied at the Weimar Bauhaus and worked as an architectural sculptor. His minor works consisted mainly of animal figures, though he also sculpted portraits of Hitler and other personalities of the Nazi era.

SCHWERDTNER, Karl Maria 1874-
Born in Vienna on May 27, 1874, he was the son of the medallic engraver Johann Schwerdtner. He studied under Hellmer at the Academy and specialised in portrait busts, heads and bas-reliefs.

SCHWERZEK, Karl 1848-1919
Born in Friedl, Austria, on October 16, 1848, he died in Vienna in February 1919. He worked as a decorative sculptor in Vienna and sculpted a number of statues and monuments there. Troppau Museum has his allegorical figures of Painting, Architecture and Science.

SCHWERZMANN, Wilhelm 1877-
Born in Zug, Switzerland, on June 21, 1877, he studied under Adolf Meyer and worked in Zurich, sculpting fountains, garden statuary and small ornaments.

SCHWESSINGER, Georg c.1874-1914
Born about 1874, he died in Munich in March 1914. He studied under J. Bradl and W. von Rümann and specialised in religious figures and bas-reliefs.

SCHWETZ-LEHMANN, Ida 1883-
Born in Vienna on April 26, 1883, she studied at the School of Fine Arts, Vienna, and became a member of the Wiener Werkstätte. She worked in Vienna and Brno as a sculptor and potter.

SCHWIND, Wilhelm 1853-1906
Born in Goldstein, Germany, on September 14, 1853, he died in Frankfurt-am-Main on May 1, 1906. He studied at the Städel Institute, Frankfurt, and the Berlin Academy, and specialised in portrait busts and allegorical groups.

SCHWYZER, Julius 1876-1929
Born at Pfaffnau, Switzerland, in 1876, he died in Zurich in February 1929. He studied under Louis Wethli and specialised in fountains, statuary and portraits. The Zurich Kunsthaus has his Head of a Young Girl.

SCOFIELD, William Bacon 1864-1930
Born in Hartford, Connecticut, on February 8, 1864, he died in Worcester, Massachusetts, on January 22, 1930. He studied under Gutzon Borglum and sculpted portraits and figures.

SCORZINI, Luigi 1799-1839
Born in Milan on September 5, 1799, he died there on November 28, 1839. He studied at the Brera Academy, Milan, and sculpted ten statues for the Cathedral. His minor works include biblical and classical figures. The Gallery of Modern Art, Milan, has his group of Aeneas, Anchises and Ascanius.

SCOTT, Gerald 1916-
Born in Horsham, Surrey, on February 9, 1916, he studied at Kingston School of Art (1946-49) and the Slade School of Art (1949-52). He has exhibited sculpture in stone, wood and bronze at the Royal Academy, the London Group and the Glasgow Institute and lives in Redland, Bristol.

SCUDDER, Janet 1873-
Born in Terre Haute, Indiana, on October 27, 1873, she studied under Rebisso at the Cincinnati Art Academy and Lorado Taft at the Chicago Art Institute. She went to Paris where she was a pupil of the Vitti and Colarossi academies and also worked with Frederick MacMonnies. She exhibited at the Salon and won several awards, including the Légion d'Honneur in 1925. She had the distinction of being the first American woman to have her sculpture purchased by the Luxembourg Museum. She took part in international exhibitions, winning a bronze medal at the Columbian Exposition (1893) and a silver medal at the Panama-Pacific Exposition (1915). She specialised in bronze figures and groups for fountains and parks. Her minor works include numerous portrait medallions and plaques and genre figures, such as Child and Fish (Museum of Modern Art, Paris), Struggle of Love (Chicago Museum of Art), Bird Bath (seated figure), Young Diana, Victory and maquettes of Frogs for the fountain in the Metropolitan Museum of Art, New York.

SEABORNE, William 1849-1917
Born in 1849, he died in New York on March 11, 1917. He worked as a portrait and decorative sculptor in New York.

SEALE, Barney 1896-1957
Born in London in 1896, he died at Walton-on-Thames on July 22, 1957. He worked in London as a painter and sculptor of portraits, his best-known work in the latter medium being his bronze head of Augustus John. He exhibited at the Royal Academy and the Royal Scottish Academy from 1937 and had one-man shows in London and New York.

SEARS, Philip Shelton 1867-
Born in Boston, Massachusetts, on November 12, 1867, he studied under Daniel Chester French and the Boston Museum School of Fine Arts. He specialised in portrait busts and bas-reliefs of prominent Americans.

SECCHI, Luigi 1853-1921
Born in Cremona in 1853, he died at Miazzina on April 24, 1921. He specialised in medallions and bas-reliefs and genre figures, such as Repose (casts of which are in the Gallery of Modern Art, Rome, and the Genoa Museum) and Ocarina.

SEEBOECK, Ferdinand 1864-
Born in Vienna on March 28, 1864, he studied under Hellmer and Hildebrand and specialised in portrait busts and heads. His bronzes include the bust of Puttkamer (Strasbourg Museum) and the Count of Schach (Schach Gallery, Munich).

SEELDS, Josef fl. 18th-19th centuries
Born in Imst, he died there in 1836. He specialised in classical figures and groups, such as Alexander mounting Bucephalus (Ferdinandeum, Innsbruck).

SEELING, Bernhard Otto 1850-1895
Born in Prague in 1850, he died there on April 20, 1895. He studied under Platzer and attended classes at the Prague Academy. He worked as an ecclesiastical sculptor in various Bohemian towns.

SEFNER, Karl Ludwig 1861-1932
Born in Leipzig on June 19, 1861, he died there on October 2, 1932. He studied at the Leipzig Academy and was a pupil of Hundreiser and Schuler in Berlin. He spent some time in Italy before returning to Leipzig in 1891. He specialised in genre figures, such as The Molecatcher, and portrait busts and medallions of historical and contemporary German celebrities and royalty.

SEGAL, Hyman 1914-
Born in London on May 26, 1914, he studied at St. Martin's School of Art and exhibited paintings and sculpture at the Royal Society of British Artists, the Paris Salon and leading London galleries. He lives in St. Ives, Cornwall.

SEGALL, Lasar — see LASAR SEGALL

SEGANTINI, Mario 1885-1916
Born in Milan on March 31, 1885, he died in Maloja in February 1916. He was the son of the painter Giovanni Segantini and studied under E. Quadrelli and G. Gurschner at the Milan Academy. Although best known as an engraver and etcher of his father's paintings he also sculpted genre figures and portraits.

SEGER, Ernst 1868-
Born in Neurode, Silesia, on September 19, 1868, he studied under Christian Behrens and worked in Berlin, specialising in war memorials, tombs, portrait busts and classical groups, with a penchant for centaurs and satyrs. His minor works include genre figures of wrestlers, nudes and dancers, and medallions, small bas-reliefs and busts portraying girls.

SÉGOFFIN, Victor Joseph Jean Ambroise 1867-1925
Born in Toulouse on March 5, 1867, he died in Paris on October 17, 1925. He studied under Cavelier and Barrias and won the Prix de Rome in 1897. He was a regular exhibitor at the Salon des Artistes Français and eventually a member of the Jury and an Officier of the Légion d'Honneur. He sculpted many statues, busts and memorials as well as genre, allegorical, classical and biblical groups, distinguished by the rich patination of the bronze. His minor works include Mankind and Human Misery (Lyons Museum), The Earth, Life and Peace (Nemours Museum), David triumphing over Goliath (Luxembourg Museum) and Warrior's Dance.

SEGUIN, Pierre 1872-
Born in Gauriac, France, on January 21, 1872, he studied at the School of Decorative Arts, Paris, and later became a professor there. He exhibited figures and ornamental sculpture at the Nationale and the Salon des Artistes Décorateurs and was an Officier of the Légion d'Honneur.

SEGURA Y MONFORTE, Francisco Rafael 1875-
Born in Barcelona on December 3, 1875, he studied under M. Unceta and worked in Madrid as a painter and sculptor of military and genre subjects. Many of his works are in the Army Museum, Madrid.

SEIB, Wilhelm 1854-1923
Born at Stockerau, Austria, on May 18, 1854, he died in Spannberg on March 7, 1923. He studied in Vienna and Rome and sculpted many statues of historic and contemporary celebrities in Austria, particularly harking back to the Middle Ages, chivalry and romanticism.

SEIBOLD, Max 1879-
Born in Stuttgart on July 5, 1879, he studied under Wadere and specialised in religious figures, groups, bas-reliefs and memorials.

SEIDAN, Thomas 1830-1890
Born in Prague in 1830, he died in Vienna in 1890.

SEIDAN, Wenzel 1817-1870
Born in Prague in 1817, he died in Vienna on March 29, 1870. He specialised in reliefs, medallions and plaques and worked with his brother Thomas.

SEIDLER, Julius 1867-
Born in Constanz on February 24, 1867, he studied under von Rümann in Munich and A. Pruschka and sculpted numerous statues, bas-reliefs and memorials, mostly in Munich.

SEIDLITZ, Nelly von (née von Eichler) 1870-
Born in St. Petersburg on March 25, 1870, she was self-taught though influenced to some extent by Slevogt. She worked as a painter, engraver and sculptress of portraits and figures in Ebenhausen, Bavaria.

SEIFERT, Franz 1866-
Born in Vienna on April 2, 1866, he studied under Kundmann and Hellmer and sculpted busts, statues and garden ornaments, largely inspired by German history and Teutonic mythology.

SEIFERT, Grete (née Tschaplowitz) 1889-
Born in Proskau, Germany, on January 17, 1889, she studied under A. Lehnert and specialised in busts and heads. She was the wife of the painter Carl Seifert.

SEIGNEUR, Jean Bernard du 1808-1866
Born in Paris on June 23, 1808, he died there on March 6, 1866. He studied under Bosio, Dupaty and Cortot and specialised in historical and romantic medieval figures, such as Orlando Furioso and Dagobert I, as well as busts of his contemporaries.

SEIGNEURET, Antoine Louis fl. 19th century
Born in France about 1840, he studied at the Orleans School of Fine Arts and was a pupil of Petitot. He exhibited figures at the Salon from 1870.

SEILER, Johannes 1871-
Born in Nuremberg on August 5, 1871, he studied under Eberle and Buttersack and worked as a landscape painter and sculptor in Munich and Erlangen. He specialised in busts of his contemporaries, genre statuettes, such as Renunciation and war memorials and tombs.

SEILER, Paul 1873-1934
Born in Neustadt in the Black Forest on June 11, 1873, he died in Frankfurt on June 9, 1934. He worked in Frankfurt as a decorative sculptor and did several statues and war memorials in that area.

SEILHADE, Prosper Jean Émile fl. 19th century
Born in the first half of the 19th century, he was killed in action at Châteaudun on October 19, 1870, during the Franco-Prussian War. He specialised in statuettes of classical and biblical figures and also sculpted several monuments of contemporary Frenchmen.

SEITZ, Gustave 1908-
Born in Mannheim in 1908, he studied in Karlsruhe and Berlin and worked with Wilhelm Gerstel and Hugo Lederer before establishing his own studio in 1938. He served in the Wehrmacht during the second world war and was appointed to head the sculpture department at the Charlottenburg Art School in 1947. In 1950 he was elected to the Academy of the German Democratic Republic and had a studio in East Berlin from 1951 till 1958, when he succeeded Edwin Scharff as professor at the Hamburg Art School. He specialises in bronze figures, particularly female nudes in the manner of Maillol, the best known being The Nurse, Rosa in Bed and the bas-reliefs Conversation and The Difficult Character. He has also sculpted a number of portrait busts, mainly of historical personalities.

SEIWERT, Franz Wilhelm 1894-1933
Born in Cologne on March 9, 1894, he died on July 3, 1933. He was a sculptor, engraver and painter of genre and neo-classical subjects. Examples of his work are in the museums of Aachen and Barmen (Wuppertal).

SELERONI, Giovanni fl. 19th century
Born in Cremona in the early 19th century, he studied under L. Manfredini at Milan, where he settled. He was employed on the decoration of Milan Cathedral and also sculpted a number of tombs in Brescia cemetery. His secular works included genre and allegorical statuettes, examples of which are in the Cremona Museum.

SELING, Heinrich 1842-1912
Born at Gesmold near Osnabruck in 1842, he died in Osnabruck on September 3, 1912.

SELLEMOND, Peter 1884-
Born at Felthurns, Austria, on January 14, 1884, he studied under Meraner in Klausen and Bachlechner in Hall and specialised in religious figures and reliefs for churches in the Tyrol.

SELVA, Attilio 1888-
Born in Trieste on February 3, 1888, he studied under Bistolfi and worked in Cairo and Rome. He produced monuments, tombs, war memorials, portrait busts, genre statuettes and heads of women and girls.

SELVINO, Johann Anton fl. 18th-19th centuries
The son and pupil of Giovanni Battista Selvino, a monumental sculptor working in Berlin in the mid-18th century, he himself sculpted busts and figures in marble and wax for casting by the cire perdue process.

SEMEGHINI, Pio 1878-
Born in Quistello, Italy, in 1878, he worked as a sculptor, painter and engraver in Venice, Modena, Florence, Rome, Paris and Switzerland.

SEMELHAK, Jakov Ivanovich fl. early 19th century
Russian sculptor, specialising in portrait busts of his contemporaries, working in St. Petersburg in the early part of the 19th century.

SEMPER, Emanuel 1848-1911
Born in Dresden on December 6, 1848, he died in Dessau on November 16, 1911. He studied under E.R. Dorer and sculpted statues, memorials and fountains in many German towns.

SENART, Louis Henri fl. 19th century
Born in Paris in the early 19th century, he exhibited figures at the Salon from 1848 to 1859.

SENE, Étienne 1784-1851
Born in Geneva on October 3, 1784, he died there on May 21, 1851. He specialised in allegorical figures and bas-reliefs. His chief work is the large relief of The Alps in the Jardin Anglais in Geneva.

SENEQUIER, Bernard Jacques Christophe 1784-1868
Born in Toulon in 1784, he died there on July 4, 1868. He was Master Sculptor to the port of Toulon and professor of sculpture at the School of Navigation. He specialised in nautical and ecclesiastical sculpture, mostly in wood.

SENGE PLATTEN, Eugen 1890-
Born at Siedlinghausen, Germany, on September 3, 1890, he studied at the Berlin Academy and sculpted the war memorials at Winterberg and Schmollenberg.

SERGEL, Johann Tobias 1740-1814
Born in Stockholm on September 8, 1740, he died there on February 26, 1814. He studied under Larchevêque, whom he accompanied on a visit to Paris in 1759, and also worked for some time in Italy and England. He sculpted many busts and statues of Swedish and German royalty and contemporary celebrities, numerous bas-reliefs, plaques and medallions, and classical figures, such as Diomede, Cupid and Psyche, Venus Callipyge, Apollo and Lying Faun. His sculpture is preserved in the museums of Cassel, Copenhagen and Stockholm.

SERGYS, François 1815-1854
Born in Louvain, Belgium, on September 26, 1815, he died there on April 5, 1854. He studied under Jean Franck at the Louvain Academy and exhibited figures and portraits in Ghent in 1838, 1841 and 1845.

SERRAO, Lucilla Varney 1865-
Born in Angola, New York, on August 11, 1865, she worked in Cleveland and specialised in portrait busts and statuary.

SERRE, Charles de fl. late 19th century
He studied under Girardon and worked as a figure sculptor in Paris.

SERRES, Provin fl. 19th century
Born in Gaillac, France, in the mid-19th century, he studied under Moreau at the École des Beaux Arts and exhibited figures at the Salon from 1879. He was an Associate of the Artistes Français and won an honourable mention at their salon in 1886.

SERVRANCKX, Victor 1897-
Born at Dieghem, near Brussels, on June 26, 1897, he studied at the Brussels Academy and worked as a painter and sculptor in the

Abstract idiom. He had a studio at Ixelles and exhibited at the Brussels Salon from 1917 onwards, and also in Paris, Rome, Berlin, Warsaw and New York in the inter-war period. He was awarded the Grand Prix of the Brussels Academy and a gold medal at the Exposition des Arts Décoratifs, Paris, in 1925. His works include Love of the Machine, Extreme Tension without Breaking and Tension of Space.

SEURRE, Charles Émile Marie 1798-1858
Born in Paris on February 22, 1798, he died there on January 11, 1858. He was the younger brother of Gabriel Bernard Seurre and like him studied under Cartellier at the École des Beaux Arts. He was runner-up in the Prix de Rome in 1822 and won the prize two years later. He exhibited at the Salon from 1831 onwards, specialising in busts and figures of historical, contemporary and heroic personalities, particularly of the Napoleonic period.

SEURRE, Gabriel Bernard 1795-1867
Born in Paris on July 11, 1795, he died there on October 3, 1867. He studied under Cartellier and won the Prix de Rome in 1818. He became a Chevalier of the Légion d'Honneur in 1837 and a member of the Institut in 1852. He specialised in busts and statuettes of contemporary celebrities.

SEVERIN, Alexander fl. 20th century
Romanian sculptor of portrait busts working in the period before the second world war.

SEVERS, Anne fl. 20th century
New Zealand sculptress of portraits and figures, working since 1950. She trained in Auckland and Rome.

SEVESTE, Charles Émile fl. 19th century
Born in Lille in the mid-19th century, he studied under Jules Cheret and exhibited genre figures at the Salon from 1878 onwards.

SEVIN, Lucie fl. 20th century
French sculptress of figures and reliefs. She was an Associate of the Artistes Français and won a bronze medal in 1932 and a silver medal in 1937. In the latter year she was also awarded a gold medal at the Exposition Internationale.

SEYSSES, Auguste 1862-
Born in Toulouse on August 22, 1862, he studied under Falguière and exhibited at the Salon des Artistes Français from 1884 onwards. He won silver medals at the Exposition Universelle of 1900 and the Exposition Internationale of 1937. He became a Chevalier of the Légion d'Honneur in 1900 and an Officier in 1932. He specialised in portrait busts and heads of his contemporaries, but also sculpted allegorical works, such as Pro Libertate (Lens), Arts of the Theatre and Arts of Drawing. His genre groups include The Return and Girl with Tortoise.

SFORZA, Cesar 1893-
Born in Argentina in 1893, he studied at the National Academy of Fine Arts in Buenos Aires and was awarded first prize in 1920 for his Caryatid. He subsequently sculpted many monuments, bas-reliefs and statues in Buenos Aires.

SHADR, I.D. fl. early 20th century
Russian sculptor of portraits, figures and bas-reliefs working in the early years of this century.

SHAH, Ila see AGA KHAN, Ginette

SHANNAN, A. McFarlane d.1915
Born in Glasgow in the mid-19th century, he died there on September 29, 1915. He served his apprenticeship with a monumental mason, studied in France and Italy, and then worked for some time in South Africa and America before returning to Scotland at the turn of the century. He exhibited at the Royal Scottish Academy (A.R.S.A. 1902) and specialised in busts of contemporary Scots. Many of his works are preserved in the Glasgow Art Gallery.

SHARP, Arnold Haigh 1891-
Born in Halifax, Yorkshire, on February 18, 1891, he studied at the Royal College of Art and went to France and Italy in the 1920s, before settling in Wakefield. He exhibited figures and portraits at the Royal Academy and the major London and provincial galleries.

SHARP, Thomas fl. 19th century
Genre and classical sculptor in marble and bronze working in London in the second half of the 19th century. The Glasgow Art Gallery has his Eve at the Well.

SHATZ, Boris fl. 19th-20th centuries
Born in Vorno, Russia in the late 19th century, he studied under Antokolsky in St. Petersburg and under Cormon in Paris. He worked in Paris at the turn of the century and took part in the Exposition Universelle of 1900. He produced a number of small figures and groups.

SHAW, Kathleen Trousdell 1870-1958
Born in Middlesex in 1870, she died in High Wycombe, Buckinghamshire, on June 13, 1958. She studied in Dublin, Paris, Rome and London and exhibited portraits and neo-classical figures at the Royal Academy and other London galleries from 1889 onwards. Her bronzes include portrait busts of the English aristocracy and statuettes, such as Myron and Nymph.

SHCH..... – see SCHTSCH.....

SHENTON, William Kernot 1836-1878
Born in June 1836, he died in London on April 19, 1878. He learned the techniques of sculpture from his brother Henry Chawnes Shenton (1825-46), a monumental mason, and produced portrait busts, reliefs and medallions.

SHEPHERD, J. Clinton 1888-
Born in Des Moines, Iowa, on September 11, 1888, he studied at the Art Institute of Chicago and the Beaux-Arts Institute, New York, and was a member of the American Professional Artists' League. He worked in New York as a painter and sculptor of Western subjects, both human and wild-life. His bronzes include such equestrian groups as The Maverick and The Bronco Twister.

SHEPHERD, Scott 1892-
Born in Fulham, London, on September 17, 1892, he studied at Heatherley's School of Art and worked in London as a miniature painter and sculptor of portrait subjects.

SHEPPARD, Oliver 1865-1941
Born in County Tyrone, Northern Ireland, in 1865, he died in London on September 14, 1941. He studied marble cutting and monumental statuary under his father Simpson Sheppard, and then attended classes at the Royal College of Art. For many years he lived in Dublin and exhibited at the Royal Hibernian Academy (A.R.H.A. 1898, R.H.A. 1901) and became a professor there in 1903. He is chiefly remembered for having revived the lost art of colouring marble. He specialised in portrait busts and heads, in marble, terra cotta and bronze.

SHEPPARD, William Laidlaw fl. 19th-20th centuries
Born in Virginia in the mid-19th century, he died in Richmond on March 27, 1912. He worked in Richmond as a sculptor, painter and illustrator, specialising in Civil War subjects. As a sculptor his chief works were the Civil War memorial in Richmond and the statue of General A.P. Hill.

SHERIDAN, Clare Consuelo (née Frewen) 1885-1970
Born in London on September 9, 1885, she died in Sussex on May 31, 1970. She studied in Paris and Germany before attending classes at the Royal College of Art under Lanteri and John Tweed and exhibited at the Royal Academy and European galleries. She worked in Paris, Moscow, Turkey, Algeria, Galway and Hastings, Sussex, and this is reflected in the cosmopolitan nature of her sculpture, paintings and writing (her books included *Russian Portraits* 1921, *My American Diary* 1922, *A Turkish Kaleidoscope* 1926, *Arab Interlude* and *My Crowded Sanctuary* 1943). She specialised in portrait busts and these included Asquith, Churchill, Marconi, Lenin and other international figures of the 1920s.

SHERRIFF, Alexander fl. 20th century
Australian sculptor of figures, busts and bas-reliefs.

SHERWOOD, Leonid Vladimirovich 1871-
Born in Moscow in 1871, he studied under his father V.O. Sherwood and was a pupil of the St. Petersburg Academy from 1893 to 1898. He produced portrait busts and heads and genre figures and groups.

SHERWOOD, Ruth 1889-
Born in Chicago in 1889, she studied under Albin Polasek at the Art Institute of Chicago. She sculpted figures and groups in plaster and bronze and got an honourable mention at the Exhibition of American Painters and Sculptors in 1922.

SHERWOOD, Vladimir Ossipovich 1832-1897
Born in Islejevo, Russia, in 1832, he died in Moscow on July 9, 1897. He studied at the Moscow School of Art and became an Academician in 1872. He sculpted a monument to Tsar Alexander II at Samara. His minor works include busts and genre groups. He was an architect and painter as well as a sculptor.

SHIELD, George William 1919-
Born in Leicester on July 7, 1919, he studied at the Leicester College of Art (1948-52) and exhibits at the Royal Academy, the Royal Scottish Academy and the Royal Society of British Artists. He works in Conisborough, Yorkshire.

SHILLAM, Kathleen fl. 20th century
Born in Queensland, she studied in Brisbane and sculpts portraits, figures and bas-reliefs. She is the wife of Leonard Shillam.

SHILLAM, Leonard 1915-
Born in Brisbane in 1915, he has sculpted memorials, monuments, figures and portraits in Queensland since the second world war.

SHONE-JONES, Ernest 1899-
Born in Oldham, Lancashire, on October 15, 1899, he studied at the Liverpool City School of Art (1915-22), Manchester Art School (1922-23), Kennington Art School (1923) and the Royal Academy schools (1925-30). He has lived in London for many years and exhibits figures in marble, wood, stone and bronze at the Royal Academy, the Royal Society of British Artists and the Glasgow Institute, being elected A.R.B.S. (1947) and F.R.B.S. (1961).

SHONNARD, Eugenie Frederica 1886-
Born in Yonkers, N.Y., on April 29, 1886, she studied at the New York School of Applied Design for Women under Alphonse Mucha (1911) and went to Paris where she was a pupil of Rodin and Bourdelle. She exhibited at the Paris Salons in 1912-13 and 1922 and specialised in animal figures and groups, particularly cats and groups of herons. She also executed portrait busts, notably that of Mucha, and genre groups of Brittany peasants. Examples of her work are in the Luxembourg Museum, the Metropolitan Museum of Art, New York, and the Cleveland Museum of Art.

SHRADY, Henry Merwin 1871-1922
Born in New York City in 1871, he died there in April 1922. He worked as a painter but was self-taught as a sculptor. He produced numerous statuettes and portrait reliefs. Among his bronzes are many depicting subjects from the American War of Independence, such as Saving the Colours, The Empty Saddle and Washington at Valley Forge.

SHUBIN, Fedor Ivanovich 1740-1805
Born in Archangelsk, Russia, in 1740, he died in St. Petersburg on November 11, 1805. He studied under Gillet at the St. Petersburg Academy from 1761 to 1767 and won a travelling scholarship which took him to Paris. He studied under Pigalle and then worked for some time in Rome, Turin and London, before returning to Russia. He specialised in statues and busts of Russian celebrities, both historic and contemporary, many of which decorated the palaces of the Russian Imperial family and the aristocracy.

SHUKOFF, Innokentii Nikolaievich 1875-
Born in Russia in 1875, he studied at the University of St. Petersburg and then went to Paris where he studied under Bourdelle (1911-14).

SIBELLATO, Ercole 1881-
Born at Riviera del Brenta, Italy, on December 24, 1881, he studied under E. Tito and worked mainly as a painter of landscapes and portraits. He also sculpted a few portrait busts and genre statuettes.

SIBELLINO, Antonio 1891-
Born in Buenos Aires in 1891, he studied under Tasso and Dresco at the National Academy of Art. He won a travelling scholarship in 1909 and went to Europe where he studied at the Albertina Academy, Turin (1909-11). He then went to Paris where he came under the influence of Cubism. He returned to Buenos Aires in 1914 and began exhibiting at the National Salon in 1916. His work was considered too avant-garde for the conservative atmosphere of South America and he had a struggle to keep going. He worked as an insect control officer for the local authority until 1938 when he obtained a teaching diploma. The turning point in his career came in 1942 when he won first prize for sculpture at the National Salon and three years later was appointed to the prestigious Manuel Belgrano Art School. Ironically, after financial worries had been removed, he produced fewer works, and these were of minor importance compared to his earlier period. He was awarded the National Grand Prix in 1956, largely on the basis of his retrospective career. His earliest sculptures were figurative, but from 1915 onwards they became increasingly severe and completely abstract from 1926 onwards. He had a bad habit of destroying his own work, so that relatively little has survived. His best known works are Composition of Forms (1926) and Gestation (1942). His minor works include a series of bas-reliefs. He worked in clay, plaster, stone and bronze.

SIBER, Gustave 1864-
Born at Küsnacht near Zurich on November 22, 1864, he was first the pupil and later assistant to Richard Kissling and spent two years (1889-91) working under Chapu in Paris. He specialised in busts and genre statuettes.

SICARD, François Léon 1862-1934
Born in Tours on April 21, 1862, he died in Paris in 1934. He studied under Barrias and Félix Laurent and won the Prix de Rome in 1891. He exhibited at the Salon des Artistes Français getting an honourable mention (1887), and second and first class medals in 1894 and 1897 respectively. He was awarded a gold medal at the Exposition Universelle of 1900 and became an Officier de la Légion d'Honneur in 1910. He was a member of the Institut and had numerous public commissions in the early years of this century. His chief works include the Revolution monument in the Pantheon and the Clemenceau monument in St. Hermine. His minor works include Oedipus and the Sphinx Apollo (Luxembourg), Agar (Petit Palais) and The Good Samaritan (Tuileries Gardens). He sculpted the figures for the Archibald fountain in Sydney. Other small bronzes, classical statuettes, such as Pan, Hercules and Apollo, and portrait busts of contemporary celebrities such as Georges Sand and Jules Fabre. The main collection of his sculpture is in the Tours Museum.

SICHEL, Ernest fl. 19th century
Born in Bradford in the mid-19th century, he worked there as a painter and sculptor of genre subjects and portraits. His bronzes include portrait busts and statuettes of historic and romantic subjects. He exhibited at the Royal Academy in 1885.

SICKINGER, Anselm 1807-1873
Born in Owingen, Bavaria, on April 20, 1807, he died in Munich on October 17, 1873. He studied under Konrad Voln at Owingen and worked in Uberlingen for two years before establishing a studio in Munich. He specialised in figures and reliefs of religious subjects and worked on the decoration of Munich Cathedral.

SIDLO, Ferenc 1882-
Born in Budapest on January 21, 1882, he studied in Budapest, Munich and Rome. He taught sculpture and modelling at the Budapest Academy and sculpted statuary and memorials, busts and genre figures.

SIEBE, Christoph 1849-1912
Born at Wallenbruck, Germany, on May 1, 1849, he died at Wiedenbruck on April 21, 1912. He studied at the Cassel Academy and worked in that city as a decorative sculptor. He sculpted figures and reliefs for the staircase of the Cassel Gallery.

SIEBE, Wilhelm 1881-
Born in Wiedenbruck on March 7, 1881, he was the son and pupil of Christoph Siebe and worked in Cassel as a sculptor, painter and poet.

SIEBRECHT, Philipp 1806-1844
Born in Cassel in 1806, he died in New Orleans in 1844. He studied under J.C. Rahl and worked in Rome for a year (1830-31) before returning to Germany. He worked in Hanau and then went to Frankfurt-am-Main in 1833, but emigrated to the United States and sculpted portrait busts and classical groups.

SIEGEL, Christian Heinrich 1808-1883
Born in Wandsbek, Denmark, on May 14, 1808, he died in Greece in 1883. He studied under Runge in Hamburg and worked in Copenhagen and Munich as a decorative sculptor. He sculpted a number of memorials and monuments, bas-reliefs and figures, and is best remembered for the memorial at Nauplia to the Bavarian volunteers killed in the Greek War of Independence.

SIEGWART, Hugo 1865-
Born in Lucerne on April 25, 1865, he studied at the Lucerne School of Art from 1880 to 1885 and then attended the Munich Academy (1885-86). He went to Paris and studied under Chapu at the Académie Julian (1886-87) and then worked in Falguière's studio till 1891. After spending three years in Lucerne he settled in Munich. He took part in many Swiss exhibitions and also won a silver medal at the Exposition Universelle of 1900. He is best known for the group of William Tell and his son Walter (Berne Museum) and the group of The Four Seasons (Lucerne). His minor works include small bas-reliefs and medallions.

SIEMERING, Leopold Rudolf 1835-1905
Born in Königsberg on August 10, 1835, he died in Berlin on January 28, 1905. He studied at the Königsberg Academy and was a pupil of Bläser in Berlin. He specialised in busts and statuettes of contemporary German personalities.

SIEVERS, Frederick William 1872-
Born in Fort Wayne, Indiana, on October 26, 1872, he studied under Ferrari in Rome and then went to Paris where he worked at the Académie Julian. On his return to the United States he received many commissions to sculpt monuments and statues honouring American generals, mainly from the Civil War period, but his minor works include numerous busts of his contemporaries. He also sculpted the busts of James Madison and Zachary Taylor in the Virginia State Capitol.

SIGAULT, Jean François 1797-1883
Born in 1797, he died in Amsterdam on January 20, 1883. He worked in Amsterdam and Haarlem and sculpted figures, portraits and bas-reliefs.

SIGHINOLFI, Cesare fl. 19th century
Born in Modena in 1833, he studied under Luigi Maimoni and sculpted busts and statues in Modena.

SIGNORET-LEDIEU, Lucie c.1858-1904
Born in Nevers about 1858, she died there at the end of 1904. She studied under Gautherin and exhibited at the Salon from 1878 onwards, getting honourable mentions in 1883 and 1886. Her chief work is the statue of Joan of Arc at St. Pierre-le-Moutier. Her minor works include genre statuettes, such as The Spinner (Chambéry Museum)

SIKLODY, Lorinc 1876-
Born in Gyergyo-Borszek, Hungary, in 1876, he specialised in genre statuettes. His chief works are the war memorials at Gödöllö and Sopron.

SILBERBERGER, Stefan 1877-
Born at Reith near Brixlegg on February 16, 1877, he studied under Gerold in Dresden and Leon von Moss in Salzburg. He had a studio in Kramsach and specialised in memorials, tombs and religious sculpture.

SILBERNAGEL, Johann Jakob 1836-1915
Born in Bolzano on January 5, 1836, he died at Andrian, Tyrol, on March 27, 1915. He studied under Franz Melnitzky and also attended classes at the Vienna Academy. He produced numerous statues and busts of his contemporaries in Vienna.

SILBERNAGEL, Karl 1837-1889
Born in Berlin in 1837, he died there at the end of 1889. He studied under Heidel and worked as a decorative sculptor. His works include the allegorical figures of Poetry and Truth.

SILLMAN, Norman H. 1921-
Born in London in 1921, he studied at the Blackheath Art School and the Royal College of Art and is a member of the Midland Group. He exhibits sculpture in wood, stone, concrete and various metals at the Royal Academy, the Royal Society of British Artists and the London Group as well as leading provincial galleries. He lives in Sherwood, Nottingham.

SILVA, Joao da 1880-
Born in Lisbon on December 1, 1880, he studied under Chaplain in Paris and got an honourable mention at the Exposition Universelle of 1900. He specialised in busts, statuettes, bas-reliefs and medallions.

SILVESTRE, Paul 1884-
Born in Toulouse on February 17, 1884, he studied under Mercié and Carlès and exhibited figures and bas-reliefs at the Salon des Artistes Français, getting an honourable mention in 1910, a silver medal in 1922 and a gold medal in 1930. He won the Prix de Rome in 1912 and was made a Chevalier of the Légion d'Honneur in 1926. He sculpted several war memorials in the 1920s and was awarded a Diploma of Honour at the Exposition Internationale of 1937.

SIMART, Pierre Charles 1806-1857
Born in Troyes on June 27, 1806, he died in Paris on May 27, 1857. He studied under Dupaty, Pradier and Ingres and was runner-up in the Prix de Rome (1831) and prize-winner in 1833. He exhibited at the Salon from 1831 to 1855 and won first class medals in 1840 and 1855. He became a Chevalier of the Légion d'Honneur in 1846 and an Officier ten years later. He succeeded his old master Pradier as a member of the Institut in 1852. After his spectacular success at the Salon of 1840 he received many important commissions for allegorical figures, monuments, decorative sculpture on public buildings and bas-reliefs. Among these were the bas-reliefs of Faith, Hope and Charity and Liberality for the Church of St. Pantaleon in Troyes and six bas-reliefs with allegorical motifs on Napoleon's tomb. His minor works include many busts of his contemporaries, classical statuettes and groups.

SIMAY, Imre Karoly 1874-
Born in Budapest on December 16, 1874, he studied in Vienna and Munich and worked as a painter, engraver and sculptor of animals, especially horses and wildlife.

SIMCOVITS, Giovanni fl. 19th century
Sculptor of Slovene and Italian origin working in Budapest in the second half of the 19th century. He specialised in genre and allegorical statuettes and groups. Examples of his work are in the Rivoltella Museum, Trieste.

SIMI, Filadelfo 1849-1923
Born at Stuzzema, Italy, on February 11, 1849, he died in Florence on January 5, 1923. He studied under Gérôme in Paris and following his return to Italy he built up a great reputation as a genre and landscape painter. He also dabbled in genre figures and portrait busts.

SIMMLER, Franz Joseph 1846-1926
Born in Geisenheim, Germany, on December 14, 1846, he died in Offenburg on October 2, 1926. He was the son of the painter Friedrich Simmler and studied at the academies of Düsseldorf and Munich and specialised in ecclesiastical sculpture in Baden.

SIMMONDS, William George 1876-1968
Born in Istanbul on March 3, 1876, of English parents, he died near Stroud, Gloucestershire, in 1968. He studied under Walter Crane at the Royal College of Art (1893-99) and the Royal Academy schools (1899-1904) and exhibited at the Royal Academy from 1903. He concentrated on painting at first but took up sculpture in 1913. From 1906 to 1910 he assisted E.A. Abbey on the mural decorations for the Pennsylvania State Capitol. In 1919 he settled in Gloucestershire and in 1950 became President of the Cheltenham Group of Artists. He sculpted animal figures in wood, ivory, stone, clay and bronze.

SIMMONS, Franklin 1839-1913
Born in Webster, New York, on January 11, 1839, he died in Rome on December 8, 1913. He spent much of his life in Italy, though catering mainly to the American market. He specialised in equestrian figures, monuments and war memorials.

SIMON, Georges fl. 20th century
Genre and portrait sculptor, exhibiting at the Salon des Artistes Français in the 1930s. He won an honourable mention in 1936 and a bronze medal in 1939.

SIMONET, John Pierre 1860-1915
Born in Geneva in 1860, he died in Florence on April 10, 1915. He studied painting under Barthelemy Sueur at the Geneva School of Fine Arts and sculpture under Jules Salmson at the School of Industrial Arts. He also attended classes at the École des Beaux Arts, Paris, in 1879 and worked in Algeria from 1883 to 1895 before returning to Geneva. He founded a private school of art in Geneva in 1901. Much of his work reflects his twelve years in North Africa, including figures and groups of native types and wildlife.

SIMONETTA, Silvestro fl. late 19th century
Sculptor of busts, portrait reliefs and biblical figures, working in Turin.

SIMONETTI, Achille 1838-1900
Born in Italy in 1838, the son of Luigi Simonetti, he died in Sydney, New South Wales, in 1900. He helped to found the New South Wales Academy of Art in 1875 and sculpted figures, memorials and monuments, notably the statue of Governor Phillip in the Sydney Botanic Gardens. His minor works include portrait busts, bas-reliefs and statuettes.

SIMONETTI, Luigi fl. 19th century
Born in Rome in the early years of the 19th century, he studied at the Academy of St. Luke and exhibited there in the 1840s. He specialised in portrait busts of Italian and German contemporary personalities, such as P.A. Stawasser (Leningrad Academy). In the 1850s he emigrated with his family to Australia and settled in Sydney where he sculpted portraits of Australian personages of that period.

SIMONIS, Louis Eugène 1810-1882
Born in Liège on July 11, 1810, he died at Kochelberg near Brussels on July 11, 1882. He studied under Finallis at Rome and worked for some time with the Geefs brothers and Fraikin. He sculpted allegorical figures for the decoration of public buildings in Brussels, and is best remembered for the equestrian statue of Godefroy de Bouillon in the Place Royale, Brussels. He had many official commissions for monuments and public statuary. His minor works include busts of his artistic contemporaries and genre figures, such as Innocence, Child with Leveret and Young Girl (Brussels Museum).

SIMONS, Amory Coffin 1869-
Born in Charleston in 1869, he studied at the Pennsylvania Academy of Fine Arts and was a pupil of Dampt, Puech and Rodin in Paris. He took part in the great international exhibitions at the turn of the century, getting honourable mentions in Paris (1900) and Buffalo (1901), a silver medal at the St. Louis World's Fair (1904) and an honourable mention at the Panama-Pacific Exposition (1915). He was a member of the American Artists' Association in Paris where he worked for many years. His bronzes consist mainly of equestrian subjects, such as Horse Scratching, Surprise, Thoroughbred Mare, The Bell-Mare, The Storm and New York Police.

SIMONSEN, Niels 1807-1885
Born in Copenhagen on December 10, 1807, he died there on December 11, 1885. He studied under J.L. Lund and began his career as a sculptor, but later turned to painting and lithography instead. He worked in Munich, Italy, the Tyrol and Algeria. Very little is known of his work as a sculptor.

SIMONY, Julius 1785-1835
Born in Berlin on September 14, 1785, he died there on November 24, 1835. He studied under Schadow and exhibited portrait busts in Berlin from 1802 onwards.

SIMYAN, Victor Étienne 1826-1886
Born at St. Gengoux, France, on September 18, 1826, he died in London in 1886. He studied under Jouffroy and Pradier and exhibited at the Salon from 1855 to 1861, getting a third class medal in 1857. He moved to London where he founded an art pottery. As a sculptor, he produced genre and allegorical figures and groups, such as Etruscan Art represented by a Seated Female (Avignon Museum), Souvenir (Tournus Museum) and portrait busts of his contemporaries.

SINDING, Stephen Abel 1846-1922
Born in Drontheim, Norway, on August 4, 1846, he died in Paris on January 23, 1922. He studied under A. Wolff in Berlin and then went to Rome for a year before returning to Scandinavia. His earlier classicism was enlivened by a spirit of naturalism. He produced numerous genre figures and groups, such as The Eldest of the Family, Joie de Vivre, The Nourishing Earth, Slave, Two Men, The Valkyrie, Young Woman beside the Corpse of her Husband and The Imprisoned Mother. He also sculpted busts and heads of his contemporaries, such as Ibsen, casts of which are in the museums of Oslo and Copenhagen.

SINDONI, Turillo 1870-
Born in Messina, Sicily, on December 24, 1870, he worked in Latin America, New York and the Far East as a genre and portrait sculptor.

SINELL, Bruno 1879-
Born in Berlin on September 26, 1879, he studied under Lewin-Funcke, Martin Körtze and the Berlin Academy and worked as a painter and sculptor of genre subjects.

SINTENIS, Renée 1888-
Born in Glatz, Poland, on March 20, 1888, she studied at the Stuttgart School of Art and the Berlin School of Arts and Crafts under König and Haverkamp. After the first world war she married the engraver Emil Rudolf Weiss and became a member of the Prussian Academy of Fine Arts in 1929, but was expelled by the Nazis. Her private collection of her works was destroyed in an air raid in 1944. She was appointed to a teaching post at the Berlin Art School in 1947. A retrospective exhibition honouring her 70th birthday was held at the Haus am Waldsee, Berlin, in 1958. Though best known for her animal figures and groups, she has also sculpted human figures and portrait busts and medallions of her contemporaries, including Joachim Ringelnatz who dedicated his poem 'Farewell to Renée' in her honour.
Crevel, René *Renée Sintenis* (1930). Kiel, Hanna *Renée Sintenis* (1956).

SINTENIS, Walter 1867-1911
Born in Zittau on July 20, 1867, he died in Dresden on November 15, 1911. He studied under Robert Diez at the Dresden Academy and later worked under Meunier and Lagae in Brussels. He specialised in genre statuettes of nudes, dancers and bathers.

SIOT-DECAUVILLE fl. 19th-20th centuries
French sculptor of genre, allegorical and neo-classical figures, he died in Paris in 1909. He exhibited at the Salon des Artistes Français and was a Chevalier of the Légion d'Honneur.

SIRINE-REAL, Ernestine fl. 20th century
She exhibited figures and groups at the Salon des Artistes Français, getting an honourable mention (1928), a bronze medal (1936) and a silver medal (1941).

SITZMANN, Johann 1854-1901
Born at Schlaifhausen, Franconia, on December 6, 1854, he died there on July 9, 1901. He worked as a decorative and ecclesiastical sculptor.

SIVIERO, Carlo 1882-
Born in Naples on July 22, 1882, he studied under T. Celentano, M. Cammarano and D. Morelli and worked in Rome as a writer, painter and sculptor.

SIX, Michael 1874-
Born at Weng near Braunau-am-Inn on September 23, 1874, he studied in Salzburg and Vienna and specialised in commemorative medallions, plaquettes and statuary.

SJOSTRAND, Karl Lucas 1828-1906
Born in Finland in 1828, he died in Helsinki in 1906. He was one of the earliest sculptors of the modern Finnish school, turning away from the classicism of Rome and deriving inspiration and subject matter from Scandinavian mythology and history. Many of his figures and reliefs were of characters and scenes from the sagas, particularly dealing with the story of the Norse hero Kullervo. He also sculpted numerous busts and statuettes of Finnish celebrities and did the monument to the historian Porthan at Abo.

SKARPA, Georg 1881-
Born in Starigrad on the Adriatic island of Hvar on November 29, 1881, he studied in Zagreb and Vienna and worked in Croatia as a decorative sculptor. He specialised in religious figures and bas-reliefs.

SKEAPING, John Rattenbury 1901-
Born at South Woodford, Essex, on June 9, 1901, the son of the painter Kenneth Mathieson Skeaping, he studied at the Goldsmiths' College School of Art, the Central School of Arts and Crafts (1917-19) and the Royal Academy schools (1919-20). He won the Prix de Rome in 1924 and married Barbara Hepworth the same year, the marriage being dissolved in 1933. He began exhibiting at the Royal Academy in 1922 and was elected A.R.A. in 1950 and R.A. in 1960. He had his first individual show, with Barbara Hepworth, at Reid and Lefevre's Gallery in Glasgow, 1928 and has since taken part in many exhibitions at home and abroad. He was a member of the Seven and Five Society and the London Group in the 1930s, was an official War Artist (1940-45) and worked in Mexico (1949-50). He was professor of sculpture at the Royal College of Art from 1953 and now lives at Chagford in Devon. He has sculpted portraits and figures, both human and animal, in stone, granite, wood, terra cotta and bronze, and is also a draughtsman, etcher and writer.

SKEIBROCK, Mathias Severin Berntsen 1851-1896
Born at Vanse on the river Lista, Norway, on December 1, 1851, he died in Oslo on March 22, 1896. He studied in Copenhagen and spent four years in Paris. He was strongly influenced by Scandinavian mythology, Viking history and Norwegian cultural traditions, which he rendered in a vigorous manner. He produced busts, statuettes, groups and reliefs of genre subjects, such as Fatigue and The Old Mother, as well as contemporary portraiture.

SKIKKILD, Chresten 1885-1927
Born in Ringköbing, Denmark, on January 2, 1885, he died at Vordingborg on November 15, 1927. He studied under Saabye and also at the Copenhagen Academy and specialised in religious figures and groups. He also designed stained glass windows for churches in Esbjerg.

SKILTERS, Gustavs 1874-
Born in Rujiena, Latvia, on November 3, 1874, he studied at the St. Petersburg Academy and the Stieglitz School of Art and then went to Paris on a travelling scholarship and was a pupil of Rodin. He later became professor of sculpture, first at Stieglitz and then St. Petersburg (1905-18). He sculpted various monuments in Latvia and Russia. His minor works, both figures and groups, are in the Riga Museum.

SKIRMUNT, Helena 1827-1874
Born in Kolodno, Poland, on November 5, 1827, she died at Amelie-les-Bains, France, on February 13, 1874. She studied under Dmochowski in Vilna, J. Cesar in Vienna and P. Galli in Rome and specialised in busts, relief portraits and medallions featuring historic and contemporary Polish and Lithuanian characters.

SKOOG, Karl Frederick 1878-
Born in Sweden on November 3, 1878, he emigrated to the United States and studied under Bela Pratt. He worked in Cambridge, Massachusetts, and specialised in busts and memorials of prominent American personalities.

SKOOGAARD, Joakim Frederik 1856-1933
Born in Copenhagen on November 18, 1856, he died there on March 9, 1933. He was the son of the landscape painter Peter K. Skoogaard and was himself a painter of genre subjects, engraver, illustrator, mosaist, potter and sculptor. In the latter context he specialised in religious figures and reliefs, and decorated a number of churches in Denmark and Norway. He participated in the Expositions Universelles, winning a bronze medal in 1889 and a silver medal in 1900.

SKOOGAARD, Nils 1858-
Born in Copenhagen on November 2, 1858, he was the younger brother of J.F. Skoogaard. He worked as a painter, potter, illustrator, engraver and sculptor of genre figures and portraits. His group of Aage and Else is in the Copenhagen Museum.

SKOVGAARD, Johan Thomas 1888-
Born in Copenhagen on August 29, 1888, he was the son of Joakim Skoogaard and studied at the Copenhagen Academy and also under H. Grönvold. He was a painter and sculptor of religious subjects and decorated a number of Danish churches.

SKRETOVICZ, Z. fl. 20th century
Polish sculptor of genre subjects, such as The Organ-grinder.

SKULME, Marta (née Liepina) 1890-
Born at Malpils, Latvia, on May 13, 1890, she married the painter Otis Skulme and studied at Kazan School of Art and was a pupil of L. Sherwood at the St. Petersburg Academy. She won the Prize of the Latvian Culture Fund in 1933. Examples of her work are in the Riga Museum.

SLEETH, L. MacDonald 1864-
Born in Groton, Massachusetts, on October 24, 1864, she studied under Whistler, MacMonnies and E. Carlssen and specialised in portrait busts of historic and contemporary Americans, such as Martha Washington (U.A.R. Building, Washington) and John M. Wilson (Corcoran Gallery).

SLENDZINSKI, Ludomir 1889-
Born in Vilna, Lithuania, on December 16, 1889, he studied at the St. Petersburg Academy and became principal of the Vilna School of Art. As a painter and sculptor, he was one of the leading exponents of neo-classicism in Poland in the 1930s.

SLOCUM, Annette Marcellus fl. early 20th century
Born in Cleveland, Ohio, she studied at the Pennsylvania Academy of Fine Arts and was a pupil of Lanteri at the Royal College of Art, London. She specialised in portrait busts, in plaster and bronze.

SLODTZ, René Michel 'Michel-Ange' 1705-1764
Born in Paris on September 27, 1705, he died there on October 26, 1764. He was the tenth child and seventh son of Sebastian Slodtz (1655-1726) and learned the techniques of direct carving from him. He studied at the Académie Royale and earned his nickname (Michelangelo) from his fellow-students on account of his brilliance. He won prizes at the Académie in 1722-24 and the premier Grand Prix in 1726. He went to Rome and sculpted statuary for St. Peter's. On his return to Paris he did ecclesiastical sculpture, statues, busts, heads and reliefs of classical, historical and religious subjects, mainly in marble. He became an Associate of the Academy in 1749 and was one of the more influential teachers of the mid-18th century. His brothers Paul Ambroise (1702-58), Sebastian Antoine (1695-1754) and Sebastien René (1693-1726) were also sculptors of religious subjects, mainly in marble.

SLOTT-MÖLLER, Agnes (née Rambusch) 1862-1937
Born in Copenhagen on June 10, 1862, she died at Lögismose on June 11, 1937. She was the wife of the painter Harald Slott-Möller and worked as a painter, writer, interior designer and sculptress. She studied under P.S. Kroyer in Copenhagen and sculpted busts, statuettes and reliefs in the pre-Raphaelite and neo-romantic styles. She won a bronze medal at the Exposition Universelle of 1900.

SMART, Alistair 1922-
Born in Cambridge in 1922, he studied at the Edinburgh College of Art, Glasgow University and the Edinburgh Theological College and was a pupil of W.G. Gillies and W. MacTaggart (1946-49). Subsequently he studied at the Beaux-Arts Institute, New York, and has been professor of fine art at Nottingham University since 1956. He has written a number of books on artists and the Italian Renaissance and has exhibited bronzes, such as Girl Leaning on Paul's Gate, at the Royal Scottish Academy.

SMETH, Louis Antoine de 1883-
Born in Brussels on October 5, 1883, he specialised in portrait busts, statuettes, bas-reliefs and medallions. He took part in the Brussels Exhibition of 1910.

SMITH, Charles R. fl. 19th century
Born in London in 1799, the son of the monumental mason James Smith, he studied at the Royal Academy schools (1816-21) and won a silver medal in 1821. He was also awarded the silver Isis medal of the Society of Arts in 1817, the gold medal in 1819 and the large gold medal in 1822 for the group The Fight for the Body of Patroclus. His chief work was a series of heroic stone figures of the Kings and Queens of England and the notable personalities of their reigns, which he executed for Sir Robert Newman between 1838 and 1842 at Mainhead Park, Devon. His bronzes include a pair of stags at Pynes near Exeter and a number of portrait busts. He exhibited at the Royal Academy from 1820-40 and the British Institution from 1829-33.

SMITH, David 1906-
Born in Decatur, Indiana, in 1906, he studied at Ohio University and then worked as a riveter at the Studebaker car factory in New York, while attending evening classes at the Art Students' League. He had a succession of jobs – taxi-driver, sailor, carpenter, travelling salesman – and took up surrealist painting. His first sculptures were polychrome abstracts executed in 1931, but two years later he turned to welded iron, influenced by Picasso's works which he had seen reproduced in *Cahiers d'Art*. He travelled extensively before the second world war, visiting London, Paris, Athens, Crete and Russia. The British Museum stimulated his interest in the art of ancient Sumeria, Egypt and Greece and this is reflected in his early spatial sculpture with ideographic elements. He did a series of bronzes entitled Medals of Dishonor (1937-40) and had his first one-man show at the East River Gallery, New York, in 1938. During the war he worked as a welder in a factory making tanks and after the war he had several teaching posts at American Universities. He has taken part in many exhibitions in America and Europe and lives at Bolton Landing in the State of New York. He carves directly in steel, iron and bronze, rarely casting but frequently cutting and welding. His works include The Royal Bird (1948) in steel, bronze and stainless steel.

SMITH, Herbert Tyson 1883-
Born in Liverpool on January 12, 1883, he was the son of the lithographer George Smith. He studied under Charles J. Allen at Liverpool University and worked in Lancashire as a sculptor of figures and portraits. He was elected a Fellow of the Royal Society of British Sculptors in 1945.

SMITH, Joachim Becher 1851-1926
Born in Copenhagen on March 15, 1851, he died there on December 31, 1926. He studied at the Academy and was a pupil of J.A. Jerichau. His figures and groups are in several Danish museums, notably that in Aalborg.

SMITH-MARI, Ismael 1886-
Born in Barcelona on July 17, 1886, he studied under R. Casella in Barcelona and enrolled at the École des Beaux Arts in Paris and later attended the classes of Rafael Atche, Baixas, Querol and Benlliure. He won a third class medal at the Brussels Exhibition of 1910 and emigrated to the United States in 1919. He worked in New York as a sculptor, painter, etcher and illustrator. His sculpture consists mainly of busts and portrait reliefs.

SNOPKA, L. fl. 20th century
Czechoslovak sculptor of allegorical and genre figures working in Prague since the second world war. His best known work is Forward (a statue of a partisan with upraised rifle).

SNOWDEN, George Holburn 1902-
Born in Yonkers, New York, on December 17, 1902, he studied in New York and at the École des Beaux Arts in Paris, winning the Prix de Rome in 1927. He sculpted portraits, bas-reliefs, memorials and allegorical groups.

SNOWDEN, Michael fl. 20th century
Sculptor of figures and portraits working in Edinburgh. He has exhibited bronzes at the Royal Scottish Academy, such as Dancer.

SOARES DOS REIS, Antonio 1847-1889
Born in Sao Christovao, Portugal, on October 14, 1847, he died in Oporto on February 16, 1889. He studied under Joao Correira and M. de Fonseca and worked in Rome and Paris for some time. He specialised in portrait busts and genre figures, such as The Damned (Oporto Museum).

SOBRE, François Hyacinthe 1793-c.1860
Born in Paris on March 28, 1793, he studied at the École des Beaux Arts and was a pupil of Cartellier. He exhibited figures and groups at the Salon from 1827 to 1859.

SOBRE, Hyacinthe Phileas 1826-1902
Born in Paris on February 3, 1826, the son of F.H. Sobre, he died there in 1902. He studied under Ramey and Dumont and won the Prix de Rome in 1851. He exhibited figures at the Salon from 1850, getting an honourable mention in 1858

SOCHET, Auguste fl. 19th century
Born at Vendeuvre-sur-Barse, France, in the mid-19th century, he studied under Cavelier and exhibited figures and bas-reliefs at the Salon from 1878 onwards.

SOCHOS, Antonios 1880-
Born on the island of Tenos in the Aegean Sea in 1880, he studied in Athens and Paris and specialised in tombs and memorials.

SOCHOS, Lazaros 1862-1911
Born in Tenos on January 6, 1862, he died in Athens in 1911. He studied at the École des Beaux Arts, Paris, and was a pupil of Mercié. He specialised in memorials and mausolea in Athens, Istanbul and Paris and was awarded an honourable mention and a gold medal respectively at the Expositions Universelles of 1889 and 1900. His minor works include portrait busts and reliefs of contemporary Greek personalities, and allegorical groups, such as Greece protecting the Antiquities.

SÖDERMAN, Carl August 1835-1907
Born in Orebro, Sweden, on August 26, 1885, he died in Stockholm on April 22, 1907. He studied at the Stockholm Academy and specialised in heads, busts and medallions of Swedish celebrities.

SODINI, Dante 1858-1934
Born in Florence on August 29, 1858, he died there on December 31, 1934. He worked on the decoration of Florence Cathedral and sculpted numerous portrait busts and allegorical figures. He was awarded a gold medal at the Exposition Universelle of 1889. Examples of his work are in the Gallery of Modern Art, Rome.

SOITOUT, Jean Baptiste François 1816-1891
Born in Besançon on September 5, 1816, he died in Paris on May 21, 1891. He studied under David d'Angers and J.J. Feuchère and sculpted public statuary in Paris. He was an Associate of the Artistes Français and a Chevalier of the Légion d'Honneur. He specialised in portrait busts and medallions of historic and contemporary celebrities, such as Léon Gambetta, Robert Houdin and Denis Papin, and classical figures and groups. Examples of his sculpture are in the museums of Blois and Alfort.

SOJC, Ivan 1879-
Born in Ljubnica near Vitanje (now Yugoslavia). He specialised in ecclesiastical sculpture in wood and stone and worked mainly in Maribor. No bronzes have been recorded by him.

SOKOLOFF, Pavel Petrovich 1765-1831
Born in Russia in 1765, he died in St. Petersburg in 1831. He studied at the St. Petersburg Academy and specialised in busts and statuary. He decorated a number of churches, public buildings and bridges in St. Petersburg.

SOLA, Antonio 1787-1861
Born in Barcelona in 1787, he died there on June 7, 1861. He studied in Barcelona and Rome and worked in Barcelona, Havana and Rome. The Madrid Museum has allegorical groups and portrait busts by him.

SOLARI, Philippe 1840-1906
Born at Aix-en-Provence in 1840, he died there in 1906. He studied under Jouffroy and exhibited at the Salon from 1867. He specialised in portraits and is best known for the bust of Émile Zola for his grave in Montmartre.

SOLDANI, Massimiliano 1658-1740
Sculptor of classical and allegorical figures, groups and reliefs.

SOLDATOVIC, J. fl. 20th century
Yugoslav sculptor of genre figures and groups, such as The Family.

SOLDEVILLA Y TREPAT, Ramon 1828-1873
Born in Barcelona on December 31, 1828, he died in Madrid in 1873. He studied in Barcelona and Madrid and worked as a painter, lithographer and sculptor of allegorical and genre subjects. He decorated Valencia Town Hall.

SOLDI-COLBERT, Émile Arthur 1846-1906
Born in Paris on May 27, 1846, he died in Rome on March 14, 1906. He studied under Farochon, Lequesne and Dumont and won the Prix de Rome in 1869. He exhibited busts, bas-reliefs and medallions at the Salon from 1872, winning a third class medal in 1873 and the Légion d'Honneur in 1878.

SOLDINI, Antonio 1854-
Born in Chiasso, Switzerland, in 1854, he studied under Lorenzo Vela and sculpted monuments in Berne, Locarno, Milan and Paris. His minor works include allegorical figures and bas-reliefs.

SOLER, Urbici 1890-
Born in Farrara, Spain, in 1890, he studied under P. Carbonell and Adolf von Hildebrand and worked as a figure and portrait sculptor in Barcelona and Latin America.

SOLIGNAC, Alexandre fl. 19th century
Born at St. Germain de Teil in the first half of the 19th century, he won the Crozatier Prize in 1867 and specialised in genre and allegorical figures and groups. Puy Museum has his Academy of Seated Men.

SOLITARIO, Ernesto fl. 19th century
Born at San Giorgio Lamulara, Italy, in July 1838, he studied at the Naples Academy and worked as an ecclesiastical sculptor in Baia and Saviano. His minor works include portrait busts of Italian royalty.

SOLIVA, Louis fl. late 19th century
Born in Paris in the mid-19th century, he exhibited figures at the Salon des Artistes Français and got an honourable mention in 1893.

SOLLIER, Joseph Noël Eleazar fl. 19th century
Born in Apt, France, on December 25, 1810, he studied in Paris under David d'Angers and exhibited at the Salon in 1841-43. He produced portrait busts, statuettes and allegorical groups. He sculpted the fountain in Saignon (Vaucluse).

SOLLIER, Paul Louis Eugène fl. 19th-20th centuries
Born in Paris in the first half of the 19th century, he died there in April 1915. He studied under Claude Cordier and exhibited figures at the Salons from 1869 to 1909, getting honourable mentions in 1881 and 1883.

SOMAINI, Francesco 1795-1855
Born in Maroggia, Italy, on May 14, 1795, he died in Milan on August 13, 1855. He studied at the Brera Academy in Milan and was a pupil of Camillo Pacetti. He sculpted statues of saints, bas-reliefs and busts of his contemporaries.

SOMAINI, Francesco 1926-
Born in Lomazzo, Italy, in 1926, he studied at the Brera Academy in Milan and also trained as a lawyer. Since 1948 he has taken part in all the major Italian exhibitions, including the Rome Quadriennial, the Milan Triennial and the Venice Biennale. He was represented in the first Salon de la Sculpture Abstraite at the Galerie Denise Réné in Paris (1954) and has also had numerous one-man shows in Italy and France. He lives at Lomazzo near Lake Como. His best known bronze is Large Bleeding Martyrdom (1960).

SOMAINI, Giuseppe fl. 19th century
The son and pupil of Francesco Somaini, with whom he worked as a decorative sculptor in northern Italy. He also sculpted portrait busts and genre figures.

SOMMER, Carl Wilhelm August 1839-1921
Born in Coburg on March 5, 1839, he died there on September 15, 1921. He studied in Stuttgart, Munich, Vienna, Budapest and Rome before returning to his native city. He specialised in classical figures such as Bacchante, Faun and Sleeping Siren.

SOMMER, Heinrich Philipp 1778-1827
Born in Staden, Germany, on March 1, 1778, he died in Hanau on April 6, 1827. He worked in Hanau, Aschaffenburg and Frankfurt-am-Main and specialised in neo-classical figures and groups. His son Heinrich Philipp Wilhelm was also a decorative sculptor in Frankfurt-am-Main.

SOMMER, Joseph 1876-
Born in Aachen on November 5, 1876, he studied at the Berlin Academy under Menzel and produced tombs, fountains, war memorials and public statuary.

SOMOGYI, Imre 1902-
Born in Budapest on May 27, 1902, he worked as a decorative sculptor in Hungary before the second world war.

SÖNDERGAARD, Povl 1905-
Born in Ringsted, Denmark, on June 4, 1905, the son and pupil of the painter Ole Olsen Söndergaard. He studied sculpture under Utzon Fraken at the Copenhagen Academy and has produced figures and groups. The main collection of his work is in the Maribo Museum.

SONDHEIMER, Maier Salomon fl. 19th century
Born in Mannheim in 1806, he worked as a portrait painter and sculptor, specialising in the heads and busts of artistic and theatrical contemporaries. He also produced a number of genre and classical figures, such as the Shepherd finding the Infant Romulus and Remus.

SONDRUP, Jost Nielsen 1873-
Born in Barmer, Denmark, on April 2, 1873, he studied under H.V. Bissen and attended classes at the Copenhagen Academy. He worked in Lyingby as a decorative sculptor. Examples of his minor sculpture are in the museums of Aalborg, Copenhagen, Horsens and Hjörring.

SONNENSCHEIN, Johann Valentin 1749-1828
Born in Stuttgart in 1749, he died in Berne on September 22, 1828. He studied under Wilhelm Bayer in Stuttgart and was employed by the Duke of Württemberg before settling in Zürich in 1775. He was a versatile sculptor, producing classical groups and bas-reliefs, historic and heroic reliefs, genre figures and busts of his contemporaries. He also executed decorative sculpture, particularly plaster friezes.

SONNLEITHNER, Ludwig fl. 19th century
Born in Landau, Germany, on July 20, 1817, he worked in Wurzburg as an architectural sculptor. His minor works include a number of figures of saints and religious personalities.

SOPHER, Bernhard 1879-
Born in Safed, Palestine, on June 15, 1879, he studied at the academies of Berlin and Weimar and settled in Düsseldorf in 1908. He specialised in genre figures, such as Penitent Monk, Boy Muleteer, Little Girl Muleteer and Mother and Child, as well as busts of men and torsos of children.

SORANZO, Giuseppe fl. early 20th century
Born in Venice in the late 19th century, he worked there as a decorative sculptor. His chief work is the statue of Teodoro Correr in the Correr Museum, Venice.

SORBILLI, Giuseppe Antonio 1824-1890
Born at Quammaro, Italy, in 1824, he died in Naples on January 10, 1890. He worked for various churches in Naples and also decorated the cathedrals of Capua and Avellino.

SORENSEN-DIEMANN, Clara Leonhard 1877-
Born in Indianapolis on November 29, 1877, she studied under Lorado Taft and V. Brenner in Chicago and had a studio at Cedar Rapids.

SORENSEN-RINGI, Harald 1872-1912
Born at Shon, Sweden, on March 3, 1872, he died in Stockholm on April 11, 1912. He specialised in portrait busts and allegorical figures and won an honourable mention at the Exposition Universelle of 1889.

SORIA Y FERRANDO, Ricardo 1839-1906
Born in Valencia on December 30, 1839, he died there in 1906. He worked in that city as a decorative sculptor, producing statuary and bas-reliefs.

SORNET, Edmé Jean Louis 1802-1876
Born in Paris on January 18, 1802, he died there in 1876. He studied under Bosio and exhibited portrait busts in marble, terra cotta and bronze at the Salon where he won a third class medal in 1839. Examples of his work are in the museums of Versailles and Valenciennes.

SORTINI, Saverio 1860-1925
Born in Noto, Italy, on January 1, 1860, he died in Venice in March 1925. He exhibited in Naples, Rome and Paris and got an honourable mention at the Exposition Universelle of 1900. The Museum of Modern Art, Rome, has his figure of a Breton Fisherman.

SORTIS, Edouardo de 1861-
Born in Naples in 1861, he died at Monte Cassino, Italy. He specialised in sculpture in the ancient Roman manner, mainly bronze statuettes and heads. He also produced a number of historic figures, notably that of Charles III of Naples, in bronze, terra cotta and marble.

SOS, Geza 1870-1918
Born in Vienna on December 31, 1870, he died in Budapest on January 30, 1918. He worked in Budapest and Buenos Aires and specialised in animal figures and groups.

SOSNOWSKI, Tomasz Oskar, Count 1810-1886
Born at Norvomalin, Poland, on October 12, 1810, he died in Rome on January 27, 1886. He studied under Rauch in Berlin and settled in Rome where he executed numerous statues for churches and public buildings. He was a major contributor to the revival of Polish sculpture in the 19th century. His minor works include classical statuettes and groups and busts of his contemporaries. Many of his works are preserved in various Polish museums.

SOTRIFFER, Franz fl. 19th-20th centuries
Decorative and ecclesiastical sculptor working in Bolzano (Bozen) at the turn of the century.

SOTRIFFER, Johann Jakob fl. 19th century
Born in Pläsches, Austria, in 1796, he studied at the Vienna Academy and worked in stone, wood, alabaster and bronze as an ecclesiastical sculptor.

SOTRIFFER, Josef fl. 19th century
Born in 1802, the younger brother of Johann Jakob, he worked as an ecclesiastical sculptor in the Tyrol and is best known for the group of four Angels in Brixen church.

SOUBRICAS, Henri Augustin fl. 20th century
Born in Lille at the end of the 19th century, he studied under Injalbert and J. Boucher in Paris. He exhibited at the Salon des Artistes Français from 1920 and won a bronze medal in 1927. He took part in the Exposition Internationale of 1937 and received the Légion d'Honneur that year.

SOUGEZ, Madeleine 1891-1945
Born in Bordeaux on December 8, 1891, she died in Paris on July 19, 1945. She studied at the Bordeaux School of Fine Arts and the École des Beaux Arts in Paris. Although she originally worked as a sculptor of genre figures, she later turned to painting. Examples of her sculpture are in the museums of La Rochelle, Munich, Leeds and Dresden.

SOUKOP, Willi 1907-
Born in Vienna on January 5, 1907, he studied at the Vienna Academy from 1928 to 1934 and then emigrated to England. He has exhibited at the Royal Academy since 1935 (A.R.A. 1963, R.A. 1969), and had his first one-man show at the Stafford Gallery in 1938. He taught sculpture at the Chelsea School of Art from 1947 and has been Master of the Sculpture School at the Royal Academy since 1969. His work is represented in several British public collections. He now lives in London.

SOULACROIX, Joseph Frédéric Charles fl. 19th century
Born in Montpellier on July 6, 1825, he studied under Ramey, Cornelius and Dumont and attended the École des Beaux Arts in Paris from 1845. He began exhibiting at the Salon in 1849. He specialised in genre figures and groups, such as Jeu d'Esprit (Philadelphia National Gallery), Au Revoir and The Declaration.

SOULES, Félix 1857-1904
Born at Eauze on October 12, 1857, he died in Paris in March 1904. He studied under Jouffroy and Falguière and exhibited at the Salon from 1881. He was runner-up in the Prix de Rome of 1887 and won a silver medal at the Exposition Universelle of 1900. He worked mostly as a decorative sculptor, but his minor pieces include classical figures and groups, such as Bacchante and Goat (Bordeaux Museum).

SOUNES, William Henry 1830-1873
Born in London in 1830, he died in Sheffield on September 6, 1873. He studied at the Birmingham School of Art and became Director of Sheffield Art School. He worked as a modeller and sculptor and produced busts, statuettes, reliefs, plaques and medals.

SOUTHWICK, Alfred 1875-
Born at Southwick on April 5, 1875, he studied at Armstrong College, Newcastle-upon-Tyne and the City and Guilds Institute of London. Though he settled in London much of his work was commissioned in the north of England, notably decoration for the Anglican cathedrals of Liverpool and Carlisle and Downside Abbey. He exhibited figures and bas-reliefs at the Royal Academy.

SOVARI, Janos 1895-
Born in Papolc, Hungary, on November 15, 1895, he worked as a portrait and decorative sculptor in Budapest.

SOYER, A. fl. early 19th century
Born in Paris in the late 18th century, he died there about 1844. He exhibited busts, statuettes, medallions and bas-reliefs at the Salon from 1822 to 1827 and worked as a sculptor and bronze-founder.

SOZZI, Giacomo fl. late 19th century
Born at Castione, Italy, in the mid-19th century, he studied at the Brera Academy and subsequently taught there from 1872 to 1894. He worked on the decoration of Milan Cathedral and also produced tombs and memorials for the cemeteries of that city.

SPACKMAN, Cyril Saunders 1887-1963
Born in Cleveland, Ohio, on August 15, 1887, he died in Surrey, England, in 1963. He studied under T.E. Lilliard James and Henry A. Keller in Cleveland and became a member of the American Federation of Arts. He exhibited paintings, etchings and sculpture in Cleveland, Chicago and New York at the turn of the century and was employed as a painter and draughtsman of architectural subjects by a Cleveland construction company from 1905 to 1910. Subsequently he came to England and studied architecture at King's College, London and the Central Foundation School. He exhibited at the Royal Academy, the Paris Salons and leading national and provincial galleries in Britain (R.B.A. 1916). As a sculptor he specialised in religious and portrait subjects.

SPADINI, Andrea fl. 20th century
Italian sculptor working in the first half of this century. The Gallery of Modern Art in Rome has examples of his work.

SPAETHE, Oscar 1875-
Born in Bucharest in 1875, he specialised in figures and groups in the classical idiom. Examples of his work are in the Simu Museum in Bucharest.

SPAGNOLI, Antonio 1849-1932
Born in Isera, Italy, on April 16, 1849, he died there on March 19, 1932. He studied at the Milan Academy and was a pupil of Antonio Tantardini. Subsequently he worked as a decorative sculptor in Innsbruck and Rovereto for some time.

SPAGNOLI, Umberto c.1872-1922
Born in Cairo, Egypt, about 1872, he died at Mas del Plata, Argentina, in March 1922. He sculpted portraits, figures, bas-reliefs and monumental statuary.

SPALLA, Giacomo c.1775-1834
Born in Turin about 1775, he died there on January 31, 1834. He specialised in portrait busts of his contemporaries and classical and allegorical statuettes. His works may be seen in the museums of Compiegne, Versailles and Chambery.

SPALMACH fl. 20th century
Bronzes bearing this signature were produced by an Austrian sculptor working in Venice at the turn of the century. Examples of his work are in the Simu Museum, Bucharest.

SPALT, Janos 1880-
Born in Budapest on November 6, 1880, he studied in Paris and worked there in the inter-war period as a decorative sculptor.

SPANG, Michael Henry fl. 18th century
Born in Denmark, he died in London in 1762. He came to London about 1756 and two years later won a prize of 30 guineas for modelling the letter seal of the Society of Arts. He produced a number of statuettes, monuments and chimney ornaments, which he exhibited at the Society of Artists in 1760-62. The Victoria and Albert Museum has a bronzed terra cotta of Hogarth and an anatomical figure in bronze by him.

SPANIEL, Otaker 1881-1955
Born at Jaromer, Bohemia, on June 13, 1881, he died in Prague in 1955. He studied under Joseph Tautenhayn and J.V. Myslbek and specialised in busts and portrait medallions. Many of his bronzes are preserved in the Prague Modern Art Gallery.

SPAZZI, Antoni fl. 19th century
Born in Pellio at the end of the 18th century, he died in S. Trinita on November 22, 1848. He worked as an ecclesiastical sculptor and decorated churches in the Verona area.

SPAZZI, Attilio 1854-1915
Born in Verona in 1854, he died there in 1915. He was the son and pupil of Grazioso Spazzi and worked with his twin-brother Carlo on portrait sculpture.

SPAZZI, Carlo 1854-1936
He sculpted monuments, statues, bas-reliefs and portrait busts in Verona.

SPAZZI, Grazioso fl. 19th century
Born in Verona on August 15, 1816, he specialised in religious figures, memorials and tombs in Verona.

SPECKBACHER, Romed 1889-
Born at Thaur in the Tyrol, on January 22, 1889, he studied in Innsbruck and Hall and worked as a religious sculptor in the Tyrol.

SPELUZZI, Giuseppe c.1827-1890
Born in Milan about 1827, he died there on April 26, 1890. A bronze-founder and decorative sculptor, he worked mainly on La Scala, Milan.

SPENCE, Benjamin Edward 1822-1866
Born in Liverpool in 1822, he died in Leghorn, Italy, on October 21, 1866. He was the son and pupil of William Spence, a wood-carver, and produced portrait busts, genre figures and groups in the mood of the Romantic movement. His works include The Lady of the Lake, Highland Girl, Hippolyte and Psyche at the Spring.

SPENCER, Edna Isbester 1883-
Born in St. John, New Brunswick, Canada, on November 12, 1883, she studied under Bela Pratt and Robert Aitken and exhibited at the Paris Salons in the 1920s.

SPERTINI, Giovanni 1821-1895
Born in Pavia in 1821, he died in Milan on February 13, 1895. He studied at the Milan Academy and was a pupil of Benzoni, Labus and Magni. He specialised in portrait busts, but also produced tombs, memorials and genre figures, such as The Letter-writer (Brera Museum).

SPETHMANN, Karl 1888-
Born in Altona, Germany, on April 17, 1888, he worked as a decorative sculptor in Hamburg.

SPICER-SIMSON, Theodore 1871-
Born at Le Havre, France, of American parents on June 25, 1871, he studied at the École des Beaux Arts, Paris, under Dampt and continued his studies in England and Germany. Though best known for his contribution to the regeneration of the art of the medal in the early years of this century, he also sculpted a number of portrait busts, bas-reliefs and statuettes. Examples of his work are in the Museum of Modern Art, Paris, and the Massachusetts Historical Society Museum, Boston, as well as the leading British public collections.

SPIEKER, Klemens 1874-
Born at Ottbergen near Höxter, Germany, on March 10, 1874, he worked in Wiedenbruck as a sculptor of animal figures and groups.

SPIELER, Hugo 1854-1922
Born in Berlin on February 28, 1854, he died in Dresden in February 1922. He studied at the Munich Academy and worked as a modeller at the Meissen porcelain factory.

SPIERA, Giacomo 1792-1874
Born in Venice on September 12, 1792, he died there on March 18, 1874. He specialised in the sculpture of small ornamental pieces.

SPIES, Robert 1886-1914
Born at St. Petersburg on May 6, 1886, he was killed in action near Juvincourt on September 17, 1914. He studied at the Dresden Academy and was a pupil of Sascha Schneider. He was a painter, engraver and sculptor of genre subjects.

SPIESS, August Karlovich d.1904
German sculptor working in St. Petersburg where he died on April 15, 1904. He studied at the Berlin Academy and sculpted ornaments and bas-reliefs for the Winter Palace.

SPIESS, Heinrich 1838-1884
Born at Uhwiesen, Germany, on October 18, 1838, he died at Schaffhausen on November 28, 1884. He studied in Rome and specialised in neo-classical figures and bas-reliefs.

SPIESS, Michael 1838-1894
Born in Wurzburg in 1838, he died in Rome on December 27, 1894. He settled in Rome in 1868 and specialised in busts of historic and classical personalities. His chief work was the series of eight busts of Roman emperors at Herrenchiemsee.

SPIRIDONOV, Z. fl. 19th century
Bulgarian portrait sculptor of the late 19th century. He studied in Germany and became professor at the Sofia Academy. His works include Girl's Head and portraits of contemporary Bulgarian celebrities.

SPITERIS, Jeanne 1922-
Born in Smyrna, Turkey, in 1922, she fled with her Greek parents from Anatolia and settled in Athens where she studied literature at the University and then spent four years at the Art School. After the second world war she became a member of the Stathmi avant-garde art movement and took part in its exhibitions. She also exhibited in Italy and the United States, especially in Venice where she settled in 1958. A major retrospective exhibition of her work was held at the Bevilacqua Gallery in Venice in 1960. Much of her work has been designed for theatrical décor, but she has also produced small abstract bronzes, characterised by their violent, explosive masses and sharp, spiky contours.

SPLIETH, Heinrich 1877-1929
Born at Elbing on February 18, 1877, he died in Berlin on March 21, 1929. He studied at the Berlin Academy under L. Manzel and specialised in equestrian figures and monuments.

SPORER, Josef 1906-
Born at Ramsau, Zillertal, on April 11, 1906, he was the son of a wood-carver, Johann Sporer. He has worked as a decorative sculptor in the Innsbruck area.

SPORRER, Theobald Joseph 1857-
Born in Bordeaux in 1857, he became an Associate of the Artistes Français in 1886 and won an honourable mention in 1893. He specialised in medallions and bas-reliefs portraying French contemporary celebrities.

SPRANCK, Marcel Henri 1896-
Born in Chantilly on November 1, 1896, he exhibited figures and groups at the Salon des Artistes Français in the 1920s.

SPRIGGE, A.B.S. 1906-
Born in London on March 3, 1906, she studied at the Royal College of Art in 1926-27 and has a studio at Loughton, Essex, where she sculpts mainly in stone, marble and wood. She has exhibited at the major London galleries.

SPRING, Edward Adolphus fl. 19th century
Born in New York in 1837, he studied under W.K. Brown and W.R. Rimmer and worked as a decorative sculptor in New York.

SPRUCE, Edward Caldwell fl. 19th-20th centuries
Born in Knutsford, Cheshire, about 1850, he died in Leeds in 1922. He specialised in portrait busts of contemporary figures.

SPULER-KREBS, Anna c.1860-1933
Born in Mariendorf, near Berlin, about 1860, she died at Erlangen on April 20, 1933. She studied under Manzel in Berlin and specialised in figures and groups of children many of which decorate fountains in Germany.

STABLER, Phoebe (née McLeish) d.1955
The wife of the potter, painter and designer, Harold Stabler, she studied at the Royal College of Art and was elected F.R.B.S. in 1923. She sculpted in stone, bronze and terra cotta and exhibited at the Royal Academy, the Glasgow Institute and other leading British galleries. She lived in Poole, Dorset, and latterly in Hammersmith, London, for many years.

STACKPOLE, Ralph 1885-
Born in Williams, Oregon, on May 1, 1885, he studied at the California Art School in San Francisco and was subsequently a pupil of the animal sculptor Arthur Putnam. He worked in the studio of Mercié in Paris in 1906-7 and studied painting under Robert Henri in 1911. He returned to Europe in 1921 and worked for some time in Italy and Paris, exhibiting at the Salon des Tuileries and the Indépendants. On his return to America he taught sculpture at the San Francisco Art School for twenty years. In 1949 he returned to France and settled in Puy-de-Dôme. Since the second world war his work has become more abstract. He was one of the finalists in the competition for the monument to The Unknown Political Prisoner and has since exhibited at the Salon des Réalités Nouvelles.

STADELHOFER, Emil 1872-
Born at Wollmatingen, Germany, on December 2, 1872, he studied at the Karlsruhe Academy and specialised in portrait statuary and busts.

STADLER, Toni 1888-
Born in Munich on September 5, 1888, he was the son and pupil of the painter Anton von Stadler. He was taught the elements of sculpture by August Gaul in Berlin and then studied under Hermann Hahn in Munich and Aristide Maillol in Paris. He won the Prix de Rome in 1934 and the Villa Romana Prize in 1938 and 1959. From 1946 to 1958 he taught sculpture at the Munich Academy, bringing a quasi-Mediterranean influence to bear on the post-war development of German sculpture. After the war he turned from clay and concrete to bronze and has worked in that medium ever since, using the *cire perdue* process. He has specialised in the interpretation of the female form, both in full-size figures and in heads and busts.

STAGER, Walter 1874-
Born at Vitmergen, Switzerland, on March 12, 1874, he studied at Lausanne School of Art and was a pupil of A. Rivalta in Florence.

STAHLY, François 1911-
Born in Konstanz, Switzerland, on March 8, 1911, he studied at the Académie Ranson in Paris from 1931 to 1938 where he was a pupil of Malfray. He has exhibited at the Salon de Mai, the Salon de la Jeune Sculpture and the Salon des Réalités Nouvelles since the war, specialising in abstracts carved from rare and exotic woods. Since 1952, however, he has also turned to other media, both stone and metal, for architectural sculpture, and even experimented with coloured glass and stone constructions such as the stained glass reliefs executed for the church of Baccarat. His recent abstracts have been executed in stainless steel, bronze and aluminium. He has a studio at Meudon which has become a teaching centre for group-work by the up and coming generation of artist-craftsmen.

STAIGER, Lucien Nicolas d.1908
French sculptor active at the turn of the century. He exhibited portrait and figure sculpture at the Salon des Artistes Français.

STAMMEN, Peter 1886-
Born in Crefeld, Germany, on September 29, 1886, he studied at the Institut Städel in Frankfurt and also in Düsseldorf, and specialised in public statuary, fountains and war memorials.

STANFIELD, Marion Willis fl. 20th century
She studied at the Goldsmiths' College School of Art and worked with Bourdelle in Paris. She exhibited at the Royal Academy, the Glasgow Institute and the Paris Salons in the inter-war period and had a studio in London till about 1965. Her sculpture was executed in stone and bronze.

STANGL, Hans 1888-
Born in Munich on March 8, 1888, he studied under Ignatius Taschner and Hermann Hahn. He specialised in heads and busts, particularly of women and girls.

STANILAND, Bernard Gareth 1900-
Born in Canterbury on October 4, 1900, he trained as a doctor of medicine and practised in London and Newcastle. An amateur artist of some distinction, he worked in oils and watercolours and sculpted in wood, stone and bronze. He has occupied a number of positions in artistic circles in the north-east of England, including the chairmanship of the Federation of Northern Art Societies.

STANKIEWICZ, Richard 1922-
Born in Philadelphia in 1922, he was brought up in Detroit, Michigan, and learned to sculpt while serving in the United States Navy during the second world war. He studied painting at the Hans Hofmann School of Fine Arts in New York in 1948-49, but turned to sculpture and went to Paris where he worked under Léger and Zadkine. He settled in New York in 1951 and helped to found the Hansa Gallery that year, having several exhibitions there in the ensuing decade. He has also taken part in the Venice Biennales and a number of major American exhibitions. He produces abstracts, often incorporating discarded metal, though more recent work concentrates on the form of individual *objets trouvés*.

STANLEY, Carl Frederik 1740-1813
Born in England in 1740 of Danish parents, he died in Copenhagen on March 9, 1813. He learned the rudiments of sculpture from his father, the decorative sculptor Simon Carl Stanley (1703-1761) and returned to Copenhagen with him in 1746. He studied at the Copenhagen Academy and specialised in busts of his Danish contemporaries. He is regarded as an important precursor of Thorvaldsen.

STANSON, George C. 1885-
Born at Briscour, France, in 1885. He emigrated to the United States and became a painter and decorative sculptor. He had a studio in Los Angeles and sculpted ornament for buildings in California. His minor works are in the museums of La Jolla and Golden Gate, San Francisco.

STAPPEN, Charles Pierre van der 1843-1910
Born in Brussels on December 19, 1843, he died there on October 21, 1910. He studied under Portaels at the Brussels Academy and visited France, England, Holland and Italy before settling in Brussels. He eventually became Director of the Brussels Academy and the leader of the renaissance of Belgian art after the long period of stagnation resulting from the overwhelming influence of Holland and France. He was always receptive to new ideas and was a very prolific and versatile artist. His sculpture includes busts of his contemporaries, genre figures, classical and biblical figures, medallions, plaques and bas-reliefs, statuettes, groups and large monumental statuary, such as The Teaching of Art decorating the façade of the Palais des Beaux Arts, Brussels.

STARCK, Karl Constantin 1866-
Born in Riga, Latvia, on March 2, 1866, he studied under A. Wolff, F. Schaper, Herter and Begas at the Berlin Academy and Donnsdorf at the Stuttgart School of Fine Arts. He produced portrait busts and medallions and genre figures and groups such as Reverie and The Spring.

STARCKE, Henrik 1899-
Born in Copenhagen on April 16, 1899, he studied under Einar Nielsen and worked as a painter, sculptor and designer, often in collaboration with his wife Dagmar. He has produced numerous abstracts, figures and architectural sculpture, notably the stylised figure in the Trusteeship Council Chamber of the United Nations building in New York.

STARK, Robert 1853-1931
Born in Torquay, Devon, on May 1, 1853, he died in Victoria, British Columbia, on August 27, 1931. He sculpted animal figures and groups in bronze, and also painted animal and landscape subjects in oils. He studied at the Royal College of Art and also worked for some time in Paris and Florence. He exhibited regularly at the Royal Academy from 1883 to 1897 and was elected F.R.B.S. in 1905.

STARKOPF, Anton 1889-
Born in Kiel on April 11, 1889, he studied in Munich, Paris and Berlin and settled in Dorpat where he worked as a decorative sculptor.

STARTUP, Peter 1921-
Born in London on December 11, 1921, he studied at the Hammersmith School of Arts and Crafts (1935-39), the Central School (1943-44), the Ruskin School of Drawing (1944-45) and the Slade School (1945-48). He turned from painting to sculpture while working in Brussels in 1948-49 and finally abandoned painting altogether in 1952. He had his first one-man show of sculpture in 1962 at the A.I.A. Gallery.

STAUFFER-BERN, Karl 1857-1891
Born in Trübschachen, Switzerland, on September 2, 1857, he died in Florence on January 25, 1891. He studied in Munich and Berlin and worked as a portrait painter, engraver, etcher, poet and sculptor. He took up sculpture comparatively late in life, while working in Rome, and specialised in portrait reliefs, busts and heads.

STAVASSER, Peter Andreivich 1816-1850
Born in St. Petersburg in 1816, he died in Rome on April 24, 1850. He studied at St. Petersburg Academy and specialised in classical figures of nymphs and busts of his Russian contemporaries.

STAVENHAGEN, Wilhelm Siegfried 1814-1881
Born at Goldingen on September 27, 1814, he died at Mitau on January 8, 1881. He studied at St. Petersburg Academy and was a pupil of Eduard Schmidt von der Launitz at Frankfurt-am-Main.

STEA, Caesar 1893-
Born in Bari, Italy, in 1893, he emigrated to the United States and studied at the National Academy of Design, the Cooper Union and the Beaux Arts Institute of Design, New York. He was a pupil of A. Stirling Calder, Hermon A. MacNiel, Carl Heber and Victor Salvatore. He won the Beaux Arts prize for a relief panel commissioned by the Educational Building at the Panama-Pacific International Exposition, San Francisco. He specialised in large reliefs in plaster and bronze.

STEBBINS, Emma 1810-1882
Born in New York in 1810, she died there in 1882. She was self-taught as a painter and sculptor though influenced by P. Acker. She sculpted statuary for parks and public buildings in New York and Boston.

STECCHI, Fabio 1855-1928
Born in Urbino on May 12, 1855, he became a naturalised Frenchman and died in Nice on October 3, 1928. He studied under Fedi in Florence and Paul Dubois in Paris. He exhibited at the Salons and got an honourable mention at the Exposition Universelle of 1889 for a group of children, and a gold medal at the Milan Exhibition of 1906. He specialised in busts of Italian and French personalities and genre figures. His best known work is the group of four statues on the clock tower of the Gare de Lyon in Paris.

STEELL, Gourlay 1819-1894
Born in Edinburgh on March 22, 1819, he died there on January 31, 1894. He was the son of a wood-carver named John Steell and brother of the sculptor Sir John R. Steell, and was educated at the School of the Board of Manufacturers in Edinburgh. He studied under Robert Scott Lauder and exhibited at the Royal Scottish Academy from the age of thirteen, enjoying a great reputation as a child prodigy. He modelled animals, many of which were cast in precious metals for presentation pieces. He succeeded his father as professor of modelling at the Watt Institute, Edinburgh. He became A.R.S.A. in 1846 and R.S.A. in 1859 and also exhibited at the Royal Academy from 1865 to 1880. He succeeded Landseer as Animal Painter to Queen Victoria in Scotland. He became Director of the National Gallery, Edinburgh, in 1882.

STEELL, Sir John Robert 1804-1891
Born in Aberdeen on September 18, 1804, he died in Edinburgh on September 15, 1891. He was the eldest son of the wood-carver John Steell, who moved to Edinburgh when his son was a year old. At the age of fourteen he was apprenticed to a wood-carver, but also studied at the Trustees Academy and spent several years in Rome studying sculpture. Following his return to Scotland he received many important public commissions, notably the colossal wooden statue for the North British Fire and Insurance Corporation (1827). Two years later he became a member of the Royal Scottish Academy and in 1838 was appointed Sculptor to the Queen in Scotland. At the unveiling of his memorial to the Prince Consort in 1876 he was knighted by Queen Victoria. His best known work is the seated figure of Sir Walter Scott which forms the centre-piece of the Scott Monument in Princes Street, Edinburgh — the first marble statue in Scotland to have been commissioned from a native artist. He was the first to introduce artistic bronze-casting to Scotland and established his own foundry which eventually was used by most of the other sculptors in the second half of the 19th century in Scotland. His other bronzes include classical groups, such as Alexander and Bucephalus, and numerous statuettes and busts of historic and contemporary Scots.

STEEN-HERTEL, Elna Sophie Cathrine 1872-
Born in Copenhagen on March 31, 1872, she studied under A. Saabye at the Copenhagen Academy and the Académie Colarossi in Paris. Examples of her genre figures are in the museums of Göteborg and Copenhagen.

STEENACKERS, François Frédéric fl. late 19th century
Born in Lisbon of Flemish parents in the early 19th century, he settled in Paris and worked as a sculptor of neo-classical figures and portraits. He won an honourable mention at the Salon of 1861.

STEENE, William 1888-
Born in Syracuse, New York, on August 18, 1888, he studied under Robert Henri and the Art Students' League of New York, and subsequently worked as a decorative sculptor in that city.

STEFFANUTTI, Petrus 1820-c.1860
Born in Fiume in 1820, he died some time after 1859. He was the pupil and later assistant of Luigi Zandomenghi in Venice and specialised in religious sculpture in Fiume and Trieste.

STEFIC, Anton 1878-1915
Born at Gabernik, Slovenia, on January 12, 1878, he was killed in action near Gorizia on May 4, 1915. He studied in Ljubljana and Zagreb and specialised in portrait busts. Examples of his work are in the Ljubljana Museum.

STEGER, Milly 1881-
Born at Rheinberg, Germany, on June 15, 1881, she studied under Karl Janssen in Düsseldorf and Georg Kilbe in Berlin. She specialised in heads and figures of girls and women, especially dancers.

STEHLIK, Edouard fl. 19th century
Polish sculptor active in the second half of the 19th century.

STEHLIK, Zygmunt 1834-1864
Born in Cracow in 1834, he died there in 1864. He studied under K. Ceptowski and specialised in religious figures and bas-reliefs. He decorated the altar in Krzemienic Cathedral.

STEIDLE, Alfred 1878-
Born in Stuttgart on January 21, 1878, he studied in Karlsruhe, Munich and Stuttgart, and specialised in portrait reliefs, medals and busts.

STEIGER, Édouard and Otto fl. 19th century
Brothers working in Rapperswil, Switzerland, on tombs, memorials, monuments and fountain statuary.

STEIGERWALD, Otto 1886-1918
Born in Mainz in 1886, he was killed in action on May 25, 1918. He studied under Ch. Samuel in Brussels and Rodin in Paris. He specialised in busts and bas-reliefs.

STEIN, Arthur 1880-
Born in Kahnsdorf, Germany, on October 10, 1880, he studied in Dresden and Leipzig and worked as a painter, etcher and sculptor.

STEIN, Johann Carl Heinrich Theobald 1829-1901
Born in Copenhagen on February 7, 1829, he died there on November 16, 1901. He specialised in busts of his artistic contemporaries in Denmark, and allegorical and genre figures, such as Love Triumphant (Copenhagen Museum). He won a silver medal at the Exposition Universelle of 1900.

STEIN, Werner 1855-1930
Born in Brunswick on January 10, 1855, he died in Streitwald on January 18, 1930. He studied under Schilling in Dresden and specialised in tombs and mausolea, notably those of Mendelssohn, Schumann and Grazzi, and also sculpted busts and relief portraits.

STEINEL, Johann Paul 1878-
Born in Heidelberg on December 14, 1878, he studied at Munich Academy and specialised in figures of women and girls, examples of his work being in the museums of Mannheim and Munich.

STEINER, Antonie 1866-
Born in Innsbruck on January 22, 1866, she was the daughter and pupil of Sebastian Steiner and specialised in religious figures.

STEINER, Arthur 1885-
Born at Gumbinnen, Germany, on July 2, 1885, he was a painter and sculptor of animals working in Königsberg.

STEINER, Clement Leopold 1853-1899
Born in Paris on March 7, 1853, he died there in December 1899. He studied under A. Millet, Jouffroy and Bailly and exhibited at the Salon from 1876 onwards. He won a first class medal and a travelling scholarship in 1884 and a gold medal at the Exposition Universelle of 1889. He specialised in classical and genre figures, often in gilt-bronze, including Pegasus, Lady holding the infant Bacchus in her arms, The Foster-father and similar subjects. He sculpted much of the decoration for the Alexandre III bridge in Paris.

STEINER, Emil fl. late 19th century
A pupil of Karl H. Miller, he worked in Berlin and exhibited there from 1868 to 1892. He specialised in portraits of Prussian generals.

STEINER, Julius I. 1863-1904
Born in Innsbruck on March 4, 1863, he died in Vienna on February 19, 1904. He was a very prolific sculptor, producing over a thousand different busts and heads of his contemporaries. Examples of his work are in the Merano museum.

STEINER, Julius (Gyula) 1878-
Born in Budapest on July 9, 1878, he studied at the Vienna Academy and worked in Berlin as a sculptor and engraver. He specialised in busts and relief portraits.

STEINER, Sebastian 1837-1896
Born in Sterzing, Austria, in 1837, he died in Merano on April 6, 1896. He was the father of Antonie and Julius I. and specialised in tombs, plaques and busts in Innsbruck. Examples of his work are in the Ferdinandeum.

STEINHÄUSER, Adolph Georg Gustav 1825-1888
Born in Bremen on May 14, 1825, he died there on May 28, 1858. He was the brother of Carl Steinhäuser and studied under J.B. Scholl (Darmstadt) and A. Wolff (Berlin). For some time he worked in Rome and this gave his genre and allegorical figures a distinctly Mediterranean character, typified by Love and The Young Fisherman.

STEINHÄUSER, Carl Johann 1813-1879
Born in Bremen on July 3, 1813, he died in Karlsruhe on December 9, 1879. He studied at the Bremen School of Design and was a pupil of Rauch in Berlin. He worked in Rome from 1835 to 1863 and was appointed professor of sculpture at Karlsruhe on his return. He exhibited at the Paris Salon and got an honourable mention in 1861. He specialised in classical figures, such as Psyche and Pandora and semi-allegorical groups such as Goethe and Psyche, busts of historical, classical and contemporary personalities, bas-reliefs for monuments and genre figures, such as The Violinist.

STEINLEN, Théophile Alexandre 1859-1923
Born in Lausanne on November 10, 1859, he died in Paris on December 14, 1923. He was a painter, etcher, lithographer and sculptor of genre subjects.

STELLA, Étienne Alexandre fl. 19th century
Born in Paris in the mid-19th century, he studied under Dumont and exhibited at the Salon from 1879 onwards. He was a member of a family of Flemish origin which was engaged in decorative sculpture from the 16th century onwards.

STELLEZKIJ, Dimitri Semionovich 1875-
Born in St. Petersburg in 1875, he studied in Paris at the turn of the century and exhibited at the Salon of the Société Nationale des Beaux Arts before the first world war. He worked as a painter and decorative sculptor.

STEMOLAK, Karl 1875-
Born in Graz, Austria, on November 11, 1875, he studied under E. Hellmer in Vienna and produced monuments, statuary and busts, genre and allegorical figures, such as Self-conscious Beauty (Vienna Municipal Museum).

STENBERG, Johan Erland 1838-1917
Born in Koikhala, Finland, on September 21, 1838, he died in Helsinki on February 9, 1917. He sculpted classical figures and groups, portrait medallions and busts of Finnish and Swedish contemporary personalities.

STENDLER, Karl 1858-
Born in Hamburg on January 14, 1858, he studied at the Dresden Academy and worked in Saxony as an architectural sculptor.

STENGLIN, Ernst Hugo, Baron von 1862-1914
Born in Schwerin on November 13, 1862, he was killed in action near Dixmude on November 10, 1914. He studied at the Munich Academy and worked as a painter and sculptor of hunting subjects.

STEPHANI, Erich 1879-
Born in Waldkirchen on January 30, 1879, he studied under Weinhold and Hermann Groeber at the Karlsruhe Academy and later worked under Rodin in Paris. Examples of his sculpture, in terra cotta and bronze, are in the Mannheim Kunsthalle.

STEPHEN, Douglas George 1909-
Born in London on May 23, 1909, he studied at the Camberwell School of Arts and Crafts (1939-41) and the City and Guilds School under E.A. Howes. He has exhibited at the Royal Academy and other London galleries and has a studio at Lodsworth in Sussex. His work is sculpted in wood, stone and bronze.

STEPHENS, Edward Bowring 1815-1882
Born in Exeter on December 10, 1815, he died in London on November 9, 1882. He studied under John Glendall, a landscape painter, and then went to London to study sculpture under E.H. Baily. He enrolled at the Royal Academy schools in 1836 and won a silver medal of the Society of Arts that year. The following year he was awarded the Royal Academy silver medal for modelling Ajax defying the Gods. His first commission came in 1838 when he sculpted a bust of Miss Blanche Sheffield, and from 1839 to 1841 he worked in Italy. He returned to Exeter in 1841 but moved to London the following year. He won the Royal Academy gold medal in 1842 for a relief of the Battle of the Centaurs and Lapiths. Subsequently he sculpted a number of bas-reliefs in the classical idiom, but his most ambitious work was a bronze relief of the Battle of Balaclava for the memorial to Colonel Morris on Hetherleigh Down in Devon. He exhibited at the Royal Academy from 1838 to 1883 (A.R.A. 1864) and the British Institution from 1838 to 1853.

STERLING, Lindsey Morris 1876-
Born at Mauch-Chunk in the United States in 1876, he studied at the Cooper Union in New York under George T. Brewster and the Art Students' League under James Earle Fraser. Later he worked under Bartlett and Bourdelle in Paris. He was awarded a bronze medal at the Panama-Pacific International Exposition, San Francisco, for a number of plaster studies.

STERN, Marguerite Louise Delphine (née Fould) 1866-
Born at Marnes-la-Coquette on September 23, 1866, she studied under Millet and Marcilly and exhibited at the Salon des Artistes Français from 1914 onwards, getting an honourable mention in 1926 and a bronze medal in 1932. She was a member of the Société des Femmes Peintres et Sculpteurs and president of the French Federation of Artists. She worked in the Netherlands for many years and was an Officer of the Order of Oranje-Nassau. She specialised in animal figures, particularly dogs, and also figures of ballet dancers and busts of French generals.

STERN, Rosa 1868-
Born in Szeged, Hungary, on March 6, 1868, she sculpted figures and groups at the turn of the century.

STEUER, Bernard Adrien 1853-1913
Born in Paris on June 21, 1853, he died there in 1913. He studied under Jouffroy, Lequesne and Aimé Millet and won honourable mentions at the Salon in 1882, 1884, 1886 and 1900. He specialised in busts of his contemporaries and genre and hunting groups.

STEVENS, Alfred George 1817-1875
Born in Blandford, Dorset, on December 30, 1817, he died in London on May 1, 1875. He was the son of a painter and decorative sculptor and completed his training in Italy where he was influenced by the primitives and Renaissance art. He later became a modeller and designer for a large bronze foundry. His best known work is the bronze and marble Wellington monument in St. Paul's Cathedral. His minor works include figures and groups of genre and biblical subjects.

STEVENS, Lawrence Tenney 1896-
Born in Brighton, Massachusetts, on July 16, 1896, he worked as a painter, engraver and sculptor of religious subjects.

STEVENSON, David Watson 1842-1904
Born in Edinburgh on March 25, 1842, he died there on March 18, 1904. He studied under William Brodie and attended classes at the modelling school of the Royal Scottish Academy. He exhibited at the Royal Scottish Academy, becoming A.R.S.A. in 1877 and R.S.A. in 1886. His best known work consists of the hunting scenes that decorate the Queensberry Memorial in Edinburgh. His lesser works include preliminary studies for the Albert Monument, classical groups, such as Nymph by the Stream, Echo and Galatea, and genre figures, such as Young Scottish Girl (Edinburgh National Gallery).

STEVENSON, James Alexander 1881-1937
Born in Chester on October 18, 1881, he died in London on October 5, 1937. He studied at the Royal College of Art under Lanteri and, having won the travelling scholarship for sculpture, he completed his studies in Italy. He became Landseer Scholar at the Royal Academy schools in 1906 and began exhibiting at the Royal Academy the same year. From 1911 to 1914 he was modelling master at the Regent Street Polytechnic. He was elected A.R.B.S. in 1908 and F.R.B.S. in 1926. His portrait and figure sculpture was signed 'Myrander'.

STEVENSON, William Grant 1849-1919
Born in Ratho, Midlothian, on March 7, 1849, he died in Edinburgh on May 6, 1919. He was the younger brother of David Stevenson and was educated at the Royal Institution, Edinburgh, and the Royal Scottish Academy and the leading English galleries from 1874, becoming A.R.S.A. in 1885 and R.S.A. in 1896. He is best known for his colossal figure of Sir William Wallace in Aberdeen, but also sculpted several figures of Robert Burns for Kilmarnock, Chicago and Denver, and Highland Mary for Dunoon. His minor works include several animal subjects, notably a bronze Stag which was shown at the Royal Scottish Academy in 1894.

STEWARDSON, Edmond Austin 1860-
Born in Philadelphia in 1860, he studied in New York and Paris and exhibited genre figures at the Paris Salons at the turn of the century. The Metropolitan Museum of Art, New York, has his figure of a Bather.

STEWART, Thomas Kirk 1848-1879
Born in New York on November 11, 1848, he died in Kansas City on October 8, 1879. He specialised in heads and busts of his contemporaries.

STICHLING, Otto 1866-1912
Born in Ohrdruf, Germany, on April 10, 1866, he died in Berlin on April 28, 1912. He studied at the Berlin Academy under Schaper and Herter and became successively professor of sculpture at Altona and Charlottenburg. He produced figures of women and girls and allegorical studies, such as the series depicting Sculpture, Painting, Music and Poetry in the Cologne Museum of the Decorative Arts.

STIEPANOFF, Daniel 1882-1937
Born in St. Petersburg in 1882, he died in Venice in 1937. He was the son and pupil of the painter known as Daniel Claude and studied at the St. Petersburg Academy. He became chief medallist at the St. Petersburg Imperial Mint, but after the Revolution he moved to Italy. He exhibited figures and bas-reliefs at the Venice Biennale in the 1920s.

STIEPANOFF, Fiodor fl. 19th century
Born in St. Petersburg on February 7, 1815, he studied at the Academy from 1824 to 1831 and then at the Munich Academy from 1841 to 1843, before returning to St. Petersburg.

STIEPANOFF, Nikolai Alexandrovich 1805-1877
Born in St. Petersburg in 1805, he died there in 1877. He specialised in caricatures, mainly in terra cotta.

STIFFENHOFFEN, Antoine fl. 18th-19th centuries
Born in Bregenz, Austria, in 1758, he studied under Luc Breton and attended classes at the School of Painting and Sculpture in Besançon where he won second prize in 1781. He produced classical figures and groups and sculpted portrait busts of French royalty and contemporary personalities.

STIGELL, Robert 1852-1907
Born in Helsinki on May 14, 1852, he died there on December 1, 1907. He spent many years in France and exhibited at the Paris Salons at the turn of the century, getting an honourable mention in 1891 and a third class medal in 1898. He was awarded a gold medal at the Exposition Universelle of 1900. He is best known for The Shipwrecks (Helsinki Observatory), but his minor works include studies of archers and sling-throwers, the allegorical composition Who Gains? and various busts of his contemporaries.

STIGELMAIER, Johann Baptist 1791-1844
Born at Fürstenfeldbruck, Bavaria, on October 18, 1791, he died in Munich on March 2, 1844. He studied at the Munich Academy and specialised in figures, busts, bas-reliefs and medallions.

STOCK, Carl 1876-
Born in Hanau-Hesselstadt on March 10, 1876, he studied at the Hanau Academy under M. Wiese and later went to the Munich Academy. He worked in Frankfurt from 1908 onwards and is best known for the monumental groups at the Frankfurter Bahnhof and various monuments and fountains in the Frankfurt area, notably the memorial to the poet Körner.

STOCKER, Daniel Georg 1865-
Born in Stuttgart on July 9, 1865, he studied under Donndorf and worked in Italy and France for several years before returning to Stuttgart. He specialised in memorials but his minor works include genre, allegorical and biblical figures, such as Cain (Stuttgart Museum), Day and Night and portrait busts of historical and contemporary artistic and literary figures.

STOCKER, Rudolf 1879-
Born in Stuttgart on June 8, 1879, the younger brother of Daniel Stocker. He studied at the Stuttgart School of Art and latterly the Stuttgart Academy and then worked in Berlin, Florence and Rome before settling in his native city in 1907. He produced numerous war memorials in the 1920s, but his lesser works include busts of cultural celebrities and such genre and allegorical works as Speed and Bowls-player Resting.

STÖCKLIN, Friedrich 'Fritz' 1899-
Born in Basle, Switzerland, in 1899, he studied under Eugène Niederer and attended classes at the School of Decorative Arts in Basle. He works as a sculptor, wood-carver and jeweller.

STOCKMANN, Arnold 1882-
Born at Sarnern, Switzerland, on September 12, 1882, he studied under Johan Karl Bossard at the Lucerne School of Fine Arts and later continued his training in Zürich and Geneva. He produced numerous heads, busts, medals and bas-reliefs.

STOEVING, Curt 1863-
Born in Leipzig, Saxony, on March 6, 1863, he studied there and in Stuttgart before becoming a professor of modelling in Berlin. He specialised in busts of contemporary celebrities.

STOFFYN, Paul 1884-
Born in Brussels in 1884, he studied under J. Dillens and Van der Stappen at the Brussels Academy. He specialised in genre groups such as Tenderness (Ixelles Museum).

STOJANOVICH, Streten 1898-
Born at Prijedor, Bosnia, on February 2, 1898, he studied in Vienna and worked under Bourdelle in Paris. He has produced many colossal statues and memorials in Yugoslavia, notably the Insurrection Monument at Bosansko Grahovo, but his minor works include small bas-reliefs and portrait busts of historical and contemporary personalities.

STOLBA, Leopold 1863-1929
Born at Gaudenzdorf near Vienna on November 11, 1863, he died in Vienna on November 17, 1929. He studied at the Vienna Academy from 1879 to 1881 and worked as a painter, engraver and sculptor, acquiring a considerable reputation as a caricaturist.

STOLBERG, Oskar 1882-
Born in New York on November 27, 1882, he studied at the Vienna Academy and worked as a decorative sculptor in Graz.

STOLL, Fredy Balthazar fl. 20th century
Born in France in the late 19th century of Austrian parentage, he exhibited figures and portraits at the Salon des Artistes Français and the Tuileries in the inter-war period. He won a gold medal at the Exposition Internationale of 1937.

STOLTENBERG-LERCHE, Hans 1867-1920
Born in Düsseldorf in 1867, he died in Rome on April 17, 1920. He worked for two years in a small German pottery as a modeller, but later went to Italy and thence to Paris where he studied sculpture under Carrière. He exhibited at the Nationale from 1895 to 1912 and settled in Rome in 1900. He specialised in busts, reliefs, small figures and medallions.

STOLZ, Jakob 1867-1932
Born at St. Ingbert, Germany, on November 28, 1867, he died in Kaiserslautern on January 5, 1932. He studied at the Munich Academy under Rümann and became professor of sculpture at the Kaiserslautern School of Fine Arts in 1895.

STOLZ, Michael 1820-1890
Born at Matrei, Austria, on April 1, 1820, he died in Innsbruck on November 16, 1890. He studied under Franz Renn at Imst and Josef Kleber in Vienna. Subsequently he worked under Knabl and Eberhard in Munich. He was professor of drawing at Innsbruck from 1854 to 1884, but also sculpted decoration and public statuary in that city.

STÖLZER, Berthold 1881-
Born in Sömmerda on February 21, 1881, he produced genre and allegorical figures such as Veritas and animal groups.

STONE, Frank Frederic 1863-
Born in London on March 28, 1863, he studied under Richard Belt and worked in London, Canada and the United States at the turn of the century. He specialised in portrait busts, his best known work being the portrait of Gladstone in the Treasury, London.

STONE, Horatio 1808-1875
Born in the United States in 1808, he died in Italy in 1875. He trained as a doctor of medicine but later turned to drawing and sculpture and spent the later years of his life in Italy copying classical figures and bas-reliefs.

STONE, Madeline 1877-1932
Born in Boston in 1877, she died in Washington on September 25, 1932. She was the sister of the poet, Edgar Lee Masters and studied under Gutzon Borglum and Antoine Bourdelle.

STORCH, Arthur 1870-
Born in Volkstedt, Thuringia, on March 22, 1870, he studied under W. von Rümann at the Munich Academy from 1892 to 1903 and worked in that city till 1911 and in Hamburg till 1917. He specialised in classical groups, such as Hercules and the Serpents (Hamburg Museum) and busts and groups of children.

STORCK, Carol fl. 19th century
Romanian sculptor working in Bucharest, he won a silver medal at the Exposition Universelle in 1900.

STORCK, F. fl. late 19th century
Born in Bucharest in the mid-19th century, he studied there and in Berlin and worked in Germany at the turn of the century. He got an honourable mention at the Exposition Universelle of 1889.

STORCK, Fritz 1872-
Born in Bucharest on January 19, 1872, he was the son and pupil of Karl Storck the Elder. Later he studied under J. Georgescu and W. von Rümann. He was one of the founders of Tinerimea Artistica, a group which played a major role in the development of Romanian art in the early years of this century. Examples of his sculpture in the Simu Museum include The Clown, The Penitent and various busts of Romanian personalities.

STORCK, Karl the Elder 1826-1887
Born in Hanau, Germany, in 1826, he died in Bucharest in 1887. He studied in Paris till the Revolution of 1848 and settled in Bucharest the following year. Later he returned briefly to Germany to study in Munich (1856-57), but became professor at the Bucharest School of Fine Arts in 1865. He specialised in portrait busts of Romanian royalty and contemporary celebrities and sculpted the monuments to Prince Mihai Cantacuzino and Queen Elisabeth.

STORCK, Karl the Younger 1854-1924
Born in Bucharest in 1854, he died there in 1924. He was the son and pupil of Karl Storck the Elder and also studied in Florence under A. Rivalta. He spent four years in the United States before settling in Romania. He produced numerous memorials and portrait busts, plaques and medallions of Romanian celebrities at the turn of the century.

STORDEUR, Jean Baptiste 1836-1885
Born in Brussels on November 25, 1836, he died there on June 9, 1885. He studied at the Brussels Academy and worked under J.P. Braemt. He spent a number of years in Malines and then worked in Antwerp from 1879 to 1881 before settling in Brussels. He specialised in portrait reliefs and medals.

STORRS, John 1885-
Born in Chicago on June 29, 1885, he studied under Grafly, Bartlett and Rodin. He spent most of his working life in Paris and is best remembered for the monument to Wilbur Wright in Le Mans.

STORY, Waldo Thomas 1855-1915
Born in Rome in 1855, he died in New York on October 23, 1915. He spent his entire working life in England and was a member of the Society of British Artists. He exhibited at the Royal Academy from 1882 and also the Grosvenor Gallery. He specialised in portrait busts of contemporary British celebrities, examples of which are in the Ashmolean Museum and the National Portrait Gallery.

STORY, William Wetmore 1819-1895
Born in Salem, Massachusetts, on February 12, 1819, he died at Vallombrosa, Italy, on October 9, 1895. He was the father of Waldo Story and worked in Rome from 1855 till his death. He produced allegorical and classical figures, mainly in marble and including Salome, Medea, Electra, Cleopatra, Semiramis and other tragic heroines of classical mythology. His major works include Jerusalem in Sorrow (Philadelphia) and The Saviour (Boston). His minor works include a number of bronze busts and statuettes of his family and contemporary personalities.

STÖVER, Johann Heinrich fl. 19th century
Born in Amsterdam in 1829, he worked in Rome from 1852 to 1872 and specialised in biblical groups, such as Christ Healing the Blind (1856).

STRACKE, Frans 1820-1898
Born at Dorsten, Holland, on May 5, 1820, he died at Baarn on March 26, 1898. He was the son and pupil of Ignatius Johann Stracke and worked in Arnhem from 1842 till 1868 when he was appointed professor of sculpture at the Amsterdam Academy. He specialised in genre groups, such as Two Mothers, Italian Fisherman and Snow-white.

STRACKE, Ignatius Johann fl. 19th century
Dutch sculptor active in the first half of the 19th century. He studied under Rauch in Berlin and became Director of the School of Fine Arts in Hertogenbosch.

STRACKE, Johannes Theodorus 1817-1891
Born in Dorsten, Holland, on July 9, 1817, he died in Cologne on November 11, 1891. He studied under his father Ignatius Stracke and Geefs in Brussels and eventually became professor of sculpture at the Rotterdam Academy and Director of the School of Fine Arts in Hertogenbosch. He specialised in portrait busts of his artistic contemporaries.

STRACKE, Leo Paulus Johannes 1851-
Born in Rotterdam on July 30, 1851, the son and pupil of Johannes Theodorus Stracke. He worked as a decorative sculptor in Rotterdam from 1879 onwards.

STRAETEN, Georges van der 1856-
Born in Ghent on December 21, 1856, he trained as a lawyer but turned to sculpture and studied under G. Kasteleyn and Jef Lambeaux. He worked in Paris from 1883 to 1928 and exhibited at the Salon from 1912 onwards. His small ornaments and figures were inspired by the paintings of Watteau. He spent the latter part of his career in Ghent.

STRAHAMMER, Heinrich 1903-
Born in Vienna on March 13, 1903, he studied under Schufinsky at the Vienna School of Fine Arts and then under Joseph Muller at the Vienna Academy. He won the Austrian State Prize for sculpture in 1935. His speciality is memorials, tombs and monumental reliefs.

STRAMBOE, Otto Valdemar 1871-
Born in Göteborg on December 26, 1871, he studied at the Stockholm Academy from 1891 to 1895 and then worked in Germany, Italy and France before becoming professor at the Stockholm Technical High School in 1907. He was elected a member of the Stockholm Academy in 1915. He specialised in genre figures, such as The Dance (Stockholm National Museum).

STRASSEN, Melchior Anton Zur 1832-1896
Born in Münster on December 28, 1832, he died in Leipzig on February 27, 1896. He worked in Cologne, Berlin and Rome and was professor at the Nuremberg School of Fine Arts from 1870 to 1875. He specialised in portrait reliefs and medals of literary celebrities.

STRASSER, Arthur 1854-1927
Born in Adelsberg on April 8, 1854, he died in Vienna on November 8, 1927. He studied at the Vienna Academy 1871-75 and worked in Paris from 1881 onwards. He was an exponent of naturalism, with a penchant for Oriental subjects.

STRATTON, Hilary Byfield 1906-
Born in Amberley, Sussex, on June 29, 1906, he was the son and pupil of the painter Fred Stratton. He studied under Eric Gill (1919-22) and at the Royal College of Art (1933-36) and has exhibited at the Royal Academy and the principal London galleries. He has a studio at Barns Green near Horsham, Sussex, and works in stone, clay, wood, ivory and metal.

STRAUB, Joseph 1756-1836
Born in Vienna in 1756, he died there on March 12, 1836. He worked as a decorative and religious sculptor.

STRAUB, Otto 1890-
Born in Munich on April 26, 1890, he studied at the Munich Academy and sculpted memorials and public statuary in the 1920s.

STRAUBE, Adolph Friedrich Leonhardt 1810-1839
Born in Weimar, Saxony, on February 24, 1810, he died there on February 25, 1839. He was a protégé of the Duke of Saxe-Weimar who had him educated in Paris where he studied under David d'Angers. He specialised in busts of German historical and contemporary personalities and members of the Saxon royal families.

STRAZZA, Giovanni 1818-1875
Born in Milan in 1818, he died there on April 19, 1875. He studied at the Brera Academy, Milan, and was a pupil of F. Somaini. He worked in Rome from 1840 to 1858 and then returned to Milan to become a professor at the Brera Academy. He sculpted còlossal statuary and portrait busts of Italian celebrities.

STRECKER, Hermann fl. 19th century
Born in Philadelphia on March 24, 1836, he worked in Pennsylvania as a decorative sculptor.

STREICHER, Josef 1806-1867
Born in Innsbruck in 1806, he died there on September 16, 1867. He studied under F.X. Renn in Imst and spent some time in Munich in 1826. Examples of his religious and classical works are preserved in the Ferdinandeum, including Mercury, Cupid and Psyche, Faith, Hope and Charity and the Betrothal of St. Catherine.

STRESCHNAK, Anton 1833-1906
Born in Nieder-Schwägersdorf, Austria, on January 21, 1833, he died in Vienna on June 8, 1906. He studied at the Vienna Academy and specialised in allegorical and religious sculpture, such as The Birth of Light (1863).

STRESCHNAK, Robert 1827-1897
Born in Nieder-Schwägersdorf in 1827, he died in Vienna on June 4, 1897. He worked as a decorative sculptor in Vienna.

STRICKNER, Anton 1822-1895
Born in Steinach on March 3, 1822, he died there on November 9, 1895.

STRINGOVITS, Franciska 'Ferry' (née Czipek) 1893-
Born in Budapest on October 12, 1893, she sculpted statuettes and portraits in the inter-war period.

STROBEL, Daniele de 1873-
Born in Parma, Italy, on March 30, 1873, he studied at the Parma Institute of Fine Arts, the Brera Academy, Milan, and also in Rome. He became professor of modelling at the Brera Academy and exhibited in Rome (1893, 1899) and Milan (1897 and 1937), as well as Venice, Turin, Florence, London and Munich in the early years of this century. He specialised in genre and allegorical figures and groups, particularly featuring children.

STROBL VON LIPTOUJVAR, Alois 1856-1926
Born at Kiralylehota, Hungary, on June 21, 1856, he died in Budapest on December 13, 1926. He worked in Budapest as a sculptor and painter of historical, classical and genre subjects. He was awarded a Grand Prix at the Exposition Universelle of 1900.

STROHL-FERN, Alfred 1845-1927
Born in Markirch, Alsace, in 1845, he died in Rome in 1927. He left Alsace in 1870 and settled in Rome where he worked as a painter and sculptor of neo-classical subjects.

STROHOFFER, Bela 1871-
Born in Budapest on August 25, 1871, he specialised in portrait busts and heads.

STROINSKI, Christine 1905-
Born in Darmstadt on May 4, 1905, she studied under Anthes and worked as a painter and sculptor, spending many years in Berlin and Paris before returning to Darmstadt.

STRYMANS, Alphonse Joseph 1866-
Born in Turnhout, Belgium, on July 24, 1866, he attended evening classes at the Antwerp Academy from 1890 to 1892 and then enrolled at the Higher Institute of Fine Arts in Antwerp. He sculpted classical and genre figures, such as The Vine, Beatrice (Antwerp Museum) and The Snake Charmer (Tervueren Museum).

STRYNKIEWICZ, Franciszek 1893-
Born in Moglielnica, Poland, on July 6, 1893, he served in the Polish Legion in 1915-17 and studied sculpture at the Warsaw School of Fine Arts from 1923 to 1927. He specialises in heads and busts, particularly of children.

STUARDI, Antonio Giovanni 1862-
Born at Poirino near Turin in 1862, he worked as a decorative sculptor in northern Italy at the turn of the century.

STUBINITZKI fl. 19th century
Portrait busts of the Bourbon royal family and French cultural celebrities bearing this signature were produced by a sculptor working in Paris from 1812 to 1824.

STUCK, Franz von 1863-1928
Born in Tettweis, Bavaria, on February 23, 1863, he died in Teschen, Silesia, on August 30, 1928. He studied at the Munich Academy (1882-84) and was inspired by Diaz, Böcklin and Lenbach in his painting. He contributed illustrations to the *Fliegende Blätter* and became one of the leading exponents of Jugendstil. As a sculptor, he did numerous busts of women and figures of athletes, amazons, dancers and neo-classical statuettes such as The Wounded Centaur and Salome.

STÜCKGOLD, Stanislaus 1868-1933
Born in Poland in 1868, he died in Paris in January 1933. He worked in Hungary in 1911-12 and then moved successively to Munich and Paris. He was primarily a painter of still-life, but also sculpted busts of his contemporaries and experimented in abstracts influenced by the occult.

STUDHALTER, Eligius 1819-1859
Born in Horw near Zürich in 1819, he died in Lucerne in 1859. He worked as a sculptor and lithographer of genre subjects.

STUDIN, Marin 1895-
Born at Novice Kastelima, Dalmatia, on November 28, 1895, he studied and worked in Split, Zagreb, Vienna and Paris (under Bourdelle at the Académie de la Grande Chaumière). His works include Tower of Joy, Tower of Grief and Tower of Prophesy.

STUFLESSER, Ferdinand 1855-1926
Born at St. Ulrich on December 19, 1855, he died in Munich on October 9, 1926. He studied under Knabl in the 1880s and settled in Munich where he sculpted figures and portraits.

STUHR, Heinrich 1833-1919
Born at Brunshaupten, Germany, on September 2, 1833, he died in Schwerin on April 7, 1919. He was a draughtsman, modeller and amateur sculptor of considerable accomplishment.

STUNDL, Theodor 1875-1934
Born in Marburg on June 28, 1875, he died at Hohenberg on August 12, 1934. He studied at Graz School of Fine Arts and the Vienna Academy and established a reputation for his memorials to the Habsburg family. His best known work is the Schubert fountain in Vienna, but his minor works include statuettes and busts of Schubert.

STURBELLE, Camille Marc 1873-
Born in Brussels on September 29, 1873, he studied at the Brussels Academy and the School of Decorative Arts in Paris and worked under Hector Lemaire. He won the Grand Prix of the Brussels Academy and a silver medal at the St. Louis World's Fair in 1904. He was an animalier sculptor, noted for such works as English Bull-dog and Billy-goat, but also sculpted busts of artistic and literary Belgian contemporaries.

STURLA, Alfredo F. 1905-
Born in Buenos Aires in 1905, he specialised in statuettes of female nudes, strongly influenced by the work of Maillol.

STURM, Paul 1859-
Born in Leipzig on April 1, 1859, he studied at the academies of Leipzig and Lyons. The museums of Bremen and Karl-Marx-Stadt have examples of his busts, heads, reliefs and medallions, mainly portraying women.

STÜRMER, Wilhelm Ludwig 1812-
Born in Berlin in 1812, he studied at the Academy under Ludwig Wichmann and the Munich Academy under Schwanthaler. He produced a series of statuettes of Prussian royalty, contrasting with his colossal statuary which formerly adorned the gateways of Königsberg (now Kaliningrad). He also sculpted busts and statuettes of his artistic contemporaries.

STURNE, Émile Hyacinthe fl. late 19th century
Born at St. Omer, France, in the mid-19th century, he studied under Clovis-Normand and exhibited romantic figures at the Salon from 1874 onwards.

STURSA, Jan 1880-1925
Born at Neustadtl in Moravia on May 15, 1880, he died in Prague on May 2, 1925. He studied at the Horice School of Art (1894-88) and the Prague Academy (1899-1903) and became one of the leading figures in the renaissance of Czech art in the decade following the death of Rodin. He was appointed professor at the Prague Academy in 1916 and was Rector in 1923-24. He produced genre and allegorical figures and busts, such as Primavera, Eve, Melancholy, Girl, Messalina, Woman at her Toilet, Puberty, The Wounded, Gift of Heaven and Earth, The dancer Sulamith Rahu. Examples of his bronzes are in the museums and galleries of Prague, Vienna and Munich.

STÜTTGEN, Christian 1876-
Born in Eupen, Belgium, on May 4, 1876, he studied at the Berlin Academy and produced figures, busts and reliefs in the inter-war period.

STYX, G. fl. 19th century
Decorative sculptor working in Berlin from 1844 to 1883.

SUBIRACHS, José 1927-
Born in Barcelona in 1927, he studied at the local Art School from 1945 to 1948 and had his first one-man exhibition at the Casa del Libro, Barcelona, in the latter year. He won a scholarship which enabled him to further his studies in Paris in 1951 and then worked in Belgium till 1955 when he returned to Spain. He has taken part in major international exhibitions, since the Sao Paulo Biennial of 1951, and has had many important commissions for public sculpture in Spain. His abstracts are executed in iron, bronze, concrete and terra cotta.

SUBIRAT Y CODORNIU, Ramon fl. 19th century
Born at Mora del Ebro, Spain, in the first half of the 19th century, he studied at the Barcelona Academy and the Academy of San Fernando in Madrid. He worked in Madrid as a decorative sculptor and exhibited figures and bas-reliefs there from 1856 to 1871.

SUC, Étienne Nicolas Édouard 1807-1855
Born in Lorient on June 22, 1807, he died in Nantes on March 16, 1855. He studied under Lemaire and exhibited at the Salon from 1834 to 1848, winning a third class medal in 1838. His work includes busts of his contemporaries and genre figures, such as Young Breton Beggar, Fisherman, Young Breton Fisherman and Head of the Virgin.

SUCHARDA, Adalbert 1884-
Born in Nova Paka, Slovenia, on January 16, 1884, he studied under his brother Stanislav.

SUCHARDA, Stanislav 1866-1916
Born in Nova Paka on November 12, 1866, he died in Prague on May 5, 1916. He studied at the Prague School of Fine Arts and was professor there from 1892 to 1915, and taught at the Prague Academy in 1915-16. He is best known for the Palacky Monument — a statue of the historian surrounded by allegorical groups symbolising the history of the Czech nation. His lesser works include numerous portrait busts, reliefs and medallions of historic and contemporary celebrities.

SUCHETET, Auguste Edmé 1854-1932
Born at Vandeuvre-sur-Barse on December 3, 1854, he died in Paris in May 1932. He studied under Cavelier and M.P. Dubois and exhibited at the Salon des Artistes Français from 1880 onwards, becoming an Associate in 1887. He won gold medals at the Expositions of 1889 and 1900 and became a Chevalier of the Légion d'Honneur in 1895. He produced busts of his contemporaries, genre and allegorical figures, and groups of nude children with such coy titles as Nest of Love.

SUL-ABADIE, Jean c.1850-1890
Born in Toulouse about 1850, he died there on April 15, 1890. He studied under Jouffroy and Falguière and exhibited at the Salon from 1872 onwards. The Toulouse Museum has his genre figure Idyll.

SULZER-FORRER, Emma Elise 1882-
Born in Winterthur, Switzerland, on May 28, 1882, she produced busts of her contemporaries and nude figures of young boys and girls.

SUMMERS, Charles 1827-1878
Born in West Charlton, England, on July 27, 1827, he died in Rome on November 30, 1878. He exhibited at the Royal Academy from 1849 to 1876 and became a member of the Royal Hibernian Academy in 1871. He sculpted heads and busts of royalty and contemporary celebrities, notably Australian personalities while he worked in Melbourne for some time. His genre figures and groups include Maternal Affection, The Sunnamite and Roman Peasants.

SUNOL, Jeronimo 1839-1902
Born in Barcelona on December 13, 1839, he died there on October 16, 1902. He exhibited in Paris and won a medal at the Exposition of 1867. His best known work is the statue of Columbus at Santander. The Madrid Museum has his plaster study of Dante.

SURAND, Gustave 1860-
Born in Paris on April 25, 1860, he studied under J.P. Laurens and exhibited at the Salon des Artistes Français from 1881, winning an honourable mention in 1884 and bronze and silver medals at the Expositions of 1889 and 1900 respectively. He became a Chevalier of the Légion d'Honneur in 1910. He was a painter and sculptor of animal subjects.

SUSENBETH, Hermann Anton 1857-
Born in Frankfurt-am-Main on December 10, 1857, he studied in Vienna (1881-84) and specialised in busts, reliefs and medals portraying Hessian royalty and celebrities.

SUSENBETH, Kaspar Johann 1821-1873
Born in Frankfurt on May 29, 1821, he died there on December 14, 1873. He studied at the Städel Institute and was a pupil of Schmidt von der Launitz.

SUSILLO Y FERNANDEZ, Don Antonio fl. 19th century
Genre sculptor working in Seville in the second half of the 19th century. His best known work is First Quarrel, awarded a second class medal at the Spanish National Exhibition of 1887.

SUSSMANN-HELLBORN, Ludwig 1828-1908
Born in Berlin on March 20, 1828, he died there on August 15, 1908. He studied at the Berlin Academy and was a pupil of Wredow. Later he worked in Italy, France and Holland before returning to Berlin. He sculpted portrait busts of Prussian royalty, notably Frederick II and Frederick William III, statuettes of historical personalities such as Holbein, Peter Vischer and other German renaissance artists, and characters from classical mythology, folklore and literature, such as Sleeping Beauty, Romeo and Juliet and Drunken Faun.

SUTER, August 1887-
Born in Eptingen, Switzerland, on July 19, 1887, he worked in Basle with Hermann Meyer at the turn of the century and was a pupil of Rodin in Paris in 1910-14. Later he worked with Bourdelle and A. de Niederhausern. He specialised in bronze busts of his artistic and cultural contemporaries. Ghent Museum has his torso of a man.

SUTERA, Giuseppe 1878-
Born in Castrogiovanni, Italy, on October 17, 1878, he studied under Achille d'Orsi and Luigi de Luca. Examples of his sculpture are in the museums of Naples.

SUTERMEISTER, Arnold 1830-1907
Genre sculptor born in Zofingen, Switzerland, on July 11, 1830. Later he emigrated to the United States and worked in Kansas City where he died on May 3, 1907.

SUTHERLAND, Scott 1910-
Born in Wick, Caithness, on May 15, 1910, he studied at Gray's School of Art, Aberdeen (1928-29), Edinburgh College of Art (1929-33), the École des Beaux Arts, Paris (1934) and worked in Germany, Italy, Greece and Egypt in 1934-35. He has been a lecturer at the Dundee College of Art since 1947. He has exhibited at the Royal Scottish Academy (A.R.S.A. 1949, A.R.B.S. 1954 and F.R.B.S. 1961) and lives at Newport-on-Tay. He has sculpted portrait busts, figures of athletes and boxers and genre subjects. His best known work is the Commando Monument at Spean Bridge, Invernessshire.

SUTKOWSKI, Walter 1890-
Born in Danzig on October 4, 1890, he settled in Berlin where he sculpted public statuary and fountains in the inter-war period, notably the allegories of Theatre, Music and Dancing in Wuhlheide Park.

SUTOR, Emil 1888-
Born in Offenburg on June 19, 1888, he studied at the Karlsruhe Academy (1907-9) under Votz, was a pupil of Faierlein in Berlin (1910-11) and of Bruno Wollstätter in Leipzig. He worked in Saxony as a decorative sculptor and is best known for the figures decorating the Leipzig Hauptbahnhof.

SUTRE, Ernest 1904-
Born in Basle on June 16, 1904, he worked with Maillol in Paris and exhibited figures at the Salon d'Automne in the inter-war period.

SUZANNE, François Marie fl. 18th-19th centuries
Born in Paris in 1750, he studied under Huez at the Academy of St. Luc and later became an associate professor there. He exhibited at the Salon from 1793 to 1802 and was employed on the decoration of the Pantheon in 1792. His bronzes includ a series of statuettes portraying Rousseau, Voltaire and Mirabeau.

SVEC, Otakar 1892-
Born in Prague on November 23, 1892, he studied under J.V. Myslbek and J. Stursa. He specialised in genre figures, such as The Motor Cyclist (Prague Modern Gallery).

SVELSTRUP-MADSEN, Charles 1883-
Born in Copenhagen on May 9, 1883, he studied under L. Brandstrup and H.V. Bissen. Many of his portraits and figures are preserved in Copenhagen Town Hall.

SVENDSEN, Munthe 1869-
Born in Volda, Norway, on February 27, 1869, he worked in Oslo and Chicago and then studied under Injalbert in Paris and spent some time in Italy before settling in Trondhjem in the early years of this century. Many of his works are in Oslo.

SVOR, Anders Rasmussen 1864-1929
Born in Hornindal, Norway, on December 14, 1864, he died in Oslo on May 6, 1929. He studied at the School of Fine Arts in Christiania (Oslo) and the Copenhagen Academy and completed his studies in Paris (1888-92). He produced genre figures, such as Grief, various biblical groups and busts of Norwegian celebrities. He also sculpted fountains and public statuary for Oslo.

SWAN, John Macallan 1847-1910
Born at Old Brentford, Middlesex, in 1847, he died at Niton, Isle of Wight, on February 14, 1910. He studied at the Worcester School of Art, the Lambeth School of Art under John Sparkes and finally in Paris under Bastien-Lepage and Gérôme. He exhibited at the Royal Academy from 1878 onwards and was elected A.R.A. in 1894 and R.A. in 1905. He worked as a painter, watercolourist and sculptor of animal subjects, especially the large predators such as leopards, tigers and lions.

SWAN, Paul fl. 20th century
Born in Chicago in the late 19th century, he studied at the Art Institute of Chicago under John Vanderpoel and Lorado Taft. He worked in New York for some time before going to Paris after the first world war. He exhibited at the Paris Salon and the National Academy of Design, New York, in the 1920s, both paintings and busts of allegorical subjects.

SWANSON, Jonathan M. 1888-
Born in Chicago in 1888, he worked there as a sculptor of busts, heads, bas-reliefs and portrait medals.

SWIECINSKI, Georges Clément de 1878-
Born at Radautz, Bukovina, in May 1878, he emigrated to France and was naturalised. He originally studied medicine and was introduced to sculpture by modelling anatomy and preparing dissection models. He exhibited at the Indépendants and the Salon d'Automne in the 1920s and specialised in busts of his contemporaries.

SWIECKI, Wojciech c.1825-1873
Born in Poland about 1825, he died in Paris on March 27, 1873. He studied at the Warsaw School of Fine Arts and worked there and in London, Rio de Janeiro and Paris. He specialised in busts, bas-reliefs and medallions of Polish celebrities.

SWIGGERS, Pierre François 1816-1872
Born in Antwerp on June 6, 1816, he died in Brussels on March 5, 1872. He studied under Willem Geefs and exhibited figures and portraits in Antwerp and Brussels from 1837 to 1857.

SWILLENS, P.M.J. fl. 19th century
Dutch sculptor of portrait busts working in the Utrecht area.

SWOBODA VON WIKINGEN, Emmerich Alexius 1849-1920
Born at Wörth near Glöggnitz, Austria, on July 17, 1849, he died in Vienna on February 1, 1920. He studied under Franz Bauer at the Vienna Academy and won the Prix de Rome, enabling him to work in Italy for two years.

SWYNNERTON, Joseph William 1848-1910
Born in Douglas, Isle of Man, in 1848, he died at Port St. Mary on August 8, 1910. He worked in Rome for many years and exhibited allegorical, romantic and neo-classical figures and groups at the Royal Academy from 1873 onwards. The main collection of his work is in the Salford Museum and includes Cain and Abel, Victory and a portrait of Oliver Heywood.

SYAMOUR, Marguerite (née Gegout-Gagneur) 1861-
Born at Brery, France, in August 1861, she studied under Mercié and exhibited neo-classical statuettes at the Salon des Artistes Français, winning honourable mentions in 1887 and at the Exposition Universelle of 1900. Her bronzes include Diana and The New France.

SYKES, Charles 1875-1950
Born in Yorkshire in 1875, he died in London in 1950. He studied at the Newcastle College of Art and the Royal College of Art and worked as a commercial artist, graphic designer, oil painter, lithographer and sculptor. Many of his pictures, commissioned by the De Reszke cigarette company, were signed with the nom de plume of 'Rilette'. As a sculptor, however, he is best remembered for the series of female figures which he modelled as mascots for the Rolls Royce motor cars. The original Spirit of Ecstasy was commissioned by Lord Montagu of Beaulieu in 1911 and Montagu's secretary posed as the model. A later version, modelled as a kneeling figure, was sculpted in 1934 for the Silver Dawn range of cars. These figures exist in bronze and silver as well as in the brass- or silver-plated mascot versions. Sykes also sculpted portrait busts, bas-reliefs and masks, in bronze or bronzed plaster.

SYKORA, Eduard 1835-1897
Born at Morawetz, Bohemia, on July 5, 1835, he died in Brno on August 25, 1897. He studied under Franz Richter and Franz Stiasny. Examples of his paintings and sculpture are preserved in the Brno Museum.

SYMIAN, Victor Étienne fl. 19th century
Born at St. Gengoux-le-Royal, France, on September 19, 1826, he studied under Jouffroy and then went to Tournus where he worked with Abbé Garnier. For a number of years he was employed as a modeller at the potteries in Stoke-on-Trent, England. The main collection of his sculpture in the Tournus Museum includes a statuette and a bust of Grueze and genre figures, Velleda and The Souvenir.

SYREWICZ, Boleslav 1835-1899
Born in Warsaw on May 21, 1835, he died there on February 10, 1899. He studied under J.F. Piwarski and attended classes at the Warsaw School of Fine Arts and the academies of Berlin and Munich. He also worked in Rome for some time before returning to Warsaw in 1866. He specialised in busts and statuettes portraying Polish historical and contemporary personalities, in marble and bronze.

SZABADOS, Bela 1894-
Born in Budapest on July 20, 1894, he studied in Budapest and Rome and worked in Hungary as a decorative sculptor in the period before the second world war.

SZABO, Antal 1853-
Born in Budapest on June 13, 1853, he studied in Munich and Berlin and sculpted genre figures and groups.

SZABO, Istvan 1899-
Born at Oravicabanya, Hungary, on October 29, 1899, he studied in Budapest and worked as a painter and decorative sculptor in that city. His works include genre and allegorical groups, such as Bread.

SZABO, Laszlo 1917-
Born in Debrecen, Hungary, in 1917, he studied at Debrecen University and took post-graduate courses in Geneva and Lausanne before settling in Paris where he taught himself the elements of sculpture. Since 1949 he has exhibited at the Salon de la Jeune Sculpture and, since 1951, at the Salon des Réalités Nouvelles. His earlier works consisted of bas-reliefs derived from the animal world, but then tended towards the abstract, as in Disc of the Sun and Dawn and Germination, finally becoming surrealist. His works are executed in bronze, steel, terra cotta and black granite. In 1954 he founded the group Quinze Sculpteurs, with whom he exhibits at the Galerie Suzanne de Conninck in Paris.

SZADEBERG, Tadeusz 1901-
Born at Vloclawek, Poland, on January 24, 1901, he studied at the Warsaw School of Design (1916-17), the School of Painting and the School of Fine Arts. He specialises in portrait busts of historic and contemporary Polish celebrities.

SZAMOSI, Imre 1887-
Born at Marosujvar, Hungary, on December 30, 1887, he studied in Budapest and Paris and emigrated to South Africa. He produced statuary and decorative sculpture for Johannesburg from 1908 to 1918.

SZAMOVOLSZKY, Odön 1878-1914
Born at Nagyberezna, Hungary, on December 26, 1878, he died in Budapest on December 28, 1914. He studied in Budapest, Paris and Rome and examples of his figures and portraits are in the Budapest Municipal Museum.

SZANDHAZ, Ferenc 1827-1902
Born at Eger, Hungary, in 1827, he died in Budapest in 1902. He sculpted romantic and genre figures and groups.

SZANDHAZ, Karoly 1824-1892
Born in Eger on January 9, 1824, he died in Budapest on December 16, 1892. He worked with his brother Ferenc and was professor of sculpture at the Budapest Polytechnic.

SZARNOVSKY, Ferenc 1863-1903
Born in Budapest on December 23, 1863, he died there on April 29, 1903. He studied in Vienna and Paris and was a pupil of Chapu and Falguière. Later he worked in London before returning to Budapest. He specialised in portrait medallions, bas-reliefs and busts.

SZASZ, Gyula 1850-1904
Born in Szekesfehervar, Hungary, in 1850, he died in Budapest on June 24, 1904. He studied in Budapest and Vienna and worked in the latter city, decorating the Opera, the Parliament Buildings and other public buildings in Vienna with bas-reliefs and statuary.

SZCZEPKOVSKI, Jean 1878-
Born in Stanislavov, Poland, on March 8, 1878, he studied at the Cracow Academy and was a pupil of Daun and Laszczka. He was noted for the charm and elegance of his female busts, but he also modelled genre figures illustrating the peasant way of life. He also sculpted colossal monuments and memorials and worked in Helsinki as a decorative sculptor in 1902-5.

SZCZYTT-LEDNICKA, Maria 1895-
Born in Moscow on March 23, 1895, she studied under Bourdelle in Paris (1913-14) and then settled in Milan. Her works were imbued with the religious imagery often associated with the Cracovian school of the 13th-14th centuries. Examples of her statuettes are in the museums of Venice, Turin and Forli.

SZECSI, Antal 1856-1904
Born in Budapest on May 29, 1856, he died there on June 15, 1904. He studied in Budapest and Vienna and worked as an architectural sculptor.

SZEKELY, Karoly 1880-
Born in Marosvasarhely, Hungary, on January 22, 1880, he studied in Budapest and Brussels and settled in Budapest where he worked as a decorative and portrait sculptor.

SZEKELY, Moric 1893-
Born in Szolnok, Hungary, on November 14, 1893, he worked in Budapest as a sculptor of bas-reliefs, plaques, medallions, busts and heads.

SZEKELY, Pierre 1923-
Born in Budapest in 1923, he studied drawing and modelling under Hanna Dallos. In 1945 he came to Austria and from there went to France the following year, working at Bures-sur-Yvette and then moving to Marcoussis in 1956. Prior to 1950 he modelled in clay for bronze-casting and also produced some metal sculpture in 1957-59, but otherwise he has preferred to work in stone. His abstracts have been exhibited at the Salon de la Jeune Sculpture, the Salon des Réalités Nouvelles and various galleries in Paris and Berlin.

SZEKESSY, Zoltan 1899-
Born in Dombiratos, Hungary, on March 7, 1899, he worked as a decorative sculptor in Budapest and Düsseldorf.

SZENTGYÖRGYI, Istvan 1881-
Born at Begaszentgyörgyi, Hungary, on June 20, 1881, he studied in Budapest and Brussels and became professor at the Budapest Academy of Fine Arts. He specialised in nude figures and did many monuments and statues for public parks and buildings in Budapest. Examples of his minor works are in the Budapest Museum and the Gallery of Modern Art in Rome.

SZILAGYI, Margit 1894-
Born in Budapest on April 3, 1894, she sculpted statuettes and romantic groups in the period before the second world war.

SZOBOTKA, Antal fl. 20th century
Sculptor of Hungarian origin working in Romania since the second world war. He has sculpted portraits of contemporary personalities and allegorical groups, such as Birth of an Idea.

SZOMOR, Laszlo 1908-
Born in Budapest on April 8, 1908, he sculpted portraits, figures, groups and bas-reliefs before the second world war. The Budapest Municipal Gallery has many of his works.

SZTANKO, Gyula 1900-
Born in Ungvar, Hungary, on March 2, 1900, he sculpted figures and portraits in the inter-war period.

SZUCHODOVSZKY, Mihaly 1885-
Born in Budapest on September 22, 1885, he sculpted figures and busts in the early part of this century.

SZUKALSKI, Stanislaw 1898-
Born in Warta, Poland, in 1898, he studied at the Cracow Academy and spent many years in the United States before returning to Poland in 1936. He produced figures strongly influenced by Rodin, but since about 1930 has sculpted abstracts in the cubist idiom.

SZWARC, Marek 1892-1958
Born in Zgiers, Poland, on May 9, 1892, he died in Paris in December 1958. He studied under Mercié at the École des Beaux Arts but returned to Poland in 1914 and did not settle in Paris till 1920. On the outbreak of the second world war he joined the Polish Army in France but was later employed as a teacher of sculpture at the French Army Rehabilitation Centre in London and executed a tapestry for General de Gaulle. After the war he returned to Paris. His earliest work consists of bas-reliefs hammered in copper, but after the second world war he began sculpting in the round, working in stone, wood and bronze, and latterly in lead. A convert to Catholicism in 1920, he imbued much of his work with a deep sense of religion. Among his best known works were the colossal reliefs for the Papal Pavilion at the Exposition Internationale of 1937, the statuette of David (1954) and his last work appropriately named Libera Me (1958). A retrospective exhibition of his sculpture was held at the Galerie Madeleine Rauch in 1960.
Vauxcelles, Louis *Marek Szwarc* (1929).

TABACCHI, Odoardo 1831-1905
Born in Valsugana, Italy, in 1831, he died in Milan on March 23, 1905. He studied at the Brera Academy and also in Rome. He received many important state commissions and is remembered for the colossal monuments and statues to Cavour (Milan), Garibaldi (Turin) and Victor Emmanuel (Asti). He was a major influence on the younger Italian sculptors at the turn of the century. He exhibited widely in Europe and was decorated with the Légion d'Honneur for his contribution to the Exposition Internationale of 1878.

TADOLINI, Adamo 1788-1868
Born in Bologna on December 21, 1788, he died in Rome on February 23, 1868. He studied under De Maria at the Bologna Academy and then followed his master to Ferrara where he sculpted a statue of Napoleon Bonaparte. Later he worked in the studio of Canova. He specialised in monuments to the international celebrities of the early 19th century and his work was exhibited in Italy, Paris and London (Royal Academy, 1830). His minor works include Bacchante (Borghese Museum, Rome) and The Slave (Valenciennes Museum).

TADOLINI, Enrico 1888-
Born in Rome in 1888, the son and pupil of Giulio Tadolini. He specialised in tombs, memorials and bas-reliefs.

TADOLINI, Giulio 1849-1918
Born in Rome on October 22, 1849, the son of Scipione Tadolini, he died in Rome on April 18, 1918. He studied at the Rome Academy and was a pupil of Fracassini. He sculpted memorials to Victor Emmanuel at Perugia and Pope Leo XIII in the Church of St. John Lateran.

TADOLINI, Petronio 1727-1813
Born in Bologna in 1727, he died there in 1813. He studied under Bolognini and sculpted numerous statues in Bologna and religious figures for the cathedrals of Faenza and Mirandola.

TADOLINI, Scipione 1822-1892
Born in Rome in 1822, he died there in 1892. He was the son and pupil of Adamo Tadolini and continued his father's work as a monumental sculptor. His larger works include the monuments to Bolivar (Lima), St. Michael (Boston) and Victor Emmanuel (Rome Senate). He exhibited at the Royal Academy in 1853. His minor works include various figures on the theme of slavery, examples of which are in the museums of Glasgow, Madrid and Sydney.

TADOLINI, Tito 1825-c.1900
Born in Bologna in 1825, he died there about 1900. He specialised in busts of historical and contemporary artistic and musical celebrities, classical and genre figures, such as Narcissus and The Siesta.

TAFT, Lorado 1860-1936
Born at Elmwood, Illinois, on April 29, 1860, he was educated at the University of Illinois and studied at the École des Beaux Arts, Paris, from 1880 to 1883 under Dumont, Bonnaissiez and Jules Thomas. He became a teacher at the Art Institute of Chicago in 1886 and subsequently a lecturer in art at the University of Chicago. He was elected to the National Academy in 1911 and was Director of the American Federation of Art from 1914 to 1917. He was awarded the designer's medal at the Columbian Exposition (1893) and a silver medal at the Panama-Pacific Exposition, San Francisco (1915) and a gold medal at the St. Louis World's Fair (1904). His major works as a sculptor include Sleep of the Flowers and Awakening of the Flowers (both for the Columbian Exposition), Despair (1898), Solitude of the Soul (1900), Fountain of the Lakes (1903), Black Hawk (1912), the statue of Abraham Lincoln in Springfield, Illinois, the Thatcher memorial fountain in Denver, Colorado (1918) and the Fountain of Time, Chicago (1920). His minor works, in plaster, cement, marble and bronze, include numerous busts and heads of his contemporaries. Apart from his influence on the development of American sculpture at the turn of the century he was the leading authority on American sculpture of the 19th century, and was a prodigious writer on the subject, his works including *The History of American Sculpture* (1903, revised 1924), and *Modern Tendencies in Sculpture* (1920).

TAGLANG, Hermann 1877-
Born at Überlingen, Germany, on June 1, 1877, he studied under Joseph Eberle and attended classes at the academies of Karlsruhe and Munich. He sculpted a number of memorials after the first world war. His lesser works include statuettes of religious subjects and portrait busts of his contemporaries.

TAGLANG, Hugo 1874-
Born in Vienna on May 14, 1874, he studied under Edmund Hellmer at the Vienna Academy and specialised in portrait busts, bas-reliefs and medals.

TAGLIONI, Alfonso fl. 19th century
Born in Novara, Italy, in the first half of the 19th century, he exhibited figures and portraits in Turin, Milan, Rome and Venice.

TAIEE, Jean Alfred fl. 19th century
Born in Paris on January 21, 1820, he worked as an etcher and sculptor of genre subjects. He exhibited at the Salon from 1868 to 1880.

TAILLIET, Jean Marie 1888-
Born in Rheims on February 25, 1888, he made his début at the Salon at the age of fifteen. He was appointed Curator of the Oran Museum of Fine Arts in 1935. He worked as a painter in watercolours and as a sculptor of genre subjects.

TAISZER, Janos 1878-
Born at Törökbalint, Hungary, on July 17, 1878, he studied in Budapest and sculpted busts, reliefs and medallions.

TAJIRI, Shinkichi 1923-
Born in Los Angeles in 1923, he studied under Daniel Hord in San Diego (1940-41) and then served with a Nisei (Japanese-American) battalion during the second world war. In 1946 he studied under Zadkine and Leger and attended classes at the Académie de la Grande Chaumière. He married a Dutch artist and has lived in Amsterdam since 1956. He has taken part in many international exhibitions in France, Germany, Holland, Belgium, Switzerland, the United States and Japan. His work, though entirely European in concept, has overtones of his Oriental origins, typified by such bronzes as Relic from an Ossuary (1957) and Warrior (1959).

TAKANEN, Johannes 1849-1885
Born in Vederlak, Finland, on December 8, 1849, he died in Rome on September 30, 1885. He was a prolific and versatile sculptor in plaster, bronze, wax, marble, wood and terra cotta. He sculpted numerous busts and heads of his contemporaries, genre figures, such as Young Boy playing with his Dog and Praying Angel, and classical statuettes, such as Andromeda, Cupid wounding Hearts and Venus and Cupid.

TAKIS, Vassilakis 1925-
Born in Athens in 1925, he taught himself the rudiments of sculpture, but perfected his technique during prolonged visits to London and Paris after the second world war. He had his first one-man shows in London and Paris in 1955. He worked originally in clay, then wood, but now prefers iron, aluminium and bronze. His earlier work was figurative but more recently he has produced abstracts and linear constructions which he exhibits at the Salon de la Jeune Sculpture and the Salon des Réalités Nouvelles.

TALARN, Domingo fl. late 19th century
Spanish sculptor of religious figures and bas-reliefs, working in Barcelona from 1838 to 1891.

TALBOT, Grace Helen 1901-
Born in North Billerica, Massachusetts, in 1901, she studied under Harriet W. Frishmuth for three years. She specialises in portraiture and neo-classical figures, such as her bronze Leda.

TALLONE, Filippo 1902-
Born in Turin in 1902, he studied in Pavia and now works in Milan. Examples of his sculpture are in the Gallery of Modern Art, Rome.

TALON, Henri Alexandre fl. late 19th century
Born in Paris in the mid-19th century, he studied under G. Leroux and L. Steiner. He exhibited at the Salon des Artistes Français and got an honourable mention in 1889. He specialised in busts and statuettes of genre subjects, such as Negro and Sheaf-binder.

TALRICH, Jules V.J. fl. 19th-20th centuries
French sculptor of genre and neo-classical figures working in Paris in the late 19th century. He was an Associate of the Artistes Français and died in 1904.

TALUET, Ferdinand 1821-1904
Born in Angers on November 15, 1821, he died in Paris in 1904. He studied under Mercier and David d'Angers and enrolled at the École des Beaux Arts in 1842. He exhibited at the Salon from 1848 onwards and won a medal in 1865. He specialised in busts of historic and contemporary figures, allegorical groups, bas-reliefs and decorative sculpture in Angers and Vincennes. His individual works include The Spirit of Roman Art (Louvre) and bronze panels on the high altar of the Church of Chalon-sur-Saône.

TAMARI, S. fl. 20th century
Russian portrait sculptor active in the early years of this century.

TAMBUYSCH, Egide Corneille 1822-1889
Born in Malines (Mechelen), Belgium, on September 16, 1822, he died there on May 6, 1889. He was the son and pupil of Pierre Jean Tambuysch and worked as a religious sculptor. He decorated the cathedral and various churches in Malines.

TAMBUYSCH, Pierre Jean fl. 19th century
Born in Malines in the late 18th century, he studied under Pierre Valckx and produced ecclesiastical sculpture for the churches, convents and cemeteries in the Malines area.

TANCHETTE, Eugène fl. 19th century
Born in Nancy in the first half of the 19th century, he studied under Jouffroy and Mercié and exhibited portrait busts, bas-reliefs and medallions at the Salon from 1869 onwards.

TANTARDINI, Antonio 1829-1879
Born in Milan on June 12, 1829, he died there on January 7, 1879. He studied under Bartolini and sculpted a number of important monuments, notably that to Cavour in Milan and the Independence Monument in Vienna (1871). Madrid Museum has two figures of children by him while his figure of a Bather is in the Brescia Pinacoteca. He also sculpted portrait busts of his contemporaries.

TAPIÉ, Michel fl. 20th century
A distant cousin of Toulouse-Lautrec, he worked as a surrealist painter and sculptor strongly influenced by primitive African fetishes. He was one of the originators of the artistic movement known as L'Art Brut.

TARJAN, Oszkar 1875-
Born in Budapest on March 5, 1875, he worked in Budapest as a medallist, jeweller and sculptor of religious figures and bas-reliefs.

TARNOWSKI, Michel de 1870-
Born in Nice on April 20, 1870, he studied under Falguière and exhibited portrait busts and genre studies at the Salon des Artistes Français, getting an honourable mention in 1895 and another at the Exposition Universelle of 1900. Amiens Museum has his bust of a child.

TARRIT, Jean 1866-
Born at Châtillon-sur-Chaloronne, France, on January 1, 1866, he studied under Thomas and Moreau-Vauthier. He exhibited figures and portraits at the Salon des Artistes Français, getting an honourable mention in 1898, third class and second class medals in 1907 and 1911 respectively and a gold medal in 1913. He became a Chevalier of the Légion d'Honneur in 1938.

TASCHNER, Ignatius 1871-1913
Born in Lohr, Germany, on April 9, 1871, he died at Mitterndorf near Dachau on November 25, 1913. He studied at the Munich Academy and worked in Breslau, Vienna and Berlin. His equestrian statuette of Parsifal is in the Berlin Museum.

TASSAERT, Jean Pierre Antoine 1727-1788
Born in Antwerp in 1727, he died in Berlin on January 21, 1788. He was a nephew of the painter of the same name and after training in Belgium went to England. Later he moved to Paris where he lived for thirty years and latterly was employed by Frederick the Great in Berlin. He specialised in portrait busts of French and German personalities. The Louvre has his group of Cupid launching a Dart.

TASSARA, Giovanni Battista 1841-1916
Born in Genoa on June 23, 1841, he died there on November 15, 1916. He studied under Cevasco and worked as a religious sculptor, decorating the cemetery of Staglieno and the cathedrals of Catania and Florence.

TASSI, Luigi fl. 19th century
Born in Piacenza in 1845, he worked in Rome as a decorative sculptor and wood engraver.

TASSO Y NADAL, Torcuato fl. 19th century
Born in Barcelona in the mid-19th century, he studied at the Barcelona School of Fine Arts and exhibited in that city from 1876 to 1894. He later moved to Rome.

TATARKIEWICZ, Jakob 1798-1854
Born in Warsaw on March 31, 1798, he died there on September 3, 1854. He studied under P. Malinski in Warsaw and was later influenced by Thorvaldsen. He sculpted tombs, memorials, bas-reliefs and busts of prominent Polish contemporaries. Examples of his work are in the museums of Warsaw and Cracow.

TATE, W.K. fl. early 19th century
Portrait sculptor working in London between 1828 and 1834. He exhibited at the Royal Academy in 1828-29. He produced busts and heads of contemporary celebrities in plaster, marble and bronze.

TATHAM, Frederick 1805-1878
Born in London in 1805, he died there in 1878. He worked in London as a miniaturist and portrait sculptor and exhibited busts and heads of his contemporaries at the Royal Academy and the British Institute.

TATTEGRAIN, André Georges 1906-
Born at Devise on December 20, 1906, he studied under Albert Roze and worked as a sculptor and writer. He became a Laureat de L'Institut in 1936 and admitted to the Académie Française in 1940, the Académie des Beaux Arts in 1950, and the Académie des Sciences Morales et Politiques in 1952. He is also an Officier of the Légion d'Honneur. He was awarded a first class medal at the Salon of 1953 and has had many state commissions, including that for the official insignia worn by mayors of France.

TATTEGRAIN, Georges Gabriel 1845-1916
Born in Peronne on November 5, 1845, he died in Paris on December 16, 1916. He trained as an advocate and served as a lieutenant during the Franco-Prussion War of 1870-71. He began exhibiting at the Salon in 1877 and subsequently submitted over 60 pieces of sculpture. He was president of the Friends of the Arts and a member of the Amiens Academy. He served as mayor of Devise from 1880 to 1906. In

addition to his sculpture he was a poet of some note. He produced numerous busts of his contemporaries and genre figures, such as Florentine Scholar, The Harvester, The Labourer, Old Woman of Picardy and Young Italian.

TAUBMANN, Frank Mowbray 1868-
Born in London on June 13, 1868, of an old-established Manx family, he began studying chemistry and later turned to art. In 1893 he enrolled at the Académie Julian in Paris and later attended classes at the Brussels School of Fine Arts. He returned to London in 1897, imbued with the mystic form of romanticism which was fashionable in Belgium at the turn of the cetury, and this is evident in his equestrian group which is preserved in the Manx Museum, Douglas. He exhibited at the Royal Academy from 1893 onwards and also exhibited at the Royal Scottish Academy and the Royal Hibernian Academy as well as the major London and provincial galleries.

TAUCHER, Konrad 1874-
Born in Nuremberg on October 24, 1874, he studied under Hermann Volz and worked in Karlsruhe. He produced a number of fountains and war memorials, notably in Karlsruhe, Freiburg and Aachen.

TAUCHER, Waldine Amanda 1894-
Born in Schulenburg, Texas, on January 28, 1894, she studied under Pompeo Cappini and became a member of the American League of Professional Artists. She specialised in fountains, memorials and public statuary.

TAUNAY, Auguste Marie 1786-1824
Born in Paris on May 26, 1768, he died in Rio de Janeiro on April 24, 1824. He specialised in portrait busts and is best remembered for a lengthy series of Napoleonic generals. He exhibited at the Salon from 1808 to 1814.

TAUSS, Ferdinand 1881-1925
Born at Bruck an der Mur on January 13, 1881, he died in Graz on March 29, 1925. He studied at the Vienna Academy and specialised in genre figures. Graz Museum has his figure of a Young Girl lying down.

TAUTENHAYN, Johann Josef 1868-
Born in Vienna on September 10, 1868, the son and pupil of Josef Tautenhayn. He studied at the Vienna Academy and sculpted bas-reliefs and medallions of Austrian celebrities.

TAUTENHAYN, Josef 1837-1911
Born in Vienna on May 5, 1837, he died there on April 1, 1911. He produced bas-reliefs, plaques and medallions and the Berlin National Gallery has two shields ornamented with bas-reliefs to represent War and Peace. He was awarded a silver medal at the Exposition Internationale of 1878 and a gold medal at the Exposition Universelle of 1900.

TAUTENHAYN, Richard 1865-
Born in Vienna on March 29, 1865, the son of Josef Tautenhayn, he worked in Vienna as a potter and sculptor. The Simu Museum, Bucharest, has his bronze of Jesus Christ.

TAVERNA, F.P. de fl. 19th century
Born in Manila, Philippines, in the mid-19th century, he was educated in Madrid and worked in Spain at the turn of the century. He won a bronze medal at the Exposition Universelle of 1889.

TAYLOR, Barbara Austin fl. 19th-20th centuries
Born in London in the late 19th century, she died in Chelsea in 1951. She studied at the Westminster School of Art, the Grosvenor Art School and the British School in Rome and exhibited figures and portraits at the Royal Academy and the leading London and provincial galleries.

TAYLOR, Eric Wilfred 1909-
Born in London on August 6, 1909, he studied at the Royal College of Art under Rothenstein and Osborne (1932-35) and won the British Institution scholarship (1932) and was runner-up in the Prix de Rome (1934). He has exhibited at the Royal Academy, the Royal Scottish Academy and major galleries in Britain and the Continent. He taught at the Camberwell School of Art from 1936 to 1939 and also at Willesden School of Art (1936-39 and 1945-49), the Central School of Arts (1946-48) and was Principal of Leeds College of Art (1956-69) and Assistant Director of Leeds Polytechnic (1969-71). He has lived at Bramhope, near Leeds, for some years and works as an etcher and sculptor.

TEE, Viviane fl. 20th century
Born in Le Havre at the beginning of the century, she studied under Févola and exhibited figures at the Nationale and the Tuileries in the 1930s.

TEGNER, Rudolf Christopher Puggard 1873-
Born in Copenhagen on July 12, 1873, he studied in Copenhagen and Paris and won a bronze medal at the Exposition Universelle of 1900. He specialised in portrait busts, but also produced genre and classical figures and groups, such as Flood Scene (Maribo Museum), Hercules and Hydra, and Hercules and the Erymanthian Boar.

TEICHMEISTER fl. 19th century
Portrait busts and religious figures bearing this signature were the work of an Austrian sculptor, born in St. Georgen, Styria, who died in Marburg on August 15, 1878.

TEINTORIER, Jules Laurent fl. 19th century
Born in Paris in the mid-19th century, he exhibited animal figures and groups at the Salon from 1880 onwards.

TEIXERA DE MATTOS, Henri 1856-1908
Born in Amsterdam on December 21, 1856, he died at The Hague on December 23, 1908. He studied at the Amsterdam Academy and specialised in busts of native types and animal figures, many of which are preserved in the Amsterdam Municipal Museum. He got an honourable mention at the Exposition Universelle of 1900.

TEIXERA LOPES, Antonio 1866-
Born at Villa Nova de Gaya, Portugal, in 1866, he studied under Soares dos Reis in Lisbon and attended classes at the École des Beaux Arts, Paris. He produced many monuments and memorials in Lisbon and other Portuguese cities.

TEIXERA LOPES, José Joaquin fl. 19th-20th centuries
Born at Villa Nova de Gaya, the younger brother of Antonio, he studied under Jouffroy at the École des Beaux Arts, Paris, and exhibited at the Salon, getting an honourable mention in 1889 and a third class medal the following year. He was awarded a Grand Prix and the Légion d'Honneur at the Exposition Universelle of 1900. Most of his career, however, was spent in Villa Nova de Gaya, where he sculpted figures and portraits.

TEIXERA PINTO, Joao fl. 19th century
Born in Lisbon in the early years of the 19th century, he became Sculptor to the Portuguese Court and specialised in heads and busts of contemporary celebrities.

TELCS, Edouard 1872-
Born in Baja, Hungary, on May 12, 1872, he sculpted numerous statues and monuments in Budapest and other Hungarian cities. He won a bronze medal at the Exposition Universelle of 1900.

TELCS-STRICKER, Gina 1880-
Born in Budapest on October 2, 1880, she was the wife of the painter Karoly Kernstock and sculpted genre figures and portraits in the early years of this century.

TENDER, Jean Baptiste de 1792-1847
Born in St. Nicholas, Belgium, on July 4, 1792, he died in Brussels on October 26, 1847. He worked in Godecharles' studio and executed decorative sculpture for the royal palaces, castles, churches and cemeteries in Brussels.

TENERANI, Pietro 1789-1869
Born in Torano, Italy, on November 11, 1789, he died in Rome on December 14, 1869. He executed numerous busts, memorials and tombs in Rome, but also received many commissions from other parts of the world. In addition he sculpted high reliefs and figures of allegorical subjects, such as Love, Venus and Cupid, The Spirits of Life and Death, the Spirit of Hunting, Guardian Angel and Psyche Abandoned.

TENNANT, Dudley Trevor 1900-
Born in London on July 2, 1900, he was the son of C. Dudley Tennant, the painter. He studied at the Goldsmiths' College School of Art and the Royal Academy schools and has exhibited at the Royal Academy and the major London galleries. He taught at Camberwell School of Art (1930-34), Dulwich College (1934-40), Hammersmith

School of Art (1946-53) and Guildford School of Art (1947-52). He now works in London as a sculptor in stone, concrete, wood, terra cotta and bronze. His work is signed 'Trevor Tennant'.

TER MEER, Herman Hendricus 1871-1934
Born in Leyden, Holland, on December 16, 1871, he died in Leipzig on March 9, 1934. He specialised in animal figures and groups, many of which are preserved in the Natural History museums of Europe, notably the Ethnological Museum in Leipzig.

TEREBENEFF, Alexander Ivanovich 1812-1859
Born in St. Petersburg on January 9, 1812, he died there on July 31, 1859. He studied at the St. Petersburg Academy and sculpted many statues of saints and angels and bas-reliefs of religious subjects for the churches in Leningrad.

TEREBENEFF, Ivan Ivanovich 1780-1815
Born in St. Petersburg on May 10, 1780, he died there on January 16, 1815. He was the father of Alexander Ivanovich Terebeneff and worked in St. Petersburg as a sculptor of historical and religious subjects.

TERKATZ, Peter 1880-
Born in Viersen, Germany, on February 7, 1880, he studied at the academies of Düsseldorf and Berlin and sculpted religious statuary and memorials.

TERMOTE, Albert 1887-
Born in Lichterfelde, Germany, on March 30, 1887, he studied at the Amsterdam Academy and specialised in busts and portrait statuettes.

TERNOIS, Jacques 1861-
Born in Semur on December 18, 1861, he studied under Thomas and Dampt and exhibited portrait busts and heads at the Salon des Artistes Français, winning an honourable mention in 1907 and a bronze medal in 1913.

TERNOUTH, John 1795-1849
Born in London in 1795, he died there in 1849. He enrolled at the Royal Academy schools in 1820 and won the silver medal in 1822. He exhibited at the Royal Academy from 1819 till 1849 and specialised in portrait busts of contemporary celebrities. In addition he produced a number of statues and a great many memorials which were mainly stereotyped in concept and lacking in inspiration. His best known work is the bronze bas-relief of the Battle of Copenhagen at the base of Nelson's Column in Trafalgar Square, London. His figure of a Penitent, exhibited at Westminster Hall in 1844, had a very mixed reception from the critics. His last major work was the carved figures of St. George and Britannia for the centre of the east front of Buckingham Palace (1847).

TERROIR, Alphonse Camille 1875-
Born in Marly, France, on November 12, 1875, he studied under Barrias and Coutan and exhibited at the Salon des Artistes Français from 1912 onwards, winning a second class medal and the Prix de Rome in 1902 and a first class medal in 1909. He was awarded the medal of honour in 1929 and the diploma of honour at the Exposition Internationale of 1937. He became a Chevalier of the Légion d'Honneur in 1938. He produced numerous statuettes of genre subjects, religious figures, monumental statuary and memorials.

TERRY, Sarah fl. 19th century
Portrait and genre sculptress working in London between 1862 and 1879.

TESCHNER, Richard 1879-
Born in Karlsbad (Karlovy Vary), Bohemia, on March 22, 1879, he studied at the Prague Academy and worked as a magazine and book illustrator, stage director and designer, landscape painter, puppeteer and sculptor of genre and allegorical subjects. Examples of his work are preserved in Prague Modern Gallery.

TEUTENBERG, Reibold 1864-
Born in Werl, Bavaria, on July 22, 1864, he studied under W. von Rümann at the Munich Academy. Later he became a Benedictine monk and sculpted statuary and bas-reliefs in the Abbey of Maria Laach.

TEXIER, Jean Ernest 1829-1900
Born in Paris on April 29, 1829, he died there in 1900. He studied under Guitton and Mazerolle and exhibited figures at the Salon from 1861 to 1881, getting an honourable mention in 1861.

TEXTOIR, Charles 1835-1905
Born in Lyons in 1835, he died there in September 1905. He specialised in busts of his literary and artistic contemporaries, many of which are preserved in the Lyons Museum.

THABART, Adolphe Martial 1831-1905
Born in Limoges on November 13, 1831, he died at Clamart on December 2, 1905. He studied under Duret and exhibited at the Salon from 1863, winning third class (1868) and second class (1872) medals and a silver medal at the Exposition Universelle of 1889. He became a Chevalier of the Légion d'Honneur in 1884. He specialised in genre figures, such as Snake Charmer, Child with Cygnet, Young Man with a Merlin Falcon and The Poet with his Muse. He also sculpted numerous busts of his contemporaries.

THALBITZER, Ellen (née Locher) 1883-
Born in Denmark on February 18, 1883, she was the sister of the artist Carl Locher and worked in Charlottenburg as a decorative sculptor from 1903 to 1908.

THAMM, Albrecht 1839-1882
Born in Habelschwerdt, Prussia, on April 10, 1839, he died there on May 5, 1882. He studied at the Berlin Academy and specialised in religious sculpture for churches in Liegnitz and other towns in Silesia.

THARARD, Adolphe 1878-
Born in Limoges on April 20, 1878, he exhibited figures and portraits at the Salon des Artistes Français, winning a second class medal in 1872, the Légion d'Honneur in 1884 and a silver medal at the Exposition Universelle of 1889.

THARP, Charles Julian Theodore 1878-
Born at Denston Park, Suffolk, on May 24, 1878, he studied at the Slade School of Art and exhibited paintings and portrait sculpture at the Royal Academy and the major London galleries in the early years of this century.

THAXTER, Edward R. c.1820-1881
Born in Maine about 1820, he died in Naples on June 29, 1881. He worked as a portrait and figures sculptor in Boston, Massachusetts, and Florence.

THAYAHT, Ernesto Michehelles 1893-
Born in Florence on August 21, 1893, he studied under L. Andreotti and became a painter, sculptor, jeweller, engraver and medallist, working in the Futurist and Symbolist idioms.

THEED, William the Elder 1764-1817
Born in London in 1764, he died there in 1817. He was the son of a wigmaker in Wych Street and enrolled at the Royal Academy Schools in 1786. He began his artistic career as a portrait painter, then specialised in classical subjects following a four-year sojourn in Rome (1791-95). He was employed as a modeller for Wedgwood from 1799 to 1804 and then went to the London silversmiths Rundell and Bridges (1804-17), though for a short time in 1811 he was again with Wedgwood in Etruria. He exhibited at the Royal Academy from 1789 to 1805 and was awarded their diploma in 1813 for a bronze Bacchanalian Group. His sculpture includes various statues and groups, including Hercules Capturing the Thracian Horses (Royal Mews, Buckingham Palace), The Prodigal Son (Ussher Art Gallery, Lincoln) and Thetis Returning from Vulcan with Arms for Achilles (Royal Collection, 1812). He also modelled a number of portrait busts of contemporary personalities.

THEED, William the Younger 1804-1891
Born in London in 1804, the son of the above, he died there on September 10, 1891. Theed studied at the Royal Academy schools and worked as an engraver of medals and dies for postage stamps, executing profiles of Queen Victoria for De La Rue and the East India Company. As a sculptor he produced a number of heads and busts of his contemporaries.

THEILER, Friedrich 1748-1826
Born in Ebermannstadt, Germany, on December 29, 1748, he died

there on February 25, 1826. He studied under Mutschele in Bamberg and worked for the churches and cathedral in that city. His minor works include statuettes and bas-reliefs of saints.

THEIS, Franz 1881-
Born in Laas, Austria, in 1881, he worked in Innsbruck and produced war memorials, fountains and public statuary in that area.

THEIS, Josef 1875-
Born in Laas in 1875, the elder brother of Franz Theis, he worked as a decorative sculptor in Innsbruck.

THELENE, Ambrosius Josephus 1768-1819
Born in Liège in 1768, he died in Brussels on December 9, 1819. He worked as a decorative sculptor in Brussels, Compiègne and Paris and was employed on the bas-reliefs of the Arc de Triomphe de l'Étoile.

THELENE, Léon Ambroise 1811-1881
Born in Paris on March 12, 1811, he died in Brussels on March 26, 1881. He was the son and pupil of Ambrosius J. Thelene and worked in Paris and Brussels as an ornamental sculptor.

THENOT, Maurice R.G. fl. 20th century
French sculptor of portraits and genre figures working in Paris in the inter-war period. He exhibited at the Salon des Artistes Français and won a bronze medal in 1927 and a silver medal in 1936.

THERASSE, Victor 1796-1864
Born in Paris on March 25, 1796, he died at Auteuil on February 4, 1864. He studied under Bridan and Lemot and exhibited at the Salon from 1831 to 1848, winning a second class medal in 1834. He produced classical statuettes, portrait busts and statues of French historical and contemporary personalities.

THEUNIS, Pierre 1883-
Born in Antwerp on May 1, 1883, he studied at the Brussels Academy under Vinçotte and worked in that city. He specialised in busts of women and genre figures, such as Supplication (Ghent Museum).

THEUNISSEN, Corneille Henri 1863-1918
Born in Anzin, France, on November 6, 1863, he died in Paris in December 1918. He studied under Fache and Cavelier and exhibited at the Salon des Artistes Français, winning an honourable mention in 1890, a third class medal in 1891 and a second class medal in 1896. He got an honourable mention at the Exposition Universelle of 1900 and became a Chevalier of the Légion d'Honneur two years later. He produced masks, busts and portrait reliefs of historic and contemporary celebrities, mainly in artistic and musical circles, in bronze and marble.

THEUNISSEN, Paul Louis 1873-
Born in Anzin on August 3, 1873, the younger brother of Corneille Henri Theunissen, he studied under Cavelier, Barrias and Maugendre. He exhibited figures and portraits at the Salon des Artistes Français, winning a third class medal and a travelling scholarship in 1901 and a second class medal in 1909.

THEZE, Marc d'Arach de 1880-
Born in Toulouse on November 17, 1880, he exhibited figures at the Salon des Artistes Français, the Salon d'Automne and the Salon des Artistes Décorateurs in the early years of this century.

THIBAUD, Henri fl.19th century
Born in Clermont Ferrand in the early part of the 19th century, he studied under Antoine Moine and exhibited classical figures at the Salon from 1849 onwards.

THIBAULT, L. see AMLEHN, Salesia

THIEBAULT, Henri Léon 1855-1899
Born in Paris in 1855, he died there on January 12, 1899. He studied under Lequien and exhibited small figures and groups at the Salon from 1878 onwards. He was a bronze-founder as well as sculptor in his own right.

THIEBAUT, Édouard 1878-
Born at Schaarbeeck, Belgium, on December 2, 1878, he studied under Stallaert at the Brussels Academy and worked as a book illustrator, writer, musician, painter and sculptor. His works in the latter medium include war memorials and genre figures. He exhibited his sculpture at the Brussels Exposition of 1919.

THIEDE, Oskar 1879-
Born in Vienna on February 13, 1879, he studied at the Academy and sculpted fountains, monuments and public statuary in Vienna.

THIELE, Alfred 1886-
Born in Leipzig on September 21, 1886, he studied at the academies of Leipzig and Munich and produced statues, busts and figures of animals. The Leipzig Museum of Fine Arts has his bust of a woman and the genre figure The Worshipper.

THIELE, Rudolf 1856-1930
Born in Munich in 1856, he died there in November 1930. He worked as a decorative sculptor in that city.

THIELMANN, Christian 1804-1870
Born in Copenhagen on May 28, 1804, he died at Kjärsgaard on July 28, 1870. He studied at the Copenhagen Academy and sculpted statuary and small ornaments.

THIELMANN, Theobald 1819-1903
Born in Copenhagen on March 29, 1819, he died there on July 27, 1903. He was the younger brother of the above and studied under him and H.V. Bissen at the Copenhagen Academy. He worked as a decorative sculptor in Copenhagen, Hilleröd and Ribe.

THIERARD, Jean Baptiste 1746-1822
Born in Rethel, France, in 1746, he died in Paris on February 23, 1822. He studied under Barthélemy and exhibited romantic and classical figures at the Salon from 1791 to 1810.

THIERRY, Eugenio fl. 19th century
Allegorical and portrait sculptor working in Milan. He exhibited at the Brera Academy from 1839 to 1858.

THIJOFF, M.A. fl. 19th century
Sculptor of Russian origin, working in Paris in the latter part of the last century. He won a third class medal at the Exposition Internationale of 1878.

THIOLET, Pina fl. 19th century
French sculptress working in Paris in the second half of the 19th century. She studied under Caudron and exhibited figures and portraits at the Salon from 1861 onwards.

THIOLLIER, Claude Emma fl. 20th century
Born at St. Étienne in the late 19th century, she exhibited figures and groups at the Paris Salons from 1908 onwards, getting an honourable mention in 1912 and a bronze medal at the Exposition Internationale of 1937.

THIRIOT, Henri 1866-1897
Born in Metz in 1866, he died there in 1897. He studied under Cavelier and Aimé Millet and worked in Paris and Metz, specialising in portrait busts and heads.

THIVIER, Simeon Eugène 1845-1920
Born in Paris on October 11, 1845, he died there on December 27, 1920. He studied under Dumont, Loison and Vital Dubray and exhibited at the Salon from 1865 onwards. He became an Associate of the Artistes Français in 1887 and got an honourable mention the same year, followed by a third class medal in 1892 and a bronze medal at the Exposition Universelle of 1900. He specialised in classical and allegorical figures, such as Amphitrite (Orleans Museum), Phantom (Pont de Vaux Museum), Fortune and Love (Rouen Museum).

THOINET, Benôit fl. 19th century
Born in Haute Rivoire in the mid-19th century he exhibited figures at the Salon des Artistes Français, getting a third class medal in 1881.

THOM, James 1802-1850
Born in Dumfries, Scotland, in 1802, he died in New York on April 17, 1850. He was apprenticed to a stone-mason but later took up modelling and sculpted a number of portrait busts and statues of historical and contemporary Scottish personalities. His best known work is the Burns monument at Ayr. Later he emigrated to the United States and worked as a portrait sculptor in New York.

THOMAS, Cecil 1885-
Born in London on March 3, 1885, he studied at the Central School of Arts and Crafts, Heatherley's and the Slade School. He exhibited at the Royal Academy and the Salon des Artistes Français as well as galleries in London and the United States. He was appointed to membership of the Master Art Workers' Guild in 1946. His paintings and sculpture are represented in several public collections in Britain. His works include the figure of Peter Pan at Virginia Lake, Wanganui, New Zealand.

THOMAS, Eugène Émile 1817-1882
Born in Paris on February 6, 1817, he died in Neuilly on January 2, 1882. He studied under Pradier and exhibited at the Salon from 1843 onwards. He received many state commissions and sculpted portrait busts, statues, monuments and the decoration on public buildings. His minor works include statuettes and groups of religious, allegorical and historical subjects.

THOMAS, Félix 1815-1875
Born in Nantes on September 29, 1815, he died there on April 5, 1875. He studied under Lebas and won the Prix de Rome for architecture in 1845. Subsequently he developed as an engraver, painter and sculptor and exhibited at the Salon, winning a second class medal in 1859 and a first class medal in 1865. He was awarded a bronze medal at the Exposition of 1867 and was decorated with the Légion d'Honneur.

THOMAS, Frederick fl. late 19th century
Sculptor of portrait medals, bas-reliefs and busts working in London. He exhibited at the Royal Academy from 1892 to 1901.

THOMAS, Gabriel Jules 1824-1905
Born in Paris on September 10, 1824, he died there on March 8, 1905. He studied under Ramey and Dumont and exhibited at the Salon from 1857, winning a third class medal (1857), a first class medal (1861) and the medal of honour (1880). He also won gold medals at the Expositions of 1867 and 1878. He sculpted portrait busts and statues of his artistic contemporaries historic groups and allegorical studies, such as Industry, Youth, The Thought, and portraits of Attila, Virgil and other classical personalities.

THOMAS, George Havard 1893-1933
Born in Sorrento, Italy, on May 9, 1893, the son of James H. Thomas, he died in London on December 1, 1933. He studied under his father at the Slade School (1914-15) and resumed his studies in 1919 after service in the first world war. He exhibited at the Royal Academy from 1919 onwards and taught sculpture at the Slade from 1920. He sculpted figures and portraits as well as a number of war memorials for various English towns. Manchester Museum has his head of a child.

THOMAS, Henri Joseph 1878-
Born at Molenbeck St. Jean, Belgium, on June 22, 1878, he studied at the Brussels Academy and exhibited with the Brussels Artistic Circle from 1906 to 1921. He specialised in genre figures and groups which he also exhibited at the Nationale in Paris before the first world war.

THOMAS, James Havard 1854-1921
Born in Bristol on December 22, 1854, he died in London on June 6, 1921. He studied at Bristol School of Art and worked under Cavelier in Paris. He exhibited at the Royal Academy, the British Institute and the Paris Salon, gaining an honourable mention at the latter in 1885. He specialised in busts and statuettes of his contemporaries, but also sculpted figures of dancers and classical and historical personalities, including Lycidas, Thyrsis and Boadicea. He became a lecturer in sculpture at the Slade in 1911 and professor there in 1915.

THOMAS, John 1813-1862
Born at Chalford, Gloucestershire, in 1813, he died in London on April 9, 1862. He spent most of his career in the Midlands, teaching drawing at Birmingham Grammar School. He exhibited 41 pieces of sculpture at the British Institute between 1842 and 1861. His best known works decorate the Houses of Parliament, Euston Station and other public buildings in London and he sculpted the lions on Britannia Bridge. His bronze group of Boadicea and her Daughters is in the Birmingham Museum. He produced numerous busts of his contemporaries and examples of these are preserved in the Dublin Museum and the Tate Gallery. His last work was a colossal statue of Shakespeare, erected at the International Exhibition of 1862. The main collection of his work is preserved in the Fine Arts Academy, Bristol.

THOMAS, John Evan 1809-1873
Born in Brecon, Wales, in 1809, he died in London on October 9, 1873. He exhibited at the Royal Academy from 1838 to 1870, showing 53 pieces of sculpture. He specialised in portrait busts of his contemporaries, but also sculpted several important historical groups, notably the Death of Tewdric (Birmingham Museum), and produced public statuary and decorative sculpture for various Welsh towns.

THOMAS, Margaret fl. 19th-20th centuries
Born in Croydon, Surrey, about the middle of the 19th century, she emigrated with her family to Australia, but returned to England in 1868 and died in London on December 24, 1929. She studied at the Royal College of Art and spent two years in Rome before enrolling at the Royal Academy schools. She exhibited at the Royal Academy from 1868 onwards and travelled extensively in the Mediterranean area. She wrote a number of books, including *A Hero of the Workshop* (1880), *A Scamper through Spain and Tangier* (1892), *Denmark, Past and Present* (1901), *A Painter's Pastime* (1908) and *How to Understand Sculpture* (1911). She worked as a landscape painter and sculptor of portraits and genre subjects and had a studio in Letchworth.

THOMAS, William Meredyth c.1819-1877
Born in Brecon, Wales, about 1819, he died in London on September 7, 1877. He studied under Chantrey and was assistant to John Evan Thomas. He exhibited portrait busts and medallions at the Royal Academy from 1848 to 1871.

THOMAS-SOYER, Mathilde 1860-
Born in Troyes on August 19, 1860, she studied under Chapu and Cain and exhibited at the Salon from 1879 onwards, getting an honourable mention in 1880 and a third class medal in 1881. She was awarded bronze medals at the Expositions Universelles of 1889 and 1900. She specialised in animal figures and groups, including Dogs of the Auvergne (Bourges Museum), Hunter and Poacher (Semur), Cow chasing off a Wolf (Nevers Museum), Stag pursued by a Greyhound and Dog-fight (Troyes Museum).

THOMASON, Sir Edward 1769-1849
Born in Birmingham in 1769, he died there in 1849. Though best known as the manufacturer and inventor of jewellery, medals, buttons, badges, coins and tokens in base and precious metals, he also made an important contribution to sculpture in the round. He pioneered the medallic series with a strong didactic element, and also experimented with the reproduction of works of art, such as his bronze replicas of the Warwick Vase, which took seven years to complete. His sculpture included the controversial life-size bronze of George IV, commissioned by the City of Birmingham. Though judged to be an excellent likeness 'by all who have witnessed the progress of the model, standing as it does in all the majesty of Truth and exhibiting a noble specimen of the near approach of art to the stamp of nature', it was dismissed by the *Literary Gazette* as 'Brummagem and contemptible' when exhibited at Westminster Hall in 1844. This statue has since disappeared and it has been surmised by Gunnis that it was melted down by the ungrateful citizens of Birmingham. Thomason also sculpted a bronze bust of the Duke of Wellington, now in the Cavalry Barracks, Canterbury.
Thomason, Sir Edward *Memoirs* – 2 vols. (1845).

THOMIRE, Louis 1757-1838
Born in Paris on December 20, 1757, he died there on June 10, 1838. He was a cousin of Pierre Philippe Thomire and assisted him in the manufacture of bronzes at the Sèvres factory. He produced small ornamental bronzes and ormolu mounts for clocks and wall decoration in the classical idiom. His best known work is Zephyr crowning Erigone (1801).

THOMIRE, Pierre Philippe fils 1751-1843
Born in Paris on December 5, 1751, he died there on June 9, 1843. He was the son of the decorative sculptor Luc Philippe Thomire and a member of a family which produced many notable sculptors, carvers and bronze-founders. He studied under Houdon and Paju at the Académie de St. Luc and then worked with Gouthière. He was one of the outstanding sculptors of the First Empire. One of his first important commissions was to sculpt the bronze decoration on the state coach of King Louis XVI (1775). He succeeded Jean Claude Duplessis as chief modeller at Sèvres, and subsequently produced decorative and ormolu sculpture for furniture, wall ornaments and clocks. He was regarded as the finest bronzist of the reign of Louis XVI. He was awarded a gold medal at the Paris Exposition of 1806 for his bronze and malachite sculptures, and produced many bronzes in the heroic idiom during the Napoleonic era. He remained in favour after the restoration of the Bourbons and sculpted a great surtout (table decoration) for Louis XVIII in 1823. He was made a Chevalier of the Légion d'Honneur in 1934.
Niclausse, Juliette *Thomire* (1947).

THOMSEN, Arnoff 1891-
Born in Aarhus on March 27, 1891, he studied under Maurice Denis in Paris and also the Copenhagen Academy. Aarhus Museum has his group The Poet in Convalescence.

THOMSEN, Christian 1860-1921
Born in Kolding, Denmark, on January 13, 1860, he died in Copenhagen on May 18, 1921. He specialised in figures and groups based on characters from the stories of Hans Christian Andersen.

THOMSON, Launt 1833-1894
Born in Abbeyleix, Ireland, on February 8, 1833, he died in Middleton, New York, on September 27, 1894. He emigrated to the United States in 1847 and settled in Albany. Originally he studied medicine but later turned to sculpture and worked under Palmer in Albany for nine years before moving to New York City in 1858. He became an Associate of the National Academy in 1859 and an Academician in 1862. In 1875 he established a studio in Florence and thereafter spent the winter in Italy. He exhibited a statue of Napoleon at the Exposition Internationale of 1867. He specialised in portrait busts of American celebrities, several of which are preserved in the Metropolitan Museum of Art, New York.

THORESEN, Ida Caroline 1863-
Born in Göteborg, Sweden, on August 10, 1863, she studied at the Colarossi and Julian academies in Paris and sculpted many busts of Scottish and Swedish personalities at the turn of the century.

THORIS, Henri 1831-1881
Born in Kemmel, Belgium, on June 13, 1831, he died in Brussels in June, 1881. He studied under Puyenbrouck and attended classes at the academies of Brussels and Bruges. He specialised in portrait busts and bas-reliefs of his contemporaries, in marble and bronze.

THORMAEHLEN, Ludwig 1889-
Born in Hanau, Germany, on May 24, 1889, he became professor of art history at Berlin Academy and specialised in busts and statuettes of his contemporaries.

THORNTON, Leslie 1925-
Born in Skipton, Yorkshire, in 1925, he studied at the Leeds College of Art and the Royal College of Art, London. He had his first one-man show in 1957 and has also taken part in international exhibitions since that year, including the Sao Paulo Biennial. His earlier work consisted of constructions in welded steel, iron and brass rods, but in more recent years he has worked in bronze, producing abstracts with a more solid form.

THORNYCROFT, Alyn fl. 19th century
The daughter and pupil of Thomas Thornycroft, she exhibited romantic figures and portraits at the Royal Academy from 1864 to 1892.

THORNYCROFT, Mary (née Francis) 1814-1895
Born in Thornham in 1814, the daughter of John Francis, she died in London on February 1, 1895. She studied under her father and was regarded as a child prodigy. She married Thomas Thornycroft, then a pupil and assistant of her father. She made her début at the Royal Academy in 1835 with a genre figure, The Young Woodcutter. She worked in Rome in 1842-43 and was commissioned by Queen Victoria to sculpt the group of the Queen's daughters as the four seasons. She is best known for her busts and groups portraying the British royal family, but she also sculpted genre figures, such as Young Girl Jumping (Salford Museum).

THORNYCROFT, Thomas 1815-1885
Born in Congleton, Cheshire, in 1815, he died in London on August 30, 1885. Originally apprenticed to a surgeon in Cheshire, he later

went to London to study sculpture under Francis and there met and married his wife. Most of his work was carved direct in stone, but he also worked in bronze, his best known work in this medium being the large group of Boadicea which took fifteen years to model and was not cast till after his death, and not erected till 1902. His minor works included many portrait busts of contemporary, historical and classical personalities. He exhibited 42 pieces of sculpture at the Royal Academy between 1836 and 1874 and also exhibited at the British Institution from 1840 to 1860.

THORNYCROFT, Sir William Hamo 1850-1925
Born in London on March 9, 1850, he died in Oxford on December 18, 1925. He was the younger son of Thomas and Mary Thornycroft. He studied at the Royal Academy schools and won the gold medal in 1875. He exhibited at the Royal Academy from 1872 and was elected A.R.A. in 1881 and R.A. in 1888. He assisted his father in sculpting the Park Lane fountain and modelled the figures of Shakespeare, Fame and Clio. The Greek classical influence is evident in much of his work, typical examples being Lot's Wife, Artemis, Teucer and Warrior bearing a Youth from the Field of Battle. His genre figures include the Mower (1884) but he is best remembered for his portrait sculpture. He sculpted many busts of his contemporaries and did memorials and statues honouring General Gordon (Trafalgar Square), Oliver Cromwell (Westminster) and Gladstone (The Strand). His minor bronzes are represented in public collections in Britain and America. He was knighted in 1917, and received the medal of honour at the Exposition Universelle of 1900.

THRUPP, Frederick 1812-1895
Born in Paddington, London, on June 20, 1812, he died in Torquay, Devon, on March 21, 1895. He was the youngest son of the decorative sculptor Joseph Thrupp and studied drawing and modelling at the academy run by Henry Sass in Bloomsbury. In 1829 he was awarded the silver medal of the Society of Arts for a model of a dog and the following year he enrolled at the Royal Academy schools. From 1837 to 1842 he worked in Rome. He exhibited at the Royal Academy from 1832 to 1880, at the British Institution from 1837 to 1862, at Westminster Hall in 1844-45 and at the Birmingham Society of Artists. At the Great Exhibition of 1851 he showed The Maid and the Mischievous Boy, and at the International Exhibition of 1862 he showed Nymph and Cupid and a bas-relief of Hamadryads. His group Boy with a Butterfly was shown at the Exhibition of Art Treasures in Manchester, 1857. He had a studio in Winchester and most of his works were bequeathed to that city. He also sculpted a number of statues and portrait busts of contemporary worthies. Most of his work was executed in marble, but his bronzes include the bas-reliefs on the pair of doors of St. Martin's Hall, Longacre (1868), illustrating the scenes from Bunyan's *Pilgrim's Progress*. When St. Martin's Hall was demolished these doors were removed to the Bunyan Chapel in Bedford. Another pair of bronze doors, with panels illustrating George Herbert's poems, is in the Divinity School at Cambridge.

THUBERT, Paul fl. late 19th century
Born at Rennes in the mid-19th century, he worked in that town as a genre sculptor and exhibited at the Salon from 1881 onwards. Rennes Museum has his group At Seville.

THUMA, Friedrich the Elder 1829-1882
Born at Erotzheim, Germany, in 1829, he died in Biberach in 1882. He worked in Biberach as an ecclesiastical sculptor.

THUMA, Friedrich the Younger 1873-
Born in Biberach on November 6, 1873, he studied in Munich and worked in Stuttgart on religious subjects, fountains, war memorials, monuments and genre figures, such as The Kiss (Stuttgart National Gallery).

THYLSTRUP, Frederik Oscar Leopold 1848-
Born in Copenhagen on May 15, 1848, he studied under H.V. Bissen and attended classes at the Copenhagen Academy. He specialised in genre statuettes.

THYLSTRUP, Georg Christian Peter 1884-1930
Born in Roskilde on July 31, 1884, he died in Copenhagen on February 21, 1930. He worked as a modeller at the Royal Copenhagen Porcelain Manufactory and sculpted numerous statuettes and small groups which were produced in porcelain, precious metals and bronze.

THYS, Joseph 1891-
Born in Liège on December 4, 1891, he worked as a painter, illustrator and sculptor of genre subjects. He exhibited figures and portrait busts at the Brussels Academy from 1928.

TIBOR, Joseph 1877-1922
Born in Klein Konarzin on July 12, 1877, he died in Altona on June 29, 1922. He studied at the Berlin Academy and specialised in portrait busts, bas-reliefs and tombs.

TIECK, Christian Friedrich 1776-1851
Born in Berlin on August 14, 1776, he died there on May 12, 1851. He studied under Botthober and Schadow and later worked with David D'Angers in Paris. After spending some time in Rome he settled in Berlin and sculpted busts and relief portraits of contemporary German royalty and celebrities.

TIGERSTEDT, Gregoria 1891-
Born in Finland in 1891, she studied in Lausanne, Berlin and Paris and worked in Finland as a sculptor, potter and illustrator of genre subjects.

TILDEN, Douglas 1860-1935
Born in Chico, U.S.A., on May 1, 1860, he died in Oakland, California, in 1935. He studied in Paris and exhibited at the Salon des Artistes Français, getting an honourable mention in 1890 and a bronze medal at the Exposition Universelle of 1900. He specialised in genre subjects of boxers, baseball-players and other sporting subjects.

TILGNER, Victor Oskar 1844-1896
Born in Przemysl, Galicia, on October 25, 1844, he died in Vienna on April 14, 1896. He specialised in portrait busts and statues, fountains and tombs of Austrian worthies for various towns and cities. Many of his busts are preserved in Viennese museums.

TILLEQUIN, Magdeleine fl. 20th century
Genre sculptress working in Paris before the second world war. She exhibited statuettes at the Salon des Artistes Français and won a gold medal at the Exposition of 1937.

TILLOY, Jean Baptiste fl. 19th century
Born in Berzieux, France, in the early 19th century, he exhibited figures at the Salon from 1868 onwards.

TINANT, Louis Félix fl. mid-19th century
Born in Liège in the early 19th century, he studied under Rude in Paris and exhibited figures and groups at the Salon from 1859 to 1863.

TINAYRE, Noël 1896-
Born in Paris on December 30, 1896, he was the son of the wood-carver Jean Julien Tinayre. He worked in Paris as a decorative sculptor and exhibited at the Exposition Internationale in 1937.

TINWORTH, George 1843-1913
Born in London on November 5, 1843, he died there on September 10, 1913. He worked as a modeller and decorative sculptor.

TIOLIER, Pierre Nicolas 1784-1853
Born in Paris on May 9, 1784, he died there on December 25, 1853. He was a son of the medallist Pierre Joseph Tiolier and specialised in allegorical and classical groups. He also produced bas-reliefs and medallions portraying members of the Bourbon dynasty.

TIRRART, Antoine Xavier Claude fl. 19th century
Born in Paris in 1792, he studied under Semyse and worked as a sculptor of ornaments.

TISNE, Jean Lucien 1875-1918
Born in Salles Mongiscard, France, in 1875, he died in Paris on November 4, 1918. He studied under Mercié and exhibited figures and portraits at the Salon des Artistes Français, winning an honourable mention (1905) and third class and second class medals in 1907 and 1909 respectively.

TISSOT, Marius fl. late 19th century
Born in Annecy in the mid-19th century, he exhibited at the Salon des Artistes Français and got an honourable mention in 1897.

TIZZANO, Giovanni 1889-
Born in Naples on February 1, 1889, he worked as a decorative sculptor there before the second world war and exhibited regularly from 1930 onwards.

TOBERENTZ, Robert 1849-1895
Born in Berlin on December 4, 1849, he died at Kostock on July 3, 1895. He studied at the Berlin Academy and was a pupil of Johann Schilling at Dresden. He specialised in genre figures, such as Shepherds at Rest (Berlin Museum) and Italian Girl (Hamburg Museum).

TOBON-MEJIA, Marco 1876-
Born at Santa Rosa de Osos, Colombia, on October 24, 1876, he studied in Paris under Laurens and worked there for several years before returning to Colombia where he sculpted many monuments, statues, busts, bas-reliefs, plaques and medals.

TOFANARI, Sirio 1886-
Born in Florence on April 9, 1886, he was self-taught and worked in London and Paris. He specialised in animal figures and groups, such as Vulture, Rabbit, Stag-hunt, Billy-goats and She-wolf.

TOFT, Albert 1862-1949
Born in Birmingham on June 3, 1862, he died in Worthing, Sussex, on December 18, 1949. He studied at Hanley and Newcastle-under-Lyme art schools and won a scholarship to the Royal College of Art in 1880. He studied under Lanteri and exhibited at the Royal Academy from 1885, being elected F.R.B.S. in 1923. He had a studio in London for many years and specialised in genre figures and groups such as Mother and Child (Preston Museum) and The Metal-pourer.

TOKAREFF, Nikolai Andreivich 1787-1866
Born in St. Petersburg on November 3, 1787, he died there on October 2, 1866. He trained at the St. Petersburg Academy and worked on the decoration of the Hermitage and Kazan Cathedral. A series of eight bas-reliefs by him is in the Winter Palace.

TOLCH, José Antonio fl. early 19th century
Spanish sculptor working on the decoration of Toledo Cathedral in 1811.

TOLLEMACHE, William d.1817
Very little is known of this sculptor who died in obscurity and great poverty in 1817. His widow received a grant of £10 from the Royal Academy in that year. He enrolled at the Royal Academy schools in 1805 and won a gold medal for his group Prometheus Chained to the Rock. In 1813 he won a silver medal and a prize of £20 offered by the Society of Arts for a bronze figure of Venus. He exhibited classical figures and groups at the Royal Academy from 1812 to 1814 and at the British Institution from 1814 to 1816.

TOLNAY, Akos 1861-
Born in Budapest on August 10, 1861, he studied in Budapest, Vienna and Munich and specialised in genre figures, examples of which are in the Hungarian National Gallery.

TOLSTOI, Fedor Petrovich, Count 1783-1873
Born in St. Petersburg on February 10, 1783, he died there on April 13, 1873. He trained as a naval officer and later turned to sculpture. After studying at the St. Petersburg Academy he became a historical sculptor, specialising in medallions and bas-reliefs in the classical idiom. His best known work is the bronze doors of Isaac Cathedral in Moscow. He sculpted numerous bas-reliefs illustrating scenes from Homer's Odyssey. He also sculpted a series of 21 medals illustrating the campaigns of 1812-15.

TOMAGNINI, Arturo 1879-
Born in Vallecchia, Italy, on November 29, 1879, he was self-taught and produced monuments and statues for various towns in Italy and Latin America.

TOMAN, Ignaz 1815-1870
Born in Ljubljana on January 5, 1815, he died there on October 2, 1870. He worked as a decorative and ecclesiastical sculptor in Slovenia and Croatia.

TOMAS, Juan de 1795-1848
Born in Cordoba in 1795, he died in Madrid on November 10, 1848. He worked as a decorative sculptor in Madrid and produced a number of fountains, statues and bas-reliefs.

TOMAS, Miguel fl. 18th century
Born in Palma de Majorca in the mid-18th century, he died there in 1809. He sculpted figures and ornaments in Majorca.

TOMAS Y ROTGER, Francisco 1762-1807
Born in Palma de Majorca on February 26, 1762, he died there on April 1, 1807. He was the son and pupil of Miguel Tomas and worked with him on ornamental and religious sculpture in Palma.

TOMBA, Alessandro 1825-1864
Born in Faenza on May 19, 1825, he died in Florence on April 15, 1864. He studied under Giovanni Dupré in Florence and specialised in classical and genre figures, such as Angel of Peace (Faenza Municipal Museum).

TOMBA, Cleto 1898-
Born in Bologna in 1898, he has sculpted figures, portraits and bas-reliefs.

TOMBAY, Alexandre de fl. 19th century
Born in Liège in the early 19th century, he participated in the Brussels Exhibition of 1842 and specialised in statues of saints and religious personalities.

TOMBAY, François Bernard Marie Alphonse de 1843-1918
Born in Liège on November 9, 1843, he died in Brussels on January 31, 1918. He was the son and pupil of Alexandre de Tombay and specialised in busts of Belgian personalities. He won an honourable mention and a bronze medal at the Expositions of 1878 and 1889 respectively.

TOMBAY, Mathieu de 1768-1852
Born at Grivegnee near Liège on January 31, 1768, he died in Liège on November 17, 1852. He studied at the Liège Academy and worked as a religious sculptor in that city. He was the father of Alexandre de Tombay.

TOMLIN, Stephen 1901-1937
Born in London on March 2, 1901, he died there on January 5, 1937. He was the youngest son of Lord Justice Tomlin and studied at New College Oxford for a short time before taking up sculpture. He was a pupil of Frank Dobson for two years and specialised in portrait sculpture. Examples of his heads and busts of contemporary celebrities, such as Virginia Woolf and Lytton Strachey, are in the Tate Gallery.

TOMMASI, Eugen 1891-
Born in Trieste in 1891, he studied in Munich and settled in Innsbruck where he sculpted memorials, bas-reliefs and portrait busts.

TOMSEN, Constant Auguste fl. late 19th century
Born in Paris, he studied under Thomas Gauthier and Aimé Millet and exhibited figures and groups at the Salon des Artistes Français, where he got an honourable mention in 1893.

TONCIC, Franz Xaver 1865-1919
Born in Crni, Slovenia, on November 10, 1865, he died at Kamnik, Yugoslavia, on March 14, 1919. He worked as an ecclesiastical sculptor in Slovenia and Croatia.

TONDEUR, Alexander 1829-1905
Born in Berlin on July 17, 1829, he died there on April 21, 1905. He studied under G. Bläser at the Berlin Academy and specialised in busts and figures of theatrical personalities.

TONETTI, François Michel Louis 1863-1920
Born in Paris on April 7, 1863, he died in New York on May 2, 1920. He studied under Falguière and won a third class medal at the Salon of 1911. Later he emigrated to the United States and settled in New York. The St. Louis Museum has his statue of Victory.

TONETTI-DIZZI, Louis fl. late 19th century
Born in Paris of Italian parentage, he studied at the École des Beaux Arts and exhibited genre figures at the Salon des Artistes Français, winning an honourable mention in 1892. Roanne Museum has his figure of a Benedictine monk.

TONNELIER, Georges 1858-
Born in Paris on March 28, 1858, he studied under Gauthier and Millet and exhibited at the Salon des Artistes Français, becoming an

Associate in 1892. He won an honourable mention in 1887, a second class medal in 1890 and a first class medal in 1893. He received a gold medal and the Légion d'Honneur at the Exposition Universelle of 1900. The main collection of his work is in the Galliera Museum and includes busts and relief portraits of his artistic contemporaries, historical, classical and biblical figures and groups, genre figures (such as Harvester Resting) and cameos and carved gemstones.

TÖNNESEN, Ambrosia Theodora 1859-
Born in Aalesund, Norway, on January 28, 1859, she studied in Paris under Marceaux and exhibited portraits and genre figures at the Salon at the turn of the century, winning an honourable mention in 1903. Bergen Museum has her group Abandoned.

TÖPFER, Jean Charles 1832-1905
Born in Geneva on April 23, 1832, he died in Paris on March 13, 1905. He was the son and pupil of Rodolphe Töpfer the painter and was regarded as a child prodigy. He studied sculpture under Barthelemy Menn and then went to Paris where he specialised in statuettes. Later he settled in his native city and produced numerous portrait busts of his contemporaries. His chief work, however, was the series of 28 marble figures for the memorial to the Duke of Brunswick. He exhibited regularly in Geneva from 1864 onwards. His works in the museums of Geneva and Zürich include such genre figures as Zingarella, Repose and Sorcerer.

TORELLI, Jafet fl. 19th century
Born in Florence, he was a prolific painter and sculptor of genre subjects and exhibited in Italy, Paris, London, Russia and the United States in the late 19th century.

TORELLI, Lot 1835-c.1900
Born in Florence on October 30, 1835, he died there about 1900. He studied at the Florence Academy and specialised in portrait busts and memorial plaques.

TORHAMM, Gunnar 1894-
Born in Kungshamm, Sweden, on December 21, 1894, he studied at the Stockholm Academy and worked as a landscape painter and decorative sculptor, mainly for the churches of Sweden and Norway.

TORIBIO, Antonio 1922-
Born in La Vega, Dominican Republic, in 1922, he studied at the National School of Fine Arts in Ciudad Trujillo and exhibited there from 1950 onwards. Since 1955 he has experimented with abstract forms and turned to metal constructions about 1959. His earlier works were inspired by the primitive art of the Tainos people. He has lived in New York since 1959.

TÖRNSTRÖM, Carl fl. 18th century
An army officer who sculpted figures and bas-reliefs as a pastime, he died in Sweden in 1814.

TÖRNSTRÖM, Emanuel fl. 19th century
Born in Karlskrona in 1798, he was the younger brother of Carl and the son of a wood-carver, Johan Törnström. He worked as a decorative sculptor in Stockholm.

TORRE, Gaetano Giorgio Flavio Torquato delle fl. 19th century
Born in Verona on February 19, 1827, he studied at the academies of Venice and Rome and produced groups, statues and memorials inspired by the work of Michelangelo.

TORREGGIANI, Camillo fl. 19th century
Born in Ferrara on March 19, 1820, he studied under Pampaloni in Florence and specialised in portrait busts and memorials, mainly in marble.

TORREY, Fred Martin 1884-
Born in Fairmont, U.S.A., on July 29, 1884, he studied under C.J. Mulligan and Lorado Taft in Chicago, where he subsequently worked as an architectural sculptor. His minor works include bas-reliefs, fountain statuary and portrait busts.

TORREY, Mabel Landrum 1886-
Born in Sterling, U.S.A., on June 23, 1886, she studied under Mulligan and specialised in figures and groups for parks and fountains.

TORRINI, Girolamo fl. 19th century
He studied at the Florence Academy and specialised in statues and busts portraying historical Italian personalities. His figure of Donatello is in the Uffizi Gallery.

TORTONA, Antonio fl. late 19th century
Born in Carmagnola, Italy, in the first half of the 19th century, he studied at the academies of Turin and Vela and specialised in portrait busts which he exhibited at Turin from 1862 onwards.

TOSCANI, Fedele 1876-1906
Born in Farini d'Olmo, Italy, 1876, he died in Piacenza on April 8, 1906. He studied under E. Butti and produced romantic and genre figures.

TOSCANI, Tommasso fl. 19th century
Tuscan sculptor of portraits and figures working in the second half of the 19th century.

TOSCANO DE MELLO, Braz fl. 18th century
Born at Alvito, Portugal, in the 18th century, he studied under Alejandro Giusti and worked in Lisbon as a decorative sculptor.

TOSTI, Luigi fl. 19th century
Born in Piacenza in 1845, he worked as a decorative sculptor in Florence, Rome and the United States.

TOTH, Istvan 1861-1934
Born at Szombathely, Hungary, on November 9, 1861, he died in Budapest on December 12, 1934. He sculpted public statuary in Szombathely and Budapest and decorative panels and figures for the cathedrals of Nagyvarad and Szeged. Examples of his minor works are in the Budapest and Szombathely museums. He was awarded a silver medal at the Exposition Universelle of 1900.

TOTH VON FELSÖ-SZOPOR, Agoston 1812-1889
Born at Marcali, Hungary, in 1812, he died in Graz, Austria, in 1889. He was an army officer by profession, and a talented amateur painter and sculptor of genre subjects, examples of which are in the Budapest Museum.

TOULMOUCHE, René fl. 19th century
Born in Nantes in the early years of the 19th century, he exhibited figures at the Salon from 1846 to 1853. His figure of Satan is in Rennes Museum.

TOURET, Jean Marie 1916-
Born in Lassay, France, in 1916, he studied at the Albert Magnan School in Le Mans and worked in Hervé Mathé's studio. After 1950 he spent more time on sculpture than on painting and began producing large monumental pieces. His work was influenced successively by Rodin and Henry Moore, and has always been figurative. He has worked in wood, cement and metal to produce panels and bas-reliefs.

TOURNIER, Victor 1834-1911
Born in Grenoble on November 16, 1834, he died in Paris in 1911. He studied under M.M. Sepey and Michel Pascal and specialised in religious figures and groups. He began exhibiting at the Salon in 1876 and became an Associate of the Artistes Français in 1886.

TOURNIER, Victorien fl. 19th-20th centuries
Born in Paris in the second half of the 19th century, he studied under Cavelier and Barrias. He exhibited figures and groups at the Salon des Artistes Français, winning an honourable mention (1894), a travelling scholarship and a third class medal (1900) and a second class medal (1903). At the Exposition Universelle of 1900 he was awarded an honourable mention.

TOURNOIS, Gustave Georges 1904-
Born in Paris on December 22, 1904, he studied under Seguin and C. Lefebvre. He specialises in ecclesiastical sculpture.

TOURNOIS, Joseph 1830-1891
Born in Chazeuil, France, on May 18, 1830, he died in Paris in 1891. He studied under Jouffroy and enrolled at the École des Beaux Arts in 1831. He won the Prix de Rome in 1857 and exhibited at the Salon from 1868 onwards, winning medals in 1869 and 1870. He was awarded a silver medal at the Exposition Internationale of 1878. He produced classical and genre figures, such as the Farewells of Hector and Andromache (Dijon Museum) and Quoits-player (Orleans Museum).

TOURNOIS, Louis 1875-1931
Born in Paris on May 21, 1875, he died there on February 1, 1931. He studied under Wast and worked as a decorative and ornamental sculptor.

TOURNOUX, Auguste fl. 19th-20th centuries
Born at Meudon in the mid-19th century, he studied under Cavelier and Dumont and exhibited at the Salon from 1872 to 1878. Later he became an Associate of the Artistes Français and exhibited at the Salon from 1902 onwards. He won a third class medal in 1876.

TOURNOUX, Jean fl. 19th century
Sculptor of genre subjects working in Paris in the latter part of the 19th century. He studied under Cavelier and Dumont and was probably a brother of the foregoing. He exhibited figures at the Salon from 1874 to 1877.

TOURTE, Frédéric Pierre Marc 1873-
Born in Cazières, France, on July 11, 1873, he studied under Falguière and Soules and exhibited busts of his contemporaries at the Salon des Artistes Français. He won a third class medal in 1899 and a bronze medal at the Exposition Universelle the following year.

TOUSSAINT, François Christoph Armand 1806-1862
Born in Paris on April 7, 1806, he died there on May 24, 1862. He studied under David d'Angers and exhibited at the Salon from 1836 onwards. He became a Chevalier of the Légion d'Honneur in 1852. He specialised in busts of his contemporaries.

TOUSSAINT, Gaston Henri 1872-1946
Born in Rocquencourt on September 7, 1872, he died in Paris on March 20, 1946. He studied under Rodin and Bourdelle and exhibited at the Nationale and the Salon des Tuileries. He became an Officier of the Légion d'Honneur. In the 1920s he sculpted many war memorials all over France. His minor works include Youth, Maternity, Grandmother and other genre figures. The main collection of his work is in the Goya Museum, Castres.

TOUZIN, Jenny fl. 19th century
Born in Paris about the middle of the 19th century, he studied under Maillet and exhibited figures at the Salon from 1876.

TOVAR Y CONDE, Manuel 1847-1921
Born in Seville on December 14, 1847, he died in Madrid on June 7, 1921. He exhibited small ornamental sculpture at Seville in 1867-68. He was employed on the decoration of the Alcazar.

TOWNROE, Reuben 1835-1911
Although he was born and died in London, he spent most of his life working in Italy. He worked as a portrait sculptor and architectural designer and exhibited at the Royal Academy and other major galleries from 1874 till his death .

TRABACCHI, Giuseppe 1839-1909
Born in Rome in 1839, he died there on December 12, 1909. He studied at the Academy of St. Luke in Rome and produced statuary and groups for public buildings, memorials and bas-reliefs.

TRABALZA, Leopoldo fl. mid-19th century
Decorative sculptor working in Rome in the 1840s.

TRABUCCO, Giovanni Battista fl. 19th century
Born in Turin in 1844, he studied under Vela and then went to Nice where he worked as a decorative sculptor. Nice Museum has several busts and statuettes of his contemporaries and a figure of a Young Girl with a Felt Hat.

TRAGIN, Pierre 1812-c.1870
Born in Paris on January 7, 1812, he died after 1870. He studied under David d'Angers and exhibited at the Salon from 1847 to 1870.

TRAGSEILER, Ludwig 1879-
Born in Innsbruck on February 13, 1879, he studied under Senn there and worked as an ecclesiastical sculptor in the towns of the Tyrol.

TRAMAZZINI, Serafino 1859-
Born in Ascoli Piceno, Italy, on January 21, 1859, he studied under G. Paci in Ascoli and specialised in busts portraying classical and Roman personalities.

TRAUTENBERG, Janos 1899-
Born in Budapest on October 3, 1899, he worked there as a genre painter and sculptor.

TRAUTZL, Julius 1859-
Born in Arco, Austria, on October 21, 1859, he studied at the Vienna Academy and produced monuments, statues and façades for public buildings. His minor works include bas-reliefs, plaques and medals.

TRAVAUX, Pierre 1822-1869
Born at Corsaint, France, on March 10, 1822, he died in Paris on March 19, 1869. He studied at the Semur School of Fine Arts and worked with Jouffroy. He exhibited at the Salon from 1851 onwards and produced busts of his contemporaries and genre, biblical and classical figures, such as Sappho playing her Lyre, Reverie, David defeating Goliath, Wrestler, Education, Hannibal's Oath and Frilleuse (an allegory of winter). His work may be found in the museums of Auxerre, Dieppe, Dijon, Montpellier and Semur.

TRAVERSE, Pierre 1892-
Born at St. André de Cubzac, France, on April 1, 1892, he studied under Injalbert and exhibited figures and portraits at the Salon des Artistes Français, the Salon d'Automne, and the Salon des Artistes Décorateurs. He won a silver medal in 1921, a gold medal in 1926 and the medal of honour in 1942. He was awarded a diploma of honour at the Exposition Internationale of 1937. His works are preserved in the Petit Palais and the Detroit Museum.

TRAVERSO, Nicolo Stefano 1745-1823
Born in Genoa on February 1, 1745, he died there on February 2, 1823. He studied under Schiaffino and P. Bocciardo and became one of the leading exponents of neo-classicism in northern Italy. He sculpted decoration for the churches and palaces of Genoa.

TREBICKI, Michal 1842-1902
Born in Warsaw on September 29, 1842, he died there on October 14, 1902. He studied at the Dresden Academy and the École des Beaux Arts, Paris, and worked in Warsaw, mainly on busts, bas-reliefs and medallions.

TREBST, Friedrich Arthur 1861-1922
Born in Lössning-Leipzig, Saxony, on June 12, 1861, he died in Leipzig on August 27, 1922. He worked in Leipzig and Dresden and specialised in busts of his contemporaries.

TRECHARD fl. late 18th century
Signature found on bronze relief portraits of philosophers, poets, historians and members of the French royal family of the late 19th century.

TREHARD, Constant Henri fl. 19th century
Born in Nantes about the middle of the 19th century, he studied under Toussaint and exhibited figures at the Salon from 1872 to 1887.

TREMBECKI, Zygmunt 1847-1882
Born in Cracow on May 13, 1847, he died in Paris in 1882. He exhibited busts in Vienna in 1873. The Cracow Museum has his group of the poet Jan Kochanoski and his daughter Urchulka.

TREMBLEY, Albert Jules 1878-
Born in Geneva in 1878, he studied in Paris and specialised in busts and relief portraits.

TRENKWALDER, Dominikus 1841-1897
Born at Angedair-Landeck, Austria, on April 22, 1841, he died in Innsbruck on July 8, 1897. He studied in Innsbruck, Munich and Vienna and specialised in religious figures for Tyrolean churches.

TRENT, Newbury Abbot 1885-1953
Born in London on October 14, 1885, he died in Abbots Langley, Hertfordshire, on August 2, 1953. He studied at the Royal College of Art and later at the Royal Academy schools. He specialised in memorials, the best known being that to King Edward VII at Brighton. He had studios in London, Clymping (Sussex) and latterly in Abbots Langley.

TRENTACOSTE, Domenico 1859-1933
Born in Palermo, Italy, on September 20, 1859, he died in Florence on March 18, 1933. He studied in Palermo and Paris and was influenced by Rodin. He exhibited in Venice from 1895 onwards and specialised in allegorical, religious and genre figures and groups. His work includes Meditation, The Sleeper, The Sower, Niobe, Death of Christ, Little Faun and Cain. His figure The Collector of Cigarette Butts is in the Gallery of Modern Art, Venice.

TRENTANOVE, A.T. fl. 19th century
Sculptor of busts, heads and relief portraits working in London in the 1860s.

TRENTANOVE, Gaetano 1858-1937
Born in Florence on February 21, 1858, he died in the United States on March 13, 1937. He studied at the Florence Academy before emigrating to America. He produced a number of colossal war memorials in the 1920s. His minor works in the classical idiom are preserved in the Milwaukee Museum.

TRENTANOVE, Michele fl. 19th-20th centuries
Born in Italy about the middle of the 19th century, he died in Rome in February 1925. He specialised in public statuary portraying prominent figures, such as the equestrian statue of Victor Emmanuel in Rome and the statue commemorating President McKinley (1907).

TRENTANOVE, Raimondo 1792-1832
Born in Faenza on January 24, 1792, he died in Rome on June 5, 1832. He was the son and pupil of Antonio Trentanove, a *stuccateur* and plasterer, and later studied at the Carrara Academy and worked under Canova in Rome. He specialised in portrait busts, memorials and bas-reliefs. Ajaccio Museum, Corsica, has his portraits of Letitia and Charlotte Bonaparte.

TREU, Philipp Jakob 1761-1825
Born in Basle in 1761, he died there in 1825. He produced bas-reliefs, plaques and roundels bearing profiles of contemporary celebrities, especially the Bonaparte family. His works are preserved in the Basle Historical Museum.

TREUNER, Robert 1877-
Born in Coburg on November 28, 1877, he studied under Hasselhorst in Frankfurt and worked as a landscape painter and genre sculptor.

TRIBE, Barbara (Mrs. Singleman) fl. 20th century
Born in Edgecliff, New South Wales, at the beginning of this century, she studied at the Sydney Technical College (1928-33) and won an Australian travelling scholarship in 1935. This enabled her to continue her studies at the City and Guilds School of Art, Kennington (1936-37) and the Regent Street Polytechnic School of Art under Brownsword. She has exhibited at the Royal Academy and the leading galleries in London, Glasgow and Edinburgh and has a studio at Paul in Cornwall. She specialises in busts and heads and is a member of the Society of Portrait Sculptors.

TRIEBEL, Frederick Ernest 1865-
Born in Peoria, Illinois, on December 29, 1865, he studied at the Florence Academy and specialised in genre and allegorical bas-reliefs in marble and bronze. Tokyo Museum has his sculpture Mysterious Music.

TRILLES, Miguel Angel 1866-
Born in Madrid on March 20, 1866, he was the son and pupil of Jose Trilles y Badenes and later studied at the Academy of San Fernando, Madrid, and the Academy of St. Luke, Rome. He specialised in classical and genre groups and won a gold medal at the Madrid Exhibition of 1904.

TRILLES Y BADENES, José fl. 19th century
Decorative sculptor working in Castellon de la Plana and Madrid in the mid-19th century.

TRIMMEL, Robert 1859-
Born in Vienna on March 20, 1859, he studied under Kundmann at the Vienna Academy and executed public statuary for Graz, Salzburg and Bruck an der Mur.

TRIPISCIANO, Michele 1860-1913
Born in Caltanisetta, Italy, on July 13, 1860, he died there on September 21, 1913. He studied under Fabio Altini in Rome and sculpted figures and groups of religious and genre subjects. He exhibited in Rome from 1890 onwards.

TRIPPEL, Alexandre 1744-1793
Born in Schaffhausen on September 23, 1744, he died in Rome on September 24, 1793. He studied under Wiedewelt in Copenhagen and spent many years in Paris before settling in Rome. He was one of the important predecessors of Canova and specialised in medallions, plaques and busts of his contemporaries. His classical groups include Andromeda unchained, Hercules at Rest and Milo attacked by the Lion. Examples of his work are in the museums of Basle, Berne and Schaffhausen.

TRSAR, Drago 1927-
Born in Planina, Yugoslavia, in 1927, he studied at the Ljubljana Academy and has taken part in national and international exhibitions since 1953. His work is a blend of the figurative and the abstract, with such titles as Demonstrators, City-dwellers, and Spectators.

TUDOR-HART, Percyval 1873-1954
Born in Montreal, Canada, on December 27, 1873, he died in Dinard, France, in 1954. He studied at the École des Beaux Arts, Paris, and exhibited at the various Paris Salons, winning silver and gold medals in 1903 and 1905 respectively. He worked as a landscape painter and genre sculptor and had studios in London and Dinard.

TUERLINCKX, Louis Benoit Antoine 1820-1894
Born at Malines, Belgium, on December 31, 1820, he died in Ixelles near Brussels on March 21, 1894. He worked as a portrait sculptor, lithographer and musician.

TUFFET, Henri fl. 19th century
Born in Lyons in the mid-19th century, he studied under Vauthier and exhibited figures at the Salon from 1879.

TUPPER, John L. 1879-
Born in Rugby, Leicestershire, on September 30, 1879, he was a sculptor, designer and writer.

TURCAN, Jean 1846-1895
Born in Arles on September 13, 1846, he died in Paris on January 3, 1895. He studied under Cavelier and exhibited at the Salon from 1878, specialising in busts of historic and contemporary artists, such as the sculptors Houdon and Idrac. His genre works include The Blind and the Paralytic (Marseilles Museum and the Louvre), The Hunter and the Ant and The Wrestlers.

TURCSANYI, Laszlo 1899-
Born in Budapest on July 2, 1899, he specialises in busts, bas-reliefs and portrait medallions.

TURIN, Pierre 1891-
Born at Sucy-en-Brie, France, on August 3, 1891, he studied under Vernon, Coutan and Patey and became an Associate of the Artistes Français. He exhibited at that Salon from 1911 onwards and won the Prix de Rome in 1920, a gold medal in 1925 and the Légion d'Honneur in 1936. He was a member of the Conseil Supérieur des Beaux Arts from 1928 to 1931. He has exhibited at the Salon de la Monnaie and specialised in busts, reliefs and medals.

TURNBULL, William 1922-
Born in Dundee on January 11, 1922, he studied at the Slade School after war service as a pilot in the R.A.F. and then worked in Paris from 1948 till 1950. He taught at the Central School of Arts and Crafts from 1951 and had his first one-man show the following year. Since then he has participated in international exhibitions including the Venice and Sao Paulo Biennales. His earlier abstracts were influenced by Giacometti, but latterly he has concentrated on spatial constructions. His bronzes include Standing Female Figure (1955), Drumhead and Head Object (both 1955).

TURNER, Alfred 1874-1940
Born in London on May 28, 1874, he died there on March 18, 1940. He studied at the City and Guilds School of Art and the Royal Academy schools (1894-98) and won several prizes including a travelling scholarship. For some time he worked in the studio of Harry Bates before establishing his own studio in London. He

exhibited at the Royal Academy from 1898 and was elected A.R.A. in 1922 and R.A. in 1931. He sculpted monuments to Queen Victoria, a number of war memorials in the 1920s and specialised in figure subjects.

TURNER, Jean Baptiste 1743-1818
Born in Malines, Belgium, on July 31, 1743, he died there on December 25, 1818. He studied under Pierre Valckx, whose widow he married in 1785. He specialised in portrait busts, in terra cotta and bronze.

TURNER, Winifred 1903-
Born in London on March 13, 1903, she was the daughter and pupil of Alfred Turner and also studied at the Central School of Arts and Crafts (1921-24) and the Royal Academy schools (1924-27). She has exhibited at the Royal Academy since 1924 and he her work is represented in the Tate Gallery. She specialises in figure sculpture.

TURNERELLI, Peter 1774-1839
Born in Belfast in 1774, he died in London on March 20, 1839. He exhibited at the Royal Academy from 1802 to 1838 and specialised in portrait busts, statuary and bas-reliefs in marble, plaster and bronze. His best known work is the Burns Mausoleum in Dumfries.

TÜSHAUS, Joseph 1851-1901
Born in Münster on July 7, 1851, he died in Düsseldorf on October 21, 1901. He studied under Witting at the Düsseldorf Academy and worked for some time in Rome before settling in Düsseldorf. His figure of St. Sebastian is in the Berlin Museum.

TWEED, John 1869-1933
Born in Glasgow, Scotland, on January 21, 1869, he died in London on November 12, 1933. He studied at the Glasgow School of Art, the Lambeth School of Art and the Royal Academy schools. He visited Paris in 1893 and studied for a time at the École des Beaux Arts. He exhibited at the Royal Academy from 1894 onwards and produced busts and bas-relief portraits of his contemporaries. He was strongly influenced by Rodin, whose relief portrait by him is in the Victoria and Albert Museum. His death mask of Cecil Rhodes is in the National Portrait Gallery.

TYNYS, Arvi 1902-
Born in Finland in 1902, he studied at the Helsinki Athenaeum whose museum has his bronze Head of a Man.

TYRELL, Thomas 1857-1929
Born in London in 1857, he died there in 1929. He studied at the City and Guilds Technical School, Kensington, and the Royal Academy schools. He exhibited at the Royal Academy from 1884 and also at the major London and provincial galleries.

UBALDI, Carlo 1821-c.1884
Born in Milan in 1821, he died there some time after 1884. He exhibited genre figures in Naples (1877) and Milan (1860-84) and took part in the Vienna International Exhibition of 1873.

UBAUDI, Pierre fl. 19th century
French decorative and ecclesiastical sculptor employed in the decoration of Lyons Town Hall and Rouen Cathedral.

ÜBERBACHER, Heinrich 1852-1929
Born in Bozen (Bolzano) on July 6, 1852, he died there on February 23, 1929. He worked in Munich for many years as an ecclesiastical sculptor.

UFERT, Oskar 1876-
Born in Frankfurt-am-Main on January 27, 1876, he studied under W. Schwind and specialised in genre heads and figures. The Frankfurt Municipal Gallery has his statuette of Torment.

UFFRECHT, Rudolf fl. 19th century
Born at Althaldensleben near Magdeburg on July 9, 1840, he studied at the Berlin Academy and produced bronzes and terra cottas of musicians, artists, poets and writers as well as allegorical figures and groups.

UGO, Antonio 1870-
Born in Palermo, Sicily, in 1870, he studied under Rota in Rome and became one of the leading Italian sculptors of the early 20th century. The Palermo Museum has his David, remarkable for its realism, while the Gallery of Modern Art, Rome, has his bust of Cardinal Celesia.

UGOLINI, Giuseppe 1828-1897
Born in Reggio Emilia on June 3, 1828, he died at S. Felipe Circeo on October 28, 1897. He specialised in busts and portrait reliefs and exhibited in Rome, Milan and Turin.

UHLMANN, Hans 1900-
Born in Berlin in 1900, he trained as an engineer at the Berlin Technisches Hochschule and taught there till 1933. From 1925 onwards, however, he took up sculpture and studied in Paris and Moscow. He had his first exhibition in 1930, at the Gurlitt Gallery in Berlin. He fell foul of the Nazis on account of his political views and was imprisoned from 1933 to 1935. Over the ensuing decade he was unable to pursue his artistic career, but in 1945 he resumed his work as a sculptor and five years later was awarded the Arts Prize of the City of Berlin. His entry in the competition for the monument to the Unknown Political Prisoner (1952) won for him the prize of the Federal Union of German Industry. He won the German critics' prize in 1954 and had exhibitions at the Venice Biennale (1954) and the Documenta II Exhibition in Kassel (1959). Most of his sculpture consists of abstract constructions in thin metal plates and drawn wire.

ULI, Julius 1897-
Born in Berlin on May 22, 1897, he studied under Klimsch and specialised in genre figures. His Young Girl Standing is in the Bremen Kunsthalle.

ULLMAN, Allen 1905-
Born in Paris on April 27, 1905, he studied under his father, the painter E.P. Ullman, and A. Bitter. He has exhibited at the Paris Salons and also in the United States. His speciality is genre figures, such as The Boxer (Brooklyn Museum).

ULLRICH, Friedrich Andreas fl. 18th-19th centuries
Born in Meissen, Saxony, about 1760, he studied at the Dresden Academy and later worked under Schadow in Berlin. He travelled widely all over Europe and produced busts, memorials and statuary of mythological subjects.

ULMER, Oskar E. 1888-
Born in Hamburg on June 19, 1888, he studied at the Munich Academy and produced figures and groups of mainly religious subjects. Examples of his work are in the Hamburg Kunsthalle.

UNDERWOOD, Leon 1890-
Born in London on December 25, 1890, he studied at the Regent Street Polytechnic (1907-10), the Royal College of Art (1910-13) and the Slade School (1919-20). He visited the Netherlands, Germany and Russia before the first world war and travelled extensively in Europe, West Africa and America in the 1920s and 1930s. He served during the first world war in the camouflage section of the Royal Engineers. He had his first one-man show in 1922 at the Chenil Galleries, London. He has worked as a painter in oils and watercolours, wood-engraver, lithographer and sculptor of figure subjects, and written a number of books, including *Art for Heaven's Sake* (1934) and *Bronzes of West Africa* (1949). His work is represented in the British Museum, the Victoria and Albert Museum and the Tate Gallery.

UNGER, Johann Christian 1746-1827
Born in Spandau near Berlin on September 20, 1746, he died in Berlin on March 9, 1827. He studied under Tassaert and Schadow and specialised in busts and statuary portraying Prussian royalty. Many of his works decorated the former Royal Castle in Berlin.

UNGER, Max 1854-1918
Born in Berlin on January 26, 1854, he died in Kissingen on May 31, 1918. He studied at the Berlin Academy and sculpted numerous equestrian statues, fountains and memorials in many parts of Germany.

UNGERER, Jacob 1840-1920
Born in Munich on June 13, 1840, he died there on April 27, 1920. He worked in Munich and Leipzig as a decorative sculptor. The Simu Museum, Bucharest, has a bronze by him.

UNGLEICH, Tobias fl. 18th century
Born in Tann, Bavaria, in the early 18th century, he worked as a decorative sculptor in Wurzburg. Busts and statuary by him are in the university and museum of Wurzburg.

UNTERHOLZER, Josef 1880-
Born in Lankowitz, Austria, on March 15, 1880, he studied under Bitterlich and Hellmer at the Vienna Academy and produced war memorials, statuary, fountains, bas-reliefs and plaquettes.

UPHOFF, Carl Emil 1885-
Born in Witten, Germany, on March 17, 1885, he studied under Rohlfs and was influenced by Matisse. He founded the Worpswede Community and worked as a painter, illustrator, engraver, writer and sculptor.

UPHUES, Josef 1850-1911
Born in Sassenberg, Germany, on May 23, 1850, he died in Berlin on January 2, 1911. He studied under R. Begas at the Berlin Academy and sculpted many monuments in Berlin and other German cities. His minor works include genre and classical figures, such as Sagittarius (Melbourne Museum). He won a silver medal at the Exposition Universelle of 1900.

UPRKA, Franta 1868-1929
Born at Knezdub, Bohemia, on February 24, 1868, he died in Tuchmerice near Prague on September 8, 1929. He worked under J. Capek and Schnirch in Prague. The Prague Modern Gallery has three of his bronze statuettes, Going to Church, Farmworker with a Hoe and The Corn-thresher.

UPTON, Charles 1911-
Born in the Midlands on August 18, 1911, he studied at the Birmingham College of Art under William Bloye, Clifford Webb, Noel Spencer and E.W. Dinkel. He has exhibited at the Royal Academy, the Paris Salon (honourable mention 1953) and the leading galleries in Britain. He has been the head of the sculpture department at the Portsmouth College of Art since 1946 and lives at Warsash, Hampshire.

URAY, Hilde (Mme. Leitich) 1904-
Born at Schladming, Austria, on October 2, 1904, she studied under Bitterlich at the Vienna Academy. She specialises in religious figures, in wood, terra cotta and bronze.

URBANIJA, Josef 1877-
Born in Ljubljana in 1877, he studied at the Vienna Academy and specialised in genre figures and groups. His works include allegories of Electricity and Water and the group Consoler of the Last Combat.

URDANETA, Abelardo Rodriguez 1870-
Born in the Dominican Republic in 1870, he worked as a decorative sculptor in San Domingo. His allegorical works include The Prisoner and One of Many.

USHER, Leila fl. 20th century
A pupil of George T. Brewster at Cambridge, Massachusetts, and the Art Students' League of New York, she also studied in Paris and became a member of the American League of Professional Artists and the American Federation of Arts. She specialises in busts, heads and relief portraits.

USSING, Stephan Peter Johannes Hjort 1828-1855
Born in Ribe, Denmark, on September 15, 1828, he died in Copenhagen on July 19, 1855. He specialised in genre and religious subjects, such as Children with a Crab, Irrigation Scene and the Murder of the Children of Bethlehem.

UTECH , Bogislav Friedrich Gotthilf 1782-1829
Born in Heydebreck, Germany, on March 2, 1782, he died in Belgard, Germany, on November 25, 1829. He specialised in heads and figures of Greek heroes and decorative sculpture for public buildings. His minor works are in the museums of Colberg and Stettin.

UTECH, Joachim Christoph Ludwig 1889-
Born in Belgard on May 15, 1889, he studied at the academies of Berlin and Leipzig and produced statues, busts and genre figures, such as Man of the North, Pomeranian Grenadier, Young Pomeranian Girl, Old Shepherd and Female Torso. He also sculpted a number of heads of children and young girls.

UTINGER, Gebhard 1874-
Born in Baar, Switzerland, on April 3, 1874, he studied at the Dresden Academy and worked in Silesia on religious figures and memorials.

UTINGER, W.B. Christian 1819-1893
Born in Zug, Switzerland, on March 19, 1819, he died there on April 1, 1893. He worked mainly in Rome where he was a member of the Swiss Guard. He sculpted figures and groups in alabaster. marble and wood and no bronzes have so far been recorded.

UTNE, Lars 1862-1922
Born in Ullensvang, Norway, on November 24, 1862, he died in Asker on August 8, 1922. He studied under B. Bergslien at Oslo and was employed on the decorative sculpture of the Reichstag in Berlin and the Oslo National Theatre. His minor works include genre figures, such as Child carrying a Belt (Oslo National Gallery).

UTSOND, Gunnar Karenius 1864-
Born in Kviteseid, Norway, on August 30, 1864, he studied in Paris and was influenced by Rodin. He exhibited allegorical figures and groups at the Paris Salon in 1894 and received favourable notice from the critics at the Exposition Universelle of 1900 for his Horse of Hell.

UYTVANCK, Benoit van 1857-1927
Born in Hamme, Belgium, on June 25, 1857, he died in Louvain on November 6, 1927. He studied under J.B. Bethune and worked as a restorer of sculpture for the churches in Louvain and Malines.

UYTVANCK, Joseph François Benoît van 1884-
Born in Louvain on July 27, 1884, the son and assistant of Benoît van Uytvanck. He specialised in religious figures and altar bas-reliefs.

UZELAC, Milivoy 1897-
Born in Mostar (now Yugoslavia) on July 27, 1897, he studied under Preisler at the Prague School of Fine Arts. He exhibited in Zagreb, Belgrade, Brussels, London and Amsterdam as well as the Paris Salons in the 1920s. He works as a painter, illustrator and sculptor and is influenced by post-war developments in French sculpture. His sculpture was shown at the United Nations Exhibition in Paris, 1946.

VAA, Dyre 1903-
Born in Kviteseid, Norway, on January 19, 1903, he studied at the Oslo Academy under W. Rasmussen and worked in Oslo as a painter and sculptor, specialising in figures and busts of his contemporaries. He has also produced a number of bronze allegories.

VAAST, Paul 1879-
Born in Paris on February 3, 1879, he studied under Poulin and Truphème. He began exhibiting at the Salons in 1900 and produced statues and busts. His Woman with Gourd is in the Musée Galliera, Paris.

VACATKO, Ludwig 1873-
Born in Simmering, Austria, in 1873, he worked in Prague and exhibited paintings and sculpture of nudes and horses at Munich (1906-8) and Vienna from 1910 onwards.

VACCA, Giuseppe 1803-1871
Born in Carrara on December 22, 1803, he died in Naples on December 12, 1871. He worked in Naples as an ecclesiastical sculptor.

VACCARO, Giuseppe fl. 19th century
Born in Caltagirone, Italy, in the early 19th century, he sculpted figurines in terra cotta representing Sicilian peasant types. Examples of his work are in the museum of Caltagirone.

VACOSSIN, Georges Lucien 1870-
Born in Granvilliers, France, on March 1, 1870, he studied under Lemaire and exhibited bas-reliefs, plaques and medals at the Salon des Artistes Français from 1902 onwards, winning an honourable mention (1904), third class medal (1908) and a second class medal (1913).

VADELL Y MAS, Damian fl. early 19th century
Born at Manacor, Spain, in the early 19th century, he came to Paris and studied under Claude Ramey. He spent 25 years in Paris before returning to Spain and produced statues, busts and memorials. He died some time after 1884.

VAGIS, Polygnotos Georgios 1894-
Born on the Greek island of Thasos in 1894, he studied at the Beaux-Arts Institute in New York under Gutzon Borglum, Leo Lentelli and John Gregory. He exhibited at the National Academy of Design in 1920-22 and later at the Pennsylvania Academy of Fine Arts. He specialises in allegorical figures, such as Repentence, in bronze or bronzed plaster.

VAGNETTI, Italo 1864-1933
Born in Florence on July 19, 1864, he died there on April 17, 1933. He studied at the Rome Academy and produced statues, busts and memorials.

VAGO, Gabor 1894-
Born in Belenyes, Hungary, in 1894, he studied in Rome and specialised in statuary.

VALADIER, C. Luigi 1726-1785
Born in Rome on February 26, 1726, he died in the same city on September 15, 1785. He worked there as an ornamental sculptor, jeweller and bronze-founder.

VALBODEA, Stefan Ionescu 1865-1918
Born in Bucharest in 1865, he died there in 1918. He specialised in busts and figures of his Romanian contemporaries. He exhibited in Paris, and won an honourable mention at the Salon of 1885 and a bronze medal at the Exposition Universelle of 1889.

VALENTI, Giuseppe fl. mid-19th century
Sicilian sculptor, working in Palermo in the mid-19th century. He was the son and pupil of Salvatore Valenti and produced statuary and memorials.

VALENTI, Salvatore 1835-1903
Born in Palermo in 1835, he died there in 1903. The son of a wood-carver, he worked as a decorative sculptor and was represented in the Italian Pavilion at the Exposition Internationale of 1878.

VALENTIM, J.M. fl. late 19th century
Born at Bourg-des-Comptes, France, in the mid-19th century, he exhibited figures at the Salon des Artistes Français, and got an honourable mention in 1888.

VALENTINE, Edward Virginius 1838-1930
Born in Richmond, Virginia, on November 12, 1838, he died there on November 12, 1930. He studied in Europe and worked as a monumental sculptor in Richmond. His minor works include classical figures, such as Andromache and Astyanax.

VALERIE, Berthe fl. 19th century
Born in Paris in the mid-19th century, she studied under Hegel and exhibited figures at the Salon from 1878 onwards.

VALERIOLA, Edmond de fl. 20th century
Sculptor working in Brussels before the first world war.

VALETTE, Henri 1891-
Born in Paris on January 31, 1891, he worked as a genre sculptor and designer and exhibited in Vienna, Prague, Buenos Aires, New York and London, as well as the Salon des Indépendants and the Salon des Artistes Décorateurs in Paris.

VALETTE, Jean 1825-1877
Born at Ainay-le-Vieil, France, on May 30, 1825, he died in 1877. He studied under Bonnassieux and Jouffroy and exhibited at the Salon from 1847, winning a third class medal in 1861. He produced genre figures and groups, such as The Sower of Drunkenness, Garde Mobile, Seated Black Cat, etc. He also sculpted numerous busts of contemporary French celebrities.

VALK, Willem Johann 1898-
Born at Zoeterwoude near Leiden on December 22, 1898. He studied at the Hague Academy and was a pupil of Frans Zwollo. He produced busts and bas-reliefs in wood, stone, terra cotta and bronze.

VALLET, Joseph fl. 19th-20th centuries
Born at Boissière-le-Doré, France, on August 6, 1841, he exhibited portraits and figures at the Salon des Artistes Français, winning an honourable mention in 1899.

VALLET, Marius fl. 19th century
Born at Chambery in the mid-19th century, he exhibited at the Salon des Artistes Français, getting an honourable mention in 1895.

VALLETTE, Henri 1877-
Born in Basle on September 16, 1877, he studied in Paris and worked in France, producing several war memorials in the 1920s. His minor works consist mainly of animal figures and groups.

VALLGREN, Ville fl. 19th-20th centuries
Born at Borga, Sweden, in the mid-19th century, he moved to Paris and became a naturalised Frenchman. He exhibited at the Salon, winning an honourable mention in 1886. At the Expositions Universelle of 1889 and 1900 he won a gold medal and the Grand Prix respectively. He became a Chevalier of the Légion d'Honneur in 1894 and an Officier in 1901. He specialised in genre figures, such as Mother Love, Meditation, Dying Christ, Youth and Breton Girl.

VALLMITJANA Y ABARCO, Agapito d.1916
Born in Barcelona in the mid-19th century, he died there in 1916. The Museum of Modern Art, Madrid, has a plaster study by him for a group of Peasants.

VALLMITJANA Y BARBANY, Agapito d.1905
Born in Barcelona in the early 19th century, he died there in December 1905. His best known work is the marble group in the Madrid Museum showing figures of saints surrounding Queen Isabella II of Spain holding the infant Prince of the Asturias in her arms.

VALLMITJANA Y BARBANY, Venancio 1830-1919
Brother of the above, he specialised in busts and statues of saints and Spanish royalty.

VALLOTON, Félix Édouard 1865-1925
Born in Lausanne, Switzerland, on December 28, 1865, he became a naturalised Frenchman and died in Paris on December 29, 1925. He worked as a painter, engraver, designer and sculptor.

VALOIS, Achille Joseph Étienne 1785-1862
Born in Paris on January 13, 1785, he died there on December 17, 1862. He studied under L. David and Chaudet and exhibited at the Salon from 1814 onwards. He sculpted the decoration on the Medicis fountain in the Luxembourg Gardens (1807), but is best known for the many portrait busts of historical and contemporary French figures.

VALORI, Henri Zozime, Marquis de 1786-1859
Born in Chateaubriand on June 5, 1786, he died there on January 31, 1859. He specialised in busts and figures of his contemporaries. The Avignon Museum has his portrait of La Belle Laure.

VALTON, Charles 1851-1918
Born in Pau on January 26, 1851, he died in Chinon on May 21, 1918. He studied under Barye and Levasseur and began exhibiting at the Salon in 1868. He won a third class medal in 1875, a second class medal in 1885 and also got medals at the Expositions of 1889 and

1900. He was an animalier, specialising in the more exotic creatures, such as Mammoth and Polar Bear, Mountain Wolf, Tiger and Tigress and Head of a Lion.

VALYI, Gabor 1899-
Born at Kaposztas-Szentmiklos, Hungary, in 1899, he worked as a decorative sculptor in Budapest.

VANCELIS Y PUIGCERCOS, Juan fl. 20th century
Born at Guixes, Spain, in the late 19th century, he studied in Barcelona and worked as a portrait and decorative sculptor in Madrid. The Museum of Modern Art has his statue of Tirso de Molina.

VANCZAK, Ferenc 1908-
Born in Budapest in 1908, he specialised in allegorical figures, bas-reliefs and monuments. His best known work is the memorial to the Hungarian Army carrier pigeons of the first world war.

VANDENBOSCH, Charles Édouard fl. 19th century
Portrait and figure sculptor working in London. He exhibited at the Royal Academy from 1866 to 1871.

VANDRAK, Samuel 1820-1860
Born in Rozsnyo, Hungary, on November 8, 1820, he died in Budapest in 1860. He was a painter, genre sculptor and bronze founder.

VANETTI, José fl. 20th century
Sculptor of bas-reliefs and friezes, such as the colossal World of Tomorrow.

VANHINDEN, Pierre fl. 19th century
Sculptor of Flemish origin, working in London. He exhibited figures and groups at the Royal Academy from 1852 to 1875.

VANTONGERLOO, Georges 1886-
Born in Antwerp in 1886, he studied sculpture and architecture at the Antwerp Academy. He was wounded during the first world war and later moved to Holland where he was interned. Here he made contact with the De Stijl movement led by Mondriaan and Van Doesburg and this led him to produce some of the earliest abstract sculpture, such as Construction in a Sphere (1917). He worked in Brussels and Menton from 1919 to 1927 and then settled in Paris. From 1931 to 1937 he was the president of the Abstraction-Création group. After the second world war he began experimenting with spatial constructions using iron wires and plexiglass. His earlier works were executed in a wide variety of materials, including nickel, steel, iron, bronze and wood.
Vantongerloo, G. *Art and its Future* (1924). *Paintings, Sculptures, Reflections* (1948).

VARENNE, Henry Frédéric 1860-1933
Born in Chantilly on July 3, 1860, he died in Tours in March 1933. He studied under A. Dumont and exhibited statuettes and busts at the Salon des Artistes Français from 1886 onwards. He got an honourable mention in 1894 and a third class medal in 1900. He became a Chevalier of the Légion d'Honneur in 1900.

VARGA, Emil 1884-
Born at Minkowicz, Hungary, on April 13, 1884, he worked in Budapest as a painter and sculptor of genre subjects.

VARGA, Oszkar 1888-
Born in Ujpest, Hungary, on February 2, 1888, he studied in Budapest and Brussels and worked in Budapest on busts, heads, portrait reliefs and memorials.

VARIN, Max 1898-1931
Born in Basle on March 1, 1898, he died there on June 13, 1931. He specialised in portrait busts and small ornamental sculpture and exhibited in Basle from 1923 till his death. The Basle Museum has his Head of a Woman.

VARIN, Pierre d.1753
Born in the late 17th century, he died in Paris on November 29, 1753. He worked in that city as a sculptor and bronze founder and executed the equestrian statue of Louis XIV formerly in Bordeaux.

VARNI, Domenico fl. 19th century
Born in Genoa, he was the nephew and pupil of Santo Varni and he specialised in bas-reliefs and memorials. His best known work is the group of the Three Marys at the Tomb of Christ.

VARNI, Santo 1807-1885
Born in Genoa on November 1, 1807, he died there on November 11, 1885. He studied at the Genoa Academy and was a pupil of Giuseppe Gaggini. He specialised in statues, portrait busts and allegorical groups.

VARNIER, Pierre Henri Léon fl. 19th century
Born at Bourg-les-Valence in the early 19th century, he died there in 1890. He studied under Jouffroy and began exhibiting at the Salon in 1857, winning third class medals in 1859, 1861 and 1863. He participated in the Exposition of 1867 but did not receive an award. He produced classical figures and busts and statues of historical personalities. Examples of his work are preserved in Valence Museum.

VASADI, Ferenc 1848-1916
Born in Budapest on September 19, 1848, he died there on November 12, 1916. He was employed as a decorative sculptor on the Parliament Buildings and the Royal Palace in Budapest (now the Hungarian Historical Museum).

VASCONCELLOS, Josephine Alys de 1904-
Born at Molesey on Thames, the daughter of H.H. de Vasconcellos, the Brazilian Consul-General in Great Britain, she was educated in Southampton and Bournemouth and studied at the Regent Street Polytechnic under Brownsword, the Royal Academy schools, the Florence Academy under Andreotti and in Bourdelle's studio in Paris. She has exhibited at the Royal Academy and leading British and overseas galleries, and has had several shows, either on her own or in conjunction with her husband, Delmar Banner. She has a studio in Ambleside, Cumbria. She specialises in portraits, in stone, wood, lead, bronze and plastics and was a founder member of the Society of Portrait Sculptors.

VASILESCU, Georg 1864-1898
Born in Craiova, Romania, in 1864, he died in 1898. He studied under L. Ferrari in Venice and Rome. His best known work is the monument to the dead in Ploesti, 1897.

VASILIU-FALTI, V. 1902-
Born in Falticeni, Romania, in 1902, he studied under Paciurea in Bucharest and J. Boucher, Bourdelle and Despiau in Paris. He specialises in busts and heads of contemporary Romanian celebrities.

VASSALI, Luigi 1867-1933
Born in Lugano on September 11, 1867, he died there in 1933. He studied at the Milan Academy and specialised in genre and religious figures. He was awarded a bronze medal at the Exposition Universelle of 1900.

VASSÉ, Antoine François 1681-1736
Born in Toulon on October 27, 1681, he died in Paris on January 1, 1736. He was elected to Associate Membership of the Académie in 1723. He worked as a decorative sculptor and executed the gilt bronze ornaments at the Palace of Versailles, as well as bas-reliefs and statuettes in the Tuileries and Notre Dame cathedral.

VASSÉ, Louis Claude 1716-1772
Born in Paris in 1716, he died there on November 30, 1772. He was the son and pupil of Antoine Vassé and also studied under Puget and Bouchardon. He won the Prix de Rome in 1739 and became an Associate of the Académie in 1748, an Académicien in 1751, Associate professor in 1758 and professor in 1761. He was Sculptor and Designer at the Académie des Inscriptions et Belles Lettres. Tempestuous and quarrelsome by nature, he had a long-standing feud with Bouchardon, on whose death Pigalle was given the commission to sculpt a statue of Louis XV. Vassé wrote a book arguing against the choice, and as a result the Académie was forced to defend itself. The ensuing quarrel split the French artistic establishment of the period. Vassé exhibited at the Salon from 1748 to 1771, mainly portrait busts but including also genre figures, such as The Sleeping Shepherd, and allegories of Comedy, Grief and Glory.

VASSELOT, Jean Joseph Marie Anatole, Marquet de 1840-1904
Born in Paris in 1840, he died there in 1904. He studied under Le Bourg, Jouffroy and Bonnat and exhibited at the Salon from 1866 onwards, winning a third class medal in 1873 and a second class medal in 1876. He specialised in busts and statuettes of his contemporaries, but also sculpted genre figures, such as The Little Music-box Player,

and classical figures such as Chloe, casts of which are in the museums of Angers, Lyons and Rouen.

VASSEUR-LOMBARD, Amédée fl. 19th century
Born at Vienne-le-Château, France, in the mid-19th century, he studied under M.J. Feuge and exhibited figures at the Salon from 1881.

VASSILEV, Marine fl. 19th century
Born in Bulgaria in the first half of the 19th century, he studied in Prague and became professor of sculpture at the Sofia Academy of Fine Arts, instituted after the liberation from the Turks in 1878.

VASTAG, György 1868-
Born in Klausenburg, Austria, on September 18, 1868, he specialised in genre figures based on the peasantry of Austria-Hungary at the turn of the century. He was awarded a gold medal at the Exposition Universelle of 1900.

VASTAG, Laszlo 1902-
Born in Budapest on May 25, 1902, he was the son and pupil of the above. He specialised in busts, heads and relief portraits.

VASZARY, Laszlo 1876-
Born in Hencse, Hungary, on January 18, 1876, he studied under Strobl in Budapest and produced portrait medals, reliefs, busts and heads of his contemporaries.

VATINELLE, Ursin Jules 1798-1881
Born in Paris on August 23, 1798, he died there on September 16, 1881. He studied under Gatteaux and exhibited at the Salon from 1831. He was a Chevalier of the Légion d'Honneur. The chief collection of his genre figures, heads and bas-reliefs is in the Aix Museum.

VAUDESCAL, Henri Ernest fl. 19th century
Born in Paris in the mid-19th century, he studied under Diebolt, Jouffroy and Eugène Toller and exhibited genre figures at the Salon from 1878 onwards.

VAUTHIER-GALLE, André 1818-1899
Born in Paris on August 2, 1818, he died there on May 2, 1899. He was the son of the printer and lithographer Jules A. Vauthier and studied under his grandfather André Galle as well as Petitot and Blondel. He exhibited medallions and bas-reliefs at the Salon from 1852 to 1862 and won the Prix de Rome in 1839.

VAUTHIER, Louis fl. 19th century
Born in Paris in the early 19th century, he studied under Richard and exhibited figures at the Salon in 1869.

VAUTIER, Renée 1900-
Born in Paris on February 23, 1900, she has exhibited at the Salon d'Automne, the Indépendants and the Tuileries. The main collection of her sculpture is in the museum of Le Havre.

VAY, Miklos, Baron de 1828-1886
Born in Golop, Hungary, on December 24, 1828, he died there on January 28, 1886. He specialised in portrait busts and animal statuettes. Examples of his work are in the Budapest National Museum and the Simu Museum, Bucharest.

VECHTE, Antoine 1799-1868
Born at Vic-sous-Thil, France, in 1799, he died in Avallon on August 30, 1868. He exhibited at the Salon from 1847 to 1861 and won a third class medal in 1847 and a first class medal and the Légion d'Honneur the following year. He produced classical figures and groups, such as Combat of Amazons (Berlin Museum) and God the Creator (the Louvre), as well as numerous vases with bas-relief ornament, and medallions.

VEDANI, Michele 1874-
Born in Milan on June 9, 1874, he studied under Enrico Butti and specialised in memorials and tombstones for the cemeteries of Milan.

VEDDER, Elihu 1836-1922
Born in New York in 1836, he died at Capri in 1922. He studied in Paris under Picot, and worked in Italy for some time before returning to New York. In 1867 he moved to Capri. Although best known as a painter of imaginative and decorative subjects he also sculpted bas-reliefs and ornamented vases in bronze. He got an honourable mention at the Exposition Universelle of 1889.

VEDDER, Simon Harmon 1866-
Born in Amsterdam, New York, on October 9, 1866, the son of Elihu Vedder, he studied at the school of the Metropolitan Museum of Art before going to Paris where he was a pupil of Bougereau and Robert Fleury at the Académie Julian. Later he studied at the art schools of Cremona and Glaire. He exhibited genre figures at the Paris Salons (honourable mention 1899) and won a second prize at the Franco-British Exhibition in the Crystal Palace, London, in 1908.

VEDOVA, Pietro della 1831-1899
Born at Prima San Giuseppe, Italy, in 1831, he died in 1899. His parents were extremely poor and he had a long struggle to become established. In 1851 he went to Munich where he was apprenticed to a plasterer for two years, but later managed to gain admittance to the Munich Academy. He studied under Wichmann till 1854, then returned to Italy where he continued his studies at the Albertine Academy and eventually became professor of sculpture there. He sculpted various monuments and statues in Turin from 1868 onwards.

VEDRES, Mark Weinberger 1871-
Born in Ungvar, Hungary, on September 14, 1871, he specialised in male nudes, influenced by the work of Rodin and Hildebrand. He was awarded a bronze medal at the Exposition Universelle of 1900. Examples of his bronzes are in the Budapest National Museum.

VEECK, Charles fl. 19th-20th centuries
Born in Idar, Belgium, in the first half of the 19th century, he moved to Paris and became a naturalised Frenchman. He studied under Marcellin and L. Cogniet and exhibited figures and groups at the Salon from 1861 to 1894. He died in Paris in 1904.

VEGA Y MUNOZ, Antonio Maria fl. 19th century
Born in Seville in the early 19th century, he died there on November 12, 1878. He studied at the Seville Academy and specialised in portrait sculpture.

VELA, Lorenzo 1812-1897
Born in Ligornetto, Italy, in 1812, he died in Milan on January 10, 1897. He sculpted small ornaments, bas-reliefs and animal figures and groups, examples of which are in the museums of Ligornetto and Milan.

VELA, Vincenzo 1820-1891
Born in Ligornetto on May 3, 1820, he died there on October 3, 1891. He was the younger brother of Lorenzo Vela and studied under him and Cacciatari in Milan. He became one of the outstanding Italian sculptors of the 19th century, best known for his Spartacus and the group Death of Napoleon (Versailles). He exhibited at the major Italian salons and also in Paris. Studies for his monument Italy Recognising France were shown at the Salon of 1863, the monument commemorating the victims who died in the construction of the St. Gotthard tunnel.

VELAY, Amedée Joseph fl. 19th century
Born in Laval, France, in the mid-19th century, he studied under Lalanne and Vasselot and specialised in bronze busts, statuettes and medallions.

VELIMIROVIC, Vukosava 1891-
Born in Pirot, Yugoslavia, on June 30, 1891, she studied in Belgrade, Paris and Rome and worked with Bourdelle in Paris. She exhibited at the Salon des Indépendants in Paris and also in Rome and Belgrade before the second world war. Her sculptures bear the signature 'Vouka'.

VEN, Anthonie Johannes 1800-1866
Born at Hertogenbosch, Holland, in 1800, he died at Gemert on July 12, 1866. He studied at the Antwerp Academy and worked originally as a painter, but later turned to sculpture and produced busts of his contemporaries and classical figures, such as Eve and Narcissus.

VENARD, Salomé 1904-
Born in Paris in 1904, she studied arts and law at the Sorbonne and graduated as a Doctor of Law, before turning to sculpture. In this respect she was largely self-taught and worked for some time in Canada and Latin America before returning to Paris in 1936. There she met Wlérick, Hernandez and Laurens who encouraged her to take up direct carving in stone. Her first exhibition was held in 1943 at the Galerie Jeanne Castel. She concentrates mainly on busts, heads, portrait reliefs and nude figures and exhibits at the Salon de la Jeune Sculpture.

VENNING, Dorothy Mary 1885-
Born in Camberwell, London, on January 15, 1885, she exhibited portrait sculpture and miniature painting at the Royal Academy.

VENOT, Cyprien François 1808-1886
Born in Paris on September 17, 1808, he died there in 1886. He studied under E. Ludet and David d'Angers and exhibited portrait busts at the Salon from 1833 to 1850.

VERBANCK, George 1881-
Born in Ghent, Belgium, in 1881, he worked there as a decorative sculptor. The Ghent Museum has his group Orpheus and Meditation.

VERBOECKHOVEN, Barthélemy 'Fickaert' 1754-1840
Born in Brussels on March 11, 1754, he died there on September 22, 1840. He sculpted allegories, such as Charity, classical figures and groups such as Minerva, Venus rising from the Sea and Aeneas carrying his Father Anchises; religious groups like The Descent from the Cross and Samson surprised by the Philistines in the arms of Delilah; and animal figures and groups such as Dog on a Rabbit, Dog on a Partridge, Boar-hunt and Three Children playing with a Billy-goat.

VERBOECKHOVEN, Eugen Joseph 1798-1881
Born in Warneton, Belgium, on June 8, 1798, he died in Brussels on January 19, 1881. He was the son and pupil of the above and worked as a painter, lithographer, etcher and sculptor, specialising in animal subjects. These were mainly studies subsidiary to his work as a painter.

VERBUNT, Joseph Hubert 1809-1870
Born in Tilburg, Holland, on March 27, 1809, he died at Lyss on October 15, 1870. He studied under Lienard in Paris and worked as an ecclesiastical sculptor in Drieux and Berne.

VERDIER, Auguste Maurice fl. 19th-20th centuries
Born in Milan in the second half of the 19th century, of French parents, he studied in Paris under Falguière and exhibited at the Salon des Artistes Français, winning an honourable mention in 1897 and a third class medal in 1900. He specialised in bronze plaques, bas-reliefs and medallions portraying French historical celebrities.

VERDILHAN, André fl. 20th century
Born in Marseilles in the late 19th century, he worked mainly as a painter, but also exhibited sculpture at the Salon des Indépendants in 1910.

VEREZ, Georges Armand 1877-1933
Born in Lille on August 1, 1877, he died there on January 17, 1933. He studied in Paris under Barrias and exhibited figures at the Salon des Artistes Français, winning a third class medal in 1907, a second class in 1908 and a first class medal in 1909.

VERHY, Jean Louis fl. 19th century
Born at Barbentane, France, on June 11, 1820, he studied under Lehmann and enrolled at the École des Beaux Arts in 1842. He exhibited at the Salon from 1853 to 1884 and won a third class medal in 1853. He produced allegorical, historical and heroic figures and groups and genre figures illustrating French provincial life.

VERIANE, Renée de fl. late 19th century
Born in Paris, she studied under Mercié, Marqueste and Peynot and exhibited portraits at the Salon des Artistes Français, getting an honourable mention in 1896.

VERLET, Charles Raoul 1857-1923
Born in Angoulême on September 7, 1857, he died in Paris in December 1923. He studied under Cavelier, Barrias, Jouffroy, Millet and E. May and began exhibiting at the Salon in 1880. He won a second class medal in 1887 and received a gold medal and the medal of honour with the grand prix at the Expositions Universelles of 1889 and 1900 respectively. He also became Officer of the Légion d'Honneur in 1900 and a member of the Institut in 1910. He produced busts and statuettes of his contemporaries, genre figures such as The Flute-player and Filial Piety, biblical subjects like The

Prodigal Son, and classical works which included a series of bas-reliefs based on the Parthenon friezes and figures like Diana and The Grief of Orpheus.

VERMARE, André César 1869-
Born in Lyons on November 27, 1869, he studied under Charles Dufraine in that city before going to Paris where he became Falguière's assistant. He won the Prix Chenavard in 1894 for his study The Child Giotto (later carved direct in marble), and three years later was runner-up in the Prix de Rome with his group of Orpheus and Eurydice. His bas-relief of Adam and Eve finding the body of Abel won favourable notices at the Salon of 1898. He later sculpted allegorical figures and decorative sculpture for public buildings in Paris and other French towns. In the 1920s he produced a number of war memorials, monuments, fountains and other public statuary. His minor works include genre figures such as Suzanne, Pierrot and By the Abattoir, classical groups like Mercury escorting Eurydice to Hades, and many busts of his contemporaries.

VERMARE, Pierre 1835-1906
Born in Legny, France, in March 1835, he died in Lyons in 1906. He studied under Fabisch and specialised in religious figures and bas-reliefs. He was awarded the gold medal of the Lyons School of Fine Arts.

VERMEYLEN, Franz 1857-1922
Born in Louvain on November 25, 1857, he died there in 1922. He was the son and pupil of J.F. Vermeylen and also studied under A. Dumont in Paris. He worked with his father on ecclesiastical sculpture, but also did busts, portrait reliefs and medals.

VERMEYLEN, Jan Frans 1824-1888
Born at Werchter near Louvain on May 24, 1824, he died in Louvain on July 27, 1888. He studied under C.H. Geerts and sculpted statues and groups for churches in Louvain, Liège and Antwerp.

VERNET, Louis François Xavier 1744-1784
Born in Avignon on January 29, 1744, he died in Paris on December 6, 1784. He worked in Paris as a sculptor of small ornaments.

VERNHES, Henri Édouard 1854-
Born in Bozouls, France, in 1854, he studied under Jouffroy and A. Millet. He exhibited at the Salon from 1880 onwards and became an Associate of the Artistes Français in 1884, winning an honourable mention the same year. He was awarded a bronze medal at the Exposition Universelle of 1900. He produced portrait busts in polychrome plaster as well as bronze, and also sculpted genre figures, such as Young Breton, On the Road, The Second Turning of Life and Donkey-driver of Cairo.

VERNIER, Émile Séraphin 1852-1927
Born in Paris on October 16, 1852, he died there on September 9, 1927. He began exhibiting at the Salon in 1876 and won an honourable mention in 1886. At the Expositions of 1889 and 1900 he won an honourable mention and a bronze medal respectively. He became a Chevalier of the Légion d'Honneur in 1903 and an Officier in 1911. He was president of the Société des Artistes Décorateurs from 1905 to 1910. He produced busts and statues of contemporary celebrities and allegorical figures, such as The Republic.

VERNON, Frédéric Charles Victor de 1858-1912
Born in Paris on November 17, 1858, he died there on October 28, 1912. He studied under Cavelier, Chaplain and Tasset and exhibited at the Salon from 1884, winning third class (1884), second class (1892) and first class (1895) medals. He won the Prix de Rome in 1887 and was awarded bronze and gold medals at the Expositions of 1889 and 1900 respectively. He became a Chevalier of the Légion d'Honneur in 1900, won the medal of honour in 1907 and became a member of the Institut in 1909. He specialised in bronze plaques and medallions, featuring both allegorical and portrait subjects.

VERNON, Jean Émile Louis de 1897-
Born in Paris on April 1, 1897, he studied under Coutan and Lefebvre and exhibited figures at the Salon des Artistes Français from 1922 onwards, winning a silver medal in 1924 and a gold medal in 1936.

VERSCHNEIDER, Jean fl. early 20th century
Born in Lyons in the late 19th century, he studied under Perrin and Injalbert and exhibited portraits and genre figures at the Salon des Artistes Français, getting an honourable mention in 1909.

VETELET, Félix Alexandre fl. 19th century
Born in Nantes on September 12, 1826, he studied under E. Suc and worked as a painter and decorative sculptor.

VETTER, Joseph 1860-
Born in Lucerne in 1860, he specialised in relief portraits, busts and memorials.

VEYRASSAT, Antoine 1804-1852
Born in Vevey, Switzerland, on November 5, 1804, he died in Lausanne in 1952.

VEYSSET, Raymond 1913-
Born in Vars, France, in 1913, he studied at the École des Beaux Arts, Paris, and was a pupil of Malfray, Derain and Wlérick. He began as an Expressionist, but was gradually influenced by the sculpture of ancient Greece and the Middle Ages. After the second world war, however, he turned towards abstract sculpture and began experimenting with unorthodox materials such as old bricks and weathered down railway sleepers, tiles and concrete. He exhibits at the Salon de le Jeune Sculpture and the Salon des Réalités Nouvelles.

VEZIEN, Elie Jean 1890-
Born in Marseilles on July 18, 1890, he studied under Coutan and Carli and exhibited at the Salon des Artistes Français from 1921 onwards. He won a silver medal in 1924 and a gold medal in 1931. He became a Chevalier of the Légion d'Honneur in 1935 and was awarded a gold medal at the Exposition Internationale of 1937. He worked as a decorative sculptor and was employed in the ornamentation of Douaumont memorial chapel. Examples of his figures and reliefs may be found in the Petit Palais, Paris Town Hall, Notre Dame de la Garde, Marseilles and St. John Lateran, Rome.

VIANI, Alberto 1906-
Born in Questello, Italy, in 1906, he was brought up in Arezzo and then went to Venice where he studied at the Academy under Arturo Martini, whose assistant he subsequently became. After the second world war he joined the Fronte Nuovo delle Arte and exhibited with this group at the Cairola Gallery in Milan in 1947. He participated in the Venice Biennale of 1948 and on that occasion won the Young Sculptors' Prize. He has exhibited at the subsequent Venice Biennales and won first prize at the International Exhibition in Varese in 1959. His bronzes are semi-figurative and semi-abstract and are strongly influenced by the sleek, polished lines of Arp. His works include Caryatid (1952) and Woman Swimming under Water.
Sculpture di Alberto Viani (1946).

VIARD, Giorné 1823-1885
Born at St. Clément, France, in 1823, he died in Nancy in 1885. He studied under Bonnassieux and produced busts and figures of historical and contemporary personalities, the main collection of which is in the museum of Bar-le-Duc. He also sculpted the figures of Christ and the saints in the Deaf-Mute Institute, Nancy.

VIARD, Julien Henri 1883-
Born in Paris on May 29, 1883, he studied under Mercié, Chaplain and Loiseau-Rousseau. He exhibited at the Salon des Artistes Français from 1904 onwards, winning an honourable mention in 1905 and a third class medal and travelling scholarship in 1909. He specialised in bas-reliefs, plaques and medallions.

VIBERT, Alexandre fl. 19th century
Born at Epinay-sur-Orge in the first half of the 19th century, he died in Paris in 1909. He exhibited busts, relief portraits and medals at the Salon des Artistes Français, getting an honourable mention in 1893.

VIBERT, James 1872-
Born in Carrouge, Switzerland, on August 15, 1872, he studied at the Geneva School of Fine Arts and the School of Arts and Crafts. He worked in Lyons for some time on artistic wrought iron, but then moved to Paris in 1891 and was employed in Rodin's workshop. He was strongly imbued with the Symbolism of the turn of the century and participated in the Salon de la Rose Croix and the Salon de

Plume. He was awarded a silver medal at the Exposition Universelle of 1900 and returned to Switzerland in 1902 to take over the chair of sculpture at the Geneva School of Fine Arts. He produced numerous portrait busts of his contemporaries, and genre figures such as Seated Wrestlers. He also sculpted a number of monuments and public statuary, the best known being Human Effort, for the International Labour Office.

VICAIRE, Marcel 1893-
Born in Paris on September 29, 1893, he studied under Baschet and Royer at the École des Beaux Arts. He began exhibiting at the Salon des Artistes Français in 1920 and won a silver medal in 1925. Later he also exhibited at the Salon d'Automne and participated in art exhibitions in Rabat, Casablanca and the Netherlands in the 1930s. He was the founder of the French Association of Painters and Sculptors in Morocco, while serving in North Africa as Inspector of Native Arts. He was a painter, illustrator and writer as well as sculptor and his works are in the museums of Casablanca, Chantilly and New York.

VICIANO MARTI, José 1855-
Born in Castellon de la Plana, Spain, on September 19, 1855, he studied under M. Pastor and attended classes at the Valencia Academy.

VIDAL, Henri 1864-1918
Born in Charenton on May 4, 1864, he died in Paris in 1918. He studied under Mathurin-Moreau and exhibited at the Salon des Artistes Français, winning an honourable mention in 1884, a third class medal in 1890, a second class medal in 1899 and a first class medal in 1900. He also won the Prix de Paris in 1892 and a silver medal at the Exposition Universelle of 1900. He specialised in genre figures illustrating the peasantry of Europe.

VIDAL, Louis (known as 'Navatel') 1831-1892
Born in Nîmes on December 6, 1831, he died in Paris on May 7, 1892. He studied under Barye and Rouillard and exhibited at the Salon from 1859 onwards, winning a third class medal in 1861. Though blind, he was a sensitive sculptor of animal subjects, his works including Dying Stag, Greyhound, Lion, Lion Walking, American Lioness, Bull and Jaguar.

VIDONI, Francesco fl. 19th century
Born in Ferrara in the first half of the 19th century, he produced public statuary in that district. His best known work is the statue of Ariosto.

VIEIRA, Mary 1927-
Born in Sao Paulo, Brazil, in 1927, she studied sculpture in that city and came to Zürich in 1952 after being strongly influenced by an exhibition of Max Bill's sculpture in Brazil. Since then she has developed her own version of linear and geometric sculpture, using a variety of metals including steel, aluminium and silver. Her abstracts have been exhibited in France, Germany, Brazil and Switzerland and she now works in Basle.

VIERTHALER, Johann 1869-
Born in Munich on July 5, 1869, he studied under Eberlé at the Munich Academy. He worked in Bavaria and Saxony as a decorative sculptor, but his minor works include busts, heads and genre statuettes. Examples of his work are in the museums of Leipzig, and Munich.

VIETH, Carl Valdemar 1870-1922
Born in Copenhagen on January 23, 1870, he died at Meriden, Connecticut, on October 3, 1922. He studied at the Copenhagen Academy and emigrated to the United States, settling in Bridgeport, Connecticut. He sculpted portraits and memorials.

VIETH, Ernst Ludwig Emil 1824-1887
Born in Engestofte, Denmark, on July 8, 1824, he died in Copenhagen on May 12, 1887. He studied at the Copenhagen Academy and worked as a decorative sculptor on the public buildings of Copenhagen and other Danish towns.

VIGAN d.1829
Portrait sculptor working in Toulouse, where he specialised in busts of Bourbon royalty and contemporary personalities.

VIGELAND, Adolf Gustav 1869-1943
Born in Mandal, Norway, on April 11, 1869, he died in Oslo on March 12, 1943. As a child he took up wood engraving and carving and made his début in Christiania (Oslo) in 1889 with a carved panel illustrating scenes from Homer's *Iliad*. He studied under Bergslien in Oslo and H.V. Bissen in Copenhagen and latterly worked in Rodin's studio in Paris. On his return to Norway in 1893 he began carving neo-Gothic statuary for Trondhjem Cathedral. At the turn of the century he sculpted figures and busts of historic and contemporary Norwegian literary and artistic celebrities, but then he conceived the grandiose project which was to be his life's work. The preliminary models for the Fountain of Mankind were first exhibited in 1906 and caused a controversy which raged long after his death. The actual work, housed in Oslo's Frogner Park, was begun in 1915 and was not completed when the German invasion in 1940 brought the project to a halt. It consists of four large granite groups and 58 bronze figures depicting the story of mankind from barbarism to civilization, from the embryo to the grave. The central obelisk consists of more than a hundred intertwined bodies, a veritable *tour de force* of the sculptor's art. Throughout the rest of his long career, however, Vigeland continued to work as a portrait sculptor in both stone and bronze.
Stang, Ragna *The Vigeland Sculpture Park in Oslo* (various editions). Vidalene, M.G. *L'art Norvegien Contemporain* (1921).

VIGH, Ferenc 1881-
Born at Hodmezovasarhely, Hungary, on March 30, 1881, he worked as a decorative sculptor in Szeged and Rakospalota.

VIGIER, Walter Werner 1883-
Born in Soleure, Switzerland, in 1883, the son of the genre painter, Walter Vigier. He studied in Munich and Paris and sculpted genre figures and groups.

VIGNE, Paul de 1843-1901
Born in Ghent on April 26, 1843, he died in Brussels on February 13, 1901. He was the son and pupil of Pierre de Vigne and worked with his father in Antwerp. He made his début in 1868 at the Ghent Salon with a figure of Fra Angelico da Fiesole and from 1872 onwards he exhibited at the Brussels Salon. He received many commissions from the state for decorative sculpture, notably the series of caryatids for the Brussels Conservatoire. For several years he lived in Paris but returned to Belgium in 1882. To this period belong the marble Immortality and the bronze Crowning of Art which now graces the façade of the Palace of Fine Arts in Brussels. He sculpted numerous busts and figures of historical and contemporary Belgian celebrities, his best known works being the monument to Jean Breydel and Pierre de Coninck, unveiled in Bruges in 1887. The Anspach monument, unfinished at the time of his death, was completed by his colleagues and erected in Brussels. His minor works include genre figures, such as Italian Woman, and classical busts and statuettes, such as Psyche (Brussels Gallery).

VIGNE, Petrus or Pierre de (known as 'Vigne-Quyo') 1812-1877
Born in Ghent on July 29, 1812, he died there on February 7, 1877. He was the younger brother of the painters Félix and Édouard de Vigne. He studied under J.R. Calloigne in Belgium and in 1837 went to Rome, where he worked for four years before returning to Ghent. He specialised in busts of his contemporaries, but also sculpted allegories, such as The Angel of Evil (Ghent Museum).

VIGNERON, Pierre Roch 1789-1872
Born at Vosnon, France, on August 16, 1789, he died in Paris on October 12, 1872. He studied under Gautherot and Gros and later worked with Roque in Toulouse. He worked in Toulouse as a miniature painter, but also dabbled in lithography and sculpture. In later life he concentrated on genre painting. His sculpture consists of portrait busts and genre figures.

VIGNI, Corrado 1888-
Born in Florence in 1888, he studied under A. Passaglia and sculpted figures and groups.

VIGOUREUX, Pierre Octave 1884-
Born in Avallon, France, on April 4, 1884, he studied under Hector Lemaire and exhibited at the Salon des Artistes Français from 1906 onwards. He got an honourable mention in 1907 and a third class

medal in 1909. He was awarded a travelling scholarship in 1913 and became a Chevalier of the Légion d'Honneur in 1936, crowning his career with a gold medal at the Exposition Internationale the following year. He is best remembered for the war memorial in Avallon, but his minor works include such genre figures and groups as Idyll, The Sower, Sale of the Pig, Haymaker at Rest, Reapers Resting, Two Washerwomen, Cooper and Digger. Examples of his work are in the Museum of Modern Art, Paris.

VIGRESTAD, Magnus 1887-
Born in Stavanger, Norway, on April 12, 1887, he was influenced by Vigeland and specialised in figures and bas-reliefs depicting seamen.

VIK, Ingebrigt Hansen 1867-1927
Born in Vikör i Hardanger, Norway, on March 5, 1867, he died in Oslo on March 22, 1927. He studied at the Copenhagen Academy and was a pupil of Injalbert in Paris. He exhibited at the Salon des Artistes Français, getting an honourable mention in 1904. He specialised in genre figures portraying adolescents, such as Young Girl (Budapest), Young Man and Young Girl (Oslo Museum) and Workman (Bergen).

VIKSTRÖM, Emil 1864-
Born in Abo, Finland, on April 13, 1864, he worked in Helsinki as a decorative sculptor but also sculpted memorials and portrait busts. Examples of his sculpture are in the museums of Abo and Helsinki.

VILIGIARDI, Arturo 1869-
Born in Siena on July 27, 1869, he studied at the Academy in that city and worked as a painter, architect and sculptor on the churches of Rome and Fiori Cathedral.

VILLA, Federico Gaetano 1837-1907
Born in Rome in 1837, he died in Schianno in 1907. He specialised in genre figures, often with classical overtones, such as his Young Girl of Pompeii (Brera Academy Museum, Milan).

VILLANI, Emmanuele fl. 19th century
Italian decorative sculptor of the late 19th century. He exhibited bas-reliefs at the Paris Salons and got an honourable mention at the Exposition Universelle of 1889.

VILLEMINOT, Louis 1826-c.1914
Born in Paris on September 14, 1826, he died about 1914. He exhibited at the Salon from 1850 to 1875.

VILLEMOTTE, Jacques d.1746
Ornamental sculptor and bronze founder of French origin working in Munich from 1718 till March 1746 when he died. He was employed as a decorative sculptor by the Ansbach Court.

VILLENEUVE, Jacques Louis Robert 1865-1933
Born in Bassan, France, on January 1, 1865, he died in Paris in February 1933. He was a pupil of Thomas and Injalbert and exhibited at the Salon des Artistes Français, winning third class (1897), second class (1899) and first class (1904) medals. He was awarded a silver medal at the Exposition Universelle of 1900 and the Légion d'Honneur in 1906. He produced classical, heroic and historical scenes and genre groups, including the Battle of Muret, Fiat Volontas Tua, Prometheus Enchained and The Republic. He also sculpted numerous busts of his contemporaries.

VILLIERS, Roger de 1887-
Born at Châtillon-sur-Seine on June 19, 1887, he studied under Mercier and Peter and exhibited figures at the Salon des Artistes Français from 1910 onwards. His awards include a bronze medal (1920), a silver medal (1922), a gold medal (1927) and a grand prix at the Exposition Internationale of 1937.

VILLODAS, Alejandro fl. 19th-20th centuries
Spanish genre sculptor active at the turn of the century. He was a son of the painter Ricardo Villodas.

VILON, François 1902-
Born in Lourdes on June 8, 1902, he studied under Michelet and J. Boucher. He exhibited portraits and figures at the Salon des Artistes Français, winning a bronze medal and a travelling scholarship in 1934 and a silver medal at the 1937 Exposition.

VILT, Tibor 1905-
Born in Budapest on December 15, 1905, he specialised in busts and portrait statuary. His sculpture may be found in the museums of Budapest.

VIMERCATI, Luigi 1828-1893
Born in Milan in 1828, he died there in 1893. He exhibited figures and groups in Milan, Turin and Rome from 1861 to 1884.

VIMEUX, Jacques Firmin 1740-1828
Born in Amiens on January 12, 1740, he died there on January 30, 1828. He sculpted statues and bas-reliefs for Amiens cathedral and many of the churches in that area.

VINCENT, Charles 1862-1918
Born in Rouen in 1862, he died there on July 3, 1918. He studied under Falguière and Mercié and became an Associate of the Artistes Français in 1903. He specialised in religious and genre figures and groups. His statuette The Shepherd is in Rouen Museum.

VINÇOTTE, Thomas Jules, Baron de 1850-1925
Born at Borgerhout, Belgium, on January 8, 1850, he died in Brussels on March 25, 1925. He studied under J.J. Jaquet and attended classes at the Brussels Academy and the École des Beaux Arts, Paris. Later he worked for some time in Italy before settling in Brussels. He was successively professor of sculpture at the academies of Antwerp and Brussels and a member of the Corps Académique from 1901 till his death. He exhibited widely, and won a third class medal in Paris (1874) and showed at the Royal Academy in 1881. He sculpted numerous portrait busts of classical, historical and contemporary celebrities and Belgian royalty. Antwerp Museum has his figure of a Goat.

VINCZE, Paul 1907-
Born at Galgagyork, Hungary, on August 15, 1907, he studied at the State School of Arts and Crafts in Budapest and worked with E. Telcs from 1924 to 1935. He continued his studies in Rome (1935-37) and then settled in England, but now commutes between London and France. He has exhibited widely in Britain and on the continent and though best known as a medallist has also sculpted busts and bas-reliefs. His work is represented in several public collections in Britain.

VIRIEU, Paul 1826-1880
Born at Grand-Lemps, France, in 1826, he died in Grenoble in September 1880. He studied under M. Lequesne and exhibited at the Salon from 1850 to 1869. Grenoble Museum has his statue of Cain and a figure of a Young Woodcutter.

VIRIEUX, François Louis fl. early 20th century
Born in Naples of French parents in the second half of the 19th century, he exhibited figures at the Salon des Artistes Français, winning an honourable mention in 1905.

VIRION, Charles Louis Eugène 1865-
Born in Ajaccio, Corsica, on December 1, 1865, he studied under P. Aubé and C. Gauthier. He exhibited at the Salon des Artistes Français from 1886 and got an honourable mention in 1893 and a third class medal in 1895. He was awarded a bronze medal at the Exposition Universelle of 1900. He specialised in animal figures and groups and also produced medals and pottery. His sculpture is preserved in the museums of Calais, Nemours, Rochefort and St. Dizier.

VISSER, Carel Nicolaas 1928-
Born at Papendrecht, near Rotterdam, in 1928, he studied architecture in Rotterdam and sculpture at the Hague Academy and spent some time in Britain and Spain. He won a travelling scholarship in 1957, enabling him to continue his studies in Sicily and Sardinia before settling in the Netherlands. His earlier works consist of figures of animals and birds, mostly executed in galvanised iron, but latterly he has turned to pure abstract forms in iron, wood and concrete.

VISSER, Tijpke 1876-
Born in Workum, Holland, on December 12, 1876, he was self-taught and sculpted a large number of allegories, statues, memorials, tombstones, nudes and animal figures and groups. His works include The Eternal Rebirth, Penguin (Boymans Museum), Penguin and Seagull (Amsterdam Municipal Museum).

VITAL-CORNU, Charles c.1851-1927
Born in Paris about 1851, he died there in 1927. He studied under Pils and Jouffroy and began exhibiting painting and sculpture at the Salon des Artistes Français in 1880, winning honourable mentions in 1880-81, a third class medal in 1882 and a travelling scholarship in 1886. He was awarded bronze and silver medals at the Expositions of 1889 and 1900 respectively and became a Chevalier of the Légion d'Honneur in 1896. He produced allegorical and classical figures, such as The Child Narcissus, Archimedes, The Dawn, Spleen and Good Harvests.

VITALE, Giuseppe 1875-1911
Born at San Giacomo degli Schiavoni, Italy, on January 11, 1875, he died in Naples in 1911. He studied under R. Balliazzi and worked in Naples as a decorative sculptor.

VITALI, Giovanni 1794-1855
Born in St. Petersburg in 1794 of Italian parents, he died in Moscow on July 28, 1855. He studied under Paolo Triscornia and Ivan Timofieff in Moscow and worked as a decorative sculptor in that city. His minor works include genre and classical statuettes, such as Venus (Russian Museum, Leningrad).

VITERBO, Davio 1890-
Born in Florence on January 25, 1890, he studied at the Florence Academy and was strongly influenced by Rodin. He worked for several years in France and exhibited at the Salon des Artistes Français, the Salon des Tuileries and also in Florence and Berlin. He was also represented at the international exhibitions in Venice, Dresden and Rome before the second world war.

VITOLO, Uriele fl. 19th century
Born in Avellino, Italy, on January 14, 1831, he studied at the Naples Academy and was a pupil of Gennaro Cali. He specialised in portrait busts, bas-reliefs and memorials.

VITSARIS, J. fl. late 19th century
Greek sculptor of genre and classical figures and reliefs. He got an honourable mention at the Exposition Universelle of 1889.

VITTOR, F. fl. 19th-20th centuries
American sculptor of portrait busts, statues and memorials working in Philadelphia at the turn of the century. His best known work is the statue of Colonel George Washington on the site of the battle of Braddock's Field, Pennsylvania.

VITTOZ fl. 19th century
Nothing is known of the sculptor whose signature appears on two bronzes, of the Flood and Laocoon, in Sydney Museum.

VITULLO, Sesostris 1899-1953
Born in Buenos Aires in 1899, he died in Paris in 1953. He studied for a short time at the Buenos Aires School of Art but was dissatisfied with the academic approach and thereafter worked on his own. He turned from painting to sculpture after seeing an exhibition of Rodin's work in Buenos Aires and in 1925 he went to Paris, where he spent the rest of his life. He was strongly influenced by Rodin and Bourdelle throughout his career, but also brought the cultural background of Latin America to bear on his sculpture. He had a one-man show at the Galerie Jeanne Bucher in 1945 and a retrospective exhibition at the Musée d'Art Moderne in 1952. Most of his abstracts and semi-figurative works were carved direct in wood or stone.

VIVROUX, André fl. 18th century
Born in Liège in 1749, he was the son and pupil of the stone-carver Jacques Vivroux. He specialised in religious statuary and portrait busts and exhibited in Liège from 1781 onwards.

VLAD, I. fl. 20th century
Romanian portrait sculptor working in Bucharest.

VLIEN, J. fl. 19th century
French sculptor of the mid-19th century. He produced bas-reliefs, roundels, plaques and medallions portraying his contemporaries.

VLOORS, Émile 1871-
Born in Borgerhout, Belgium, on August 31, 1871, he studied under Albert de Vriendt at the Antwerp Academy and Bonnat at the École des Beaux Arts in Paris. He exhibited internationally at the turn of the century and received awards at the Rome and Munich exhibitions as well as the Brussels Exposition of 1910. He became director of the Antwerp Academy and sculpted a number of monuments and statues in Antwerp as well as the decoration for the Antwerp Opera House. His minor works include allegorical figures and groups.

VOCKE, Alfred 1886-
Born in Breslau on April 24, 1886, he studied under T. von Gosen and attended classes at the Breslau Academy. He specialised in bas-reliefs and medallions, but the Breslau Museum also had his genre group Nocturnal Accents.

VOETEN, Emilius 1898-
Born in Rotterdam in 1898, he attended the Academy in that city and has a studio there. He produced figurative sculpture in wood, ivory, plaster and bronze, but since 1949 has concentrated on abstracts in the same media.

VOGEL, August d.1932
German genre sculptor who died in Berlin on November 10, 1932. He exhibited in Berlin and at the Paris Salons and won a silver medal at the Exposition Universelle of 1900.

VÖGELE, Anton 1860-1924
Born in Innsbruck, Austria, on June 10, 1860, he died in Buenos Aires on September 23, 1924. He studied at the Vienna Academy and in 1884 settled in the Argentine, where he worked as a decorative sculptor.

VOGL, Franz 1861-
Born in Vienna in 1861, he studied under Hellmer and Weyr at the Academy and specialised in busts, memorials, bas-reliefs and monumental statuary.

VOGT, Adelgunde (née Herbst) 1811-1892
Born in Copenhagen on July 17, 1811, she died there on June 10, 1892. She was an Animalier sculptor, specialising in figures of horses.

VOGT, Gundo Sigfred 1852-1939
Born in Copenhagen on June 3, 1852, he died at Selchausdal on January 23, 1939. He was the son of Adelgunde Vogt and worked with her.

VOISON-DELACROIX, Alphonse 1857-1893
Born in Besançon on September 9, 1857, he died in Paris on April 3, 1893. He exhibited heads and busts of his contemporaries at the Salon des Artistes Français.

VOITURON, Albert Joseph 1787-1847
Born in Ghent on August 4, 1787, he died there on March 25, 1847. He studied at the Ghent Academy and specialised in portrait busts and small ornamental sculpture.

VOKES, Albert Ernest 1874-
Born in 1874, he worked in London as a landscape and portrait painter and a sculptor of busts and heads in bronze. He exhibited at the Royal Academy and other London galleries.

VOLK, Leonard Wells 1828-1895
Born in Wellstown, U.S.A., on November 7, 1828, he died in 1895. He sculpted many monuments for American towns, particularly historical bas-reliefs and groups. The Metropolitan Museum of Art in New York has his bronze bust of Abraham Lincoln.

VOLKMANN, Arthur Joseph Wilhelm fl. late 19th century
Born in Leipzig on August 28, 1851, he studied under Hahnel at the Dresden Academy (1870-73) and Wolff in Berlin (1873-76) before settling in Rome. He specialised in busts of contemporary celebrities as well as unknown models. His genre figures include Young Archer, Cavalier and Bishop Germanus the Hunter.

VOLL, Christoph 1897-1939
Born in Munich on April 25, 1897, he died in Karlsruhe on June 16, 1939. He worked in Bavaria and Württemberg as a decorative sculptor. The Karlsruhe Kunsthalle has his bust of a Young Girl.

VOLMAR, Joseph Simon 1796-1865
Born in Berne on October 26, 1796, he died there on October 6, 1865. He was the son and pupil of the painter Georg Johann Volmar and also studied under Horace Vernet. He became professor of

painting at Berne and exhibited landscapes, animal and genre subjects at the Paris Salon from 1824 to 1827. He also dabbled in animal sculpture, mainly horses.

VOLTEN, André 1925-
Born in Andijk, Holland, in 1925, he spent several years working as a painter abroad before settling in Amsterdam in 1950. In 1953 he took up sculpture and now produces abstracts welded and rivetted together – techniques he learned from the naval yards in Amsterdam. His abstracts are severely geometric in construction.

VOLTI, Antoniucci 1915-
Born in Albano, Italy, in 1915, he came from a family of stone-carvers. He studied at the Nice School of Decorative Arts and the École des Beaux Arts, Paris, and worked for a time in the studio of Jean Boucher. He became a naturalised Frenchman and was conscripted into the army in 1937. He was captured by the Germans in the opening campaign of the second world war and not released from prison camp till 1943. On his return to Paris he found that his studio and its contents had been destroyed in an air raid. This forced him to start from scratch and marked a turning point in his career. Though still figurative, his works became more impressionistic. His figures were at first carved direct in stone, but in more recent years he has turned to modelling in clay for bronze-casting. He teaches at the School of Applied Arts in Paris and had a major retrospective exhibition at the Maison de la Pensée Français in 1957.

VONMETZ, Karl 1875-
Born in Storo, Austria, on July 8, 1875, he worked as a sculptor and modeller in Innsbruck.

VONNOH, Bessie Potter 1872-1955
Born in St. Louis, Missouri, on August 17, 1872, she died in New York in 1955. She studied at the Art Institute of Chicago under Lorado Taft and became a member of the National Sculpture Society in 1898 and married the painter Robert Vonnoh the following year. She won a bronze medal at the Exposition Universelle of 1900 and a silver medal at the Panama-Pacific International Exposition of 1915 and was elected to membership of the National Academy of Design in 1921. She specialised in genre and allegorical figures and groups, including Allegresse, a group of three dancing figures (Detroit Institute of Art), La Petite, Will-o-the-Wisp, Figure for Bird Bath, Motherhood, Adolescence and Young Mother. She also sculpted a number of bas-reliefs and medals. Her work is represented in the Chicago Art Institute, the Metropolitan Museum of Art, New York, the Brooklyn Museum and the Corcoran Art Gallery, Washington.

VORDERMAYER, Ludwig 1868-
Born in Munich on December 25, 1868, he studied in Berlin and was a pupil of Rheinhold Begas. Later he worked in Italy for some time before settling in Berlin. He specialised in bronzes of animals and birds, examples of which are in the museums of Berlin and Hamburg.

VOSMIK, Vincenz 1860-
Born in Humpolei, Bohemia, on April 5, 1860, he worked in Prague as a decorative sculptor. He got an honourable mention at the Exposition Universelle of 1900.

VOSS, Karl 1825-1896
Born in Dunnwald, Germany, on November 5, 1825, he died in Bonn on August 22, 1896. He worked in Rome from 1850 to 1894 and specialised in classical groups.

VOTOCEK, Heinrich 1828-c.1861
Born at Forst near Hohenelbe, Germany, on December 8, 1828, he died about 1861. He studied in Dresden and Prague and specialised in religious figures and bas-reliefs.

VOUKA – see VELIMIROVIC, Vukosava

VOYEZ, Émile d.1895
Born in Paris, where he also died in 1895. He studied under Duret, Lequesne, Guillaume and Cavelier and exhibited allegorical and genre figures and groups at the Salon from 1873 to 1892. His figure of Evening is in Castres Museum.

VOYMONT, Hippolyte fl. 19th century
Born in Dunkirk on February 8, 1810, he specialised in busts of Napoleonic generals and statuettes of soldiers of the Napoleonic period.

VOZZAOTRA, Pietro fl. 18th century
Born at Massa, Italy, in the early years of the 18th century, he worked as a sculptor and bronze-founder for the Abbey of Monte Cassino.

VREESE, Constant de 1823-1900
Born in Courtrai on June 5, 1823, he died there on November 22, 1900. He studied at the local Academy and worked as a decorative sculptor on the Town Hall and other buildings in Courtrai. The Courtrai Museum has his figure of a Sleeping Child.

VREESE, Godefroid de 1861-
Born in Brussels in 1861, he was the son and pupil of Constant de Vreese. He produced classical bas-reliefs, such as The Death of Caesar, statuettes of children, animal figures and groups and medallions.

VROUTOS, Georgios fl. 19th-20th centuries
Born in Athens in the second half of the 19th century, he sculpted genre and portrait subjects. He won a bronze medal at the Exposition Universelle of 1900.

VUCETIC, Pasko 1871-1925
Born in Split (Spalato) on February 17, 1871, he died in Belgrade on March 19, 1925. He studied at the academies of Vienna and Munich and worked in Belgrade as a painter and sculptor of religious subjects. During and after the first world war, however, he also sculpted figures and groups of soldiers and produced a number of war memorials.

VUCHETICH, E. fl. 20th century
Russian sculptor of Yugoslav origins, specialising in allegorical subjects with a propaganda element, such as Swords into Ploughshares.

VYSE, Charles 1882-
Born in London on March 16, 1882, he worked there as a sculptor and potter in the early years of this century.

WAAGEN fl. 19th century
This signature, found on animal bronzes of horses, dogs, sheep and similar subjects, is thought to be that of a German sculptor active in the 1860s. A group of Shepherds with a Dead Wolf is in the Sheffield Museum.

WACKERLE, Joseph 1880-
Born in Partenkirchen, Germany, on May 15, 1880, he studied at the Munich Academy and worked in Italy for some time. He sculpted figurines and statuary, memorials, altars and fountains in many parts of Germany.

WADE, George Edward 1853-1933
Born in London in 1853, he died there on February 5, 1933. He was educated at Charterhouse but was self-taught as an artist. He exhibited at the Royal Academy and other leading galleries in London from 1887 onwards and sculpted a number of statues of royalty and British politicians. His minor works include bronze statuettes of guardsmen and other military subjects, and portrait busts and heads.

WADERE, Heinrich 1865-
Born in Colmar, Germany, on July 2, 1865, he worked in France and became a professor at the École des Beaux Arts, Paris. He exhibited busts and heads in marble and bronze at the Salon and won an honourable mention in 1895 and a bronze medal at the Exposition Universelle of 1900. A prolific portrait sculptor, many of his works are preserved in the museums of Colmar, Mulhouse and Munich.

WAGNER, Adolf 1884-
Born in Rohrbach, Austria, on February 2, 1884, he studied in Vienna and exhibited statuettes and busts there from 1920 onwards.

WAGNER, Anton Paul 1834-1895
Born at Königinhof, Austria, on July 3, 1834, he died in Vienna on January 26, 1895. He studied under Josef Max in Prague and later attended classes at the Vienna Academy. He sculpted allegorical groups, fountains, portrait busts and statues in Vienna and Prague.

WAGNER, Ernest 1877-
Born in Cilli, Austria, on February 2, 1877, he studied under Bitterlich at the Vienna Academy and worked as a writer, engraver, painter and sculptor. His sculpture consists mainly of female figures, nudes, dancers and athletes.

WAGNER, Frank Hugh 1870-
Born in Milton, U.S.A., on January 4, 1870, he studied under Freer, John Vanderpoel and C. von Saltza and worked in Sangatouk as a painter, illustrator and sculptor of genre subjects.

WAGNER, Karl Christopher fl. early 19th century
Decorative sculptor working in Stockholm from 1816 to 1818.

WAGNER, Siegfried 1874-
Born in Hamburg on April 13, 1874, he studied at the Copenhagen Academy and sculpted portrait busts and memorials in Denmark. Examples of his work are in the National Museum in Copenhagen.

WAGNER, Theodor 1800-1880
Born in Stuttgart on March 21, 1800, he died there on July 10, 1880. He studied under Dannecker and sculpted busts and statues of historical and contemporary German personalities.

WAHL, Joseph the Elder c.1760-1833
Born in Strasbourg about 1760, he died there in 1833. He was a decorative sculptor, employed in the restoration of Strasbourg cathedral.

WAHL, Joseph the Younger fl. 19th century
Born in 1803, he was the son and assistant of the above.

WAHLBON, Johannes Wilhelm Carl 1810-1858
Born in Kalmar, Sweden, on October 16, 1810, he died in London on April 23, 1858. He began as a sculptor but later turned to portrait painting, engraving and drawing in the style of Winterhalter. His sculpture consists of portrait busts and genre figures.

WAIN-HOBSON, Douglas 1918-
Born in Sheffield, Yorkshire, on August 12, 1918, he studied at the Royal College of Art in 1938-40 and 1946-47 and then returned to Sheffield. He has exhibited sculpture in stone, wood and terra cotta at the Royal Academy and the major London and provincial galleries, and participated in international exhibitions.

WAKEMAN, Robert C. 1889-
Born in Norwalk, Connecticut, in 1889, he studied at the Yale University School of Fine Arts and sculpted figures and reliefs, mainly in marble.

WALCH, Adam fl. 19th century
Decorative sculptor working at Veszprem, Hungary, in the 1830s.

WALCH, Charles 1896-1948
Born in Thann on August 4, 1896, he died in Paris on December 12, 1948. He was a child prodigy who excelled in both painting and sculpture from an early age and won a state scholarship which brought him to Paris, where he studied at the School of Decorative Arts under F. Desnoyer. Later he attended the École des Beaux Arts and was appointed professor of drawing there in 1923. He began exhibiting at the Paris Salons in 1925 and won a gold medal at the Exposition Internationale in 1937. In the same year he had his first one-man show. He became a Chevalier of the Légion d'Honneur in 1948, shortly before his death in a fall from his horse. His paintings, engravings and sculpture are preserved in many French museums.

WALCHER, Jacques François 1793-1877
Born in Paris on July 12, 1793, he died there in 1877. He studied at the École des Beaux Arts, Paris, and specialised in statuettes of French historical personalities.

WALCHER, Philippe Jacob d.1835
Elder brother of the above, he was born in Lorraine about 1770 and settled in Paris in 1785. He worked as a decorative sculptor.

WALCHER, Joseph Adolphe Alexandre fl. 19th century
Born in Paris on October 20, 1810, he studied under Cortot at the École des Beaux Arts and exhibited figures at the Salon from 1840 to 1849

WALD, Jakob 1860-1903
Born at Mauthen, Austria, on July 25, 1860, he died in Klagenfurt on December 29, 1903. He studied under Rudolf Weyr in Vienna and worked as a decorative sculptor in Klagenfurt.

WALDBERG, Isabelle 1917-
Born at Ober Stammheim, Switzerland, in 1917, she studied in Zürich under Hans Meyer from 1934 to 1936, then went to Paris, where she worked in the studios of Gimond, Wlérick and Malfray. Later she spent some time in Florence and then abandoned sculpture for a time while she took up the study of ethnography at the Sorbonne. Up to 1942 she concentrated on nude modelling, but was then converted to surrealism on visiting an exhibition of Giacometti's work in New York. She had her first individual show at the Peggy Guggenheim Gallery in New York the following year. She returned to Paris in 1945 and participated in the international surrealist exhibition at the Galerie Maeght in 1947. Since then she has reverted to representational sculpture. She has also written many articles on contemporary sculpture.

WALDEMANN, Oscar fl. 19th-20th centuries
Born in Geneva on June 25, 1856, he studied under Gardet in Paris. He exhibited animal figures at the Salon from 1885 onwards, getting an honourable mention in 1891 and a silver medal at the Exposition Universelle of 1900. His allegorical group The Victory of Art over Force is in the Art Museum in Geneva.

WALKER, Arthur George 1861-1939
Born in London on October 20, 1861, he died there on September 13, 1939. He studied at the Royal Academy schools from 1883 onwards and won a number of medals and prizes. He began exhibiting at the Royal Academy in 1884 and was elected A.R.A. in 1925 and R.A. in 1936. He worked in London as a book illuminator, mosaic designer and sculptor of monuments, bas-reliefs and small figures.

WALKER, Ethel 1867-
Born in Edinburgh in 1867, she studied at the Slade School and worked in London as a painter of landscapes and still life, and as a decorative and genre sculptress.

WALKER, Hilda Annetta fl. early 20th century
Genre sculptress and watercolourist working in Mirfield, Yorkshire, in the 1920s. She exhibited at the Royal Academy and the Salon des Artistes Français, as well as the main London and provincial galleries.

WALKER, Nellie Verne 1874-
Born in Red Oak, U.S.A., in 1874, she studied under Lorado Taft at the Art Institute of Chicago and specialised in large ideal groups and portrait busts.

WALKER, Sophia A. fl. 19th century
Born at Rockland, U.S.A., on June 22, 1855, she studied in Paris under Lefebvre and worked in the United States as a painter, etcher and sculptor of genre subjects.

WALLENBERG, Axel Gerson 1898-
Born in Nässjö, Sweden, on May 22, 1898, he studied at the Stockholm Academy and produced portrait busts, statuettes, fonts, bas-reliefs and altar pieces.

WALLER, Edvard 1870-1921
Born in Uppsala, Sweden, on March 22, 1870, he died in Paris on March 13, 1921. He studied under Injalbert and Rodin in Paris and exhibited in Paris and Stockholm from 1906 onwards. He specialised in busts and statuettes of his artistic and literary contemporaries.

WALLET, Georges fl. late 19th century
Born in Elbeuf in the mid-19th century, he exhibited figures and groups at the Salon des Artistes Français, becoming an Associate in 1889 and getting an honourable mention in 1894.

WALLIS, Katherine Elizabeth fl. early 20th century
Born in Peterborough, Canada, in the second half of the 19th century, she studied in London and Paris at the turn of the century and exhibited at the Royal Academy, the Nationale and the Salon des Artistes Français, as well as the leading galleries in Liverpool, Glasgow, Ottawa and Montreal. She got an honourable mention at the Exposition Universelle in 1900. She specialised in genre and light romantic figures and groups, such as Mon Petit Chou (Walker Gallery, Liverpool).

WALSLEBEN, Emil d.1887
Sculptor of statuettes and groups of historical subjects working in Berlin, where he died in 1887.

WALTER, Edgar 1877-
Born in San Francisco in 1877, he studied at the Mark Hopkins Institute of Art in that city and went to Paris, where he was a pupil of Perrin and Cormon. He exhibited at the Salon from 1899 onwards and got an honourable mention two years later. He was a member of the jury at the Panama-Pacific International Exposition in 1915. His bronzes include Primitive Man (Metropolitan Museum of Art) and Nymph and Bears.

WALTER, Valerie fl. 20th century
Born in Baltimore, Maryland, she studied at the Maryland Institute and then worked for some time in Paris. She specialised in genre figures, such as The Dip and portrait bas-reliefs and busts.

WALTHER, Louis Clemens Paul 1876-
Born in Meissen, Saxony, on October 28, 1876, he was self-taught and specialised in animal figures and groups. His works include Heron, Deer, Pheasant, Antelope, Magpie, Crane and various groups of Parrots.

WALTON, Cecile 1891-1956
Born in Glasgow on March 22, 1891, she died in Edinburgh on April 26, 1956. She was the daughter of the painter E.A. Walton and studied in London, Edinburgh, Paris and Florence. She won the Guthrie Prize of the Royal Scottish Academy. She married the painter Eric H.M. Robertson and exhibited at the Royal Academy, the Royal Scottish Academy and the leading British and French galleries. She worked in Edinburgh as a painter, illustrator and sculptor of portraits and genre subjects.

WANDAHL, Finn 1859-
Born in Copenhagen on August 7, 1859, he studied under Anders Bundgaard and worked in Gentofte as a painter and sculptor of genre subjects.

WANDSCHNEIDER, Wilhelm 1866-
Born in Plau, Germany, on June 6, 1866, he studied at the Berlin Academy and sculpted numerous memorials, monuments and religious groups in different parts of Germany. His minor works include Youth (Dortmund Museum), Wounded Warrior and Cain and Abel (Schwerin Museum).

WARBURG, Eugène fl. 19th century
Born in New Orleans in 1825, he studied in Europe and died young.

WARD, Herbert fl. 19th-20th centuries
Born in London in the mid-19th century, he died there on August 7, 1919. He was an amateur painter and sculptor whose main career was as an explorer and travel writer. His chief claim to fame was that he was a survivor of H.M. Stanley's ill-fated expedition for the relief of Emin Pasha. His books include Five Years with the Congo Cannibals, My Life with Stanley's Rear Guard (1891), A Voice from the Congo (1912) and Mr. Poilu (1916). He lived in London, Paris and Rolleboise in France.

WARD, John Quincy Adams 1830-1910
Born in Urbana, Ohio, on June 29, 1830, he died in New York on May 1, 1910. He was the brother of the painter Edgar Ward and studied under Henry K. Brown in New York from 1850 to 1857. He established his own studio there in 1861 and specialised in portrait sculpture, though he also made a reputation as a sculptor of the Indian way of life. He became a member of the National Academy of Design in 1863 and was its president in 1872-73. He received many commissions for monuments and statuary all over the United States. Examples of his portrait busts are in the Metropolitan Museum of Art, New York.

WARNEKE, Heinrich 1895-
Born in Germany on June 30, 1895, he emigrated to the United States and worked in New York as a decorative sculptor.

WARNER, Olin 1844-1896
Born in New Suffield, U.S.A., in 1844, he died in New York on August 14, 1896. He studied in New York and then went to Paris. where he worked in the studios of Jouffroy and Carpeaux before returning to New York in 1872. He sculpted many busts of his contemporaries but is best known for his bas-reliefs and large medallion portraits. In 1889 he sculpted a series of Indian figures and medallions, following a trip through the North-western Territories. He produced several full-scale sculptures in the neo-classical idiom, such as Diana (1884) and The Night (Metropolitan Museum of Art).

WARNER, Stefano fl. late 19th century
Italian sculptor working in Trentino in the late 19th century. He is chiefly noted for tombs, altar-pieces and decorative sculpture in Trent cathedral.

WAROQUIER, Henry de 1881-
Born in Paris on January 8, 1881, he worked as a painter, engraver and sculptor influenced by Fauvism and Cubism. His sculpture is preserved in the Musée d'Art Moderne, Paris.

WAROQUIEZ, Paul 1888-
Born in Paris on October 10, 1888, he studied under Mercié and exhibited groups and figures at the Salon des Artistes Français from 1913 onwards.

WASILKOWSKI, Leopold 1865-1929
Born in Lublin, Poland, on December 24, 1865, he died in Warsaw on October 15, 1929. He studied in Paris at the Académie Julian and specialised in ecclesiastical sculpture and memorials in Warsaw and Wilno.

WASLEY, Léon John 1880-1917
Born in Paris in 1880, he was killed at Verdun on March 22, 1917. He exhibited figures and groups of religious subjects at the Salon from 1906 to 1914.

WASSILIEFF, Marie 1894-
Born in Smolensk, Russia, in 1894, she studied at the St. Petersburg Academy and the École des Beaux Arts, Paris, and was a pupil of Matisse in 1907. She settled in Montmartre after the first world war but also lived in Poland, Romania and Spain for some time. She exhibited at the Paris Salons in the 1920s and at the Royal Academy in 1928-30 and participated in the Exposition d'Arts Décoratifs in 1925 and the Exposition Internationale of 1937. She specialised in busts and statuettes of contemporary celebrities.

WASSLER, Josef 1841-1908
Born in Lana in the south Tyrol on February 14, 1841, he died in Meran (Merano) in 1908. He studied under Pendl in Merano and specialised in ecclesiastical sculpture in the neo-gothic idiom.

WATAGIN, Vassili Alexeivich 1884-
Born in Moscow on January 2, 1884, he specialised in animal figures which he painted and engraved as well as sculpted.

WATERS, George Fite 1894-
Born in San Francisco on October 6, 1894, he was a pupil of the Art Students' League, New York, and worked with Rodin in Paris. He became a member of the American Artists' Association and the Société Moderne in Paris. He specialised in portrait reliefs, busts and heads.

WATKIN, Gaston 1920-
Born in Toulouse in 1920, he won the Prix de Rome in 1946 and became a member of the Evolution Group in 1955. He is an Associate of the Salon d'Automne.

WATKINS, Jesse 1899-
Born in Gravesend, Kent, on December 31, 1899, he studied in London and now works as a figure and portrait sculptor at New Barnet, Hertfordshire.

WATKINS, Joseph 1838-1871
Born in Fermanagh, Northern Ireland, in 1838, he died in Dublin on November 22, 1871. He studied at the Dublin Academy and was a pupil of Baompani in Rome. He worked as a painter and sculptor of portraits and exhibited at the Royal Academy in 1867-70.

WATRINELLE, Antoine Gustave 1818-1913
Born in Verdun on October 24, 1818, he died at Oustreham in June 1913. He studied under Toussaint and was runner-up in the Prix de Rome in 1858. He exhibited at the Salon in 1859-60 only and specialised in busts and statuettes of his contemporaries. He also sculpted allegorical figures, such as Springtime.

WATSON, Mary Spencer 1913-
Born in London in 1913, she was the daughter of the painter G. Spencer Watson. She studied at the Slade School (1931-32) the Royal Academy schools (1932-36), the Central School of Arts and Crafts (1936) and the École des Beaux Arts, Paris, (1938). She has a studio in Langton Maltravers, Dorset, and sculpts mainly in stone, terra cotta and wood. She has exhibited at the Royal Academy and leading London galleries.

WATTS, George Frederick 1817-1904
Born in London on February 23, 1817, he died at Limmerlease, Compton, Surrey, on July 1, 1904. Apart from a very brief attendance at the Royal Academy schools he was self-taught, though strongly influenced by ancient Greek sculpture. His reputation rests mainly on his historical and portrait painting and at the height of his career his genre pictures enjoyed enormous popularity. His pictures have a sculptural rather than pictorial quality and it is evident that sculpture was his natural metier. He visited the studio of Behnes but never received any instruction from him as is sometimes implied. He sculpted monuments to the Marquis of Lothian, Lord Tennyson, and Bishop Lonsdale. His large equestrian figure entitled Physical Energy was dedicated to the memory of Cecil Rhodes and now stands in the Matopo Hills, Rhodesia; a cast is in Kensington Gardens, London. The best known of his portrait busts is that of Clytie (1868). Watts was elected both A.R.A. and R.A. in 1867 — a record in meteoric artistic promotion. He twice declined a baronetcy, but became one of the original twelve members of the Order of Merit when it was instituted in 1902. With his second wife, Mary Fraser-Tytler, he was closely connected with the promotion of the Home Arts and Industries Association and founded an art pottery at Compton, Surrey. He exhibited widely abroad and won a first prize and the Légion d'Honneur at the Exposition Internationale of 1878.
Ady, Julia Cartwright *G.F. Watts, Royal Academician, His Life and Work* (1896). Barrington, Mrs. *George F. Watts* (1905). Bateman, Charles T. *G.F. Watts, RA* (1901). Britten, W.E.T. *The Work of George Frederick Watts, in Architectural Review* (1888-89). Chesterton, G.K. *George F. Watts* (1905). Pantini, G. *George Frederick Watts* (1904). Watts, Mary *The Life of George F. Watts* (1912).

WATTS, Peter 1916-
Born in Chilcompton, Bath, on October 12, 1916, he studied at the Bath School of Art (1937-38), the City and Guilds School of Art, Kennington (1938-39) and was a pupil of P. Lindsey Clark. He works mainly in stone and wood and has exhibited widely in Britain and the United States. He has a studio near Bath.

WATZAL, Johannes 1887-
Born in Eger, Austria, on February 22, 1887, he studied at the Vienna School of Fine Arts and specialised in monuments, memorials, statues and portrait busts.

WAUGH, Sidney fl. 20th century
American sculptor of portrait medallions and busts, both historical and contemporary.

WAUQUIER, Étienne Omer 1808-1869
Born in Cambrai, Belgium, on October 16, 1808, he died in Mons on April 4, 1869. He studied at the Mons Academy and worked in Belgium and France as a painter, lithographer and sculptor. He exhibited at the Paris Salon from 1843 onwards and specialised in busts and statuettes of his contemporaries.

WEBB, Cecilia 1888-1957
Born in Stamford, Lincolnshire, on March 25, 1888, she died at Melton Mowbray, Leicestershire, in 1957. She sculpted figures in clay, plaster and bronze and exhibited at the Royal Academy, the Royal Scottish Academy, the Glasgow Institute and the Paris Salons in the inter-war period.

WEBB, Mahala Theodora 1887-
Born in Stamford, Lincolnshire, on May 6, 1887, she was the elder sister of the above. She studied under Alyn Williams and then went to the Grosvenor School of Art under Walter Donne (1904). She worked with her sister in Melton Mowbray, as a miniature painter and portrait sculptor. Her work is signed 'Dora Webb'.

WEBB, William John Seward fl. 19th century
Born in Exeter, Devon, in 1843, he studied under J. Gendall in that town and then attended the Royal Academy schools. He exhibited romantic figures and portraits at the Royal Academy from 1870 onwards.

WEBB-GILBERT, Charles 1869-1925
Born in Talbot, Australia, in 1869, he died in London on October 3, 1925. He was one of the leading Australian sculptors at the turn of the century, though largely self-taught. He is best remembered for the war memorial at St. Quentin, France. His minor works include portrait busts and genre figures, such as The Critic (Tate Gallery).

WEBER, Ella 1860-
Born in Vienna on October 25, 1860, she studied under R. Geyling in Vienna and Puech in Paris. She specialised in heads, busts and relief portraits.

WEBER, Frederick Theodore 1883-
Born in Columbia, South Carolina, on March 9, 1883, he studied in Paris under J.P. Laurens and also attended classes at the École des Beaux Arts. He was a member of the American Professional Artists' League and worked in New York as a painter, engraver and sculptor of genre subjects.

WEBER, Max 1897-
Born in Zürich in 1897, he was self-taught and specialised in nude figures.

WEBER-FREY, Charles 1858-1902
Born in Fribourg, Switzerland, on October 10, 1858, he died at Asnières on July 1, 1902. He studied at the academies of Milan and Munich and specialised in portraits and religious figures. His figure of the Dying Christ is in Fribourg Museum.

WEDERKINCH, Holger 1886-
Born in Femo, Denmark, on March 3, 1886, he settled in France and exhibited animal figures and groups at the Paris Salons, and also in Copenhagen, Brighton and London.

WEEKES, Henry 1807-1877
Born in Canterbury, Kent, in 1807, he died in London on May 28, 1877. He exhibited at the Royal Academy from 1828 to 1877 and was elected A.R.A. in 1851 and R.A. in 1865. He specialised in classical and genre figures.

WEGER, Franz Andreas 1767-1832
Born at Salmansweiler, Saxony, on November 21, 1767, he died in Meissen in 1832. He studied at the Dresden Academy and was a pupil of G.A. Casanova. He worked as a modeller at the Meissen porcelain factory.

WEIDANZ, Gustav 1883-1970
Born in Hamburg in 1883, he died in Halle, German Democratic Republic, in 1970. He taught sculpture at the Technical High School of Burg Giebichenstein for many years and wielded an enormous influence on the development of German figure sculpture since the second world war. He received many state commissions for fountains, public statuary and memorials, the best known of which are the war memorials in Apolda (1951) and Zerbst. His minor works, however, include numerous bronze bas-reliefs, medallions and statuettes, giving an ultra-modern interpretation to genre themes, such as The Conversation.

WEIDENHAUPT, Andreas 1738-1805
Born in Copenhagen on August 13, 1738, he died there on April 26, 1805. He studied at the Academy in that city and produced portrait busts, statues, bas-reliefs and memorials. Copenhagen Museum has his head of a Bearded Old Man.

WEIGALL, Henry c.1800-1883
Born in London about 1800, he died there in 1883. He exhibited at the Royal Academy from 1837 to 1854, and specialised in portrait busts of contemporary personalities. His busts of Carlyle and Warren were shown at the Great Exhibition. His best known work is the small bronze bust of the Duke of Wellington, of which numerous casts were made, and a full-sized bronze of the Duke, casts of which are in the Birmingham Art Gallery and the United Services Club.

WEIGELE, Henri 1858-1927
Born in Schlierbach on September 20, 1858, he died in Neuilly in 1927. He studied in Paris under Jules Franceschi and exhibited at the Salon des Artistes Français, getting an honourable mention in 1893, a third class medal in 1907 and a first class medal in 1909. He sculpted classical and genre figures in marble and bronze.

WEIN, Albert fl. 20th century
American sculptor of German origins, specialising in allegorical groups and abstracts, such as To a God Unknown.

WEINBERGER, Anton Rudolf 1879-
Born in Reschitza, Austria, on October 5, 1879, he studied at the Vienna Academy and specialised in medallions and bas-reliefs representing contemporary personalities and events.

WEINERT, Albert 1863-
Born in Leipzig on June 13, 1863, he studied at the Brussels School of Fine Arts and worked in Paris for several years, becoming a member of the Société des Arts Indépendants. Later he emigrated to the United States and sculpted monuments and memorials in many parts of the country.

WEINKOPF, Anton 1886-
Born in Vienna on February 12, 1886, he studied at the Academy and worked in Graz as a decorative sculptor. His minor works include medallions and portrait busts.

WEINMAN, Adolph Alexander 1870-
Born in Karlsruhe, Germany, in 1870, he came to the United States at the age of ten and was apprenticed to a wood-carver named Kaldenberg. During this period he attended evening classes at the Cooper Union, New York, and in 1889 became a pupil of Philip Martiny. Later he worked under Saint-Gaudens at the Art Students' League and was successively assistant to Olin Warner, C.H. Niehaus and Daniel Chester French. He is best known as a medallist, and sculpted the reliefs for the American dime and half dollar coins and the victory emblems for the United States Navy and Army. He also sculpted genre statuettes, such as On Nimble Toe, Indian (Brooklyn Museum), Nightfall (Kansas City Museum) and Duet, and portrait busts of historic and contemporary figures, especially politicians.

WEINMAN, Robert fl. 20th century
Son and pupil of the above, he specialises in animal and bird figures.

WEINZORN, Eugen fl. 19th century
Born at Ensisheim, Germany, in the early years of the 19th century, he worked in Colmar as a medallist and modeller of portrait busts.

WEIR, John Ferguson 1841-1926
Born at West Point, New York, on August 28, 1841, he died in Providence, Rhode Island, on April 8, 1926. He was the son and pupil of the painter Robert Walter Weir and specialised in genre figures, such as At the Forge, and busts of his contemporaries. He won a bronze medal at the Exposition Universelle of 1900.

WEIRICH, Ignaz 1856-1916
Born in Fugau, Austria, on July 22, 1856, he died in Vienna on December 1, 1916. He studied at the Vienna Academy and worked in that city as a decorative sculptor. He also sculpted numerous busts and bas-reliefs, and memorials for churches and public buildings.

WEISKOPF, Bartholomeus fl. 19th century
Born in Matrei, Austria, in 1806, he worked as a painter and sculptor of religious subjects.

WEISS, Felix 1908-
Born in Vienna in 1908, he studied in Paris under Bourdelle and exhibited there and in London in the 1930s. He specialises in busts, statues and reliefs of worldwide celebrities.

WEISSENBERGER, Franz 1819-1875
Born in Vienna in 1819, he died there on February 12, 1875. He studied at the Academy and sculpted monuments, equestrian statues and portrait busts.

WEITMANN, Joseph fl. 19th century
Born at Gmünd, Württemberg, on March 9, 1811, he studied at the Vienna Academy and specialised in animal figures and groups.

WEITMANN, Minna 1839-1875
Born in Austria in 1839, she died in Vienna on December 12, 1875. She sculpted genre scenes and animal groups, in terra cotta and bronze.

WEITMEN, Claude Jean Baptiste fl. 19th-20th centuries
Born at Albertville in the mid-19th century, he studied under Thomas and exhibited busts and heads at the Salon des Artistes Français, winning a third class medal in 1894. The main collection of his work is in the Chambéry Museum.

WEIZENBERG, August Ludwig 1837-1921
Born at Erastfer, Estonia, on May 25, 1837, he died in Reval on November 23, 1921. He studied at the academies of Berlin and St. Petersburg and specialised in statuettes portraying the heroes and heroines of literature and folklore, such as Hamlet, Linda and Amarik.

WEIZLGÄRTNER, Josephine 'Pepi' (née Neutra) 1886-
Born in Vienna on January 19, 1886, she studied at the School of Decorative Arts in Vienna and specialised in portrait busts and heads, nudes and genre figures.

WELHAVEN-KRAG, Sigri 1894-
Born in Christiania (Oslo) on May 4, 1894, he studied at the local academy and about 1937 went to Paris, where he sculpted busts, fonts, altar-pieces and fountains.

WELLES, Florent 1922-
Born in Brussels in 1922, he sculpts genre and allegorical groups such as Apport (assets).

WELLS, Charles S. 1872-
Born in Glasgow on June 24, 1872, he emigrated to the United States and studied under Karl Bitter, Saint-Gaudens and G.G. Bernard. He worked as a decorative sculptor in Minneapolis.

WELLS, Marion F. 1848-1903
Born in San Francisco in 1848, she died there on July 22, 1903. She specialised in genre figures and portraits.

WELLS, Newton Alonzo 1852-
Born in Lisbon on April 9, 1852, of American parents, he studied under Drowning in Syracuse, New Jersey, and B. Constant and J.P. Laurens in Paris. He worked as a painter and decorative sculptor.

WELLS, Reginald Fairfax 1877-1951
Born in Norfolk in 1877, he died in Pulborough, Sussex, in 1951. He studied at the Royal College of Art and settled in Sussex, where he worked as an architectural sculptor and art potter.

WENCKEBACH, Ludwig Oswald 1895-
Born in Heerlen, Belgium, on June 16, 1895, he studied under his uncle Willem Wenckebach, a landscape painter and engraver. He himself was a wood engraver and sculptor of genre subjects.

WENDLING, Henri Félix 1813-1896
Born in Rheims in 1813, he died in Paris in 1896. He studied under Farrochon and Carpeaux and exhibited figures at the Salon from 1876.

WENDT, Julia Bracken 1871-
Born in Apple River, U.S.A. in 1871, she studied at the Art Institute of Chicago and was Lorado Taft's assistant from 1887 to 1892. She taught sculpture at the Otis Art Institute of Los Angeles and sculpted statuettes, monuments, fountains and relief portraits. Her allegorical works include the group of Art, Science and History in Los Angeles.

WENIGER, Maria P. 1880-
Born in Bevensen, Germany, in 1880, she studied in Munich under von Debschitz and Vierthaler and worked with Maria Cacer. Later she emigrated to the United States and sculpted small bronzes of dancers and nudes.

WENING, Rudolf 1893-
Born in Landquart, Switzerland, on February 4, 1893, he studied under Richard Kissling and in 1927 settled in Zürich, where he worked as a decorative sculptor.

WENKER, Oskar 1894-1929
Born in Berne in 1894, he died there in April 1929. He studied under A. Meyer and W. Schwerzmann and specialised in genre and neo-classical bas-reliefs.

WENTWORTH, Judith Blunt, Baroness 1873-1957
Born in 1873, the daughter of the poet Wilfred Scawen Blunt, she died at Crabbet Park, near Horsham, Sussex, in 1957. She inherited the barony of Wentworth from her mother, the Lady Anne Blunt, in 1917. She wrote many books, including poetry and standard works on Arab horses and toy dogs. She carried on the tradition established by her parents of breeding Arab horses and was the dominant figure in the Arab Horse Society from the 1920s till her death. As a sculptor she specialised in figures and groups of Arab horses.

WERCOLLIER, Lucien 1908-
Born in Luxembourg in 1908, he studied in the Brussels Academy and the École des Beaux Arts, Paris, and was strongly influenced by the work of Maillol and Laurens. About 1950 he turned away from naturalism and tended towards semi-figurative works in which female nudes formed the basis for abstract interpretation. In the mid-1950s he concentrated on totally abstract works in the manner of Arp and Brancusi, with soft, rounded volumes and highly polished surfaces. He sculpted the decoration on the Luxembourg pavilion at the Brussels Exposition of 1958.

WERNER, Franz 1872-1910
Born in Birkigt, Austria, on June 11, 1872, he died there on September 4, 1910. He studied at the Vienna Academy and sculpted statuettes and bas-reliefs. The Modern Gallery, Prague has his bronze statue for a fountain.

WERNER, Michael 1912-
Born in Austria on July 27, 1912, the son of Baron Vollrath von Alvensleben, he studied in Vienna, Oxford and Paris. He settled in London, where he sculpts in bronze, stone, wood and concrete. He exhibits in the major London and provincial galleries.

WERTHEIMSTEIN, Carl von 1846-1866
Born in Vienna in 1846, he died there in 1866. He produced portrait busts of his artistic and musical contemporaries.

WERTHNER, August fl. 19th century
Viennese decorative sculptor, born on August 23, 1852.

WESSELENYI-TONZOR, Eszter 1900-
Born at Tenke, Hungary, on December 1, 1900, she studied in Budapest and Nagybanya and produced plaques and medallions portraying the Hungarian nobility.

WESSELY, Eduard fl. 19th century
Born in Pirkstein, Bohemia, on February 2, 1817, he studied at the Prague Academy and sculpted statuary and bas-reliefs for churches in Prague and Bohemia.

WESTMACOTT, James Sherwood 1823-1888
Born in London on August 27, 1823, he died there in 1888. He was the son of Henry Westmacott and nephew of Sir Richard Westmacott under whom he studied. He made his début at Westminster Hall in 1844 with figures of Alfred the Great and Richard I planting the Standard of England on the Walls of Acre. The following year he was awarded the gold medal of the Dresden Academy for his statuette of Victory. He went to Rome in 1849 and sculpted the group of Satan Overthrown, commissioned by Theophilus Burnand and subsequently cast in bronze by Elkington. Thereafter he sculpted many statuettes, busts, altar-pieces, reredos and fonts and exhibited portrait sculpture at the Royal Academy from 1846 to 1885 and at the British Institution from 1852 to 1867.

WESTMACOTT, Sir Richard 1775-1856
Born in London in 1775, he died at Chastleton, Oxfordshire, on September 1, 1856. He was a son of the stone sculptor Richard Westmacott the Elder (1747-1808) and studied under his father before going in 1793 to Rome, where he was a pupil of Canova. Two years later he was admitted to membership of the Florence Academy. He was awarded the premier gold medal of the Academy of St. Luke for a bas-relief of Joseph and his Brethren. He returned to England in 1797 and established a studio near his father's. He rapidly built up a large reputation and by 1803 was reputed to be earning £16,000 annually — second only to Chantrey in his earning capacity. He is best known for his statuary and monuments, notably the figures on the façade of the British Museum and the colossal bronze Achilles in Hyde Park. He was one of the most prolific sculptors of the 19th century and sculpted numerous portrait busts, bas-reliefs and chimney pieces. He exhibited at the Royal Academy from 1797 to 1839, becoming A.R.A. in 1805 and R.A. in 1811. He succeeded Flaxman as professor of sculpture at the Royal Academy in 1827 and ten years later was knighted. His bronzes include the bust of an unknown man in Exeter Art Gallery (1810) and the figures of The Fighting Gladiator and the Dying Gladiator (1820), both in Woburn Abbey.

WETHERED, Maud Llewellyn 1898-
Born in Bury, Sussex, on February 15, 1898, she was the daughter of the landscape painter Vernon Wethered. She studied at the Slade School (1916-21) and worked in Hampstead for many years as a painter in oils and watercolours and as a sculptress in marble, stone and bronze. She exhibited at the Royal Academy and provincial and overseas galleries before the second world war.

WETHLI, Louis I 1842-1914
Born in Hottingen on October 17, 1842, he died in Zürich on February 21, 1914. He sculpted memorials, commemorative bas-reliefs and tombstones.

WETHLI, Louis II 1867-
Born in Zürich on December 31, 1867, the son of the above, he specialised in portrait busts and statuettes of his contemporaries.

WETHLI, Moritz 1870-1925
Born in Zürich on December 5, 1870, he died in Scherlingen on May 9, 1925. He assisted his father in decorative sculpture in the Zürich area.

WETTERLUND, Johan Axel 1858-1927
Born in Habo, Sweden, on January 15, 1858, he died in Cologne on October 24, 1927. He sculpted statuettes and small groups of religious subjects and was employed as a decorative sculptor on the Royal Castle of Stockholm.

WEYGERS, Désiré fl. late 19th century
Born in Belgium in the mid-19th century, he studied under Van der Stappen and exhibited figures in Brussels from 1897 onwards.

WEYNS, Jules fl. 19th-20th centuries
Genre sculptor working in Antwerp at the turn of the century. He exhibited at the Royal Academy in 1887 and also in Berlin (1890) and Brussels (1897).

WEYR, Rudolf von 1847-1914
Born in Vienna on March 22, 1847, he died there on October 30, 1914. He studied under Franz Bauer at the Vienna Academy and sculpted numerous monuments, statues, bas-reliefs and small ornaments in Vienna.

WEZELAAR, Han 1901-
Born in Haarlem, Holland, on November 25, 1901, he studied at the School of Arts and Crafts in Amsterdam and worked in Zadkine's studio in Paris. He has exhibited figures at the Salon des Tuileries since 1931 and also in Amsterdam.

WHAGEN, Arthur fl. 19th century
Decorative sculptor working in Memel on the Baltic coast in the mid-19th century. He got an honourable mention at the Paris Salon in 1861.

WHALEN, Thomas 1903-1975
Born in Edinburgh in 1903, he died there in 1975. He studied at the Edinburgh College of Art and exhibited genre figures at the Royal Scottish Academy and the Glasgow Institute. His works include the bronze fountain at Prestonfield School, Edinburgh (1936) and The Linseed Sower, Kirkcaldy (1951).

WHEATLEY, Edith Grace (née Wolfe) 1888-1970
Born in London on June 26, 1888, she died there on November 28, 1970. She studied at the Slade School under Tonks and Steer (1906-8) and at the Académie Colarossi in Paris. She was senior lecturer in fine art at Cape Town University from 1925 to 1937. On her return to England she settled in Sheffield but spent the last years of her life in London. She was a painter in oils and watercolours and sculptress in bronze and terra cotta, specialising in animal, bird and figure subjects.

WHEATLEY, Oliver fl. 19th-20th centuries
Born in Birmingham in the mid-19th century, he studied under Aman-Jean in Paris and worked in Birmingham as a decorative sculptor. He exhibited at the Royal Academy and other London galleries from 1892 to 1920.

WHEELER, Sir Charles Thomas 1892-1974
Born at Codsall, Staffordshire, on March 14, 1892, he died at Lishome Five Ashes near Mayfield, Sussex, on August 22, 1974. He studied at the Wolverhampton School of Art under R.J. Emerson (1908-12) and the Royal College of Art under Lanteri (1912-17). He married the sculptress Muriel Bourne in 1918. He exhibited at the Royal Academy from 1914 (A.R.A. 1934 and R.A. 1940) and was President of the Academy from 1956 to 1966. He was created C.B.E. in 1948 and K.C.V.O. in 1958 and received the R.B.S. gold medal for Distinguished Services to Sculpture in 1949. He specialised in figures, in stone and bronze. His work is in many public collections, notably the Tate Gallery which has his Infant Jesus and Spring.

WHEELER, E. Kathleen 1884-
Born in Reading, Berkshire, in 1884, she studied under Esther Moore and Frank Calderon and attended the Slade School. She exhibited at the Salon des Artistes Français in 1906 and the Royal Academy in 1910. She emigrated to the United States in 1914 where she had a studio. She specialised in animal figures and groups and was latterly engaged on a lengthy series portraying the leading thoroughbreds of America. Her other bronzes include the animal group Death and Sleep.

WHEELER, Lady Muriel (née Bourne) fl. 20th century
Portrait painter and sculptor and wife of Sir Charles Wheeler. She exhibited at the Royal Academy and provincial and overseas galleries in the inter-war period.

WHEELER, William 1895-
Born in London on January 23, 1895, he worked as a decorative sculptor in that city.

WHEELOCK, Lila Audubon 1890-
Born in Parsaic Park, New York, in 1890, she studied at the New York Academy and specialises in animal figures.

WHEELOCK, Warren 1880-
Born in Sutton, Massachusetts, on January 15, 1880, he studied at the Pratt Institute and worked as a painter, engraver and sculptor of genre subjects.

WHILE, Ethel (née Collingwood) fl. 20th century
Born at Mitcham, Surrey, in the late 19th century, she was the wife of Harry Samuel While with whom she collaborated.

WHILE, Harry Samuel 1871-
Born in West Bromwich, Staffordshire, on April 12, 1871, he worked in London as a sculptor of statuettes and small groups.

WHITE, Adam Seaton 1893-
Born in Bangor, North Wales, on April 10, 1893, he studied at the Slade School and worked in Cheltenham as a painter and sculptor.

WHITE, Arthur C. fl. 19th-20th centuries
Born in London in the mid-19th century, he died there in January 1927. He studied at the Royal Academy schools and worked as assistant to Sir Bertram Mackennal.

WHITE, Erica 1904-
Born in Kingsdown on June 13, 1904, she studied at the Slade School, the Central School of Arts and Crafts and the Royal Academy schools, where she won silver and bronze medals and the Feodora Gleichen award. She exhibited paintings and sculpture at the Royal Academy and various London and provincial galleries from the 1920s onwards and now works at Bexhill-on-Sea.

WHITE, H. Mabel fl. 19th-20th centuries
English sculptress of portraits and genre figures, working in London at the turn of the century. She studied under O. Waldmann and exhibited at the Royal Academy from 1898 onwards.

WHITE, William fl. 19th century
Decorative sculptor working in London. He exhibited bas-reliefs at the Royal Academy from 1863 to 1886.

WHITING, Onslow fl. 20th century
Painter and sculptor of portraits and animal subjects, working in Helston, Cornwall, from about 1920 to 1935. He studied at the Slade School and the Central School of Arts and Crafts and exhibited at the Royal Academy and the Paris Salons before the second world war.

WHITNEY, Anne 1821-1915
Born in Watertown, Massachusetts, in September 1821, she died in Boston on January 23, 1915. She studied in Rome, Paris and Munich and sculpted allegorical figures. Her figure entitled Rome is in the St. Louis Museum.

WHITNEY, Gertrude (née Vanderbilt) fl. 20th century
Born in New York City in the late 19th century, she studied under Henry Anderson and James Earle Fraser at the Art Students' League and was a pupil of Andrew O'Connor in Paris. She got an honourable mention at the Paris Salon in 1913 and a bronze medal at the Panama-Pacific International Exposition, San Francisco (1915). She sculpted public statuary, memorials, monuments and fountains, mainly in marble and plaster, though a bronze Caryatid by her is in the Metropolitan Museum of Art, New York.

WHITNEY-SMITH, Edwin 1880-1952
Born in Bath on August 2, 1880, he died in London on January 8, 1952. He studied at the Bath and Bristol schools of art and exhibited at the Royal Academy from 1915, being elected F.R.B.S. in that year. He settled in London and was a member of the St. John's Wood Art Club. He specialised in portrait busts of contemporary personalities and also sculpted bronze nudes and allegories, such as The Awakening (Preston Museum).

WIBMER, Jacob 1814-1881
Born at Windisch-Matrei, Austria, in 1814, he died at Deutschlandsberg in 1881. He trained at the Vienna Academy and specialised in crucifixes and religious statuary.

WICHMANN, Karl Friedrich 1775-1836
Born in Potsdam on June 28, 1775, he died in Berlin on April 9, 1836. He was the elder brother of Ludwig Wichmann and studied under Unger and Schadow. He specialised in portrait busts.

WICHMANN, Ludwig Wilhelm 1788-1859
Born in Potsdam on October 10, 1788, he died in Berlin on June 29, 1859. He studied under Schadow in Berlin, and Bosio and David d'Angers in Paris. He taught at the Berlin School of Fine Arts in 1818-19 and then spent two years in Italy before returning to Berlin. He produced numerous busts and genre figures, in marble, plaster and bronze.

WICKHAM, Geoffrey Earle 1919-
Born in Wembley, Middlesex, on July 10, 1919, he studied at the Willesden School of Arts and Crafts (1935-38) and the Royal College of Arts (1946-49). He has exhibited at the Royal Society of British Artists and other London galleries and was elected A.R.B.S. in 1965 and F.R.B.S. two years later.

WIDEMANN, Wilhelm 1856-1915
Born in Schwäbisch-Gmund on October 28, 1856, he died in Berlin on September 4, 1915. He sculpted figures and portraits and exhibited in Berlin and Paris, winning a silver medal at the Exposition Universelle of 1900.

WIDMANN, Johann fl. 19th century
Born at Hopfgarten, Austria, in the early 19th century, he sculpted statuary, altars and fonts for the churches in the Kitzbühel area.

WIDMER, Philipp 1870-
Born in Killwangen, Germany, on October 24, 1870, he studied at the Munich Academy and the Nuremberg School of Decorative Art, settling in the latter city. He specialised in genre figures and groups, his best known work being the statue of a Fisherman on the Hechtplatz in Zürich.

WIDNMANN, Max von 1812-1895
Born in Eichstatt, Bavaria, on October 16, 1812, he died in Munich on March 6, 1895. He studied at the Munich Academy under Schwanthaler and became a professor at the Academy in 1849. He produced genre figures and groups. Leipzig Museum has his Man defending a Woman and Child against a Panther.

WIDTER, Konrad 1861-1904
Born in Vienna on June 28, 1861, he died there on March 30, 1904. He studied under C. Kundmann at the Academy and worked as a decorative sculptor.

WIEDEWELT, Johannes 1731-1802
Born in Copenhagen on July 1, 1731, he died there on December 17, 1802. He was the son and pupil of Justus Wiedewelt, a stone-carver, and studied under Coustou in Paris from 1750 to 1754. He specialised in memorials and monuments dedicated to the Danish Royal family and aristocracy.

WIEGMANN, Jenny 1895-
Born at Spandau, Berlin, on December 1, 1895, she has produced stained glass and religious figures for churches in Hagen, Bielefeld and other German towns.

WIENER, Leopold 1823-1891
Born in Venlo, Belgium, on July 2, 1823, he died in Brussels on February 11, 1891. He was the brother of the medallists and stamp engravers Jacob and Karl Wiener and studied in Brussels and under David d'Angers in Paris. He specialised in medallions, bas-reliefs, and portrait busts of contemporary celebrities.

WIENS, Stephen M. 1871-1956
Born in London on February 26, 1871, of German parentage, he died in Worthing, Sussex, on June 25, 1956. He studied at the Royal Academy schools from 1890 onwards and first exhibited at the Royal Academy in 1893. He was a painter and sculptor of portraits and figure subjects. Examples of his work are preserved in the Tate Gallery.

WIGAND, Edit 1891-
Born at Panesova, Hungary, on January 2, 1891, she studied in Budapest, Berlin and Nagybanya and specialised in portrait busts.

WIKSTRÖM, Emil Erik 1864-1942
Born in Abo, Finland, on April 13, 1864, he died in Helsinki in September 1942. He specialised in allegorical and genre figures and groups, examples being in the museums of Abo, Helsinki, Tampere and Göteborg. He exhibited internationally and won a bronze medal at the Exposition Universelle of 1900 and a gold medal at the Exposition Internationale in 1937.

WILCOXSON, Frederick John 1888-
Born in Liverpool on January 12, 1888, he worked in London and produced statuary and monuments.

WILDE, Paul 1893-1936
Born in Switzerland in 1893, he died in Basle on March 1, 1936. He worked as a decorative and genre sculptor.

WILDERMANN, Hans 1884-
Born in Cologne on February 21, 1884, he worked in Breslau as a painter, engraver and sculptor of portraits, religious figures and allegorical subjects.

WILDT, Adolfo 1868-1931
Born in Milan on March 1, 1868, he died there on March 12, 1931. Despite his Germanic name he came from a very old Lombard family. He overcame the difficulties of extreme poverty by sheer hard work and eventually became one of the most successful Italian sculptors of his day. He began exhibiting in Rome in 1894 and achieved distinction in 1911 with his large triptych, The Saint, The Sage and Youth. He sculpted numerous allegorical and genre figures and groups, bas-reliefs and busts of contemporary personalities.

WILDT, Josef the Elder fl. 19th century
Born in Elbogen in 1831, he worked in Pilsen from 1850 to 1884 as a decorative sculptor. He produced a large number of statues and bas-reliefs for towns in Bohemia.

WILDT, Josef the Younger 1874-
Born in Elbogen, he was the son of the ecclesiastical wood-carver Franz Wenzel Wildt and nephew of Josef Wildt the Elder. He sculpted portraits and religious figures.

WILDT, Ludwig 1824-1843
Born in Elbogen in 1824, he died in Pilsen in 1843. He was a painter and decorative sculptor.

WILES, Francis 1889-
Born in Larne, Co. Antrim, on January 7, 1889, he exhibited figures and portraits at the Royal Academy and the Royal Hibernian Academy in the early part of this century.

WILFERT, Karl the Elder 1847-1916
Born in Schönefeld, Bohemia, on April 8, 1847, he died in Karlsbad (Karlovy Vary) in 1916. He sculpted memorials and statuary for many towns in Bohemia.

WILFERT, Karl the Younger 1879-
Born in Eger on February 17, 1879, he studied at the Prague Academy and sculpted memorials and commemorative statuary and fountains in many parts of Czechoslovakia.

WILHELMS, Carl Wilhelm 1889-
Born in St. Petersburg on October 20, 1889, he studied under Bourdelle about 1920 and settled in Finland where he specialised in small ornamental bronzes.

WILL, Blanca 1881-
Born in Rochester, New York, on July 7, 1881, she sculpted genre figures and portraits.

WILLARD, Salomon 1783-1862
Born in Petersham, U.S.A., on June 20, 1783, he died in Quincy, Massachusetts, on February 27, 1862. He sculpted monuments and memorials in Charlestown and Cambridge, Massachusetts.

WILLEMS, Joseph 1845-1910
Born in Malines, Belgium, in 1845, he died there in 1910. He sculpted historic figures and groups, monuments and public statuary. He won a bronze medal at the Exposition Universelle of 1889.

WILLIAMS, Alice fl. 19th-20th centuries
The wife of Morris Meredith the watercolourist, she sculpted memorials and tombstones at the turn of the century.

WILLIAMS, Lucy Gwendolen c.1870-1955
Born in Liverpool about 1870, she died in Buxton, Derbyshire, on February 11, 1955. She studied at Wimbledon Art College, the Royal College of Art and the Académie Colarossi in Paris. She exhibited at the Royal Academy from 1893 onwards and also took part in exhibitions in Europe. She had an individual show of her bronzes and watercolours at Brook Street Gallery, London, in 1935.

WILLIAMS, Walter Reid 1885-
Born in Indianapolis on November 23, 1885, he studied under Mulligan and Bela Pratt in Chicago and Mercié in Paris and sculpted monuments and statuary in many parts of the United States.

WILLIAMS, Wheeler fl. 20th century
American sculptor active in the first half of this century. He has produced a wide range of sculpture, from genre and portrait figures to memorials and statuary, and animal figures and groups, such as Cub eating a Fish.

WILLIAMSON, Francis John 1833-1920
Born in Hampstead, London, on July 17, 1833, he died in Esher, Surrey, on March 12, 1920. He studied under J.H. Foley and later became his assistant. He exhibited at the Royal Academy and other London galleries from 1853 and sculpted statuettes and portrait busts.

WILLIS, Richard Henry Albert 1853-1905
Born in Dingle, Ireland, on July 5, 1853, he died at Ballinskelligs on August 15, 1905. He trained under James Brennan and worked as a painter and sculptor of portraits and genre subjects.

WILLIS, Samuel William Ward 1870-1948
Born in Paddington, London, in 1870, he died in Parkstone, Dorset, on March 1, 1948. He studied at the West London School of Art under Simpson and attended the Royal Academy schools from 1890 to 1895, winning a silver medal. He exhibited at the Royal Academy and London and provincial galleries and specialised in humanoid animal figures and groups. His bronzes include Right Triumphant, Fear, Blood, Toil, Tears, Sweat, The Poacher and similar rather mawkish subjects.

WILLUMSEN, Bode Bertel Willum 1895-
Born in Copenhagen on March 6, 1895, he was the son and pupil of Jens Ferdinand Willumsen. He worked as a painter, potter and genre sculptor and examples of his work are in the museums of Copenhagen, Stockholm and Berlin.

WILLUMSEN, Jens Ferdinand 1863-
Born in Copenhagen on September 7, 1863, he was a painter, poet, architect and art connoisseur who dabbled in genre figures and groups. He studied under Kroyer at the Copenhagen Academy and was one of the first Danes to adopt the decorative style in sculpture.

WILLUMSEN, Juliette (née Meyer) 1863-
Born in Copenhagen on April 20, 1863, she was the first wife of Jens Ferdinand Willumsen. She sculpted genre figures, examples of which are in the Museum of Decorative Arts in Copenhagen.

WILSON, Melva Beatrice 1866-1921
Born in Madison, Wisconsin, in 1866, she died in New York on June 2, 1921. She was a painter poetess and sculptress, specialising in memorials and ecclesiastical decoration. She was employed in the ornamentation of the cathedral of St. Louis, Missouri.

WINANS, Walter 1852-1920
Born in Russia in 1852, he died in London on August 12, 1920. He worked for many years in the United States as a painter and sculptor of genre subjects.

WIND, Josef 1864-
Born in Munich on June 16, 1864, he studied at the Academy in that city and sculpted genre statuettes. The Munich Glyptothek has his Child carrying a Canopy.

WINDBICHLER, Erich 1904-
Born in Salzburg, Austria, on September 15, 1904, he studied at the Weimar Academy and was a pupil of Walter Klemm. He worked in Eisenach as a sculptor and painter.

WINDER, Arthur 1873-
Born in Vienna in 1873, he collaborated with Kompatscher as a decorative sculptor. His minor works are preserved in the Simu Museum, Bucharest.

WINDER, Rudolf fl. 19th century
Born in Vienna on December 4, 1842, he studied under Fernkorn and specialised in genre and romantic statuettes. He took part in the Vienna Exhibition of 1873.

WINEBRENNER, Harry Fielding 1884-
Born in Summerville, U.S.A., on January 4, 1884, he studied under Lorado Taft, C. Mulligan and Sciortino and specialised in paintings and sculpture of the Wild West. He had a studio in Santa Monica, California.

WINKLER, Ferdinand 1879-
Born in Graz, Austria, on April 10, 1879, he studied at the Vienna Academy and specialised in memorials and genre figures. Graz National Museum has his figure of a Donkey-man.

WINKLER, Georg 1862-1933
Born at Fladnitz, Austria, on January 31, 1862, he died in Graz on February 2, 1933. He studied at the Vienna Academy and sculpted tombstones, animal figures and decorative reliefs.

WINKLER, Othmar 1906-
Born in Brixen, Austria, in 1906, he worked in Bruneck and Gröden and in 1929 settled in Rome, where he sculpted portrait busts and statuettes.

WINN, James Herbert 1866-
Born in Newburyport, Massachusetts, on September 10, 1866, he studied at the Art Institute of Chicago and became a member of the American League of Professional Artists. He worked in Chicago and Pasadena and sculpted, painted and engraved genre subjects.

WINT, Jean Baptiste van c.1835-1906
Born in Antwerp about 1835, he died in Brussels on December 8, 1906. He sculpted statues and bas-reliefs of religious subjects for churches in Ostend and Antwerp.

WINTER, Frederick d.1924
Portrait sculptor of busts, medals and bas-reliefs working in London. He exhibited at the Royal Academy from 1873 to 1899 and examples of his work are in the National Portrait Gallery.

WINTER, George 1875-
Born in St. Petersburg on January 21, 1875, he worked in Antrea, Finland. He sculpted allegorical and genre figures and groups. The Helsinki Athenaeum has Life's Recompense and The Warmth of Life.

WINTER, Lumen M. fl. 20th century
Sculptor of bas-reliefs and friezes working in the United States. His best known work is the large wall panel Man, Woman and Child in the A.F.L. – C.I.O. headquarters in New York.

WINTERHALDER, Erwin 1879-
Born in Winterthur, Switzerland, on May 19, 1879, he worked as a decorative sculptor in Zürich.

WIPPLINGER, Franz 1880-
Born in Austria in 1880, he worked in Switzerland with Aloys Payer on ecclesiastical sculpture, mainly bas-reliefs and altar-pieces. Examples of his work may be found in the churches of Zürich and Einsiedeln.

WISNIOWIECKI, Tadeusz fl. 19th-20th centuries
Polish sculptor working in Cracow at the turn of the century. He specialised in portrait busts of Polish historical and contemporary celebrities.

WISS, Alfons 1880-
Born in Fullenbach, Switzerland, on June 9, 1880, he studied under Alfred Schnetzer in St. Gall and worked as a painter and sculptor of genre subjects. His sculpture includes After the Bath, Young Man, Swabian Peasant, Young Mother and Child and Old Woman.

WISSLER, Anders Henrik 1869-1941
Born in Linköping, Sweden, on February 3, 1869, he died in Brevik on February 28, 1941. He studied at the Stockholm Academy and specialised in portrait busts, statuary and fountains.

WITSCHI, W. fl. 19th century
Sculptor of historical bas-reliefs and monuments. His best known work is the iron group The Oath of Allegiance at Fluelen, Switzerland.

WITTIG, Edward 1879-1941
Born in Warsaw in 1879, he died in Vienna on March 3, 1941. He studied at the Vienna Academy and was a pupil of A. Charpentier in Paris. He was strongly influenced by Rodin in the development of his monumental style.

WITTMANN, Ernest fl. 19th century
Born at Sarre-Union, Saarland, on September 25, 1846, he studied under T.L. Devilly in Nancy and worked as a painter and sculptor of genre subjects.

WIWOLSKI, Antoni 1877-1919
Born in Poland in 1877, he died in Wilno on January 10, 1919. He worked as an ecclesiastical sculptor in Cracow and Wilno.

WLÉRICK, Robert 1882-1944
Born in Mont-de-Marsan, France, in 1882, he died in Paris in 1944. He studied at the Toulouse School of Fine Arts (1899-1903) and then went to Paris where he established a studio and began exhibiting at the Salon d'Automne and the Tuileries in 1905. He rapidly built up a reputation as one of the leading sculptors of the younger generation. He specialised in monumental sculpture, and is best remembered for the memorials to Condorcet (Ribemont), Victor Bérard (Morez-du-Jura) and the equestrian statue of Marshal Foch. His minor works include preliminary studies for monuments, portrait busts and heads in bronze.

WOITOVITSCH, Pietr 1862-
Born in Przemysl, Galicia, on June 10, 1862, he studied at the Vienna Academy under Zumbusch and specialised in genre and classical figures and groups. The Cracow Museum has his figure of a Slave and the group Rape of the Sabines.

WOLFERS, Marcel 1886-
Born in Ixelles near Brussels on May 18, 1886, he studied under Isidore de Rudder and sculpted numerous monuments, statues, fountains and bas-reliefs in Belgium. He became a Chevalier of the Order of Leopold and exhibited widely in Europe. His minor bronzes are to be found in the museums of Ixelles, Brussels and Barcelona.

WOLFF, Emil 1802-1879
Born in Berlin on March 2, 1802, he died in Rome on September 21, 1879. He studied under Schadow and then settled in Rome where he eventually became Director of the Academy of St. Luke. He sculpted portraits of his contemporaries, but his chief forte was classical figures and groups.

WOLFF, Franz Alexander Friedrich Wilhelm 1816-1887
Born in Fehrbellin, Prussia, on April 6, 1816, he died in Berlin on May 30, 1887. He studied in Berlin, Paris and Munich and settled in Berlin where he sculpted busts of his contemporaries and animal figures and groups, particularly dogs.

WOLFF, Karl Konrad Albert 1814-1892
Born in Fehrbellin on April 6, 1814, he died in Berlin on June 20, 1892. He was the elder brother of the above and studied under Rauch. Later he worked for some time in Italy before becoming professor at the Berlin Academy in 1866. He sculpted portrait busts of his contemporaries in marble and bronze. The Berlin Museum has his group Dionysus and Eros.

WOLKONSKY, Prince Peter 1901-
Born in St. Petersburg in March 1901, he studied painting under his mother, Princess Maria Wolkonska and then was a pupil of Ernest Laurent in Paris. He settled in Paris after the Revolution and works as a painter of landscapes, though also sculpting genre figures. He has exhibited in London since 1923 and also at the Paris Salons since 1924.

WOLKOWSKI, Alexander 1883-
Born in Vitebsk, Russia, on June 27, 1883, he studied under Injalbert and worked in Paris from 1910 onwards. He combined Russian baroque with the French style of the early 1900s evolved by Maillol and Zadkine, a mixture of realism and abstract. He exhibited at the Salon d'Automne, becoming an Associate in 1920.

WOLLEK, Carl 1862-1936
Born in Brunn (Brno) on October 31, 1862, he died in Vienna on September 8, 1936. He exhibited in Vienna from 1889 and also participated in the Paris Salons, gaining an honourable mention in 1894. His work consisted mainly of memorials, statuary and busts intended for public buildings in Vienna, but his minor works include a number of medallions, plaques and portrait reliefs. The Vienna National Gallery has his Young Elephant and Woman riding a Unicorn.

WOLNOUCHIN, Sergei Michaelovich 1859-
Born in Moscow in 1859, he studied at the Moscow School of Art and sculpted bas-reliefs and monuments in that city.

WOLTRECK, Franz 1800-1847
Born in Zerbst, Germany, on August 20, 1800, he died in Dessau on December 5, 1847. He studied at the Kassel Academy under Werner Henschel and under David d'Angers in Paris. He specialised in busts and portrait reliefs of contemporary celebrities. There is a large collection of his medallions in the Zerbst Museum, and a number of his busts in the Versailles Museum.

WOOD, Francis Derwent 1871-1926
Born in Keswick, Cumbria, on October 15, 1871, he died in London on February 19, 1926. He was educated in Switzerland and Germany and studied art in Karlsruhe, returning to England in 1889. He attended Lanteri's classes at the Royal College of Art in 1889 and became assistant to Legros at the Slade (1890-92) and studied at the Royal Academy schools, winning the gold medal and a travelling scholarship in 1895. He assisted Sir Thomas Brock (1894-95) and began exhibiting at the Royal Academy in the latter year. He was instructor in modelling at the Glasgow School of Art (1897-1901), but then settled in London. He enlisted in the Royal Army Medical Corps in 1915 and was commissioned the following year. He was elected A.R.A. in 1910 and R.A. in 1920. He was professor of sculpture at the Royal College of Art from 1918 to 1923. He worked as a painter, engraver and sculptor of portraits, figures and monumental groups. His portrait busts include those of the Maharaja of Baroda, the singer Denis O'Sullivan, Henry Vanes, T.E. Lawrence and Bess Morris. He also sculpted classical figures, such as Psyche.

WOOD, John Warrington 1839-1886
Born in Warrington, Lancashire, in 1839, he died there in 1886. He exhibited at the Royal Academy from 1868 to 1884 and specialised in busts and groups, such as Ruth and Naomi and St. Michael slaying the Demon.

WOOD, Marshall fl. 19th century
London sculptor who died in Brighton in July 1882. He exhibited at the British Institution and the Royal Academy from 1854 and specialised in classical statuettes, such as Daphne, Psyche, Hebe, Proserpine and Sappho, and busts and figures of British royalty and contemporary personalities.

WOOD, Shakespeare fl. 19th century
Born in Belfast in the first half of the 19th century, he died in Rome in 1886. He exhibited at the Royal Academy from 1868 to 1871 and produced medallions, relief portraits and busts of contemporary personalities and allegorical groups, mainly in marble.

WOODFORD, James Arthur 1893-
Born in Nottingham on September 25, 1893, he studied at the local art school and the Royal College of Art. He exhibited at the Royal Academy for many years and was elected A.R.A. in 1937 and R.A. in 1945. He had a studio in London and sculpted portraits and figures.

WOODINGTON, William Frederick 1806-1893
Born in Sutton Coldfield, Warwickshire, on February 10, 1806, he died in Norwood near London on December 24, 1893. He came to London as a boy and was apprenticed in 1820 to the engraver Robert Sievier. After winning the silver medal of the Society of Arts in 1823 he took up sculpture and worked for Croggan, Coade's successor. Most of his work from this early period consisted of classical groups in artificial stone. At the Westminster Hall exhibition of 1844 he showed The Deluge and Milton dictating to his Daughters. Thereafter he sculpted a number of portrait busts, statues and monuments of contemporary personalities. His best known work, however, is the bronze relief of the Battle of the Nile, for Nelson's Column in Trafalgar Square. He exhibited paintings and sculpture at the Royal Academy from 1825 to 1882 and at the British Institution from 1827 to 1832. He became Curator of the Academy School of Sculpture in 1851 and was elected A.R.A. in 1876.

WOODRUFF, John Kellogg 1879-
Born at Bridgeport, Connecticut, on September 6, 1879, he studied under Walter Shulaw, Arthur Dow and Charles J. Martin and worked in New York as a painter and sculptor. Examples of his genre sculpture are in the Brooklyn Museum.

WOOLF, Meg 1923-
Born in Thanet, Kent, on December 10, 1923, she studied at the Bromley and Beckenham Schools of Art (1939-42) and has since exhibited at the Royal Academy and the Royal Society of British Artists as well as major London and overseas galleries. She works in London as a watercolourist and sculptor in stone, wood and ivory mainly.

WOOLLATT, Leighton Hall 1905-
Born in Nottingham on September 8, 1905, he was the son of the painter Edgar Woollatt. He studied at the Nottingham College of Art, the Royal Academy schools and Chelsea Polytechnic School. He works in Budleigh Salterton, Devon, as a painter, etcher, lithographer, mural decorator and sculptor of bas-reliefs.

WOOLNER, Thomas 1825-1892
Born in Hadleigh, Suffolk, on December 17, 1825, he died in Hendon, London, on October 7, 1892. He went to school in Ipswich but when his father got a Post Office appointment in London he studied art under Behnes. He attended classes at the Royal Academy schools from 1842 to 1845 and won the silver medal of the Society of Arts in the latter year for a bas-relief entitled Affection. In 1847 he met Rossetti and joined the Pre-Raphaelites. The poor reception given at the 1848 British Institution exhibition to his group Titania and the Indian Boy turned him from three-dimensional sculpture to bas-reliefs and medallions and he subsequently sculpted numerous portrait medals of contemporary celebrities, including Mrs. Coventry Patmore, Carlyle and Wordsworth. He failed to win the competition for the Wordsworth memorial and this, coupled with an unfortunate love

affair, impelled him to emigrate to Australia in 1852. He set up a studio in Melbourne and produced a number of portrait medals, but returned to England in 1854. His bust of Tennyson and a portrait medallion of Carlyle the following year marked the turning point in his career. Thereafter he secured numerous commissions for busts and relief portraits. Many of these were produced in plaster but several are also known in bronze. He exhibited at the Royal Academy from 1843 to 1893 and was elected A.R.A. in 1871 and R.A. in 1874. He was professor of sculpture from 1877 to 1879. His last work, The Housemaid, was posthumously cast in bronze and exhibited at the Royal Academy in 1893.

WORONICHIN, Alexei Ilyich 1788-1846
Born in St. Petersburg on February 7, 1788, he died there on June 26, 1846. He studied at the St. Petersburg Academy and became a modeller at a porcelain factory.

WORSWICK, Lloyd 1899-
Born in Albany, New York, on May 30, 1899, he studied under Ulrich, Cedarstrom, Brewster and Olinsky and works as a painter, engraver and sculptor of genre and portrait subjects.

WORTHINGTON, Beatrice Maude 1883-
Born in Wigan, Lancashire, in 1883, she studied under Lanteri and sculpted genre figures.

WORTMAN, Johann Hendrick Philip 1872-1898
Born in The Hague in 1872, he died in Rome in September 1898. The Amsterdam Academy possesses a number of busts by him of the Dutch royal family.

WOSMIK, Vincenz 1860-
Born at Humpolecz, Bohemia, on April 5, 1860, he studied under Anton Wagner in Vienna and worked as a decorative sculptor in Prague.

WOSTAN (Stanislas Wojcieszynski) 1915-
Born in Kozmin, Poland, in 1915, he studied at the Institute of Fine Arts in Poznan and won two travelling scholarships in 1939, but was conscripted into the army. He escaped to Hungary following the collapse of Poland in 1939 and subsequently made his way to France where he joined the free Polish forces. He was captured at St. Dié and remained in German hands till 1945. After his release he went to Paris where he established a studio and began experimenting with abstract painting and sculpture. He was a founder member of the Salon de la Jeune Sculpture in 1949 and had his first one-man show in 1953 at the Galerie Colette Allendy. He used hammered copper and brass sheet in his bas-reliefs but prefers wood and bronze for his three-dimensional work. He is also a poet and has had several volumes published.

WOTRUBA, Fritz 1907-
Born in Vienna in 1907, he studied under Anton Hanak and began exhibiting in Vienna in 1930. During the Nazi period he lived in Switzerland and on his return to Vienna after the war was appointed head of the sculpture department at the Academy. He has had many one-man shows since 1942, in Zürich, Basle, Essen, Vienna, Brussels and Paris, and has participated in the major art exhibitions of Europe since the war. A travelling exhibition of his works was mounted in America in 1955-56. Wotruba is one of the foremost sculptors in Europe today, his influence extending far beyond his native country. His works have an architectural quality and though often cast in bronze usually originate from direct carving in limestone.

WOUTERS, Rik 1882-1916
Born in Malines, Belgium, in 1882, he died in Amsterdam in 1916. He began wood-carving in 1894 and later studied at the academies of Malines and Brussels. In 1907 he settled in Boisfort, a suburb of Brussels, where he worked as a painter and sculptor. He served in the Belgian army during the opening campaign of the first world war but was interned in neutral Holland when his regiment withdrew before the German advance. He was released from prison camp on grounds of ill health but died after a cerebral illness had robbed him of his sight. Shortly before his death his friends organised a one-man show for him in Amsterdam. Though his career was so tragically brief he established himself as one of the outstanding sculptors of the Belgian school. Though his bronzes have sometimes been compared with those of

Dégas and Bourdelle they are more monumental than the first and more exuberant than the second. His best known work is The Foolish Virgin, said to have been modelled by Isadora Duncan. Several casts of it exist. His other genre figures include The Coquette, In the Sun, Repose, Anxiety, The Repast and Domestic Worries. He won the Picard Prize in 1913. He also sculpted portrait busts of his artistic contemporaries.

WOUW, Anton van 1862-
Born in South Africa in 1862, he studied at the Rotterdam Academy and specialised in busts and figures illustrating Boer and Kaffir ways of life. His best known work is the seated figure of President Paul Kruger.

WRBA, Georg 1872-1939
Born in Munich on January 3, 1872, he died in Dresden on January 9, 1939. He studied at the Munich Academy under Eberle and won a travelling scholarship which took him to Italy in 1897. Later he became professor at the Dresden Academy. He specialised in busts of his contemporaries, allegorical figures, such as Europa, Diana and female nudes.

WREN, T.H. fl. early 20th century
Sculptor of romantic bronzes, working in England in the early years of this century. The Preston Museum has his group Naked Warrior on Horseback (1914).

WRENN, Elizabeth Jenks 1892-
Born in New York on December 8, 1892, she was the wife of the painter and architect Harold Holmes Wrenn and was herself a painter and sculptress of portraits and genre figures.

WRIGHT, Alice Morgan 1881-
Born in Albany, New York, in 1881, she was a pupil of the Art Students' League and studied under Gutzon Borglum and James Earle Fraser. Later she attended the Académie Colarossi in Paris and sculpted neo-classical statuettes, such as Young Faun.

WRIGHT, Austin 1911-
Born in Chester in 1911, he studied in Cardiff and Oxford University, graduating in languages. After the second world war he took up art and had his first one-man show at York in 1950. Subsequently he has participated in national and international exhibitions and won the Ricardo Xavier Prize at the Sao Paulo Biennale of 1957. He has a studio in York where he works on tapestry and sculpture in the modern semi-figurative idiom. His favourite material is lead.

WRIGHT, Frank Arnold 1874-
Born in London on May 17, 1874, he studied at the Goldsmiths' Institute School and the Royal Academy schools where he won the Landseer scholarship. He began exhibiting figures and portraits at the Royal Academy in 1903 and worked at East Molesey in Surrey.

WRONBETZKOY, Paolo fl. 19th century
Italian decorative sculptor of Russian descent. He got an honourable mention at the Exposition Universelle of 1889.

WROUBEL, Michael Alexandrovich 1856-1910
Born in Omsk on March 5, 1856, he died in St. Petersburg on April 1, 1910. He studied at the St. Petersburg Academy and worked in that city as a painter, draughtsman, interior designer and sculptor, specialising in allegorical and classical figures.

WUERST, Emiel H. 1856-1898
Born in St. Albans, U.S.A., in 1856, he died in New York on July 4, 1898. He studied in Paris under Rodin, Chapu and Mercié and worked in New York as a figure sculptor.

WUILLEUMIER, Willy 1898-
Born at Châtelaine near Geneva on September 11, 1898, he specialised in portrait busts and animal figures, in terra cotta, iron and bronze.

WULFF, Willie 1881-
Born in Copenhagen on March 15, 1881, he studied at the Copenhagen Academy and sculpted monuments, public statuary and fountains for that city. His minor works include portrait busts, examples of which are in the museums of Copenhagen, London, Munich and Lyons.

WUNDERLICH, Max Julius 1878-
Born in Sereth, Austria, on October 20, 1878, he worked in Vienna as an etcher, writer and sculptor. He sculpted monuments, memorials and allegorical groups.

WÜRTENBERGER, Karl Maximilian 1872-1933
Born in Steisslingen, Germany, on February 27, 1872, he died in Illenau on October 26, 1933. He specialised in portrait busts of his artistic contemporaries.

WÜRTH, Ernst 1901-
Born in Wormeldingen, Luxembourg, on September 20, 1901, he studied at the École des Beaux Arts, Paris, and works as a painter and sculptor of figures and portraits.

WÜRTH, Hermann 1888-
Born in Basle on May 23, 1888, he studied in Paris and New York and sculpted statuary, fountains and bas-reliefs.

WURZEL, Ludvik 1865-1913
Born in Prague on January 24, 1865, he died there on November 25, 1913. He studied under Schnirch in Prague and sculpted genre figures, examples of which are in the museums of Prague and Pilsen.

WURZER, Wilhelm Johann 1773-1846
Born in Bamberg on March 12, 1773, he died there on October 20, 1846. He sculpted figures, bas-reliefs and altar-pieces for the churches in the Bamberg area.

WYATT, Edward 1757-1833
Born in London in 1757, he died in Surrey in 1833. He was a decorative sculptor and gilder of small ornaments.

WYATT, James 1808-1893
Born in London in 1808, he died there in 1893. He was the son and pupil of Matthew Wyatt and assisted his father. He exhibited at the Royal Academy from 1838 to 1844. His works include equestrian statues of Richard Coeur de Lion, Viscount Hardinge, Queen Victoria and Prince Albert, and a model of a quadriga for a triumphal arch.

WYATT, Matthew Coles 1777-1862
Born in London in 1777, he died there on January 3, 1862. He was the youngest son of the architect and Surveyor-General James Wyatt and was educated at Eton. At an early age he was employed to paint the ceilings at Windsor Castle. His first work as a sculptor was the Nelson monument for Liverpool, 1813. He sculpted an equestrian statue of George III in 1822 but controversy raged over it and it was not erected till 1836, in Cockspur Street, London. His most important work, however, was the monument to the Duchess of Rutland in the mausoleum of Belvoir Castle, 1828. His minor bronzes include a preliminary study of St. George and the Dragon, shown at the Great Exhibition of 1851 and now at Stratfield Saye, and a pair of small horses in high relief, commissioned by King George IV. He exhibited at the Royal Academy from 1800 to 1814 and at the British Institution from 1808 to 1822.

WYATT, Richard James 1799-1850
Born in London on May 3, 1799, he died in Rome on May 28, 1850. He was the son and pupil of Edward Wyatt and settled in Rome in 1820. He specialised in nude female figures.

WYK, Charles van 1875-1917
Born in Rotterdam in 1875, he died at The Hague in 1917. He studied under E. Lacomble and worked as a decorative sculptor in The Hague. He was awarded a bronze medal at the Exposition Universelle of 1900. His minor works consist of genre figures, such as The Prodigal Son, Mother and Child and Peasant at Work, and animalier subjects, such as Fishermen on Horseback and Woman with a Bull.

WYNANTS, Ernest 1878-
Born in Malines, Belgium, on September 27, 1878, he studied at the Brussels Academy and produced truly eclectic sculptures, which combined a glorious mixture of gothic, classical and baroque styles.

WYNNE, David 1926-
Born in 1926, he was educated at Stowe School and served in the Royal Navy for three years during the second world war. On demobilisation, he went to Cambridge University but left without taking a degree. While at Cambridge he became interested in art and took up sculpture

without any formal training in this medium. Since 1946, he has worked in a wide variety of sculptural fields, from direct carving in granite and marble, through modelling for casting in bronze or stainless steel, to plasters for coins and medals. His monumental sculpture comprises eleven large pieces in London, including the Tug of War (commissioned by Taylor Woodrow), the Hammersmith Column (for British Oxygen) and The Dancers (Cadogan Square). More than twenty of his works are on open-air exhibition in the United States, including the colossal figure of a Grizzly Bear, sculpted in Yugoslav marble for the Pepsi-Cola Sculpture Collection. As an Animalier he has had phases where he specialised in exotic creatures like bears and gorillas, dolphins, birds and more recently horses, ranging from the anatomically exact to the more stylised steel equestrian group for the city of Sheffield, modelled on the Celtic White Horse of Uffington. Since his first portrait head, of Sir Thomas Beecham, he has sculpted the portraits of numerous contemporary celebrities, often adopting an unusual treatment of the subject, evident in his portraits of Yehudi Menuhin and the Beatles. One of his more recent commissions was the crowned head of Queen Elizabeth, commissioned for Goldsmiths' Hall. He has also sculpted in low relief, and among his numismatic work was the reverse of the EEC 50p coin (1973), and the Silver Jubilee medal (1977). He lives and works in Wimbledon, London.

Boase, T.S.R. *The Sculpture of David Wynne, 1946-67,* (1968).

WYON, Allan Gairdner 1882-1962
Member of a family renowned chiefly as engravers of medals in the 19th century. He was born in London on June 1, 1882, and died in Cambridge in 1962. He was educated at Highgate Grammar School and entered holy orders, becoming vicar of Newlyn, Cornwall (1936-55). He studied sculpture at the Royal Academy and won silver medals there. Later he was a pupil of Sir Hamo Thornycroft. He exhibited at the Royal Academy, the Royal Scottish Academy, the Paris Salons and the leading London and provincial galleries. He sculpted genre and religious figures and groups, such as Pax Dolorosa, A Worshipper and Spirit of Slumber and also produced bas-reliefs, plaques and medals.

WYON, Edward William 1811-1885
Born in London in 1811, he died there in 1885. He was the son and pupil of Thomas Wyon (1767-1830), chief engraver of the seals at the Royal Mint, and studied at the Royal Academy schools. He made his début at the Academy in 1831 with a bust of General Maitland. Subsequently he specialised in portraits of contemporary political and military figures and historic literary personalities, such as Shakespeare and Milton. At the Great Exhibition of 1851 he showed a tazza modelled from a Greek original and subsequently cast by the Art Union of London. He also produced a number of busts and profiles for reproduction in jasperware by Wedgwood. His bronzes include the statue of Richard Green and his Newfoundland dog (1866), a statuette of Lord Dalhousie and numerous busts between 1835 and 1860. He sculpted copper reliefs and bronze plaques for memorials and tombstones in Berkshire and Sussex churches.

WYSPIANSKI, Francis fl. 19th century
Polish sculptor who died in Cracow on November 10, 1901. He sculpted busts, statuettes, groups, bas-reliefs, high reliefs, and ecclesiastical ornament for Polish churches. His minor works are preserved in the Cracow Museum.

XAVERY, Jean Baptiste 1697-1742
Born in Antwerp on March 30, 1697, he died in The Hague on July 19, 1742. He was the son and pupil of the sculptor Albert Xavery and worked in Italy for several years before settling in The Hague. He did a great deal of ornamental sculpture for the Stadholder William IV and decorative sculpture on public buildings and churches all over Holland. His minor works include memorial plaques and portrait busts of Dutch celebrities.

XAVIER, Raul 1894-
Born in Macao on March 23, 1894, he studied at the Lisbon Academy and sculpted statues, fountains and monuments in Lisbon and other Portuguese cities.

XIMENES, Antonio 1829-1896
Born in Palermo, Sicily, in 1829, he died there in 1896. He studied under Nungio Morello and exhibited figures and portrait sculpture in Vienna, Paris and the major Italian salons. He was a Cavaliere of the Order of the Crown of Italy.

XIMENES, Ettore 1855-1926
Born in Palermo on April 11, 1855, he died in Rome on December 20, 1926. He was the son of Antonio Ximenes and studied under Domenico Morelli at the Palermo Academy of Fine Arts. He exhibited in Palermo, Florence, Naples, Vienna and Paris and won a gold medal at the Exposition Universelle of 1900. He worked as a painter, book illustrator and sculptor, specialising in portrait busts of Italian royalty and contemporary celebrities.

YANDELL, Enid 1870-
Born in Louisville, Kentucky, on October 6, 1870, she studied under Philip Martiny in New York and Rodin in Paris. She specialised in portrait busts and statuary and sculpted monuments for various American towns. Her figure of Victory is in the St. Louis Museum.

YATES, Julie Chamberlain fl. early 20th century
Born in Governor's Island, U.S.A., in the late 19th century, she died on November 4, 1929. She studied under Rodin and worked as a genre sculptress in France and England.

YATES, Mary 1891-
Born in Chislehurst, Kent, on November 12, 1891, she was the daughter of the painter Frederick Yates. She studied under her father and worked in Rydal, Westmorland, as a painter and sculptor of landscapes and genre subjects. She has exhibited at the Royal Academy, the Royal Scottish Academy and various provincial galleries.

YENCESSE, Hubert 1900-
Born in Paris in 1900, he studied under his father who sculpted in stone and his mother who was a painter. Later he was Maillol's pupil and began exhibiting at the Salon d'Automne in 1931. His main career was as a decorative sculptor and he was responsible for a number of monuments and the decoration of the League of Nations headquarters in Geneva. His minor works consist mostly of female nudes.

YEPES, Eduardo Diaz 1910-
Born in Madrid in 1910, he emigrated to Latin America and acquired Uruguayan nationality in 1956. He was self-taught and began exhibiting in 1930, at the Madrid Fine Arts Circle. He had his first one-man show at the Athenaeum the following year. He left Madrid in 1934 and went to Montevideo where he married the daughter of the painter Torrès Garcia. He returned to Spain in 1937 and took part in the Exposition Internationale in Paris, but was imprisoned during the Civil War. After his release he settled in Barcelona, but returned to Montevideo in 1948. He has produced decorative sculpture for public buildings in Uruguay, often using exotic hardstones, but many of his smaller abstracts are cast in bronze. Since 1956 he has been a professor at the National School of Fine Arts in Montevideo.

YERRO-FELTRER, Antonio fl. 19th-20th centuries
Born in Valencia in 1842, he sculpted romantic figures and groups. He got an honourable mention at the Exposition Universelle of 1900.

YON, Charles Pierre 1803-1851
Born in Dijon in 1803, he died in Paris in 1851. He studied under Bornier and worked in Paris as an engraver, medallist and sculptor of bas-reliefs. He exhibited at the Salon from 1846 to 1848.

YOUNG, G.H.R. 1826-1865
Born in Berwick-on-Tweed in 1826, he died at Newcastle-on-Tyne on January 4, 1865. He worked as a decorative sculptor in Ulverston and Newcastle.

YOUNG, Mahonri M. 1877-
Born in Salt Lake City, Utah, in 1877, he was a pupil of the Art Students' League in New York and the Académie Colarossi in Paris and later taught at the Art Students' League. He was awarded a silver medal at the Panama-Pacific Exposition of 1915. He specialised in genre bronzes, such as A Labourer, The Rigger, The Chiseller, The Stevedore, The Shoveller, French Iron Worker, The Labourer Bovet Arthur and The Piper at the Gate.

YOUNGMAN, Harold James 1886-
Born in Bradford, Yorkshire, on October 17, 1886, he studied at the Plymouth School of Art, the Royal College of Art under Lanteri and the Royal Academy schools. He exhibited at the Royal Academy, the Royal Scottish Academy and provincial galleries. He sculpted figures and portraits and worked in London for many years. He was elected A.R.B.S. in 1921 and F.R.B.S. in 1937.

YOURIEVITCH, Sergei fl. 20th century
Born in Paris in the late 19th century, he sculpted figures and groups in the idiom of Rodin. He began exhibiting at the Salon des Indépendants in 1909 and later exhibited also at the Salon d'Automne. He was an Officier of the Légion d'Honneur.

YOVANOVIC, Georges Paul fl. 19th-20th centuries
Born in Belgrade in the mid-19th century, he studied under Chapu and Injalbert and settled in Paris where he specialised in historical and heroic Serb figures and groups. He won bronze and gold medals at the Expositions of 1889 and 1900 respectively.

YRONDY, Charles Gaston 1885-
Born in Paris on August 16, 1885, he studied under Injalbert and exhibited at the Salon des Artistes Français from 1907, winning a third class medal in 1911 and a silver medal in 1927. He became a Chevalier of the Légion d'Honneur in 1932, and was President of the Federation of Arts and Letters. His best known work as a sculptor is the war memorial at Lavallois-Perret. His minor works include the statuette of Parsifal (Petit Palais) and Return of the Father (Vannes Museum).

YRURTIA, Rogelio 1879-
Born in Buenos Aires on December 6, 1879, he studied at the Buenos Aires School of Art and later worked in Paris where he was inspired by the work of Rodin. He specialised in allegory, characterised by apocalyptic realism. The individual figures were reduced to their simplest form. His works include The Son of Labour, Action (for the Argentine Independence Monument), The Fisher-girls and Moses. He was awarded a grand prix at the St. Louis World's Fair of 1904.

YSABEAU, Louis Guillaume fl. 19th century
Born at Bourges on October 30, 1879, he exhibited at the Salon from 1835 to 1850 and specialised in medallions portraying European historical personalities, and statuettes of French historical celebrities from Vercingetorix onwards.

YSSIM — see MORNY, Mathilde, Marquise de

YZERDRAAT, Willem 1835-1907
Born in The Hague on October 31, 1835, he died in Haarlem on February 17, 1907. He worked in The Hague, Amsterdam and Haarlem as a decorative sculptor and also produced small bas-reliefs, medallions, busts and portrait statuettes.

ZADKINE, Ossip 1890-
Born in Smolensk, Russia, in 1890, he came to England in 1906 and completed his education in Sunderland where he also studied art at evening classes. He then went to London and began practising as a painter and sculptor but it was not until 1909, when he settled in Paris, that he found his true metier in Cubism. He became one of the leaders of the avant-garde in modern sculpture, but after 1920 he turned away from Cubism and adopted a more naturalistic style which was highly individualistic. Constantly experimenting with new forms and techniques, he explored ways of opening up the masses of his sculpture and by 1940 had formulated a kind of spatialism while remaining fundamentally a figurative sculptor. He is one of the most prolific and versatile sculptors of this century, his work ranging from the monumental (Destroyed Town, Rotterdam) to the semi-figurative Female Form (1918), from the baroque (Homage to J.S. Bach, 1932) to the abstract (Birth of Forms, 1943).He has also sculpted a number of busts of his contemporaries. He has worked in stone, wood and bronze and as a teacher, at the Académie de la Grande Chaumière and in his own studio, he has wielded tremendous influence on the present generation of sculptors in all three media. He has had a number of retrospective exhibitions since the second world war, in Paris, Amsterdam, London and Tokyo.

ZADOW, Fritz 1862-1926
Born in Nuremberg on May 14, 1862, he died there on November 30, 1926. He studied at the Nuremberg School of Arts and Crafts and the Berlin Academy and worked as a decorative and portrait sculptor in Nuremberg whose museums preserve many of his minor works.

ZAGORSKA, Wanda 1855-
Born in Poland in 1855, she worked as a decorative sculptor in Lwov. The Lwov Museum has her statue of Tadeusz Kosciuszko.

ZAISER, Johann fl. 19th century
Religious sculptor working in Stuttgart in the mid-19th century.

ZALE-ZALITIS, Karlis 1888-1942
Born in Latvia in 1888, he died in Riga in 1942. He studied at the St. Petersburg Academy and worked in Berlin for some time before settling in Riga as a decorative sculptor. He exhibited bronzes at the annual Latvian art show in Riga from 1931 to 1940.

ZALKALNS, Teodors 1876-
Born in Allazi, Latvia, in 1876, he studied at the Stieglitz School of Art and the St. Petersburg Academy and was a pupil of Rodin in Paris. He completed his studies at the Ekaterinburg School of Art. He sculpted numerous monuments and bas-reliefs in St. Petersburg and Latvia and his minor works are preserved in the museums of Riga, Malmö and Leningrad. He won the Latvian Culture Fund Prize in 1926, 1930, 1935 and 1937 and took part in the Latvian Art Exhibition in Paris, 1939.

ZAMBONI, Dante 1905-
American sculptor of Italian origin, specialising in nude figures and groups, such as Dancer (1959) and Rape of the Nymph (1961).

ZAMOYSKI, Auguste Count 1893-
Born in Jablon, Poland, on June 28, 1893, he worked in Paris and Bourg-la-Reine. He exhibited figures and portraits at the Paris Salons and also in Vienna, Zürich, Brussels, Berlin and New York in the inter-war period.

ZANDOMENEGHI, Luigi 1778-1850
Born in Colognola, Venezia, on February 20, 1778, he died in Venice on May 15, 1850. He worked mainly in Venice as a decorative and ecclesiastical sculptor. His minor works include many busts of his contemporaries.

ZANDOMENEGHI, Pietro 1806-1866
Born in Venice in 1806, he died there on October 24, 1866. He was the son and pupil of the above and also studied under Thorvaldsen in Rome. He worked as a decorative sculptor in Venice and Este.

ZANELLI, Angelo 1879-
Born in San Felice de Scovolo on March 17, 1879, he studied at the Florence Academy and worked in Rome and Naples as a decorative sculptor. He sculpted the Victor Emmanuel II monument in Rome.

ZARING, Louise Eleanor fl. 20th century
Born in Cincinnati, Ohio, at the turn of the century, she studied in Paris under Merson and was a pupil of the Art Students' League in New York. She settled in Paris and sculpted genre statuettes and portraits. She was a member of the American Female Artists' Association of Paris.

ZAUNER, Franz Anton von 1746-1822
Born at Unterwalpatann, Tyrol, on July 5, 1746, he died in Vienna on March 3, 1822. He sculpted fountains, statues and bas-reliefs for the churches, public buildings and parks of Vienna and Schönbrunn. His minor works include classical groups and busts of his contemporaries.

ZBINDEN, Joseph 1873-
Born in Lucerne on August 6, 1873, he studied at the Florence Academy and the École des Beaux Arts, Paris. He worked in Lucerne for several years as a portrait sculptor but later settled in Florence where he founded the International Academy of Fine Arts.

ZEGADLO, A. fl. 20th century
Polish sculptor of genre subjects, working in Warsaw since the second world war.

ZEILLER, Ottomar 1868-1921
Born in St. Vigil, Austria, on November 21, 1868, he died in Innsbruck on June 9, 1921. He specialised in statuettes of Tyrolean peasant subjects.

ZEITLIN, Alexander 1872-
Born in Tiflis, Georgia, on July 15, 1872, he studied under Zumbusch in Vienna and Falguière in Paris and exhibited at the Paris Salons from 1901 to 1914. After the first world war he worked in the United States and exhibited in New York in 1923. He specialised in portrait reliefs, medals and busts.

ZELEZNY, Franz 1866-1932
Born in Vienna on August 8, 1866, he died there on November 8, 1932. He studied at the Vienna School of Decorative Arts and assisted his father Franz Xavier Zelezny. He sculpted numerous busts and statues of contemporary celebrities.

ZELEZNY, Franz Xavier 1836-1911
Born at Sternberg on the Zazawa, Austria, on November 16, 1836, he died in Wolkersdorf on July 13, 1911. He sculpted portrait busts and statues of Austrian personalities, many of which are preserved in the Army Museum in Vienna.

ZELIKSON, Serge c.1890-
Born in Polotsk, Russia, about 1890, he won a travelling scholarship in 1912 and came to Paris where he studied at the École des Beaux Arts under Injalbert, Landowsky and Bouchard. He became a naturalised Frenchman in 1920. He exhibited at the Nationale, the Indépendants and the Salon d'Automne and various provincial galleries in France and specialised in busts, medallions and bas-reliefs portraying contemporary personalities, and genre figures and groups. His figure of a Volga Boatman is in the Paris Municipal Museum.

ZEMDEGA, Karlis 1894-
Born at Gesinde Gaili, Latvia, on April 7, 1894, he studied at the Riga Academy and sculpted many statues in Latvia. He won the Culture Fund Prize in 1928. He specialised in genre figures and groups, examples of which are in the Riga Museum.

ZERRITSCH, Fritz 1864-1938
Born in Vienna on February 26, 1864, he died there on November 30, 1938. He studied under Tilgner and worked as his assistant for eight years. He produced portrait busts, commemorative bas-reliefs and statuary.

ZETTLER, Emil Robert 1878-
Born in Karlsruhe in 1878, he studied at the Art Institute of Chicago, the Berlin Academy and the Académie Julian. He settled in Chicago whose museum has the chief collection of his portrait sculpture.

ZETTLITZER, Hermann 1901-
Born in Dux, Bohemia, on August 22, 1901, he studied at the Vienna Academy and won the Prix de Rome in 1927. He settled in Berlin in 1937 and later worked in Nuremberg, mainly as a wood-carver.

ZIEGLER, Archibald 1903-
Born in London on June 21, 1903, he studied at the Central School of Arts and Crafts and the Royal College of Art and has exhibited oil and watercolour paintings and portrait sculpture in the major galleries of London and the provinces, including several one-man shows. He has a studio in London.

ZIEGLER, Wilhelm 1857-
Born in Rosenberg, Switzerland, in 1857, he studied at the Vienna School of Fine Arts and became a professor at the Cantonal Technical College, Winterthur, in 1888. He worked as a modeller of small figures and a decorative sculptor in the Zürich area.

ZIESENIS, Anthony 1731-1801
Born in Hanover on December 26, 1731, he died in Amsterdam on March 25, 1801. He worked in Hamburg and Amsterdam as a decorative sculptor and architect.

ZIESENIS, Bartholomeus Wilhelmus Hendrikus 1762-1820
Born in Amsterdam in 1762, he died in The Hague on May 1, 1820. He was the son and assistant of Anthony Ziesenis.

ZIESENIS, Johannes 1770-1799
Born in Amsterdam in 1770, he died there in 1799. He was the second son of Anthony Ziesenis and studied under J. Andriesen and A. de Lelie. He specialised in portrait busts of the Dutch royal family and their ancestors.

ZIESENIS, Zacharias c.1775-
The youngest son of Anthony Ziesenis, he worked as a decorative sculptor in Amsterdam in the early 19th century.

ZIGLIO, Giuseppe fl. early 20th century
Ecclesiastical sculptor working in Rovereto, where he died in June 1931.

ZILLI, R. fl. 20th century
Portrait sculptor working in Italy, France and Luxembourg since the second world war. He produces busts, heads and bas-reliefs depicting international celebrities.

ZILOCCHI, Giacomo fl. 20th century
Born in Piacenza, Italy, in the late 19th century, he worked in Pietrasanta on tombs, memorials and commemorative statuary.

ZILZER, Hajnalka 1893-
Born in Budapest in 1893, she studied under M. Liget and specialised in heads and busts of Hungarian peasants.

ZIM, Marco 1880-
Born in Moscow in 1880, he emigrated to the United States and studied at the National Academy of Design and the École des Beaux Arts, Paris. He worked as a portrait sculptor in Los Angeles.

ZIMM, Bruno Louis 1876-
Born in New York on December 29, 1876, he studied under John Q.A. Ward, Saint-Gaudens and Karl Bitter. He won a silver medal at the Exposition Universelle of 1900. He sculpted bas-reliefs, plaques, medallions, memorials and statues for many parts of the United States, notably in New York, Houston and Wichita. The main collection of his works is in the San Francisco Art Building.

ZIMMERMANN, Édouard 1872-
Born in Stams, Switzerland, on August 2, 1872, he studied at the Munich Academy and sculpted figures, memorials, monumental statuary and fountains, religious, classical and allegorical groups and busts of contemporary celebrities. His chief works are the monument to the Swiss Guard (Vatican) and The Three Graces (Zürich Polytechnikum).

ZIMMERMANN, Gabriel Eugène Lucien 1877-
Born in Paris on January 22, 1877, he studied under Thomas and exhibited at the Salon des Artistes Français from 1901 onwards, winning a third class medal that year and a second class medal in 1902. He specialised in genre figures, such as The Goose-stealer (Amiens Museum).

ZINKEISEN, Anna Katrina 1901-1976
Born at Kilcreggan, Argyll, on August 28, 1901, she spent the latter years of her life at Burgh in Suffolk and died in London on September 23, 1976. She studied at the Royal Academy schools and began exhibiting at the Royal Academy and the Salon des Artistes Français in 1926, winning a silver medal with her début at the latter. She worked as a painter, designer (including posters and greetings telegrams) and sculptor of figures and bas-reliefs. She sculpted the decoration in the banqueting saloon of the liner *Queen Mary*.

ZINKEISEN, Doris Clare 1898-
Born at Gareloch, Dunbartonshire, at the beginning of this century, the elder sister of the above. She began exhibiting at the Royal Academy and the Salon des Artistes Français in 1929, winning a bronze medal in 1929 and a silver medal the following year. She worked as a painter of portraits and landscapes, costume designer, interior decorator and decorative sculptress.

ZITA, Heinrich 1882-
Born at Esseklee, Austria, on June 29, 1882, he studied at the Vienna Academy and began exhibiting there in 1902. He has sculpted many statues, monuments, busts, bas-reliefs and medals and had a studio in Vienna.

ZIVIC, Mihajlo 1899-
Born in Sikirevci, Croatia, in 1899, he studied at the Zagreb Academy and worked as a decorative sculptor in Osijek.

ZLATAREV, T. fl. 20th century
Figure and portrait sculptor working in Sofia since the second world war. He has sculpted a number of monuments, bas-reliefs and statues commemorating historic and political events in Bulgaria.

ZNIDER, Jakob 1862-
Born at St. Bartholima, Styria, on July 4, 1862, he studied at the Vienna Academy and worked as a decorative and ecclesiastical sculptor in Styria and Carinthia.

ZOCCHI, Arnaldo 1862-1940
Born in Florence on September 20, 1862, he died in Rome on July 17, 1940. He was the son and pupil of Emilio Zocchi and exhibited in Rome and Palermo from 1890 onwards. He sculpted many statues and monuments in Italy and Latin America.

ZOCCHI, Cesare 1851-1922
Born in Florence on June 7, 1851, he died in Turin on March 19, 1922. He was a cousin of Emilio Zocchi under whom he worked in Florence for several years before settling in Rome. He sculpted statuary in Rome, Ravenna, Venice and Florence.

ZOCCHI, Emilio 1835-1913
Born in Florence on March 5, 1835, he died there on January 10, 1913. He studied under Girolamo Torrini and Costalli and sculpted busts, bas-reliefs and statuettes of classical and Renaissance personalities. His allegorical groups include Work and Study (Sydney Museum). Other sculptures include the Head of a Horse, and The Graven Serpent.

ZOEGGER, François Antoine 1829-1885
Born in Wissembourg, France, on December 17, 1829, he died in Paris on January 3, 1885. He studied under Duret, Cogniet and Oudiné and exhibited at the Salon from 1865 to 1883. He was an ecclesiastical sculptor, specialising in medallions, reliefs and figures of the Virgin Mary.

ZOGBAUM, Wilfrid 1915-1965
Born in Newport, Rhode Island, in 1915, he died in East Hampton, New York, in 1965. He sculpted abstracts combining stone, steel and bronze.

ZOGELMANN, Karl 1826-1869
Born in Vienna in 1826, he died there on January 16, 1869. He studied at the Academy and worked in Vienna as a decorative sculptor.

ZOLLINGER, Heinrich 1821-1891
Born in Zürich on March 30, 1821, he died at Reisbach on April 28, 1891. He worked as a watercolourist, designer and engraver and is best known for his aquatints and lithographs. He also dabbled in genre sculpture.

ZOLNAY, George Julian 1863-
Born in Pecs, Romania, on July 4, 1863, he studied in Bucharest, Paris and Vienna and settled in the United States in 1892. He sculpted many monuments and statues all over the United States and participated in the St. Louis World's Fair of 1904. His minor works include numerous portrait busts and memorials. He had a studio in Washington, D.C.

ZOMERS, Joseph 1895-1928
Born in Liège in 1895, he died there in 1928. He worked in that city as a decorative sculptor and the local museum has several of his minor works.

ZONZA BRIANO, Pedro 1888-
Born in Buenos Aires on November 27, 1888, he studied in Buenos Aires and Rome and sculpted monuments and statuary in Buenos Aires whose museums have many of his smaller works.

ZORACH, William 1887-
Born in Eurburg, Lithuania, in 1887, he emigrated with his family to the United States in 1891. They settled in Cleveland, Ohio, and he attended evening classes at the local art school. Later he studied at the National Academy of Design in New York (1907-8) and worked in Paris under J.E. Blanche and J.D. Fergusson (1910-11). He made his début as a painter in 1911 at the Salon d'Automne and two years later exhibited paintings at the New York Armory show. He took up sculpture in 1917 but did not abandon painting altogether until 1922. He had one-man shows at the Kraushaar Galleries in 1924 and 1928 and exhibited regularly at the Downtown Gallery from 1931 onwards. He became a teacher at the Art Students' League in 1929. He received a number of major commissions for decorative sculpture, notably in Radio City (1932), the Post Office headquarters building, Washington (1937) and the Mayo Clinic. He has sculpted portrait busts, heads, figures, torsos, animals, children and genre subjects in stone and wood, using the direct carving method, often showing rough unfinished surfaces contrasting with highly polished areas.
Zorach, William *Zorach explains Sculpture* (1960).

ZORILLA DE SAN MARTIN, José Luis 1891-
Born in Montevideo on September 6, 1891, the son of the romantic poet Juan Zorilla de San Martin. He was brought up in an intensely Catholic atmosphere and this is reflected in his work, combined with classicism and the primitive art forms of South America. He received many state commissions in Uruguay and sculpted monuments, statues and busts of historical and contemporary celebrities. His minor works include a bronze Pietà. He was awarded a medal by the Salon des Artistes Français for his Fountain of Athletes.

ZORN, Anders 1860-1920
Born at Mora in the province of Dalecarlia, Sweden, on February 18, 1860, he died there on August 22, 1920. The fact that he was born and died in the same village belies the fact that he led an intensely nomadic existence, spending much of his time in France and Britain and visiting the United States on six occasions. He painted landscapes and genre subjects and the portraits of international celebrities of the turn of the century. As an etcher he is regarded as one of the leading exponents of this medium in the late 19th century. He took up sculpture in the 1880s and produced a large number of portrait busts and figures of genre subjects, such as peasants and bathers. His best known works in this medium include Nymph and Faun (1895), Morning Bath, Broken Pitcher and Alma (1911). He also sculpted the monument to Gustavus Vasa at Mora (1903) and the Monument of the Waves, Copenhagen.
Asplund, K. *Anders Zorn: his Life and Work* (1921). Hedberg, T. *Anders Zorn* (1910). Lang, E.M. *Anders Zorn* (1923). Malmberg, E. *Larsson, Liljefors, Zorn* (1919). Servaes, F. *Anders Zorn* (1910).

ZOTTO, Antonio da 1841-1918
Born in Venice in 1841, he died there on February 19, 1918. He made his début in 1857 with a group of St. Anthony and the Infant Jesus. He became professor at the School of Arts and Industries in Venice in 1870 and later became a professor at the Venice Academy. He sculpted statues and busts of historic and contemporary Italian personalities.

ZOULA 1871-1915
Born in Prague on August 9, 1871, he died there on August 4, 1915. He studied at the Academy in his native city and sculpted numerous monuments and memorials there. His minor works include portrait busts and statuettes.

ZSCHOKKE, Alexander 1894-
Born in Basle on November 25, 1894, he studied at the Munich Academy and exhibited in that city from 1918 onwards, mostly portrait busts and figures characterised by their outstretched limbs. He took part in the exhibitions of the Swiss Society of Painters and Sculptors. His works are preserved in the museums of Basle, Berlin, Essen, Hanover and Munich.

ZUECH, Stefan 1877-
Born in Brez, Austria, on November 5, 1877, he studied at the Vienna Academy and worked in the Trieste area on memorials, tombs, ecclesiastical sculpture and the decoration of public buildings.

ZÜGEL, Wilhelm 1876-
Born in Munich on June 22, 1876, he studied painting under his father, Heinrich Zügel, but later turned to sculpture, a medium in which he taught himself. He specialised in animal figures, particularly birds. His bronzes include Pelican at Rest, Pelican preening its Feathers, Condor, Giraffe (Berlin Museum), Bear Playing, Rhinoceros (Bremen Museum) and Eagle (National Gallery, Munich).

ZÜLLI, Michael 1815-1896
Born in Sur, Switzerland, on January 2, 1815, he died in Munich on March 3, 1896. He studied at the Munich Academy and exhibited in Lucerne from 1869 to 1889. He specialised in busts of historical German celebrities and figures of biblical characters.

ZÜLLICH VON ZÜLBORN, Rudolf 1813-1890
Born in Gyulafehervar, Hungary, on July 3, 1813, he died in Cairo, Egypt, on January 13, 1890. He studied in Vienna and Rome and specialised in classical figures and groups.

ZUMBUSCH, Kaspar Clemens Eduard von 1830-1915
Born in Herzebrock, Austria, on November 27, 1830, he died in Rimsting on September 27, 1915. He settled in Vienna where he sculpted numerous statues and monuments and taught at the Academy. He exhibited widely in Europe and among his many awards was a first class medal at the Exposition Internationale of 1878. His minor works include busts of his artistic and musical contemporaries.

ZUMBUSCH, Nora von (née Exner) 1879-1915
Born in Vienna on February 3, 1879, she died there on February 18, 1915. She studied under Alfred Roller and worked as a potter and genre sculptor in Vienna.

ZÜRCHER, Max 1868-1926
Born in Zürich on April 7, 1868, he died in Rome on June 19, 1926. He studied in Dresden, Berlin and Paris and exhibited in Munich from 1896 onwards. He worked as a painter, architect and modeller of statuettes.

ZUTT, Richard Adolf 1887-
Born in Basle on January 25, 1887, he studied in Munich and Florence and worked as a painter, jeweller and sculptor. The Budapest National Museum has his Head of a Roman.

ZWOBADA, Jacques Charles 1900-
Born in Neuilly-sur-Seine on August 6, 1900, descended from a Slavonic family which had settled in France in the 18th century. He studied painting under his father and picked up the rudiments of sculpture from a schoolmaster. He spent less than six months at the École des Beaux Arts but rejected the academic approach of his teachers. His interest was revitalised by an exhibition of Rodin's works. Thereafter he gradually moved away from representational sculpture and experimented with semi-figurative and abstract forms.

In the 1920s he sculpted a number of monuments, culminating in his Bolivar Monument for Quito, Ecuador (1933), and the gateway of the Belfort Cemetery completed the same year. Thereafter he spent eight years teaching drawing at the École Supérieure de l'Enseignement Technique, the Académie de la Grande Chaumière and the Académie Julian. In 1948 he took up a teaching post in Caracas, but returned to France and took up sculpture again in the 1950s. His chief work in this period was the large bronze The Couple (1956) and this, together with many of his subsequent works, was designed as part of the memorial at Camp Santo Mentana near Rome to his late mistress. Other bronzes by Zwobada include Wrestlers (1953), Orpheus (1954), Night Ride (1957) and Vertical (1960).

ZYL, Lambertus 1866-
Born at Kralingen, Holland, in 1866, he studied at the School of Decorative Art in Amsterdam and settled in that city where he specialised in statuettes.

ZYSSET, Ernest 1887-
Born at Reconvilier, Switzerland, on April 7, 1887, he studied under Wadere in Munich and became professor of sculpture at Bienne, Switzerland.

FAMILY TREES

THE CAUER FAMILY TREE — all sculptors

Emil the Elder
1800-1867

Karl
1828-1885

Robert the Elder
1831-1893

Robert the Younger
1863-

Hugo
1864-

Ludwig
1866-

Emil the Younger
1867-

Hans
1870-

Friedrich
1874-

Stanislaus
1867-

THE DUTHOIT FAMILY TREE

Jacques François
F. early 18th century
Tournai

Marcelin François
1765-1845

Louis Joseph
1766-1824

Seraphin Joseph
1760-

Jean Baptiste
1811-1893

Aimé
1805-1869

Alcide

Louis
1807-1874

THE ECKHARDT FAMILY of Darmstadt and Vienna

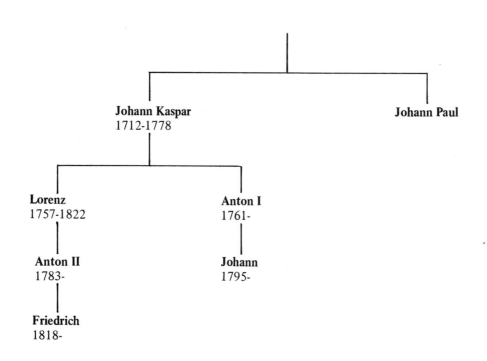

THE GEEFS FAMILY TREE

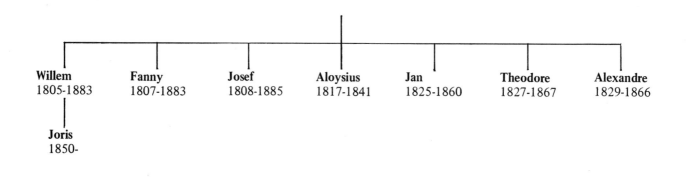

THE HAUTTMAN FAMILY TREE

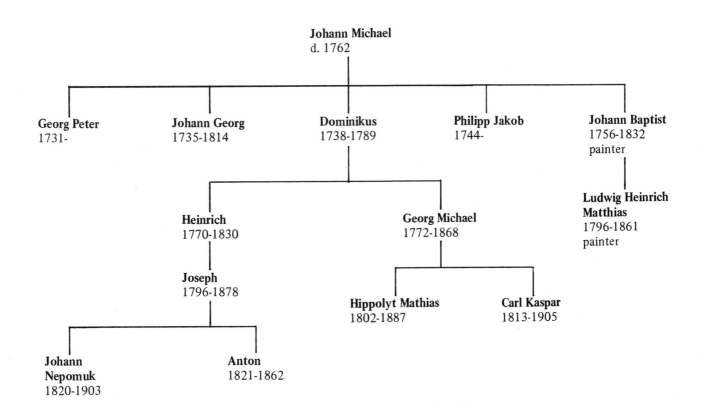

Johann Michael
d. 1762

Georg Peter
1731-

Johann Georg
1735-1814

Dominikus
1738-1789

Philipp Jakob
1744-

Johann Baptist
1756-1832
painter

Ludwig Heinrich
Matthias
1796-1861
painter

Heinrich
1770-1830

Georg Michael
1772-1868

Joseph
1796-1878

Hippolyt Mathias
1802-1887

Carl Kaspar
1813-1905

Johann
Nepomuk
1820-1903

Anton
1821-1862

THE POZZI FAMILY TREE fl. 18th-19th centuries

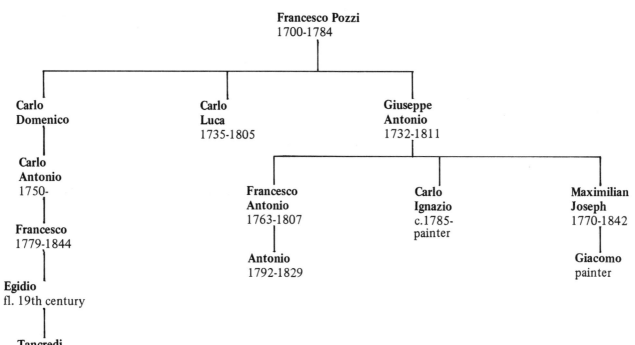

Francesco Pozzi
1700-1784

Carlo
Domenico

Carlo
Luca
1735-1805

Giuseppe
Antonio
1732-1811

Carlo
Antonio
1750-

Francesco
Antonio
1763-1807

Carlo
Ignazio
c.1785-
painter

Maximilian
Joseph
1770-1842

Francesco
1779-1844

Antonio
1792-1829

Giacomo
painter

Egidio
fl. 19th century

Tancredi
1864-1929

THE SCHOLL FAMILY TREE — fl. 18th-19th centuries

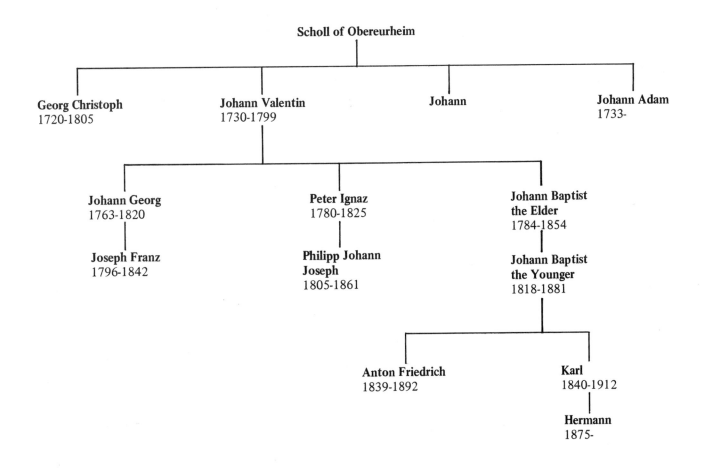

Scholl of Obereurheim

Georg Christoph
1720-1805

Johann Valentin
1730-1799

Johann

Johann Adam
1733-

Johann Georg
1763-1820

Peter Ignaz
1780-1825

Johann Baptist
the Elder
1784-1854

Joseph Franz
1796-1842

Philipp Johann
Joseph
1805-1861

Johann Baptist
the Younger
1818-1881

Anton Friedrich
1839-1892

Karl
1840-1912

Hermann
1875-

THE SCHWANTHALER FAMILY TREE

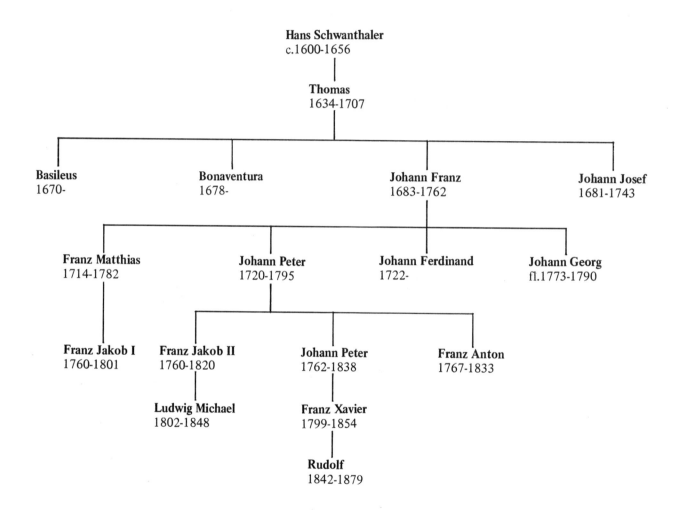

Hans Schwanthaler
c.1600-1656

Thomas
1634-1707

Basileus
1670-

Bonaventura
1678-

Johann Franz
1683-1762

Johann Josef
1681-1743

Franz Matthias
1714-1782

Johann Peter
1720-1795

Johann Ferdinand
1722-

Johann Georg
fl.1773-1790

Franz Jakob I
1760-1801

Franz Jakob II
1760-1820

Johann Peter
1762-1838

Franz Anton
1767-1833

Ludwig Michael
1802-1848

Franz Xavier
1799-1854

Rudolf
1842-1879

SELECT BIBLIOGRAPHY

General Works

Arwas, Victor *Art Deco Sculpture* (London, 1976)

Barr, Alfred H. Jr. *Masters of Modern Art* (London, New York, 1954)

Benezit, Emmanuel *Dictionnaire critique et documentaire des Peintres, Sculpteurs, Dessinateurs et Graveurs* 8 vols. (Paris, 1966)

Bernhardt, M. *Medaillen und Plaketten* (Berlin, 1920)

Bowness, Alan *Modern Sculpture* (London, 1965)

Champeaux, A. de *Dictionnaire des Fondeurs, Ciseleurs, Modeleures en Bronze A-C* (uncompleted) (Paris, 1886)

Cheney, Sheldon *Sculpture of the World* (London, New York, 1968)

Cooper, Jeremy *Nineteenth Century Romantic Bronzes* (Newton Abbott, 1975)

Fegdal, Charles *Ateliers d'Artistes* (Paris, 1925)

Fierens, Paul *Sculpteurs d'Aujourdhui* (Paris, London, 1933)

Forrer, Leonard *Biographical Dictionary of Medallists* 8 vols. (London, 1904-30)

Giedion-Welcker, Carola *Modern Plastic Art* (London, 1937; revised edition, 1955)

Gonse, Louis *Les Chefs-d'oeuvre des Musées de France* (Paris, 1904)

Grohmann, Will *Art of our Time: Painting and Sculpture throughout the World* (London, 1966)

Hager, Werner and Wagner, Eva-Maria *Baroque Sculpture* (New York, 1965)

Huyghe, René *Larousse Encyclopaedia of Modern Art from 1800 to the Present Day* (London, New York, 1965)

Knaur *Lexikon moderner Kunst* (Berlin, 1955)

Lüer, Hermann and Creutz, Max *Geschichte der Metalkunst* 2 vols. (Stuttgart, 1904)

Mackay, James *The Animaliers* (London, New York, 1973)

Maillard, Robert (ed.) *A Dictionary of Modern Sculpture* (Paris, 1960; London, 1962)

Molesworth, H.D. and Brookes, P. Cannon *European Sculpture from Romanesque to Neo-Classic* (London, New York, 1965)

Montagu, Jennifer *Bronzes* (London, 1963)

Newton, Eric *European Painting and Sculpture* (London 1961)

Parkes, Kineton *Sculpture of Today: America, Great Britain and Japan* (London, 1921)

Post, Chandler R. *A History of European and American Sculpture from the Early Christian Period to the Present Day* 2 vols. (New York, 1969)

Ramsden, E.H. *Twentieth Century Sculpture* (London, 1949)

Read, Herbert *A Concise History of Modern Sculpture* (London, 1964)

Rheims, Maurice *La Sculpture au XIX Siècle* (Paris, 1972)

Rindge, Agnes M. *Sculpture* (New York, 1929)

Ritchie, Andrew C. *Sculpture of the Twentieth Century* (New York, 1953)

Rothschild, Lincoln *Sculpture through the Ages* (New York, 1942)

Savage, George *A Concise History of Bronzes* (London, New York, 1968)

Scheffler, Karl *Geschichte der europäischen Plastik in 19ten und 20ten Jahrhundert* (Berlin, 1927)

Selz, Jean *Modern Sculpture: Origins and Evolution* (London, 1963)

Seuphor, Michel *The Sculpture of this Century* (Neuchatel, London, 1959)

Silvestre, Théophile *Histoire des Artistes Vivantes* (Paris, 1957)

Struppeck, Jules *The Creation of Sculpture* (New York, 1952)

Taft, Lorado *Modern Tendencies in Sculpture* (New York, 1921)

Thieme, U. and Becker, F. *Allgemeines Lexikon der bildenden Künstler von der Antike zur Gegenwart* 37 vols. (Leipzig, 1907-33, 1951)

Trier, Eduard *Form and Space* (London, New York, 1968)

Vollmer, H. *Allgemeines Lexikon der bildenden Künstler* (Munich, 1953)

Who's Who in Art: various editions since 1927 (Havant, Hants.)

Catalogue of Collections

Baldry, A.L. *The Wallace Collection at Hertford House* (London, Paris, 1904)

Bange, E.F. *Die Bildwerke in Bronze – Staatliche Museen zu Berlin* (Berlin, 1923)

Dijon Museum *Catalogue historique et descriptif du Musée de Dijon* (Dijon, 1883)

Figdor Collection *Bronzen aus der Sammlung Figdor* (Berlin, 1930)

Fortnum Collection *Summary Guide, Ashmolean Museum* (Oxford, 1920)

Gardner, A.T. *Catalogue of American Sculpture in the Metropolitan Museum* (New York, 1965)

Gerdts, W. *Sculpture by Nineteenth Century American Sculptors in the Collection of the Newark Museum* (Newark, New Jersey, 1962)

Lanna Collection *Sammlung des Freiherrn Adalbert von Lanna, Prag* 2 vols. (Berlin, 1909-11)

Louvre *Catalogue des bronzes et cuivres* (Paris, 1904-)

Mann, J.G. *Wallace Collection Catalogues: Sculpture* (London, 1931)

Musée Retrospectif *Catalogue des objets d'Art et de curiosité exposes au Musée Retrospectif ouvert au Palais de d'Industrie en 1865* (Paris 1867)

Shelley, H.C. *The Art of the Wallace Collection* (Boston, 1913)

Spitzer Collection *Catalogue, vol. IV: Sculpture* (London, Paris, 1891)

Stockholm National Museum *Nationalmusei Skulptursamling* (Stockholm, 1929)

Tietze-Conrat, E. *Die Bronzen der fürstliches Liechtensteinischen Kunstkammer* (Vienna, 1918)

Abstract Sculpture

Barr, Alfred H. Jr. *Cubism and Abstract Art* (New York, 1936) *Masters of Modern Art* (London, New York, 1954)

Bouret, J. *L'Art abstrait* (Paris, 1957)

Brion, M. *Art abstrait* (Paris, 1956)

Giedion-Welcker, Carola *Contemporary Sculpture: An Evolution in Volume and Space* (Zürich, 1960)

Kultermann, Udo *The New Sculpture: Environments and Assemblages* (London, 1970)

Ragon, M. *L'Art abstrait* (Paris, 1956)

Ritchie, Andrew C. *The New Decade: 22 European Painters and Sculptors* (London, New York, 1955)

Seuphor, Michel *L'Art abstrait* (Paris, 1949)

Seymour, Charles *Tradition and Experiment in modern Sculpture* (Washington, 1949)

Valentiner, Wilhelm R. *Origins of Modern Sculpture* (New York, 1946)

Wilenski, Reginald H. *The Meaning of Modern Sculpture* (New York, 1935)

American Sculpture

Brumme, C. Ludwig *Contemporary American Sculpture* (New York, 1948)

Caffin, Charles H. *American Masters of Sculpture* (New York, 1913)

Craven, W. *Sculpture in America* (New York, 1968)

Larkin, Oliver W. *Art and Life in America* (New York, 1949)

Ritchie, Andrew C. *Abstract Painting and Sculpture in America* (New York, 1951)

Schnier, Jacques *Sculpture in Modern America* (Berkeley, Los Angeles, 1948)

Taft, Lorado *The History of American Sculpture* (New York, 1903; revised 1930)

University of Illinois *Contemporary American Painting and Sculpture* (Urbana, 1953)

British Sculpture

Cox, Kenyon *Old Masters and New* (London, 1925)

Cunningham, Allan *The Lives of the Most Eminent British Painters, Sculptors and Architects* 3 vols. (London, 1830)

Esdaile, Katherine A. *English Monumental Sculpture since the Renaissance* (London, 1927)

Fine Arts Society *British Sculpture 1850 to 1914* (London, 1968)

Grant, Col. Maurice H. *A Dictionary of British Sculptors* (London, 1953)

Graves, Algernon *A Dictionary of Artists . . . exhibiting at the Royal Academy, 1760-1893* (London, 1884-1901; reprinted Bath, 1969)

Gunnis, Rupert *Dictionary of British Sculptors 1660 to 1850* (London, 1953 and 1968)

Halliday, T.S. and Bruce, George *Scottish Sculpture* (London, Edinburgh, 1946)

Hammacher, A.M. *Modern English Sculpture* (London, New York, 1967)

Newton, Eric *British Sculpture 1944-46* (London, 1947)

Parr, Lenton *Arts in Australia: Sculptors* (Sydney)

Ramsay, L.G.G. *Connoisseur Guide to English Painting and Sculpture: Tudor to Early Victorian* (London, 1962)

Redgrave, Samuel *A Dictionary of Artists of the English School* (London, 1878; reprinted Bath, 1970)

Rothenstein, Sir John *British Art since 1900* (London, 1962)

Spielmann, M.H. *British Sculpture and Sculptors of Today* (London, 1901)

Strickland *Dictionary of Irish Artists*

Underwood, E. *Short History of English Sculpture* (London, 1933)

Whinney, Margaret *English Sculpture, 1720-1830* (London, 1971) *Sculpture in Britain, 1530-1830* (Harmondsworth, 1964)

Waters, Grant M. *Dictionary of British Artists working 1900-1950* (Eastbourne, 1975)

French, Belgian and Swiss Sculpture

Basler, Adolphe *Modern Sculpture in France* (Paris, 1928)

Bellier de la Chavignerie, Émile *Dictionnaire General des Artistes de l'École Française* (Paris, 1885)

Benedite, L. *Les Sculpteurs Français contemporains* (Paris, 1901)

Benoist, L. *La Sculpture romantique* (Paris, 1928)

Boucher, François *Le Pont Neuf* 2 vols. (Paris, 1926)

Brownell, W.C. *French Art: Classic and Contemporary Painting and Sculpture* (London, 1892)

Chevalier, Edmond *La Sculpture belge* (Brussels, undated)

Coquiot, G. *Les Indépendants, 1880-1920* (Paris, 1920)

Destree, O.G. *The Renaissance of Sculpture in Belgium* (Brussels, London, 1895)

Dilke, Lady *French Architects and Sculptors of the XVIIIth Century* (London, 1900)

Eaton, D.C. *A Handbook of Modern French Sculpture* (New York, 1913)

Édouard, Joseph *Dictionnaire biographique des Artistes contemporains, 1910-30* 3 vols. (Paris, 1930-36)

George, W. *Jeunes Sculpteurs français* (Paris, undated)

Georges-Michel, Michel *Peintres er Sculpteurs que j'ai connus 1900-42* (New York, 1942)

Gonse, Louis *La Sculpture française depuis le XIVe Siècle* (Paris, 1895)

Horswell, Jane *Les Animaliers* (Woodbridge, 1971)

Houssaye, Arsène *Histoire de l'Art Français au XVIIIe Siècle* (Paris, 1860)

Jalabert, D. *La Sculpture française* (Paris, 1931)

Joray, Marcel *La Sculpture moderne en Suisse: Schweizer Plastik der Gegenwart* (Neuchâtel, 1959)

Jouin, H. *La Sculpture aux Salons* (Paris, 1870)

Lami, Stanislas *Dictionnaire des Sculpteurs de l'École française, Part III: au dix-huitième Siècle* 2 vols. (Paris, 1911-19)

Marchiori, Giuseppe *Modern French Sculpture* (London, 1964)

Pradel, P. *La Sculpture du XIX Siècle* (Paris, 1958)

Salmon, André *La jeune Sculpture française* (Paris, 1919)

Salon de la Jeune Sculpture *La jeune Sculpture* (Paris, 1954)

Speed Art Museum *Nineteenth Century French Sculpture* (Louisville, Kentucky, 1971)

Taeye, E.L. de *Les Artistes belges contemporains* (Brussels, 1896)

Van Oest Publications *Histoire de la Peinture et de la Sculpture en Belgique de 1830 à 1930* (Paris, 1930)

Vanzype, G. *L'Art belge du XIX Siècle* (Paris, 1923)

German Sculpture

Dehio, G. *Geschichte der deutschen Kunst* 4 vols. (Berlin, 1930-34)

Hentzen, Alfred *Deutsche Bildhauer der Gegenwart* (Berlin, 1934)

Hildebrandt, Hans *Deutsche Plastik der Gegenwart* (Munich, 1952)

Lucerne Kunstmuseum *Deutsche Kunst: Meisterwerke des 20 Jahrhunderts* (Lucerne, 1953)

Nemitz, Fritz *Junge Bildhauer* (Berlin, 1939)

Italian Sculpture

Carrieri, Raffaele *Pittura, Scultura d'Avanguardia in Italia, 1890-1950* (Milan, 1950)

Constantini, Vincenzo *Scultura e Pittura Italiana contemporanea (1880-1926)* (Milan, 1940)

Marchiori, Giuseppe *Scultura Italiana Moderna* (Venice, 1953)

Salvini, Roberto *Modern Italian Sculpture* (London, 1962)

Sapori, Francesco *Scultura Italiana Moderna* (Rome, 1949; London, 1950)

Soby, J.T. and Barr, Alfred H. Jr. *Twentieth Century Italian Art* (New York, London, 1949)

Venturi, A. *Storia dell'Arte Italiana* (Milan, 1901-28)

Zervos, Christian *Un Demi-siècle d'Art Italien* (Paris, 1950)

Other Countries

Calvert, A.F. *Sculpture in Spain* (London, 1912)

Divald, C. *Histoire de l'Art hongrois* (Budapest, 1927)

Jorga, N. and Bals, G. *Histoire de l'Art Roumain* (Paris, 1922)

Kuhn, A. *Die polnische Künst von 1800 bis zur Gegenwart* (Berlin, 1930)

Madsen, Kurt *Künstens Historie in Danmark* (Copenhagen, 1901-7)

Matajcek, A. and Wirth, Z. *Contemporary Czech Art* (Prague, 1921)

Pagano, J.L. *Historia del Arte Argentino* (Buenos Aires, 1944)

Peter, A. *History of Hungarian Art* (Budapest, 1930)

Romdahl and Roosval *Svensk Konsthistoria* (Stockholm, 1913)